BYZANTIUM
AND
ISLAM
AGE OF TRANSITION

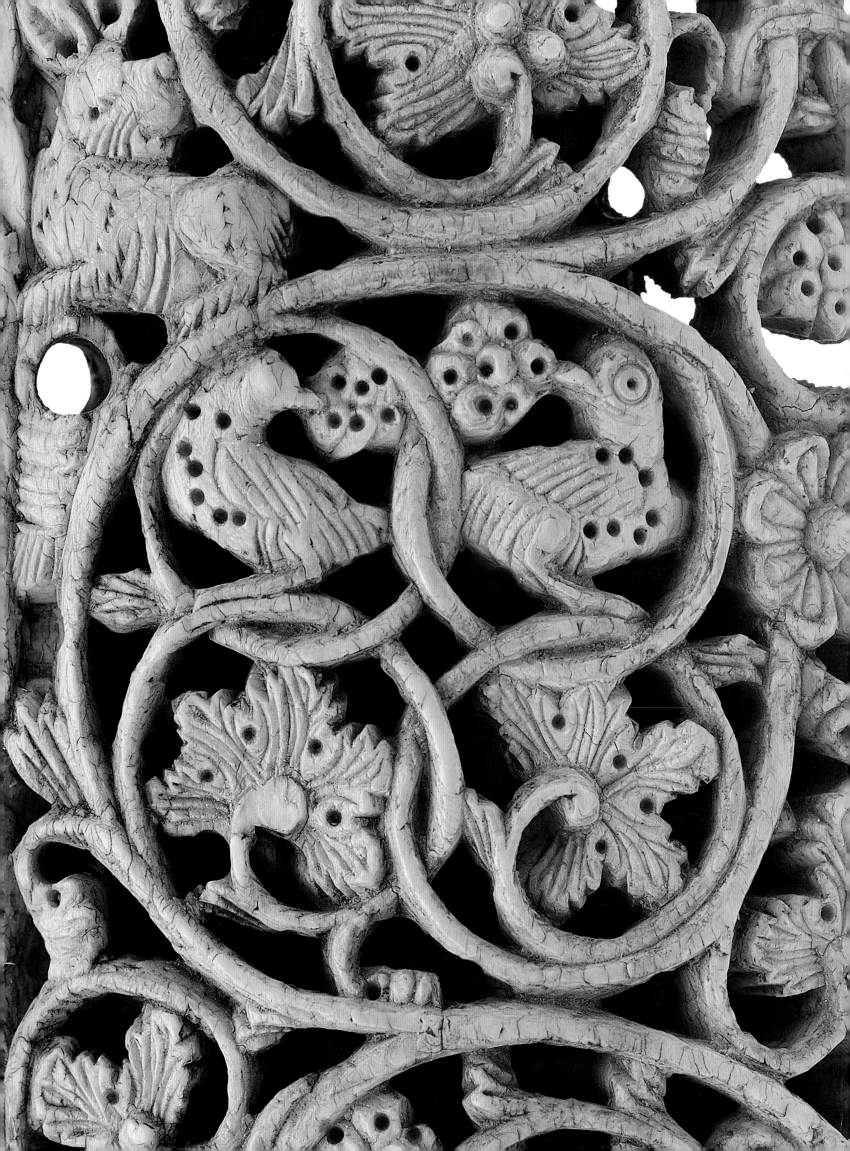

BYZANTIUM
AND
ISLAM

AGE OF TRANSITION
7th – 9th Century

EDITED BY

Helen C. Evans with Brandie Ratliff

The Metropolitan Museum of Art, New York

Distributed by Yale University Press, New Haven and London

Published in conjunction with the exhibition "Byzantium and Islam: Age of Transition (7th–9th Century)" organized by The Metropolitan Museum of Art, New York, March 14–July 8, 2012.

Major support for the exhibition and this publication has been provided by
 Mary and Michael Jaharis
 The Stavros Niarchos Foundation
 The Hagop Kevorkian Fund.

Additional support has been provided by the National Endowment for the Arts.

The exhibition is supported by an indemnity from the Federal Council on the Arts and the Humanities.

Published by The Metropolitan Museum of Art, New York
Mark Polizzotti, Publisher and Editor in Chief
Gwen Roginsky, Associate Publisher and General Manager of
 Publications
Peter Antony, Chief Production Manager
Michael Sittenfeld, Managing Editor
Robert Weisberg, Assistant Managing Editor

Edited by Alexandra Bonfante-Warren and Cynthia Clark
Designed by Bruce Campbell
Bibliography by Philomena Mariani
Production by Jennifer Van Dalsen
Map by Anandaroop Roy

Typeset in Bembo Std, Perpetua Titling MT, and Trajan Pro.
Arabic typeset in Lotus Linotype. Greek and Coptic typeset in
Garamond Premier Pro, Athena, and New Athena Unicode.
Aramaic typeset in Estrangelo Edessa.
Printed on 150 gsm Creator Silk
Separations by Professional Graphics, Inc., Rockford, Illinois
Printed and bound by Mondadori Printing S.p.A., Verona, Italy

Front jacket/cover illustration: Detail of *Ivories of the So-Called
 Grado Chair*, cat. no. 24B
Back jacket/cover illustration: Detail of *Luster-Painted Flask*,
 cat. no. 155
Page 2: Detail of *Hanging with Images of Abundance*, cat. no. 3
Page 122: Detail of *Silks with "Samson" and the Lion*, cat. no. 102B
Page 198: Detail of *Architectural Fragments with Carved Decoration*,
 cat. no. 142B
Hardcover case illustration: Detail of *Icon with the Three Hebrews
 in the Fiery Furnace*, cat. no. 26
Endpapers: Detail of *Lattice-Patterned Silks*, cat. no. 99C
Frontispiece: Detail of *Decorative Ivory Plaques*, cat. no. 121A

The Metropolitan Museum of Art
1000 Fifth Avenue
New York, New York 10028
metmuseum.org

Distributed by
Yale University Press, New Haven and London
yalebooks.com/art
yalebooks.co.uk

Cataloging-in-Publication Data is available from the Library of Congress.
ISBN 978-1-58839-457-6 (hc: The Metropolitan Museum of Art)
ISBN 978-1-58839-458-3 (pbk: The Metropolitan Museum of Art)
ISBN 978-0-300-17950-7 (hc: Yale University Press)

Contents

ISLAM

Director's Foreword

As the Arab Spring transforms countries from Tunisia to Syria and down the Red Sea to Yemen, "Byzantium and Islam: Age of Transition (7th–9th Century)" offers a unique opportunity to understand a climactic transformation in the region's earlier history, an era that remains influential today. Between the seventh and the ninth centuries, the wealthy southern provinces of the Byzantine Empire, extending around the Mediterranean basin from Syria to Egypt and across North Africa to Spain, long part of the Hellenistic tradition and the Roman world, became part of the emerging Islamic world. The Christian and Jewish populace went from being central to the fortunes of the Christian state ruled from New Rome, Constantinople (modern Istanbul), to being governed initially by the Muslim Umayyads from Damascus in modern Syria and ultimately by the Abbasids in Baghdad in modern Iraq. The trade route along the Red Sea past Yemen once dominated by Byzantine allies became part of the new Islamic order.

"Byzantium and Islam: Age of Transition," the Museum's fourth major exhibition on the art and culture of the Byzantine Empire, displays the exceptional traditions of the southern provinces of the empire in the seventh to ninth century and traces their impact on Christian communities under Islamic rule and the emerging aesthetic of the first generations of Islamic art and culture. In so doing, this exhibition concludes the exploration of the arts of Byzantium surveyed in the Museum's earlier landmark shows—"Age of Spirituality: Late Antique and Early Christian Art, Third to Seventh Century" in 1977; "The Glory of Byzantium: Art and Culture of the Middle Byzantine Era (A.D. 841–1261)" in 1997; and "Byzantium: Faith and Power (1261–1557)" in 2004. Together these exhibitions have expanded our understanding of the importance and accomplishments of an empire whose influence was at one time nearly forgotten.

Exhibitions of this international scale are increasingly rare; this project and its predecessors are among the most ambitious undertaken during the past three decades. We appreciate the major loans from forty-nine institutions in fifteen countries that have made this exhibition possible. Most especially, we thank the Benaki Museum in Athens and the Department of Antiquities in Jordan, whose extensive loans have enabled us to display appropriately the arts of the first centuries of Islamic rule in the region. As this publication goes to print, we continue to hope that events of the Arab Spring will allow works of art from the Holy Monastery of Saint Catherine at Sinai and the Islamic and Coptic museums of Cairo to be present in New York for the exhibition.

"Byzantium and Islam: Age of Transition" has been made possible by generous donors who have long been committed to the Metropolitan's work in this field. Mary and Michael Jaharis have once again provided exceptional leadership support. The Stavros Niarchos Foundation has also continued its generous commitment to scholarship in this area. Under the leadership of Ralph Minasian, The Hagop Kevorkian Fund's long-standing dedication to our Byzantine projects is remarkable. The major support provided by these donors is a reminder that, with an inspirational idea and enthusiastic friends, anything is possible. We also thank the National Endowment for the Arts for its renewed support of the Museum's exhibition program. Additionally, we would like to recognize the Federal Council on the Arts and Humanities for granting an indemnity for this project.

Conceived more than six years ago by its curator, Helen C. Evans, under my predecessor, Director Philippe de Montebello, and Mahrukh Tarapor, former Associate Director for Exhibitions and Director of International Affairs, "Byzantium and Islam: Age of Transition" has been brought to a most successful conclusion through the strong support of Jennifer Russell, Associate Director for Exhibitions; Peter Barnet, Michel David-Weill Curator in Charge of the Department of Medieval Art and The Cloisters; and Brandie Ratliff, Research Associate for Byzantine Art in the Medieval Department, as well as many other members of the Museum staff.

Thomas P. Campbell
Director
The Metropolitan Museum of Art

Sponsors' Statements

Inspired by the wealth of knowledge and beauty presented in the series of special exhibitions on Byzantium held at The Metropolitan Museum of Art in 1977, 1997, and 2004, we are honored and pleased to support "Byzantium and Islam: Age of Transition (7th–9th Century)."

We are very proud to have supported the Metropolitan Museum through the Mary and Michael Jaharis Galleries for Byzantine Art, the first permanent installation of Byzantine art in an encyclopedic museum. These permanent galleries contain works that reflect many of the concepts of "Byzantium and Islam: Age of Transition," especially the importance of the southern provinces of the Byzantine state.

Given our personal interest in the art of this era and our Hellenic heritage, we are grateful to the Metropolitan Museum for its groundbreaking initiatives and efforts in presenting a magnificent series of exhibitions that focus on the art and culture of the Byzantine world.

Mary and Michael Jaharis

In 2004 the Stavros Niarchos Foundation provided major support for The Metropolitan Museum of Art's groundbreaking exhibition "Byzantium: Faith and Power (1261–1557)." In supporting the exhibition, the Foundation expressed its commitment to enhancing public perception and understanding of Byzantium's remarkably beautiful and influential artistic heritage. It is in the same spirit and with great pleasure that the Foundation has collaborated again with the Metropolitan by becoming a major contributor to "Byzantium and Islam: Age of Transition (7th–9th Century)," the fourth exhibition in Museum's series on Byzantine art and civilization. While most view the period from the seventh to the ninth century as a time of continuous conflict, it was also an era of cultural dialogue and interaction between two important artistic traditions, one established and the other developing. The Stavros Niarchos Foundation is pleased to support an exhibition that will reveal to the public, for the first time in such a comprehensive way, the profound artistic and cultural transformations that resulted from Byzantium's interaction with Islam.

The Board of Directors
Stavros Niarchos Foundation

*i*ΣΝ/SΝ*f* STAVROS NIARCHOS FOUNDATION

It is a great pleasure for The Hagop Kevorkian Fund to contribute to the historic exhibition "Byzantium and Islam: Age of Transition (7th–9th Century)." From his arrival in New York City in the late nineteenth century, Hagop Kevorkian formed a close relationship with The Metropolitan Museum of Art, particularly in the areas of his collecting interests—ancient Near Eastern, Islamic, and Byzantine art. An Armenian archaeologist, art connoisseur, and collector, Kevorkian was a generous supporter of the Museum, making regular gifts from his exquisite collection. In 1951 Kevorkian established The Hagop Kevorkian Fund, which has continued to support the Museum's fellowships, publications, acquisitions, and The Hagop Kevorkian Fund Special Exhibition Gallery in the Galleries for the Art of the Arab Lands, Turkey, Iran, Central Asia, and Later South Asia.

A particularly fruitful relationship with the Fund was forged in 1983 when it supported the fellowship of Helen Evans as a doctoral student in Byzantine art at New York University's Institute of Fine Arts. Since that time, the Fund's dedication to Dr. Evans's widely acclaimed exhibitions, catalogues, and projects—from explorations of the artistic achievements of Byzantium to the acquisition of Armenian masterpieces—has not wavered. We are particularly proud to help realize her present endeavor, the first exhibition to merge the study of Byzantine art with that of the cultural achievements of the Islamic world, both of which were so beloved by our founder.

Ralph D. Minasian
President
The Hagop Kevorkian Fund

Acknowledgments

Without the support of many institutions and individuals it would have been impossible to bring together the works and the intellectual content of "Byzantium and Islam: Age of Transition (7th–9th Century)." We would like to thank all who gave advice on the project directly or indirectly. Most especially, we wish to thank the staffs of the forty-nine institutions that have lent to the exhibition. Many generously supported the Museum's earlier exhibitions on Byzantium—"Age of Spirituality: Late Antique and Early Christian Art, Third to Seventh Century" in 1977; "The Glory of Byzantium: Art and Culture of the Middle Byzantine Era (A.D. 843–1261)" in 1997; and "Byzantium: Faith and Power (1261–1557)" in 2004—while others are participating for the first time.

In Austria, at the Austrian National Library in Vienna, we thank Johanna Rachinger, Director General, and Bernhard Palme, Peter Prokop, and Angelika Zdiarsky; in Canada, at the University of Toronto Art Centre, Niamh O'Laoghaire, Director, and Heather Pigat; and in Denmark, at the David Collection in Copenhagen, Kjeld von Folsach, Director, and Mette Korsholm.

In Egypt, many people sought to make participation in the exhibition possible. Mohamed Ibrahim Ali and Mostafa Amin, Secretaries-General of the Supreme Council of Antiquities, and Zahi Hawass, former Secretary General and Minister of State for Antiquities, understood the significance of the project from its conception. Lyn Younes, Nadja Tomoun, and Iman R. Abdulfattah must also be thanked for their efforts on our behalf.

His Eminence Archbishop Damianos and the Holy Fathers of the Holy Greek Orthodox Monastery of Saint Catherine at Sinai, Egypt, have been most generous in their understanding of the importance of the Monastery to our concept, as they were when lending to "The Glory of Byzantium" in 1997 and "Byzantium: Faith and Power" in 2004. The Very Reverend Father John and Hieromonk Justin have done much to support our endeavor, as have Stasinopoulos Stergios and Nikolaos Vadis.

In France, at the Bibliothèque Nationale de France, Paris, M. Bruno Racine, President, and Thierry Delcourt, Laurent Héricher, Annie Vernay-Nouri, Marie-Geneviève Guesdon, Christian Förstel, Brigitte Robin-Loiseau, and Françoise Simeray have enabled crucial access to the library's Byzantine, Coptic, and Islamic collections. Also in Paris, Élisabeth Taburet-Delahaye, Director of the Musée National du Moyen Âge, Thermes et Hôtel de Cluny, and her staff, especially Florence Ertaud, and, at the Musée du Louvre, Henri Loyrette, Director, and Jannic Durand, Dominique Bénazeth, Élisabeth Fontan, Anne-Laure Renoux, and Laurent Creuzet have been most supportive of all aspects of the exhibition. We also thank Jacques Mercier for his generous assistance.

In Georgia, in Tbilisi, David Lordkipanidze, General Director of the Georgian National Museum, and Elene Kavlelashvili and Alisa Datunashvili have lent to the exhibition an exceptional work that has never traveled before. Nino Simonischvili must also be thanked for her efforts there on our behalf. In Germany, in Berlin, we appreciate the Byzantine loans from the Skulpturensammlung und Museum für Byzantinische Kunst arranged through Bernd Wolfgang Lindemann, Director, Gemäldegalerie–Skulpturensammlung und Museum für Byzantinische Kunst, Staatliche Museen zu Berlin, as well as the exceptional support offered by Julien Chapuis, Gabriele Mietke, and Cäcilia Fluck. Stefan Weber, Director of the Museum für Islamische Kunst, Staatliche Museen zu Berlin, and Thomas Tunsch are to be thanked for their understanding of our project.

In Greece, the Benaki Museum in Athens under its director, Angelos Delivorias, has been especially generous with its loans. Members of the museum's staff who have provided outstanding support include Anna Ballian, Mina Moriatou, Anastasia Drandaki, and Irini Yeroulanou. Mata Tsolozidis-Zisiadis and Eleni Strataki deserve thanks, as do Yannis S. Costopoulos, Chairman of Alpha Bank, and Hector P. Verykios, Director of the J. F. Costopoulos Foundation. In Israel, appreciation is owed to Dieter Vieweger, Director General, and Barbara Herfurth of the Deutsches Evangelisches Institut für Altertumswissenschaft des Heiligen Landes in Jerusalem and to George Blumenthal for their efforts on our behalf. In Italy, Vera Valitutto, Director, Maria Prunai Falciani, former Director, and Anna Rita Fantoni, Dina Giuliani, and Leonardo Meoni of the Biblioteca Medicea Laurenziana in Florence are to be thanked for their generous support, as are Claudio Salsi, Director, and Francesca Tasso, Valentina Ricetti, and Elena Ottina of the Castello Sforzesco, Milan. At the Biblioteca Nazionale di Napoli, we are grateful to Mauro Giancaspro, Director, and Vincenzo Boni, Valentina Cosentino, and Maria Francesca Stamuli. Special thanks are also due to Patricia Lurati for her efforts on our behalf in Italy.

In Jordan, the Department of Antiquities has been especially generous in its understanding and support. Faris Al Hmoud,

Acting Director General, and Huda Kilani are to be thanked for their exceptional efforts in completing the loan process begun under Fawwaz Al-Khraysheh and Ziad Al Saad, former Directors General. The department's Tammam Ahmad Khasawneh, Catreena Hamarneh, and Maysoun Qatarneh have provided valuable assistance, as have Robert Schick and Bill Lyons. We also thank Father Carmelo Pappalardo of the Franciscan Archaeological Institute at Mount Nebo for his interest in our undertaking. Barbara Porter, Director of the American Center for Oriental Research in Amman, has been a source of invaluable advice throughout the planning process. In Russia, in Saint Petersburg, we are grateful to Mikhail Piotrovsky, Director of the State Hermitage Museum, and Natalia Kozlova, Anatoly Ivanov, Olga W. Oscharina, Vera Zalesskaya, Anastasia Mikliaeva, Andrei Terchenin, and, especially, Yuri Piatnitsky. Also in Saint Petersburg, Anton Likhomanov, Director of the Russian National Library, Vladimir Zaitsev, former Director, and Olga Vasilyeva, in particular, have been supportive of our requests.

In the United Kingdom, at Cambridge University Library, Jill Whitelock, Head of Special Collections; Ben Outhwaite, Head, Taylor-Schechter Genizah Research Unit; and Don Manning have offered welcome support. In London, at the British Library, gratitude is due to Dame Lynne Brindley, Chief Executive, and Scott McKendrick, Ilana Tahan, Colin F. Baker, Andrea Clarke, Barbara O'Connor, Laura Fielder, and Andrew Gough. The British Museum has lent generously to the exhibition through Neil MacGregor, Director, with the help of Venetia Porter, Chris Entwistle, Robert Owen, and Agata Rutkowska. At the Victoria and Albert Museum, we are indebted to Martin Roth, Director, Sir Mark Jones, former Director, and Paul Williamson, Helen Persson, Mariam Rosser-Owen, Rebecca Wallace, Roxanne Peters, Miranda McLaughlan, Peter Ellis, Elizabeth-Anne Haldane, Claire Johnson, Jon Thompson, and Alanna Davidson. Recognition is also due to Maria Balshaw, Director, and Frances Pritchard of the Whitworth Art Gallery, University of Manchester, and to Christopher Brown, Director, Ashmolean Museum of Art and Archaeology, University of Oxford, and Aisha Burtenshaw, Katherine Wodehouse, and Amy Taylor. The interest Paul Ruddock and Sam Fogg have taken in our project is also much appreciated.

In the United States, at the University of Michigan in Ann Arbor, Paul N. Courant, University Librarian and Dean of Libraries; Arthur Verhoogt, Archivist, Papyrus Collection; and Shannon Zachary and Adam Hyatt have been gracious toward us, as have, in Corning, New York, at the Corning Glass Museum, David B. Whitehouse, former Director; Karol Wight, Director; and Warren Bunn and Mary B. Chervenak. At the Los Angeles County Museum of Art, Michael Govan, Director, and Linda Komaroff and Amy Wright have been accommodating and supportive. Mary Sue Sweeney Price, Director, and Amber Woods Germano and Heidi Warbasse at the Newark Museum in Newark, New Jersey, are also to be thanked. At the Yale University Art Gallery in New Haven, Jock Reynolds, Henry J. Heinz II Director, and Susan B. Matheson, Lisa R. Brody, Carol Snow, Kathleen Mylen-Coulombe, and David Whaples made difficult loans possible. In New York, the cooperation of Ute Wartenberg Kagan, Executive Director, and Elena Stolyarik of the American Numismatic Society is much appreciated. At the Brooklyn Museum, Arnold Lehman, Director, and Edward Bleiberg, Ann Russman, Yekaterina Barbash, Ladan Akbarnia, Kenneth S. Moser, Ruth Janson, and Elisa Flynn were generous with their time and expertise. In Philadelphia, Dr. Richard Hodges, Director of the University of Pennsylvania Museum of Archaeology and Anthropology, and James Moss, Tara Kowalski, and Maureen Goldsmith offered welcome assistance. In Washington, D.C., loans from the Byzantine Collection of Dumbarton Oaks were made through the efforts of Gudrun Bühl, Director of the Museum, and Stephen R. Zwirn and Marta G. Zlotnick. The encouragement of Jan M. Ziolkowski, Director of Dumbarton Oaks, and Margaret Mullet, Director of Byzantine Studies, was also much appreciated.

Others in the United States who offered valuable assistance include Susan Ashbrook Harvey, Brown University; Örgü Dalgiç, Dumbarton Oaks; Inge Reist, The Frick Collection; Clive Foss, Georgetown University; Kristen Collins, The J. Paul Getty Museum; Priscilla Soucek, Institute of Fine Arts, New York University; Sarah T. Brooks, James Madison University; Max Marmor, Samuel H. Kress Foundation; Angela Hero and Warren Woodfin, Queens College, City University of New York; Jerilynn Dodds, Sarah Lawrence College; Andrew Crislip, Virginia Commonwealth University; Vasileios Marinis and Magdalene Breidenthal, Yale University; Edwin C. Schroeder, Beinecke Rare Book and Manuscript Library, Yale University; Julie Lee, Bowers Museum; Michelle Fontenot, Kelsey Museum of Archaeology, University of Michigan; and Nina Joukowsky Koprulu, Beth G. Weingast, Alexander Shedrinsky, and Martha Fling.

At the Vatican, loans were kindly approved by Antonio Paolucci, Director, Musei Vaticani–Monumenti, Musei e Gallerie Pontificie, and Francesco Buranelli, former Director, with the support of Isabella di Montezemolo and Rosanna Di Pinto. Cristina Carlo-Stella is also to be thanked for her assistance.

At The Metropolitan Museum of Art, Thomas P. Campbell, Director, has strongly supported the exhibition, which was conceived under his predecessor, Philippe de Montebello. Emily Rafferty, President, has never faltered in her interest. Jennifer Russell, Associate Director for Exhibitions, has been unstinting in her efforts on our behalf, as has Mahrukh Tarapor, former Associate Director for Exhibitions and Director for International Affairs. Carrie Rebora Barratt, Associate Director for Collections and Administration—like her predecessor, Doralynn Pines—has bolstered the exhibition, along with the staff of the Director's office, particulary Martha Deese, Ryan Wong, Ashley Williams, and Rachel Tofel.

Peter Barnet, Michel David-Weill Curator in Charge of the Department of Medieval Art and The Cloisters, has most favorably encouraged the exhibition's development since its inception. Our colleagues in the department have also been generous with their advice and assistance, including Barbara D. Boehm, Melanie Holcomb, Charles T. Little, Timothy B. Husband, Christine E. Brennan, Thomas C. Vinton, R. Theo Margelony, Christine D. McDermott, Wendy Stein, and Andrew Winslow. The staff of the Museum's Department of Islamic Art has graciously collaborated as they opened their own outstanding Galleries of the Art of the Arab Lands, Turkey, Iran, Central Asia, and Later South Asia. Sheila Canby, Patti Cadby Birch Curator in Charge, and Navina Najat Haidar, Maryam Ekhtiar, Annick Des Roches, Tim Caster, Kent Henricksen, and Rina Indictor are to be especially thanked for their efforts on our behalf. The interest Michael Barry, Stefano Carboni, and Stefan Heidemann have taken in the exhibition is also much appreciated. Joan Aruz, Curator in Charge, Department of Ancient Near Eastern Art, and her staff, notably Elisabetta Valtz Fino, Kim Benzel, Sarah Graff, Tim Healing, and Shawn Osborne-Campbell, are owed our appreciation for their efforts, as are Dorothea Arnold, Curator in Charge, Department of Egyptian Art, and Adela Oppenheim and Janice Kamrin.

The impeccable work of the Museum's conservation departments has been critical to our ability to understand and display the works of art in the exhibition. Lawrence Becker, Sherman Fairchild Curator in Charge, Department of Objects Conservation, has been generous with his own support and that of his staff, especially Pete Dandridge, Lisa Pilosi, Jean-François de Lapérouse, Jack Soultanian Jr., Mechthild Baumeister, and Wendy Walker. Frederick J. Sager, Jenna Wainwright, Warren L. Bennett, and

Matthew Cumbie provided excellent mounts for many works in the installation. The contributions of the Department of Paper Conservation under Marjorie Shelley, Sherman Fairchild Conservator in Charge, especially those of Yana Van Dyke, are much appreciated. In the Department of Textile Conservation, special appreciation goes to Florica Zaharia, Curator in Charge, and Kathrin Colburn, Janina Poskrobko, Min Sun Hwang, Gemma Rossi, and Caroline Borderies. Nobuko Shibayama and Tony Frantz of the Department of Scientific Research performed essential carbon dating of textiles. The staff of the Antonio Ratti Textile Center has also been magnanimous: we must thank Melinda Watt, Giovanna P. Fiorino-Iannace, Eva Labson, Kieran D. McCulloch, and Eva Holiday DeAngelis-Glasser for their efforts on our behalf and that of several of the catalogue authors.

Others in the Museum have made major contributions to the project. We owe much appreciation to Sharon Cott, Senior Vice President, Secretary, and General Counsel, and to Kirstie Howard and Rebecca L. Murray in her office. Harold Holzer, Senior Vice President for External Affairs, and Karin Grafstrom, Market Research Manager, have offered useful advice. In Development, Nina McN. Diefenbach, Vice President for Development and Membership, and Christine S. Begley, Sarah Higby, and Lesley Cannady have brought their skills to bear on the project. In Communications, we greatly appreciate the work of Elyse Topalian, Vice President for Communications, and Egle Žygas. Aileen Chuk, Registrar, and Meryl Cohen, Nina S. Maruca, and Mary McNamara in her office have helped extensively with the loans.

In the Museum's Education Department, Peggy Fogelman, Frederick P. and Sandra P. Rose Chairman of Education, is to be thanked for her interest in outreach for the exhibition. Members of her staff especially involved in the project include Joseph Loh, Jacqueline Terrassa, Jennifer Mock, William B. Crow, Michael Norris, Alice Schwarz, Rebecca McGinnis, Karen Ohland, Merantine Hens, Claire E. Moore, and Brittany Prieto. We also thank Missy McHugh, Chief Advisor to the President, and Limor Timor, General Manager of Concerts and Lectures, and her staff, particularly Lisa Musco Doyle and Debra Garrin. In the Digital Media Department, Erin Coburn, Chief Officer, and Teresa W. Lai, Christopher A. Noey, Eileen M. Willis, and Stella Paul are to be thanked for their interest in the exhibition. We are grateful to Kenneth Soehner, Arthur K. Watson Chief Librarian, and to all his staff for the resources they were able to provide for this project.

In Design, Linda Sylling, Manager for Special Exhibitions, Gallery Installations, and Design, and Patricia A. Gilkison, Sian Wetherill, and Christopher Gorman were essential in coordinating the project. Michael Batista conceived an exceptional exhibition design, and Sophia Geronimus provided handsome graphics.

Clint Coller and Richard Lichte lit the installation most impressively. Many others helped make the installation possible. We would like to recognize those in the Buildings Department under Tom Scally, Buildings Manager, who were integral to the process: Taylor Miller, who manages exhibitions, and the staffs of the Carpentry Shop under Vadim Danilov, the Electronics Shop under Basil Pascall, the Machine Shop under Abdool Ali, the Paint Shop under Howard Halpin, the Plexi Shop under Sean Thomas, and the Rigging Shop under Crayton Sohan. We also appreciate the security provided through John Barelli, Chief Security Officer, and the maintenance of the galleries under Gordon Hairston.

The catalogue's authors (see Contributors to the Catalogue) have been generous in their advice regarding the exhibition. Many are mentioned elsewhere in the acknowledgments. We also wish to recognize the insights provided by Jennifer Ball, Elizabeth Bolman, Ana Cabrera, Kathleen Corrigan, Steven Fine, Finbarr Barry Flood, Rebecca Foote, Sidney Griffith, Nancy Khalek, Maria Mavroudi, Alexander Nagel, Robert Schick, Annemarie Stauffer, Karen Stern, and Thelma Thomas.

Above all, thanks must be extended to the Museum's exceptional editorial staff for their work on this catalogue. Mark Polizzotti, Publisher and Editor in Chief, brought to completion a concept conceived under John P. O'Neill, former head of the department. The efforts of Gwen Roginsky and Peter Antony during the transition period are much appreciated. Our outstanding editors, led by Alexandra Bonfante-Warren, have worked unstintingly on the project. We thank Fronia Simpson, Emily Dana Shapiro, Amy Teschner, Ellyn Allison, Margaret Donovan, Elizabeth Zechella, Hilary Becker, and, most especially, Cynthia Clark for their efforts. Michael Sittenfeld, Robert Weisberg, Mary Jo Mace, Sally Van Devanter, Jennifer Van Dalsen, Anandaroop Roy, and designer Bruce Campbell have done exceptional work in their areas of expertise. We are obliged to Pamela T. Barr for editing the exhibition label copy. We also acknowledge Barbara Bridgers, General Manager for Imaging and Photography, and her staff, notably Joe Coscia, Anna-Marie Kellen and Bruce Schwarz, for their contributions. Carol Lekarew has been most helpful in the Image Library. Daniel Kershaw is owed our thanks, too, for assistance with photography in Georgia; Guozhen Li of the Cultural Heritage Bureau of Xinjiang Uygur Autonomous Region for assistance in China; and Mieke van Raemdonck and Greet van Deuren for theirs at the Royal Museum of Art and History in Brussels. Finally, Laura Rodríguez Peinado in Madrid must be thanked for her support of the research on the Marwan textiles.

Exhibitions are exceptional opportunities to involve students. Alzahraa Ahmed, Constance Alchermes, Elene Chkuaseli, Iris Colburn, Stephanie Georgiadis, Annie Labatt, Tuna Ortayli, Yitzchak Schwartz, and Elizabeth Williams have contributed invaluably to the exhibition in many ways. Their work has ranged from fact checking to translating texts, helping consolidate information for government applications, making external contacts, and writing installation labels. Their interest in the project has helped immensely in our efforts to make our concept accessible to all.

The participation of all those mentioned above and many others has made "Byzantium and Islam: Age of Transition (7th–9th Century)" a gratifying reality. We thank everyone involved in its achievement.

Helen C. Evans
Mary and Michael Jaharis Curator of Byzantine Art, Department of Medieval Art and The Cloisters

Brandie Ratliff
Research Associate for Byzantine Art, Department of Medieval Art and The Cloisters

Lenders to the Exhibition

Austria

Austrian National Library, Vienna 98

Canada

Malcove Collection, University of Toronto Art Centre, Toronto 64, 122

Denmark

The David Collection, Copenhagen 121, 155, 156, 166, 175, 181, 188, 191

Egypt

The Coptic Museum, Cairo 42, 47, 48, 53, 138

The Islamic Museum, Cairo 118, 135, 163, 167, 171, 177, 178, 182

The Holy Monastery of Saint Catherine, Sinai 25–38, 82

France

Bibliothèque Nationale de France, Paris 21, 49, 80, 190, 193

Musée du Louvre, Paris 2, 23, 24, 52, 70, 71, 122, 128, 137

Musée National du Moyen Âge, Thermes et Hôtel de Cluny, Paris 24, 102, 103

Georgia

Georgian National Museum, Tbilisi 152

Germany

Museum für Islamische Kunst, Staatliche Museen zu Berlin–Stiftung Preußischer Kulturbesitz, Berlin 154

Skulpturensammlung und Museum für Byzantinische Kunst, Staatliche Museen zu Berlin–Stiftung Preußischer Kulturbesitz, Berlin 46, 63, 65, 114, 120, 139

Greece

Benaki Museum, Athens 17, 93, 99, 117, 121, 123–125, 132, 135, 140, 159, 160–162, 164, 165, 170, 172, 176, 179, 180, 185, 187

Tsolidizis Collection, Thessaloniki 64, 65

Israel

Deutsches Evangelisches Institut für Altertumswissenschaft des Heiligen Landes, Jerusalem 69

Italy

Biblioteca Medicea Laurenziana, Florence 39

Biblioteca Nazionale "Vittorio Emanuele III," Naples 4, 14

Civiche Raccolte d'Arte Applicata–Castello Sforzesco, Milan 24

Jordan

Department of Antiquities, Amman, 142, 149, 153

Archaeological Museum, Aqaba 97

Archaeological Museum, Irbid 126, 127

Archaeological Museum, Jerash 126

Jordan Archaeological Museum, Amman 92, 126, 129, 142–148, 150

Archaeological Museum, Madaba 100, 151

Archaeological Park, Madaba 79

Museum of Jordanian Heritage, Irbid 141

Spanish Mission, Amman 151

Franciscan Archaeological Institute–Mount Nebo, Custody of the Holy Land 66, 67

Contributors to the Catalogue

IRA Iman R. Abdulfattah, Sheldon Solow Scholar, Institute of Fine Arts, New York University

LA Ladan Akbarnia, Curator of Islamic Art, Department of the Middle East, The British Museum, London

HB Heather A. Badamo, Collegiate Assistant Professor in Art History, Chicago Society of Fellows, University of Chicago

JB Jennifer L. Ball, Associate Professor of Medieval Art History, Brooklyn College and The Graduate Center of the City University of New York

AB Anna Ballian, Senior Curator, Islamic Collection, Benaki Museum, Athens

DB Dominique Bénazeth, Curator, Musée du Louvre, Département des Antiquités Égyptiennes, Paris

ESB Elizabeth S. Bolman, Associate Professor of Art History, Tyler School of Art, Temple University; Adjunct Associate Professor in the History of Art, and Art and Archaeology of the Mediterranean World, University of Pennsylvania, Philadelphia

LB Lisa R. Brody, Associate Curator of Ancient Art, Yale University Art Gallery, New Haven

GB Gudrun Bühl, Curator, Byzantine Art, and Museum Director, Dumbarton Oaks, Washington, D.C.

AC Ana Cabrera, Collection Manager and Textile Curator, Museo Nacional de Artes Decorativas, Madrid

KCol Kathrin Colburn, Conservator, Department of Textile Conservation, The Metropolitan Museum of Art, New York

KCor Kathleen Corrigan, Associate Professor of Art History, Dartmouth College, Hanover

AD Anastasia Drandaki, Curator, Byzantine Collection, Benaki Museum, Athens

HCE Helen C. Evans, Mary and Michael Jaharis Curator for Byzantine Art, Department of Medieval Art and The Cloisters, The Metropolitan Museum of Art, New York

SF Steven Fine, Professor of Jewish History and Director, Center for Israel Studies, Yeshiva University, New York

FBF Finbarr Barry Flood, William R. Kenan Jr. Professor of the Humanities; Professor of Art History, Middle Eastern and Islamic Studies; Institute of Fine Arts, New York University

CF Cäcilia Fluck, Curator for Byzantine Egypt, Skulpturensammlung und Museum für Byzantinische Kunst, Staatliche Museen zu Berlin–Stiftung Preußischer Kulturbesitz

RMF Rebecca M. Foote, Independent Scholar, London

CFF Clive Foss, Visiting Professor, History Department, Georgetown University, Washington, D.C.

SHG Sidney H. Griffith, Professor, Department of Semitics, The Catholic University of America, Washington, D.C.

SH Stefan Heidemann, Professor of Islamic Studies, Asia Africa Institute, University of Hamburg

AI Anatoly Ivanov, Senior Researcher, Curator of Iranian Art Collection, Oriental Department, The State Hermitage Museum, Saint Petersburg

HJS Hieromonk Justin of Sinai, Librarian, Holy Monastery of Saint Catherine, Sinai, Egypt

NK Nancy Khalek, Assistant Professor, Brown University, Providence

LK Linda Komaroff, Curator of Islamic Art, Los Angeles County Museum of Art

AL Annie Labatt, Chester Dale Fellow, The Metropolitan Museum of Art, New York

MVM Maria Mavroudi, Professor, Departments of History and Classics, University of California, Berkeley

GM Gabriele Mietke, Curator for Byzantine Art, Skulpturensammlung und Museum für Byzantinische Kunst, Staatliche Museen zu Berlin–Stiftung Preußischer Kulturbesitz

MM Mina Moraitou, Curator, Islamic Collection, Benaki Museum, Athens

Alexander Nagel, Assistant Curator of Ancient Near Eastern Art, Freer/Sackler, The Smithsonian's Museums of Asian Art, Washington, D.C.

OO Olga Oscharina, Researcher, Curator of Coptic Collection, Oriental Department, The State Hermitage Museum, Saint Petersburg

YP Yuri Piatnitsky, Senior Researcher, Curator of Byzantine Collection, Oriental Department, The State Hermitage Museum, Saint Petersburg

BR Brandie Ratliff, Research Associate for Byzantine Art, Department of Medieval Art and The Cloisters, The Metropolitan Museum of Art, New York

MR-O Mariam Rosser-Owen, Curator Middle East, Asian Department, Victoria and Albert Museum, London

RS Robert E. Schick, Independent Scholar, Amman

YS Yitzchak Schwartz, Research Associate, Center for Israel Studies, Yeshiva University, New York; Bard Graduate Center for Decorative Arts, Design History, and Material Culture, New York

ASt Annemarie Stauffer, Professor in Textile Conservation and Textile History, University of Applied Sciences, Cologne

KS Karen B. Stern, Assistant Professor, Brooklyn College, City University of New York

TKT Thelma K. Thomas, Associate Professor of Fine Arts, Institute of Fine Arts, New York University

EV Elisabetta Valtz Fino, Curator, Department of Ancient Near Eastern Art, The Metropolitan Museum of Art, New York

OV Olga Vasilyeva, Curator of Oriental Collections, Manuscript Department, National Library of Russia, Saint Petersburg

EW Elizabeth A. Williams, Jane and Morgan Whitney Fellow, The Metropolitan Museum of Art, New York

VZ Vera Zalesskaia, Senior Researcher, Curator of Byzantine Collection, Oriental Department, The State Hermitage Museum, Saint Petersburg

SRZ Stephen R. Zwirn, Assistant Curator, Byzantine Collection, Dumbarton Oaks, Washington, D.C.

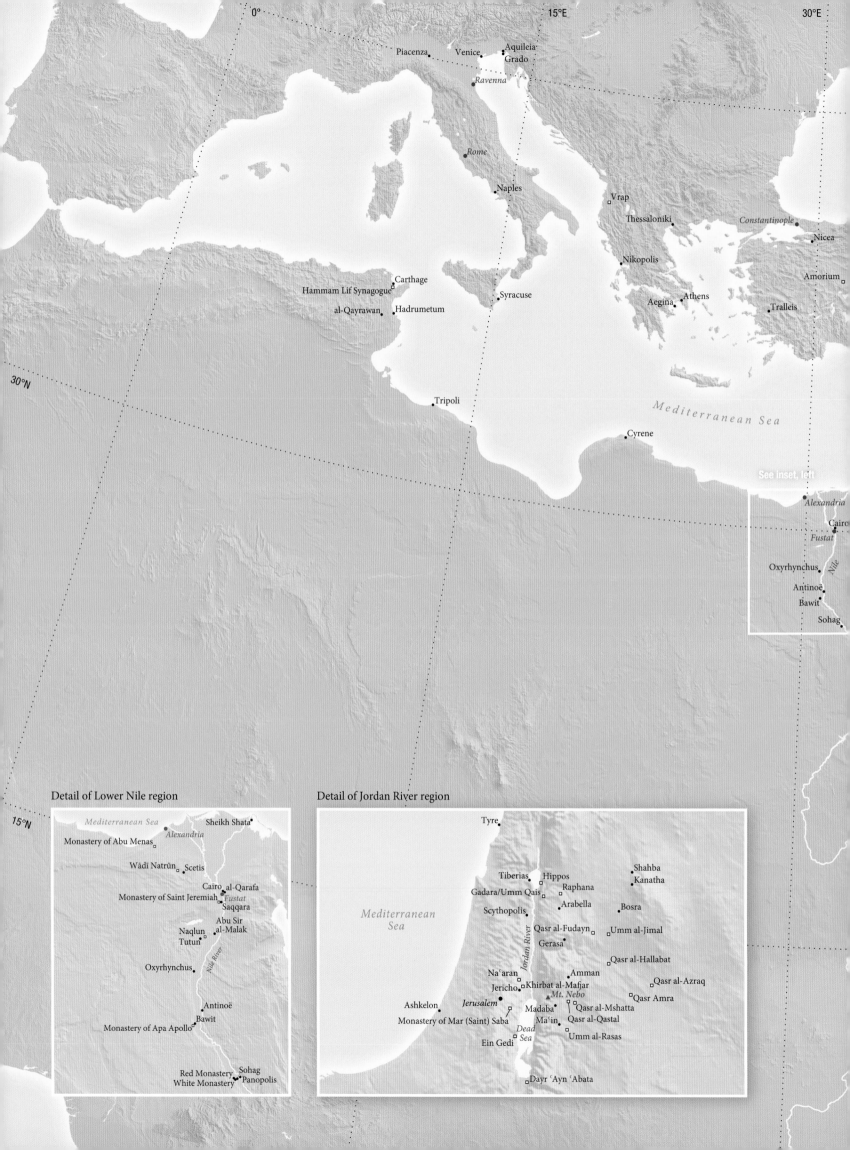

0° 15°E 30°E

Piacenza Venice Aquileia
Grado
Ravenna
Rome
Naples
Vrap
Thessaloniki *Constantinople*
Nicea
Nikopolis
Amorium
Carthage
Hammam Lif Synagogue Aegina Athens
al-Qayrawan Hadrumetum Tralleis
Syracuse

30°N

Tripoli *Mediterranean Sea*

Cyrene

See inset, left

Alexandria
Cairo
Fustat

Oxyrhynchus *Nile*

Antinoë
Bawit
Sohag

Detail of Lower Nile region

Mediterranean Sea Sheikh Shata
Monastery of Abu Menas *Alexandria*
Wādī Natrūn Scetis
Cairo al-Qarafa
Monastery of Saint Jeremiah *Fustat*
Saqqara
Abu Sir
Naqlun al-Malak
Tutun
Oxyrhynchus *Nile River*

Antinoë
Bawit
Monastery of Apa Apollo

Red Monastery Sohag
White Monastery Panopolis

Detail of Jordan River region

Tyre

15°N

Shahba
Tiberias Hippos Kanatha
Gadara/Umm Qais Raphana
Mediterranean Sea Arabella Bosra
Scythopolis
Qasr al-Fudayn Umm al-Jimal
Gerasa

Qasr al-Hallabat
Naʿaran Amman
Jericho Khirbat al-Mafjar Qasr al-Azraq
Mt. Nebo Qasr Amra
Ashkelon *Jerusalem* Madaba
Monastery of Mar (Saint) Saba Maʿin Qasr al-Mshatta
Qasr al-Qastal
Dead Sea Umm al-Rasas
Ein Gedi

Dayr ʿAyn ʿAbata

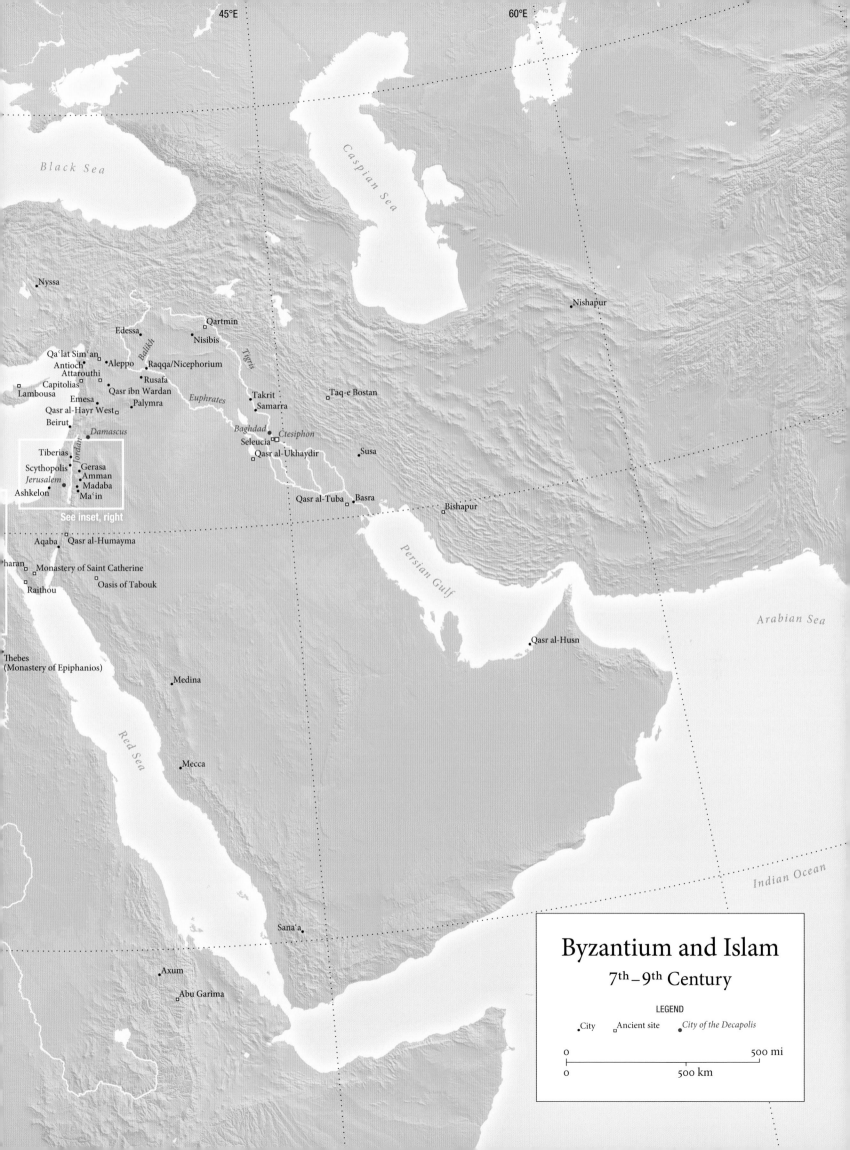

Black Sea

Caspian Sea

45°E 60°E

Nyssa

Nishapur

Qartmin

Edessa
Nisibis

Balikh

Qaʿlat Simʿan
Antioch Aleppo Raqqa/Nicephorium
Attarouthi Rusafa Tigris
Capitolias Qasr ibn Wardan Taq-e Bostan
Lambousa
Emesa Palymra Euphrates Takrit
Qasr al-Hayr West Samarra
Beirut
Damascus Baghdad
Jordan Seleucia Ctesiphon
Tiberias Qasr al-Ukhaydir Susa
Scythopolis Gerasa
Jerusalem Amman
 Madaba
Ashkelon Maʿin
 Qasr al-Tuba Basra
See inset, right
 Bishapur

Aqaba Qasr al-Humayma

ʰaran Monastery of Saint Catherine
Raithou Oasis of Tabouk

Persian Gulf

Arabian Sea

Qasr al-Husn

Thebes
(Monastery of Epiphanios)

Medina

Red Sea

Mecca

Sanaʿa

Byzantium and Islam

7th–9th Century

LEGEND

• City □ Ancient site • *City of the Decapolis*

Axum

Abu Garima

Indian Ocean

0 ————————— 500 mi

0 ————————— 500 km

Note to the Reader

The many languages used in this publication were transliterated as far as possible according to the systems established for foreign languages in the *Oxford Dictionary of Byzantium* and the Museum's *Masterpieces from the Department of Islamic Art in The Metropolitan Museum of Art.* In most other cases, the Library of Congress transliteration systems were followed. For Arabic and Persian terms, *ayn* and *hamza*, letters of the alphabet, are marked, but other diacritical signs are not used. Translations of passages in the Bible are based on the New Revised Standard Version. References to and translations of the Qur'an are taken from *The Holy Qur'an: English Translation of the Meanings and Commentary* (Medina, 1989). As this catalogue was edited before the Museum's new *Masterpieces from the Department of Islamic Art in The Metropolitan Museum of Art* was published, references to it are not included here, most relevantly for cat. nos. 154, 160, 167, 171, 185, and 192.

Throughout the catalogue, dimensions are given in the following sequence: height precedes width precedes depth. When necessary, the abbreviations H. (height), L. (length), W. (width), and Diam. (diameter) are used for clarity.

BYZANTIUM
AND
ISLAM
AGE OF TRANSITION

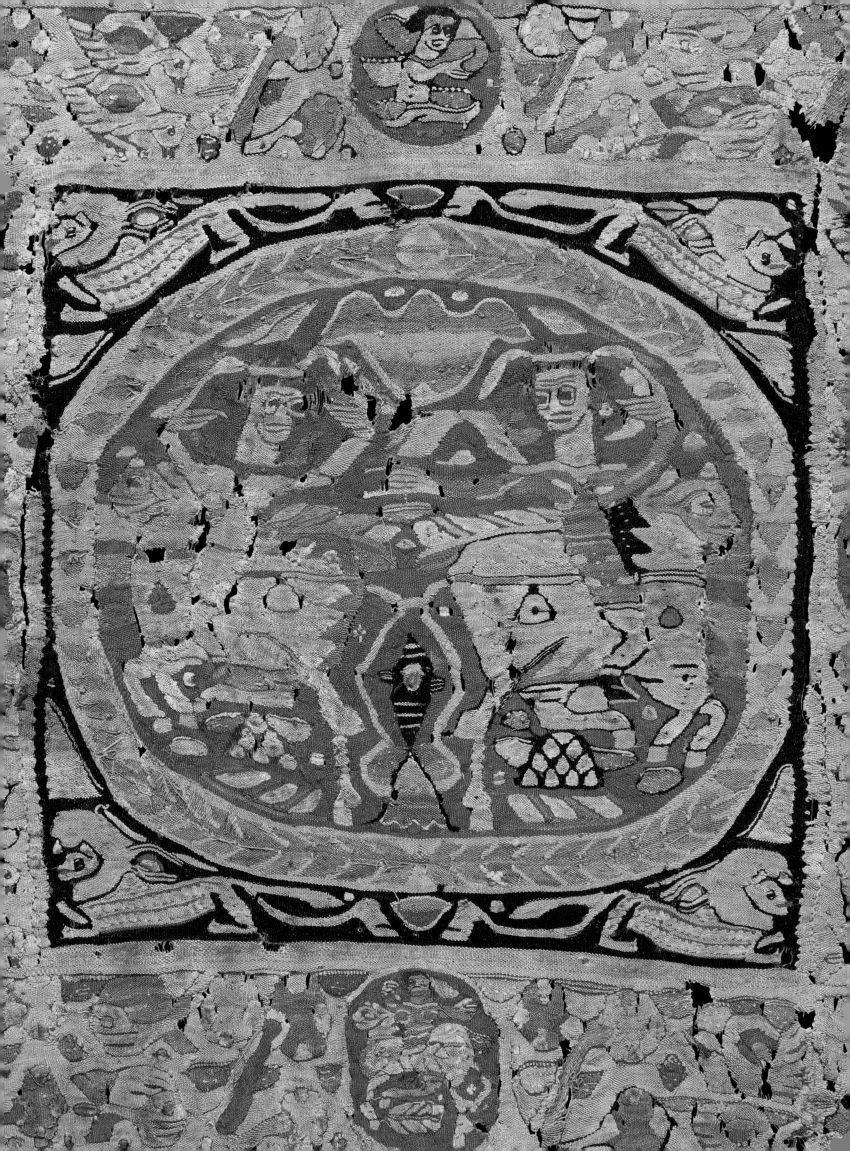

BYZANTIUM

Byzantium and Islam: Age of Transition (7th–9th Century)

Helen C. Evans

As the seventh century began, the area of the eastern Mediterranean—from Syria through Egypt and across North Africa—was central to the spiritual and political heart of the Byzantine Empire, which was ruled from Constantinople (also called New Rome, modern Istanbul). These territories, almost as extensive as they were during the era of the Roman Empire from which Byzantium emerged, were among the richest provinces of the state. In the early sixth century, the emperor Justinian I (r. 527–65) had regained the North African Roman lands and a small portion of southern Spain that had been lost to the Vandals in the fifth century. He rejoined them with Egypt and the empire's eastern Mediterranean lands to control all the southern Mediterranean.[1] The important cities and towns along the major trade routes reached around the Mediterranean and along the Red Sea (fig. 1). Their inhabitants, who lived in close proximity to one another, if not always in close collaboration, included peoples of many faiths and varied ethnic backgrounds. Surviving manuscripts and inscriptions on mosaic floors and liturgical objects reveal some of the languages spoken or written by the populace, including Greek, Coptic, Aramaic, Syriac, and Arabic (for Greek, cat. nos. 1, 15A, 22, 59, 66B; for Coptic, cat. nos. 15B, 46; for Aramaic, cat. nos. 66A, 70; for Syriac, cat. nos. 39, 40; and for Arabic, cat. no. 67). Missing from this list is Latin, then the official language of the Byzantine state; its lack reflects the preference for Greek in the eastern Mediterranean.

By the end of the seventh century, with the rise of the Islamic world, these Byzantine provinces included Arabs from the Arabian Peninsula. Byzantine forces struggled to regain control of their territories for more than a hundred years. During this period of transition from Byzantine to Islamic power, Constantinople was attacked by various armies, most especially the Avars, Slavs, and Persians. In an effort to preserve a secure capital, several emperors, including Heraclius (r. 610–41), considered moving to a new site, which Heraclius's grandson the emperor Constans II (r. 641–68) did, when he moved the capital to Syracuse in Sicily for the last years of his reign.[2] From the eighth into the ninth century, during the Iconoclastic controversy, the church in Constantinople and the Byzantine state forcefully debated the correct role of religious images. Men like Saint John of Damascus

(ca. 675–749), who lived in the southern provinces still claimed by the empire, became leaders in the defense of the religious veneration of icons (see Ratliff, p. 32, and cat. no. 80).

The revived Byzantine Empire that emerged in the ninth century could no longer claim the southern provinces that reached around the eastern Mediterranean and across North Africa. Rather, the empire, ruled from Constantinople, looked northward, successfully expanding into the Balkans and converting the Slavs. Significant contacts, both political and military, were established between the capital and Muslim courts. Trade routes to the east were maintained and even flourished, but they now followed northern, not southern, paths. The southern provinces, though lost, retained contact with Byzantium through their Christian communities and trade connections, but they were ruled by powers of the Muslim world.[3]

The critical period of transition and transformation for the empire and its southern provinces was the span from the seventh into the ninth century. At the beginning of that time, the territories were under the universal law of the Byzantine state (the Codex Justinianus), its governors were appointed from Constantinople, taxes were paid to the capital, and the church of Constantinople was the official authority in the region (fig. 2) (cat. no. 21). The poor of the capital were fed with grain shipped from Egypt, and the provinces emulated the styles of the capital.[4] As military incursions by the Sasanian Persians (see Nagel, p. 27, and cat. nos. 16–20) and subsequently the Umayyads (see Ballian, p. 200, and cat. nos. 141–151) wrested territories from imperial control, however, their role as a major source of grain and taxes for the empire was diverted to their new rulers, and the Orthodox Church of Constantinople lost its authority over the region.[5] Many of the same languages that were in use during the Byzantine era continued in the first generations of Muslim rule, with Christian texts increasingly written in Arabic (Greek, cat. no. 42, or Greek/Arabic, cat. no. 32; Coptic, cat. nos. 43, 48, 49; Syriac, cat. no. 31; Arabic, cat. nos. 32–36, 81, 83A, 188–193).

During the early seventh century, however, the territories were still central to the empire's power. Heraclius, the greatest emperor of the seventh century, sailed from the wealthy North

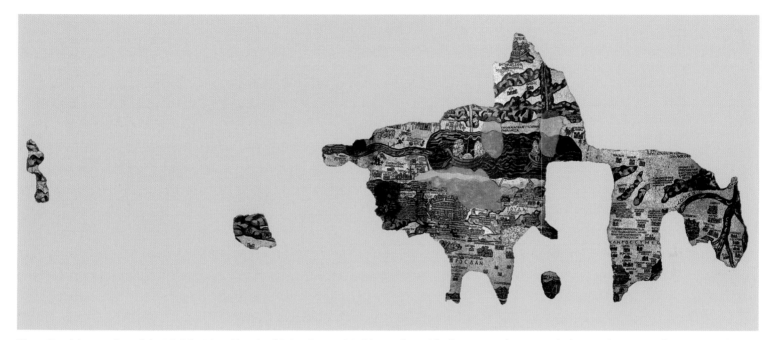

Fig. 1. Surviving portion of the Madaba Map, Church of Saint George, Madaba, Jordan, mid-6th century. The map includes sites from across the eastern and southern provinces of the Byzantine Empire; 157 sites with captions are preserved. Reproduced from Piccirillo 1992, Madaba Map foldout

African Byzantine provinces with their major cities, such as Carthage, Tripoli, and Hadrumentum/Justinianopolis (modern Sousse, Tunisia), to take the imperium (see also Evans, p. 14).[6] His first wife, Fabia, the daughter of a North African landowner, who probably spoke Latin, took the Greek name Eudokia when she became empress, in recognition of the fact that Greek was becoming the language of the Byzantine court.[7] Coming to the throne as part of the rebellion against the emperor Phokas (Focas) (r. 602–10), Heraclius, responding to the internal and external problems that led to the overthrow of his predecessor, focused his attention on the Sasanian Persian threat to the empire and was the first Byzantine ruler since the fourth century to lead his armies into battle.[8] When he marched toward the Persian threat, he left regents from his family, the patrician Bonos and the patriarch Sergios, to protect Constantinople. During the frightening, but failed, joint attack on the city by the Avars with Slavic allies and the Persians in 626, the patriarch carried an icon of the Virgin on the capital's walls. Defenders and attackers alike saw a veiled woman, who was identified as the Virgin, walking its ramparts. Because of this event, the Virgin was known as the city's protector throughout

the rest of Constantinople's history as the capital of the Byzantine Empire.[9]

Heraclius and his armies would best the Persians by 630, briefly restoring the eastern Mediterranean to Constantinopolitan control. Among those who fought along with him were the Ghassanid Arab Christians, who had long helped protect the eastern borders of the empire.[10] Soon after the defeat of the Persians, a new, unanticipated problem arose: raids by Arab armies from Arabia whose threat was initially not adequately recognized by either the Byzantines or the Sasanian Persians.[11] The decisive Arab victory at the battle of Yarmuk in 636 during the last years of Heraclius's reign led to the conquest of all the southern Byzantine provinces and those of North Africa in rapid order.[12] It can be argued that Heraclius helped save Constantinople and its surrounding territories for another eight hundred years by preserving Anatolia through a border defense along the northern edge of the empire's southern provinces that prevented further Arab penetration.[13] Certainly Byzantine forces under Heraclius's successors, members of his own dynasty, persisted in attempting to halt the Arab advance. Under Constantine IV (r. 668–85), Greek fire, a substance with properties similar to those of napalm, was recorded as

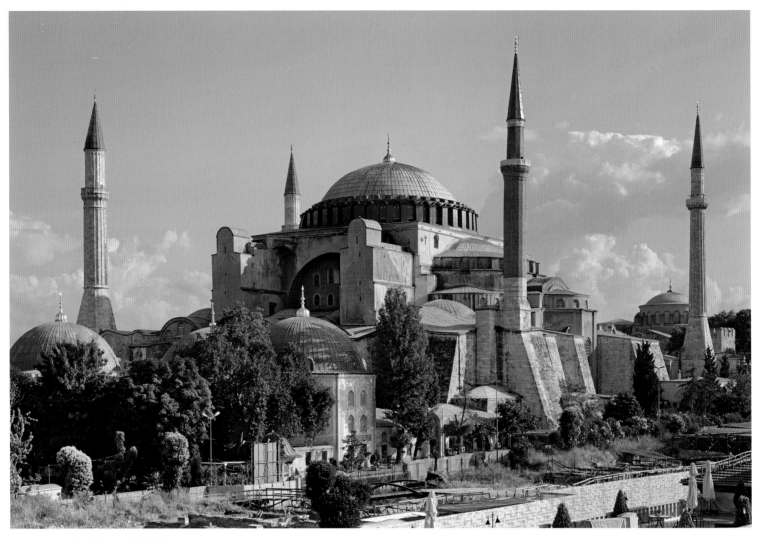

Fig. 2. Hagia Sophia, Istanbul, Turkey, 532–37

Fig. 3. Detail showing a personification of the Alexandria lighthouse (*pharos*) from the mosaic floor of the Justinianic church at Qasr Libya, Libya, 6th century

being used in a successful naval battle against an Arab fleet, the first mention of its existence. Successful military advances by the Byzantines at the same time forced the first Umayyad caliph, Mu'awiya (r. 661–80), to sue for a thirty-year peace with Byzantium and to provide the empire with substantial annual payments in gold.[14] Portions of the population of the southern provinces remained intensely loyal to the empire and its church (see Hieromonk Justin of Sinai, p. 50, and cat. nos. 26–30). People from religious communities that had resisted the efforts of Heraclius and the patriarch to unite all the citizens of the empire under one Christian church may have been more receptive to a new ruling elite and thus less hostile to the arrival of the Arabs.[15]

The imperial provinces along the eastern and southern shores of the Mediterranean were important for their wealth and their central positions on trade routes to and from the East. From Alexandria—the second-largest city of the empire, with its famous lighthouse (fig. 3)—merchants traveled along the coast of North Africa and down the Red Sea to the riches of India and China (see Thomas, p. 124). Christian Byzantine efforts to

control access to the silks and spices of the East had reached their greatest success in the sixth century. The emperor Justin I (r. 518–27), who was succeeded by his nephew Justinian I, supported the conquest of the kingdom of Himyar (in what is now modern Yemen) by the Ethiopians of the kingdom of Axum (in modern Ethiopia). The new Ethiopian rulers, having converted to Christianity in the mid-fourth century, built numerous Christian churches in their new territories and forced the conversion of much of the existing Jewish population. As a result, the Red Sea, a critical trade route, was dominated by Christian states closely allied with Constantinople. It is recorded that mosaic specialists were even brought from the capital to Himyar to work on the great cathedral of Sana'a.[16]

Kosmas Indikopleustes, a sixth-century merchant from Alexandria, traced the trade route in his *Christian Topography*, a work possibly written as a report to the Byzantine court of Justinian (see Thomas, p. 124, and cat. no. 82). In it he noted that the coinage of the Byzantine Empire was the finest in the world (see cat. nos. 86A, 86C).[17] Indeed, the authority of its coinage remained unquestioned into the Early Islamic period (see Foss, p. 136). Although Byzantine dominance of the Red Sea trade route ended with the Persian advance across Arabia to the Red Sea in the late sixth century, the importance of the route itself continued. Now, however, the Christians of the region were subject to the Persians, with their Zoroastrian faith and their officially recognized Christian community, the Church of the East

(once called Nestorian Christians), until the region became part of the expanding Muslim world in 632.[18] Syrian Orthodox Christians were also active as missionaries in the area during these centuries (see Khalek, p. 66, and cat. no. 39).[19]

Alexandria, on the Mediterranean coast near the northern end of the Red Sea, was important not only for its position on the trade routes but also as one of the patriarchal sees of the Christian church.[20] Because Alexandria had long been a center of learning, many of the issues that drove the early debates within the church arose there.[21] Christian pilgrims of all persuasions from as far as Spain and Ireland in the west and Yemen in the east came to the city whose first bishop had been Saint Mark the Evangelist. Many in nearby regions, including the Ethiopians, were under the jurisdiction of the patriarch of Alexandria. Elegantly carved images of Saint Mark—taking dictation from Saint Peter in Rome, in Alexandria, and converting his successor, Anianos—appear on ivories of the period (cat. nos. 23, 24). Saint Mark also appears at Coptic sites, since he is considered the founder of the Coptic Church (see Bolman, p. 69). Christian pilgrims flocked to other great pilgrimage sites of the empire's southern provinces as well, most especially Jerusalem (see Ratliff, p. 86, and cat. nos. 54–56, 58–60, 72). Mosaics like the Armenian-inscribed floor outside the Damascus Gate in Jerusalem attest to the presence and affluence of communities there, who had arrived from as far as the northeastern borders of the empire.[22] Some pilgrimage centers, such as Qal'at Sem'an, were also known for attracting Arab

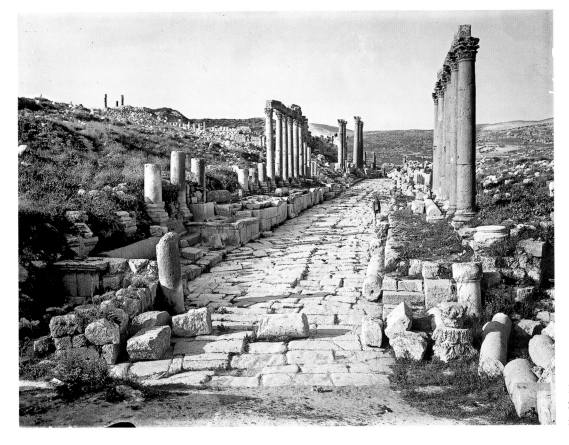

Fig. 4. View of Via Antoninianus from the South Tetrapylon, Gerasa (Jerash), Jordan, in 1931

Fig. 5. Fragment of a mosaic pavement showing a villa in a garden, from the northern section of the peristyle courtyard of the Great Palace in Constantinople, 6th century. Istanbul Mosaic Museum, Turkey

converts as early as the fifth century (see Ratliff, p. 94, and cat. nos. 62–65).[23]

Like Alexandria, most of the cities supporting the trade and pilgrimage routes were well established before the Byzantine era and continued to flourish in the Muslim world. The Romans had built, or rebuilt, many of these cities in their style with broad streets (*cardines*) flanked by tall columns (fig. 4 and Brody, p. 11) and large public monuments, including baths, theaters, forums, and hippodromes (fig. 1). In Byzantine Syria, the elaborate Roman-style cities of the Decapolis, including Gerasa (Jerash in modern Jordan) (cat. no. 1), Philadelphia (Amman in modern Jordan), and Damascus, directed trade goods from the Red Sea north toward Constantinople (see Thomas, p. 124).[24] Throughout the provinces, elaborate public and private buildings, including religious sites, were richly decorated with classically inspired capitals (see cat. no. 51A). Their doorways were hung with huge curtains decorated with images of columns, hunting and Nilotic

scenes, and trees (see cat. nos. 2, 3, 50). Curtains are known to have decorated the streets in Constantinople on state occasions and may well have done so elsewhere. The curtains appearing over the entrance to the palace in a mosaic in Ravenna, the western capital of the empire, are very similar to the design of a curtain found in Egypt.[25] Carbon-14 testing has confirmed that the curtain is a product of the first years of Islamic rule there, evidence of the persistent relevance of Byzantine taste to the new rulers of the eastern Mediterranean (cat. no. 3).

By the sixth century, the classical form of these cities had begun to change: shops pushed forward into the streets, and fewer large public buildings were being built or used. Smaller public baths were developed that were used into the Islamic period. Towns like Attarouthi (Taroutia Emperön in modern Syria) (cat. no. 22) had elaborate buildings, but they were now crowded together, with the great public spaces of the past increasingly filled in with buildings of varied use. Newly built cities followed the classical city plans less and less, a transformation that persisted as the needs of the cities of the empire changed under Islamic rule.[26] Elaborate silver treasures, like that of Attarouthi, found in the eastern Mediterranean demonstrate that these changes did not reflect increasing poverty in the region.[27] The elaborate houses shown on the mosaic floor of the emperor's Great Palace in Constantinople (fig. 5) found echoes in the mosaics of the facade of the Umayyad Great Mosque of Damascus (figs. 101–103), evidence of the ongoing popularity of building styles. The cityscapes frequently depicted on mosaic church floors under Byzantine and Early Islamic rule continue the same traditions (cat. nos. 1, 79). Religious sites were built for the various Christian, Jewish, and other communities of the region. While Orthodox churches and pilgrimage centers remained loyal to Constantinople, other churches rejected its authority, most especially the Coptic Church in Egypt and the Syriac Church in the eastern Mediterranean (see Ratliff, p. 32; Hieromonk Justin of Sinai, p. 50; Khalek, p. 66; Bolman, p. 69; and cat. nos. 25, 27–30, 46–49, 51–53). Synagogues were also found throughout the empire's lands (see Fine, p. 102, and cat. nos. 69, 70, 73).

Religious and secular buildings were furnished with exceptional works of art, both in the capital and throughout the empire's southern provinces, even as the political turmoil of the seventh century transformed the ruling elite. Byzantine art of the period expanded on traditions derived from the classical models popular among the aristocracy throughout the empire and applied it to Christian imagery (see Evans, p. 18).[28] Silver vessels with imperial control stamps dating from the era of Heraclius into the mid-seventh century offer classical themes in skillfully worked naturalistic styles (cat. nos. 8, 9, 11, 12). Other silver vessels from the reign of Heraclius also display the same exceptional naturalism and

artistry being applied to the narrative of the life of the biblical King David (fig. 6) (cat. no. 6). These unique works of the capital—featuring realistic detail, anatomical accuracy, naturalistically fluttering draperies, and notable craftsmanship—embrace antique concepts as shown by a classical personification of a river god, who appears at the top center of the largest plate between David and Goliath (cat. no. 6F). Less elegantly wrought classicizing motifs were produced in the southern provinces on less expensive bone carvings meant to decorate furniture and boxes (cat. no. 10) and as motifs in textiles (cat. no. 13). Figures associated with the realm of Dionysos, god of wine, are found in various media (cat. no. 122). Many Early Islamic works continued the tradition of displaying his grapevines growing from pots or alone, probably to represent a general sense of prosperity and plenty (see Mietke, p. 175, and cat. nos. 120B, 120C, 121). When shown in a specifically Christian context, the vines refer to Christ's statement "I am the true vine" (John 15:1) and the Christian Eucharist (cat. nos. 1, 120A).

The naturalistic style found on the silver of Constantinople also appears on the most elite silks (see Thomas, p. 148, and cat. no. 101). Hunting scenes and mounted warriors that reflect the common pastimes of the aristocracy throughout the Byzantine world were also very popular in the Early Islamic period (cat. no. 103). One Byzantine silk depicting a man fighting a lion closely resembles the image of David fighting the lion on the David Plates (see cat. nos. 6, 102). Linen textiles copying the more detailed styles that were possible on finely woven silks display other David scenes in a more stylized manner, since the threads depicting the narrative could not be as closely woven (cat. no. 7). Carbon-14 dating of decorated tunics found in burial sites in Egypt proves that clothing styles of the region continued without significant changes into at least the ninth century (cat. nos. 111–114).

Silver and textiles meant for liturgical use among all the churches of the region attempted the elegance of Constantinopolitan images with greater and lesser success. Christ, the Virgin, the archangels, and the saints worked in relief on the Attarouthi Treasure (cat. no. 22) include figures closely related in style to the classical tradition (see cat. no. 22, detail, for the image of the military saint in full armor), while other images are worked in a far less sophisticated, schematic manner. Many of the ivories of the so-called Grado chair are exquisitely carved, whereas others display simpler, more angular images (cat. no. 24). Certain narrative poses, such as those on the David Plates, are echoed in some of the illuminations for the Rabbula Gospels, a work of the Syrian Church (cat. no. 39). Coptic churches are covered with vibrant frescoes (see Bolman, p. 75, and figs. 27–30). Jewish synagogues had floor mosaics decorated with creatures found on works

throughout the empire (cat. no. 73). As the ruling elite of the region changed, the populace carried on with most aspects of its daily life. Inscriptions on Byzantine metalwork are argued to have influenced the use of inscriptions on Islamic metalwork, a relationship that can easily be seen on chalices, jugs, and often bilingual clay lamps (cat. nos. 22, 126, 128, 129).[29] Arab authors wrote of their admiration for the Byzantine artisans within their newly occupied territories as well as within the continuing empire.[30]

In addition to classical motifs, classical literature was valued into the seventh century (see Evans, p. 18, and cat. no. 14). As far south in Egypt as the Monastery of Epiphanios, someone practiced his Greek by repeatedly copying the first line of the *Iliad*.[31] Ostraka from there record classical literary texts (cat. no. 15A). Interest in scientific learning continued, as scholars of all faiths pursued their inquiries into the Islamic era. Christian, Jewish, and Muslim scholars explored various means of divination.[32] A provincial Dioscorides manuscript and an ostrakon with medical recipes prove that investigative learning was not restricted to the capital (cat. nos. 14, 15B). The gracefully realistic plants depicted on a fragment of a dish from a synagogue demonstrate that the careful observation apparent in the illustrations in the Dioscorides manuscript was a tradition not uniquely reserved for scholars (fig. 7 and cat. no. 14).

Regional religious figures remained active in Orthodox debates; the influence of their opinions reached far beyond the empire's southern provinces. Saint John Klimax, abbot of the

Fig. 6. Detail of one of the Plates with Scenes from the Life of David (cat. no. 6E) showing a silver stamp from the reign of Emperor Heraclius (610–41)

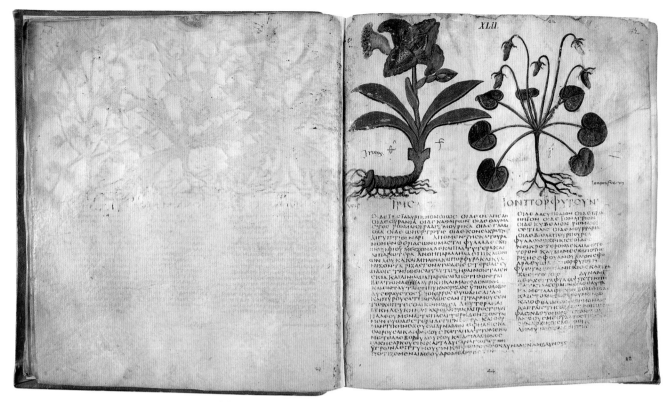

Fig. 7. The Naples Dioscorides (cat. no. 14), fols. 41v–42r

Monastery of Saint Catherine at Sinai (before 579–ca. 650), for instance, wrote *The Ladder of Divine Ascent*. His instructions on the path to salvation for those in monasteries near his site became a standard text in the Orthodox world and were translated into many languages, including Arabic (see Hieromonk Justin of Sinai, p. 50, and cat. no. 25).[33] Saint John of Damascus, from the Monastery of Mar Saba in Jerusalem, another Orthodox site, was the great defender of icons. His writings were of primary importance within the empire in the successful reinstatement of the use of icons during the Iconoclastic controversy of the eighth and early ninth centuries (see Ratliff, p. 32, and cat. no. 80).

During that time, the controversy only indirectly affected the Christians in the empire's southern provinces. Men like Saint John of Damascus were integral to the new Islamic order. A member of the Arab Christian Mansur family, he had, like his father, served in the financial administration of the court of the Umayyad rulers of Damascus before entering the monastery.[34] There is no evidence that the early Muslim rulers participated in the extended destruction of images in the region.[35] In fact, the Monastery of Saint Catherine at Sinai retains a copy of the *Achtiname*, a promise of protection in the name of the Prophet, given the site in the first years of the Muslim advance across the Sinai Peninsula (cat. no. 37). The monumental sixth-century icon of the Transfiguration still fills the apse of the church within the monastery's walls, despite objections to images on the part of both Muslims and Christians.[36] Religious icons of the period also survive there (cat. nos. 27–29). Even at the Coptic monastery of Bawit, where a carved stone image of the Miracle of the Loaves and Fishes was defaced at some date (cat. no. 51C), portable icons survived (cat. nos. 52, 53). At those Christian churches and Jewish synagogues where images of living creatures on mosaic floors were deliberately distorted by rearranging the tesserae, the figures so transformed were not emblems of faith. The alteration of the mosaics is attributed to the beginning of the ninth century; this suggests an increasing effort by certain early Abbasid rulers to respect the hadith forbidding the depiction of living creatures—a practice arising from Muhammad's lifetime—rather than a focus on signifiers of a non-Muslim faith (see Fine, p. 102; Flood, p. 117; and cat. no. 79).[37]

The transformation of the Byzantine Empire's southern provinces into territories of the Muslim world resulted in the continuation of many traditions. It can be argued that neither victory nor defeat was inevitable during the first centuries of the process.[38] Governments functioned as before until about 700, when Arabic became the official language of the state.[39] Along the North African shore, however, the situation was different. The lands from which Heraclius sailed to gain the once-lost imperial throne would increasingly lose contact with Constantinople.[40] From Egypt north, by contrast, the interest in the classical traditions that extended back in time to before Alexander the Great remained influential. Existing Christian and Jewish communities continued to produce works for their own use and for the new elite who ruled their world, the Umayyads (the first generation of Muslim rulers) and their successors. The results would be not an end but a beginning for the new powers of the former southern provinces of Byzantium and for Byzantium itself. The arts of the state and of the religions that existed in the region in the

age of Heraclius reflected a complicated culture, at a time when loyalty to the political structure and the official church of Constantinople vied with local ambitions and religious concepts.[41] With the advance of Islam, the culture of Byzantium's southern provinces became integral to the development of Umayyad rule from Damascus. The new order was both a change from and a continuum with the immediate past, not, as once argued, a new order reviving much earlier traditions of the classical past (see Ballian, p. 200, and Flood, p. 244).[42]

With the rise to power of the Abbasids (750) and their establishment of their capital, Baghdad, in the newly conquered Sasanian Empire (762), Sasanian taste, long present in the region, would increasingly spread beyond it. This aesthetic is evident, for instance, in the Mosque of Ibn Tulun at al-Qitai', completed in 879 for the founder of the Tulunid dynasty in Egypt, Ahmad ibn Tulun, an Abbasid appointee who governed as an independent power (r. 868–84) (cat. no. 181 and figs. 107, 108). By the end of the ninth century, the Byzantine influence, while never lost, was less important. The transition was complete. Islamic rule continued in what had been Byzantium's southern provinces. Over the next centuries, the Byzantine Empire would successfully direct its power elsewhere from its capital, Constantinople.

Gerasa

Lisa R. Brody

Ancient Gerasa, located beneath the modern city of Jerash on the Chrysorhoas River in Jordan, is a site that contributes much to scholars' understanding of the Roman and Byzantine Near East. Its long and significant history has been revealed by its high level of preservation and years of systematic archaeological exploration. The site was first excavated in the 1920s and 1930s by joint teams from Yale University, the British School of Archaeology in Jerusalem, and the American Schools of Oriental Research.[1] These excavations focused primarily on the early Byzantine churches and their associated pagan temples. The areas have been further investigated since 1982 by the Jerash Archaeological Project, sponsored by Jordan's Department of Antiquities and composed of a team of international scholars. The current expedition has expanded its focus to study other aspects of the Roman city, such as the hippodrome, as well as the site's Islamic structures, including houses, shops, and a large Ummayad mosque.[2]

Gerasa is the best-preserved city of the Decapolis, a collective of ten cities in Roman Judaea and Syria,[3] and it is considered to have been one of the most important cities in the Roman Near East, due to its strategic position on ancient trade routes. Although some historical sources, such as Pliny the Elder,[4] imply that the Decapolis cities were all founded during the Hellenistic period (ca. 323– 63 B.C.E.), excavations at Gerasa have found evidence of occupation as least as early as the Bronze Age (third to second millennium B.C.E.). The first and second centuries C.E.

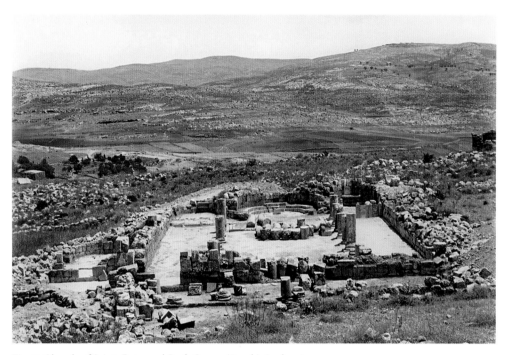

Fig. 8. Church of Saints Peter and Paul, Gerasa (Jerash), Jordan, in 1931

were a time of prosperity for Gerasa, reflected architecturally by its paved and colonnaded streets, theaters, temples, baths, fountains, grand public squares, and hippodrome.[5] At its peak, Gerasa is estimated to have contained a population of approximately twenty thousand. The city's wealth gradually diminished during the third century C.E., as overland trade routes were superseded by shipping routes.

By the fourth century, Gerasa began to foster a significant Christian community.[6] The fifth and sixth centuries saw the construction of more than a dozen churches, including a cathedral, most of them adorned with elaborate mosaic floors and architec-

tural detail (cat. no. 1). Although the Persian invasion of 614 and the Muslim conquest of 636 led to the city's decline, recent excavations have revealed a thriving city during the Umayyad period (661–750).[7] The city was hit hard by a series of earthquakes in 749, and its population decreased sharply. Gerasa remained virtually abandoned, its ruins always a feature of the landscape. The site was rediscovered in 1806 by the German traveler Ulrich Jasper Seetzen, followed by Johann Ludwig Burckhardt and James Silk Buckingham in 1812 and 1816, respectively, all travelers who explored the area and recorded visible archaeological remains.

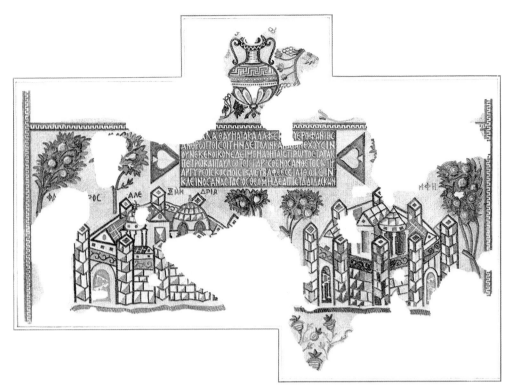

Fig. 9. Watercolor of the complete mosaic (cat. no. 1) by Ignaz Reich of the Joint Expedition of Yale University and the British School of Archaeology in Jerusalem. Reproduced from the *Illustrated London News*, November 23, 1929, p. 902

1. Floor Mosaic Depicting the Cities of Memphis and Alexandria

..................

Gerasa (modern Jerash), Jordan, Church of Saints Peter and Paul, ca. 540

Limestone in ivory, dark ocher, beige, light gray, dark gray, and shades of red

6.1 × 4 m (20 × 13 ft.); tesserae, each, 1–1.5 cm² (⁷⁄₁₆–⁹⁄₁₆ in.²)

Inscribed: In Greek, central tabula ansata: [+ Η ΜΑ]ΛΑ ΘΑΥΜΑΤΑ ΚΑΛΑ ΦΕΡ [ΕΙ ΜΟ]C ΙΕΡΟΦΑΝΤΗC ΑΝΘΡΩΠΟΙC ΟΙ ΤΗΝΔΕ ΠΟΛΙΝ ΚΑΙ ΓΑΙΑΝ ΕΧΟΥCΙΝ ΟΥΝΕΚΕΝ ΟΙΚΟΝ ΕΔΕΙΜΕ ΜΑΘΗΤΑΙC ΠΡΩΤΟCΤΑΤΑΙ[C] ΠΕΤΡΩ ΚΑΙ ΠΑΥΛΩ ΤΟΙC ΓΑΡ 'CΘΕΝΟC ΑΝΘΕΤΟ CΩΤΗΡ ΑΡΓΥΡΕΟΙC ΚΟCΜΟΙCΙ ΚΑΙ ΕΥΒΑΦΕΕCCΙ ΛΙΘΟΙCΙΝ ΚΛΕΙΝΟC ΑΝΑCΤΑCΙΟC ΘΕΟΜΗΔΕΑ ΠΙCΤΑ ΔΙΔΑCΚΩΝ (Certainly, my bishop brings beautiful marvels to the people who inhabit this city and land, because he built a house [of worship] to Peter and Paul, the chiefs of the disciples (for the Savior imparted the authority to them), and adorned it with silver and beautifully colored stones; the renowned Anastasios who teaches the true precepts of God)¹

Over cities, from left to right: ΦΑ ΡΟC (Pharos), ΑΛΕ ΞΑΝ ΔΡΙΑ (Alexandria), [ΜΕ] ΜΦΗ (Memphis)

Provenance: Excavated by the Yale–British School Archaeological Expedition, 1928–29. After its excavation, as part of the *partage* agreement, the mosaic was shipped to New Haven to become part of the Art Gallery's collection.

Condition: This piece preserves 15 to 20 percent of the original nave floor. Most of the tabula ansata inscription survives, as do the amphora above it and most of the representation of Memphis. A large section of the floor between the cities is missing, as is a large portion of Alexandria and its Pharos (lighthouse). The two lower corners and the upper right corner are lost, and there are several other small losses. On the lower edge of the fragment, a small triangular protrusion preserves the floral

motif that originally decorated that area of the nave floor. The surviving tesserae are in good condition and stable, with their colors appearing as they would have in antiquity. In 1933 the mosaic was backed with reinforced concrete and set in an iron frame according to the standard conservation practice of the time. On view for about a decade, it was then placed in storage until it was reexamined in 2009. The heavy, brittle backing had fractured over the years, separating and even splitting the tesserae. An innovative conservation treatment was undertaken. the concrete was removed and replaced with a much lighter, more stable backing of fiberglass, foam, and epoxy, which made it possible for the mosaic to travel.

Yale University Art Gallery, New Haven, Excavated by the Yale–British School Archaeological Expedition, 1928–29 (1932.1735)

This floor mosaic was discovered in 1929 in the nave of the Church of Saints Peter and Paul at Gerasa. The church was founded by a bishop, Anastasios, named in the dedicatory inscription on this fragment and in two other inscriptions from the building. The structure had three apses and was oriented eastward, and, as in the case of the city's other churches, its plain exterior contrasted with an elaborately decorated interior, with carved ornament and mosaic floors. Classical traditions characterize architectural details such as columns, capitals, and moldings. The mosaics, on the other hand, manifest an emerging Byzantine aesthetic and style and relate closely to other such floors, both at Gerasa and at other Jordanian sites.

The construction of the church is dated by internal evidence and by comparison

with other churches at Gerasa. In the composition of its mosaic and the details of its design it is closest to the churches of Prokopios (526–27) and Saint John the Baptist (531), but the quality of these details suggests that it is the latest of the three, constructed around 540.²

The Gerasa example belongs stylistically to a genre of Jordanian floor mosaics known as "city mosaics" (cat. no. 79). Images of Memphis (detail) and Alexandria, with its renowned Pharos (lighthouse), appear within a landscape of fruit-laden trees. Above the cities is a representation of an amphora with grapevines emerging from its mouth and a tabula ansata containing the church's primary dedicatory inscription. At least one other church at Gerasa also contained a city mosaic: the Church of Saint John the Baptist mentioned above. One of the most elaborate and well-preserved examples of the type is the Madaba Map from the early Byzantine church of Saint George in Madaba, Jordan (fig. 1).³ LB

1 The restoration of the text follows Merkelbach and Stauber 2002, p. 356. A. H. M. Jones (in Kraeling 1938, p. 484) restores the text as "[ΕΙ ΠΑ]C." Translation by Angela Constantinides Hero, Professor Emeritus, Queens College, CUNY (May 30, 2011). In line 1, the reference to a bishop is assumed because the term *hierophantes* (teacher of sacred things) was used for the Jewish high priest; see Liddell and Scott 1968, *s.v.* On *ermos* as a term of endearment, see ibid., *s.v.* II.2. Line 3 is an allusion to Matthew 16:18: "You are Peter, and on this rock I will build my church," and John 21:16: "He said to him [Peter] 'Tend my sheep.'"

2 Kraeling 1938, p. 251.

3 H. Donner 1992.

References: Kraeling 1938; Podany and Matheson 1999; Gerasa 2010.

Detail of cat. no. 1 showing the city of Memphis; image taken during conservation treatment

2. Textile Fragment with Tree

....................

Possibly Egypt,[1] 6th–7th century
Tapestry weave in polychrome wool and undyed linen
on plain-weave ground of undyed linen
87 × 62 cm (34¼ × 24⁷⁄₁₆ in.)
Provenance: In the collections of the Musée du Louvre
since the late 19th century.
Condition: The fragment contains a nearly complete tree
motif, cut off at the trunk, and one other flower on a
linen ground that has had some repairs. The colors are
vibrant, although the ground is discolored in several places.
Musée du Louvre, Département des Antiquités
Égyptiennes, Paris (AF 12137)

This textile depicts a stylized tree; its three
branches carry dark and light green leaves
and six pomegranates, which are maroon
with pink tips. To the upper left of the tree
floats a small pink and white blossom enclosed
in dark green leaves. The tree and flower rest
on a linen ground, suggesting that the object
was originally a hanging or a curtain.

Numerous textiles—many of which were
likely hangings—using the same iconography
of fruit trees, even including similar leaves,
survive in collections throughout Europe
and the United States, suggesting that this
motif was widely used in domestic interiors.
Some larger examples, such as two from
Saint Gall, Switzerland, have trees of differ-
ing varieties repeated across the textile, remi-
niscent of a garden.[2] Enclosed, cultivated
gardens, symbolic of prosperity, were wide-
spread around the Mediterranean from
antiquity into the Middle Ages, making
them a perfect motif for a rich interior space.

Similar trees, with and without fruit,
are found in many other media, such as

manuscript illumination, fresco, and mosaic,
most notably at the Great Mosque of
Damascus, Syria (fig. 102). In both
Christianity and Islam, fruit trees connoted
a heavenly paradise, which may be the sub-
ject of the Damascus mosaics. A Christian
example survives on the mosaic floor of the
baptistery at Mount Nebo;[3] there the trees
are interspersed with deer (for a similar
motif, see cat. no. 67). The pomegranates of
the Louvre textile further link this tree with
paradise, since the pomegranate has been
associated with immortality since antiquity.

JB

1 A number of textiles with the same motif have been
 published and demonstrated to be from Egypt in
 Stauffer 1991, pp. 33–35.
2 Ibid.
3 Ibid., p. 47.

Reference: Chaserant et al. 2009.

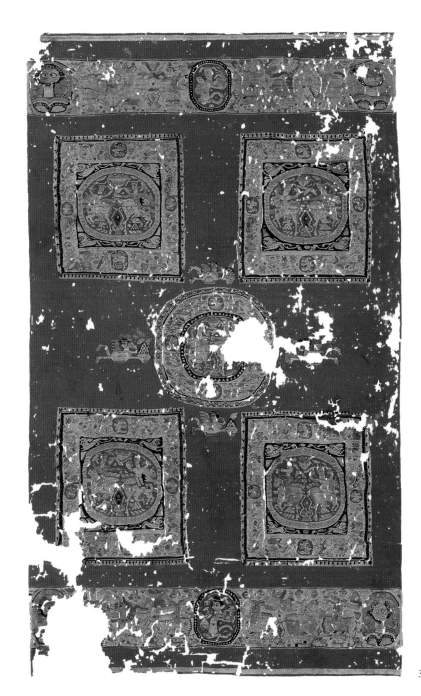

3

3. Hanging with Images of Abundance

.....................

Egypt; 640–60 (radiocarbon dating, 95% probability)[1]
Tapestry weave in polychrome wool on plain-weave
ground of red wool
Overall: 265.5 × 162.7 cm (8 ft. 8⁹⁄₁₆ in. × 64¹⁄₁₆ in.)
Provenance: Edward S. Harkness, Cleveland, Ohio (until
1929).
Condition: The hanging is complete. Significant sections
of the red ground have deteriorated, and some areas are
discolored. The color preservation is good. There is
ancient repair throughout.
The Metropolitan Museum of Art, New York, Gift of
Edward S. Harkness, 1929 (29.9.3)

This wall hanging features a central
medallion and four outer squares whose
borders are filled with various creatures. In
the middle of the medallion and squares ride
five pairs of Amazons. Wide bands across the
top and bottom of the textile present, in
ovals, busts that possibly represent Ge (Earth),

3, detail

Heraclius

Helen C. Evans

Heraclius/Herakleios (r. 610–41) was the most famous and successful Byzantine emperor of the seventh century, even though earlier historians may have overstated his significance in the development of the empire.[1] The varied spellings of his name—Heraclius (Latin), Herakleios (Greek)—exemplify the cultural change under way during his reign, a time when Greek increasingly replaced Latin as the official language of the state. The transformation was recognized at the highest level in 629, when Heraclius replaced the Latin imperial title with the Greek term *basileus*, which would remain in effect throughout the empire's history.[2]

Coming to the throne from a military family of Armenian ancestry, Heraclius spent much of his young adult life in North Africa, where his father, a general, was governor, exarch, of the wealthy southernmost provinces of the empire.[3] The territories, long a prosperous, cultivated part of the Roman Empire, had produced earlier Roman emperors like Septimius Severus (r. 193–211) and major religious leaders, including Saint Augustine (354–430).[4] When summoned to be emperor, Heraclius sailed with Berber troops to Constantinople, while his cousin Niketas took the land route, ensuring Egypt's support of the new regime.[5] As a new emperor, Heraclius was faced by such severe economic troubles following the loss of Jerusalem and nearby lands to the Sasanian Persians that he considered moving the imperial capital to Carthage, which he knew from his youth.[6] Instead, he remained in the East and led his troops into battles so successfully over the next years that he forced the surrender of the Persian army and regained Egypt by 629. In celebration in 630, he ceremonially returned to Jerusalem the portion of the True Cross that had been taken by the Persians from there to their capital, Ctesiphon, when they conquered the city in 614.[7]

Throughout his reign, Heraclius made extensive yet unsuccessful efforts to resolve the Christian religious controversies that exacerbated divisions within the empire's southern provinces. He attempted to encourage compromise solutions, first Monoenergism and then Monotheletism, that resolved the debates over the nature of Christ by arguing that it was more important that he was of one

riders with wreaths in their hands, and small figures carrying food, all on a jumble of birds, fish, and geometric patterns. The iconography is a pastiche of motifs typically found throughout the Byzantine and Islamic worlds. The mounted Amazons do not trample the expected snarling beast; instead, the legs of their horses trot over bowls piled with fruits. In addition, the Amazons' arms pull back bows that are not there.

The many references to food, hunting, and Ge suggest abundance.[2] The textile's grand dimensions and use of many colors—a rich red background with details in pink, blue, green, yellow, black, and white—testify to the undoubted expense of this item. The iconography of Amazons and Nilotic creatures, such as Nereids and ducks, can be found in many of the secular arts around the eastern Mediterranean. Taken together, the scale,

the references to the good life, and the mythological motifs point to a wealthy patron invoking prosperity by hanging this work in the home.

The many textiles in this volume with Amazons, hunters, mythological figures, and animals attest to the popularity of these themes (cat. no. 103). What sets this textile apart from others are the blending of these designs, the simplicity of execution, and the disregard for naturalism.　　　　JB

1　Nobuko Shibayama, Associate Research Scientist, and Tony Frantz, Research Scientist, Department of Scientific Research, The Metropolitan Museum of Art, assisted in the radiocarbon age determinations. The tests were performed by Beta Analytic, Inc., in 2011.
2　Maguire 1990, p. 217.

Reference: "List of Gifts and Bequests of Mr. and Mrs. Harkness," *Metropolitan Museum of Art Bulletin* 10 (October 1951), pp. 81–88.

energy.[8] Heraclius also mandated the forced conversion of the Jews and Samaritans, at least in the prefecture of Africa, in his search for religious unity.[9] It may be that his efforts for religious accommodation encouraged the belief among early Arab writers that he recognized the importance of the Prophet Muhammad and would have converted if it had been allowed. As a result, he long remained a hero in Islamic literature.[10] In later centuries in the West, he would also be seen as a great Crusader hero.[11] In his own time, his second marriage, to his niece Martina, lessened his popularity within the empire. Although his dynasty survived into the eighth century, he and his successors would lose the territories he had regained from the Persians to the rising Islamic orders that followed.[12]

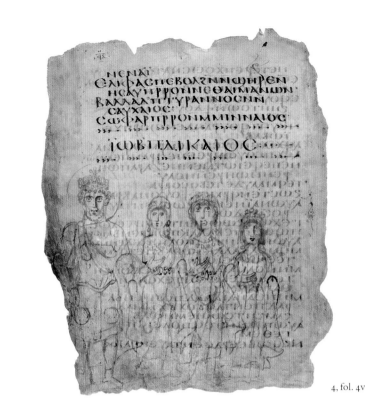

4, fol. 4v

4. Drawing of Job and His Family Represented as Heraclius and His Family

..................

Egypt, 5th century (text), ca. 615–29 (drawing)
Ink on parchment; 8 folios
28 × 24 cm (11 × 9⁷⁄₁₆ in.)
Provenance: From the White Monastery, Sohag, Upper Egypt; purchased by Cardinal Stefano Borgia (1731–1804) in the late 18th century; MS no. 25 in the Museo Borgiano, Velletri, Italy; purchased from Countess Adelaide Borgia in 1821 for the Biblioteca Borbonica (now the Biblioteca Nazionale "Vittorio Emanuele III," Naples).
Condition: The drawing is in good condition.
Biblioteca Nazionale "Vittorio Emanuele III," Naples (Ms.I.B.18)

This leaf appears at the end of the Septuagint version of the book of Job, where Job is identified as having been the king of Edom, a site mentioned in Genesis 36:30–32. The royal dress of Job and his three daughters thus relates to the text. The images have also been noted as being modeled on the contemporary Byzantine emperor Heraclius (r. 610–41), and possibly his second wife and niece, Martina (married 614), his sister and mother-in-law Epiphania, and his daughter Eudokia (b. 611).[1] Coins with images of Heraclius made before 629 show him with a beard and crown like those in the drawing (cat. no. 90B). While the drawing cannot be proven to represent the emperor, his popularity as the savior of Egypt from the Persian occupation would make the identification probable (cat. nos. 5, 16). The Red and White Monasteries at Sohag were among the major Coptic monastic sites of the period (see Bolman, p. 75, and cat. nos. 46–49). HCE

1 Weitzmann 1979a, pp. 35–36, cat. no. 29 (James D. Breckenridge); Spatharakis 1976, pp. 14–20, fig. 5; Fantoni and Crinelli 1997, pp. 24–25, identify the figure only with Job.

References: Spatharakis 1976, pp. 14–20, fig. 5; Weitzmann 1979a, pp. 35–36, cat. no. 29 (James D. Breckenridge); Fantoni and Crinelli 1997, pp. 24–25.

5. Roundel with a Byzantine Emperor, Probably Heraclius

....................

Egypt, possibly Panopolis (Akhmim), 8th century
Tapestry weave in red, pale brown, and blue wools and undyed linen on plain-weave ground of undyed linen
28.7 × 26.6 cm (11¼ × 10½ in.)
Provenance: Uncertain burial site in Egypt; acquired, with other textiles, from Harold Wallis, Esq., St. Albans, Godstone Road, Purley, 1919.

Condition: The textile has been restored and is in good condition; the inscription has been lost.
Victoria and Albert Museum, London (T.794-1919)

An imperial figure, who may be the Byzantine emperor Heraclius (r. 610–41), is shown mounted on a magnificent steed in a large roundel (orbiculus).[1] His flying purple cloak, now faded to brown, his large crown, and the orb and scepter in his hands confirm his imperial status, while his armor marks the scene as a celebration of a military victory. To his sides are two captives in Persian dress (see cat. no. 17) with their hands tied behind their backs. One is led by a rope held by the emperor; the other, possibly a woman, stands free. Beneath the

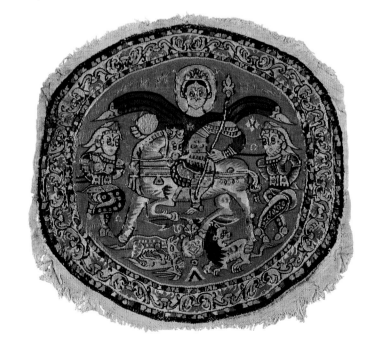

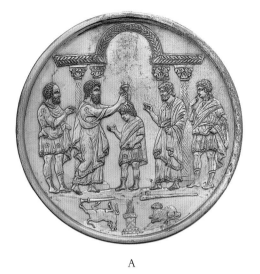

B

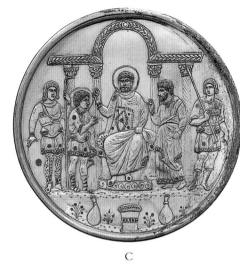

E

A

C

steed's feet are a lion and an antelope being attacked by a spotted animal. They flank a vase with a plant of a type described as a Persian motif.[2] Beside the emperor's halo are traces of an inscription, which may have identified him as Heraclius. Two roundels displaying confronted mounted warriors have similarly placed inscriptions calling the pairs of figures "Alexander the Macedonian," the ancient hero who founded the city of Alexandria in Egypt. Possibly modeled on patterned silks, the pair may have been attached to a tunic as protective amulets.[3]

Woven during the first centuries of Arab rule, the Heraclius roundel was made to be applied to a tunic or domestic textile. Heraclius, the most famous Byzantine ruler of the seventh century, was also a hero in early Muslim historiography and thus would have been an acceptable, possibly protective, image for both Christian Egyptians and their new Muslim rulers.[4] HCE

1 Victoria and Albert Museum website, http://collections.vam.ac.uk/item/093452/panel-from-a/; V&A Museum 1963, fig. 13.
2 Von Falck 1996, pp. 364–65, cat. no. 418 (Sabine Schrenk).
3 Rutschowscaya 1990, pp. 137, 140, 142, 143; Maguire 1996, pp. 126, 128, 136–37, n. 41.
4 El-Cheikh 2004, pp. 39–54.

References: Kendrick 1922, pp. 24–25, pl. XIII; V&A Museum 1963, fig. 13; Victoria and Albert Museum website, http://collections.vam.ac.uk/item/093452/panel-from-a/.

6A–F. Plates with Scenes from the Life of David

....................

Byzantine, Constantinople, 629–30
Silver, cast, hammered, engraved, punched, and chased

A. (.398) Samuel Anoints David
Diam. 26.6 cm (10½ in.); 1,334 g

B. (.395) David Confronts Eliab
Diam. 14 cm (5½ in.); 380 g

C. (.397) David Appears before Saul
Diam. 27.2 cm (10¹¹⁄₁₆ in.); 1,397 g

D. (.399) Saul Arms David
Diam. 26.6 cm (10½ in.); 1,397 g

E. (.394) David Battles a Lion
Diam. 13.9 cm (5½ in.); 389 g

F. (.396) David and Goliath Battle
Diam. 49.4 cm (19⁷⁄₁₆ in.); 5,780 g

Provenance: J. Pierpont Morgan (1837–1913), London and New York (until 1917).
Condition: The plates are in generally good condition with limited pitting and corrosion.
The Metropolitan Museum of Art, New York, Gift of J. Pierpont Morgan, 1917 (17.190.394–.399)

These six solid silver plates from a set of nine depict youthful events in the life of King David as described in the biblical text 1 Samuel 16–17.[1] On the Metropolitan Museum's plates, in chronological order, (A) Samuel anoints David, (B) David confronts Eliab, (C) David appears before Saul, (D) Saul arms David, (E) David battles a lion,

and (F) David and Goliath do battle. The three other plates are on Cyprus and display David summoned to Saul, David battling a bear, and David's marriage to Michal after his victory.[2] Silver stamps on the reverse of the plates (fig. 6) date them to 613–29/30, during the early part of the reign of the Byzantine emperor Heraclius (610–41).[3]

The largest plate (F) displays the battle of David and Goliath in three zones. At the top, the equal-size combatants confront each other across a reclining male personification drawn from the classical tradition. In the center, the unarmed David, again shown the same size as Goliath, leans back as if on the defensive with his arm upraised to ward off the heavily armed, advancing Goliath. The confident pose of David's troops to his side and the timorous turning away of those with Goliath foretell the outcome. At the base, the now gigantic size of Goliath and the smallness of David emphasize the shock of his victory. The medium-size plates (A, C, D) present the narrative as if occurring at the contemporary Byzantine court. The calm, symmetrically arranged figures appear before the articulated (arched) lintels used in court ceremonials. Saul is shown enthroned wearing an imperial mantle (C). In contrast, David's more animated stance on the smallest plates (B and E) advances the narrative action. The compositions of the scenes have been sought in many sources, from manuscripts to wall paintings to textiles (compare the battle with the lion [E] with cat. no. 102).[4]

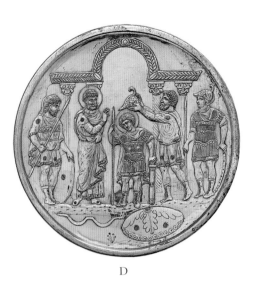

D

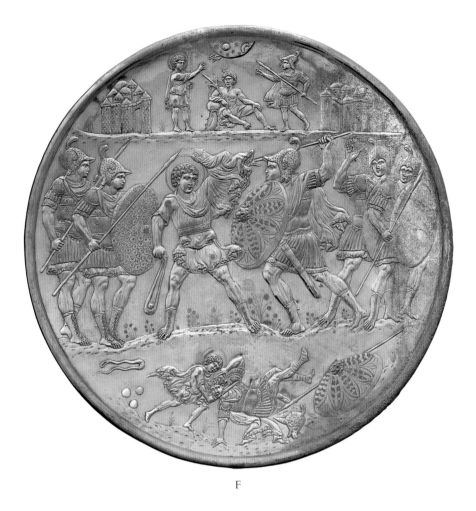

F

Egyptian textiles survive with narratives from David's life in medallions (cat. no. 7), but no one source provides exact parallels for all the images.[5]

The plates that emphasize battles have been identified as display pieces made to honor the Byzantine emperor Heraclius. Evidence for this includes the fact that Heraclius gave the name David to his son born after his victory over the Persians. Contemporary and slightly later Byzantine authors compared Heraclius with David and other biblical heroes and described his legendary single-handed combat with the Persian general Razatis (Roch Vehan) in 627.[6] Surviving texts by Fredegar, a contemporary Burgundian chronicler in the West, called Heraclius a "second David."[7] The exquisite workmanship and the weight of the plates have been seen as commensurate with the gifts, *largitio*, made for distribution by emperors on state occasions.[8] A girdle of gold coins associated with court ceremonial found with the plates marks the owner as being of a rank to receive such gifts. Eight of the coins, including the four largest, were minted for the emperor Maurice Tiberios (r. 582–602), whom Heraclius's father served and admired.[9] Alternatively, the plates have been described as nonimperial domestic ware, rare examples of the Christianization of a tradition whereby tableware displaying classical themes was connected to the education and culture (*paideia*) common to the elite of the empire.[10] As the emperor's

court represented the elite for whom *paideia* was most important, the Christianization of such a relevant classical theme would have been an appropriate innovation for an imperial commission.

The plates may have been arranged around the monumental battle scene (F) to form an elaborate chrismon (a type of Chi-Rho). The four middle-size plates (A, C, D, and the marriage plate) would have been arranged as a cross on the vertical and horizontal with the four small plates (David summoned to Saul, B, battling the bear, and E) filling the diagonals.[11] Since the feet of the plates have no holes that would allow them to be hung, the plates must have been arranged on stands or a table.[12] If arranged in sequential narrative order, the set appears incomplete. Seven plates would precede the monumental battle scene (F), and a single plate, that of the wedding, would appear alone at the end.

The Museum's plates belong to the Second Cyprus Treasure; the First Cyprus Treasure, now largely in the British Museum, was found nearby.[13] It is possible that there were more plates in the original set, now lost, that would have further expanded the postbattle narrative. Whatever their original number, the superb quality of the plates suggests they were made

for the most elite levels of society, probably the imperial court. As such, the association of Heraclius with David would have been immediately identifiable. HCE

1 The plates were found with three more of the series and other works now in various institutions or lost; see Entwistle 2003 for all the works associated with the treasure.
2 Wander 1973; Evans et al. 2001, pp. 34–36; Spier 2007, pp. 285–87, cat. no. 84A.
3 Dodd 1961, pp. 178–95, nos. 58–66.
4 Wander 1973, pp. 96–102.
5 Dale 1993.
6 Wander 1973. M. Mango 1994, p. 124, for an additional contemporary comparison to David.
7 Wander 1975. I thank Brandie Ratliff for bringing to my attention the recent scholarship on Fredegar's text, which recognizes that no copies from before the ninth century survive.
8 M. Mango 1994, pp. 122–31; M. Mango 1991a, 1991b.
9 Kaegi 2003, p. 25; for the girdle, see Weitzmann 1979a, pp. 71–72, cat. no. 61 (Stephen R. Zwirn).
10 Leader-Newby 2004, pp. 173–219; Leader 2000; Cormack and Vasilakē 2008, p. 385, cat. nos. 30–33 (Pavlos Flourentzos), pls. pp. 36–37.
11 Wander 1973, pp. 89–96.
12 I thank Alzahraa Ahmed for noting that the feet of the plates have no holes for hanging.
13 Entwistle 2003, p. 226.

References: Dodd 1961, pp. 178–95, nos. 58–66; Wander 1973; Evans et al. 2001, pp. 34–36; Entwistle 2003 (for all the works argued to have been found with the treasure); Leader-Newby 2004; Cormack and Vasilakē 2008, p. 385, cat. nos. 30–33 (Pavlos Flourentzos), pls. pp. 36–37.

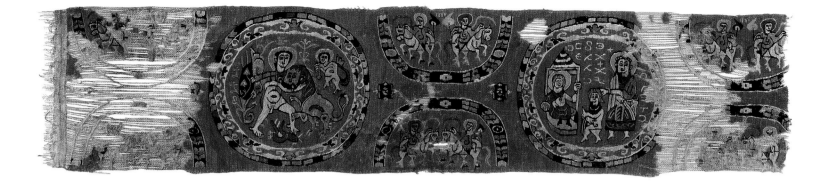

7. Textile Fragment with Episodes from the Life of David

....................

Egypt, 7th–8th century
Tapestry weave in polychrome wool and undyed linen
34.5 × 12 cm (13⁹⁄₁₆ × 4¹¹⁄₁₆ in.)
Provenance: Purchased in Egypt by Vladimir Bock (1850–1899) in 1898; Museum of the Stieglitz School of Industrial Design, Saint Petersburg, until 1931; transferred to the collections of the State Hermitage Museum, 1931.
Condition: There are tears in the fabric, and the colored warp wool has been lost in some places.
The State Hermitage Museum, Saint Petersburg
(AB 11641)

Originally sewn onto the bottom of a tunic, this band depicts scenes from the life of the biblical king David. In the medallion at the right, David is presented to Saul in an image reminiscent of one found on a wall painting from the Monastery of Saint Apollo at Bawit (see Bénazeth, p. 81).[1] On the other medallion, David fights a lion single-handedly; a similar composition appears on the silver David Plates (cat. no. 6). Both the medallion and the plates feature a dead sheep lying beneath the combatants. However, the textile also has a small winged figure with a pink halo and green cloak to the right of David. Comparable figures with haloes, which symbolize strength and courage, occur in early Greek miniatures.[2]

This scene of single combat between David and the lion also appears in later Byzantine miniatures, which, according to Hugo Buchthal, followed early models of the Alexandrian School. In its iconography and style, the work represents one stage in the continuing development of the Hellenistic tradition in Byzantium. Textile fragments with closely related patterns are found in Florence, London, and Baltimore.[3] The use of a wide border, as here, is characteristic of fabrics from the seventh and eighth centuries. oo

1 Clédat 1904, pp. 245–48, pl. XVIII.
2 Omont 1902, pl. IV.
3 Guerrini 1957, pl. XXXVIII; Kendrick 1922, no. 613, in the Victoria and Albert Museum; Dale 1993.

Reference: Bystrikova 1965, pp. 28–31.

Classical Survival
Helen C. Evans

Scholars have long recognized the continuity of classical motifs into seventh-century Byzantium. The best works of the period (cat. no. 9) were often identified as being the decadent end of the arts of an earlier age, especially that of the sixth-century emperor Justinian.[1] The continuing use of classical texts for education in the eastern Mediterranean was recognized, but the texts were identified as debased versions of the earlier works and limited to a small educated elite.[2] Stress was laid on discovering reinterpretations of classical themes in Christian contexts.[3]

More recently, interest has focused on a more positive interpretation of the importance of the continuity of classical learning and images as part of the *paideia*, that is, the common education and culture, by which the elite of the Roman and then the Byzantine empires recognized each other throughout the imperial territories.[4] The breadth of the survival of classical texts has been recognized (cat. no. 14). In this context, the *Dionysiaka*, a long poem describing Dionysos's conquest of India that was written in the fifth century by Nonnos of Panopolis, is recognized as an exemplar of the common cultural tradition of the cultivated elite.[5] Nonnos, as a Christian writing in Panopolis (Akhmim), a city in Egypt near the Coptic monasteries at Sohag (see Bolman, p. 75, and cat. nos. 46–49), is seen as among the elite who retained their classical heritage even as they embraced Christianity. The monks of Sohag represent the less elite who, in becoming Christians, chose to reject the pagan past.[6] The presence of similar motifs on less expensive textiles and bone carvings that survive in Egypt as well (cat. nos. 10, 13) suggests that the assimilation of a common

cultural memory of the classical past may have been more widespread than usually recognized.[7] The grapevine, one of the most ubiquitous of the attributes of Dionysos in seventh-century Byzantine art, would continue to be popular into the Islamic period (cat. no. 120). Ostraka covered with classical texts (cat. no. 15A) found at monasteries like that of Epiphanios in the far south of Egypt demonstrate that monastic Christians did not necessarily reject traditional learning.

8. Plate with Meleager and Atalanta

.

Constantinople, 613–29/30
Silver, chased and incised; on the base, five control stamps from the first decades of the reign of Emperor Heraclius (610–41)
Diam. 27.8 cm (10¹⁵⁄₁₆ in.)
Provenance: Probably found in the Kharkiv district in Ukraine or in Perm Province in Russia; acquired by the Imperial Hermitage Museum in 1840.
Condition: The obverse has one hole near the rim, scratches, and spots of patina. On the reverse, several notches have been made with a sharp object.
The State Hermitage Museum, Saint Petersburg (ω-1)

The hero Meleager is shown here as he prepares to join Atalanta on the Calydonian Boar Hunt. Depicted in relief, he stands nude, save for a cloak around his arms, while Atalanta wears Amazonian dress. They are the central figures of a composition filled with servants, horses, and dogs, set amid a bucolic landscape with a tree and a stone tower in the distance. One of the most common themes in classical art, the epic story with its complex plot lines was frequently depicted on Roman sarcophagi and vases and in Pompeian frescoes and was widespread in the Byzantine world as well.[1] The classicizing composition on the Hermitage plate is peaceful in nature: the characters stand in repose, enjoying each other's company and anticipating the pleasures of the forthcoming hunt. Nothing foretells the ultimately tragic outcome, although the theme of fate is clearly suggested by the scene. Meleager was of particular interest to the Byzantines because the prophecy of his death—at his birth, one of the Fates foretold that he would die when a log burning upon the hearth was consumed—could be seen in a Christian context as foreshadowing the death of Christ. The moral of this story and its multiple associations, both secular and religious, contributed to the popularity of the legend of Meleager and Atalanta in Byzantine art.

YP

1 See, for example, Toynbee and Painter 1986, p. 34, no. 29, pl. XIV,b, on a silver plate in the Bayerisches Nationalmuseum, Munich, with an almost identical figure of Meleager, probably also dated to the time of Heraclius, and Leader-Newby 2004, pp. 137–39, fig. 3.8, on the large plate in the Sevso Treasure, dating to the fourth–fifth century, with the figures of Meleager and Atalanta in the central medallion and four other hunters after the capture of the Calydonian boar.

References: Matzulevich 1929, pp. 9–17, pl. 1; Bank 1985, p. 284, pl. 83; Leader-Newby 2004, pp. 139–40, fig. 3.9; Althaus and Sutcliffe 2006, p. 159, cat. no. 87 (Vera N. Zalesskaia); Zalesskaia 2006c, pp. 70–71, no. 39.

9. Plate with Silenus and a Maenad

.

Constantinople, 613–29/30
Silver, gilded, chased, and incised; on the base, five control stamps from the first decades of the reign of Emperor Heraclius (610–41)
Diam. 25.7 cm (10⅛ in.)
Provenance: Found by Ivan Plotnikov, a peasant, in June 1878, together with two silver Sasanian plates and two Byzantine plates with Emperor Heraclius control stamps, on the bank of the Kalganovka stream, near the village of Maltseva, Solikamsk District, Perm Province, Russia; bought for Count Gregory Stroganov's collection, Saint Petersburg;[1] transported to the State Hermitage Museum in 1925.
Condition: The plate has small scratches, signs of patina, and soil spots.
The State Hermitage Museum, Saint Petersburg (ω-282)

The relief scene on this plate depicts two companions of Dionysos: a dancing Silenus carrying a wineskin on his shoulders and a Maenad holding percussive musical instruments. On the ground before them are a bunch of grapes and a wineskin (the latter perhaps a bagpipelike musical instrument). Comparable scenes with dancing Maenads, Satyrs, and Pan decorate two smaller dishes and one large plate from the fourth-century Mildenhall Treasure.[2] A plate from Constantinople with silver stamps of 550–65 bears a dancing Maenad with similar musical instruments.[3] From the fourth through the seventh century, Dionysiac imagery was very common in Greco-Roman and Early Christian art. According to some scholars, this genre was associated with the Dionysian Mysteries and had a funerary context in Christian times; others question this interpretation.

8

9

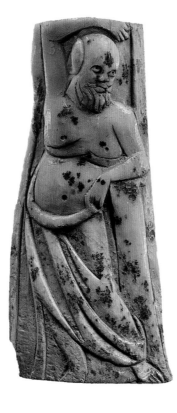

B

A

possibly part of a shield, suggests that the attributes for this figure may have been on an adjoining plaque. On B, Silenus appears as a drunken old man, a popular presentation of Dionysos's tutor (see cat. no. 9). Works related to the long-established cult of Dionysos continued to be popular in seventh-century Byzantine art in many media, ranging from expensive silver dishes to simple textiles and bone carvings like these (see cat. nos. 9, 119, 122). Images related to his world penetrated Sasanian art (cat. no. 20), and his attribute, the grapevine, would be absorbed in early Islamic art (see cat. nos. 155, 156 and Mietke, p. 175).

HCE

1. Carra 2000. I thank Charles T. Little for bringing this text to my attention. St. Clair 1996.
2. Marangou 1976, pp. 27, 34, pls. 16c, 17a.
3. Wixom 1999, p. 30, cat. no. 35 (Helen C. Evans); Marangou 1976, pp. 31–32, 87–89, pls. 2a, 3a, 5a, 5b, 7a.

Reference: (A) Wixom 1999, p. 30, cat. no. 35 (Helen C. Evans); (B) unpublished.

There is no doubt, however, that the widespread occurrence of mythological scenes, including Dionysian themes, was connected to the tradition of Hellenistic literary culture. In seventh-century Byzantium, there was a special interest in the Hellenistic traditions, especially in elite court art, to which these chased-silver objects belong. Silver plates with Dionysian scenes similar to this one served as display objects and may have been part of a dinner service.[4] YP

1. Trever and Lukonin 1987, p. 123.
2. Toynbee and Painter 1986, pls. VII,a, X,b, X,c, in the British Museum.
3. *Ortiz* 1993, cat. no. 253.
4. Leader-Newby 2006, pp. 70–72.

References: Matzulevich 1929, pp. 18–24, pl. 2; Bank 1985, p. 284; Althaus and Sutcliffe 2006, p. 158, cat. no. 85 (Vera N. Zalesskaia); Zalesskaia 2006c, p. 69, no. 38; *Byzantion* 2010, pp. 109, 456, cat. no. 110 (Yuri Piatnitskii).

10A, B. Bone Carvings

......................

A. Dionysos

Egypt, 4th–6th century
Bone
13.6 × 5.3 × 1.5 cm (5⅜ × 2¹⁄₁₆ × ⁹⁄₁₆ in.)
Provenance: Collection of Mr. and Mrs. Maxime Levy Hermanos (1899–1985 and 1908–1992), Paris and New York; Robert L. Hermanos and Miriam H. Knapp, (1991–93).

Condition: The work is in good condition with some damage to the upper and lower edge on the right side. The Metropolitan Museum of Art, New York, Gift of Robert L. Hermanos and Miriam H. Knapp, in memory of their parents, Mr. and Mrs. Maxime Levy Hermanos, 1993 (1993.516.1)

B. Silenus

Egypt, 4th–7th century
Bone
10.7 × 4.5 × 1.9 cm (4³⁄₁₆ × 1¾ × ¾ in.)
Provenance: [Maurice Nahman, Cairo, Egypt (1907)].
Condition: The work is in good condition with some spotting and discoloration from age.
The Metropolitan Museum of Art, New York, Rogers Fund, 1907 (07.228.44)

Throughout the Byzantine Empire, bone plaques were used to decorate furniture, small boxes, and pyxides, most of the numerous surviving examples having been preserved by the dry climate of Egypt.[1] Images like these could have been used alone or brought together in more extensive compositions, often depicting Dionysian revels, or *thiasos.*[2] The heroic nude figure, A, is Dionysos, god of wine. By the Hellenistic era, Dionysos was often posed, as here, in a stance first used for an image of Apollo Lykeios by Praxiteles in the fourth century B.C.E.[3] At the lower left, a semicircular form,

11. Ladle with Neptune and Fishing Scenes

......................

Constantinople, 641–51
Silver, gilded, chased, and engraved; on the base, five control stamps from the first decades of the reign of Emperor Constans II (641–68)
H. 6.3 cm (2⁷⁄₁₆ in.); Diam. 13.5 cm (5⁵⁄₁₆ in.)
Provenance: Collection of M. A. Obolensky, 1870s; entered the collections of the State Hermitage Museum through the *Antiquariat* (People's Commissariat [Ministry] of Foreign Trade), Moscow, in 1927.[1]
Condition: The inside wall of the ladle is damaged, and some gilding is erased.
The State Hermitage Museum, Saint Petersburg (ω-292)

Fishermen with tridents and harpoons, fishnets surrounded by fish, shells, and a swimming bird adorn the exterior of this ladle. On the handle Neptune stands with his characteristic trident atop a fish. Frequently appearing on ladle handles in both ancient Rome and Early Byzantium,[2] deities from classical mythology not only were embodiments of physical beauty but also apparently acted as guardians to protect the contents of the vessels. Neptune, surrounded by real and imaginary inhabitants of the sea, was the most commonly portrayed.[3] Also sometimes shown were Adonis and Herakles, who might be depicted in hunting poses,[4] as the Byzantines considered a successful hunt to be the equivalent of a victory over temptation, sin, and death. Adonis in

such a context would signify the revival of nature, while Herakles would symbolize the suppression of evil forces. Such interpretations of a heroic hunt were clearly in accordance with Christian precepts and thus quite acceptable as decoration for Byzantine monuments. Images of fishing scenes and personifications of the world's oceans are found on the Byzantine monuments of Attica as well as on mosaic floors in the Middle East, including those at Khirbat al-Mukhayyat, Shahba, and Madaba (fig. 1).[5] VZ

1 According to L. A. Matzulevich, the ladle was found in 1853 as part of a hoard at Peshnigort village, Solikamsky district, Perm Province, Russia.
2 For earlier examples of the theme, see Baratte 1989, p. 227, cat. no. 185, a ladle from the second–third century, in the Musée Calvet, Avignon, with a handle showing Neptune sitting on his throne holding the trident in one hand and a dolphin in the other; Cormack and Vasilakē 2008, p. 156, cat. no. 104, a silver ladle with control stamps of Heraclius

(r. 610–41) and a handle depicting Venus holding a flower under a schematic head of the world ocean-cosmos, in the Museum of Byzantine and Christian Art, Athens.
3 Bianchini 1992, pp. 108–9, fig. 56, a sixth-century patera in the Louvre; Hermitage 2007, p. 355, cat. no. 392 (Vera N. Zalesskaia), the handle of a fifth-century ladle with a Nilometer measuring the rise of the water in the Nile, Hermitage collection.
4 M. Martin 1997, pp. 60–61, fig. 25, ladle in the Musée du Petit Palais, Paris, dated 380, from Alexandria, showing Adonis with his dog and spear on the obverse and Venus with a mirror on the reverse; Zalesskaia 2007, fig. 3, a ladle in the Kremlin Museums, Moscow, made, according to the inscription, in fourth-century Sebastia (a few miles from modern Palestinian Nablus), with a handle depicting Dionysian processions and, framing the crown of the handle, Herakles, with a dog and spear, after striking the Erymanthian Boar.
5 Buschhausen 1986, p. 144, figs. 78, 79, 121, 126, 127, pl. XI.

References: Matzulevich 1929, pp. 65–71, 75, pls. 12–15; Dodd 1961, pp. 218–19, pl. 17; Bank 1985, p. 285, pls. 85–87; Althaus and Sutcliffe 2006, p. 160, cat. no. 88 (Vera N. Zalesskaia); Zalesskaia 2006c, p. 76, no. 50.

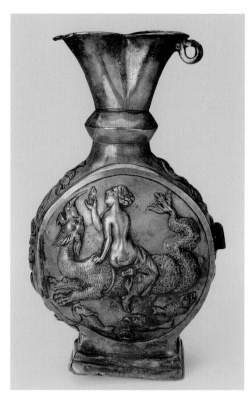

12

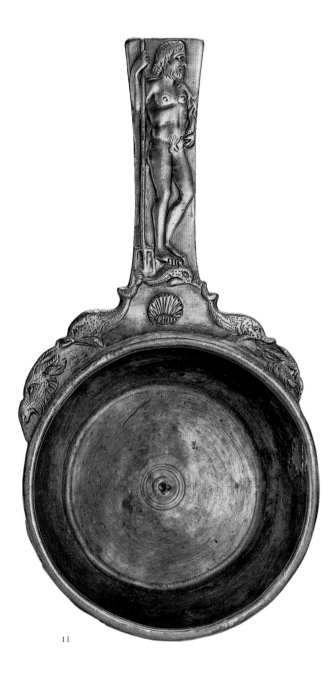

11

12. Flask with Nereids

Constantinople, 641–51
Silver, embossed and engraved; on the base, five control stamps from the first decade of the reign of Emperor Constans II (641–68)
H. 25.2 cm (9¹⁵⁄₁₆ in.); Diam. at sides 13.5 cm (5⁵⁄₁₆ in.)
Provenance: Probably found near the city of Perm; acquired by The State Hermitage Museum in 1925.
Condition: The flask has lost its handle and lid; the hinge for the lid and part of the handle attached to the side wall are preserved. One side is damaged.
The State Hermitage Museum, Saint Petersburg (ω-256)

The body of the flask is decorated on its broad sides with medallions showing Nereids seated on sea creatures and on its narrow sides with fish, water birds, and shells. Images of Nereids, creatures of the sea, were quite common in both ancient and Byzantine art.[1] Daughters of Nereus, the god of the sea, they inhabited the cave of the nymphs—a grotto in which King Odysseus hid the gifts of the Phaeacians as he returned to his native Ithaca.[2]

In ancient Rome special commemorative items were given as gifts during the Kalends of January, and later, with Christianity, during the Christmas season. In homilies, polemical treatises, and messages by Saint Gregory of Nyssa, the nymphs' cave signified the sinful terrestrial world; in Christmas sermons, however, the cave represented the cave of Bethlehem, making the scene a symbolic

parallel to the Nativity story.[3] On the Hermitage flask, the Nereids are presented with iconographic features typical of Venus—the flower held by the Nereid, for example, resembles the anemone that Venus extends to Adonis on a bowl in the Musée du Cabinet des Médailles et Antiques, Bibliothèque Nationale de France, Paris.[4] A characteristic motif of Byzantine art, Nereids also appear on mosaic floors in the Middle East, in particular the Shahba and Madaba mosaics.[5] VZ

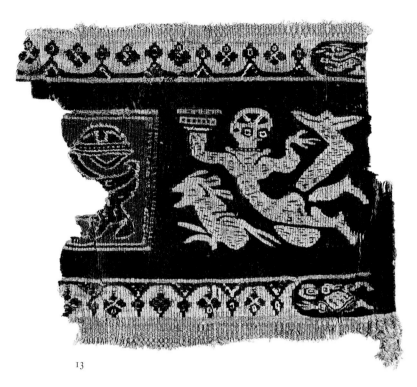

13

1 Pelekanidēs 1977, pp. 179–208, figs. 3–7; of five silver vessels in the Benaki Museum, Athens, one portrays a Nereid and Eros (fig. 6), the others depict Nereids swimming on sea monsters.
2 Papanikola-Bakirtzē 2002, pp. 306–7 (Vera N. Zalesskaia).
3 Althaus and Sutcliffe 2006, p. 162, cat. no. 95 (Vera N. Zalesskaia).
4 Bianchini 1992, pp. 106–7, fig. 55; Cormack and Vasilakē 2008, pp. 380–81, cat. no. 12, for the gesture of the goddess of love in the depiction of Venus at the Mirror on the Projecta casket, in the British Museum, London, which is similar to that of the Nereid holding a mirror on the reverse of the flask here.
5 Buschhausen 1986, p. 128, fig. 121.

References: Matzulevich 1929, pp. 589–91, pls. 19–21; Dodd 1961, pp. 214–15, pl. 15, no. 75a,b; Bank 1985, p. 285, pls. 88–90; *Greek Treasures* 2004, pp. 285–90.

13. Textile Fragment with Nereid
.....................

Egypt, 8th–9th century
Tapestry weave in polychrome wool and undyed linen
12 × 10.5 cm (4¹¹⁄₁₆ × 4⅛ in.)
Provenance: Acquired by the State Hermitage Museum in 1953.
Condition: The image on the left is only partially preserved, and there are tears in some areas of the textile. The State Hermitage Museum, Saint Petersburg (AB 18957)

A Nereid holding a torch rides a sea creature with upraised tail. They move toward a framed object resembling an incense burner, which may refer to the tradition of burning incense in honor of rivers and springs.[1] The borders of the band are decorated with pendant ornaments and two oval medallions, one of which contains an image of a running lion, the other of a person dancing. Since Egyptian Christians revered rivers and springs, it is not surprising that the sea and the Nile were themes that occupied a significant place in the art of Early Christian Egypt, particularly in weaving.[2] Compositions with images of Nereids, serving an apotropaic, or protective, function,

can be found in the Hellenistic and Early Christian periods on paintings, sculptures, and decorative objects.[3] Such images were especially popular on sarcophagi, where they transformed an ancient symbol of immortality into one representing Christian salvation. The closest analogies to the iconography and style of this work appear on a tenth-century tunic fragment and a textile square from the eighth or ninth century, both in the Brooklyn Museum.[4] Dancing humans, running animals, and fish are combined on two clavi that function as tunic decorations.[5]

OO

1 Maguire 1998, p. 151.
2 Ibid., p. 150.
3 Dunbabin 1978, pp. 151–52, pl. 143.
4 Thompson 1971, p. 82, no. 36, p. 72. no. 31.
5 Trilling 1982, p. 76, cat. nos. 75, 76.

Reference: Kakovkin 2004, p. 107, no. 242.

14. The Naples Dioscorides
.....................

Italy, end of the 6th or beginning of the 7th century[1]
Ink and pigment on parchment, 172 fols.
Approx. 29.7 × 25.5 cm (11¾ × 10 in.); exact measurements vary by folio.
Provenance: Italy (based on the type of script used for the main text of the manuscript and its physical makeup [prickings, ruling, marks of the gatherings]).[2] Later annotations: slanted uncial of the 9th century compatible with

Italo-Greek scripts of the same period (see detail, fol 50r);[3] indices of plants in 11th-century Greek cursive (see detail, fol. 33v);[4] names of plants and pharmacological notes by four different 14th-century Latin hands;[5] 15th-century numbering of the plants in Roman numerals; 16th-century Greek numbering of the leaves and Greek notes dated 1537 and 1538;[6] 16th- or 17th-century names of some plants in Italian;[7] 18th-century leaf numbering in Roman numerals.[8] Possibly belonged to the prominent Byzantine scholar Demetrios Chalkokondyles (1424–1511), who may have brought it to Italy in 1447. However, the 14th- and 15th-century Latin notes suggest that it was there earlier, perhaps since its creation.[9] Transferred in 1718 from the convent of Saint John at Carbonara, Naples, to the Imperial Library, Vienna;[10] returned to Italy in 1919, first to the Biblioteca Marciana, Venice, then, in 1923, to the Biblioteca Nazionale "Vittorio Emanuele III," Naples.[11]
Condition: The manuscript is badly damaged in parts, and the order of its leaves is disturbed.[12] Early 20th-century restorations were carried out at the workshop of the Abbey of Grottaferrata.[13]
Biblioteca Nazionale "Vittorio Emanuele III," Naples (Ms.Ex-Vind.Gr.1)

This lavishly illustrated manuscript contains the first-century C.E. work of Dioscorides, which outlines the medicinal properties of 827 ingredients from the world of plants, animals, and minerals.[14] As is standard with technical treatises circulating in the manuscript age, its subsequent users rearranged, updated, added, or eliminated information depending on their own purposes. Fragments of Dioscorides' work on papyri produced soon after his lifetime[15] and later medieval manuscripts preserve a number of

different recensions.[16] The Naples Dioscorides is the second-oldest surviving manuscript of this work, after the sixth-century one now in the Austrian National Library, Vienna (MS Vindob. Med. Gr. 1). The two present the *materia medica* alphabetically, changing Dioscorides' original arrangement by potency of the ingredients,[17] and thus eliminating the need for a reader's prior pharmacological knowledge. The illustrations of both manuscripts indicate that they are descended from the same model but not directly copied from one another.[18] The third-oldest known Greek manuscript of Dioscorides in existence, only partly illustrated, is now in the Bibliothèque Nationale de France, Paris (MS Paris. Gr. 2179). Written toward the end of the eighth or in the ninth century, it was subsequently annotated by several different hands in Greek, Latin, and Arabic. Scholars have debated whether it was originally produced in Byzantine southern Italy, Egypt, or Byzantine Palestine.[19]

The survival of these three uncial manuscripts of Dioscorides' treatise is unusual in the history of the preservation of Greek scientific texts, especially because the Naples and Paris Dioscorides were created during a period generally poor in Greek written sources and are the products of the Byzantine periphery rather than the imperial center. Their longevity is related to their heirloom quality but especially to their continued practical importance and invites further reflection on the state of Byzantine science from the seventh to the ninth century.

This period, dominated by the Iconoclastic controversy (730–87 and 814–42), is generally understood to be one of intellectual stagnation in Byzantium. However, the composition of a few Greek scientific manuals can be placed roughly at this time, although several Byzantine scientific texts are difficult to date firmly. This is because references to concrete historic events are usually absent, and while the texts may contain references to earlier authorities, it is impossible to know how much older these are relative to the author who cites them. The last resort, dating on the basis of literary style, is tenuous: scientific treatises overall use a stable technical vocabulary that they share with the ancient Greek authors and they tend to follow enduring methods of presenting their material, such as a head-to-toe arrangement and a question-and-answer mode. Fortunately, Paul of Aegina's medical compendium, a

cornerstone for both the Byzantine and the Islamic medical traditions, can be securely dated to the seventh century. The Greek evidence alone yields a date between the sixth century (Paul mentions Alexander of Tralleis, who died about 605) and the tenth (the earliest surviving manuscript with his work). In addition, Paul was translated into Latin about the year 800,[20] he is mentioned by a ninth-century Arabic author, and the Arabic biographical tradition places him in Alexandria "at the beginning of Islam."[21] Less is known regarding the dating and authors of the medical, alchemical, and astrological works attributed to Stephen (of Athens, of Alexandria, or the *mathematikos*, "astrologer"), which were written between the seventh and the late eighth centuries;[22] or about the medical writers Theophilos Protospatharios,[23] Philaretos (possibly about 700),[24] Meletios (credited with *On the Nature of Man,* Hippocratic commentaries, and other compositions),[25] and Paul of Nicaea (who can be placed between the seventh and the ninth centuries because he quotes Paul of Aegina, and his textual tradition suggests an uncial archetype).[26] The emphasis these writings placed on practical application helped secure their considerable afterlife. Theophilos Protospatharios's work on uroscopy and Philaretos's on pulses—addressing the two most standard methods of medical diagnosis—ended up in the *Articella*, the collection of treatises used for medical instruction in Bologna, Paris, and elsewhere during the later Middle Ages.[27] Activity continued during the "dark" seventh to ninth centuries in scientific fields other than medicine, such as astronomy.[28]

Incidental translation from Greek into Arabic for administrative and other practical purposes inevitably began as soon as the Arabs moved into the heavily Greek-speaking areas of formerly Byzantine Syria, Palestine, and Egypt, while translations of texts on political science from Greek and perhaps also on medicine from Syriac were sponsored by the elite of the Umayyad period (661–750).[29] Significantly, two of the most important eighth-century authors writing in Greek on science lived not in the Byzantine Empire but in the caliphate: the Chalcedonian Saint John of Damascus (ca. 675–749; cat. no. 80) and the Maronite Theophilos of Edessa, astrologer to the caliph al-Mahdi (r. 775–85).[30]

The translation of originally Greek materials from Greek or Syriac grew into a

social movement in the course of the ninth and tenth centuries, when it served to legitimize the Abbasid dynasty's ascent to power and was patronized not only by royalty and aristocracy but also by all literate classes in Baghdad.[31]

Although the Arabic translation of Greek materials involved primarily, though not exclusively, philosophical and scientific texts from the curriculum of Greek and Syriac education in the seventh century, Arabic texts occasionally bear witness to an interest in later Greek science, such as the field of instrument making. For example, the twelfth-century astronomer Ibn al-Salah reported having seen a book with the description of a Greek globe, the astronomical data on which yields the year 738 for its construction.[32] Since the translation of Greek materials into Arabic provided an indispensable foundation on which later Islamic science was built, occasional recourse to Greek texts continued even after the end of the translation movement, in order to keep scientific knowledge correct and current. Ibn al-Salah found it necessary to discuss the earlier translations of Ptolemy's *Almagest* from Greek and Syriac into Arabic down to their manuscript tradition in order to expose the mistakes in the transmission of Ptolemy's catalogue of 1,025 fixed stars. Subsequent authors used these stars to convey astronomical coordinates, which made them for centuries a requisite point of reference for astronomy both within and beyond the Islamic world. The fortunes of Dioscorides in Arabic also prove this point: new translations of it were made not necessarily because older ones were unavailable, but to update the botanical information and verify the identification of the plants.

Illustrated manuscripts such as the Naples Dioscorides advanced this goal but were not entirely efficient: there is a marked difference between a plant as illustrated in a herbal manuscript and its condition as found in the field over the seasons of the year. In addition, Dioscorides' work was used for more than fifteen centuries in geographies far beyond where he executed his fieldwork. Local varieties, plant evolution, international trade patterns in procuring *materia medica*, and linguistic change contributed to making plant identification a complicated process—several plants mentioned by Dioscorides remain unidentified today. Two translations of the Greek text into Arabic were made in ninth-century Baghdad, and a third in

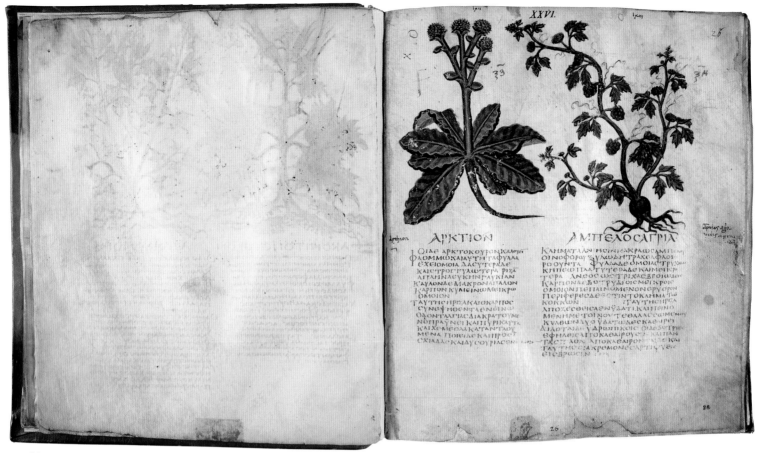

14, fols. 25v–26r

14, fol. 50r, with note in a 9th-century slanted uncial script

14, fol. 33v, with an index of plants in 11th-century Greek cursive

tenth-century Cordoba. Toward the end of the tenth century, the Cordoban Ibn Juljul wrote a commentary. In the twelfth century, two more Arabic translations were made via Syriac under the patronage of the Turkish Artuqid court.[33] The following century, the Malagan Ibn al-Baytar (ca. 1204–1248) wrote another commentary.[34] In the course of his research, Ibn al-Baytar traveled from his native Spain to the "Land of the Romans" in order to observe Dioscorides' plants in the same geographic space as the ancient master. He ended up in Damascus, where he befriended Ibn Abi Usaybi'a, the author of a biographical note on Ibn al-Baytar that tells of their joint excursions to the fields outside Damascus in order to observe and collect plants. Together with Dioscorides, Ibn al-Baytar's contribution to botany remained a standard reference for centuries.

Byzantine and Islamic science from the seventh century onward built upon the knowledge collected and systematized in Greco-Roman antiquity in works by authors such as Dioscorides, Galen, and Ptolemy, the scientific "classics" of the medieval period, which were also available in languages other than Greek and Arabic. This does not mean that Byzantine and Islamic science lacked the originality and innovation that are so valued today, but that the Byzantine and the Islamic worlds perceived their exercise of these qualities in another light: they considered their activity to be the updating, supplementing, and correcting of preexisting knowledge, rather than a departure from it. In the process of their continued engagement with earlier learning, the Byzantine and Islamic worlds occasionally profited from each other's views on it: Ibn al-Salah's interest in the text describing a Byzantine celestial globe can be regarded in the context of further translations of Byzantine (as distinct from ancient) Greek texts into Arabic, as well as of the translation of Arabic texts into Greek.[35] MVM

1 Guglielmo Cavallo in Bertelli et al. 1992, pp. 11–12.
2 Ibid.
3 Ibid., p. 12; Salvatore Lilla in Bertelli et al. 1992, p. 57.
4 Cavallo in Bertelli et al. 1992, p. 12; Lilla in Bertelli et al. 1992, p. 61.
5 Lilla in Bertelli et al. 1992, pp. 57–58, 74.
6 Ibid., p. 73.
7 Ibid., p. 74.
8 Ibid.
9 Ibid., pp. 76–79.
10 Ibid., p. 78.
11 Ibid., p. 79.
12 Ibid., p. 60.
13 Ibid., p. 58.

14 Riddle 1980, p. 4.
15 Ibid.
16 Outlined in M. Collins 2000, pp. 31–35.
17 Riddle 1985, pp. 94–131.
18 M. Collins 2000, pp. 51–58.
19 Ibid., pp. 84–93.
20 Thorndike 1964, p. 5.
21 Pormann 2004, p. 5.
22 Wolska-Conus 1989.
23 Grimm-Stadelmann 2008, pp. 8–42.
24 Scarborough 1988, p. 28.
25 Hunger 1978, pp. 304–5.
26 Paul of Nicaea 1996, pp. 15, 40.
27 Baader 1980.
28 Tihon 1993.
29 Gutas 1998, pp. 23–27.
30 On the language in which the work was originally written, see Mavroudi 2007b, pp. 87–89.
31 Gutas 1998, pp. 28–104.
32 Ibn al-Salah 1975, pp. 132 (Arabic) and 72 (German); for dating the coordinates on the globe, see Savage-Smith and Belloli 1985, p. 15.
33 For a brief history of the Arabic translations of Dioscorides, see Saliba and Komaroff 2005, pp. 8–10.
34 Dietrich 1991, p. 387 [∂].
35 On these translations, see Mavroudi 2002, pp. 392–429; on translations of the Palaiologan period, see Mavroudi 2007a.

Reference: Bertelli et al. 1992, with earlier bibliography.

15A, B. Two Ostraka

....................

Ostraka are potsherds or chips of limestone (abundant in Upper Egypt) used as writing surfaces, an ancient and medieval equivalent to today's scraps of paper. The two ostraka here, one inscribed in Greek and one in Coptic, were excavated in western Thebes (near modern-day Luxor), at the site of an Eleventh-Dynasty Egyptian tomb subsequently outfitted for habitation and occupied about 580–640 C.E.[1] The site is known as the Monastery of Epiphanios. A series of monumental painted inscriptions in Coptic, Greek, and Syriac with anti-Chalcedonian and anti-Arian content indicates the linguistic competence and theological leanings of the inhabitants.[2] Its excavation yielded thousands of papyri and ostraka, mostly in Coptic, which suggests a primarily Coptic-speaking environment.[3] However, a significant number are in Greek or in both languages, indicating that literacy in the two went hand in hand.[4] Coptic represents the last phase in the development of the ancient Egyptian language, written in the Greek alphabet with the addition of seven characters derived from demotic, that is, the immediately preceding phase of Egyptian writing. Though no longer spoken, to this day it remains the liturgical language of the Coptic

Church and the last living link with the civilization of ancient Egypt. Much of its vocabulary consists of Greek words naturalized in Coptic.

Older scholarly consensus on Byzantine Egypt drew a sharp contrast between Greek-speaking pro-Chalcedonian city dwellers and a Coptic-speaking rural Miaphysite majority and held that the use of written Coptic was expanded after the Muslim conquest in 642 owing to the abandonment of Greek and a relatively slow pace of Arabization. More recent scholarship views the pre-Islamic situation as far more complex,[5] consistent with the linguistic and other evidence from the rural Monastery of Epiphanios and other sites.[6] In addition, it is now understood that contracts and legal transactions were drawn up in Coptic at least since the late sixth century,[7] whereas the bulk of the known private correspondence in Coptic dates between the fifth and the eighth century.[8] As for Greek, it most probably ceased to be a spoken language in Egypt in the eighth century,[9] though evidence from the papyri suggests that it continued to be studied in Coptic-speaking environments as late as the tenth to the eleventh century.[10]

A. Ostrakon with Menander's *Sentences*
Egypt, 580–640
Limestone, ink
22.5 × 22.8 cm (8⅞ × 9 in.)
Provenance: Excavated at the Monastery of Epiphanios, Thebes, Egypt (cell A), by an expedition of The Metropolitan Museum of Art, New York (1913–14); ceded in the division of finds (1914).
Condition: The right, left, and lower edges have been destroyed. The action of salts has affected the entire surface.
The Metropolitan Museum of Art, New York, Rogers Fund, 1914 (14.1.210)

Menander's *Sentences* is an assemblage of maxims (mostly single verses in iambic trimeter, but also double verses and prose sentences) arranged alphabetically. Thirty-three of these are copied in Greek on the present ostrakon. The collection does not have a stable length: papyri, ostraka, and stelae written between the first and the sixth to seventh century preserve up to a few dozen sentences each. Byzantine manuscripts, of which the earliest was copied in the thirteenth century, include up to four hundred or five hundred maxims each. When put together, this evidence yields a total of approximately nine hundred maxims.[11] They were used as writing exercises in elementary education and were also read, memorized,

and used by more advanced students to develop themes in the context of rhetorical training, especially as they offer advice on virtue and correct conduct.[12]

The present ostrakon, which served either as the model for school lessons or as a text for private study,[13] was found in the same room as a number of Greek and Coptic liturgical and biblical texts.[14] Although this ostrakon is entirely in Greek, Menander's *Sentences* are known in bilingual Coptic-Greek copies.[15] In the ninth century, a version of the collection was translated from Greek into Arabic; its maxims (attributed to Homer) found their way into a number of Arabic texts composed between the tenth and the thirteenth centuries.[16] A second Arabic version, accrediting the maxims to Gregory of Nazianzus, exists in a single manuscript. Ullmann has identified the Greek equivalents of more than four hundred of the documented Arabic sentences.

A

B

B. Ostrakon with Medical Recipe

Egypt, 580–640
Pottery, ink
13.8 × 10 cm (5⅞₆ × 3¹⁵⁄₁₆ in.).
Provenance: Excavated at the Monastery of Epiphanios, Thebes, Egypt (west rubbish heaps), by an expedition of The Metropolitan Museum of Art, New York (1912); ceded in the division of finds (1912).
Condition: The fragment is in good condition; the writing remains legible.
The Metropolitan Museum of Art, New York, Rogers Fund, 1912 (12.180.79)

This potsherd preserves the formula for an ointment of warm radish oil, burnt sulfur, and a hen's egg that relieves the spitting of blood. It is one of two recipes found in the Monastery of Epiphanios, both written in the Coptic language. A Coptic letter and three Greek graffiti record by name the presence of three physicians on the site.[17] Egyptian monasteries either had resident physicians (who might be monks) or hired them from the outside.[18] However, known medical texts in Coptic are few and far between.[19] All are recipes and survive in mostly fragmentary copies that date from the fifth to the twelfth century, written on papyrus, parchment, paper, ostraka, and the walls of a monastic complex.[20] The only lengthy text is a collection of 237 recipes preserved on a large ninth- or tenth-century papyrus. The sentence structure in a number of the surviving Coptic recipes indicates that they are translations from Greek or Arabic,[21] while others seem to incorporate ancient Egyptian medical practice.[22] MVM

1 For a detailed description of the site and recent photographs, see O'Connell 2007, esp. pp. 250–54.
2 Ibid., p. 254. Syriac is a rarity in the Monastery of Epiphanios (one piece of graffiti and one ostrakon), but see the discussion by Crum in Winlock and Crum 1926, pp. 140–41.
3 See also the discussion on the use of Greek by Crum in Winlock and Crum 1926, p. 143: Greek seems to be confined to more "official" purposes, whereas daily communication seems to be in Coptic.
4 A detailed treatment of the linguistic evidence in the Monastery of Epiphanios can be found in Bucking 2007, esp. pp. 23–24.
5 See Wilfong 1998, esp. p. 177.
6 See Clackson 2000b.
7 MacCoull 2007, p. 75.
8 Bagnall and Cribiore 2006, p. 105.
9 Cribiore 2000, p. 29, n. 15.
10 Clackson 2000b, p. 195.
11 Ullmann 1961, pp. 1–2. The total number of sentences in the most recent critical edition by Jäkel (Menander 1964) is 877, an increase over the 757 given by Meineke in 1841. The attribution to Menander, in evidence at least since the second or third century C.E., is spurious: only a few can be traced to the comedies (now mostly lost) of this famous fourth-century B.C.E. poet, while others can be detected in the comedies of his contemporary Diphilos and the plays of Euripides (fifth century B.C.E.). The source of most remains unknown. See Ullmann 1961, p. 2.
12 Cribiore 2001, pp. 199–200.
13 Ibid., p. 24, views it as a teacher's model for students to copy; Bucking 2007 regards it as the object of private study.
14 For a detailed description of the archaeological context, see Bucking 2007.
15 The bilingual works are published in Hagedorn and Weber 1968.
16 Ullmann 1961.
17 Crum and White 1926, nos. 223, 676, 679, 681.
18 Ibid., notes to no. 223, p. 212.
19 Chronological diagram in Kolta 1991, p. 1578; the entire corpus is inventoried and translated into German in Till 1951, pp. 110–37; two recipes from the Monastery of Epiphanios can be found on p. 129. To these add the papyrus from the seventh–eighth century published by Crislip 2006.
20 Quibell 1909, p. 57, no. 103.
21 Till 1951, p. 5.
22 Kolta 1991, p. 1582.

References: (A) Crum and White 1926, no. 615 (for text and translation); Ullmann 1961; Hagedorn and Weber 1968; Clackson 2000b; Cribiore 2001; Bucking 2007; (B) Quibell 1909; Crum and White 1926, no. 574 (for text and translation); Kolta 1991; Crislip 2006.

Sasanian Expansion to the Mediterranean

Alexander Nagel

Between the third and seventh centuries, the homelands of the Greek-speaking populations in the eastern Mediterranean—specifically the Arabian Peninsula, Syria, and Armenia—were under constant threat from invading Sasanian armies. Geographically peripheral but essential to both the Sasanian and the Roman empires, these areas were the centers of diplomatic intrigue as well as of military actions, especially in the seventh century.

Historians reported the first attempts to invade western territories in Syria, Armenia, and Cappadocia under Ardashir I (r. 224–40), the first Sasanian ruler (Herodian, *Roman History*, book 6).[1] His son Shapur I (r. 241–72) left behind his res gestae (literally, "things done") inscribed on a tower monument in Naqsh-e Rustam in the Sasanian homeland in southwestern Iran; the inscription refers to long campaigns in which Shapur invaded parts of the Roman Empire and glorifies his victories over Roman emperors, including Gordianus III (r. 238–44), in Mesopotamia (Middle Persian: Misikhe). (It is important to remember that Roman sources often presented conflicting accounts of the circumstances of the emperors' deaths.) Shapur successfully occupied the city of Dura-Europos in modern Syria in 256. Although no written accounts of the siege survive, the Roman author Ammianus Marcellinus's description of the siege of Amida one century later and archaeological evidence from Dura have permitted a reconstruction of the events that led to the sack of the city, the main siege weapons being catapults, movable towers, and elephants. According to Shapur's res gestae, some thirty-seven towns in Mesopotamia and Syria were conquered. In 260 Shapur I became the first Iranian king to reach the coast of the eastern Mediterranean. In the summer of that year he took the Roman emperor Valerian (r. 253–60) prisoner in the battle of Edessa. Shapur's victory is depicted on a monumental relief in Bishapur in the Sasanian homelands in Fars.

The Sasanian Empire reached its greatest extent under Khusrau I (r. 531–79). Under his kingship, a series of fortification walls were built, similar to Hadrian's Wall and the Great Wall of China. The wall on the southwestern frontier was referred to throughout the region as the "wall of the Arabs."[2] In the south, Khusrau was able to enter the Arabian Peninsula and even invaded Yemen. His grandson Khusrau II (r. 590–628) expanded the empire to the west; not only did the Arabian Lakhmid state became officially part of the empire, but Syria, Byzantine Palestine, Egypt, and parts of Libya were invaded between 619 and 622. In Jerusalem, which he had conquered in 614, Khusrau removed the True Cross as a trophy. The Byzantine emperor Heraclius (r. 610–41) defeated Khusrau thirteen years later at the battle of Nineveh and regained the relic in 629.

The Sasasian Empire may have failed more than fourteen hundred years ago, yet extensive archaeological data and historical evidence show a sophisticated spread of Sasanian identity and presence in the eastern Mediterranean.[3] Examples of material culture such as coinage, trade patterns, shared court ceremonies, and artistic iconography form a second and more enduring base of influence of Sasanian arts into the late Roman Empire and beyond.

16. Ostrakon Referring to the Persian Occupation

...................

Monastery of Epiphanios at Thebes, Egypt, 618–29
Pottery fragment with ink inscription
6.3 × 11 cm (2½ × 4⁵⁄₁₆ in.)
Provenance: Excavated at the Monastery of Epiphanios, Thebes, Egypt (east buildings), by an expedition of The Metropolitan Museum of Art, New York (1913–14); ceded in the division of finds (1914).[1]
Condition: This ostrakon is broken in two parts and restored. It is a portion of a longer text written on another ostrakon.[2]
The Metropolitan Museum of Art, New York, Rogers Fund (14.1.189)

This ostrakon is from the Coptic Monastery of Epiphanios near Thebes in Middle Egypt, which flourished between 580 and 640 (cat. no. 15). It is one of many letters written between the monks of that monastery and others that reveal aspects of their daily lives. This particular letter reveals the impact of the Persian occupation of the region between 618 and 629; the author refers to having had to obtain permission from the Persian in Nê (the Persian name for Thebes), probably the foreigners' chief official installed in that city, to travel south for grain.[3] Other texts refer to sixth-century events reaching as far beyond Egypt as the Byzantine capital, Constantinople.[4]

HCE

1 Crum and White 1926, p. v.
2 Ibid., p. 239, no. 324, n. 1.
3 Ibid., n. 2.
4 Dijkstra and Greatrex 2009, pp. 246–55, a copy of a letter by Severos, patriarch of Antioch (r. 512–18), to Bishop Soterichus of Caesarea concerning the emperor Anastasios I (r. 491–518) and the downfall of the patriarchs of Constantinople Euphemios (496) and Makedonios II (511), preserved in a Coptic copy of ca. 600.

Reference: Crum and White 1926, p. 239, no. 324 (for text and translation).

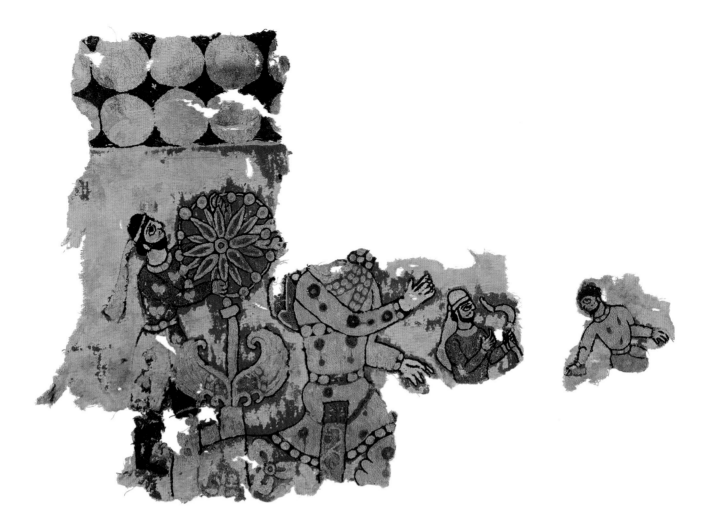

17. Fragments of a Wall Hanging with Figures in Persian Dress

.....................

Eastern Mediterranean, late 6th–early 7th century
Embroidery in polychrome wool on plain-weave ground
of undyed linen[1]
39 × 42 cm (15⅜ × 16½ in.)
Provenance: Collection of Antonis Benakis (1873–1954);
part of the original Benaki Museum, which was given to
the Greek state in 1931 and inaugurated on April 22 of
that year.
Condition: The original size of this hanging cannot be
determined because the selvages are missing. In addition,
the red threads used for the ground fabric have fallen out.
The larger fragment shows remnants of an upper border.
Benaki Museum, Athens (7001)

Only a few hangings with embroidered decoration survive.[2] Just as rare are textiles with what seem to be narrative scenes. Hence, despite their fragmentary condition, these two pieces are exceptional among textiles that survive from antiquity.

Remnants of a border with plain disks on a dark background can still be seen on the upper part of the larger fragment. Below, four figures remain, and their apparel is of special interest. All are dressed in garments known from Sasanian sculpture. The largest figure, in the middle, seems to sit on horseback. He wears a garment embellished with pearl bands around the chest, waist, lower hem, and cuffs. Large blue and smaller red roundels connected by fine lines all over the garment may be interpreted as metal appliqués. Two diagonal dotted red bands cross the chest from the left shoulder. A long object, probably a scabbard for a sword, hangs from his hip. His head is lost, but two ribbons of his headgear can be seen floating down his back.

The other three figures are smaller, and all have black beards. The man on the left and the one to the right of the rider wear a headband, that of the latter combined with a sort of turban. The person behind the rider, on the left, is dressed in a belted shirt decorated with heart-shaped motifs and boots. He is holding a sixteen-pointed star within a pearled roundel at the top of a winged rod, an object that most probably belongs to the royal insignia of a Sasanian king.[3] Actually, the decoration of the figures' dresses represented here shows close similarities to the reliefs from Taq-e Bostan in western Iran that depict Sasanian royalties. Thus, these two fragments in the Benaki Museum could have been a product of the later Sasanian empire whose "origins are clearly rooted in the pre-Islamic Persian artistic traditions."[4]

CF

1. According to Lamm 1937, p. 87, the fabric could be cotton.
2. The completely preserved hanging in the Victoria and Albert Museum, London (T.233-1917), from Late Antique Egypt with tree motifs and a row of vases with tendrils is exceptional; see http://collections.vam.ac.uk/item/O93219/hanging/.
3. Compareti 2005, p. 156. Apostolaki (1951, pp. 129–38) interpreted this object as a solar symbol and proposed that the scene shows a procession in honor of Mithra. For a similar motif, also embroidered, see Lamm 1937, p. 90, pl. XV.A.
4. Compareti 2005, p. 158.

References: Lamm 1937, pp. 87–89; Schuette and Müller-Christensen 1963, p. 25, fig. 6; Compareti 2005, esp. pp. 153–59, fig. 8; Compareti 2006, pp. 172–74, 193, fig. 19; Compareti 2009, fig. 4.

18A–C. Stucco Elements from Ctesiphon

.....................

A. Element of a Wall Frieze with Palmettes
6th century
Stucco (gypsum plaster)
17.1 × 10.8 × 55.9 cm (6¾ × 4¼ × 22 in.)
Provenance: Excavated at Umm ez-Za'tir, Ctesiphon, Mesopotamia, by the Joint Expedition of the Staatliche Museen zu Berlin and The Metropolitan Museum of Art, New York (1931–32); ceded in the division of finds (1932).
Condition: The work is in good condition.
The Metropolitan Museum of Art, New York, Rogers Fund, 1932 (32.150.10)

B. Element of a Frame with a Half-Palmette Scroll

6th century
Stucco (gypsum plaster)
7 × 44.5 cm (2¾ × 17½ in.)
Provenance: Excavated at Ma'aridh, Ctesiphon,
Mesopotamia, by the Joint Expedition of the Staatliche
Museen zu Berlin and The Metropolitan Museum of Art,
New York (1931–32); ceded in the division of finds (1932).
Condition: The work is cracked on the right and chipped
at the edges.
The Metropolitan Museum of Art, New York, Rogers
Fund, 1932 (32.150.46)

C. Panel of Four Tiles with Interlaced Vine Scrolls and Acorns

6th century
Stucco (gypsum plaster)
64.8 × 64.8 cm (25½ × 25½ in.)
Provenance: Excavated at Ma'aridh, Ctesiphon,
Mesopotamia, by the Joint Expedition of the Staatliche
Museen zu Berlin and The Metropolitan Museum of Art,
New York (1931–32); ceded in the division of finds (1932).
Condition: The work is in good condition.
The Metropolitan Museum of Art, New York, Rogers
Fund, 1932 (32.150.5–.8)

These stuccoes belong to a group of seventy assigned to The Metropolitan Museum of Art in 1932, at the end of the joint German–American archaeological expedition to Ctesiphon in present-day Iraq. The excavations of the palace and the surrounding residences at the site of the Sasanian capital brought to light a large number of architectural stuccoes.[1] They are all that remains of the sumptuous decoration of these nobles' houses and the fabled palace of the emperor Khusrau I (r. 531–79). Described by ancient sources as one of the world's marvels, it consisted of many vaulted buildings of baked bricks around a central courtyard, its walls and floors decorated with colored marbles and mosaics of precious stones.[2]

The Sasanians inherited the vaulted hall (*iwan*), with its stucco embellishments, from the Parthians, who had themselves probably adopted this gypsum-plaster technique and repertoire from the Greco-Roman culture. This ornamental form evolved into an original and homogeneous artistic language that would deeply influence the vocabulary of Islamic decorative art. Sasanian artisans introduced a new technique: instead of individually carving stucco tiles, they produced them serially in molds and arranged them in regular and repetitive patterns. Often polychrome, with blue as a background color, the tiles highlighted specific architectural elements, such as archivolts, and embellished wide portions of walls. The most widespread decorations are animal, floral, and geometric motifs, while representational ornamentation includes royal busts, deities, and dancing and drinking figures[3] as well as narrative scenes of subjects such as hunting, battles, and royal investitures.

Animals, both real (rams, bulls, boars, guinea fowl) and fantastic (winged horses and the dog-headed *senmurw*), bear a symbolic significance, related to the Zoroastrian religion and astrology. Floral elements are the most varied, combining ancient Near Eastern and Greco-Roman traditions. Assyrian and Achaemenid palmettes and lotuses, Hellenistic and Roman acanthus and grapevine scrolls, as well as pomegranates, acorns, grape leaves, trefoils, pinecones, and undulating stems were extensively deployed, in apparently endless combinations, within a broad stylistic range.

A higher degree of naturalism characterizes the production of Ctesiphon in particular. The city was already flourishing in the Parthian period—the first century C.E.—and had strong ties to the very Hellenized former capital, Seleucia, as well as commercial links to the Greco-Roman sphere. The artisans of this urban center also frequently used geometric motifs, such as meanders, lozenges, guilloches, and circles, alone or adjoining floral designs in friezes. The Metropolitan Museum's fragment of such a wall frieze (A), which once defined the top of a wall panel,[4] features a band of palmettes, alternating simple ones with others stemming from trapezoidal roots, with half-palmettes branching off their stems like wings.[5] Vegetal motifs become

more stylized over time, at Ctesiphon and in other Sasanian centers in Iran and Mesopotamia: an element with a half-palmette scroll (B), for instance, belonged to a narrow frame for large panels made of adjoining tiles. The three-lobed half-palmettes that compose its wavy meander have lost their floral features, becoming almost abstract signs.

Beginning in the fifth century, in the late Sasanian period, decorative schemes become increasingly complex, with motifs interlacing from one tile to another, to compose an overall pattern. A group of four tiles (C), once part of a larger decorative panel applied to a wall,[6] is one of the best-preserved examples of this pattern system: the interlaced vine scrolls, each one ending in three acorns, create a regular, overall repeated motif of meandering circles that carpets the walls in a kind of composition that would later be taken up in early Islamic decorative arts.[7] EV

1 See E. Kühnel and Wachtsmuth 1933; Upton 1932; and Kröger 1982. The findings were divided among the Iraq Museum, Baghdad; the Staatliche Museen zu Berlin; and The Metropolitan Museum of Art, New York.
2 See Yarshater 2008, vol. 3.1, p. 570, n. 4.
3 See the Metropolitan Museum's female dancer and drinking youth from the excavations at Ctesiphon (both Rogers Fund, 1932 [32.150.25, 32.150.30]).
4 Other fragments of the same frieze are in the Baghdad, Berlin, and London museums. See Kröger 1982, pp. 65–66, no. 71, figs. 29a–b, pl. 20:1, and p. 279 (with bibl.).
5 See cat. no. 161B, an eighth- to ninth-century carved wood panel; for a stucco archivolt at Qasr al-Hayr al-Gharbi, see Schlumberger 1939, pl. XLV, 2.
6 Sixteen identical tiles are divided among the Baghdad, Berlin, and London museums. For the largest group, nine tiles at Berlin, see Kröger 1982, pp. 125–27, no. 189, fig. 68, pl. 51:3, and pp. 282–83 (with bibl.); see Overlaet 1993, p. 156.
7 For early Islamic decoration related to Sasanian antecedents, see Moraitou 2001; the doors appear in the present volume as cat. no. 160; for interlacing scrolls similar in composition to cat. no. 18A, see cat. no. 121, bone plaques from Egypt or Syria; for the stone fragments from the Mshatta palace, see cat. nos. 142A–C; for the stucco decoration at Khirbat al-Mafjar, see Hamilton 1959, pp. 241–93.

References: (A) Kröger 1982, pp. 65–66, no. 71, figs. 29a–b, pl. 20:1, and p. 279 (with bibl.); (B) Kröger 1982, pp. 98–99, no. 132, fig. 54, pl. 38:4, and p. 281; (C) Dimand 1933, p. 81, fig. 3; Kröger 1982, pp. 125–27, no. 189, fig. 68, pl. 51:3, and pp. 282–83 (with bibl.).

19. Bowl with Inhabited Vine Scroll

....................

Iran (?), 6th–7th century
Silver, mercury gilding, hammered, repoussé, chased, gilded
7 × 11.1 × 23.3 cm (2¾ × 4⅜ × 9⅛ in.)
Provenance: [Khalil Rabenou, New York, (1959)].
Condition: The bowl is in good condition.
The Metropolitan Museum of Art, New York, Fletcher Fund, 1959 (59.130.1)

This oval bowl is a fine example of the kind of silverware that entered the Sasanian repertoire in the early sixth century.[1] Oval and lobed bowls, forms that originated probably in China,[2] as well as bottles, ewers, and footed bowls inspired by Roman shapes, bear decorative motifs and narrative scenes representing dancers (see cat. no. 20), musicians, fighters, hunters, and grape harvesting. These Western themes were introduced through trade and warfare with Syria and the eastern Mediterranean. One of the common motifs decorating this typical drinking shape is the inhabited vine (see Mietke, p. 175), which features leaves, grapes,

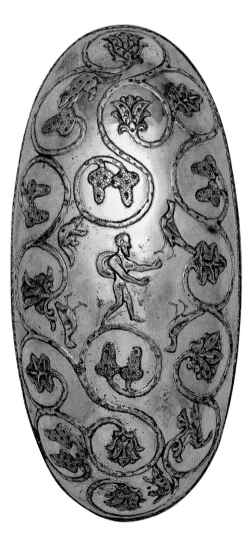

animals, and humans in an overall composition of meandering scrolls. The theme, widespread in the arts of Late Antiquity, from Constantinian mosaics in Rome to Chinese Tang metalware, and in Byzantine ivories and textiles (see cat. no. 119), was adopted in Sasanian art and continued to be used, with various combinations and degrees of stylization in different media, in the Umayyad age (cat. no. 121).[3]

Punched bosses cover the interior of this bowl, and a bird with a leaf in its beak stands at the center. The background of the exterior has been carved out and then gilded, leaving the silver decoration in high relief. The bearded and naked figure in the center may be identified with Silenus or Dionysos himself. Stylized grapes and leaves and luxuriant lotus palmettes, spiraling around birds and jackals, play a decorative as well symbolic role (abundance and eternal life) within a balanced composition that reflects the Zoroastrian ideology of the world's harmony.

EV

1 This later production was apparently no longer restricted to the court but also made for the new noble and military classes that arose under Khusrau I (r. 531–79). In previous centuries, lavishly gilded silver plates representing the king at the hunt had been made as royal propaganda to be given in diplomatic exchanges, like the Roman and Byzantine court silverware. Sasanian silverware, together with glassware, silk, seals, and coins, traveled along the sea and land routes connecting Europe to Southeast Asia as part of the international luxury trade and was imitated in peripheral workshops, particularly in Central Asia, western Iran, and the South Caspian region; this imitation would continue after the fall of the dynasty in the seventh century and the advent of Islam.
On the historical background of Sasanian silverware, see Harper 1978; Harper 1979a, fig. 57 (for this bowl); Harper and Meyers 1981; Harper 1998; and Harper and Marshak 2006.
2 Harper 1988; see esp. pp. 333–35, n. 8, with the list of other similar examples, and bibl.
3 For stucco decoration, see Schlumberger 1939, pl. XLIV, 2; Hamilton 1959, esp. pl. XLIX, details of a stucco panel from the divan.

References: C. Wilkinson 1960, fig. 32 (with view of the interior); Dimand 1967, pp. 3024–25, pl. 1499; Imai 1983; Overlaet 1993, p. 229; Demange 2006, pp. 102–3.

20. Ewer with Dancing Female Figures within Arcades

....................

Iran (?), 6th–7th century

Silver and gilt; body, base, and lid formed separately from hammered silver; soldered, repoussé, chased, punched, embossed, gilded

H. 34.2 cm (13½ in.), max. diam. 13.3 cm (5¼ in.)

Inscribed: Punched, in Pahlavi ﺮﻴﺍﻝﻙ ﺮﺍﺯ ﺲﻟﻪ ﺱﻭ ﺍﻭﻩﺱ

(Wastarčīn, son of Ardānaf [name of owner])

Provenance: [Nuri Farhadi and Habib Anavian, New York, (1967)].

Condition: The lower body has sustained a large area of loss, accompanied by fracture and deformation.

The Metropolitan Museum of Art, New York, Purchase, Mr. and Mrs. C. Douglas Dillon Gift and Rogers Fund, 1967 (67.10a, b)

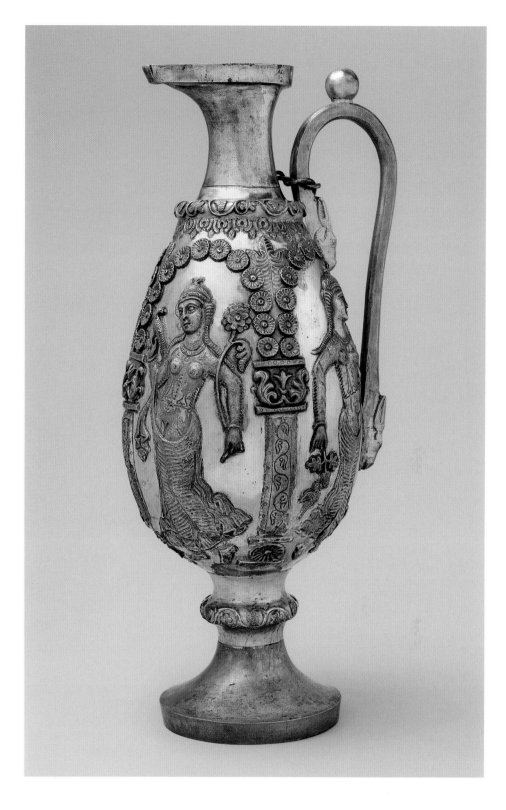

This type of ewer, derived ultimately from a Roman–Byzantine shape, does not appear in Sasanian silverware before the sixth century. Similar examples have been found in Central Asia and China.[1] The lavish decoration on the body consists of four female figures in a dancing pose dressed in diaphanous clothing, each holding two objects. They stand under arches formed of rosettes that are supported by pilasters decorated with a spiraling vine. The subject is common in Sasanian art (on silverware, seals, stucco, and mosaics), but its meaning is still debated.[2] The ubiquitous grapevine and some of the objects held by the figures (such as grapes, leaves, and the jug from which a small panther is drinking) are unmistakably related to Dionysiac imagery, which had been introduced into Iran and Central Asia in the aftermath of Alexander the Great's conquests, in the third century B.C.E., becoming assimilated into the local fertility cult of the goddess Anahita. Another interpretation sees the dancing females as inspired by the Roman personification of the months and seasons: ewers and bottles bearing this iconography would have been used to pour wine during specific seasonal festivals such as Nowruz, the Zoroastrian spring festival celebrating the new year, the renewal of life, and the power of the king. It is also possible that the Bacchic theme, with its symbolism of happiness and abundance, inspired the festive treatment of the motif of dancing women, echoed in the decorative program of the Ummayad palaces and celebrated in Abbasid poetry.[3] EV

1 For a survey of the historical and archaeological evidence of this class of vessels, see Harper 1971 and figs. 1 and 2 for the Metropolitan Museum's ewer.

2 For a discussion of the iconography, see O. Grabar 1967; Harper 1971, figs. 1, 2; Ettinghausen 1972,

pp. 3–10, pl. IX; Harper 1978, pp. 60–61, cat. no. 18 (with bibl.) (Martha L. Carter); Harper 1979a (fig. 59 for the Metropolitan Museum's ewer); Marshak 2006.

3 The Dionysiac and/or festive meaning is debated also for the mosaics in the palace of Shapur I (r. 241–72) at Bishapur, inspired by the lavish mosaics decorating the residences in Antioch, the city conquered by the Sasanian king in 256 and 260: female figures, in dancing poses, playing music and holding flowers, similar to those on the silverware, are part of a composition with typical Roman Dionysiac masks. See Ghirshman 1962, pp. 138–47; Overlaet 1993, pp. 67–69, cat. nos. 20–22 (Janine Balty); Demange 2006, pp. 63–67. For Dionysiac scenes set under arcades, see the brazier from Fudayn (cat. no. 143).

See also the female torso from Mshatta (cat. no. 142D); the female statues in stucco at Khirbat

al-Mafjar, Hamilton 1959, pp. 233–36, pls. XXXV,3, XLIV, LV, LVI; and at Qasr al-Hayr al-Gharbi, stucco figures holding objects connected to abundance, Schlumberger 1939, figs. 21, 25.

For silverware and wine drinking in poems by Abu Nuwaz and Abu al-Abbas al-Nashi, see Ghirshman 1962, pp. 203–7; O. Grabar 1967, pp. 34–36, 66–67.

References: Metropolitan Museum of Art Bulletin (October 1967), pp. 51–52, fig. p. 52; Brunner 1974, p. 118; Kent and Painter 1977, p. 154, cat. no. 322; Harper 1978, pp. 60–61, cat. no. 18 (Martha L. Carter); Overlaet 1993, p. 99, fig. 85.

Christian Communities during the Early Islamic Centuries

Brandie Ratliff

In the sixth century, Byzantium's eastern and southern provinces were among its richest and most ethnically, linguistically, and religiously diverse. While polytheists and, in much larger numbers, Jewish and Samaritan communities (see Fine, p. 102) contributed to the religious composition of the population, Christians were in the majority. Christianity's roots lay in and around Jerusalem (fig. 10), where a group of Jews who numbered among the followers of Jesus of Nazareth professed the belief that Jesus, who was crucified by order of Pontius Pilate, prefect of the province of Judaea (r. ca. 26–36), had risen from the dead as God's Messiah. From this early group of believers, Christianity spread throughout the Roman world; its earliest history is told in the New Testament, particularly the Acts of the Apostles and the Epistles of Paul. In the fourth century, Emperor Constantine I (r. as sole Augustus 324–37) began directing imperial support toward the Christian Church. His patronage, along with burgeoning interest in sites associated with the life of Christ and with monasticism, helped to transform the eastern and southern territories of the late Roman Empire into a Christian landscape.[1] The Sees of Jerusalem, Alexandria, and Antioch were recognized at the Council of Nicaea in 325. As the empire became Christianized, non-Christians and Christians labeled as heterodox were marginalized and even persecuted. This was especially true during the sixth and seventh centuries when, in the face of increasing military threats from the west and the east, Byzantine emperors strove to unify the empire.[2]

The seventh century ushered in dramatic political change. The Sasanians occupied the Roman provinces of Syria, Palestine, and Arabia between 613/14 and 629 and Egypt between 618/19 and 628/29 (see Evans, p. 14, and Nagel, p. 27). This upheaval was followed by a brief period of reestablished Byzantine rule. Then came the Arab-Islamic invasions of the 630s and 640s. The Byzantine Empire lost five major cities in seven years: Damascus (635), Jerusalem (637), Antioch (637), Edessa (640), and Alexandria (642). Despite the tumult, evidence suggests that life in the region's Christian communities continued much as it had under Byzantine rule, until at least the end of the eighth century.

Economic and social transformations in the region happened much more gradually, but they had lasting effects. Changes in taxation and civil administration created the need for a new class of Muslim officials, thereby lessening the importance of Christians in the government.[3] Ties with the larger Christian world were reduced, and the change in hegemony brought an end to state funding of the church, resulting in much-reduced circumstances for Christians.[4] Cities and towns generally surrendered under treaties granting some measure of protection to the local inhabitants, including property rights and religious freedom, in exchange for the payment of taxes.[5] Coastal communities and, to a lesser extent, towns in the border regions of northern Syria tended not to follow this pattern. Caesarea Palaestinae, for example, suffered a six- or seven-year siege before the city was finally taken. Such towns that linked the region to the larger Byzantine world were strategic sites on the Arab-Islamic frontier, and they experienced an early wave of emigration, particularly on the part of the Greek-speaking elite, and repopulation by Muslims. Evidence of this demographic change may be found inland, in the thriving communities of interior Palestine and Transjordan, where some of the coastal inhabitants may have resettled.[6]

Even as Byzantine influence declined, Christianity remained a vital force. The archaeological record presents a picture of continued use, and in some instances expansion, of Christian sites. Some of the most striking examples are found in modern Jordan. At Umm al-Rasas, the Roman garrison town of Kastron Mefaa, near Madaba, the large ecclesiastical complex of Saint Stephen saw construction from the sixth to the mid-eighth century.[7] Excavations in the 1980s revealed a massive mosaic pavement laid in 718 in the main church of the complex (fig. 11). The mosaic has a complex program that shows a continuity of Hellenized visual culture in the region. In the nave a series of interconnected vine scrolls, inhabited with scenes of wine making, hunting, and pastoral life, springs from a pair of acanthus leaves. A wide border filled with Nilotic imagery and ten Egyptian cityscapes frames the central panel. Narrow running-wave borders delineate the Nilotic frieze. Additional cityscapes of Palestine and Transjordan fill the pavement between the columns of the nave and the aisles. Geometric patterns filled with flora, fauna, and other symbols of abundance carpet the aisles. The mosaics of the bema (sanctuary)

Fig. 10. View of the old city of Jerusalem from the west. The dome of the Church of the Holy Sepulchre is visible in the foreground and the Dome of the Rock can be seen in the distance.

and flanking service rooms are almost purely geometric. A donor frieze with images of trees and two additional local cities immediately precedes the tripartite apse. Inscriptions in the central and northern apses and in the donor frieze document the building of the church in honor of Saint Stephen by the people of Kastron Mefaa and the deacon John, chief of the Mefaonites, during the incumbency of Bishop Sergios II of Madaba. An inscription near the altar states that the upper mosaic of the bema was laid in 756, when Job of Madaba was bishop, and identifies the mosaicist, Staurachios Ezbontinos.[8]

Equally impressive are other mosaics found in the Madaba region (see Schick, p. 98). At the Church on the Acropolis in

Ma'in, west of Madaba, the remains of a pavement similar to the one in Saint Stephen at Umm al-Rasas are preserved and dated by inscription to 719/20 (see cat. no. 79). In the town of Madaba, the pavement of the Church of the Virgin, constructed about 608, was relaid in 767 (fig. 12).[9] The new mosaic is entirely geometric. At its center is an inscription extolling the Virgin Mary's role as Mother of God and directing the faithful to purify themselves through prayer before venerating the church's Marian icon.[10] Such an inscription would have made a powerful statement about the foundation of Christian faith—the Incarnation of Christ—which was a key point of dispute between Christians and Muslims. These mosaics attest to continued use of Christian

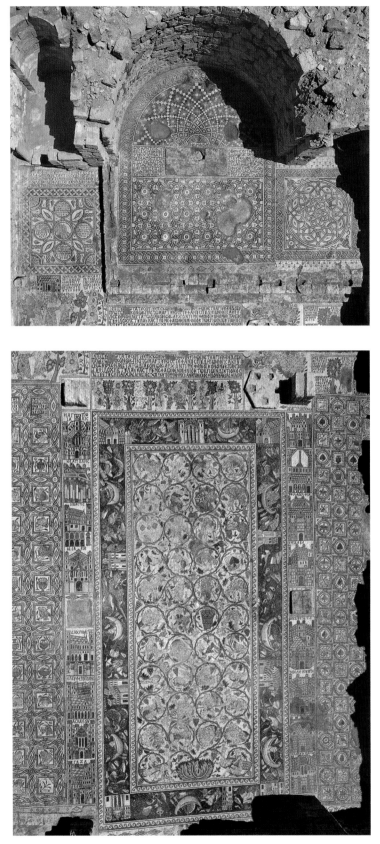

Fig. 11. Mosaic pavement in the Church of Saint Stephen at Umm al-Rasas, Jordan; the main pavement was laid in 718. Editing of the mosaic is especially visible in the central carpet and in the donor friezes before the sanctuary. Reproduced from Piccirillo 1992, figs. 345, 346

sites and to the persistence of an established visual vocabulary throughout the Byzantine East (cat. no 1 and figs. 1, 3). That vocabulary was carried over into the arts of the Umayyads (figs. 101–103).[11]

Jordan does not present the only evidence of Christian communities in the Early Islamic centuries. In Jerusalem, the main religious center of Early Islamic Palestine, a large network of monasteries and agricultural complexes, particularly in areas north and east of the city walls, was established in the Byzantine period, and it continued to expand and flourish up to at least the tenth century.[12] Further evidence of an active Christian community comes from recent surveys and excavations at the Church of the Holy Sepulchre, which commemorates the Crucifixion, Entombment, and Resurrection of Christ. The excavations reveal considerable construction and renovation at the site, including a previously unknown church adjacent to the main complex that was built during the Early Islamic period and continued in use through the tenth century.[13] Similar patterns of activity are seen in Egypt.[14] Two of Cairo's oldest churches—Saint Barbara (formerly Abu Qir and Yuhanna) and Abu Serga—likely date to the late seventh or early eighth century.[15] The Church of the Holy Virgin in Deir al-Surian (the Syrian Monastery) at Wadi Natrun was built in the mid-seventh century. Several layers of painting have been uncovered; the first three layers date from the seventh century (the initial construction of the church) and the eighth and ninth centuries.[16] Many of the vibrant frescoes of the Red Monastery, near the modern city of Sohag, were painted in the seventh and eighth centuries (fig. 13). The paintings of the Monastery of Apa Apollo at Bawit date to the same general period (fig. 34 and see Benazeth, p. 81).[17]

The archaeological record presents little evidence of the deliberate demolition of Christian churches, and with the exception of the construction of the Great Mosque on the site of the basilica of Saint John the Baptist in Damascus (fig. 100) there are few instances of the conversion of Christian churches to mosques.[18] There is, however, evidence of Muslim interest in Christian holy sites. In the Church of the Kathisma on the Jerusalem–Bethlehem road, where the Virgin was believed to have rested, a mihrab may have been added in the eighth century to accommodate Muslim worship.[19] At Rusafa (Sergiopolis) (fig. 14), seat of the popular cult of Saint Sergios, Caliph Hisham (r. 724–43), who relocated his royal residence to the town for part of the year, built a mosque adjacent to Rusafa's most famous church, ensuring the importance of his mosque-palace complex (see Ballian, p. 200).[20] This interest in Christian holy sites is further attested in reports of Muslim prayer in Christian holy places (see Flood, p. 244) and the tradition of *diyarat* literature (books about monasteries written by Muslims in Egypt and Iraq).[21]

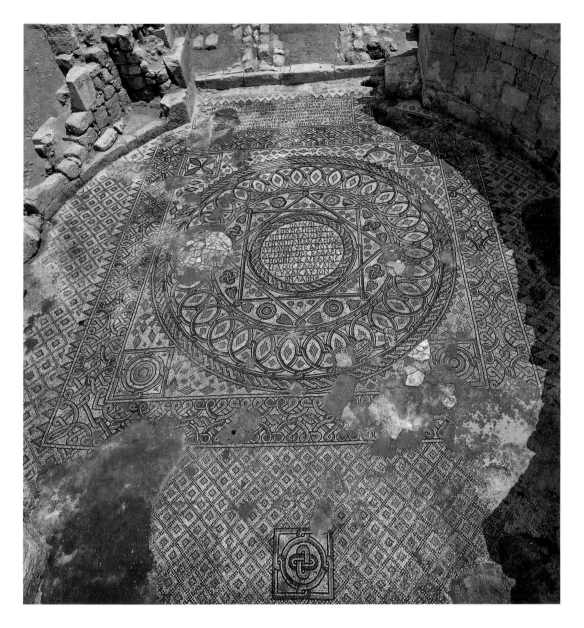

Fig. 12. Mosaic pavement in the
Church of the Virgin in Madaba,
Jordan, laid in 767. The inscription in
the central medallion refers to the
icon of the Virgin kept in the church.
Reproduced from Piccirillo 1992,
fig. 2

Although the conquerors of Byzantium's eastern and southern provinces inherited a majority Christian population, it was by no means a homogeneous Christian polity. Since its beginnings, theological controversies wrought divisions in the church, and large segments of the community of believers were deemed heterodox. Particularly contentious were debates over the correct interpretation of the person of Christ and how the divine Word was united with or incarnated in the human Jesus.[22] The first major Christological controversy centered on the teachings of Arius (ca. 250–336), an Alexandrian priest who argued that the Son of God, or Word of God, who became enfleshed in Jesus, was created. Constantine I intervened in the conflict, calling a church council at Nicaea in 325; his actions aimed at church unity set a precedent that would be followed by emperors throughout the history of the Byzantine Empire. The council rejected Arius and defined the Word of God as eternal and of the same substance as God.

By the early fifth century, two schools of theological interpretation and biblical exegesis emerged around the question of the

nature of Christ and his role in the world, and from those differing schools of thought emerged the various ecclesial groups of eastern Christianity. The Antiochene school, whose major figures included Theodore of Mopsuestia (ca. 350–ca. 428), Nestorios (ca. 381–after 451), and Theodoret of Cyrrhus (ca. 393–ca. 466), can broadly be said to have argued that the eternal Word, or Son of God, is fully divine in nature and dwells in the human Jesus; God the Son and Jesus are not of the same nature but share a common form. In Antiochene exegesis, God reveals his will through human events but remained independent of history, and New Testament texts applicable to the divine Word were distinguished from those dealing with human Jesus. The Alexandrian school, principally represented by Cyril, patriarch of Alexandria (r. 412–44), argued that Jesus always remained God the Word, and thus Christ had a single nature (Miaphysite). In Alexandrian exegesis, God has an active personal presence in the world. Emperor Theodosios II (r. 408–50) called the Council of Ephesos in 431 to settle the dispute between the schools, which was brought to a

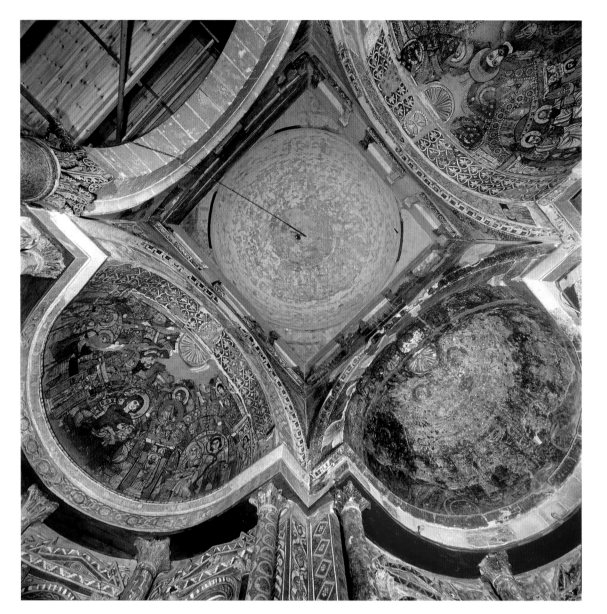

Fig. 13. Red Monastery Church, near Sohag, Egypt (ca. 6th–7th century); view of semidomes from below. © ARCE

head by Nestorios, the newly appointed bishop of Constantinople (r. 428–31), who attacked the tradition of using the title "God-bearer" (Theotokos) to describe the Virgin Mary because it seemed to contradict God's transcendence. Cyril, who had adopted the term, saw its rejection as a denial of God's involvement in human salvation. The council did not formulate its own statement but accepted the statement of the Council of Nicaea as interpreted by Cyril. The decision was not accepted by bishops from Antioch, and in 433 Cyril reached a short-lived compromise with John, patriarch of Antioch (r. 428–42), by suggesting an understanding of Christ's nature that used language from both sides.[23]

Divisions within the church continued, and in 451 Emperor Marcian (r. 450–57) brought together a synod of bishops at Chalcedon to settle the Christological controversy and unite church and empire. The bishops formulated a statement in which Christ was described as having two natures, without division or separation, in one person and one hypostasis.[24] The statement of

Chalcedon did little to bring unity to the church, however; if anything, it intensified conflict in the eastern patriarchates. Many eastern Christians saw the language as misrepresenting or abandoning Cyril's original theology (that before the 433 compromise). Throughout the late fifth century and the opening years of the sixth century, there seems to have been little imperial interest in enforcing the Chalcedonian formula.

Beginning in the reign of Justin I (r. 518–27) and continuing well into the seventh century, when the empire's eastern and southern provinces were lost, emperors worked to achieve church unity, a consequence of which was the oppression of anti-Chalcedonians. This is the period when we see the beginnings of separate hierarchies in the patriarchates of Alexandria and Antioch. In 553 Justinian I (r. 527–65) convened the second Council of Constantinople. That body reaffirmed the statement of Chalcedon and sought to clarify it, outlined accepted ways of understanding the nature of Christ, and condemned the works of three important Antiochene thinkers, Theodore of Mopsuestia,

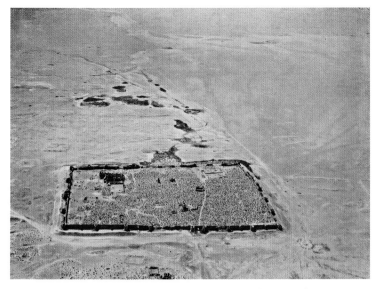

Fig. 14. View of the frontier town of Rusafa (Sergiopolis) in modern Syria. Reproduced from Mouterde and Poidebard 1945, pl. LXXIV

Theodoret of Cyrrhus, and Ibas, bishop of Edessa (r. 435–49, 451–57). The council had little impact and did not achieve Justinian's goal of a unified church.

Further attempts to unite the church were made in the seventh century. Emperor Heraclius (r. 610–41), with Sergios I, patriarch of Constantinople (r. 610–38), and Kyros, the Chalcedonian archbishop of Alexandria (r. 631–42), promoted Monoenergism, a formula defining the two natures of Christ as operating through a single energy. But Monoenergism was widely rejected and an alternative position, Monotheletism, was developed, according to which the two natures of Christ are united in a single will. Maximos the Confessor (580–662) led the opposition to Monotheletism, and the debates continued throughout much of the seventh century.[25] In 680 Emperor Constantine IV (r. 668–85) called the third Council of Constantinople, which condemned both Monoenergism and Monotheletism and defined Christ as having two natures and two wills that operate in harmony.[26]

The Christological controversies of the fourth and fifth centuries fostered the growth of the many ecclesial communities of the Christian East (see Bolman, p. 69; Khalek, p. 66; Griffith, p. 60; and Hieromonk Justin of Sinai, p. 50). It was during the first centuries of Islam, when the hegemony of the Byzantine imperial church was broken and all Christian communities were on equal footing, that those communities came to express their mature identities in a body of writing that has as much to do with self-definition as it does with the challenges of Islam. This body of writing comprised intrareligious dialogues aimed at establishing the orthodoxy of each community's Christological position and interreligious dialogues defending Christian doctrine.[27]

The church in Egypt traditionally traces its origins to Mark the Evangelist, who is considered the first of the Alexandrian patriarchs, a line of succession that may be expressed in the Musée du Louvre's exquisite ivory carving of Saint Mark and thirty-five bishops (cat. no. 23).[28] After the Council of Chalcedon, the Egyptian Church for the most part rejected the Chalcedonian formulation in favor of Cyril's Miaphysite Christology, particularly as presented by Severos of Antioch, a Syrian bishop who spent the last twenty years of his life in exile in Egypt (518–38).[29] The rejection of Chalcedon led to the establishment of an imperially backed Chalcedonian ecclesiastical hierarchy by Justinian I in 538 and the oppression of the anti-Chalcedonian hierarchy and its followers.[30] Under Islamic rule, the Miaphysite leaders and theologians of the Egyptian Church continued to assert the orthodoxy of Cyril's Christology over that of the smaller Chalcedonian community. The Christological position expressed in the inscription on the al-Mu'allaqa lintel (cat. no. 42) can be read as an example of the community's attempts at self-definition. The church retained Coptic as its primary language until the tenth century, considerably longer than other communities of the region.[31]

In Syria the controversy over Chalcedon split the churches of that sprawling region. Partisan disputes in fifth-century Edessa (modern Urfa in Turkey) forced the emigration of Narsai—a poet from Persian Mesopotamia who was greatly influenced by the Dyophysite (two natures) Christology of Theodore of Mopsuestia—and his followers to the city of Nisibis (modern Nusaybin in Turkey), in Persian territory. The school of Nisibis became the intellectual center of Persian Christianity, which adopted the Christology of Theodore of Mopsuestia as its official doctrine at synods held in 484 and 486. The Christology of the East Syrian Church, referred to by contemporary polemicists as the Nestorian church, and known today as the Church of the East, was incompatible with the Chalcedonian formula and was judged heretical at the second Council of Constantinople in 553.[32]

A sizable portion of the Syrian population followed the teachings of Cyril. In the sixth century, Severos of Antioch emerged as one of the most important figures in the anti-Chalcedonian movement. He was exiled and his followers suppressed in the anti-Chalcedonian persecutions of Justinian I. At the urging of the leaders of the Ghassanid Arab tribal federation—important Byzantine allies along the eastern frontier and generally adherents of Miaphysite Christology—Jacob Baradaeus was installed as bishop of Edessa (r. 542/43–78). Jacob supported the anti-Chalcedonian cause and appointed sympathetic bishops, mainly drawn from Syrian monasteries. The Syrian Orthodox Church did not emerge fully as a church with its own independent hierarchy until after the Arab-Islamic conquests. Syriac remained an

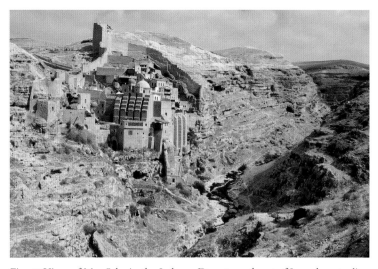

Fig. 15. View of Mar Saba in the Judaean Desert, southeast of Jerusalem, traditionally considered to have been founded in 483 by the ascetic Saint Saba. The monastery was an important intellectual center for the Melkite community.

important language for the church, even after the ninth century, when the church adopted Arabic.[33] The stunning Syriac Rabbula Gospels (cat. no. 39) preserve examples of Garshuni (Arabic text written in Syriac script) charting the history of the manuscript as it moved through the Syriac community.

Another group of Christians professed the Chalcedonian faith and used as liturgical languages Greek and an Aramaic dialect known as Christian-Palestinian Aramaic (cat. no. 66A). Their communities were generally located in Palestine, Transjordan, and the Sinai. Unlike the churches in Egypt and Syria, these Melkites ("royalists")—so-called by their contemporaries because they accepted the conclusions of the six councils of the Byzantine

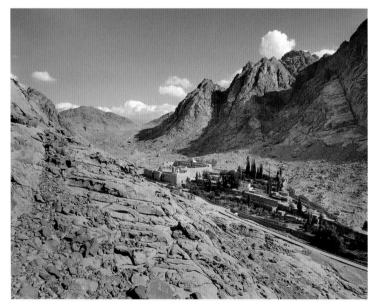

Fig. 16. View of the Holy Monastery of Saint Catherine, Sinai, Egypt. The current structure was built under Emperor Justinian (r. 527–65) at the traditional site of the Burning Bush seen by Moses. The Monastery houses an important collection of early Christian Arabic texts. A survey of colophons from the Monastery's collection reveals that Saint Catherine's was a key center for the Melkite community.

imperial church—only emerged as a distinct group after the shift in regional power. The See of Jerusalem and the monasteries of Mar Saba in the Judaean desert (fig. 15) and Saint Catherine in the Sinai (fig. 16) were important intellectual centers. The Melkite community provides the earliest evidence of the use of Arabic as an ecclesiastical language—in the mid-eighth century.[34] The earliest dated Arabic manuscript (cat. no. 34), dated to the year 859 in a colophon (fig. 17), is housed at Saint Catherine's, an important repository for Christian texts written in Arabic. This fragmentary early example of an Arabic lectionary is unusually lavish. It preserves two full-page Evangelist portraits and two sets of frontispieces. A survey of colophons in Melkite manuscripts reveals a network of communities in Palestine, Antioch, Baghdad, Damascus, Sinai, Alexandria, and the Edessa-Harran area.[35]

By the eighth century, significant transformation had taken place in the former eastern and southern Byzantine provinces. Monetary and linguistic reforms had been instituted, the sacred landscape of Jerusalem had been reoriented with the building of the Dome of the Rock on the Temple Mount, and the basilica of Saint John the Baptist in Damascus had been replaced by the Great Mosque. Restrictions were imposed on the construction of churches and on practices that were offensive to Muslims or disruptive to Muslim worship. These limitations extended, for example, to the display of the cross, which proclaimed the Christian belief in the Incarnation and Resurrection, and to religious processions.[36]

By this period, new pastoral problems appeared in Christian communities. Of particular interest within the broader context of the Mediterranean world in the eighth and ninth centuries is the question of icon veneration, which was also a matter of contention in the Byzantine Empire, where Iconoclasm was imperially sponsored (726–74, 813–42).[37] Theodore Abu Qurrah (ca. 777–ca. 830), the first Melkite theologian to write regularly in Arabic, addressed the issue in his *Treatise on the Veneration of the Holy Icons* (cat. no. 81), written in 799 or 800.[38] His argument makes it clear that certain Christians were refusing to venerate icons because of Muslim and Jewish polemics against the practice. The problem had already been the subject of a debate that took place in the 720s between a monk of the monastery of Bet Hale and a Muslim emir, in which the emir questioned the monk about the Christian custom of prostration before images.[39] In the same period John of Damascus (ca. 675–749), one of the earliest Christian scholars to write in the Islamic milieu, composed a three-part defense of icons, known in English as *On the Divine Images*, which was later used in the Iconophile defense of images in Constantinople.[40] Further evidence of an internal dialogue over the appropriateness of images is seen in the alteration of mosaics in Palestine and Transjordan (see Schick, p. 98, and Flood, p. 117, as well as

Fig. 17. Arabic lectionary (cat. no. 34 [Arabic NF Ms 16]), bifolium showing the manuscript's colophon dating it to 859. The manuscript is the earliest dated Christian manuscript in Arabic.

cat. no. 79).[41] At Umm al-Rasas, large-scale editing is seen not only in the eighth-century mosaics of the Church of Saint Stephen (fig. 11) but also in earlier mosaics, such as those in the Church of the Lions.[42] While Byzantine Iconoclasm focused on holy images alone, in the mosaics of Palestine and Transjordan most creatures have been systematically removed and replaced with white tesserae or floral and vegetal motifs. The issues with icon veneration addressed in texts of the period and the evidence of mosaic alterations should not, however, be taken to indicate a large-scale iconoclastic movement among Christians of the caliphate. Evidence of continued icon veneration is found in the mosaic inscription at the Church of the Virgin in Madaba (fig. 12) and in the many figural programs found in Egyptian churches. Rather, the questions related to icon veneration and the depiction of creatures in an ecclesiastical setting should be considered within the context of the self-definition of Christian communities in an increasingly Islamic world.

Here, at the end of the Early Islamic centuries in our region of interest, we can see a Christianized world that has become and will increasingly become Arabicized. Intrareligious dialogues, which were often focused on Christology, a doctrinal matter that frequently put Christians on the defensive in discussions with Muslims,[43] took place in Arabic, and a large body of apologetical and polemical literature in Arabic was produced.[44] Christian thinkers continued to play vital cultural roles, particularly in the translation movement in the Abbasid capital of Baghdad, where, from the eighth to the tenth century, works of learning from Hellenistic and Persian traditions were translated into Arabic.[45] Toward the end of the ninth century, however, instances of conversion to the Muslim faith increased and the Christian population began to decline, a trend that would only strengthen as time went on.

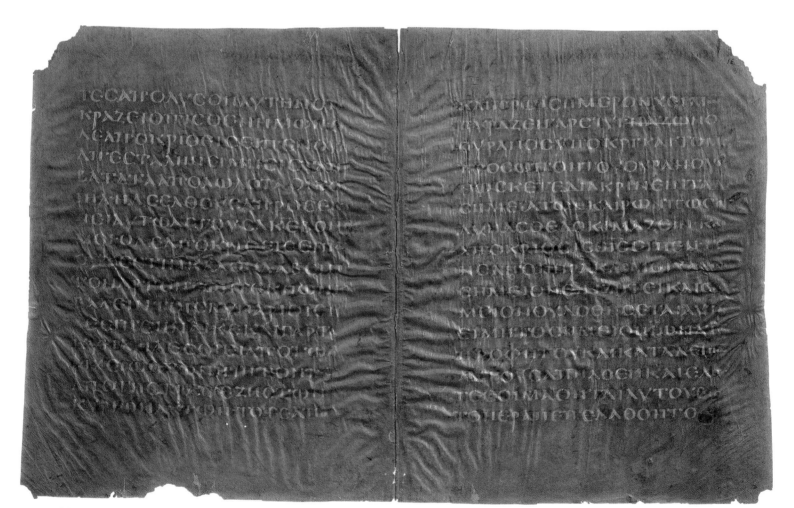

21A, fol. 3r

21A, fol. 4r

21B, fols. 13v, 16r

21 A, B. Leaves from the Purple Vellum Gospels
....................

A. Codex Purpureus Petropolitanus, Matthew 26:57–65
Syria or Constantinople (?), 500–600
Silver and, for *nomina sacra*, gold on parchment, dyed purple; 2 folios
Each folio: 32 × 26.5 cm (12⅝ × 10⁷⁄₁₆ in.)
Provenance: Sir Robert Cotton (d. 1631) (by 1600); by descent to his grandson, Sir John Cotton (d. 1702); his gift to the nation (in 1702); entered the British Museum, London, at its foundation (1753); transferred to the British Library at its foundation (1973).[1]
Condition: The folios' condition is stable, with some damage. The silver ink is oxidized.
The British Library, London (Cotton Titus Cxv), folios 3, 4

B. Codex Sinopensis, Matthew 15:19–28, 16:3–10
Syria, Byzantine Palestine, or Constantinople (?), 550–600
Gold ink on parchment, dyed purple; 1 bifolium
Bifolium: 50 × 56.5 cm (19¹¹⁄₁₆ × 22¼ in.)
Provenance: Purchased in December 1899 in Sinop (ancient Sinope), Turkey, by Jean de la Taille, who sold it to a book dealer in Orléans; acquired for the Bibliothèque Nationale by Henri Omont (April 1900).[2]
Condition: The condition of the bifolium is stable.
Bibliothèque Nationale de France, Paris (suppl. grec 1286), folios 13, 16

These dramatic purple leaves, their texts elegantly written in Greek uncial (capital) letters in gold or silver, are from two of the most luxurious Byzantine Gospel books that survive, at least in part.[3] The Codex Purpureus Petropolitanus text, A, is set down in two columns per page. More unusually, the text of the Codex Sinopensis, B, extends across each page in one wide column. Since relatively few words can be accommodated on each of its pages, the complete Gospel would have been so large that it may have been part of a set in which the four Gospels were bound separately, or perhaps in pairs.[4]

The texts of the two manuscripts are closely related, having similar textual variants and paleographic anomalies. Some scholars attribute them to Syria or to Byzantine Palestine in the century before the loss of that region to the new polity of the Umayyads (661–750); others prefer to consider them products of the imperial capital, Constantinople.[5] Their sumptuous quality evokes the grandeur associated with the liturgical objects used in Constantinople's majestic church of Hagia Sophia (fig. 1) and at the imperial court (cat. no. 6). However, an argument can be made for continuing to view the two manuscripts as products of the empire's wealthy eastern provinces. An analysis by Robert Fuchs in 1977 of a leaf from the Codex Purpureus Petropolitanus in the Morgan Library and Museum in New York showed that the dye was made from lichens and not extracted from murex shells as was the Tyrian purple dye associated with the imperial court.[6] Moreover, the existence of a Gospel book, the Codex Brixianus, written in Latin on purple-dyed vellum and dating from the same century, indicates that that there was no one center of luxury book production at the time.[7]

Whether made in the Byzantine Empire's eastern Mediterranean provinces or in Constantinople, purple-dyed works such as these were admired and sought after from the first years of the Arab expansion. They are thought to have influenced the development of the most luxurious of the early Qur'ans, which were written in gold on indigo-dyed paper (cat. no. 192). HCE

1 The manuscript is also known as Codex N and Codex Caesariensis. It may have been broken up by the twelfth century. Most of the surviving leaves (182) were found in the mid-nineteenth century at Sarumsahly, Cappadocia; these entered the collection of the Russian czar in 1896 and are now in the National Library of Russia, Saint Petersburg. Other leaves are in the Monastery of Saint John the Theologian, Patmos; the Byzantine Museum, Athens; the Museum of Byzantine Culture, Thessaloniki; the Biblioteca Apostolica Vaticana, Vatican City; the Austrian National Library, Vienna; the British Library, London; the Bibliothèque Nationale, Paris; the Morgan Library and Museum, New York; and the Spinola Library, Lerma; Voelkle, in M. Brown 2006, p. 303.
2 Forty-three leaves from the Codex Sinopensis are extant, and all are now in Paris. One other leaf, once in Mariupol (formerly Zhdanov), Ukraine, and now lost, has been attributed to the manuscript. At the bottom of the page, five of the Paris leaves have Christological narrative scenes flanked by prophets. Closely related to the text, those scenes are Herod's Feast, the Death of John the Forerunner (the Baptist), the two versions of the Miracle of the Loaves and Fishes, and the Healing of the Two Blind Men at Jericho. Lowden 1999, pp. 21–24.
3 Ibid., pp. 13–24: two other extant Byzantine purple manuscripts written in uncial script in silver and gold probably have the same textual source. They are the Rossano Gospels (Cathedral of Rossano, Italy), close in format to the Codex Sinopensis, and the codex from Berat (Codex Beratinus [Albanian National Archives, Tirana (Nr. 1)]). Additionally, the Vienna Genesis (Austrian National Library [cod. theol. gr. 31]) is written in silver on purple vellum.
4 Lowden (1999, pp. 22–23) observed that the bookcase in the *Saint Lawrence* (?) mosaic in the so-called Mausoleum of Galla Placidia in Ravenna shows each Gospel bound separately; see also Kessler, in M. Brown 2006, p. 302.
5 Lowden (1999, pp. 23–24) accepts the close relationship proposed between the Codex Sinopensis and the Rossano Gospels, and between the former and Codex N (the Codex Purpureus Petropolitanus) and the Codex Beratinus. He notes that while they all are generally attributed to Byzantine Syro-Palestine, he considers their luxurious formats as evidence of a Constantinopolitan origin. Kessler (in M. Brown 2006, p. 302) accepts Constantinople as the city of origin for the Codex Sinopensis, but Voelkle (in M. Brown 2006, p. 302) retains Syria as the site where the related Codex Purpureus Petropolitanus was written. Förstel (in Cormack and Vasilakē 2008, p. 390) argues for a "Syrian or Palestinian" origin for the Codex Sinopensis.
6 Voelkle, in M. Brown 2006, p. 303.
7 M. Brown 2006, pp. 46, 306, cat. no. 70.

References: (A) Weitzmann 1979a, pp. 491–92, cat. no. 442 (Herbert L. Kessler); M. Mango 1986, p. 258, cat. no. 87 (Marlia Mundell Mango); Buckton 1994, pp. 78–79, cat. no. 71 (Scott McKendrick); Lowden 1999; M. Brown 2006, pp. 45–75, 302–3, cat. no. 65 (William M. Voelkle); (B) Weitzmann 1979a, p. 493, cat. no. 444 (Herbert L. Kessler); J. Durand 1992, p. 143, cat. no. 97 (Marie-Odile Germain); Lowden 1999; M. Brown 2006, pp. 45–75, 302, cat. no. 64 (Herbert L. Kessler); Cormack and Vasilakē 2008, p. 390, cat. no. 49 (Christian Förstel).

22 A–N. Attarouthi Treasure
....................

Attarouthi, Syria, late 6th–early 7th century
Silver, silver gilt
Provenance: [Elias Bustros, Beirut (by 1940)]; [Sleiman Abou Taam, Beirut and Switzerland (1965–1986)].
Condition: The nine chalices and the strainer are in good condition with original burnishing marks visible. The three silver censers are in good condition with corrosion on the copper liners. The dove's body is complete; the lower arms of the cross dangling from its beak are lost.
The Metropolitan Museum of Art, New York, Purchase, Rogers Fund and Henry J. and Drue E. Heinz Foundation, Norbert Schimmel and Lila Acheson Wallace Gifts, 1986 (1986.3.1–.5, .7–.15)[1]

A. (.1) Chalice with Christ, a Deacon Saint with Censer, a Youthful Saint with Staff, the Orant Virgin Mary, a Military Saint in Armor Killing a Dragon, and Saint John the Forerunner, under Arcades
H. 24.3 cm (9⁹⁄₁₆ in.); max. Diam. of cup 16.8 cm (6⅝ in.)
Inscribed: In Greek, ✝ ΑΓΙΟΥ ϹΤΕΦΑΝΟΥ ΚѠΜΗϹ ΑΤΤΑΡѠΘΙϹ (Of [the Church of] Saint Stephen of the village of Attarouthi)[2]

B. (.2) Chalice with Christ, a Deacon Saint with Censer, a Youthful Saint with Staff, the Orant Virgin Mary, a Military Saint in Armor Killing a Dragon, and Saint John the Forerunner, under Arcades
H. 24.6 cm (9⁹⁄₁₆ in.); max. Diam. of cup 16.7 cm (6⁹⁄₁₆ in.)
Inscribed: In Greek, ✝ ΑΓΙΟΥ ϹΤΕΦΑΝΟΥ ΚѠΜΗϹ ΑΤΤΑΡѠΘΙϹ (Of [the Church of] Saint Stephen of the village of Attarouthi)

C. (.3) Chalice with Saint John the Forerunner, the Orant Virgin Mary, an Orant Saint, a Military Saint with Staff and Shield, Christ, and a Military Saint in Armor Killing a Dragon, under Arcades
H. 21.3 cm (8⅜ in.); max. Diam. of cup 16 cm (6⁵⁄₁₆ in.)
Inscribed: In Greek, ✝ ΥΠΕΡ ϹѠΤΗΡΙΑϹ ΕΥΔΟΞΙΑϹ ΠΡΟϹΗΝΕΝΚΕΝ ΤѠ ΑΓΙѠ ϹΤΕΦΑΝѠ ΚΟΜϹ ΑΤΑΡΡ (For her salvation Eudoxia has offered [this] to [the Church of] Saint Stephen of the village of Attarouthi)

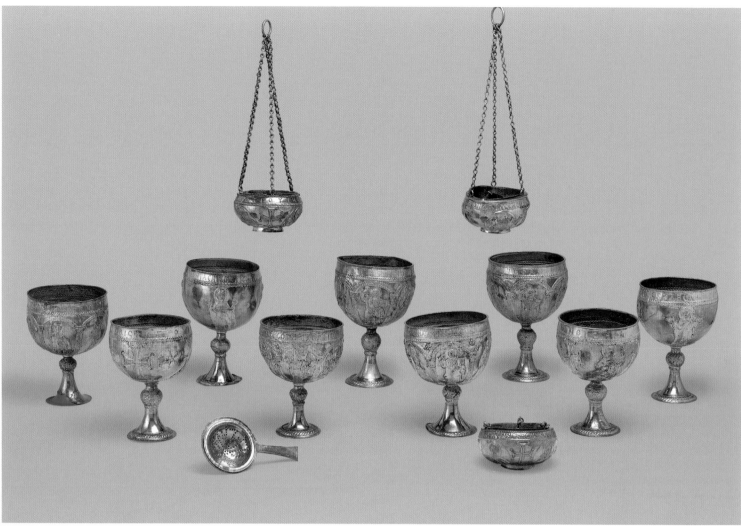

22A–M

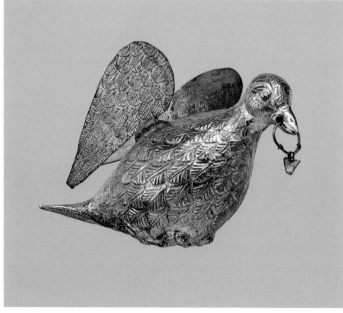

N

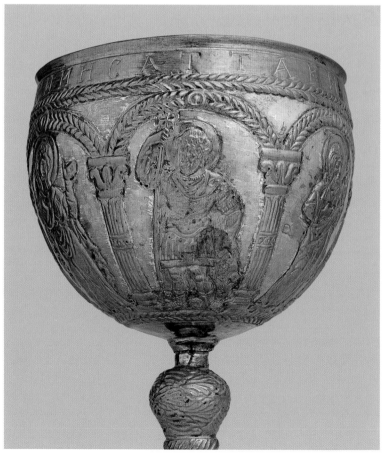

Detail of A showing military saint

D. (.4) Chalice with Christ Flanked by a Deacon Saint with Censer and a Youthful Saint with Staff, and the Orant Virgin Mary Flanked by Archangels, under Arcades

H. 19.9 cm (7¹³/₁₆ in.); max. Diam. of cup 15.7 cm (6³/₁₆ in.)

Inscribed: In Greek, ꙮ ΔΙΟΔΟΡΟC ✳ ΑΤΤΑΡΟΥΘΙC ΥΠΕΡ CΩΤΗΡΙΑC ΑΥΤΟΥ ΠΡΟϹΗΝΕΝΚΕΝ (For his salvation Diodoros has offered [this] to [the Church of] Saint Stephen of the village of Attarouthi)

E. (.5) Chalice with Christ Flanked by a Deacon Saint Holding a Gospel Book (?) and a Saint with Staff and Shield, and the Orant Virgin Mary Flanked by Archangels, under Arcades

H. 20.4 cm (8¹/₁₆ in.); max. Diam. of cup 15.9 cm (6¼ in.)

Inscribed: In Greek, ✝ ΔΙΟΔΩΡΟC ΔΙΑΚˢ ΕΥΧΑΡΙϹΤΩ ΤΩ ΘΩ ϛ ΤΟΙC ΑΓΙΟΙC CΤΕΦΑΝΩ ϛ ΓΕΩΡΓΙΩ ΠΡΟCˢ ΚΟΜΗ ΑΤΑΡΩΘΩΝ (I, Diodoros, deacon, express my gratitude to God and Saints Stephen and George and also to the people of the village of Attarouthi)

F. (.7) Chalice with a Deacon Saint with a Censer, the Orant Virgin Mary, and a Youthful Saint with Staff

H. 23.9 cm (9⁷/₁₆ in.); max. Diam. of cup 17 cm (6¹¹/₁₆ in.)

Inscribed: In Greek, ✝ ΥΠΕΡ ΕΥΧΗC ϛ CΩΤΗΡΙΑC ΩΝ Ο ΚΥΡΙΟC ΤΟ ΟΝΟΜΑ ΓΙΝΩCΚΙ (In fulfillment of a vow and for the salvation of those whose names are known unto the Lord)

G. (.8) Chalice with Christ, Saint John the Forerunner, the Orant Virgin Mary, and a Saint Holding a Gospel Book

H. 22.2 cm (8¾ in.); max. Diam. of cup 16 cm (6⁵/₁₆ in.)

Inscribed: In Greek, ✝ ΑΓΙΟΥ ΙΩΑΝΝΟΥ ΕΚΚΛΗCΙΑC ΚΩΜΗC ΑΤΤΑΡΟΘΙC (Of [the Church of] Saint John of the village of Attarouthi)

H. (.9) Chalice with Stars and Crosses

H. 20.7 cm (8⅛ in.); max. Diam. of cup 14.9 cm (5⅞ in.)

Inscribed: : In Greek, ✝ ΑΓΙΟΥ ΙΩΑΝΝΟΥ ΚΩΜΗC ΤΑΡΩΘΙC (Of [the Church of] Saint John of the village of Attarouthi)

I. (.10) Chalice with Saint John the Forerunner, a Deacon Saint, a Bishop Saint, and Crosses

H. 20.5 cm (8¹/₁₆ in.); max. Diam. of cup 15.1 cm (5¹⁵/₁₆ in.)

Inscribed: In Greek, ✝ ΑΓΙΟΥ ΙΩΑΝΝΟΥ ΚΩΜΗC ΑΤΑΡΩΘΙC (Of [the Church of] Saint John of the village of Attarouthi)

J. (.11) Censer with Christ, Two Archangels, and Crosses with Copper Liner

H. without chain 8.2 cm (3¼ in.); Diam. 13.2 cm (5³/₁₆ in.)

Inscribed: In Greek, ✝ ΑΓΙΟΥ ΙΩΑΝΝΟΥ ΚΩΜΗ ΑΤΤΑΡꙮΘΙC (Of [the Church of] Saint John of the village of Attarouthi)

K. (.12) Censer with Christ, Saint John the Forerunner, the Orant Virgin Mary, a Deacon Saint, and Crosses with Copper Liner

H. without chain 8.5 × 13.2 × 12.6 cm (3⅜ × 5³/₁₆ × 4¹⁵/₁₆ in.)

Inscribed: In Greek, ΥΠΕΡ ΑΝΑΠΑΥCΕΩC ΕΡΘΑC ϛ CΤΕΦΑΝΟΥC ΤΕΚΝΩΝ ΚΥΡΙΑΚΟΥ (For the repose of the souls of Ertha and Stephen, children of Kyriakos)

L. (.13) Censer with Saint John the Forerunner, a Youthful Saint, a Deacon Saint with a Censer, a Saint in Orant Pose, and Crosses with Copper Liner

H. without chain 7.6 cm (3 in.); Diam. 13.1 cm (5³/₁₆ in.)

Inscribed: In Greek, ✝ ΥΠΕΡ CΩΤΗΡΙΑC ΚΗΡΥΚꙮ ϛ ΒΑΡΩΧΙꙮ ϛ ΜΑΡΤΥΡΙΟΥ ΑΔΕΛΦΩΝ ΓΝΗCΙΩΝ (For the salvation of Kerykos, Barochios, and Martyrios, genuine brothers)

M. (.14) Wine Strainer

5.8 × 17.6 × 9.8 cm (2⁵/₁₆ × 6¹⁵/₁₆ × 3⅞ in.)

N. (.15) Dove

9.2 × 15.8 × 6.8 cm (3⅝ × 6¼ × 2¹¹/₁₆ in.)

Attarouthi, the site identified in many inscriptions on the ten chalices, three censers, wine strainer, and dove in this treasure, is thought to be the large merchant city of Attarouthi (Taroutia Emperön, "city of merchants") in northern Syria.[3] Excavations there found a large, probably episcopal, church with an inscription to Saint Stephen and a smaller church nearby.[4] Five chalices have inscriptions referring to Saint Stephen, the first Christian deacon and martyr, which may link them with the larger church. A Saint John is named on three chalices and one censer, and it may be to him that the other church was dedicated. All the chalices and censers share common shapes, but their images are varied in style, suggesting the possibility of several hands at work, possibly in one workshop.[5] Stylistically, the chalices are very similar to one from the Hamah Treasure attributed to the early seventh century.[6] On five chalices, arcades frame six holy figures, whereas on four, four figures are evenly spaced on the undecorated silver ground. The youthful Christ, the Virgin Orant (praying) flanked by archangels, Saint Stephen, Saint John the Forerunner (known in the Latin West as John the Baptist), and military saints in battle armor and court dress can be recognized among the select group of unidentified holy figures on the chalices. The military saints are argued to be exceptionally early images of Saint George, who is named in one inscription, or Saint Theodore, both venerated in Syria. Those in court dress may represent the military Saints Sergios and Bakchos, also popular in Syria.[7] The emphasis on military saints suggests that the donors wished protection from impending military threats. Five chalices display Saint Stephen with a censer and a Gospel book, objects associated with the role of a deacon. The censers, similar to those he carries on the chalices, are decorated with crosses and busts of a youthful Christ, archangels, and saints, including a long-haired

John the Forerunner.[8] Appearing also on two chalices, he may be the Saint John of the inscriptions. One aniconic chalice is decorated with repeating stars and crosses, symbolic of Christ's birth and death. The strainer has a punched Chi-Rho and would have been used to filter impurities from the wine as it was poured for the liturgy.[9]

The dove's tucked feet and attached wings, which are worked with feathers only on the underside, are evidence that the object was meant to be suspended over the viewer.[10] It must be like the "gold and silver doves representing the Holy Ghost . . . hung above the sacred fonts and altars" that the Miaphysite Severos, patriarch of Antioch (r. 512–18), removed, "saying that the Holy Ghost should not be designated in the form of a dove." The description, which survives in an attack on his action in the Acts of the Council of 536, reflects the developing debate over the proper use of religious images in sixth-century Syria.[11] Possibly buried during the Persian or Arab incursions of the early seventh century, these works would have originally been joined with now lost patens, rhipidia (cat. no. 44), and other church furnishings. HCE

Following iconographic trends in Late Antique Syria, three chalices in the Attarouthi Treasure, A–C, depict a warrior saint in military garb, grasping a spear that rests on the head of a serpent coiled beneath his feet. The costume differentiates the warrior saint from the deacon saint and emphasizes his role as divine protector, while the iconography of a saint piercing a serpent with a cross-topped spear highlights the function of the cross as a powerful weapon against evil.[12] Related to Late Antique apotropaic imagery, this iconography is employed for various soldier saints on seals, jewelry, and icons, such as the panel painting of Saint Theodore from the Coptic Museum in Cairo (cat. no. 53).[13] Typically for the period, the figure does not bear an identifying inscription, but it is likely Saint George, whose name appears in the dedicatory inscriptions on a chalice from the treasure, E.[14]

Military saints such as George received widespread devotion in Late Antique Syria, Palestine, and Egypt, which continued into the Early Islamic era. Both Christians and Muslims venerated Saint George at his shrine in Lydda. The caliph Mahdi's (r. 775–85) poet-singer al-Mu'alla bin Tarif writes about attending the feast day of *mari sirdjis*

(Saint Sergios), where he saw "ladies like gazelles in their covert,"[15] while the tenth-century Arab geographer al-Muqqadasi mentions a mosque built close to the church, suggesting continued Muslim presence at the site.[16] Ultimately, in Islam, Saint George was transformed into al-Khidr, an amorphous holy figure also associated with the Old Testament prophet Elijah.[17] Such practices did not necessarily involve images, but Muslims in Anatolia later adopted dragon-slayer iconography to represent their own heroic ancestors.[18] HB

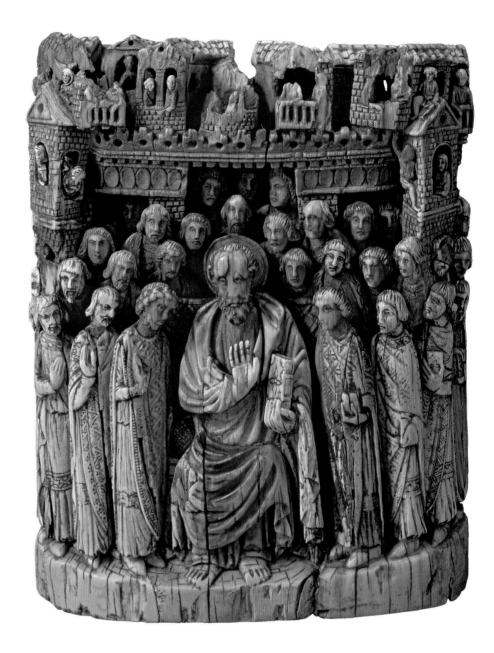

1 The treasure includes a tenth chalice (1986.3.6). Because it is badly damaged, its decoration and inscription are not considered here.

2 My appreciation to Angela Constantinides Hero, emerita professor, Queens College, City University of New York, for her review of the existing translations and improvement of their texts.

3 Identification of the site suggested by Marlia Mundell Mango to Margaret English Frazer; see Wixom 1999, pp. 37–38, cat. no. 46, n. 2.

4 Butler 1920, pp. 71–83.

5 Wixom 1999, pp. 37–38, cat. no. 46; Piguet-Panayotova 2009.

6 M. Mango 1986, pp. 74–77, cat. no. 3; Piguet-Panayotova 2009.

7 Wixom 1999, pp. 37–38, cat. no. 46; Piguet-Panayotova 2009.

8 Piguet-Panayotova 1998.

9 M. Mango 1986, pp. 133–34, cat. no. 26.

10 For the only other similar dove of the Holy Spirit known from this period, see Spier 2010, pp. 270–71, no. 195.

11 Sarah Graff, "Context, Use, and Evolution of The Metropolitan Museum of Art's Attarouthi Dove," unpublished seminar report, *Christian Art before Iconoclasm*, Institute of Fine Arts, New York University, Fall 2002, pp. 6–8.

12 For this reading of the clothing, see Parani 2003, pp. 152–53; Kalavrezou-Maxeiner 1985, p. 63. On the iconography, see Pitarakis 2006, p. 167.

13 This iconography was particularly popular for images of Saint Theodore, the first military saint attributed with a dragon-slaying feat; see Nesbitt 2003, pp. 110–12. Apparently, the iconography of dragon-slaying preceded the inclusion of the episode in hagiographic accounts, which did not appear until the eighth century; see Cotsonis 2005, p. 449.

14 For the practice of leaving saints unidentified, see Maguire 1996, p. 105. For Saint George, see Walter 2003, pp. 109–44.

15 Translation in Sharon 1986, p. 800. Saints Sergios and George were often confused (or conflated) in the Islamic tradition; see Key Fowden 1999, p. 190.

16 Le Strange 1965, p. 493.

17 Hasluck 1929, pp. 319–36.

18 Pancaroğlu 2004.

References: (A–N) Piguet-Panayotova 1998; Wixom 1999, pp. 37–38, cat. no. 46 (Margaret English Frazer and Helen C. Evans); Evans et al. 2001, p. 38; Sarah Graff, "Context, Use, and Evolution of The Metropolitan Museum of Art's Attarouthi Dove," unpublished seminar report, *Christian Art before Iconoclasm*, Institute of Fine Arts, New York University, Fall 2002; Piguet-Panayotova 2009.

23. Tusk Fragment with Apostle (Saint Mark?) on Throne, Surrounded by Followers in Front of a City

.

Syria or Egypt (Alexandria), second half of the 6th century (?)

Ivory

15 × 12 cm (5 15/16 × 4 11/16 in.)

Provenance: Acquired by an unnamed Venetian art dealer in Piedmont, Italy; purchased from Émile Meyer (1823–1893), Paris, until 1893; purchased by the Musée du Louvre, Paris, in 1893.

Condition: The lower third is badly damaged; the base and most of the figures in the foreground are the result of a modern restoration.

Musée du Louvre, Département des Objets d'Art, Paris (OA 3317)

The convex shape of this ivory plaque is unusual. Its curved front is occupied by a group of men gathered around an enthroned figure. Behind them, a highly detailed carved cityscape is animated by many people looking at the group in front

through windows and other architectural openings. The carving has an uncommonly high degree of three-dimensionality, most pronounced in the figures in the center.

It is likely that the object was intended to function as an appliqué, but whether to decorate a piece of furniture or an interior architectural space is open to question. The poor state of preservation—most of the base and the majority of the flanking figures have been restored—presents an additional difficulty. It is not easy to compare the ivory stylistically with any other known relief of the period, and the problem of its localization and date is as challenging as the identification of the subject depicted. The nimbed figure seated in the foreground has been interpreted as Saint Mark surrounded by his thirty-five successor Coptic patriarchs of Alexandria, up to and including Anastasios Apozygatios (r. 607–9). This reading led to the assumption that the relief was conceived

and fabricated in Alexandria before the early seventh century. However, it has been pointed out that the cityscape, albeit sophisticated and detailed, follows a standardized schema, with no specific features that allow it to be identified as Alexandria, and the figures with ornate mantles seem to represent secular officials rather than members of the clergy.[1] Stylistic comparisons to support a sixth-century date—for example, the five-part panel from Saint-Lupicin, now in the Bibliothèque Nationale de France, Paris, or the five-part relief in Etchmiadzin, Armenia, with their heavy, neckless figures—lack convincing evidence. Further research, ideally supported by scientific analysis, may help to corroborate the hypothetical attribution to Syria or Alexandria in the sixth century.

GB

1 Gaborit-Chopin 2003, pp. 55–57 (with bibl.).

References: Volbach 1976, no. 144, pl. 76; Bénazeth 1995; Gaborit-Chopin 2003, pp. 55–57; Davis 2004, pp. 1–2.

24A–N. Ivories of the So-Called Grado Chair

....................

A. Saint Peter Dictating the Gospel to Saint Mark
Eastern Mediterranean or Egypt, 440–670 (radiocarbon date, 95.4% probability; smaller range of 550–650, 68.2% probability)
Ivory
13.5 × 10 × 0.8 cm (5⁵⁄₁₆ × 3¹⁵⁄₁₆ × ⁵⁄₁₆ in.)
Inscribed: In Greek, on the upper border, ΠΟΛΙС ΡѠΜΗ (city of Rome); on Peter's knee, Π; in Mark's Gospel, Α
Provenance: Collection of John Webb (1799–1880), London, by 1862; purchased by the Victoria and Albert Museum (then the South Kensington Museum) from Webb in 1867.
Condition: The plaque has some damage to the carved surface and several deep vertical cracks. A section of the bottom right corner is lost. The plaque has been cut down. There are six holes for fixing the ivory to a support.
Victoria and Albert Museum, London (270:1-1867)

B. Saint Mark Preaching
Eastern Mediterranean or Egypt, 7th–8th century
Ivory
18.9 × 10.5 × 0.95 cm (7⁷⁄₁₆ × 4⅛ × ³⁄₁₆ in.)
Inscribed: In Greek, on the pages of the open book, + ΑΡΧΗ ΤΟΥ ΕΥΑΓΓΕΛΙΟΥ Ι(ησοῦ)С Χ(ριστο)С ([The] beginning of the Gospel of Jesus Christ [Mark 1:1])
Provenance: Collection of Giuseppe Bossi (1777–1815; painter); purchased from the Bossi heirs in 1817 by the Accademia di Brera, Milan; exhibited in the Museo Patrio Archeologico from 1864 to 1898; given to Milan's civic collections to be exhibited in the Castello Sforzesco, which opened in 1900.
Condition: This small panel has a fracture passing through the center of the lower section, which corresponds to the thinning of the ivory; the fracture is chipped on the lower

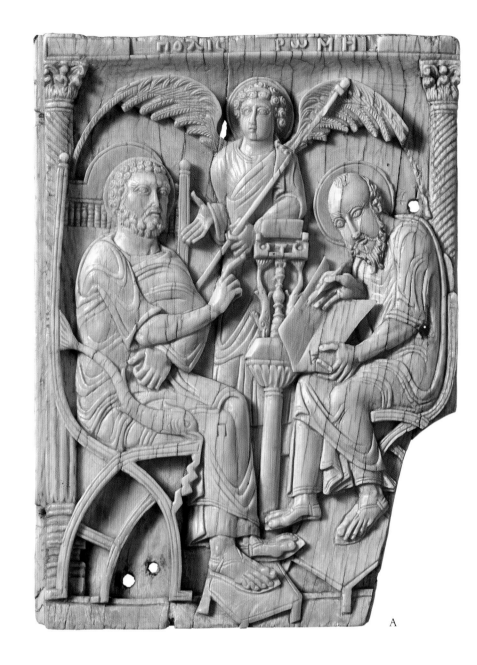

A

corners. The eight piercings probably correspond to the ancient (original?) points at which the piece was joined to a support.
Civiche Raccolte d'Arte Applicata—Castello Sforzesco, Milan (avori n. 2)

C. Saint Mark Healing Anianos
Eastern Mediterranean or Egypt, 7th–8th century
Ivory
19 × 8.25 × 0.7 cm (7½ × 3¼ × ¼ in.)
Provenance: Collection of Giuseppe Bossi (1777–1815; painter); purchased from the Bossi heirs in 1817 by the Accademia di Brera, Milan; exhibited in the Museo Patrio Archeologico from 1864 to 1898; given to Milan's civic collections to be exhibited in the Castello Sforzesco, which opened in 1900.
Condition: The small panel has a long fracture passing throughout. Five piercings are visible; these correspond to the ancient (original?) points at which the piece was joined to a support, two of which caused the fracture. On the right side a border projects a few millimeters below the rest of the tablet; this was probably an area of juncture with the later part in the sequence.
Civiche Raccolte d'Arte Applicata—Castello Sforzesco, Milan (avori n. 3)

D. Saint Mark Baptizing Anianos
Eastern Mediterranean or Egypt, 7th–8th century
Ivory
19 × 9.2 × 0.7 cm (7½ × 3⅝ × ¼ in.)
Provenance: Collection of Giuseppe Bossi (1777–1815; painter); purchased from the Bossi heirs in 1817 by the Accademia di Brera, Milan; exhibited in the Museo Patrio Archeologico from 1864 to 1898; given to Milan's civic collections to be exhibited in the Castello Sforzesco, which opened in 1900.
Condition: The small panel has at least six visible piercings, each of which corresponds to the ancient (original?) points at which the piece was joined to a support. In two cases (at top left and above the heads of the baptized figures) the hole has grown to become a lacuna. There are at least three clearly visible vertical fractures passing throughout. During an undocumented restoration campaign, four very thin patches were applied to the back in order to augment the structural cohesion of the materials.
Civiche Raccolte d'Arte Applicata—Castello Sforzesco, Milan (avori n. 4)

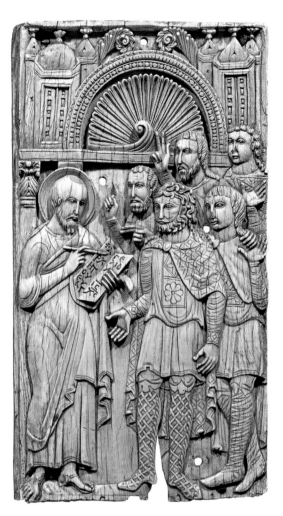

B

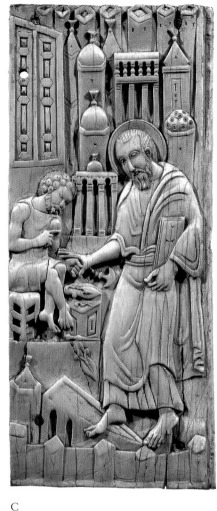

C

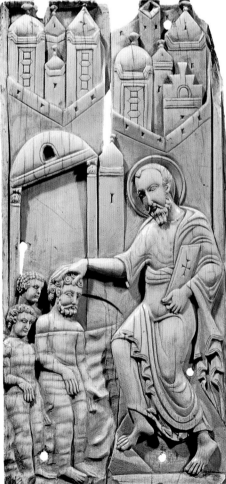

D

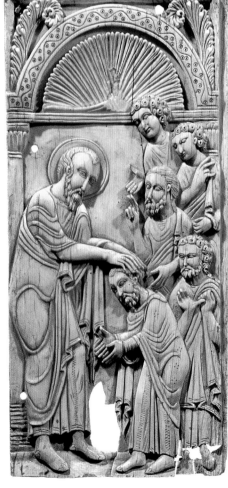

E

E. Saint Mark Consecrating Anianos

Eastern Mediterranean or Egypt, 7th–8th century
Ivory
19 × 9.35 × 0.6 cm (7½ × 3¹¹⁄₁₆ × ¼ in.)
Provenance: Collection of Giuseppe Bossi (1777–1815; painter); purchased from the Bossi heirs in 1817 by the Accademia di Brera, Milan; exhibited in the Museo Patrio Archeologico from 1864 to 1898; given to Milan's civic collections to be exhibited in the Castello Sforzesco, which opened in 1900.
Condition: The small panel has at least at least seven visible piercings, each of which corresponds to ancient (original?) points at which the piece was joined to a support. At bottom center there is a considerable hole from which emanates a nonlinear fracture that passes throughout. At least five fractures are visible. During an undocumented restoration campaign, four very thin patches were applied to the back in order to augment the structural cohesion of the materials.
Civiche Raccolte d'Arte Applicata—Castello Sforzesco, Milan (avori n. 5)

F. Fragment with Saint Mark

Eastern Mediterranean or Egypt, 7th–8th century
Ivory
19 × 4.1 × 0.6 cm (7½ × 1⅝ × ¼ in.)
Provenance: Collection of Giuseppe Bossi (1777–1815; painter); purchased from the Bossi heirs in 1817 by the Accademia di Brera, Milan; exhibited in the Museo Patrio Archeologico from 1864 to 1898; given to Milan's civic collections to be exhibited in the Castello Sforzesco, which opened in 1900.
Condition: The small panel entered the civic collection in its present fragmentary state. Its two piercings correspond to the ancient (original?) points at which the piece was joined to a support. One visible vertical fracture passes through the piece. Other less visible fractures and thinner fractures are seen in the upper part.
Civiche Raccolte d'Arte Applicata—Castello Sforzesco, Milan (avori n. 6)

G. Nativity of Christ

Eastern Mediterranean or Egypt, 7th–8th century
Ivory
9.3 × 19.1 cm (3¹¹⁄₁₆ × 7½ in.)
Provenance: Collection of Albin Chalandon, Lyons; collection of Georges Chalandon, Paris; Galerie Les Tourettes S.A., Basel (Otto Wertheimer, Paris) 1951.
Condition: The condition is good, with losses on right of upper and lower borders.
Byzantine Collection, Dumbarton Oaks, Washington, D.C. (BZ.1951.30)

H. Annunciation to the Virgin

Eastern Mediterranean or Egypt, 7th–8th century
Ivory
19.7 × 9.5 × 0.6 cm (7¾ × 3¾ × ¼ in.)
Inscribed: In Greek, above the angel: + ΓΑΒΡΙΗΛ (Gabriel); above the virgin: + [monogram for] H ΑΓΙΑ [monogram for] ΜΑΡΙΑ (Saint Mary)
Provenance: Trivulzio Collection, Milan, until 1888; entered the city's civic collections (now the Castello Sforzesco), along with the majority of the Trivulzio Collection, in 1888.
Condition: The small panel has a fracture that passes lengthwise throughout. Already documented in the nineteenth century, this prompted the separation of the piece into two parts; the ivory was conserved in 1998. It is missing a portion of the lower side and there are small missing parts on the edges and along the split. There are ten visible

piercings, which correspond to the ancient (original?) points at which the piece was joined to a support. Civiche Raccolte d'Arte Applicata—Castle Sforzesco, Milan (avori n. 14)

I. Wedding at Cana
Eastern Mediterranean or Egypt, 630–820
(radiocarbon date, 95.4% probability; smaller ranges of 650–720 and 740–70 [emphasis on the earlier range], 68.2% probability)
Ivory
11.3 × 9.2 × 0.8 cm (4⁷⁄₁₆ × 3⅝ × ⁵⁄₁₆ in.)
Provenance: At the end of the 18th century, while in the Veneto, Jan Grevenbroeck (1731–1807) illustrated the plaque in a watercolor; the illustration appeared in the album *Supplimenti alle Antichità delineate alle varie venete curiosità sacre e profane ed alle cisterne qui ed altrove scoperte* (Venice, Correr Library, MS 108 II, fol. 4); Thomas Gambier Parry (1816–1888), Highnam Court, Gloucestershire, acquired the ivory between 1837 and 1860; by descent to Major Ernest Gambier Parry (1853–1936), Highnam Court, Gloucestershire; purchased by the Victoria and Albert Museum from Major Ernest Gambier Parry in 1921.
Condition: A considerable portion of the upper part of the ivory is lost. There are four holes for fixing the ivory to a support.
Victoria and Albert Museum, London (A.1-1921)

J. Raising of Lazarus
Eastern Mediterranean or Egypt, 7th–8th century
Ivory
19.5 × 8.8 × 0.7 cm (7¹¹⁄₁₆ × 3⁷⁄₁₆ × ⁵⁄₁₆ in.)
Provenance: Said to have been given to the Cathedral of Amalfi in 1460 by Pope Pius II (r. 1458–64); at the beginning of the eighteenth century, Michele Bologna, archbishop of Amalfi (r. 1701–31), presented the plaque to the Convent of the Holy Apostles in Naples; Saint Andrew's Cathedral; purchased by the British Museum from William Maskell (1814–1890) in 1856.
Condition: The panel has several vertical cracks and losses in the center of the panel, with smaller losses along the edge. Several holes for fixing the ivory to a support are visible.
The British Museum, London (1856,0623.26)

K. The Prophet Joel
Eastern Mediterranean or Egypt, 7th–8th century
Ivory
10 × 8.5 cm (3¹⁵⁄₁₆ × 3⅜ in.)
Inscribed: In Greek, on the scroll, + ΚΑΙ ΕΖΗΛѠϹΕΝ Κ[ύριο]Ϲ ΤΗΝ ΓΗΝ ΑΥΤΟΥ ΚΑΙ ΕΦΕΙϹΑΤΟ ΤΟΥ ΛΑΟΥ ΑΥΤΟΥ + (Then the Lord became jealous for his land, and had pity on his people [Joel 2:18])
Provenance: Collection of Michel Boy (1845?–1905), Paris, until 1905; collection of Sigismond Bardac (1856–1919), Paris; collection of Claudius Côte (1881–1956), Lyons, by 1912; bequest of Mme Claudius Côte, 1960.
Condition: The panel has losses around the prophet's head and along the upper left border. Holes for attaching the ivory to a support are visible.
Musée du Louvre, Département des Objets d'Art, Paris (AC 864)

L. Prophet with a Plaque
Eastern Mediterranean or Egypt, 7th–8th century
Ivory
9 × 8 × 0.8 cm (3⁹⁄₁₆ × 3⅛ × ⁵⁄₁₆ in.)
Provenance: Collection of Giuseppe Bossi (1777–1815; painter); purchased from the Bossi heirs in 1817 by the Accademia di Brera, Milan; exhibited in the Museo Patrio Archeologico from 1864 to 1898; given to Milan's

G

F

I

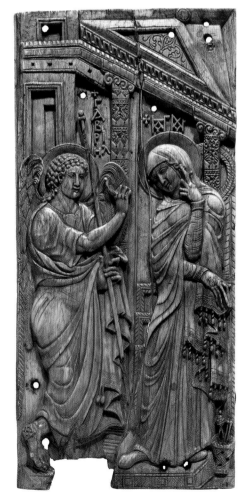

H

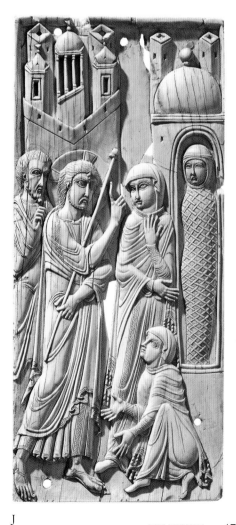

J

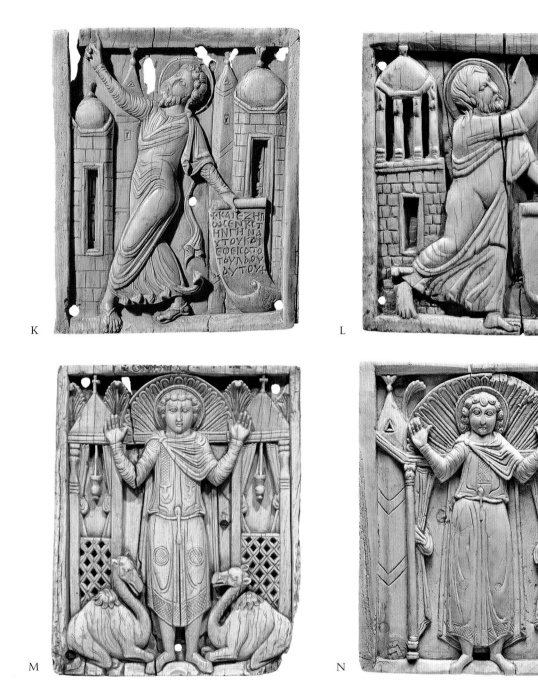

K L

M N

civic collections to be exhibited in the Castello Sforzesco, which opened in 1900.

Condition: The small panel has numerous lengthwise fissures and an extensive fracture along the entire height of the piece. The latter resulted in the separation of the piece into two parts; it was conserved in 1998. Six visible piercings correspond to the ancient (original?) points at which the piece was joined to a support.

Civiche Raccolte d'Arte Applicata—Castello Sforzesco, Milan (avori n. 7)

M. Saint Menas with Flanking Camels

Eastern Mediterranean or Egypt, 7th–8th century
Ivory
10.2 × 8.5 × 0.6 cm (4 × 3¼ × ¼ in.)
Inscribed: In Greek, on the upper border, + ⒶMHNAC (Saint Menas)
Provenance: Collection of Giuseppe Bossi (1777–1815; painter); purchased from the Bossi heirs in 1817 by the Accademia di Brera, Milan; exhibited in the Museo Patrio Archeologico from 1864 to 1898; given to Milan's civic collections to be exhibited in the Castello Sforzesco, which opened in 1900.

Condition: The small panel is divided in two lengthwise and has been conserved. The lower right-hand corner is missing. Five visible holes correspond to the ancient (original?) points at which the piece was joined to a support. The sixth hole, in the lower right-hand corner, probably caused the break on that same corner. There are losses along the margins.

Civiche Raccolte d'Arte Applicata—Castello Sforzesco, Milan (avori n. 1)

N. Saint in Orant Pose

Eastern Mediterranean or Egypt, 7th–8th century
Ivory
10.3 × 8.3 × 0.8 cm (4¹⁄₁₆ × 3¼ × ⁵⁄₁₆ in.)
Provenance: Purchased Delange sale, Paris, February 27, 1851, lot 43.
Condition: The plaque is in good condition. Several holes for attaching the ivory have been plugged.
Musée National du Moyen Âge, Thermes et Hôtel de Cluny, Paris (Cl. 1932)

For more than a century, this group of fourteen carved ivory panels prompted scholars to focus almost exclusively on questions of chronology and localization. Were the panels carved in Alexandria, southern Italy, Constantinople, Egypt, Syria, or Palestine, and in the sixth, seventh to eighth, or eleventh century? Earlier scholars thought that commonalities of style and iconography among the panels demonstrated that the plaques originally formed a group, but that unity has come under question, and it is still open to debate whether the panels were made to decorate a single object. Did the plaques originally embellish a throne, a door, a chest, an antependium, or a pulpit?

The ivory panels have been associated with the so-called Grado chair since the core group was discussed in an article in 1899.[1]

They were thought to be remnants of an ivory throne supposedly made in Alexandria and given as a gift by the emperor Heraclius (r. 610–41) to the Cathedral of Grado, in northeastern Italy, sometime during his reign. The obvious diversity in style and iconography, however, as well as the difficulty of ascertaining the original purpose of the panels, resulted in a wide range of scholarly opinions and provoked suggestions about their date of fabrication that span more than five hundred years. Up to the present day, it seems that art historians can think of nothing else to discuss in regard to these remarkable works of ivory other than their date and place of origin.

The panels are preserved in six different museum collections with a concentration in Italy. The Castello Sforzesco in Milan has five of six plaques depicting episodes of the life of Saint Mark: Saint Mark preaching in front of a cityscape representing either the Pentapolis of North Africa or Aquileia, B; Saint Mark healing the injured hand of the cobbler Anianos, C; Saint Mark baptizing Anianos, D; Saint Mark consecrating Anianos as bishop of Alexandria, E; and, last, an unidentified scene in fragmentary condition with the apostle walking toward the left, F. In the Victoria and Albert Museum a plaque whose upper third is missing depicts Saint Peter and Saint Mark sitting on thrones, the former dictating the Gospel to the latter, while an angel is standing behind them with outstretched wings, A. In addition to these reliefs dedicated to the scenes from the life of Saint Mark, four plaques display New Testament scenes: a panel with the Annunciation in the Castello Sforzesco, H; a Nativity in the Dumbarton Oaks Byzantine Collection, G; a fragmentary piece in the Victoria and Albert Museum showing the filling of the water jugs at the Wedding at Cana, I; and the Raising of Lazarus in the British Museum, J. The plaques with Saint Mark and New Testament imagery have been grouped further with four panels of a different, almost square format. On each of two panels, one in the Musée du Louvre and the other in the Castello Sforzesco, a prophet presents a scroll in his outstretched left hand while pointing upward with the other hand, K, L. On the last relief of the group in the Castello Sforzesco, M, as well as on a plaque, N, in the Musée National du Moyen Âge, Paris, frontally standing saints are depicted. The one with flanking camels at his feet is clearly identifiable as Saint Menas. Whether a panel in Palma de Mallorca with the Entry into Jerusalem belongs to the same group is a question that will not be addressed here.

Although Kurt Weitzmann in his seminal monographic article convincingly argued that the literary sources cited in support of the theory associating these plaques with an ivory throne in Grado are vague and contradictory—and therefore to be dismissed[2]—it is remarkable that the latest publications still put forward this connection as the most likely theory. This mode of thinking demonstrates the desire to solve the problem of portable art and unproven provenance by creating a link to specific historic events recorded in literary sources, even if these are only tenuously connected with the extant objects themselves.

A turning point in the bumpy path of the history of the research into the ivories occurred when Paul Williamson allowed two of the plaques in the Victoria and Albert Museum to be sampled and radiocarbon-dated.[3] The analysis revealed two slightly different date brackets. According to the published results, the raw material used to carve the Wedding at Cana relief, I, became available between the years 630 and 820 with a 95.4% probability, or between the years 650 and 720 with a 68.2% degree of confidence; an alternative range of 740–70 is given with the same probability. The analysis of the panel with Saint Peter Dictating the Gospel to Saint Mark, A, yielded a date range of 440–670 with a 95.4% degree of probability, and a smaller window of the years 550–650 with a 68.2% probability.

However, Williamson's suggestions—first, to rehabilitate the Grado chair thesis for the Saint Mark panels, because the radiocarbon results allow a date around the year 600; second, to therefore accept as the place of fabrication either Alexandria or Constantinople; and, finally, to distinguish the Saint Mark reliefs from the New Testament panels, with the implicit understanding that they originally adorned different objects—are not convincing.[4] Even if the given range of the radiocarbon date tolerates the production of the plaque depicting Saint Mark during the reign of Emperor Heraclius, it does not change the critical assessment of the literary sources with regard to an ivory throne given by the Byzantine emperor to the bishop of the city of Grado; the connection between the extant panels and the recorded throne remains unsupported.

Both the latest research and the earlier studies have struggled with the theory of a single object that this group of panels—and presumably additional plaques—originally may have adorned. Weitzmann separated the reliefs based on stylistic similarities into an earlier group that he recognized as deeply indebted to the classical tradition and a later group that showed a higher degree of abstraction.[5] Williamson pondered, as shown, the idea of two distinct uses because of the variance in the results of the scientific analysis.[6] However, identical technical details—edges cut at a slight angle in combination with identical dimensions and thicknesses of the panels with the scenes of the Life of Saint Mark in Milan, B–F; the Nativity plaque, G; and the Annunciation panel, H—prove that the reliefs were prepared in the same fashion to be assembled. There is no reason to doubt their original contemporaneity nor that they were designed and manufactured for one and the same object.

In the light of the radiocarbon dates for the Saint Mark and the Wedding at Cana panels in London, A and I—and we may assume a similar result for the other panels—the plausible conclusions are that, first, different raw material was used—freshly exploited tusks as well as stockpiled material—and, second, the time of fabrication for the whole ensemble should be determined by the latest possible date yielded by the scientific analysis.

The stylistic diversity of the reliefs is an integral component of the group and does not speak against the contemporaneity of the plaques. In fact, diversity of style is an often-discussed feature of the only extant ivory throne, the sixth-century cathedra of Maximian in Ravenna;[7] the ensemble is perfect proof of the simultaneity of dissimilar stylistic evidence.

As Weitzmann has cogently summarized, the ivories of the so-called Grado group belong to a period of time that was overlooked as well as underestimated by twentieth-century Western European scholarship.[8] In this reading, the Migration of Nations in the West, on the one hand, and Iconoclasm in the Byzantine Empire, on the other hand, were made responsible for the "Dark Ages." For works of art like the ivory group only two extreme options were acceptable: either they were considered a late product of the golden era of Early Byzantium; or they were given an eleventh-century date because of the close similarities with the large group of so-called Salerno ivories of the eleventh or early twelfth century.[9] To accept and understand a continued, unbroken tradition of artistic production in major parts of the

Christian East in the Early Islamic period marked for Weitzmann an important indicator of progress, and this notion has now become more widely accepted.[10]

The intermingling of Islamic and Byzantine iconographic elements—the bulbous domes, the steplike shape of the crenelations, the ornamented column shafts in the Annunciation panel, H, interpreted as influenced by one tradition or the other—demonstrates the cultural flux and diversity of the late seventh and eighth centuries. It also exhibits the ability of craftsmen to fuse and integrate different working techniques and carving methods. The tendency toward elaborate, stylized architectural backdrops on all the panels of the so-called Grado group is a reflection of the cultural milieu, and it may not be a coincidence that we find in the Umayyad wall mosaics of the Great Mosque in Damascus a similar fascination with idealized representations of architecture in the form of striking cityscapes. GB

1 Graeven 1899.
2 Weitzmann 1972.
3 Williamson 2003.
4 Williamson 2008; Williamson 2010, pp. 56–61, nos. 9, 10.
5 Weitzmann 1972, pp. 64–69 ("Earlier Group"), 70–73 ("Later Group").
6 Williamson 2010, p. 61.
7 Effenberger 2000, pp. 95–97 (Raffaella Farioli Campanati).
8 Weitzmann 1972, pp. 90ff.
9 Bologna 2008.
10 H. Kessler 2007.

References: (A) Weitzmann 1972; Volbach 1976, p. 141, no. 243; Bologna 2008, vol. 2, p. 318, cat. no. 30; Williamson 2008; Williamson 2010, no. 9; (B) Weitzmann 1972; Volbach 1976, p. 139, no. 237; Bologna 2008, vol. 2, p. 318, cat. no. 31; Williamson 2008; (C) Weitzmann 1972; Volbach 1976, p. 140, no. 239; Bologna 2008, vol. 2, p. 318, cat. no. 32; Williamson 2008; (D) Weitzmann 1972; Volbach 1976, p. 139, no. 238; Bologna 2008, vol. 2, p. 318, cat. no. 34; Williamson 2008; (E) Weitzmann 1972; Volbach 1976, p. 140, no. 240; Bologna 2008, vol. 2, p. 318, cat. no. 35; Williamson 2008; (F) Weitzmann 1972; Volbach 1976, p. 140, no. 241; Bologna 2008, vol. 2, p. 318, cat. no. 33; Williamson 2008; (G) Weitzmann 1972; Volbach 1976, p. 142, no. 249; Bühl 2008, p. 128; Williamson 2008; (H) Weitzmann 1972; Volbach 1976, p. 143, no. 251; Bologna 2008, vol. 2, p. 318, cat. no. 37; Williamson 2008; (I) Weitzmann 1972; Bologna 2008, vol. 2, p. 318, cat. no. 38; Williamson 2008; Williamson 2010, no. 10; (J) Weitzmann 1972; Volbach 1976, p. 141, no. 246; Bologna 2008, vol. 2, p. 318, cat. no. 39; Williamson 2008; (K) Weitzmann 1972; Volbach 1976, p. 141, no. 245; Gaborit-Chopin 2003, pp. 68–71, no. 15; Williamson 2008; (L) Weitzmann 1972; Volbach 1976, p. 142, no. 248; Gaborit-Chopin 2003, pp. 68–71, fig. 15c; Williamson 2008; (M) Weitzmann 1972; Volbach 1976, p. 140, no. 242; Weitzmann 1979a, p. 578, cat. no. 517; Bologna 2008, vol. 2, p. 318, cat. no. 36; Williamson 2008; Ćurčić and Chatzētryphōnos 2010, pp. 204ff., cat. no. 22; (N) Weitzmann 1972; Volbach 1976, p. 141, no. 244; Caillet 1985, pp. 121–23, no. 57; Williamson 2008.

Sinai from the Seventh to the Ninth Century: Continuity in the Midst of Change

Hieromonk Justin of Sinai

Pilgrims to Sinai in the latter fourth century witnessed what was already a flourishing monastic presence, as they themselves were even then following established pilgrim routes. In the middle of the sixth century, the emperor Justinian (r. 527–65) ordered the construction of a basilica and high surrounding walls at the traditional site of the Burning Bush (Exodus 3:2). This did not supplant the earlier tradition of monks living in scattered settlements throughout the region, but it did provide the area with a great fortress at what was still the perimeter of the Byzantine Empire.

All of this changed in the seventh century.

In 630, reports reached Medina that a large Byzantine army was assembling against the Arabs. The Prophet Muhammad himself led a large force to the oasis of Tabouk. Although they encountered no Byzantine army, Muhammad took the opportunity to send envoys to the Christian city of Ayla (modern Aqaba), at the head of the Gulf of Aqaba, an important trade center and the gateway to southern Palestine and Sinai. Ibn Isaq (d. 767) records that the governor of Ayla, Yuhanna ibn-Ru'bah, came to Muhammad in person, wearing a gold cross (he may have been the bishop of Ayla). Yuhanna agreed to give the Arabs right of passage and access to water, to provide travelers with food and lodging, and to pay annually one dinar for every adult. Muhammad in turn promised the inhabitants of Ayla security, both in their city and when traveling, whether by land or by sea, and the same to all those who traveled with them. He confirmed this with a document sealed with his own seal, and gave Yuhanna a mantle that had been woven in Yemen.[1]

In 632, the Prophet Muhammad planned raids into Syria and Palestine, but these were prevented by his death that same year. In the following year, Abu-Bakr led an army against Syria, while 'Amr ibn al-'As invaded Palestine, traveling by way of Ayla and Sinai.[2] Syria was taken in 636, Palestine in 638, Mesopotamia and Armenia in 639/40, and Egypt by 642.[3]

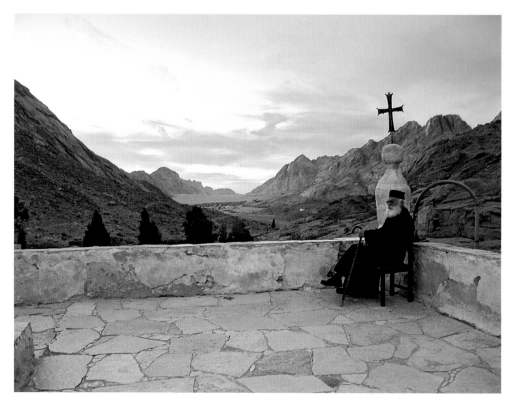

Fig. 18. View from a roof to the Plain of ar-Raaha, Holy Monastery of Saint Catherine, Sinai, Egypt. According to tradition, the Israelites camped on the plain.

In this way, Sinai became a part of the world of Islam. But Muslims also revere Mount Sinai as the sacred mountain of the revelations of God.[4] This shared veneration for the holy mountain has placed the monks of Sinai and their Muslim rulers in a special relationship. The monks were able to show them a Testament from the Prophet Muhammad himself, granting protection to the monks and to the Christian families living in the area (cat. no. 37). This document, with its guarantees of safe travel and protection in time of war, resembles the one granted by Muhammad to the inhabitants of Ayla. Adults were to pay an annual capitation tax (*jizya*), but monks were exempt. The Testament also confirmed the monks in the possession of their churches. In these provisions, the document is similar to the decree accorded by the caliph 'Umar to Mar Gabriel (d. 648), the abbot of the monastery at Qartmin, in Asia Minor.[5] Parallels may thus be found between the Testament granted to Sinai and other letters of protection dated to the seventh century. Guarantees to Christian families living in the Sinai ceased to be relevant after the seventh century: Eutychios of Alexandria records that they converted to Islam at the time of the Umayyad caliph 'Abd al-Malik ibn Marwan (r. 685–705).[6]

We know that subsequent rulers confirmed the protected status of the Sinai monastery. In 1134, Al-Hafiz, the eleventh Fatimid caliph, sent a decree to the governor of Ayla, ordering him to observe the ancient agreements with the monks of Sinai. These documents, considered old at the time, must already have existed for some centuries.[7]

Yet, in the midst of change, there was also continuity. There is evidence of pilgrimage to Sinai during the seventh, eighth, and ninth centuries.[8] Monks also continued to come to Sinai, attracted by its austerity, its biblical associations, and its reputation as an established center of monasticism (fig. 18). Anastasios of Sinai, who lived in the late seventh century, compiled narratives concerning the holy fathers, in the tradition of *The Spiritual Meadow* by Saint John Moschus

(d. 619). Anastasios describes Sinai as a desolate wilderness. Conditions there could be dangerous. But it was also a place where holy anchorites dwelt—a place where remote chapels suddenly became luminous in the presence of holy angels.[9]

There are three saints whose spiritual texts form a distinctly Sinaite school of ascetic theology. John, the abbot of Sinai, lived in the late sixth and early seventh century. He wrote a spiritual guide called *The Ladder of Divine Ascent* (cat. no. 25), in which he summons all to a life suffused with prayer and guarded by humility and spiritual vigilance. The *Ladder* is "an invitation to pilgrimage."[10] As we make our ascent, sorrow gives birth to joy, and fear is replaced by love. He writes, "There is actually no limit to love. We shall never cease to advance in it, either in the present or in the future life, continually adding light to light."[11]

Hesychios the Priest, who lived about the eighth–ninth century, was abbot of the Monastery of the Burning Bush. He wrote an ascetic treatise, *On Watchfulness and Holiness*, in which he stresses the central importance of inner attentiveness, the guarding of the heart, and the unceasing invocation of Jesus Christ. "Just as a man blind from birth does not see the sun's light, so one who fails to pursue watchfulness does not see the rich radiance of divine grace."[12]

Philotheos of Sinai is known to us only from his work, *Forty Texts on Watchfulness*. He lived in perhaps the ninth or tenth century. "At every hour and moment let us guard the heart with all diligence from thoughts that obscure the soul's mirror; for in that mirror Jesus Christ, the wisdom and power of God the Father, is typified and luminously reflected."[13] The writings of these three saints had a profound influence on the development of later Orthodox spirituality in Constantinople and on Mount Athos.

The Sinai library contains a number of manuscripts dating from the seventh to the ninth century and written in Greek, Arabic, Syriac, and Georgian. These include manuscripts that were copied at Sinai. The range of languages and the bilingual texts in Greek

and Arabic (cat. no. 32) are evidence that Sinai, always predominantly Greek, was also a meeting point for Christians from diverse lands. A number of these manuscripts are palimpsests (cat. no. 33): the original writing has been erased, and the valuable parchment used a second time. The original writing survives as a faint image. Recent advances in digital imaging techniques show promise in recovering these texts.

Iconography continued at Sinai during this period, the time of Iconoclasm, when icons in the Byzantine world were being deliberately destroyed. We see depictions of the Crucifixion (cat. no. 27, 28), holy martyrs (cat. no. 29), and the Three Hebrews in the Fiery Furnace (cat. no. 26). These are perennial images of Christian faith and hope.

From the seventh century, the number of monks in the Sinai Peninsula declined. Remote cells and hermitages were abandoned. Eventually, even the great monasteries at Pharan and Raithou fell into ruin. From the fifth century there had been a bishop at Pharan, a large oasis to the west of Mount Sinai. After the seventh century, the office was retained, but the see was transferred to the fortress monastery, where monastic life continued. In the seventeen centuries of its existence, the monastery has never been destroyed or deserted, an exceptional record of continuity. Within these ancient walls are still preserved the cycle of services, times of prayer, and the spiritual goals that have all remained the same throughout the years.

Although Sinai became a part of the world of Islam in the seventh century, the monastery has been respected by its Muslim rulers. The monks have continued to live in harmony and reciprocal support with the local Gebeliya Bedouin, who trace their descent to the soldiers who built the fortress in the sixth century. The monks and the Bedouin differ in their religion, language, and culture. Yet each respects the other. In this way, Sinai emerges as a symbol of peace for our own times, an emblem of hope.

25A, fols. 2v–3r

25B, fols. 12v–13r

25A, B. Manuscripts of *The Ladder of Divine Ascent*, by Saint John Klimax (Ἰωάννης τῆς Κλίμακος)

.....................

A. The Ladder of Divine Ascent
Sinai, Egypt, 7th–8th century
Vermilion and black ink on parchment; 2
contiguous bifolia
21 × 14 cm (8¼ × 5½ in.)
Provenance: In the collections of the Holy Monastery of
Saint Catherine since the Middle Ages.
Condition: The parchment is stained, split, and chipped.
The ink has flaked in places.
The Holy Monastery of Saint Catherine, Sinai, Egypt
(Greek New Finds ΜΓ 71)

B. The Ladder of Divine Ascent
Sinai, Egypt, mid-10th century
Tempera, gold, and ink on parchment; 254 folios
25.5 × 18.8 cm (10¹/₁₆ × 7⅜ in.)
Provenance: In the collections of the Holy Monastery of
Saint Catherine since the Middle Ages.
Condition: There are no front or back boards. What
remains of the binding is quite worn; it is likely the orig-
inal tenth-century binding. The first four and the last two
quires have become detached from the sewing. The first
two quaternia are intact, but foliated in disorder. There is
some flaking and corrosion of the green pigment, and the
gilt letters and ornamental bands have lost their brilliance.
The Holy Monastery of Saint Catherine, Sinai, Egypt
(Greek Ms 417)

*T*he Ladder of Divine Ascent was written
by an abbot of Sinai named John, who
lived in the late sixth and early seventh
centuries. He is thus known as John of the
Ladder. Taking as his inspiration the ladder
that Jacob saw extending from earth to
heaven (Genesis 28:12), he wrote a spiritual
guide consisting of thirty steps—rungs on
the ladder of spiritual ascent. Saint John was
a shrewd observer of the complexities of
human nature, and the astute advice he gives,
drawn from his own profound experience
in the spiritual life, has won the respect of
monastics and laity alike. Recent studies have
drawn attention to the sophisticated manner
in which Saint John uses classical models
of rhetoric.[1]

Manuscript A consists of only four folia.
These contain the opening sections of Step
One, written twenty-five lines to the page in
a majuscule script. The leaves date to within
one hundred years of Saint John's lifetime
and are the earliest that survive of the *Ladder*.

Manuscript B dates to the middle of the
tenth century. The text is written twenty-
seven lines to the page in a *Kirchenlehrerstil*
minuscule, with marginalia in carmine red,
brown, and occasionally green. Saint John
writes in a very laconic style, and, because of

this, many have written commentaries on
the text. The marginal notes in this manu-
script are of great interest, in that they are
so early.

The first two quaternia have been foliated
in disorder, but this is easily corrected. The
manuscript opens with a bifolium (a single
leaf folded in half), the leaves numbered 1
and 2. This bifolium is attached by a frag-
ment of the spine lining to a quaternion
(four double leaves folded in half, the stan-
dard unit in binding a manuscript), num-
bered folios 3 to 10. The next quire (sheets
folded together for binding) consists of only
three double leaves, numbered folios 11 to
16. If this quire were placed within the first
bifolium, we would then have two quaternia,
with all of the leaves in correct order, the
texts continuing from one folio to the next
in exact sequence.[2]

Folio 13r includes an author portrait set
within a medallion. The saint wears a purple
cloak and, under it, the monastic *schema*, a
cloth with the sign of the cross. His hands
are raised before him in prayer. This portrait
in outline may be compared to that in a
ninth-century manuscript of the *Sacra
Parallela* of Saint John of Damascus (cat.
no. 80). In the seventh-century Sinai icon of
the Three Hebrews in the Fiery Furnace,
two of the saints are depicted with their
hands raised before them in prayer in the
same manner (cat. no. 26).

The border around the portrait contains a
rinceau of cornucopias, from which emerge
half-palmettes. These were drawn in red,
and filled with deep carmine and green. The
border and the four corner medallions were
also adorned with blue rings, set with white
pearl dots. In the manuscript's ornaments
and paleography, Kurt Weitzmann has noted
both Constantinopolitan and Islamic influ-
ences. This convergence increases the pos-
sibility that it was executed at Sinai.[3] HJS

1 Duffy 1999; Johnsén 2007.
2 This reconstruction differs from that proposed by
 Weitzmann and Galavaris 1990, p. 28.
3 Ibid., pp. 30–31.

References: (A) Sinai 1999, p. 153, table 12; (B) Weitzmann
and Galavaris 1990, pp. 28–31, colorpl. 1b, pls. 32–44.

Icons from the Monastery of Saint Catherine at Mount Sinai

Kathleen Corrigan

Some forty icons from the Monastery of
Saint Catherine on Mount Sinai fall within
the range of dates defining the present vol-
ume.[1] This is the largest single collection of
Byzantine icons in existence dating from the
seventh through ninth century. The Sinai
icons vary in style, subject, and iconography.
They include depictions of saints, Christ, the
Virgin, Old Testament prophets, and a num-
ber of New Testament narratives. Because so
few icons of this period from other centers
are preserved, it is unclear whether this
range of subjects is representative.

Dating these icons and assigning them to
centers of production have proven difficult.
Only a small number of the icons have been
dated to the period before the Muslim con-
quest. These include several of the most
famous sixth- (or perhaps seventh-) century
panels, attributed to Constantinople.[2]

Given that for much of the period in
question, contact between Sinai and

Fig. 19. Icon with the Crucifixion. Tempera on
wood, 8th–9th century. The Holy Monastery of
Saint Catherine, Sinai, Egypt

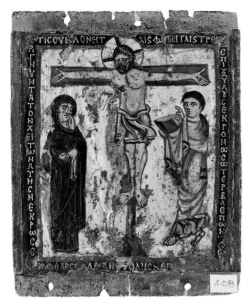

Fig. 20. Icon with the Crucifixion. Tempera on wood, 9th century. The Holy Monastery of Saint Catherine, Sinai, Egypt

Constantinople and Asia Minor was not close, it is possible that many of these early icons were produced in Byzantine Palestine or at Sinai itself. This number would include many of those icons from the eighth or ninth century, when Iconoclasm was in force in the empire, making production of icons there unlikely.

Study of the early Sinai icons has focused especially on what they can tell us about the beginnings of the cult of icons in Byzantium. Were early practices similar to what we know from the middle and late Byzantine periods, or to what is described in the writings of theologians from the period of Iconoclasm? It is still unclear to what extent people thought these early icons had special powers or deserved special devotion, making them different from other Christian images.[3] It is clear, however, that they were made in a context in which people believed in the miracle-working power of some icons (cat. no. 30), in which devotion to the saints and belief in the power of their relics and cult centers was strong (cat. nos. 26, 29), and in which there was an intense desire for continuing connection to the places of Christ's life and death in the Holy Land and the attendant sensual experience of religious belief (see the icons with New Testament images that reference particular Holy Land sites,[4] and cat. nos. 24G, 56, 59).

One can also argue that some of the panels reflect a belief in the power of icons to address complex theological concepts and issues of representation such as those contemporaneous theologians struggled with in their writings. This may be the case with the several Crucifixion icons (cat. nos. 27, 28, and figs. 19, 20). These early icons also can be seen as an attempt to figure out how to represent the relationship between the human and divine aspects of Christ without falling into the error of idolatry,[5] a project not unlike that of the Christians' Muslim neighbors, who were working out ways to express their religious beliefs without resorting to figural imagery.

26. Icon with the Three Hebrews in the Fiery Furnace

.....................

Egypt or Sinai (?), 7th century
Encaustic on wood
35.5 × 49.6 cm (14 × 19½ in.)
Inscribed: In Greek, flanking the three figures, [O ΑΓΙΟΣ ΑΝΑ]ΝΙΑΣ (Saint Hananiah); [O Α]ΓΙΟΣ [ΑΖ]ΑΡΙΑΣ (Saint Azariah); [O ΑΓ]ΙΟΣ [ΜΙΣΑΗΛ] (Saint Mishael); on the frame, top, O ΔΕ ΑΓΓΕΛΟΣ Κ(υριο)Υ ΣΥΝΚΑΤΕΒΗ ΑΜΑ ΤΟΙΣ ΠΕΡΙ ΤΟΝ ΑΖΑΡ; probable reading on right, [ΙΑΝ ΕΙΣ ΤΗΝ ΚΑΜΙΝΟΝ ΚΑΙ ΕΞΕΤΙΝΑΞΕΝ]; left, ΤΗΝ ΦΛΟΓΑ [ΤΟΥ ΠΥΡΟΣ ΕΚ] ΤΗΣ [ΚΑΜΙ]; bottom, ΝΟΥ ΩΣ ΠΝ(ευμ)Α ΔΡΟ[ΣΟΥ] ΔΙΑΣ[ΥΡΙΖΟΝ] (probable reading: But the angel of the Lord came down into the furnace with Azariah and his companions, and made the furnace as if a dewy breeze were whistling through it. The fire did not touch them at all [cf. Daniel 3:49–50])[1]
Provenance: In the collections of the Holy Monastery of Saint Catherine since the Middle Ages.
Condition: The panel is missing a horizontal strip at the top. On the right side some of the wood grain is visible where the paint has rubbed off. On the horizontal sections of the frame, most of the inscription has flaked off.
The Holy Monastery of Saint Catherine, Sinai, Egypt

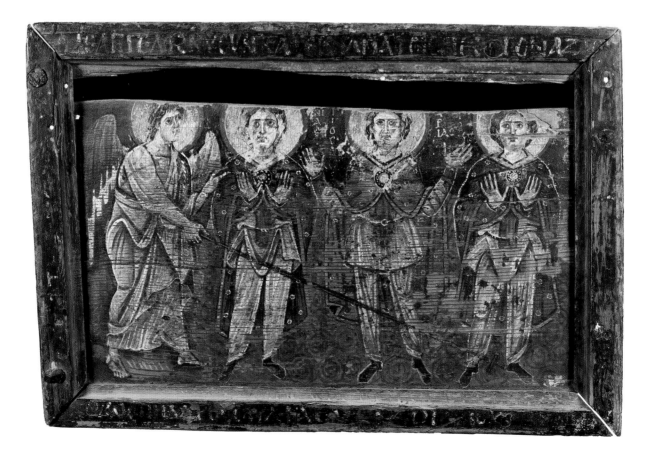

The three Hebrew youths stand unfazed among the flames to which Nebuchadnezzar condemned them for refusing to worship idols. Because they survived the flames, these Old Testament figures were considered models for Christian martyrs. Their relics were collected, and cult centers developed, primarily in Mesopotamia and Egypt. Thus, their representation on a small icon undoubtedly meant for private devotion is not surprising.[2]

Images of the three "saints" were especially popular in Egypt in the sixth and seventh centuries. Both in the icon and in a sixth- or seventh-century wall painting from the Monastery of Saint Jeremiah in Saqqara, the three Hebrew youths stand frontally with their hands raised, wearing Persian garb, while a slightly crouching angel at the left reaches in front of them with a long cross-staff.[3]

The garment the three Hebrews wear over their tunics and under their cloaks, probably a koukoullion or scapular, suggests the icon came from a monastic context. The three Hebrew youths were seen as models of endurance for the Christian monk; the monastic cell was referred to as "the furnace of Babylon in which the three children saw the Son of God." Their wearing of the monastic garment would have encouraged a monastic viewer to identify with them.[4]

While the closest comparisons for the composition come from Coptic Egypt, the icon's inscription is in Greek, not Coptic, and the closest comparisons for the scapular are in ninth- and eleventh-century Byzantine manuscripts, where the garment often indicates the suffering or penitent monk.[5]

KCor

1 This section of Daniel occurs only in Greek versions of the book (and versions derived from it). See J. Collins 1993, p. 196; and Corrigan 2009, p. 94.
2 On the cult of the Three Hebrews, see BHG 1957, vol. 1, pp. 147–50; Maraval 1985, p. 268; J. Collins 1993, p. 196; Papaconstantinou 2001, pp. 198–200. Further references and discussion can be found in Corrigan 2009.
3 Corrigan 2009, pp. 97–99; for the wall painting, see fig. 6.
4 Ibid., pp. 99–103.
5 Ibid., p. 100.

References: Soteriou 1956–58, vol. 1, pls. 12, 13, vol. 2, pp. 26–28; Weitzmann 1976, p. 56, pls. XXII, LXXXII, LXXXIII (Icon B.31); Corrigan 2009.

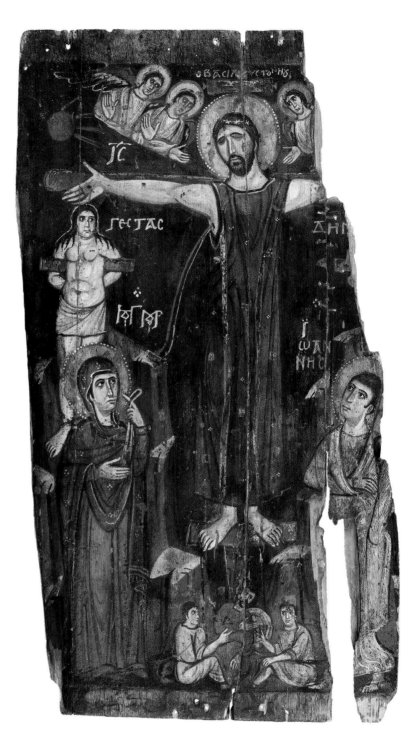

27. Icon with the Crucifixion

....................

Early Islamic Palestine, perhaps Sinai, Egypt, 8th century
Tempera on wood
46.4 × 25.5 cm (18¼ × 10⅟₁₆ in.)
Inscribed: In Greek, above the titulus, O ΒΑΣΙΛΕΥΣ ΤΟΝ HOY|Δ[ΑΙΩΝ] (King of the Jews);[1] above left, I(ησού)Σ [X(ριστο)Σ] (Jesus Christ); next to thief on left, ΓΕΣΤΑΣ (Gestas); next to thief on right, ΔΗΜ(ας) (Demas); next to Mary, [monogram of] Η ΑΓΙΑ ΜΑΡΙΑ (Saint Mary); next to John, ΙΩΑΝΝΗΣ (John)
Provenance: In the collections of the Holy Monastery of Saint Catherine since the Middle Ages.
Condition: The icon is missing about one-quarter of its right side where the figure of the good thief would have been; only a small portion of his cross is visible. A narrow strip is missing along the left. Vertical splits are held together by metal strips at the top and bottom or by metal wire. Presumably a wooden frame was nailed onto the front of the icon.
The Holy Monastery of Saint Catherine, Sinai, Egypt

This is the earliest known representation of Christ dead on the cross. Christ's eyes are obviously closed, blood and water flow from his side, and he is wearing the crown of thorns—the earliest preserved example of this motif as well.[2] The interest in exploring Christ's suffering and death has been related to the theological controversies concerning the relation between Christ's human and divine natures, especially at the time of his death. This icon's emphasis on Christ's humanity has been seen as a rebuttal of the

Miaphysites, whose teachings implied that Christ's divine nature had suffered and died (Theopaschitism). In a text written in the 680s, the Orthodox monk Anastasios of Sinai suggested that images of the dead Christ on the cross could be used to argue that it was only Christ's human body that died on the cross.[3] This connection, along with certain stylistic and iconographic features, supports the eighth-century date and perhaps places the icon's production at Mount Sinai.[4]

This and other Crucifixion images of the period refer to the upheavals of nature mentioned by the prophets Joel (2:30–31) and Amos (8:9) and referenced in the Gospels and by other Christian writers. The sun was darkened, the earth shook, and the rocks were rent (Matthew 27:51).[5] The blood and water from Christ's side flow directly onto the steep cliffs flanking him, which look as if they are being torn asunder by the bottom of the cross.[6] KCor

1 Weitzmann 1976, p. 63, notes that the delta is written on the titulus itself.
2 Ibid., pp. 61–64 (Icon B.36), pls. XXV, LXXXIX, and XC. Leslie Brubaker suggests a date of ca. 800; see Brubaker and Haldon 2001, pp. 60–61.
3 Belting-Ihm and Belting 1966; Kartsonis 1986, pp. 40–68.
4 Brubaker and Haldon 2001, p. 61.
5 See also Luke 39:44–45. For discussion of the later interpretations, see Corrigan 1992, pp. 83–87; Corrigan 1995; Engemann 1986.
6 Another, slightly later Crucifixion icon at Mount Sinai shares this dramatic rocky setting, with mountains that are bluish below and turn fiery red above. See fig. 19 and Weitzmann 1976, pp. 57–58 (Icon B.32), pls. XXIII, LXXIV. For the breaking open of the earth in Anastasis imagery, see Kartsonis 1986, p. 208.

References: Soteriou 1956–58, vol. 1, pl. 35, vol. 2, pp. 39–41; Weitzmann 1976, pp. 61–64; Brubaker and Haldon 2001, pp. 60–61; R. Nelson and Collins 2006, p. 129.

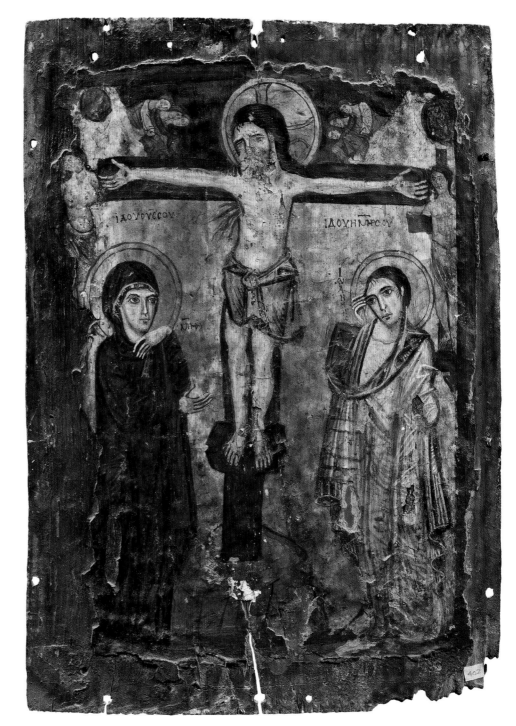

28. Icon of the Crucifixion with Christ in a Loincloth

....................

Egypt, Mount Sinai (?), 9th century
Tempera on wood
47.1 × 34.4 cm (18⅜₆ × 13⅝₆ in.)
Inscribed: In Greek, next to the Virgin, MH(τηρ) Θ(εο)Υ (Mother of God); next to John, ΙΩΑΝΝΗΣ (John); above the Virgin, ΙΔΟΥ Ο Υ(ιο)Σ ΣΟΥ (Behold your Son); above John, ΙΔΟΥ Η ΜΗ(τη)Ρ ΣΟΥ (Behold your Mother)
Provenance: In the collections of the Holy Monastery of Saint Catherine since the Middle Ages.
Condition: The entire perimeter of the painted surface is damaged, and sections of paint are missing, especially along the left side. The lower part of Christ's face has been damaged. Presumably a wooden frame was nailed onto the surface of the icon.
The Holy Monastery of Saint Catherine, Sinai, Egypt

This icon shares many features with the other eighth- and ninth-century icons of the Crucifixion now at Mount Sinai (figs. 19, 20).[1] As in catalogue number 27, Christ stands erect on the suppedaneum with his head tilted and his eyes closed. He is flanked by the Virgin and Saint John; in the background are the two thieves, and the sun, moon, and groups of angels are above the arms of the cross.[2] Prominent in this icon is the near nudity of Christ: a sheer loincloth allows most of his body to be seen. This display of Christ's body was apparently a new feature in the East at this time.[3]

Like the depiction of Christ's death, showing his naked body was a way of emphasizing Christ's humanity, thereby countering not only the various Miaphysite heresies but also the teachings of the Iconoclasts. Furthermore, Christian theologians, especially those living in Palestine and at Mount Sinai, were well aware of the Muslim denial of Christ's death on the cross. Because of the shame and humiliation attached to crucifixion, Muslims, who respected Jesus as a prophet, denied that Christ was crucified (Qur'an 4:157).[4] Some Christian writers also were concerned about the humiliating and potentially emasculating connotations of the Crucifixion.[5] The bad thieves in this icon and in catalogue number 27 have been described as feminized

because of their seemingly enlarged breasts and, in the case of catalogue number 27, the long, disheveled hair. This interpretation has been challenged recently and is in need of further investigation.[6] KCor

1 Weitzmann 1976, pp. 79–82 (Icon B.50), pls. XXXII, CV (B.32, B.36, B.51).

2 Weitzmann 1976, pp. 79–82 (Icon B.50), pls. XXXII, CV, CVI. Brubaker and Haldon 2001, pp. 68–69. Both Weitzmann and Brubaker suggest that this icon was copied from icon B.36, but with significant changes.

3 A number of Crucifixion images show Christ wearing only the loincloth and with a seeming emphasis on the articulation of his flesh. See Corrigan 1992, figs. 87, 88, 92. On the somewhat earlier icon, Weitzmann B.32 (fig. 19), enough paint has flaked off to reveal that Christ was originally wearing a loincloth that was subsequently covered by a colobium (tunic), suggesting that the choice was still problematic at this time. The same phenomenon occurs in a Crucifixion image in the Paris Homilies of Gregory Nazianzus of 879–82 (Bibliothèque Nationale de France, Paris, gr. 510), for which see Brubaker and Haldon 2001, p. 62. See also Corrigan 1995. In the West, the loincloth was more common than the colobium in the Early Christian period; see *Dictionary of the Middle Ages*, edited by Joseph R. Strayer (New York, 1982–2004), vol. 4, p. 13.

4 Lawson 2009, chap. 2; Corrigan 1992, pp. 81–90.

5 Conway 2008.

6 Brubaker and Haldon 2001, p. 60, n. 25, p. 68 (with earlier bibl.). Brubaker suggests that the apparently enlarged breasts of the thief may be a misreading of earlier photographs of the icon taken before its recent cleaning.

References: Soteriou 1956–58, vol. 1, pl. 26, vol. 2, p. 41; Weitzmann 1976, pp. 61–64; Brubaker and Haldon 2001, pp. 68–69.

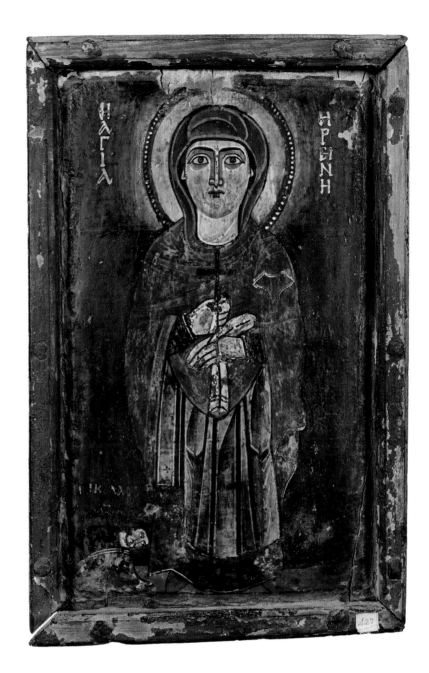

29. Icon with Saint Irene and Donor

....................

Early Islamic Palestine or Egypt, 8th–9th century
Tempera on wood
38.3 × 24.5 cm (15⅟₁₆ × 9⅝ in.)
Inscribed: In Greek, at either side of saint, ΗΑΓΙΑ ΗΡΕΙΝΗ (Hagia Eirene); at lower left, ΝΙΚΟΛΑΟΣ [SAB?]ΑΤΙΑΝΟΣ (Nikolaos [Sab?]atianos)
Provenance: In the collections of the Holy Monastery of Saint Catherine since the Middle Ages.
Condition: The paint is in fairly good condition but somewhat discolored. Paint loss is evident on the lower portion of the kneeling donor and in the beginning of the inscription.
The Holy Monastery of Saint Catherine, Sinai, Egypt

Saint Irene stands frontally, holding a martyr's cross in her right hand and a folded cloth in her left. She wears a carmine maphorion (garment covering the head and shoulders) over a greenish chiton. A small male figure kneels at her feet; his brown tunic and black mantle decorated with white lines suggest he is a monk. The icon has much in common with other Sinai panels dated to the eighth–ninth centuries, but it also shares features with frescoes in Bawit and Saqqara.[1]

Daughter of the pagan king Licinius, Irene converted to Christianity and underwent astounding tortures before her death. Raised from the dead, she appeared to her followers in a cloud, asking them to rebury her in a stone coffin. When they returned to the tomb, they found only her clothes and an angel.[2]

The donor at Irene's feet is difficult to identify. The first name is clearly Nikolaos, but the next word is only partly preserved. It certainly ends "ΑΤΙΑΝΟΣ," and Kurt Weitzmann discerned "ΣΑΒ" at the beginning. I can see only a faint sigma and possibly the lower right portion of a beta. The word "Sabbatianos," with two betas, appears, along with the alternative "Sabbatios," in the sixth-century *Ethnika* of Stephen of Byzantium, referring to a geographic area and an ethnic group.[3] "Sabbatios" is also mentioned in the Life of Nicholas of Sion as the abbot of a monastery in Lycia, in what are the modern provinces of Anatalya and Muǧla on the southern coast of Turkey.[4] Thus, the inscription seems to associate Nikolaos with a particular area and ethnic group.[5] KCor

1 Weitzmann 1976, pp. 66–67, pls. XXVI, XCIII (Icon B.39). Leslie Brubaker suggests a date of ca. 800; see Brubaker and Haldon 2001, p. 66. For the frescoes in Bawit and Saqqara, see Bolman 2007a, p. 421, fig. 20.9, p. 427, fig. 20.12.

2 BHG 1957, vol. 2, pp. 42–43, and BHG 1984, p. 120. There are many martyrs named Irene, and many versions of the life and passion of the daughter of Licinius. The relationships among these have not been fully sorted out, and only a few have been published. Besides the publications referred to in BHG, see the English translation of the Syriac version preserved in the Codex Sinaiticus Syrus dated 778, in Lewis 1900, pp. 94–148, available at http://www.archive.org /details/selectnarratives017362mbp.

3 The *Ethnika* is a geographical dictionary. The entry reads, Σαββατία, κώμη Κελτική. τὸ ἐθνικὸν Σαββατιανός καί Σαββάτιος.

4 Nicholas of Sion 1984 (see index). Sabbatios was archimandrite of the Monastery of Akalissos, where Nicholas the Elder was deputy.

5 A less likely possibility is that Nicholas was associated with the Monastery of Saint Sabas in Palestine. However, I have found no instance of "Sabatianos" used in this way; affiliation with the Sabas monastery is generally indicated by "Sabaite" or, as in some colophons, "from the holy Lavra of our holy father Sabas."

References: Soteriou 1956–58, vol. 1, pl. 35, vol. 2, pp. 39–41; Weitzmann 1976, pp. 66–67, pls. XXVI, XCIII (Icon B.39); Ševčenko 1993–94; Brubaker and Haldon 2001, p. 66.

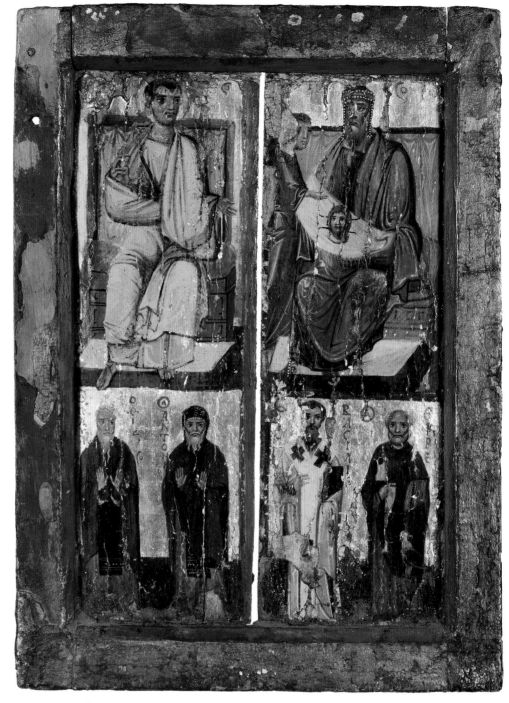

30. Two Icon Panels with Saints Thaddaeus, Paul of Thebes, and Antony (*left*), and King Abgar and Messenger (Ananias?), and Saints Basil and Ephrem (*right*)

....................

Early Islamic Palestine, mid-10th century
Tempera on wood
With frame, 34.5 × 25.2 cm (13⅝ × 9⅞ in.)
Inscribed: In Greek, left panel, Ο Α(γιος) ΘΑ[Δ]ΕΟΣ (Saint Thaddaeus); Ο Α(γιος) ΠΑΥΛΟΣ Ο ΘΙΒΕΟΣ (Saint Paul of Thebes); Ο Α(γιος) ΑΝΤΟΝΙΟΣ (Saint Antony); right panel, ΑΥΓΑΡΟΣ (Abgar); Ο Α(γιος) ΒΑΣΙΛΙΟΣ (Saint Basil); Ο Α(γιος) ΕΦΡΕΜ (Saint Ephrem)
Provenance: In the collections of the Holy Monastery of Saint Catherine since the Middle Ages.
Condition: The two panels are enclosed in a later frame, but may have originally served as the wings of a triptych, whose central panel contained a representation of the Mandylion.[1] The paint surface is rubbed throughout, and there are significant paint losses in the figures of the messenger and Saint Basil. A crack and some paint loss can be seen in the face of Abgar.
The Holy Monastery of Saint Catherine, Sinai, Egypt

This icon represents the story of a contemporary of Christ, King Abgar of Edessa, whom the apostle Thaddaeus converted to Christianity. Abgar sent Ananias to paint a portrait of Christ, but he could not. Instead, Christ imprinted his features on a cloth (the Mandylion). By the late sixth century, the story, preserved in Greek and Syriac sources, mentions the acheiropoietos image (not made by human hands) and credits it with protecting Edessa. By the early eighth century, John of Damascus used the example of the Mandylion to defend the production and veneration of images of Christ against the Iconoclasts.[2]

This icon is the earliest visual evidence of the existence and appearance of the Mandylion. The facial type can be seen on the sixth-century icon of Christ at Mount

Sinai, on the gold coins of Justinian II (r. 685–711), and on a Holy Land ampulla (cat. no. 59).[3] In the mid-tenth century the Byzantine emperor Romanos I Lekapenos (r. 920–44) negotiated with the Muslim rulers of Edessa to bring the Mandylion to Constantinople. The negotiations and the icon's reception are recorded in the *Narratio*, a text probably commissioned by Romanos's successor, Constantine VII Porphyrogennetos (r. 945–59).[4] The face of Abgar may be based on portraits of Constantine VII, thus making him a hero of the icon's history.[5]

The link to Constantine VII and the *Narratio* suggests the icon was made in Constantinople, but it shares stylistic features with other Sinai icons attributed to Early

Islamic Palestine, and several of the saints have Eastern, monastic connections.[6]

KCor

1 See the reconstruction in Weitzmann 1976, pp. 97–98, fig. B.

2 Av. Cameron 1984; Guscin 2009; H. Drijvers 1998; Brock 2004.

3 Weitzmann 1976, pl. I and fig. 3.

4 *Narratio de Imagine Edessena*. See Guscin 2009, pp. 7–69.

5 Weitzmann 1960a.

6 Weitzmann 1976, p. 97. Saints Antony and Paul were considered the founders of Egyptian monasticism; their monasteries in Egypt's eastern desert drew pilgrims who also went to Mount Sinai. See Bolman 2002 and Lyster 2008. Saint Ephrem spent the later part of his life in Edessa.

References: Soteriou 1956–58, vol. 1, pls. 34–36, vol. 2, p. 49; Weitzmann 1976, pp. 61–64; R. Nelson and Collins 2006, pp. 134–35; Guscin 2009, p. 135.

31. Syriac Translation of the Book of Kings (I) with a Portrait of King David

....................

Syria, 7th century

Ink and gold on parchment; 19 folios

24.6 × 17 cm (9¹¹⁄₁₆ × 6¹¹⁄₁₆ in.)

Provenance: In the collections of the Holy Monastery of Saint Catherine since the Middle Ages. Among a cache of several hundred complete manuscripts and more than a thousand folios discovered in 1975, sealed in one of the monastery's walls.

Condition: The manuscript consists of two quires with the sewing intact. The leaves are cracked along the outer edges, and there is some staining. The first two leaves of the manuscript were originally glued together to give more support for the very important frontispiece illumination. These leaves are only partially attached at present.

The Holy Monastery of Saint Catherine, Sinai, Egypt (Syriac New Finds Ms. 24)

King David, crowned and haloed, appears in a strictly frontal pose, as befitting an austere and learned ruler. He wears a short, knee-length tunic covered by a full-length semicircular cloak called a chlamys. Rather than the youth of the David Plates (cat. no. 6), the depiction of this biblical hero is an almost exact copy of the famous mid-sixth-century mosaic portrait of the Byzantine emperor Justinian (r. 527–65) at San Vitale in Ravenna, the Western imperial capital.[1] Here, Justinian's distinctive *tablion*[2] has been converted into a large, golden codex clasped in David's right hand, perhaps an allusion to his authorship of a number of the Psalms, or to the biblical Book of Kings. The inscription identifying David is in Syriac, whereas the identification in the Ravenna mosaic is in Latin. The confluence of such seemingly divergent entities—

Italian mosaic, Byzantine emperor, Syriac Christianity—speaks to the large-scale artistic exchange during the period and the multicultural nature of the community in which the manuscript originated and to which it belonged. Found at the Monastery of Saint Catherine at Sinai, it demonstrates that the linguistic fluidity at Sinai had a striking artistic counterpart.[3]

AL

1 For a discussion of the same open-footed stance, placement and shape of the gold decorations on the white tunic, and fall of the folds in his dark purple cloak, see A. Grabar 1966, fig. 171.

2 The *tablion* was a square, colored panel on the midriff of the Byzantine chlamys, identifying the rank of the wearer.

3 Brock 2003, p. 105.

References: Philothea of Sinai 1983; Manaphēs 1990, p. 372, fig. 15; Philothea of Sinai 2008.

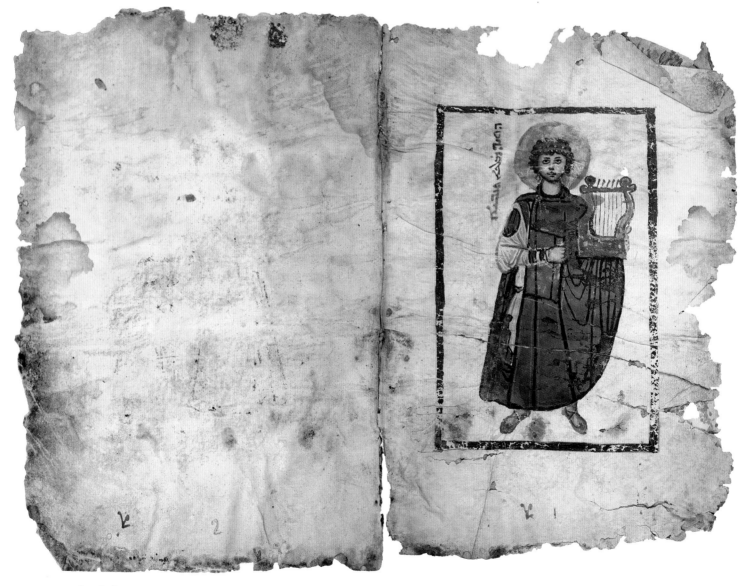

31, frontispiece

Arab Christians

Sidney H. Griffith

Less than a decade after the Roman emperor Heraclius (r. 610–41) conquered the Persians in 628, invading Arab armies from the south defeated the Romans at the battle of the Yarmuk River in Syria in 636. As a result, by the mid-seventh century, the territories of Alexandria, Antioch, and Jerusalem had come permanently under Muslim rule.[1] Save for a brief respite from 969 to 1085, when Roman forces once again occupied Antioch and its environs, and the years of Crusader dominance (1099–1291) in Syria/Palestine, when Byzantium exerted some influence in Jerusalem, Eastern Christians were effectively cut off from easy access to Rome or Constantinople until modern times. By the mid-eighth century in Syria/Palestine, they had begun to adopt Arabic for public purposes, and by the ninth century they had accommodated themselves to the then burgeoning culture of the Islamic commonwealth; in Egypt this process of acculturation took another century.[2]

While there had been Arabic-speaking Jews and Christians in Arabia before and during the years of Islam's rise and successful expansion, the vast majority of Christians lived in the conquered territories—Egypt, Syria/Palestine, and Mesopotamia. Before the coming of Islamic hegemony, they spoke Coptic, Armenian, Aramaic, and Syriac, as well as much Greek, especially in learned or cosmopolitan centers. As a result of the emperor Justinian I's (r. 527–65) enforcement of the Christological doctrine of the Council of Chalcedon (451) throughout the Byzantine territories, by the time of the Islamic conquest Christians in Alexandria, Antioch, and Jerusalem were already divided into rival confessional communities: those who accepted the formula of Chalcedon, and those who did not.[3] Among the latter were the mostly Coptic, Armenian, and Syriac-speaking communities, called by their adversaries Miaphysites or Jacobites, and the so-called Nestorians, who spoke Syriac. These communities continued to define themselves doctrinally even after they adopted the Arabic language and responded to the religious and social challenges of Islam. In fact, they developed the distinctive expression of their ecclesiastical identities only in Early Islamic times.

From the seventh to the ninth century, Jerusalem was the focus for Christians in the East. Pilgrims from all confessional communities continued to visit the Holy Land, and the monastic establishments of the Holy Land and the Judaean desert were cosmopolitan in character. Greek was the dominant written language, but Aramaic, Syriac, and Armenian were common. This was the milieu in which the earliest Christian texts in Arabic appeared; they were both translations of the scriptures and original theological compositions. It was also here in the seventh and eighth centuries that the imperial heresies of Monoenergism and Monotheletism were effectively resisted.[4] Here, too, in the wake of the construction of the Dome of the Rock—that monumental statement of Jerusalem's Muslim identity—the first defense of the veneration of icons was written in Greek by Saint John of Damascus (ca. 675–749), who was also the author of the first systematic summary of the Orthodox faith in Greek, the composite *Fountain of Knowledge* (see Ratliff, p. 32).[5]

By the mid-ninth century, the first Arab Christian theologians whose names we know were regularly writing theological treatises in Arabic, usually in opposition to one another's confessional formulae: the Chalcedonian Theodore Abu Qurrah (ca. 755–ca. 830; cat. no 81; Ratliff, p. 32), the Jacobite Habib ibn Khidmah Abu Ra'itah (d. ca. 851), and the Nestorian 'Ammar al-Basri (act. ca. 850).[6] With their pioneering works, along with the Bible newly translated into Arabic and the translation of selected patristic texts, the Arab Christian churches came into the full possession of their distinctive ecclesiastical and cultural identities as integral societies within the world of Islam.

32. Greek-Arabic Diglot
....................

Eastern Mediterranean, probably 9th century
Black and red ink on parchment; 200 folios
20.5 × 17.6 cm (8¹⁄₁₆ × 6¹⁵⁄₁₆ in.)
Provenance: In the collections of the Holy Monastery of Saint Catherine since the Middle Ages.
Condition: This manuscript is in an early Sinai binding, with a punched design on the front and back boards. A later piece of leather has been applied over the spine, attached with four metal nails. There are vestiges of braided leather ties, two across the foredge, one at the head and one at the tail. Of these, only one metal knob survives, from the top tie along the foredge. Offset from papyrus leaves may be seen on fols. 3r and 198v. The first seven quires are detached, as are the last quire and the last leaf, fol. 199. The leather cover is no longer attached to the book block. The end bands are frayed. The parchment folios are very well preserved, the red ink retaining its gloss.
The Holy Monastery of Saint Catherine, Sinai, Egypt (Greek Ms. 36)

The Psalms were among the earliest of the biblical texts used in the liturgy to be translated into Arabic and to be copied in diglots, or bilingual manuscripts, to facilitate their recitation in both languages. One of the earliest such manuscripts features the Arabic text written in Greek characters.[1] Later in Egypt, dual-language Coptic-Arabic biblical manuscripts were not uncommon, and they are often enhanced by colorful illuminations. The present Greek-Arabic manuscript of the Psalms and Odes, probably of the ninth century, is one of several in the library of the Monastery of Saint Catherine, testifying to their early popularity. The illustration shows Psalm 17 (16):14–15 and the beginning of Psalm 18 (17), written in alternating columns of Arabic and Greek, and Greek and Arabic, with the Greek columns across the gutter from each other. Liturgical notations and the Psalm headings are in red ink (rubrics). Curiously, someone has written, in a much later, scrawling Arabic hand between the opening lines of the Arabic version of Psalm 18(17):1–2, a note containing a report of an ecclesiastical dignitary, whose name is written too cursorily for ready identification, seemingly referring to the monastic population at the time of writing.

SHG

1 G. Graf 1944–53, vol. 1, pp. 114–16.

References: G. Graf 1944–53, vol. 1, p. 115; Kamil 1970, p. 63; Nasrallah 1988, p. 184; M. Brown 2006, pp. 192–93, 285, cat. no. 46.

32, fols. 38v–39r

mirrors the change in tongues in the Christian communities in Syria/Palestine, as Arabic replaced the earlier Aramaic, Syriac, and Greek that had been the customary languages of the monasteries of Jerusalem and the Judaean desert.[2] The translated Arabic texts are representative of the popular ecclesiastical literature required by the newly Arabic-speaking Christians in the Islamic world. The two pages opened here contain the beginning of the martyrdom of Saint Tatian.
SHG

1 Atiya 1955, p. 19.
2 Griffith 1988, 1997.

References: Atiya 1952; Atiya 1955, p. 19, no. 514; Atiya 1959; Atiya 1967.

33. Codex Arabicus

.....................

Eastern Mediterranean, 8th–early 9th century
Black ink on parchment; 175 folios
23 × 15 cm (9¹⁄₁₆ × 5⅞ in.)
Provenance: In the collections of the Holy Monastery of Saint Catherine since the Middle Ages.
Condition: Part of the leather binding is missing from the front board and wholly missing from the spine. The original spine lining remains, attached only along the back edge. The head and tail bands are present but loose and frayed. The parchment is very desiccated, with most of the leaves cracked and some chipped along the outer edges. There are vestiges of two braided leather ties along the foredge.
The Holy Monastery of Saint Catherine, Sinai, Egypt (Arabic Ms. 514)

The Codex Arabicus, so named by its modern cataloguer, is "a quintuple palimpsest in three languages, Syriac, Greek, and Arabic."[1] The underlying texts of the Gospels in Syriac were erased sometime in the sixth or seventh century to make way for a Greek Gospel lectionary on the same parchment leaves, which were in turn erased to allow an Early Islamic scribe to set down a collection of patristic and hagiographic texts translated from Syriac and Greek into Arabic. The Arabic hand is in the Kufic style characteristic of the earliest Christian Arabic texts of the eighth and early ninth centuries. The sequence of languages in this palimpsest

34. Folios from a Gospel Lectionary

.....................

Eastern Mediterranean, 859
Inks on parchment; 1 quire of 8 folios (Arabic New Finds Ms. 14); 2 contiguous bifolia (Arabic New Finds Ms. 16)
21.5 × 16.7 cm (8⁷⁄₁₆ × 6⁹⁄₁₆ in.)
Provenance: In the collections of the Holy Monastery of Saint Catherine since the Middle Ages. Among a cache of several hundred complete manuscripts and more than a thousand folios discovered in 1975 sealed in one of the monastery's walls.
Condition: This manuscript consists of loose quires. A few filaments of thread remain from the original sewing. The leaves have suffered some damage and are in need of conservation.
The Holy Monastery of Saint Catherine, Sinai, Egypt (Arabic New Finds Mss. 14 + 16)

Written in a hand common in the monastic scriptoria of ninth-century Syria/Palestine, one of the folios carries the date of the copying of the Gospel lectionary as the year 859, the earliest known dated copy of any part of the Bible in Arabic.[1] The translation of the Gospel text from Greek or Syriac would have been done earlier. As a lectionary, albeit with the Gospels in canonical, not liturgical, order, the text is complete with rubrics indicating the pericopes, or selections, to be read according to the liturgical calendar. Unusually sumptuous for a text playing a secondary role in the liturgy—that is, providing the vernacular translation of the Gospel proclamation made in Greek or Syriac—the surviving pages of this lectionary feature illuminations in the form of colored line drawings of crosses and ecclesiastical structures (fig. 112), along with full-page portraits of the evangelists Luke and John at the beginning of their

33, fols. 122v–123r

34, fols. 60v–61r

Gospels. The pages open here include the portrait of Saint John the Evangelist and the beginning of his Gospel. The opening formula, "In the name of the Father, and of the Son, and of the Holy Spirit, one God," is standard in Christian Arabic texts of the Early Islamic period. SHG

1 Meimaris 1985, pp. 27 (Greek), 24–25 (Arabic).

References: Meimaris 1985, p. 27; Manaphēs 1990, p. 370, fig. 12; M. Brown 2006, pp. 166–67, 274–75, cat. no. 35

Epistles of Saint Paul, following the text and notes on the final verses of the Epistle to the Hebrews, says, "The weakling, the poor sinner Bishr ibn as-Sirri translated these fourteen epistles from Syriac into Arabic, and as best as he could set forth their interpretation for his spiritual brother, Sulayman. He finished the work in the month of Ramadan of the year A.H. 253 [867 C.E.] in the city of Damascus." Over the centuries, others added notes of their own: a later colophon records the year 1030. The translation seems to have

been made for purposes of Bible study rather than for use in the liturgy. The translator's exegetical comments are indexed by red rubrics, or sigla, in the text that refer to notes circled in red in the margin and at the foot of the page. The text has an ecumenical character in that the commentator made use of exegetical material from scholars other than those of his own Melkite community, and it seems also to have come into the hands of Jacobite users. The pages illustrated include the end of the Epistle to the

35. Arabic Epistles and Acts
..................

Syria, Damascus, A.H. 253 (867 C.E.)
Black and red ink on parchment; 269 folios
26.9 × 19.5 cm (10%6 × 7¹¹⁄₁₆ in.)
Provenance: Copied in Damascus, Syria; in the collections of the Holy Monastery of Saint Catherine since the Middle Ages.
Condition: The leather binding is brittle, with flaking at the edges of the front and back boards and along the spine. The back board is split and held together with tape. Internally, the manuscript is in a remarkable state of preservation.
The Holy Monastery of Saint Catherine, Sinai, Egypt (Arabic Ms. 151)

This manuscript contains one of the earliest dated translations of any portion of the Bible into Arabic and is one of the very few that carries the name of a translator.[1] The colophon written at the end of the

35, fols. 186v–187r

Hebrews and the early colophon translated in part above. SHG

1 It is also one of the few Arabic Bible manuscripts from which translations of some books have been published in modern editions. See Staal 1969, 1983.

References: Atiya 1955, p. 6; Staal 1969; Kamil 1970, p. 16; Staal 1983; M. Brown 2006, pp. 160–61, 272, cat. no. 32.

36. Epistle of Paul to the Romans

....................

Eastern Mediterranean, 9th–10th century
Black and red inks on parchment; 10 folios
26.7 × 18.5 cm (10½ × 7⁵⁄₁₆ in.)
Provenance: In the collections of the Holy Monastery of Saint Catherine since the Middle Ages. Among a cache of several hundred complete manuscripts and more than a thousand folios discovered in 1975, sealed in one of the monastery's walls.
Condition: This manuscript consists of only one quire and one loose leaf. There are only vestiges of the original sewing. The outer edges of the leaves are damaged and in need of conservation.
The Holy Monastery of Saint Catherine, Sinai, Egypt (Arabic New Finds Ms. 52)

These pages, written in a very clear Arabic hand, with the diacritical marks inscribed in red ink over the forms of the letters, were part of a manuscript probably intended for the use of a lector in the Syriac or Greek liturgy, to interpret the scripture passages proclaimed in the liturgical language for an Arabic-speaking congregation. The translation on the pages illustrated here presents a very interpretive Arabic rendering of Paul's Epistle to the Romans 10:16–21, in that the translator, who was working from the Syriac Bible, the Peshitta, which is itself a bit different in wording from the original Greek compilation, expanded the text to enhance understanding. For example, he rendered the famous saying "Faith comes from the hearing of the ear, and the hearing of the ear is of the Word of God" (Peshitta, verse 17) as follows: "Faith is only from the hearing of the ear, and the ear hears only God's word spoken in the recollection of Him and the preaching of Him." In the last phrase, words reminiscent of the Qur'an's Arabic diction call attention to the Muslim cast of the translator's language, a common feature of the Bible in Arabic. Translators wanted both their versions to sound like scripture in the target language and, as here, to make use of the exegetical potential of familiar Arabic words and phrases. SHG

References: Meimaris 1985; Manaphēs 1990, p. 370, fig. 10.

37. *Achtiname* (Testament) of Muhammad

....................

Egypt, Sinai, 1858
Ink on paper, bordered by green silk
70.4 × 38.1 cm (27¹¹⁄₁₆ × 15 in.)
Inscribed: In Turkish, in Arabic script, at the top of the document, as heading,

سبب تحرير رقم فصيح اللسان وموجب تقرير رقم صحيح البيان بودر كه

(Here is the reason for the writing of this document of eloquent language and the condition that necessitated the formulation of this document of true statements)
Provenance: The Sinai Metochion at Canea, Crete.
Condition: There are splits in the paper along the horizontal folds, and at the top and bottom of the document.
The Holy Monastery of Saint Catherine, Sinai, Egypt (Turkish scroll no. 4)

The *Achtiname* (Testament) of Muhammad is a document dated to the second year of the *hijra*, granted to the monks and to the Christian families living in the area of Mount Sinai. It consists of eleven articles pertaining to the monks and another seven pertaining to the Christian families, to ensure peaceful relations between Christians and Muslims. The document concludes, "This Testament was written on parchment from Tā'if by the hand of Ali ibn Abi Talib in the mosque of the Prophet (upon whom be peace), the third day of Muharram, the second year of

36, fols. 6v–7r

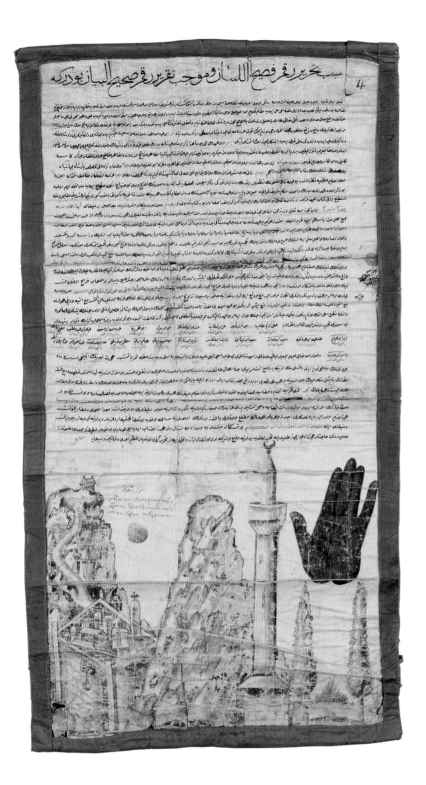

38. Bird-Shaped Vessel

Syria or Iraq, early 9th century
Copper alloy, cast, engraved; handle and supporting rod made separately and riveted
36.1 × 12.7 × 31.6 cm (14³⁄₁₆ × 5 × 12⁷⁄₁₆ in.)
Inscribed: In Arabic, بسم الله بركة من الله لصاحبه
(In the name of God the blessing of God to the owner)
Provenance: In the collections of the Holy Monastery of Saint Catherine since the Middle Ages.
Condition: One claw and the lid covering the filler hole for the water are missing. There is a later large irregular hole in the bottom.
The Holy Monastery of Saint Catherine, Sinai, Egypt

This aquamanile in the shape of an eagle or falcon forms a group with three others, in the Museum für Islamische Kunst, Berlin; the Church of San Frediano, Lucca; and the Hermitage Museum (cat. no. 169), this last inscribed and dated 796–97.[1] The Sinai bird has a special hole for filling with water and a handle in the shape of a quadruped holding a small ball in its mouth.[2] The ferocity of the raptor may be realistic, but the engraved decoration of plumage, dotted-scale pattern, rosettes, and vine scrolls is conventional.[3] Although zoomorphic vessels are found in all cultures, Iran is especially famed for such objects.[4] The Sinai bird, like the rest of the group, is a prestigious object made for the market but destined for a contemporary elite, who deemed it suitable as a donation to the Monastery of Saint Catherine.

The inscription follows a formula that would become standard. It begins with the Muslim invocation to God, the bismillah, "In the name of God," a shortened form used on certain objects for reasons of space; it is followed by the supplicatory prayer of the anonymous owner.[5] He or a subsequent owner donated the aquamanile and could have been either Christian or Muslim, since the monastery, in addition to being a Christian shrine, was a Muslim holy site from as early as the seventh century.[6]

We know that in the eighth and especially the ninth century the monastery was part of a nexus linking centers of the caliphate and monasteries in Palestine, where, for example, the monk Anthony of Baghdad copied and translated into Arabic religious texts commissioned by the Sinai monastery. There is evidence of similar mobility in the example of two other Sinai monks who later became martyrs: the itinerant monk Pachomios, who is said to have been a cousin of the caliph, and the abbot Qays, whose travels, starting from his birthplace, Najran in Arabia, included visits to the

the *hijra*,[1] and a copy has been deposited in the Sultan's treasury; the Prophet (upon whom be peace) sealed it with his own hand."[2] Copies of this document include the depiction of a hand, as here, indicating that Muhammad touched the original.

In 1517 the Ottoman sultan Selim I conquered Egypt, receiving the title of caliph; in that same year, the monks of Sinai presented him with the original *Achtiname*, bearing it into his presence on a tray, covered with green brocade,[3] a color traditionally associated with Muhammad. The Testament was confirmed by Sultan Selim, and by subsequent rulers, to the time of Sultan Abdul Hamid II in 1904.[4]

The present document, copied in 1858, bears the seal of the Sinai dependency at Canea, Crete. The depiction of the monastery shows the mosque within its walls. It lies at the foot of Mount Sinai, revered in both the Bible and the Qur'an as the sacred mountain of the revelations of God. HJS

1 This corresponds to July 7, 623.
2 Translated from the Arabic text in Shuqayr 1916, p. 497. For a detailed review of this document, see pp. 495–504.
3 Nektarios 1980, p. 433.
4 Papamichalopoulos 1932, p. 216.

Reference: Manaphēs 1990, p. 374, fig. 18.

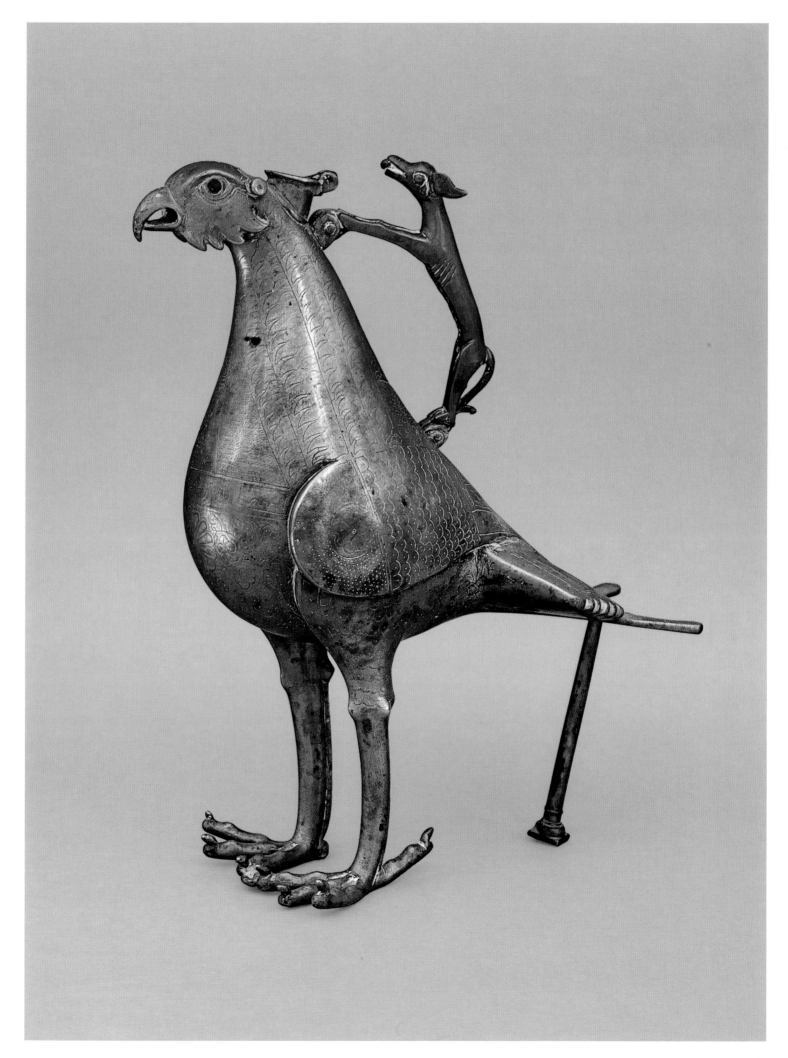

Palestinian monastery of Mar Saba, Ayla, Ramla, and Edessa.[7]

During this period the pilgrimage routes mostly went through Syria/Palestine,[8] to which the route from Iraq also led, making it quite likely that the bird came from one of these two areas. The Iraqi option seems plausible, since ninth-century Baghdad and its port of Basra were leaders in most artistic innovations in this period. AB

1 Enderlein et al. 2001, pp. 27–28; Contadini 2010, pp. 55–57, figs. 1.10–1.12. Also in Curatola 1993, cat. no. 24.
2 The zoomorphic handle is a typical feature of late Roman vessels, something that was transmitted at an early stage to Sasanian Iran; see Harper 1978, p. 67, fig. 22a. However, the ball in the quadruped's mouth is reminiscent of either Aphrodite's pearl held in the mouth of dolphins (see Alaoui 2000, cat. no. 158) or the Buddhist pearl in the dragon's mouth (see a Chinese rhyton in the Art Institute of Chicago, http://www.flickr.com/photos/unforth/4224085472/). The Berlin bird also retains its handle, which ends in a dolphin.
3 All the birds have a central rosette on the breast and decorative scaling, but the most elaborate engraving is on the raptor in Berlin, with guilloche roundels enclosing birds and hares; Sarre 1930; Sarre 1934, fig. 6. The raptors in Berlin and the Hermitage are said to have been originally inlaid, and they also have molded details on the plumage, including a boss. The birds from Sinai and Lucca appear to have been only engraved, with no inlay, but in all cases only metal analysis can prove whether inlaid material once existed.
4 Apparently as late as 740, vases in the shape of animals were made in Merv and presented to the caliph; see Demange 2006, p. 79. There are no other known examples of Islamic vessels of this size in the form of raptors, but there are roosters and peacocks and a much larger number of felines and other quadrupeds; Piotrovskii and Rogers 2004, pp. 85–87, cat. nos. 35–37, p. 89, cat. no. 39; and Bernus-Taylor and Delpont 2000, p. 34, cat. no. 18, pp. 111–13, cat. nos. 87–89.
5 The Lucca bird is similarly inscribed "bismillah baraka min allah"; see Contadini 2010, p. 55. By contrast, on the bird in the Hermitage (cat. no. 169), the inscription is not generic: the bismillah is inscribed in full, followed by the maker, the city, and the date.
6 Brubaker and Haldon 2001, pp. 56–60; Manginis 2010, pp. 153–60.
7 Griffith 1989; Ratliff 2008; Swanson 2001.
8 Only one Western pilgrim, Fromont, from Rennes, in Brittany, is known to have traveled to Sinai in this early period, and he traveled via Rome and Jerusalem; see Manginis 2010, pp. 163–64.

References: Weitzmann and Anderegg 1964; Baer 1983, p. 190, fig. 167; Blair 1998, pp. 103–4.

The Syriac Church

Nancy Khalek

The Syriac Orthodox Church is among the earliest-established Christian churches. Traditionally, its roots are in Antioch, the city in which the term "Christians" was first used by Christ's disciples.[1] During the first half of the first century, the apostle Peter established a church there. In 325 the bishopric of Antioch was included in the ecumenical council held at Nicaea and was officially recognized as a patriarchate.

Reflecting the trend toward Hellenization among the cities of the eastern Roman Empire, Greek became the official and elite language of Antioch. The lingua franca of the region, however, was Syriac, a dialect of Aramaic. A number of disciples, among them the apostle Thomas, are believed to have spread the Gospel in Syriac to cities including Mesopotamian Edessa and Persian Nisibis, which would house major schools of religious learning. The Syriac Doctrine of Addai describes a correspondence between Christ and King Abgar of Edessa (cat. no. 30), and Edessa is considered by many scholars to be the cradle of Syriac Christianity. In general, the geographical region encompassed by the Syriac Church is northern Mesopotamia and its adjacent eastern frontier, a region comprising modern-day Iraq, northeast Syria, southeast Turkey, and western Iran. It is not confined to the Middle East, however, having been established in India traditionally by Thomas. Other centers, especially Adiabene and Nisibis, were influential in the work of the most famous and important Syriac writers, including Aphrahat, the Persian Sage (ca. 270–345), and Ephrem the Syrian (ca. 306–373), a church father and hymnographer.[2]

The Syriac Church played a role in synods at Constantinople (381) and Ephesus (431). Proceedings at the Council of Chalcedon in 451 ended in a major division over the nature of Christ that affected those who were under the care of the See of Antioch. The Syriac Orthodox (non-Chalcedonian) understanding is that Christ has one nature as the Incarnate Word, with full humanity and full divinity. The Chalcedonian understanding is that Christ is one person in two natures, one fully human and the other fully divine. Those who agreed with the council's position on the nature of Christ became known as the Eastern or Melkite Orthodox, while some of those who held a different position became the Syriac Orthodox Church. Because the Council of Chalcedon's position was the official view of the Byzantine authorities, years of struggle ensued over control of the patriarchate in Antioch. In 518 the Syriac Orthodox patriarch Severos (r. 512–18) was exiled, and leadership of the church passed to a series of monastic centers in modern-day Turkey and Syria, including Qartmin, Qenneshrin, Amida, and, in the thirteenth century, Mardin. By the fourth century in Sasanian Persia, the Church of the East, once called Nestorian (for Nestorios [ca. 381–after 451], to whom was attributed a belief in God's fully divine nature dwelling in Jesus in a single, common form), had become the officially recognized Christian community of the state. This independent church grew out of early Assyrian Christian communities in the first century, in the Aramaic-speaking regions of Babylonia, Assyria, and northwest Persia.[3]

The Syriac Orthodox churches use the Peshitta (a Syriac word that means simple or common) as their Bible. The Old Testament of the Peshitta was translated from the Hebrew about the second century. The New Testament, which has undergone some changes in scope since it originally excluded certain disputed books, became standard by the early fifth century, replacing two earlier Syriac versions of the Gospels (fig. 21 and cat. 39).[4]

Because of the doctrinal disagreements at the Council of Chalcedon, the Syriac Church endured occasional persecution under the Byzantine Empire until the seventh century. The rise of Islam and the subsequent fall of many eastern Mediterranean territories to the Muslim armies beginning in 635 had extremely important consequences for the Syriac Church. At first, Islam was seen as an ethnic or Arab movement, a political occupation similar to the one Christians had experienced in the region when the Persians, former opponents of Byzantium, had occupied the area.

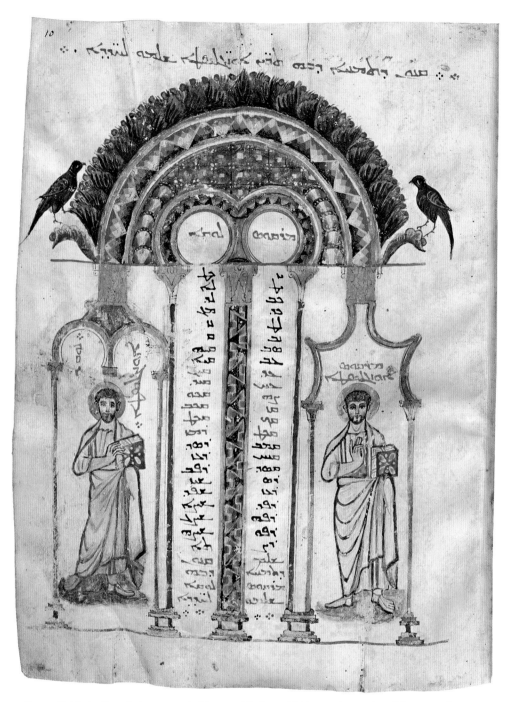

Fig. 21. Rabbula Gospels (cat. no. 39), fol. 10r, with Canon Table 8 and portraits of the evangelists Mark and Luke

39. Rabbula Gospels
.
Scribe: Rabbula
Syria (?), completed in 586
Ink and colors on parchment; 292 folios
33.5 × 26.5 cm (13³⁄₁₆ × 10⁷⁄₁₆ in.)
Provenance: Completed in the Monastery of Saint John, Beth Zagba, between Antioch and Damascus, in 586 according to the colophon near the end of the codex; at the Church of Saint George, presumably also in Antioch, in the eleventh or twelfth century;[1] entered the monastery of Qannubin, Lebanon, according to a note dated May 15, 1361; donated by curates Gergis and Hallal of the Monastery of Hawqa to the Monastery of Santa Maria di Quannubin in 1460/61 according to a notation written in Garshuni on folio IIv; entered the Biblioteca Medicea Laurenziana, Florence, probably in 1573.[2]
Condition: During several rebindings, the pages were trimmed. It was last restored in 1574.
Biblioteca Medicea Laurenziana, Florence (Plut. I. 56)

The Rabbula Gospels are the most handsomely illuminated work of the Syriac Church. Twenty-six pages of illustrations, including the canon tables (fols. 3v–12v; fig. 21), precede the Gospels, which are based on the Peshitta (Syriac) version of the Bible and written to be read from right to left. The canon tables are presented under elaborate arcades with extensive marginal illuminations of Christological concepts relating the Old to the New Testament.[3]

On the first pair of tables (fol. 4v on right), a standing King David, who resembles his portrait in the Sinai Book of Kings (cat. no. 31), a later Syriac work, is balanced by an enthroned Solomon. Below David is a depiction of the Nativity. The Virgin's awkwardly crossed arms relate to those of John the Baptist as he baptizes Christ across the page, beneath Solomon. Below the Baptism, Herod gestures toward a scene of the Massacre of the Innocents, a break with the practice of reading from right to left.[4] On the facing page (fol. 5r), the prophets Hosea and Joel stand to the right and left of the arcade, respectively. Below Hosea, servants pour water into goblets, where it is shown transformed into wine, and, across the page, the Virgin and Christ witness that miracle as it takes place during the Wedding at Cana.

The Rabbula Gospels have long been celebrated as a masterpiece of Early Christian art. Recently scholars led by Massimo Bernabò

Eventually, it became clear that Islam was a religious movement, and Syriac Christianity, now free from persecution by Byzantium, continued to flourish in some regions under Muslim rulers. A number of Christians entered the employ of the Muslim caliphs who ruled from Damascus. While at times the relationship was strained, the Syriac Church enjoyed relatively greater freedom from persecution under Muslim authorities, and Christians constituted the majority of the population of Syria and other parts of the Middle East well into the Middle Ages.[5]

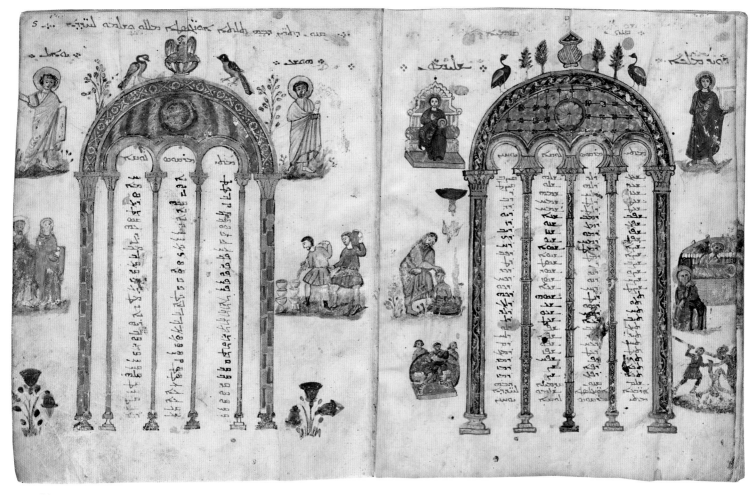

39, fols. 4v–5r

have identified extensive repainting through-
out the manuscript, probably done when it
came to Italy in the sixteenth century, appar-
ently in an attempt to temper its more
"Syrian" features.[5] AL

1 Colophons throughout the manuscript chart its his-
 tory. On folio 292v we learn that after the death of a
 certain Romano, "priest and visitor from Antioch,"
 the Gospels (most of the manuscript) were given to
 the Church of Saint George in the eleventh or twelfth
 century. Probably the pericopes used for the liturgy
 (fols. 15–19) were integrated into the manuscript at
 that time.

2 An alternative date of 1497 was suggested by the
 eighteenth-century Lebanese scholar Joseph Assemani.

3 The canon tables are a system, devised in the fourth
 century by Eusebius of Caesarea, showing the con-
 cordance of Gospel passages.

4 Leroy (1964, p. 142) argues that John, Herod, and the
 figures in the Massacre scene are roughly done and, as
 such, were likely retouched at a later date.

5 According to Massimo Bernabò (2008, pp. 5, 89, 91),
 the restoration may have taken place about the time
 that the codex passed into the hands of the Medici
 family. Bernabò is uncertain as to whether the later
 painting was done while the manuscript was in Syria
 or in a workshop in Italy, by a "Raphael-esque" artist,
 but the intervention was not solely an effort of con-
 servation. For example, in the Crucifixion scene
 Christ's originally short beard was elongated so as to
 fit with current taste. Most of the evidence on
 fols. 4v and 5r is accidental—the meaningless streak
 of yellow paint to the right of the Baptismal scene is
 from the later artist's brush, as are the splotches of
 dark brown ink strewn throughout.

References: Cecchelli 1959; Leroy 1964, pp. 139–206;
Lowden 1999, pp. 26–30; M. Brown 2006, p. 300, cat.
no. 62 (Herbert L. Kessler); Bernabò 2008.

40. Pauline Epistles from the Peshitta

.

Syria, 622
Black and red inks on parchment; 143 folios
23.5 × 17 cm (9¼ × 6¹¹⁄₁₆ in.)
Provenance: A colophon on folio 143r says the manuscript
was copied by John bar Sergius from the village of
Haluga in the district of Serug, Syria; taken to the Syrian
Convent of Saint Mary Deipara by Abbot Moses of
Nisibis; acquired by the British Museum before 1870;
transferred to the British Library at its foundation (1973).
Condition: The condition is good, with some wear.
The British Library, London (Add 14478)

These folios reproduce the last
section of Saint Paul's letter to the
Ephesians—at the beginning of which is
the famous injunction "Honor your father
and mother"—and the first part of his letter
to the Philippians, indicated with red ink.
Read from right to left, the text is written
in a Syriac script called *estrangela.* The name
derives from the Greek word *stroggylē*, or
"rounded," and means "to write the Gospels"
in Syriac. Classic *estrangela* provided the basis
for two later types of Syriac writing styles—

serta, used for text in the western Syriac dialect, and *madnhaya*, used for the eastern Syriac dialect. While variants of the script started appearing after the fifth century, thereby reflecting the division between the two Syrian communities, it was only about then that the text of the Syriac Bible took its final form. Known as the Peshitta, a term meaning "simple" or "common," the Bible ultimately accommodated the Syrian canon to that of the Greeks, while excluding Peter 2, John 2, John 3, Jude, and Revelation. Although the Old Testament of the Peshitta was translated from Hebrew about the second century, the New Testament remained a source of contention until the fifth century. The final text ultimately replaced two Syriac versions of the Gospels. AL

References: W. Wright 1870, pp. 90–92; Juckel 2003; M. Brown 2006, pp. 164–65, 274, cat. no. 34.

Coptic Christianity

Elizabeth S. Bolman

The Coptic Orthodox Church traces its origins back to Saint Mark the Evangelist (fig. 22), the first patriarch of Alexandria.[1] By the early seventh century, Egypt was an almost exclusively Christian province of the Byzantine Empire. Then, between 639 and 642, Muslim Arabs conquered the country. At first the Copts functioned much as they had under the Byzantines, continuing to serve as civil servants in the new administration.[2] Their lives began to change significantly, however, in 705, when Arabic replaced Greek as the language of government. Christian officials were obliged to become bilingual, and the process of their Arabization began.[3] By the end of the ninth century, the Egyptians had widely adopted Arabic, and a substantial number of them, especially those residing in the Delta, had converted to Islam.[4]

The See of Alexandria broke with both Constantinople and Rome over the precise nature of Christ as defined in 451 by the Council of Chalcedon.[5] The doctrinal position of the Copts, Miaphysitism,[6] asserts that Christ's divinity and humanity are seamlessly united in one nature, in contrast to the opposing conviction, adopted by the council, that he has two distinct natures.[7] Although contentious before the Arab conquest, this conflict between the Chalcedonians and the Miaphysites became largely meaningless afterward. At first an embattled majority, the Miaphysites eventually reaped the benefits of governmental support—Egypt's Muslim rulers recognized their patriarchs and granted them churches and shrines that had been under Chalcedonian control.[8]

From the time of Antony the Great (ca. 252–356), known as the father of monasticism, and Athanasios of Alexandria (295–373), monks and patriarchs (fig. 23) had a close relationship that affected the character of the Coptic Church. Mark's successors were usually drawn from the monastic community, a tradition that continues today.[9] These two groups shaped much of Egyptian Christian literary and visual culture. Large monasteries had thriving scriptoria (cat. no. 49). Art, architecture, and other physical remains of monasticism have survived exceptionally well in the desert, as seen at the White and Red monasteries near Sohag (see Bolman, p. 75), and at the Monastery of the Archangel Gabriel at Naqlun, on the edge of the Fayyum. These settlements outside of cities and towns give us a somewhat limited sense of the range and character of Coptic art, however, because with rare exceptions, the major wealthy patriarchal, episcopal, and urban churches no longer exist.

The Arab conquest of Egypt affected not only the linguistic character of the country, but also its centers of power. The Muslim government established itself at Fustat (see Abdulfattah, p. 229), now part of Cairo, rather than in the former capital, Alexandria. Fustat began as a military camp established for the siege of the Roman fortress of Babylon, located strategically on the Nile.[10] After the takeover, Christians built several churches in the fortress, including one dedicated to Saints Sergios and Bakchos that is popularly known as Abu Serga. Tradition has it that during their sojourn in Egypt the Holy Family stayed at the site where this basilica now stands.[11] The church probably dates to the late seventh or early eighth century, and it became one of the places in which new

40, fols. 85v–86r

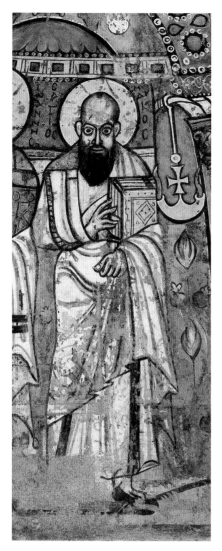

Fig. 22. Saint Mark the Evangelist. Secco painting, ca. 7th century. South lobe of the sanctuary, Red Monastery Church, near Sohag, Egypt. © ARCE

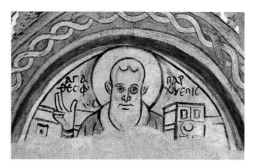

Fig. 23. Patriarch Theophilos of Alexandria. Secco painting, ca. 7th century. North lobe of the sanctuary, Red Monastery Church, near Sohag, Egypt. © ARCE

collapse.[18] Then the Fatimid conquest in 969 inaugurated a period of renewed tolerance and an easing of taxation, which permitted a flourishing of Coptic art and culture in the centuries that followed.[19]

patriarchs were consecrated.[12] In the eleventh century, the patriarchal seat moved to Cairo, acknowledging the supreme importance of this city in Muslim-controlled Egypt.[13]

The relatively good relations enjoyed by the Copts and their new rulers disintegrated in the eighth century.[14] Crushing taxation and increasing pressure on the Copts to convert to Islam[15] provoked revolts that were violently suppressed, and Muslim governors required the patriarch to collect taxes from Christians.[16] Attacks by Bedouin on eremitic settlements in Scetis (Wadi al-Natrun) necessitated the construction of massive walls around monastic buildings, and these protective enclosures have been a distinctive feature of Egyptian monasteries ever since.[17] By the end of the ninth century, the Coptic Orthodox Church seemed on the verge of

41. Fragmentary Stele with Orant Monk

....................

Egypt (Saqqara?), 6th–7th century
Limestone
30.5 × 35.6 × 4.6 cm (12 × 14 × 1 13/16 in.)
Provenance: Purchased from Kelekian, New York (no. 6711), by Mildred and Robert Woods Bliss, 1935; collection of Mildred and Robert Woods Bliss, 1935–40. *Condition:* The bottom half has been broken off and lost. Traces of the thin plaster and paint that originally covered the sculpture have survived.
Byzantine Collection, Dumbarton Oaks, Washington, D.C. (BZ.1935.11)

This stele belongs to an extensive set of Byzantine objects portraying holy monks that were created in various media and styles and functioned as integral parts of Egyptian monasticism in Late Antiquity and beyond (cat. nos. 46, 52A). Now a fragmentary sculpture that once presented the entire

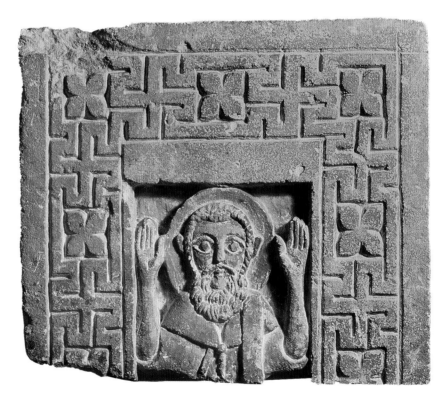

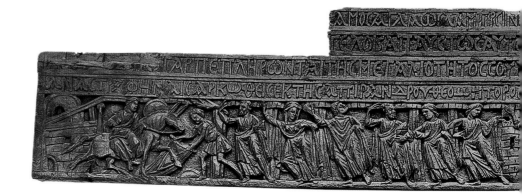

body of the ascetic, it still conveys his authority—the halo indicates that he was venerated as a saint and his short cloak announces his status as a monk; the scarf he wears hanging from his left shoulder may mean that he was a deacon or it could be an item of monastic dress.[1] Shenoute wears the same scarf in the Red Monastery paintings (fig. 30) and on a stone relief sculpture in the Museum für Byzantinische Kunst, Berlin (cat. no. 46). The figure on the stele is an orant, that is, he raises his hands in the traditional pose of prayer—imitating Christ on the cross—and thus manifests two goals of the angelic life: assimilation to Christ and ceaseless prayer. A wide meander pattern framing the image forms stylized crosses, in harmony with the central theme of salvation. Like many other Egyptian sculptures from Late Antiquity, this piece was covered with a thin layer of plaster that was then painted.[2] The broad, unadorned rectangle above the head probably included a painted inscription with the figure's name, now lost.[3] This low-relief stele has been described as a grave marker, but it is just as likely that it functioned as a stone icon.[4] An agent in the construction of the monk as a saint, the image provides a model for emulation and a focus of veneration. We can imagine a monastic viewer assuming the same pose while directing his devotional gaze at the holy figure.

ESB

1 Stephen Zwirn and Gary Vikan describe this figure as a deacon; see Zwirn in Bühl 2008, pp. 106–7, and Vikan 1995. Karel Innemée (1992, pp. 45–48, 105–6) lists the scarf as an attribute of a deacon, but also, separately, as an item of monastic dress that may have been used to tie up tunics during work. The precise meaning and function of the scarf are unclear.
2 T. Thomas 2000, pp. 26–27.
3 Vikan 1995, p. 55.
4 Vikan 1995; Bühl 2008, pp. 106–7.

References: Kelekian 1928; Weitzmann 1979a, pp. 553–54, cat. no. 499; Vikan 1995, pp. 55–57, no. 21; T. Thomas 2000, p. 11, fig. 86; Bühl 2008, pp. 106–7 (Stephen Zwirn).

42. Al-Mu'allaqa Lintel

Egypt, 735
Wood, possibly sycamore
35 × 274 cm (13¾ × 107⅞ in.)
Inscribed: In Greek, [✝ ... (+/-22) O O]Y(PA)NOC AΓΛΑωC ΛΛΜΠΕΙΝΕΤΑΙ ΑΧΛΥC ΠΑΝΤΕΛωC ΜΗ ΚΕΚΤΗΜΕΝΟC ΕΝΘΑ ΚΑΤωΚΕΙ ΠΑΝ ΤΟ ΠΛΗΡωΜΑ ΤΗC ΘΕΟΤΗΤΟC ωC ΕΠΟΥΠΑΝΙΟΝ CΙΝΑΙ ΑΝω[/[(+/-20) ΟΙ ΑΓ]ΓΕΛΟΙ (ΚΑΙ) ΑΠΑΥCΤωC ΑΥΤΟΝ ΓΕΡΕΡΟΥCΙΝ ΕΝ ΤΡΙCΑΓΙΑ ΦωΝΗ ΑΔΟΝΤΕC (ΚΑΙ) ΛΕΓΟΝΤΕC· ΑΓΙΟC ΑΓΙΟC ΑΓΙΟC ΕΙ Κ(ΥΡΙ)Ε· ΠΛΗΡΗC Ο ΟΥ(ΡΑ)ΝΟC (ΚΑΙ) Η ΓΗ ΤΗ[C ΑΓΙ-/ΑC CΟΥ [ΔΟ]ΞΗC· (ΚΑΙ) ΓΑΡ ΠΕΠΛΗΡωΝΤΑΙ ΤΗC ΜΕΓΑΛΙΟΤΗΤΟC CΟΥ ΠΟΛΥΕΥCΠ(Λ)Α(Γ)ΧΝΕ Κ(Υ ΡΙ)Ε ΟΤΙ ΕΝ ΟΥ(ΡΑ)ΝΟΙC ΑωΠΑΤΟC ωΝ ΠΟΙΚΙΛΟΙC ΔΥΝΑΜΕCΙΝ ΕΝ ΗΜΙΝ ΕΥΔΟΚΗCΑC ΤΟΙC ΒΡωΤΟΙC CΥΝ-/ΑΝΑCΤΡΑΦΗΝΑΙ CΑΡΚωΘΕΙC ΕΚ ΤΗC ΑΠΙΡΑΝΔΡΟΥ ΘΕΟΜΗΤΟΡΟC ΜΑΡΙΑC ΕΠΙΚΟΥ ΡΟC ΓΕΝΟΥ ΑΒΒΑ ΘΕΟΔωΡΟΥ ΠΡΟΕΔΡΟ(Υ) (ΚΑΙ) ΓΕωΡΓΙω ΔΙΑΚ(ΟΝω) ΚΑΙ ΟΙΚΟΝΟ(Μ ω). Μ(ΗΝ)ΟC ΜΠΤΑΧ(ωΝ) ΙΒ ΙΝ(ΔΙΚΤΙωΝΟC) Γ ΔΙΟΚ(ΛΗΤΙΑΝΟΥ) ΥΝΔ ([Be praised, Jesus Christ, descendent of] Abraham, shining splendidly, with no darkness at all, in whom dwells all the fullness of divinity,/ to whom the heavenly host, holy angels and holy archangels ceaselessly honor him with thrice-holy voice [in the Trisagion] singing and saying: Holy, holy, holy are you, O Lord. Heaven and earth are full of your holy glory./ For they are filled with your greatness, O Lord of great mercy, as you are invisible in the heavens amidst manifold powers, and you were content to dwell together with us mortals,/ having become incarnate from the Mother of God, Mary, who has never known man. Be a helper to Abba Theodore the patriarch and George the deacon and oeconomus. Pachon 12, indiction 3, year of Diocletian 451 [735 C.E.])[1]
Provenance: Though its original location cannot be confirmed with certainty, the lintel is thought to be from al-Mu'allaqa in Cairo.[2] In 1872 the Reverend Greville Chester saw the lintel in the church, over a door, "partly concealed in the masonry"; he noted that the beam was published in "Murray's Hand-book for Egypt."[3] During renovations undertaken by Nakhle Bey al-Barati between 1892 and 1896, the lintel was placed on the west wall of the church. The Comité de Conservation des Monuments de l'Art Arabe moved it to the Coptic Museum between 1915 and 1919.[4]
Condition: The lintel is in generally good condition. Portions of the inscription have been lost completely or are abraded, as are the lower bodies of the three right-most figures.
Coptic Museum, Cairo (753)

The lintel from Cairo's al-Mu'allaqa (the Hanging Church) combines a Greek inscription with a depiction of the Entry into Jerusalem (left) and the Ascension of Christ (right). By the eighth century, both scenes had well-established iconography within a broader Christian milieu and within the Christian arts of Egypt, making the lintel's iconographic particularities readily apparent and meaningful to members of the Coptic Church.[5] The eighth century was a period of decreasing tolerance on the part of Egypt's Muslim authorities toward the Christian population and of increasing competition among Christian confessions;[6] the lintel can be read as an expression of the Coptic Church's changing fortunes. In this context, most remarkable is the architectural backdrop. At the left edge, Christ rides away from a cut-stone building, behind which is an archway, to enter a colonnade joined to the building's roof. The building may be al-Mu'allaqa, and the colonnade that stretches the lintel's length, linking the scenes at the two ends, suggests an interior, perhaps that of the church.[7]

Depictions of the Entry were understood historically as Christ's Entry into Jerusalem, scripturally as the start of his reign in the eternal Jerusalem, and liturgically as the arrival of the divine presence. A similarly complex image, the Ascension on the right end refers to both Christ's ascent into heaven and the Second Coming. In Egypt, the image had strong Eucharistic overtones, representing divine presence in the sanctuary. Paired as they are on the lintel, the scenes proclaim Christ's return.[8] Placed within a setting recalling one of Cairo's churches, the imagery becomes a statement promising Christian triumph over Islam and a statement about the Coptic community's role in the eternal Church.[9] The figures witnessing the events and bridging the two scenes can be read as members of this community.

The inscription participates in the lintel's refutation of Islam and promotion of the Coptic Church.[10] Greek was widely recognized as the language of the church's past and of cultured learning; the choice of Greek

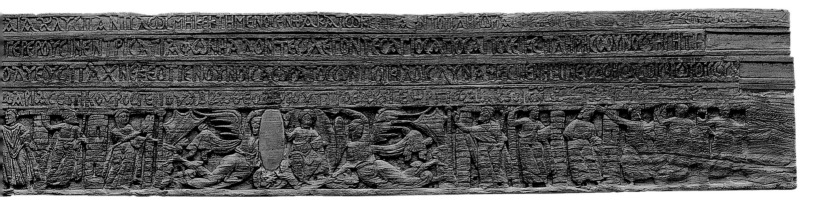

for the inscription therefore affirmed the church's superiority over Islam.[11] The content, too, with its insistence on the Incarnation, was a rejection of Islam's characterization of Christ as a prophet, second to Muhammad.[12] The inscription also claims the correctness of the Coptic theology over that of other Christian communities. It explicitly directs the Trisagion (a hymn sung during all Eastern liturgies) to Christ rather than to God, a long-standing point of contention between Miaphysite and Chalcedonian churches.[13]

BR

1 The diplomatic transcription reproduced here follows Leslie MacCoull (1986, p. 231); the translation is by Glenn Peers (2007, p. 25), who collates MacCoull's translation (1986, pp. 231–32) with corrections suggested by Jürgen Hammerstaedt (1999, pp. 188–89, no. 17). The poor condition of the last part of the fourth line has left the reading of the date open to question; see MacCoull 1986, pp. 232–33. Pachon is the ninth month of the Coptic calendar, corresponding to April 26–May 25. An indiction indicates one year in a fifteen-year cycle, but does not specify the cycle. On the Coptic calendar, see Cody 1991. The accomplished quality of the lintel's craftsmanship, particularly the elegant, naturalistically rendered figures, and its iconography have further contributed to the debate over its date. For a review of dates proposed by various scholars, see Török 2005b, pp. 353–56.

2 Al-Mu'allaqa, or the Hanging Church, is built over the south gate of the Roman fortress of Babylon, the oldest part of Cairo; the church takes its name from its suspended position over the gateway. For a brief discussion of the church, see P. Grossmann 1991, pp. 319–20.

3 Chester 1872, p. 129. The guidebook mentioned by Chester is J. G. Wilkinson 1847; the lintel is described on p. 158.

4 Sheehan 2010, pp. 123, 128–29. For a list of objects and manuscripts removed from the church, see Coquin 1974, pp. 81–86.

5 For an in-depth discussion of the lintel considered in its eighth-century context, see Peers 2007.

6 Ibid., p. 29. See also Bolman, p. 69, and Mark Swanson's overview of this period in Swanson 2010, pp. 15–42.

7 Sacopoulo 1957, p. 102; Peers 2007, pp. 27, 28–29.

8 On the lintel's iconography, see Sacopoulo 1957, pp. 100–108; Spieser 1995, pp. 313–17; Peers 2007.

9 MacCoull 1986, p. 234; Peers 2007, p. 27.

10 See Sacopoulo 1957, pp. 108–12; MacCoull 1986; Fournet 1993; and Hammerstaedt 1999, pp. 187–99, no. 17, on the inscription.

11 Peers 2007, pp. 40–41. For discussions of the use of Greek in Egypt during this period, see, in this volume, Maria Mavroudi's introduction to two ostraka (cat. no. 15) and Bolman, p. 69.

12 Peers 2007, pp. 41–42.

13 Ibid., pp. 37–39; also see Sacopoulo 1957, pp. 108–12; MacCoull 1986, p. 233. On the Trisagion, see Brock 1985, esp. pp. 28–30.

References: Sacopoulo 1957; MacCoull 1986; Spieser 1995; Török 2005b; Peers 2007.

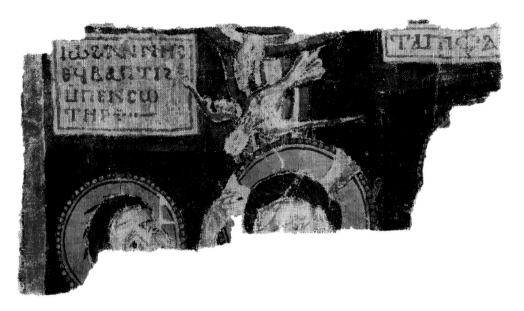

43. Painted Textile Fragment with the Baptism of Christ

.

Egypt, 8th–11th century
Tempera on linen ground
17 × 31 cm (6¹¹⁄₁₆ × 12³⁄₁₆ in.).
Inscribed: In Coptic, at top left: ΙѠ2ΑΝΝΗϹ/ЄϤΒΑΠΤ
ΙΖЄ/ΜΠЄΝϹѠ/ΤΗΡ; and right: ΤΑΠΙϕΑ[ΝΙΑ]
(left: John baptizing our savior; right: the Epipha[ny])[1]
Provenance: Purchased in Egypt by Vladimir Bock (1850–1899) in 1898.
Condition: Only the top left of the composition is preserved with wear, especially on the faces, and tears.
The State Hermitage Museum, Saint Petersburg
(ΔΒ 11257)

The top of Christ's head appears in a nimbed halo at the center of the fragment. To the left is a remnant of the face of John the Forerunner (John the Baptist in the Western tradition), whose hand touches the halo of the Savior with a blessing gesture. Extending from curved bands above the head of Christ are the Hand of God and a beam of white light upon which the dove of the Holy Spirit descends. Inscriptions in Coptic enclosed in rectangular frames appear to the left and right. The color scheme is notable for its muted tones, for example the blue-green background, with details traced in brown and red, and the barely visible shadows.

Monumental works of this kind from Egypt are rare. As one of the seven great feasts of the Coptic Church, the Baptism was a popular subject in the art of Egyptian Christians. Judging by the composition and iconography of this fragment, the scene follows the Byzantine tradition; stylistic affinities can be found in certain late paintings from Faras.[2] The free-form brushwork,

the preference for monumental images, and the colors and red outlines all characterize Coptic miniatures of the tenth and eleventh centuries.[3]

OO

1 Translation by A. I. Yelanskaya. The paleography of the inscriptions provides a date no earlier than the eighth century. Our appreciation to Andrew Crislip, Blake Chair in the History of Christianity, Department of History, Virginia Commonwealth University, for his review of the translation and for his transcription.

2 Michałowski 1974, nos. 33, 45.

3 Leroy 1974, p. 118.

Reference: Kakovkin 1984.

44A, B. Pair of Liturgical Fans (Rhipidia)

.

Egypt, 11th–12th century
Silver, repoussé relief
Provenance: Reportedly from Syria; formerly collection of Marguerite Mallon, wife of Paul Mallon; acquired by the Brooklyn Museum in 1946.
Condition: The two rhipidia show similar damage. Each of the tube-shaped shafts that served to attach the disks to the staffs, together with a piece of each disk, has broken off and been reattached by soldering. The lower end of the shafts, the borders, and the surfaces of the disks show minor dents. In some places the silver is tarnished.

A. Fan with the Heads of an Ox and a Lion

H. 40.8 cm, Diam. 22 cm (H. 16¹⁄₁₆ in., Diam. 8¹¹⁄₁₆ in.)
Inscribed: In Greek using Coptic letters, around the border, terminating in the middle of a phrase, ΑΓΙѠϹ ΑΓΙѠϹ ΑΓΙѠϹ ΚΗΡΙѠϹ ϹΒΑѠΘ ΠΛΗΡϹ Ѡ ȢѠΡΑΝѠϹ ΚΑЄΙ ΧΗ ΤϹ ΑΓΙѠϹ ѠȢ ΤΑΖΙϹ ѠȢϹΑΝΝΑ Ν ΘΙϹ ΠΟϹΘΙϹ ЄȢΛ[Ο]ΙΓΙ (Holy, holy, holy, is the Lord of hosts, heaven and earth are full of His glory. Hosanna in the highest. Blessed is [he who came and comes in the name of the Lord]). On the disk, near the mount of the shaft, in Greek using the Coptic definite article, ΠΙΑΓΙΟϹ ϕΛΟȢΘЄΟϹ (The holy Philotheos)

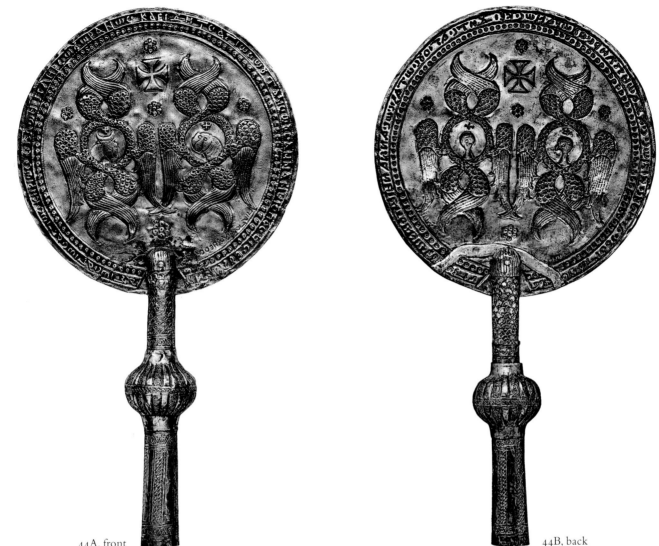

44A, front

44B, back

B. Fan with the Heads of an Eagle and an Angel
H. 40.8 cm, Diam. 22.7 cm (H. 16⅟₁₆ in., Diam. 8¹⁵⁄₁₆ in.)
Inscribed: In Greek using Coptic letters, around the border, terminating in the middle of a phrase, ΔΓΙШС
ΔΓΙΟδC ΔΓΙΟδC ΚΙΡΙШС CΔΒΔШΘ ΠΛΗΡC Ο
δШΡΔΝШC ΚΕΙ ΧΗ ΤC ΔΓΙΟδC Ш ΤΔЗΙC
ШCΔΝΗΔ Η ΘΙC ΠΟCΘΙC ΕδΛШΓΙ(.)
([Translation as above]). On the disk, near the mount of the shaft, in Greek using the Coptic definite article,
ΠΙΔΓΙΟC ΦΙΛΟδΘΘCΟC ([Translation as above])
Brooklyn Museum, New York, Charles Edwin Wilbour Fund (46.126.1 and 46.126.2)

Rhipidia are liturgical fans that were always made in pairs and carried by two deacons during the church service. Originally intended to keep away insects from the bread and wine of the Eucharist, by the sixth century they had taken on an emblematic meaning. Referring to the vision of Isaiah (6:2–3), they symbolized the seraphim praising God, who was considered present in the Eucharist.

Theologically and iconographically, Isaiah's seraphim were often combined or equated with the beasts of the book of Revelation (4:6–8) and the living creatures

of the vision of Ezekiel (1:4–20). The earliest pair of metal rhipidia preserved, divided between Dumbarton Oaks, Washington, D.C., and the Archaeological Museum, Istanbul, and dated to 565–78, shows an angel-headed, six-winged seraph from Isaiah on one disk and a four-headed, four-winged creature from Ezekiel on the other disk, both in a circle of peacock feathers, which allude to the eyes covering the beasts of the book of Revelation.[1]

As in these earlier examples, the decoration and inscription of the Brooklyn rhipidia reflect their symbolic meaning. Both are decorated with two biblical creatures. Each being has six wings, originating from a central loop and crossing in ornamental curves. Each loop encircles a head, an ox's and a lion's on A, and an eagle's and an angel's head on B. The creatures are the beasts of the book of Revelation, but, like seraphim, they have no visible bodies.

The circular Greek inscription, written in Coptic letters, is a quotation from the Coptic anaphora (Eucharistic prayer) of Saint

Gregory.[2] It is the only one in the orbit of the Coptic Church to combine praise of God from the vision of Isaiah (6:2–3) and the acclamation of Christ by the crowd during his Entry into Jerusalem (Matt. 21:9 and

Fig. 24. Rhipidion. Silver, repoussé relief, 11th–12th century. Coptic Museum, Cairo (1597)

Mark 11:9–10).[3] Part of the acclamation is extensively misspelled but can still be made out.

The second inscription, incised later, gives the name of Saint Philotheos, probably the patron of the church to which the rhipidia once belonged.[4]

The Brooklyn rhipidia are closely related to a single rhipidion in Cairo with a similar circular inscription and ornamentation (fig. 24).[5] There, the four beasts follow the same iconographic scheme but are gathered on one disk. On its shaft an Arabic inscription states the donation to a church of Saint Barbara.[6] The similarity between the Brooklyn rhipidia and the Cairo example and the use of Coptic letters point to an Egyptian, not Syrian, origin. Their decoration is an example of the continuity of Late Antique Christian iconographic traditions far into the Islamic period.[7] GM

1 M. Mango 1986, pp. 147–54, cat. nos. 31–32; Bühl 2008, p. 82.
2 Hammerschmidt 1957, pp. 26–27, 119–20; Gerhards 1994, p. 57.
3 Gerhards 1984, p. 224. Since its publication by Bréhier 1945, the inscription has been identified as a quote from the Coptic liturgy of Saint Mark, which, however, is lacking the acclamation; see Brightman 1896, pp. 132, 176; Cuming 1990, pp. 38, 70.
4 Philotheos was an Antiochian martyr but was particularly venerated in Egypt; see van Esbroeck 1976, p. 109. For the saint as patron of Egyptian churches, see Baumeister 1972, pp. 126–27, esp. n. 180; Horn 1992, pp. 176–82.
5 Simaika 1937, p. 40. In his short description, Simaika does not mention the four biblical beings: "Eventail de procession, en cuivre, en forme de disque rond orné de croix et de motifs floraux stylisés"; see Basilios 1991, fig. p. 1473 (the only illustration published to date; the rhipidion is not mentioned in the text); Bénazeth et al. 1999, p. 154. All references to the Brooklyn rhipidia say that the one in Cairo is similar, but none provides its inventory number, a reproduction, or further information. A photograph from the 1940s with a few notes on the back is kept in the archives of the Brooklyn Museum. I thank Dominique Bénazeth for further information and bibliography.
6 Bénazeth et al. 1999, p. 154.
7 I thank Edward Bleiberg for information from the files in the archives of the Brooklyn Museum.

References: Bréhier 1945; Cooney 1947, p. 325; Miner 1947, p. 91, cat. no. 416; Renner 1963, p. 269, cat. no. 165; Snelders and Immerzeel 2004, p. 116.

45A, B. Two Tusk Fragments with the Ascension of Christ

....................

A. Tusk Fragment with the Ascension of Christ
Egypt, 720–970 (radiocarbon date, 95% probability)
Ivory

19.7 × 12.5 × 6.1 cm (7¾ × 4¹⁵⁄₁₆ × 2⅜ in.)
Provenance: J. Pierpont Morgan (1837–1913), London and New York (until 1917).
Condition: The fragment was carved from half a tusk. There are losses on the upper and lower edges and the face of Christ. Small holes on the sides suggest it was once attached to a larger object.
The Metropolitan Museum of Art, New York, Gift of J. Pierpont Morgan, 1917 (17.190.46)

B. Tusk Fragment with the Ascension of Christ
Egypt, 810–1010 (radiocarbon date, 95% probability)
Ivory
11.8 × 9.9 × 3.4 cm (4⅝ × 3⅞ × 1¹⁵⁄₁₆ in.)
Provenance: J. Pierpont Morgan (1837–1913), London and New York (until 1917).
Condition: This fragment of a larger scene has losses at the upper edge of Christ's mandorla.
The Metropolitan Museum of Art, New York, Gift of J. Pierpont Morgan, 1917 (17.190.48)

Conforming to the shape of the ivory tusks from which they were carved, these two fragmentary images of the Ascension are so similar that they must have been carved by the same workshop. On the larger fragment, A, Christ enthroned in a mandorla is carried to heaven by four horizontally posed angels; the Virgin Orans flanked by six of the apostles stands below. The smaller work, B, replicates Christ and one angel from the larger work. They were originally attributed to Egyptians working in Byzantine Palestine in the late sixth or early seventh century,[1] but recent Carbon-14 testing has confirmed that the works are later products of the era of Muslim rule.[2] The potential overlapping ninth- to tenth-century dates for the ivories conform to a suggested attribution of the larger ivory and allow for a common workshop production.[3] The ivories' densely patterned compositions and stylized figures with large eyes and drilled pupils are similar to wood carvings of the same period from the Church of Abu Serga (dedicated to Saint Sergios), then a very important Coptic church, functioning as the See of Misr (Old Cairo).[4] Additional Carbon-14 testing may reveal other ivories of this period, which would be more evidence of the continuing prosperity of some Christian communities in the eastern Mediterranean in the Early Islamic era. HCE

1 Breck 1919; Miner 1947, p. 50, no. 157, pl. XXI.
2 Charles T. Little, Peter Barnet, Pete Dandridge, Helen C. Evans, Melanie Holcomb, Barbara Boehm, *The Medieval Ivory Project at The Metropolitan Museum of Art*, Carbon-14 analysis undertaken under the direction of Pete Dandridge by Beta Analytic Inc., in 2010–11; the

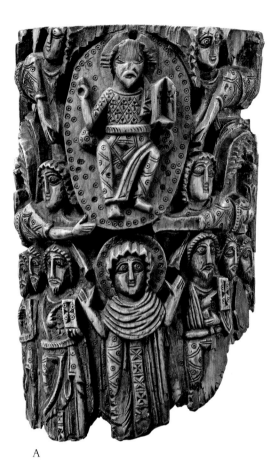

A

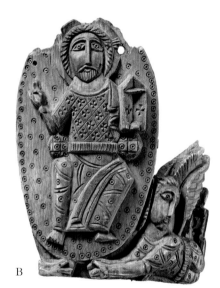

B

2 sigma calibration for 45A was reported as 720–40 and 770–970 and for 45B, 810–1010, with 95% probability for both analyses, and the ninth–tenth century being the overlapping time frame. Previously unpublished results on file in The Metropolitan Museum of Art's departments of Objects Conservation and Medieval Art.
3 Beckwith 1963, pp. 30, 41, n. 125, p. 56, cat. no. 134, fig. 134; Volbach 1952, p. 106, no. 255, pl. 68, fig. 255, places it with works of the same period.
4 Volbach and Lafontaine-Dosogne 1968, p. 359, no. 401b; T. Thomas 1997, p. 368; Gabra and Eaton-Krauss 2006, pp. 231–39, 277, figs. 146–149.

References: (A, B) Breck 1919; (A) Volbach 1952, p. 144, no. 55; Beckwith 1963, p. 30, no. 134; (B) Volbach 1952, p. 145, no. 255a; Beckwith 1963, p. 56, fig. 134.

The White Monastery Federation and the Angelic Life

Elizabeth S. Bolman

In Late Antiquity, monasticism was called the *bios angelikos*—"the angelic life"—because the faithful regarded its holiest practitioners as angels on earth. Despite this spiritual designation, monks belonged to a prominent social institution of great authority and wealth. Between the seventh and ninth centuries, Egyptian monasticism generated vast quantities of objects and texts that help chronicle the historic shift from Byzantine to Islamic rule in a Christian milieu. At the beginning of this period, monasteries functioned within a Mediterranean-wide cultural network, while retaining local elements, such as the use of Coptic, the final phase of the ancient Egyptian language. By the beginning of the tenth century, there are surprisingly few indications of a redirection toward the cultural sphere of the Dar al-Islam (lands under Islamic rule). Egyptian Christians, or Copts, had lost their close ties to the larger Byzantine Empire, and for several centuries the monasteries maintained an insular tradition. The White Monastery Federation in Upper Egypt, located near the modern city of Sohag, provides exceptionally well-preserved evidence across a broad spectrum of materials that illuminate the character of this period. The federation, best known for its charismatic leader Shenoute (346/47–465) (cat. no. 46 and fig. 30), consisted of two monasteries for men (now called the White and Red monasteries), one for women, and a number of hermits.[1] It continued to flourish until at least the early fourteenth century.[2] Shenoute and other leaders of the community implemented hundreds of rules that regulated virtually all aspects of life.[3] The extensive archaeological and textual remains attest to substantial industrial and economic activity, as well as to abundant literary and artistic creativity. Excavations in 1987 at the White Monastery uncovered two ceramic vessels containing four hundred Byzantine gold coins that date between 602 and 668,[4] suggesting real wealth not only in Shenoute's lifetime, but also in the seventh or early eighth century when the coins were buried.

The federation's two monumental churches (figs. 25, 26) are of the highest quality, yet not all practitioners of the angelic life

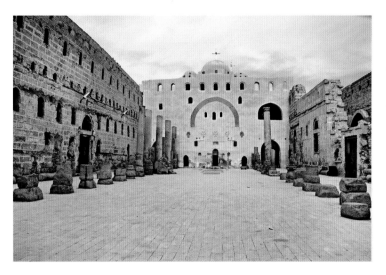

Fig. 25. View of the nave looking east, ca. 440 and later. White Monastery Church, near Sohag, Egypt

approved of beauty in monastic architecture and its decoration. One of the earliest founders of communal monasticism, Pachomios (ca. 290–346), considered the appreciation of church architecture "a diabolical activity."[5] Shenoute, on the other hand, self-consciously wielded this aesthetic power, commissioning a massive limestone church with lavish embellishment. He envisioned this monument as the body of Christ, and as the collective body of the community. Accordingly, it had to be beautiful.[6] Both of the federation's large churches are triconch

basilicas with a considerable amount of purpose-made sculpture.[7] Their principal architectural antecedents are late Roman buildings found throughout the Mediterranean. The Red Monastery Church sanctuary survives in exceptionally good condition, adorned with figural representations and a fantastic array of decorative motifs in tempera and encaustic (fig. 27).[8] The aesthetic system deployed inside the triconch demonstrates a Late Antique taste popular throughout the empire. Referred to by scholars as "the jeweled style," its manifestations

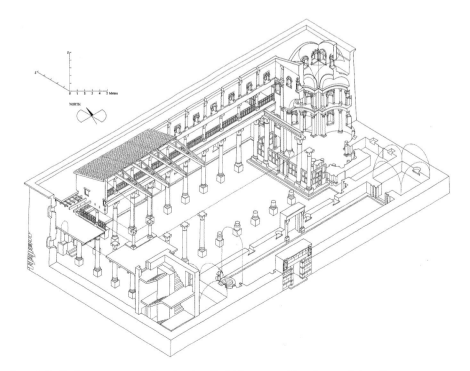

Fig. 26. Preliminary reconstruction drawing. Red Monastery Church, near Sohag, Egypt

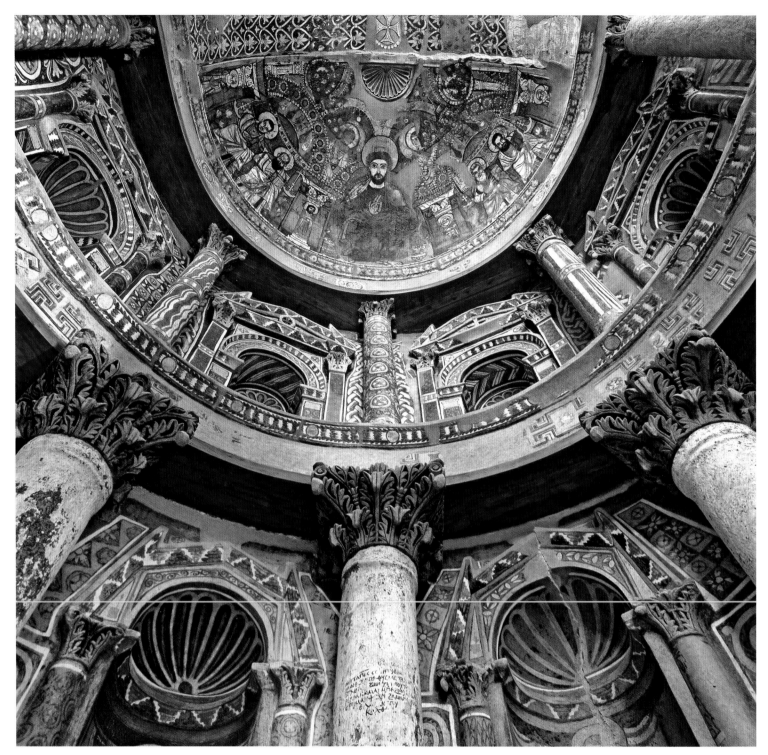

Fig. 27. View looking into the south lobe of the sanctuary, ca. 6th–7th century. Red Monastery Church, near Sohag, Egypt. © ARCE

in the visual arts express delight in the variety and contrast of colors, patterns, materials, qualities of light, and architectural spaces.[9] We see examples of this style in several objects included in this volume (cat. nos. 39, 50, 108). Practitioners of the jeweled style played with media, for example representing columns on a series of fabric hangings (cat. no. 50) that may have been suspended in an actual colonnade. One of the illusory columns is even decorated with a braid, a completely nonarchitectural motif. At the Red

Monastery, similar brightly colored braid patterns, rendered in paint on actual masonry, destabilize some of the wall surfaces. Three-dimensional columns in the church are painted with designs commonly found on textiles and in mosaics, further unsettling the viewer's expectations (fig. 32).

Like many monastics, Shenoute and his followers used art and architecture to create and maintain identity. They employed visual tools such as paintings, censers, and book covers in the celebration of the liturgy and

other facets of monastic life.[10] The seventh-century figural paintings in the Red Monastery feature images of leaders from the federation and of Alexandrian patriarchs (fig. 23), giving the program a local inflection and charting the spiritual pedigree of the community. A monumental representation in the north apse of the newly incarnate Christ child suckling from Mary's breast (fig. 28) faces one in the south apse of the adult, enthroned Christ (fig. 27). Flanking Mary and the child are four prophets who

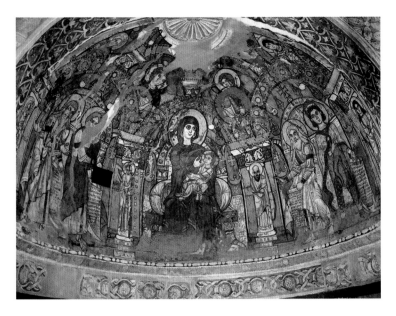

Fig. 28. Virgin Galaktotrophousa (The Virgin nursing the Christ Child). Secco painting, ca. 7th century. North lobe of the sanctuary, Red Monastery Church, near Sohag, Egypt. © ARCE

The White Monastery had a thriving scriptorium and a large library (cat. nos. 4, 49). Most of the surviving manuscripts date from the ninth to the eleventh century, and are made of parchment. They include biblical, homiletic, hagiographic, apocryphal, and liturgical texts, as well as lives of monks and Shenoute's extensive writings. In the eleventh century, the White Monastery library had at least one thousand manuscripts, easily double the number known to have been in any collection in the West at that time.[16] The monks continued to copy and use texts written centuries earlier, as well as the practice of making books from costly parchment. Interestingly, the Fatimid rulers of Egypt (969–1171) are reputed to have had a vast library containing more than one hundred thousand books.[17] Most of these volumes were probably made of paper, a far less expensive material than animal skin.[18] The absence of texts written on paper from the White Monastery Federation thus indicates the monks' relative detachment from the innovations that were taking place in the center of government at Cairo.[19] The practitioners of the angelic life in this isolated community, looking backward to their collective past, persisted in their traditions for several centuries after the Arab conquest.

hold scrolls with passages from the Old Testament foretelling the coming of Christ and the virgin birth (fig. 29). Prophets figured prominently in the monastic life, as "biblical heroes" and models for emulation.[11]

Angels surrounding the nursing pair swing vessels of incense similar to the censers used by the monastery's priests during the liturgy. These containers carried rich metaphorical associations with the womb of Mary, which enclosed the burning coal of Christ.[12] A censer in the collection of the Coptic Museum (cat. no. 48) is a late example of a common type found in and outside of Egypt.[13] Dating

to roughly the ninth century—and thus made more than one hundred and fifty years after the Arab conquest—its dedication is in Coptic, by a man named Abu al-Fakhr (Father of Glory).[14] So although this censer continues a Late Antique tradition in its iconography and style, the name of the donor follows Arab nomenclature, indicating the growing Arabization of the Copts, which would eventually be manifested in the visual arts: in the thirteenth century, the monks of the Monastery of Saint Antony would commission a painted church vault incorporating the decorative language of the Dar al-Islam.[15]

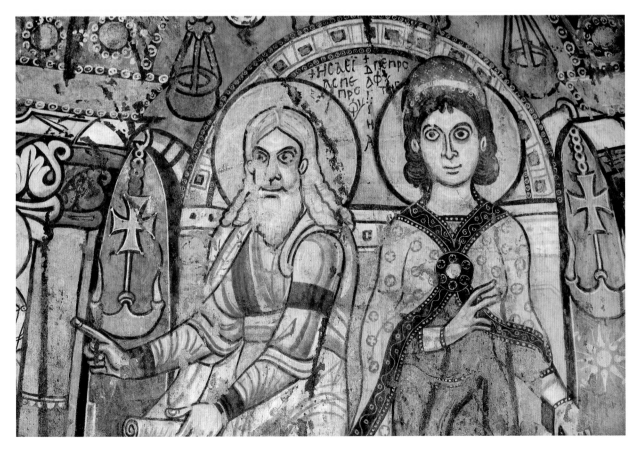

Fig. 29. The prophets Isaiah and Daniel. Secco painting, ca. 7th century. North lobe of the sanctuary, Red Monastery Church, near Sohag, Egypt. © ARCE

46. Stele of Apa Shenoute

....................

Egypt, 5th–6th century
Limestone
53 × 31 cm (20⅞ × 12¼ in.)
Inscribed: At bottom, in Coptic, ΑΠΑ ϢΕΝΟΥΤΕ
(Apa [Father] Shenoute)
Provenance: Acquired by Josef Strzygowski on the
antiquities market in Cairo, 1900–1901, for the
Skulpturensammlung und Museum für Byzantinische
Kunst (formerly the Kaiser-Friedrich-Museum), Berlin.
Condition: The lower part of the stele was broken into
three pieces, which were cemented together before 1902,
when the stele entered the Museum für Byzantinische
Kunst. The surface of the relief is partly scratched and
weathered, and the lower and right edges are partly bat-
tered. The rod the figure holds in his right hand is dam-
aged in the middle. The work was restored and
consolidated in 1952.
Stiftung Preußischer Kulturbesitz, Staatliche Museen zu
Berlin—Skulpturensammlung und Museum für
Byzantinische Kunst, Berlin (4475)

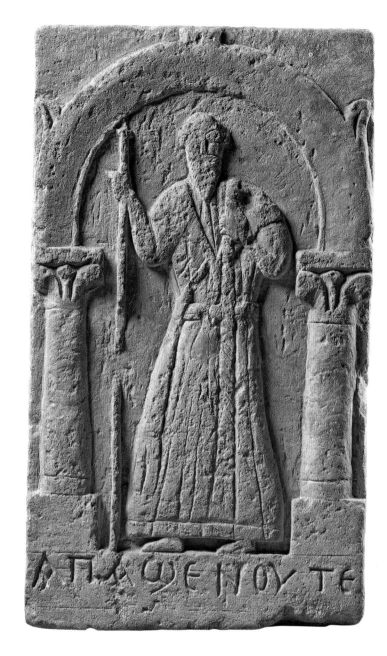

A male figure is depicted standing under
an arcade facing front, with his bare feet
turned to the left. The inscribed title, "Apa,"
and his habit identify him as a monk.[1] The
name suggests that the figure depicted is the
famous Egyptian abbot Shenoute (346–465;
fig. 30) of the Dayr Anba Shenouda (popu-
larly called the White Monastery) near
Sohag. However, the standardized rendering
of the figure and the lack of provenance
mean that the figure could represent any
monk named after his famous patron.

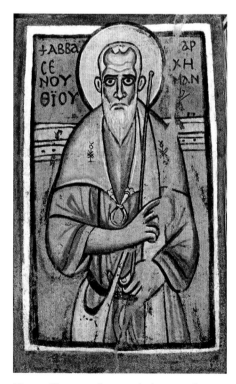

Fig. 30. Shenoute. Secco painting, ca. 7th
century. North lobe of the sanctuary, Red
Monastery Church, near Sohag, Egypt.
© ARCE

Shenoute is dressed in a long sack tunic
(*kolobion*) that is cinched at the waist by a
knotted girdle. Beneath the tunic—marked
by a simply scratched horizontal line at the
bottom hem—an undergarment can be
seen. His large hood (*koukoullion*) does not
cover his head but lies over his shoulders like
a mantle and is fastened at the chest. At the
right side of the body can be seen a long
pouch or apron ending in fringe; its straps
are put around the monk's neck. This is
probably the goatskin called *melote* in the
written sources.[2] With his raised right hand
the monk holds a rod, and with his left, a
narrow band with diagonal incisions that
loops over his left shoulder. It is reminiscent
of a twisted length of fabric—a common
monk's attribute that could serve as a mantle
or covering when unfolded. On a wall
painting in Faras (Nubia) dated before 925
and showing the eremite Amoun of Tuna

al-Gebel it is depicted more clearly.[3]
Shenoute, Amoun, and other monks repre-
sented on monuments from the sixth to
eighth centuries are similarly dressed
(fig. 30 and cat. no. 41).[4] Their clothing
demonstrates that the Egyptian monastic
habit remained unchanged for at least four
centuries. CF

1 The most detailed description of the monastic habit
 in Egypt comes from Johannes Cassianus
 (ca. 360–430/35); see Cassianus 1965, chap. 1.
2 For instance, ibid., chap. 1, pp. 7–8.
3 See, for instance, Seipel 2002, pp. 76–77, cat. no. 10.
4 See, for instance, the wall paintings from the seventh
 and eighth centuries representing a "Shenoutian
 monastic portrait gallery" of the semidome (northern
 lobe) in the church of Dayr Anba Bishoi (the so-
 called Red Monastery; fig. 30): Bolman 2007b,
 pp. 273–79.

References: Wulff 1909, p. 34, no. 73; Effenberger and
Severin 1992, p. 136, no. 69; von Falck 1996, p. 108, cat.
no. 93; Rocca 2000, pp. 130–31, cat. no. 3 (Nicole
Gourdier); Effenberger 2008, p. 74.

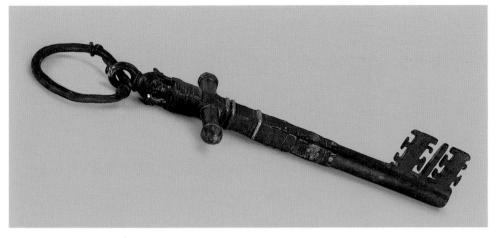

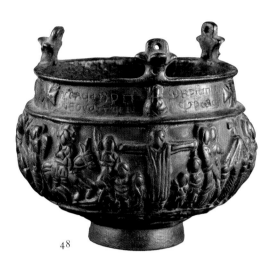

47

48

47. Key

....................

Egypt, probably made at the White Monastery for the
Red Monastery, 6th–7th century (?)
Iron, copper alloy
39.5 cm (15⅝ in.)
Provenance: Acquired from the Red Monastery, Sohag,
Upper Egypt; entered the Egyptian Museum in 1912
(JE 43890); transferred to the Coptic Museum in 1939.
Condition: The key is in very good condition.
Coptic Museum, Cairo (5775)

In Late Antique monasticism keys repre-
sented authority and power. Signaling val-
ued objects such as books, money, liturgical
vessels, and supplies of wine and food, they
also represented access to the interiors of priv-
ileged spaces such as churches. Keys were
therefore badges of rank and status. At the
Monastery of Apa Apollo, Bawit, not far from
the Red Monastery, the monastic steward
Mena (fig. 31), was painted holding two keys

Fig. 31. Mena the monk holding keys. Secco
painting, ca. 6th century. Chapel LVI, Monastery
of Apa Apollo, Bawit, Egypt

prominently in front of him.¹ The present key
takes the form of a cross, a symbol that per-
meated the monastic life, a visual reminder of
Christ's suffering and his victory over death. It
belongs to a set of six keys associated with the
White and Red monasteries.² Dominique
Bénazeth and Anne Boud'hors have observed
that surviving keys of the early period tend
to be much simpler than this one, and sug-
gest a later date for the group.³ ESB

1 See Bénazeth, p. 81.
2 Bénazeth and Boud'hors 2003, pp. 19–22.
3 Ibid., pp. 26, 33, 35–36.

References: Du Bourguet 1964a, p. 137, cat. no. 134; Alaoui
2000, p. 113, cat. no. 78 (Dominique Bénazeth); Bénazeth
and Boud'hors 2003; Gabra and Eaton-Krauss 2006,
pp. 98–99, no. 66.

48. Censer with Scenes from the Life of Christ

....................

Egypt, 7th–9th century
Copper alloy
13 × 14.6 cm (5⅛ × 5¾ in.)
Inscribed: In Coptic, on the neck, with a votive dedication,
ⲁⲣⲓⲫⲙⲉⲩ ⳨ ⲡ̅ϭⲟ̅ⲥ ⲙⲡⲉⲣ ∷ ⲃⲱⲕ ⲉⲡⲟ ⳨ ⲅⲉⲗϭⲁⲑⲣⲡ ∷ ⳙⲏⲣⲓ ⲙⲡⲓⲇⲓ ⳨ ⲁⲕⲟⲛ
ⲓⲱⲁⲛⲛ ∷ ⲏⲥ ⲡⳙⲏⲣⲓ ⲙⲡ ⳨ [ⲓ] ⲉⲩϭⲟⲩⲙⲉⲛⲟⲥ ∷ [ⲉ] – – [ⲥ] ⲉ ⳨ ⲛⲉⲟⲩⲁⲧϭⲓ
[ⲙ] ∷ – ⳨ⲣ[ⲱ]ⳙ ⳨ ⲛⲧⳙⲟⲩⲣⲏ (Remember, O Lord, thy servant
Abu al-Fakhr, the son of John the deacon. The son of the
Hegoumenos [Jeremiah?] those who had provided for
the censer)¹
Provenance: Said to be from the White Monastery, Sohag,
Egypt; purchased by the Egyptian Museum in 1907
(JE38890); transferred to the Coptic Museum in 1939.
Condition: The censer is stable; the chains are lost.
Coptic Museum, Cairo (5144)

Monumental churches such as the one
at the White Monastery provided
magnificent settings for the Christian liturgy,
a series of multisensory rituals involving the
use of many objects, including incense hold-
ers. At the time this censer was made, priests

burned incense during church services, to
carry prayers to heaven.² It has been proposed
that the inscription is considerably later than
the censer,³ because the styling of a name
in the dedication, Abu al-Fakhr (Father of
Glory), follows Arab conventions; although
the Copts began the process of linguistic
Arabization in the eighth century,⁴ they did
not engage with the artistic language of the
Dar al-Islam until several centuries later.
Possibly from the White Monastery, the
censer depicts nine episodes in the life of
Christ, in abbreviated, low-relief scenes: the
Annunciation, Nativity, Adoration of the
Magi, Baptism, Entry into Jerusalem,
Crucifixion, Women at the Tomb, Doubting
Thomas, and Ascension. These events were
commemorated in the annual cycle of the
liturgy, in which censers were used, giving
this utilitarian object several dimensions of
significance. ESB

1 Misihah 1959.
2 Harvey 2006b, pp. 14, 57–58.
3 Maspero 1908.
4 Swanson 2010, pp. 59–61.

References: Maspero 1908; Misihah 1959; Alaoui 2000,
p. 182, cat. no. 192 (Samiha 'Abd el-Shaheed); Bénazeth
2001, pp. 316–18, no. 271.

49. Manuscript Folios, Isaiah 12:2–13:12

....................

Egypt, White Monastery (Monastery of Apa Shenoute),
8th–9th century
Red and black ink on parchment; 7 folios
42 × 34 cm (16�9⁄19 × 13⅜ in.)
Provenance: Among a large cache of manuscripts and
manuscript leaves seen by the Egyptologist Gaston
Maspero (1846–1916) at the White Monastery, Sohag,
Upper Egypt, in 1882–83. Maspero negotiated the sale of
these manuscripts; the manuscripts arrived in museums
and on the antiquities market in three lots in 1886–87.
This manuscript was purchased in Cairo by the Institut

49, fols. 1v–2r

Français d'Archéologie Orientale in 1900; it was given to the Bibliothèque Nationale de France, Paris, in 1954. *Condition:* The folios have suffered losses around most edges, but the text and designs are reasonably clear and intact.
Bibliothèque Nationale de France, Paris (Copte 129²²)

These folios from the Book of Isaiah once formed part of a codex belonging to the White Monastery. They are written in an archaizing biblical style in the Sahidic dialect of Coptic, which was spoken by Shenoute and his followers. The title for chapter 13 on folio 2r is in red, with an enlarged and decorated first letter, *fai*, one of the few non-Greek letters in the Coptic alphabet.[1] The fanciful decorative creatures drawn on the page belong to a relatively stable group of marginalia that persisted for centuries in Egyptian Christian manuscripts. While distinct from Late Antique decoration, they are otherwise very difficult to date.[2] The folios, produced in the eighth or ninth century, demonstrate the continued flourishing of the White Monastery several centuries after Shenoute's death. ESB

1 Alaoui 2000, p. 71, cat. no. 47 (Anne Boud'hors).
2 Jules Leroy (1974, p. 66) notes that decorated letters first appear in the period of the Hamouli manuscripts,

about the ninth to tenth century. While he discusses categories of marginalia (p. 53), aniconic motifs, and embellished letters, he makes no attempt to date them.

References: Lacau 1901, pp. 114–15 (for folio 2r); Alaoui 2000, p. 71, cat. no. 47 (Anne Boud'hors); Boud'hors 2004, p. 36, cat. no. 7.

50. Hanging with Columns and Flowers

.....................

Egypt, 5th–6th century
Tapestry weave in polychrome wool and undyed linen on plain-weave ground of undyed linen; details in flying shuttle with undyed linen
217 × 144.5 cm (85⁷⁄₁₆ × 56⁷⁄₈ in.)
Provenance: Sheikh Shata near Damietta, Egypt; Arthur S. Vernay, New York (until 1922).
Condition: Significant sections of the linen ground have deteriorated; the design elements woven in tapestry weave are almost intact. The color preservation is good. Selvages are preserved along the top and bottom edges of the hanging. There are holes along the top edge, possibly from its original installation. There is ancient repair.
The Metropolitan Museum of Art, New York, Gift of Arthur S. Vernay, Inc., 1922 (22.124.3, .4)

Textiles created luxurious soft architecture that enhanced the interior spaces of the ancient and medieval worlds. Evidence

of this aesthetic practice can be seen in depictions of Saint Menas (cat. no. 24M) and an unidentified orant (cat. no. 24N), as well as in this curtain, which belonged to a set of at least four.[1] Engaging in the artistic game of mixing media, the tapestry-weave columns exhibit the "jeweled style," which also appears in paint at the Red Monastery (fig. 32). In their probable original location, between columns, the curtains would have expanded the colonnade—but in fabric rather than stone. The absence of explicitly Christian subject matter most likely indicates that the curtain hung in a secular space, perhaps in an aristocratic house or a public building. An identical textile is in the collection of the Victoria and Albert Museum, London.[2] ESB

1 Stauffer 1995, p. 7.
2 For the Victoria and Albert piece (T.232-1917), see Kendrick 1921, pp. 24–25, no. 341, frontispiece; Kendrick 1918, pp. 10, 15, pl. I; Gayet 1900, pp. 228–29, cat. nos. 471–474. The Vernay gift to The Metropolitan Museum of Art included nineteen textiles, a number of them large hangings. One of the textiles (22.124.6) is clearly related to the present example; it has a similar braided column, a roundel containing a head, and scattered floral motifs.

References: Stauffer 1995, pp. 20, 43, cat. no. 1; McKenzie 2007, p. 311, fig. 515.

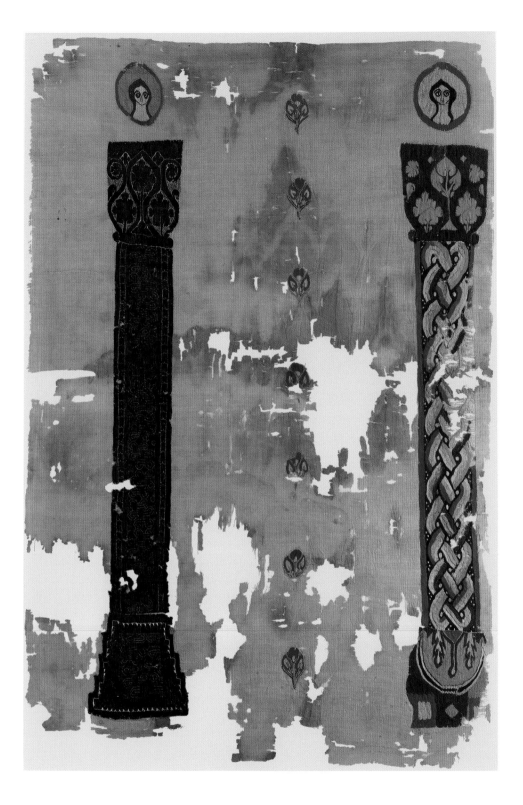

The Coptic Monastery of Bawit

Dominique Bénazeth

The monastery of Bawit, in Upper Egypt, was founded in the late fourth century—according to literary tradition, by Saint Apollo, "the Equal of the Angels"—and expanded over the following centuries. The institution was associated with the monastery of Saint Jeremiah in Saqqara: the names of both saints appear on the walls in the two monasteries, and the styles of the buildings' sculpted architectural details are very similar, suggesting they came from the same workshop.[1]

Today, the ruins cover an area of 99 acres (40 ha), not including the structures scattered atop the desert cliff and several necropolises. The churches were at the center (fig. 33), with the monastery buildings clustered around them like a large village. Though open toward the desert and walled off from the rest of the world, the monastery lay close to its cropland, which was either cultivated by the monks or leased to farmers. The large quantities of ceramics found at the site provide clues to the daily life of the monks and their exchanges with the world outside. Bookkeeping accounts written on papyrus and potsherds give an idea of the institution's economic life, while paintings portray the bearded, white-robed monks, young and old, their names and functions identified in inscriptions. Under the abbot's rule, they bear the titles of bursar, scribe, cantor, deacon. Some ply trades, others work the fields, still others collect taxes—which increased during the Arab period.

Although evidence exists that a section of the complex was reserved for nuns, the convent's existence has yet to be proved conclusively. The monks lived in whitewashed mud-brick cells, but the chapels and reception rooms were decorated with edifying paintings. The largest hall unearthed so far—some 99 feet (30 m) long—displays many graffiti written by visitors, including laypersons. The kitchens that have been excavated were apparently intended to feed small numbers of people; no refectory or large kitchen has yet been found. The location of the library also remains unknown.

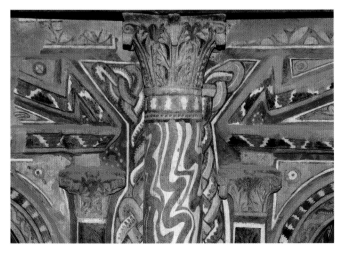

Fig. 32. Detail of architectural polychromy. Secco and encaustic painting, ca. 6th–7th century. North lobe of the sanctuary, Red Monastery Church, near Sohag, Egypt. © ARCE

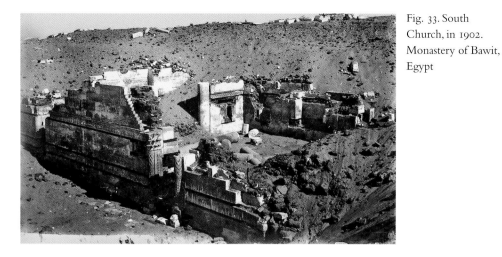

Fig. 33. South Church, in 1902. Monastery of Bawit, Egypt

remains of liturgical furnishings have been identified, that is, the supports for the legs of the altar, pulpit, and elements of other furniture. Two remarkable icons were found,[5] in addition to the monks' portraits (cat. no. 52).

A third, even larger, church was discovered, which connected with the so-called South Church. The latter has become the best known of the three since its sculptures were removed in 1902, published in 1911,[6] and exhibited, after 1902, at the Egyptian Museum and later the Coptic Museum, both in Cairo, and at the Musée du Louvre, Paris.

A building complex was found on the north side of the site in 2003–9. Grouped around a palm-shaded courtyard, the eighteen rooms seem to have been offices dedicated to the monastery's day-to-day operations. However, the largest (20 × 16 ft. [8.9 × 5.1 m]) was magnificently adorned with niches, murals, and polychrome wood sculptures.[7] The paintings depict the Nativity (fig. 34), with a double representation of the Three Kings bearing their gifts and adoring the Christ child, who sits on the lap of the Virgin in Majesty. On the facing wall are depictions of the prophets and of seated figures, probably the monastery's founders, paintings that further enhance the extraordinarily rich inventory of Bawit's pictorial art from the sixth to eighth century.

Ever since the site was rediscovered, in 1900, archaeological excavations have yielded a great deal of information,[2] but not nearly enough to answer our questions about the monastery's operations and its development before the eleventh century, when it seems to have been abandoned. The reasons for its decline are unclear. There were undoubtedly fewer vocations in the wake of the country's Islamization; the sanding up of the site probably also contributed to its demise—the desert completely blanketed the monastery complex.

In 1900 Jean Clédat discovered and identified the remains of the great monastery in an enormous archaeological mound rising in places to almost 30 feet (9 m). A thorough geophysical survey of the area in the course of the excavations undertaken beginning in 2002 allowed archaeologists to map out the site, including a floor plan of ruins still hidden beneath the sand, as well as those previously excavated.[3] The locations of two known churches were once more identified. That of the Archangel Michael, known as the North Church, was excavated anew.[4] The small basilica includes a *khurus*, that is, a space between the sanctuary and the nave, which points to a date of construction after the late seventh century. Built of brick, with limestone columns and paving stones, the entire church was decorated with murals and wooden screens. The windows were covered with disks of colored glass set in plaster. The

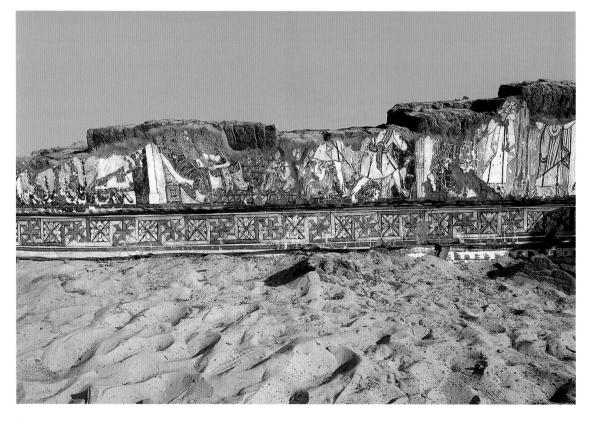

Fig. 34. The Nativity Cycle, ca. 6th–8th century. Monastery of Bawit, Egypt

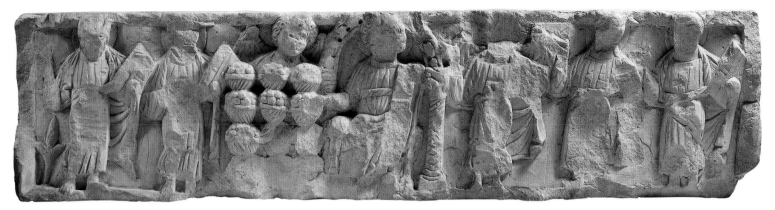

C

51A–C. Three Architectural Elements Probably from Bawit

......................

A. Capital
Egypt, 6th century (?)
Limestone
49.2 × 57.2 × 57.8 cm (19⅜ × 22½ × 22¾ in.)
Provenance: Edward S. Harkness, Cleveland, Ohio (until 1914).
Condition: The capital is in good condition.
The Metropolitan Museum of Art, New York, Gift of Edward S. Harkness, 1914 (14.7.5)

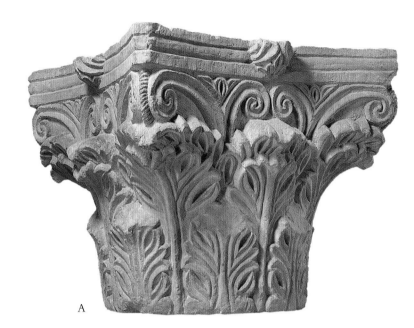

A

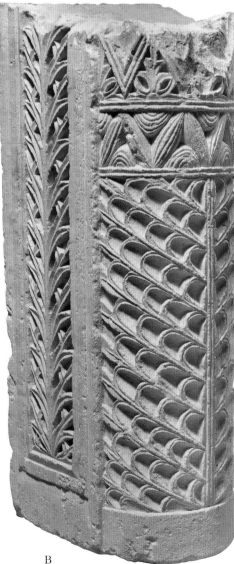

B

B. Fragment of a Door Jamb with Geometric and Vegetal Motifs
Egypt, 6th century (?)
Limestone; traces of paint on plaster
87 × 27 × 40 cm (34¼ × 10⅝ × 15¾ in.)
Provenance: Egyptian government (1910).
Condition: The top part has been broken off and is missing.
The Metropolitan Museum of Art, New York, Rogers Fund, 1910 (10.175.77)

C. Relief with the Miracle of the Loaves and the Fishes
Egypt, 6th–7th century
Limestone
24.5 × 100 × 11.5 cm (9⅝ × 39⅜ × 4½ in.)
Provenance: [Michael Casira, Cairo (1910)].
Condition: There is chipping in places; the figures and baskets have been mutilated.
The Metropolitan Museum of Art, New York, Rogers Fund, 1910 (10.176.21)

All three sculptures are representative of the highly developed art of the monastery at Bawit and of its environs during the period of Byzantine dominance in Egypt.

Of the ten column capitals unearthed in 1902–3, during the official excavations, nine came from churches. One group derives from the classical Corinthian type,[1] another is made up of Byzantine basket capitals,[2] while the third comprises atypical examples.[3] This diversity of styles supports the possibility of a provenance from Bawit of the Metropolitan Museum's capital, A, which belongs to the first group. Its double crown of acanthus leaves is carved in low relief, in a dry, decorative manner like that on fifth- and sixth-century Coptic columns. Unusually, the contour of the upper crown is doubled by a festoon of foliate loops. The caulicoles above it exhibit concave profiles, and a small motif is repeated between the spirals. This treatment is very close to an example at the Coptic Museum, Cairo (JE 35818), as is the decorated abacus with sculpted buds. The carved marks on top of the capital were probably made when it was set in place.[4] Some forty of these marks were observed during the first excavations at Bawit. Others were found on wooden elements from there that are preserved today in the Musée du Louvre.

The fragment of a shaft, B, was part of a door jamb. Similar pieces stood at the

entrances to the naves of two churches in Bawit and the church of the Monastery of Saint Jeremiah in Saqqara.[5] The half-cylinder faced front, the undecorated side was against the wall, and the flat carved side faced the passage. Based on this articulation, it is easy to imaginatively reconstitute symmetrical jambs topped by two capitals bearing a lintel. Comparable monolithic jambs incorporate bases, which this shaft does not—it would have sat either directly on a threshold or on a separate base. The decorated areas are bordered by framing bands and reflect their architectural orientation. The shaft, like the sculptures found in the churches at Bawit, was painted. The geometric and plant motifs were carved very precisely in sunk relief. Adorning the side is a vertical palm frond with very regular leaves, while the engaged column is divided into three parts, each with a different carved decoration. Here again, comparisons with the jambs at Bawit and Saqqara show that there were once two registers of the same height, separated by a band.

This decorative arrangement appears also on the column represented on the relief (C). It belongs to an archway, beneath which the enthroned Christ stretches his arm over twelve baskets filled with round objects. The pile almost completely conceals an angel, whose companion, on his right, is shown full length. At either end of the panel are two figures clad in the antique style, each holding a book; they are probably the Evangelists. All four Gospels relate that, after the miracle of the multiplication of the bread loaves and fishes, twelve baskets were filled with the leftovers (Matthew 14:20, Mark 6:43, Luke 9:17, and John 6:13). The subject appears in Alexandria's Karmouz catacombs,[6] the site of some of the oldest Christian paintings in Egypt, where the twelve baskets are arranged on either side of Christ. At Bawit, a column in the North Church alludes to the episode in its depiction of twelve baskets filled to overflowing below jugs of wine.[7] Although this beverage is not mentioned in the Gospel accounts of the miracle, its appearance within the church and its association with bread clearly relate it to the Eucharist.

The relief's original placement, however, remains unknown. Belonging to a rare type in the repertory of sculptures in Bawit, which are seldom historiated, it resembles two reliefs that were purchased in the vicinity and that are generally attributed to Bawit.[8] The latter display the same elongated horizontal format framed by a band and

relate lively biblical episodes from the books of David and Daniel. On the relief of the multiplication of the loaves, the miracle and its result are condensed into a single masterful composition. The action—the performance of the miracle—is counterbalanced by the figures' static poses, while the symmetry focuses the gaze on Christ's majesty. The mutilation of the faces, parts of the bodies, and the baskets is all the more deplorable, given the quality of the work. This phenomenon, often encountered at Bawit, is probably to be ascribed to Muslim iconoclasm. In the nineteenth century, however, the descendants of these iconoclasts would incorporate sculpted fragments from the monastery into their mosques without erasing the cross.[9]

DB

1 Coptic Museum, Cairo (7180 [JE 35818]); Musée du Louvre, Paris (E 16962, E 16909, E 16910).
2 Musée du Louvre, Paris (E 16963, E 16964, E 16965).
3 Coptic Museum, Cairo (7179 [JE 35819]); Musée du Louvre, Paris (E 27656); an example in situ (on the pavement of the North Church).
4 I would like to thank Jean-François de Lapérouse, Conservator, Department of Objects Conservation, The Metropolitan Museum of Art, for calling my attention to these marks.
5 The jambs of the south door of the South Church are preserved at the Coptic Museum, Cairo (7105 [JE 35821]). Those of the north door are in the Musée du Louvre, Paris (E 17055). Another set has been recently found in the north wall of Church D in Bawit; see Midant-Reynes and Denoix 2010, p. 372, fig. 43. An example photographed in situ at the Monastery of Saint Jeremiah is reproduced in Friedman 1989, p. 62, fig. 10.
6 McKenzie 2007, p. 239, fig. 404 a, b; Rutschowscaya 1998, pp. 46–47, fig. 40. Known only from a watercolor rendering, the work is generally dated to the third century, but the figure of Christ, which is in the Byzantine style, may have been repainted at a later date.
7 The painting is damaged and located in an inaccessible area. The baskets have the same shape as those on the relief and are painted brown to imitate basketwork.
8 Purchased by the Service des Antiquités in Dashlout (?) in 1905. Coptic Museum, Cairo (7125 [JE 37797], 7139 [JE 37803]). Torp 1965. Bénazeth 1997, p. 45, n. 19, p. 56, n. 76. According to Clédat 1999 (p. 362, n. 149), they came not from Bawit but from the nearby, unexplored monastery in Dalga.
9 Bénazeth 2000, p. 61.

References: (A) Unpublished; (B) Friedman 1989, p. 230, cat. no. 143; (C) unpublished.

52A, B. Two Fragments of Painted Panels from Bawit
....................

A. Fragment of a Panel with Brother George the Scribe

Egypt, probably Church of the Archangel Michael at Bawit, 8th century
Tempera on *Ficus sp.*
24.5 × 40.3 × 1 cm (9⅝ × 15⅞ × ⅜ in.)
Inscribed: In Coptic, ⳋⲁⳉ [ⲅ]ⲉⲱⲣⲅⲉ (The scribe [G]eorge)
Provenance: Sotheby Parke-Bernet (New York) auction no. 4497Y, December 11, 1980, lot 312; purchased from Charles Dikran Kekekian, 1983.
Condition: The panel is sawed away to half its height on the right and broken off above, as well as broken off on the other sides.
The Newark Museum, Newark, Purchase 1983
The Members' Fund (83.42)

B. Fragment of a Painted Panel with a Flower Motif

Egypt, Bawit, 8th century
Tempera[1] on *Ficus sp.*
15 × 30 × 1.2 cm (5⅞ × 11¹³⁄₁₆ × ½ in.)
Provenance: Excavated from the Monastery of Saint Apollo, Bawit, Egypt. The panel entered the Musée du Louvre through *partage* in 1902.
Condition: One half is missing, and one side has been sawed off almost completely. There is poor adhesion of the paint layer, especially the green.
Musée du Louvre, Département des Antiquités Égyptiennes, Paris (AF 4766)

On an unprepared wood panel, A, are painted two pictures. On the right is a bearded figure with a halo, dressed in white, against a red background. The top of a pen holder—the attribute of a scribe—and the five reed pens that emerge from it are painted in black in front of the figure's left shoulder. The inscription gives the figure's name, George, and the title *sah*, that is, "scribe" or "master."[2] All that remains of the painting on the left is the top of a leaf rendered in two colors.

The foliate motif is better preserved on panel B, the fragment from the Bawit excavation. Three other panels from the Church of the Archangel Michael[3] display four leaves, yellow/red and green/red; alternating with lotus buds, the leaves are arranged in a rosette. One of these panels presents a second

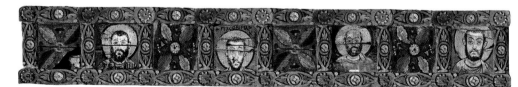

Fig. 35. Proposed reconstruction of the original arrangement of the panels, now in Newark, Auch, Bawit, and Paris

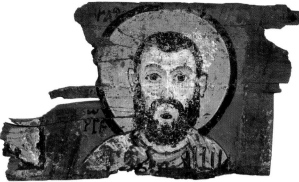

52A

52B

painting, a portrait (as is A). Four other portraits belong to this series.[4] They may have come from the same church, where a fragment with a similar bearded and haloed figure was found in 2005.

The panels' original placement is unknown. Susan Auth compared the sequence of motif and bust with the alternation of similar elements in a painted frieze in Chapel XXXVII of Bawit monastery.[5] If we align the known paintings, we can see that the areas without paint were once masked by frames. Among the moldings found in the church, there is a group whose shapes and dimensions suggest they could have been assembled to make surrounds for the panels.[6] Carved in circles and secants, they would have framed the busts like medallions, forming modules. A digital reconstruction (fig. 35) suggests what the sequence of these framed paintings would have looked like.

DB

1 The pigments were calcium carbonate (white), carbon black, jarosite or natrojarosite (yellow), hematite (red), and terre verte (green). The tests were performed on the panel in 2000 by Claude Coupry, Laboratoire de Dynamique, Interactions et Réactivité, Centre national de la recherche scientifique (CNRS), Thiais, France (Coupry 2003).
2 Clackson 2000a, p. 31. Two scribes named George are documented in the papyri of Bawit from the eighth century (Clackson 2008, p. 9); this was a very common name at the time.
3 In a recent excavation. Auth 2005, p. 32, pl. 15, and Coptic Museum, Cairo (inv. 12830).
4 IFAO excavations of 1902. Three fragments of portraits are preserved at the Musée des Jacobins, Auch, France. Two of the fragments, including the one called "Brother Mark," were combined to create a single portrait (985.229); the other, unnamed, is the only example painted against a green background (985.228). Auth 2005, pp. 21–23, pls. 4, 5.
5 Auth 2005, pp. 29–30, pl. 13.
6 Preserved at the Musée du Louvre, Paris; see Rutschowscaya 1986, pp. 138–39, nos. 470–476.

References: (A) Auth 2005; van Loon 2005; (B) Rutschowscaya 1992, p. 52, no. 23; Coupry 2003; Auth 2005, p. 32, pl. 14.

53. Part of a Double-Sided Icon with Saint Theodore and the Archangel Gabriel

....................

Bawit, Egypt, 6th century; then 7th or 8th century (?)
Tempera on sycamore
61.5 × 25.2 × 2.5 cm (24¼ × 9⅞ × 1 in.)
Inscribed: In Greek/Coptic texts: A. Underpainting: +Ο ΑΓΙ[ΟϹ] ΦΙΒ (+ Sai[nt] Phib); overpainting: [ΤΕΟΔ]ΟΡΟϹ ([Theod]ore); B. other side (both layers):

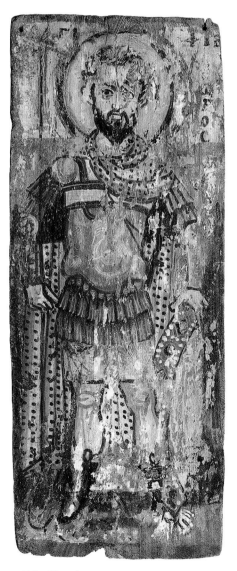

53, Saint Theodore

+Ο ΑΡΧΑΓΓΕΛΟϹ ΓΑΒΡΙΗΛ (+ the archangel Gabriel)
Provenance: Excavated from the Church of the Archangel Michael (North Church), Monastery of Saint Apollo, Bawit, Egypt. The Coptic collection of the Egyptian Museum, Cairo, was transferred to the Coptic Museum in 1939.
Condition: The panel constitutes half an icon; the other half is unknown. The paint layer, well preserved when it was discovered by archaeologists in 1902, has deteriorated, revealing another layer underneath.
Coptic Museum, Cairo (9083)

The photographs that Émile Chassinat and Jean Clédat took at Bawit in 1902 provide valuable documentation of the panel's earlier state. On one side, a standing Saint Theodore is represented as a soldier slaying a serpent; on the other is a bust of the archangel Gabriel. Flaking paint has revealed older works under both paintings. On the layer beneath the figure of Theodore is a depiction of Saint Phib, a companion of Saint Apollo;[1] on the back is a second image of Gabriel. One of the side edges has two holes;

53, The Archangel Gabriel

a peg was still projecting from the upper hole when the panel was found. From this evidence, Zuzana Skalova reconstructed the original appearance of the panel, which was roughly square and composed of two planks joined by pegs inserted horizontally into holes in the thickness of the planks.[2] The top and bottom edges of the panel's surface are unpainted, and there is a hole in each of the top corners for attaching the icon to some unknown support.

Concerning the paintings on the missing plank, there are indications that the figure beside Saint Theodore may have been a monk,[3] while one might expect the archangel Michael to be paired with Gabriel, though there are no traces to support this conjecture.

We do not know how or where the icon was situated in the North Church.[4] Because both sides were meant to be seen, the panel may have been placed in the screen separating the nave from the *khurus*, the room preceding the sanctuary in Coptic churches of the period (the term is Arabic). The subject of the later layer of paint is consistent with the iconography of the columns in the nave, which represent archangels facing east and soldier saints—George and probably Theodore as a horseman—facing west. The dating that Skalova proposes on the basis of the paintings' style is the sixth century for the earlier examples, and the seventh or eighth century for the overpaintings.[5] This is the only double-sided Coptic icon known from this period. DB

1 See Bénazeth, p. 81.
2 Skalova and Gabra 2003, pp. 168–69, fig. 5d.
3 Ibid., p. 169.
4 Nor do we have this information for the other painted wood panels found in the North Church (cat. no. 52).
5 Skalova and Gabra 2003, p. 168.

References: Bénazeth 1997, p. 45, n. 15, p. 62, fig. 1; Skalova et al. 1999, pp. 379–80, 385, figs. 1a–d, p. 386, figs. 2a–b; Skalova and Gabra 2003, pp. 168–69; Auth 2005, p. 34, no. 12; Gabra and Eaton-Krauss 2007, p. 106.

To Travel to the Holy

Brandie Ratliff

On the eve of the Arab conquest, holy sites and the paths leading to them spread across Byzantium's southern provinces. The most holy of all locations was Jerusalem, where the final events of Christ's life unfolded. Shrines there and across the region charted the narrative of his life, monumentalized the sacred places and people of the Old Testament, and marked the tombs of martyrs and saints. Monastic communities and holy men and women attracted pilgrims drawn to their own special auras.

Christian travel to holy places—pilgrimage—is well attested from the fourth century, and interest in biblical Palestine dates back to the second century.[1] Contemporary written sources and material culture provide evidence of the phenomenon. The surge of interest in the Holy Land is generally credited to the building efforts of Constantine I (r. as sole Augustus 324–37), who erected churches at Christ's tomb in Jerusalem and at the sites of his birth in Bethlehem and of his Ascension on the Mount of Olives.[2]

Although pilgrims traveled for myriad reasons, underlying them all was the belief that the power of a holy person, a holy object (relic), or a holy site (Latin *locus sanctus*; pl. *loca sancta*) could be transferred through contact.[3] Pilgrims went to venerate—to touch, to kiss, to pray.[4] In describing his contact with the relic at Bethlehem, Sophronios (ca. 560–638), the Patriarch of Jerusalem, wrote, "I will touch with my eyes, my mouth, [and] my forehead."[5] Incubation (the practice of sleeping in a sacred precinct until the god or saint of the shrine cures the supplicant) was not uncommon at cult centers, and many instances of healing through proximity to a saint's tomb are recorded. A pilgrim's ritual might include reading biblical verses, participating in liturgical processions, or reenacting sacred events. Pilgrims filled pots of water at Cana, bathed in the Jordan River, and ate at the site of the Last Supper.[6] As an anonymous sixth-century pilgrim from Piacenza explained, pilgrims performed those actions to gain blessings (Greek *eulogiai*). He described Alexandrian shipowners collecting water from the Jordan

River on the Feast of the Epiphany (the feast of lights commemorating the baptism of Christ in the Jordan River), taking earth from the tomb of Christ and oil from the lamp that burns there, and receiving manna (the food given by God to the Israelites during their forty years in the desert) from monks in the valley between Mount Sinai and Mount Horeb.[7] Away from the *locus sanctus*, these treasures acted as aide-mémoire, protected their owners, and were vehicles for miracles.[8]

Accounts of pilgrimage suggest that while the great shrines—those in Jerusalem and others, such as Abu Mina, outside of Alexandria in Egypt—drew large numbers of pilgrims from lands far to the west and east, most pilgrimage took place on a more modest scale, involving journeys of a week or less. In his *Lives of the Eastern Saints*, John of Ephesus (ca. 507–586/88) describes visits to local ascetics around the city of Amida (Diyarbakir, in modern Turkey).[9] In his description of the miracles associated with the healing shrine of Saint Cyrus and Saint John at Menouthis, east of Alexandria, Sophronios recorded seventy miracles, thirty-five of which involved Alexandrians and fifteen of which, visitors from Egypt and

Fig. 36. Tomb of Christ in the Church of the Holy Sepulchre, Jerusalem. The present structure, built under the direction of Nikolaos Ch. Komenos following a fire in the church, dates to 1809–10.

Fig. 37. Reliquary of the True Cross (detail of cat. no. 54), underside of lid

Fig. 38. Flask with Saint Menas flanked by kneeling camels. Terracotta, late 6th to mid-8th century. The Metropolitan Museum of Art, New York, Rogers Fund, 1927 (27.94.19)

Libya.[10] From these accounts, we also learn that pilgrims came from a wide range of social classes, followed different vocations, and represented different ecclesial groups.[11]

The heterogeneity of pilgrims is well illustrated by the example of Saint Symeon Stylites the Elder (ca. 389–459; see Ratliff, p. 94). His Syriac Life describes the holy man's assistance in alleviating heavy taxation

on a group of skin-dyers from Antioch.[12] Theodoret, bishop of Cyrrhus, reports Symeon's role as adviser to the king of the Persians; he also recounts several miracles involving Arab Christians.[13] With the arrival of Islam, the ecumenical appeal of some sites extended to Muslims. In Damascus the basilica where the head of Saint John the Baptist was housed attracted Muslim faithful, who recognized the saint as a prophet (Yahya ibn Zakariyy). The Umayyad caliph al-Walid I (r. 705–15) ordered the construction of the city's Great Mosque on the site of the basilica; the saint's relics were kept in the mosque and marked by a shrine.[14]

Travel to visit holy places and holy figures flourished in the century before the Arab occupation of the region. Undoubtedly, displacement of the old power structure by the new disrupted travel in certain areas and at particular times, but evidence suggests that pilgrimage continued.[15] Two papyrus fragments from the Negev village of Nessana (modern Nitzana), tentatively dated to the early 680s, record the requests for local guides for trips to Mount Sinai (see Hieromonk Justin of Sinai, p. 50).[16] Vitae dating to the early Abbasid period describe pilgrimage throughout the region.[17] In the vita of Saint Stephen of Mar Sabas (725–794), we hear of pilgrims visiting his monastery in the Judaean desert and of pilgrimages to Jerusalem and Sinai; the pilgrims hailed from Gerasa (modern Jerash), Homs, Damascus, and Egypt.[18] The late eighth-century or early ninth-century *Life of Saint Timothy* reports pilgrims seeking the aid of Timothy, a stylite in the village of Kakhushta in the Limestone Massif of northwestern Syria; in one instance a man from Persia traveled three months to obtain a cure for his son.[19] Pilgrimages to Jerusalem and Mount Sinai are a regular occurrence.[20] A third vita, that of Saint Anthony of Ruwah (d. 799), describes group pilgrimage from Damascus to the Holy Land.[21]

When pilgrims arrived at their sacred destination, they generally found it set off by architecture, which might range in size from a simple open-air shrine or aedicula to a church or sprawling complex. Architecture

had an immediate impact on the pilgrim's experience: it framed the object of pilgrimage and the rituals that took place there. The Church of the Holy Sepulchre, which commemorated the Crucifixion, the Entombment, and the Resurrection of Christ, was the holiest place in Jerusalem (fig. 36), but the city itself was also a *locus sanctus*.[22] Jerusalem's sacred sites and those of the surrounding countryside and neighboring towns were incorporated into its stational liturgy.[23] Pilgrims arrived in the holy city to participate in these processions and rituals. Traveling south from Jerusalem, they passed several holy sites, including the Kathisma Church, built on the rock where Mary is said to have rested on the way to Bethlehem.[24] A similar experience of progressing through sacred topography to an ultimate goal is expressed in a manuscript describing a procession through the desert around the monastery of Apa Shenoute (see Bolman, p. 75).[25]

Other sites commemorated the tombs and relics of saints. At Abu Mina is the tomb of the fourth-century martyr Menas. During the fifth century, a basilica was built there,[26] and it was replaced by a larger church during the reign of the emperor Justinian I (r. 527–65). Reliquaries and a basin open to the earth at the saint's tomb allowed for the production of sanctified oil that was collected by pilgrims.[27] A town was also constructed, which included an ecclesiastical district; living areas for those administering the cult; a monastic church and cells; a settlement with houses, squares, and public buildings; and facilities for pilgrims. The town produced wine for trade and had a local ceramics industry related to the shrine.[28] Persians destroyed the town in 619, but after the Arab conquest of the area (639/42), rebuilding took place, including the reconstruction of the pilgrimage church by the Alexandrian patriarch Michael I (r. 744–68). The site then came under the stewardship of the Coptic Church.[29]

Equally well preserved is the shrine of another fourth-century martyr, Saint Sergios.[30] By the sixth century, Rusafa (Sergiopolis), an important town located in the culturally mixed frontier zone between

the Romano-Byzantine empire and Sasanian Persia (see fig. 14),[31] had become a major eastern pilgrimage destination and was a particularly important shrine for Arab Christians.[32] Basilica A, the martyrium, preserves a system for the production of sanctified oil or water.[33]

Pilgrims carried their tangible blessings home. Those *eulogiai* could be transported in any protective container, but evidence dating from the sixth and seventh centuries suggests that they were collected in special containers and that different shrines developed distinctive types with special iconography.[34] In some instances—for example, the stylite tokens made from earth dug up at stylite complexes—the blessing itself was transformed into a portable object (cat. no. 64). The imagery developed at each holy site alludes to the pilgrim's experience there by including specific architectural, topographical, or narrative details (cat. no. 58), references to ritual acts (cat. no. 55), and images of veneration (cat. no. 59). While there are lavish containers for relics (cat. no. 54 and fig. 37), most are more pedestrian. By far the most common type preserved at archaeological sites and in museum collections are unglazed clay ampullae from Abu Mina (fig. 38). They most often show the orant Saint Menas flanked by two camels and encircled in a beaded frame. Findspots are scattered throughout the Mediterranean area and Europe. At Kom el-Dikka, a neighborhood in Alexandria, some one hundred and fifty examples have been discovered.[35]

Pilgrims frequently left behind gifts to commemorate their journey to a site, to assure continued prayer there, or to offer thanks for blessings received or anticipated.[36] The Piacenza pilgrim described the votives he saw at the tomb of Christ: "There are ornaments in vast numbers . . . armlets, bracelets, necklaces, rings, tiaras, plaited girdles, belts, emperors' crowns of gold and precious stones, and the insignia of an empress."[37] The gifts, the objects carried home from pilgrimage sites, and the pilgrims' descriptions of holy places all attest to the "tactile" and "sensorily engaged" piety that characterized the rituals of Late Antique Christianity.[38]

54. Reliquary of the True Cross (*Staurotheke*)

Constantinople (?), early 9th century
Gold, silver, silver gilt, cloisonné enamel, niello
10.3 × 7.1 × 2.7 cm (4¹⁄₁₆ × 2¹³⁄₁₆ × 1¹⁄₁₆ in.)
Inscribed: In Greek, on lid at center top, ІС (Jesus); on either side of Christ's head, ΙΔΙ ω ΥωС СΟΥ · ΙΔΟΥ Η ΜΙΤΙΡ С (Here is your son . . . Here is your mother); ΘΕωΤωΚС (Mother of God); ΗωΑΝΙС (John); on lid, clockwise from upper left, Ο ΑΓΙΟС ΔΗΜΙΤΡΙΟС (Saint Demetrios); Ο ΑΓΙΟС ΕΥСΤΑΘΙΟС (Saint Eustathios); Ο ΑΓΙΟС ΛΑΥΡΕΝΤΙΟС (Saint Lawrence); ΛΟΥΚΑС (Luke); ΜΑΡΚΟС (Mark); ΘωΜΑС (Thomas); ΙΑΚΟΒΟС (James); Ο ΑΓΙΟС ΔΑΜΙΑΝΟС (Saint Damianos); Ο ΑΓΙΟС ΚΟСΜΑС (Saint Kosmas); Ο ΑΓΙΟС ΓΡΙΓΟΡΙΟС ΜΘΑΛ (Saint Gregory the Miracle Worker); ΒΑΡΘΟΛΟΜΕΟ (Bartholomew); ΜΑΤΘΕΟС (Matthew); ΙΟΥΔΑС (Jude); СΗΜωΝ (Simon); on side, clockwise from upper left, Ο ΑΓΙΟС ΑΝΑСΤΑСΙΟС (Saint Anastasios); Ο ΑΓΙΟС ΝΙΚΟΛΑΟС (Saint Nicholas); Ο ΑΓΙΟС ΠΛΑΤωΝ (Saint Platon); Ο ΑΓΙΟС ΘΕΟΔΟΡΟС (Saint Theodore); Ο ΑΓΙΟС ΠΡΟΚΟΠΙΟС (Saint Prokopios); Ο ΑΓΙΟС ΓΕωΡΓΙΟС (Saint George); Ο ΑΓΙΟС ΜΕΡΚΟΥΡΗΟС (Saint Merkourios); Ο ΑΓΙΟС ΕΥСΤΡΑΤΗωС (Saint Eustratios); Ο ΑΓΙΟС ΠΑΝΤΕΛΕΗΜωΝ (Saint Panteleemon); Ο ΑΓΙΟС ΑΝΔΡΕΑ (Saint Andrew); Ο ΑΓΙΟС ΙωΑΝΙС (Saint John); Ο ΑΓΙΟС ΠΑΥΛΟС (Saint Paul); Ο ΑΓΙΟС ΠΕΤΡΟС (Saint Peter); inside lid, ΧΑΙΡΕС ΧΑΡΙΤΟΜ (Hail, full of grace!); Η ΓΕΝΑ (The Nativity); ΙΔΕ Ο ΥΟС СΟΥ · ΙΔΟΥ Η ΜΗΡ СΟΥ (Here is your son . . . Here is your mother)
Provenance: Pope Innocent IV (Sinibaldo Fieschi) (1243–54) and descendants; Baron Albert Oppenheim, Cologne (until 1904); [Jacques Seligmann & Co., Paris and New York (until 1906)]; J. Pierpont Morgan (1837–1913), London and New York (1906–17).
Condition: The reliquary is in excellent condition; there are a few losses in the enamel.
The Metropolitan Museum of Art, New York, Gift of J. Pierpont Morgan, 1917 (17.190.715a, b)

Relics of the True Cross, which are believed to be fragments of the wood cross on which Christ was crucified, are among the holiest of Christendom. Tradition credits Helena, emperor Constantine I's mother (ca. 250/57?–330/36), with the discovery of the cross, which was then divided between Jerusalem and the imperial city, Constantinople (today's Istanbul).[1] Egeria, in her account of her trip to the Holy Land in the fourth century, described the veneration of the relic at Golgotha, the site of the Crucifixion, on the Friday before Easter; it was kept in a gold and silver reliquary.[2] The cross was taken in the Persian siege of Jerusalem in 614 and returned by the emperor Heraclius (r. 610–41) in 630.[3]

This small reliquary was made to contain a relic of the True Cross. The fragment would have been contained in a cross that fit into the cross-shaped cavity. On the exterior, the Crucifixion and the busts of twenty-seven saints are depicted in cloisonné enamel. Christ's wide-open eyes and erect posture, the sun and moon flanking his head, and the flowers growing at the base of the cross proclaim his triumph over death. The underside of the lid, divided into four quadrants by a cross, depicts the Annunciation, Nativity, Crucifixion, and Anastasis (Resurrection, known in the West as the Descent into Hell), all rendered in niello (fig. 37). The choice of narrative scenes, particularly the Anastasis, and the inscriptions—the title *theotokos*, literally, "God-bearing," for the Virgin and Christ's instruction to his mother and

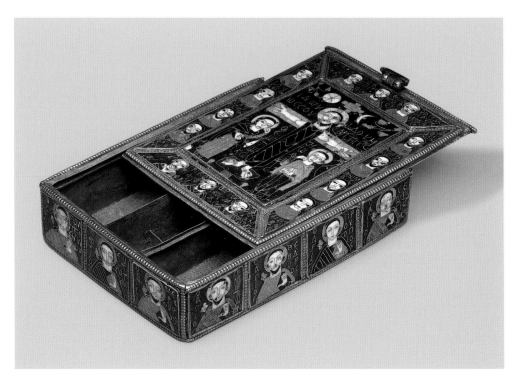

John—date the reliquary to the early ninth century and reflect developments in iconography that resulted from the debate over the use of religious imagery (commonly referred to as the Iconoclastic Controversy) that occupied the political and theological discourse of the Byzantine capital for almost a century (see Ratliff, p. 32).[4] BR

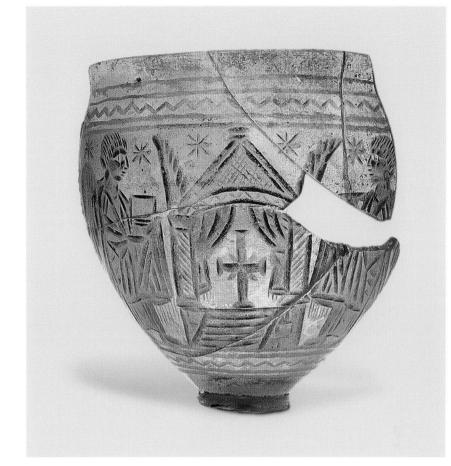

1 See J. Drijvers 1992, esp. pt. 2, chap. 4, pp. 95–118.
2 J. Wilkinson 1999, sec. 37.1–.3, pp. 155–56.
3 On Heraclius and the True Cross, see Evans, p. 14.
4 The reliquary's date has been contested since its earliest publication. Anna Kartsonis's study of the development of Anastasis imagery, which developed in Constantinople about 800 in response to debates over the nature of Christ, has secured a ninth-century date. She further notes that the title *theotokos* is not used to describe the Virgin until after the Seventh Ecumenical Council in 787; see Kartsonis 1986, pp. 94–125, for her discussion of the Metropolitan Museum's reliquary. For a further discussion of the reliquary's inscriptions, particularly Christ's instructions to the Virgin and John, see Kalavrezou 1990, pp. 168–70.

References: Kartsonis 1986, pp. 94–125; Evans and Wixom 1997, pp. 74–75, cat. no. 74 (Thomas F. Mathews); Evans et al. 2001, p. 39; Bagnoli 2010, pp. 81–82, cat. no. 37 (Barbara Boehm).

55. Chalice with Scenes of the Adoration of the Cross

....................

Syria or Byzantine Palestine, 6th–7th century
Glass
H. 14.9 cm (5⅞ in.); Diam. at rim 15.3 cm (6 in.)
Provenance: Purchased from Joseph Brummer, by Mildred and Robert Woods Bliss, 1937; Collection of Mildred and Robert Woods Bliss, Washington, D.C., 1937–November 1940; Dumbarton Oaks Research Library and Collection, Byzantine Collection, Washington, D.C.
Condition: The chalice is fragmentary and has been pieced together.
Byzantine Collection, Dumbarton Oaks, Washington, D.C. (BZ.1937.21)

This chalice is one of only two known examples made of glass. Both depict scenes of the Adoration of the Cross.[1] On one side of the Dumbarton Oaks chalice, a large jeweled cross, inside a gabled shrine preceded by steps, is approached on either side by an angel holding a Gospel book. The other, very fragmentary side shows a second scene of the Adoration of the Cross. A bearded man, hands raised in prayer, looks toward a large cross. An omega is visible between the cross and the figure. The composition would likely have included a second orant figure and certainly an alpha. The alpha and omega, the first and last letters of the Greek alphabet, refer to Revelation 1:8:

"I am the Alpha and the Omega says the Lord God, who is and who was and who is to come, the Almighty." Processional crosses dated to the same period as this chalice include the alpha and omega as pendants hanging from the cross arms.[2]

The cross in the shrine probably represents the jeweled cross erected on Golgotha, the site of the Crucifixion, by the emperor Theodosios II (r. 408–50) in 420 or early 421. Two sixth-century pilgrims report climbing steps to reach Golgotha, one of the three sites constituting the Holy Sepulchre.[3] The image of the stepped cross is closely associated with imagery of *loca sancta* (holy places) and frequently occurs on objects dated to the late sixth and seventh centuries (cat. no. 60). BR

1 The second chalice, now in the Jordan Archaeological Museum, Amman, was excavated at Gerasa (Jerash). For a discussion of its iconography, particularly in relation to *loca sancta* imagery, see B. Kühnel 1987, pp. 97–98.
2 For two examples, one in the Archaeological Museum, Istanbul, and the second in the George Ortiz Collection, Geneva, see Dodd 1987.
3 See J. Wilkinson 2002, pp. 362–63, on the Golgotha shrine. The steps at Golgotha are mentioned in the travel account of Theodosius (On the Topography of the Holy Land), sec. 7(a), p. 107, in ibid., dated by Wilkinson between 518 and 527 (p. 9), and the Piacenza pilgrim, ca. 570, sec. 19, p. 139, in ibid.

References: Weitzmann 1979a, pp. 609–10, cat. no. 545; Israeli and Mevorah 2000, p. 91; Bühl 2008, pp. 110–11 (Stephen Zwirn).

56. Octagonal Marriage Ring

....................

Constantinople (?), 7th century
Gold and niello
Diam. 2.3 cm (⅞ in.)
Inscribed: In Greek, on bezel, ΟΜΟΝΥΑ (Harmony); around edge of bezel, + ΚΥΡΙΕ ΒΟΗΘΙ ΤΟΥϹ ΔΟΥΛΟΥϹ ϹΟΥ ΠΕΤΡΟΥ ϛ ΘΕΟΔΟΤΙϹ (Lord, help thy servants, Peter and Theodote); around edges of the band, + ΕΙΡΗΝΗΝ ΤΩΝ ΕΜΗΝ ΑΦΙΗΜΗ ΥΜΗΝ (Peace I leave with you/My peace I give to you [John 14:27])
Provenance: Purchased from Joseph Brummer by Dumbarton Oaks Research Library and Collection, Washington, D.C., August 15, 1947.
Condition: The ring is in excellent condition; there are some losses of niello, and the gems or semiprecious stones are lost.
Byzantine Collection, Dumbarton Oaks, Washington, D.C. (BZ.1947.15)

In Late Antiquity as today, the visible symbol of marriage was the ring, worn by both men and women.[1] This octagonal example depicts on its eight-lobed bezel (face) Christ and the Virgin (or possibly a personification of Ecclesia, the Church) crowning the bride and groom. Gems or

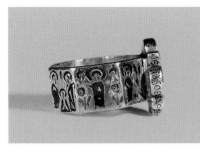

56

semiprecious stones would have filled the cavities that form the marital couple's torsos. Below the figures, the word "Harmony" expresses a wish for matrimonial concord. On the remaining seven sides, scenes from the Christological narrative are executed in niello: the Annunciation, Visitation, Nativity, Presentation in the Temple, Baptism, Crucifixion, and Christ in the Garden after the Resurrection. The inscriptions on the edges of the bezel ("Lord, help thy servants, Peter and Theodote") and on the band ("Peace I leave with you / My peace I give to you [John 14:27]") request divine assistance for the bride and groom.

The narrative scenes chosen for the ring are drawn from the cycle of imagery commonly found on sixth- and seventh-century objects associated with Holy Land sites. These scenes are also found on jewelry of the period, particularly armbands and a small group of finger rings. In this context, the images take on an amuletic function, evoking the holy power of the sites and the miracles that happened there. The octagonal shape of the ring and its bezel was also understood to be aprotropaic, or protective.[2]

BR

1 Vikan 1990a, p. 146.
2 On the amuletic function of the Holy Land imagery, see Vikan 2010, pp. 66, 70.

References: Vikan 1990a, pp. 151–62; Kalavrezou 2003, pp. 227–28, cat. no. 130 (Alicia Walker); Ross 2005, pp. 58–59, no. 69, pls. 43, 44, colorpl. E; Bühl 2008, pp. 124–25 (Stephen Zwirn).

57. Jug with Medallions

.....................

Eastern Mediterranean, 6th–8th century
Copper alloy
12.5 × 10.2 × 8.6 cm (4¹⁵⁄₁₆ × 4 × 3⅜ in.)
Provenance: [Royal-Athena Gallery, New York (1967)].
Condition: The object is stable; a repair is visible on one side.
The Metropolitan Museum of Art, New York, Rogers Fund, 1967 (67.200.2)

This jug forms part of a large group of copper alloy vessels united by a similar form and manufacturing technique (cat. no. 151 B). The type has been found at sites throughout the Mediterranean, suggesting that different workshops produced it over a relatively long period (sixth to eighth century).[1] The example illustrated here has a loop handle made separately and then attached; a chain secures the lid to the handle. A fillet decorates its broad shoulder. The band applied around the neck has three medallions, each depicting a rider; four other examples in the group carry this motif.[2]

The image recalls the amuletic holy rider that commonly appears on Late Antique art. These representations, deriving from antique precedents, generally show a rider in military attire riding a galloping horse; the horseman impales a beast beneath the horse's hooves.[3] Here, though, the image is different: the rider, dressed in military costume with a flowing cape and holding a long martyr's staff in one hand, sits atop a mount raising its right, not the more typical left, foreleg. This composition may be related to nearly identical examples preserved on a group of small-scale objects; several of these riders are identified by inscription as Saint Sergios and may represent an image of the saint associated with his shrine at Rusafa (Sergiopolis) (see Ratliff, p. 32).[4] Regardless of a specific identification of the motif on the jug, the protective associations of the image of a rider—the triumph of good over evil—would have been entirely appropriate for a vessel used in the home or during travel.

BR

1 Pitarakis 2005, p. 11; see her map (p. 12, fig. 1) for the distribution of find sites.
2 The other examples are in the collection of Christian Schmidt, Munich; the British Museum, London; the Victoria and Albert Museum, London; and the Kanellopoulos Museum, Athens; see Pitarakis 2005, pp. 19–23.
3 On the image of the holy rider, see Vikan 1984, pp. 79–81.
4 See Key Fowden 1999, pp. 35–43, for a discussion of this image type and its identification as Saint Sergios. To Key Fowden's examples can be added an ampulla in the Walters Art Museum, Baltimore; see Vikan 2010, p. 42, fig. 30.

References: Forsyth 1968; Frazer 1975; Pitarakis 2005, pp. 21, 27.

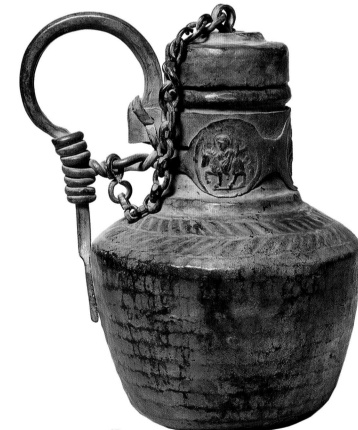

57

58 A–F. Group of Six Pilgrim Tokens
....................

Syria (?), 6th or 7th century
Terracotta
Provenance: Said to have been found at or near Qal'at
Sem'an, Syria; [Gawain McKinley Ltd., London, until
1973].
Condition: The condition of the tokens is stable; some
pitting and losses have occurred around the rims.

A. The Annunciation
Diam. 18 mm (¹¹⁄₁₆ in.)
The British Museum, London (1973,0501.1)

B. The Nativity
Diam. 17 mm (¹¹⁄₁₆ in.)
The British Museum, London (1973,0501.4)

C. The Baptism
Diam. 17 mm (¹¹⁄₁₆ in.)
The British Museum, London (1973,0501.30)

D. The Entry into Jerusalem
Diam. 16 mm (⅝ in.)
The British Museum, London (1973,0501.47)

E. The Angel of the Tomb
Diam. 17 mm (¹¹⁄₁₆ in.)
The British Museum, London (1973,0501.19)

F. Bust of Christ
Diam. 17 mm (¹¹⁄₁₆ in.)
The British Museum, London (1973,0501.78)

These six terracotta tokens are part of a
hoard of ninety-three, now divided
between the British Museum and the collec-
tion of Robert-Henri Bautier. Reputedly,
they were found in a glass bowl at or near
Qal'at Sem'an, Syria (see Ratliff, p. 94).[1]
The tokens in the hoard were stamped from
twenty-three mold types. They depict holy
figures, sacred events, and the medicinal
mandrake root with the Greek inscription
"Solomon."[2] A single token with the image
of a stylite on his column was found among
the group. The Christological scenes on the
six tokens are representative of the image
cycle associated with Holy Land sites and
include many of the same iconographic
details. Compare, for example, the represen-
tation of Christ's tomb (E) with the scene
of the Women at the Tomb on the lead
ampulla from Dumbarton Oaks (cat. no. 59).
Both make visual reference to the historical

tomb of Christ in the Anastasis Rotunda in
the Church of the Holy Sepulchre, Jerusalem.
 Although the iconography of the larger
hoard suggests a connection with the *loca
sancta* (holy sites) of Jerusalem, the tokens
raise questions about the manufacture and
distribution of objects associated with pil-
grimage shrines. Recent excavations at
Qal'at Sem'an have yielded additional
tokens of similar size, material, and iconogra-
phy.[3] A steatite mold similar to the tokens
with a mandrake root image was recovered
as well.[4] Analysis of the material composition
of a small number of stylite tokens from sev-
eral collections in France and seven *loca
sancta* tokens in the Bautier collection from
the ninety-three-token hoard revealed a
similar makeup for both groups. The clay
used is similar to that found in the region of
Qal'at Sem'an.[5] These results have broad-
ened the conventional understanding of
these and similar tokens, which assumed that
iconographically specific tokens were manu-
factured at or near the site depicted; how-
ever, no remains of ovens have been found at
Deir Sem'an.[6] BR

1 Vikan 1991, p. 76; Gerard et al. 1997, p. 10. For an
 overview of the group of tokens in the British
 Museum, see Camber 1981.
2 Vikan 1991, pp. 76–77.
3 See Sodini 1995; Gerard et al. 1997, p. 10.
4 Sodini 1995, p. 231.
5 Gerard et al. 1997, pp. 11–14.
6 For eight similar tokens excavated in Israel, see
 Rahmani 1993. Vikan (1994, p. 343, n. 14) has sug-
 gested that the place of production may not have
 been the same as the distribution site. Sodini (1995,
 p. 232) has argued that the tokens in the hoard should
 be understood in relation to the shrine at Qal'at
 Sem'an.

References: Camber 1981 (hoard in the British Museum);
Vikan 1984, pp. 81–83 (complete hoard); Vikan 1991
(complete hoard); Buckton 1994, pp. 114–15, cat. no. 130
(group of six tokens).

59. Ampulla with Scenes of the Crucifixion and the Women at the Tomb
....................

Jerusalem (?), late 6th–7th century
Lead
Diam. 4.6 cm (1¹³⁄₁₆ in.)
Inscribed: In Greek, surrounding the Crucifixion scene,
+ ΕΛΑΙΟΝ ΞΥΛΟΥ ΖΩΗϹ ΤΩΝ ΑΓΙΩΝ Χ(ρισто)Υ ΤΟΠΩΝ (Oil of
the wood of life from the holy sites of Christ); above the
Women at the Tomb, +ΑΝΕϹΤΙ Ο ΚΥΡΙΟϹ (The Lord is
risen)
Provenance: Collection of Hayford Peirce; acquired by
Dumbarton Oaks in 1948.
Condition: The flask is flattened but in good condition.
The mouth is missing and there are some losses.
Byzantine Collection, Dumbarton Oaks,
Washington, D.C. (BZ.1948.18)

About four dozen lead ampullae deco-
rated with Holy Land imagery are pre-
served in museum collections and church
treasuries.[1] The Dumbarton Oaks example is
among the finest of these Late Antique flasks.
On one side, a depiction of the Crucifixion
includes details associated with the venera-
tion of the True Cross at the Church of the
Holy Sepulchre in Jerusalem. A small cross
on a shaft rises from the hill of Golgotha;
above is a bust of Christ. Here, Christ's body
is the cross, and this is reinforced visually by
the small plaque above his halo (the title
"King of the Jews" was nailed to the cross
above Christ's head). The sun and moon and
the two thieves who were executed with
him—all standard elements of Crucifixion
scenes—flank the central image. Two pil-
grims kneeling at the foot of the cross lean
forward to touch it.[2] The encircling inscrip-
tion, which refers to the "oil of the wood of
life from the holy sites of Christ," recalls the

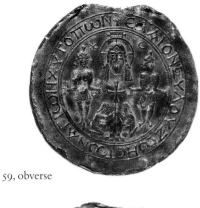

59, obverse

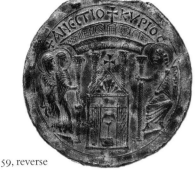

59, reverse

description of a pilgrim from Piacenza of the blessing of oil during the veneration of the cross.[3]

The reverse shows the holy women who arrived at Christ's tomb, only to find it empty, but attended by an angel who announced his resurrection (Matthew 28:1–7.) The Greek inscription, "The Lord is risen," echoes the angel's words to the Marys. On the flask the women are shown in front of Christ's tomb in the Anastasis Rotunda within the Church of the Holy Sepulchre (fig. 36). The windows of the rotunda and the entrance to the tomb are rendered in detail. Features of the rotunda described in pilgrim accounts are visible: grilles at the entrance, the lamp burning in the tomb, and the stone used to seal it.[4]

The details included on the flask, which was probably used to hold sanctified oil from the Church of the Holy Sepulchre, describe the pilgrim's experience. Those details placed the pilgrim at the events depicted on the flask.[5] BR

1 Examples depict a range of narrative scenes, but for the most part the imagery focuses on the tomb of Christ and Golgotha, the site of the Crucifixion. The best known of these ampullae are in two Italian collections, one at San Colombano. Bobbio, the other at San Giovanni Battista, Monza. The flasks in those collections are catalogued in A. Grabar 1958. For a discussion of the collections, see Elsner 1997.
2 For the identification of the figures as pilgrims, see Vikan 1990b, p. 103.
3 For more on this pilgrim and his travels, see Ratliff, p. 86.

4 See Barag and Wilkinson 1974 for an overview of pilgrims' descriptions of the tomb of Christ.
5 For discussion of the significance of contemporary details in pilgrimage art, see, for example, Hahn 1990, Vikan 1990b, and Frank 2006.

References: Ross 1962, pp. 73–74, no. 89, pl. XLVIII; Vikan 1990b, pp. 101–3; Frank 2006, pp. 197–99; Vikan 2010, pp. 38–40.

60. Hexagonal Jug with Crosses and Lozenges

.....................

Jerusalem (?), 7th century
Glass, mold-blown
15.1 × 8.6 × 7.5 cm (5 15/16 × 3 3/8 × 2 15/16 in.)
Provenance: Luigi Palma di Cesnola, New York (1899).
Condition: The jug is in excellent condition. A small chip has been repaired and there are slight encrustations.
The Metropolitan Museum of Art, New York, Purchase, 1899 (99.21.3)

This jug is one of a large group of mold-blown glass vessels associated with the city of Jerusalem; the group is distinguished by unusual sunk-relief decoration. More than twenty-five mold types decorated with a limited number of motifs have been identified.[1] The vessels were apparently manufactured, possibly in a single workshop, in Jerusalem for Christian (as in the case of this example), Jewish (cat. no. 72), and Muslim pilgrims (cat. no. 186), who would have used them to hold *eulogiai*, material blessings collected on their journey (see Ratliff, p. 86).[2]

This jug was manufactured using a mold with a series of alternating crosses and lozenges on the six sides of the body.[3] With the exception of the cross elevated on a series of steps—which refers to the cross erected by the emperor Theodosios II (r. 408–50) to memorialize the site of the Crucifixion (cat. no. 55)—the crosses are difficult to interpret. The cross with circles has been read as the cross as *omphalos* (navel) of the earth and as the cross erected by Theodosios II seen from another vantage point.[4] The third cross may be a cross with leaves—the life-giving cross—or a cross with figures at the base.[5] Even more difficult to identify are the three lozenges with dots; they may be representations of sacred scriptures or stones associated with Christ's tomb in the Anastasis Rotunda in the Church of the Holy Sepulchre.[6] Regardless of the precise meaning or meanings of the motifs, the emphasis on the cross suggests an association with the Holy Sepulchre. BR

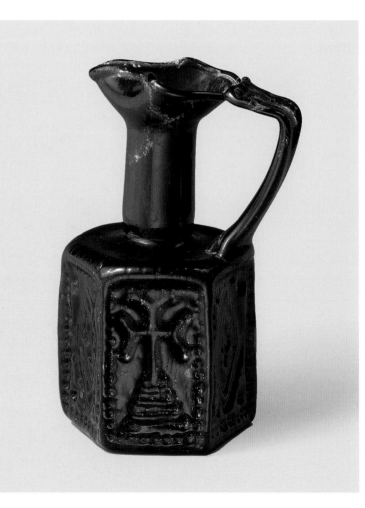

60

1 The foundational study on these vessels is Barag 1970 and 1971. Barag divided the vessels into three categories: Christian, Jewish, and Unidentified. Examples are fairly common in museum collections; see, for example, vessels in the Toledo (Ohio) Museum of Art in E. Stern 1995, pp. 253–60, nos. 169–177.

2 Raby 1999 identified the iconography suggestive of Muslim patronage; on the possibility of a single workshop, see the discussion in ibid., pp. 158–69.

3 This jug is an example of Barag's Christian vessel type IV.

4 For the cross as *omphalos*, see Barag 1970, pp. 41–42. D. Woods (2004a, pp. 193–94) identifies the cross with circles as an alternate view of the cross at Golgotha.

5 Barag (1970, p. 42) identifies the image as the life-giving cross. D. Woods (2004a, p. 195) identifies it as a cross with two figures at the base; he compares the image to the Dumbarton Oaks lead ampulla (cat. no. 59).

6 Barag (1970, pp. 43–44) identifies the lozenges as representations of bookbindings containing sacred scriptures. Raby (1999, pp. 174–75) suggests that the lozenges represent the stones associated with the tomb of Christ (the one marking the spot where Christ's body was prepared for burial and the one used to seal the tomb).

References: Unpublished.

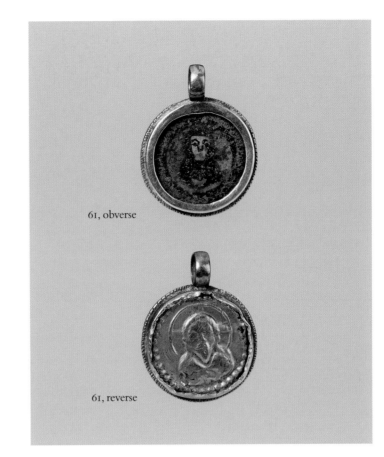

61, obverse

61, reverse

61. Double-Sided Pendant with Virgin and Child (*obverse*) and Bust of Christ Pantokrator (*reverse*)

.....................

Byzantium, probably Constantinople, 7th century (obverse); mid- to second half of 11th century (reverse)[1]
Niello on ceramic plate; gold and glass frame (obverse); gold, chased (reverse)
Diam. 2.5 cm (1 in.)
Provenance: Found in 1909 in an underground tomb on the summit of Mount Mithridates, Kerch, Crimea; acquired in 1915 by the Hermitage from the Imperial Archaeological Commission; kept with other archaeological artifacts from the Crimea; transferred to the Byzantine collection of the State Hermitage Museum in 2007.
Condition: The niello is partially chipped, and the glass has scratches, spots of dirt, and corrosion. The edges of the gold mounting are ragged. The medallion with the bust of Christ, included in the frame probably in the eleventh century, was rather roughly mounted and may have replaced an image of the Living Cross.
The State Hermitage Museum, Saint Petersburg (I-553)

The exact iconographic prototype of this Virgin and Child is hard to identify, although it may be the Virgin Nikopoios. Such miniature pendants, with images of the Virgin, Christ, and the saints, were worn on chains around the neck and often contained holy relics or other blessed objects. The Hermitage pendant is thick enough to have been such a reliquary.

Beginning in the late fifth century, the cult of the Virgin as patron of Constantinople became widespread and was highly influential in court art.[2] Two centuries later, images of the Virgin holding the child, both bust- and full-length, appeared on practically every imperial seal.[3] The bust-length image is typical of the seals of Justinian I, Tiberius II, Constantine, Constans II, and Constantine IV (that is, in reigns from 527 to 685), while the full-length representations were depicted from 582 to the end of the seventh century.[4] Images of the Virgin and Child similar to the present one are found on a bronze ring seal from the sixth or seventh century (Menil Collection, Houston),[5] a gold medallion (Staatliche Museen zu Berlin),[6] and a gold cross (Dumbarton Oaks Research Library and Collection).[7]

The dating of the medallion to the seventh century is substantiated by the find of a comparable example with a niello image of the Virgin and Child in a grave of that date in Germany. Sixth- and seventh-century objects from various museums display gold mounts similar to the one here. The medallion was clearly made in a Constantinopolitan workshop, for, as Martin Ross has pointed out, the capital of Byzantium was the main center for the production of jewelry discovered in Mediterranean and Crimean hoards and graves.[8] YP

as the shape of his goatee beard help to date the plaque. This rare type of Christ is represented on coins, first appearing on Theodora's tetartera (r. 1055–56) and later on the folles of Constantine X (r. 1059–67) and the histamena of Michael VII (r. 1071–78). Christ has the same beard, clearly outlined, on the Deesis mosaic in Hagia Sophia, Kiev (1043–46). This image was doubtless connected to a venerated icon or image—perhaps the Mandylion.

2 C. Mango 2000; Pentcheva 2006a, pp. 11–35.

3 Cheynet and Morrisson 1994, pp. 9–12; Vasilakē 2000, pp. 209–17.

4 Zacos and Veglery 1972, nos. 4, 6, 7, 9, 10, 12–15, 17–20. After the restoration of icon worship in 843, the cult of the Virgin became popular again in Constantinople, as attested primarily by mosaic images in Hagia Sophia (867, 886–912, and second half of tenth century). During the reign of Leo VI (886–912), coins began to bear the image of the Virgin as well. Found like the present object in Kerch, a miniature reliquary depicting the Virgin on a bone plaque inserted into a gold pendant dates approximately to the same period (State Russian Museum, Saint Petersburg). A similarly shaped gold pendant with a miniature enamel image of a saint is in the collection of the Cairo Museum. Other typological parallels include a gold encolpion (3.6 × 1.7 cm [1⅜ × 11/16 in.]), or reliquary pendant, dated to the tenth or eleventh century (Kanellopoulos Museum, Athens), and a gold miniature reliquary (H. 4.3 cm [1 11/16 in.]), dated from the ninth to the eleventh century (AXIA Gallery, London); both are considered products of Constantinopolitan workshops.

5 Kalavrezou 2003, p. 296, cat. no. 177.

6 Baldini Lippolis 1999, p. 172, no. 3.

7 Ross 2005, no. 6B.

8 Ibid., pp. 9–10.

References: Piatnitskii et al. 2000, p. 60, cat. no. B-20; Piatnitskii et al. 2005, pp. 46–47, 117, cat. no. 144.

1 Although the image of Christ on the reverse is blurred and polished, such clearly recognizable details

The Stylites of Syria

Brandie Ratliff

In 459 seven bishops and six hundred soldiers arrived at the column of Saint Symeon Stylites (ca. 389–459) outside of Telneshe (Telanissos, now Deir Sem'an), in northwestern Syria, where the holy man had subjected his body to extreme feats of asceticism for forty-seven years. The retinue had come to remove Symeon's body from his column and accompany it on a five-day procession to the city of Antioch, where it was to be interred.[1] Symeon, whose epithet "Stylites" (Greek *stylos*, pillar) refers to his life spent atop the column, drew visitors from as far away as Persia and Britain to the prosperous Syriac-speaking region known as the Limestone Massif.[2]

Three vitae attest to Symeon's life as a charismatic holy man.[3] They chronicle a flow of pilgrims of all Christian affiliations, as well as non-Christian Arabs, who sought the saint's worldly and spiritual advice and his healing touch, often mediated through oil, water, and dust from around his column or by *hnana*, a combination of the three.[4] While the lives do not extend to the posthumous cult centered on his column, the vast pilgrimage complex of Qal'at Sem'an (fig. 39), built through imperial donation sometime after 470, and the associated structures in Deir Sem'an attest to its longevity.[5]

Symeon's column, surrounded by an octagon radiating into a cruciform basilica, was the focal point of the magnificent complex. Housed outside, in the surrounding enclosure, were a monastery and pilgrimage facilities, including a cistern, hostel, and baptistery. Pilgrims approached the enclosure from the town of Deir Sem'an, passing through a triumphal arch that gave way to a via sacra lined with buildings for registering the visitors, shops, and baths. By 479 the town had a hostel and three monasteries.[6] Pilgrimage to Qal'at Sem'an continued until the Arab conquest in 638; there is limited evidence of activity at the site between that date and the Byzantine recapture of the region in 969.[7]

Symeon's posthumous appeal extended well beyond pilgrimage. The saint regularly appeared in homiletic literature and is included in the calendars of most Christian churches in the eastern Mediterranean.[8] Perhaps the greatest evidence of Symeon's charisma is his role as the "protostylite," founder of an ascetic movement that had adherents into the nineteenth century, from Mosul in today's northern Iraq to Gaul in France.[9] Though stylitism was spread over a vast area, it was in large part a spiritually and geographically Syrian phenomenon.[10]

Symeon was an exemplar of the asceticism for which early Syriac Christianity was known. Ascetics existed in symbiosis with the monasteries and churches of the Syrian countryside. These communities provided the supplies and assistance necessary for spiritual athleticism, while the visitors drawn to the ascetics offered a boost to the local economy. Symeon's relationship with local ecclesiastical structures is made clear through the linking of his physical deprivations to the liturgical calendar.[11]

Although few stylites are as well documented as Symeon, there are vitae, religious narratives, church histories, and archaeological remains that do preserve their memory.[12] Sites identified with stylites share a common structure: a column surrounded by an enclosure and closely associated communal buildings, presumably used by the monastic communities that served the stylite.[13]

Among the better-documented stylites, Saint Symeon Stylites the Younger (521–562) stands out. His column and monastic complex, known as the Wondrous Mountain (modern Sem'ān Daği), is located eleven miles (18 km) west of Antioch.[14] Symeon's vita chronicles his origins in Edessa, his early calling to the pillar at the age of seven, and his ascetic exercises and miracles, which drew pilgrims from Antioch and its environs, as well as from farther afield in Syria, Cilicia, Armenia, Asia Minor, and the Persian frontier.[15] Symeon the Younger was an ordained Chalcedonian priest.[16]

The complex at the Wondrous Mountain, unlike its model, Qal'at Sem'an, was not built through imperial donation but constructed by visitors as an expression of their gratitude for the holy man's aid.[17] The focal point of the site was the column, around which was built an octagon with two-tiered benches to accommodate pilgrims. Other buildings included three churches, various monastic structures, a baptistery, hospices, storage rooms, and a kitchen.[18] Much of the structure was completed between 541 and 551, the rest later in the sixth century.[19] Occupation of the site is similar to the pattern seen at Qal'at Sem'an: it functioned until the Arab conquest, after which little

Fig. 39. View of the column of Saint Symeon Stylites, Qal'at Sem'an, Syria. The pilgrimage shrine was constructed after 470.

evidence of activity exists until the Byzantine reconquest.[20] A revival in pilgrimage activity is attested by lead medallions, generally dated to the tenth or eleventh century (cat. no. 65).

Despite the impressive architectural remains of Qal'at Sem'an and the Wondrous Mountain, the material record of the stylites consists largely of portable objects, stone reliefs (cat. no. 63), and graffiti.[21] Such small-scale objects bearing stylite iconography include tokens (cat. no. 64), lead medallions (cat. no. 65), bottles (cat. no. 62), glass pendants,[22] and a stunning silver relief in the Musée du Louvre, Paris.[23] The objects, reliefs, and graffiti share a common, sometimes highly stylized iconography: a bust-length image of a stylite, generally wearing a monastic hood (*koukoullion*), atop his column. More complex compositions might feature censers, ladders, angels, supplicants, birds, crosses, stars, vines, or narrative scenes. Censers are particularly prominent in stylite imagery (cat. nos. 62, 63, 64). The earliest references to the use of incense in Christian ritual—among them the lives of the Symeons—are of Syrian origin. Like the ascetic and his symbiotic relationship with the local church, the incorporation of incense into church ritual and language is a hallmark of Late Antique Syriac Christianity.[24] Incense was an intercessory medium for private prayer, and its part in effecting miracles is vividly described in the vita of Symeon the Younger.[25]

The shared iconography poses difficulties in assigning objects to a specific site unless there is an identifying inscription. Given the sizable corpus of objects and the large number of stylite sites, it is possible that the images should be assigned more broadly, that some of the now-anonymous stylites attracted their own pilgrims (perhaps not internationally but locally), and that the tokens with generalized stylite iconography could have been distributed at these sites.

62A–C. Stylite Vessels

Syria (?), mid-5th to 7th century

A. Hexagonal Bottle with Stylite

Glass, mold-blown, greenish tint
21.7 × 6.4 × 6.5 cm (8⁹⁄₁₆ × 2½ × 2⁹⁄₁₆ in.)
Provenance: Paul Dougherty (from at least 1931); Lisa Dougherty Coon (Mrs. Carleton S. Coon) (by descent until 1961).
Condition: The bottle is intact with no significant chips or losses; the glass is in good condition with signs of corrosion, including pitting and iridescence on two of the panels and the corresponding parts of the neck and mouth.
The Metropolitan Museum of Art, New York, Gift of Mrs. Carleton S. Coon, 1961 (61.247)

B. Hexagonal Bottle with Stylite

Glass, mold-blown, dull green
25.5 × 6.5 cm (10¹⁄₁₆ × 2⁹⁄₁₆ in.)
Provenance: Said to have been found at Aleppo, Syria; purchased by the British Museum from Artin Sarkissian, Paris, in 1911.
Condition: The bottle is intact with no significant chips or losses; a small hole and short crack on the base have been consolidated. The glass is in good condition with some iridescence.
The British Museum, London (1911,0513.1)

C. Jug with Stylite

Glass, mold-blown, light green with dark green handle and thread decoration; trailed-on handle and neck ring
H. 14.2 cm (5⁹⁄₁₆ in.)
Provenance: Collection of Mrs. William H. (Ada Small) Moore (1858–1955).
Condition: The mouth is restored above the neck ring; there are strain cracks in the lower body and light brown weathering.
Yale University Art Gallery, The Hobart and Edward Small Moore Memorial Collection (1955.6.149)

These vessels reflect two mold types used in the production of a large group of mold-blown glass objects with stylite iconography.[1] A and B are from the same or very similar molds.[2] Their six sides show, in low relief, a stylite, a cross on a column, a lattice pattern (on two sides), and a palm frond (on two sides). In very legible high relief, the four sides of C depict, respectively, a stylite atop a column, a ladder, a censer, and five dots; a lattice pattern; a bird; and a cross flanked by rows of four dots.[3] All three vessels share a visual vocabulary with stylite

A B C

imagery in other media. The stylized rendering of the figure and the cross surmounting a column on A and B find close parallels in graffiti, such as those found on Jabal Barisha in Syria's Limestone Massif.[4] C finds its closest parallels in bas-reliefs (cat. no. 63).

Stylite glass can be classed among *eulogia* vessels that were presumably used to collect sanctified substances (see Ratliff, p. 86, and cat. nos. 60, 72, 186). Lacking an inscription, these objects are generally identified with Symeon the Elder.[5] His Syriac life describes the use of oil, water, dust, and *hnana*, a combination of the three, in his miracles;[6] any of these substances could have been collected by visitors to his column. Bottles could also have been used to store oil taken from lamps at Symeon's tomb in Antioch as well as oil or water poured into his sarcophagus and allowed to flow over his relics.[7] At the Wondrous Mountain, dust, used to make tokens, is linked to miracles and could have been gathered in glass vessels.[8] The discovery of sarcophagi near stylite pillars raises the possibility that these holy men were buried near their columns; oil or water sanctified through contact with their relics could have also been collected in bottles.[9] B R

1 For examples of other molds, see Matheson 1980, pp. 133–34, nos. 354–356; E. Stern 1995, pp. 266–67, no. 190; Israeli 2003, p. 279, no. 374.
2 This mold seems to have been quite common. See, for example, handled juglets/pitchers in the Toledo (Ohio) Museum of Art (1923.1352; E. Stern 1995, p. 265, no. 189); the Corning Museum of Glass, Corning, N.Y. (66.1.230; Whitehouse 2001, pp. 98–99, no. 591); the Yale University Art Gallery, New Haven (1955.6.147; Matheson 1980, pp. 134–35, no. 357); and the Musée du Louvre, Paris (OA 6418; Arveiller-Dulong and Nenna 2005, p. 481, no. 1313).
3 Another example from this mold is in the Musée du Louvre, Paris (OA 6417; Arveiller-Dulong and Nenna 2005, p. 481, no. 1312).
4 Schachner 2010, p. 372, figs. 13a–c. Eisen 1927, vol. 2, p. 474, pl. 119, published the Yale (then Moore Collection) example as bearing images of the Holy Cross with the beaker of Joseph of Arimathea; the Tree of Life (on two sides); cross-hatching with lozenge-shaped fields representing paradise (on two sides); and the Vision of Constantine. More recently, it has been argued that the figure on this mold should be understood as a monk at an altar; see D. Woods 2004b, pp. 45–49. Without an inscription, the identity of the figure is uncertain, but one of Woods's main objections to the identification is that similar representations are not preserved. This argument seems to ignore stylite graffiti, which are very often highly schematic but identified by inscriptions (see, in particular, Peña et al. 1975, pl. 41.1), along with related imagery in glass: an example in the Toledo (Ohio) Museum of Art (1948.13; E. Stern 1995, pp. 266–67, no. 190) clearly shows a stylite on a column, and the rounded torso is inscribed with a cross.
5 Sodini 1989, p. 32.
6 For instances of these substances in the Syriac Life, see Ratliff, p. 94, n. 4.

7 On these practices, see Ratliff, p. 86. Sodini 1989, p. 32, suggests a connection with Symeon's tomb in Antioch. For a discussion of Symeon's corporeal relics, see Eastmond 1999.
8 Vikan 2010, p. 15.
9 See Schachner 2010, pp. 358–59, for a list of sites where sarcophagi have been identified.

References: (A) Unpublished; (B) Harden 1968, p. 63, cat. no. 80; Buckton 1994, p. 116, cat. no. 131b; (C) Eisen 1927, vol. 2, pp. 483–84, fig. 200, pls. 121–122; Matheson 1980, pp. 132–33, no. 353; R. Grossmann 2002, p. 37, fig. 38.

63. Relief of a Stylite Saint

....................

Syria, 5th–6th century
Basalt
84.5 × 76 × 18.5 cm (33¼ × 29⅞ × 7¼ in.)
Provenance: Relief seen by Jean Lassus before 1932 in secondary use in a stone enclosure in Qasr Abu Samira, Syria.[1] Slab acquired for the Skulpturensammlung und Museum für Byzantinische Kunst on the antiquities market in 1963.
Condition: The slab retains its original edges on the top, bottom, and lower right side. The left side is broken. The bottom shows minor damages along the lower edge.
Stiftung Preußischer Kulturbesitz, Staatliche Museen zu Berlin—Skulpturensammlung und Museum für Byzantinische Kunst, Berlin (9/63)

This shallow relief depicts a stylite saint sculpted in a naive but expressive style. Shown as a bearded monk with a monk's hood, he stands on a column with a two-stepped base. The lower part of his body is hidden behind a plain parapet, the outline of which is indicated by thin lines. A dove as a messenger from God carries a wreath in its beak and holds it over the tip of his hood. A monk approaches the stylite on a ladder, swinging a censer in his hand. The incense was meant to evoke the help of the saint.[2]

The stylite is either Symeon the Elder (d. 459) or Symeon the Younger (d. 592), who were represented using very similar iconographic schemes (see cat. no. 65). In this case, a positive identification seems impossible, as ladder, monk, censer, and dove are not exclusive to either saint.[3] In addition, the figure lacks individualized features, and there is no inscription. The relative vicinity of the findspot, Qasr Abu Samira, to the pilgrimage center at Qal'at Sem'an, however, suggests an interpretation as Symeon the Elder.

As can be deduced from the different widths of the plain framing bands, the frag-

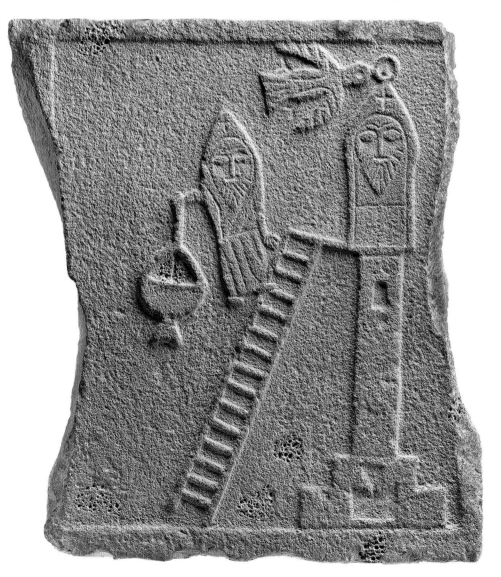

ment is probably only the right-hand side of a slab originally containing two image fields. With a once-horizontal format, it might have served as part of a chancel screen, a parapet separating the altar area from the nave of a church. However, reliefs of stylite saints are also known as decorations of the outer walls of Syrian churches.[4] G M

1 Lassus 1932, pp. 76–78, pl. 21; Lassus 1935–36, vol. 1, p. 153, fig. 155.
2 Vikan 2010, pp. 33, 50–52.
3 A close parallel, a stone relief in the Musée du Louvre, Paris, has all of these elements with the addition of a snake, but it cannot be attributed to either Symeon; see Elbern 1965, p. 283, fig. 2; Vikan 2010, pp. 54–55, fig. 34; for ladder, monk, and probably censer on pilgrimage tokens for Symeon the Younger in Bobbio and Houston, see Elbern 1965, pp. 289–90, fig. 7; Vikan 2010, p. 33, fig. 19.
4 For churches in Qalb Loze and Dehes, see Elbern 1965, p. 286.

References: Elbern 1965, pl. 1; Effenberger and Severin 1992, p. 147, no. 60; Wamser 2004, p. 207, cat. no. 296; Fansa and Bollmann 2008, pp. 176–77, cat. no. 129; Frings 2010, p. 231.

64A, B. Stylite Tokens

...................

Syria(?), 6th to 7th century
Terracotta

A. Token with Stylite, Baptism of Christ, and Adoration of the Magi
Diam. 2.5 cm (1 in.); thickness 0.7 cm (⁵⁄₁₆ in.)
Inscribed: In Greek, left, ΑΓΙΟΣ; right, ΑΓΙΟΣ (Holy Holy)
Provenance: Purchased Blumka Gallery, New York; collection of Dr. Lillian Malcove (1902–1981), New York, until 1981; bequeathed to the University of Toronto, 1982.
Condition: The object is stable with soiling and accretions. There is a small loss along the edge of the obverse; a deep gouge and three radiating cracks appear on the reverse.
Malcove Collection, University of Toronto Art Centre, Toronto (M82.242)

B. Token with Stylite
2.7 × 2.4 cm (1¹⁄₁₆ × ¹⁵⁄₁₆ in.)
Provenance: Collection of Gheorghios Tsolozidis (1928–2002) before 1962.
Condition: The object is stable with some pitting and accretions.
Tsolozidis Collection, Thessaloniki (ΣΤ169)

Some two hundred fifty small, stamped clay tokens with stylite imagery survive.[1] Generally depicting a column with a stylite being crowned by angels, these may include incense imagery (see Ratliff, p. 94), supplicants, narrative vignettes, or inscriptions in Greek or Syriac.[2] A small number of examples of portraits exist.[3] Except for a few larger, mold-made terracotta examples with inscriptions referring to Symeon the Younger

or the Wondrous Mountain, there is no consensus on the stylite depicted on the tokens.[4] Most of these objects with known find sites come from Qal'at Sem'an or Deir Sem'an.[5] Recent analysis of the clay used in the production of a small test group, including tokens without stylite imagery (cat. no. 58), points to the area around Qal'at Sem'an as a possible center of production.[6]

Token A is very legible.[7] Flying angels holding crowns approach a hooded stylite on a column. The pattern on the shaft and base of the column recalls the palm-frond pattern on glass bottles (cat. no. 62A, B) and on the engaged columns decorating the facades of churches in the Limestone Massif.[8] The beaded lines running parallel to the columns may represent ropes used to carry supplies to the stylite.[9] At the base of the column is a scene of the Baptism of Christ (left) and an enthroned Virgin and Child (right), generally identified as the Adoration of the Magi.[10] It is inscribed "Holy, Holy."[11] The iconography of B is less clear. Again, a hooded stylite perched on a column is approached by angels, at least one of whom holds a crown. The column has diagonal fluting, and the stylite's platform is clearly indicated. The poles flanking the column likely represent the ladder common in stylite imagery. Although the lower left and right are very difficult to read, they may show the same narratives as on A. Tokens such as these were more than souvenirs. Presumably made from the earth around stylite columns, they linked imagery and substance in order to evoke the healing power of the holy man, so vividly described in the lives of the two Symeons.[12] BR

1 Vikan 2010, p. 31.
2 For examples with incense imagery, see Sodini 1993, p 27, no. 6, pl. I, fig. 6; for supplicants, see Vikan 2010, p. 31, fig. 11; for narrative vignettes, p. 33, figs. 17 and 18; for inscriptions, p. 31, figs. 11 and 12, p. 33, figs. 17 and 18.
3 Sodini 1989, pp. 43–44, fig. 15; Sodini 1993, p. 26, pl. I, fig. 1; Vikan 2010, p. 31, fig. 11.
4 See Vikan 2010, p. 33 (fig. 19 shows an example) and p. 51, for a discussion of Symeon the Younger tokens; also Sodini 1989, p. 37.
5 For tokens found at Qal'at Sem'an, see Sodini 1989, pp. 38–41.
6 Gerard et al. 1997.
7 There are several examples of tokens with the same iconography; see Sodini 1993, pp. 31–32.
8 See, for instance, the west facade of Qalb Loze; Peña et al. 1975, pp. 190, 191, fig. 42, pl. 39.2.
9 Sodini 1989, p. 42. Jacqueline Lafontine-Dosogne makes this proposal; Sodini suggests they could also be read as candles.
10 For a discussion of these scenes within the context of pilgrimage tokens, see Vikan 2010, pp. 53–56 for the Baptism, and pp. 59–61 for the Adoration.

A

B

11 For an extended discussion of tokens with this inscription and liturgical overtones, see Pentcheva 2010, pp. 40–42.
12 Vikan 2010, pp. 52–53. Pentcheva 2010, p. 38, cites examples of tokens with filed sides and sees these as evidence that they were used medicinally.

References: (A) Campbell 1985, p. 80, no. 106; (B) Zapheiropoulou 2002, p. 38, cat. no. 50.

65A, B. Pilgrim Tokens with Images of Saint Symeon Stylites the Younger

...................

A. Pilgrim Token
Syria, 10th–11th century
Lead
H. 5.9 cm (2⅜ in.); Diam. 5.5 cm (2⅛ in.)
Inscribed: In Greek around the edge, + ΕΥΛΟΓΙΑ [Τ]ΟΥ ΑΓΙΟΥ ϹΥΜΕΩΝ ΤΟΥ ΘΑΥΜΑΤΟΥΡΓΟΥ ΑΜΗΝ (+ Eulogia [blessing] of Saint Symeon Thaumatourgos [miracle worker] Amen)
Provenance: Acquired by the Skulpturensammlung und Museum für Byzantinische Kunst in 1973.
Condition: The entire surface is corroded, and parts of the border are missing in two places.
Stiftung Preußischer Kulturbesitz, Staatliche Museen zu Berlin—Skulpturensammlung und Museum für Byzantinische Kunst, Berlin (32/73)

B. Pilgrim Token
Syria, 10th–11th century
Lead
Diam. 5.5 cm (2⅛ in.)
Inscribed: In Greek, around the edge, + ΕΥΛΟΓΙΑ ΤΟΥ ΑΓΙΟΥ ϹΥΜΕΩΝΟϹ ΤΟΥ ΘΑΥΜΑΤΟΥΡΓΟΥ ΑΜΗΝ (+ Eulogia [blessing] of Saint Symeon Thaumatourgos [miracle worker] Amen)
Condition: The entire surface is heavily corroded and worn. The border shows minor dents and signs of deformation.
Tsolozidis Collection, Thessaloniki, Greece (ΣΤ 7)

These two lead medallions belong to a closely related group of pilgrim tokens or blessings characterized by similar iconography,

a circular inscription on the obverse giving the name of Symeon the Younger around his depiction and with a cross on the reverse.[1] The tokens in Berlin and from the Tsolozidis Collection both show the bust of Symeon in monk's habit on top of a stout column, holding a book and accompanied by angels. Comparison with inscribed examples shows that the two figures flanking the column can be identified as Symeon's mother, Martha, and his disciple Konon.[2] A stylized ladder leads to the saint.

The overall iconographic scheme, including the ladder and the inscription, is already present on a stamped token in Bobbio made of sawdust and resin, which can be dated to the sixth to seventh century because of its close association with lead ampullae from the Holy Land of this date.[3] The arabesque-like, leafless scrolls ornamenting the crosses on the lead tokens in Columbia (Missouri), The Hague, and Princeton point to medieval, possibly Islamic, models and thus to a later date for the whole group.[4] This is supported by the design of the cross on the token in Berlin, whose pointed elements between the arms of the cross find equivalents in Middle Byzantine compositions.[5] After a long period of Muslim-Arab dominion, the region of Antioch came under Byzantine rule again between 969 and 1074. This seems to be a likely moment for the revival of Christian pilgrimage on a larger scale and thus for a market for pilgrim tokens, which, however, were modeled on an earlier iconographic scheme. GM

1 Verdier 1980 (with bibl. in notes); Vikan 2010, pp. 33, 84–85.
2 Cleveland Museum of Art, Norman O. Stone and Ella A. Stone Memorial Fund (CMA72.52); former Stoclet Collection, Brussels; Walters Art Museum, Baltimore (55.78): Verdier 1980, pp. 17–21, fig. 1, p. 19, fig. 6, p. 21, fig. 11.
3 Elbern 1965, pp. 289–90, fig. 7; Verdier 1980, p. 23, fig. 18. For the lead ampullae, see A. Grabar 1958. The iconography of Symeon the Younger is based on that of Symeon the Elder; see Vikan 2010, pp. 31–33, figs. 11, 17, 18.
4 First pointed out by Lafontaine-Dosogne 1967, pp. 146–47; Verdier 1980, p. 25. For examples from the Middle Byzantine period, see Evans and Wixom 1997, p. 221, fig. at the top; p. 187, fig. lower right, above the bust of the emperor; p. 208, cat. no. 143, suppedaneum; p. 212, fig. 14.
5 Goldschmidt and Weitzmann 1930–34, vol. 2, pl. V, no. 21b, pl. LXIII, no. 193.

References: (A) Wamser 2004, p. 211; Effenberger 2008, p. 65; (B) Zapheiropoulou 2002, cat. no. 51.

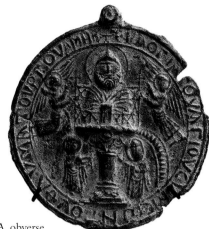

A, obverse

A, reverse

B, obverse

Mosaics during the Byzantine and Early Islamic Periods

Robert Schick

The use of colored stone cubes to produce artistic patterns on floors was an art form employed in the Mediterranean world since the Hellenistic period. In central Jordan, the focus of this short essay, the use of the mosaic arts to decorate both religious and secular buildings flourished between the fifth and eighth centuries, spanning the Byzantine and Early Islamic periods.[1] Almost every church building in the region had a mosaic floor, but plenty of secular buildings, as well as Muslim buildings in the later seventh and eighth centuries, also had mosaic floors. Some churches would have had mosaics of glass tesserae on the walls and semidomes of the apses, but only meager traces of these have survived. The larger mosaic floors are composed of hundreds of thousands of mosaic cubes and would have taken months to install.

Some mosaic floors were confined to geometric patterns of lesser or greater complexity, but many others included depictions of people and animals, often within an overall pattern of vine scrolls forming individualized vignettes. Scenes of daily life, pastoralism, agriculture, and hunting abound, including depictions of exotic people or animals that were not found in Jordan, such as in the mosaic in the diakonikon/baptistery at Mount Nebo, dating to 530 (fig. 41), along with renderings of buildings, personifications of such concepts as the seasons or the earth, and portraits of benefactors.

At times, mosaics provide clues to the social characteristics of the locals. For example, the mosaics in the church of Kayanus at 'Uyun Musa, north of Mount Nebo, Jordan (cat. no. 66), depicted a horseman with a spear and a camel driver, dressed in a loincloth and carrying a bow and a large sword, who can be identified as an Arab Christian soldier serving in the Byzantine military along the desert frontier.[2]

Many mosaic floors included dedicatory inscriptions that reveal what languages were in use. Although the bulk of the population were native speakers of Aramaic or Arabic—increasingly so after the Muslim conquest

of the 630s—most inscriptions were in the prestige language of Greek (cat. no. 66B). But a few were in a local dialect of Aramaic, called by scholars Christian-Palestinian Aramaic (cat. no. 66A).[3] One unique mosaic inscription from Khirbat al-Mukhayyat, near Mount Nebo, from about 535–36, may have been in Arabic (cat. no. 67). The mosaic inscriptions typically included people's names, whether the name of the local bishop, patrons, or, on occasion, the mosaicists themselves. Many of those names were Semitic, if not biblical or Greek.

The mosaics show that the locals were enthusiastic participants in Hellenistic culture. One secular mosaic in a building in the center of the city of Madaba from the mid-sixth century that depicted the characters in the classical Greek tragedy *Hippolytos* by Euripides shows this in most exuberant fashion (fig. 40).

Another spectacular mosaic showing classical motifs is found in nave and side aisles of the Church of Saint Stephen at Umm al-Rasas (fig. 11).[4] The mosaic, dating to 718,[5] that is, well into the Umayyad period, included vignettes of prominent cities both west and east of the Jordan River and cities in Egypt, Nilotic scenes including naked boys (putti)— very odd for a church—along with generic nature scenes and vignettes with individual animals and portraits of benefactors.

The Christians enthusiastically included images in their mosaic floors, but in the eighth century they systematically eliminated those images, often by carefully removing the cubes of the offensive images and then scrambling the cubes and putting them back in place (see Flood, p. 117). Their removal of the images often leaves detectable what the images originally were, such as most humorously in a church mosaic in Ma'in dated to 719–20, where the image of a bull has mostly been replaced by a tree and an amphora with a vine scroll, leaving the tail, hind legs, and front hooves intact (cat. no. 79B).

The motivation for the damage to the images remains an unresolved question. The

Fig. 40. Hippolytos Hall, Madaba, Jordan. Reproduced from Piccirillo 1992, fig. 3

Fig. 41. Old Diakonikon, Mount Nebo, Jordan

damaged images were not icons—images of Christ, the Virgin Mary, and the saints subject to veneration—but rather ordinary people and animals, making this phenomenon different from the roughly contemporaneous iconoclastic movement in the Byzantine Empire, where only icons and not secular images were the point of dispute. Opposition to the artistic depiction of everyday people and animals is similar to the Islamic view of images, but, in the absence of clear historical accounts of this episode, the reason Christians adopted a view of images paralleling that of their Muslim neighbors remains obscure.

The period when the damage took place continues to be a topic for debate, but it may have been in the first years after the Abbasid revolution of 749–50, when a new dynasty came to power in the Islamic caliphate. The mosaic in the apse of the Church of Saint Stephen at Umm al-Rasas, dating to 756, for example, used purely geometric motifs, unlike the earlier nave and aisle mosaics.[6] The mosaics in Muslim buildings normally used only geometric motifs, although the famous lion and gazelle mosaic from the bath in the Umayyad palace at Khirbat al-

Mafjar in Jericho was a spectacular exception (fig. 87).[7]

The mosaics bear further witness to the decline of the once-thriving Christian communities in the late eighth century. Completely illiterate repairs to accidental damage to the Greek inscriptions at Umm al-Rasas attest to the loss of knowledge of the Greek language, and evidence of the Christians needing to adjust to their Muslim rulers is shown by a shift in the manner of dating inscriptions. In the Byzantine period inscriptions were dated according to the era of the Province of Arabia, which began when the area of Jordan became part of the Roman Empire in 106 C.E., and also according to a fifteen-year tax cycle. Remarkably, the Christians continued to use both dating methods long after the Muslim conquest, but in the early Abbasid period the Christians shifted to using an era of the creation of the world for dating inscriptions, which thus no longer proclaimed residual loyalty to the Byzantine state. In any event, by that point in the late eighth century, mosaics were a dying art form, as the Christian communities declined and the Muslims developed other artistic interests.

66A, B. Mosaic Inscriptions from 'Uyun Musa

....................

A. Christian–Palestinian Aramaic Funerary Inscription

Early 6th century
Stone tesserae, white letters on a red background
96 × 103 × 15 cm (37¾ × 40½ × 5⅞ in.)
Inscribed: In Aramaic,

ܐܝܗ ܝܬܒܕ ܝܬܒܕ ܝܬܒܕ ܝܬܒܕ ܝܬܒܕ ܝܬܒܕ ܐܝܗ
ܐܝܗ ܝܬܒܕ ܝܬܒܕ ܝܬܒܕ ܐ ܝ

(The reader will keep the memory of the benefits of our master GY'N the priest and of his heirs who have provided the furnishings [of the church?] . . .)
Provenance: Part of the lower pavement of the Kayanus Church at 'Uyun Musa. The church was excavated by the FAI in 1983; the pavement was removed to be preserved and restored. The inscription has been on view in the Mount Nebo Interpretation Centre since 1999.
Condition: The mosaic is broken at the bottom but in good condition. It has been restored and fixed on a aerolam panel.
Franciscan Archaeological Institute–Mount Nebo, Custody of the Holy Land

B. Inscription Remembering the Benefactor Matrona

Second half of 6th century
Stone tesserae, red letters on a white background
74 × 111 × 15 cm (29⅛ × 43¾ × 5⅞ in.)
Inscribed: In Greek, ΥΠΕΡΣⲰΤΗ ΡΙΑΣΠΡΟΣϕΟ ΡΑΣΜΑΤΡⲰΝΑΣ (For the salvation [and] offering of Matrona)
Provenance: Part of the upper pavement of the Kayanus Church at 'Uyun Musa. The church was excavated by the FAI in 1983; the pavement was removed to be preserved and restored. The inscription has been on view in the Mount Nebo Interpretation Centre since 1999.
Condition: The mosaic is in good condition. It has been restored and fixed on an aerolam panel.
Franciscan Archaeological Institute–Mount Nebo, Custody of the Holy Land

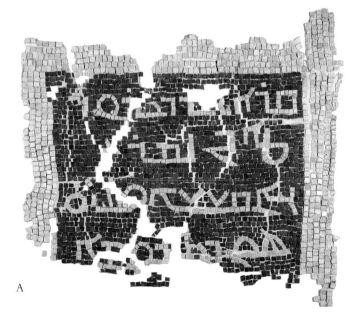

A

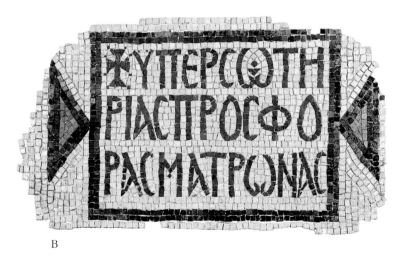

B

These two mosaic panels were found in the two-phase church/monastery given the modern name of the church of Kayanus, located in the valley of 'Uyun Musa just north of Mount Nebo, Jordan. The first-phase lower church was built as a funerary church in the early sixth century; the second-phase upper church was later constructed over it in the second half of the sixth century. The upper church seems to have gone out of use during the seventh century.

The four-line Christian-Palestinian Aramaic inscription was placed in the northern part of the sanctuary of the lower church (A), while the three-line Greek inscription was placed in the second inter-columniation of the south aisle of the upper church (B).

The Aramaic inscription mentions GY'N, Gaianus in Greek, a priest who with his family were benefactors of the church, or, less likely, Gaianus, the bishop of Madaba in the mid-fifth century.[1] Other Greek inscriptions in the first-phase lower church mention Obed, the archdeacon, and Salaman, the deacon and church steward, seemingly the mosaicists,[2] as well as other individuals with Semitic names, along with Bishop Cyrus of Madaba, in whose time in the early sixth century the church was dedicated.

In addition to the inscription identifying the benefactress Matrona, the mosaic floor of the second-phase upper church contains Greek inscriptions identifying other bene-factors as well as depicting in one only partially preserved panel a horseman with a spear and in another panel a camel driver, dressed in a loincloth and carrying a bow and a large sword, who is identifiable as an Arab Christian soldier, one of the Ghassanid tribal soldiers serving in the Byzantine military.

R S

1 Di Segni 1998, p. 455, preferring her readings to those of Piccirillo; see Puech 2011, p. 77, figs. 209–211.
2 Di Segni 1998, pp. 452–53.

References: Piccirillo 1989, pp. 205–16; Piccirillo and Alliata 1989; Piccirillo 1992, pp. 189–91; Di Segni 1998, pp. 455–56; Michel 2001, pp. 354–57.

67. Mosaic Fragment with a Pair of Goats

....................

Khirbat al-Mukhayyat, Jordan. ca. 535/36
Colored stone tesserae on a white background
343 × 315 × 15 cm (135 × 124 × 5⅞ in.)
Inscribed: In Greek at right, ϹΑѠΛΛ (Saola); perhaps in Arabic at left, بسلام (in peace)
Provenance: Part of the pavement of the southern sacristy of the Church of Saint George at Khirbat al-Mukhayyat, the village of Nebo. The hill and its ruins are property of the Custody of the Holy Land since 1932. The church was excavated in 1935; the mosaic was removed at that time. The mosaic has been in the FAI restoration lab on Mount Nebo since 2004.
Condition: The mosaic has been divided into thirteen pieces. It is in good condition and has been restored.
Franciscan Archaeological Institute–Mount Nebo, Custody of the Holy Land

This mosaic panel formed the floor of the southeast room flanking the apse of the Church of Saint George, one of four churches at the site,[1] dated by a dedicatory Greek inscription in the east end of the nave to 535/36.[2] Two goats flank a central palm tree, and two doves face each other above the tree; other stylized plants also flank the tree. To the right of the tree is a single word in Greek, "Saola," likely a funerary text invoking repose for an archdeacon named Saolos, who appears in two of the other Greek mosaic inscriptions in the church. To the left of the tree are a few problematic letters, perhaps in Arabic, "bi-salam" (in peace), although some scholars have identified the language as Christian-Palestinian Aramaic, with one possible reading, "Give repose [and] give salvation."[3] If Arabic, the inscription would be one of only a handful of Arabic inscriptions from the pre-Islamic period known in Syria-Palestine, and the only one in a mosaic floor. In the Early Islamic period the use of Arabic in mosaic inscriptions, even in Muslim buildings, remained rare.

R S

1 Saller and Bagatti 1949; Piccirillo 1989, pp. 176–200; Michel 2001, pp. 339–53.
2 Saller and Bagatti 1949, pp. 139–58; Piccirillo 1989, p. 180; Michel 2001, p. 344.
3 Puech 2011, p. 77, fig. 212; Hoyland 2010, pp. 29–37; Milik 1960, pp. 167–69.

References: Saller and Bagatti 1949, pp. 76, 171–72; Knauf 1984; Piccirillo 1989, pp. 177–81; Piccirillo 1992, pp. 178–79; Hoyland 2010.

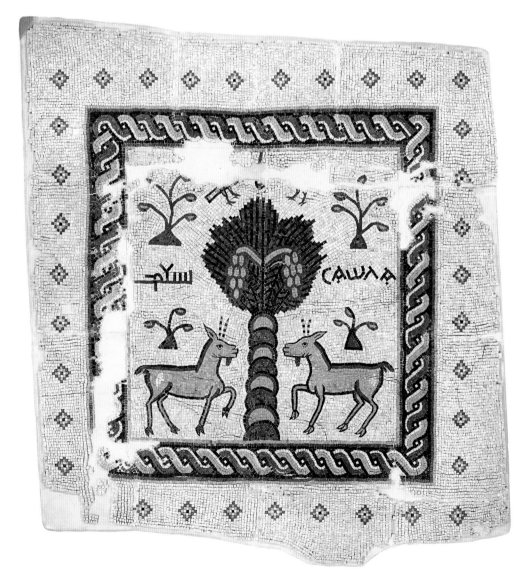

Jews and Judaism between Byzantium and Islam

Steven Fine

In his famous compendium of biblical sites in the Holy Land, the great fourth-century church father Eusebios of Caesarea (ca. 260–339 or 340) includes Naarah, a place mentioned in Joshua 16:7. Eusebios identifies Naarah with a locale called Noorath, writing that it "is now a village of Jews five miles from Jericho."[1] The site, built on a bluff overlooking the Jordan River, was known to Late Antique Jews as Na'aran, and in more recent times was called Ayn Duq, the "Spring of Duq." In September 1918, during the final months of World War I, troops from New Zealand discovered there a beautiful synagogue mosaic of the fifth to sixth century—struck soon after by an Austrian shell aimed at British military installations.[2] The synagogue of Na'aran provides an excellent lens for viewing the transition of Jewish culture from the world of Christian Rome to the Islamic Empire (figs. 42, 43, 50). Although transformed by its encounter with Islam, this minority culture maintained deep continuities with Jewish culture under Rome and Byzantium, and this ancient floor epitomizes those associations.

The Na'aran synagogue was a rather typical rural basilica of its age, with a large courtyard, a broad narthex, a large central nave, and two side aisles. It was the same architecture used in contemporary rural churches, and from the outside, it would have been hard to distinguish it from a church, except perhaps if there had been a Hebrew inscription or a seven-branched lampstand—a menorah—rather than a cross on the (now lost) lintel above the main portal. At the focal point of the synagogue, there was likely a broad apse (also lost), and within that, a large Torah ark that may have been flanked by menorahs. A richly patterned mosaic pavement, with a large zodiac panel in its center, decorated the entire floor (fig. 50). Zodiacs began to appear on synagogue floors during the late fourth or early fifth century (fig. 44) and remained popular well into the sixth. In fact, they continued within the Jewish milieu for centuries after they had fallen out of favor in the larger society due to Late Antique Christian hostility toward such imagery, which they regarded as pagan.[3] Jews had no such qualms. This difference is

likely owing to Judaism's abiding interest in the heavens, both for the practical reason of constructing Jewish time (particularly the lunar–solar calendar, and hence the dates of holidays) and relatedly, for the heavenly realm, considered the dwelling place of God and his divine court. These themes are well expressed throughout ancient Jewish literature—legal, homiletic, and liturgical—of the period.[4]

A second mosaic panel, before the Torah shrine, contained an image of a Torah ark, evoking the biblical Ark of the Covenant and flanked by seven-branched menorahs with suspended lamps for additional light, apparently a mirror image of the synagogue's actual furnishings, before which it was placed. Stone arks and large menorahs have been discovered at a number of locations. Images of Torah shrines and menorahs appear in both Jewish and Samaritan synagogue mosaics, in bas-reliefs, and on ritual objects (cat. no. 71). Most unusually, however, at Na'aran a man with his arms raised in prayer and flanked by lions appears below the ark. Statues and mosaic depictions of lions that heraldically protected the most holy section of the synagogue have been discovered. Labeled "Daniel" in Hebrew, this is the biblical Daniel, in the lions' den. A number of synagogues have floors decorated with biblical imagery, including the Binding of Isaac (Exodus 22), Aaron in the Tabernacle, Noah, and Daniel in the Lions' Den, who can also be seen on the base of a Torah shrine from the Golan Heights (fig. 45). The illustration of Daniel at Na'aran appears in the place where the synagogue prayer leader might stand. Rabbinic sources treat the biblical Daniel as the archetype for Jewish prayer.[5]

The synagogue pavement at Na'aran, like those of most synagogues discovered in Byzantine Palestine, was richly decorated with inscriptions composed in Jewish Aramaic, the spoken language of most rural Palestinian Jews during this period, Greek being more common in urban environments. Hebrew, which occurs occasionally, was by then mainly a literary and not a spoken language.[6] There was little difference between the Aramaic of the Jews, Samaritans, and Palestinian Christians. Jewish Aramaic, however, included many Hebrew loanwords and

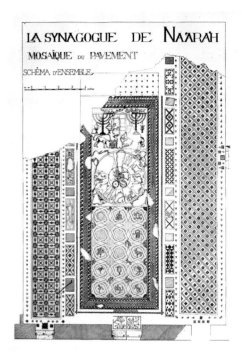

Fig. 42. Reconstruction drawing of the synagogue at Na'aran, floor plan. Published in Vincent 1961, pl. VI

was composed in a script, drawn from the letters of the Hebrew Bible, that could be read by Jews and a small group of Christian scholars (cat. no. 70). Similarly, Samaritan Hebrew and Aramaic were written in an ancient "paleo-" Hebrew script dating to biblical times, which in the general course of things only Samaritans could read. The Samaritan Israelites, as they now call themselves, trace their ancestry to the northern tribes of biblical Israel whose religious center was on Mount Gerizim in central Palestine (fig. 46).[7] While script served to distinguish Jewish and Samaritan public spaces even in Roman times, by Late Antiquity the scripts used by these communities were deeply symbolic markers of identity—a model that was likely not lost on early practitioners of Islam.[8]

The inscriptions at Na'aran provide rich evidence of public benefaction by individuals within this rural community, as seen in the following examples:[9]

> Remembered for good is Halifu, daughter of Rabbi Safra, who has supported this holy place. Amen.

Remembered for good each person who supports and contributes, or will [in the future] give in this holy place, whether gold, silver or anything else. Amen. Their portion is in this holy place. Amen.

Referring to the synagogue as a "holy place" reflects a long development that predates the destruction of the Jerusalem Temple in 70 C.E. The entire environment of the synagogue was designed to establish the sacred nature of the space, derived from Jewish interpretation of Scripture, particularly the presence of the scrolls of the Pentateuch—the Torah—and the sanctity of Jewish time, of the holy nation, and of God as "the Holy One, Blessed be He."[10] The design of the synagogue interior and even notions of a synagogue's holiness developed in conversation with contemporary Christian forms, and they drew inspiration from the religious architecture of the majority culture. One Christian writer, albeit a rather unsympathetic one, the rampaging monk Bar Sauma, accurately describes the brightness of light within a synagogue in Areopolis, biblical Rabbat Amon, in modern Jordan, and connects it to the Solomonic Temple:[11]

Nowhere was there a synagogue equal to this one, other than the temple that Solomon himself built in Jerusalem. It was built with large and carefully hewn stones, encrusted with silver and gold and lit with golden chandeliers.

The apses of numerous synagogues were enclosed with low fences drawn directly from Christian contexts, where they were called "chancel" screens.[12] In Scythopolis—biblical Beth Shean (rabbinic *Beishan*)—screens for synagogues and churches were made in the same workshops, a menorah added for a synagogue, a cross for a church (fig. 47). In the church, this screen separated the clergy from the laity; in the synagogue, where no similar hierarchy is known to have existed, it might have been explained as separating the greater "sanctity of the ark" from the lesser "sanctity of the synagogue [hall]." Significantly, the floors of the Beth Alpha synagogue and a Samaritan synagogue at Beth Shean just to the north of the city were both decorated with images of Torah arks

and menorahs by the same father-and-son team (figs. 48, 49). Even Christians occasionally used images of seven-branched lamps in burial contexts, on lamps, and on pilgrimage bottles (cat. no. 72), and, by the ninth century, to illuminate the church, the new "tabernacle of God."[13]

The synagogue of Na'aran was built at a time when Roman law forbade Jewish synagogue construction, a prohibition that was not uniformly enforced.[14] Beginning in the late fourth century, imperial legislators were forced to intervene when particularly zealous Christian clergy and their followers destroyed or took over synagogues for their own use. While at first Jewish synagogues (though not Samaritan ones) were protected, these protections eroded over the centuries. Jews and Samaritans in Byzantine Palestine were reasonably wealthy in the Christian holy land, reaping the economic benefits of Christian pilgrimages. Christians behaved toward Jews with scorn, pilgrims sometimes treating the local Jews and Samaritans—who together constituted the majority population—as ethnographic specimens, that is, as the vestigial (if occasionally ornery) natives of Jesus's past.[15] Evidence for legally sanctioned attacks on synagogues is plentiful, and it is thought that Christians burned the synagogue at Ein Gedi to the south of Na'aran on the Dead Sea.[16]

Many Jews saw the Islamic invaders as nothing less than harbingers of the Messiah, rescuing them from "the Evil Empire" made up of Bible-reading, deeply supersessionist Christian "pagans." Though Jews did not join

the Samaritans in revolting in 529, they reacted with messianic enthusiasm to the Sasanian invasion of Palestine in 614, apparently joining the Persians in burning numerous churches and perhaps massacring Christians in Jerusalem. The Persian defeat in 631, and the reassertion of Byzantine power, seem to have led to massacres of Jews.[17]

The advent of Islamic rule brought on significant changes in Jewish life, though continuities between the latter Byzantine and the Islamic periods were profound. On the local level, synagogues such as Na'aran were transformed through iconoclastic tinkering that brought the imagery of the synagogue in line with Muslim approaches to religious space (fig. 50). Thus, human and most animal images at Na'aran were removed from the mosaic with utmost care to preserve the pavement as a whole, while menorahs and inscriptions were left untouched. The floor was retrofitted to the new aesthetic of the new umbrella civilization. Jewish interpretation of biblical prohibitions regarding idolatrous imagery was epitomized by the so-called Second Commandment of the Decalogue (Exod. 20, Deut. 5), which had often been interpreted quite broadly in the late Roman and Byzantine period. With the coming of Islam, more stringent approaches prevailed.[18] Jews could thus differentiate themselves from the other "People of the Book"—the other *dhimmi*, that is, protected, though legally subject, population, the Christians. The nearby eighth-to-ninth-century synagogue at Jericho, being close to "Hisham's Palace" (Khirbat al-Mafjar), reflects

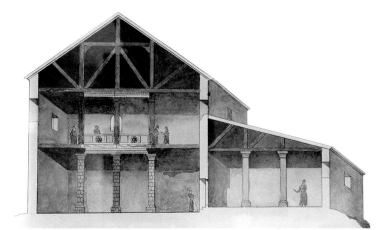

Fig. 43. Reconstruction drawing of the synagogue at Na'aran, vertical cross-section. Published in Vincent 1961, pl. VII

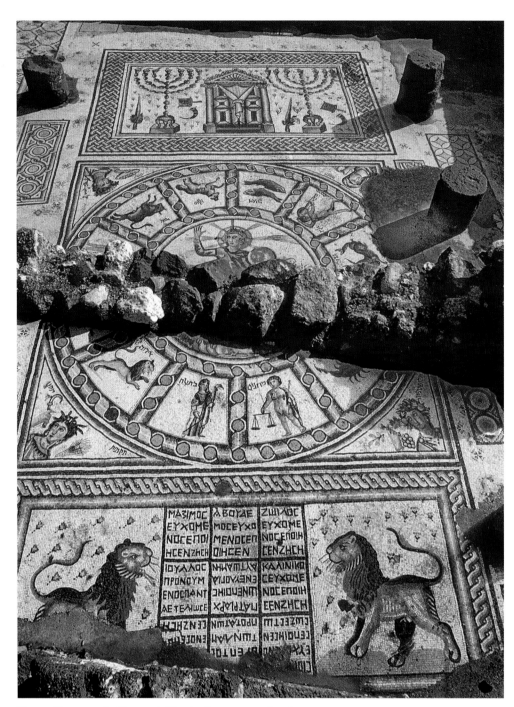

Fig. 44. Floor mosaic, Hammath Tiberias Synagogue, 4th–5th century

Jewish life, particularly in Tiberias, Jerusalem, Baghdad, and Cairo—both in Hebrew and increasingly in Arabic. Together with rabbinic texts, large codices of Scripture were meticulously composed. Punctuation signs that could maintain previously oral reading traditions were created, and a sophisticated form of notation developed. This notation system was sometimes formed by scribes in intricate calligraphic patterns called micrography; the calligraphic use of Arabic script by Muslims clearly reinforced and gave voice to Jewish interest in the symbolic and aesthetic aspects of Hebrew script (cat. no. 76).[22] This focus upon Scripture and its preservation parallels similar developments in the Christian, Samaritan, and Muslim communities. Jewish manuscripts, many associated with the Ben Asher family in Tiberias, became the standard biblical text for all future generations. As Aramaic fell out of use among Jews and was replaced with Arabic, rabbinic texts that had been composed in Aramaic during the Byzantine period were rewritten, and new books were composed in a kind of biblicized Hebrew. This emphasis on Scripture and on Hebrew as God's holy tongue comes from deep roots in Jewish tradition, particularly in Byzantine Palestine, but it also speaks to broader questions within the Islamic world regarding the relationship between language and Scripture. While the Samaritans continued to write in Aramaic, this now-literary language was increasingly influenced by Arabic.[23] As they moved to Arabic for their vernacular, Jews and Samaritans began to write treatises in Arabic, including legal works, philosophy, biblical exegesis, and biblical translations.

The Islamic occupation led to the development of a flourishing Jewish community in Jerusalem for the first time since 70 C.E.[24] Throughout much of Late Antiquity, Jews had been barred from living in the holy city, a prohibition that the church interpreted as punishment for killing Jesus and not accepting Christianity. On a social level, the coming of Islam effected deep restructuring within the Jewish community. This period saw a resurgence of the biblical priesthood, as Jews, again absorbing the Muslim model, attempted to assert and reassert biblical pedigrees. These efforts included claims of descent from the high priest Aaron and from King David. Those with messianic aspirations, including the heads of the rival rabbinic academies in Jerusalem and in Baghdad,

this transformation, as do illustrations that decorated Bible codices.[19] In the eighth-century Jericho synagogue, the image of the Torah ark is deeply geometrical and abstracted (fig. 51), not unlike the image of an ark (be it the Torah shrine, the Ark of the Covenant, or, likely, both) that appears in a ninth-century manuscript fragment discovered in Cairo, now in Saint Petersburg, and not so different from Muslim visions of the mihrab (cat. no. 76).[20] Here, a stylized menorah appears in a roundel of the synagogue, beneath it the biblical hope "Peace upon Israel" in Hebrew, in Jewish script (Psalm 25). While Islamic law often looked

unfavorably upon the public display of crosses, which were construed to be idols, no such strictures were applied to menorahs.[21]

Jewish literary output of this period suggests careful maintenance of ancient, or seemingly ancient, traditions. While the earliest evidence of written rabbinic text on parchment appeared in the scroll form, parallel to the Torah and Scripture, by the eighth century, Jews, like Christians and—more importantly—like Muslims, had adopted the codex form. A literary culture with deep roots in the rabbinic scholarship of the Roman and Sasanian empires developed at this time in the urban centers of

Fig. 45. Stone relief with Daniel in the lions' den, Ein Samsam Synagogue, 4th–5th century. Archaeological Museum of the Golan, Katzrin, Israel. Courtesy of the Israel Antiquities Authority

Fig. 46. Floor mosaic with Greek and Samaritan Hebrew inscriptions and two menorahs flanking Mt. Gerizim, Samaritan Synagogue, Shalabim, 6th century (IAA48-3001/1). Courtesy of the Israel Antiquities Authority

Fig. 47. Chancel screen with crosses, Massuot Yitzhak, the Negev. Marble, 6th–7th century. Israel Museum, Jerusalem (IAA53-4). Courtesy of the Israel Antiquities Authority

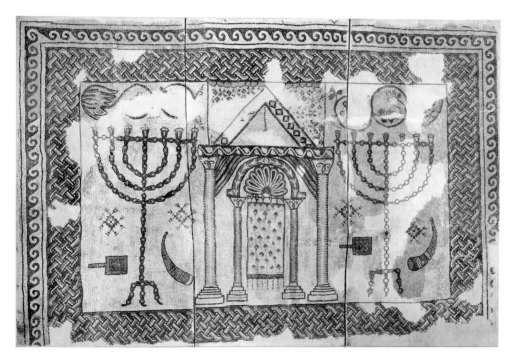

Fig. 48. Floor mosaic depicting the Ark of the Covenant flanked by two menorahs and ritual objects, synagogue at Beth Shean A, 5th–7th century. Israel Museum, Jerusalem (IAA1963-934/1-3). Courtesy of the Israel Antiquities Authority

were particularly keen on associating themselves with David.[25]

The ninth and tenth centuries witnessed a proliferation of these Jewish messianic groups, some originating as far away as Persia. Among the most interesting was an apocalyptic sect of extreme ascetics known as the *Aveilei Zion*, the "Mourners of Zion," who hoped to hasten the rebuilding of the Temple through emigration to Jerusalem.[26] From the polemics against the synagogues of the "Rabbanites"—those who continued to follow rabbinic tradition—written by a leader of this community, Daniel al-Qumisi, we learn both about the continued ritual life of that institution and something of the austerity of this sect:[27]

> And in the days of the Greek kingdom the Rabbis set a stumbling block before Israel by decreeing their own commandments that violated the words of God. They said to Israel: "We derive these commandments from the Torah itself [even though they were in fact of rabbinic origin, and not biblically ordained]. . . .

> And they set up [illicit] monuments in their synagogues and placed within [each] an "ark" and they prostrate to it, for they do not understand. And know this, that never in the [biblical] past was there an ark in any place of Israel other than the [singular divinely ordained] Ark of the Covenant of God [in the biblical Tabernacle]. They [the rabbis] placed "arks" in their synagogues in many places—in each and every synagogue, [placing] an [illicit] "ark."

Various groups that by the tenth century were congealing as the Qaraites, literally the "scripturalists," may have drawn from traditions dating to the first century C.E.

Sectarian documents known from the Dead Sea Scrolls were discovered in the repository of the Ben Ezra Synagogue—the Cairo Genizah—and Christian sources relate the discovery of ancient Jewish scrolls near the Dead Sea in the eighth century. In the tumult of the early Islamic period, Jewish groups broke from the Babylonian rabbinic leadership and formed a more Bible-centered separatist community, sparking a rich legacy of biblical interpretation, legal thought, philosophy, and grammatical studies within both communities. Perhaps emblematic of this schism, Qaraites, like Muslims, calculated their calendar on the basis of observation of the moon, unlike the Rabbanites, who were

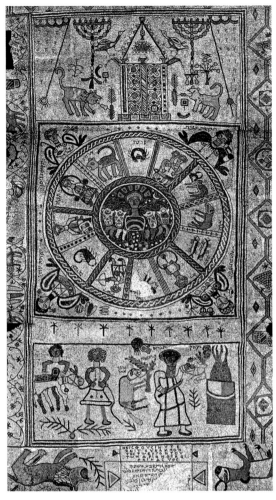

Fig. 49. Floor mosaic, Beth Alpha Synagogue, 6th century

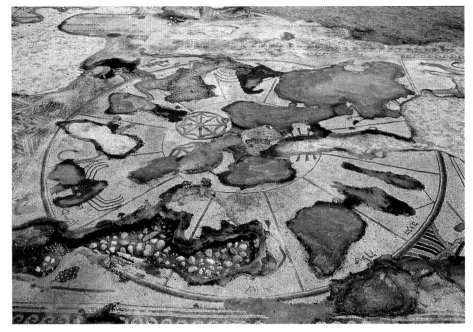

Fig. 50. Floor mosaic with zodiac panel, Na'aran Synagogue, 5th–6th century

in the process of developing mathematical formulas for intercalation that would standardize Jewish practice. Thus, Qaraite holidays fell on different days than those celebrated by the majority of Jews. Though Qaraite–Rabbanite polemics were often quite strident, there were nonetheless ample family relations between the larger Rabbanite and the smaller Qaraite communities.[28]

The transition from Byzantine rule to the world of Islam was indeed monumental for both Jews and Samaritans. The status of *dhimmi*, a subject, though essentially "protected" group, was far less disadvantageous to Jews under Late Antique Christianity, and somewhat better for the still-persecuted Samaritans (whose *dhimmi* status was less stable).[29] While the new construction of synagogues was officially limited, Judaism—and synagogue buildings—often flourished under Islamic rule.[30] Jews across the Middle East were transformed by the new umbrella civilization, even as they assumed a unique, if subject, place in the world of Islam.

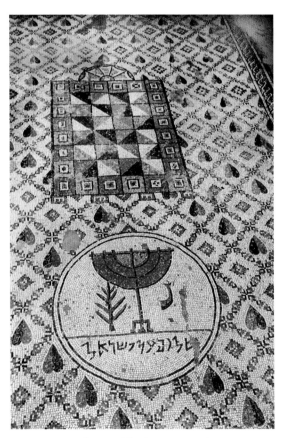

Fig. 51. Mosaic floor, Jericho Synagogue, 8th century

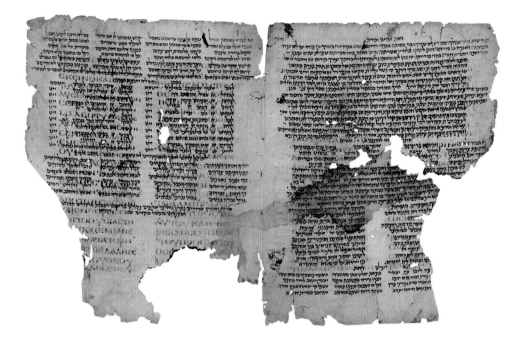

68. Palimpsest of the Hebrew Liturgical Poet Yannai over Aquila's Greek Translation of 2 Kings 23:11–27

....................

Egypt or Palestine (?), 5th–6th century; overtext, 9th–10th century
Ink on parchment; bifolium
Folio 1: 27 × 21.6 cm (10⅝ × 8½ in.); folio 2: 27 × 22.1 cm (10⅝ × 8¾ in.)
Provenance: From the Cairo Genizah. Held in the Ben Ezra Synagogue, Cairo, until 1896–97; gifted from Dr. Solomon Schecter (1847–1915) and Dr. Charles Taylor (1840–1908) to the University of Cambridge in 1898.
Condition: Both folios are badly torn. The Greek undertext has been scraped off and the parchment reused by the ninth- or tenth-century Hebrew scribe.
Cambridge University Library, Taylor-Schechter Genizah Collection, Cambridge (T-S 20.50)

This bifolium is part of a quire of six pages of poems by Yannai, a significant sixth-century Palestinian liturgical poet whose work was rediscovered in hundreds of fragments in the Cairo Genizah. Yannai composed poems (Hebrew *piyyut*) for each Sabbath and holiday, following a Palestinian triennial schedule of Torah reading. These pages include poems to Leviticus 13:29, 14:1, 21:1, and 22:13. Composed in elegant Hebrew, Yannai's poems expand midrashically—that is, based on a rabbinic interpretation—on the weekly readings, leading to the recitation of the Trisagion (Isaiah 6:3).

These pages of Yannai's poems were copied on reused parchment, a sixth-century manuscript of Aquila's Greek translation of 2 Kings 23:11–27, written in a majuscule script. Undertexts of other pages in the quire include the Gospel of John in Christian-Palestinian Aramaic and Origen's textual studies on the Psalms. Aquila, a proselyte, followed the hyperliteralist approach to biblical interpretation of his teacher, the early second-century rabbinic leader Aqiva, son of Joseph, who was executed about 132–35. The Tetragrammaton (Y. H. W. H., the four-letter Hebrew name of God, usually translated "Lord") is written in a stylized paleo-Hebrew script, a practice known among Jews during the latter Second Temple period from the Dead Sea Scrolls. This script was unique to Samaritans in later periods. We cannot know whether this manuscript was originally used by Greek-speaking Jewish communities, by Christian scholars, or perhaps by both at different times. Nonetheless, it gives visual expression to the decline of the use of Greek among Jews in the Early Islamic period, even as they maintained Late Antique liturgical sources in Hebrew.

SF

References: Burkitt 1897, pp. 5–32, pls. 3–6; Davidson 1919; Rabinowitz 1985; M. Brown 2006, pp. 249–50, cat. no. 5 (Ben Outhwaite); Lieber 2010.

69A, B. Fragments of a Synagogue Screen

....................

Israel, Ashkelon, 6th–7th century
Marble
Provenance: Two of three fragments from a chancel screen associated with the archaeological surveys of Charles Clermont-Ganneau (1846–1923).

A. Fragment with Menorah
18 × 45 × 10 cm (7¹⁄₁₆ × 17¹¹⁄₁₆ × 3¹⁵⁄₁₆ in.)
Condition: The fragment is in good condition.

B. Fragment with Inscription
18 × 61 × 9.5 cm (7¹⁄₁₆ × 24 × 3¾ in.)
Inscribed: In Greek, Θ(εές) β(οήθεια) ΚΥΡΑ ΔΟΜΝΑ Ιϑ[λιανοῦ? και κυ] / Ρ(ός) ΜΑΡΙ(ν) ΝΟΝΝϑ ΕΥΧΑΡ[ιστοῦντες] / ΠΡΟCΦΕΡѠΜΕΝ ΚΥΡ[ός—/—ἐγ]ΓΟΝΙΝ ΕΛΙΚΙΟΥ [εὐχαριστῶν] / ΤѠ Θ(ε)Ѡ Κ(αι) ΤѠ ΑΓ[ίῳ τόπῳ προσήνεγκ] / Α ΥΠΕΡ CѠΤΕΡ(ίας) ΚΥΡ(ος) ΚΟΜ(μοδος προσήν) / ΕΓΚΑ ΥΠΕΡ CѠΤΕΡ(ίας) [καὶ] / ΖΟΗΝ ΕΤϑC ΘΨ (God help Lady Domna, daughter of Ju[lianus, and / Lo]rd Mari, son of Nonnos, in grati[tude] / present. I Mas[ter . . . Gra]ndson of Helikias [present] / to God and to the Ho[ly places] / for my salvation. Master Com[modus presents] / for my salvation [and] / my life. The year 709.)[1]
Condition: The fragment is in good condition.
Deutsches Evangelisches Institut für Altertumswissenschaft des Heiligen Landes, Jerusalem (02-001, 02-018)

Fragment A is decorated in bas-relief on two faces: a large menorah appears on each side, with triangles set above each branch to represent its flames. Next to each menorah, a large beveled guilloche filled with rosettes of different forms decorates the face of the screen. To the left of each menorah is a *lulav* bunch, a ritual object consisting of a palm frond, willow, and myrtle twigs tied together at the base, and an *ethrog*, the citron used during Sukkot, the Feast of Tabernacles. Just to the right of the menorah is a shofar, a ram's horn with messianic significance associated with Rosh ha-Shanah, the Jewish new year. These features commonly appear together in depictions from Palestinian and diaspora communities, and distinguish Jewish menorahs from Samaritan or Christian representations.[2] The bottom of the slab contains a groove where it likely sat within a larger screen, perhaps of openwork as in the Gaza synagogue and on church chancel screens. Screens separating the large platform containing the Torah shrine from the rest of the hall were common in Byzantine-period synagogues. Two other extant pieces of this screen are of similar size and contain a fragmentary Greek inscription in bas-relief, divided by a broad band reminiscent of manuscript ruling similar to the one that appears on an Aramaic inscription,

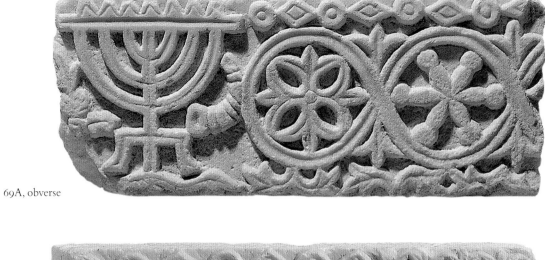

69A, obverse

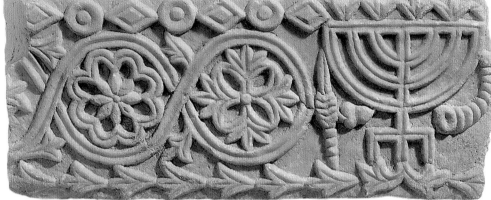

69A, reverse

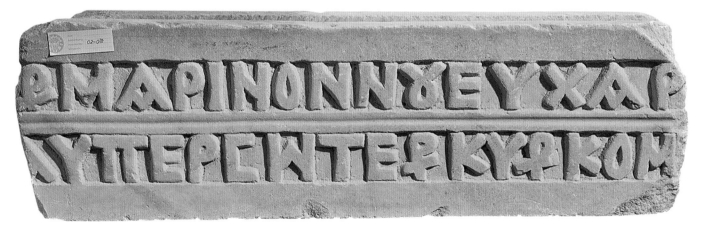

69B, obverse

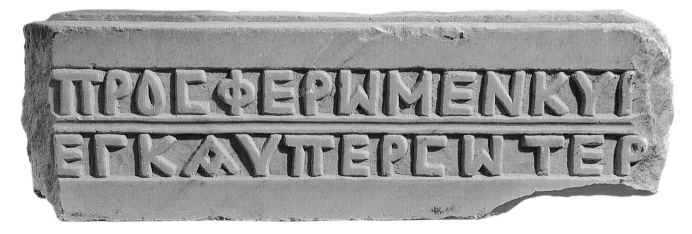

69B, reverse

also found at Ashkelon (cat. no. 70). The date on the inscription, 709, represents the local chronology used in the city of Ashkelon, which corresponds to the date 604/5 C.E.[3] The synagogue itself has not been discovered but, in addition to the present fragments and catalogue number 70, a column base bearing the image of a menorah has been found.

SF

1 Proposed reconstruction and translation following Roth-Gerson 1987, p. 25.
2 Fine 2010, pp. 158–60.
3 Following the reconstruction of Roth-Gerson 1987, p. 25.

References: (A, B) Clermont-Ganneau 1905; Sukenik 1935, pp. 62–67; Weitzmann 1979a, pp. 378–79; Roth-Gerson 1987, pp. 23–28.

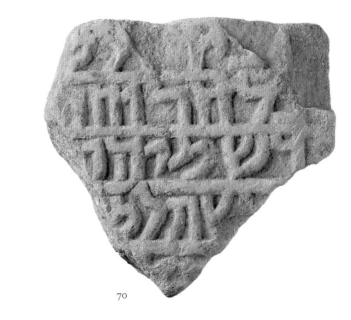

70

70. Fragment with Dedicatory Inscription

.

Israel, Ashkelon, 5th–7th century
Marble
26 × 29 cm (10¼ × 11⅞ in.)
Inscribed: In Aramaic,

<div dir="rtl">

]
כל חד וחד]
דשמיה ו]
שתלמ[]
]

</div>

(. . . each and every one . . . / of heaven and . . . / . . . sh.t.l.m . . .)
Provenance: Discovered at Ashkelon by Charles Clermont-Ganneau (1846–1923) during the archaeological survey (*Mission en Palestin et Phénicie*) undertaken in 1881 on behalf of the Ministère de l'Instruction Publique. The fragment entered the Musée du Louvre in 1882 or 1883.
Condition: The inscription is in fragmentary condition.
Musée du Louvre, Département des Antiquités Orientales, Paris (AO 1274)

Nearly one hundred dedicatory inscriptions in Aramaic, Greek, and occasionally Hebrew have been published from Late Antique Palestinian synagogues, many of which contained inscriptions in both Aramaic and Greek. These inscriptions commemorate the benefaction of synagogues on a subscription basis, similar to the ways that local Christian communities financed church construction. When Clermont-Ganneau discovered this one in Ashkelon, he also found three fragments of a chancel screen (cat. no. 69) and a column base bearing the image of a menorah, but not the synagogue itself.

Written in Jewish square script, this finely carved though fragmentary Aramaic inscription is the only extant synagogue dedicatory inscription to be carved in bas-relief rather than being incised. Too fragmentary to be translated, the text does include elements that are known from other sources. The phrase "each and every one," for example, commonly appears in rabbinic sources. Naveh suggests that "of Heaven" in line 3 might have been preceded by "Master," thus yielding the phrase "Master of Heaven." This divine appellation appears in literary sources as well as in a synagogue dedicatory inscription from Horvat Ammudim in the Galilee that refers to the synagogue, or some location within the synagogue, as the "Place of the Master of Heaven."[1] Aramaic held a place second to Hebrew,[2] which was dubbed "the language of the holy place" (that is, the synagogue and the Jerusalem Temple) in Aramaic biblical paraphrases (*Targumim*) and in Jewish liturgical contexts.[3] Aramaic was used for the nearly simultaneous translation/explanation of the Hebrew readings of Scripture (*Targum*) and for vernacular homilies. Jewish Aramaic was a vernacular language in Late Antique Palestine, even in the predominantly Greek-speaking cities of the coastal plain, where the inscription originates.

SF

1 Sokoloff 1990, p. 218, n. 2; Fine 2006, pp. 204–6.
2 Naveh 1978, pp. 40–41, 89–90.
3 Shinan 1992, pp. 248–50.

References: Clermont-Ganneau 1884, p. 71, pl. 1b; Dussaud 1912, pp. 71–72, no. 86; Naveh 1978, pp. 89–90; Fine 1996, p. 145, cat. no. 74.

71. Plate with a Menorah and Torah Shrine

.

Israel, Naanah, 4th–7th century
Bronze, incised decoration
Diam. 50 cm (9¹¹⁄₁₆ in.)
Provenance: Discovered at Naanah (near Kibbutz Naan), Israel, by Charles Clermont-Ganneau (1846–1923) during the archaeological survey (*Mission en Palestin et Phénicie*) undertaken in 1881 on behalf of the Ministère de l'Instruction Publique. The fragment entered the Musée du Louvre in 1882 or 1883.
Condition: This plate is fragmentary and shows signs of bronze disease. A section of the central disk that appears in an early drawing is no longer attached.
Musée du Louvre, Département des Antiquités Orientales, Paris (AO 1265)

An inhabited scroll patterned with blooming flowers decorates the scalloped rim of this large plate, while an incised seven-branched menorah and a Torah shrine occupy the center of the rim. A sequence of globular segments depicts the menorah, with each segment separated by a small line (the biblical calyx and flower, Exod. 25:31–6) and topped with a crossbar, flames rising. The gabled Torah shrine preserves a hint of a shell in its triangular gable.

Although this artifact is generally thought to be of Jewish origin, recent discoveries of Samaritan synagogues raise the distinct possibility that it served a Samaritan community. The menorah and Torah shrine resemble similar objects represented in Samaritan art, most specifically in the synagogue mosaic from el-Hirbe.[1] The flowers on the rim of the present plate parallel geometric patterning on a large plate shown with an array of dining utensils in the mosaic. As Ilan noted, the ark is likely flanked by what look like olive twigs, rather than the palm fronds and

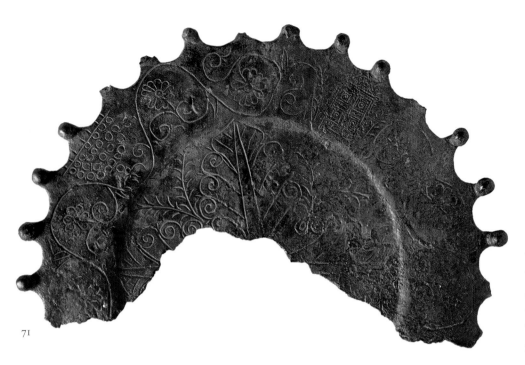

71

lulav bunches common in Jewish contexts.[2] *Lulavim* never appear in Samaritan art, as they are not part of the Samaritan celebration of Sukkot (the Feast of Tabernacles). Two square capitals were discovered at Naanah, one with the image of a wreath containing the Greek inscription *eis theos* (one god), a phrase common in Samaritan contexts (among Christians, rarely Jews), leading Clermont-Ganneau and, following him, Dussaud and Reeg to suggest their origin in a Samaritan synagogue.[3] Ilan notes that the remains of a large public building, perhaps a synagogue, have been noted at the unexcavated site of Naanah.[4] SF

1 Magen 2008, pp. 117–80.
2 Ilan 1991, p. 287.
3 Clermont-Ganneau 1884, p. 79; Dussaud 1912, p. 76; Reeg 1977, p. 622.
4 Ilan 1991, p. 287.

References: Clermont-Ganneau 1884, pp. 78–79, no. 62; Dussaud 1912, p. 76, no. 97; Reeg 1977, pp. 621–22; Ilan 1991, pp. 286–87; Fine 1996, pp. 118, 172, cat. no. 73.

72. Hexagonal Pilgrim's Jar with Jewish Symbol

..................

Jerusalem, ca. 578–636
8.1 × 7 × 7.7 cm (3³⁄₁₆ × 2¾ × 3¹⁄₁₆ in.)
Glass, mold-blown
Provenance: [P. Jackson Higgs (1931)]; Walter C. Baker, New York (1931 to 1971).
Condition: The flask is in good condition.
The Metropolitan Museum of Art, New York, Bequest of Walter C. Baker, 1971 (1972.118.180)

This hexagonal mold-blown glass flask is part of a larger group likely created in a single workshop in Jerusalem.[1] Decorations appear on all six of its sides in sunk relief and include an arch, a diamond-shaped lozenge, and the seven-branched candelabrum, or menorah, which is flanked on the right by a palm frond and on the left by a shofar (ram's horn) and rests upon a three-legged base, which is common in Jewish depictions. Flasks with images of the menorah were made in the same workshop as flasks bearing images of Christian import, most strikingly the cross set by Theodosius II atop Golgotha in the year 420 (cat. no. 60). Christian pilgrims filled these flasks with consecrated oil from the holy sites of Jerusalem and its environs, and they have been found at sites throughout the Mediterranean world.

72

The question of what Jews might have done with such bottles remains unanswered, particularly because Jews had limited access to Jerusalem during this period. Some scholars have connected Jewish use with a comment of the fourth-century Bordeaux pilgrim who described Jews ascending the Temple Mount on the anniversary of the Temple's destruction, the ninth of the Hebrew month of Av (roughly July). According to this account, Jews rent their garments and anointed a rock with oil,[2] so some scholars have suggested that Jewish flasks were used by Jewish pilgrims to carry consecrated oil. We have no external evidence, however, for such a practice. Flasks depicting the image of the menorah might also have been created by Christians for Christian pilgrims, as limited evidence for Christian use of menorahs during this period does exist, some of it from Byzantine Palestine.[3] SF

1 Weitzmann 1979a, pp. 386–88.
2 Barag 1970, pp. 54, 62.
3 See Fine 2010, pp. 158–60.

References: D. von Bothmer 1950, cat. no. 118; D. von Bothmer 1961, p. 78, cat. no. 301.

73A–C. Mosaics from the Hammam Lif Synagogue

..................

6th century
Stone tesserae

A. Mosaic of Menorah

57 × 89.5 × 4.4 cm (22⁷⁄₁₆ × 35¼ × 1¾ in.)
Provenance: Excavated from the Hammam Lif synagogue in 1883 under the direction of Ernest de Prudhomme;[1] 25 panels sold by Prudhomme's estate at auction in the Hôtel Drouot, Paris, on March 26, 1891; 21 purchased at auction by Édouard Schenk;[2] sold to the Brooklyn Museum in 1905 through Messieurs Rollins and Feuardent, with Henri de Morgan acting as agent.
Condition: Before arriving at the Brooklyn Museum, the mosaics were divided into rectangular panels, reset in cement, and decorated with black borders.[3]
Brooklyn Museum, New York, Museum Collection Fund (05.27)

B. Mosaic of Menorah with Lulav and Ethrog

57.4 × 88.8 × 4.4 cm (22⅝ × 34¹⁵⁄₁₆ × 1¾ in.)
Provenance: See A, above.
Condition: Before arriving at the Brooklyn Museum, the mosaics were divided into rectangular panels, reset in cement, and decorated with black borders. Comparisons of this panel with earlier drawings published by Ernest Renan reveal stylistic shifts from the panel's original composition.[4] The basic shape and dimensions of this menorah resemble their depictions in earliest drawings, except the branches of the menorah are somewhat truncated. The

symbols on either side of the menorah, moreover, appear significantly transformed. Alterations to the image may result from considerable modern restoration associated with the sale of the mosaics on the antiquities market, which preceded their acquisition by the Brooklyn Museum in 1905.[5]

Brooklyn Museum, New York, Museum Collection Fund (05.26)

C. Mosaic of Lion

74.5 × 107.3 × 4.1 cm (29⁵⁄₁₆ × 42¼ × 1⅝ in.)

Provenance: See A, above.

Condition: Before arriving at the Brooklyn Museum, the mosaics were divided into rectangular panels, reset in cement, and decorated with black borders. The black tesserae forming an undulating line beneath the lion's feet, as seen in Renan's original watercolor (fig. 52), was replaced by the modern black border, which now extends along each side of the panel.

Brooklyn Museum, New York, Museum Collection Fund (05.18)

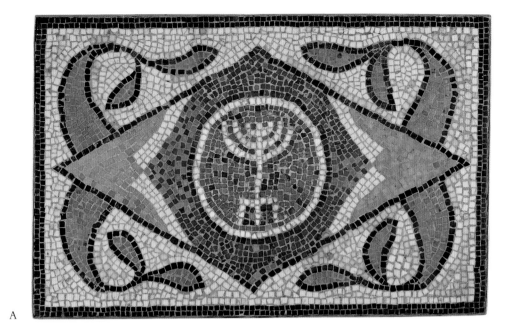

A

In the late nineteenth century, French soldiers stationed in the town of Hammam Lif, about ten miles (sixteen kilometers) south of Tunis, Tunisia, discovered an inscribed floor mosaic that explicitly identified the site as a *sancta sinagoga* (holy synagogue). These three mosaic panels represent portions of the synagogue's original floor.

Watercolors painted soon after the discovery of the central hall of the synagogue (fig. 52) record the original positions of four decorative mosaic carpets of disparate size and iconography.[6] Most of the motifs on the floor so closely align with regional conventions in mosaic design (cat. no. 67) that one archaeologist initially declared that the associated structure might be a Byzantine church.[7] The presence of two candelabra, called menorahs in Jewish ritual contexts, in the central mosaic, as well as a Latin dedicatory inscription that explicitly called the building a *sinagoga*, prompted scholars to revise this classification.

Panel A portrays a menorah with seven curved branches and a tripod base. Its shape resembles that of menorahs depicted on North African Jewish epitaphs and on the mosaic floors of synagogues from Roman and Byzantine Palestine and elsewhere in the Byzantine East. The design of menorah panel B resembles the first but includes two additional symbols; these are variously identified either as stylized representations of a scroll or as ritual objects, such as an *ethrog* (citron) and a *lulav* (date-palm branch), belonging to the pilgrimage festival of Sukkot (the Feast of Tabernacles) in biblical texts. Clusters of symbols, such as the menorah, *ethrog*, *lulav*, and shofar (ram's horn), as well as the

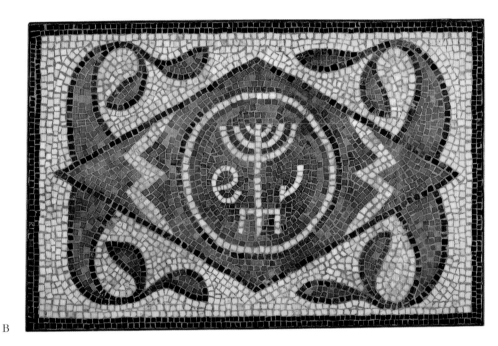

B

C

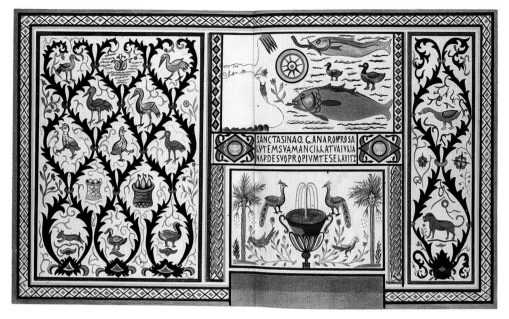

Fig. 52. Floor of the Hammam Lif Synagogue. Watercolor by Corporal Peco, 1883. Geometric patterns with *xenia* (still-life) motifs dominated the northern and southern portions of the room; these included diamond-shaped foliate grids inset with baskets of fruit, fowl, quadrupeds, and red flowers. An upper central panel combined land and nautical scenes and included large fish swimming with ducks; below was a symmetrical composition of peacocks, small birds, and date palms, which flanked a krater, or large jar, overflowing with water. Reproduced from Renan 1884, pls. VII, VIII

incense shovel, commonly appear in Late Antique synagogue iconography.[8] The original position of the two menorahs and the addition of a third menorah, following the last letter of the central dedicatory inscription, clearly associate the building with Jewish populations.[9] Scholars generally consider the menorah to be a quintessentially Jewish symbol.[10]

The image of a striding lion, C, originally occupied a central portion of the foliate geometric grid that covered the southeastern portion of the hall of the Hammam Lif synagogue (fig. 52). In ancient synagogue floor mosaics discovered in modern Israel, pairs of lions often frame dedicatory inscriptions or images of Torah shrines or the destroyed Jewish Temple of Jerusalem (figs. 44, 49).[11] During Roman rule in North Africa and elsewhere in the Mediterranean, lions pervaded mosaic scenes of the hunt and gladiatorial contests or joined other wild animals associated with Orphic or Dionysiac processions. Following the Byzantine conquest, images of lions inset in geometric fields, alongside other types of animals, birds, and vegetation, decorated an increasing number of the floors of private villas, basilicas, and churches.[12] Therefore, the presence of the lion in the Hammam Lif floor is in

keeping with prevailing regional mosaic designs of the period.[13] The availability of mosaic pattern books throughout these regions may account for the widespread stylistic similarities in floor decoration.[14]

The design of the mosaic floor of the Hammam Lif synagogue integrates distinctly Jewish iconography and regional decorative motifs. These three panels, for example, use Jewish symbols alongside imagery typically seen in neighboring Byzantine Christian and early Islamic settings—juxtapositions attesting to the complex dynamics that informed the decoration of synagogues in Late Antiquity.

KS

1 Recognizing the importance of his soldiers' findings, Captain Ernest de Prudhomme initiated an amateur excavation of the site. Prudhomme anticipated that the sale of elements from the building would be lucrative on the European art market. He commanded his soldiers to excise its decorative mosaics, which he sent to Toulouse for restoration and sale. For a recent discussion of the discovery and treatment of the synagogue, see K. Stern 2008, pp. 216–18; also Bleiberg 2005, pp. 37–39.

2 The other four mosaics, including three with inscriptions, are now in the Bardo Museum in Tunis. The remainder of the mosaics were lost or destroyed during their excavation or transfer. For photographs and transcriptions of the Bardo mosaics, see K. Stern 2008, pp. 224, 226, 231; cf. Darmon 1995.

3 The division of the panels is extensively described in Biebel 1936.

4 Renan 1884, pl. IX.

5 Discussion of this restoration in Biebel 1936; Wharton 2000, p. 210.

6 Two paintings of the floor produced soon after its discovery are published in Kaufmann 1886, pp. 48–49; Renan 1884, pls. VII, VIII.

7 Kaufmann 1886, pp. 48, 59; Renan 1884, pp. 274–75. Close comparison also reveals stylistic similarities with the mosaic floor of the Church of El-Moussat (Darmon 1995).

8 Combinations of these elements adorn Jewish burial markers discovered in North Africa, Egypt, Israel, and Turkey and appear in paintings discovered in Jewish mortuary contexts in Israel and Italy. They also decorate the central areas of certain Roman gold glasses; gold glasses, in secondary use, were plastered into tombs within Roman catacombs associated with Jewish and Christian populations in Late Antiquity. For additional discussion, see Rutgers 1995, pp. 81–85.

9 The transcription of the Latin text reads: *Sancta[m] Sinagoga[m] Naron pro salut[e] su[a] ancilla tua Iulia NaP de suo prop[r]io tesselavit* (Your servant Iulia NaP [of Naro] tiled [this mosaic] for the holy synagogue of Naro, for the sake of her salvation, from her own coffers); see the discussion of this inscription in K. Stern 2008, pp. 231–41. This transcription and translation of the text follow my analysis of the mosaic in the Bardo Museum in 2003.

10 Hachlili 2001, pp. 1–3.

11 In Byzantine synagogues discovered in Israel, for example, lions also flank images of menorahs (Ma'on Nirim) or depictions of Torah shrines (Beth Alpha; fig. 49). At other times leonine figures flank donor inscriptions encircled by wreaths (Sepphoris, Hammath Gader, Hammath Tiberias [fig. 44], Na'aran), while in multiple instances, they represent the sign of Leo inside zodiac wheels (Na'aran, Beth Alpha, figs. 49, 50). In still other synagogues, lions appear in geometric friezes (Na'aran), or in stylized motifs. See Hachlili 2009, pl. XI.1a, fig. II.2a, fig. IX-1.

12 A close chronological analogue to this geometric frame for the animals, in particular, has been discovered in the nearby Church of El-Moussat in Tunisia. See Darmon 1995; K. Stern 2008, pp. 218–25.

13 Lions have also been discovered in the geometric mosaics of churches in Jordan such as 'Uyun Musa, Mount Nebo; see Hachlili 2009, pl. VI.10.

14 Dunbabin 1999, pp. 300–303; Hachlili 2009, pp. 243–80, 286.

References: (A) Kaufmann 1886; Biebel 1936; Hachlili 2001; Bleiberg 2005; K. Stern 2008; (B) Renan 1884; Rutgers 1995; Hachlili 1996, p. 111; Wharton 2000; Fine 2005; (C) Darmon 1995; Dunbabin 1999; Levine 2005; K. Stern 2008; Hachlili 2009.

74. First Gaster Bible

..................

Egypt or Palestine, 9th–10th century

33 × 24.2 cm (13 × 9½ in.)

Ink and pigments on parchment with gold leaf ornamentation; 40 folios

Provenance: Collection of Moses Gaster (1856–1939) until 1924 (Cod. G. 151); purchased by the British Museum on April 12, 1924; transferred to the British Library with its foundation in 1973.

Condition: Only forty leaves of this manuscript of the Hebrew Bible survive, containing almost thirty Psalms and fragments of Ezra, Nehemiah, Ruth, and Proverbs.[1] The texts and margin illuminations are in good condi-

74, fols. 14v–15r

tion, though there is deterioration and tearing in almost all the margins, as well as some fading and tearing in the marginal illuminations.
The British Library, London (Or.9879)

One of the earliest examples of Near Eastern Jewish manuscript illumination in existence, this Bible has a single column of text, surrounded by scroll and floral motifs in the margins. Blue, gold, and red foliate scroll patterns fill the gaps between the verses of the Psalms, which are written in hemistichs, while gold floral and geometrical motifs fill the open spaces. The decoration of the First Gaster Bible parallels early Qur'an manuscripts more than it does other extant Jewish manuscripts, and some scholars have suggested that it represents the only surviving example of an alternate Near Eastern Jewish scribal tradition.[2] The square Hebrew script that was developing at the time can be seen in this manuscript. It resembles the formality of Kufic script; the lengthened ascenders and descenders recall the fluidity of Arabic script.[3]

The Gaster manuscript is part of a larger project among Jews in the late Byzantine and early Islamic world to develop philological tools for the standardization of the biblical text. This process, which parallels similar developments among Christians and Muslims, led to the adoption of the codex form for the creation of standard rabbinic study Bibles. The traditional notation of vocalization, referred to in Hebrew as the *Masorah*, includes vocalization and cantillation marks, as well as marginal notes that call attention to rare words, phrases, and variant readings.[4] This manuscript reflects a less developed form of the Tiberian Masorah,[5] the most refined example of which is the Aleppo Codex of 920. YS and SF

1 Gaster 1901, p. 234.
2 Avrin 1974, vol. 1, p. 209.
3 See Beit-Arié 1992, p. 37.
4 Tov 2001, pp. 6–8.
5 Gaster 1901, p. 237.

References: Gaster 1901, pp. 234–39, pl. 2; Avrin 1974, vol. 1, pp. 209–10, vol. 2, pl. 84; Narkiss 1990, p. 36, fig. 22; Beit-Arié 1992; Tahan 2007, pp. 18–19.

75. First Saint Petersburg Pentateuch
.

Egypt (?), 929
Text block: 31 × 30.4 cm (12³⁄₁₆ × 11¹⁵⁄₁₆ in.);
folio II: 42 × 38 cm (16⁹⁄₁₆ × 14¹⁵⁄₁₆ in.)
Ink and pigments on parchment; v + 242 folios
Provenance: The manuscript is one of sixteen thousand Hebrew manuscripts acquired in the nineteenth century by Abraham Firkovitch (1786–1874) and sold to the Imperial Public Library (now the National Library of Russia) in Saint Petersburg between 1862 and 1876. He is believed to have acquired most of his collection from the Cairo Genizah.[1]
Condition: The manuscript is not bound. There are losses of parchment around the margins. Folio II is badly damaged: the lower section of the page is missing and the margins are torn. The pigment has peeled in some places. The manuscript was restored in the 1960s.
The National Library of Russia, Saint Petersburg (Hebrew II B 17)

Characteristic of early Near Eastern Jewish illuminated Bibles, the First Saint Petersburg Bible is written in a vertical columnar format (three columns in the Pentateuch),[2] with intensive systems of grammatical and linguistic glossing in the margins and vocalization according to the Masoretic system of notation.[3] The columnar format recalls biblical scrolls, and ornamental motifs decorate the end of each of the five

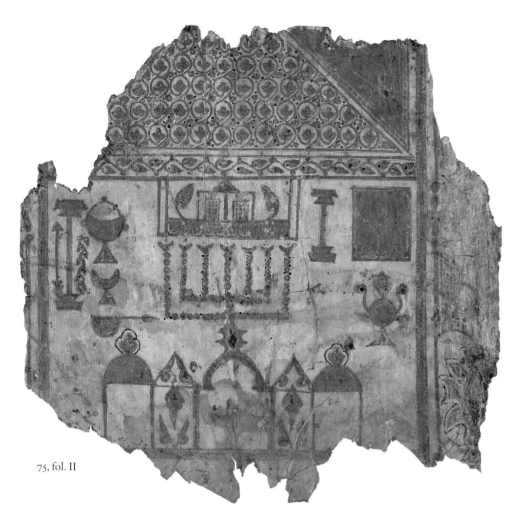

75, fol. II

books of the Torah. According to the colophons, Solomon Levi ben Buya'a, who wrote the Aleppo Codex, served as scribe, and his brother Ephraim executed the Masoretic apparatus.

Bearing resemblance to Late Antique Torah shrines, a carpet page on folio II depicts the biblical tabernacle/Jerusalem Temple and its implements: a large squared menorah stands in the center between a monumental arched entrance to the tabernacle/temple court, and what is likely the biblical Ark of the Covenant. The two large leaves that flank the Ark have been interpreted as representations of the biblical cherubim.[4] To the left and right stand various temple vessels, including an incense burner, which resembles contemporary implements of the Islamic period. This combination of imagery—bringing together tabernacle, temple, and synagogue—typifies both Late Antique Jewish art and Jewish thought of this period. Qaraite and later Rabbanite authors describe the biblical codex as a *miqdashiyya* (temple).[5] For Qaraites in particular, the Bible became a symbol of national and messianic aspirations, and carpet pages featuring symbolic diagrams of the Jerusalem Temple and its implements frequently appeared

at the beginning of biblical codices of the Islamic world.

YS and SF

1 See Narkiss 1990, pp. 18–31.
2 No examples of a manuscript punctuated with the Tiberian vocalization but not in the three-column format survive. See Beit-Arié et al. 1997, p. 23.
3 Avrin 1974, vol. 1, pp. 196–97.
4 Ibid., p. 204.
5 See Narkiss 1990, pp. 33–34.

References: Roth 1953, pp. 28–29, pl. 9a; Narkiss 1969, pp. 42–43; Günzburg and Stasov 1989–90, p. 12, pl. XI; Narkiss 1990, pp. 47–49, fig. 22; M. Brown 2006, pp. 101–2, fig. 20, pp. 115, 251–52; cat. no. 7.

76. Illuminated Carpet Page Depicting the Ark of the Covenant
....................

Egypt, late 10th century
41.5 × 37.5 cm (16�5⁄16 × 14¾ in.)
Ink and pigments on parchment
Provenance: The manuscript is one of sixteen thousand Hebrew manuscripts acquired in the nineteenth century by Abraham Firkovitch (1786–1874) and sold to the Imperial Public Library (now the National Library of Russia) in Saint Petersburg between 1862 and 1876. He is believed to have acquired most of his collection from the Cairo Genizah.[1]
Condition: The page is fraying at the edges, and the upper right corner is torn.
The National Library of Russia, Saint Petersburg (Hebrew II B 49)

This manuscript page is the most elaborate surviving Jewish carpet page from the early Islamic Near East. The rectangular form in the center and the triangular gable that surmounts it are outlined in the intricate calligraphic patterns known as micrography, recalling the use of verses to decorate synagogue arks in the Islamic world.[2] This composition has been interpreted to represent the Ark of the Covenant, and some scholars even see two tablets of the Ten Commandments at its center.[3] Arches, referring to the mihrab, were a common theme in Muslim carpet pages. It is possible that in Jewish contexts this image represents a conflation of the biblical Ark and the synagogue ark, a phenomenon that appeared first in the Dura-Europos synagogue paintings (245) and appears in rabbinic literature from about the same time.[4] The biblical verses that appear in the micrography of our page—celebrating God and the Torah—support this interpretation: "For the Commandment is a lamp and Torah is light" (Prov. 6:23), "The father of the righteous will greatly rejoice; he who begets a wise son will be glad in him" (Prov. 23:24), "For that will be your wisdom and your understanding in the sight of the nations" (Deut. 4:6), and "Blessed be the Lord, the God of Israel" (Ps. 41:14). Resulting from the Masoretic scribes' search for novel modes of presentation, Jewish micrographic art parallels the prominence of the word in Islamic art.[5]

YS and SF

1 See Narkiss 1990, pp. 18–31.
2 Perhaps the most significant extant example is the wooden Torah ark door of the Ben Ezra synagogue, now jointly owned by Yeshiva University Museum, New York, and the Walters Art Museum, Baltimore (64.181).
3 Narkiss 1990, p. 61; for published examples, see Tahan 2007, p. 53.
4 Fine 1997, pp. 45–46, 67–80, 112–21.
5 Narkiss 1990, p. 38; Avrin 1981, pp. 44–47.

References: Revel-Neher 1984; Günzburg and Stasov 1989–90, p. 12, pl. XI; Narkiss 1990, pp. 60–61, pl. XI; Levy 1993–94; M. Brown 2006, pp. 117, 252–53, cat. no. 9 (Herbert L. Kessler).

77. Qaraite Book of Exodus
....................

Egypt, 1005
24 × 18 cm (9�7⁄16 × 7�１⁄16 in)
Ink and pigments on paper; 21 folios
Provenance: One of 145 mostly Qaraite manuscripts acquired by the British Museum from Moses W. Shapira (1830–1884) in July 1882. The manuscript was transferred to the British Library with its foundation in 1973.
Condition: The manuscript, which is fraying at the edges, is also incomplete, with only Exod. 1:1–8:5 surviving. A

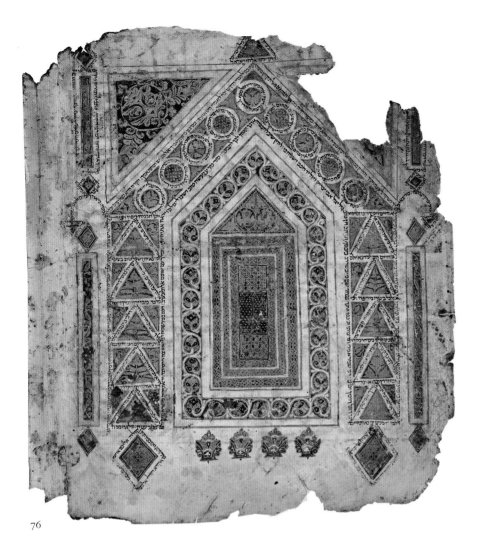

76

binder used in an attempt to mend the small holes in each of the leaves has rendered the text less distinct.[1]
The British Library, London (Or.2540)

Beginning during the Early Islamic period, Rabbanite and Qaraite Jews wrote religious texts in Arabic, in both Arabic and Hebrew characters (later known as Judaeo-Arabic). Only the Qaraites, however, transliterated the Bible into Arabic.[2] This manuscript is rendered in a *nakhshi* Arabic script on brown paper. Foliate patterns, rosettes, geometric designs, and intertwined chains in gold with red and green accents decorate the spaces between verses and major chapters, with gold lettering in the margins. The Tiberian Masoretic vocalizations that normally appear in Hebrew texts can be seen here in red ink beneath the Arabic consonants, while the *tashdid* signs—accents indicating long consonants—are in green.[3] The manuscript has two carpet pages patterned after leather book covers, each containing a rectangular frame, with script in black, red, and gold ink set within consecutive bands of geometric and floral patterns. Folio 2 verso contains a medallion decorated in a palmette motif to the left of the frame, representing the clasp of a leather bookbinding.[4]

77, fols. 18v–19r

Although paper came into use for Jewish sacred texts during the eleventh century,[5] very few paper codices from this period survive. Unlike the other surviving biblical manuscripts of the early medieval Levant, written on parchment in a tri-column format, this manuscript is written in one column, and its illuminations are paler and of a sketchier quality than other surviving examples.[6]

YS and SF

1 Hoerning 1889, p. 1.
2 Beit-Arié et al. 1997, p. 18.
3 M. Brown 2006, p. 273.
4 See Avrin 1974, vol. I, p. 198; Narkiss 1990, p. 35.
5 Beit-Arié et al. 1997, p. 20.
6 Avrin 1974, vol. I, pp. 210–11.

References: Hoerning 1889, pp. 1–20; Avrin 1974, vol. I, pp. 210–11; Sklare 2003, p. 899; M. Brown 2006, pp. 162–63, 273, cat. no. 33 (Ilana Tahan); Tahan 2007, pp. 16–17.

78. Bifolium from a Children's Alphabet Primer

....................

Egypt, 9th–12th century[1]
Blue, red, and yellow ink on parchment; bifolium
16.7 × 23.4 cm (6⁹⁄₁₆ × 9³⁄₁₆ in.)
Provenance: From the Cairo Genizah. Held in the Ben Ezra Synagogue, Cairo, until 1896–97; gifted from Dr. Solomon Schecter (1847–1915) and Dr. Charles Taylor (1840–1908) to the University of Cambridge in 1898.
Condition: The bifolium exhibits wear on the edges; there is significant tearing in the upper right corner and right edge of the recto.
Cambridge University Library, Taylor-Schechter Genizah Collection, Cambridge (T-S K5.13)

This children's alphabet primer opens with a polychromatic carpet page depicting a large arch reminiscent of a mihrab, with a lamp suspended from its apex. Below is a lighted seven-branch menorah, flanked by two six-pointed stars (beginning in the early modern period, called the Star of David, a term seldom used in medieval sources).[2] The second and third leaves contain the first five letters of the Hebrew alphabet, each letter punctuated with all possible vocalizations. The scribe wrote the letters and vowel points on the verso as outlines. Students using the primer were meant to fill in the outlines with different colors in order to learn how to form the letters properly.[3]

More than one hundred fragments of Hebrew alphabet primers for children were discovered in the genizah of Ben Ezra Synagogue in Fustat (Old Cairo), reflecting the high value set on reading scriptural, liturgical, and Talmudic texts in the original Hebrew and Aramaic even after Arabic had become the vernacular.[4] They seem to have been given to children first learning to read and write, and typically contain the letters of the Hebrew alphabet with and without vocalization points, followed by verses from the book of Leviticus, the first part of the Bible taught to children in medieval Jewish schools.[5] Following developments in Late Antiquity, literacy, especially for males, was highly valued in medieval Jewish society. Hebrew characters were used for writing in both Hebrew and Arabic.[6]

YS and SF

1 Narkiss 1972, p. 63.
2 See Scholem 2008.
3 Olszowy-Schlanger 2003, p. 60.
4 Ibid., p. 57.
5 Narkiss 1972, pp. 63–64.
6 Reif 1990, pp. 148–49. Most males achieved basic literacy in Hebrew (ibid., p. 152).

References: Narkiss 1984, p. 28; Reif 1990, pp. 148–49; Reif 1998, p. 8; Reif 2000, p. 223, fig. 53; Scholem 2008.

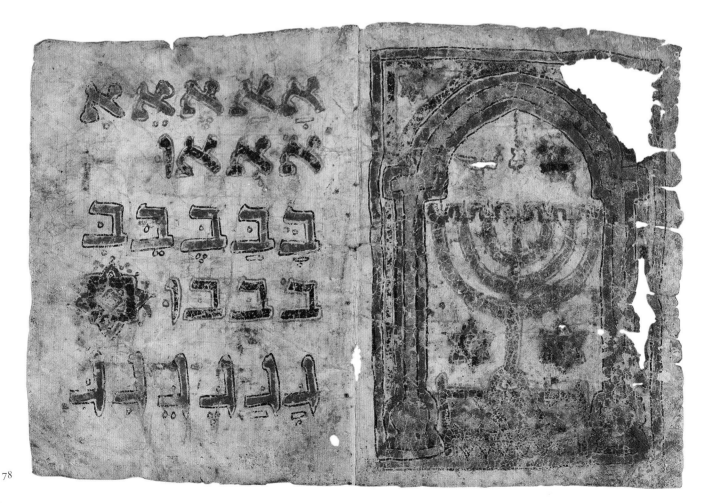

78

Christian Mosaics in Early Islamic Jordan and Palestine: A Case of Regional Iconoclasm

Finbarr B. Flood

The floor mosaics in catalogue number 79 provide two examples from the roughly sixty Byzantine and Umayyad-era churches in Jordan and Palestine that show signs of extensive alterations to their content. While inscriptions and images of inanimate objects are untouched, depictions of animal and human figures have been altered in a variety of ways. In some cases, the tesserae composing them have been deliberately scrambled and reused to "pixelate" faces, limbs, and torsos; in others, images of animate beings have been replaced by vegetation, sometimes by transforming background motifs into the primary subject; in a fascinating minority of cases (including cat. no. 79), animal and human figures have literally been transformed into flowers and plants.

Recent studies of these alterations suggest that the majority occurred approximately between the 720s and 760s; after this date, new mosaics laid in churches of the region generally make use of geometric and vegetal imagery.[1] The nature of the alterations and of their indiscriminate focus on images of all animate beings, from humans to fish and even crustaceans, suggests that the concerns underlying them were quite different from those that motivated contemporary metropolitan Byzantine Iconoclasts, who objected to images of Christ, the Virgin, saints, and angels.[2] The replacement of images of animate beings by trees and vegetation does recall complaints made against the Iconoclasts in Constantinople for replacing images of the saints with those of birds, animals, and trees,[3] but, conceptually at least, the elevation of secondary vegetal elements to the status of primary subjects in the altered church mosaics is also close to the spirit of mosaics newly commissioned for Umayyad mosques (figs. 101, 102). Perhaps more significantly, parallels for the unusual tendency to transform figures into flowers or plants exist in the alterations to figurative materials reused in Umayyad and early Abbasid mosques. In the Aqsa Mosque in Jerusalem, for example, zoomorphic figures on capitals reused in the eighth century were transformed into vegetation by recarving or by the addition of stucco leaves.[4] This emphasis on vegetation in the ornamentation of sacred space recalls certain hadith, or traditions of the Prophet Muhammad (ca. 570–632), that promote depictions of trees as alternatives to images of living beings.[5] A particularly relevant tradition recommends removing the heads of figurative images to render them treelike. The similarity is based on a common incapacity for breath or life (*ruh*) rather than a formal resemblance, but this visually striking image of metamorphosis occasionally inspired the literal transformation of animal and human figures into plants and trees in the Islamic world.[6]

The transformative practices to which mosaics from Umayyad-era churches and mosques bear witness may of course precede the hadith, being canonized within rather than inspired by them. However, although the principle of removing part of an image to obviate the danger of idolatry was enshrined in earlier rabbinical tradition, and vegetal imagery might occasionally substitute for figurative representation in Christian, Jewish, and Islamic religious art (cat. no. 190), the idea that fragmented figures become treelike is specific to the imagery and worldview of the hadith.[7]

Even if the nature of the alterations suggests a relation to early Islamic critiques of the image, this does not imply either a relation to the edict against images reportedly issued by the caliph Yazid II (r. 720–24) (see Flood, p. 244) or the involvement of Muslims.[8] On the contrary, the careful nature of these alterations suggests that they were undertaken by the Christian communities who used the churches, perhaps even by the original mosaicists. In two cases the interventions include the addition of the cross, a far greater source of friction between Christians and Muslims than images.[9]

It therefore seems likely that these alterations to church mosaics were undertaken in response to the aniconism of Muslim places of worship, as has been proposed for similar changes to figural imagery in Early Islamic Palestinian synagogues.[10] Alternatively, the modifications of Christian mosaics in ways that conform to the prescriptions and proscriptions of the hadith may reflect the sharing of churches between Christians and Muslims, a phenomenon acknowledged in hadith that prohibit Muslim worship in churches containing images.[11] The changes to the mosaics may also engage with more active critiques of Christian iconolatry that evidently had an impact on Christian communities living under Umayyad rule as early as the 680s, when some of the Christians of Edessa refused prostration to icons.[12] The relevant hadith promoting the depiction of trees were evidently known to Christians, for they are invoked defensively in a passionate justification of Christian image veneration written in Arabic about 800 by Theodore Abu Qurrah, Chalcedonian bishop of Harran (cat. no. 81).[13]

Against this background it is worth noting that the alterations not only preserve the overall iconographic program but also consistently leave a sufficient remainder (such as ears, legs, or tails) to identify the original subject (cat. no. 79)—a deliberate choice, no doubt, since most of these changes were executed with such skill that the process could have been more comprehensively masked.[14] The startling presence of remnant animal parts might therefore indicate either a lack of internal consensus on images among the Christians frequenting the churches or a subversive resistance to external pressures that nevertheless conformed to the spirit of Muslim critiques. Enabling one to reconstruct the original as a mental image, present under erasure, this solution reconciled not only two phases of the mosaic but perhaps also two distinct conceptions of what was acceptable in a place of worship.[15]

79A, B. Two Mosaics with Examples of Iconoclasm

....................

Jordan, 719–20 and later
Stone tesserae
Provenance: From the nave (A) and the north room (B) of the church on the acropolis, Ma'in, Jordan. For conservation purposes, the mosaics were moved to the Madaba Archaeological Park in the 1970s.
Madaba Archaeological Park, Jordan

A. Mosaic Depicting Nikopolis Set over an Altered Animal

113 × 118 cm (44½ × 46⁷⁄₁₆ in.)
Inscribed: In Greek, ΝΗΚѠΠΟΛΕΪϹ (Nikopolis)
Condition: The central portion is in good condition, but there are losses to the border areas.

B. Mosaic Depicting an Altered Ox

127 × 205 cm (50 × 80¹¹⁄₁₆ in.)
Inscribed: In Greek, ΚΑΙ ΛΕѠΝ ѠϹ ΒΟΥϹ ΦΑΓ(εται) (And the lion shall eat straw like the ox)
Condition: The central portion is in good condition, but there are losses to the border areas.

Each of these fragments originally formed part of a floor mosaic laid in the church on the acropolis of Ma'in in 719–20. The upper part of A depicts a schematic architectural scene identified in Greek as Nikopolis, one of eleven cities east and west of the Jordan River, bordered by large fruit trees. The lower part of the mosaic witnesses a remarkable later transformation—a feline, once set between swags of acanthus and a cornucopia, has had its torso, tail, and hind legs erased through the replacement of the original stone tesserae. Where the cat's body once was, two lilylike flowers and a small tree grow from a wedge-shaped white ground; only its head and front paws remain. The original design of fragment B featured a lion confronting an ox—an illustration of the messianic vision described in Isaiah 11:7

and 65:25, sources of the inscription in B. The ox was later replaced by a small tree, visible at the bottom left of the scene growing above the remnant tail and hooves, which project conspicuously across the trunk of a pomegranate tree the upper portion of which also seems to have been added in the second phase of the mosaics.

The specific transmutations of animals into plants seen here relate to alterations found in other mosaics, among them those in a basilical church at Khirbat 'Asida near Jericho and in the Church of Saint Stephen at Umm al-Rasas (fig. 11).[1] In all these cases, images of animate beings were either replaced by or actually transformed into plants or trees (see Flood, p. 117). FBF

1 Baramki and Avi-Yonah 1934; Ognibene 2002.

References: (A) de Vaux 1938, pp. 244–45, pl. XIII; Buschhausen 1986, p. 126, cat. no. 3; Piccirillo 1992, pp. 196–201, figs. 303, 305; Schick 1995, pp. 398–400; Duval 2003b, pp. 276–77, figs. 29–30; (B) de Vaux 1938, pl. XI i; Buschhausen 1986, p. 228, cat. no. 16; Piccirillo 1992, pp. 196–201, figs. 301, 302; Schick 1995, pp. 398–400; Brubaker and Haldon 2001, p. 33, fig. 22; Shiyyab 2006, pp. 104–6, fig. 24; Brubaker and Haldon 2011, pp. 111–12, fig. 5.

80. *Sacra Parallela*

....................

Constantinople (?), 9th century
Black, red, and brown ink on parchment; 394 folios
36.3 × 26.5 × 15 cm (14⁵⁄₁₆ × 10⁷⁄₁₆ × 5⅞ in.)
Provenance: Collection of Nicholas Mavrocordatos (1670–1730), prince of Moldavia and Wallachia, Constantinople (until 1729); acquired from him by Abbé François Sevin (1682–1741) for the Bibliothèque Royale (now the Bibliothèque Nationale), Paris; entered the Bibliothèque Royale in 1730.
Condition: The condition is good, with some damage, including some loss of text.
Bibliothèque Nationale de France, Paris (Grec 923)

The *Sacra Parallela* consists of excerpts from biblical and homiletic texts that the compiler believed would contribute to the moral edification of the reader. Included

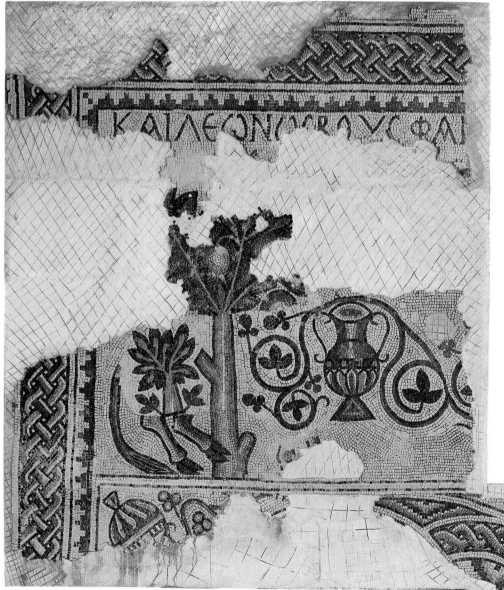

79B

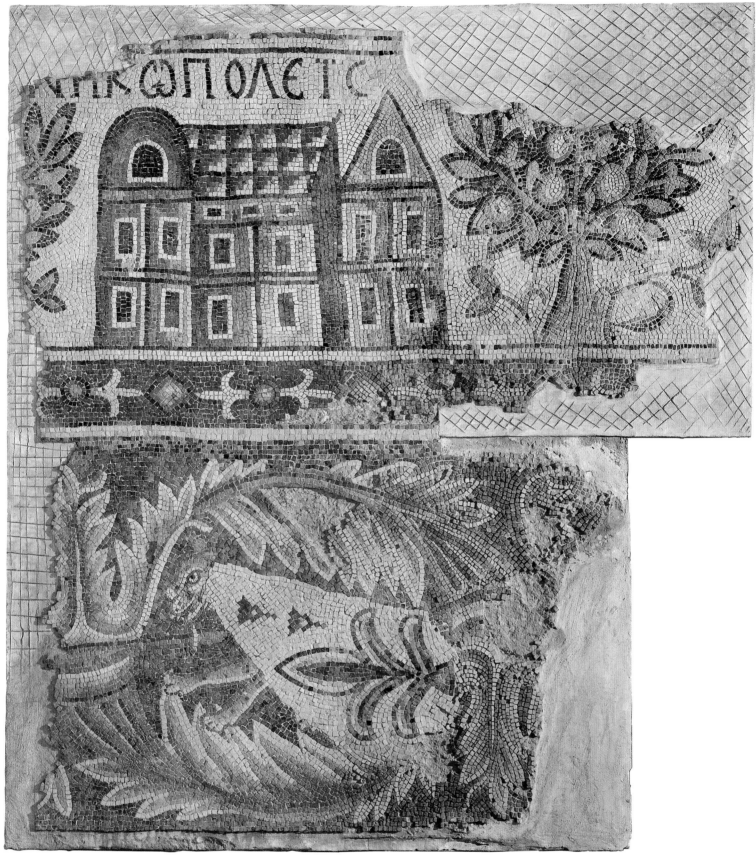

79A

80, fols. 207v–208r

are quotations attributed to John of Damascus (ca. 675–749), one of the most important theologians who wrote in defense of the use of icons (see Evans, p. 4, and Ratliff, p. 32).[1] The extensive presence of marginal illustrations in the anthology—there are a total of 1,256 portraits and 402 narrative scenes—and the predominant use of gold underscore John of Damascus's position in favor of the production of images. In his full-length portrait (fol. 208v, right margin), he gestures toward his own words with the sign of benediction, indicating that art and text respond to and justify each other. The theologian appears under a golden archway, decorated with a rope pattern, that suggests the space of a building. Perhaps it was meant to represent the kind of setting wherein John, who for many years resided at the Monastery of Mar Saba, near Jerusalem, would have delivered the sermon that appears in the text.[2] Thus, even though his writings were a century old when this manuscript was produced, the illustration

indicates that his words had an immediate relevance to a ninth-century audience.

The origin of the *Sacra Parallela* has been the subject of much scholarly debate.[3] These contrasting opinions signal the complex historiography of the manuscript but also that, just as in the case of medieval art, style was mobile. AL

1 Labatt 2011, pp. 144–45, 249; Kazhdan 1991a.
2 Weitzmann 1979b, p. 30.
3 Weitzmann (1979b, pp. 20–23) attributed the *Sacra Parallela* to the Monastery of Mar Saba in the first half of the ninth century. A. Grabar (1972, pp. 21–23, 87–88) and Cavallo (1982, pp. 506–8) argued for an Italian provenance, specifically Rome. Jaeger (1947, pp. 101–2) attributed the manuscript to Constantinople in the second half of the ninth century. D. Wright (1980, p. 8) and Cormack (1986, p. 635, n. 39) support the Constantinopolitan argument. Most recently, Brubaker (1999, p. 25), agreeing with Corrigan (1992, pp. 108–10), has supported an attribution to Constantinople in the third quarter of the ninth century.

References: Weitzmann 1979b; Cavallo 1982; Cormack 1986; Corrigan 1992; Brubaker 1999.

81. "Treatise on the Veneration of the Holy Icons" by Theodore Abu Qurrah

....................

Scribe: Stephen of Ramlah
Early Islamic Palestine, 877
Ink and pigments on parchment; 238 folios
20 × 15.9 cm (7⅞ × 6¼ in.)
Provenance: Purchased by the British Museum in 1895; transferred to the British Library at its foundation (1973).
Condition: The manuscript is in good condition.
The British Library, London (Or.4950)

Theodore Abu Qurrah (ca. 777–ca. 830), one of the best-known defenders of the Chalcedonian confessional formula who wrote in Arabic (see Ratliff, p. 32), composed his "Treatise on the Veneration of the Holy Icons" in 799 or 800. He addressed the treatise to Yannah, the official in charge of the Church of the Icon in Edessa (modern Urfa, Turkey), who had requested he write it. The occasion of its composition was the refusal of some Christian visitors to the church to venerate its famous icon, but the broader

81

purpose of Abu Qurrah's work was to defend the practice of icon veneration to Christians who had stopped observing it in response to Jewish and Muslim charges of idolatry.[1] Abu Qurrah's argumentation relies heavily on the thought of earlier scholars, particularly John of Damascus (ca. 675–749; cat. no. 80) and himself the author of one of the most influential defenses of icons (see Ratliff, p. 32). Abu Qurrah argues that the bodiliness of God implied by images is no different from that implied by the scriptures, that the veneration of images has apostolic origins, and that the practice is supported by church fathers. Thus, to reject the veneration of images is to reject the teachings of the Church and venerating images is not idolatry.[2]

The copy of Abu Qurrah's treatise preserved in the British Library, London (Or.4950, fols. 198r–237v), is one of two known copies; the second is found in Arabic Ms 330, a tenth-century manuscript in the collection of the Holy Monastery of Saint Catherine, Sinai, Egypt.[3] The London copy is the work of Stephen of Ramlah, a monk at the monastery of Mar Chariton in the Judaean desert; in his colophon, he states that he completed it on December 1, 877.[4] His manuscript includes a second text, a summary of Melkite theology in Arabic.[5]

BR

1 Griffith 2011, pp. 198–202. The icon in question is the famous Mandylion, an *acheriopoietos* ("not made by hands") said to have been an authentic likeness of Christ. One version of the icon's legend says that it was created when Christ pressed a towel to his face and it retained the impression of his features. The icon remained in Edessa until the tenth century, when it was taken to Constantinople. See cat. no. 30 and H. Drijvers 1998.
2 Abu Qurrah 1997, pp. 21–26.
3 A critical edition of the Arabic text based on the two surviving manuscripts is found in Abu Qurrah 1986.
4 Abu Qurrah 1997, pp. 26–28.
5 Stephen of Ramlah is known through a second manuscript, Arabic Ms 72, also at Sinai. Griffith 2008a, pp. 52–53.

References: Abu Qurrah 1897, 1986, 1997.

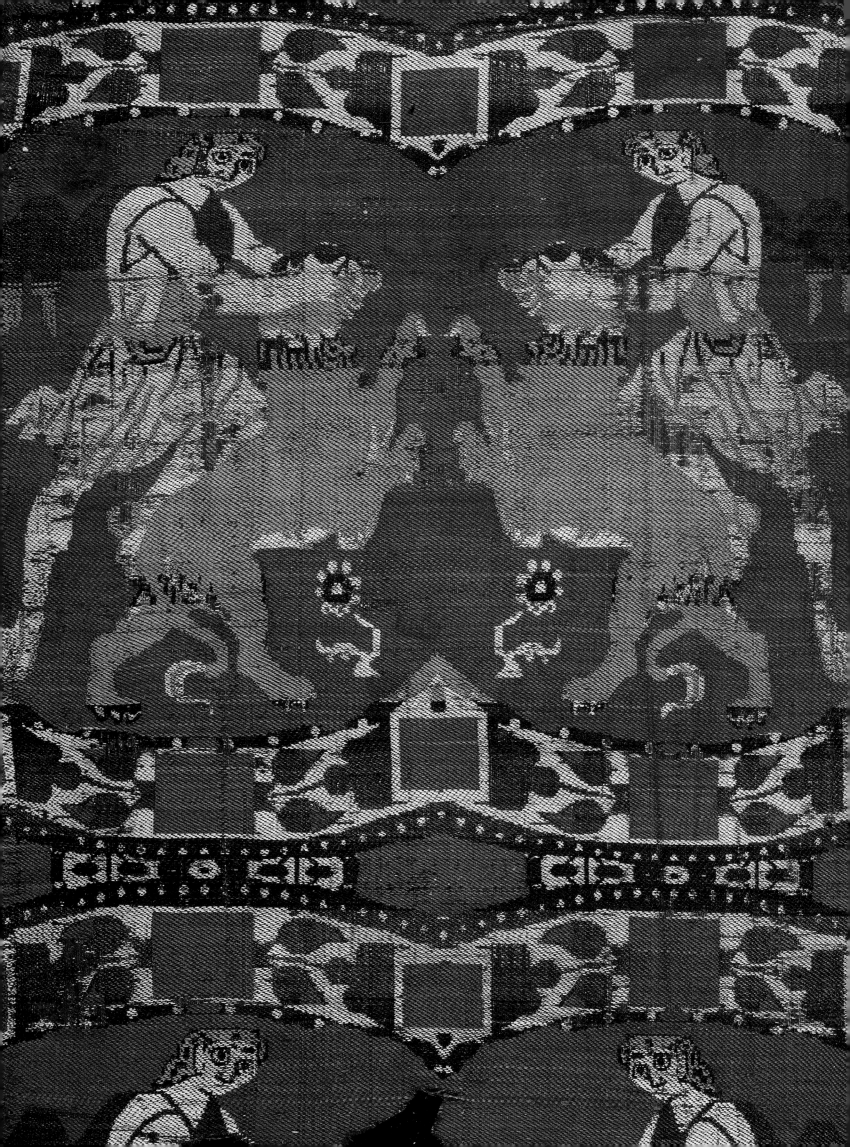

COMMERCE

"Ornaments of excellence" from "the miserable gains of commerce": Luxury Art and Byzantine Culture

Thelma K. Thomas

We use the term "luxury art" to indicate products fashioned by the hands of master artisans from prized materials and to connote both desirability and lack of utility, and we tend to characterize ornament similarly, rather than as essential to the thing itself or its use.[1] Moreover, we have inherited from a tradition reaching back to Republican Rome a negative attitude toward material extravagance, and the commerce enabling it, that is often at odds with avid consumption and celebration of prestige goods.[2] Later Romans, then Byzantines, maintained both this attitude and the far-flung trade networks along which luxury art and precious materials traveled, yet they developed alternative views and a rhetoric of worth more commensurate with actual practice. Luxury art came to be reconceived in positive moral as well as Christian terms. Precious materials—particularly gold, silver, ivory, and silk—and "conspicuous virtuosity" came to carry auspicious connotations of God's providence as the gifts and wonders of creation.[3] These materials had been transformed through their acquisition and crafting to glorify the excellence of the superior individuals who possessed them. Such themes were articulated more fully and allusively through ornament. More precise meaning came to the fore during use. This art of prestige attracted, charmed, and delighted its audiences, even as it served crucial social, political, economic, and spiritual functions.

Accounting for the manifold meanings of Byzantine luxury art requires recognition of material associations. In Byzantine culture, the qualities of gold, the noblest of metals—"scarce, brightly colored, resistant to dust, malleable," and enduring—rendered it entirely appropriate for connoting divine presence or imperial and elite identity.[4] Bright gold-glass mosaics could be construed as divine light or the light of the sunlit sky, appropriate in temples and the vaulted ceilings of churches and suitable for the audience halls in which the powerful and wealthy presented themselves.[5] Spiritual associations could mingle with expressions of high status or ideologies of control, and luxury arts could serve political ends.

Social and political meanings were enhanced by associations with currency and wealth. The gold solidus served as a special currency for government business, including military pay, gifts to high-placed officials and courtiers, and the collection of taxes (cat. no. 86).[6] Closely linked to imperial business and the emperors through imperial portraits, gold coinage epitomized imperial wealth and success on the world stage of trade; bronze and copper coins were used for the more mundane business of everyday life (cat. nos. 84, 85).[7] Silver, infrequently used in Byzantine coinage, remained an important material for gifts, especially for donations to churches by emperors and elites in sacral transactions for the thanksgiving or salvation of the donor (cat. nos. 22, 128).[8] Similarly, as ivory grew scarce after the sixth century, it continued to play a key role in gifting practices as well as in other social transactions and displays of wealth (cat. nos. 23, 24).[9] In contrast, although silk became less costly after the sixth century and more accessible owing to government intervention, it remained at the top of the hierarchy of fabrics in Byzantium (cat. no. 101).[10] Along with gold and silver bullion and coins, silk cloth was treasured, used as currency and for gifts of honor within the Byzantine court and in diplomatic exchanges linking courts throughout Eurasia and northern Africa.[11]

In Byzantine culture, nuances of material associations depended partly on artistic context, that is to say, use with other materials or fabrication by particular techniques. Certain precious materials expressed wealth and stature more powerfully in combination than separately: cloth dyed with "Tyrian" purple, especially silk, and the purple silk trimmed with gold that were reserved for imperial use were especially highly valued (cat. no. 31).[12] Techniques of artistic production contributed to a wider range of meaningful associations. The mechanical regularity of silk compound weaves featured the technological advances of looms that could be programmed to produce intricate weave structures with ornamental patterns of precise regularity (cat. no. 101).[13] Ancient techniques of sealing (creating an image by impression) not only guaranteed authenticity but were thought to maintain a special link to the original.[14] If a seal or a coin impression of an imperial image conferred imperial authority, the combination of gold and sealed imperial image elevated the amuletic powers of the solidus

above those of other coins.[15] In consequence, wearing gold jewelry utilizing actual coins or imitations of them could be a direct statement of social status and proximity to imperial power even as it evoked the magical power inherent in coined gold.[16] Jewelry frequently utilized imitation gold coins and medallions like the central medallion in the sixth-century pectoral from Byzantine Egypt (fig. 53): not so much forgeries as simulacra, such imitations were intended to evoke the same associations to status, power, and wealth. Imitation played an important role in the widespread dispersion of object types, styles, and motifs. The emulation of Byzantine coinage outside the Byzantine sphere depended, in part, on shared material associations. The early caliphate, for example, adapted Byzantine economic structures, including coinage types, while promoting different political ideologies and expressing quite different religious beliefs and practices (cat. nos. 84, 85).[17]

Much of the potential for meaning in prestige art lies in its economic character. Precious materials, subject to imperial legislation and bureaucratic oversight of their import and export, manufacture, and pricing, played key roles in the economy of the Byzantine state. Because it was mainly through the ebb and flow of trade—commerce, diplomatic exchange, and other gifting practices—that luxury art came to function as symbolic capital in different social and cultural settings, this essay focuses on those aspects of circulation.[18] From an art historical perspective, trade in luxury art promoted the display of expensive, finely crafted, rare, or difficult-to-acquire goods to express superiority of a particular kind, whether political authority or spiritual power, commercial savoir faire, affinity for the exotic, or, more often, a combination of such esteemed qualities. Moreover, long-distance trade and interactions with trading partners were critical to the continued development of this "passion for pure display" across all levels of Byzantine society.[19] Through unusually telling conjunctions of visual, written, and material evidence, silk provides an ideal example of the potential for trade to be central to the production of meaning in Byzantine luxury art, and so the final section of this essay considers silk as a Byzantine medium, with

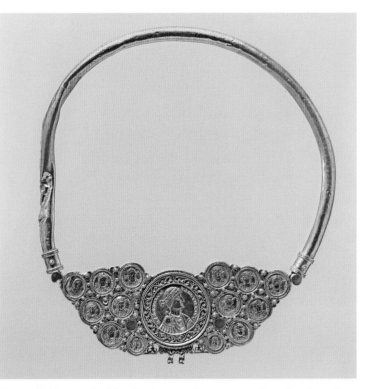

Fig. 53. Gold pectoral with coins (representing emperors from the 4th to the 6th century) and pseudo-medallion. The Metropolitan Museum of Art, New York, Gift of J. Pierpont Morgan, 1917 (17.190.1664)

meaningful associations of the main compositions, styles, and ornamental themes current during the "age of transition."

Given current knowledge of the scope of social negotiations involving luxury art objects, widespread sophisticated appreciation of materials and methods of manufacture, and the extent and complexity of the Byzantine economic system, it is ironic that much of this period (650–850) was routinely characterized until quite recently as a "Dark Age" for Byzantine culture.[20] Two centuries of military losses to Avars and Slavs, Persians, and, most notably, Arab Muslims eclipsed territorial expansion during the reign of Justinian I (527–65), which stands just before this period, and the brief moment of victory and stabilization under Heraclius (r. 610–41; see Evans, p. 14). Loss of territory entailed damaging economic consequences: Arab control of Egypt and

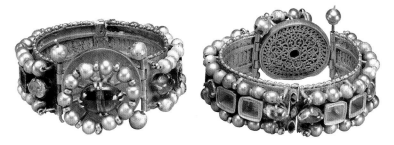

Fig. 54. Pair of gold bracelets with gems and pearls. The Metropolitan Museum of Art, New York, Gift of J. Pierpont Morgan, 1917 (17.190.1670, .1671)

Syria deprived the empire of its most prosperous provinces, where the main emporia for imported ivory, silk, and Tyrian dye were located, and where a significant share of the empire's artistic production in these materials had been concentrated. Within the remaining territories of the empire, chiefly Greece and Asia Minor, internal strife, both political and religious, posed ongoing challenges to Byzantine society. Most notably, the waves of Iconoclastic debate that ocurred between 725 and 843 had an impact on the imagery of sumptuary devotional art. Yet, now, clear archaeological evidence of both continuity and change informs characterizations of these years. As a result, more weight is being given to analysis of the complex repercussions of events and changing conditions, and to charting developments of administrative structures and the main engines of the Byzantine monetary economy—agriculture, the army, the Church—and ongoing long-distance trade.[21] One striking development apparent in archaeological discoveries of silks is the continuing production of Byzantine designs in regions that were no longer part of the empire.[22]

This was a period of significant change for Byzantine art, involving both innovation in craft and complex cultural developments. Analyses of the crafting of luxury artworks have greatly enhanced our understanding of the continued development of technologies of artistic production and should put to rest any expected loss of conceptual sophistication or technical expertise in Byzantium during this period.[23] Using traditional gold-working techniques, artisans produced dazzling combinations of openwork, braiding, and beading (fig. 54). The emergence of enameling within Byzantium during the ninth century melded colored glass with gold to create brilliant polychromatic visual effects (cat. no. 54).[24] Along with the innovative compound weaves mentioned above, the ancient tradition of automata, that is, sculptural ensembles that were made to move through hydraulic and mechanical engineering, so as to animate thrones, clocks, and fountains, were indeed conspicuous for utilizing technologies of enchantment to fascinate viewers, responding in part to the ceremonial requirements of courtly display.[25] Diplomatic exchange

between Byzantine rulers, Persian shahs, and, subsequently, Arab caliphs spurred widespread circulation of marvelous artworks. Along the frontiers of these superpowers, rulers of other polities shared the visual and material practices of what became a nearly global language of royal legitimacy.[26] These rulers followed ancient practices in exploiting associations between highly crafted goods and kingship in setting themselves apart as a family of rulers.[27]

A view from the Islamicate world is provided by the *Book of Gifts and Rarities*, which documents spectacular treasures, loot, celebrations, and political gifts from the seventh to the eleventh century. In one exchange, initiated by the Byzantine emperor Romanos I Lekapenos (r. 920–44), the emperor's initial letter to the Abbasid caliph al-Radi bi-Allah (r. 934–40) required several pages to describe the many "fine articles that reveal our deep-rooted affection and our sincere inclination to win your fraternity"—and negotiate the release of prisoners.[28] Competitive gifting and lavish celebration also became integral to social interactions among nonroyal elites and lower levels of social hierarchies.[29] Another episode, epitomizing Egypt's legendary wealth, tells of an elderly Coptic lady who had entertained the visiting caliph al-Ma'mun (r. 813–33) and his entourage with a three-day feast. The dowager had only laughed at al-Ma'mun's caution when she offered her final extraordinary gift of gold, saying it was "obtained from this soil and your justice! We have a great deal of it. So, if you wish, [it is] yours."[30] Her patrician panache in words and presentation—twenty purses of coins, on trays covered by brocade cloths, held by ten maids of honor—struck just the right tone to ensure acceptance of her gift: she was fluent in the changeable, complex language of gifting.[31]

Continued gifting required wealth, and continued production of luxury arts required access to materials. The Byzantine Empire retained domestic sources of some precious materials, such as gold and silver.[32] Trade provided access to others, while corroborating ancient Greek and Roman traditions that located the sources of luxury in the East.[33] A Byzantine merchant now known as Kosmas Indikopleustes, writing in Alexandria during the later sixth century, described the import of silk from a land so far to the east that it was the last inhabited terrain at the edge of the world. Beyond that land lay only Ocean. Beyond Ocean, if one were able to transport oneself there, was paradise: "for if there be some who to procure silk for the miserable gains of commerce hesitate not to travel to the uttermost ends of the earth in order to procure silk, how should they hesitate to go where they would gain a sight of Paradise itself?"[34] In later copies of his book (themselves luxury productions), paradise is represented as a lush, fragrant garden of flowers and blossoming, fruiting trees and as the source of the rivers of paradise (cat. no. 82).[35] Kosmas formed his view of the universe through scriptural interpretation, confirmed

through his own extensive travels as a merchant (*Indikopleustes* means, in Greek, "the one who sailed to India"). Through this work he knew that cultivated silk came from southern China, then traveled, either over the Indian Ocean and along the Persian Gulf into Persia or over land routes, through India and into Persia.[36] Either way, wrote Kosmas, "[t]his is why there is always to be found a great quantity of silk in Persia."[37]

Before Kosmas, the world of trade had long been conceptualized through the objects of trade, as in the itinerary known as the *Periplus of the Erythraean Sea* (encompassing the Red Sea, Persian Gulf, and Indian Ocean), written by an Alexandria-based merchant of the first century C.E.[38] Trade across long distances thrived mainly because it was extraordinarily profitable. One document of the second century records the cargo (Indian ivory, fabric of unspecified material, and an aromatic, nard, used for medicine as well as perfume and incense) of one of the "veritable treasure ships" of trade in luxury goods.[39] The considerable resources needed to finance trade on a large scale were beyond the means of all but the wealthiest in the uppermost tiers of society, despite often-expressed negative attitudes toward "miserable gains of commerce," since such ventures were risky because of the possibility of shipwreck and the threat of bandits for overland camel caravans. At important stops along these routes, the various governments involved in trade established outposts for policing, purchasing goods, and collecting taxes, which could be paid through a portion of the cargoes. Through such taxes the imperial government benefited from risks taken by merchants, and the cost increased for consumers.[40] Further documentation of luxuries circulating through and accumulating in the empire's eastern provinces is found in the Roman *Liber Pontificalis* (*The Book of the Popes*) on fourth-century donations of exotic spices (pepper, for example, and cinnamon) and aromatics (nard, balsam, storax, and myrrh), as well as flax and papyrus, all from the Egyptian and Syrian estates of Constantine the Great (r. as sole Augustus 324–33).[41]

In the fourth century, there emerged an alternative rhetoric reflecting positive attitudes toward commerce in luxury goods and the involvement of the upper tiers of society in lucrative trade that was more consonant with aspirations to acquire ever greater wealth.[42] Libanius (314–393), an aristocrat of the cosmopolitan city of Antioch in Syria, who earned renown as an orator and teacher of the elite young men who would rule society, noted that commerce served society by linking disparate places and goods:

> God did not bestow all products upon all parts of the earth, but distributed his gifts over different regions, to the end that men might cultivate a social relationship because one would have need of the help of another. And so he called commerce into being, that all men might be able to have common enjoyment of the fruits of the earth, no matter where produced.[43]

In this view commerce is a social good, and so are the social and political relationships it breeds. Libanius was a Hellene in religious matters who never converted to Christianity. Although Christians increasingly adopted such views, silk and other luxuries were never universally lauded. Sermons delivered by clergy of a more ascetic bent, urging their congregations to stop spending fortunes to satisfy their appetites for luxury, likely fell on deaf ears among those who were perfumed and adorned with silk, gold, and gems.[44]

Kosmas's phrase "the miserable gains of commerce," based on his merchant's experience and knowledge, resonates with both negative and positive views about the role of luxury goods in society. Trade could be difficult and dangerous, as when it crossed political frontiers during wartime. This was necessary, partly to pay tribute and ransom captives, and possible because moral values, attitudes toward commerce, and—bottom line—the monetary valuation of luxury materials and goods were commensurate. *The Book of Discernment in Commerce*, written by the prolific

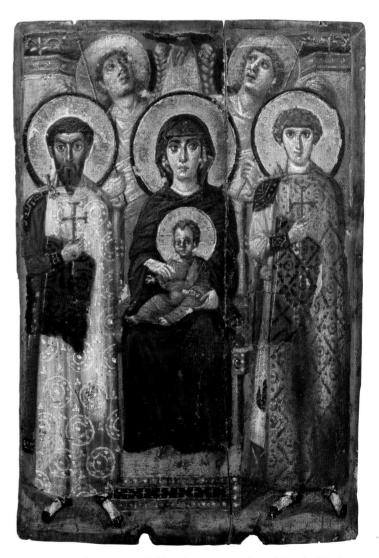

Fig. 55. Icon of Virgin and Child with Saints, Angels, and Hand of God. Encaustic (wax) paint on wood, wooden frame missing. 6th–7th century. The Holy Monastery of Saint Catherine, Sinai, Egypt

author al-Jahiz for a patron in Abbasid Baghdad around the turn of the ninth century, opens with celebratory sayings about commerce attributed to experienced men of ancient times—Byzantines, Indians, Persians, and Arabs.[45] This book was to give al-Jahiz's patron tools for success in the interconnected world of trade, words of wisdom about commerce, and knowledge of markets and products. Al-Jahiz, like Kosmas, listed aromatics and spices, precious materials, and rare goods, along with exotic animals and people with special features or skills. Al-Jahiz, too, identified lands with their products.[46] According to him, "high-tech" objects and the technological expertise of human resources were among desired Byzantine exports: most prized were gold coins, gold and silver utensils, plain cloths, stitched cloths, brocades, rare accoutrements of red leather, unbreakable locks, lyres, spirited horses, female slaves, hydraulic engineers, agronomy experts, marble workers, and eunuchs.[47]

If "[l]ists of traded items hardly lend themselves to aesthetic impressions,"[48] they do offer glimpses of objects of desire, desired knowledge, and artistic expertise. Moreover, people, ideas, and beliefs traveled along with traded items, with the result that certain aesthetic attitudes and tastes came to be shared despite political, religious, and other cultural differences.[49] Aesthetic values of materials were key to shared assessments of the quality of luxury goods. Byzantine aesthetics appreciated color allied with brightness; similarly, al-Jahiz taught appreciation of clarity, luster, and brilliance of coloration.[50] These are the special characteristics of silk, highly valued not only in the Byzantine and Islamicate spheres but all across the vast terrain described by Kosmas. One crucial point needs underscoring: silk was only one commodity among many in circulation during this period of continued trade along the network of routes now known as the Silk Road.

The history of silk as a characteristically Byzantine medium has its roots in Roman trade and in Late Roman social trends, especially the display of material wealth. In the fourth century, silk became accepted as an appropriate imperial attribute and as emblematic of rank among courtiers and provincial officials.[51] Later in the century, silk came to distinguish and honor sacred character in church furnishings, the binding of liturgical and scriptural manuscripts, wrappings for relics (cat. no. 101), and, by the sixth century, clerical vestments (cat. no. 23).[52] In the Byzantine visual imagination, too, Christ and saints in the court of heaven were clothed in silk, and their garments exhibit the typical allover medallion and diamond patterns of the twill compound weave, samit (cat. nos. 23, 45 and fig. 55). In some instances, the striking feature of reverse-color patterning on the front and back of the cloth is visible (as at the back of the lattice-patterned cloak in fig. 55).[53] Already associated with the East, near earthly

paradise, through such images silk came to be associated visually with heavenly paradise above.[54]

Texts, images, and other documents yield considerable information about imperial interest in the import of raw silk and the domestic production of silk goods. Affixed to the bales of silk products of imperial factories and silk purchased by the state for imperial use from the later seventh through the early ninth century were seals naming officials charged with oversight of silk production and acquisition for the state. Some bore the officials' monograms, whereas others were similar to coins in bearing imperial portraits; all announced imperial ownership and a guarantee of quality, much as imperial stamps on silver guaranteed purity (fig. 6).[55] Specialized workers were needed for all processes of silk production, from selecting undamaged cocoons, to degumming and unreeling them, to spinning and dyeing the thread, to preparing the loom and weaving. As for any artwork, material value rather than labor constituted the chief part of the cost.[56] Most silk artisans were paid at much the same rate as any skilled worker.[57] Silk fiber itself was expensive, yet much of the expense of the finest silk goods derived from the dyes used to color them.[58] Considerable profit went into imperial coffers, the hands of government officials in charge of collecting taxes, the owners of factories where silk was dyed and cloth was produced, and the merchants who sold silk goods.

Yet silk was more than merely profitable. From the reign of Justinian, imperial involvement in all aspects of trade, including the acquisition and production of silk, intensified as the empire resumed war against Persia. Blaming Persian tax increases for soaring prices, Justinian attempted to fix the price for raw silk; however, he set the price much too low, and the merchants who had bought at higher prices rebelled. According to the court historian, Prokopios, the merchants "gradually disposed of the remainder of their cargoes by rather furtive methods, selling no doubt to certain of the notables who found satisfaction in making a show of such finery through the lavish expenditure of their money."[59] Although Justinian reached a trade agreement with the Persians, he attempted to bypass the Persian monopoly through arrangements with the Laz to the north (Georgia) and, to the south, the Christian Axumite kingdom along the Horn of Africa (Ethiopia) bordering the Red Sea.[60] Subsequent losses of northern and southern Byzantine territories, and more fragile alliances with the kingdoms and federations of adjacent regions, made the promotion of sericulture within the empire all the more important.[61]

The period of the later sixth through the ninth century was crucial for the growth of the Byzantine silk industry. Two Byzantine historians, Prokopios in the mid-sixth century and Theophanes in the early ninth, credit the Justinianic introduction of sericulture to industrial espionage, although they give differing

accounts of the legendary theft of silkworm eggs and the knowledge of how to tend them.[62] While the accounts may not present historical "truth," they do reflect Justinian's attempts to circumvent Persia's monopoly and provide the empire with unmediated access to supplies of raw silk. The tales also emphasize Byzantine co-option of silk through advances in agronomic science. Loss of established centers of silk production in the cities of Syria (Antioch, Tyre, Beirut) and Egypt (Alexandria) may well have spurred production in Constantinople, likely the only Byzantine center of silk production during the eighth and ninth centuries.[63] Although significant quantities of silk still had to be imported, mainly through the great trade mediators of Sogdia in Central Asia (present-day Uzbekistan and Tajikistan), great amounts were available to the emperor Constantine V (r. 741–75) when, in 768, he was able to ransom prisoners from Slavic pirates with a treasure of 2,500 silk robes.[64] Silks, which arrived in European church treasuries as diplomatic gifts, relics, and commercial imports, further attest the wide circulation of Byzantine and other silks during this period.[65]

Byzantine texts on silk typically reflect an exclusively Constantinopolitan point of view. Best known among these texts is a late ninth- or early tenth-century compilation of regulations, *The Book of the Eparch*, which offers a glimpse of long-established practices of silk production, trade, and distribution in the regulatory machinery of the capital city. *The Book of the Eparch* guided the oversight of twenty-two guilds of the businesses, industries, and markets of imperial concern within the capital city, five of which had to do with silk; others dealt with linen, for example, as well as spices, dyes, and perfume, bullion and moneylending, goldsmithing, candles, and contracting for building crafts. Silk shops and imperial factories were located in the vicinity of the imperial palace and hippodrome, near shops for spices, dyes, and perfumers—clearly an area of high-end real estate and merchandise.[66] Although a few of the great periodic fairs were markets for luxury arts, established markets were mainly in cities. Constantinople was remarkable for the sheer number of colonnaded streets, its porticoes accommodating workshops and retail shops; however, similar avenues served the same functions in other Byzantine cities.[67]

The Book of the Eparch underscores that silk accounted for just a fraction of the fabric products available in Constantinopolitan markets or produced in local domestic, noncommercial settings. The *Book* lists cotton, flax, and wool, and specifies whether a finished good was wholly silk, partly silk, or trimmed with silk.[68] Imperial use of a wide range of domestic and imported silk products, other luxury cloths, and goods for payments and gifts is made especially clear in a compilation of the early reign of Constantine VII Porphyrogennetos ("born to the purple";

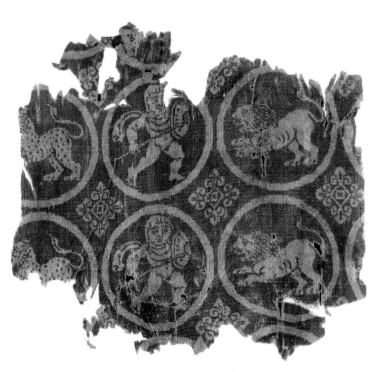

Fig. 56. Textile fragment with medallions (nude hunter with shield and spear facing crouching lion). Weft-faced compound twill (samit) in polychrome silk. Found in Egypt, 5th century. Newark Museum of Art, Purchase 1977 Harry E. Sautter Bequest Fund (77.29)

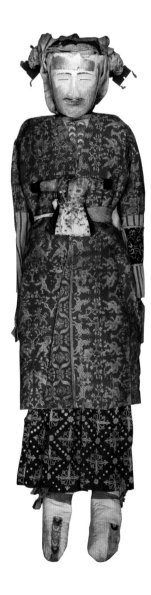

Fig. 57. Adult male mummy of "Ying Pan." Compound-woven wool robe with repeating pattern of symmetrical pomegranate trees, pairs of nude hunters with spears, bulls, and goats. Excavated in 1999 from Ying Pan, Yuli (Lopnur) County, Uyghur Autonomous Province, China, 5th century. Xinjiang Institute of Archaeology Collection

Fig. 58. Detail of silk fragment with elephant and "candelabra tree" medallions with inscription. Weft-faced compound twill weave (samit) in polychrome silk. Taken from the tomb of Charlemagne (r. 800–814) in 1843, deposited after his death; late 10th or 11th century (?). Cathedral Treasury, Aachen, Germany

r. 945–59); known as *The Book of Ceremonies*, it choreographed in great detail the imposing spectacle of the court. An appendix to the main text, *Three Treatises on Military Expeditions*, provides instructions for the emperor on campaign, including complete packing lists for everything from matching feed sacks (burlap dyed purple) to the tents and furnishings necessary for the magnificence of Byzantine kingship on the move, even specifying the different grades of silk appropriate as gifts for various possible encounters.[69] In these texts, as in those reflecting views from outside Constantinople, textiles are described by type of product, such as Siqlatun (which may have been a scarlet cloth or a kind of cloth ornamented with gold).[70] Although many "brand names" and varieties of silk are mentioned in these texts, the type or appearance of the cloth so designated is rarely known.

It is clear from such texts that the history of a dynamic silk trade circulating in multiple directions over long distances gave many cultures access to the same materials, technical expertise, and formal repertories.[71] Archaeological evidence presents a complementary view. Already by the fifth century, silk was being woven in Egypt in the precisely repeating compositions typical of compound weaves (fig. 56). These were made with techniques similar to roughly contemporaneous silks found in western China, some of which are striking for their use of Late Roman

and Persian motifs and styles (note the hunters and lattice motifs in fig. 57). Central Asian motifs and styles, Sasanian and Sogdian, remained popular in subsequent, parallel developments across numerous cultures from China to Byzantium.[72] The stepped outlines of Sogdian compound weaving were widely emulated in silks from the Byzantine and Islamicate spheres (fig. 67 and Thomas, p. 148). By the later sixth to seventh century, small-scale ornamental units for overall repeating patterns—most commonly utilizing grids of medallions, often with smaller linking and/or interstitial motifs, and lattice patterns with small and relatively simple linking motifs—grew larger and increasingly complex (fig. 58).[73] Moreover, the long-term circulation of goods and artisans, as well as the emulation of imported products, muted distinctions between silks produced at great distances from each other.[74] Silk cloth was widely produced not only in Byzantium but as far west in the Islamicate world as Spain by the tenth century, since silk had become representative of the wealth and advancement of the caliphate (cat. no. 173).[75]

This helps explain why the all-purpose term for things Eastern, "Saracen," designated silk products from Abbasid Syria and the capital city of Baghdad in the eparch's manual.[76] "Saracen" was used in similar generic ways in Western Europe, where greater distance seems to have exerted a stronger exotic allure.[77] The cloth relic associated with the Virgin kept at Chartres, brought from Jerusalem with an influx of relics during the ninth century, furnishes an enlightening case in point.[78] Its characterization during the later Middle Ages as a "Saracen" veil, robe, or chemise of the Virgin continued to fit Crusading and later notions of Jerusalem as both a holy place and a place of trade in exotic silk, linen, and spices.[79] Some late medieval pilgrims' badges reflect this exoticism in the silhouette and patterning of the cloth, a typical Persian/Byzantine/Islamic lattice motif.[80]

The long history of European collection of exotic silks has proved invaluable for our understanding of Byzantine silk. For example, scholars closely tracking eighth- and ninth-century descriptions of silk donations in the *Liber Pontificalis* have noted fluctuations in the quantity of donations and in imagery in apparent correspondence to phases of the Iconoclastic controversy.[81] From 750 to 815—the period between the two phases of Iconoclasm—silk donations proliferated. These included a few subjects from the Life of Christ, but mainly traditional, secular imagery of the sort popular among the surviving Byzantine and Islamic silks of this period: hunters, equestrians, different kinds of birds and beasts of prey, mythological animals, fruits, and plants. Within the Byzantine sphere this imagery was used throughout the period of Iconoclasm for imperial arts and church decoration. The disappearance of specifically Christian iconography from secular silks after the eighth century, and its survival only in

liturgical vestments and cloths, is a likely response to the formulation of iconic imagery following the end of the controversy.[82]

Recent detailed analyses of individual silks in catalogues of European church treasuries and modern museum collections have provided a much firmer foundation for recognition of patterns of use and reuse, stylistic and iconographic affinity groups, and fabric structures.[83] For the uninitiated, the silk artifacts themselves can be quite difficult to "read," since, having served many purposes over the centuries, they now survive in fragmentary, damaged condition.[84] The assignment of dates and places of production remains difficult because archaeological documentation and certain touchstones are rare. That situation is changing thanks to the accumulated results of radiocarbon analysis, even though the dating of any piece of silk may be complicated by ongoing use, repair, and reuse. For example, a series of Carbon-14 dates available for a burial assemblage from Antinoë (now Sheikh Abada) indicates that its silk appliqués may be a century or two later than the ground fabrics they decorate.[85]

Style can be an unreliable indicator of cultural origin. Fortunately, inscriptions and monograms on a precious few of the samits in European treasuries provide critically important confirmation of Byzantine imperial provenance for silks in a range of styles.[86] Without the inscriptions at its lower border, for example, the Constantinopolitan origin of the "Elephant" silk found in the tomb of Charlemagne (fig. 58) likely would not have been suspected, given the strong Central Asian inflections of

its style. More illustrative of art historical expectations for a strongly classicizing style is silk in the Vatican collection (cat. no. 101). Corresponding generally to a late eighth-century entry in the *Liber Pontificalis*, this is an extraordinary instance of conspicuous virtuosity in silk production, utilizing five colors for its repeating design of asymmetrical, large-format Annunciation and Nativity scenes. Here, naturalistically draped figures inhabit a pictorial space of some depth.[87] The figural scenes are located within medallions composed of flatly rendered wreaths within narrow strands of jewels and pearls; related but more lushly rendered foliate motifs fill the interstices. Inside the Elephant silk medallions, in contrast, shallow pictorial depth is indicated by subtly curving lines, and overlapping; the framing medallion is also flatly rendered.[88]

From Egypt, outside the empire, silks with subjects similar to those documented as Byzantine diplomatic gifts and described in the *Liber Pontificalis* provide some sense of a wide-ranging formal repertory for Byzantine silks and other textiles. Through documentary texts and artifactual remains dating from antiquity through the Byzantine period and into the Early Islamic period, Egypt is known to have produced fine linens of locally grown flax, wools, silks, and cloths of mixed fibers.[89] On the loose, boxy tunics in the Late Roman and Early Byzantine tradition, silk ornamental bands, or *segmenta*, were attached in the same manner as those in-woven in tapestry or reused as appliqués on tunics of wool or linen (cat. nos. 110, 112). On the fitted tunics and jackets of Persianate style, silk trim was applied at edges and seams (cat. no. 114). Samits were emulated in brocading and in techniques less commonly used for Byzantine silk, such as tapestry (note the lattice patterning in the wool trim at the hem of the tunic in cat. no. 112) and embroidery (fig. 59).[90]

Although there is no evidence for sericulture in Egypt and the extent of Egyptian silk production is unclear, a number of silks, including catalogue number 101, have been attributed tenuously to silk factories in Alexandria. Even though no textiles have been discovered in Alexandria, excavations at the turn of the twentieth century at cemeteries for the cities of Antinoë and Panopolis (Akhmim) yielded great quantities of textiles, including silk compound weaves,[91] which were assigned Late Roman and Early Byzantine dates. The preponderance of evidence, however, now indicates assignment of dates between the seventh and ninth centuries.[92] In the aggregate, the silks found at these sites (and attributed to them) reflect prosperity and ready access to a wide range of luxury textiles.[93] Multiple finds of similar compositions—groups of hunters, for example, and Amazons—suggest that their weavers followed the same models, varying only in color schemes and compositional details (such as the cross in the linking motif, mantle, or Arabic inscription in the background;

Fig. 59. Medallion with Annunciation and Visitation scenes. Embroidery in polychrome silk on undyed linen ground. Found in Egypt (Akhmim/Panopolis?), 7th–9th century. Victoria and Albert Museum, London (814-1903)

Fig. 60. Fragment of a tapestry-weave imitation of a compound-woven silk with "candelabra tree." Wool and linen. 7th–10th century. Kelsey Museum of Archaeology, Ann Arbor (10583)

cat. no. 103 and fig. 68).[94] Further comparisons suggest that the two sites had access to different centers of production and/or commercial networks: Persian motifs and garment types are prominent at Antinoë (cat. no. 114), whereas from Panopolis come numerous examples of two-color silks with princely equestrians and hunters, fierce beasts, and exotic plants, as well as mythical animals.

Within the Panopolitan repertory, material richness finds resonance in the motifs of the organizing grids of diamond shapes and linked or intersecting medallions, each unit composed of motifs connoting abundance (pearls, jewels, vines, or other vegetation). Common to the Panopolitan two-color silks, as well as related versions using more colors (for example, cat. no. 101), is a motif known as the candelabra tree—also called a lotus tree, a palmette tree, the Tree of Life, a spindly vine, and an arabesque (for example, figs. 58, 60 and cat. no. 103).[95] This motif seems to represent no single plant but instead kaleidoscopic combinations of different types of plants distinguished by leaf shapes, varieties of fruit, and the changing form of the trunk. These submotifs resonate with the exotic spices, plants, and fruits of the luxury trade and may in some cases depict them,[96] yet their composite fantastic forms have a long history in mosaics decorating churches, baptisteries, mosques, and shrines (figs. 61 and 96).[97] Typically, colors and details (gold, jewels) indicate they are not meant to be interpreted as actual or hybrid plants but as nonstructural ornate columns, vases, or fountains—and possibly as the elaborate automated fountains in gardens of Byzantine and Islamic elites.[98] In both mosaics and silks, candelabra trees articulate compositional space as rhythmic, framing elements. The precise nature of this tree eludes specificity, as these ever-blooming, ever-fruiting trees exist outside earthly time and the earthly nature of actual plants, closer to Eastern splendor and paradise.

The various depictions of the candelabra tree motif draw from and resonate with a wide range of artistic traditions. Among the

Panopolitan finds it is treated both in a fluidly delineated manner associated with the Greco-Roman tradition and in a manner emphasizing the angular character of the weft steps in the weaving, accomplished by a laborious weaving process closely associated with Central Asian textiles (fig. 67).[99] Why there should be such divergent renditions of the same motif at the same site merits further exploration, as do apparent parallels in contemporaneous Constantinopolitan silks.[100]

The glittering brilliance of glass mosaic is a pertinent analogy for silks. In mosaics, the use of light is deliberately manipulated by changing the size, angles, and background colors of tesserae. The surface variability of silk, accomplished by changing the color, length, and direction of surface threads as well as the height of their relief, similarly affects the casting of light and the flickering brilliance of the material.[101] The attention to surface relief can be found in silk embroideries and brocades, and in brocade and tapestry imitations, coarsely executed in humbler materials (at the neck of cat. no. 105B). Luster is enhanced conceptually as well by the formal evocation of objects with shiny surfaces (pearls, gold beads and coins, jewels, and jewelry; compare, for example, the leaf form in the pendant in cat. no. 130 to fig. 67), apotropaic powers of cast light (aureoles, haloes [fig. 66], the cross), and binding knots (guilloches and other interlaced forms, for example, cat. no. 103D in the outermost framing bands of the medallion).[102] Color schemes typically utilized contrasting colors and shades to make the most of bright against dark, with the result that designs remain legible despite reflection and ambient sheen.[103]

Much of the common repertory of motifs on silks can be seen as commentary on the identity of the wearer—although this is not the only possible expression. Monograms, as on jewelry and architecture, identified the item with its commissioner, permanently associating the object with that person regardless of subsequent ownership or use. Hunting imagery on silks presents noble, commanding figures: the hunters wear rich clothing and adornments; ride splendidly adorned, spirited steeds; and hunt with attendants, trained birds, and beasts. Their dramatic gestures invite the viewer to witness their prowess while simultaneously addressing supernatural powers as talismans, intended, like the apotropaic motifs, to avert the evil eye.[104] In contrast, the prosperity evoked by the candelabra tree, as with other auspicious motifs of abundance, was intended to attract good things.[105] Many of the foliate, floral, and bird motifs are found in other luxury arts, such as gold and ivory work, where they also evoke supernatural forces and associations with paradise.[106]

Some motifs can be understood to associate the cloth with the character of the commissioner or owner, specifically with virtues similarly seen as "ornaments of excellence."[107] The hunters, for

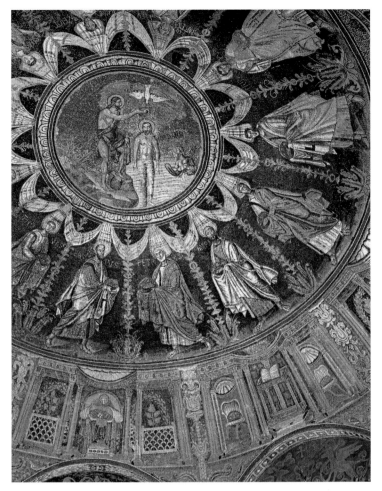

Fig. 61. Mosaic dome of the Orthodox baptistry of Bishop Neon. Tesserae of colored and gold glass. Ravenna, late 5th century

example, figures of bravery and cultivated skill, control fierce animals to do their bidding. In another light, animal imagery may be read as characteristic of virtue (and vice), as in moralizing tales popular across medieval cultures and social classes.[108] Similarly, Greek inscriptions with the names Zachariah and Joseph (cat. no. 103) may have developed from an earlier tradition of identifying exemplars noted for their virtues. The many wool tapestries with scenes from the life of David (cat. no. 7) emulate silk compositions and employ the revered figure in much the same way as the famed silver David Plates, themselves

part of a widespread practice of self-presentation that extended from furnishings to items of dress (cat. no. 6).[109] Other figures popular on silks and other textiles include exemplary emperors, ancient rulers (Alexander, r. 336 b.c.e.–323 b.c.e.; Bahram Gur, r. 421–38), as well as figures of myth (Amazons; cat. no. 103), who appear in similar widely circulating tales.[110] These tales, like the silks, developed across political and religious frontiers.

Although not portrayed on silks, the story of one exceedingly popular hero in Byzantine epic poetry, Digenes Akritas, epitomizes the high social value and inalienable worth of luxury art in the presentation of the good life as lived by an excellent fellow. Emerging in Byzantine oral tradition of the eighth to tenth century, the story takes place within a fictionalized Eastern "Saracen" frontier.[111] Digenes ("born of two races"), son of an Arab prince and Byzantine noblewoman, is strong, handsome, clever, and wealthy. His wedding to a Byzantine noblewoman is memorable for the three-month-long party and the gifts, which constitute a paean to expensive rarities from around the known world, as do possessions glimpsed in other aspects of his life.[112] Digenes rides richly caparisoned horses of the finest stock and hunts exotic birds and beasts of prey. After receiving his office as a frontier lord (Akritas from the Greek *akrai*, "borders") directly from the admiring emperor, who had traveled from The City to meet him, Digenes performs his duties justly and with flair. He later retires to an estate in the East, on the Euphrates River, "with its source in the great Paradise itself," which waters his brilliantly blooming garden—featuring an automated fountain in one version. The ceiling of one of the dining rooms is sheathed in gold mosaic recounting the exploits of ancient heroes (Moses, Samson, David, Achilles, and Alexander), similar to his own brave deeds.[113] Needless to say, Digenes dresses in silk and furnishes his home with silk, luxuriating in the comfort due him, "the ornament of all young men." Only in one of his many battles (an altogether shameful episode with an Amazon in an otherwise perfect life) and in the final stanzas that recount his death is his entertaining life revealed to be a Christian morality tale.[114]

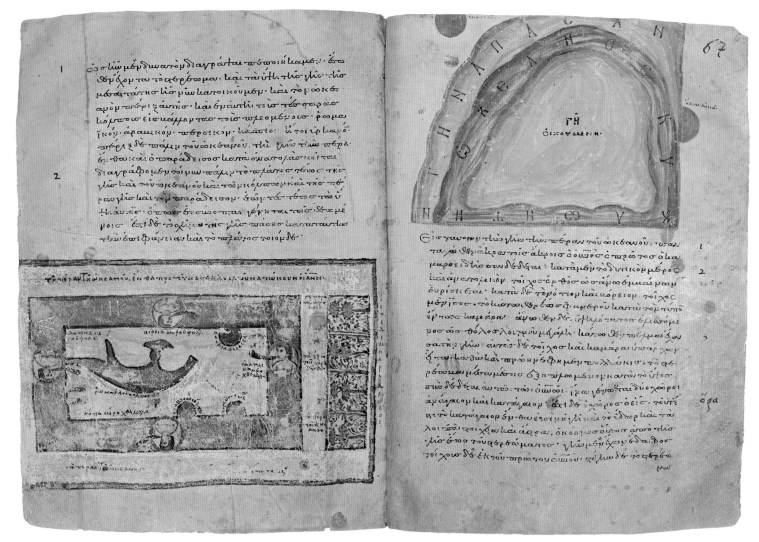

Fols. 66v–67r

82. *The Christian Topography* of Kosmas Indikopleustes

......................

Sinai (?), early 11th century

Ink on parchment, with some titles and captions in gold, other captions in white and red, some gold initials; 211 surviving folios

25.2 × 18.3 cm (9¹⁵⁄₁₆ × 7³⁄₁₆ in.)

Provenance: In the collections of the Holy Monastery of Saint Catherine since the Middle Ages.

Condition: Most gatherings are loose and approximately nine folios are missing. A number of illuminations have been removed or mutilated (30v, 31r, 59v, 67v, 74r, 75r, 75v, 81r, 82r, 92v, 126r, 145r, 174r, 201, 202r). Folios 1–2 are flyleaves in parchment with later text. Some explanatory captions are later. The leather binding dates to the 14th or 15th century.

The Holy Monastery of Saint Catherine, Sinai, Egypt (Codex 1186)

By the eleventh century, when this manuscript was produced, this text had been titled *The Christian Topography* and authorship attributed to "Kosmas, a monk."[1] Written and illustrated in Alexandria during the sixth century, the main project, which comprises a book of five chapters explaining the nature and shape of the cosmos based on a Syrian tradition of scriptural interpretation, received sufficient criticism that five more chapters were added for refutation and further explanation. An eleventh chapter, drawing from the author's extensive travels as a merchant, is thick with descriptions of commerce in luxury goods with distant, exotic lands. A final chapter provides pagan sayings to support his interpretation.[2]

This richly illustrated manuscript contains twelve decorative headpieces separating the prologue and chapters, and fifty-seven finely executed miniatures adhering closely to the sixth-century systems of illustration: this was a production undertaken with attention to detail at significant expense.[3] Similarly lavish production of the two other known copies of this text would seem to reflect considerable respect for and interest in this project in later centuries.[4] There is no evidence as to when or where this manuscript was produced, nor any clue as to the identity of its commissioner, or when or how it arrived in the extensive library collection at the Holy Monastery of Saint Catherine.[5] The locale is featured, however, in the visions that Moses experienced at the summit of the holy mountain: these visions of Creation became the basis for Moses' composition of the Ark of the Covenant and the author's characterization of Moses as a cosmographer.[6] TKT

1 Clark 2008, pp. 10–11.
2 For a critical edition of the text, see Wolska 1962.
3 In their description of this manuscript, Weitzmann and Galavaris 1990, pp. 52–62, use fifty distinct color terms, of which several indicate multiple tones. Brubaker's analysis (1977) considers the system of illustration.
4 The other manuscripts are Vatican Gr. 699 of the ninth century, and the eleventh-century Pluteus IX.28 in the Laurentian Library in Florence. Lowden 1992b, pp. 86–93, and H. Kessler 1995 consider interrelationships between other manuscript traditions and that of *The Christian Topography*. See Clark 2008, esp. pp. 20–25 on "the so-called 'condemnation of Photios.'"
5 Attributed by Weitzmann and Galavaris 1990, p. 63, on the basis of style to a manuscript workshop at the monastery.
6 Clark 2008, p. 151.

References: Wolska 1962; Brubaker 1977; Weitzmann and Galavaris 1990, no. 23, pp. 52–65, figs. 123–183, color-pls. IX–XIII; Lowden 1992b; H. Kessler 1995; Clark 2008.

A B

83A, B. Two Letters Concerning Trade in Egypt

....................

Black ink on papyrus

A. Letter in Arabic Concerning Trade along the Nile

Sent from Alexandria, Egypt, 735

35.1 × 25.4 cm (13¹³⁄₁₆ × 10 in.)

Provenance: Part of a lot purchased in 1930–31 by the University of Michigan from the Egyptian dealer Maurice Nahman via the British Museum.

Condition: The document is in fragmentary condition, the top is missing, and there are several tears; however, the original cutting lines and margins are preserved on the left, right, and bottom.

Papyrus Collection, University of Michigan Library, Ann Arbor (P.Mich.inv. 5614)

B. Letter in Greek Concerning Purchase of Wool

Egypt, 6th century

23.5 × 29.9 cm (9¼ × 11¾ in.)

Provenance: Purchased in Egypt by B. P. Grenfell and F. W. Kelsey, 1920.

Condition: Although torn and incomplete, missing greeting and signature, the body of the letter is preserved on the recto, the address on the verso.

Papyrus Collection, University of Michigan Library, Ann Arbor (P.Mich.inv. 497)

The preservation of great numbers of documentary texts from Egypt is unparalleled elsewhere in the medieval world. Capturing moments in day-to-day life much like modern-day snapshots, the documents present the information within the frame of their immediate concern. Thus, even when papyrus and text are complete, that entirety represents only a part of the full story. Informal associations between clients, as between artisans, were very common and routinely documented in frequent written communications. In letter A, the estate holder writes to his estate manager, first describing his ongoing business trip, then issuing instructions for the agricultural business of his estate in the Fayyum. The letter illustrates how, during the first century after the Islamic conquest, commerce was carried out in the nascent Islamic state through constant movement along roads as well as on the Nile, and continued to rely on effective postal systems. Fustat, the political center for the newly established state, is a mere transfer point during the author's journey to Alexandria, still an important center for commerce, where he stays to sell his goods. Despite the detailed information given in this account, it is not possible to ascertain exactly what the writer was selling. It is evident that during the age of transition business continued as usual between this Muslim estate owner and neighboring Christian estate holders in the Fayyum.

The acquisition of materials for textile production described in letter B offers a glimpse into the fluid business environment in Early Byzantine Egypt.[1] The writer tells of accompanying Apa Romanos—presumably a local monastic leader—on a trip to a nearby village to procure, at the specified cost, a substantial amount of fine wool for a local woman of means, "the lady Patricia," and a small amount of wool for himself.[2] Although the wool was not available at the time of their visit, they were able to arrange future delivery. The writer could make this arrangement on credit and, in this note, writes to his brother for a loan to cover the amount, which he promises to repay when he is reimbursed by his employer. As is evident from this document, the production of a garment or furnishing might involve numerous people and operations, as well as multiple letters. Evidence of a monk doing business in secular society can be found in other documents from Byzantine Egypt.[3] Documents from later periods confirm the continuation of such small-scale, informal, ad hoc arrangements. Although there are no parallels of this kind of documentary evidence from Constantinople, it is possible that private production in the capital was similarly informal alongside better-known imperial, industrial-scale concerns. TKT

1 Wipszycka 1991.

2 The purchase of a small amount of colored silk is documented in an eighth-century papyrus from Egypt: Abbott Collection (Abbott 64, PCtYBR inv.2651qua) in the Beinecke Library of Yale University.

3 A subject recently studied by Clackson 2008, followed by Markiewicz 2009; also attested in documents from the Monastery of Epiphanios in western Thebes (cat. no. 104).

References: (A) For a transcription and translation of the text, http://quod.lib.umich.edu/a/apis/x-4189/5614r.tif; Goitein 1967; Sijpesteijn 2004b, pl. 6; (B) for a transcription and translation of the text, http://quod.lib.umich.edu/a/apis/x-2365/497v.tif; Gignac 1975; Wipszycka 1991; Sijpesteijn 2004a; Clackson 2008; Markiewicz 2009.

Arab-Byzantine Coins: Money as Cultural Continuity

Clive Foss

Coins and papyri, together with a very few building inscriptions, are the only contemporary documentary evidence for the transition from Byzantium to Islam in the Levant, and for the entire Umayyad century.[1] The papyri are by far the most abundant and detailed, but their evidence is mostly limited to Egypt and deals only with very local matters.[2] Coins, for their part, are products of a government; the images they feature can illustrate official policies and ideologies. Their findspots can reveal patterns of local and regional trade, relations between states, and the extent of a monetary economy. They are prime sources for cultural continuity and change.

The Byzantine Empire operated a money economy, striking abundant issues of gold and copper coins, but not silver. The gold came in one denomination, the solidus or nomisma, struck at seventy-two to the pound with a high level of purity (fig. 62). Copper coins were clearly marked by Greek letters, which stood for numbers: *M* for forty nummi, *K* for twenty, *I* for ten, and *E* for five. The large *M* (cat. no. 84A) was the most common except in Egypt, which used a twelve-nummus (*IB*) denomination (cat. no. 84B). Two mints, Antioch in Syria and Alexandria in Egypt, provided most of the coinage of the region, though issues of Constantinople are common in southern Syria and Palestine. The Persian occupation of Syria (610–30) and Egypt (619–29) brought no major change: their regime produced coins that imitated the Byzantine, with traditional types and Greek inscriptions.

The conquering Arab armies found a functioning and long-established system of coinage, which circulated in city and country alike: the copper evidently fulfilled the needs of local trade and business, while the gold covered larger transactions, especially the payment of taxes. For a long time, the Arabs did little to change this.

Stray finds and excavations reveal a surprising phenomenon. Byzantine coins, both gold and copper, continued to circulate extensively in Syria and Palestine long after the Arab conquest: gold until the coinage reform of 696, and copper until about 658.[3]

The copper coins were overwhelmingly issued by Emperor Constans II (r. 641–68; cat. no. 85B), who came to the throne after these lands had been lost to Byzantium. The mechanism by which newly issued coins reached what was generally hostile territory has not been determined. Their quantity seems too large to be explained by trade but may suggest a conscious government policy. In any case, the coins reveal close economic ties between the rival powers of Byzantium and Islam.

A large series of coins struck in Syria and Egypt imitate the issues of Constans II, some closely, others in a bewildering variety of types derived from them (cat. nos. 85C, 85F). The complex Syrian coinage would seem to represent a chaotic period when locals were taking the issue of coins into their own hands. Recent research, however, has shown that these anonymous pieces, without date or mintmark, were actually struck according to the declining weight standard of contemporary Byzantine coins, enabling them to be dated from 638 to about 670.[4] This was a local coinage, with types circulating in definable areas of Syria and Palestine, but the authority that issued them is unknown.

This coinage continued to use Christian images: the imperial figure of the obverse has crosses in his hands and on his crown; the Byzantine *M* adorns the reverse. They were issued under Arab rule (some bear inscriptions in Arabic), but there is nothing Islamic about them. It seems that the new conquerors were far more tolerant of Christian symbols than often believed. They produced coins that answered the desire and maintained the traditions of the Christian population, the overwhelming majority long past the Umayyad period. In fact, when the

first Umayyad caliph, Mu'awiya (r. 661–80), issued a new coinage soon after 660, it was rejected because it did not bear the sign of the cross (cat. no. 86B).[5] These coins, then, witness cultural continuity as well as unbroken contact with Byzantium.

Despite his initial failure with the gold and silver, Mu'awiya did introduce order to the minor coins, in two stages. The first series featured the traditional standing imperial figure but added the name of five mints in Greek or in both Greek and Arabic (cat. no. 87B). The main issue, struck in nine or ten mints, similarly had inscriptions in Greek, Arabic, or both, with a distinctive type at each mint. Most of these are small and well struck, but the area around Scythopolis (modern-day Beisan, in Israel) and Gerasa (modern-day Jerash, in Jordan) issued much larger pieces (cat. no. 87C), modeled on the folles of the Eastern Roman emperor Justin II (r. 565–78). That was a local coinage, unlike the issues of the capital, Damascus, which circulated throughout Syria and Palestine, suggesting widespread commerce. These new bilingual coins still functioned in a traditional context, with familiar Byzantine types and crosses prominently displayed.

The reign of 'Abd al-Malik ibn Marwan (685–705) brought the greatest changes, reflective of a broader Islamic program manifested in Jerusalem's Dome of the Rock and the order to conduct all government business in Arabic. Experimentation marked the first decade: the caliph replaces the imperial figure, the cross disappears, inscriptions are entirely in Arabic, and—for the first time—religious slogans predominate, notably the profession of the faith, There is no god but God, and Muhammad is the messenger of

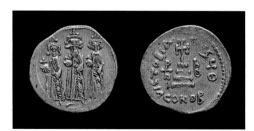

Fig. 62. Cat. no. 86A, obverse, reverse

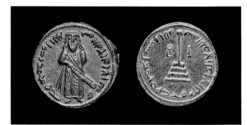

Fig. 63. Cat. no. 89A, obverse, reverse

God (cat. no. 88B). The rare silver issue, a step in the integration of the Roman and Persian halves of the caliphate, presents another novelty, by indicating the date it was issued (cat. no. 88D).

The new gold coins, with their religious Arabic inscriptions, caused an international crisis. Because of an earlier defeat, 'Abd al-Malik had been paying tribute to the Byzantines. When, in 692, he tried to pay it with the new coins, the emperor Justinian II (r. 685–711) refused to accept them, as the coins were of a type never seen before.[6] War followed. Whether the coins really provoked the war, they certainly played an important role in relations between the two hostile states and can be seen as an important vehicle of propaganda.

In the next stage, the image of the caliph appears on gold (fig. 63), silver (cat. no. 89C), and copper (cat. no. 89D). The precious metal coins are rare, but the copper, issued at sixteen mints, are very common. Several of the mints were in the frontier region from which armies were constantly being launched against Byzantium, suggesting production of coins for the military or its suppliers. The coppers still bear the figure of the ruler and on their reverse an object that has been identified as the *qutb*, or pole, symbolizing the caliph as center of the community.[7] Coins struck in Early Islamic Palestine (cat. no. 89C) and Mesopotamia (the largest and best-designed issue was in Jerusalem) present an intriguing anomaly. The figure they portray is different from the caliph of the main series. Their inscription names "Muhammad messenger of God." The conclusion seems obvious and very surprising: Could this be the image of the Prophet himself?[8] Considering how little we know of the iconography of this period, the possibility cannot be excluded.

The coinage of Egypt, far less varied, follows the same lines as the Syrian: Byzantine coins—especially gold—in use after the Arab conquest (cat. no. 90A), a series of copper imitations still bearing the cross (cat. no. 90C), then, under the governor 'Abd al-Aziz, 'Abd al-Malik's brother (cat. no. 90D), coins that name him and contain no

Christian symbols. These were all struck on the peculiar Egyptian denomination of twelve (*IB*). They rarely circulated in Syria, except for southern Palestine, while Syrian coins are virtually never found in Egypt. Syria and Egypt evidently formed separate economic zones.

One Egyptian issue, inscribed in Greek "ΠΑΝ" (PAN), stands out: although it bears an image derived from the coinage of Heraclius (r. 610–41), its reverse is unparalleled, with an alpha and omega flanking a cross and no mark of denomination. The "ΠΑΝ" suggests Panopolis in Upper Egypt, but these pieces are found near Alexandria and Cairo, not Upper Egypt. They may not be official issues at all but produced by Benjamin, the Miaphysite patriarch of Alexandria (r. 626–65) expelled by Heraclius and his orthodox bishop Cyrus at the time of the Arab invasions.[9] Benjamin took up residence outside Alexandria, then withdrew to Upper Egypt. The enigma remains, as with so much of this complex coinage.

Most of the Syrian and Egyptian coins are far from being works of art; some of the early imitations even look like the work of a village blacksmith. The bilingual coppers, by contrast, are far better designed and struck than contemporary Byzantine issues. Likewise, the gold reflects careful design and execution, as fine as any coinage of the age.

'Abd al-Malik carried out the final, definitive reform of the coinage that affected the entire Islamic realm from North Africa to Central Asia. The year A.H. 77 (696/97) saw the last gold dinars with a human image, and the first new issue that bore religious inscriptions alone (fig. 64). The silver (cat. no. 91A) and copper (cat. no. 91B) soon followed (images lingered longer in North Africa and Iran). This fundamental reform produced a truly Islamic, universal coinage. From 'Abd al-Malik until modern times, coins of Islamic countries, with very few exceptions, avoided use of the human figure altogether.

The Arab-Byzantine coins illustrate the age of transition and the early Umayyad period. In economic terms, they reveal a close but unexplained connection with Byzantium for two decades after the con-

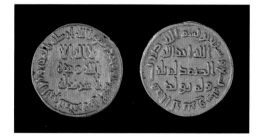

Fig. 64. Cat. no. 91A, obverse, reverse

quest. They show that the whole region remained on a money economy and that coinage was both local and regional, illustrating patterns of trade and military activity. Their cultural significance may be even greater. They show an unexpected use of Christian symbols down to the time of 'Abd al-Malik, evidently reflecting the taste of the great majority of the population. Even more striking, they bear human figures, not simply traditional Byzantine-style images but that of the caliph and—if the coins are correctly interpreted—of the Prophet himself. As contemporary official products, they give insights that can rarely be perceived through other sources.

*All coins reproduced actual size.

84A–G. Pre–Arab Conquest Coins

A. Follis of Phokas (Focas)

Antioch, 609/10
Copper
Diam. 23 mm (⅞ in.); 9.85 g
Obverse
Inscribed: In Greek, on obverse, ONFOCANEPEAV (Our Lord Focas, Perpetual Augustus [garbled]); on reverse, ∩ (40); left and right, ANNO ЧIII (year 9); in exergue, ƵHEUP (Theopolis [=Antioch])
Provenance: Collection of Hayford Peirce until 1948.
Condition: The condition is very fine.
Byzantine Collection, Dumbarton Oaks, Washington, D.C. (BZC.1948.17.1948)

B. 12 Nummi of Focas

Alexandria, 602–8
Copper
Diam. 13 mm (½ in.); 1.94 g
Inscribed: In Greek, on obverse, [garbled]; on reverse, IB (12); in exergue, ΑΛΕΞ (Alex[andria])
Provenance: Purchased from Wayte Raymond, New York, in 1928; collection of Hayford Peirce until 1948.
Condition: The condition is very fine.
Byzantine Collection, Dumbarton Oaks, Washington, D.C. (BZC.1948.17.1954)

C. Cast 12 Nummi of Egyptian Type

Caesarea, Palestine, 7th century
Copper
Diam. 10 mm (⅜ in.); 0.33 g
Inscribed: In Greek, on reverse, IB (12); in exergue, ΑΛΞ (Al[e]x[andria])
Provenance: Gift of Peter Lampinen, 2006.
Condition: The condition is good.
Byzantine Collection, Dumbarton Oaks, Washington, D.C. (BZC.2006.30)

D. Follis of Heraclius

Jerusalem, 613/14
Copper
Diam. 32 mm (1¼ in.); 15.53 g
Inscribed: In Greek, on obverse, DThhERACL·PPAVG (Our Lord Heraclius perpetual Augustus [abbreviated]); on reverse, M (40); left and right, ANNO IIII (year 4); in exergue, IEPOCO (Jerusalem)
Provenance: Purchased Sternberg sale, Zurich, no. 35, Oct. 28–29, 2000, lot 968.
Condition: The condition is fine.
Byzantine Collection, Dumbarton Oaks, Washington, D.C. (BZC.2001.5)

E. Follis of Heraclius

Constantinople, 612/13
Copper
Diam. 28 mm (1⅛ in.); 9.57 g
Inscribed: In Greek, on obverse, ddNhERACLIHSEZhERACONSZPP (Our lords Heraclius and Heraclius Constantine Perpetual Augusti [mostly illegible]); on reverse, M (40); left and right, ANNO III (year 3); in exergue, CON (Con[stantinople])
Provenance: Josef Beisser, Vienna (22.iii.47); collection of Captain Leo Schindler; acquired through his widow in 1960.

Condition: The condition is very good.
Byzantine Collection, Dumbarton Oaks, Washington, D.C. (BZC.1960.125.975)

F. Follis of Persian Occupation

Emesa (?), Syria, 622/23
Copper
Diam. 27 mm (1¹⁄₁₆ in.); 9.2 g
Inscribed: In Greek, on obverse, ON...ΓΑΛINCTO [meaningless]; on reverse, M (40); below, B (workshop 2); left and right, ANN XIII (year 13); in exergue, OCNKO (pseudo-mintmark)
Provenance: Purchased in Jerusalem in 1993; Foss Collection until 2000.
Condition: The condition is very fine.
Byzantine Collection, Dumbarton Oaks, Washington, D.C. (BZC.2000.4.1)

G. Countermarked Follis of Heraclius

Probably Caesarea, 633–36
Copper
Diam. 30 mm (1³⁄₁₆ in.); 11.6 g
Inscribed: In Greek, on reverse, M (40); below, Δ (workshop 4); left and right, ANNO XX (year 20); in exergue, CON (Con[stantinople]); countermarked with ₣, monogram for Heraclius
Provenance: Probably found in Syria; purchased from B. Franceschi, Brussels (iv.62).
Condition: The condition is very fine.
Byzantine Collection, Dumbarton Oaks, Washington, D.C. (BZC.1962.20)

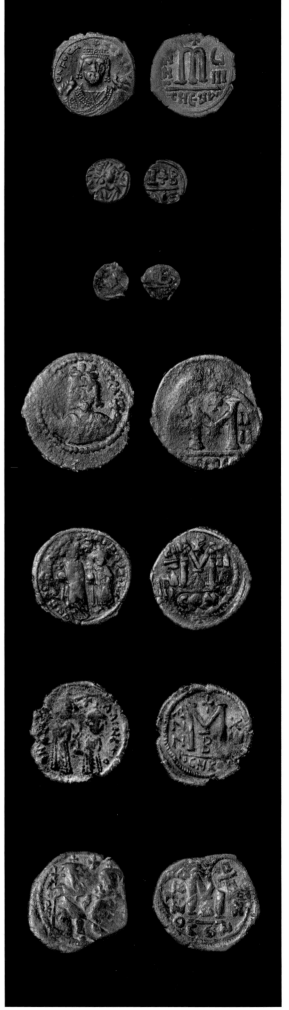

The Byzantine Empire issued great quantifies of copper coins. Most common were the forty-nummus pieces, marked with an *M* (the Greek letter used for 40), struck at mints in Greece, Asia Minor, and Syria, and circulating through the empire. In Egypt, however, the favorite denomination was the twelve nummus (*IB*).

This group represents an age of crisis: the last issue of the mint of Antioch; a contemporary Egyptian issue; a cast piece of Egyptian type used as small change at Caesarea in Palestine; an *M* of Jerusalem, struck just before the Persians captured the city; a coin of Byzantine appearance issued during the Persian occupation of Syria and the type it imitated; and an *M* of Heraclius with countermarks indicating use during the brief Byzantine reoccupation of Syria and Palestine, 630–40.

CFF

References: (A) Grierson 1968a, no. 90.1; Foss 2008, p. 5; (B) Grierson 1968a, no. 106.34; (C) Bendall 2003, p. 313; Foss 2008, p. 6; (D) Foss 2008, p. 8; (E) Grierson 1968a, no.76a.4; (F) Pottier 2004, no. 52.6; Foss 2008, p. 11, no. 1; (G) Grierson 1968a, no. 34; Foss 2008, pp. 15–17; Schulze et al. 2006.

85A–F. Early Islamic Coins and Byzantine Prototypes

.

A. Imitation of Heraclius Follis of Cyprus

Probably northern Syria, 638–45

Copper

Diam. 24 mm (15⁄16 in.); 3.94 g

Inscribed: In Greek, on reverse, M (40); below, Γ (workshop 3); left and right, ΑΝΙ/ΧΥΙΙ (year 18); in exergue, ꟻΠΥꞰ (Cyprus)

Provenance: Collection of Hayford Peirce until 1948.

Condition: The condition is fine.

Byzantine Collection, Dumbarton Oaks, Washington, D.C. (BZC.1948.17.2091)

B. Follis of Constans II

Constantinople, 642/43

Copper

Diam. 23 mm (⅞ in.); 4.95 g

Inscribed: In Greek, on obverse, ЄΝ ΤѠΤΟ ΝΙΚΑ (In this [sign of the Cross] conquer); on reverse, ∩ (40); left and right, ΟꟼΑ/ΑΝΑΝЄΟꟼ (workshop 5/[year] 2 renewal); in exergue, Є ΙΙ

Provenance: Josef Beisser, Vienna (22.iii.47); collection of Captain Leo Schindler; acquired through his widow in 1960.

Condition: The condition is very fine.

Byzantine Collection, Dumbarton Oaks, Washington, D.C. (BZC.1960.125.1131)

C. Imitation of Follis of Constans II

Syria/Palestine, ca. 647–70

Copper

Diam. 19 mm (¾ in.); 2.3 g

Inscribed: In Greek, on obverse, [ЄΝ] ΤѠΤΟ ΝΙΚΑ (In this [sign of the Cross] conquer); on reverse, ∩; left and right, ΑꟼΑ/ΟΝΔ [meaningless]

Provenance: Purchased in Jerusalem in 1993; Foss Collection until 2000.

Condition: The condition is very fine.

Byzantine Collection, Dumbarton Oaks, Washington, D.C. (BZC.2000.4.4)

D. Anonymous Follis, Byzantine Type, but without Crosses

Palestine, ca. 650–70

Copper

Diam. 18 mm (11⁄16 in.); 4.05 g

Inscribed: In Greek, on reverse, ∩; left and right, Η/Α Υ [significance unknown]

Provenance: Purchased in Jerusalem in 1993; Foss Collection until 2000.

Condition: The condition is fine.

Byzantine Collection, Dumbarton Oaks, Washington, D.C. (BZC.2000.4.24)

E. Anonymous Fals with Arabic Legend

Probably Palestine, ca. 647–58

Copper

14 × 17 mm (9⁄16 × 11⁄16 in.); 3.4 g

Inscribed: In Arabic, on obverse,

محمد

(Muhammad); on reverse, in Greek, M; in exergue, in Arabic,

بعض

[[*baʿd*] apparently meaning "a part," that is, a fractional denomination]

Provenance: Purchased in Jerusalem in 1993; Foss Collection until 2000.

Condition: The condition is good.

Byzantine Collection, Dumbarton Oaks, Washington, D.C. (BZC.2000.4.110)

F. Anonymous Fals with Arabic Legend

Probably northern Palestine, 647–58

Copper

Diam. 17 mm (11⁄16 in.); 3.7 g

Inscribed: In Arabic, on obverse,

لله الوفا

(Good faith is with God); on reverse, in Greek, M; left and right, ΑΝΑ/ΝЄΟ (Renewal [slogan used on coins of Constans II] [blundered]); in exergue, in Arabic,

الوفا لله

(Good faith is with God)

Provenance: Purchased in Jerusalem in 1993; Foss Collection until 2000.

Condition: The condition is fine.

Byzantine Collection, Dumbarton Oaks, Washington, D.C. (BZC.2000.4.107)

For two decades after the Islamic conquest, Byzantine coins continued to circulate widely in Syria and Palestine. They were accompanied by a vast range of imitations, some very close to the originals, others with significant but unexplained variations. It is not known who issued them, or where. The first coin dates from the earliest years after the Arab conquests; the others from the 640s through the 660s. Two have inscriptions in Arabic, "Muhammad" and "Good faith is with God." Most of them prominently feature the Christian cross in the hands and on the head of the "imperial" figure, even though they were struck under Islamic rule.

CFF

References: (A) Grierson 1968a, no. 184a.3; Foss 2008, pp. 22–24; (B) Grierson 1968b, no. 61e2; (C) Foss 2008, p. 27, no. 8; (D) Foss 2008, p. 33, no. 29; (E) Foss 2008, p. 34, no. 31; (F) Album and Goodwin 2002, p. 90; Foss 2008, p. 35, no. 32.

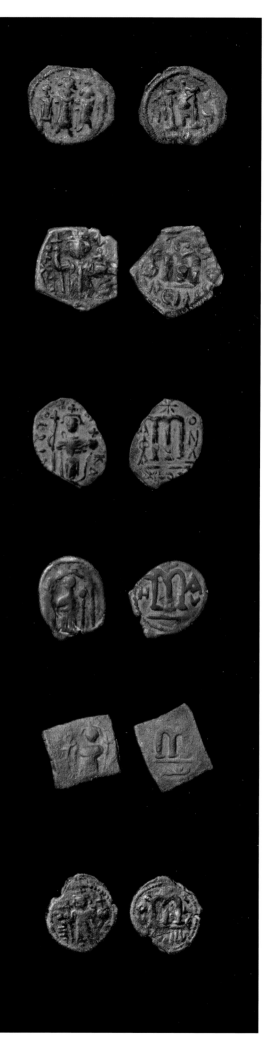

85A–F

86A–C. Caliphate of Mu'awiya: Gold Issues and Prototypes

....................

A. Solidus of Heraclius and Heraclius Constantine

Constantinople, 629–31
Gold
Diam. 21 mm (¹³⁄₁₆ in.); 4.5 g
Inscribed: In Greek, on obverse,
ddNhERACLIMSEZhERACONSZPPAV (Our lords Heraclius and Heraclius Constantine Perpetual Augusti); on reverse, left and right, VICTORIA AYGчГ (Victory of the emperors; fine gold); in exergue, CONOB (Constantinople)
Provenance: Judge E. E. Farman, Warsaw, New York (until 1904); Darius Odgen Mills, New York (1904).
Condition: The condition is extremely fine.
The Metropolitan Museum of Art, New York, Gift of Darius Ogden Mills, 1904 (04.2.821)

B. Imitative Solidus of Byzantine Type

Damascus or Jerusalem, ca. 660
Gold
Diam. 21 mm (¹³⁄₁₆ in.); 4.5 g
Inscribed: In Greek, on obverse, illegible, garbled inscription; on reverse, left and right, VICTORIA AYGчГ (Victory of the emperors; fine gold); in exergue, CONOB (Constantinople)
Provenance: Gift of Paul Z. Bedoucian, 1983.
Condition: The condition is extremely fine.
American Numismatic Society, New York (1983.122.1)

C. Solidus of Heraclius, Heraclius Constantine, and Heraclonas

Constantinople, 638–41
Gold
Diam. 21 mm (¹³⁄₁₆ in.); 4.5 g
Inscribed: In Greek, on reverse, left and right, VICTORIA AYGчГ (Victory of the emperors; fine gold); in exergue, CONOB (Constantinople); in field, IB [significance of letters unknown]
Provenance: Judge E. E. Farman, Warsaw, New York (until 1904); Darius Odgen Mills, New York (1904).
Condition: The condition is uncirculated.
The Metropolitan Museum of Art, New York, Gift of Darius Ogden Mills, 1904 (04.2.822)
For illustration, see fig. 62.

According to a contemporary chronicle, Mu'awiya, after being proclaimed caliph in Jerusalem in 660, issued gold and silver coins that were not accepted because they did not bear the sign of the cross. The second coin here (B) is one of the few surviving examples, for it was found in a hoard buried near Antioch during the reign of Mu'awiya. It features the same types as the regular Byzantine issue (A) except that the crosses have been removed from the emperors' heads and the large cross on the reverse has been transformed into something that resembles the letter *T*. The three-figure type has been similarly transformed and may belong to the same issue. CFF

References: (A) Grierson 1968a, no. 26c; (B) Miles 1967, no. 3; Foss 2008, p. 41; (C) Grierson 1968a, no. 41.

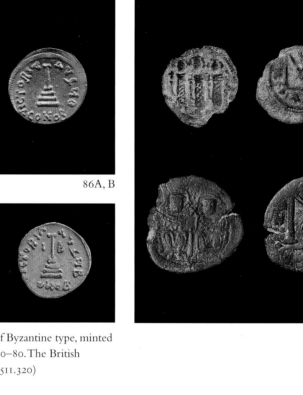

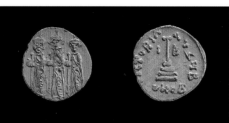

86A, B

Fig. 65. Imitative solidus of Byzantine type, minted Damascus (?). Gold, ca. 660–80. The British Museum, London (1904,0511.320)

87A–C. Caliphate of Mu'awiya: Bilingual Issues

A. Greek Fals of Damascus

Damascus, ca. 660–80
Copper
Diam. 18 mm (¹¹⁄₁₆ in.); 3.1 g
Inscribed: In Greek, on obverse, ΛЄΟ [meaningless; ultimately derived from the Greek ANANЄO that appeared on the reverse of imitations of Constans II types]; on reverse, M ([probably no longer seen as number 40]); above, ₤; below, Ω; left and right, ANO XчII (year 17 [meaningless date copied from prototype]); in exergue, ΔAM (Dam[ascus])
Provenance: Purchased in Jerusalem in 1993; Foss Collection until 2000.
Condition: The condition is very fine.
Byzantine Collection, Dumbarton Oaks, Washington, D.C. (BZC.2000.4.38)

B. Bilingual Fals of Tiberias

Tiberias, ca. 660–80
Copper
Diam. 21 mm (¹³⁄₁₆ in.); 3.8 g
Inscribed: In Greek, on reverse, M ([M probably no longer seen as number 40]); below, A; left, THBЄPIAΔO; right, in Arabic,

طبريه

([mint of] *tabariya* [Tiberias])

87A–C

Provenance: Purchased in Jerusalem in 1993; Foss Collection until 2000.
Condition: The condition is fine.
Byzantine Collection, Dumbarton Oaks, Washington, D.C. (BZC.2000.4.51)

C. Greek Fals of Gerasa

Jerash, ca. 660–90
Copper
Diam. 29 mm (1⅛ in.); 9.8 g
Inscribed: In Greek, on reverse, M; below, A; left and right, ANNO [X]чII; in exergue, NIK [inscriptions imitated from prototype]
Provenance: Acquired from P. S. Pavlou (3137), 2000.
Condition: The condition is fine.
Byzantine Collection, Dumbarton Oaks, Washington, D.C. (BZC.2000.4.34)

The regime of Mu'awiya brought order to the minor coinage, with issues that bore mintmarks and inscriptions in Greek, Arabic, or both. A preliminary series continued the familiar standing "imperial" figure, while in the main coinage each mint employed a distinctive type. Most of these are small and neatly struck, but an area of northern Palestine/Jordan including Gerasa (Jerash) produced coins of the size and type of sixth-century folles. CFF

References: (A) Album and Goodwin 2002, p. 86; Foss 2008, p. 45, no. 46; (B) Foss 2008, p. 52, no. 81. (C) Foss 2008, pp. 54–55, no. 86.

88A–D. Caliphate of 'Abd al-Malik: Early Issues

....................

A. Fals with Arabic Inscriptions, M reverse

Amman (?), ca. 685–88
Copper
Diam. 17 mm (¹¹⁄₁₆ in.); 3.4 g
Inscribed: In Arabic, on obverse,

لعبد الملك امير المؤمنين

(for 'Abd al-Malik, Commander of the Faithful); on reverse, in Greek M, in Arabic

لا اله الا الله محمد رسول الله

(There is no god but God, and Muhammad is the messenger of God)
Provenance: Foss Collection until 2000.
Condition: The condition is fine.
Byzantine Collection, Dumbarton Oaks, Washington, D.C. (BZC.2000.4.76)

B. Dinar of Byzantine Type with Arabic Inscriptions

Probably Damascus, ca. 685–94
Gold
Diam. 20 mm (¹³⁄₁₆ in.); 4.4 g
Inscribed: In Arabic, on reverse,

بسم الله لا اله الا الله وحده محمد رسول الله

(There is no god but God, and Muhammad is the messenger of God); in field, in Greek, B I [significance of letters unknown]
Provenance: Collection of Yacoub Artin Pasha; purchase funds provided by Robert C. H. Brock, 1902.
Condition: The condition is uncirculated.
University of Pennsylvania Museum of Archaeology and Anthropology, Philadelphia (1002.1.107)

C. Sasanian Drachma of Khusrau II

Darabjird, 624/25
Silver
Diam. 32 mm (1¼ in.); 4 g
Inscribed: In Pahlavi, on obverse, left and right ⟨Pahlavi script⟩ (Khusrau; may his glory increase); on reverse, left and right ⟨Pahlavi script⟩ (year 34; Da[rabjird])
Provenance: Purchased in London, 1982.
Condition: The condition is extremely fine.
Foss Collection, Cambridge, Mass.

D. Dirham of Sasanian Type

Damascus, 693/94
Silver
Diam. 31 mm (1¼ in.); 3.2 g
Inscribed: On obverse: Pahlavi inscriptions around portrait (Khusrau, may his glory increase), in Arabic, in margin:

بسم الله ᠵ لا اله الا الله ᠵ وحده ᠵ رسول الله

(In the name of God. There is no God but God Alone; Muhammad is the prophet of God.); on reverse, in Arabic, left and right

اربع وسعين / دمشق

([year] seventy-four; Dimashq [Damascus])

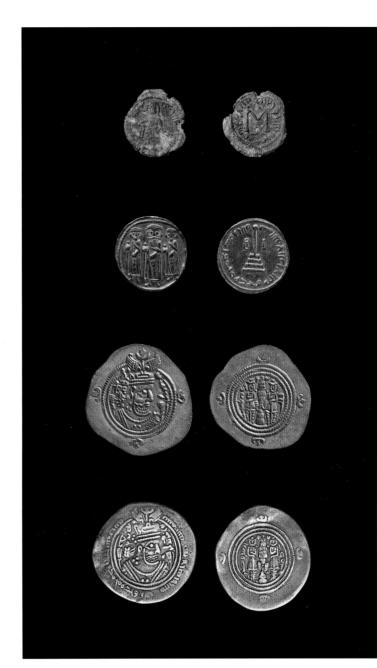

88A–D

Provenance: Gift of Eric P. Newman from the Robert W. Morris Collection.
Condition: The condition is extremely fine.
American Numismatic Society, New York (1971.316.35)

The first decade (685–95) of the reign of 'Abd al-Malik was a time of experimentation, which saw the beginning of a truly Islamic coinage, with the first appearance of the profession of the Muslim faith, in Arabic. Coins were struck in all three metals—gold, silver, and copper—in transformed traditional types. On the copper, the caliph replaces the emperor, but the Byzantine *M* still marks the reverse; crosses disappear from the gold, where the figures wear Arab dress; but the silver, which had previously been issued in Iraq and Iran but not Syria, still maintains the Sasanian types of Khusrau II (r. 590–628) and the Zoroastrian fire altar.

CFF

References: (A) Foss 2008, p. 64, no. 90; (B) Miles 1967, nos. 6–13; Foss 2008, p. 65; (C) Göbl 1968, pp. 211–15; (D) Album and Goodwin 2002, p. 27; Foss 2008, pp. 65–66.

89A–E. Caliphate of ʿAbd al-Malik: Standing Caliph
................

A. Dinar of Arab Type
Probably Damascus, 694/95
Gold
Diam. 20 mm (¹³/₁₆ in.); 4.5 g
Inscribed: In Arabic, on obverse,

بسم الله لا اله الا الله وحده محمد رسول الله

(In the name of God. There is no god but God, and Muhammad is the messenger of God); on reverse,

بسم الله ضرب هدا الدينار فى سنه خمس[ه] و سبعين

(In the name of God. This dinar was struck in the year 75)
Provenance: Purchased from the Robert W. Morris Collection, 1970.
Condition: The condition is uncirculated.
American Numismatic Society, New York (1970.63.1)
For illustration, see fig. 63.

B. Dinar of Arab Type
Probably Damascus, 696/97
Gold
Diam. 20 mm (¹³/₁₆ in.); 4.45 g
Inscribed: In Arabic, on obverse,

بسم الله لا اله الا الله وحده محمد رسول الله

(In the name of God. There is no god but God, and Muhammad is the messenger of God); on reverse,

بسم الله ضرب هدا الدينار فى سنه خمسه و سبعين

(In the name of God. This dinar was struck in the year 77)
Provenance: Collection of unnamed eighteenth-century French diplomat; purchased by the Ashmolean at auction, Peus sale, Frankfurt, lot 1029, March 24, 1971.
Condition: The condition is uncirculated.
The Ashmolean Museum, Oxford (HCR6573)

C. Sasanian-style Dirham with Arab Image
Probably Damascus, 694/95
Silver
Diam. 31 mm (1¼ in.); 3.7 g
Inscribed: In Arabic, on obverse, left and right,

ضرب فى خمسه وسبعين
بسم الله لا اله الا الله وحده محمد رسول الله

in margin: (struck in the year 75; In the name of God. There is no god but God, and Muhammad is the messenger of God); on reverse, left and right,

خلفه [sic] الله امير المومنين

(Caliph of God, Commander of the Faithful)
Provenance: Purchased from M. Azizbeglou, Tehran, 1966.
Condition: The condition is uncirculated.
American Numismatic Society, New York (1966.151.1)

D. Fals of Jerusalem
Jerusalem, ca. 692–97
Copper
Diam. 21 mm (¹³/₁₆ in.); 3.1 g
Inscribed: In Arabic, on obverse,

محمد رسول الله

(Muhammad is the messenger of God); in Arabic, on reverse, left and right,

اليا فلسطين

(Iliya [Jerusalem] Palestine)
Provenance: Purchased in Jerusalem in 1993; Foss Collection until 2000.
Condition: The condition is very fine.
Byzantine Collection, Dumbarton Oaks, Washington, D.C. (BZC.2000.4.69)

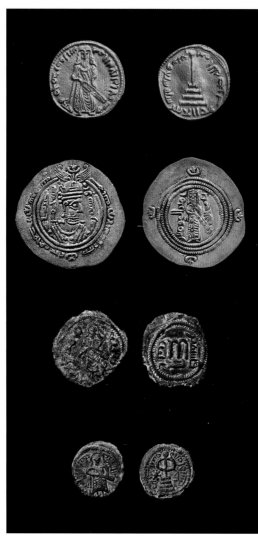

89B–E

E. Fals of Amman
Amman, ca. 692–97
Copper
Diam. 15 mm (⁹/₁₆ in.); 3 g
Inscribed: In Arabic, on obverse,

عبدالله عبدالملك امير المومنين

(the Servant of God, ʿAbd al-Malik, Commander of the Faithful); on reverse,

لا اله الا الله وحده محمد رسول الله عمان

(There is no god but God, and Muhammad is the messenger of God. Amman)
Provenance: Foss Collection until 2000.
Condition: The condition is very fine.
Byzantine Collection, Dumbarton Oaks, Washington, D.C. (BZC.2000.4.78)

The regime of ʿAbd al-Malik eventually produced a standardized series of coins that featured the image of authority, the caliph himself. On the gold, he replaces the Byzantine figure; on the silver, the fire altar yields to him; while the extensive copper coinage, struck in seventeen mints, bears his name as well as his image. On the reverse, the cross has been transformed into an object whose significance is debated. Issues of Palestine and Mesopotamia are anomalous, with a different figure apparently identified by the inscriptions as the Prophet

Muhammad himself. The Standing Caliph coins are the last to depict a human figure.

CFF

References: (A) Miles 1967, no. 15; Foss 2008, pp. 66–69; (B) Miles 1967, no. 18; Album and Goodwin 2002, pp. 94ff; Foss 2008, pp. 66–69; SICA, pp. 94ff; (C) Foss 2008, p. 68; (D) Goodwin 2005, pp. 95–102; Foss 2008, p. 70, no. 92; (E) Foss 2008, pp. 76–81, no. 107.

90A–E. Seventh-Century Egyptian Coins
....................

A. Solidus of Heraclius's Revolt
Alexandria, 609/10
Gold
Diam. 23 mm (⅞ in.); 4.39 g
Inscribed: In Greek, on obverse, DMN HERACLI CONSVAI (Our Lord, Heraclius, Consul); on reverse, left and right, VICTORIA CONSAB. IF (Victory to the Consuls); in exergue, CONOB (year 13; Constantinople, fine gold)
Provenance: Purchased from Bank Leu, Zürich, 1963.
Condition: The condition is extremely fine.
Byzantine Collection, Dumbarton Oaks, Washington, D.C. (BZC.1963.19)

B. 12 Nummi of Heraclius
Alexandria, 613–18
Copper
Diam. 17 mm (¹¹/₁₆ in.); 4.27 g
Inscribed: In Greek, on obverse, ∂OMITI ҺERACLIS (Lord Heraclius); on reverse, IB (12 [nummi]); in exergue, ΛΛEZ (Alex[andria])
Provenance: Acquired from private Swiss collection, 1956.
Condition: The condition is very fine.
Byzantine Collection, Dumbarton Oaks, Washington, D.C. (BZC.1956.23.1067)

C. 12 Nummi of Byzantine Style
Fustat, ca. 642–70
Copper
Diam. 19 mm (¾ in.); 7.4 g
Inscribed: In Greek, on reverse, IB (12); in exergue, MACP (Misr [Fustat])
Provenance: Collection of Tommaso Bertelè until 1956.
Condition: The condition is very fine.
Byzantine Collection, Dumbarton Oaks, Washington, D.C. (BZC.1956.23.1025)

D. 12 Nummi of Governor ʿAbd al-Aziz
Probably Fustat, ca. 685–700
Copper
Diam. 17 mm (¹¹/₁₆ in.); 6.6 g
Inscribed: In Greek, on reverse, M between IB (40; 12); in exergue, ABAZ ([abbreviation of] ʿAbd al-Aziz)
Provenance: Collection of Hayford Peirce until 1948.
Condition: The condition is fine.
Byzantine Collection, Dumbarton Oaks, Washington, D.C. (BZC.1948.17.2121)

E. Anomalous Bronze Coin
Alexandria (?), Panopolis (Akhmim) (?), 7th century
Copper
Diam. 15 mm (⁹/₁₆ in.); 5.1 g

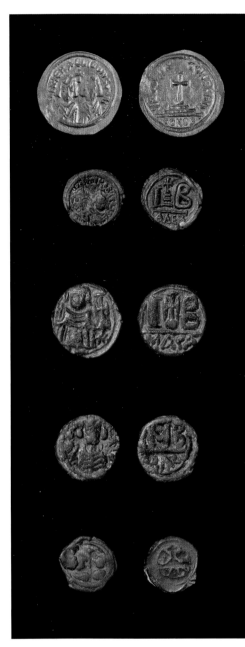

perhaps indicating an equivalence with the Syrian currency. Coins from the time of 'Abd al-Malik add the name of his brother, the governor. The type marked ΠΑΝ may be an unofficial ecclesiastical issue.

CFF

References: (A) Album and Goodwin 2002, no. 14; Foss 2008, p. 89; (B) Album and Goodwin 2002, no. 189.12; Foss 2008, pp. 91–92; (C) Metlich and Schindel 2004; Foss 2008, p. 102, no. 131; (D) Metlich and Schindel 2004; Foss 2008, pp. 103–4, no. 140; (E) Metlich and Schindel 2004; Foss 2008, pp. 104–5, no. 142.

91A–C. Caliphate of 'Abd al-Malik: Postreform Coins

....................

A. Anonymous Aniconic Dinar

Probably Damascus, 698/99
Gold
Diam. 20 mm (¹³⁄₁₆ in.); 4.3 g
Inscribed: In Arabic, in field,

لا اله الا الله وحده لا شريك له

(There is no god but God alone; he has no associate); around edge,

محمد رسول الله ارسله بالهدى ودين الحق ليظهره على الدين كله

(Muhammad is the prophet of God; He sent him with guidance and the true religion to make it victorious over every religion [Qur'an 9:33]); on reverse, in field,

الله احد الله الصمد لم يلد ولم يولد

(God is one, God is eternal; He did not give birth and He was not born [Qur'an 112:1–3]; around edge,

بسم الله ضرب هذا الدينار فى سنه تسع و سبعين

(In the name of God; this dinar was struck in the year 79)
Provenance: Purchased from A. H. Baldwin, November 2001.
Condition: The condition is extremely fine.
Byzantine Collection, Dumbarton Oaks, Washington, D.C. (BZC.2001.29)
For illustration, see fig. 64.

B. Anonymous Aniconic Dirham

Damascus, 699/700
Silver
Diam. 26 mm (1 in.); 2.9 g
Inscribed: In Arabic, on obverse, in field,

لا اله الا الله وحده لا شريك له

(There is no god but God alone; he has no associate); around edge,

بسم الله ضرب هذا الدرهم بدمشق فى سنه ثمنين

(In the name of God, this dirham was struck in Damascus in the year 80); on reverse, in field,

الله احد الله الصمد لم يلد ولم يولد ولم يكن له كفوا احد

(God is one, God is eternal; He did not give birth and He was not born, and He has no equal); around edge,

محمد رسول الله ارسله بالهدى ودين الحق ليظهره على الدين كله ولو كره المشركون

(Muhammad is the prophet of God; He sent him with guidance and the true religion to make it victorious over every religion, even if the associators [i.e., Christians] hate it [Qur'an 9:33])
Provenance: Gift of Eric P. Newman from the Robert W. Morris Collection.

Condition: The condition is extremely fine.
American Numismatic Society, New York (1971.316.1454)

C. Anonymous Aniconic Fals

Uncertain mint, ca. 698–705
Copper
Diam. 22 mm (⅞ in.); 3 g
Inscribed: In Arabic,

لا اله الا الله وحده

(There is no god but God alone); on reverse,

محمد رسول الله

(Muhammad is the prophet of God)
Provenance: Foss Collection until 2005.
Condition: The condition is very fine.
Byzantine Collection, Dumbarton Oaks, Washington, D.C. (BZC.2005.30)

'Abd al-Malik introduced fundamental reforms: he proclaimed Islam as the state religion, made Arabic the language of the administration, and banished images from the coinage. Aniconic issues, which brought the Arab-Byzantine coinage to an end, became characteristic of virtually all future Islamic states until modern times. The last images appear on the gold in 696/97, the silver two years later, and the copper around 700. Henceforth, the coinage bore Islamic slogans, often taken from the Qur'an, and proclaiming the superiority of the Faith.

CFF

References: (A) Jn. Walker 1956, p. 186–252; Foss 2008, pp. 109–11, no. 144; (B) Jn. Walker 1956, pp. 104–201; Foss 2008, pp. 109–11, no. 145; (C) Jn. Walker 1956, pp. 201–27; Foss 2008, pp. 109–11, no. 146.

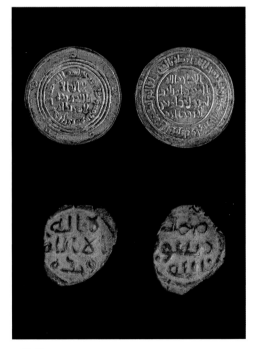

91B, C

90A–E

Inscribed: In Greek, on reverse, A ω (Alpha, Omega); in exergue, ΠΑΝ (Pan[opolis?])
Provenance: Collection of Captain Leo Schindler; acquired through his widow in 1960.
Condition: The condition is good.
Byzantine Collection, Dumbarton Oaks, Washington, D.C. (BZC.1960.125.1443)

The Egyptian coinage followed the same main lines as the Syrian, but with far less variety. It was highly centralized and adhered to the twelve-nummus standard. Only under unusual circumstances—such as the revolt of Heraclius against Phokas (Focas) in 608–10—was gold issued here. The great bulk of the coins were dumpy copper pieces, with the head of the emperor and the *IB* denomination mark. The Arabs introduced a few changes, moving the mint from Alexandria to Fustat, eventually removing crosses and adding an *M* to the reverse,

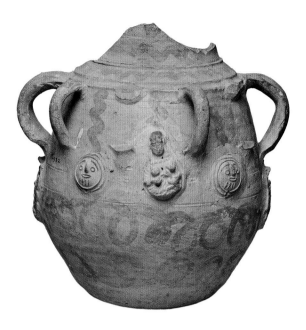

92. Storage Vessel with Applied Decoration

················

8th century
Cream ware, red paint
30.5 × 25.4 cm (12 × 10 in.)
Provenance: In the collection of the Jordan Archaeological Museum since the 1950s.
Condition: The rim, neck, and part of the shoulder are broken away; six of the eight small handles are missing.
Jordan Archaeological Museum, Amman (J. 4982)

This storage jar was made of cream ware and decorated with red hand-painted curves, which was very common within the eighth century, the late Umayyad and early Abbasid periods. The jar has two large functional handles and eight smaller handles, of which only two remain. Below each of the two large handles is another large applied element, and circling around the body of the jar just below the smaller handles are four circular applied medallions of stylized faces and two reliefs of a female figure.

The form of this storage jar has numerous parallels, but the applied decoration and the small handles make it unique. It was clearly made for no ordinary purpose. The two female figures are similar to images on Byzantine coins and mosaics. RS

Reference: Umayyads 2000, p. 67.

Weights and Measures from Byzantium and Islam

Stefan Heidemann

The rapid conquest of Egypt and Syria by the Islamic armies brought almost no change to the daily economic life of the people living in either the cities or the countryside, since the Muslim elite was interested in a functioning economy that would yield a high tax return. In the late fourth to fifth century, churches and basilicas became the new focus of urban life, supplanting temples and complexes for public entertainment. The transition to pack animals for transportation meant that large streets for wheeled traffic were no longer needed, and shops began to crowd the edges of the roads.[1] When congregational mosques were established, they created new urban centers. The Early Islamic steelyard (cat. no. 93A) might be an example of this slow change. The technical design is eastern Mediterranean, dating to the end of the Roman Empire.[2] The steelyard has two scales; one indicates pounds by long incised lines, half pounds by a short notch and three dots, and values by Greek numerals. The second scale, on the opposite side of the tetragonal long arm, shows notches for every pound, and for every five pounds an incised line, but the value is indicated in Arabic characters and symbols that have not yet

been deciphered. Whereas Byzantine steelyards are usually decorated with animal and human effigies, this one is embellished with scrolling vine leaves and foliage, which allows it to be dated into the eighth or ninth century. The new decorative design indicates a shift in taste inspired by Islamic religious art.

The most decisive change for weights and measures was the reforms by the caliph 'Abd al-Malik ibn Marwan (r. 685–705). Besides introducing Arabic as the language of administration, he reduced the weight of the Byzantine gold nomisma (4.55 g) to the *mithqal* (4.2 g) and that of the still current Sasanian silver coin (4.2 g) to the dirham weight (2.9 g). *Mithqal*-dinar and dirham became the basic units for precious metals and other valuable substances. The *ratl* (between 337 and 440 g) took the place of the Roman pound (ca. 440 g), but it was never completely standardized throughout the empire. Its weight varied both from region to region and over time.

Egypt had a special position in terms of the administration of weights and measures and the materials used for them. In the Late Roman–Byzantine period, weights for coins and substances were usually simple bronze

disks or flat bronze "bricks" with the value incised, usually in combination with a cross.

In Egypt, however, weights were made of glass and stamped with the Greek monogram of the responsible officer and sometimes even with his effigy. Glass has advantages. The amount for a certain weight can be measured precisely and then melted into a blob, which can be stamped. Any alteration of the weight is immediately visible as a chip. The Byzantine practice continued probably into the first decades of Arab rule. The Umayyad governor of Egypt, Qurra ibn Sharik (r. 709–14), Arabized the administration and reorganized the fiscal system of Egypt in every regard. Precisely adjusted glass tokens were stamped in Arabic with the name of the governor, sometimes with that of the responsible officer, and usually with the value; sometimes Coptic numerals and Greek letters were added. In Syria glass weights were used only for brief periods, and they never became popular. Likewise, in all other regions of the eastern Mediterranean, bronze or lead weights were preferred. In Egypt, by contrast, while bronze and lead weights existed side by side with glass weights beginning in the Fatimid period (969–1171), glass weights

continued to be used until the Mamluk period (1250–1517). Qurra and his Umayyad and Abbasid successors in Egypt also regulated all other weights and measures used in public, through official stamps. Thousands of glass weights and vessel stamps of Qurra and his successors survive. Vessel stamps were flat blobs of glass set usually in place below the rim of an already blown and adjusted glass container and then stamped.

The weights and measures indicated their value not only in general terms; many are more specific, such as the *ratl* for meat, the measure *qist* for olive oil, and the *mikyala* for white cumin. Stamps for more than a hundred pharmaceutical substances are named on glass. This system of controlling all measurements and weights with stamps was abandoned by the Tulunid period (868–905), and only coin weights continued to be made of glass until the Mamluk period.

93A, B. Steelyard with Counterweight

....................

Egypt or Syria, 9th–10th century
Copper alloy
Provenance: Collection of Antonis Benakis (1873–1954); part of the original Benaki Museum, which was given to the Greek state in 1931 and inaugurated on April 22 of that year.
Condition: The steelyard and counterweight are in stable condition.

A. Steelyard
L. 73.5 cm (28 15/16 in.)
Benaki Museum, Athens (13275)

B. Counterweight
H. 34.5 cm (13 9/16 in.)
Benaki Museum, Athens (13266a)

The steelyard was a Roman invention that allowed a scale for heavier weights to be made much lighter and that used just one weight instead of a set of weights. Another improvement was the inclusion of two or three different scales on the longer arm, which permitted greater precision. The technology continued uninterrupted in the marketplaces of the eastern Mediterranean under Islamic rule. Many Late Roman steelyards have survived, but Early Islamic ones are rare. The only visible change is in the taste for embellishment—vine scrolls instead of figural images—and the numbering system. The measurements themselves remained the same.

The steelyard hung on one of two hooks (Lat. *fulcrum*), which was the point of suspension. One of the hooks is still attached to this steelyard; the second hook would have hung from the loop hole on the upper side of the arm. The long steelyard arm, obviously meant for quite heavy loads—at least forty Roman pounds (about 27 1/2 lbs [12.5 kg])—is calibrated on two sides with notches and numerals, each side providing a different scale. The object to be weighed hung from a weighing collar (now missing) near the end of the shorter arm. The shorter the load arm, the higher the maximum load. Once the steelyard was set up with the object to be weighed, the counterweight was allowed to slide along the edge of the long arm with the 45-degree offset scale until it reached a notch where it was in balance. The state of equilibrium meant that the counterweight had compensated through its distance from the point of suspension for the weight of the load hanging from the shorter arm. To change the scale, the steelyard was suspended from the other hook, and the counterweight was slid along the notches of the second scale.[1]

SH

1 Garbsch 1988a, 1988b.

References: (A, B) Unpublished.

B

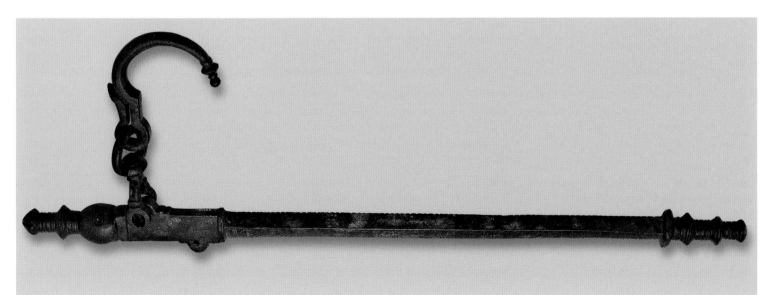

A

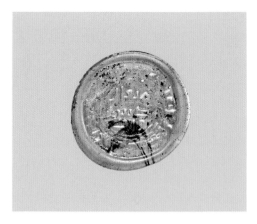

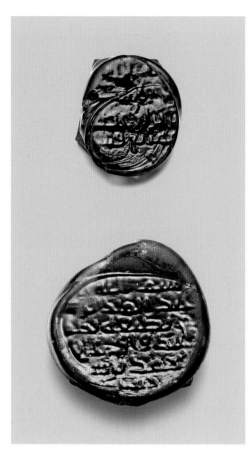

vessel stamps. If the vessel breaks, part of it remains as a shard attached to the thick stamp. Only this part usually survives. The stamps indicate a measure of a quarter and a half *qist*, respectively. Due to the nature of broken glass, we do not know the precise value of the *qist*.[1] A *qist* can be estimated, however, to be about 1.5 liters (a little more than 1½ quarts). The vessel attached to the shard measured a quarter *qist*, probably about 0.38 liter (a little more than 1½ cups), the second about 0.75 liter (a little more than 3 cups).

The first stamp (A) was manufactured under the Umayyad financial director 'Isa ibn Abi 'Ata (r. 743–45; 745–49). The authorizing governor of the second container was 'Abdallah ibn Yazid (r. 751–53; 755–58). The high-ranking official responsible for weights and measures is named as Muhammad ibn Shurahbil, who served several governors in the Abbasid period in this capacity.

SH

1 Balog 1976, p. 30.

References: (A) Petrie 1926, p. 16, no. 135; Launois 1957, nos. 106–109 (same die as no. 106); Balog 1976, p. 100, no. 249; (B) unpublished, compare Balog 1976, p. 121, nos. 326–331; Petrie 1926, p. 17, no. 147; Launois 1957, p. 143, nos. 162–163.

94A, B. Vessel Stamps

....................

A. Quarter *Qist*
Egypt, 743–49
Glass, bottle green
3.5 × 2.5 cm (1⅜ × 1 in.)
Inscribed: In Arabic,

(بسـ)ـم الله/ (امـ)ـر الامير/ (عيسـ)ـى بن ابي عطـ(ـا)/ (بصنـ)ـعه ربع قسط/ (واف)

(In the name of God/[orde]red the amir 'Isa ibn Abi 'Ata/ the manufacture of one-quarter of a *qist*, full measure)
Provenance: [Michael Casira, Cairo (until 1908)].
Condition: The vessel stamp is attached to a glass shard showing parts of a rim.
The Metropolitan Museum of Art, New York, Rogers Fund, 1908 (08.256.7)

B. Half *Qist*
Egypt, 751–53 or 755–58
Glass, bottle green
Diam. 4.4 cm (1¾ in.)
Inscribed: In Arabic,

بسم الله (امر)/ عبد الملك بن (يز)/ (يـ)ـد بصنعه نصف/ قسط واف على يـ(ـدي)/ محمد بن شر(ا)/ حبيل

(In the name of God;/ [ordered] 'Abd al-Malik ibn [Ya/zi]d the manufacture of one-half *qist*, full measure, at the hands of Muhammad ibn Shura/hbil)
Provenance: [Michael Casira, Cairo (until 1908)].
Condition: The vessel stamp is attached to an irregular glass shard.
The Metropolitan Museum of Art, New York, Rogers Fund, 1908 (08.256.3)

Only about ten complete measures have survived, but there are hundreds of

95. Coin Weight

....................

Egypt, 808–10
Glass, blue-green
Diam. 2.9 cm (1⅛ in.); 4.19 g
Inscribed: In Arabic, obverse, center,

مثقال

(*mithqal* weight),

دينار .ْ.

(dinar [three dots]),

واف

(full [weight]); obverse margin,

مما امر به الامير الحسن بن البجاح ابقاه الله

(Of what the amir al-Hasan ibn al-Bahbah ordered, may God preserve him); on reverse,

(على يـ)ـدي (...)/ (...)

([blurred] [blurred] ([at the h]ands/[blurred]/[blurred]))
Provenance: [Michael Casira, Cairo (until 1908)].
Condition: The glass weight is in mint condition with inclusion of charcoal traces.
The Metropolitan Museum of Art, New York, Rogers Fund, 1908 (08.256.20)

Dry Egyptian soil preserved perfectly the weight of this *mithqal*, the weight of a dinar, the legal standard of gold. This coin weight was stamped under the governor al-Hasan ibn al-Bahbah (r. 808–10). The

reverse would have given the name of the person in charge, but the glass was stamped in its viscous state, and the inscription became blurred when the glass cooled.

SH

Reference: Balog 1976, pp. 229–30, compare nos. 642–644.

96. Ring Weight

....................

Egypt, 847–61
Glass, bottle green
6.7 × 5.7 × 5 cm (2⅝ × 2¼ × 1¹⁵⁄₁₆ in.); 381.5 g
Inscribed: In Arabic,

(بسم الله الرحمن الرحيم)/ (امر الله بالعدل و)الوفا/ (وبذلك)امر به عبدالله/ (جعفر ا)لامام المتوكل/ (على الله)امير/ (المؤمنين)(اطال)الله ابقا(ه)

(In the name of God, the Merciful Benefactor,/[God ordered with justice and]/honesty [and therefore] ordered this 'Abdallah/Ja'far, the Imam al-Mutawak-kil/['ala Allah] the Commander of the Believers [May] God [prolong his] life)
Provenance: [Michael Casira, Cairo (until 1908)].
Condition: The ring weight was heavily used in ancient times and also has some modern chips; at the top, two identical stamps were applied.
The Metropolitan Museum of Art, New York, Rogers Fund, 1908 (08.256.1)

The innovative system of control by weights and measures distributed by Umayyad and Abbasid authorities also

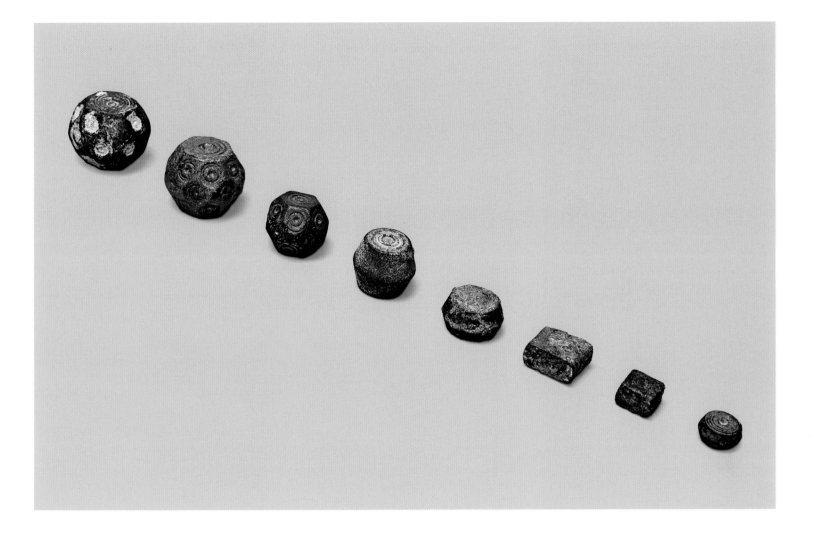

included heavier weights, produced at the same official glass workshops as coin weights and vessel stamps. These heavier weights usually took the form of large glass disks or heavy glass rings, made by folding thick bars of viscous glass. Glass rings could be suspended from a string. Due to the thick, hot, viscous material of these large objects, the inscription of the stamp is rarely clearly legible. This one names the caliph al-Mutawakkil 'ala Allah (r. 847–61) and has the weight of a *ratl*. SH

References: Balog 1976, p. 250, no. 688; Jenkins-Madina 1986, p. 53, no. 74 (this weight).

97. A–H. Eight Bronze Weights

....................

Jordan, 750–1050
Bronze, molded and punch-marked
0.4–2.4 × 1.3–2.5 cm (³⁄₁₆–1 × ½–1 in.); 2.1–146.2 g
Provenance: Excavated in Areas A, D, J, and K of the archaeological site at Ayla / Aqaba during the 1992 season.
Condition: The weights are in good condition, with some evidence of wear.
Aqaba Archaeological Museum, Jordan (right to left: AM 649, 514, 648, 645, 528, 647, 527, 644)

For the first 150 years after the Umayyad caliph 'Abd al-Malik ibn Marwan (r. 685–705) introduced new weight standards for precious-metal coinage, coins were carefully adjusted in the mints, but this rigid control faded in the middle of the ninth century, and the weighing of coins in circulation was left to the public. Everyone handling money needed a balance and coin weights. Early Islamic bronze weights are distinguished from Late Roman ones by shape, punched decoration, assayer marks, and, most of all, by their belonging to the new weight systems of the *mithqal* and dirham. Whereas Byzantine weights are in simple forms such as a disk or a square "brick," Early Islamic weights take the form of a barrel, a truncated bicone, or a polyhedron; for the smaller weights the very common brick shape prevailed. Bird's-eyes were punched on the facets and / or a peripheral groove was incised along the edge of a planar surface, sometimes with one word or a name punched into it indicating a validation or an assayer's name. None of these weights, however, has a mark indicating the weight standard applied or the value it represents. The largest and heaviest barrel-shaped weight of this sample measures fifty dirhams, the smallest probably just half a *mithqal*.

This group was excavated in the Byzantine and Early Islamic port city of Ayla, modern-day Aqaba, at the northern tip of the Red Sea, which connected Arabia, Byzantine Palestine, and Egypt. The weights were discovered in archaeological layers from the Abbasid to the Fatimid period and concentrated in the central building, behind the western Egyptian Gate and also behind the southern Sea Gate—places within the city where market activities can be assumed to have taken place.[1] SH

1 Whitcomb 1994, pp. 38–41.

References: Holland 1986; Whitcomb 1994.

Silks

Thelma K. Thomas

Extruded in long, fine strands from the mulberry caterpillar, *Bombyx mori*, the fiber of cultivated silk is nearly pure protein, as smooth along its length as any modern manmade fiber and even stronger, while remaining soft, flexible, and lightweight. It is also translucent, with a triangular prismlike formation visible in cross section that allows silk to refract light. Light entering at one angle and leaving through the face of another angle is like the "fire" that lights a diamond, scintillating as it disperses light and appearing to shimmer. The smooth surface of the fiber reflects light, so silk is also shiny and lustrous. Silk takes dyes exceptionally well, resulting in clarity, strength, and subtlety of color. Reflection and refraction make the colors appear to flicker among several shades, an effect open to manipulation by the shaping of surface topography and weave structure, as well as the spinning and dyeing of yarns. Best represented among the surviving remains are color schemes using two to five colors. Color schemes with strong contrasts are most legible and most common, yet closely related colors were used together as well (pinkish yellow and gold, for example) to create more atmospheric effects.

The weaving technique most commonly represented among the surviving silks discussed here is the twill compound weave, samit, which displays the weft patterning on both sides of the cloth. The weft threads on the surface, usually only loosely spun if spun at all, utilize the smooth and lustrous surface of the fiber to full brilliant effect to display the expertise of the dyer. Brocading takes advantage of unspun or loosely spun threads to create lustrous staccato accents (cat. no. 99D). In embroidery, blocks of color were laid down in unidirectional groups of stitches; light effects were manipulated by changing the direction of threads, strategically placing single lines of thread, and using short lines and dots as staccato punctuation (fig. 59).

Silk cloth on a large scale is known mainly through representations. A few rare examples of sheets of silk, however, have been preserved (figs. 58, 66, and cat. no. 102A). Most surviving silk artifacts were cut from larger pieces of cloth; some were woven as sets to be cut apart and applied to clothing (as were some tapestry-woven wool ornaments).[1] Often the pieces suffered damage over time, as colors faded and fibers became brittle and broken or disintegrated completely. Modern practice has sometimes removed fragile pieces of silk from secondary applications to enable their conservation, exhibition, and study (fig. 67).

The silks discussed here have commonly been attributed to Alexandria (less frequently to the chief find sites in Egypt, Antinoë, and Panopolis [Akhmim]) or to Syria. Dating is complicated by coexisting styles: a given design might be executed in different styles (with fluid, curvilinear outlines or angular, stepped outlines; see figs. 67, 68). When first discovered at the turn of the twentieth century, the Egyptian finds were assigned dates in the sixth century, largely on the basis of hypothetical stylistic trends. Recent forays into radiocarbon dating indicate a range of dates between the sixth and ninth centuries, and it is possible that older designs remained in use. Consequently, some of these silks with Byzantine compositions and styles were not only used in the Islamicate world, they were, quite likely, produced there as well.

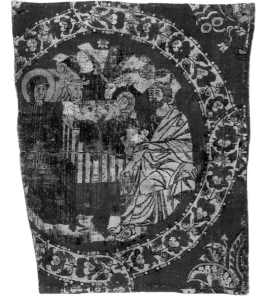

Fig. 66. Nativity. Weft-faced compound twill (samit) in polychrome silk, 8th–9th century. Vatican Museums, Vatican City (61258)

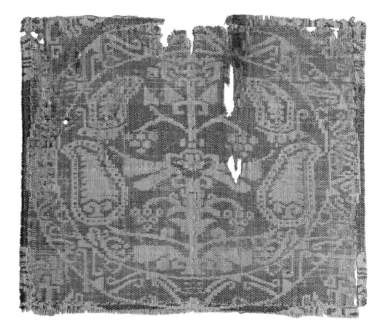

Fig. 67. Roundel with Central Asian–style "candelabra tree." Weft-faced compound twill (samit) in polychrome silk, 7th–9th century. The Metropolitan Museum of Art, New York, Rogers Fund, 1917 (17.22.1)

98. Pattern Sheet with Diaper Design

....................

Egypt, 5th–6th century
Black ink and light yellow, dark yellow, pink, blue, and white paint on light brown papyrus
7 × 7 cm (2¾ × 2¾ in.)
Provenance: From the collection "Papyrus Archduke Rainer," founded in 1883. In 1889, Archduke Rainer presented his collection to Emperor Josef I, who included it as a special collection in the Royal and Imperial Court Library (now the Austrian National Library).
Condition: The sheet is in fair condition, preserving the lower edge.
The Austrian National Library, Department of Papyri, Vienna (P.Vindob. G 1.310)

The bottom edge of this papyrus shows a clavus (narrow band) with a diaper design that includes a bunch of feathers in the middle, flanking palmettes, pearls, and squares. The drawing served as a model for the woven decoration of a tunic and displays the typical elements of a pattern sheet used by weavers (cat. no. 105). The pictorial elements are highly simplified and rendered easily legible with dark contours. Instead of the red square, the weaver could substitute other ornamental motifs, such as small leaves or beads.

This pattern imitates early Persian silks of the fifth and sixth centuries, which found their way to Egypt in large numbers from the fifth century on, especially to Antinoë (see Thomas, p. 148). Pearls, gems, and small palmettes were typical motifs on Sasanid silk fabrics. Since silk was very expensive, it was cut into strips and sewn onto solid-color garments. Persian clothes, as well as domestic-made tunics with appliquéd strips of Persian silk, have been found in Egypt. These decorative elements greatly influenced Egyptian weavers starting in the fifth century and stimulated the imitation of Sasanid silk patterns in tapestry-weave woolen textile embellishments. At a distance, the regular repetition of these motifs applied on wool or linen garments would have made these ornaments look like real silk. Because of its close affinities with fifth-century Sasanid silk, this model may have been made in the late fifth or early sixth century. It may be that such patterns were known in other workshops and that they contributed to the spread of Persian motifs in the other arts, such as mosaics.

ASt

References: Horak 1992, p. 67, no. 2, pl. 1, table 1; Buschhausen et al. 1995, p. 126, cat. no 131; Martiniani-Reber 1997; Fluck and Vogelsang-Eastwood 2004; Stauffer 2008, pp. 160–61, colorpl. 40.

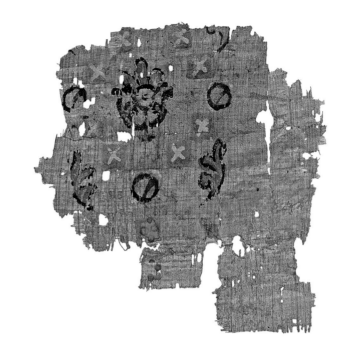

99A–D. Lattice-Patterned Silks

....................

The design known as a lattice, diaper, or diamond pattern enjoyed great popularity during Late Antiquity in Roman, Byzantine, Persian, and Islamic art, especially in textiles.[1] A grid of diagonal lines crosses in an allover, expandable pattern. The grid may be composed of any motif. These examples exhibit a vine scroll, a ribbon, a guilloche, and a string of heart-shaped flower buds. A crossing is usually marked by a distinctive motif. Here, each intersection is filled with a four-petaled rosette within a thin circular frame; each heart-shaped petal faces a cardinal direction; and each lobe follows a different line of the grid. The diamond-shaped spaces between the grid lines are usually filled, as seen here. Several patterns found in multiple examples, which may be distinguished by color and ornamental variations, may reflect the expected desires of consumers for distinction in serially produced items or the choices of individuals who commissioned unique cloths.

A. Guilloche Lattice with Pinecone (?)

Egypt, 7th–9th century
Weft-faced compound twill (samit) in red, black, and blue silk
20 × 18 cm (7⅞ × 7¹⁄₁₆ in.)
Provenance: Dikran Kelekian (1868–1952), Paris, Istanbul, and New York; Charles Kelekian (1900–1982), New York (by descent); Nanette B. Kelekian, New York (by descent until 2002).
Condition: This silk fragment in red and black weft (nearly entirely deteriorated) on a black and blue warp is in fragile condition. It is worn and there are losses throughout the fragment. There are remnants of stitches in yellow silk and stitch holes from attachment of the tabula to a ground of yellow silk, of which a fragment is visible below the tabula. The color of the red silk weft is well preserved.
The Metropolitan Museum of Art, New York, Gift of Nanette B. Kelekian, in honor of Nobuko Kajitani, 2002 (2002.239.27)[2]

This grid is composed of a slender guilloche (a winding or interlacing ribbon) framed by a thin, straight line on both sides. As mounted, the scarlet red ground is the brighter color, and the linear details are in dark brown (deepening to black and blue under magnification). Each interior diamond shape of the grid is filled by a motif—apparently vegetal, ovoid and wider at the bottom, with lines curving out from the exterior, and the interior is subdivided into smaller rounded units in systematic progression. Similar motifs in other circumstances have been identified as pinecones (or perhaps artichokes). Here, it is presented on a two-part base, a striated foundation supporting a triangular foot.

B. Ribbon Lattice with Pinecone (?)

Egypt, 7th–9th century
Weft-faced compound twill (samit) in red, black, and beige silk
22.5 × 23.8 cm (8⅞ × 9⅜ in.)
Provenance: [Galleria Sangiorgi, Rome]; [Adolph Loewi, Inc., Los Angeles (1946)].
Condition: This silk fragment in red (faded to pink) and black wefts (nearly entirely deteriorated) on a black and beige warp is in fragile condition. It is worn and there are losses throughout the fragment. The edges are cut. There are remnants of stitches in yellow silk. This fragment was glued to a piece of black cardboard (painted to match the color of the pink weft) prior to entering the museum's collection.
The Metropolitan Museum of Art, New York, Fletcher Fund, 1946 (46.156.13)

This design is a close variation on that of A. Against a red ground (faded to pink), the lattice pattern is worked in black (faded to dark brownish purple); short sections of curling ribbon are placed between widely spaced, thin lines. Changing proportions and discrepancies in the repetitions of each motif suggest manual execution rather than the precision and regularity that characterize weaving done on a fully mechanized loom.

Again, the featured motif, a pinecone (or perhaps an artichoke), stands on a plain, tri-angular base, as if it were a sculpture, like the sculpted pinecones found on fountains.[3] There may have been several associations for this motif: pinecone kernels (and artichokes) were eaten in Byzantium and thought to have a beneficial effect on health.[4] The motif was used in contemporaneous Islamic settings (cat. no. 161, where it is combined with pomegranates). A different rendering was identified as a pinecone or artichoke in the ninth-century carved wooden casings for tie beams in the West Gallery at Hagia Sophia in Constantinople, where they emerge from "Sassanian-Umayyad" split-palmette motifs.[5]

C. Vine Lattice with Birds

Egypt, perhaps Panopolis (Akhmim), 6th–9th century
Weft-faced compound twill (samit) in red and beige silk
15.5 × 15.3 cm (6⅛ × 6 in.)
Provenance: The Metropolitan Museum of Art (1915).
Condition: This silk fragment in red and beige weft on a beige warp is in fragile condition. It is worn and there

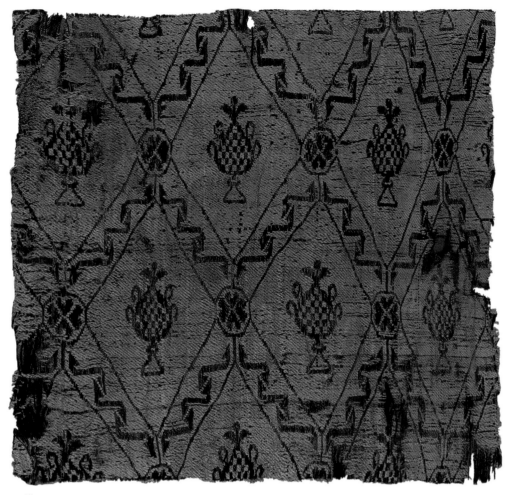

B

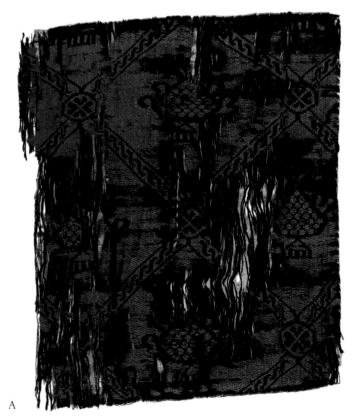

A

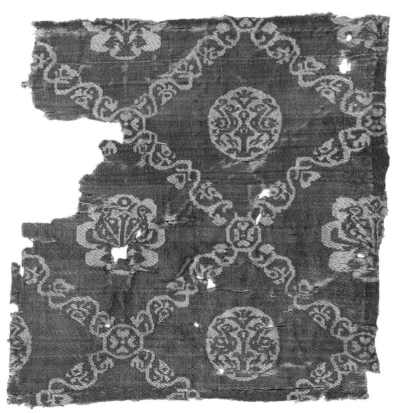

C

C, obverse

C, reverse

are small losses throughout the fragment with one larger loss along the left side. Originally turned to the back, the edges have been opened prior to entering the museum's collection. The folding lines are visible, and some areas are broken, leaving long slits. There are stitch holes. The Metropolitan Museum of Art, New York, Charles Stewart Smith Memorial Fund, 1915 (15.109)

In this more complex version of a lattice design, a vine scroll generates the grid. Within the diamond-shaped spaces, symmetrical compositions of affronted birds in circles alternate with addorsed birds in eight-lobed lozenges. A vertical plant motif separates the birds along the axis of symmetry. Each compositional element can be found in a range of media: the facing birds, for example, are common on jewelry (cat. no. 132). The surface of this side of the cloth presents the lighter, beige threads against the lower ground of light red.

Several examples of this design are known, including two among the published silk finds from Panopolis (Akhmim).[6] A number of pieces in other museum collections exhibit

this composition as well. All seem to have been cut for application to tunics, and they utilize a range of color schemes (whitish or yellow against darker red, purple, or blue grounds), with minor variations in the treatment of motifs (such as, for example, whether the beaks are closed or open) and slight differences in scale. Within each cloth, minute details within a single motif diverge from the absolute symmetry that is indicative of weaving on a fully developed drawloom.[7]

D. Lattice

Egypt, 7th–9th century (?)
Plain-weave ground in undyed linen with pattern in brocading weft in polychrome silk
Two larger fragments 11.5 × 16.5 cm (4½ × 6½ in.); 18 × 11.5 cm (7¹/₁₆ × 4½ in.)
Provenance: Collection of Antonis Benakis (1873–1954); part of the original Benaki Museum, which was given to the Greek state in 1931 and inaugurated on April 22 of that year.
Condition: Torn and fragmentary, in numerous pieces. There are remnants of a selvage along one edge.
Benaki Museum, Athens (15043)

In this design, stepped, concentric rhomboids, in red, are framed on the exterior by a larger rhombus of a "string" of hexagons and, on the interior, articulated by hexagons or stepped rhomboids of tan, blue, blue-green, and black silk threads. The design is brocaded, a technique in which discontinuous wefts of unspun, uneven silk threads are pulled across the surface of the woven fabric and secured under selected warp threads. The technique as executed here, using relatively little silk, in uneven threads, is paralleled by a similar example in the publication of finds from the excavation at Panopolis (Akhmim) and by examples of higher quality.[8] One spectacular example in the Cleveland Museum of Art uses much finer threads in a similar color scheme, except for gold metallic thread in place of the tan silk of this piece, and alternates geometric shapes with a fantastical plant as a featured motif.[9] The domestic production of this kind of cloth is suggested in a documentary papyrus from eighth-century Egypt.[10] TKT

1 Gonosová 1987.
2 The author wishes to thank Nanette Kelekian for her patient, continuing generous assistance with research into the background of the textiles donated in 2002. Any errors in presentation are my own.
3 A Byzantine tradition reaching back to the Constantinian period: Wixom 2003, p. 8.
4 Dalby 2010, pp. 75, 79, 139, 168, considers both their flavors and Byzantine beliefs of their beneficial effects. The pinecone is more prominent in traditional imagery, where it may have alluded to ancient votive offerings, sacred groves, and the earth's bounty. Originally a pagan motif (sacred to Dionysos, placed atop his thyrsus, a giant fennel stalk), it had entered Jewish and Christian repertories long before this period. K. Stern 2010 discusses the motif of the pinecone as found in the mid-third-century synagogue at Dura-Europos, among ceilings that also displayed fantastic creatures from myth, apotropaic motifs, and other vegetal motifs (pomegranates, grapes, apples), as well as dedicatory inscriptions: their "collective meaning . . . remains elusive and polyvalent" (p. 501).
5 Sheppard 1965, p. 240, fig. 5.
6 Forrer 1891b, pl. VIII, 4–5: examples in blue and pink.
7 The author wishes to thank Amy Hughes for sharing her unpublished research on this piece.
8 Forrer 1891a, pl. XII.
9 Baker 1995, p. 34: Cleveland (1950.526).
10 Sijpesteijn 2004a believed the small quantity of colored silk mentioned in this document in the Beinecke Library at Yale University (P.CtYBR inv. 2651qua) would have been used for embroidery (of which brocading is a close relation). This article offers an inclusive overview of silk in Early Islamic–period texts.

References: (A) Unpublished; (B) Sheppard 1965; Wixom 2003; Dalby 2010; K. Stern 2010; (C) Forrer 1891b; (D) Forrer 1891a; Baker 1995; Sijpesteijn 2004a.

D

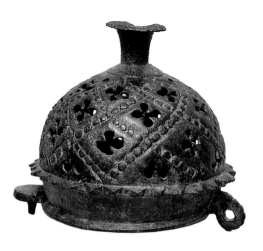

100. Lid of an Incense Burner

....................

Jordan, 8th century
Leaded bronze, cast, pierced, and engraved[1]
L. 9; W. 8.5 cm (3½ × 3⅜ in.)
Provenance: Excavated at Umm al-Walid, Jordan, in 1990 in the eastern *qasr* of the Umayyad-period palatial buildings.
Condition: The condition is good. The metal has an irregular green and red patina. There are remains of the hinge and a tab on the base.
Madaba Archaeological Museum, Jordan (667)

The dome of this lid is decorated with lozenges delineated by rows of "pearls." At the center of each lozenge is a pierced quatrefoil, except along the bottom, where the lozenges become triangles and the pierced motifs, trefoils. On either side of the plain base are a circular hinge and a tab with pin, by means of which the lid was attached to the now-lost body of the vessel.

Incense burners with elaborate, architectonically shaped lids are a type that has been traced from Late Roman times through the Middle Ages (see cat. nos. 122, 148, 150). In the fifth and sixth centuries they were in use throughout the Mediterranean area. The discovery of Late Roman incense burners on the western shores of the Mediterranean and other examples, such as the present one, from Umayyad hoards has shown that the geographic and chronological extent of their production was much greater than was once believed.[2] It also points to a link with incense burners with inlaid metalwork decoration produced in Syria and Iraq (Mosul) in the thirteenth and fourteenth centuries.[3]

The lozenge pattern has no parallels in other known incense burners.[4] The same pattern is found, however, in the designs on luxury silks produced in eastern Mediterranean workshops from the seventh to the ninth century (see cat. no. 99). The use of "pearls" is an interesting feature:[5] pearl motifs are a hallmark of both Roman and Sasanian metalwork. The Umm al-Walid lid, with its secure excavation provenance and dating, provides a valuable connecting link between Islamic metalwork and the Late Antique tradition. AD

1 In 1991 the conservation laboratory of the Musée d'Art et d'Histoire in Geneva conducted an analysis of this lid, establishing that it is made of leaded bronze and was cast by the lost-wax process. After the casting, the artisan significantly reworked the piece. See Bujard and Schweizer 1994; Bujard 2005.
2 For a Late Roman example found in Lerida, Spain, see *Bronces* 1990, pp. 151, 228, cat. no. 122.
3 Aga-Oglu 1945; Baer 1983, pp. 45–61; R. Ward 1993, p. 83, fig. 61.
4 A small seventh-century silver bucket found in Vrap, Albania, now in The Metropolitan Museum of Art

(17.190.1707), is decorated with a lozenge pattern, and the lozenges are also divided by rows of stylized pearls; see Dodd 1961, no. 88.
5 They also occur on the silver bucket from Vrap mentioned in note 4 above.

References: Bujard and Schweizer 1992, p. 17; Bujard and Schweizer 1994; Augé et al. 1997, pp. 170–71; *Umayyads* 2000, pp. 91–92; Bujard 2005.

101. Annunciation

....................

Alexandria or Egypt (?), Syria (?), or Constantinople (?), 8th–9th century
Weft-faced compound twill (samit) in polychrome silk
33.6 × 68.7 cm (13¼ × 27¹/₁₆ in.)
Provenance: Possibly the silk recorded in the *Liber Pontificalis* associated with the papacy of Gregory IV (r. 827–44) in the years 835–37; alternatively part of the collection of silks sent from Byzantium to the papacy in 781. The silk was discovered lining the inside of a silver reliquary casket for the sandals of Christ in the treasury of the Sancta Sanctorum, Biblioteca Apostolica Vaticana, in 1905; transferred to the Vatican Museums in 1906.[1]
Condition: The silk is creased where folded, with traces of stitching at edges indicating it was once applied to another piece of fabric. The surface abrasion is most noticeable on the figure of Mary.
Vatican Museums, Vatican City (61231)

This piece belongs to a larger sheet of repeating medallions, likely part of the same piece of fabric as the Nativity scene in the Vatican (fig. 66).[2] Both compositions utilize five colors (vivid crimson red, gold, green, dark purple, and white), exploiting the potential of this palette for color contrasts and tonal variations. The angel gleams in white and gold opposite Mary, who is

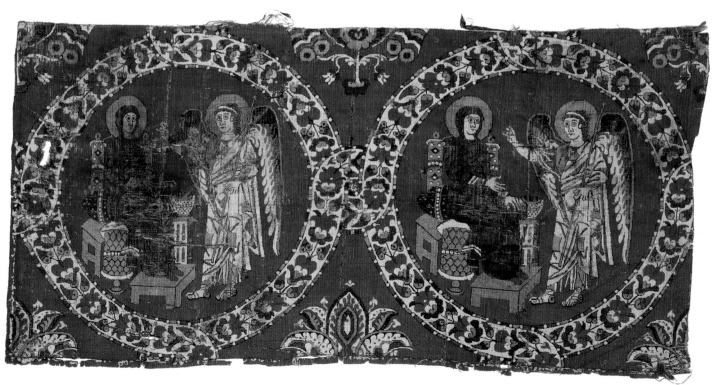

swathed and veiled in dark purple. Within this limited scheme, fine details indicate pictorial depth and delineate motion: drapery outlines indicate wind blowing the angel's tunic against his legs, and the position of the wings suggest they are still moving. Both compositions depart from symmetrical repetition, distinguishing them from the majority of strictly regular compositions. Even so, the interlaced medallions and their unremittingly flat ornamental motifs, treated to a systematic alternation of colors, are closely related to contemporaneous compound woven silks.[3] Animation of the composition derives partly from effective color contrasts. Large blocks of colors for the figures hold attention by allowing the eye to rest, and the plant and jewel motifs in the borders and between the medallions busily send the eye from here to there while suggesting a gardenlike setting. The virtuosity of the composition is matched by the complexity of the weave and the technical sophistication of the loom on which it was woven. This piece has been attributed to Alexandria and Syria, based in large part on its design and ornament, and to an imperial workshop in Constantinople, for its technique and style.[4]

TKT

1 *Vatican Collections* 1982, p. 157.
2 Cormack and Vasilakē 2008, p. 389 (Guido Cornini).
3 The combination of styles was noted by Grisar 1907, p. 179.
4 Gonosová 1990; Muthesius 1997, pp. 65–66.

References: Grisar 1907; *Vatican Collections* 1982, pp. 102–3 (Margaret E. Frazer); Gonosová 1990; Muthesius 1997, no. M35, pp. 67, 175, pls. 20a–b; Cormack and Vasilakē 2008, p. 389 (Guido Cornini).

102A, B. Silks with "Samson" and the Lion

...................

A. Silk with "Samson" and the Lion

Eastern Mediterranean, late 6th–early 7th century
Weft-faced compound twill (samit) in polychrome silk
94.2 × 38.4 cm (37 1/16 × 15 1/8 in.)
Provenance: Purchased from Galleria Sangiorgi, Rome, September 1934, by Mildred and Robert Woods Bliss; gift of Mr. and Mrs. Robert Woods Bliss to Harvard University, Dumbarton Oaks Library and Collection, 1940.
Condition: The textile is in fragmentary but good condition with some losses in the lower left edge.
Byzantine Collection, Dumbarton Oaks, Washington, D.C. (BZ.1934.1)

A

B

B. Silk with "Samson" and the Lion

Eastern Mediterranean, 7th–9th century
Weft-faced compound twill (samit) in polychrome silk
31 × 35.6 cm (12³⁄₁₆ × 14 in.)
Provenance: From the treasury of the cathedral at Chur, Switzerland; collection of Franz Johann Joseph Bock (1823–1899) until 1860; purchased for the Cluny by Edmond du Sommerard (1817–1885) in 1860.
Condition: The textile is in fragmentary but good condition with some losses along the bottom.
Musée National du Moyen Âge, Thermes et Hôtel de Cluny, Paris (Cl. 3055)

Nearly twenty silk textiles exist with this same motif of a strong man subduing a lion, in rows bordered by wavy lines containing plants sprouting from squares.[1] The figure is typically interpreted as the biblical Samson, wrestling with a lion, owing to the fact that a large number of these textiles have been found in church treasuries[2] and that the figure has long hair, for which Samson was famous. However, we should be cautious when assuming a Christian subject: the figure could easily be read as Herakles skinning the Nemean lion. Lions are also associated with the biblical Daniel and David as well as Roman gladiators.

The extant fragments share not only iconography and technique—all are weft-faced twills—but also the colors of yarns used. These similarities attest to the popularity of the design and also suggest that such textiles

were produced in quantity as opposed to being solitary commissions. Nevertheless, these textiles, with their fine silk weave and saturated colors, were no doubt luxury items.

The use of these textiles remains unclear. While they are commonly referred to as hangings, the Christian subject matter, if it is to be interpreted as such, was less often seen on articles in a domestic context.[3] Carolyn Connor has proposed that the Dumbarton Oaks silk was once part of a garment.[4] Using narrative Christian motifs on clothing apparently became popular as early as the fourth century, according to Bishop Asterios in northern Turkey.[5] Mythological subjects, however, are known largely on domestic textiles. Because the same motifs occur across different media, and a single textile may have been reused as clothing and then placed in a liturgical or domestic setting during its lifetime, we should imagine that these examples found their way both into homes and onto clothing and were interpreted as either Christian or mythological depending on the predilections of the patron.

JB

1 Muthesius 1997, pp. 213–14.
2 There is an example of this textile at the Vatican (T103; Volbach 1942, pp. 38–39), and another at Sens Cathedral (B135/1). The version at the Musée

Historique des Tissus in Lyons (875.III.1) was originally found in the cathedral of Coire, Switzerland. For a complete list of the dozen or so versions of this textile, see Martiniani-Reber 1986, pp. 99–100.
3 Maguire 1990, p. 218.
4 Connor 2004, p. 144.
5 C. Mango 1972, pp. 50–51.

References: (A, B) Migeon 1909; Volbach 1942, pp. 38–39; Morris 1943; Bianchini 1992, cat. no. 134; Muthesius 1997, pp. 213–14; Desrosiers 2004, pp. 208–10, no. 104; Bühl 2008, p. 131.

103A–G. Silks of the Panopolis (Akhmim) Group

......................

Robert Forrer's excavations at the site of Panopolis (Akhmim) in Upper Egypt yielded numerous textiles, including the two-color silks of several of the tunic ornaments included here. Forrer's brief report of 1891 was illustrated with drawings of the triumphant equestrians inscribed "Joseph" and "Zachariah" and a much-reproduced nameless saint who dispatches fierce creatures with a lance in one hand and a cross in the other.[1] Beginning about the same time as Forrer's excavations, many other silks were sold on the art market as having been found at the site, although rarely with secure documentation. A significant number of these silks from the art market that are very close in subject matter, composition, and ornament are within the stylistic range attested by Forrer's publication, and have provenance histories that make attribution to the site possible. In consequence, the group of silks associated with the site is now very large; it comprises a wide range of ornamental motifs and as yet poorly identified subjects, such as the noble equestrians (A–C), Amazons (D, E), and Harvester (?) (F, G) silks presented here. Recent radiocarbon analysis of several examples indicates a range of dates between the seventh and ninth centuries, that is, spanning the transition from Byzantine to Islamic rule.[2] At present, it is not possible to assign dates with any greater precision. In the future, the range of dates might well be enlarged.

These silks present variations on themes that raise interesting questions about the processes that led to their composition and production. A group of three silks representing noble, perhaps kingly or imperial, equestrians, depicts much the same scene in

bilaterally symmetrical compositions, show-
ing each of the following motifs twice:
above, the rider brandishing a mace and a
bird of prey hovering near his head; below,
on one side, a soldier in body armor and
Persian-style helmet and, on the other, a
crane (or other long-legged marsh bird).
Despite these fundamental similarities, care
was taken to distinguish the subjects:
"Joseph" is inscribed by the head of the
horseman of one (A), "Zachariah" is inscribed
in the same location in another (B), and
there is no inscription in the third (C). The
soldiers below bend one knee, as if off bal-
ance and leaning on their spears. The soldiers
have also been read as impaling the horses,
but, as horse and rider strike triumphant
poses and hold dominant positions in the
composition, this seems unlikely. Identification
of the subjects of these compositions is by
no means as secure as it is for related, more
elaborate, polychrome compositions, where
the equestrian figures are hunters dispatch-
ing their prey.[3]

Differences between the two-color com-
positions are minor. For example, the mane
of the horse of "Joseph" is incompletely
drawn, the soldier's lance is completely out-
lined, the soldier's head faces front, and the
crane's beak is short. Below "Zachariah," the
soldier's head is shown in profile, and the
long-beaked crane eats something round.
The composition of the unnamed rider is
the most neatly symmetrical. Indeed, varia-
tions on Hunting compositions in polychro-
matic silks attest to the popularity and
wide-ranging production of this subject.

Also related by their symmetrical eques-
trian compositions and the occasional use of
inscriptions is a series of medallions (D, E).
The frame of each medallion encompasses
four sections separated by smaller linking
medallions: in each section, a slender guil-
loche borders the outside and a strand of a
heart-shaped motif the inside of a composite
wreathlike motif of acanthuslike foliage, pal-
mettes, and a heart-shaped bud. In each of
these medallions, two Amazon archers on
rearing horses aim arrows across the compo-
sition at the leopards on the other side,
which are cringing below the horses' hooves
with their tails between their legs but still
roaring and fighting. The Amazons are rep-
resented as heroic women of substance and
skill. Their horses are richly caparisoned,
they wear bracelets on their forearms and
wrists, and they are consummate archers
who can twist around to take aim and shoot

F

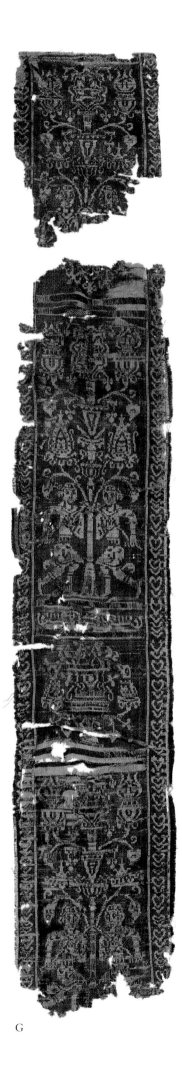

G

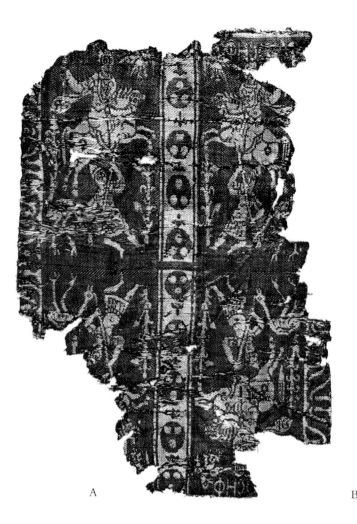

A

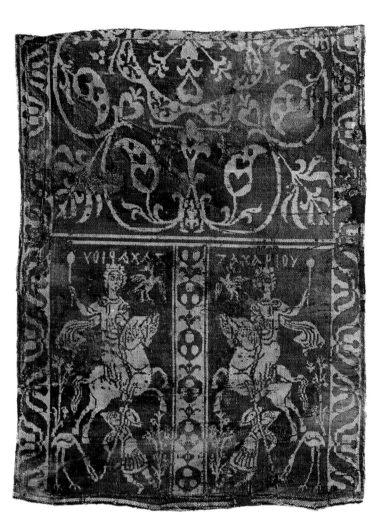

B

behind them while remaining astride their agitated mounts. These women are also represented as outside the social mores of the medieval Near East: the decorated tunics they wear leave one breast bare, in a nod to ancient Greek representations of Amazons; their legs are bare as well, and their heads are uncovered.

Differences in coloration and, again, iconographic details may well reflect the requirements of the local Panopolitan market for silks. In E and another example in The Metropolitan Museum of Art,[4] the leopards are clearly doomed as arrows jut from their backs. In place of the identical flowing mantles worn by the Amazons in the other compositions, the latter Metropolitan Museum silk and a second textile (fig. 68) bear Arabic inscriptions invoking God. These examples might have been made for Arabic speakers, whether Christian or Muslim, or perhaps for those who wished to project the appearance of Arabic speakers (as might have been the case for the use of inscriptions in the Harvester [?] compositions, F and G) and perhaps more specifically as Muslims.[5] Only one example (E) presents a cross at the top

of the preserved linking medallion, a motif almost certainly identifying the wearer as Christian.

Through such intriguing variations, scholars once traced the continuity of subject matter from antiquity into Byzantine and Islamic art, noting, for example, the close similarity of these equestrian Amazons to depictions on a third-century ceremonial shield from Dura-Europos.[6] The subject may have presented a range of associations to patrons and other viewers who knew the ancient tale of Achilles and Penthesilea, as well as the popular epics of their own day featuring Amazons and warrior women.[7] Clothing that fully covers the figures in most polychrome versions is closer to descriptions of the Amazon Maximou in the epic of Digenes Akritas and warrior women in Arabic epics, as in the fascinating tale of Qannasa bint Muzahim.[8]

Interchangeable motifs and compositional variations underscore how little we know about the meanings of these ornaments and processes of production. Written documents attest to commissioners involved at different stages of production, from decisions about

type of garment to materials and colors (including quality and cost, as the commissioner usually provided the materials). Texts and cartoons for tapestry weavers indicating involvement in the selection of motifs invite speculation about the role of commissioners of such compound-woven silks (cat. nos. 98, 105). From the Cairo Genizah, an extraordinarily rich archive of documents for early medieval commerce in everyday and luxury goods, a weaver's will describes, among the contents of his workshop, a basket of prepared warps, apparently precursors to those noted by Louise Mackie as used in modern practice:[9] pre-tied lashes, or simples, for tying up the warp according to a designated pattern, that can be detached from the loom, labeled for storage, and reused. If there were medieval specialists in warp preparation who produced multiples of the same pattern and/or variations on that pattern, then, as now, simples could have been tied in small design units, to be combined and recombined as desired to replace an Amazon's mantle with a bismillah, or vice versa, or insert a cross into a linking motif.[10]

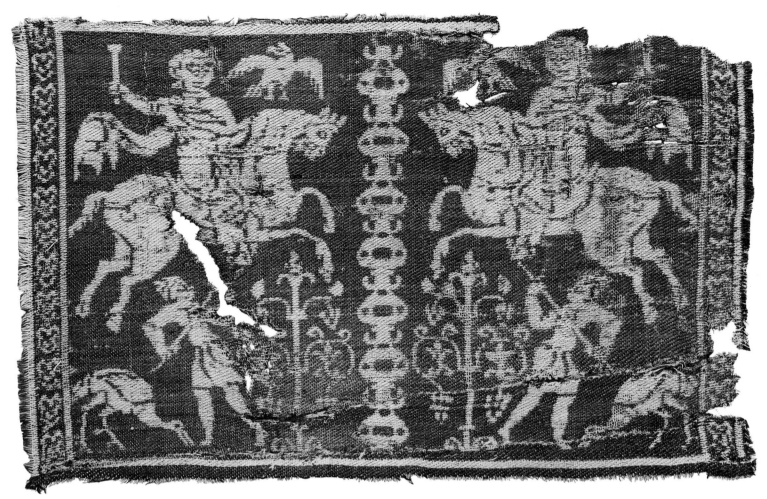

C

A. Fragment of a Band with Noble Equestrian and Soldier, Inscribed "Joseph" in Greek or Coptic
Egypt or Syria (?), 7th–9th century (?)
Weft-faced compound twill (samit) in blue-violet and beige silk
26.4 × 17.2 cm (10⅜ × 6¾ in.)
Inscribed: In Greek or Coptic, above and below, IOCHΦ (Joseph)[11]
Provenance: Said to have been excavated at Panopolis (Akhmim), Egypt; purchased from Charles D. Kelekian, New York, by Dumbarton Oaks in 1956.
Condition: The textile is in good condition.
Byzantine Collection, Dumbarton Oaks, Washingtion, D.C. (BZ.1956.2)

B. Fragment of a Band with Noble Equestrian and Soldier, Inscribed "Zacharaiou" in Greek
Egypt or Syria (?), 7th–9th century (?)
Weft-faced compound twill (samit) in reddish purple and beige silk
37 × 29 cm (14⅘6 × 11⅞6 in.)
Inscribed: In Greek, left (/) and right, reversed, ZAXAPIOY (Zachariah)[12]
Provenance: Said to have been excavated at Panopolis (Akhmim), Egypt; purchased by the British Museum from Henry Wallis (1830–1916) in 1904.
Condition: This fragment of a clavus (?) is in good condition.
The British Museum, London (1904,0706.41)

A nearly identical textile is in the Victoria and Albert Museum, London (303-1887).

C. Fragment of a Band with Noble Equestrian and Soldier
Egypt or Syria (?), 7th–9th century (?)
Weft-faced compound twill (samit) in bluish-green and beige silk
20.5 × 13 cm (8⅛6 × 5⅛ in.)
Provenance: Purchased in Egypt by Vladimir Bock (1850–1899) in 1898.
Condition: This fragmentary tunic ornament is in fair condition with losses along the center, lower right, and upper left corners.
The State Hermitage Museum, Saint Petersburg (11194)

There is a companion to this finely executed piece in the Victoria and Albert Museum, London (769–1893).

D. Roundel with Amazons
Egypt or Syria (?), 7th–9th century (?)
Weft-faced compound twill (samit) in blue-violet and beige silk
20.5 × 20.5 cm (8⅛6 × 8⅛6 in.)
Provenance: Said to have been excavated at Panopolis (Akhmim), Egypt; collection of Claudius Côte (1881–1956), Lyons; bequest of David David-Weill (1871–1952), 1933.
Condition: This square fragment has losses on all four sides, but especially at the bottom and on the left.
Musée National du Moyen Âge, Thermes et Hôtel de Cluny, Paris (Cl. 21840)

E. Roundel with Amazons and a Cross
Egypt or Syria (?), 7th–9th century (?)
Weft-faced compound twill (samit) in green, beige, and brownish silk
21 × 19.9 cm (8¼ × 7¾ in.)
Provenance: Hayford Peirce (1883–1946) Collection (until 1946); Mrs. Hayford Peirce, San Diego (until 1987).
Condition: This silk fragment in green and beige weft on a brownish warp is in fragile condition. It is worn and there are losses throughout the fragment. It is discolored. The edges are turned to the back. There are remnants of stitches in linen and stitch holes.
The Metropolitan Museum of Art, New York, Gift of Mrs. Hayford Peirce, 1987 (1987.442.5)

F. Fragment of a Band with Harvesters (?)
Egypt or Syria (?), 7th–9th century (?)
Weft-faced compound twill (samit) in yellow and green silk
55.8 × 9.5 cm (21⅘6 × 3¾ in.)
Inscribed: Possibly in Arabic,

عيسى or عيس

([Reading 1])
(Jesus)
or

الأعسر

([Reading 2])
(The person who uses his left hand [*Ashwal*])*
Provenance: Said to have been excavated at Panopolis (Akhmim), Egypt; collection of Major W. J. Myers (d. 1899); gifted to the V&A by Robert Taylor Esq., the executor of the Myers estate, in 1900.

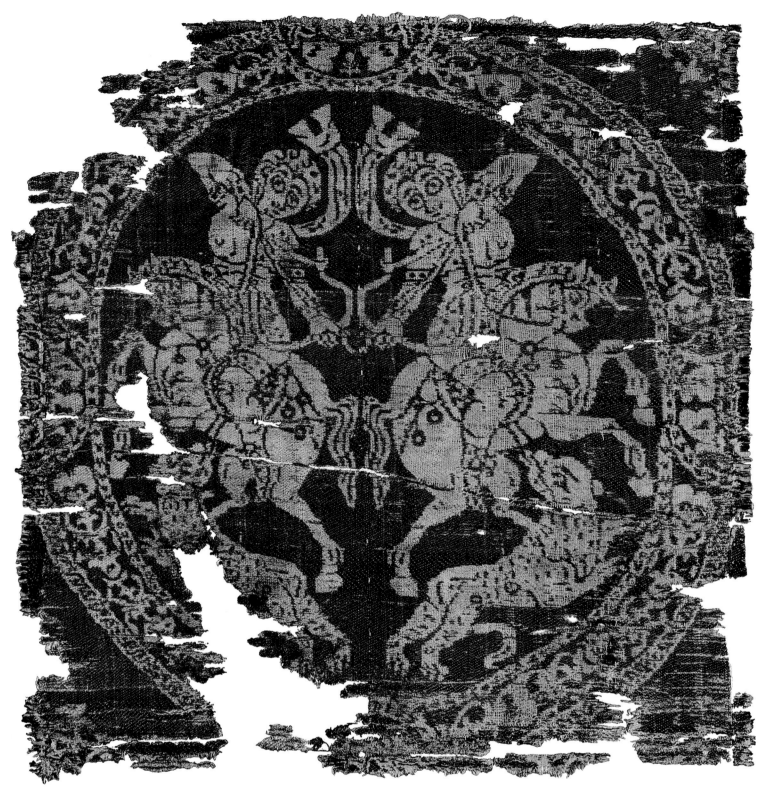

D

Condition: This fragment of a clavus is in good condition, with a few tears and breaks at the edges.
Victoria and Albert Museum, London, given by Robert Taylor Esq. (2150-1900)

Ga, b. Fragments of a Band with Harvesters (?)

Egypt or Syria (?), 7th–9th century (?)
Weft-faced compound twill (samit) in yellow and green silk
a. 768-1893: 45.7 × 10 cm (18 × 4 in.)
b. T.57-1936: 12.2 × 9.5 cm (4¹³⁄₁₆ × 3¾ in.)

Inscribed: Possibly in Arabic,

عيس or عيسى

([Reading 1])
(Jesus)
or

الأعسر

([Reading 2])
(The person who uses his left hand [*Ashwal*])*
Provenance: (a. 768-1893) Said to have been excavated at Panopolis (Akhmim), Egypt; purchased by the V&A (then the South Kensington Museum) from M. Stanislas Baron

(b. 1824–1908), rue Grange Batelière 28, Paris, in 1893. (T.57-1936) Acquired in 1936 by the V&A from Dame Joan Evans (1893–1976) in a batch of textiles with the accession numbers T.38 to 57-1936.
Condition: (a. 768-1893) This fragment of a clavus band has suffered surface abrasion, several tears, and breaks at edges. (b. T.57-1936) The fragment is in good condition with a few minor losses.
Victoria and Albert Museum, London ([a] 768-1893; [b] T.57-1936)

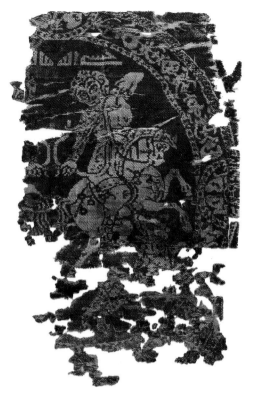

Fig. 68. Roundel fragment with Amazon and bismillah. Weft-faced compound twill (samit) in polychrome silk, 7th–9th century. The Metropolitan Museum of Art, New York, Rogers Fund, 1951 (51.57)

In these closely related clavi (F; Ga, b), active figures (note the fluttering hems of their garments) placed to either side of a fantastical tree combining several types of plants appear to pull the tree with ropes or push poles; the workers have been compared with harvesting figures.[13] An inscription appears to be in Arabic, but it cannot be read in a fully satisfactory way.[14] TKT

* We thank Alzahraa Ahmed for her suggested transcription and translation. In this reading, it is understood that the inscription located on the left side of the tree reads right to left and is mirrored on the right side of the tree. Al-a'sar [Ashwal] may refer to the name of the wearer of the tunic.

1 Forrer 1891b, Joseph, pl. 5, 1, and Zachariou, pl. 7, 1, respectively, and the saint, frontispiece and pl. 3, 1–2.
2 See Thomas, p. 148.
3 On the hunting silks, see Muthesius 1997, pp. 68–71.
4 MMA 1987.440.1.
5 On the Amazon silk (MMA 51.57), the inscription may be an abbreviated bismillah, the phrase invoking the name of God in the first verse of each sura of the Qur'an: "In the name of God, Most Gracious, Most Merciful." Grube 1962, p. 78, reads this inscription as the phrase in Qur'an 9:129 "God is sufficient for me." It seems possible, however, that this brief inscription may not be so specific.
6 Grube 1962, p. 80 and pl. XIV in an image that was digitally altered to obtain a symmetrical composition from a single motif; see also Weitzmann 1960b, pp. 48–49.

7 A pair of tapestry roundels, inscribed "Alexander the Great" to identify a noble equestrian figure on horseback (Cleveland Museum of Art [59.123], with a companion piece in The Textile Museum, Washington, D.C. [11.18]), may have belonged to an extended set of ornaments with additional scenes, like the David Plates discussed in Evans, p. 4. It is possible that the thirteen-day sex-and-hunting interlude he enjoyed with the Amazon queen Thalestris, according to the Alexander Romance, belongs to a rich network of associations: published in Shepherd 1971, pp. 244–45.
8 See Muthesius 1997, pp. 71–72, on "The Amazon Hunter Silks."
9 Mackie 1992.
10 I thank Lindsey Tyne for bringing this possibility to my attention.
11 Martiniani-Reber 2004, p. 117, noted that the name as inscribed is not declined, so it could be either Greek or Coptic.
12 The name is given in the genitive case (ibid.), so it perhaps refers to the iconography of or a story about Zachariah, which, as only the names "Zachariah" and "Joseph" appear in these silks, seems most likely, or the name may refer to the owner or the weaver.
13 Grube 1962, p. 79. Kendrick 1922, p. 78, identifies them as "spearmen."
14 Grube 1962, p. 79.

References: (A) Kendrick 1922, no. 806, p. 78, pl. XXIV, no. 800, pl. XXII; Grube 1962; Martiniani-Reber 2004; (B, C, D) unpublished; (E) Sangiorgi 1906, p. 196, fig. 3; Stauffer 1992a, fig. 3; (F) unpublished; (Ga) Kendrick 1922, p. 78; Grube 1962, p. 79, pl. XV, no. 5; (Gb) unpublished.

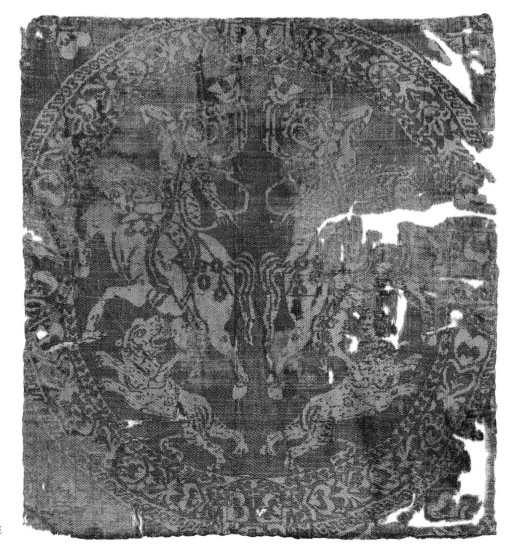

E

Dress Styles from Syria to Libya

Cäcilia Fluck

On two wall hangings from Late Antiquity (cat. nos. 108, 109), human figures in two very different styles of dress are represented side by side. One costume is in the Roman style, which was the norm in all the Mediterranean basin. The other, more popular in the eastern part of the Byzantine Empire, was influenced by a riding costume that harks back to the nomadic tribes of the Central Asian steppe. Dating to at least the early first millennium B.C.E., it was still worn in the late Sasanian period, in the seventh century C.E. Both fashions are known from many Near Eastern and North African works of art, especially mosaics, wall paintings, and manuscript illuminations.

The conventional Roman garment—worn by men, women, and children alike throughout the first millennium C.E.—was a simply constructed tunic with straight sides. It was woven to shape, that is, the front and back panels were both made from loom-width lengths of cloth (fig. 69). It could be worn belted or not, and its decoration was always symmetrical. In Byzantine times, the typical tunic was adorned with two vertical stripes (clavi), one running down either side of the neck opening. Roundels (orbiculi) or squares (tabulae) were placed in the areas of the shoulders and knees. A slit opening for the neck was often embellished with horizontal stripes, whereas a round or half-round

opening was commonly finished with applied borders. Stripes or wide trimming also enlivened the sleeves. The patterns and motifs were usually tapestry woven, but other techniques were used as well (see cat. nos. 110, 112, 113).[1]

It is difficult to distinguish tunics made for women and girls from those worn by men and boys, except for a few details. Women's garments are longer, display a horizontal tuck at the chest, and—as actual garments as well as depictions show—were often belted just below the breast.[2] Cloaks were worn by both sexes, while veils and shawls were reserved for women; these rectangular outer garments were made of fine—mostly woolen—fabrics that were draped around the body. Those who could afford them wore sandals or shoes.

Vividly represented in the late Sasanian Taq-e Bostan reliefs of the early seventh century, the male apparel influenced by the traditional Central Asian riding costume consisted of a shirt, caftan, coat, headgear, trousers, gaiters, and boots.[3] Where Roman garments were shaped by draping or belting only, the Central Asian–inspired garments are tailored, sometimes elaborately so. Typically, the upper garments have flared sides and decoration that emphasizes the center front (cat. no. 114); the several types of leggings range from tight to bulky.[4] As in the case of

Roman-Byzantine fashion, certain articles of clothing were almost identical for both sexes and all ages. In both styles of dress, gender was marked at most by accessories such as headwear and jewelry; in addition, women in tailored garments also draped shawls and veils over the head and around the body.

The driving forces in Byzantine times were the trade and cultural exchanges with the Middle and Far East. Exotic fabrics and elements of clothing entered the western regions of the empire, where they were adopted alongside local traditions,[5] still heir to the Roman styles. Although the contours of Roman-Byzantine and Persian dress were no different from those of the preceding centuries,[6] their decoration changed, becoming increasingly colorful and richer in ornamentation. People arbitrarily mixed motifs from both cultural traditions, for example applying the symmetrical arrangement of decorative elements typical of tunics to tailored garments in the Persian style (fig. 70).[7] Or the opposite might be true: Persian silks in the Kunstgewerbemuseum, Berlin, and the Museo Sacro, Biblioteca Apostolica Vaticana, show mirrored motifs of figures dressed in traditional Roman style against the strawberry red background rendered fashionable by its royal associations.[8]

In the first decades after the Muslim conquest, workshops and their artisans no doubt

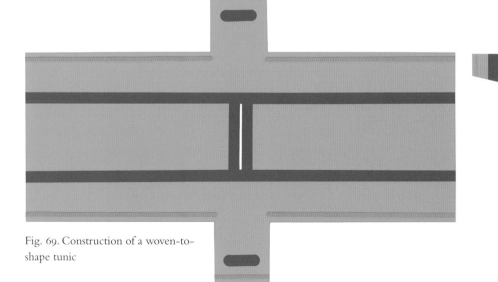

Fig. 69. Construction of a woven-to-shape tunic

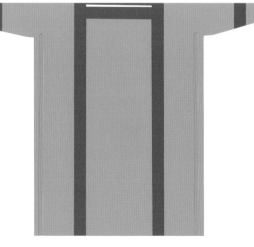

Materials and Techniques of Late Antique and Early Islamic Textiles Found in Egypt

Kathrin Colburn

Fig. 70. Watercolor of a mural painting in the Monastery of Bawit, Egypt, showing Saint Sisinnios on horseback dressed in a flared shirt displaying a mix of Roman and Persian decorations, Persian trousers and boots, and a draped Roman coat. After Clédat 1906, pl. 56

continued their trades as before. As we have seen, styles of dress, too, evolved only very slowly, with the decorative elements being the first features to exhibit change.[9] Sculptures and mural paintings from the palaces of the Umayyad rulers (661–750), in particular at Khirbat al-Mafjar, Qasr al-Hayr West, and Qusayr 'Amra,[10] clearly illustrate the survival in Early Islamic times of the Roman-Byzantine and Persian styles, both side by side and in combination.[11] We should remember that most garments depicted on artworks represent the clothing of only some members of a society, usually an urban population. The simpler, more convenient, and more functional clothing, outside any fashion streams, that must also have existed would have been worn by nomads and other country-dwellers, images of whom are rare.[12] In the age of transition, with its myriad cultural currents, the only feature that unequivocally identifies a textile as Islamic is an Arabic inscription (see Fluck, p. 183).[13]

Late Antique textiles are relatively abundant, and all but a handful were found in Egypt, where the dry sand and the custom of burying the dead swathed in clothes led to the survival of many textiles. Most of these were unearthed during a sweep of haphazard excavations in the nineteenth and early twentieth centuries. Sadly, the contents of graves were widely dispersed, and considerable information about the textiles has been lost owing to the lack of proper documentation and knowledge of the context in which they were found. Still, surviving textiles include wall hangings, curtains, and clothing (tunics in particular). Complete textiles, though, are rare. Far more common are small weavings that were used to decorate garments, such as roundels (orbiculi), narrow bands (clavi), and squares (tabulae). An examination of textiles that have been discovered offers insights into the material and aesthetic culture of Late Antiquity.

The manufacture of cloth in Late Antiquity was based on the experience of centuries of weaving during the Greco-Roman period. A large part of the population was occupied as dyers, spinners, weavers, fullers, and as traders of fibers and textiles. Workshops were often family-run. Although information on looms and weaving tools used during this epoch is limited, a variety of the two-beam vertical loom was probably used.[1] A small number of sketches on papyri survive, which have been identified as cartoons. Placed behind the warps, they provided the weaver with a guide for weaving (a sketch such as cat. no. 105A could have been a guide for the clavus of a child's tunic, cat. no. 105B).[2]

Late Antique textiles were made mainly of linen and wool. There were silk weavings, too, but these were rare. Linen was strong and could be spun exceptionally fine. It was used as both warp and weft fiber. Wool was primarily used as weft fiber. Since it was more elastic and softer, it complemented the linen.[3] In addition, wool took dye well. The main weave structures were plain weave in undyed, unbleached linen for the ground; and discontinuous weft-faced weave (tapestry weave) in hues of brown and purple-colored wool, and bleached linen weft for the design elements.[4] Small slits and dovetailing were employed to join areas of different colors within tapestry weave (fig. 71); long slits were sewn closed (fig. 72).

As further decoration, the regularity of the plain weave could be interrupted either by inserting more than one weft thread into the same shed (self-bands) or by not introducing weft threads and leaving the warp exposed (open weave). The weavers further embellished the adorned parts of the weaving with different techniques: to accomplish the effect of shading, a lighter weft yarn in undyed linen, which was usually bleached, could be combined with a darker wool weft in various combinations (false hatching) (cat. no. 119B). To create delicate interlace patterns and to draw facial features and body contours, a technique—unique to weavings of this period—called flying shuttle was used. Here, weft yarn, commonly of bleached linen, was passed over the surface of the textile during the weaving process. When a weft was wrapped over at least two warps and carried back under the last warp successively to the desired length, it formed a slightly stepped line, visible on both sides of the weaving (fig. 73). Fine lines were also defined by wrapping individual warp threads (warp wrapping).

Embroidery existed in Late Antique textiles, but it was rare. Not until the Early Islamic period did this technique begin to flower. A unique piece in the collection of The Metropolitan Museum of Art is a notable example, even though the original function of this small fragment is unknown (cat. no. 168). Geometric designs were formed by couching down linen and colored wool threads on an undyed linen ground in plain weave (fig. 74); the borderlike top edge of the fragment was embroidered in satin stitch.

With the introduction of wool by the Romans, color was added more generously, and figural compositions became more elaborate. Technical features such as the flying shuttle appear less frequently. The colored shapes that were woven side by side to create the design were now frequently separated by

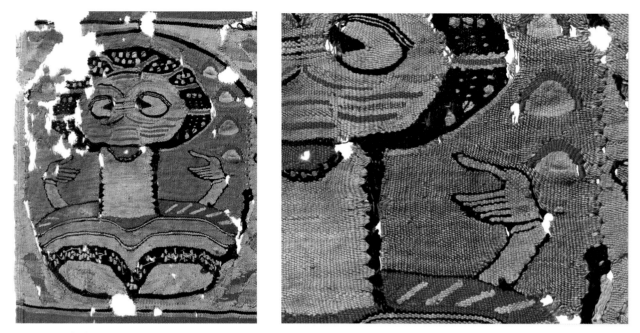

Fig. 71. Detail of cat. no. 3. Slits were used to bridge color junctures and dovetailing to interweave areas of different colors; single warp threads were wrapped with weft for detail.

contours in dark wool weft within the tapestry weaving. To achieve vibrant hues, a variety of dyes of vegetable and animal origin were employed. Many were locally available, and some proved to be relatively lightfast. Various shades could be achieved with the same dye source by using different mordants or by combining different sources. Widely used dyes were weld for yellow, an indigotin-containing dye like woad or indigo for blue, woad or indigo and weld for green (sometimes madder was added), madder (*Rubia tinctorum* and other related species) for pink and red, and madder and a tannin or indigotin-containing dye for brown.[5] This palette has been confirmed through a recent analysis of catalogue number 3.[6] After the Arab conquest in the seventh century, lac dye was used to achieve a bright red tone.[7] Tyrian purple, the most valued dyestuff, was extracted from a mollusk of the genus *Murex* and offered reddish purple and brown-violet tones. To imitate this expensive hue, fibers were sometimes dyed with an indigotin-containing dye and madder.[8] Recent analysis of the purple-colored yarn of catalogue number 119A established the presence of both madder and an indigotin-containing dye.[9]

Starting in the Early Byzantine period, embellishments for clothes were frequently woven separately and sewn on to an otherwise finished garment.[10] A smaller, more portable frame-type loom could be used to weave the small decorations separately. The warp was sometimes of strongly twisted

plied linen yarn and ran vertically through the image, such as in catalogue number 7.[11] Stylistically, the layout of the design on these garments appears much less homogeneous,

Fig. 72. Detail of cat. no. 50 showing a long slit sewn closed with linen thread

owing to the custom of reusing decorations from worn garments, which could result in a mismatch of styles. As further adornment, narrow borders with stylized designs were

Fig. 73. Detail of cat. no. 115B showing the heart-shaped design created by successively carrying linen weft over two warps and turning it under the last warp to the required length

Fig. 74. Detail of cat. no. 168 showing the geometric designs created by couching down linen threads and polychrome wool threads to a linen ground in plain weave

Fig. 75. Detail of cat. no. 113 showing the carefully tailored neckline with a patterned border. A button closed the slit along the shoulder.

woven separately in brocade, with pattern and brocading weft in wool and undyed linen.[12] These borders were applied to decorate a neck opening (fig. 75), cuff, or hemline (cat. nos. 112, 113).

A group of fine silk in weft-faced compound weave (samit) or *taqueté* weavings in wool with repeat patterns demonstrates the existence of sophisticated draw looms and the growing influence of the East.[13] Frequently, these weavings survive in the form of clavi, orbiculi, and tabulae, having been cut from a larger weaving to decorate garments, mostly tunics. A tabula of this kind, in The Metropolitan Museum of Art, preserves remnants of yellow silk on the reverse, an indication that this decoration was once part of a precious silk garment (cat. no. 99A).

It is not easy to differentiate weavings from the transitional Late Antique–Early Islamic period on the basis of technique; only later do these differences become more readily apparent. Wool became the predominant fiber for warp and weft, and the warp yarn could be dyed. Backgrounds were no longer of undyed linen but could be vividly colored, including in red or blue. Under Arab rule various new conventions developed: the long-standing tradition of weaving garments to shape vanished; cloth was cut to shape, and sewing styles accommodated new fashions in decoration. However, it is

difficult to determine the pace and reach of change. Carbon-14 analyses of two garments that appear stylistically different—a tunic (cat. no. 112) and a child's dress (cat. no. 113)—both gave similar dates: 660–870 for the tunic, and 660–880 for the dress (with 95% probability).[14] While the adult tunic is woven to shape and displays a traditional layout of

decoration, the child's dress is marked by new conventions: the warp and weft of the ground fabric is a vivid red (dyed with madder),[15] and the garment was cut to shape and finished by sewing the outer edges with undyed linen thread. A button made of yarn closed the neck opening (fig. 75).

Abstract designs replaced figurative elements, and inscribed textiles became popular. Three fragments (most likely belonging originally to the same textile) in the *tiraz* style of unknown function display an inscription in Coptic in tapestry weave with red wool on a yellowish (undyed) wool ground in plain weave (cat. no. 124B). Carbon-14 dating of these fragments resulted in a date of 810–1010, placing them late in the Early Islamic period.[16] A shawl fragment inscribed in pseudo-Kufic with stylized decorative elements in tapestry weave in linen and wool on an open plain weave in dark blue wool (cat. no. 125B and fig. 76) is from the same period.[17]

Late Antique and Early Islamic textiles offer a window into the cultures of the epoch. Close study of surviving textiles serves as a reminder of how multifaceted cultures were in the greater Mediterranean region, and how they were very much in flux, shaped by a whirlwind of peoples, goods, and ideas.

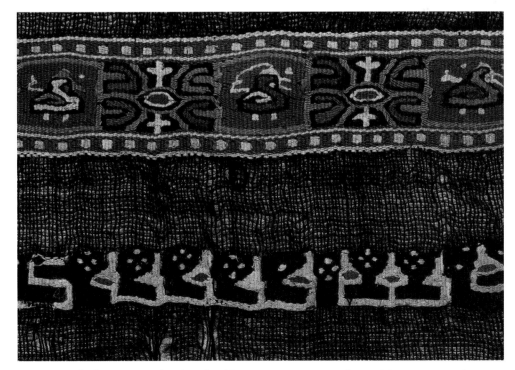

Fig. 76. Detail of cat. no. 125B showing a band in tapestry-weave woven into a plain-weave ground

104A, B. Ostraka Referring to Textile Production

....................

Egypt, 580–640

Pottery and black ink

Provenance: Excavated at the Monastery of Epiphanios, Thebes, Egypt (east buildings), by an expedition of The Metropolitan Museum of Art, New York (1913–14); ceded in the division of finds (1914).

A. Ostrakon Referring to a Loom, Linen, and Bandages

14.2 × 11 × 0.5–1 cm (5⁹⁄₁₆ × 4⁵⁄₁₆ × ³⁄₁₆–³⁄₈ in.)

Condition: Shard of the body of a smooth-grained, soft red-brown, ribbed pottery vessel, possibly an amphora, with 22 lines of inscription in black on its convex side in good condition. A cross is inscribed at the beginning of the text, in the left-hand margin.

The Metropolitan Museum of Art, New York, Rogers Fund, 1914 (14.1.157)

B. Ostrakon Referring to Flax and Bleached Linen

20.4 × 12.5 × 0.7–1.1 cm (8 × 4⅞ × ¼–⅜ in.)

Condition: Shard of the body of a smooth-grained, soft red-brown, ribbed pottery vessel, possibly an amphora, with 23 lines of inscription in black on its convex side and a cross at the beginning of the text, in the left-hand margin. A horizontal break in the center has been joined. The inscription covers an earlier, indecipherable one.

The Metropolitan Museum of Art, New York, Rogers Fund, 1914 (14.1.158)

M any of the inscribed potsherds (ostraka) found in a cell at the Monastery of Epiphanios provide information about the economic activities undertaken there.[1] One ostrakon, A, with a Coptic inscription, says that the weaver Frange needs one lot of linen yarn to complete "some bandages mounted on the loom." He asks Brother Enoch to receive it "cleansed" by Brother Daniel. A second ostrakon, B, found in the same cell and also in Coptic, conveys the importance of flax production and the bleaching of linen.

Linen was used for many purposes in Egypt, including bandaging the deceased in preparation for burial.[2] Dried bodies were copiously wrapped in strips of linen cloth, and linen shroud tapes were often used to lace the mummy from head to foot.[3] The tapes were woven on narrow looms designed to accommodate a limited number of warp threads. Warp-faced tapes in plain weave were produced by inserting linen weft threads thinner than the warp threads (which were probably plied) into the shed.[4]

The monastery cultivated flax plants, the raw material of linen. Turning flax fibers into linen thread was an elaborate, multistep process, requiring close cooperation among various craftsmen. Once the plants were harvested and the seeds removed, the stems

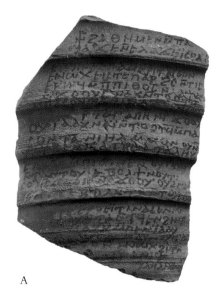

A

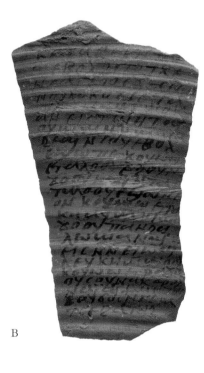

B

were placed in water to soften the bark. After drying in the sun, the stems were crushed to separate their fibers from the woody parts. The fibers were further cleansed of impurities and then separated for spinning. The quality of the fibers depended on growing conditions, the maturity of the plant at the time of harvest, and the harvesting techniques. A still-green plant produces the fiber most suited for weaving the finest linen. Harvesting plants in a mature state results in a coarser fiber, used for rougher fabrics, mats, or ropes.[5]

Linen does not take dye well; its natural color is off-white with a slightly yellow tinge. Egyptians preferred pure white clothing; it was a status symbol and relatively expensive. How they bleached their cloth is not known. Linens could have been washed and exposed to sunlight, or a substance such

as natron (a mineral deposit of the desert) could have been scrubbed into the fibers of the cloth, which would then have been beaten, washed, and left in the sun to whiten.[6]

KCOL

1 For an ostrakon from the same monastery with a medical recipe, see cat. no. 15B.
2 Krause 1991, pp. 1696–98, and Taconis 2005, pp. 35–40.
3 Crum and White 1926, pp. 48–50, pl. XIc. Fully wrapped mummies were excavated at the monastery and demonstrate burial customs practiced there.
4 Ibid., p. 71, pl. XXIIc.
5 Vogelsang-Eastwood 2000, pp. 269–74.
6 Ibid., p. 280.

References: (A, B) Crum and White 1926, pp. 87, 246–47, nos. 351, 353 (includes transcription and translation).

105A, B. Pattern Sheet and Tunic Fragments

....................

A. Pattern Sheet with Scattered Design

Egypt, 5th–6th century

Dark brown ink with yellow, red, blue, and black paint on papyrus

15 × 6.7 cm (5⅞ × 2⅝ in.)

Inscribed: In Greek, on verso, remnants of a 4th-century inscription

Provenance: From the collection "Papyrus Archduke Rainer," founded in 1883. In 1889, Archduke Rainer presented his collection to Emperor Josef I, who included it as a special collection in the Royal and Imperial Court Library (now The Austrian National Library).

Condition: The sheet is in fair condition, presenting top and left edges.

The Austrian National Library, Department of Papyri, Vienna (P.Vindob. G 1.301 + G 1.307)

B. Tunic Fragments with Scattered Design

Egypt, 6th–8th century

a. Tapestry weave in polychrome wool and undyed linen on plain-weave ground of undyed linen; applied band in pattern weft in red wool and undyed linen

17.1 × 11.4 cm (6¾ × 4½ in.)

b. Tapestry weave in polychrome wool and undyed linen on plain-weave ground of undyed linen

25.4 × 5.1 cm (10 × 2 in.)

Provenance: Friedrich Fischbach (1839–1908), Wiesbaden, Germany, and Saint Gall, Switzerland.

Condition: The two fragments belong to a child's tunic, with losses in the roundel.

The Metropolitan Museum of Art, New York, Rogers Fund, 1909 (09.50.1819)

T he pattern sheet from a textile workshop, A, was used for tapestry-weave leaflike decorations and clavi (narrow ornamental bands). In the middle of the sheet is a vase, which is flanked by putti riding on dolphins. A palmette grows from the vase. The ornamental strip to the right is composed of a net design with red dots and yellow beads.

The lozenges are filled by regular rows of rosettes and small leaves.

The putti with disproportionately large stylized heads, hair, and facial features and the dark contours display the style of decoration and figuration that was typical of the Early Byzantine–Islamic period. The clavus shows the diaper and band [tape] patterns that had been in vogue in Egypt since the end of the sixth and increasingly in the seventh century (cat. no. 98).

This pattern was used to make tunics decorated with two clavi on the sides of the front and back of the garment, and leaflike ornaments on the shoulders and at the bottom. This kind of decoration—which coincides both formally and iconographically with the painted pattern sheet—appears on the neck and shoulder parts of a garment, B. In spite of considerable damage, the ornaments on the shoulders also show putti on fish.

Like catalogue number 98, the diaper design with pearls and repeated leaf motifs imitates Sasanid silks with repeating patterns. The popularity of such designs is documented by other examples of pattern sheets

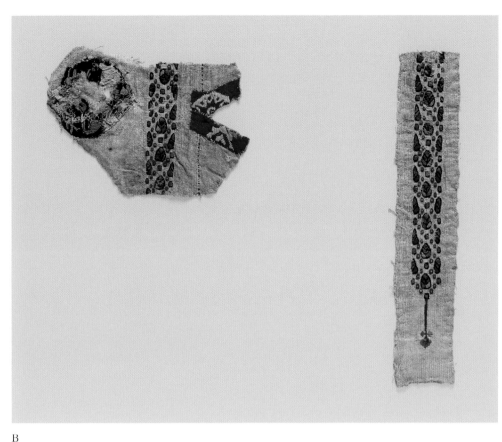

B

with nearly identical motifs, as well as the large number of tunics with related ornaments that have come down to us.

<div align="right">AST</div>

References: (A) Thompson 1986; Horak 1992, pp. 63ff., no. 1, table 15; Buschhausen et al. 1995, pp. 124ff., cat. no. 128; Stauffer 2008, pp. 164–69, colorpls. 38, 39; (B) unpublished.

106. Receipt for Garments

....................

Egypt, 5th–6th century
Ink on papyrus
16.8 × 12 cm (6½ × 4¾ in.)
Provenance: Acquired from Maurice Nahman, Cairo, through the British Museum for Papyrus Collection, University of Michigan, June 1922.
Condition: The papyrus is broken off at the bottom.
Papyrus Collection, University of Michigan, Ann Arbor (P.Mich.inv. 1050)

A certain Zenon wrote this receipt for garments, embroidered panels, linen cloth, and silver spoons to be delivered to Theodosios by Martyrios. While there has been speculation that this receipt was for goods that belonged to a man named Theodosios who is now dead and that were passed on to Zenon,[1] according to Herwig Maehler, no language suggests that anyone referred to in the papyrus is deceased.[2] It is unclear why these goods were taken to

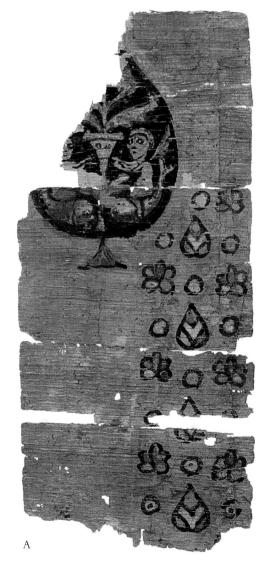

A

Theodosios; it is only known that he owes Zenon for them.

Most of these goods are garments, and the few details given tell us that they were colorful. One tunic was multicolored, another was light green, and the inventory contained embroidered panels, which were typically used to ornament clothing.

We cannot know exactly what "Antioch" refers to, although both textiles and garments were often given names according to their

places of origin. Frequently the techniques and/or materials used simply referred to a type that originated in a particular city; thus, the hood and cloak may not literally have been made in that city but, rather, were of a type common to Antioch. References to "cloth of Antioch" date back as early as the third century C.E., and such textiles were known throughout Europe into Crusader times.[3] Antioch was recognized as an important site of silk production. Furthermore, one study of textiles in church inventories that were labeled Antiochian has found that they were often red and had lampas-weave designs.[4] At the very least, the label "Antioch" implied that these garments were precious.

JB

1 McCarren 1980, no. 684.
2 Maehler 1985.
3 Vorderstrasse 2010, p. 161.
4 Ibid., pp. 163–64.

References: McCarren 1980, no. 684; Maehler 1985; Diethart 1991; Record 1310, Advanced Papyrological Information System, University of Michigan, http://quod.lib.umich.edu/cgi/i/image /image-idx?id=S-APIS-X-1310%5D1050R.TIF (for a transcription and translation).

107. Order for Veils or Handkerchiefs

....................

Egypt, 8th century
Ink on papyrus
24.2 × 19.5 cm (9½ × 7¹¹⁄₁₆ in.)
Provenance: Brought to the British Museum by Maurice Nahman, Cairo, July 17, 1930; purchased by the University of Michigan in 1931.
Condition: The original cutting lines have been preserved on all four sides. There are some small holes in the papyrus. One vertical papyrus fiber was lost from the right bottom corner in antiquity, but no letters are missing.[1] Papyrus Collection, University of Michigan, Ann Arbor (P.Mich.inv. 5621)

This letter from a weaver and tailor named Kalim to his client 'Abd Allah ibn As'ad, who was a bureaucrat and merchant from the Fayyum oasis in Egypt,[2] informs the buyer of the tailor's progress on an order of veils or handkerchiefs, which he has nearly completed at the time of writing. The papyrus begins with a formulaic greeting and blessing and continues with Kalim's request for more *riyat*, a type of textile, to complete the order. He ends by conveying good wishes from a woman, presumably a relation; this convention was seen often in letters of the time.[3]

The letter gives interesting information about the systems in place for commerce. Kalim names the amount of *riyat* needed, not in length or weight, but in monetary terms, one dinar's worth. This suggests that pricing was standardized, at least for textiles.[4] It has also been posited that the dinar is the payment for Kalim's work on the textiles, but this seems less likely, given the small amount of money.

Riyat literally means "thin cloth" and could alternatively be read *ribat*, or ribbons.[5] Given that this letter concerns finishing the veils, the ribbons were likely added decoration. When this papyrus was originally published, the word *mandil* was translated as "veil"; however a *mandil* was more akin to a handkerchief or small towel used in myriad ways.[6] *Manadil*, markers of wealth, were typical places for a weaver to show off his virtuosity, as perhaps Kalim was planning to do with the addition of the *riyat*.

JB

1 Record 4187, Advanced Papyrological Information System, University of Michigan, http://quod.lib .umich.edu/cgi/i/image/image-idx?id=S-APIS-X -4187%5D5621V.TIF.
2 Sijpesteijn 2004b, p. iii.
3 Ibid., p. 452.
4 Ibid.
5 Ibid.
6 Rosenthal 1988. The term is commonly found in the documents of the Cairo Genizah, published in Goitein 1983.

References: Sijpesteijn 2004b, pp. 448–54; Record 4187, Advanced Papyrological Information System, University of Michigan, http://quod.lib.umich.edu/cgi/i/image /image-idx?id=S-APIS-X-4187%5D5621V.TIF (for a transcription and translation).

108. Fragments of a Wall Hanging with Figures in Elaborate Dress

....................

Egypt, 5th–7th century
Tapestry weave in polychrome wool
a. 103 × 148.2 cm (40½ × 58⅜ in.)
b. 15.5 × 5.5 cm (6⅛ × 2³⁄₁₆ in.)
Provenance: Purchased in Egypt.
Condition: Only the lower section of the hanging survives, and at least one more register is missing. Selvages on both sides attest that the hanging is preserved in its original width. The left and lower borders are badly damaged. The figures and columns are in relatively good condition, despite several holes.
Brooklyn Museum, New York, Charles Edwin Wilbour Fund (46.128a–b)

This large fragment from the lower part of a hanging belongs to a group of textiles characterized by rows of figures. The figures most probably represent personifications of the months, carrying the gifts of the seasons.[1] This fragment is framed by a border of two stripes, a zigzag pattern with half rosettes in the outer and small buds in the narrower inner stripe.

Four figures are depicted in each of the two rows. All are standing frontally under arcades; six of them are crowned by haloes. The eight figures are distinguished by the variety of their clothing and attributes. The two figures in the middle of the top row wear richly ornamented tunics and long, voluminous mantles that cover their hands. They also wear shoes.[2] The person at the upper right and the three figures to the right in the bottom row are all barefoot and also dressed in tunics, decorated in the classical

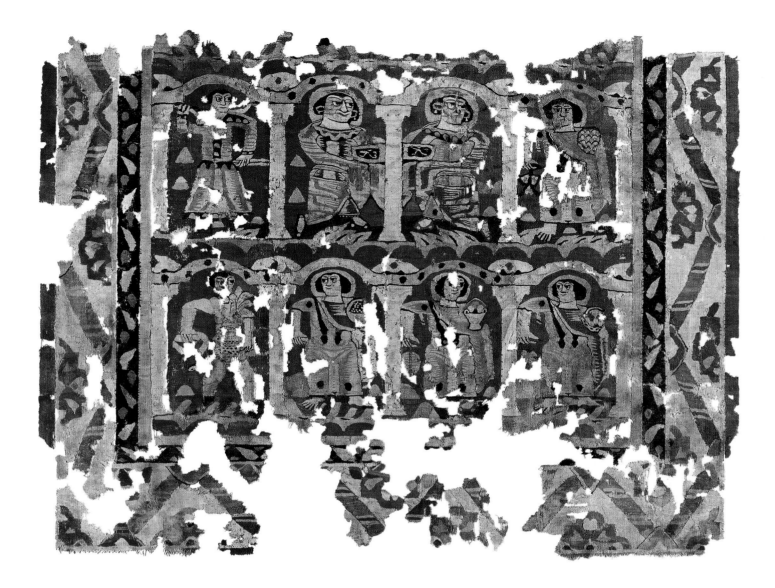

manner of symmetrically arranged vertical stripes (clavi) and roundels (orbiculi) on the shoulders and at the lower edges. A light mantle draped around their necks falls to the left. The figure at the upper left is represented in a flared dress whose decoration emphasizes the center of the front; it is influenced by Persian fashion (see Fluck, p. 160, and cat. no. 114).[3] The figure at the lower left seems to wear a lion's or panther's skin, leaving one shoulder bare, and boots.

Closely related and almost identical pieces in other collections most probably were also made in the same workshop that produced this fragment.[4] It seems that these hangings were manufactured to two different standards: catalogue number 109 is a high-quality tapestry, demonstrating a remarkable play of light and shadow in the modeling, whereas in this fragment, which is of lesser quality, the colors are more uniform and the weaving is less skilled.

An interesting technical feature of this hanging is the use of alternate groups of undyed and red warp threads.[5]

CF

1. Schrenk 2004, pp. 70–73, esp. p. 72. For representations of months in the Roman and Byzantine periods, see, for instance, Dunbabin 1999, pp. 110, 112, fig. 113 (mosaic from Thysdrus, House of the Months, third century), pp. 220–21, fig. 233 (Argos, Villa of the Falconer, sixth century).

2. On the calendar mosaic from Argos, Villa of the Falconer, the month of January is dressed in the same way; see Dunbabin 1999, p. 221, fig. 233.

3. A similar dress is shown on the mosaic in the Villa of the Falconer (see notes 1 and 2) in connection with the month of May.

4. Abegg-Stiftung, Riggisberg, Switzerland: Schrenk 2004, pp. 70–73, no. 16. Coptic Museum, Cairo: Török 2005a, pp. 122–34, cat. no. 64. Musée National du Moyen Âge, Thermes et Hôtel de Cluny, Paris: Lorquin 1992, pp. 188–90, no. 63. Dumbarton Oaks, Washington, D.C. (cat. no. 109). On the question of provenance and symbolism, see also Török 2005b, esp. pp. 219–20.

5. The fragment at Dumbarton Oaks (cat. no. 109) and another tapestry fragment of the same style but with a Dionysian scene in the Katoen Natie Collection, Antwerp (inv. 154; De Moor et al. 2008, p. 250), show the same feature of two different colors used for the warp. This might be another indication that all the textiles with two-color warps were made in one workshop.

References: Ghirshman 1948, p. 305, fig. 17; Weibel 1952, fig. 32; Thompson 1971, pp. 54–55, no. 22; Török 2005a, p. 122, fig. 17; http://www.brooklynmuseum.org /opencollection/search/?q=46.128a-b.

109. Fragment of a Wall Hanging with Figures in Elaborate Dress

....................

Egypt, 4th–6th century
Tapestry weave in polychrome wool
42.5 × 63.5 cm (16¾ × 25 in.)
Provenance: Collection of the Byzantine Institute until 1970.
Condition: Only a small section of the upper part of the hanging has survived, with the selvage preserved on the left side. The upper border is damaged. The figures under the arcades are in a good condition. Parts of the background are missing.
Byzantine Collection, Dumbarton Oaks, Washington D.C. (BZ.1970.43)

Like catalogue number 108, this fragment belongs to a special type of hanging that depicts beneficent personifications symbolizing the abundance of the earth and are thought to guarantee a prosperous and happy life.[1] In addition, all the hangings of this type were made with two colors of warp threads.

Two figures are preserved in this fragment. They stand, facing each other, under a jeweled arcade, and haloes surround their

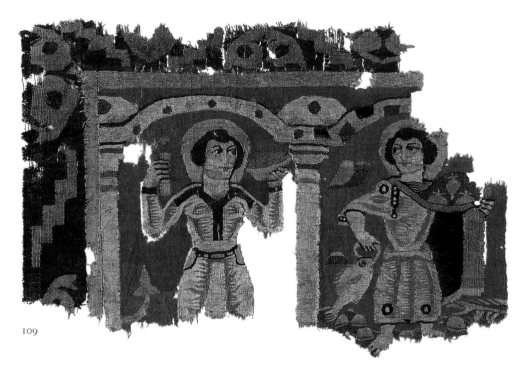

109

heads. With their raised or bent arms they carry gifts—a bowl, an elongated flask, a fish, and pomegranates. The figure on the left is dressed in a Persian-style garment (see Fluck, p. 160, and cat. no. 114) with flared sides and bands at the wrists, on the shoulders, around the triangular cutout neckline, and down to the belt. From the belt hang two little pouches that fall to the hips. The figure on the right is wearing a belted dress with the symmetric decoration typical of a classical woven-to-shape tunic (see Fluck, p. 160, and cat. no. 112). He lifts the mantle that is draped around his shoulder with his left arm to form a hollow in which to carry pomegranates. It is striking that the tunic's right sleeve hangs loose, while the bare arm of the person obviously passes through an armhole opening in the seam, a quite common way of wearing tunics (cat. no. 108).[2]

CF

1 Maguire 1999; Török 2005b, esp. pp. 219–20.
2 See, in cat. no. 108, the figure at the upper right and all but the one on the left on the bottom, and figures depicted on several Late Antique mosaics, sculptures, and reliefs as well. For this phenomenon, see the remarks in Knauer 2004, esp. pp. 13–16. For the making of tunics, see the references in ibid., p. 13, n. 23.

Reference: Maguire 1999, pp. 239, 244, 247, fig. 8.

110. Tunic with Mythological Motifs

....................

Egypt, 5th–7th century
Tapestry weave in polychrome wool on plain-weave ground of yellowish wool; fringe in yellowish wool, purple-colored, and nearly black wool along lower edges
131.9 × 265 cm (51¹⁵⁄₁₆ in. × 8 ft. 8⅜ in.), including sleeves

Provenance: Purchased by the Brooklyn Museum in 1941.
Condition: The tunic is completely preserved, with the exception of a few little holes in the ground fabric, and the fringe at the bottom, some of which has fallen out. Brooklyn Museum, New York, Charles Edwin Wilbour Fund (41.523)

The large size of this woven-to-shape tunic and the heaviness of the material indicate that it was probably made for a man, and that it was very likely an outer garment (see Fluck, p. 160). The tunic is disproportionately wide in relation to the length and the narrow width of the sleeves. To reinforce the areas subject to strain and to stabilize the edges, a special twining and cord were attached, with the utmost care.[1]

Such a tunic required a great deal of fabric. It is a high-quality garment that only a wealthy client could have afforded. The decorative elements, woven directly into the ground, consist of alternating squares and roundels filled with animals; figures beside columns and others fighting with animals (hunters?); horsemen; and nereids. On one side, a row of amphorae embellishes the second horizontal panel below the neck slit, while the panel on the other side shows human figures flanked by animals.[2] The trimming of thick fringes attached to the lower edge of the tunic is not just decorative but also guarantees a gently undulated fall of the tunic.

A couple of woolen tunics and fragments with very similar motifs and technical features suggest that they were manufactured in the same workshop as this tunic.[3] Recent radiocarbon analyses undertaken for a series of closely related pieces indicate that this type of tunic flourished from the fifth to the mid-seventh century.[4] Thus they are to be assigned to Late Antiquity and not to the Islamic period, as previously believed.[5]

CF

1 See the technical drawings and details of closely related tunics in the Abegg-Foundation in Verhecken-Lammens 1994, esp. pp. 79–92.

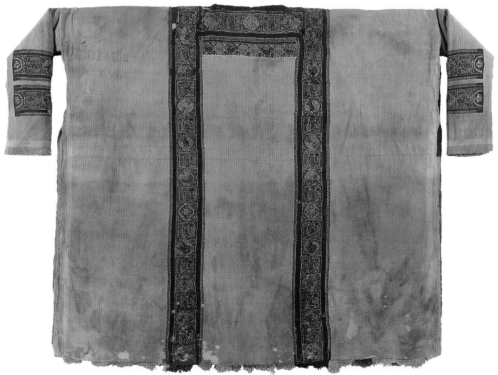

110

2 Thompson 1985, p. 68, fig. 13; Verhecken-Lammens 1994, p. 97, fig. 21.

3 For the most relevant parallels, see the study by Verhecken-Lammens 1994, pp. 95–103, and De Moor et al. 2008, pp. 160–61.

4 Two tunics in the Abegg-Foundation, Riggisberg, Switzerland (Schrenk 2004, pp. 152–58, nos. 51, 52, and table 1, nos. 23, 26) and twelve pieces in the Katoen Natie Collection, Antwerp (De Moor et al. 2004a), were radiocarbon dated.

5 Thompson 1971, pp. 84, 86; Thompson 1985, p. 68.

References: Thompson 1971, pp. 84–87, no. 37; Thompson 1985, esp. pp. 66, 68, fig. 13; Verhecken-Lammens 1994, esp. pp. 97–98, fig. 21.

111. Child's Tunic with Hood

.

Egypt, 430–620 (radiocarbon date, 95% probability)[1]
Tapestry weave in purple-colored, red-brown, and undyed wool on plain-weave ground of green wool; fringes in green and red-brown along the perimeter of the hood and lower edges
89 × 101 cm (35 × 39¾ in.), including sleeves and hood
Provenance: George D. Pratt, New York (until 1927).
Condition: The tunic is complete. There are fragile and worn areas throughout, as well as discoloration and soiling. The fringes along the lower edges and the hood are fragile and partially missing.
The Metropolitan Museum of Art, New York, Gift of George D. Pratt, 1927 (27.239)

This tunic would have fitted a child of about seven or eight years old, though the construction and decoration are like those of an adult's tunic (cat. no. 110).[2] Here, however, a hood was sewn onto the back of the neck opening.

Hoods were typical features of Egyptian children's garments from Roman to Byzantine times.[3] They are commonly made of a separately woven rectangular piece of cloth that was simply folded in the middle of the longitudinal axis and closed at the top. As here, they are often adorned with roundels (orbiculi) and fringes along the top seam and the edges surrounding the face. The decoration of the hood matches that of the tunic, whose cuffs—originally closed but now open—and sides are ornamented with bright stripes, while the lower edge is fringed (cat. no. 110). The sleeves could be tied closed at the cuffs with two blue wool cords, of which one, on the proper right sleeve, remains.

The ornamental bands (clavi) that run down to the lower edge and the double sleeve bands show very stylized frontal figures encircled by laurel-leaf scrolls. Because of the simplified rendering it is not possible to identify the individual depictions, except for a few dancers that are characterized by their crossed legs. Because dancers and laurel leaves are closely associated with the cult of Dionysos—one of the most popular themes in Roman and Early Christian art—the other figures on the tunic's bands probably relate to the Dionysian theme as well.[4]

CF

1 Nobuko Shibayama, Associate Research Scientist, and Tony Frantz, Research Scientist, Department of Scientific Research, The Metropolitan Museum of Art, assisted in the radiocarbon age determinations. The tests were performed by Beta Analytic, Inc., in 2011.

2 For the dating, see the discussion under cat. no. 110.

3 For further examples, see Pitarakis 2009, pp. 181–84; Fluck 2010, pp. 182–84.

4 For a flask with a decoration of dancers, see cat. no. 139.

References: Kajitani 1981, p. 67, no. 92; Dauterman Maguire et al. 1989, p. 145, cat. no. 69; Stauffer 1995, pp. 27 and 46, cat. no. 37; Pitarakis 2009, p. 183.

112. Richly Decorated Tunic

.

Egypt, said to be from Tuna al-Gebel, 660–870 (radiocarbon date, 95% probability)[1]
Tapestry weave in polychrome wool and undyed wool on plain-weave ground of undyed wool; applied borders with pattern and brocading weft in polychrome wool and undyed linen
119 × 201.5 cm (46⅞ × 79⁵⁄₁₆ in.), including sleeves
Provenance: Maurice Nahman, Cairo (until 1912).
Condition: The tunic is complete. The front is well preserved, while the back has missing areas in the ground weave. There are discoloration and soiling throughout. The stitching for closing the sleeves is original. The borders along the cuffs and hemlines were once removed and have recently been reapplied; it is not certain that the borders were original to the tunic, though the color palette of the cuff borders corresponds to the tapestry-weave borders of the sleeves and the roundels. There is no indication that there was a border along the neckline.
The Metropolitan Museum of Art, New York, Gift of Maurice Nahman, 1912 (12.185.2)

This garment clearly demonstrates how the decoration of tunics developed from Late Antiquity to Early Islamic times. The patterns and motifs of Late Antique tunics are usually based on a contrast between light and dark (cat. nos. 110, 111). In the Byzantine and Early Islamic period, however, they grew increasingly colorful, with symmetrical, polychrome figures and other motifs, often on red backgrounds, becoming very popular.

Over time, the manufacturing processes of the decorative elements also changed. Rather than being woven directly into a garment's ground fabric, they were, for reasons of economy, produced separately in sets that were later sewn onto the tunic.

The Metropolitan Museum's tunic has a band with a repeat pattern of lozenges filled with rosettes applied on the cuffs and at the lower edge. The remaining decoration is woven into the ground fabric. The vertical stripes (clavi) are divided into rectangles with frontal haloed figures alternating with palmettes rendered on a bright ground. The same figures occur on the sleeve bands. The roundels (orbiculi) on the body and the

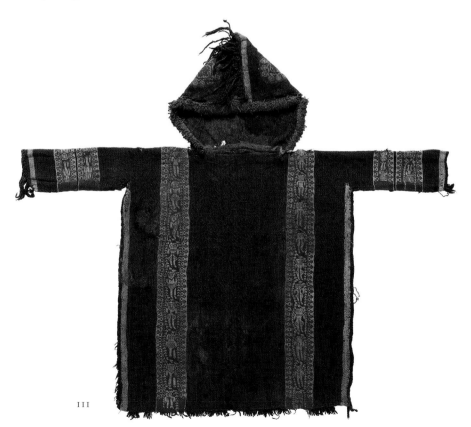

111

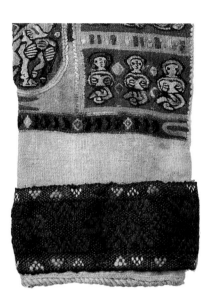

112, detail

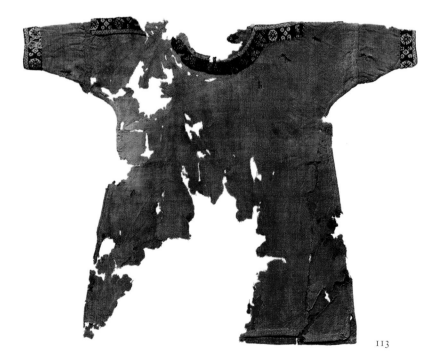

112

medallions in the center of the sleeve bands show horsemen, cupids, and other figures in an abstract movement vaguely reminiscent of dancers.[2] The quality of the tunic's ground fabric and of the figures and motifs—despite the highly stylized rendering—testifies to the weaver's great technical skill.

It is worth noting that another tunic in the Metropolitan Museum's collection is almost identical, except for an additional band around the neck slit.[3]

A similar tunic in the Katoen Natie Collection, Antwerp, with woven-in decorations in tapestry weave and applied weft-pattern bands has been radiocarbon dated recently to the seventh to eighth century. This supports the results obtained for the present tunic.[4] CF

1 Nobuko Shibayama, Associate Research Scientist, and Tony Frantz, Research Scientist, Department of Scientific Research, The Metropolitan Museum of Art, assisted in the radiocarbon age determinations. The tests were performed by Beta Analytic, Inc., in 2011.
2 The Christian interpretation of the figures suggested by Dimand 1930, esp. pp. 246–47, is doubtful.
3 12.185.3; see Dimand 1930, fig. 18; Dauterman Maguire et al. 1989, p. 144, cat. no. 68.
4 De Moor et al. 2008, pp. 188–89.

References: Dimand 1930, pp. 245–48, 250–51, figs. 8, 10, 11, 19; Kajitani 1981, p. 65, no. 90; Stauffer 1995, pp. 27, 46, cat. no. 37.

113. Child's Dress

....................

Egypt, probably Panopolis (Akhmim), 660–880 (radio-carbon date, 95% probability)[1]
Plain weave in red wool; applied borders with pattern weft in blue and red wool and undyed linen
52 × 65 cm (20½ × 25⁹⁄₁₆ in.), including sleeves
Provenance: [Emil Brugsch Bey, Cairo (until 1890)]; George F. Baker, New York (1890).
Condition: The dress is fragile. Significant areas of the red ground have deteriorated, and there are discoloration and soiling throughout. Sections of the neck border are missing. The color preservation is good.
The Metropolitan Museum of Art, New York, Gift of George F. Baker, 1890 (90.5.174)

In contrast with woven-to-shape tunics with straight sides, this dress—in a style worn by children from infancy to preadolescence—is tailored. Several pieces were cut from a red woolen cloth; the front and back

113

and the upper part of the sleeves are one piece, while the lower part of the sleeves and the triangular side gores were cut out separately and sewn to the body of the garment. The sides and sleeves were then sewn closed. A small slit at the hem on either side was left open. The triangular gores, which extend up to the armpits, give the dress its flared line. A similar method was used to construct the Persian riding coat (cat. no. 114).

The semicircular neck opening is decorated with a finely crafted applied border with a pattern of alternating rosettes and quincunx motifs and a small red border with a zigzag design. The same bands occur around the cuffs. A slit on the proper left shoulder facilitated putting on the dress; the slit could be closed with a little linen button attached to the trimming on the front.

A remarkable number of flared woolen children's dresses from Egypt were dyed red, blue, or blue-green;[2] related pieces have been found in particular in the Fayyum. Radiocarbon analyses of selected samples indicate a date between the late seventh and the tenth century.[3] C F

1 Nobuko Shibayama, Associate Research Scientist, and Tony Frantz, Research Scientist, Department of Scientific Research, The Metropolitan Museum of Art, assisted in the radiocarbon age determinations. The tests were performed by Beta Analytic, Inc., in 2011.
2 Aben 1979, pp. 12–13; Noever 2005, pp. 122–24, cat. nos. 65, 66; Pritchard 2006, pp. 42–43, 103–4, 108, 112–14; Fluck and Mälck 2007, pp. 154–55; Museum für Byzantinische Kunst, Berlin, Schweinfurth, no. 415 (unpublished).
3 Pritchard 2006, table on p. 115; Fluck and Mälck 2007, pp. 154–55, and table on p. 166.

References: Unpublished.

114. Persian-Style Riding Coat
.....................

Egypt, Antinoë (now Sheikh Abada), 440–640 (radiocarbon date, 95% probability)[1]
Plain weave in blue-green sheep's wool and cashmere; applied borders in tablet weave of polychrome wool and undyed linen; patches of fabric in plain weave of undyed linen to reinforce armpits and hemline
120 × 252 cm (47¼ × 8 ft. 3¼ in.), including sleeves

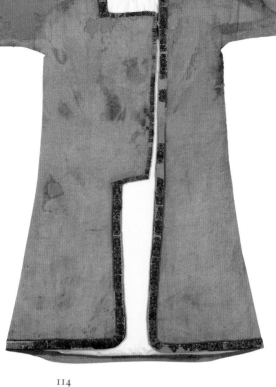

114

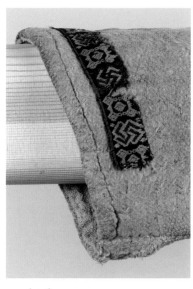

114, detail

Provenance: Excavated by Carl Schmidt in Antinoë in 1896; acquired by the Ägyptisches Museum, Berlin, in 1897 (inv. no 14231); transferred to the Skulpturensammlung und Museum für Byzantinische Kunst (former Kaiser-Friedrich-Museum), Berlin, 1934.
Condition: The coat is sewn onto a modern support. The front is well preserved apart from minor cuts and brownish stains. Smaller parts of the borders are destroyed. The back side is badly damaged. A first restoration was carried out before 1906 by Carlotta Brinckmann. In 1999 it was consolidated by Kathrin Mälck. The borders were fixed with crepeline.
Stiftung Preußischer Kulturbesitz, Staatliche Museen zu Berlin—Skulpturensammlung und Museum für Byzantinische Kunst, Berlin (9695)

A male body discovered in a tomb in the Northern Cemetery of Antinoë, in Middle Egypt, was wearing a tailored shirt, a tunic, a pair of stockings, boots, and a type of wrapped trousers. This coat was around the man's shoulders covering the other clothes.

The coat belongs to a group of Persian-style garments discovered in Antinoë. The overlong sleeves, flared sides, rectangular neck opening, and overlapping panel across the chest display the influence of Central Asian riding costumes (see Fluck, p. 160). The coat's turquoise fabric was made from a combination of sheep's wool and cashmere; the fabric was then processed with a comb-like tool that produced a napped surface on both sides, resulting in a fleecy appearance and texture. The edges are decorated with tablet-weave bands.

All known coats from Antinoë are elaborately tailored in precious fabrics. Some are decorated with tablet-weave bands, others with silk appliqué.[2] The raw materials and technical features point to a Persian origin.[3] Since its founding by the Roman emperor Hadrian about 130 C.E., Antinoë had been a lively trading town connecting the Nile Valley with the harbors at the Red Sea.[4] Coats such as this one were probably prized imports. Their owners must have been wealthy, whether native Egyptians who favored Persian fashions or Persian citizens who had settled in the town. These coats were dyed either turquoise or red, suggesting that the color indicated the wearer's high rank or special function.[5] C F

1 De Moor et al. 2004b, p. 184.
2 For instance, Demange 2006, p. 162, cat. no. 102 (Dominique Bénazeth).
3 The basic weave of the coats was of wool yarns spun in the Z direction, which is unusual for Egypt, where S-spun yarns were preferred; see Pfister 1948, p. 63; De Moor et al. 2004b, pp. 181–82.
4 For the history of the town, see Timm 1984, pp. 111–28.
5 Tafazzoli 1974, pp. 192–93; Martiniani-Reber 1986, p. 41.

References: Tilke 1923, p. 13, pl. 27; Wulff and Volbach 1926, p. 137, pl. 126 (under the earlier inv. no., 14231); Fluck 2004, figs. 26, 29, 54–56; Mälck 2004, pp. 163–68, figs. 67b–69; Demange 2006, p. 161, cat. no. 101 (Cäcilia Fluck).

Animal Motifs

Mina Moraitou

Often reiterating depictions dating from the Roman period, animal motifs are prominent in the religious and secular iconography of Late Antiquity, where they appear in many different contexts. Included in illustrations of the Christian scriptures and in images of everyday life, they may also have allegorical connotations or act as images of power. Animals also served as symbols. The fish and the lamb, for example, are commonly associated with Christ and his sacrifice, and the Christian concepts of immortality and purification through baptism are embodied, respectively, by a peacock and by a deer drinking from a fountain.[1] In a general way, animals can also connote prosperity, happiness, and wealth. Such representations are especially common in the rich mosaic tradition of the former eastern Byzantine provinces of the Bilad al-Sham (Greater Syria). There, animal motifs decorate the floors of churches, either alone, in rows, or in confronted pairs, often flanking an object or a tree (cat. no. 67). Animals are abundant in Coptic textiles, sometimes serving as the primary decorative themes (cat. no. 115A) but also accompanying groups of men and women, or mythological deities, or both, and appearing in bucolic or Nilotic scenes (cat. no. 3).[2]

In the Islamic period, animal motifs continued to be a popular and sometimes essential part of decorative programs. For example, the rabbit was prevalent in the art of Late Antiquity and remained so in the Fatimid period (909–1171). As in Byzantine art, real animals and imaginary ones, such as

griffins, are shown in combat or in hunting scenes. Ferocious creatures attacking other animals are a recurrent theme, associated as in earlier art with power and protection against evil. A key iconographic source for such images is encountered in Sasanian art, especially in the decoration of metalwork with references to royal power. Hunting scenes with or without human figures are incorporated into the iconography of the princely life. An example is the mounted hunter pursuing game in a floor painting from Qasr al-Hayr al-Gharbi; it is paired with a scene of figures playing music, another favorite pastime of the court (fig. 84). A celebrated example is an Umayyad mosaic at the palace of Khirbat al-Mafjar (fig. 87) showing two tranquil deer feeding on one side of a tree and a lion attacking another deer on the other side, both probably allegorical references to poetical ideas of Caliph al-Walid II (r. 743–44).[3] Two hunting scenes executed on metal buckets—one dating from the sixth century showing wild animals chased by hunters (cat. no. 123A), the other from the eleventh or twelfth century depicting running animals fleeing from a leopard (cat. no. 123B)—reflect the enduring popularity of the theme.

Functional objects in animal form include aquamanilia (cat. nos. 38, 169) and fountain heads (cat. no. 118). Sculptural details representing different animals and birds are used as decorative finials and handles for containers (cat. nos. 122c, 171).[4]

115A, B. Two Textile Fragments Decorated with Animals

......................

A. Band with a Hare

Egypt, 5th–7th century
Tapestry weave in black wool and undyed linen on plain-weave ground of undyed linen; details in flying shuttle with undyed linen
20 × 50.8 cm (7⅞ × 20 in.)
Provenance: Dikran Kelekian (1868–1952), Paris, Istanbul, and New York; Charles Kelekian (1900–1982), New York (by descent); Nanette B. Kelekian, New York (by descent until 2002).
Condition: This fragment is cut from a larger textile. There are open slits, losses in the right square, and fraying edges. It is discolored.
The Metropolitan Museum of Art, New York, Gift of Nanette B. Kelekian, in honor of Nobuko Kajitani, 2002 (2002.239.14)

B. Sleeve Fragment with a Band Decorated with an Animal

Egypt, 9th–10th century
Tapestry weave in red wool (dyed with madder)[1] and undyed linen on plain weave ground of undyed linen; details in flying shuttle with undyed linen; weft loop pile with undyed linen
30.5 × 31.5 cm (12 × 12⅜ in.)
Provenance: [Emil Brugsch Bey, Cairo (until 1890)]; George F. Baker, New York (1890).
Condition: This fragment of a sleeve is from a linen tunic with weft loop pile on reverse. There are remnants of linen thread and stitch holes on the right and left edges, and losses and staining in the linen ground.
The Metropolitan Museum of Art, New York, Gift of George F. Baker, 1890 (90.5.829)

Both textiles represent the widespread use of animal motifs during the Byzantine and Early Islamic periods in Egypt, either in isolation, as here, or combined with other animals, human figures, or vegetal ornamentation. Fragment A is decorated with a band that was once part of a larger strip that formed part of a tunic. The band, in monochrome tapestry, has three rectangular compartments. The central one contains the profile of a black hare crouching on a bed of leaves against a dotted background. Flanking this section are two identical compartments with three rows of stylized leaves, typical decorative elements on Late Antique clothing.[2] Characteristic ornamental motifs on the bands include animals, such as lions or gazelles, and human figures often associated with mythology. The hare or rabbit also occurs frequently; an example of the motif comparable

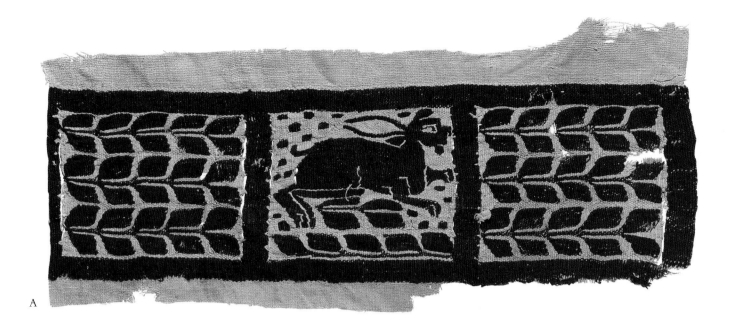

A

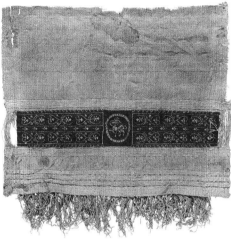

B

to the one shown here, in the Musée du Louvre, Paris, appears on a band that also features Aphrodite.[3] The Metropolitan Museum's hare is depicted in a similar position, with the ear left blank.

The fragment of a sleeve, B, is decorated with a red band featuring a linear composition made up of a central medallion flanked by two rectangular panels. In the medallion is a quadruped, while each side panel carries two rows of a composite, two-part motif: a heart-shaped and an open-ended side, each enclosing a stylized flower.[4] The animal, which looks backward with one leg raised, is a familiar one in the Early Islamic period and comparable with motifs on woodwork.[5] MM

1 Dye analysis performed in 2011 by Nobuko Shibayama, Associate Research Scientist, in the Metropolitan Museum's Department of Scientific Research.
2 See Pritchard 2006, pp. 60ff.
3 *Couleurs* 2001, cat. no. 86.
4 For comparable material, see Noever 2005, p. 114, cat. no. 58, and Pritchard 2006, figs. 4.32, 4.33.
5 For examples, see Anglade 1988, nos. 32, 38.

References: (A) Unpublished; (B) Stauffer 1995, p. 48, cat. no. 59.

116. Flask with Green Cameo Decoration

.

Probably Iran, 9th–10th century
Translucent glass with green glass overlays, relief cut, incised
H: 15.5 cm (6⅛ in.); Diam: 8.5 cm (3⅜ in.)
Provenance: Found in Iran, possibly Nishapur; purchased by the British Museum from E. T. Safani (1934–1973) in 1967.
Condition: The flask is intact.
The British Museum, London (1967,1211.1)

The two patches of emerald-green glass applied to the surface of this otherwise colorless glass bottle were each linear cut into the silhouette of an animal, perhaps a rabbit. The area between the two motifs is decorated with two stylized floral motifs, which have been carved into the spherical body of the long-necked vessel.

Embellishing plain colorless glass with applied color and incised decoration is an adaptation of the Roman technique known as cameo glass, practiced in the Mediterranean beginning in the first century C.E. The Islamic period witnessed the emergence of two variations of the technique: covering the surface with an overlay or applying patches of colored glass, as is the case with this flask. Examples recovered during the excavations in Samarra indicate an attempt to continue pre-Islamic styles. Among the finds was a cup with a square patch carved with geometric decoration.[1]

A related bottle in the David Collection, Copenhagen, is decorated in the same style, with four animals cut from applied green and brown glass.[2] The rendering of the animals on both objects is similar in that they are relatively austere and highly stylized in the

ninth-century manner. In form and posture, the animals on this flask are comparable to the figure of the rabbit on the luster-decorated bowl in catalogue number 117, which they also resemble in the long ears and, in particular, the curved line beginning under the head. MM

1 Carboni and Whitehouse 2001, p. 193, cat. no. 98. For further examples, see Goldstein 2005, p. 208, nos. 247, 248.
2 Carboni and Whitehouse 2001, pp. 195–96, cat. no. 100.

References: Pinder-Wilson 1991, pp. 119–20, fig. 148; Carboni and Whitehouse 2001, pp. 194–95, cat. no. 99.

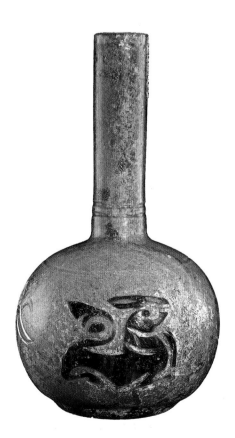

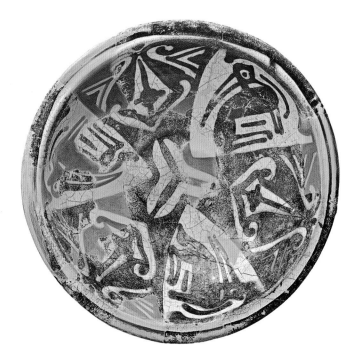

117. Luster-Painted Bowl

....................

Iraq or Egypt, 9th–10th century
Ceramic with monochrome luster decoration over an opaque glaze
Diam: 21.4 cm (8⅜ in.)
Provenance: Acquired by the Benaki Museum in 1937.
Condition: The bowl has been restored and repainted.
Benaki Museum, Athens (1157)

The decorative scheme of this ceramic bowl is a radiating pattern of triangular panels alternating with either a rabbit against a white background or a composition of stylized palmettes. The reverse features stylized leaf motifs, and the base bears traces of a mark or signature. The decorative treatment is typical of ornaments in ninth-century Abbasid Iraq. A variation on the same theme is found on a bowl in the Nasser D. Khalili Collection, London, which displays a radiating design with alternating animal and palmette motifs.[1] The rabbit is a recurring theme on ceramics. Comparable material— for example, in the Benaki Museum, Athens, or the Keir Collection, now on loan to the Museum für Islamische Kunst, Berlin— demonstrates the same bold rendering of the rabbit, shown in profile with long, straight ears, sometimes sitting on its hind legs.[2]

The same treatment is used for the motif of the palmettes, as each design interlocks with the other to achieve a symmetrical composite motif. It recalls the beveled style of carving on stucco (fig. 106) and wood (cat. nos. 162, 165), where the decoration consists primarily of floral motifs, and the depiction of animals is rare.[3] A number of ceramic fragments in the Benaki Museum,

found at Fustat, feature the same palmette design. Among them, a fragmentary plate with a radiating design of purely vegetal nature is of particular note.[4] MM

1 See Grube et al. 1994, p. 38, no. 25.
2 Philon 1980, nos. 333, 348, 351, and Grube 1976, p. 65, no. 26.
3 For an example, see Anglade 1988, no. 15.
4 Philon 1980, nos. 298, 301, 308.

References: Jones and Michell 1976, p. 390, no. 657; Philon 1980, p. 142, no. 309; Makariou 2000, p. 102, no. 60; Ballian 2006, fig. 40.

118. Figurine of a Crouching Hare

....................

Egypt, 10th–11th century
Cast bronze
12 × 4 cm (4¾ × 1⁹⁄₁₆ in.)
Provenance: Purchased by the Museum of Islamic Art before 1969.
Condition: The hare is missing one ear and has holes on the body.
Museum of Islamic Art, Cairo (14487)

This hollow-cast figurine is in the shape of a crouching hare. Its long ears touch its back, the small tail curves upward, and the mouth is agape. The unembellished body is pierced with three holes, one at either side and another at the tail. Together with two deer and a lion, it forms part of a small group of three-dimensional, cast-bronze animal figures at the Museum of Islamic Art, Cairo. Their function has not been determined, but it has been suggested that they were used as fountain decorations.[1]

The hare or rabbit is a recurring decorative theme from the pre-Islamic period, appearing on textiles (cat. no. 115A), carvings, and mosaics.[2] Its representation is also frequently encountered in the Early Islamic period, especially in Egypt during the Fatimid period, when it occurs in additional media such as wood,[3] ceramics (cat. no. 117), and glass (cat. no. 116). During the Islamic period the motif was generally associated with prosperity and fertility.

Dispersed among different collections are a variety of bronze hares. Two examples, one in the Musée du Louvre, Paris, and the other in the David Collection, Copenhagen, share a similar stance but lack the vivacity and naturalism of the Cairo hare, whose open mouth suggests panting and whose front legs seem poised to jump. MM

1 See Baer 1983, pp. 156–57, and Dodd 1972, p. 66.
2 For examples in mosaic, see Piccirillo 1992, pp. 158, 177, 280.
3 See also *Trésors fatimides* 1998, cat. nos. 11, 82.
4 David Collection, Copenhagen (33/2000); see von Folsach 2001, fig. 462; Musée du Louvre, Département des Arts de l'Islam, Paris (AF 2020).

References: Dodd 1972; Jones and Michell 1976, p. 166, cat. no. 169; O'Kane 2006, p. 76.

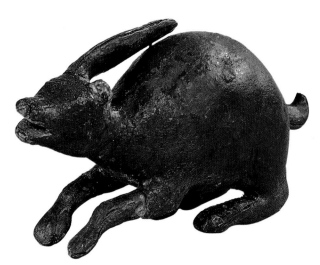

Vine Rinceaux

Gabriele Mietke

Grapevines have been well known in the Near East for more than five thousand years, the span of time that grapes have been cultivated. Grapes and the wine made from them were highly regarded all over the ancient world. In ancient Greece the grapevine was associated with Dionysos, the god of wine, ritual madness, and ecstasy, and with his entourage of female followers and satyrs, who often were represented making music and dancing frenetically (cat. no. 139). With the expansion of Greek culture during the period of Hellenism (approximately 323–30 B.C.E.), Dionysiac representations spread all over the Mediterranean and farther to the east. Depictions included vines and vine scrolls (rinceaux) either as symbols of the god or as mere decoration, now emptied of their original religious content. Dionysiac scenes and elements were adopted by the Parthians and Sasanians in Persia (cat. nos. 19, 20) and Late Antique Mediterranean-style rinceaux can be traced as far as the Arabian Peninsula and the Indian subcontinent.[1] One version consists of scrolls inhabited by human figures, animals, or birds.[2]

In Early Christian art the grapevine assumed a new meaning. Referring to the parable of the vine and the branches (John 15:5), it became a widely used symbol for Christ (cat. no. 120). Vines continued to be used as decorative ornament in both secular and religious contexts (cat. no. 119). Whether or not the motif carried symbolic meaning, it was popular throughout the eastern Mediterranean in mosaic pavements in houses and churches (cat. no. 79), on stone reliefs and wood carvings,[3] and on textiles, ivories, and metalwork (cat. nos. 119, 121, 122).

Vine rinceaux can be seen on a number of outstanding monuments in the Byzantine capital, Constantinople, and on objects that were made in metropolitan workshops, all dating from the sixth century C.E. Yet none of these displays such a rich variety of different vine ornaments carved in marble as the Church of Saint Polyeuktos in Constantinople (524–27), built at the initiative of the imperial princess Anicia Juliana (461/63–527/29). The carvings include extremely naturalistic vines with vivid leaves,

naturalistic or stylized grapes and leaves made to conform to grids of squares set on their points, symmetric compositions of vines springing from a vase, and rows of vine-scroll medallions enclosing a leaf or a grape ornamentally flanking monograms and vine leaves (fig. 77).[4]

By contrast, the most important church of Constantinople, Hagia Sophia (532–37), rebuilt by order of the emperor Justinian (r. 527–65) shortly after Saint Polyeuktos was erected, has fewer vine motifs. A carved frieze of once-gilded vine scrolls runs along the walls between the marble revetment and the mosaics of the vaults. It was notable enough that Paul Silentiarios mentioned it in his *ekphrasis*, a descriptive speech given in 563 shortly after the dome of the church was repaired.[5] Rinceaux work in opus sectile (floor and wall decoration typically using marble plaques and inlays) covers the spandrels above the galleries.[6] It combines characteristics of vine and acanthus scrolls, incorporating pomegranate-like fruits and palmette-shaped leaves. This mixture of different plants is often considered typical of Islamic art but, as can be seen here, was already present in Early Byzantine ornament.

In Early Islamic art, particularly Umayyad, the motif of the vine rinceaux was widely adopted. In the Great Mosque of Damascus (706–15), built by the Umayyad caliph al-Walid I (r. 705–15), a vine frieze of gilt marble in the prayer hall most likely referred to the corresponding frieze in Hagia Sophia. This quotation of an outstanding feature in the most important Byzantine church was an element of the caliph's claiming parity and perhaps superiority for his own faith. The frieze in Damascus was still being praised for its costliness and golden appearance by Arab authors of the twelfth century and was so emblematic that it was itself copied in Mamluk interior decorations. Although in these sources it is called *karma* (vine), it in fact combined elements of the grapevine, acanthus, and other plants, as did the opus sectile rinceaux in Hagia Sophia.[7]

The grapevine is a motif in the decoration of a number of Umayyad residences of the first half of the eighth century. The

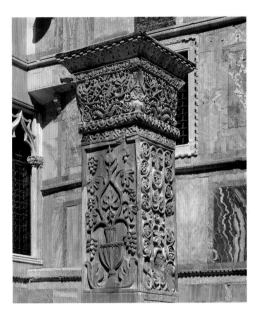

Fig. 77. Pier from the Church of Saint Polyeuktos, Constantinople. Marble, 524–27. Now the western pier in the Piazzetta di San Marco, Venice

outstanding example is the facade of the palace of Mshatta in Jordan (cat. no. 142).[8] The triangular pattern of the architectural ornament is decorated all over with every type of vine complemented with acanthus friezes (fig. 78). The carpetlike covering of the surface was considered a benchmark for the development of a characteristically Islamic ornament.[9] However, this had already been a common feature of Byzantine architectural sculpture of Constantinople in the sixth century.[10] In Mshatta the composition of the scrollwork and elements like vases, griffins, and the repertoire of the inhabited scroll clearly denote the continuation of the classical and Byzantine traditions, which were supplemented by Sasanian and possibly Late Antique Egyptian elements.[11] However, the ornament was adapted to the belief of the Muslim patron. While vines and vine scrolls to the left of the central portal were inhabited by birds, animals, and human figures, the vine ornament to the right contained no living creature, seemingly in an effort to respect the mosque that lay behind the wall.[12]

The vine motif in all its possible variations is also present in the decoration of

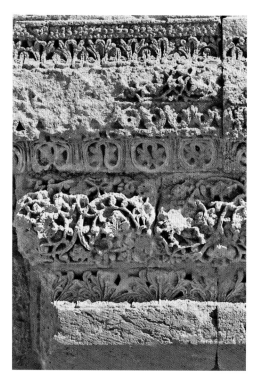

Fig. 78. Section of wall at the palace of Mshatta showing vine rinceaux (cat. no. 142 seen at top). Limestone, mid-8th century. Qasr al-Mshatta Archaeological Site, Jordan

Khirbat al-Mafjar, another Umayyad residence north of Jericho.[13] In this case, graffiti found in the construction debris prove that masons and workmen were mostly Greek- or Arabic-speaking Christians, probably hired from the local population.[14] Again, the traditional repertoire of classical art and ornament transmitted by local workshops was complemented by elements of Sasanian origin.[15]

In Umayyad desert castles, a predilection for vines seems apparent, not only in Mshatta and Khirbat al-Mafjar but also, for example, in Qusayr ʿAmra or Qasr al-Hayr al-Gharbi in Syria.[16] These places served as temporary residences, furnished with gardens and lavishly decorated with paintings and sculptures of rulers and noblemen, showing scenes of hunting and bathing, music and dance. Contemporary and later poetry points to music and dance in combination with the consumption of wine as favored pastimes of the nobility and their guests, referring in particular to the caliph al-Walid II (r. 743–44).[17] The motif of the grapevine thus conformed with Umayyad ideas of courtly leisure and luxury and with a more general perception of the ideal Islamic garden. Small luxurious objects with vine rinceaux like ivory pyxides (see cat. no. 120),

secular censers (cat. no. 122), or flasks with musicians and dancers (see cat. nos. 20, 139) fit well into this picture, serving as objects for an aristocratic style of life or its imitation.

The religiously more rigorous successors of the Umayyads, the Abbasids, opposed such a libertine lifestyle and figurative representations.[18] Nonetheless, rinceaux of grapevines and other plants remained a main theme of decoration, fantastically varied and enriched in infinite variations, moving increasingly away from naturalistic models to what is called the arabesque.

119A, B. Grapevine-Patterned Textile Fragments

....................

A. Band with Vine Scroll

Egypt, 4th–6th century
Tapestry weave in purple-colored wool and undyed linen on plain-weave ground of undyed linen; details in flying shuttle with undyed linen
31.7 × 15.9 cm (12½ × 6¼ in.)
Provenance: [Emil Brugsch Bey, Cairo (until 1890)]; George F. Baker, New York (1890).
Condition: This remnant of a longer band preserves the pattern in good condition.
The Metropolitan Museum of Art, New York, Gift of George F. Baker, 1890 (90.5.594)

B. Textile Fragment with Inhabited Vine in an Eight-Pointed Star

Egypt, 5th–6th century
Tapestry weave in polychrome wool and undyed linen applied to plain-weave ground of undyed linen; details in flying shuttle with undyed linen
27 × 31.8 cm (10⅝ × 12½ in.)
Provenance: Dikran Kelekian (1868–1952), Paris, Istanbul, and New York; Charles Kelekian (1900–1982), New York (by descent); Nanette B. Kelekian, New York (by descent until 2002).

Condition: The piece was cut from a larger textile; there are losses on the left edge of the star.
The Metropolitan Museum of Art, New York, Gift of Nanette B. Kelekian, in honor of Olga Raggio, 2002 (2002.494.824)

Textiles preserved in Egypt depict variations on the theme of the grapevine, one of the most popular motifs in Byzantine art. Here a graceful dark purple vine scrolls across the breadth of band A in an undulating rhythm. The curving stem and large leaves are emphasized by the lighter ground. Related vine scrolls in various media demonstrate that the popularity of the motif continued from the Byzantine period into the Islamic era (cat. nos. 50, 120, 155, 156, 180). Over those centuries, grapevines also often appeared emerging from pots, as seen both on monumental floor mosaics and intimate bone and ivory carvings (cat. nos. 1, 79, 120, 121, 141, 177). Often, the vine was inhabited (cat. nos. 120–122, 142). On fragment B, made to be applied to a larger textile, possibly a tunic, an inhabited vine contains two confronted four-legged creatures with bright red tongues and large ears. Flanking the pot from which the vine scrolls grow are two rather abstractly formed putti. Similar textile designs often show the putti harvesting grapes.

Originally Dionysian themes, such images may display their owner's awareness of classical traditions (see Evans, p. 18). They may also have come to be viewed within a Christian context through Christ's statement "I am the true vine" (John 15:1).[1] On this work, the vine motif is enclosed in an eight-pointed star. The star is outlined by a broad band filled with a simple interlace highlighted in yellow and bracketed by purple-

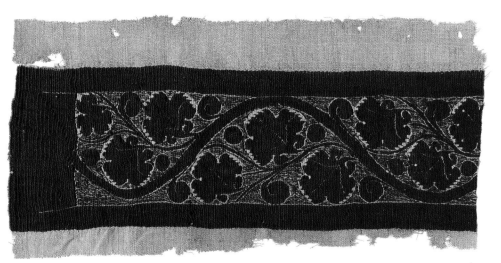

A

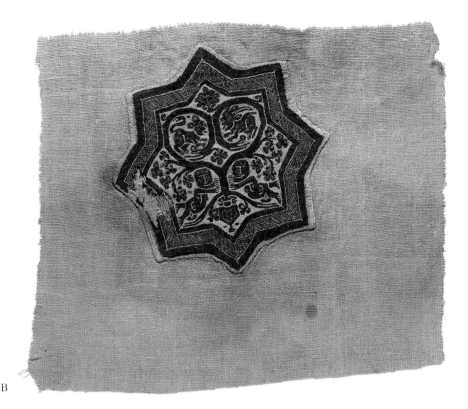

B

brown and white bands, making it a dominant element of the design. Similar stars with interlaces have been identified as being apotropaic motifs worn to protect the wearer from the evil eye.[2] Like the grapevine, the eight-pointed star would become a popular motif in Islamic art (cat. no. 160).

HCE

1 Cormack and Vassilakē 2008, pp. 188, 418–19, cat. no. 159; Rutschowscaya 1990, pp. 86, 90, 91.
2 Maguire 1990, pp. 215–16.

References: (A, B) Unpublished.

120A–C. Three Ivory Pyxides

....................

A. Pyxis with Crosses and Vine Scrolls
Syria (?), 7th–8th century
Ivory with red paint added later
H. 8.5 cm (3⅜ in.); Diam. 6.8 cm (2⅝ in.)
Provenance: As part of the Beuth-Schinkel-Museum, administered by the Nationalgalerie beginning in 1923, this pyxis, with most of the museum's holdings, taken to the Soviet Union after World War II. Returned in 1958–59; given to the Kunstgewerbemuseum; transferred in 1973 to the Frühchristlich-Byzantinische Sammlung (now Skulpturensammlung und Museum für Byzantinische Kunst), Berlin.
Condition: A piece of the rim is broken off, and a vertical fracture is kept together by metal pins. The lid is missing.
Stiftung Preußischer Kulturbesitz, Staatliche Museen zu Berlin—Skulpturensammlung und Museum für Byzantinische Kunst, Berlin (11531)

B. Pyxis with Vine Scrolls and Birds
Syria (?), 7th–8th century
Ivory and red, blue, and black paint; beechwood lid, painted and gilded, with rock crystal knob and gilt copper fittings, added later
H. 14 cm (5½ in.); Diam. 8.5 cm (3⅜ in.)
Provenance: Bought in London from H. Durlacher in 1866.
Condition: The pyxis is in good condition with later lid.
Victoria and Albert Museum, London (136-1866)

C. Pyxis with Vine Scrolls
Syria (?), 7th–8th century
Ivory; metal rim around lid added later
H. 9.5 cm (3¾ in.); Diam. 9 cm (3½ in.)
Provenance: Bourgeois Collection, Cologne; acquired for the Berliner Museen in 1905. Held by the Skulpturensammlung, on long-term loan to the Museum für Islamische Kunst.
Condition: The pyxis is in good condition with losses on lid.
Stiftung Preußischer Kulturbesitz, Staatliche Museen zu Berlin—Skulpturensammlung und Museum für Byzantinische Kunst, Berlin (2977)

These three circular ivory boxes are closely related by their common bellied shape and, in part, their carved decoration. They are distinguished from the large number of familiar Late Antique cylindrical pyxides by their curved outline.[1] In addition, the boxes in Berlin (A) and London (B) are notable because they were carved from a single piece of ivory,[2] while the bottoms of the cylindrical containers were always worked separately.

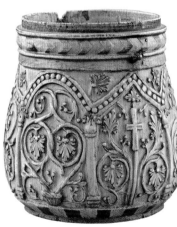

A

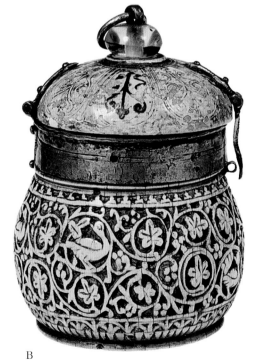

B

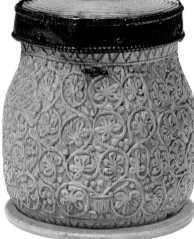

C

The body of pyxis A is articulated by a row of six columns joined alternately by arches and gables, which are decorated with a continous bead molding. Symmetrically spreading vine scrolls constitute the predominant ornament in the six intercolumniations. In the arched spaces the vines spring from fluted vases, whereas in each of the gabled spaces they flank a small cross mounted on a staff, defining the pyxis as an object made for a Christian.

Apart from framing ornamental bands, vines are the sole motif on pyxis B, where they uniformly cover the whole surface. The vine scrolls originate from a vase, unfolding in two rows. Each whirl encloses one vine leaf, which in three places is supplanted by a bird. A few grapes and short tendrils fill the interstices. An almost identical ivory container, but with no birds, was once in the collection of the marquis Hubert de Ganay in Paris,[3] pointing to production of these boxes on a possibly larger scale. Pyxis C is decorated following the same scheme, with vines growing from four vases. Because of its larger dimensions, the vines unfold in five to six rows.

Similar vine scrolls, vases, beaded arches, and gables are common motifs on Late Antique and Early Islamic carvings in bone and occasionally in ivory (see cat. no. 121A–G).[4] Many bone carvings now in museums have been acquired in Egypt, and indeed an extensive bone-carving industry existed in Alexandria.[5] This has led to the assumption that the pyxides also were produced in Egypt.[6] However, scraps left over from carving objects of bone have also been found in other places around the Mediterranean.[7] The lack of Christian symbols on pyxides B and C made them suitable for Muslim customers who were looking for prestigious objects. As luxury products for a wealthy clientele, the ivory pyxides may as well have been produced in Syria, perhaps even in Damascus, the center of Umayyad power.[8] G M

1 Volbach 1976, pp. 69–76, 103–21, nos. 89–106, 161–201a, pls. 49–56, 82–98.
2 E. Kühnel 1971, p. 25, no. 2; Jehle 2008, p. 141, pl. 19, fig. 8. This feature is also typical of tenth-century Umayyad pyxides from Spain: Cutler 2005.
3 E. Kühnel 1971, p. 25, no. 3, pl. II. Its present whereabouts are unknown.
4 Wulff 1909, pp. 144–54, pls. 16–19; Loverdou-Tsigarida 1983; Rawska-Rodziewicz 2007, pp. 98–102, nos. 65–75, pls. 23–25, 101–103.
5 St. Clair 2003, pp. 34–36; Rawska-Rodziewicz 2007, pp. 37–50.
6 Loverdou-Tsigarida 1983; Effenberger and Severin 1992, p. 199, no. 111; Wamser 2004, p. 269, with question mark.

7 St. Clair 2003, pp. 36–37.
8 Provenance from Syria: E. Kühnel 1971, p. 25, nos. 1, 2, with question mark.

References: (A) E. Kühnel 1971, p. 27, fig. 37; Volbach 1976, p. 146, no. 257b, pl. 114; Loverdou-Tsigarida 1983, pp. 220, 224, pl. 4a; Effenberger and Severin 1992, p. 199, no. 111; Wamser 2004, p. 269; (B) E. Kühnel 1971, p. 25, no. 2, pl. I; Volbach 1976, p. 145, no. 257, pl. 113; Loverdou-Tsigarida 1983, p. 225, pl. 4c; (C) E. Kühnel 1971, p. 25, no. 1, pl. I; Volbach 1976, p. 146, no. 257a, pl. 113; Loverdou-Tsigarida 1983, p. 225, pl. 4b; Enderlein et al. 2001, p. 19.

121A–G. Decorative Ivory Plaques
....................

A. Plaque Decorated with Vine Scroll, Birds, and a Rabbit
Egypt or Syria, 8th century
Carved ivory
15 × 7 cm (5⅞ × 2¾ in.)
Provenance: Acquired by Antonis Benakis (1873–1954) in Egypt in 1919; collection of Antonis Benakis; part of the original Benaki Museum, which was given to the Greek state in 1931 and inaugurated on April 22 of that year.
Condition: The bottom and the right side are missing.
Benaki Museum, Athens (10411)

B. Plaque Decorated with Vine Scroll and Animals
Egypt or Syria, 8th century
Carved ivory
11.5 × 7.7 × 2 cm (4½ × 3⁵⁄₁₆ × ¹³⁄₁₆ in.)
Condition: There are areas of loss at the top and bottom and on the left side.
David Collection, Copenhagen (20/1978)

C. Plaque Decorated with Vine Scroll Springing from a Vase
Egypt or Syria, 8th century
Carved bone
10.8 × 6.5 cm (4¼ × 2⁹⁄₁₆ in.)
Provenance: Collection of Antonis Benakis (1873–1954); part of the original Benaki Museum, which was given to the Greek state in 1931 and inaugurated on April 22 of that year.
Condition: The lower part is missing.
Benaki Museum, Athens (10410)

D. Plaque Decorated with Stylized Vine Scroll and a Deer
Egypt or Syria, 8th century
Carved bone
4.3 × 11.4 cm (1¹¹⁄₁₆ × 4½ in.)
Provenance: Collection of Antonis Benakis (1873–1954); part of the original Benaki Museum, which was given to the Greek state in 1931 and inaugurated on April 22 of that year.
Condition: The bottom and the left side are missing.
Benaki Museum, Athens (10450)

E. Plaque Decorated with Vine Scroll and a Bird
Egypt or Syria, 8th century
Carved ivory
10.7 × 5.3 cm (4³⁄₁₆ × 2¹⁄₁₆ in.)

Provenance: Acquired by Antonis Benakis (1873–1954) in Egypt in 1921; collection of Antonis Benakis; part of the original Benaki Museum, which was given to the Greek state in 1931 and inaugurated on April 22 of that year.
Condition: Areas of the surface are missing on the left side of the plaque; areas of loss on the leaves have been reattached at the top.
Benaki Museum, Athens (10413)

F. Plaque Decorated with Leaves
Egypt or Syria, 8th century
Carved bone
16 × 4.3 cm (6⁵⁄₁₆ × 1¹¹⁄₁₆ in.)
Provenance: Collection of Antonis Benakis (1873–1954); part of the original Benaki Museum, which was given to the Greek state in 1931 and inaugurated on April 22 of that year.
Condition: There is an area of loss in the top right corner.
Benaki Museum, Athens (10422)

G. Plaque Decorated with Stylized Vine Leaves
Egypt or Syria, 8th century
Carved bone
4 × 17 cm (1⁹⁄₁₆ × 6¹¹⁄₁₆ in.)
Provenance: Collection of Antonis Benakis (1873–1954); part of the original Benaki Museum, which was given to the Greek state in 1931 and inaugurated on April 22 of that year.
Condition: There is a fine crack across the middle.
Benaki Museum, Athens (10435)

There is a strong tradition of ivory and bone carving in the eastern Mediterranean, and these fragmentary plaques are a sample from the early Islamic period. The style of carving varies. The three ivory plaques, A, B, and E, are carved in high relief with deeply undercut ornament, while the rest, which are made of bone, are carved in low relief. Except for D and E, all the plaques are curved on the back. Most have holes that allowed them to be peg-mounted on furniture such as seats and chests.[1]

The dominant decorative theme is the vine scroll, intertwined to create symmetrical compositions, usually on the vertical axis, and sometimes inhabited by animals. On the ivory plaques A and B, the vine stems create circles enclosing leaves and animals. On plaque A, a rosette at the far right indicates that the ornament probably continued symmetrically on the missing part.[2] On plaque B, the vine scroll issues from a vase. The decoration of bone plaque C includes a similar vase; the five-lobed leaves and bunches of grapes stemming from it create heart-shaped designs like those on a contemporary cylindrical ivory box from the Museum für Islamische Kunst, Berlin (cat. no. 120c). The design on bone plaque D likely resembled the arrangement on plaque C, and includes a deer. Ivory plaque E displays a tree motif composed of intertwined stems flanked by a

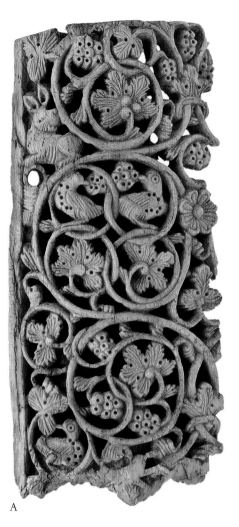

A

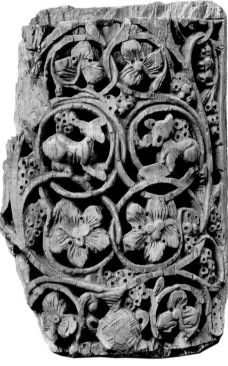

B

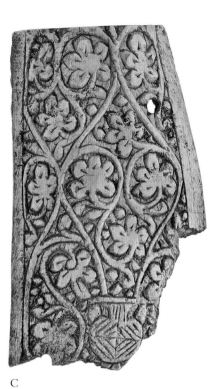

C

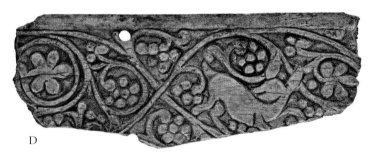

D

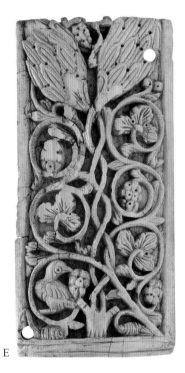

E

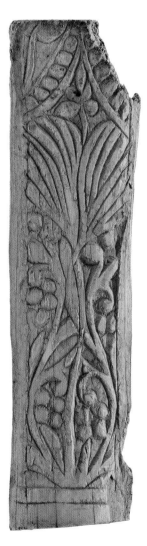

F

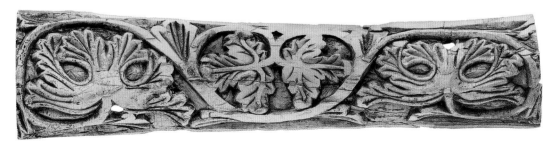

G

scrolling vine with three-lobed leaves. A bird appears in the lower left corner. Bone plaque F features a simplified version of the intertwined stem design, while the vine scroll in bone plaque G is more naturalistic.

The dating and attribution of these fragmentary plaques are subjects of debate.[3] Of the numerous examples preserved in museum collections, many, including most of this group, were acquired in Egypt.[4] Their decorative themes are characteristic of the Umayyad period, with precedents in the art of Late Antiquity. For example, on the door of the Coptic church of Saint Barbara, Cairo, datable to the sixth century, undulating vine stalks spring out of vases and create a symmetrical arrangement of circles linked by rosettes.[5] Inhabited vine scrolls punctuated by clusters of grapes, as in A and B, also appear in the carvings on the ambo of Henry II, in Aachen Cathedral, which belongs to the Late Antique tradition of Egyptian carving.[6] In an Umayyad context, the fragmentary plaques' designs relate to the vine scroll decoration on the richly ornamented facade of the palace of Mshatta, in Jordan (cat. no. 142), as well as to the motifs on the contemporary carved wood panels from al-Aqsa Mosque, in Jerusalem. Both the palace facade and the mosque panels share with the plaques similar foliate interlacing, symmetrical compositions, and some individual motifs, such as the tree.[7]

MM

1 See O'Kane 2006, p. 43, fig. 33.
2 For a sketch of what ivory plaque A might have looked like intact, see H. Stern 1954, fig. 17.

3 Creswell 1969, vol. 1, pt. 2, pp. 621–22, and H. Stern 1954, pp. 130–31.
4 Some of these plaques are published in H. Stern 1954, figs. 5–8. See also Kawatoko and Shindo 2010, p. 9, and *Staunen* 1995, pp. 44–47.
5 See Gabra and Eaton-Krauss 2006, p. 216.
6 In the Aachen plaques, the vine scroll surrounds mythological figures. For different date attributions, see K. Mathews 1999, p. 176, and H. Stern 1963.
7 Hillenbrand 1999b, figs. 46, 52, 53.

References: (A) H. Stern 1954, pp. 130–31, fig. 17; Creswell 1969, vol. 1, pt. 2, p. 621, fig. 683; Viguera Molins 2001, vol. 2, p. 76; Ballian 2006, p. 58, fig. 37; (B) von Folsach et al. 1996, p. 67, cat. no. 34; von Folsach 2001, p. 254, no. 405; Blair and Bloom 2006, p. 194; (C) unpublished; (D) unpublished; (E) Ballian 2006, p. 36, fig. 16; (F) unpublished; (G) unpublished.

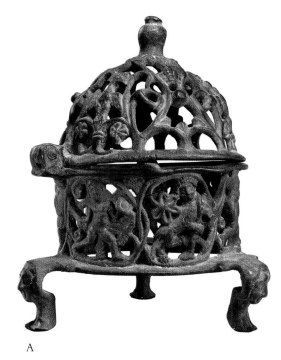

A

122A–C. Three Openwork Incense Burners

....................

A. Censer Frame with Inhabited Vine Scroll

Eastern Mediterranean, 6th century
Copper alloy, cast in parts
H. 16.8 cm (6⅝ in.); Diam. 13.7 cm (5⅜ in.)
Provenance: [J. J. Klejman, New York (1963)].
Condition: The frame is in good condition; the liner and handle are lost.
The Metropolitan Museum of Art, New York, Rogers Fund, 1963 (63.150)

B. Censer with Standing Women

Eastern Mediterranean, 8th century
Copper alloy, cast in parts, pierced, and engraved
H. 15 cm (5⅞ in.); W. with handle 31 cm (12³⁄₁₆ in.); Diam. 18 cm (7¹⁄₁₆ in.)
Provenance: Purchased from J. J. Klejman (1906–1981), New York; collection of Dr. Lillian Malcove (1902–1981),

New York, until 1981; bequeathed to the University of Toronto, 1982.
Condition: A portion of the lid is missing and there are accretions on the body.
Malcove Collection, University of Toronto Art Centre (M82.409)

C. Eagle Censer

Eastern Mediterranean, 8th–10th century
Bronze, cast in parts, pierced, and engraved
28 × 17.8 cm (11 × 7 in.)
Provenance: Acquired in Egypt in 1925.
Condition: The condition is good; the handle is lost.
Musée du Louvre, Département des Antiquités Égyptiennes, Paris (E 11708)

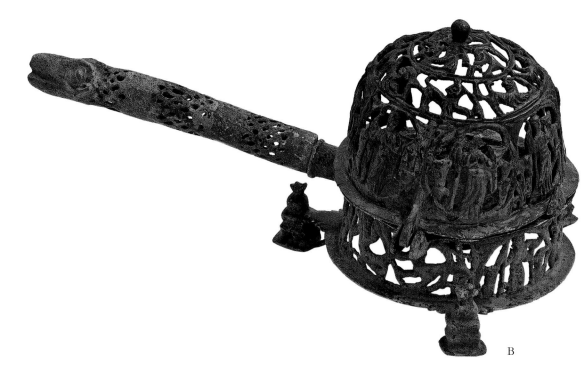

B

These three objects belong to a type of incense burner with an ornate domed lid (cat. nos. 100, 148). On all three examples the bodies and lids, which are hinged together, are covered with openwork foliate motifs. Originally, each had a long handle affixed to the body, but only the one on B survives.

The external casing is all that remains of A. On the body the openwork shows putti, some armed, among vine scrolls and rosettes; on the lid are eagles in a heraldic pose. The highly stylized animal feet are decorated with human masks. Armed putti appear in decoration of the Hellenistic period (fourth–first century B.C.E.),[1] when masks were also first added to metal and ceramic vessels at the point of attachment of feet and handles.[2] The inhabited vine scroll, a Dionysian motif that celebrates abundance, the pleasures of earthly life, and the promise of heaven, was one of the most popular subjects in Late Antique art, not only in the Late Roman and Byzantine worlds but also in Sasanian culture.[3]

Several features of A—the thickness of the metal, the rounded shape of the foliate scrolls, and the three-dimensionality of the figures—are reminiscent of the so-called Antioch Chalice, a sixth-century openwork silver lamp from Syria.[4] Despite differences

in materials and techniques, the similarities suggest the two objects were produced in the same time frame and environment.[5]

Although it has suffered some damage, all the parts of B, including the handle, are in place. The openwork decoration is arranged in three registers. The top one has plant decoration. Vine scrolls and racing quadrupeds, possibly hares, fill the middle of the lid. The taller bottom register contains female figures wearing ankle-length tunics and cloaks and holding long staffs or spears and open bowls. Below, on the body of the burner, human figures alternate with quadrupeds in the foliate scrolls, and three palmettes emerge from the sides as guides for the swiveling lid. The long tubular handle ends in a stylized ram's head. The vessel stands on three stepped feet, each topped with a pomegranate.

All the motifs are from the Late Antique repertoire. The standing women are reminiscent of goddesses or personifications, although there are no attributes to identify them as specific mythological figures. The juxtaposition of human figures and animals on the body of the burner is equally vague in narrative terms. Fertility symbols, pomegranates are often found as finials on Early Islamic burners but are uncommon as the feet of vessels.[6] By contrast, the ram's head is the most common form of zoomorphic terminal on tubular metal handles of Roman manufacture, especially paterae.[7]

On the striking incense burner C, the body and lid are decorated with foliate scrolls, and three palmettes emerge from the body, as on the incense burner in Toronto. The tubular mortise for the lost handle is still in place. The three feet take the form of hares rearing on their hind legs. The lid's flaring finial ends in a rosette that supports an eagle with a snake in its beak. Zoomorphic feet, finials, and handles are found in abundance in both Late Roman and Islamic metalwork (cat. nos. 38, 143, 171). The highly symbolic grouping of the eagle and snake— the triumph of good over evil—is seen on a seventh-century silver signum found at Voznesenka on the Dnieper and in the mosaic pavements of the Great Palace in Constantinople.[8]

Unlike the openwork motifs of the two other incense burners, those of C were formed from a flat sheet of metal and highlighted by engraved lines that follow the vine scrolls, creating a two-dimensional foliate carpet. This technique for creating metal openwork was preferred in the medieval

Islamic period, and a host of examples survive, not just incense burners but also lamps.[9]

These three incense burners illustrate how one type of domestic object, commonplace for centuries in the eastern Mediterranean, changed gradually over time. In all three examples, the craftsmen combined individual motifs and morphological elements from the Greco-Roman repertoire in a variety of ways. All the motifs seen here represent abstractions such as plenty, the triumph of good over evil, and the promise of eternal life—ideas that occur frequently in the art and inscriptions of Late Antiquity and the Islamic world. AD

1 Hausmann 1984.
2 See especially Tassinari 1993, pls. CXX–CXXXVII.
3 The mosaics in the ambulatory of the fourth-century mausoleum of Santa Costanza in Rome depict birds and putti among vines (H. Stern 1958, figs. 28, 33). Many marble sarcophagi of the period are similarly decorated (Malbon 1990, cf. pp. 95–99). For Sasanian examples, see Demange 2006, pp. 100–106.
4 It is in the Cloisters Collection of The Metropolitan Museum of Art (http://www.metmuseum.org/toah/works-of-art/50.4); see M. Mango 1986, pp. 183–87, cat. no. 40.
5 A copper-alloy incense burner from the Erich Lederer collection was displayed in 1963 at the Villa Hügel exhibition in Essen (Renner 1963, cat. no. 192). Very similar to the one in the Metropolitan Museum, it is nevertheless probably a fake. Its current whereabouts are unknown.
6 Baer 1983, figs. 67, 70.
7 Tassinari 1993, pls. XC–XCIV. The stylized rendering of the ram on this piece makes its species impossible to determine.
8 For the signum, see Dodd 1961, pp. 260–61, no. 95; for the mosaic, see Jobst et al. 1997, pp. 42–43. An overview of the iconography of eagle and snake is given in Wittkower 1939.
9 The Louvre's incense burner is most closely related to one in the Coptic Museum, Cairo, although the latter is square (see Bénazeth 2001, no. 299). For similar incense burners, see Atıl et al. 1985, cat. no. 2; Bénazeth 2001, p. 359 (with further examples). For lamps, see Drandaki forthcoming, chap. 13.

References: (A) Weitzmann 1979a, cat. no. 323 (K. Reynolds Brown); (B) Campbell 1985, p. 86, no. 112; (C) Bénazeth 1992, pp. 106–7 (with earlier bibl.)

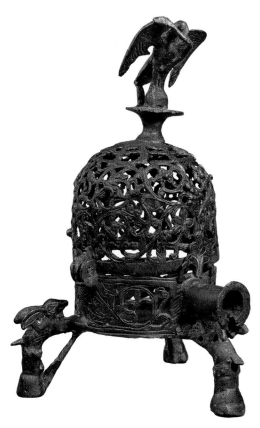

C

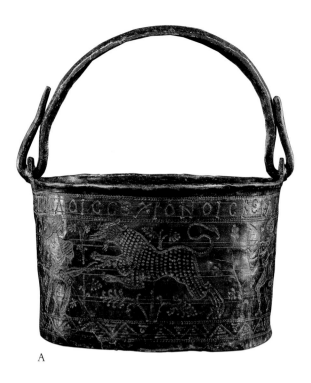

A

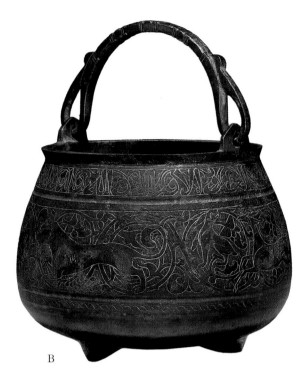

B

123A, B. Two Buckets with Animal Motifs

.

A. Bucket with a Hunting Scene

Eastern Mediterranean, 6th century
Brass, hammered, lathe-turned, chased, and ring-punched.
Handle cast separately and hammered into shape
H. 10.7 cm (4³⁄₁₆ in.); Diam. 17.8 cm (7 in.)
Inscribed: In Greek, below the rim, ΥΠΕΝΩΝ ΧΡΩ ΚΥΡΙ(Ε)
ΕΝ ΠΟΛΛΟΙϹ ϹΕ ΧΡΟΝΟΙϹ ΚΕ ΚΑΛΟΙϹ ΕΥΤΥΧΩϹ (Use this in good health, master, for many good years happily)
Provenance: Gift of Frank Steruberg (in 1993).
Condition: The bucket, which has a green, and in some places brown, patina, is in very good condition. Cracks and partial breaks around the base, at the point where it meets the vertical walls, were restored before acquisition by the Benaki Museum.
Benaki Museum, Athens (32553)

B. Bucket with Running Animals

Eastern Mediterranean, 11th–12th century
Brass, cast and engraved. Handle cast separately and hammered into shape
H. 15 cm (5⅞ in.); Diam. 21.6 cm (8½ in.)
Inscribed: In Arabic cursive script, below the rim,
العز والإقبال والدولة والسلامة والسعادة والنعمة والكرامة
(Glory and prosperity and auspiciousness and health and felicity and victory and divine grace and magnificence)
Provenance: Collection of E. Hindamian; entered the British Museum as a donation of P. T. Brooke Sewell, Esq. (1878–1958) in 1953.
Condition: The bucket, which has a brown patina, is in very good condition.
The British Museum, London (1953,0217.1)

The bucket in the Benaki Museum, A, belongs to a group of ten vessels that have the same metallurgical composition, shape, decoration, and type of inscription.[1] Each is hammered from a single sheet of brass, is cylindrical or cylindrical with slightly tapering walls, and has a swiveling handle. The main technique used for their decoration and inscriptions was ring punching, which imparts extra liveliness and a sense of motion to the figures. One bucket in the group was used in an ecclesiastical context for holy water. The others belonged to household sets of bathing equipment. They are decorated with friezes of running animals or hunting scenes—as is the present example—and one illustrates events in the life of Achilles. Four buckets have inscriptions wishing good health, happiness, and long life to their owners, and in a private collection in Germany there is a matching jug with a similar inscription.[2] Technical and stylistic details and the lettering of the inscriptions point to a date in the sixth century for this group of vessels, which were found widely distributed, from Palestine to East Anglia and Spain. Because the inscriptions are in Greek, a center of production in the eastern Mediterranean region is very probable.

The bucket in the British Museum, B, is made of cast brass. It, too, has a swiveling handle. The globular bowl, decorated with the popular theme of animals running in front of an elaborate foliate scroll, is set on three triangular feet.[3] This type of bucket, known since Greco-Roman times, became an important item in the Islamic metal-working repertoire, but most examples are set on a low, concave ring foot.[4] The subject matter and the content of the benedictory inscription suggest a direct link with the Late Antique group of hammered buckets discussed above. The details of the decoration fit comfortably into the artistic milieu of the eastern Mediterranean during the eleventh and twelfth centuries.[5]

AD

1 M. Mango et al. 1989; Drandaki 2002; J. Arce 2005.
2 The owners of the buckets included a count, a Lady Theodora, and a family with children. The inscription on the matching jug mentions a count with children; see Scholl 1994.
3 Such friezes are very common in the art of the eleventh and twelfth centuries, appearing in diverse media and contexts. See Baer 1983, pp. 180–87; Ballian and Drandaki 2003, pp. 58–59, figs. 1, 3, 10–12, 16, 20, 21 (for examples in Islamic, Byzantine, and Crusader contexts).
4 The famous "Bobrinski bucket," made in Herat in December 1163 and now in the State Hermitage Museum, Saint Petersburg, is of that type; see R. Ward 1993, pp. 74–75. The three triangular feet on the present bucket follow a tradition known from Late Roman copper-alloy bowls, which are attributed for the most part to Egyptian workshops of the third to the sixth century; see Hayes 1984, pp. 111, 121, nos. 174, 175, 191; Daim and Drauschke 2010, pp. 272–73, cat. no. 304 (Anastasia Drandaki), with further examples.
5 The British Museum bucket has been attributed to Khurasan, chiefly because of its similarities with a bronze ewer discovered in Nishapur and now in The Metropolitan Museum of Art (38.40.240), which also has benedictory inscriptions and an animal frieze; see R. Ward 1993, pp. 58–59. The bucket has even stronger links with the metalworking traditions of Late Antiquity, however, and despite the obvious similarities between the bucket and the ewer, there are also several differences in the style of the scrolls and the technical execution of the decoration.

References: (A) Drandaki 2002; Daim and Drauschke 2010, p. 275, cat. no. 310 (with earlier bibl.); (B) R. Ward 1993, pp. 58–59.

Inscribed Textiles

Cäcilia Fluck

In antiquity, decorating textiles with inscriptions was a common practice, particularly in Egypt.[1] Pharaonic textiles often carried a small mark in the border to identify the weaver or owner. More elaborately woven inscriptions appeared on royal textiles, mentioning the name of a pharaoh and praising his brilliant deeds. Textiles were also used in the same way as papyri, namely, to convey messages of all kinds, written with black ink on the cloth.[2] Many inscribed mummy wrappings with magic spells in demotic script have survived in Egypt from the Greco-Roman period, whereas there is only scarce evidence of writing on textiles in the Late Antique and Early Christian era, mostly in the form of explanatory comments or single words in connection with figural representations, in Greek or Coptic. Under the first Muslim rulers the practice of embellishing textiles with inscriptions became widespread. "Lettered" garments became fashionable and were worn by virtually everyone, from the caliphs on down the social scale.[3] At this time the content and meaning of inscriptions on textiles changed significantly. From serving a merely descriptive function on textiles in Late Antiquity, subordinated to an image,[4] they became important transmitters of messages. They were carried out in various techniques, including tapestry weaving, embroidery, brocading, painting, or printing.

Under the Umayyad dynasty (661–750), royal textile workshops (sing. *tiraz*, pl. *turuz*) were introduced and spread throughout the entire Islamic world. At first, the workshops primarily served the caliph and his court. Later, but still under the Umayyads, another type of *tiraz* was established that worked for a wider clientele. The term *tiraz* is said to be of Persian origin and originally meant "made with the needle." It also refers to the Arabic inscriptions on textiles, regardless of how the textiles were made. For us, these *turuz* are historical documents, because they often mention the name of a ruler, the producer, and sometimes a date. But for the people of the time, they were items of royal power and social prestige.[5] Official Arabic *turuz* also had a political function. In a system of "robes of honor" (*khil'a*), they served as official gifts of the respective ruler.[6]

The *tiraz* style, that is, putting lettering on textiles, was popular in the Early Islamic period and over time was not restricted to Muslims. Inscriptions in Greek and Coptic can be found, occasionally combined on the same fabric with those in Kufic script. They are less numerous,[7] but they had the same intent: to convey a message, on the one hand, and to signify a privileged social status, on the other. In a world with a high rate of illiteracy, wearing a garment with a row of letters on it elevated the wearer to the status of an intellectual or at least of an educated person. Whether these inscriptions were actually legible was of secondary importance. This might explain the large number of misspelled inscriptions found on textiles.

Inscriptions could contain invocations either to Allah or to God and Jesus Christ, wishes of blessing, short prayers, or even cryptograms and onomatopoeic syllables of magical character. Arabic texts often quoted from the Qur'an,[8] and Christian ones from the Bible, especially from the Psalms (cat. no. 124A).[9] In the age of transition, text became an important decorative element on textiles for the whole society, independent of the religious belief of the individual.

124A, B. Textiles with Coptic Inscriptions
....................

A. Fragment of a Shawl
Egypt, the Fayyum (probably Tutun), 9th–10th century
Plain weave in polychrome wool with embroidered inscription in dark blue wool and a row of floral designs in dark blue and purplish wool; fringe along one edge[1]
41 × 71.5 cm (16⅛ × 28⅛ in.)
Inscribed: In a Fayyumi-Sahidic dialect of Coptic, + Π̅6̅С̅ I̅С̅ Х̅С̅ ВШIФI ПАПА ΘШТΕР 2АМНN6 ⁝ 6С6 ШШП6 П6С П6INА NIМАI 6ΥТРАТАШШТ АN 6NΛΛОΥ6Ч (Oh Lord, Jesus Christ! Help Father Toter. Amen! So be it! Oh Lord! This mercy on me, I shall not want. Amen [?])
Provenance: Collection of Antonis Benakis (1873–1954); part of the original Benaki Museum, which was given to the Greek state in 1931 and inaugurated on April 22 of that year.
Condition: One end of the fringed shawl has survived. Selvages are preserved, determining the original width of the weaving. One edge is uneven, and there are holes in the brown stripe and in the ground weave. The textile was restored in 2002 by V. Nikolopoulou and A. Ozoline. Benaki Museum, Athens (15343)

The end of this shawl is decorated with a wide brown stripe below its fringed edge. An inscription is embroidered into the ground weave, below which is a row of crosses between two lines.

The inscription, written in a Fayyumi-Sahidic dialect of the Coptic language, is full of mistakes but legible. It contains a petition of a priest (Coptic title "Father") called Toter and includes a phrase from Psalm 22:1 (23:1).[2]

Similar woolen shawls or cloths, often dyed blue but with similar decoration, are assigned to a specific *tiraz* workshop in Tutun, a provincial town in the Fayyum, about seventy-eight miles (130 kilometers) southwest of Cairo.[3] They all bear inscriptions in either Greek, Coptic, or Arabic, and sometimes in two languages. The content of the inscription on the Benaki shawl and the row of crosses identify its owner as a Christian.[4] Christians, like Muslims, used inscriptions not only as decorative elements or symbols of status but also as a way to express their personal beliefs. The Austrian National Library, Vienna, owns a closely related fabric, again with a quotation from a psalm.[5]

Most scholars date these inscribed *tiraz*-style fabrics from the ninth to the eleventh century.[6] This was recently disputed, because a radiocarbon analysis of a large woolen cloth—probably a hanging—in the Katoen Natie Collection, Antwerp, suggested a later date, between 1029 and 1219. The textile is probably from Tutun and adorned with a pseudo-Kufic and a Coptic inscription quoting a psalm.[7] Some woolen *tiraz* with exclusively Arabic inscriptions include dates between the late ninth and early tenth century.[8] However, a single radiocarbon-dated sample is not sufficient to prove a later date for textiles with Christian inscriptions in general. More analyses are needed to ascertain reliable dates.[9]

B. Three Fragments with a Coptic Inscription
Egypt, 810–1010 (radiocarbon date, 95% probability)[10]
Tapestry weave in polychrome and undyed wool on plain-weave ground of undyed wool; a row of stitches in undyed wool below the top edge (looking at the inscription)
a. 31.5 × 63 cm (12⁷⁄₁₆ × 24¹³⁄₁₆ in.)
b. 17.2 × 28 cm (6¹³⁄₁₆ × 11¹⁄₁₆ in.)
c. 31.6 × 52.7 cm (12⁷⁄₁₆ × 20¾ in.)

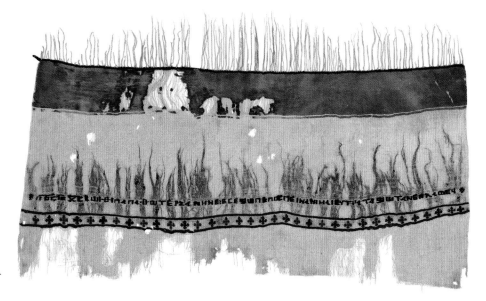

A

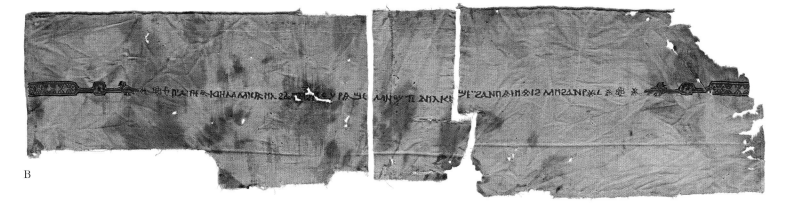

B

Inscribed: In Coptic, one line on each piece, only single words are legible; piece a: + ΠΑΙ ΠΕ ΑΚΙΗΜ ΜΙCΑΗΛ ϨΑΤϤ ϨΝ ΟΥΡΑϢΕ (This is . . . Misael [name?] use it in happiness); piece b: ΜΝ ΟΥΤΕΛΗΛ ΚΕ; piece c: ϢΕ ·· ϨΑΝ ΠΑΙ ΠΑΙ ϨΜϨϨΑΝΡ + (and rejoice . . . this [word written twice] in . . .)
Provenance: [Emil Brugsch Bey, Cairo (until 1890)]; George F. Baker, New York (1890).
Condition: Three fragments of a larger piece of cloth have survived. Fragments a (left) and c (right) display a finishing border of twined threads along the top edge as well as reinforced selvages on both sides. The lower edges of all three fragments are uneven, and the vertical edges are cut. They are stained and discolored.
The Metropolitan Museum of Art, New York, Gift of George F. Baker, 1890 (90.5.877)

These three fragments belong to the upper or lower end of a large rectangular cloth. The frayed edges of fragments b and c fit together, and, given the condition of the three fragments (staining, fold line, degradation, and the word order of the inscription), it appears that fragment a was originally directly to the left of fragment b.

Each piece is decorated with an inscription, preceded (a) or terminated (c) by an ornamental band with a row of yellow and blue lozenges on a red background. The band narrows and widens to connect a circle and a little bird. The inscription begins and ends with small crosses and a rosette. It is a mock inscription, and only a few words are legible. However, the words "use it in happiness" and "and rejoice" indicate a prayer of joy or a quotation from the Bible. The words "happiness and rejoice" appear in exactly the same sequence on a fragment with similar tapestry bands in the Suermondt-Ludwig-Museum in Aachen, Germany, which most probably belongs to the same cloth.[11] It is an expression used also in ninth-century book colophons from the Fayyum.[12]

Other woolen textiles with a dense weaving structure like the one seen here, similar motifs, and a one-line inscription constitute a special group to which these fragments can be added.[13] They seem to have been made in one and the same workshop. Without reliable information about the findspot of such fabrics, however, it is not possible to localize their place of production. CF

1 This and further information about the textile is owed to Roberta Cortopassi, whom I would like to thank.
2 Van der Vliet 2006, p. 50, no. 3.
3 M. Durand and Rettig 2002; M. Durand and Saragoza 2002, pp. 198–99, cat. no. 165, and p. 200, cat. no. 167. See also De Moor et al. 2006b, pp. 224–25 (with

further references), fig. 28, and van der Vliet 2006, pp. 33–35, 52–57, figs. 5–8.
4 For Christian texts and the *tiraz* style, see van der Vliet 2006, esp. pp. 30–35.
5 Froschauer 2006, pp. 141–42, no. 6, fig. 28; two further related pieces bear illegible inscriptions, maybe cryptograms: ibid., pp. 142–45, no. 7, fig. 16; pp. 145–46, no. 8, fig. 29.
6 See M. Durand and Rettig 2002; De Moor et al. 2006b, p. 225, with references in note 9.
7 De Moor et al. 2006b, p. 226. See also the critical remark in van der Vliet 2006, p. 34, n. 48.
8 Lamm 1936, p. 76; and Lamm 1938, pp. 115–16, no. 18, pl. 6.
9 A Coptic inscription in the Fayyumic dialect is written on a tunic kept in the Musée du Louvre, Paris. It has been radiocarbon dated between 770 and 980. The inscription mentions the owner, Apa Kolthi, and contains a prayer with citations of Psalm 26(27):9 . For the date, see Froschauer 2006, p. 140; and Chaserant et al. 2009, p. 162 (under cat. no. 143).
10 Nobuko Shibayama, Associate Research Scientist, and Tony Frantz, Research Scientist, Department of Scientific Research, The Metropolitan Museum of Art, assisted in the radiocarbon age determinations. The tests were performed by Beta Analytic, Inc., in 2011.
11 Inv. no. T331/SB 0331; mentioned by Paetz gen. Schieck 2002, p. 102, n. 878. I am grateful to Annette Schieck, who showed me photos of the fragments.
12 Van der Vliet 2006, pp. 38–39; for further textiles, see Froschauer 2006, pp. 141–42, no. 6 (only the word "rejoice"); Fluck et al. 2000, p. 234, no. 166.
13 For related pieces, see Stauffer 1991, p. 184, cat. no. 86; Fluck 1996, p. 167 (inv. 6829a), pl. XII, fig. 8; Fluck 1997, pp. 59, 61, 63–64, 67, 69; similar bands in tapestry weaving: E. Kühnel and Bellinger 1952, p. 83, pl. XLIII (above).

References: (A) Phōtopoulos and Delēvorrias 1997, pp. 200–202, no. 336; Bosson and Aufrère 1999, pp. 254, 268; M. Durand and Saragoza 2002, p. 199, cat. no. 166; Boud'hors and Calament 2004, p. 468, no. 32; van der Vliet 2006, pp. 41 (with n. 88), 42–43, and 50, no. 3; (B) unpublished.

125A, B. Two Fragments of Fayyum Shawls

....................

Egypt, 9th–10th century

A. Fragment of a Fringed Shawl

Tapestry weave in polychrome wool and linen; fringe along one edge
74 × 91.5 cm (29⅛ × 36 in.)

Inscribed: In Arabic,

...(?)"... نعمه وسعاده وسلامه ...

(?) (. . . Blessing and happiness and safety . . .)[1]
Provenance: Collection of Antonis Benakis (1873–1954);
part of the original Benaki Museum, which was given to
the Greek state in 1931 and inaugurated on April 22 of
that year.
Condition: The fragment, which has been conserved, has
missing parts, with worn-out threads and tears.
Benaki Museum, Athens (15608)

B. Fragment of a Shawl

Tapestry weave in polychrome wool and undyed linen
on plain weave ground in dark blue wool
22.2 × 59.7 cm (8¾ × 23½ in.)
Provenance: George D. Pratt, New York (until 1931).
Condition: The fragment is in fragile condition. While the
colors are well preserved, there are holes and major losses
throughout the fragment. Selvages are preserved on the right
and left edges, giving information on the original width
of the cloth. The original height cannot be determined.
The Metropolitan Museum, New York, Gift of
George D. Pratt, 1931 (31.19.14)

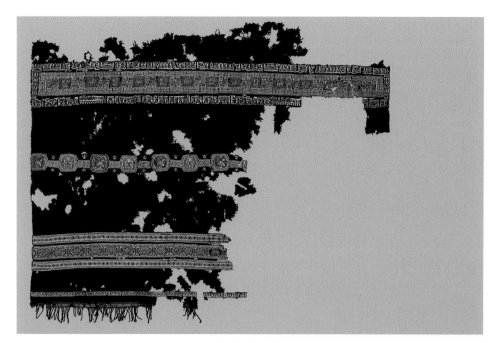

A

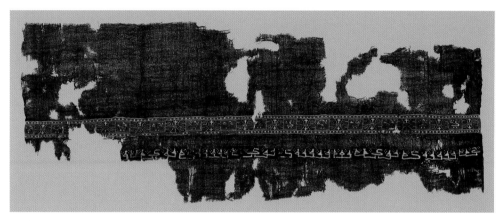

B

These large blue-black fragments of shawls made of loosely woven wool are attributed to the Fayyum, an important Coptic weaving center in Upper Egypt. In the Early Islamic period, even though textile production did not alter dramatically, either technically or stylistically, it was gradually adapted to the needs and tastes of the new ruling Muslim elite (see Fluck, p. 160, and Colburn, p. 161).

Characteristic features of the Fayyum shawls are the horizontal tapestry bands of varying sizes, woven of polychrome wool and linen and decorated with inscriptions and highly stylized figures.[2] The lower band of fragment A consists of a typical Fayyumi pseudo-Kufic inscription with vertical shafts terminating in triangles. The top band is surrounded by a more highly ornamented Kufic inscription with repeating benedictions running above and below in mirror writing. The remaining decoration consists of double volutes and rows of pearled hexagons enclosing quadrupeds, human figures, and birds with Sasanian ribbons floating from their necks in a style reminiscent of luxury silks. The overall stylization, and especially that of the human figure, is characteristic of textiles from Upper Egypt.

Fragment B has two bands, one of which has what is probably a pseudo-Kufic inscription with the characteristic triangular terminals on the shafts and decorative dots between letters.[3] The other has cartouches containing birds of various sorts set among stylized foliate decoration.

There is evidence from early Muslim writers that the area of the Fayyum specialized in the weaving of woolen fabrics and was known for its private *tiraz* workshops (cat. no. 124).[4] The evidence of the literary sources is confirmed by several extant inscribed pieces, some of them with bilingual inscriptions in Arabic and Coptic. A recently deciphered example specifies that the town of Tutun (Tebtynis) housed an important private *tiraz* workshop, to which two other shawls inscribed in Arabic also refer. Another two, one inscribed in Coptic (cat. no. 124A) and the other with a bilingual inscription, have been associated with a wooden funerary panel from Tutun dated 925.[5] Fayyum shawls are generally dated to the second half of the ninth and the tenth centuries, though they seem to have continued to be produced later on, as radiocarbon dating of an inscribed shawl in the Katoen Natie Collection, Antwerp, points to somewhere between the eleventh and the thirteenth centuries.[6]

The *tiraz* workshops of the Fayyum are thought to have been first established and developed in the time of Ahmad Ibn Tulun (r. 868–84) as part of his attempt to legitimize his power independently from the Abbasid caliph in Baghdad. This may be why the Arabic inscriptions we know of do not mention the caliph's name, something that is often found, along with other information, on products of the *tiraz* workshops of the delta. AB

1 Read by Mohammad Panahi.
2 Cornu 1992, pp. 486–99; for A, see esp. BAV 6856, BAV 6863, BAV 6857, BAV 68; Cornu 1993, pp. 138–55.
3 Cf. Cornu 1992, p. 115, BAV 6861.
4 E. Kühnel and Bellinger 1952, pp. 84–85, 122.
5 M. Durand and Rettig 2002.
6 De Moor et al. 2006b, pp. 224–25. For textiles inscribed in Coptic, see van der Vliet 2006, pp. 30–35.

References: (A) Seipel 1998, pp. 208–9, cat. no. 221; *Trésors fatimides* 1998, pp. 206–7, cat. no. 191; Eugenidou and Albani 2002, p. 289, cat. no. 154; Cormack and Vasilakē 2008, p. 419, cat. no. 161; (B) Dimand 1931, pp. 89–90; Thompson 1965, p. 145, n. 3; Walker and Froom 1992, pp. 17–18, cat. no. 6.

Inscribed Objects

Robert Schick

In the Byzantine and Early Islamic periods, alongside monumental, public inscriptions on buildings, mosaic floors, tombstones, and the like, inscriptions in Greek, Arabic, or other languages graced a range of portable objects.

A number of such inscriptions can be seen on portable objects, including lamps (cat. no. 126), a water jug (cat. no. 129), and a chalice (cat. no. 128), but inscriptions were also occasionally placed on other types of pottery (cat. no. 175) or metal vessels (cat. no. 169) as well as on other objects. Some items, such as the lamps and water jug, were intended for utilitarian, private use, and so the inscriptions they bear are of primary interest to their owners, while other objects, such as the chalice of precious metal, had a public use, and so their inscriptions address a wider audience. Coins, as a product of the state, have texts and iconography that convey obvious public, political meaning (see Foss, p. 136).

Given the small size of portable objects, especially pottery lamps, the inscriptions are often no more than a few words long. The texts are of two general types: those that date the object and identify the maker or recipient; and those that include religious expressions or prayers for blessings, happiness, or prosperity for the users.

Those two types of content can be seen in "Jerash" lamps, which were the type of lamp produced in Jordan on which inscriptions were most often placed in the Byzantine and Early Islamic periods. "Jerash" lamps, on which at least eight different potters are named, bear such Arabic Islamic inscriptions as "Jarwal made it in Jerash in the year 133 [750–51],"[1] "Made by Habrun son of Yusuf in Jerash in the year 135 [753–54]—Blessing from God for whoever has light from this lamp,"[2] "Abu Hassun made it. God bless the maker,"[3] and "Blessings from God for whoever had light and listened."[4] The Arabic Islamic inscription on the water jug (cat. no. 129) combines both types of content.

In addition to a lamp that has both Christian and Islamic inscriptions (cat. no. 126C), another "Jerash" lamp reads in Arabic on the top: "In the name of God, this lamp was made by Bishr, son of Samid in

Jerash in the year 211 [826–27]," while on the bottom are Greek letters that with the exception of "God" (Theos) have no meaning.[5] It is remarkable that the potters thought that there was a market for such lamps, of which multiple copies were made, with different religious inscriptions on the molds for the top and bottom halves.

126A–G. Oil Lamps from Gerasa (Jerash)

....................

A. Oil Lamp
6th century
Red ware
4.7 × 5.5 × 9.5 cm (1⅞ × 2³⁄₁₆ × 3¾ in.)
Provenance: Excavated by the Yale–British School of Archaeological Expedition, 1928–29. After its excavation, as part of the *partage* agreement, the lamp was shipped to New Haven to become part of the Art Gallery's collection.
Condition: The lamp is intact.
Yale University Art Gallery, New Haven, The Yale Excavations at Gerasa (1929.656)

B. Oil Lamp
8th century
Gray ware
5.8 × 5.6 × 9.4 cm (2⁵⁄₁₆ × 2³⁄₁₆ × 3¹¹⁄₁₆ in.)
Provenance: Excavated by the Yale–British School of Archaeological Expedition, 1928–29. After its excavation, as part of the *partage* agreement, the lamp was shipped to New Haven to become part of the Art Gallery's collection.
Condition: The lamp is intact.
Yale University Art Gallery, New Haven, The Yale Excavations at Gerasa (1929.653)

C. Oil Lamp with Greek and Arabic Inscriptions
8th century
Red ware
4.9 × 6.1 × 9.4 cm (1¹⁵⁄₁₆ × 2⅜ × 3¹¹⁄₁₆ in.)
Inscribed: In Greek, on the right shoulder, ΦΟC ΧC ΑΝΑCΤΑCΙC (The light of Christ [is] the Resurrection); in Greek, on the left shoulder, ΧC (Christ) and ΦΟC (Light); in Arabic, in reverse on the bottom, بسم الله الرحمن الر[حيم] (In the name of God, the Merciful, the Com[passionate])
Provenance: Excavated by the Yale–British School Archaeological Expedition, 1928–29. After its excavation, as part of the *partage* agreement, the lamp was shipped to New Haven to become part of the Art Gallery's collection.
Condition: The lamp is intact, except for the broken handle.
Yale University Art Gallery, New Haven, The Yale Excavations at Gerasa (1929.674)

D. Oil Lamp
8th century
Light red ware
11.2 × 6.8 × 3.5 cm (4⅜ × 2⅝ × 1⅜ in.)

Provenance: The lamp was found in 1968 during excavations in Jerash by the Department of Antiquities of Jordan.
Condition: The lamp is intact, except for a chip at the handle.
Jordan Archaeological Museum, Amman (J. 12244)

E. Oil Lamp
8th century
Buff-red ware
8.8 × 6 × 2.6 cm (3½ × 2⅜ × 1¹⁄₁₆ in.)
Inscribed: In Arabic, بركه من [ا]لله لعامر بن خرج (Blessings from God for 'Amir son of Kharaj)
Provenance: Excavated from the North Theater, Jerash, Jordan, as part of the Jerash Archaeological Project (1981–83).
Condition: The lamp is intact, except for a chip at the handle.
Jerash Archaeological Museum, Jordan (683)

F. Oil Lamp with Arabic Inscription
8th century
Buff-red ware
11 × 6.7 × 3.5 cm (4⅜ × 2⅝ × 1⅜ in.)
Inscribed: In Arabic, صنعه نذور بن صطفن بجر[ش] (Made it Nudhur, son of Stafan in Jera[sh])
Provenance: Excavated near Irbid, Jordan, in the 1980s.
Condition: The lamp is intact, except for a chip around the nozzle.
Irbid Archaeological Museum, Jordan (IR-1977)

G. Oil Lamp with Arabic Inscription
8th century
Pink ware
Approx. 11 × 6.7 × 3.5 cm (4⅜ × 2⅝ × 1⅜ in.)
Inscribed: In Arabic, [صنعه] بن حديج بجرش للجاموس ([Made it] son of Hudayj in Jerash for al-Jamus)
Provenance: Excavated near Irbid, Jordan, in the 1980s.
Condition: The right end and handle of the lamp have been reconstructed.
Irbid Archaeological Museum, Jordan (IR-2182)

Most of these lamps were excavated at Gerasa (Jerash), the major city in northern Jordan during the Hellenistic and Early Islamic periods. They are typical examples of a common type of lamp manufactured at Jerash from the sixth to the eighth century, dubbed "Jerash" lamps, one among the many different types of lamps produced in Jordan in the Late Byzantine and Early Islamic periods.[1] The lamps were made from two separate molds for the top and bottom halves and are characterized by a thin almond shape, with a nozzle that is not indented and a tall, freestanding handle, typically pinched at the top into a stylized animal head. The fill hole is surrounded by a rim. Beginning in the early eighth century,

A B C D

E F G 126c, bottom

the functionality of the lamps was improved through the addition of a channel extending between the fill hole and the wick hole. The base has a foot that is either round or long and pointed. The top halves, and sometimes the bottom halves, are covered with line relief decoration consisting of geometric designs, dots or circles, floral elements, and occasionally, on lamps of the Early Islamic period, short inscriptions in Greek, Arabic, or both.

The first two lamps, unpublished, are covered with geometric decorations but have no inscriptions. Lamp A, without the channel between the fill hole and the wick hole, is early, while B, with the channel, is later. Lamp C is exceptionally interesting. On the top it has a crudely written Christian Greek inscription, "The light of Christ [is] the Resurrection," a Christian sentiment that is also found on other lamps. The bottom has an Islamic Arabic inscription, "In the name of God, the Merciful, the Com[passionate]," written crudely in reverse. This lamp thus was made using an explicitly Christian mold for the top and an Islamic mold for the bottom by someone who seemingly was not comfortable enough with Arabic to incise the Arabic inscription in reverse so

that it could be read properly. A second lamp made from the identical top and bottom molds is on display in the Jordan Archaeological Museum on the Amman Citadel,[2] showing that this lamp was not just a onetime product.

The upper half of lamp D is decorated with crescents, circles, and crosses, while its lower half is embellished with small circles alternating with palm trees; its base is decorated with a large ovoid, pedestaled jar that has five fish inside. A second incomplete example was found during the same excavations at Jerash in 1968.[3] Another example, seemingly from the same mold, was found during an excavation at Qasr Hallabat, in northern Jordan, in 1980,[4] and a further example, of unknown provenance, was included in the *Voie royale* exhibition of 1986–87.[5]

The fifth lamp, E, has a decoration of incised lines on the top and half volutes and lines on the bottom. The Arabic words in Kufic script that run on both shoulders include a pious Islamic phrase and the name of the recipient, ʿAmir ibn Kharaj. A second closely parallel lamp bears the same text.[6]

The other two, F and G, are typical "Jerash" lamps with an almond shape and

handle ending in a stylized animal head. Lamp F has a cross in front of the handle and a few parallel ridges as decoration. The Arabic inscription in Kufic script along both shoulders identifies the name of the potter: Nudhur, son of Stafan (Stephan, a Christian), and the place of manufacture as Jerash itself. The handle of G has been reconstructed, and parallel ridges decorate the body on either side of the handle. The inscribed Arabic words in Kufic script running on both shoulders identify the potter (Ibn Hudayj), the recipient (al-Jamus), and the place of manufacture (again, Jerash itself). R S

1 See most recently, Da Costa 2010.
2 Khairy and ʿAmr 1986, p. 150, fig. 12, p. 152, no. 15, pl. 41.14.
3 Daʿnah 1969, pl. 24.
4 Bishah 1982, pp. 134–35, pl. 37, 1–3.
5 *Voie royale* 1986, p. 272, cat. no. 360 (Alain Desreumaux).
6 Khairy and ʿAmr 1986, p. 149, no. 9, fig. 8, p. 148, pl. 39.9.

References: (A) Unpublished; (B) unpublished; (C) Day 1942, p. 76, pl. 14.1, p. 78; (D) Daʿnah 1969, pl. 22; (E) Khairy and ʿAmr 1986, p. 149, no. 10, fig. 9; *Umayyads* 2000, p. 153; (F) Khairy and ʿAmr 1986, no. 5, p. 145, fig. 4, pp. 146–47, p. 148, pl. 39.5; *Umayyads* 2000, p. 160; (G) ʿAmr 1988, pp. 163, 164, fig. 1; *Umayyads* 2000, p. 160.

127. Oil Lamp with a Cross

....................

Eastern Mediterranean, 8th century
Red ware
Approx. 11 × 6.7 × 3.5 cm (4⅜ × 2⅝ × 1⅜ in.)
Provenance: Excavated around Irbid, Jordan, in the 1980s.
Condition: The lamp is intact.
Irbid Archaeological Museum, Jordan (IR-130)

This lamp is another example from the Early Islamic period. With its conical handle, it is not a standard "Jerash" lamp. It has an almond shape, with a single rim around the fill and wick holes. It is decorated with parallel ridges along the shoulders and a large cross near the nozzle, marking it as intended for a Christian clientele.

RS

Reference: Umayyads 2000, p. 160.

128. Chalice with Inscription in the Dialect of the Fayyum

....................

Egypt, 6th–7th century (chalice), Early Islamic period (inscription)
Silver with gold and gilded silver inlay
H. 20 cm (7⅞ in.); Diam. 15.5 cm (6⅛ in.)
Inscribed: In the Fayyumic dialect of Coptic,
+ZMΠΛΕΜΠΝΟΥ ΠΠΕΙΓΕΠ ΚΥΜΗΛΙѠΝ Ν ΠΑΡΘΕΝΑС
[or NOC] ΜΠΕΛΛΗСѠ ѠΚΝΠΗΡѠСΕΝΟΥС ΙΡΗΝΗС
ΑΜΗΝ (In the name of God, it is the precious object of the Virgin [or the community of the Virgins] of Pelčisok-Aburš. In peace. Amen.)
Provenance: Collection of comtesse M. de Béhague (1870–1939); by descent to marquis Hubert de Ganay; sold Sotheby's, Monaco, September 5, 1987; given by champagne Charles Heidsieck, 1987.
Condition: The chalice is intact.
Musée du Louvre, Département des Antiquités Orientales, Paris (OA 11311)

The chalice has a deep bowl, its height greater than its width, and a tall stem with a trumpet-shaped foot and a globular knob. Although there are traces of a cross on the side, the vessel is less elaborately decorated than some other similar examples.[1] It can be dated to the sixth or seventh century, whereas the inscription that is engraved into a gilded band just below the rim is a later addition, as its inferior style of lettering suggests.

Written in the Fayyumic dialect of Coptic, the inscription indicates that the chalice was dedicated to a church of the Virgin Mary or a convent of virgins in the village of Pelčisok-Aburš in the Fayyum, the large oasis south of Cairo. This village is also mentioned in a papyrus document dated to

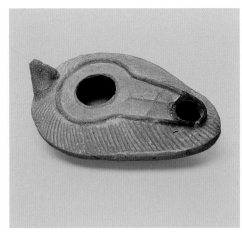

947. Pelčisok-Aburš is a double mention of the place-name in its Coptic (Pelčisok) and Arabic (Aburš) versions.

Although the inscription does not provide a date, its addition to the chalice can be dated to the Early Islamic period, when Arabic had started to be known and a Muslim presence was being felt by the Christians even in rural areas. The beginning of the inscription, "In the name of God," is a typically Islamic phrase that is not found in Coptic before the Muslim conquest of the mid-seventh century.

RS

1 Dodd 1974, pp. 14–16.

References: Dodd 1974, pp. 14, 16, fig. 6; Bianchini 1992, pp. 116–17, cat. no. 64; Bosson and Aufrère 1999, pp. 297–98, cat. no. 127; Alaoui 2000, p. 181, cat. no. 190.

129. Jug from Dayr 'Ayn 'Abata

....................

Dayr 'Ayn 'Abata, Jordan, 700–800
Cream ware with roll-on stamp decoration
Diam. rim, 6.4 cm (2½ in.), Diam. base 9.5 cm (3¾ in.)
Inscribed: In Arabic, in Kufic script, مما عمل ابو عيسى الواثق الله حس[به] [وهو] الوكيل بركة من الله (Among the things which Abu 'Isa al-Wathiq made. God is sufficient for him, [and He is] the One to be Trusted. A blessing is from God [?])
Provenance: Found in situ during the 1994 season of archaeological excavations at the site of Dayr 'Ayn 'Abata, Jordan.
Condition: The jug is complete except for a knob on the top of the handle that has broken off.
Jordan Archaeological Museum, Amman (J.16694)

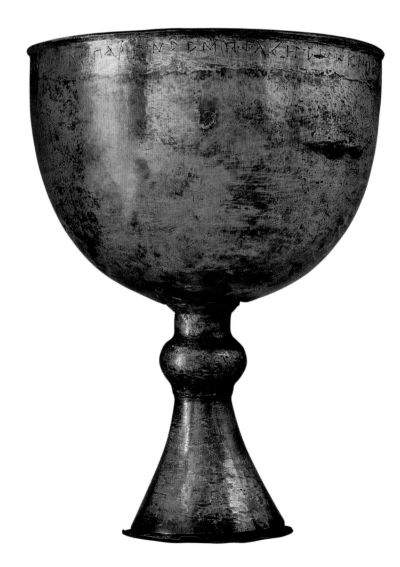

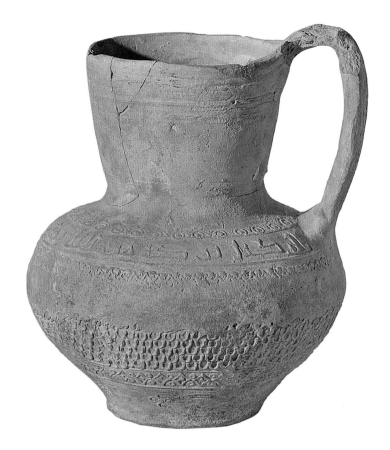

Jewelry: Ideologies and Transformation

Stephen R. Zwirn

In sixth-century Byzantium, imperial prestige and sacred charisma were expressed through highly symbolic, related languages of precious ornament.[1] Representative examples are the visual inventory of jewelry that occurs on the mosaics of Justinian and Theodora in San Vitale, Ravenna (ca. 548),[2] and the verbal inventory of the votive gifts at the shrine of Christ's tomb in Jerusalem that a pilgrim recorded about 570.[3]

As far as we know, the conquering Arabs did not bring with them a tradition of social and spiritual values expressed in these terms, so the worldly temptations available after the conquest of the rich Byzantine provinces of the eastern Mediterranean region and the Sasanian Empire raised new issues of conscience. The luxury of owning precious metal objects and jewelry was to be shunned, not sought.[4] Hadith literature records an ongoing concern within the self-consciously developing Islamic society during its first two centuries—just as the apparent disparity between having great wealth and being a committed Christian had been a concern among churchmen and the ruling elite in the highly stratified society of the late Roman world.[5]

With the establishment of the Umayyad caliphate in Damascus (661–750), a court culture flourished. Although little jewelry from this or the early Abbasid period (750–969) is known, this may be a problem of identification rather than of a dearth of extant material.[6] The smooth transition of ring types from Sasanian to Islamic makes this point clear.[7] The crescent, which would become an important symbol in Islam, had had a long history throughout western Asia; worn on a necklace it survived into this period as an *apotropaion*, an object to avert evil.[8] Other amulets no doubt existed, with spiritual, medicinal, or magical properties endowed by their stones, colors, or shapes.

The widely diffused motif of pairs of birds, usually peacocks, on earrings (cat. no. 131) offers an avenue for tracing direct Byzantine influence. Though the Islamic rendition of this motif would come to be

This water jug has a tall, wide neck; a broad, squat body; a slight ring base; and a single loop handle that extends from below the rim to the shoulder with an applied thumb stop on top of the handle. The molded design is complex, comprising lozenges, circles, guilloches, palmettes, and flowers.[1] An Arabic inscription in Kufic script that identifies the potter as Abu 'Isa al-Wathiq is stamped around the shoulder.[2] The phrasing of the inscription recalls a verse from the Qur'an (3:173), "God is sufficient for us. Most excellent is He in whom we trust."

The jug was found during excavations in the monastery of Dayr 'Ayn 'Abata, built around a natural cave that Christians during the Byzantine period identified as the cave where Lot and his two daughters had stayed after the destruction of Sodom and Gomorrah

(Gen. 19:30–38). The jug was found in a small room next to a large stone oven within the living area of the monastery, north of the church and cave. A second, closely similar jug but without any inscription was found nearby.[3] Similar jugs are generally dated to the late Umayyad or early Abbasid period (eighth to ninth century).

This jug, along with Islamic Arabic graffiti and lamps with Islamic inscriptions, attest a Muslim presence during the last phase of occupation at the site in the early Abbasid period, after the Christian use of the church and monastery had ended. RS

1 Politis forthcoming.
2 Sheila Canby, in Politis forthcoming.
3 Politis forthcoming.

References: Politis 1995, pp. 480–82; Politis forthcoming.

transformed by an increasing use of geometric forms (cat. no. 132), the aesthetic affinity with the greater naturalism of the early Byzantine tradition remains perceptible. A fine teardrop-shaped gold earring with addorsed birds in repoussé[9] stands within this same tradition, the teardrop shape itself deriving from Byzantine jewelry.[10]

"Eventually, the prohibition against wearing gold in any form, as well as the ban on wearing silk, was restricted to men,[11] women being excluded from this ban as long as they bedecked and beautified themselves only in the seclusion of their homes in order to please their husbands."[12] This concession may account for the lavish display of jewelry on women and even female nudes painted on the walls of Qusayr 'Amra.[13] The surviving audience hall and bath suite of this princely retreat is frescoed with a wide variety of figures, including dancers, servants, unidentified women standing near the enthroned prince, and seminude personifications of victory, adorned with tiaras, necklaces, belts, and breast chains.[14] While the jewelry certainly reflects Byzantine sources, it may also reveal an Indian influence.[15]

Inscribing invocations for personal protection on jewelry was a common practice in Byzantium; similarly, placing praises of God, quotations from the Qur'an, and invocations on jewelry began within Islam's first century. Faith in communication between the believer and God was extended from speech to the written word; for example, the openwork letters on a seventh-century Byzantine gold ring read, "Lord, help Maria,"[16] while a ninth-century circular tin amulet bears the Qur'anic quotation "And God will suffice you against them [the unbelievers]."[17]

Jewelry, though a small part of a culture's artistic production, reflects its attitudes toward wealth and its display and toward the communication of status and personal meaning. The making of jewelry within the nascent Islamic world seems historically as inevitable as the Arab expansion into Sasanian and Byzantine territories. Settling and ruling over the lands of these imperial societies may have encouraged—and even led to—the victors' adoption of the tastes of the vanquished.[18]

130. Necklace with Pendants

Eastern Mediterranean, ca. 7th century
Gold
55 × 4.9 × 0.9 cm (21⅝ × 1⅞ × ⅜ in.); chain 55 cm (21⅝ in.); fluted cylindrical beads 3.6 × 0.9 cm (1⅜ × ⅜ in.); medallions 4.9 x 3.8 × 0.7 cm (1⅞ × 1½ × ¼ in.); curved pendants 4.7 × 2.6 × 0.7 cm (1⅞ × 1 × ¼ in.)
Provenance: Amedeo Canessa, Paris; purchased by J. Pierpont Morgan, New York 1911; estate of J. Pierpont Morgan, 1913–17.
Condition: The chains and pendants are in good condition; the fluted beads are slightly dented.
The Metropolitan Museum of Art, New York, Gift of J. Pierpont Morgan, 1917 (17.190.1656)

This necklace demonstrates techniques, designs, and motifs current in jewelry production in the eastern Mediterranean during the Byzantine and early Islamic periods. Four gold pendants in the form of medallions and curved leaves are spaced by fluted gold cylinders at equal intervals along a gold chain. The pendants are made in openwork, a technique in which a gold sheet is pierced to create an intricate play of light and dark over the worked surface.[1]

Although openwork first appeared in the third century, its continued popularity is attested by a range of jewelry dating well into the seventh century (cat. no. 131). Vegetal patterns and geometric forms predominate in the Metropolitan Museum's pendants, their shapes emphasized by spaces cut into the gold sheet around them. Stylized vines scrolling around abstracted petals recall ornamental trends in other media, which similarly employ floral patterns as central motifs rather than as framing devices (cat. nos. 119, 120, 142).

Jewelry of this period is often difficult to date or localize, because production of certain styles continued in innumerable workshops into the early Islamic period. The difficulties of attribution are compounded by the lack of archaeological context for many objects; scholars must rely on comparative works to ascribe pieces purchased on the art market. This necklace relates in technique and design to others found in the eastern Mediterranean. For example, a gold necklace discovered in Mersin, Turkey, can be assigned to the mid-seventh century—the period of

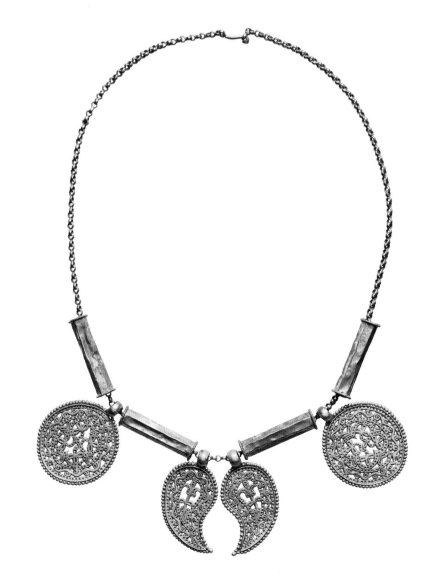

Dionysiac retine.[5] In Late Antiquity Dionysiac figures were increasingly used alone or in repetitive sequences, deprived of their religious context.[6] This lack of a specific religious symbolism characterizes the flasks with dancers and musicians and would have made them suitable for use by Christians and Muslims alike. GM

1 Coptic Museum, Cairo (journal d'entrée nos. 9082, 9083): Strzygowski 1904, pp. 273–74.
2 Musée du Louvre, Paris (E 11883): Bénazeth 1992, p. 65. Museum für Byzantinische Kunst, Berlin (4916); since 1945 only part of the rim and lid have been preserved: Wulff 1909, pp. 216–17, no. 1040. Coptic Museum, Cairo (journal d'entrée nos. 9081, 9096), with varying proportions/sizes: Strzygowski 1904, pp. 273, 276–77.
3 Kettle and vessel in the shape of a vase, both Coptic Museum, Cairo (journal d'entrée nos. 9048, 9052): Strzygowski 1904, pp. 263, no. 9048, pp. 264–65, no. 9052; kettle in Ikonenmuseum, Recklinghausen (formerly the Christian Grand collection, Zurich), and kettle, in 1967 in Munich, antiquities market: Dannheimer 1979, p. 131, no. 5, p. 132, no. 12.
4 Hillenbrand 1982, pp. 18–20; Baer 1999a, pp. 16–17; for paintings in the palace of Qusayr 'Amra (Jordan), first half of the eighth century, see Vibert-Guigue and Bishah 2007, p. 3, pls. 38, 49, 65, 102, 107a, 112, 134.
5 For vases, see Gasparri 1986, vol. 3.1, cols. 463–73; for sarcophagi, see Matz 1968–75, *passim*; for textiles, see, for example, Schrenk 2004, pp. 26–39, nos. 1–3.
6 Especially on textiles: see, for example, Du Bourguet 1964b, p. 97, no. C 33, p. 146, no. D 72, p. 150, no. D 86, p. 156, no. D 100; Trilling 1982, p. 77, cat. no. 75, p. 86, cat. no. 92.

References: Bloch 1983, p. 38, cat. no. 14; Bénazeth 1992, p. 65.

140. Fragment of a Wall Hanging with a Musician Playing the Oud

.....................

Egypt, 8th–9th century
Tapestry weave in polychrome wool and undyed linen
32 × 30.5 cm (12⅝ × 12 in.)
Provenance: Collection of Antonis Benakis (1873–1954); part of the original Benaki Museum, which was given to the Greek state in 1931 and inaugurated on April 22 of that year.
Condition: There are areas of loss on the side of the face and between the eyes, as well as a hole in the hand.
Benaki Museum, Athens (8496)

The female musician in this fragment is depicted in frontal view with big eyes, thick eyebrows, and long dark hair, probably held back by a ribbon. Her polychrome costume with short sleeves is decorated with dark blue, yellow, green, and red circular motifs with a dot in the middle.

The subject matter is drawn from the typical leisure activities of the court. The costume is depicted in some detail,[1] as are the stringed instrument—an oud—and more especially the fingers plucking the strings. The portrayal of musicians (including oud players), isolated or incorporated into a courtly cycle, was a frequent theme on objects of the Fatimid period, such as luster pottery, ivory, wood, or the painted ceiling of the Cappella Palatina in Palermo.[2] This fragment, however, is attributed to the pre-Fatimid period, that is, before the first decade of the tenth century. The facial features and hairstyle recall monumental wall paintings of the Abbasid capital, Samarra, and the early luster painting on ceramics, which influenced Egyptian art from the early ninth century onward.[3] A comparable wool and linen fragment in the Bouvier Collection depicts another musician within a medallion on a red ground.[4] Another fragment of wool and linen, decorated with a male figure who is probably going hunting, also on a red ground, resembles this one in the design of the faces, the colors, and the dimensions; the two pieces may have come from similar hangings.[5] MM

1 A piece from a decorative strip from a tunic in Israel has a design similar to that on the costume of the musician. See Baginski and Tidhar 1980, p. 112, cat. no. 158.
2 For luster pottery, see Ballian 2006, p. 29, figs. 11, 12. For ivory, see *Trésors fatimides* 1998, p. 138, and Ballian 2006, p. 73, fig. 65. For wood, see *Trésors fatimides* 1998, p. 89. For the ceiling in Palermo, see Grube and Johns 2005, pp. 128–29.
3 Atıl 1975, p. 32.
4 Cornu 1993, cat. no. 21.
5 For the second fragment, in the Egyptian Textile Museum, Cairo, see Alaoui 2000, p. 172, cat. no. 177; and Antiquities 2007, p. 161. Only technical analysis of the two fragments can confirm whether they come from similar hangings.

References: Athens 2002, p. 288, cat. no. 153; M. Durand and Saragoza 2002, p. 182, cat. no. 137; Ballian 2006, p. 81, fig. 47; Moraitou 2008a, p. 63.

mounted on a flexible handle. Their sound seems to have been very much appreciated in Egypt. While clappers and *menat* necklaces, with their rattling beads, were invented in early Pharaonic times, crotales arrived with the Roman occupation. This was the instrument the Maenads shook during the festivals in honor of Dionysos, and its metallic clang accompanied their wild movements during processions and banquets. Crotales are always shown played by female dancers, who are usually depicted with their legs crossed to evoke their twirling motion. Egypt was so imbued with classical culture that this type of image, widespread during the Byzantine era, was still popular in the Early Islamic period. It occurs especially frequently on Coptic fabrics, but metal figurines like this one are not unusual. The dancers often seem quite stiff—here, she is completely static. Both her frontality and her symmetry contradict the motion we would expect, as if the musician/dancer had suddenly frozen, stopped dead in her tracks. The figure is treated in the Coptic style, characterized by nonnaturalistic proportions, bulging eyes, and a geometric head and torso, as well as by the caricatured rendering of the face that appears on many small bronzes. The nudity, the emphasis on the sexual characteristics, and the heavy necklace and bracelets—her only adornment—recall the subject's pagan origins. However, the purpose of this object remains unknown. DB

References: Bénazeth 1992, pp. 222–23; Bénazeth 1994; Alaoui 2000, p. 226, cat. no. 285.

138. Relief with Musicians and Acrobats

....................

Eastern Mediterranean, 5th–7th century (?)
Wood
23 × 34 cm (9 1/16 × 13 3/8 in.)
Provenance: Part of the original collection of the Coptic Museum, which was inaugurated in 1910.
Condition: The relief is chipped and worn in places.
Coptic Museum, Cairo (766)

The subject is presented within a festooned frame. Two corners display decorative motifs; it is impossible to say if the upper left corner does as well, given the worn state of the relief. The fourth corner, at the lower right, contains an aedicule, represented by a pair of columns, an apse, and an archivolt; it is difficult to make out what is depicted below the apse. The panel's lively scene is peopled with five figures of different sizes, who, with their accessories, fill the entire pictorial space. The two principal figures are musicians who stand on low platforms. Their full, ankle-length robes and long hair identify them as female. One plays a trumpet with a curved mouthpiece, while the other strikes a pair of cymbals. The latter is flanked by two smaller figures on pedestals. The smaller figure on the left and its support are so damaged that only the head is clearly visible. The fifth figure, an acrobat, bends backward, balancing on a ball atop the aedicule. There is so little space that the acrobat's head and hands touch the musician's cymbals. Raouf Habib suggests that the scene represents the Dance of Salome; however, the anonymous figure's body was originally

depicted whole: the head is damaged, not decapitated. Rather, the musicians and acrobats may be performing a mime show, a secular entertainment. The tongues carved along the edges and the three holes held the panel in a frame or attached it to a piece of furniture. DB

References: Habib 1967, p. 114, no. 279, fig. 74; Alaoui 2000, p. 227, cat. no. 287.

139. Flask with Dancers

....................

Egypt, 5th–8th century
Bronze, cast
H. 17.3 cm (6 7/8 in.), max. Diam. 8 cm (3 1/8 in.), Diam. at bottom 6.3 cm (2 1/2 in.)
Provenance: Acquired by the Skulpturensammlung und Museum für Byzantinische Kunst, Berlin, in 1979.
Condition: Due to the overall corrosion of the surface, there are two small holes in one side of the wall. The lid is missing.
Stiftung Preußischer Kulturbesitz, Staatliche Museen zu Berlin—Skulpturensammlung und Museum für Byzantinische Kunst, Berlin (12/79)

This cylindrical flask on four feet has a long, narrow neck that culminates in a cone-shaped spout surrounded by a row of beads. A hinge served to fasten a now-lost lid. The body of the vessel is surrounded by four arcades in relief, each framing a female dancer with her legs crossed and her left arm, raised above her head, holding handle castanets. A piece of cloth ripples behind the lower part of her body, which is otherwise naked.

This piece belongs to a group of similarly proportioned flasks decorated with arcades. Two of them in Cairo are closely related. One shows the same type of dancer, the other, male musicians with drum, cymbal, flute, and syrinx.[1] A flask in Paris has alternating scrolls and bands of pearls, whereas others lack all decoration underneath the arcades.[2]

Female dancers of the same posture and similar in size decorated not only flasks but other vessels as well.[3] Stamps may have been used in the manufacture of the molds from which the vessels were cast, and this would have allowed for increased flexibility and speed of production. These flasks and vessels were most probably made in Egypt, as the majority of them have been found or acquired there.

The subjects of dance and music as elements of courtly life were common in Late Antique as well as in Early Islamic art.[4] In classical iconography Maenads in the guise of female dancers often were part of the

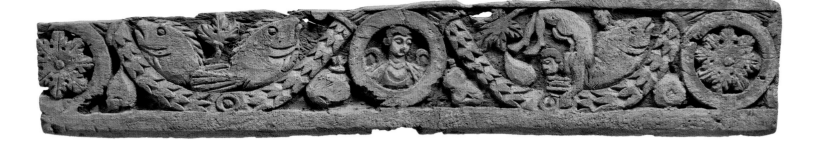

An interesting comparison is a fragment of a linen textile painted with a stylized face in black paint. It was found in Egypt—probably in Fustat—and has been identified as the face of a doll.[6] It was probably part of a textile doll, similar to some examples preserved in the Benaki Museum.[7] The painted face shares features with the figurines, such as the side curls and the curve of the hair on the forehead, the long eyebrow, and the line at the root of the nose, a sign associated with the protection of children.[8] MM

1 A small figurine in the British Museum, London, still preserves its earring. See Argyriadē 1991, fig. 35.
2 For the figure in Cairo, see Alaoui 2000, p. 210, cat. no. 266b. The figurine in Athens is a simplified version of those belonging to the group of nude statuettes with painted designs. Benaki Museum (10741), Cormack and Vasilakē 2008, p. 419, cat. no. 164.
3 Ballian 2006, p. 29, no. 12, and p. 67, no. 52.
4 Rice 1958, p. 33.
5 Hoffman 2000.
6 Cornu 1993, p. 306. I am grateful to Maria Sardi for pointing this fragment out to me.
7 Argyriadē 1991, figs. 26, 27, 29.
8 The hair on the forehead is especially apparent when compared with A. A dot on the face may even suggest markings on the cheeks. Smeaton 1937, p. 55, discusses the protection of children.

References: (A) Rice 1958, pl. 1; Alaoui 2000, p. 216, cat. no. 266a; (B) Argyriadē 1991, fig. 31; Papanikola-Bakirtzē 2002, cat. no. 675c; Ballian 2006, p. 73, no. 66; Cormack and Vasilakē 2008, p. 419, cat. no. 162; (C) unpublished.

136. Architectural Relief with "Nilotic" Motifs

.

Egypt, 6th–8th century
Wood, paint
24.1 × 130.8 × 3.8 cm (9½ × 51½ × 1½ in.)
Provenance: Collection of Hagop Kevorkian (1872–1962), New York.[1]
Condition: This relief is in good condition, preserving the lower and part of the upper frame (at right) and the frame along the right side, as well as traces of paint on the surface.
The Metropolitan Museum of Art, New York, Gift of The Hagop Kevorkian Fund, 1970 (1970.327.1)

This nearly complete architectural frieze presents an angel in a medallion amid comparatively large-scale Nilotic, vegetal, and figural motifs. On either side of the central medallion, a jeweled wreath snakes past lush fruits and leafy rosettes in medallions below; above are, at left, a pair of fish among leaves and, at right, fruit and another fish, over which another small-scale figure seems to execute an acrobatic maneuver. Such motifs evoked the legendary fertility of the Nile and in Christian settings may have been interpreted literally as the wonders of Creation, or allegorically as earthly paradise, or perhaps the souls of the just in heavenly paradise.[2]

Divergence from symmetricality and from exact repetition of motifs enhances the impression of liveliness created by the figures' postures. The head of the angel, at the center of the composition, is turned to the right and tilted down, suggesting that this frieze would have been placed at head height or higher. Self-assured, crisply economical carving articulates depth by beveling shallow planes into the deep relief. Originally, paint mitigated the angularity of the carving and depicted features in more detail by adding outlines and color. Traces of color survive throughout: on the somersaulting figure, for example, the hair was black, the body light brown, and the jewel in the wreath below brownish red. The manner of carving and the polychromy are similar to those features in a frieze from al-Muʻallaqa, the Hanging Church, in Old Cairo, recently redated to the eighth century (cat. no. 42).[3] TKT

1 From the Collection of Mr. H. Kevorkian, Pagan 1941, p. 29, cat. no. 66: "Said to be from Bawit."
2 Maguire 1987, pp. 23–29; specifically, pp. 43–44 on Nilotic imagery, pp. 60–66 on the souls of the just, and p. 32 on their literal interpretation. On human creation and adornment compared to God's Creation of the world, pp. 48–49.
3 On polychromy in architectural decoration, see Bolman 2011; on recently discovered relief carvings with well-preserved polychromy, see Bénazeth 2010,

pp. 130–31, figs. 7a, 7b (relief sculptures of the archangels Michael and Gabriel), 133 (details of 7b, Gabriel), and 134 (details of Michael); on the redating of the similar carving from al-Muʻallaqa, see MacCoull 1986.

Reference: Pagan 1941, p. 29, cat. no. 66.

137. Statuette of a Woman Playing Crotales

.

Eastern Mediterranean, 500–1000
Copper-based alloy
22 cm (8¹¹⁄₁₆ in.)
Provenance: Purchased in Egypt, 1954.
Condition: Remains of cloth adhering to the oxidation were removed during restoration.
Musée du Louvre, Département des Antiquités Égyptiennes, Paris (E 25393)

The two identical objects that this figurine brandishes are crotales, percussion instruments made of a pair of small cymbals

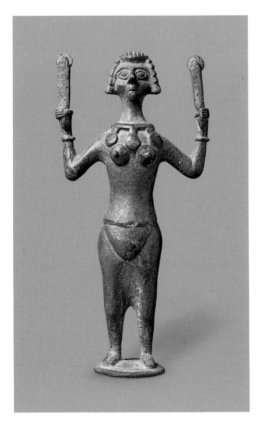

suggested that they may have been used as amulets related to fertility.[2] Usually linked with the Christian population of Egypt, they continue a pre-Islamic tradition of statuettes that survive in a variety of materials including clay and wood, and some have been discovered in children's tombs.[3]

The majority of the figurines that survive are plain and take a variety of forms but in general show some common characteristics, with their simple carving of little artistic value. Some are dressed in clothes and have real hair or black paste on their heads.[4] The great number of them in museum collections and the fact that they are frequent finds in excavations suggest that they were common, everyday objects made in large numbers out of bone, a cheaper material than ivory, and thus more easily available.[5] MM

1 See Scanlon 1968, pp. 16–17, and Kawatoko and Shindo 2010, pls. 10, 11.
2 Cortese and Calderini 2006, p. 218.
3 Alaoui 2000, p. 216; Argyriadē 1991, no. 24; and Rutschowscaya 1986, pp. 85–91.
4 For three examples, see Alaoui 2000, p. 217.
5 As, for example, the Museum für Byzantinische Kunst, Berlin (see Fluck and Finneiser 2009, p. 49); the Benaki Museum, Athens,; and the British Museum, London (see Argyriadē 1991).

References: (A, B) Unpublished.

Each of these three female figurines is shaped from a single piece of bone. The decoration of the body is almost identical on all of them: the schematic carving of anatomical details is enhanced with painted designs on the head and body. The decoration is confined to the front, leaving the back plain. The faces are characterized by long, almond-shaped eyes, elaborate curls of hair, and two different symbols on the cheeks: a circle surrounded by dots and an S-shaped symbol. Scrolls and heart-shaped motifs embellish the body, while the navels are defined by two circles. Figurine B is the only one whose arms were formed from two separate pieces. Two holes in the ears suggest that they once were adorned with jewelry— green stains suggest earrings made probably of copper alloy rings.[1] Together with two other figurines, one in the Museum of Islamic Art, Cairo, and the other in the Benaki Museum,[2] they form a group characterized by painted decoration that does not occur on the more common so-called Coptic dolls frequently found in Egypt (cat. no. 134).

Details of the face, such as the scalloped curls on the forehead, the long curls, and the almond-shaped eyes, conform to familiar characteristics of figural representation of the Fatimid period as found on luster ceramics.[3]

The figures on ceramics, however, are rarely unclothed. A rare drawing on paper, in the Israel Museum, Jerusalem, of a nude figure holding a musical instrument and a vase with flowers shares many similarities. This drawing has been connected to the figurines in Cairo; the most striking similarities are the asymmetrical markings on each cheek and the line below the nose. These are identified as tattoos (or henna), which were thought to protect against the evil eye.[4] Further correspondences are the heart-shaped motifs on the bodies, the ornamentation of the hands and feet, and the decoration on the necks, indicative of a necklace.

The Fatimid drawing has been interpreted as an illustration for a scientific manuscript, a personification of a calendar month,[5] or simply a figure of a musician. However, in spite of the similarities, its connection with the figurines remains unclear. Markings on the body might have been applied for therapeutic or protective purposes but also for ornamentation, especially during festivities and weddings. Bone dolls are in general associated with toys (cat. no. 134), but these markings suggest a more specific meaning, linked to the beliefs of popular culture in Egypt, associated with either celebrations or protection against the evil eye.

135A–C. Figurines

....................

Egypt, late 10th–12th century
Bone, carved; painted with black organic material

A. Figurine

18.3 × 4 cm (7³⁄₁₆ × 1⁹⁄₁₆ in.)
Provenance: Private collection in 1958; in the Museum of Islamic Art by 2000.
Condition: The figure is in good condition.
Museum of Islamic Art, Cairo (15438)

B. Figurine

15.6 × 6.2 cm (6⅛ × 2⁷⁄₁₆ in.)
Provenance: Collection of Antonis Benakis (1873–1954); part of the original Benaki Museum, which was given to the Greek state in 1931 and inaugurated on April 22 of that year.
Condition: The figure is in good condition, except for an area of loss on the right leg.
Benaki Museum, Athens (10738)

C. Figurine

15.5 × 4 × 2 cm (6⅛ × 1⁹⁄₁₆ × ¹³⁄₁₆ in.)
Provenance: Gifted to the Victoria and Albert Museum by Sir Leigh Ashton in 1958 (registration number A.18-1958); transferred to the British Museum in 1979.
Condition: The figure is in good condition.
The British Museum, London (1979,1017.203)

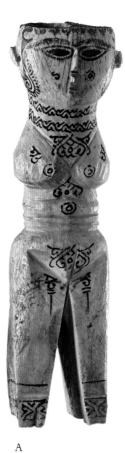

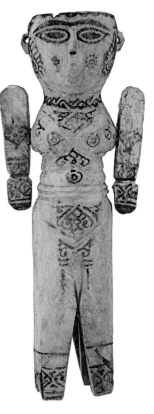

A B C

133. Necklace and Pendant with Aphrodite Anadyomene

....................

Eastern Mediterranean, 7th century
Gold, lapis lazuli, garnet (?), and rock crystal
L. of chain 83 cm (32¹¹⁄₁₆ in.); H. of pendant without
short chains 4.5 cm (1¾ in.)
Provenance: Formerly collection baron de Ménascé, Paris;
purchased from Kalebdjian Frères, Paris, by Mildred and
Robert Woods Bliss, 1928; Collection of Mildred and
Robert Woods Bliss, Washington, D.C., 1928–40.
Condition: The necklace is in very good condition. The
pendant lacks two gemstones from its collar, one from the
pedestal for the goddess, and two clear (rock crystal?)
beads at the ends of short chains.
Byzantine Collection, Dumbarton Oaks,
Washington, D.C. (BZ.1928.6)

Aphrodite Anadyomene—"rising from the sea"—wrings water from her hair within this shell-shaped pendant. Her gesture, the "shell," and the dark blue color refer to the legend of the goddess's birth from the ocean's depths. The figure's pose and the drapery over one leg imitate Greco-Roman statues of the popular Anadyomene type. The pendant hangs from a necklace of biconical beads of gold and lapis lazuli; this stone, often associated with Aphrodite, was employed for amulets for centuries.[1] The alluring figure of Aphrodite, the goddess of love renowned for her beauty, graces this necklace.[2] Made to adorn a woman, it features an Aphrodite herself adorned with a necklace and pendant.

The gods and goddesses of pagan antiquity populated the arts of the Byzantine elite, just as ancient Greek literature, philosophy, and science were elements of Byzantine culture. Silver dinner plates were often decorated with mythological imagery (cat. nos. 8, 9, 11, 12): the engraved handle of a *trulla*, or shallow bowl, dated about 610–25,[3] shows Aphrodite in a similar pose and standing on a pedestal.

In antiquity, the area of Central Asia that is today Afghanistan was the only source for lapis lazuli, which reached western Asia and the Mediterranean overland along the silk roads or by ship along the spice routes of the Indian Ocean. The stone is extremely rare in early Byzantine jewelry;[4] here, the beads vary in length and width and many are chipped around the narrow ends, suggesting that they were not made for this necklace but were reused by an imaginative jeweler. The odd

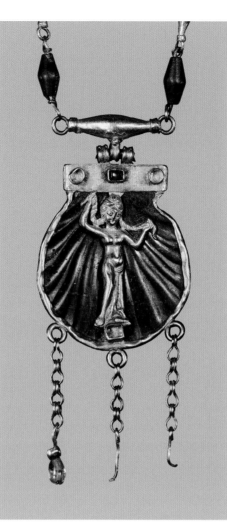

number of twenty-five beads required the gold disk to be placed off-center on the suspension chain. Such asymmetry is very unusual on a Byzantine necklace and points to this solution as a response to the availability of the lapis lazuli beads rather than as a freely conceived design. SRZ

1 Delatte and Derchain 1964, pp. 183–89; Faraone
 forthcoming.
2 A gold relief of Aphrodite (H: 3.5 cm [1⅜ in.]), comparable in pose, size, and technique, was perhaps also intended for a piece of jewelry: Segall 1938, p. 133, no. 203, pl. 42, dated to the Roman Imperial period.
3 Although not of the Anadyomene type, Aphrodite's arms are raised and emulate this famous pose: Cormack and Vasilakē 2008, p. 156, cat. no. 104.
4 Another example from this period with biconical lapis lazuli beads is a portion of a necklace (?) with two lapis beads, one of gold, two coins of the emperor Maurice Tiberios (r. 582–602), and a cross; see *Jewelry* 1979, cat. no. 440.

References: Ross 2005, no. 12; Bühl 2008, pp. 118–19.

134A, B. Figurines

....................

Egypt, 7th–10th century
Bone, carved and incised

A. Figurine

12.3 × 3.7 × 1.5 cm (4¹³⁄₁₆ × 1⁷⁄₁₆ × ⁹⁄₁₆ in.)
Provenance: [Mathias Komor, New York (1970s)]; Bess Myerson (1970s–2001).
Condition: There are two cracks in the figure.
The Metropolitan Museum of Art, New York, Gift of Bess Myerson, 2001 (2001.761.3)

B. Figurine

6 × 2.6 × 0.7 cm (2⅜ × 1 × ¼ in.)
Provenance: Lily S. Place (until 1921).
Condition: The figure is in good condition.
The Metropolitan Museum of Art, New York, Gift of Lily S. Place, 1921 (21.6.107)

Each of these two figurines was shaped from a single piece of bone, with the facial features and details of the bodies formed by simple angular incisions. The decoration is confined to the front, while the back is left plain. The arms and the body of B were made from the same piece, whereas the holes on the sides of A indicate it once had movable arms.

A number of these figurines have been unearthed in Egypt and attributed to a wide range of dates on the basis of neighboring finds or architectural evidence.[1] These objects were probably toys, although it has also been

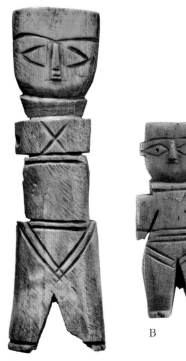

A B

Representative of the transition to a new era, these earrings mark the point at which pierced jewelry ceased to prevail in the eastern Mediterranean and filigree decoration began to predominate, in both the Islamic world and Byzantium.

They appear to be among the earliest examples in a series of similar pieces attributed to a range of dates from the seventh to the tenth century.[1] Large and semicircular in shape, the earrings are made of wire and granulation and feature pairs of cast confronted birds, possibly partridges. The birds touch bills above a filigree roundel, which contained a pearl (now lost), rather than the cross or fountain usually found on Byzantine earrings. There is room for two more pearls below the birds. This central part is surrounded by figures of eight and heart shapes, all fashioned with exquisite artistry and almost perfect geometric precision. The full-circle hoop has a loop catch.

Earrings of this type are a development of the sixth- to seventh-century Byzantine crescent-shaped earrings with confronted birds (cat. no. 131), which were mass-produced in the pierced-work technique and widely distributed over a large geographic area.[2] Their production seems to have declined from the end of the seventh century, while at the same time filigree jewelry in precious metals or copper alloys was emerging, with the latter clearly imitating gold or silver models.[3] AB

1 For another example in the Benaki Museum, see Segall 1938, p. 157, no. 246. Other published examples are found in the L. A. Mayer Memorial Institute for Islamic Art, Jerusalem; the Museum für Islamische Kunst, Berlin; and the Museum of Islamic Art, Cairo: Hasson 1987, pp. 18–19, cat. nos. 11–13, 107; von Gladiss 1998, pp. 89–90, nos. 13–14, and p. 93, no. 2; O'Kane 2006, p. 72, no. 60.
2 Yeroulanou 1999, pp. 74, 196–97.
3 Bianchini 1992, p. 130, cat. no. 83; Papanikola-Bakirtzē 2002, p. 558, cat. no. 770; Drandaki 2005, pp. 65–66.

Reference: Segall 1938, pp. 156–57, no. 245.

Women

Mina Moraitou

The Umayyad elite, perceiving themselves as the heirs of Byzantium and the Sasanian Empire in the regions they had conquered, continued the familiar lifestyle that had prevailed during Late Antiquity, including the manner in which the female figure was portrayed in the decoration of their palaces and works of art.

One way of representing women in antiquity was as personifications: deities, cities, the seasons, and other elements of nature.[1] A celebrated example, the sixth-century floor mosaic in the Hippolytus Hall in Madaba, depicts the cities of Rome, Gregoria, and Madaba as women wearing jewelry and sitting on high seats.[2] In Qusayr 'Amra, in the Jordanian desert, three female figures representing intellectual activities, labeled in Greek as Inquiry (ΣΚΕΨΗ), History (ΙΣΤΟΡΙΑ), and Poetry (ΠΟΙΗΣΗ), follow precedents found in Roman mosaics.[3] A mosaic in the Church of the Apostles, also in Madaba, bears an image of the sea (ΘΑΛΑΣΣΑ) depicted as a female figure. It belongs to the type representing nature that is also encountered in a floor fresco in the Umayyad palace of Qasr al-Hayr al-Gharbi in Syria.[4] It illustrates the figure of Earth (ΓΗ), a pre-Islamic subject that symbolizes abundance, fertility, and the good life.[5]

A second type of portrayal relates to court entertainments and depicts women as dancers, musicians, or courtesans. For example, another floor painting in Qasr al-Hayr al-Gharbi shows two female musicians above a hunter, while a separate fragmentary piece pictures the veiled head of a songstress.[6] This type of subject, popular in decorative programs throughout antiquity, survives in abundance in pre-Islamic Egypt, especially on textiles (cat. no. 108). Other examples in this volume include a sixth-century relief carving with female musicians (cat. no. 138) and a flask with dancers (cat. no. 139).

Women occupied a prominent position in the literature and arts of the Umayyads, whether as heroines of love poetry or slave girls who entertained with music and storytelling. The popular *Thousand and One Nights* features the tales of Scheherazade in a plethora of adventures inspired by Persian oral narrative tradition.

Figural iconography incorporating women is plentiful; in Qusayr 'Amra it is most clearly illustrated in fresco paintings (see fig. 81). There, female dancers, musicians, and attendants appear repeatedly in the complex iconographical program, where, following pre-Islamic prototypes, they are associated with a princely lifestyle. Other conventional images are found on silver-gilt ewers from the sixth and seventh centuries, including one in The Metropolitan Museum of Art (cat. no. 20), that show women dancing, holding flowers or objects of bounty, and accompanied by animals. Such scenes, with references to the processions of Dionysos and his Maenads, exemplify the influence of Roman and Byzantine imagery, as well as the Eastern interpretations of that imagery permeating Umayyad art. Relevant in this regard are a fragment of a woman's torso from Mshatta (cat. no. 142D) and the figures on a brazier from al-Fudayn (cat. no. 143), which echo the three-dimensional representations of nude or seminude court entertainers that decorate other desert palaces.[7]

the coins with which it was found. The Mersin necklace features medallion and curved-leaf openwork pendants on a chain, though its pendants' vegetal motifs are more simply rendered.[2] The necklace also prominently displays a pendant cross, as the Metropolitan Museum's example perhaps once did. EW

1 See Yeroulanou 1999 and, more recently, Tóth 2010.
2 State Hermitage Museum, Saint Petersburg (ω 105, 106); for a brief discussion of the archaeological context of the Mersin hoard, see Baldini Lippolis 1999, p. 38, with bibl.; J. Durand 1999, colorpl. p. 52.

References: Peirce and Tyler 1932–34, vol. 2, pp. 131–32, fig. 189c; Dimand and McAllister 1940, pl. 7; Yeroulanou 1999, no. 25, fig. 231; Komaroff 2011, cat. no. 238, fig. 70.

131A, B. Earrings
....................

A. Earring with Peacocks
Eastern Mediterranean, late 6th–7th century
Gold
Each 5.5 × 4.9 × 0.3 cm (2³⁄₁₆ × 1¹⁵⁄₁₆ × ⅛ in.)
Provenance: [Hagop Kevorkian, New York (1938)].
Condition: The condition is excellent, except for damage to the hollow balls along the rim.
The Metropolitan Museum of Art, New York, Rogers Fund 1938 (38.171.1)

B. Pair of Crescent-Shaped Earrings with Peacocks
Eastern Mediterranean, late 6th–7th century
Gold
Each 3.2 × 2.5 cm (1¼ × 1 in.)
Provenance: Purchased from Mrs. Margaret Burg, Scarsdale, N.Y.; Dumbarton Oaks Research Library and Collection, Byzantine Collection, Washington, D.C., November 1952.
Condition: The crescents are slightly out of plane, otherwise, the condition of both earrings is excellent.
Byzantine Collection, Dumbarton Oaks, Washington, D.C. (BZ.1952.13.1–2)

This single earring and the pair are related by form, technique, and imagery. Each piece is a crescent of sheet gold that has been chisel-cut into a symmetrical, openwork pattern of confronted peacocks. On the single earring, the birds flank a palmette, on the pair, a vase or a fountain. A wire hoop with a simple hook closure and a beaded wire along the outer edge are soldered to the crescents. The Metropolitan Museum's earring is additionally embellished with fine wire loops and seven hollow balls (crushed), as well as a row of punched dots on the inner border of the crescent.

In antiquity and the early Byzantine era, the image of the peacock was widespread;[1] among its many associations was renewal,

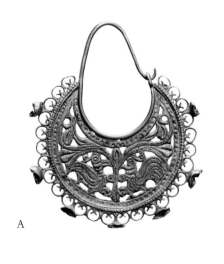

A

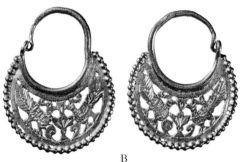

B

because new feathers were thought to grow each spring. This idea was extended within a Christian context to include paradise, a place where life flourishes eternally, while the legend of the peacock's incorruptible flesh made the bird a symbol of resurrection and everlasting life.

A primary motif from the sixth to seventh century, peacocks appear on the extensive series of crescent earrings that survive from the period. Other types of birds, crosses, scrolls, floral rinceaux, and different treatments of the outer edge decorate them as well.[2] Examples have been found over a wide area, from Sicily to Lebanon and from Germany to Crete.[3]

These earrings date to the same period as the majority of extant Byzantine wedding rings. In all likelihood, these peacocks, palm leaves, vases, and crosses, like those on other earrings, should be interpreted as auspicious symbols and *apotropaia*, that is, objects intended to ward off evil. As such, they may have been presented to young women at engagement ceremonies or as wedding gifts.[4] SRZ

1 Sodini 1998.
2 Baldini Lippolis 1991; for tables of iconographic motifs, see pp. 99–100. Yeroulanou 1999, pp. 179–88, 279–95, nos. 475–588.
3 For findspots, see the map in Baldini Lippolis 1991, pl. 1; for the two sets of earrings found in Germany, see (1) Wamser and Zahlhaas 1998, cat. no. 235; Yeroulanou 1999, nos. 514, 557; and (2) Yeroulanou 1999, p. 188, fig. 360, no. 489.
4 Yeroulanou 1999, pp. 183–88, discusses the religious connotations of earrings with confronted birds and their probable functions as amulets and wedding gifts.

References: (A) Dimand and McAllister 1940, fig. 9; Dimand 1944, fig. 76; Yeroulanou 1999, pp. 132, 186, fig. 354, p. 283, no. 508; (B) Yeroulanou 1999, p. 284, no. 515; Ross 2005, p. 68, no. 87, pl. 47.

132. Pair of Earrings with Birds
....................

Egypt or Syria, 7th–8th century
Gold wire, granulation, cast details, pearls
Each 6.6 × 5.3 cm (2⅝ × 2⅛ in.)
Provenance: Found in Farshoot, Upper Egypt; collection of Antonis Benakis (1873–1954); part of the original Benaki Museum, which was given to the Greek state in 1931 and inaugurated on April 22 of that year.
Condition: The condition is very good; three of six pearls are missing.
Benaki Museum, Athens (1812)

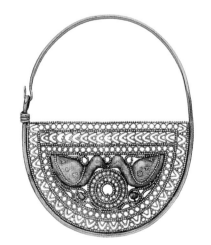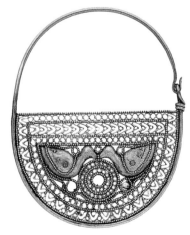

ISLAM

Country Estates, Material Culture, and the Celebration of Princely Life: Islamic Art and the Secular Domain

Anna Ballian

In the study of medieval art it is common and useful to make a distinction between sacred and secular art; however, there are some drawbacks to the convention that can often be restrictive. The overlaps and similarities between the two may be greater—and more interesting—than the differences. The Dome of the Rock in Jerusalem, the oldest Islamic religious building, is decorated with foliate motifs and imperial jewels (figs. 96, 98), and imagery of agrarian and everyday life is found in abundance on the mosaic pavements of churches. The custom of distinguishing the sacred from the secular grew out of nineteenth-century European scholars' conviction that religion permeated every aspect of medieval society and in importance far outweighed secular matters.[1] In the same period the art of the Muslims was categorized as Islamic and the art of the peoples of the Christianized Roman Empire was grouped together as Christian. The absence of figural religious art in the Islamic world—and in Byzantium the opposite phenomenon, its strong presence—suggested that medieval artistic production was defined and inspired by religious norms, that is, that art's only purpose was to serve religion. Islam's negative position on the depiction of animate beings, interpreted by strictly religious criteria, led to the conviction that Islamic art was entirely aniconic, though in fact the precept applied only to the art of the mosque and of the Qur'an. Even nonfigurative decoration, whether vegetal or geometric, was interpreted using ideological and theological criteria. Thus, when nineteenth-century Europeans traveling along the margins of the Syro-Palestinian desert came upon Umayyad castles or villas decorated with figural sculpture and paintings, they were astonished (fig. 79). In Arabic those desert castles are called *qasr* (pl. *qusur*), a word that can also refer to a large estate, a smaller settlement, an agricultural compound, a bathhouse, or an administrative center.

The *qusur* have been the subject of intensive study and scholarly debate from their initial discovery up to the present day. At first the main concerns were dating the structures and ascribing them to a culture (Roman, Byzantine, Iranian, or Early Islamic); later, debate focused on the uses to which they were put, the provenance of Umayyad palace art, and the patronage of the Umayyad elite. The most impressive and best-known *qusur*—the baths at Qusayr 'Amra, in Jordan (fig. 80), Qasr al-Hayr al-Gharbi, in Syria, and Khirbat al-Mafjar, in the Palestinian territories—have a wealth of figurative decoration, and not surprisingly scholars focused on their subject matter. This included scantily dressed or naked female figures, either sculpted in the round or painted (fig. 81 and cat. no. 142D); hunting scenes (fig. 84); maps of the heavens, such as the zodiac dome at Qusayr 'Amra; and depictions of rulers wearing Byzantine or Sasanian costumes (figs. 86, 88). Study of the Umayyad castles has been furthered by archaeological research, which investigates and foregrounds the economic, political, and recreational functions of the monuments and their relationships with the surrounding inhabited or agricultural land. The field has also been significantly extended in the post–World War II period by the discovery of new sites.

The ongoing debate over the *qusur* is part of a larger investigation into the emergence and sources of Islamic art in Syria and the transition from Byzantium to Islamic culture.[2] The appropriation by the new Arab elite of the traditions of the conquered peoples of the eastern provinces of the Byzantine Empire and the Sasanian Empire in Iran created a backdrop against which ideas about Early Islamic art have been elaborated. Those ideas are sometimes quite divergent, yet they shed light on the ideologies that shaped them, and some of them, though modified, are still current or at least implicit.

The Arabic sources that mention the *qusur* are all late, written during the caliphate of the Umayyads' enemies and successors, the Abbasids, who were trying to undermine and tarnish their predecessors' reputation in every possible way. The hard-drinking, womanizing, playboy-poet and bon viveur al-Walid II (r. 743–44) and his dolce vita in richly decorated *qusur* are often mentioned in Abbasid literature.[3] Most Umayyad caliphs still stand accused of not being good Muslims and of squandering money on vast irrigation projects to enrich their estates.[4] Mu'awiya himself, the first Umayyad caliph (r. 661–80), when he was rebuked for his expensive tastes and extravagant lifestyle, replied that a Muslim ruler had to appear as much like his Christian opponent as possible.[5]

In the early twentieth century, travelers in the Middle East and students of Umayyad castles approached the experience with the

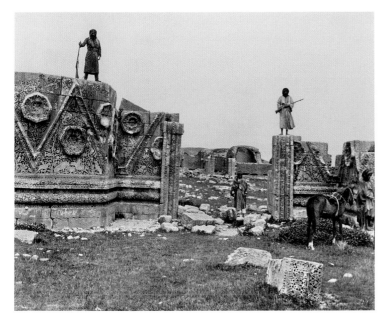

Fig. 79. Gateway at Qasr al-Mshatta in 1900. Photograph by Gertrude Bell (1868–1926). A_233 from Album A 1905—Italy, Turkey, Lebanon, West Bank, Syria, Jordan, Israel, Gertrude Bell Archive, Newcastle University Library, Newcastle, United Kingdom

Western European Orientalist mind-set. Most of them had studied classics and were interested in Byzantium; others had studied Arabic, Semitic, or Oriental languages, or ancient Eastern civilizations. This last emphasized relations with Sasanian Iran, and, indeed, the earliest study of the emergence of Islamic art focuses on the example of the Umayyad palace at Mshatta, Jordan (see Ballian, p. 209), which is considered to owe a great deal to the art of Sasanian Iraq.[6] Above all, those with a classical education attempted to bridge the gap—or what they saw as the gap—between Byzantine or Late Antique examples and the Early Islamic monuments (see Evans, p. 18).[7] Umayyad art was thus interpreted as a departure from earlier, classical models and therefore as representing a decline.

The romantic view was promoted in the 1930s by Henri Lammens (1862–1937), who stressed the Arab character of Umayyad secular buildings. In his opinion it was a quasi-atavistic yearning for the desert that led the first caliphs to abandon the cities for the freedom of the boundless desert, where they built the grand villas whose fortified appearance inspired the name

"castles in the desert."[8] This theory has been extremely long-lived, and it can be difficult to resist its charms.

A more modern, pragmatic view was first expressed by the French archaeologist Jean Sauvaget (1901–1950). According to him, the princely Umayyad villas resulted from the systematic colonization by the Arabs of border and desert land and were in fact agrarian settlements, made viable by complex irrigation systems. He viewed them as a direct translation of the Roman landed estate (*latifundium*) and country villa (*villa rustica*), usually found in the western provinces of the Roman Empire, into a Syrian environment.[9] Sauvaget's ideas, which still have their supporters today, have been refined and developed in the light of subsequent archaeological findings.

Recent research has shown that most Umayyad castles were abandoned after the eighth century and had little influence on later caliphal architecture, which usually consisted of large, centralized palace complexes. The probable reason for the discontinuance of the model is that the needs of the first Arab elites and the particular circumstances they had encountered did not arise again, at least not in Greater Syria, which would never again be central to the life of the caliphate. As Oleg Grabar put it, the *qasr* was of limited importance for Islamic art, but of paramount importance for pre-Islamic forms.[10] There is no doubt that the *qasr* was an eclectic expression that had no profound influence on the culture, as did, for example, the reform of the coinage in 696–97 under 'Abd al-Malik ibn Marwan (r. 685–705), or the religious architecture of al-Walid I (r. 705–15). Instead, it underwent subtle transformations and contributed to a gradual reordering of things. Basic choices that influenced the development of Islamic art from the outset, such as the use of writing as a visual language and aniconic decoration, are not found in the art and architecture of *qusur*. A different approach by some Islamic art historians has seen in Umayyad secular architecture an attempt to break with Byzantine culture and the classical past, whereas, by contrast, the two great Umayyad religious buildings—the Dome of the Rock and the Great Mosque of Damascus—are examples of direct appropriation of earlier Christian models. On a political level, it may have been the failure of the siege of Constantinople in

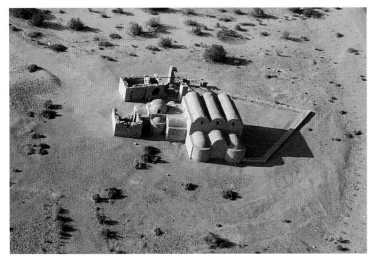

Fig. 80. Aerial view of bathhouse and inner enclosure, 705–15. Qusayr 'Amra, Jordan

717–18 that motivated the Umayyad caliphs to turn their eyes eastward and reject Byzantine for Sasanian culture.[11] An example of the change in models is the cruciform monumental gate of the citadel at Amman, Jordan, which served as an audience hall and was decorated with Sasanian-style blind niches featuring carved vegetal and geometric patterns (fig. 82).

But if the Umayyad castles are not in the mainstream of the culture's development from the point of view of Islamic art, for Byzantine art they are a lost link with the secular art of the empire, expressed in the artistic vernacular of Late Antiquity, a visual koine.[12] It is perhaps not surprising that the period of their construction—between 'Abd al-Malik's reforms of 696–97 and the fall of the Umayyad dynasty in 750—should have had such

fascination even for nonspecialists in Islamic history and art. Early Islam was fitted into the framework of Late Antiquity by classically trained scholars investigating the transition from the classical to the medieval period. Looking for instances of continuity, innovation, and change with fresh eyes, they fueled a different, broader vision of the period.[13]

Finally, there is the Arab factor to consider, and the Umayyad elite, who played a catalytic role in shaping Early Islamic art. Contrary to earlier beliefs, Arabs did not emerge from the Arabian Peninsula out of a cultural void. Arabic poetry describes a chivalrous pre-Islamic world, which was by no means isolated from the great empires of the time, but in touch with the natural environment and society of the Middle East.[14] Recent archaeological investigation in the ancient commercial metropolis of Qaryat al-Faw, southwest of modern Riyadh, and the caravan city of Mecca show that the Arabs had long been exposed to the visual culture of Late Antiquity.[15] As a merchant, Muhammad himself is said to have visited Bostra (today's Bosra), the Syrian town where the Mecca-bound caravans stopped, and there he had an encounter with the Syrian Christian monk Bahira.[16] The episode suggests how the Muslim Arabs of the Arabian Peninsula became acquainted with Byzantine and Sasanian culture along the commercial routes and how they encountered the Ghassanids and the Lakhmids, Christian Arab tribes who lived in Bilad al-Sham (Greater Syria).[17]

The *qasr* rarely stood alone in the desert landscape. It was made up of various components, including a mosque, baths, audience hall, residences, service buildings, farms, and irrigation systems. There are more than thirty-five examples of *qusur*, all dating to the first half of the eighth century.[18] The Umayyad castles in Bilad

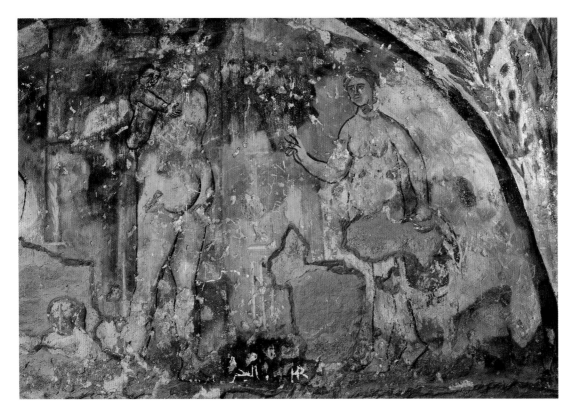

Fig. 81. Bathing women. Fresco, 705–15. South wall, tepidarium, bathhouse, Qusayr 'Amra, Jordan

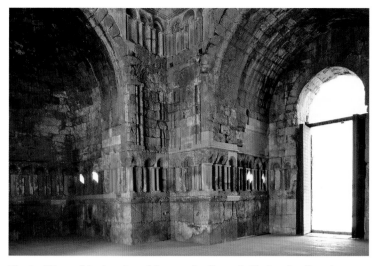

Fig. 82. View of the interior of the gate (audience hall) showing Sasanian-style blind niches, mid-8th century. Citadel, Amman, Jordan

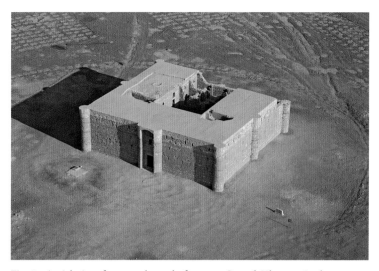

Fig. 83. Aerial view from southeast, before 710. Qasr al-Kharana, Jordan

al-Sham are mainly distributed on the edge of the Syrian steppe, which begins in the north at the Taurus Mountains and extends southeastward along the Euphrates River as far as the Arabian desert and then westward to the Gulf of Aqaba. The terrain ranges from semiarid land where dry-farming settlements can survive, to barren desert where settlements could survive only if supplied with carefully constructed irrigation systems.[19] West of this axis and the Jordan valley are the few surviving *qusur* located in what are now Israel and the Palestinian territories. Khirbat al-Mafjar, outside Jericho, is one of the three or four most richly decorated of all Umayyad examples.

Most of the Umayyad castles and estates were concentrated in the relatively fertile regions of the steppe along the Euphrates, in places such as Raqqa, Balis, and Rusafa (Sergiopolis), the favorite residence of Caliph Hisham (r. 724–43), and on the central plain of Jordan (the Balqa), on the fringes of the steppe, where Yazid II (r. 720–24) and al-Walid II preferred to live. Most of the extant *qusur* are located on the Balqa: Qasr al-Qastal (see Ballian, p. 216), Qasr al-Mshatta (see Ballian, p. 209), Qasr al-Fudayn (see Ballian, p. 212), the baths of Qusayr 'Amra (fig. 80), the reservoir of Qasr al-Muwaqqar, Qasr al-Kharana (fig. 83), and Qasr al-Hallabat, with its adjacent baths, the Hammam al-Sarah.[20] In a less hospitable region are found the two famous castles of Qasr al-Hayr al-Sharqi and Qasr al-Hayr al-Gharbi, to the east and west of the Palmyra oasis, respectively.[21] They lie on the route from the Euphrates to Damascus, which went through the Palmyran desert and thus required extensive irrigation systems.

Most *qusur* were built on or near one of the trade and pilgrimage roads that linked various parts of the Middle East with the northern Arabian Peninsula and the area of western Arabia known as the Hijaz, where the two holy cities of Islam—Mecca and Medina—are situated. An adequate provision of water was a precondition of their routing, and a nearby, irrigated *qasr* could

function as a kind of caravanserai, or inn for travelers. South of Amman one such route passes through al-Humayma (ancient Hawara), where a villa belonging to the Abbasid family was recently discovered (see Foote, p. 221). It continues from there to the harbor of Ayla (modern Aqaba) on the Red Sea, from where one can cross by boat to the Hijaz. The Emperor Trajan's Road (*via nova Traiana*) followed much the same route, crossing the Roman province of Arabia from Bosra, in what is now Syria, to Ayla. Similarly, the *qusur* around the Palmyran desert seem to have been built on or near Emperor Diocletian's Road (*strata Diocletiana*), which began at the southern bank of the Euphrates and ran south and west, linking the city of Palmyra to Damascus and extending into northeast Arabia.[22]

These Roman roads were part of a defensive system called the *limes*, built on the frontier of the empire to hold back invaders, whether nomadic tribes or an Iranian army. The geographical distribution of the *qusur* on the edges of the Syrian steppe coincides more or less with the Roman frontier. With semicircular, or more rarely square, towers at the corners and on either side of the entrance, they repeat the plan of the military camps and large or small forts (*quadriburgium*) constructed by the Romans and later the Byzantines all along the *limes*.[23] Of course, the *qusur* were not built for a military purpose (the towers were either solid masonry or used as latrines) but served as prestige architecture, reflecting the power of the owner. Their fortified appearance and their position on or near strategic Roman roads emphasize the continuity with Late Antiquity, but whether any of them replaced a real Roman or Byzantine fort has been difficult to prove through excavations.[24]

The *qusur* were also used as meeting places for the Umayyad owner and the Arab tribes of the Syrian desert. In the sixth century the Byzantines had delegated the defense of their eastern *limes* to the Ghassanids, who led a confederacy of tribes and

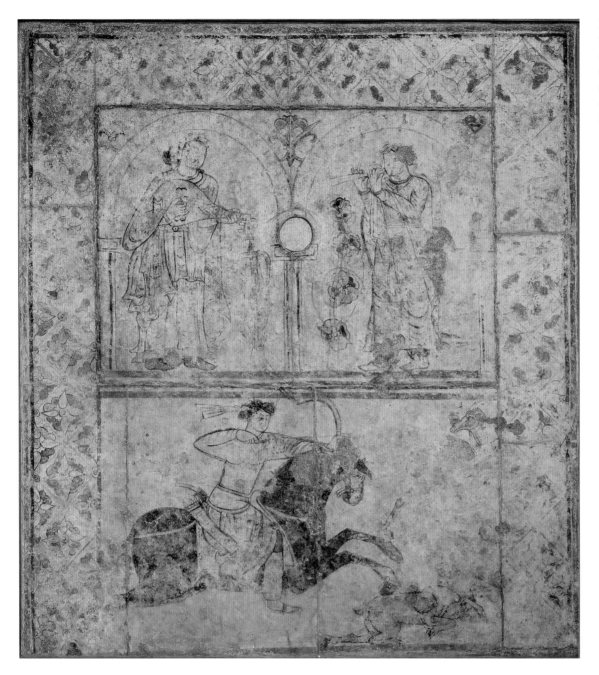

Fig. 84. Painted floor showing musicians and a hunter from a reception room on the first floor of the east wing of Qasr al-Hayr al-Gharbi, Syria. Secco painting, ca. 727. National Museum, Damascus

whose sphere of influence extended throughout the Syrian steppe. They also kept the peace among the turbulent Arab tribes and protected the trade routes.[25] On the other side of the border, the Sasanians had delegated the role of guardians and peacekeepers to the Lakhmids, who were based in Hira in southern Iraq. Apart from the by then unnecessary guarding of the frontier, the Ghassanids' role was later taken over by the Umayyads, not least because they needed the support of the tribes. Their castles became places for diplomatic contact between the caliph, his officials, and the Arab nomad tribes of the Syrian steppe, who had brought him to power and now supported him.[26] Unlike the Ghassanids, who had limited power of a military nature, the Umayyad elite had not only political power but also the economic means to finance irrigation projects and transform the meeting places into fortified palaces and hunting lodges amid gardens and agricultural enclosures.[27]

Epigraphic evidence and other indicators suggest that some of the *qusur* replaced monasteries as meeting places for the desert tribes and in fact maintained their function, serving similar religious and secular, social and political needs.[28] Later Arabic literary sources on the Ghassanids present them as great builders and include lists of buildings, mainly Miaphysite monasteries, since the Arab tribes of the Syrian steppe had embraced Christianity. Of the many instances cited in the literature, a few are substantiated by archaeological evidence, for example, at Qasr al-Fudayn (see Ballian, p. 212) and Qasr al-Hayr al-Gharbi.[29] It is tempting to suppose that, even if not continuously, Qasr al-Hayr al-Gharbi was nevertheless used successively as a Roman fort, Christian monastery, and Islamic country estate. An abandoned Roman fort inhabited by holy men, monks, or solitary ascetics is a literary *topos* of saints' lives, which reflects conditions on the Syrian steppe frontier in Late Antiquity. And the transformation of a monastery into an

Umayyad residence brings to mind another literary genre, the collection of Arabic poetry and anecdotes set in monasteries. Such compilations indicate that the Umayyad elite were attracted to the isolation of the monastic site as a refuge in times of plague or for more prosaic reasons, such as its supply of wine.[30]

A combination of monastic and Umayyad buildings is found at Rusafa (fig. 14). The pre-Islamic monastic complex, with its church and the relics of Saint Sergios, was a place of pilgrimage and assembly for the Arab Christian tribes, and it offered a way to display the might of the Byzantine state and the church hierarchy, which administered the shrine. The Ghassanids certainly played a role in the spread of Saint Sergios's cult, and their presence is attested by a carved inscription found in a basilical hall (either a church or an audience hall, or perhaps both), containing the name of the Ghassanid tribal chief al-Mundir (hellenized as Alamoundaros). Roughly two hundred years later the city attracted Caliph Hisham, who exploited the thriving pilgrimage center to strengthen his political power over the Arab Christian tribes. Outside the walls he built a *qasr* and a city and he appropriated the saint's cult space by electing to build a large mosque next to the basilica of Saint Sergios. The mosque's *qibla* wall adjoins the church's northern courtyard, and the mosque communicates with the church through a passage in the wall that leads the pilgrim straight to the northeastern chapel, where the saint's relics were kept.[31] This transition from one cult space to another via an intervening courtyard is symbolic of the gradual transition from one period to another. It may also reflect the Umayyad caliph's view of the place he held in his world: an undisputed ruler but by no means a foreign interloper, imposing himself by force and usurping the property of others; rather, a relative and neighbor, a fellow traveler who shares the same heritage.[32]

Earlier views of the Arab conquest held that in the 630s the Muslim Bedouin hordes took over Syria and swept away its Late Antique civilization. More recent opinion, based on archaeological research, speaks of an invisible conquest and a seamless transition from the Byzantine to the Umayyad era. Fundamental changes in the country's civic and economic fabric, long thought to have taken place in the Islamic period, had in fact begun to be implemented in the sixth century. A characteristic and much debated example is the shrinking of antique cities and the breakdown of the classical street plan. In Byzantine Syria, it became customary to build with *spolia*—reused earlier building material—and to convert the wide traffic arteries of the Late Antique city into narrow alleyways and covered markets, anticipating the Islamic suq.[33] These so-called anarchic construction practices were in fact developed when local small-scale industries proliferated, necessitating the conversion of empty public spaces to meet the needs of commercial enterprise. A related phenomenon in

the same period was the increased use of pack animals as a means of transport—unlike carts, these could maneuver through the narrow streets.[34]

Nowhere is the smooth transition from Byzantium to Islam clearer than in the area of material culture. In the first generations after the Islamic expansion the objects that were produced, traded, and used in Bilad al-Sham differed little from those predating the 630s or those of the sixth century in general.[35] Two examples are small glass pilgrim jugs with molded decoration used by Christians, Jews, and Muslims alike (cat. nos. 60, 62, 72, 186) and the clay lamps with crosses and Greek or Arabic inscriptions (cat. nos. 126C–G, 127).

Continuities are clear but innovations begin to be discernible at the end of the eighth century and during the ninth. In ceramics, important changes took place with the increasing use of glaze, which was made to a new recipe, pointing to a change in ceramic technology.[36] The first reflections of imported Chinese ceramics began to appear, in the form of colored splashes on otherwise typical Late Antique pottery (cat. no. 175), a phenomenon that in its fully developed form we know from excavations at Samarra, the capital city of the Abbasid caliphs from 836 to 892.[37] This receptiveness of the Islamic world to Chinese culture was

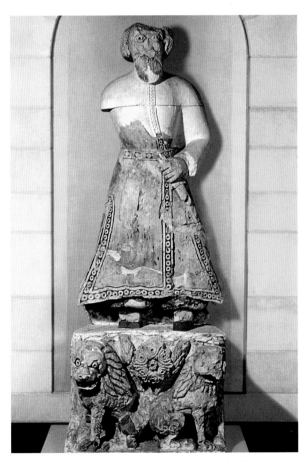

Fig. 85. Standing caliph from the entrance portal of the bath-house at Khirbat al-Mafjar, Palestinian Territories. Molded plaster around bricks, 724–43 or 743–46. The Rockefeller Museum, Jerusalem. Courtesy of the Israel Antiquities Authority

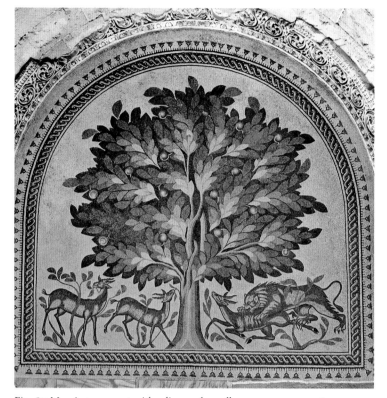

Fig. 86. Drawing of enthroned prince. Fresco, 705–15. South wall, alcove, hall, Qusayr 'Amra, Jordan. Reproduced from Musil 1907, vol. 2, pl. XV

Fig. 87. Mosaic pavement with a lion and gazelle, 724–43 or 743–46. Reception hall, Khirbat al-Mafjar, Palestinian Territories

something new: the Byzantines seem to have been virtually unaware of the art of the Far East. The great surge in international trade based on Basra and Baghdad was at the root of the development, but this does not mean that Syria was entirely relegated to the background. From 796 until his death, Caliph Harun al-Rashid (r. 786–809) made Raqqa his imperial residence (cat. no. 154), and it was probably in that Syrian city that the caliph received the much-talked-about gift of two thousand pieces of Chinese porcelain sent to him by the governor of Khurasan.[38]

Umayyad and Byzantine clear glass have the same properties and were worked into the same shapes and patterns.[39] As for luxury wares, two techniques of known Roman ancestry, sandwich glassmaking (cat. no. 158) and cameo glassmaking (cat. no. 116), were occasionally used by Islamic artisans—the former in Syria and the latter in Iran or Iraq. Whether these are cases of the survival or the revival of a Roman technique in the Islamic period and whether Byzantine glass played an intermediary role or not are questions that research has yet to answer. The earliest technique of glass painting in the Islamic period involved the application of luster pigments to luxury glass vessels, a technological innovation in which Egyptian glassmakers of the Late Roman period played a pioneering role. In the eighth century both Syria and Egypt seem to have produced such wares (cat. nos. 155, 174). But the real break with Late Antique traditions came in the ninth century, with the transfer of the luster technology from glass to pottery (cat. nos. 117, 155, 166, 174).

Everyday objects made of copper alloy also tell a story of continuity, innovation, and change: vessels common in the Late Roman and Early Islamic world share the same uses and shapes. Some continued to develop up to the eleventh and twelfth centuries, others were more freely adapted to Muslim needs. Others began to change in the ninth century and continued to develop up to the eleventh and twelfth centuries. Typical examples are the copper-alloy flasks with a strip used to fasten the handle to the neck (cat. nos. 57, 151) and incense burners (cat. nos. 122, 148, 150A). Objects that show parallels and continuities with Roman or Byzantine copperwork are found in places as far afield as Iran, as in the case of some ninth- to tenth-century flasks excavated in Iranian Nishapur, or an incense burner now in Afghanistan, or a bucket that is associated with Khurasan but still clearly shows a relationship to similar objects from Late Antiquity (cat. no. 123B).[40]

Trade and communication between the Mediterranean countries and Iran flourished in the centuries before the arrival of the Muslim armies. Sasanian silverware of the late fifth and sixth centuries adopted Late Roman forms and was decorated with Dionysiac imagery (cat. nos. 19, 20); examples traveled along the Silk Road and influenced the wares of Central Asia and China.[41] The Dionysiac imagery is a striking example of cultural continuity, transcending political and religious boundaries. On a brazier found at Qasr al-Fudayn (cat. no. 143) the depiction of the retinue (thiasos) of Dionysos, a classical subject, must have been understood by the Umayyad elite, if not as part of its original

mythological context, then at least as a depiction of the "good life," including material wealth and good fortune. A similar example of cultural continuity is presented by a series of painted ceramic bowls produced on a large scale in the sixth and seventh centuries at Gerasa (present-day Jerash, Jordan) in kilns at the abandoned hippodrome. Among the subjects depicted are Pan, satyrs, and other pagan classical themes, all part of the baggage of Late Antique popular culture and art appropriated by the Umayyads.[42] There is no need to posit Sasanian influence or Coptic craftsmen in the service of the Umayyads. The parallels with Egyptian works in copper alloy lend weight to the view that the metalwork objects with common technical and iconographical characteristics made in Egypt and other parts of the eastern Mediterranean area in the Late Roman or Byzantine period continued to be produced in the Umayyad period.[43]

As mentioned above, copper-alloy objects datable to the turn of the eighth century show obvious signs of innovation and a transition to another era. The bird-shaped ewers from Mount Sinai (cat. no. 38) and in the State Hermitage Museum, Saint Petersburg (cat. no. 169), reflect such a shift in decoration and form as well as in their function. Though eagles with clear connotations of power are a common motif in the Late Antique world, the precise models of these ewers cannot at present be identified. It is more important that they seem to stand at the start of a tradition that included later Islamic zoomorphic statuettes,

incense burners, and aquamanilia; the latter, coming mostly from Iran or Spain, in turn influenced the production of Western European aquamanilia.[44] The shapes of and the decoration on two other Early Islamic ewers still recall Late Antique models. The one in the Georgian National Museum, Tbilisi (cat. no. 152), which is the earliest signed Islamic work with a known manufacture in Basra, has the appearance of late Sasanian silverware, with the characteristic high conical foot of Syrian ewers and the punched decoration found on Late Roman and Byzantine copper-alloy vessels.[45] The other, the so-called Marwan ewer (cat. no. 171), remains a controversial object; despite strong similarities with Syrian works, it is innovative and also suggestive of the Chinese porcelain jugs with bird-shaped spouts of Iranian inspiration imported to Basra.

By contrast with later Islamic art, where metalwork and ceramics predominate, the types of artistic production that best represent the early period are the ones that so impressed the early twentieth-century European visitors to the desert castles: mosaics, wall paintings, and sculpture. Yet we should not forget that, of the thirty-five or so known Umayyad country estates, the number in which elaborate figurative decoration and court imagery have been found can be counted on the fingers of one hand. Mosaics and figural sculpture demonstrate a continuity with the art of Late Antiquity, but they disappeared in the later Islamic periods.[46] Wall painting with figurative and nonfigurative subjects continued to grace the palaces of Muslim rulers, as did pictures showing the life of the ruler and his courtiers celebrating the princely life, with its dancing, song, wine, and hunting. These subjects evoke images of prosperity and luxury not unknown in the art of Late Antiquity. The difference is that in the Early Islamic world the accouterments of the good life were enjoyed exclusively by the elite, and patronage was in the hands of the prince and not the local landowner, community elder, or bishop. It is in the desert castles that the iconography of courtly life was first developed around the ceremonial and leisure activities of the prince. It remained the only figural iconography in the Islamic world for centuries and was closely associated with the ruler and the propagation of his power.

The court imagery of the Umayyad princely residences does not yet have the timeless formality that it would later acquire, but the half-naked dancing girls still recall classical Maenads, and scenes such as one with a servant girl bathing a child evoke private family moments in a Roman bath (fig. 81).[47] Although the theme of princely life is thought to be of Iranian origin, the visual vocabulary used in the *qusur* is the hybrid language of Late Antiquity, found on both sides of the frontier: in the Sasanian palace at Bishapur and the Great Palace at Constantinople. Whether for dancing girls or for rulers, the Umayyads drew largely

Fig. 88. Drawing of six kings. Fresco, 705–15. West wall, hall, Qusayr 'Amra, Jordan. Reproduced from Musil 1907, vol. 2, pl. XXVI

on artistic models available (and probably still visible) in Syria, where influences from Old and New Rome and from neighboring Iran had been integrated. The appropriation of ornamental motifs and the visual insignia of power had begun in the sixth century between the Byzantine and the Sasanian courts, and the trend continued under the Umayyads.[48]

The distinction between the Roman-Byzantine tradition and the Sasanian tradition was formerly ideologically weighted, creating two poles, the classical West and the remote and exotic East.[49] A striking confrontation between those two poles is made in the painted floor of Qasr al-Hayr al-Gharbi. On one side of a staircase is depicted Ge (Gaia), the Late Antique personification of abundance and well-being, just as one might expect to come across her in the mosaic floors of Antioch or in a sixth-century church on Mount Nebo. On the other side, a Sasanian or Sogdian horseman is shown hunting gazelles and other wild animals, as on Sasanian-inspired silverware (fig. 84).[50]

More often than not traditions overlapped. A straightforward example is found in the iconography of the ruler, who is depicted in distinctive ways that exploit the imagery of power. At Khirbat al-Mafjar, above the entrance portal to the bathhouse, was set a stucco statue of the prince who owned the qasr (fig. 85). He is dressed in the Sasanian manner, with baggy trousers and a long coat, and is holding what is probably a dagger or a sword. He stands in a niche on a pedestal decorated with heraldic lions. A niche setting was de rigueur for imperial statues in Late Antiquity, and lions, usually flying, were a necessary part of an apotheosis scene, which through the ages in both East and West has connoted the glorification of a ruler.[51]

A different ruler image is found in the baths at Qusayr 'Amra (fig. 86). It is based on a Late Roman image of a seated emperor that was turned into an Enthroned Christ or prophet-king (cat. no. 6c). That figure has been transformed into an emir. He is flanked by two servants, at least one of whom holds a fly whisk, while a Nilotic scene can be made out below. Birds (probably a type of partridge) flock about him, in procession around the arch and perched on the columns of the arch. They come from different sources and are here combined to emphasize—or rather to glorify—power. The procession recalls the plaques of stucco birds decorating the Sasanian royal audience halls (iwan), while the columns with birds are reminiscent of the canon tables on the prefatory pages of Gospel books (cat. no. 39 and fig. 21).[52] The process of selecting images from the large visual repertoire of antiquity and then adapting them required the intellectual involvement of the patron (and perhaps also the artist), who was thus shaping a new Umayyad cultural identity.

If the famous Early Islamic mosaic floor with a central fruit tree and two gazelles peacefully browsing on leaves on one side while on the other a lion attacks a third gazelle had not been found in an excavation at Khirbat al-Mafjar, it might have been thought to come from the mosaic floor of the Great Palace in Constantinople (fig. 87).[53] Equally well known is a wall painting from Qusayr 'Amra in which six kings are shown paying homage to the Umayyad ruler, who is depicted at the end of the audience hall (fig. 88). Lined up like the retinues of Justinian and Theodora in the Byzantine mosaics at San Vitale, Ravenna, they are identified by inscriptions in Greek and Arabic.[54] The subject of the family of kings is part of the Iranian literary tradition. It promotes the idea of an international hierarchy of sovereigns, an exclusive club of powerful leaders, who are welcoming a new ruler into the bosom of the family. The message is strictly political, and the image serves propaganda purposes: standing aloof, the new monarch accepts the homage of the great kings of the earth and declares himself first among equals.[55] He is fully aware of his glorious ancestry, as was Yazid III (r. 744), whose proud words al-Tabari later recorded as follows: "I am the son of Kisra [Khusrau]; my grandfather is Marwan; one grandfather is a Qaysar [Caesar]; the other is a Khaqan [Great Khan]."[56]

The breakup of the Umayyad dynasty in 750 and the rise of the Abbasids have been described as concurrent with the cultural turn of the Islamic caliphate toward the east; the Late Antique traditions of Mediterranean Islam were relinquished and the focus shifted to the territory of Iraq, where a new capital, Baghdad, was built on the Tigris River, not far from Ctesiphon, the capital of the former Sasanian kingdom. However, that is only half the truth. The idea seems to coincide with the Abbasid chroniclers' desire to suppress every trace of the Umayyads. It is true that no more castles were built after the eighth century, but in the art and architecture of Samarra, the temporary Abbasid capital (founded in 836), most of the decorative and iconographic motifs are inconceivable without the earlier Umayyad qusur and their decoration. If in nothing else, the Umayyad period is reflected in the transitional composition of the vine and the tree over the Baghdad doors of catalogue number 160, and above all in the content of the wall paintings of Dar al-Khilafa in Samarra, with their huge cornucopias, dancing girls, and abundant vegetation. And it is perhaps also reflected in the style of these wall paintings, which modern scholars consider naturalistic and closely related to Umayyad models.[57] In short, a transition was formally accomplished, but the traditions of Late Antiquity, which secular art in particular continued to reflect, lived on.

Qasr al-Mshatta

Anna Ballian

One of the best-known Early Islamic monuments, of which numerous accounts have been written, is the vast but unfinished Umayyad castle of Mshatta (fig. 89).[1] From the moment of its discovery, this monument has been attributed at one time or another to every civilization and to all the likely tribal and religious groups in the Middle East, from the Parthians and Copts to the Ghassanids (a Christian Arab tribe) and Abbasids.[2]

Built in the Balqa region, south of Amman, roughly equidistant from al-Qastal and the reservoir at al-Muwaqqar, Mshatta is twice the size of the other Umayyad castles, roughly 158 yards (144 meters) long on each side—almost the size of a small town. Its appearance was that of an enormous fortress, with twenty-five semicircular towers and a single monumental entrance embellished with extravagant carved stone reliefs proclaiming its palatial character.

The organization of space at Mshatta along a longitudinal axis differs from that of other Umayyad castles (*qusur*, pl.; *qasr*, sing.), which are arranged around a central court. At Mshatta there is a central precinct with three adjoining areas: the gatehouse complex, which includes the mosque; the central courtyard; and the main palace, marked with a triple triumphal arch leading into a basilican hall and a triconch throne room, that is, with apses on three sides of a central square. The Umayyad palace on the acropolis in Amman presents a similarly longitudinal axial layout from portal to throne room. Both structures may be compared with the Sasanian palace Qasr-i Shirin, in today's Iran.[3] The throne room harks back to Roman imperial architecture and its Late Antique derivatives; in fact, the triconch plan with its familiar connotations of power is used in the nearby bishop's palace in Bosra dating to the sixth century.[4]

Mshatta's significance, however, is not its similarities to earlier monuments, which one would expect, but, rather, its relation to later Abbasid palace architecture. The extent and strictly geometric conception of the plan, the overall decoration of the walls, and the emphatically axial formal area ending in a throne room and separated from the living areas all foreshadow the palace at Ukhaydir

141. Relief with an Amphora

...................

Jordan, 8th century
Basalt
52 × 58.5 × 17.2 cm (20½ × 23¹⁄₁₆ × 6¾ in.)
Provenance: One of thirty-five reliefs recovered by the Department of Antiquities of the Kingdom of Jordan during the course of reed clearance in the lake/reservoir at 'Ayn as-Sawda (Azraq al Shishan) in 1983. They were put on loan to the Museum of Jordanian Heritage in 1988.
Condition: The surviving section is in good condition.
Museum of Jordanian Heritage, Yarmouk University, Irbid, Jordan (A822)

Azraq, about sixty-two miles (100 kilometers) east of Amman, is the only oasis in the eastern desert, which stretches from Jordan to Iraq; in earlier times, it was endowed with huge spring-fed pools and abundant vegetation. Azraq has always been an international crossroads and, from at least the Roman period on, a vibrant commercial center—the main caravan route from Arabia to Jordan and Syria passed through there. The present citadel (most probably Ayyubid [1169–1260]) was preceded by two earlier ones, the first built under Septimius Severus (r. 193–211), followed by the fort raised under Diocletian (r. 284–305).[1] Though no Early Islamic–built complexes have survived, the thirty-five reliefs found near the citadel in 1983 and the thirty-two found in 2004 are attributed to the Umayyad period (661–750) and testify to the site's continuous habitation. Some of these sculptures have rounded edges, which suggests they may have formed an arch above a platform overlooking the water reservoirs near Qasr al-Azraq.

This particular basalt relief depicts a two-handled amphora from which sprout pomegranates on foliate tendrils; other fragments found with this one depict real and imaginary animals, such as the *senmurw* and a Pegasus. These motifs are representative of the decorative repertoire of Late Antiquity, which was inherited by the Umayyads and adapted to their needs. The Dionysian and Christian symbolism of the vine scrolls springing from a vase has been lost, and the motif can be seen on the Mshatta facade (cat. no. 142B), on ivory panels (cat. no. 121), on pyxides (cat. no. 120), and on the carved wood panels of al-Aqsa Mosque in Jerusalem.[2]

AB

1 MacAdam 1994, p. 67.
2 Hillenbrand 1999b.

References: Bishah 1986; Aida Naghawy, "Four Basalt Reliefs," in *Discover Islamic Art: Museum With No Frontiers*, 2010, http://www.discoverislamicart.org/database_item .php?id=object;ISL;jo;Mus01_C;18;en.

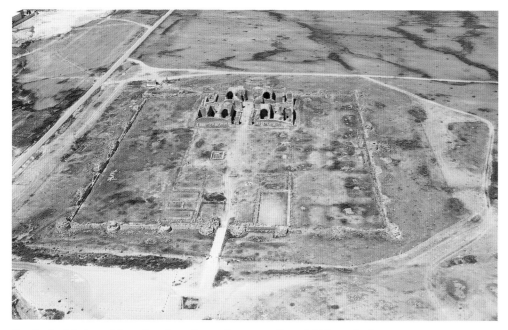

Fig. 89. Aerial view of the palace from the south, 743–44. Qasr al-Mshatta, Jordan

in Iraq (ca. 776) and the vast ninth-century complex at Samarra on the Tigris.[5]

Like other Umayyad palaces in the Balqa region, Mshatta is thought to have been commissioned by al-Walid II (r. 743–44). Al-Tabari, a ninth-century historian, tells us that at Ziza, a pilgrims' staging post not far from Mshatta, Walid, when still the heir apparent, received the annual Syrian caravan of pilgrims returning from Mecca and supplied them with food for three days.[6] This may be an indication that Mshatta was intended for that very purpose. The only historical personage securely linked with the site, however, was discovered, as a result of excavations, in a letter that mentions Sulaym ibn Kaysan al-Kalbi, a well-known official in the service of both the caliph Hisham (r. 724–43) and al-Walid II.[7]

142A–D. Architectural Fragments with Carved Decoration

....................

Qasr al-Mshatta, Jordan, mid-8th century
Limestone, carved

A. Fragment Carved with a Rosette
Approx. 45.7 × 83.8 × 30.5 cm (18 × 33 × 12 in.)
Provenance: In situ, at the archaeological site of Qasr al-Mshatta, Jordan.
Condition: There is limited damage to the carving.

B. Fragment Carved with Vine Scroll and a Vase
Approx. 45.7 × 83.8 × 30.5 cm (18 × 33 × 12 in.)
Provenance: In situ, at the archaeological site of Qasr al-Mshatta, Jordan.
Condition: There is limited damage to the carving.

C. Fragment Carved with Vine Scroll and a Triangle Trimmed with Bead-and-Reel Motif
Approx. 68.6 × 83.8 × 30.5 cm (27 × 33 × 12 in.)
Provenance: In situ, at the archaeological site of Qasr al-Mshatta, Jordan.
Condition: There is limited damage to the carving.
(A–C) Department of Antiquities, Qasr al-Mshatta Archaeological Site, Jordan

D. Female Torso
72 × 52 cm (23⅜ × 20½ in.)
Provenance: Found in an archaeological excavation at Qasr al-Mshatta, 1962.
Condition: Only the figure's torso survives; it displays some damage.
Jordan Archaeological Museum, Amman (J.16583)

The stone facade of al-Mshatta, the greater part of which is in Berlin, is divided geometrically into large triangles about 9 feet 5 inches high (2.9 meters) carved with luxurious vegetation and fauna (fig. 79).

It was clearly intended to be seen from afar by arriving caravans. It is probably no coincidence that the extremely ornate carved part of the facade comes from the central section, which leads to the throne room.

In the center of each triangle is a large six-lobed rosette.[1] The decoration on the triangles to the west of the entrance consists of vine scrolls inhabited by birds and real or imaginary animals drinking from a central vase. Among the animals are a classical centaur and a Persian *senmurw*. These mythical creatures were favorite examples adduced to support an invented East–West bipolarity, but they best visualize the common world of the eastern Mediterranean. There is also a fragmentary depiction of the Labors of the Months, a small human figure holding a basket for the grape harvest. The eastern part of the facade, which is the qibla wall—the wall facing toward Mecca and the Ka'ba—of the mosque, is decorated with similar grapevines and foliage but without the birds and animals, a composition usually interpreted as having been designed to comply with the Muslim prohibition on depicting living beings in religious buildings.

The six-lobed rosette can be seen clearly in fragment A, which was carved on two stone blocks joined horizontally. Fragment B has been identified as the central part of a triangle from the eastern side of the entrance,

D

one-third of which is in Berlin and on which a vase is depicted without the usual creatures shown drinking water.[2] On fragment C, at the left-hand side, part of a triangle is preserved, while on the right, part of the end triangle with beaded medallions (now in Berlin) has been identified.[3]

Though it may seem odd given the strict observance of the ban on depicting living creatures on the qibla wall, in the audience hall of the palace there was a procession of naked male and female statues. The female torso in the Jordan Archaeological Museum (D) is virtually naked; the artist drew attention to the pubic area and the buttocks, which are partly covered by a piece of drapery, as on the Bacchic dancing girls who accompany Dionysos. In her right hand she holds something, perhaps a piece of fruit, in front of her, while on the left is visible a basket or bag, which, though smaller, resembles the basket held by a naked female bather in Qusayr 'Amra (fig. 81). A similar female torso, whose buttocks are even more exposed, is preserved in the Museum für Islamische Kunst, Berlin, as are the other fragments of statuary.[4]

Similar sculptural decoration found in the audience rooms of Khirbat al-Mafjar has been interpreted as entertainers serving the caliph and his visitors.[5] Yet the female figures in Mshatta flaunt their sexuality without a trace of puritanical prudery; in this they are more reminiscent of the painted figures, whether bathing or otherwise, of Qusayr 'Amra than of the stiff female figures at Khirbat al-Mafjar, which are fully clothed from the waist down. AB

1 According to Creswell's (1932–40) numbering, triangles R, S, T, and U lack their six-lobed rosettes. At least one other rosette is still in situ, and there is another in the Jordan Archaeological Museum.
2 Triangle R: Creswell 1932–40, vol. 1, p. 373, pl. 77c.
3 Triangles U and V: ibid., pp. 373–74, pls. 78a–b.
4 Trümpelmann 1965, figs. 9–12.
5 Hamilton 1988; Baer 1999a, p. 23.

References: Creswell 1932–40, vol. 1, pp. 350–89; Trümpelmann 1965; Hillenbrand 1981; Creswell 1989, pp. 201–14; Enderlein and Meinecke 1992; Aida Naghawy, "Lower Part of a Semi-Naked Female Statue," *Discover Islamic Art: Museum With No Frontiers*, 2010, http://www.discoverislamicart.org/database _item.php?id=object;ISL;jo;Mus01;32;en.

A

B

C

Al-Fudayn

Anna Ballian

The Umayyad residence al-Fudayn is located in the small town of Mafraq, northeast of Amman, not far from the Syrian border, on the fringes of the desert known as the *badiya*, a region that was mainly agrarian in the past, just as it is today. In the Roman period, Mafraq was a crossroads that led to the Via Nova Traiana and connected Gerasa with Bosra;[1] after the seventh century it was an important staging post on the pilgrimage route to the holy places of Hijaz, on the Arabian Peninsula, via the oasis of al-Azraq.

The site had been inhabited since antiquity, and in the Byzantine period it accommodated a monastery—probably for the Ghassanids, a Christian Arab tribe—which the Umayyads transformed into an opulent residence (fig. 90).[2] The remains show two important groups of buildings organized around a central courtyard. In 1986 part of a mosaic pavement was found in the older of the two complexes. The mosaic was in a church that was identified as belonging to the Miaphysite monastery at Phedin, or al-Fudayn, an Aramaic place-name that has survived to the present day.[3] In the second group of buildings, where the apartments of the Umayyad owner were located, archaeologists found a mosque with fragments of plaster decoration around the mihrab attributed to the Early Abbasid period (fig. 91) and a bath complex, complete with furnace; hypocaust (under-the-floor heating system); cold, warm, and hot chambers; and a disrobing room.

Unlike the famous Umayyad castles (*qusur*), the agricultural estate of al-Fudayn has no encircling fortified walls or luxurious audience hall. However, according to the literary sources, two caliphs, Yazid II (r. 720–24) and his son Walid II (r. 743–44), visited it. Though we can only surmise who the owners of most castles were, we have plenty of evidence relating to al-Fudayn's Umayyad lord, Sa'id ibn Khalid ibn 'Amr ibn 'Uthman, great-grandson of the third Orthodox caliph, one of the first four caliphs after Muhammad, an exceptionally wealthy man with extensive properties in Damascus.[4]

Al-Fudayn is also mentioned in the early ninth century, when a namesake of Sa'id, Sa'id al-Fudayni, rebelled against the Abbasid caliph al-Ma'mun (r. 813–33), contending for power. But the revolution was swiftly snuffed out and al-Fudayn laid waste.

In 1987 in a passageway south of the church, which had been converted into storage space, a hoard was found containing luxury utensils made of metal, glass, steatite, ivory, and other materials, evidently buried to protect them from some natural or human disaster, probably in the early ninth century. The presence of objects made of valuable steatite and ivory brings into relief two significant aspects of al-Fudayn. First, these utensils demonstrate the owners' elevated social status, in some ways compensating for the archaeological lack of architecture, mosaics, and painted decoration. Second, they demonstrate that the site was oriented, both commercially and culturally, toward the Arabian Peninsula, as the steatite and ivory probably came from southern Arabia and the Hijaz via the pilgrimage routes.

143. Brazier

Jordan, 8th century (modern reproduction)
Copper alloy, cast and openwork; iron frame and rods
48 × 68 × 56 cm (18⅞ × 26¾ × 22¹/₁₆ in.)
Provenance: Excavated, along with a large cache of objects, in a corridor on the eastern side of the complex at the site of al-Fudayn (Mafraq) during the 1986 season.
Condition: This is a modern reconstruction from fragments. Conservation took place at the Jordan Archaeological Museum, Amman.
Jordan Archaeological Museum, Amman
(J.15700–J.15707)

One surviving side and seven pieces that once belonged to the brazier were found buried in the Umayyad storage room, formerly the entrance to the Byzantine church at al-Fudayn. The reconstruction incorporated the original side and replicated elements visible in the seven fragments. Square, with feet in the shape of eagles standing on wheels, the brazier was held together at the corners with iron rods that ended in handles in the form of statuettes of naked women wearing jewelry and holding birds.[1]

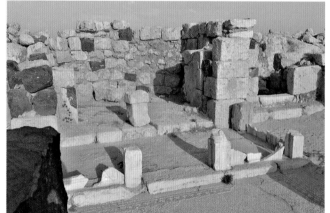

Fig. 90. View of church adjacent to the corridor where cat. nos. 143–148 were excavated, 6th–7th century. Al-Fudayn, Mafraq, Jordan

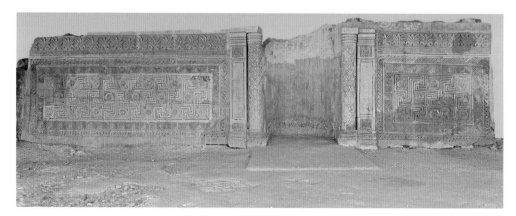

Fig. 91. Qibla wall and mihrab, 8th century. Mosque, al-Fudayn, Mafraq, Jordan

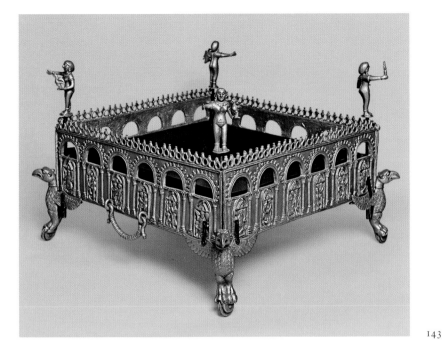

143

The architectural decoration consists of an arcade with six niches on a side showing Dionysiac scenes. Miniature pomegranates frame the arches and crown the crenellated superstructure like merlons. The architectural concept derives from Late Roman braziers, which have rectangular openings and stepped merlons as well as zoomorphic feet.[2]

In the niches at either end a seminaked satyr is depicted holding in one hand a wineskin and in the other a boat-shaped bowl, like the Sasanian bowl with Dionysiac scenes (cat. no. 19). He is leaning on a young boy, and on his right a long, thin vessel for decanting wine can be made out. The other niches contain Pan, recognizable from his goat's feet and horns, pouncing on a naked Maenad; a couple consisting of a naked woman and a seminaked man; a scene of sexual congress; and a follower of Bacchus holding a thyrsus and lunging at a nymph. A small panther, Dionysos's favorite feline, is under the feet of all the couples. We may suppose that the decoration on the other three sides would have completed the depiction of a Dionysiac procession, a Hellenistic theme whose transformations in its wanderings from Egypt and Constantinople to Khurasan and China provided inspiration for Umayyad art, too.[3]

These braziers were certainly luxury objects. The Book of Songs, a tenth-century compilation of early Arabic poetry by Abu l-Faraj al-Isfahani, mentions that a court poet once asked the caliph to give him the brazier that stood in front of his throne in payment for his services. However, a brazier with erotic imagery would be more suitable

in the context of the baths, where, as we know from the paintings at Qusayr 'Amra, it was customary to find decorative programs with scenes conducive to physical pleasure.[4] AB

1 Cf. the naked Sasanian and Egyptian dancers holding a bird or other object, Marshak 1986, pl. 189, and cat. nos. 137, 139.
2 Bronces 1990, p. 284, cat. no. 229.
3 Ettinghausen 1972, pp. 1–10. See also cat. nos. 9, 10.
4 Fowden 2004b, pp. 77–78, 180.

References: Humbert 1986, pl. 75; Voie royale 1986, pp. 267–68, cat. no. 353; Augé et al. 1997, pp. 160–64; Umayyads 2000, p. 68; "Brazier," in Qantara: Mediterranean Heritage, 2008, http://www.qantara-med.org/qantara4/public/show_document.php?do_id=102; Aida Naghawy, "Brazier," in Discover Islamic Art: Museum With No Frontiers, 2010, http://www.discoverislamicart.org/database_item.php?id=object;ISL;jo;Mus01;6;en.

144. Triangular Plaque

Eastern Mediterranean, 8th century
Ivory, incised
28 × 7 cm (11 × 2¾ in.)
Provenance: Excavated, along with a large cache of objects, in a corridor on the eastern side of the complex at the site of al-Fudayn (Mafraq) during the 1986 season.
Condition: The plaque was found in fragmentary condition in 1987 and partly reconstructed.
Jordan Archaeological Museum, Amman (J.15709)

The triangular shape of this ivory object is reminiscent of a sword blade. The hilts on high-quality swords were usually made of ivory, which raises questions about the use of this particular, certainly decorative artifact. On one side is a summary depiction of a palm tree in front of an arch decorated with a hanging lamp; on the other, a camel with her calf.

All the iconographic features point to a Syrian/Umayyad context. The arch with the hanging lamp is depicted on a steatite lantern, also found at al-Fudayn (cat. no. 146). Camels and palm trees appear in the pavement mosaics of Syrian churches, while depictions of palm trees predominate in the mosaics of the Dome of the Rock.[1] In this case, the combination of the palm tree with the arch in the background recalls the mosaic decoration in the inner courtyard of the Umayyad mosque at Damascus, with its fruit trees in the foreground and architectural landscape behind (figs. 101, 102).

From this early period on, the arch with a hanging lamp has been depicted frequently all over the Islamic world. It has become the visual symbol of the niche of the mihrab, associated and often inscribed with the "Sura of Light" (Qur'an: 24:35), which says: "God is the Light of Heaven and Earth! His light may be compared to a niche in which there is a lamp; the lamp is in a glass; the glass is just as if it were a glittering star." AB

1 Piccirillo 1992, pls. 166, 250, 277, 572; Creswell 1932–40, vol. 1, figs. 146–149.

References: Humbert 1986; Voie royale 1986, p. 269, cat. no. 355, with a drawing of the one side; Aida Naghawy, "Fragment of an Ivory Dagger," in Discover Islamic Art: Museum With No Frontiers, 2010, http://www.discoverislamicart.org/database_item.hp?id=object;ISL;jo;Mus01;13;en.

144 obverse 144 reverse

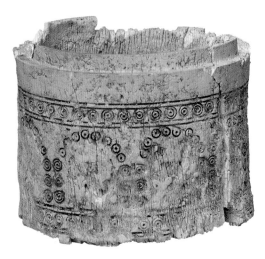

easy access to these materials, whether ready-worked or in their raw state. By contrast, in Constantinople in the same period—the seventh to eighth century—ivory had ceased to be available for reasons that remain obscure. Trade connections with East Africa may have been disrupted, perhaps by hostilities between the Arabs and the Byzantines. When ivory once more became available in Byzantium, from the ninth century onward, the trade was in the hands of Arab merchants.[3]

<div style="text-align: right">AB</div>

1 Alaoui 2000, pp. 210–11, cat. nos. 254–256, pp. 118–19, cat. nos. 272, 273; Rosser-Owen 2004, pp. 18–23, cat. nos. 2–4.
2 E. Kühnel 1971, no. 18; Shalem 2005, p. 27; a dating between 762 and 764 is given in Ettinghausen et al. 2001, p. 63.
3 Cutler 1985, pp. 29–30, 39–40; Cutler 1994a, pp. 56–59, 199–200.

References: Humbert 1986; *Voie royale* 1986, p. 270, cat. no. 356; "Pyxis," in *Qantara: Mediterranean Heritage,* 2008, http://www.qantara-med.org/qantara4/public/show _document.php?do_id=118; Aida Naghawy, "Ivory Container (Pyxis)," in *Discover Islamic Art: Museum With No Frontiers,* 2010, http://www.discoverislamicart.org /database_item.php?id=object;ISL;jo;Mus01;12;en.

145. Pyxis

....................

Eastern Mediterranean, 8th century
Ivory, carved, incised, and infilled with red and black pigments
H. 8 cm (3⅛ in.); Diam. 9 cm (3½ in.)
Provenance: Excavated, along with a large cache of objects, in a corridor on the eastern side of the complex at the site of al-Fudayn (Mafraq) during the 1986 season.
Condition: The pyxis was found in fragmentary condition and partly reconstructed. The lid is missing.
Jordan Archaeological Museum, Amman (J.15708)

A notch at the top of the sides of this small cylindrical box shows where the lid was once attached. The sides are carved with an arcade between two parallel bands of concentric circles, each with a dot in its center. The arches are formed of similar circles with dots, whereas their supports are made of concentric red circles that may have been stamped. Circles with dots, an extremely common decorative motif in antiquity and the Middle Ages, appear on wood, leather, bone, and ivory objects,[1] including dice, examples of which have also been found at al-Fudayn.

The al-Fudayn pyxis recalls the one preserved at the Church of Saint Gereon, Cologne, which has a pyramidal cover and a similar ornamentation of red and black circles and dots. According to its inscription, it was made in Aden between 778 and 784.[2] The evidence of the inscription is a reminder of the route the ivory took from East Africa and Ethiopia to the port of Oman, where it was worked, before arriving at Bilad al-Sham (Greater Syria) via the trade routes of the Arabian Peninsula. Al-Fudayn was one of the last stops on the journey between Medina and Damascus.

The ivory finds from al-Fudayn represent a significant group of objects that reveal the high status of the villa's owners and their

146. Part of a Lantern

....................

Eastern Mediterranean, 8th century
Steatite, carved and engraved
H. 20 cm (7⅞ in.); Diam. 15 cm (5⅞ in.)
Provenance: Excavated, along with a large cache of objects, in a corridor on the eastern side of the complex at the site of al-Fudayn (Mafraq) during the 1986 season.
Condition: The object has been pieced together from about thirty fragments and partly reconstructed; nearly half of the bell shape is missing.
Jordan Archeological Museum, Amman (J.19312)

Although only one side survives, this bell-shaped object has been identified as a lantern.[1] The surface is divided into six zones, of which five contain geometric decorations of triangles, rhombuses, rosettes, dots, and circles. The broad band on the base depicts an arcade with hanging, probably bowl-shaped, lamps. This is an emblematic form of decoration of which perhaps the earliest and undoubtedly the most striking example is in the Umayyad Qur'an found at Sana'a, which depicts a hypostyle mosque (fig. 110).[2] In this case, the shape of the lantern suggests the dome of a building. In Late Antiquity, lighting devices and incense burners often had architectural shapes (cat. no. 150). It may have been the Dome of the Rock in

Jerusalem that inspired the arcade on this lantern.

Steatite is an expensive imported material, and artifacts made of this soft soap stone were luxury goods, intended for the elite of the period. The lantern was found in a cache, probably to save it from some sudden catastrophe in the early ninth century. Indeed, such prized objects were likely to be carefully preserved and repaired; an example is a steatite cooking pot, found with others in the Amman excavations, which had a new bottom attached with iron rivets.[3] However, it is less sure whether the decoration was added in situ or if the ready-made product was imported from Arabia.

<div style="text-align: right">AB</div>

1 The undecorated earthenware lanterns found at Susa and Nishapur, in modern-day Iran, are similar in shape, though made to more humble specifications; see Joel and Peli 2005, p. 188, nos. 252, 253; C. Wilkinson 1973, p. 307, nos. 52, 53.
2 Piotrovskii 1999, pp. 100–101, cat. no. 36.
3 Harding 1951, p. 10.

References: Voie royale 1986, p. 270, cat. no. 357; Augé et al. 1997, pp. 161, 167; *Umayyads* 2000, p. 69; "Part of a Steatite Lantern," in *Qantara: Mediterranean Heritage,* 2008, http://www.qantara-med.org/qantara4/public/show _document.php?do_id=107; Aida Naghawy, "Steatite Base," in *Discover Islamic Art: Museum With No Frontiers,* 2010, http://www.discoverislamicart.org/database_item .php?id=object;ISL;jo;Mus01;44;en.

147. Cooking Pot

....................

Eastern Mediterranean, 8th century
Steatite, carved and engraved
20.3 × 25.4 cm (8 × 10 in.)
Inscribed: In Arabic, in Kufic script, on the interior, لنوار (For Nawwar)
Provenance: Excavated, along with a large cache of objects, in a corridor on the eastern side of the complex at the site of al-Fudayn (Mafraq) during the 1986 season.
Condition: The vessel is in good condition with limited losses around the opening.
Jordan Archaeological Museum, Amman (J.19308)

One of ten steatite vessels found during the excavations of al-Fudayn in a hoard that contained other household objects, this nearly cylindrical pot has upright sides with ledge handles. Two of the cooking pots are inscribed "For Nawwar," apparently their owner.

Cooking pots of similar shape have been found among Umayyad and Abbasid ceramic and copper-alloy vessels of the eighth and ninth centuries.[1] The surface is covered with a geometric design made with a ruler: upright

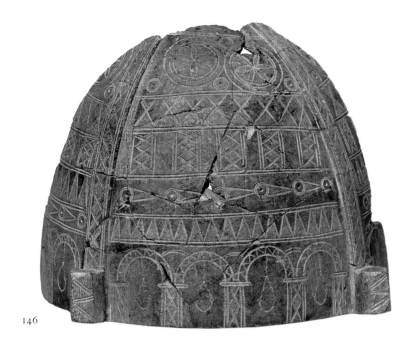

146

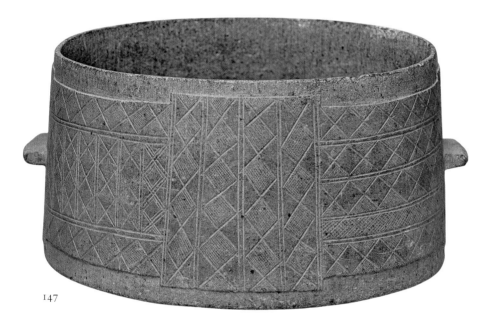

147

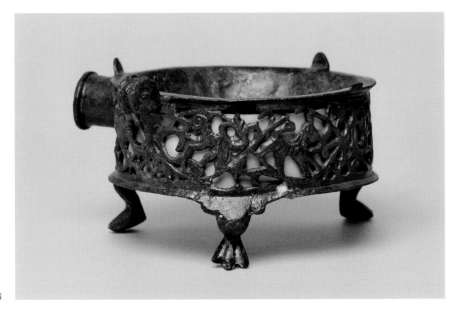

148

and horizontal panels contain lozenges and triangles filled with cross-hatching or left blank. This linear geometric style recalls the engraved glass of the period, which in turn imitates certain metalwork prototypes.[2]

Steatite is a soft stone, gray-green in color and easy to carve. Because of its high tolerance to changes in temperature and resistance to extreme heat, it was used for manufacturing cooking vessels, incense burners, and lamps. Though the steatite quarries in Yemen were known in antiquity, in this later period the raw material came from the Hijaz in what is today western Saudia Arabia (al-Hawra' and Ta'if regions).[3] Reflecting the seventh-century political unification of the Middle East and the Arabian Peninsula, steatite artifacts became common excavation finds in the cities dotted along the north–south trade and pilgrimage routes, with important finds at Ayla (today's Aqaba), Amman, Umm al-Walid, al-Fudayn, Gerasa (today's Jerash), Pella (today's Fihl), and Tiberias (today's Tabariya).[4] AB

1 *Umayyads* 2000, pp. 51, 155.
2 Carboni and Whitehouse 2001, pp. 162–67, cat. nos. 68–73.
3 Al-Ghabban et al. 2010, p. 442.
4 Walmsley 2007, p. 68.

References: Humbert 1986; Augé et al. 1997, pp. 168–69; *Umayyads* 2000, p. 52; "Cooking Pot," in *Qantara: Mediterranean Heritage*, 2008, http://www.qantara-med .org/qantara4/public/show_document.php?do_id=113.

148. Incense Burner
....................

Eastern Mediterranean, 8th century
Cast copper alloy, openwork
6.5 × 12 cm (2⅝ × 4⅝ in.)
Provenance: Excavated, along with a large cache of objects, in a corridor on the eastern side of the complex at the site of al-Fudayn (Mafraq) during the 1986 season.
Condition: Three small projections on the lip and a hinge bear traces of the pin that once secured the now-lost lid. The hollow cylindrical socket on the side was intended for a long horizontal handle.[1]
Jordan Archaeological Museum, Amman (J.15710)

All that survives of this incense burner is the openwork cylindrical base that stands on three zoomorphic feet and holds a shallow bowl. This type of openwork incense burner is well known from fifth- and sixth-century examples, the most famous perhaps being the one in The Metropolitan Museum of Art (cat. no. 122A), which is decorated with an inhabited foliate scroll.[2] Here, as on

the New York example, scrollwork encircles six quadrupeds trotting amid stylized foliage. The lid probably closely resembled those on the incense burners in the Malcove Collection, Toronto (cat. no. 122B) and the Musée du Louvre, Paris (cat. no. 122C); once attributed to Coptic Egypt, these have been redated by more recent scholarship to the Early Islamic period, on the basis of archaeological finds such as those at al-Fudayn.

The production of household base-metal utensils does not seem to have changed dramatically in the period before and after the Muslim conquest of the areas around the Mediterranean. On the contrary, the transition is almost imperceptible, and developments continued uninterrupted. Examples of incense burners come from Spain, Egypt, and Syria, and there is a group originally thought to be of Persian origin and attributed to Khurasan, on today's Plateau of Iran.[3] AB

1 The handle would have been similar to the one on the incense burner found on the acropolis in Amman (cat. no. 150A) or the one in the Malcove Collection (cat. no. 122B). See also Atıl et al. 1985, cat. no. 2; Augé et al. 1997, p. 172; Khalili 2005, p. 110.
2 Weitzmann 1979a, cat. no. 323.
3 Baer 1983, figs. 32–35; Allan 1986, pp. 25–34; Alaoui 2000, p. 116, cat. no. 92. See also Melikian-Chirvani 1982, p. 32, fig. 7, for a piece found in Kabul but of unknown provenance. The striking way in which these incense burners developed in the Islamic world was identified as early as 1945 by Mehmet Aga-Oglu. They are forerunners of the thirteenth- and fourteenth-century copper-alloy incense burners inlaid with silver from Syria and the Jazira. See Aga-Oglu 1945; Allan 1986, pp. 66–75, nos. 1–3.

References: Humbert 1986; Voie royale 1986, p. 269, cat. no. 354; Augé et al. 1997, p. 165; "Incense Burner," in Qantara: Mediterranean Heritage, 2008, http://www .qantara-med.org/qantara4/public/show_document .php?do_id=988.

Al-Qastal

Anna Ballian

Al-Qastal, an Umayyad castle fifteen miles (twenty-five kilometers) south of Amman, is a complex of buildings—a residential palace, a mosque, a bathhouse, a cemetery, and domestic quarters—scattered among what were once large tracts of land under cultivation. These were maintained by means of sophisticated water-harvesting systems, consisting of a large reservoir, many smaller underground cisterns, and a 437-yard-long (400 meters) dam. By the early twentieth century, the area was abandoned and isolated.

The palace complex was located inside a walled precinct measuring about eighty-one square yards (sixty-eight square meters). The towers placed at intervals and flanking the entrance gave the impression of a fortress; in fact, they were either solid structures or used as latrines. As with most Umayyad castles, the gatehouse was impressive. It was originally two stories high, with two staircases, one on either side of the portal; this opened onto a double-length audience chamber or entrance hall, furnished along either wall with finely carved stone benches with armrests. On the upper floor, above the entrance, was the main triconch, or triple-apsed, audience hall, like the one on the Amman acropolis (fig. 82). The gatehouse opened to a porticoed court around which were organized six apartments or bayts (self-contained living units), each one consisting of four rooms around a small courtyard.[1]

The mosque stood outside the precinct; only the lower parts of the walls and a minaret almost twenty feet (six meters) high survive (fig. 92).[2] The latter, with its ribbed Corinthian pilasters at the second-floor level, is one of the earliest minarets known in the Islamic world. The cemetery at al-Qastal is also extremely old; it was used continuously up to the tenth century, and some of the earliest tombstones are oriented toward Jerusalem, not Mecca.

In another building in this complex, about 437 yards (400 meters) from the qasr, or castle, some exceptional mosaic pavements were recently discovered; the scenes depict a lion fighting a bull and a leopard devouring a gazelle.[3] The iconography suggests that this area was probably the audience

room of a bathhouse: these subjects, relating to bodily strength and invigoration and represented in Late Antique baths, appear on the floor of the Umayyad bathhouse at Khirbat al-Mafjar outside Jericho (fig. 87).

Al-Qastal was built in the border zone between the agricultural land and the desert, an area known in Arabic as badiya. Like other high-profile luxury properties in the area, such as nearby al-Mshatta (see Ballian, p. 209, and cat. no. 142), al-Fudayn (see Ballian, p. 212, and cat. nos. 143–148), and al-Muwaqqar (of which only the reservoir survives), al-Qastal is connected with the caliph Yazid II (r. 720–24), whose patronage, like that of his son al-Walid II (r. 743–44), was active in this part of Jordan.[4] In a panegyric addressed to Yazid, the court poet Kuthayyir 'Azza (d. 723) mentions al-Muwaqqar and Qastal al-Balqa as belonging to Yazid and gives Qastal the toponym "al-Balqa," which designates the surrounding area to this day. Walid II seems to have inherited his father's love of the area, because he repaired there when relations soured between himself and his uncle, the caliph Hisham; according to the tenth-century historian al-Azdi, Walid was residing at al-Qastal when the news of Hisham's death reached him.[5]

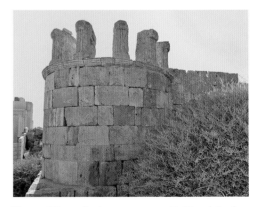

Fig. 92. View of minaret, 720–24. Al-Qastal, Jordan

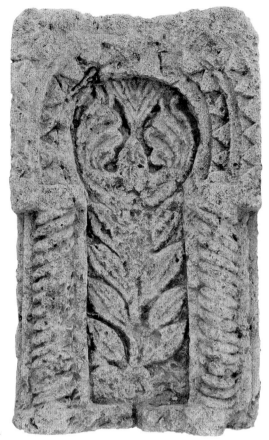

A

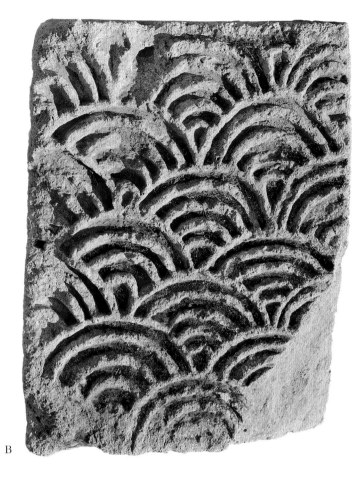

B

149A–C. Three Carved Stone Blocks with Architectural Decoration

......................

Jordan, Al-Qastal, 720–24
Limestone, carved

A. Block Carved with an Arch
Approx. 45.7 × 83.8 × 30.5 cm (18 × 33 × 12 in.)

B. Block Carved with a Fan Pattern
Approx. 45.7 × 83.8 × 30.5 cm (18 × 33 × 12 in.)

C. Block Carved with Acanthus and Palmette
Approx. 45.7 × 83.8 × 30.5 cm (18 × 33 × 12 in.)

Provenance: In situ, in the courtyard of the archaeological site of Qasr al-Qastal.
Condition: There is limited damage to the carving of the blocks.
Department of Antiquities, Qasr al-Qastal Archaeological Site, Jordan

Excavations in the residential palace at al-Qastal have brought to light at least one hundred blocks of stone carved with foliate or other decorations, which had been part of the ornamentation of the gatehouse. They had either fallen from the audience chamber on the floor above or embellished the ground-floor entrance hall.

In the courtyard near the portal were found many fragments of stone blocks carved with blind niches, as, for example, catalogue number 149A, which may have

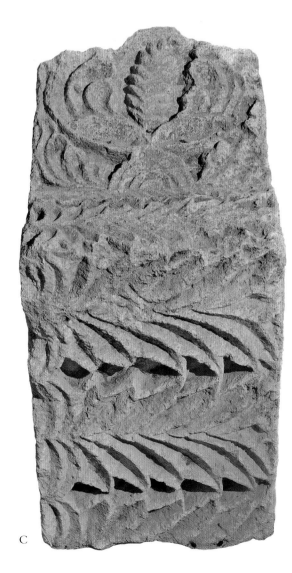

C

been located on the upper part of the walls above a dado. In the Amman citadel, the interior of the monumental audience hall is decorated similarly, with blind arcading in three superimposed registers, a treatment that also occurs on the external walls of the building and on the surviving wall of the neighboring mosque (fig. 82).

Blind niches are a feature of Sasanian architecture, immediately recognizable on the facade of the palace at Ctesiphon; transformed in various ways, they were transferred to Umayyad and Abbasid facades, interior decoration, monumental gateways, and palace complexes, as at Qasr al-Hayr al-Gharbi and Ukhaydir.[1] On Sasanian monuments the blind arcades still evoke their origins in the structure of the building, but in Umayyad architecture they become a decorative device framing foliate and palmette decoration, with each arch being different.

The blind niches in both the Amman palace and al-Qastal are decorated with indentations, sit on engaged columns, and frame foliate designs. The repertoire is similar at both sites; block A, for example, has an upright foliated stalk ending in a split palmette. The most likely reason for the similarity of the design is that the same team of craftsmen worked on both palaces.

Another motif common to the Amman acropolis and al-Qastal, the fan pattern or scales, is seen on B. An exceptionally widespread form of Greco-Roman decoration, scales are transformed in the Early Islamic period in terms of both size and medium and translated from the mosaic pavement (fig. 5) or painting to the decoration of architectural sculpture in stone.[2]

The third block, C, which probably comes from a cornice that projected some way from the upper part of the walls, displays ornamentation on two sides. The lower edge, which the viewer would have seen from below, is decorated with three parallel series of acanthus leaves, while the upright edge slopes slightly outward and has an open split palmette. The roof beams probably sprang from the top of the block, or it could have been a base for three-dimensional sculpture, as at Khirbat al-Mafjar.[3] AB

1 Schlumberger 1986, pl. 58; Creswell 1932–40, vol. 1, fig. 44.
2 Piccirillo 1992, p. 147, fig. 184, p. 307, fig. 606, p. 331, fig. 703.
3 Hamilton 1988, pp. 24–25, fig. 6, p. 39, fig. 13.

References: (A) Unpublished; (B) *Umayyads* 2000, p. 108 and front cover; (C) unpublished.

150A, B. Incense Burners from the Citadel of Amman

....................

A. Censer with a Ram's Head Handle
Eastern Mediterranean, 8th century
Cast copper alloy, engraved and punched
11.5 × 21 cm (4½ × 8¼ in.)
Provenance: Excavated at the citadel of Ammam, Jordan, in 1949 by the Jordan Department of Antiquities during construction of the Jordan Archaeological Museum. Found in Room D of a large house dating to the Umayyad period.
Condition: The incense burner is in good condition, with limited damage.
Jordan Archaeological Museum, Amman (J.1660)

B. Censer with Architectural Elements
Eastern Mediterranean, 8th century
Basalt
21 × 16.5 cm (8¼ × 6½ in.)
Provenance: Excavated at the citadel of Ammam, Jordan, in 1949 by the Jordan Department of Antiquities during construction of the Jordan Archaeological Museum. Found in Room F of a large house dating to the Umayyad period.
Condition: The incense burner has been broken and restored.
Jordan Archaeological Museum, Amman (J.1663)

Although these two incense burners come from the excavation of a single site on the acropolis in Amman, they represent two distinct but geographically neighboring traditions, the Mediterranean world of Late Antiquity and the Arabian Peninsula.

The form of A is known to us from both Byzantine and Early Islamic examples.[1] The handle terminating in a ram's head was probably added at a later date. The architectural shape of the lid is reminiscent of depictions of ciboria on ivory panels and is attested on censers of the sixth to eighth century from areas around the Mediterranean, such as Syria, Dalmatia (today's Croatia), and Morocco.[2]

The body of the censer is engraved with a repeating floral pattern on a finely ring-punched ground between beaded lines and recalls textile, rather than mosaic, decoration. Early Islamic textile design, which is often small in scale, was transferred and adapted more or less successfully to the decoration of both metalwork and glass.[3]

Censer B is made of basalt, a stone typically found in the Hawran and Bosra regions of Syria; this means that it was transported to Amman either en bloc or ready-fashioned. It is an open structure with four arched apertures, with engaged columns at the corners; a roof with crenelations; and a low dome. Originally it was thought to be a model of a fire altar; however, although no trace of burning was discovered, it is more likely an incense burner in the tradition of those found in pre-Islamic Arabia and Syria.[4] Nevertheless, the most attractive theory compares this basalt artifact with extant Umayyad structures such as the monumental gatehouse to the palace on the Amman acropolis, which served as an audience hall (fig. 82). AB

A

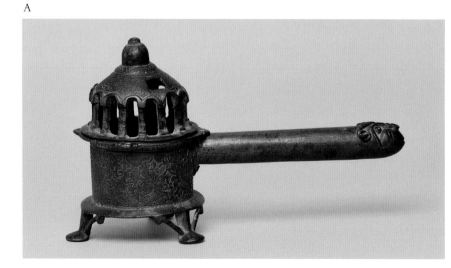

B

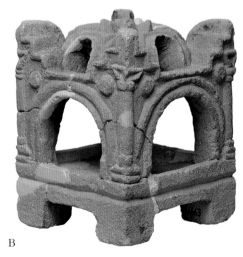

1 Cf. cat. nos. 122, 148.
2 See cat. nos. 24, 148. For censers, see Atıl et al. 1985,
 cat. no. 2. For a censer found in Crikvine (Dalmatia),
 dated to the sixth century, see Cabrol 1907, vol. 1,
 col. 24, fig. 4066, col. 28, fig. 4069. The Volubilis
 (Morocco) censer was a chance surface find in the
 area of the Early Islamic *hammam* (bath); see Allan
 1986, p. 27, fig. 18, and also his chapter on Early
 Islamic incense burners, ibid., pp. 25–34. The devel-
 opment of the architectonic lid in western Europe
 leads to the Romanesque and Gothic censers; Gousset
 1982. In the Islamic world, the thirteenth-century
 inlaid incense burners from Syria and the Jazira con-
 tinue the tradition.
3 Cf. cat. no. 174.
4 Al-Ghabban et al. 2010, p. 261, cat. nos. 109, 110,
 pp. 326–29, cat. nos. 137–145.

References: (A) Harding 1951; Allan 1986, p. 27, fig. 19;
Voie royale 1986, p. 276, cat. no. 371; Aida Naghawy,
"Incense Burner," in *Discover Islamic Art: Museum With No
Frontiers,* 2010, http://www.discoverislamicart.org
/database_item.php?id=object;ISL;jo;Mus01;9;en;
(B) Harding 1951, pp. 10–11, pl. II/20; *Voie royale* 1986,
p. 276, cat. no. 369; *Umayyads* 2000, pp. 69–70; "Brûle-
parfum de forme architecturale," in *Qantara: Patrimoine
Méditerranéen,* 2008, http://www.qantara-med.org
/qantara4/public/show_document.php?do_id=106.

151 A, B. Jugs
....................

A. Jug with Rope Decoration
Eastern Mediterranean, 8th century
Copper alloy (98.2% Cu, 0.74% Pb), four parts
joined together
H. 41.8 cm (16⁷⁄₁₆ in.); Diam. of neck 7 cm (2¾ in.)
Provenance: The object was recovered in the bath
(*hammam*) of Umayyad-period palatial buildings during
archaeological excavations at Umm al-Walid, Jordan,
in 1992.
Condition: The jug is in good condition, with signs of wear.
Madaba Archaeological Museum, Jordan (M.4862)

B. Jug with Loop Handle
Eastern Mediterranean, first half of 8th century
Copper alloy
H. 40 cm (15¾ in.); Diam. of body 27 cm (10⅝ in.)
Provenance: The object was recovered during the course
of archaeological excavations in 1999–2000 in a house
that lay south of the mosque on the Citadel of Amman.
Condition: The jug is in good condition, with limited wear.
Spanish Archaeological Mission, Amman

These two bronze jugs were found during
archaeological excavations of Umayyad-
period palatial buildings in Jordan. Jug A,
from Umm al-Walid, without a handle, has a
tall neck divided into two unequal parts by a
decorative rope band. The cylindrical body is
plain, although the shoulder is divided into
narrow bands that are filled with short verti-
cal strokes. It was found in the *hammam*
(bath) at the site. Jug B, from the Amman
Citadel, has a high loop handle attached to

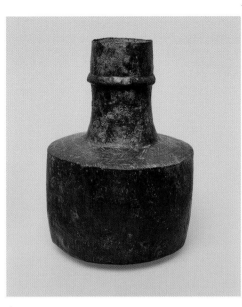

A

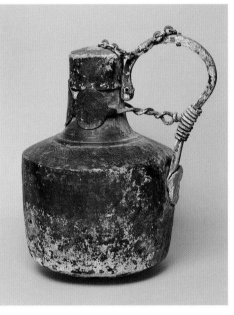

B

the lid with a chain. On the neck, three
disks, decorated with incised rosettes and
concentric circles, form a collar that is nailed
to a twisted arm ending with a curled spiral
on the lower part of the handle. The vessel
was found in a room in a building to the
south of the Umayyad-period mosque that
may have been part of the governmental
administrative complex (*dar al-imara*) there.[1]
 Such decorated jugs in copper alloy were
more expensive than ordinary water jugs
made of pottery, indicating that their users
had some status, befitting their findspots in
palatial buildings of the Umayyad rulers. Their
use as water jugs for the purification washing
ritual before the daily Islamic prayers is plau-
sible, although their findspots do not con-
firm such an assumption about their religious
use. A parallel bronze jug missing its handle
was excavated in Pella in northern Jordan

within a deposit of debris from the 749
earthquake.[2] RS

1 See I. Arce 2008 for information about the site in
 general.
3 Smith and Day 1989, p. 69, object no. 350126, pl. 38h,
 pl. 62.9.

References: (A) Haldimann 1992; Bujard and Schweizer
1994; Joguin 2001, fig. 5; Bujard 2005; (B) Aida Naghawy,
"Jug," in *Discover Islamic Art: Museum With No Frontiers,*
2010, http://www.discoverislamicart.org/database_item
.php?id=object;ISL;jo;Mus01_H;34;en.

152. Ewer, Signed by Ibn Yazid
....................

Iraq, dated A.H. 69 (688/89) or [1]69 (783/84) or [2]69
(882/83)
Copper alloy, cast
65.2 × 32.2 × 47.2 cm (25¹¹⁄₁₆ × 12¹¹⁄₁₆ × 18⁹⁄₁₆ in.);
10.3 kg
Inscribed: In Arabic, in Kufic script, around the rim,
بركة من صنعه ابن يزيد مما عمل بالبصرة سنة تسع وستين.
(Blessings to he who fashioned it, Ibn Yazid, part of what
was made at Basra in the year sixty-nine)
Provenance: Collection of Alexander Roinishvili
(1846–1898), until 1889; entered the collections of the
Society for the Spreading of Literacy among Georgians
in 1889; the society's collections became part of Georgian
National Museum in 1925.
Condition: The ewer is dented with holes in neck and
body; otherwise intact.
Georgian National Museum, Tbilisi (w\k I\5)

Beginning in the Early Islamic period,
utilitarian base-metal objects such as this
ewer were transformed into sophisticated
works of art. Signed and dated, the ewer is
evidently among the first such objects in this
medium. It demonstrates a continuation and
synthesis of pre-Islamic practices combined
with new patronage and taste, which would
make metalwork one of the most important
art forms in the Islamic world.
 Inscribed in a single line encircling the
rim and written in a plain Kufic script with-
out either the points that distinguish one
consonant from another or short vowels, the
ewer's dated signature has been the subject
of much debate.[1] A possible reading of the
inscription is suggested above. The artist's
name also might be read as Abu Yazid,[2] but,
more significant, a date of A.H. 169 or even
269 has been proposed, on the supposition
that a lack of space may have caused the
word(s) indicating the century to be omit-
ted.[3] One of the two later dates is generally
preferred on stylistic grounds.
 The ewer's pear-shaped body, long neck,
and high, flaring foot, as well as the handle

terminating in a half-palmette-shaped thumb rest, relate it to Sasanian and especially post-Sasanian metalwork.[4] The somewhat heavier form and the faceting on the body and neck, however, suggest a late eighth- or ninth-century date, as do the playful stylized birds at the base of the handle and around the mouth, which seem to be morphing from or into leaves. The rich surface decoration, composed of classically inspired, highly stylized scrolling leaves marked by circular punches, likewise recommends a date in the Abbasid period, in particular the ninth century.[5]

Because its inscription clearly specifies that the ewer was made in Basra, in today's southern Iraq, a number of other vessels of the identical shape with the same distinctive thumb rest have been similarly attributed.[6] From its place of origin, this type of metal object traveled to the eastern Iranian world, where it seems to have remained in use into the twelfth century.[7] LK

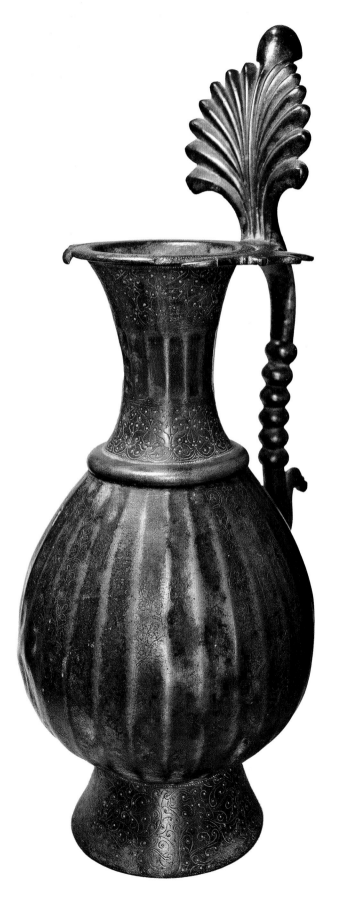

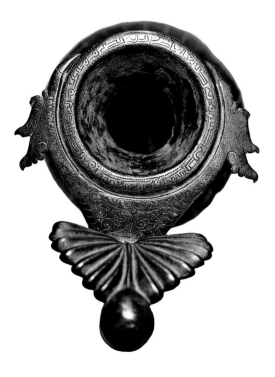

1 Summarized in Blair 1998, pp. 117–18, where she suggests "sixth–seventh" as another possible reading of the date, but see also Lukonin and Ivanov 1996, pp. 112–13.
2 See Lukonin and Ivanov 1996, pp. 112–13.
3 Marshak 1972, pp. 69ff. The date is written out in words and, as is typical, begins with the units followed by the tens, that is, "nine and sixty." Blair 1998, p. 118, has suggested that the somewhat analogous inscription on the Hermitage bird-shaped vessel (cat. no. 169), in which the date had to be squeezed in below the city name, supports such a hypothesis. The inclusion of the century in the date would have been less critical and may have been inferred, just as in modern times the date may be abbreviated, for example, to "'11," in instances when it is clearly understood that the full date is 2011.
4 See Pinder-Wilson 1960, where the author notes a familiar relationship with Roman metalwork.
5 See Lukonin and Ivanov 1996, p. 113, following Marshak 1972.
6 A partial list is provided in Baer 1983, pp. 83–84; vessels of this type continue to appear on the art market with some regularity.
7 Marshak 1972. Also see Melikian-Chirvani 1982, pp. 45–46, for an analogous example from the tenth to eleventh century, and 1966, pp. 85–86, for a related twelfth-century ewer.

References: Marshak 1972; Baer 1983, p. 83; Lukonin and Ivanov 1996, pp. 112–13, no. 86; Blair 1998, pp. 117–18.

An Abbasid Residence at al-Humayma

Rebecca M. Foote

Al-Humayma is located in the Hisma desert of southern Jordan, on an ancient and primary north–south route running between Syria and Arabia. Nabataean, Roman, Byzantine, and Muslim cultures flourished in a mixed economy of pastoralism, settled agriculture, and trade between the first century B.C.E. and the eighth century C.E., when the site was most intensively occupied. This was largely due to the extensive and sophisticated water management system the Nabataeans established to capture and control the limited local resources.

Findings from survey and excavation at al-Humayma (ancient Hawara/Havarra/Auara) and the environs since the 1980s reveal much variety and many changes over time.[1] For example, during the fifth and sixth centuries the Christian population built at least five large churches and enjoyed wide contacts, demonstrated in a hoard of gold coins issued by the Byzantine emperor Arcadius (r. 395–408) and silver coins minted by the Sasanian king Yazdegard (r. 399–420) found near the site.

The Abbasids, a Muslim family from Mecca related to the Prophet Muhammad, purchased al-Humayma sometime in the late seventh or early eighth century and built a large residence (*qasr*) and a small mosque

there (fig. 93). The route passing by the site connected the political hub of Damascus and the religious centers of Mecca and Medina, with the hajj, administration, and trade contributing greatly to its traffic. Toward the middle of the eighth century a few members of the Abbasid family sought the caliphate and covertly conspired to overthrow the reigning Umayyads (661–750; cat. no. 153). After their supporters made advances in the east, the Abbasids left the site for Iraq in 749 and just over a decade later established their caliphal capital of Baghdad.

153A–C. Furniture Veneer Panels

....................

Probably east of the Euphrates River, first half of the 8th century
Fragments of thin sheets of ivory (elephantine),[1] now consolidated
Each approx. 30 × 10 × .03–.05 cm (11 13/16 × 3 15/16 × 1/100–2/100 in.)
Provenance: Excavated from the Abbasid family residence (*qasr*) in Field F103 at al-Humayma, Jordan, 1992–2000, from a room located across the courtyard from the main entrance. Unlike any other excavated in the building, the room was frescoed; this, along with the presence of the ivories, suggests that it served a special, possibly reception, function.[2] Now under the Department of Antiquities, Amman.

Condition: Part of a group of ivory fragments discovered burned and crushed under a layer of mud brick and fresco. The fragments had been subjected to varying degrees of heat during a fire that destroyed the room (probably in the 8th century, when the Abbasids were leaving or just after). This is reflected in their color, which ranges from tan (low temperature) through black, gray, gray-blue, to white (highest temperature). The variation in heating resulted in differing degrees of porosity and fragility, which affected treatment and reconstruction. At the time of initial study, one of the figures with the bouffant hairstyle had traces of what could only be inlay or painted decoration in the hair and jewelry, appearing as a coherent layer in the carving and unlike the clay/soil that appeared elsewhere.[3]
Department of Antiquities, Amman

Each of these carved ivory panels depicts a single male figure. In panel A, one stands nearly frontal with his head in profile, wears military headgear and a chain-mail apron, and holds a long spear diagonally in front of himself. In panel C, two nearly identical figures are seated frontally, on a throne (?), wearing a diadem (?), and holding a staff (?) vertically in front of themselves. Drill holes in the ivories and their discovery with wood and iron fasteners suggest that the panels were veneer affixed to a wooden object (or objects), probably a chest or a chair.[4]

The figures wear clearly Persianate tunics (cat. no. 114) over blousy pantaloons. The headgear of the soldier, A, is a distinctive Caucasian and Central Asian type.[5] While the hairstyle of the seated figures is difficult to place, the facial features of all point again to a provenance well east of the Mediterranean world. The plaques were probably produced east of the Euphrates River; former Sogdia (modern-day Uzbekistan), Persia, or the Indian subcontinent are likely possibilities.

Of the six panels found that depict human figures, four are in military dress.[6] They seem to be evoking the rebellious activities of the Abbasids toward the end of the Umayyad period (mid-eighth century). The ivories, therefore, may testify to the close affiliation between the popular power base for the Abbasids in Khurasan (northeastern Iran) and al-Humayma, their revolutionary headquarters, even though those places were approximately fifteen hundred miles (about twenty-four hundred kilometers) apart.

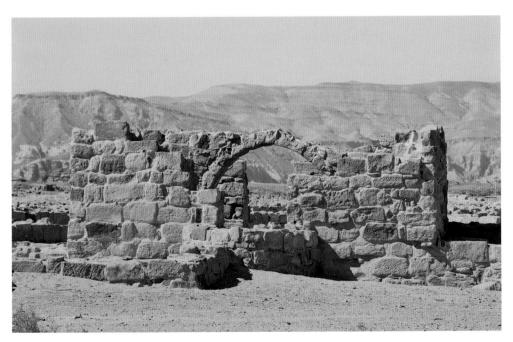

Fig. 93. View of the mosque associated with the Abbasid residence, 8th century. Al-Humayma, Jordan

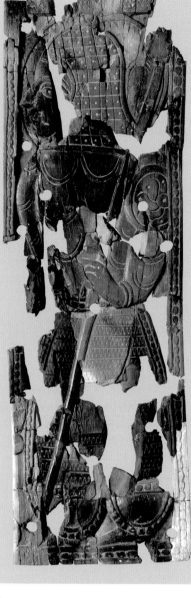

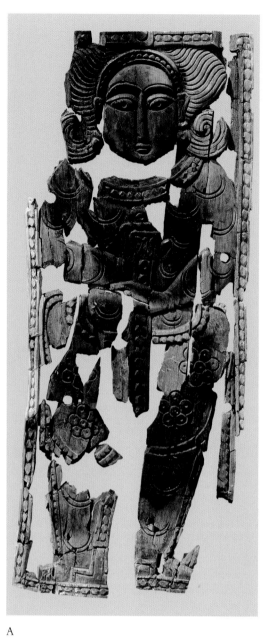

B

A

C

These panels are remarkably similar in use to those of the Byzantine so-called Grado chair (cat. no. 24), though the theme here is political rather than religious. The figure types from al-Humayma demonstrate aspects of the transformation in art and culture under Muslim rule, when the polity integrated the peoples from Portugal to Pakistan (even if, interestingly, the al-Humayma ivories at the same time reflect some of the internal conflicts in this process). The carving style itself was also changing, from a deeply cut to a rounded one, which was worked in other media as well, such as wood and stucco (cat. no. 165).[7]

RMF

1 Identified by the Canadian Conservation Institute, Ottawa.

2 Oleson et al. 1995, pp. 346–47, fig. 28; Foote 1999, pp. 425–28, figs. 5–10; Oleson et al. 1999, pp. 440–42, fig. 20. The present author (and codirector of the

excavations) supervised excavation of the ivories, which was primarily carried out by J. Boyer and V. Karas. J. Logan conserved and consolidated the material with assistance from N. Zaban.

3 Oleson et al. 1999, p. 444; J. Logan, personal communication.

4 Six human figures and various bird, fish, vegetal, trefoil, and geometric motifs have been reassembled from the ivory fragments. Large amounts of wood, some identified as ash (*Fraxinus*) (identified by the Wiener Laboratory for Aegean and Near Eastern Dendrochronology, Cornell University, Ithaca, N.Y.), iron nails, hooks, and other fasteners were discovered in association with the ivory.

5 A surviving example of the leather cap or hood covered in fabric (such as silk) worn over a metal helmet from Moshchevaya Balka, Alano-Saltova, northen Caucasus, dating to the eighth–ninth century, is in the Russian Museum of Ethnography, Saint Petersburg; see Nicolle 1997, pp. 62, 97, no. 163 (cf. pp. 20, 79, no. 16D; pp. 21, 79, nos. 16G–H; pp. 42–43, 87, nos. 76A, D, E), and personal communication.

6 The six human-figure panels are rendered as three pairs. The three panels not included here depict standing soldiers. One is the nearly identical and mirror image of A. The other pair resembles A, but

their helmets are different, they are in chain mail, and they do not wear the chain-mail apron (see Oleson et al. 1999, fig. 20, and Foote 1999, fig. 6).

7 Heusch and Meinecke 1989. The late eighth-century stucco panels at Raqqa (in northern Syria; fig. 104) are another regional example of the shift to what was by the ninth century the popular beveled style (see Moraitou, p. 223, and fig. 106).

References: (A–C) Heusch and Meinecke 1989; Oleson et al. 1995, pp. 346–47, fig. 28; Nicolle 1997, pp. 62, 97, no. 163; Foote 1999, pp. 425–28, figs. 5–10; Oleson et al. 1999, pp. 440–42, fig. 20.

154. Alabaster Capital

Syria, 9th century
Alabaster
27 × 29 × 29 cm (10⅝ × 11⁷⁄₁₆ × 11⁷⁄₁₆ in.)
Provenance: Said to be from Raqqa, Syria; purchased from
Friedrich Sarre (1865–1945; archaeologist, collector) via
an art dealer in Aleppo between 1907 and 1921.
Condition: There is limited damage to the carving.
Stiftung Preußischer Kulturbesitz, Staatliche Museen zu
Berlin—Museum für Islamische Kunst, Berlin (I.2195)

A number of alabaster capitals from
Raqqa (the classical Nicephorium)
and the surrounding area have survived in
museums and other collections.[1] This Syrian
city was built at the confluence of the
Euphrates and Balikh rivers, in a strategic
location near the border with the Byzantine
Empire. Throughout most of the eighth and
ninth centuries the annual attacks on the
Byzantine territory came from this area,
which as a result received special attention
from as early as the Umayyad period (661–
750). In 772 the Abbasid caliph al-Mansur
(r. 754–75) founded a second walled city
next to Raqqa, in a form somewhat reminis-
cent of the circular city of Baghdad, and the
twin cities quickly became a flourishing
urban center. Between 796 and 809 Harun
al-Rashid (r. 786–809) transferred his capital
there, and extensive palace and administra-
tive buildings were constructed outside the

walls. Aerial photography from 1920 shows
that the ruins of the city and surrounding
buildings covered more than nineteen square
miles (fifty square kilometers).[2]

In the tradition of Late Antique capitals,
the decoration on this relatively small-scale
example is organized in three bands: the bot-
tom band, the abacus, and the bipartite cen-
tral part. On other known Abbasid capitals,
such as those from the Haram al-Sharif in
Jerusalem, the classical acanthus leaves pre-
dominate, although they are somewhat styl-
ized.[3] On this capital the acanthus motif has
given way to half-palmettes and fanciful
combinations thereof: in the lower register
the half-palmettes form lotus palmettes,
while in the upper part interconnected
half-palmettes form a lyre-shaped palmette
in the center and curling volutes at the cor-
ners. The overall stylization is characteristic
of an early stage in the evolution of Late
Antique ornament to the classical arabesque.

AB

1 Dimand 1937, figs. 15, 16, 22–25, 40–46; *Syrie* 1993,
 p. 418, cat. no. 310; Blair and Bloom 2006, p. 156, cat.
 no. 81; Sotheby's 2001, lots 90–92; Sotheby's 2008,
 lots 74–77; Sotheby's 2010, lot 135.
2 Meinecke 1995; Walmsley 2007, pp. 97–99.
3 J. Wilkinson 1992.

References: Enderlein et al. 2001, p. 28; Annette Hagedorn,
"Capital," in *Discover Islamic Art: Museum With No
Frontiers*, 2010, http://www.discoverislamicart.org
/database_item.php?id=object;ISL;de;Mus01;5;en.

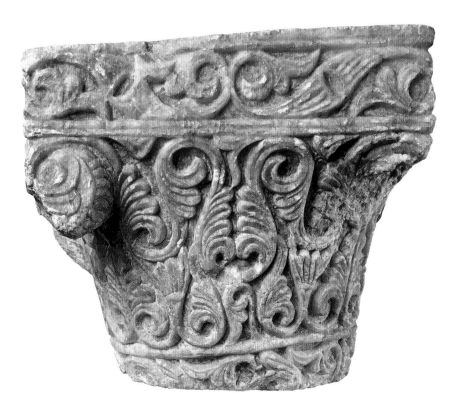

Ornamental Motifs in Early Islamic Art
Mina Moraitou

With regard to ornamentation on Islamic
works of art, the precepts of the Qur'an
and the hadith (traditions of the Prophet
Muhammad) distinguish between the secular
and the religious, which are defined by the
presence or absence of living beings, respec-
tively. Calligraphy, as a form of ornament,
epitomizes the essence of religious decoration
and represents a major theme in decorative
programs (see Fluck, p. 183, and Komaroff,
p. 258).

In the Early Islamic period, that of the
Umayyads (661–750), the decorative reper-
toire drew upon the traditions of Late
Antiquity as well as of Byzantium and
Sasanian Iran. These sources of inspiration
were applied in an eclectic manner, in accor-
dance with the context and purpose of a
particular building or work of art. Figural
motifs are prominent in paintings and sculp-
tures that decorate secular buildings, but they
also appear on objects and textiles.

The depiction of nature is a recurring
theme in Umayyad art. Plant motifs, alone or
set into architectural or geometric frame-
works, developed into either naturalistic or
stylized compositions, both marked by a
sense of vigor and energy. Examples are
found in the facade of the Mshatta palace
(fig. 79) and in small-scale works such as
ivory furniture plaques (cat. no. 121A, B).
The mosaic decoration of the Dome of the
Rock in Jerusalem offers a continuous vari-
ety of vegetal motifs blended with insignia
of royal power, including jewels, diadems,
and crowns; acanthus scrolls, garlands,
rosettes, vine scrolls, and trees are also
depicted with great liveliness and powerful
movement (figs. 96, 98). In the same spirit,
the woodwork from al-Aqsa Mosque in
Jerusalem is adorned with numerous vegetal
and floral motifs combined with architec-
tural and interlaced patterns.[1]

Geometric compositions, one of the
basic characteristics of Islamic art, were
often used during this period. They usually
enclosed other motifs within the overall
decorative scheme, as for example in the
magnificent mosaics of Qasr al-Hallabat in

northern Jordan.[2] The recent discovery of the Umayyad palace at Balis, which probably belonged to the general Maslama ibn ʿAbd al-Malik, brought to light wall paintings decorated with various geometric shapes that enclosed panels of imitation marble.[3] Purely geometric patterns are, however, most commonly seen on window grilles, both in secular buildings such as the palace of Qasr al-Hayr al-Gharbi and religious structures such as the Great Mosque of Damascus.

Architectural motifs, including friezes with stepped motifs or arches, are another decorative feature of Umayyad and early Abbasid ornamentation. Although not a novelty in the eastern Mediterranean world,[4] these designs gradually became more abstract, either reduced to framing devices or incorporated as simply another decorative element, without structural connotations or reference to a particular edifice. Such architectural motifs appear in the decoration of religious buildings, for example, within the Dome of the Rock, and of secular palaces, such as Qasr al-Hayr al-Gharbi and Khirbat al-Mafjar.[5] They are also a recurring theme on luxury objects—among them the so-called Marwan ewer (cat. no. 171), a pair of doors from Iraq (cat. no. 160), and a wooden panel from ʿAin al-Sira in Fustat (cat. no. 167)—as well as on other objects, including a steatite lamp base and an ivory pyxis, both from al-Fudayn (cat. nos. 145, 146). The fact that architectural ornamentation inspired artists and craftsmen is also clear from early religious illuminations: columns, rows of empty arches, and stepped motifs appear on the bands separating the suras in a collection of parchment Qurʾan pages from the Mosque of ʿAmr (see Flood, p. 265, fig. 111, and cat. no. 190).[6]

During the seventh and eighth centuries, Syria, with Damascus as its center of political power, was a melting pot in which Western and Eastern cultures combined with local traditions. Umayyad art blended these

influences, expressing both a passion for experimentation and a delight in ornament. The same enthusiasm continued into the early Abbasid period, as a remarkable change occurred in the decorative repertoire that coincided with the shifting of the center of the Islamic world from Syria to Iraq. This transformation is best illustrated in the decoration of Samarra, the temporary capital of the Abbasids between 836 and 883. Although hints of change are noticeable in the earlier decoration of the royal residence at Raqqa (cat. no. 154), it was actually the building of Samarra that established the new style, one that would become the first purely Islamic decorative mode.[7] In the stucco and marble decoration of that city, three distinct styles with different degrees of abstraction developed, although the overall result was a space entirely covered with repeated, predominantly vegetal motifs.[8] At their most abstract, familiar motifs such as palmettes and lotuses exhibit smooth contours and appear completely stylized, with no apparent background (fig. 106); they form fluid patterns capable of expanding indefinitely. This characteristic stylization of foliate themes, one merging into the other, is found on the single door leaf with three identical inset panels carved in the so-called beveled style (cat. no. 165) as well as on a luster-painted bowl in the David Collection, Copenhagen (cat. no. 166).

The effect of the Samarra style was widespread and immediate. It was quickly adopted in the provinces, as for example in the ninth-century architecture of Balkh[9] and in the arts of Tulunid Egypt during the second half of the ninth century (fig. 108).[10] The frontal representation of motifs found on a section from a piece of furniture carved in Egypt in the beveled style (cat. no. 162) does not differ significantly from the design on a Syrian flask with gold decoration (cat. no. 158) or that on a fragment of a wall hanging, probably from Egypt, depicting a row of stylized floral motifs (cat. no. 159).

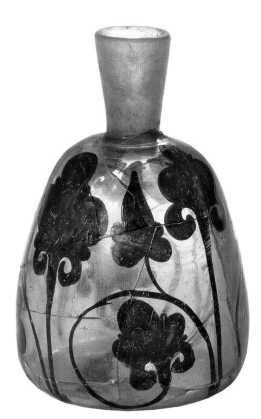

155. Luster-Painted Flask

.

Probably Egypt, 9th–10th century
Glass, bluish; free blown; dark brown and silver stains; tooled on pontil
H. 13.5 cm (5⁵⁄₁₆ in.); max. Diam. 9 cm (3⁹⁄₁₆ in.)
Condition: The body has been repaired but is almost complete; the neck is modern.
The David Collection, Copenhagen (1/1985)

The bell-shaped flask has a flat base and is ornamented with dark monochrome luster. The decoration consists of a series of leaves on alternately straight and spiraling stems, creating a rhythmical pattern. The leaves are depicted in frontal view with no attempt at naturalism. There are two variants: a three-lobed leaf terminating below in two loops and a smaller leaf with a pointed tip.

The flask is attributed to Egypt. Luster painting is a decorative technique applied to glass and ceramics. Developed during the pre-Islamic period in Egypt, it continued throughout the Fatimid period (909–1171).[1] The ornamental themes, often inspired by the classical motifs of Late Antiquity, were gradually adapted to the Islamic repertoire. A stylized element that is repeated to form a pattern is characteristic of the ninth century, as can also be seen on the bronze ewer in the David Collection (cat. no. 156). The shape of this flask is typical of the ninth to tenth century and is representative of those with an Iranian provenance, although an

undecorated example was among the finds in Fustat.[2] MM

1 For a brief discussion of the theories on the origin of luster-painted glass, see Goldstein 2005, pp. 134–35.
2 Scanlon and Pinder-Wilson 2001, no. 12.

References: Carboni and Whitehouse 2001, pp. 217–18, cat. no. 107; von Folsach 2001, no. 322.

156. Ewer

....................

Iraq or Iran, 9th century
Bronze, cast
H. 27.7 cm (10¹⁵⁄₁₆ in.); max. Diam. 14 cm (5½ in.)
Condition: The ewer is intact.
The David Collection, Copenhagen (17/2001)

The cast bronze ewer has an ovoid body, which is decorated with bold floral compositions and foliate scrollwork. The rim is lobed, and the handle has a spiral design with a round finial at the top.

The shape of the ewer corresponds to a widely known type representative of a group with which it shares a similar body, cylindrical neck, and finial on the handle but

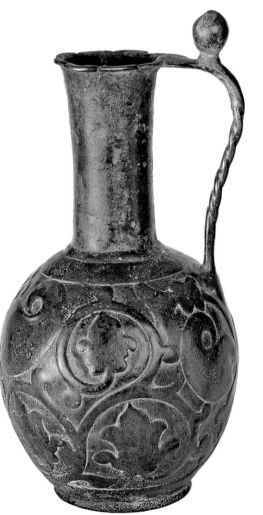

from which it differs in its decorative technique. Examples are to be found in the David Collection, the Keir Collection, and the Israel Museum, Jerusalem.[1] All of these have undecorated bodies, with the decoration confined to the necks, which bear engraved vegetal motifs, and finials in the shape of pomegranates. They are attributed to Iran between the ninth and eleventh centuries.

A more elaborate example, discovered in Nishapur, features engraved decoration on the body and has a Kufic benedictory inscription and hunting scenes.[2] The ewer in the David Collection differs in that it is cast and the decoration is on the body, while the neck is left plain. Its bold and stylized design finds parallels in other media, as, for example, the wing-shaped leaves in the decoration of a wood panel with rich vegetal decoration and a Qur'anic inscription (cat. no. 178).[3] An early comparable ewer made of brass is in the Walters Art Museum, Baltimore. Although it has a different shape,[4] it shares the same style of Sasanian-inspired motifs that appear in Early Islamic art. MM

1 David Collection: von Folsach 2001, p. 294, no. 453; Keir Collection: now in the Museum für Islamische Kunst, Berlin: see Haase 2007b, p. 110. Israel Museum: Ziffer 1996, p. 88.
2 The Metropolitan Museum of Art, New York (38.40.240); see Allan 1982, pp. 82–83.
3 Museum of Islamic Art, Cairo (2462); see cat no. 178 and O'Kane 2006, p. 26, no. 15.
4 See Baer 1983, p. 135.

Reference: Blair and Bloom 2006, p. 150, cat. no. 75.

157. Footed Bowl

....................

Iran, Iraq, or Syria, 8th century
Ceramic, earthenware, molded with applied decoration and glazed
H. 7.6 cm (3 in.); max. Diam. 13 cm (5⅛ in.)
Provenance: Collection of Maan Madina until 2002.
Condition: The bowl is in good condition.
Los Angeles County Museum of Art, The Madina Collection of Islamic Art, gift of Camilla Chandler Frost (M.2002.1.134)

This footed bowl is representative of a group of ceramics from the Umayyad and early Abbasid periods with relief decoration and characterized by the use of a green glaze.[1] On this bowl the molded relief decoration, which is confined to the exterior, is covered by a dense glaze that has left thick drops on the rim. The ornamentation is arranged in two registers. The wider band shows upright palmettes ending in two loops that alternate with inverted triangular-shaped flowers. Just below the rim runs a narrow band of relief beading. A number of teardrop shapes are applied above the relief decoration. A similar bowl, with the same alternation of palmettes and flowers, though slightly smaller and with no feet or applied decoration, is attributed to eighth-century Iran and is in the Keir Collection.[2]

The bowl follows metalwork shapes, in particular that of incense burners with straight walls and three feet, a type found in the eastern Mediterranean from the Late Roman period and continuing into the Islamic period (cat. nos. 122A, B; 148).[3] The shape of the bowl in Los Angeles can be interpreted as a simple imitation of such vessels, but with plain feet rather than zoomorphic ones.[4] A comparable object is an incense burner of copper alloy in the Nasser D.

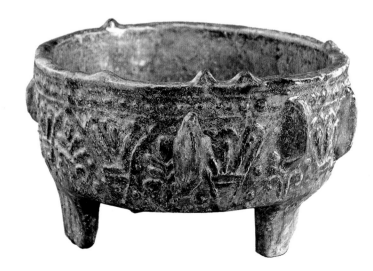

Khalili Collection, London, attributed to eighth- to ninth-century Syria, with open-work decoration with V-shaped openings reminiscent of the design of the triangular flowers.[5] Another example of a later date, in the Brooklyn Museum, New York, also has teardrops, a frequent element in the decoration of metalwork.[6] MM

1 The provenance of this group is problematic, as it had a wide distribution; see Watson 2004, pp. 157–65, and Féhervári 2000, pp. 29–30.
2 Museum für Islamische Kunst, Berlin. For the bowl, see Grube 1976, pp. 29–31, no. 2/4.
3 For pre-Islamic examples, see Hayes 1984, nos. 70, 189 (with six feet).
4 A similar example with cut and stamped instead of molded decoration is in the Benaki Museum, Athens; see Philon 1980, p. 190, no. 642.
5 Rogers 2008, p. 36, cat. no. 11.
6 See Baer 1983, p. 137. For another example of tear-drop decoration, see Féhervári 1976, no. 15.

References: Unpublished.

158. Luster-Painted Bottle
.....................

Syria, 9th–10th century
Glass, yellowish; gold and silver foil; blue enamel; facet-cut neck
H. 14.5 cm (5¹¹⁄₁₆ in.); max. Diam. 10.4 cm (4¹⁄₁₆ in.)
Provenance: Purchased by the British Museum in 1978 from Saeed Motamed, Frankfurt.
Condition: The bottle has been repaired.
The British Museum, London (1978,1011.2)

This glass bottle has a spherical shape and a long, faceted neck. The body is made up of two layers of glass, which secure the gold leaf between them. The decoration is arranged in two registers: a narrow band on the shoulder made up of a series of leaves, and a wider band with alternating palmettes and leaves separated by blue enamel dots. Details of the motifs were created by scratching the gold leaf. On the base is a stylized bird in silver leaf.

The technique employed for the decoration of this bottle is referred to as sandwich glass, a type of luxury glass dating back to the Roman period.[1] A small number of extant objects and fragments of the ninth and tenth centuries bear witness to a short-lived revival of the process during the Islamic period. The place of production of this bottle is attributed to Syria, where a number of glass fragments and wall tiles decorated with gold leaf were found.[2] The appearance of blue enamel dots is considered a novelty and has been associated with dots used in Qur'anic manuscripts.[3] Enamel dots also appear on a

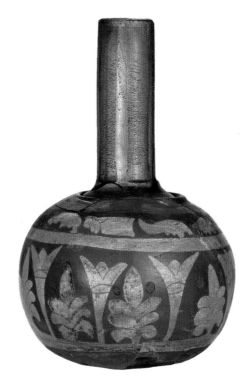

fragmentary cup in the David Collection, Copenhagen, and on a small fragment in the Benaki Museum, Athens.[4]

Only a few examples of Islamic glass decorated in this technique survive. A cup in the Corning Museum of Glass, Corning, New York, displays a very similar band of leaves and palmettes, but without the enamel dots.[5] Two fragments in the Victoria and Albert Museum, London, are also similar in that one shows comparable leaves on the shoulder, and the other, which is a fragment from the base of a vessel, is decorated with two birds.[6] MM

1 See Harden 1987, pp. 276–86; Tait 1991, p. 49.
2 Some fragments in the Victoria and Albert Museum, London, were found at al-Mina, in northern Syria (Wenzel 1988, p. 48), and a number of wall tiles with crosses, thought to come from a church, were found in Ma'arrat al-Nu'man in Syria (for a recent account, see Goldstein 2005, p. 44).

3 Wenzel 1988, pp. 50–52.
4 David Collection: Carboni and Whitehouse 2001, p. 221; von Folsach 2001, no. 325. Benaki Museum: a small fragment acquired from Egypt in the collection of the Benaki Museum, Athens (3688a), has the same design and enamel decoration as the cup in the David Collection.
5 Carboni and Whitehouse 2001, p. 225.
6 Contadini 1998, p. 95.

References: Pinder-Wilson 1991, p. 124; Carboni and Whitehouse 2001, pp. 223–24, cat. no. 107.

159. Fragment of a Wall Hanging with Floral Decoration
.....................

Probably Egypt, 9th–10th century
Tapestry weave in polychrome wool and undyed cotton
33.5 × 63.5 cm (13³⁄₁₆ × 25 in.)
Provenance: Acquired by the Benaki Museum in 1947.
Condition: From left to right, there are areas of loss at the base of the first flower, at the top of the third and fourth flowers, and between the fourth and fifth flowers.
Benaki Museum, Athens (15657)

This fragment of a wall hanging is decorated with a dark blue band with a series of five stylized flowers set between two thin lines. Below the band, in red, are traces of a Kufic inscription, possibly the top part of the letters *al.* The flowers, depicted in strict frontality, evoke the Abbasid style of decoration that influenced designs during the ninth-century Tulunid and early Fatimid periods in Egypt. This stylization impacted all aspects of the decorative arts, from the ornamentation of the Ibn Tulun Mosque (fig. 108) to the embellishment of smaller objects, such as furniture (e.g., cat. no. 162) and glassware (cat. no. 158).

A number of textile fragments with variations on this bold floral theme are preserved in museum collections.[1] Two fragments in the Bouvier Collection display designs rendered in a similar style and color scheme,

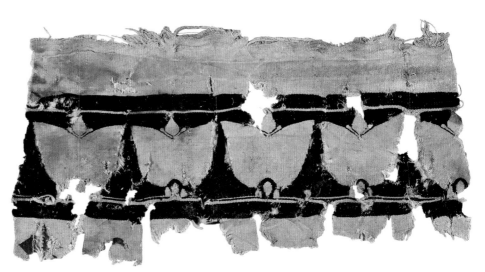

and there is another example in the collection of the Musée National du Moyen Âge, Thermes et Hôtel de Cluny, Paris.[2] A wool and linen fragment excavated at Fustat, Egypt, is ornamented in a similar style on a red ground.[3] All of these examples are associated with the workshops of Bahnasa, Egypt, which was a center for the production of a variety of textiles, including wall hangings.[4] MM

1 See Antiquities 2007 for examples in the Egyptian Textile Museum, Cairo: a polychrome example, p. 174, and a blue and white one, p. 179.
2 For the Bouvier Collection fragments, see Cornu 1993, pp. 115–16. For the Musée National du Moyen Âge example, see Desrosiers 2004, p. 69.
3 Mackie 1989, p. 90, pl. 1.
4 Lombard 1978, p. 37.

References: Unpublished.

160. Pair of Doors with Carved Decoration

....................

Probably Iraq, second half of the 8th century
Wood
255 × 123 cm (100⅜ × 48⁷⁄₁₆ in.)
Provenance: According to the papers of Antonis Benakis (1873–1954), this pair of doors, together with another fragment in the Benaki Museum, was found dismantled and reused in the vicinity of Baghdad, Iraq;[1] collection of Antonis Benakis; part of the original Benaki Museum, which was given to the Greek state in 1931 and inaugurated on April 22 of that year.
Condition: Some areas are missing. There are several holes in the lower half and extensive damage in the upper half.
Benaki Museum, Athens (9121)

The main theme of the carving on these doors is a tree, which is repeated twice on each panel. In the center of each door is a geometric composition consisting of a star within a circle filled with stylized vine scrolls. A band of architectural motifs running below the circles contains a series of arches on double columns topped by stepped motifs with arrow-shaped openings. The tree has a tall trunk decorated with an imbricated pattern. It rises under a pointed, multilobed arch outlined by double rows of small balls, or pearls. Under each lobe is a composite floral motif (fleuron) alternating with pinecones.

This remarkable pair of doors is the only known example that displays many of the motifs of Umayyad architecture as seen in the decoration of the desert palace of Qasr al-Hayr al-Gharbi and more notably in that of the Mshatta and Qasr al-Tuba palaces in Jordan. In particular, the decoration carved on a stone lintel from Qasr al-Tuba shows

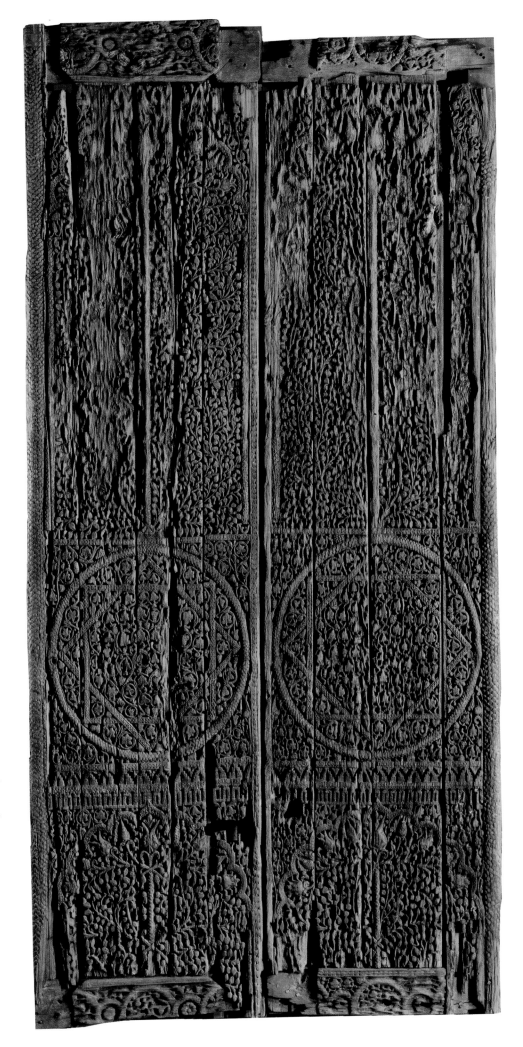

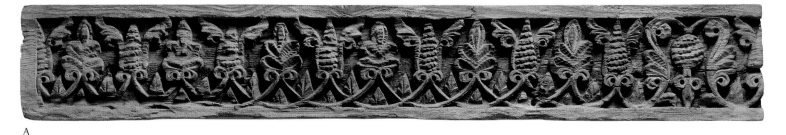

A

many similarities in the formation of the fleurons, which are placed in panels defined by imbrication combined with pearl motifs.[3] The richly carved ornamentation of the facade of Mshatta (cat. no. 142), with its variety of decorative elements that give a similarly sumptuous and lively effect, is also comparable. In particular, one of the triangular panels that decorate the facade (triangle O) displays an analogous tree motif rising among vine scrolls. Two distinctive features expressive of the Umayyad spirit of the present doors are the treatment of the vegetal motifs and the different levels of stylization found side by side. For example, there are stylized interlaced vine scrolls in the area outside each arch and again within the geometric composition, while the area inside the arches is filled with dense, naturalistic foliage springing from the base of the tree trunk and spreading organically upward.

The doors are dated between the middle and end of the eighth century because of their association with late Umayyad monuments, and it is assumed that they were made in today's Iraq because they were found there. The decoration is very similar to that on the minbar of the Great Mosque of Qairawan, in today's Tunisia. Whether it was carved in Baghdad or in Qairawan, the minbar was crafted out of wood sent from Baghdad, and as it dates from the middle of the ninth century, it displays an archaic and stylized form of Umayyad ornament popular in Iraq before the Abbasid period.[4] It is proposed here that this pair of doors, expressive of the luxury of the Abbasid court, should be regarded as an example of the transition from the late Umayyad to the early Abbasid styles. MM

1 The tomb is described as "near Baghdad" in the Benaki Museum records. In 1929 Ernst Herzfeld stated that he had seen the sarcophagus, which was supposed to be from Assur, and that it contained gold jewelry; Herzfeld to Friedrich Sarre, February 26, 1929. I am grateful to Jens Kröger for this information from the archives of the Museum für Islamische Kunst, Berlin.
2 Benaki Museum (9122; Moraitou 2001, fig. 2). That panel, which was part of a door or a minbar, is very similar to a panel in The Metropolitan Museum of Art (31.63).

B

3 For a detailed examination of the doors, see Moraitou 2001.
4 For information on the Qairawan minbar, see Ettinghausen et al. 2001, p. 94, fig. 143; see also "*Minbar* of the Great Mosque of Kairouan," in *Qantara: Mediterranean Heritage*, 2008, http://www.qantara-med.org/qantara4/publicshow document.php?do id=id640&lang=en.

References: Pauty 1931; Moraitou 2001; Moraitou 2008b.

161A, B. Fragments of Two Carved Wood Friezes
.....................

A. Section of a Frieze with Winged Pinecones and Palmettes
Possibly Eastern Mediterranean, 8th–9th century
Wood
14 × 94.3 cm (5½ × 37⅛ in.)
Provenance: V. Everit Macy, New York (until 1930).
Condition: The piece is broken on the right, and there is some surface damage.
The Metropolitan Museum of Art, New York, Gift of V. Everit Macy, 1930 (30.112.5)

B. Fragment of a Frieze with Winged Pinecones and Palmettes
Possibly Eastern Mediterranean, 8th–9th century
Wood
8.5 × 27 cm (3⅜ × 10⅝ in.)
Provenance: Gift of Phokion Tanos, Egypt.
Condition: There is some surface damage, especially on the left pinecone.
Benaki Museum, Athens (9813)

Both of these pieces are decorated with alternating palmettes and winged pinecones. On the first (A), the motifs spring from stems bearing triangular leaves. At the right end, there is a circular motif resembling a stylized pomegranate flanked by two half palmettes; it may indicate the center of the frieze to which the carving once belonged.

The decoration reflects the influence of Sasanian art on early Islamic ornament. The Sasanians favored patterns created by a repetition of motifs in frontal view and had a tendency to abandon the naturalism of Late Antique art and move toward more stylized designs. The pinecone and the pomegranate, characteristic motifs, are often seen in early Islamic stucco decoration (cat. no. 18A). Sasanian artists flanked these motifs with naturalistic leaves or more stylized versions that resemble wings. Pairs of wings, symbolic of the fertility goddess Anahita, were also used, alone or to frame animals.[1]

Pinecones—both winged and not—were incorporated into Early Islamic designs and are seen in the architectural decoration of the Umayyad period (661–750). In particular, the mosaics in the interior of the Dome of the Rock in Jerusalem include a cone-shaped motif with wings.[2] More akin to the decoration of these two wood carvings are some motifs found in the elaborate decoration of the palaces of Qasr al-Tuba and Mshatta.[3] Sasanian-inspired decoration, including pinecones and winged motifs, occurs in other types of woodwork; pinecones appear on a pair of doors in the Benaki Museum (cat. no. 160), and on an inscribed wood carving in the Museum of Islamic Art, Cairo, pairs of wings surrounding an arrangement of fruit are featured prominently.[4] MM

1 See Demange 2006, cat. no. 10, fig. 2; Harper 1978, pp. 106–7, 110.
2 For some examples, see O. Grabar 1996, figs. 36, 38, 48.
3 For the former, see *Umayyads* 2000, p. 111; for the latter, Dimand 1937, fig. 49.
4 See Pauty 1931, p. 12, and Dimand 1937, fig. 6.

References: (A) Dimand 1937, fig. 14; Ettinghausen 1979, p. 16, fig. 2; (B) unpublished.

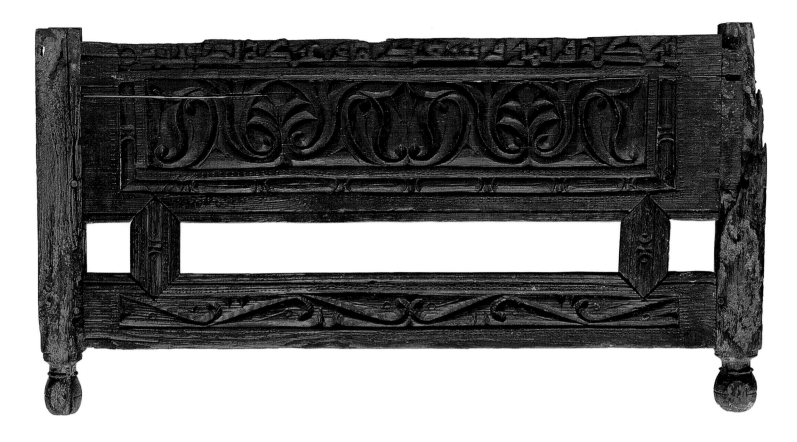

162. Section from a Piece of Furniture
.....................

Egypt, late 9th century
Carved and incised wood
50 × 97 cm (19¹¹⁄₁₆ × 38³⁄₁₆ in.)
Inscribed: In Arabic, بركة ويمن وسعادة وغبطة لصاحبه
(Blessing and good fortune and happiness and felicity to
its owner).
Provenance: Collection of Antonis Benakis (1873–1954);
part of the original Benaki Museum, which was given to
the Greek state in 1931 and inaugurated on April 22 of
that year.
Condition: The top part is missing, there are slight areas of
damage on the inscription band, and areas of loss on the
right leg.
Benaki Museum, Athens (9148)

This seat consists of two rectangular pan-
els, joined by two smaller hexagonal
supports and held between two posts termi-
nating in circular feet. The upper panel has
two tiers of decoration. At the top is a bene-
dictory inscription addressed to the anony-
mous owner in a simple Kufic script. Below
is a deeply carved design in the beveled style
typical of the ninth century (cat. no. 165).
The symmetrical composition consists of a
central lotus flanked by two fan-shaped
palmettes. The lower panel bears a half-
palmette scroll.

 The combination of stylized palmettes
and lotuses represents the influence of

Abbasid ornament on work from Egypt
during the Tulunid period (868–905). Panels
preserved in the collections of the Benaki
Museum and the Museum of Islamic Art,
Cairo, bear the same compositions and vir-
tually identical inscriptions.[1] The mihrab of
the ninth-century Ibn Tulun Mosque, Cairo,
has similar decoration, combining foliate
ornament with an inscribed band.

 This object is probably a section from a
sarir, a large chair or throne on which the
owner could sit cross-legged. Although little
is known about medieval Islamic furniture,
there is a rich tradition of seats and thrones
from the pre-Islamic period, an important
example of which is the sixth-century ivory
cathedra of Maximian, archbishop of
Ravenna. Thrones sometimes appear in the
imagery on other objects, such as a Tulunid
shard from about 900 and the tenth-century
pyxis made for the prefect of Cordoba Ziyad
ibn Aflah.[2] MM

1 Benaki Museum, Athens (9142, 9146, and 9147); for
 the Cairo examples, see O'Kane 2006, p. 43, fig. 34.
2 For the Tulunid shard, see Sadan 1976, p. 40. For the
 pyxis in the Victoria and Albert Museum, London
 (368–1880), see von Folsach and Meyer 2005, vol. 2,
 p. 319.

References: Ballian 2006, p. 75, fig. 69; Moraitou 2008b, p. 77.

Fustat

Iman R. Abdulfattah

In 641 Arab Muslim troops from the Arabian
Peninsula succeeded in conquering Byzantine
Egypt. After seizing the capital, Alexandria,
the army, led by general 'Amr ibn al-'As,
headed south and camped in tents near the
apex of the Delta. Militarily, the setting was
ideal: bounded by the Nile River to the west
and the Muqattam Hills in the east (and later
in the settlement's history by a long cem-
etery called al-Qarafa), the site was easy to
defend, unlike Alexandria. So there 'Amr ibn
al-'As built a garrison town (*misr*; pl. *amsar*)[1]
in the vicinity of the Fortress of Babylon
(Qasr al-Sham'), some of whose walls and
towers survive, and where there was a thriv-
ing Coptic community. Constructed five
years after the first two *amsar*—Basra and
Kufa, in Iraq—Fustat was the first Muslim
city established in Egypt and Africa.[2]

 When the Abbasids supplanted the
Umayyads in 750, they installed their gover-
nors in a new capital named Madinat al-'Askar,
located just north of Fustat. A succession of
governors followed until, in 868, one of
them, Ahmad ibn Tulun (r. 868–84), built his
own capital farther to the north, calling it

Madinat al-Qat'i' (the quarters). In the year 969 the Fatimids (909–1171) founded the city of al-Qahira (Cairo).

In 1168 Fustat was set on fire to prevent its falling into the hands of Crusader forces, and much of it burned to the ground.[3] Cairo became the new seat of government and gradually swallowed up the three previous capitals. Fustat was transformed into Cairo's rubbish dump, where mounds of material from the Mamluk and Ottoman periods accumulated. Moreover, until its destruction, Fustat had been the commercial and industrial capital of the country. Thus, several excavations carried out during the last century yielded extremely rich finds that cast light on the history and culture of Egypt after the advent of Islam.[4] Some of the archaeological material is of a commercial nature, but there are also the ruins of public and private buildings and evidence of the city's complex infrastructure. Many of the archaeological remains have been contextualized, thanks to the discovery in the late nineteenth century of a trove of Judeo-Arabic manuscripts in the Ben Ezra Synagogue in Fustat.[5] Although the manuscripts date to the medieval period (tenth to thirteenth century), they make it possible to reconstruct the social and economic history of Fustat within the context of the wider Mediterranean area during the city's earlier prosperous period.

163. Panel from 'Ain al-Sira

....................

Egypt, 8th–early 9th century
Wood
58 × 83 cm (22¹³⁄₁₆ × 32¹¹⁄₁₆ in.)
Provenance: Excavated at 'Ain al-Sira, Fustat (Cairo), Egypt; acquired by the Museum of Islamic Art, 1933.
Condition: The panel is in good condition; a small section of one of the insets is lost.
Museum of Islamic Art, Cairo (11594)

It has been suggested that this finely carved, uniformly arranged panel was once part of a piece of furniture, possibly a cenotaph or a box used in a domestic context.[1] The decorative program consists of four horizontally placed button-shaped roundels formed of three concentric circles, each painted a different color,[2] surrounded by a repeating pattern of trilobed leaves enclosed in a scroll.[3]

Like other vegetal motifs decorating the surface of artifacts of the Early Islamic period,[4] the trilobed leaf was borrowed from the Late Antique repertoire, the best example and closest parallel being carved ivory and wood. Similar trilobed leaves were also carved on other contemporaneous, well-published wooden panels from the cemetery of 'Ain al-Sira (early ninth century)[5] and from Takrit in Iraq (early ninth century), as well as on the famous minbar (pulpit) imported from Baghdad for the Great Mosque of Qairawan in Tunisia (856–63).[6] Contrary to the naturalism of Hellenistic and Late Antique art, the trilobed leaf here is rather stylized, a treatment that is accentuated by the repetition of its use.

IRA

1 Anglade 1988, p. 24; O'Kane 2006, p. 30, no. 20.
2 Starting in the center, the colors of the circles in the two roundels at the edge of the panel graduate from green to red to mustard; the circles in the two roundels in the center of the panel reverse the order, graduating from a mustard center to green and red.
3 Anglade 1988, p. 24. The Musée du Louvre, Paris, has in its collection a smaller wooden panel with details identical to those carved here (MAO 456). Like the larger panel in Cairo, the Louvre fragment consists of rows of trefoil scrolls that are framed by a serrated border at the top; the two panels are so similar that they may have come from the same piece of furniture. The Paris fragment corresponds with the top of the Cairo panel but preserves part of a Qur'anic inscription.
4 For example, the acanthus leaf, vine scrolls, pomegranates, grape clusters, the palmette in its multiple incarnations, and pinecones.

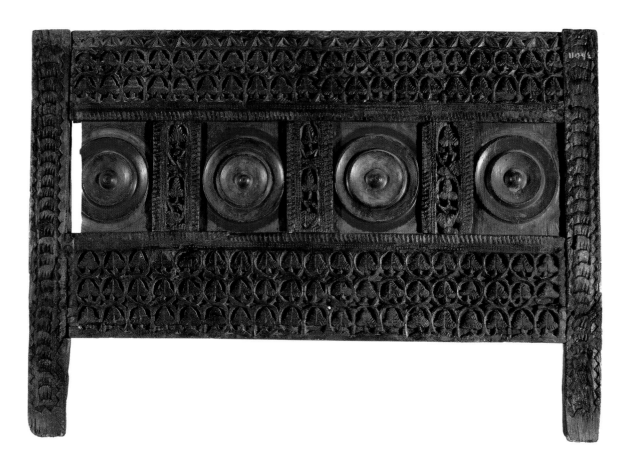

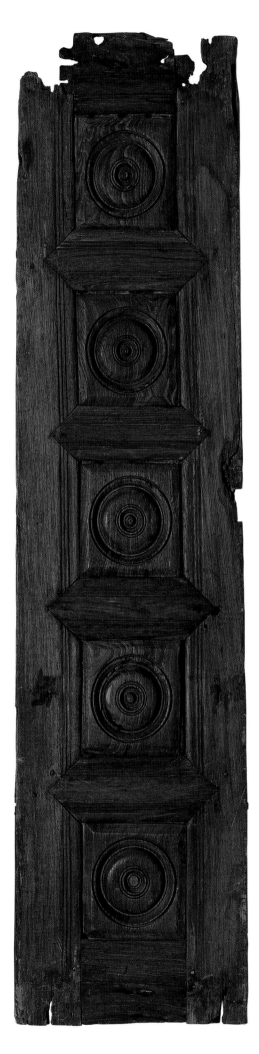

5 This panel is also in the collection of the Museum of Islamic Art, Cairo (MIA 2462); like the panel described here, a serrated or jagged border encloses the entire composition.

6 The Metropolitan Museum of Art has a series of panels from Iraq; the ones most relevant here have the following accession numbers: 33.41.1a–e and 31.63. For a comprehensive analysis of the decoration found on these panels, the Qairawan minbar, and second Cairo panel, see Dimand 1937, pp. 297–301.

References: Dimand 1937; Anglade 1988, pp. 23–24, no. 9; O'Kane 2006, p. 17, no. 8.

164. Fragment of a Panel with Disk Design

..................

Iraq, 9th century
Wood
135 × 32 cm (53⅛ × 12¹⁵⁄₁₆ in.)
Provenance: Found at Takrit, Iraq; acquired by the Benaki Museum in 1936.
Condition: The top is missing, and the lowest inset panel has lost its central boss.
Benaki Museum, Athens (9130)

The carving on this panel fragment consists of five identical square insets, each containing a design of concentric circles with a boss in the center. The pattern exists in the decorative repertoire of Samarra, frequently appearing as a border on stucco wall panels alongside the beveled style, and it continued in use into the Tulunid period (fig. 108).[1]

This type of simple carving is usually difficult to date. Here, however, an attribution to the ninth century is supported by information in a letter written by R. S. Cooke and dated July 20, 1935.[2] Cooke states that the fragment was found, together with two ninth-century door panels decorated with a typical early Abbasid ornament,[3] in a rock-cut sepulcher at Takrit. The panels and the fragment had been used to make coffins for two Christian bishops, Athanasios and Ignatios, who were buried in the sepulcher and from whose coffins the three pieces came. Takrit had an active Christian community, as is recorded in contemporary sources and as has been confirmed by archaeological finds,[4] and a number of carved wood fragments have been discovered there, some of which are in the collection of The Metropolitan Museum of Art.[5] The high level of artistic activity in Takrit, as reflected in these

findings and suggested by the influence that the Takritans had on the architectural decoration of the Syrian monastery in the Wadi Natrun in Egypt, make it difficult to determine whether the wood was locally produced or was imported from Samarra.

MM

1 On the ninth-century fragments discovered in Fustat, see Pauty 1931, esp. pp. 12–13, pl. 10.
2 The letter is in the archives of the Benaki Museum, Athens.
3 One panel is included in this exhibition (cat. no. 165); for the other, see Moraitou 2008b.
4 See Hunt 2003 and Harrak 2001.
5 See Dimand 1937, figs 1, 4, 5 (MMA 31.63, 33.41.1a–e, 33.41.14).

References: Unpublished.

165. Door Panel with Lotus and Palmettes

..................

Iraq, 9th century
Wood
162 × 23 cm (63¾ × 9¹⁄₁₆ in.)
Provenance: Found at Takrit, Iraq; acquired by the Benaki Museum in 1936.
Condition: Areas are missing from the lowest inset panel.
Benaki Museum, Athens (9129)

This carved door panel has three identical rectangular insets, each decorated with two superimposed stylized motifs: above, a large fan-shaped lotus flanked by two slender and stylized half-palmettes and below, an inverted five-lobed palmette between two scrolling leaves. At the base of the lotus are two spheres. The ornamentation is characteristic of the Samarra style, which was developed during the construction of the city of Samarra on Tigris in the ninth century (see fig. 106). For example, the composition features different plants that are carved with a beveled, or slant, cut. Also, the palmette and the lotus—both of which had been treated naturalistically in the art of Late Antiquity—here attain an abstract dimension, with no clear background indication as to where one motif ends and another begins.

A number of similar wood door panels are known. One, at the British Museum, London, is decorated with three insets.[1] Two larger examples with identical decoration and once probably part of the same door are in the collections of the Benaki Museum, Athens, and the Musée du

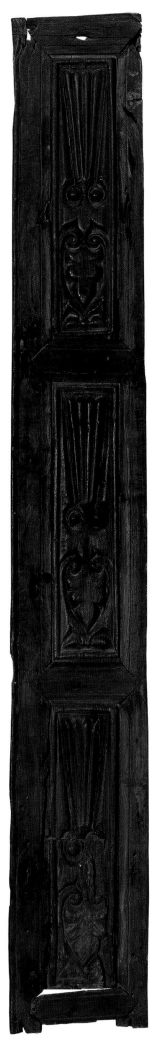

165

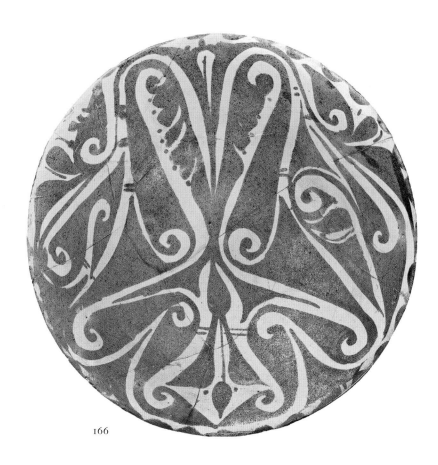

166

Louvre, Paris, respectively.[2] Their decoration is identical to that on a fragment of a marble panel found in the caliph's palace in Samarra and on a fragment from an inset panel found in Takrit.[3] A similar pattern has also been discovered in the stucco decoration of a room in the Samarra palace next to the small mosque.[4] MM

1 British Museum (1944,0513.1).
2 For the one in Athens, see Moraitou 2008b, pp. 7, 76; for the one in Paris, see Anglade 1988, pp. 18–19.
3 Herzfeld 1923, pl. 38.
4 Ibid., p. 71.

References: Unpublished.

166. Luster-Painted Bowl

....................

Iraq, 9th–10th century
Earthenware, painted in luster over an opaque white glaze
H. 6 cm (2⅜ in.); max. Diam. 20.5 cm (8⅟₁₆ in.)
Inscribed: In Arabic, in Kufic script,

بركه

(Blessing)
Condition: The bowl has been repaired.
The David Collection, Copenhagen (26/1962)

Elaborate floral motifs of interlocking half-leaves and half-palmettes in mono-chrome luster over an opaque glaze decorate this ceramic bowl. The reverse is painted with four large stylized flower buds separated by bands of foliate scroll; on the base the word *baraka* (Blessing) is written in Kufic script.

In the ninth and tenth centuries Islamic potters adapted to ceramics the luster-decorating technique known to pre-Islamic glassmakers in Egypt. The process involves applying metal oxides to a glazed ceramic object, which is then fired in an oxygen-starved environment (reduction-fired) to give it a shiny colored surface similar to that of vessels made of precious metals. Whereas the first designs to appear still reflected the motifs of Late Antique glass, this decoration gradually incorporated developments in Islamic ornament. The latter patterns exhibit the taste for abstraction that emerged during the ninth century and the early Abbasid style, which appeared while the city of Samarra was being built. This bowl displays a two-dimensional version of the carved decoration on wood and stucco that emerged from this type of ornament. A comparable dish in Kuwait carries a similar combination of motifs within a design of "peacock eyes" that adorns the wide rim.[1]

The decoration on the bowl in the David Collection at first appears purely vegetal, but it can also be interpreted as a pair of confronted, stylized birds with leaf-shaped

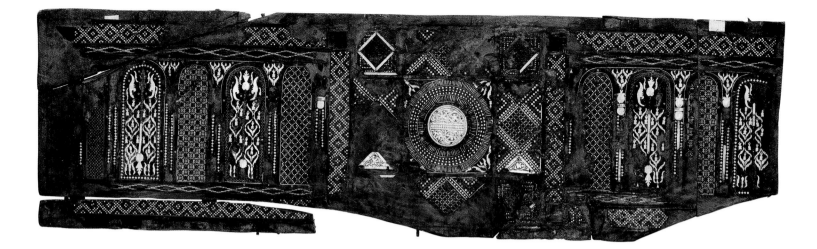

beaks. This blending of motifs recalls the painted decoration of a wooden panel found in one of the caliph's palaces in Samarra.[2] It also relates to the carved decoration of two wooden panels from Egypt in the same style on which birds are depicted springing from a group of leaves and palmettes.[3]

<div style="text-align:right">MM</div>

1 The dish is in the Dar al-Athar al-Islamiyya, Kuwait City, al-Sabah Collection; see Watson 2004, p. 194, no. E.16.
2 Herzfeld 1923, pl. XLII.
3 Anglade 1988, p. 31.

References: Jones and Michell 1976, p. 219, cat. no. 265; von Folsach 2001, p. 132, no. 106; Blair and Bloom 2006, p. 151, cat. no. 76.

167. Inlaid Panel

Egypt, second half of 8th century
Fig wood; inlaid with bone and ebony
50 × 180 × 4 cm (19¹¹⁄₁₆ × 70⅞ × 1⁹⁄₁₆ in.)
Provenance: Excavated at 'Ain al-Sira, Fustat; acquired by the Museum of Islamic Art in 1931.
Condition: Stable, with cracks and losses of inlaid elements.
Museum of Islamic Art, Cairo (9518)

Located to the east of Fustat, the necropolises of al-Qarafa al-Sughra and al-Qarafa al-Kubra, which surround the 'Ain al-Sira (Spring of al-Sira), became significant Egyptian burial sites after a military garrison and settlement were established at Fustat in the mid-seventh century. Several wood panels dating from the Umayyad (661–750) and Abbasid (750–969) caliphates have been attributed to the area, making the necropolis a major repository of Early Islamic woodwork.[1] This panel once adorned a cenotaph. The panel is inlaid with different types of

wood, which were adhered to the surface.[2] Similar panels that may have decorated the same structure survive in several other major public collections, including The Metropolitan Museum of Art, New York.[3] The decoration consists of geometric patterns and stylized vegetal motifs, and both the techniques and the composition employed show pre-Islamic tendencies: the marquetry work is in the long-standing Coptic tradition of inlaying,[4] the inclusion of winged palmettes and pomegranates can be attributed to the Sasanian artistic tradition,[5] and the leaf-ending vine scrolls and sequence of arches entered the Islamic artists' repertoire via Byzantium. Technical ingenuity aside, the 'Ain al-Sira panels are significant historically, since little architecture in Egypt survives from the Early Islamic period. Judging from their oblong shape and the identical nature of their decoration, the Cairo and New York panels may have decorated the long sides of the same structure.

<div style="text-align:right">IRA</div>

1 The Abbasid caliphs ruled Egypt through governors who administered the country from Fustat, but Egypt was semiautonomous under both the Tulunid dynasty (868–905) and the Ikhshidid dynasty (935–69), the founders of which had been installed by the Abbasids.
2 Hausdorf 2008, pp. 37–38.
3 For the Metropolitan's panel (37.103), which has identical decoration, see Dimand 1938, p. 79. Other contemporary panels with similar marquetry work, also attributed to 'Ain al-Sira, are in the collections of the Museum für Islamische Kunst, Berlin (I.5684a-b), and the Musée du Louvre, Paris (AA 201). All of the similar panels are attributed to 'Ain al-Sira.
4 The technique of inlaying wood furniture in fact dates back to antiquity; a prime example of such ancient work is an armchair with ebony and ivory inlays that belonged to King Tutankhamun (r. 1336–1327 B.C.E.), now in the Egyptian Museum, Cairo (JE 62033).
5 Dimand 1938, p. 79; Dimand 1937, pp. 294, 301.

References: Dimand, 1937, 1938; Hausdorf 2008.

168. Textile Fragment with Architectural Motif

Egypt, 7th–9th century
Embroidery in polychrome wool and undyed linen on plain-weave ground of undyed linen; narrow border of tapestry weave in red wool along top edge
9 × 10.5 cm (3½ × 4⅛ in.)
Inscribed: In arches, perhaps in Greek, but untranslated.
Provenance: Friedrich Fischbach, Wiesbaden, Germany, and Saint Gall, Switzerland (1839–1908).
Condition: This fragment has a hole in its upper section. All four edges are uneven. The colors, while faded, remain bright.
The Metropolitan Museum of Art, New York, Rogers Fund, 1909 (09.50.1402)

This fragment is so small as to make its original purpose unclear, but bands served as typical ornament for clothing. Clavi were often added to tunics, stretching from shoulder to hem on both sides of the body. On this fragment, the smaller band, in brown and red embroidery in satin stitch on a red ground, has an abstract design that looks vaguely architectural, with cross-hatching recalling window screens. The larger band has a dense pattern of various diamond and chevron patterns in undyed linen and red wool, tightly packed around four pointed arch forms with red and black accents reminiscent of voussoirs.

Together the arches recall the facade of a multidomed mosque or church, but perhaps they imitate some sort of interior arcading. Niche forms are a common motif in Byzantine and Islamic ornamental works in all media, such as those seen on the wood panel from 'Ain al-Sira, in Cairo (cat. no. 167). While arched forms may connote sacred space, such as a mihrab or apse, they are ubiquitous in Byzantine and Islamic art and may have no referent in the real world at all but

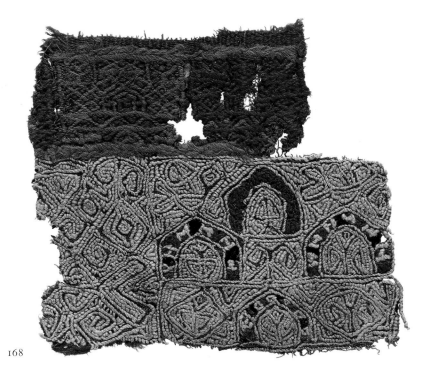

168

merely serve as a device to delineate the picture plane.

The interest in intense linear pattern and geometric designs characterizes much Islamic art after its very beginnings, which turned away from figural motifs, even in arts found outside a religious context. On this fragment the embroiderer seems to have taken pleasure in getting lost in the labyrinthine design. JB

References: Unpublished.

References: Unpublished.

169. Aquamanile in the Shape of an Eagle

..................

Iraq or Syria, A.H. 180/796–97 C.E.
Bronze (brass), silver, copper
H. 38 cm (14¹⁵⁄₁₆ in.)
Inscribed: In Arabic,

بسم الله الرحمن الرحيم بركة من الله مما عمل سليمن بمدينة
العسر سنة ثمنن ومائة

(In the name of Allah merciful, compassionate. Blessing from Allah. This is what has been done by Suleiman in the city . . . [?]. Year one hundred eighty)
Provenance: Transferred from the collections of the Chechen-Ingush Museum, Grozny, in 1939.
Condition: The aquamanile is in good condition with limited amounts of silver and copper inlay preserved.
The State Hermitage Museum, Saint Petersburg
(ИР-1567)

Most likely intended to serve as an aquamanile, or water pitcher (the handle is missing), this figure of an eagle, with an inlay of silver and copper, is consid-

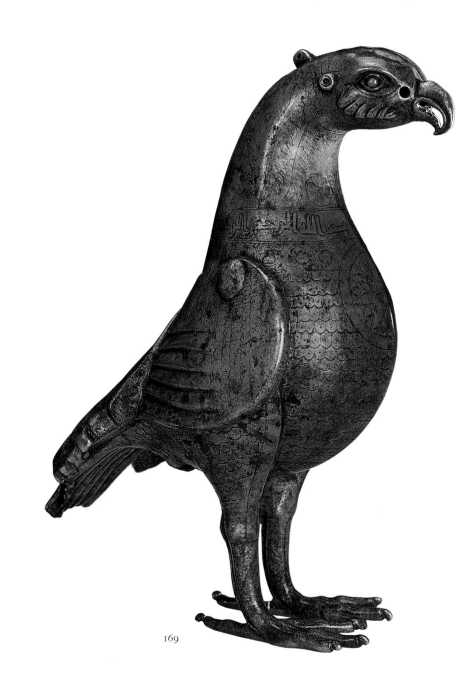

169

ered to be the oldest surviving bronze vessel from the early Islamic period that has been accurately dated. On the neck there is an inscription that identifies the artist as Master Suleiman and gives both a date and the name of the city in which the object was made. While the reading of the date is no longer in doubt, the name of the city remains uncertain. In the first centuries of Islam, bronze works inlaid with different metals were produced in the center of the caliphate, in either Iraq or Syria, where, it would appear, this eagle-shaped vessel was also created. AI

References: Hermitage 1990, p. 10, cat. no. 1; Piotrovskii 1999, cat. no. 199.

170. Fragment of Wall Hanging with Eagle

.

Egypt, 9th–10th century
Tapestry weave in polychrome wool and undyed linen
35.5 × 18 cm (14 × 7¹⁄₁₆ in.)
Provenance: Collection of Antonis Benakis (1873–1954); part of the original Benaki Museum, which was given to the Greek state in 1931 and inaugurated on April 22 of that year.
Condition: The fragment has suffered extensive losses and has undergone conservation.
Benaki Museum, Athens (15629)

This fragment from a wall hanging was most probably made at Bahnasa, in Upper Egypt. Ibn Hawkal, a tenth-century Arab geographer, reported that shops in this city produced splendid wall hangings of wool and linen in bright colors with images of animals, ranging from insects to elephants, characteristics seen here.[1]

Wall hangings and fabrics were very widely used for comfort and insulation in the Islamic world, where furniture was rare. Because they took the place of doors and walls, their iconography can be compared with that of wall paintings. The elite used them to show off their wealth and status. When Byzantine envoys visited Baghdad in the early tenth century, some thirty-eight thousand curtains were hung from the palaces of the caliph all along their route.[2]

Here, an eagle is depicted against a red background. It has a long neck and its head is turned to the side; part of a wing can be made out on the left. The body of the eagle has scalelike feathers, and its claws and beak are sharply hooked, like those of aquamanilia from Sinai (cat. no. 38) and the Hermitage Museum (cat. no. 169). Below the eagle are two bands of double pearls, with stemmed cups in between. Double-pearled borders characterize textile furnishings of the pre-Islamic period, as can be seen in catalogue number 17 or on a relief from Taq-e Bostan; they are also found on other wall hangings from Bahnasa with images of birds and recall the wall paintings from Samarra, especially those from the palace of Jawsaq al-Khaqani (Dar al-Khilafa). AB

1 Lombard 1978, pp. 37–38, 186–88.
2 Golombek 1988, pp. 30–32; O. Grabar 1973, pp. 168–71.
3 Cornu 1993, pp. 109–10, cat. no. 52; Herzfeld 1927, p. 39, fig. 23, pls. XLIX, L, XVI. For the relief from Taq-e Bostan, see ibid., p. 65, fig. 46.

References: Unpublished.

171. The "Marwan Ewer"

.

Probably Syria, late 8th–early 9th century
Copper alloy, cast in pieces; molded, engraved, and punched decoration; openwork collar; perhaps originally encrusted
H. 41 cm (16⅛ in.); Diam. 28 cm (11 in.)
Provenance: Excavated at Abusir, Fayyum, Egypt. The ewer entered the collections of the Museum of Islamic Art in 1930.
Condition: The vessel is in stable condition.
Museum of Islamic Art, Cairo (9281)

This ewer belongs to a group of six, which, with small differences, have the same shape and the distinguishing feature of the bird-shaped spout.[1] A variety of stylistic and iconographic features are combined on this idiosyncratic vessel in an eclectic, possibly haphazard fashion. For example, the shape is reminiscent of a bottle to which have been added finely crafted features: the beaded handle, the openwork collar, and the spout.[2] The recessed cavities on the neck and body, recalling a similar treatment of jewelry, may have been encrusted with precious stones or colored glass paste, once giving the ewer a bejeweled look.[3]

The spherical body, the spout emerging from the shoulder, and the upright handle, all typical of Late Roman ewers, continued to be used with variations in the Islamic period;[4] indeed, the ewer was discovered near the grave of Marwan II (r. 744–50), the last Umayyad caliph, who died at the Fayyum oasis fleeing the Abbasid forces. We find similar forms in unglazed ceramics, though the most interesting example is a small metalwork ewer with a zoomorphic spout unearthed at Umm al-Walid, Jordan.[5] So far, the direct antecedents for the avian and zoomorphic spout are unknown, but we can surmise an Iranian prototype, since such spouts are found in Chinese porcelain ewers of the sixth to tenth century, whose origins are traced to Sasanian silverware.[6]

The striking upright handle springs from a large, cast palmette, which undoubtedly copies similar palmettes on Late Sasanian and Sogdian silverware, except that in this instance there are also two dolphins whose long tails support the handle, as is often the case on Late Roman vessels.[7] The architectural frieze on the body essentially depicts an abbreviated paradise scene: arches with large sun-rosettes in the conchs and, below, among fruit trees, animals (hares, wild goats, a lion), paired groups with an eagle and a wild goat, and a deer and a bird—that is, another variation on the Mshatta facade (fig. 79).[8]

AB

1 Sarre 1934; Féhervári 1976, p. 33, no. 2, with a list of all ewers; Piotrovskii and Rogers 2004, p. 80, cat. no. 29. For the Metropolitan ewer, see *Heilbrunn Timeline of Art History*, http://www.metmuseum.org/toah/works-of-art/41.65.
2 For glass bottles, see Carboni and Whitehouse 2001, p. 102, fig. 92, p. 110, cat. no. 27, p. 181, cat. no. 86. The latter, a relief-cut bottle that imitates metalwork, has a stepped shoulder at the join to the body, as is the case with the Marwan ewers, a clear sign that they imitate a sheet-silver bottle; see Atıl et al. 1985, p. 83, cat. no. 10.

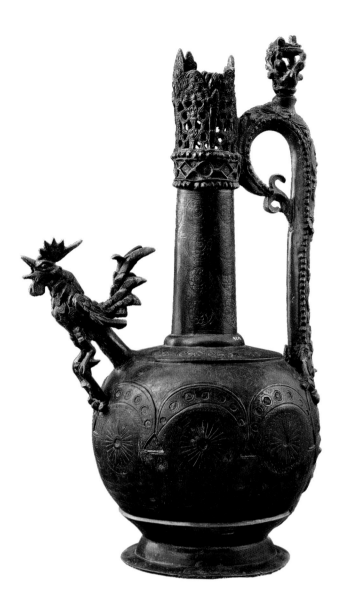

3 Without laboratory analysis of the materials, it would be premature to announce whether it had encrustation or, if so, what kind it was. For a similar bejeweled aesthetic, see the columns of Saint Polyeuktos in Constantinople, Pitarakis 2007, and the famous Sasanian bowl of Khusrau I in the Bibliothèque Nationale (Cabinet des Medailles, Paris); Demange 2006, pp. 72, 96, cat. no. 35.
4 Drandaki 2011, fig. 10; Allan 2004, p. 355.
5 *Umayyads* 2000, p. 81. For an unglazed ewer, see Bernus-Taylor and Delpont 2000, p. 31, cat. no. 12.
6 Rawson 1982; Watt 2004, p. 245, cat. no. 140. See also a Liao-dynasty ewer (907–1125), at http://www .liveauctioneers.com/item/760675. Traveling in the opposite direction, there is evidence of Chinese porcelain being imported into the Islamic world in the cargo of the Belitung shipwreck (ca. 830), which included just such a ewer; http://en.wikipedia .org/wiki/Belitung_shipwreck.
7 Harper 1978, pp. 64–65, cat. no. 21; Marshak 1986, figs. 55, 56, 199; see also the bronze inlaid ewer in the Hermitage, al-Khamis 1998, p. 12, fig. 7. For dolphins, see Boyd and Mango 1992, pp. 24–26; Alaoui 2000, p. 208, cat. no. 251; Papanikola-Bakirtzē 2002, p. 283, cat. no. 296, p. 305, cat. no. 332.
8 The arcade arrangement corresponds to similar architectural decoration on Late Sasanian silverware; see O. Grabar 1973, fig. 99; Demange 2006, pp. 106–7, cat. nos. 44, 45. For fruit trees and animals in an imaginative terrestrial world, see a sixth-century mosaic in Dauterman Maguire and Maguire 2007, pp. 58–61, fig. 51.

References: Sarre 1934; King 1982; Baer 1983, pp. 86–87; O'Kane 2006, pp. 20–21, fig. 11; "Ewer of Marwan II," in *Qantara: Mediterranean Heritage*, 2008, http://www .qantara-med.org/qantara4/public/show_document .php?do_id=813#; Al-Sayyed Muhammad Khalifa Hammad, "Ewer," in *Discover Islamic Art: Museum With No Frontiers*, 2010, http://www.discoverislamicart.org /database_item.php?id=object;ISL;eg;Mus01;20;en.

172A, B. Fragments of Two Textiles with Confronted Animals

.....................

A. Fragment of a Mat Fan or Fly Whisk with Quadrupeds

Probably Egypt, 10th century
Strips of date palm, woven
9.5 × 26 cm (3¾ × 10¼ in.)
Provenance: Collection of Antonis Benakis (1873–1954); part of the original Benaki Museum, which was given to the Greek state in 1931 and inaugurated on April 22 of that year.
Condition: Areas are missing from the edges.
Benaki Museum, Athens (14744)

B. Textile Fragment with Birds

Egypt, 8th century
Plain-weave ground in brown cotton and linen with design in pattern and brocading weft in undyed linen and light blue cotton
8 × 14 cm (3⅛ × 5½ in.)
Provenance: George D. Pratt (until 1933).
Condition: This is a fragment of a larger textile with a repeated pattern. It is worn. There is a tear on the lower left edge. The edges are fraying. A selvage is preserved along the right side. It is discolored.
The Metropolitan Museum of Art, New York, Gift of George D. Pratt, 1933 (33.17.4)

Fragment A, probably from a fan or a fly whisk, is woven in such a way that the design is visible on both sides of the fabric. Within a rectangular panel defined by three parallel lines, two lions are shown drinking from a footed vessel. They are accompanied by two smaller quadrupeds resembling dogs, with cocked ears and curled and lifted tails. Each lion is shown in profile, standing on four feet with the head in frontal view. The tail is raised and extended over the body, and it ends in a knot motif. This piece belongs to a group of similar fragments, of approximately the same size, showing a decorative theme within a rectangular panel defined by parallel lines.[1] The main motif is often a Kufic inscription, a stylized depiction of animals, or a combination of the two.[2]

Fragment B is decorated with a pair of birds flanking a tree. Each bird is depicted in a highly stylized fashion, standing on outspread claws, its head turned back. The motif is surrounded by decorative bands; the two on the short sides of the textile contain rows of small parallel lines, while the band remaining on one of the long sides has a linear pattern reminiscent of pseudo-Kufic inscriptions.

Both fragments rely on two colors alone, and in each case the main decoration is shown in a rectangular panel. The theme of both was a popular subject in Islamic art, a pair of animals conventionally represented as confronted (sometimes looking backward) or addorsed, and flanking a plant or other object. MM

1 Cornu 1993, cat. nos. 67, 68; M. Durand and Saragoza 2002, p. 175; E. Kühnel and Bellinger 1952, p. 87.
2 A fragmentary mat depicting a row of birds combined with inscriptions is in the Benaki Museum, Athens (14747) (unpublished).

References: (A, B) Unpublished.

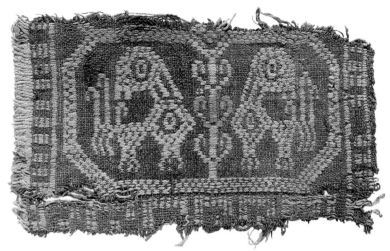

B

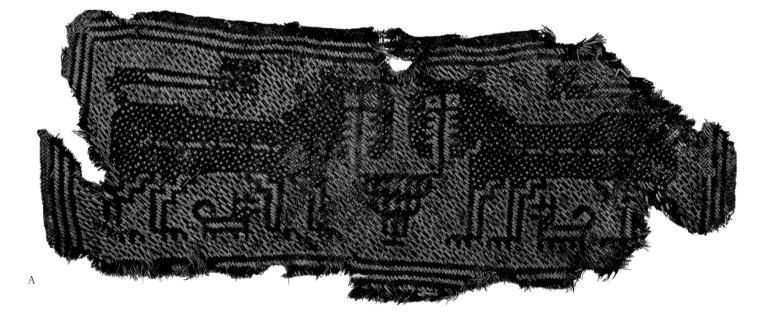

A

Secular Inscriptions

Mina Moraitou

The presence of inscriptions on objects has been one of the defining characteristics of Islamic art from the very beginning (see Komaroff, p. 258). Writing as a form of decoration appears in every form of artistic expression, from architecture and luxury goods to objects of everyday use. The tradition of inscriptions, whether on buildings or objects, was not an Islamic innovation, however, but was carried over from the Late Antique world. This practice grew in extent and frequency, and from the seventh to the tenth century inscriptions communicated a variety of messages—informative or benedictory, in both public and private contexts.

Secular inscriptions reveal historical facts about the objects they decorate. Following established formulas, they may convey formal political messages glorifying a ruler. An early example is a column capital with a lengthy inscription concerning the building of a water reservoir for the Umayyad palace of al-Muwaqqar. Stating that it was commissioned by the caliph Yazid II (r. 720–24) and supervised by 'Abdallah, the son of Süleyman, it includes blessings for the ruler.[1] Similar factual information is found carved on milestones of the Umayyad period as well as woven into textiles.[2] Numerous *tiraz* textiles throughout the Abbasid and Fatimid periods have inscriptions whose contents follow a specific and relatively consistent pattern: the invocation to God is followed by wishes for long life or victory for the caliph; then comes detailed information on the type of workshop that made the textile, including its location and sometimes the name of the supervisor. A date is customarily included at the end (cat. nos. 173, 176). Other, less official inscriptions also disclose historical facts about the creation of the works, often honoring the owner or the maker. Examples can be found on objects made of glass (cat. no. 174), ivory,[3] and metalwork, an early example of the last being a vessel from the State Hermitage Museum, Saint Petersburg (cat. no. 169).

Epigraphic bands are often central to the decoration. For example, a vessel in the Holy Monastery of Saint Catherine, Sinai (cat. no. 38), prominently displays the phrase "In the name of God the blessing of God to the owner." A piece of furniture in the Benaki Museum, Athens, also features an inscription (cat. no. 162), while two inscriptions are the only decoration on a reed mat from Tiberias (today's Tabariya; cat. no. 185). In the case of ceramics, the content of the inscriptions ranges from blessings and historical information to popular sayings (cat. no. 175).[4] Following Christian prototypes, the inscriptions on

oil lamps often reveal different kinds of content (cat. no. 126C, E–G, and Schick, p. 186).

The prevailing form of epigraphy was an austere angular script with clear vertical and horizontal lines, called Kufic. During the ninth century one form of this script took on a particularly decorative aspect, with certain letters terminating in half-palmettes or leaf forms that integrated words into the broader decorative scheme (cat. no. 179). This type of calligraphy, which reached its peak in the Fatimid period, was the beginning of a great tradition of writing on objects of art, utilizing all the decorative potential of the Arabic alphabet.

173A–C. Fragments of the So-Called Marwan *Tiraz*

.....................

Eastern Mediterranean or Central Asia, 8th century
Weft-faced compound twill weave (samit) in polychrome silk; inscription embroidered in yellow silk in Ifriqiya (modern Tunisia)
Condition: All the fragments are pieces from one silk textile, conserved.

A. Three Fragments of a *Tiraz* Inscribed with the Name of the Caliph Marwan
(1314-1888) 30.3 × 50.7 cm (11¹⁵⁄₁₆ × 19¹⁵⁄₁₆ in.)
(1385-1888) 5.5 × 45 cm (2³⁄₁₆ × 17¹¹⁄₁₆ in.)
(T.13-1960) 15.2 × 21.5 cm (6 × 8⁷⁄₁₆ in.)
Inscribed: In Arabic, الله مروا[ن امير المؤ . . . فى طراز افريقية
(. . . [the servant of] God Marwan commander of the [faithful] . . . in the *tiraz* of Ifriqiya)
Provenance: (1314-1888 and 1385-1888) Purchased from Reverend Greville J. Chester (1830–1892) in 1888; (T.13-1960) in the collection of John Charles Robinson (1824–1913) until 1889; gifted to the Manchester Whitworth Institute (now the Whitworth Art Gallery) in 1889; acquired by the Victoria and Albert Museum by exchange in 1960.
Victoria and Albert Museum, London (1314-1888, 1385-1888)
Victoria and Albert Museum, London, given by the Whitworth Art Gallery, Manchester (T.13-1960)

B. Inscribed Fragments of the So-Called Marwan *Tiraz*
Both pieces, 8.9 × 10.2 cm (3½ × 4 in.)
Inscribed: In Arabic, . . . الر . . . امر . . . [مذ]سين مما . . .
([faithful], what was ordered [to be made by] . . . al-R [or al-Z])
Provenance: Gift of Pratt Institute; to Brooklyn Museum, 1941.
Brooklyn Museum, New York, Gift of Pratt Institute (41.1265)

C. Fragment of the So-Called Marwan *Tiraz*
14 × 13.3 cm (5½ × 5¼ in.)
Provenance: Collection of John Charles Robinson (1824–1913) until 1889; gifted to the Manchester Whitworth Institute (now the Whitworth Art Gallery) in 1889.
The Whitworth Art Gallery, The University of Manchester (T.8496)

These silk fragments, divided among different collections, are among the earliest examples of *tiraz* production. They are united by an inscription identifying the *tiraz* embroidered in yellow silk. Section A, the largest, consists of three fragments. The inscription on the first piece mentions the name of the caliph Marwan, followed by the typical title "commander of the faithful." Below the inscription is a band subdivided in three parts: a chain of hearts between two rows of pearls on a green-and-red background interrupted by squares.[1] The second piece is inscribed with the name of a *tiraz* workshop in Ifriqiya (modern Tunisia). Together with fragment C and the third and smallest piece of A, they display an arrangement of composite medallions made up of a scrolling design with white dots that looks like a pearl border, a series of stylized bunches of grapes, and, in the center, a rosette of heart-shaped motifs. The medallions are separated by rosettes with a quatrefoil design. The fragments of B belong to a

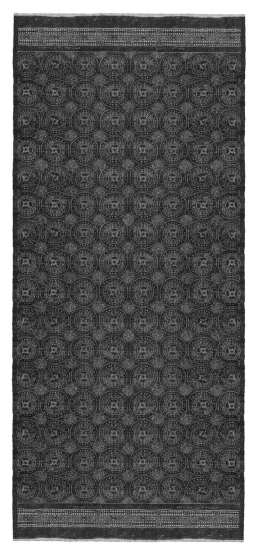

Fig. 94. Digital reconstruction of Marwan *Tiraz*; the inscription is not included in the reconstruction.

section that was once between two of the above-mentioned pieces (fig. 94). The inscription completes the word *al-mu'minin* (faithful) and ends with the first letter of a name, probably the supervisor of the workshop. The use of the caliph's name assigns the textile to the period of either Marwan ibn al-Hakam (Marwan I; r. 684–85) or Marwan ibn Muhammad (Marwan II; r. 744–50). Most likely it dates from the time of the latter, since the former reigned for only one year. These fragments constitute one of the two earliest dated Islamic textiles; the other also bears the name of Marwan.[2]

Identifying the place of production is a complicated matter. Little is known about *tiraz* workshops in the Umayyad period, although some references in the sources suggest the existence of such institutions.[3] While no specific mention of a weaving center in Umayyad Tunisia exists, it has been suggested that a pre-Islamic tradition in the area may have continued after the Arab conquests.[4] Whether woven in Ifriqiya or not, the place-name is significant because it indicates where the textile was embroidered.

Byzantine workshops, from the fourth century, produced woven goods to meet the demand for luxury textiles (cat. nos. 101, 102),[5] often imitating imports from Iran or farther east. Individual designs on the Marwan fragments such as quatrefoils, heart-shaped motifs, and rosettes are familiar in the eastern Mediterranean, but pearl-beaded borders and roundels are more typical of textiles influenced by Sasanian models and are particularly associated with costumes of the court.[6] Textiles were commonly transported from one place to another as a product of trade or gift exchange. Although the general layout of the design is reminiscent of Sasanian textiles, certain examples from Central Asia also share motifs, possibly tipping the balance toward the East.[7] (See the scientific analysis by Ana Cabrera below for similarly ambiguous results.) MM

A silk textile, probably woven in Byzantium or Central Asia, was exported to Tunisia, embroidered during the reign of Marwan II (r. 744–50), and subsequently taken to Egypt, where it dressed the body of someone lying in a grave at Panopolis (Akhmim). The fragments of this textile found their way into at least four different international institutions on different continents, and there is anecdotal evidence of further fragments known in other collections. The

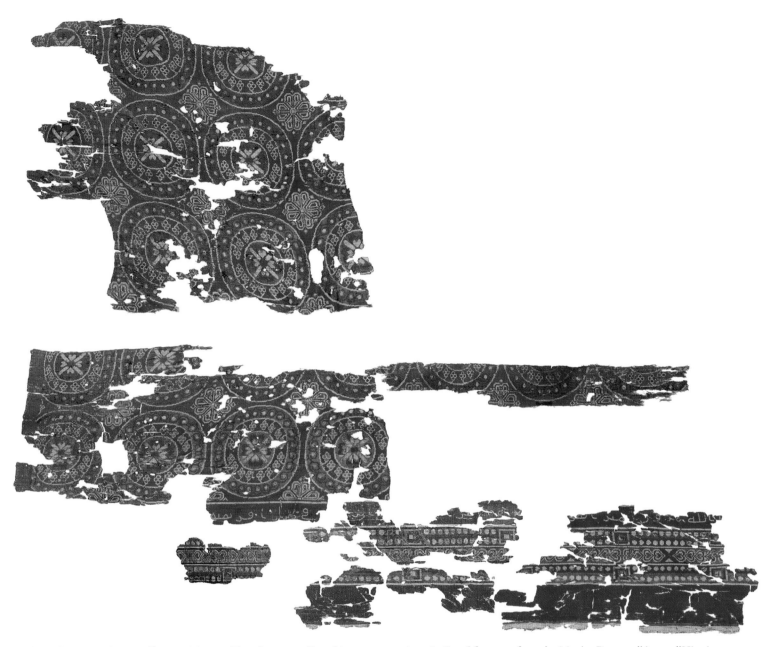

173A–C. Composite image of known Marwan *Tiraz* fragments aligned in pattern: sections A–C and fragment from the Musées Royaux d'Art et d'Histoire, Brussels (JS.Tx. 606)

reason for this dispersal lies in the history of late nineteenth-century collecting, especially the feverish manner in which the cemeteries of Akhmim in Upper Egypt were plundered by dealers and collectors after its treasures were first revealed in 1884 through excavations directed by Gaston Maspero.[8]

These burials, dating from Roman to medieval times, contained thousands of rich examples of the whole history of textile art and culture in Egypt, preserved in the dry conditions. One contemporary observer— probably Flinders Petrie (1853–1942)— described "hundreds of coffins, still intact in the dry soil, containing mummied corpses . . . literally decked out in their best clothes."[9]

These "tattered robes," systematically cut up to multiply the quantity available, soon began to enter public and private collections, with the Victoria and Albert Museum acquiring material from the site by 1886.[10]

Two fragments of the Marwan *tiraz* were sold to the Victoria and Albert in 1888 by the Reverend Greville J. Chester (1830–1892), a keen antiquary who sought new collections every winter, very often in Egypt. By 1871 he had already been commissioned by the Victoria and Albert to "purchase . . . Arabian antiquities," mainly woodwork, in Egypt.[11] Textiles were clearly a particular interest of his, and in April 1888 he dispatched from Luxor to London a crate containing 722 items of

"ancient Roman and early Christian textiles from Echmin [*sic*] and Erment [*sic*], Upper Egypt," including two fragments registered as 1314-1888 (from Akhmim) and 1385-1888 (from Armant [Hermonthis], near Luxor) (two fragments of A).[12] While the different locations might suggest that these two related fragments actually came from different textiles,[13] the assigned provenance cannot always be taken for granted, as "Akhmim" became a selling point allowing dealers to fetch a higher price. Although Chester is known to have acquired material from the site itself, he also bought from dealers in Cairo and evidently took their attributions on trust.[14]

John Charles Robinson (1824–1913) undoubtedly acquired his two large fragments of the Marwan *tiraz* from dealers (the third fragments of A and C). He amassed a collection of some seventy textiles, reputedly from Akhmim, which he presented to the Manchester Whitworth Institute (now The Whitworth Art Gallery) when it was founded in 1889.[15] In 1958 Donald King, then assistant keeper in the Victoria and Albert's Textiles Department, wrote to Margaret Pilkington, honorary director of the Whitworth, suggesting uniting the fragments for the benefit of scholarship.[16] After some negotiation, a "mutually satisfactory" exchange of objects was agreed. The large inscribed fragment from Manchester was formally accessioned by the Victoria and Albert as T.13-1960 and mounted together with the small fragment bought from Chester for ten shillings in 1888 (third fragment of A).[17]

<div align="right">MR-O</div>

Scientific Analysis of the Marwan *Tiraz* Fragments in the Victoria and Albert Museum[18]

Translated by Mariam Rosser-Owen; analysis conducted by Enrique Parra at the Alfonso X El Sabio University, Madrid

Summary Table of Results (numbers in brackets indicate the number of samples of each color)[19]

Color	1314-1888	1385-1888	T.13-1960
Red / orange red	Madder (3)	Madder (1)	Madder (2) Madder + kermes (1)
Green	Indigo (1)		Indigo (1)
Yellow		No dyestuff detected	Persian berries (1)
White			No dyestuff detected

The results of dye analyses undertaken on fourteen samples from the three fragments of A support its identification as a textile of Byzantine or Middle Eastern manufacture from the period 600 to 900. The absence of further analyses and studies of textiles of this period—and especially of Byzantine textiles—makes it difficult to say anything more definitive about the origins of this particular silk.

The study provides an idea of the variety of dyestuffs used during Late Antiquity and the early Middle Ages. Dyes at this time came from only two sources: the vegetable world (madder, indigo, woad, weld, Persian berries, and others) and the insect world (kermes, cochineal, and others). On the present textile the color red was obtained with madder on 1314-1888 (three samples) and 1385-1888 (one sample), with one example of added

kermes on T.13-1960.[20] The color blue comes from indigo.[21] The yellow dye, detected only in T.13-1960, is from Persian berries.[22] The white color analyzed did not yield a result, probably because it is the natural color of the silk. Finally, the mordants detected by scanning electron microscope are the usual ones for this type of textile.[23]

These findings provide significant, but inconclusive, clues to the textile's place of manufacture. The use of kermes as a red dyestuff indicates a western provenance, since no analysis of a textile made in Central Asia has yet revealed the use of kermes. However, the use of Persian berries has until recently been found only on Central Asian textiles.[24] AC

We would like to thank our colleagues at the Victoria and Albert Museum, most especially Clare Johnson in the Victoria and Albert Photography Studio and Elizabeth-Anne Haldane, Senior Textile Conservator. We would also like to acknowledge the expert advice of Dr. Jon Thompson.

1 See Errera 1907, p. 10, for another small fragment found in an Egyptian tomb that bears the same design.
2 The other inscribed textile is datable to the eighth century: a piece of wool tapestry in the Textile Museum, Washington, D.C. (73.524); see E. Kühnel and Bellinger 1952, p. 5. A similarly decorated textile fragment but with no inscription is kept in the same museum (73.550) and is attributed to eighth-century Iran or Iraq. See Harper 1978, cat. no. 62.
3 Serjeant (1942, pp. 14–15) says that, according to the fourteenth-century writer Qalqashandi, a *tiraz* workshop existed in Alexandria in the Umayyad and Abbasid periods.
4 Day 1952, pp. 58–60, a point questioned in Jacoby 2004, p. 200, n. 12.
5 Desrosiers 2004, nos. 104–106.
6 Day 1952 indicates that isolated motifs find precedents in the eastern Mediterranean of the Roman period through to the decoration of the Umayyad palaces. For Sasanian influence, see Overlaet 1993, p. 115. See also the garments worn by the kings depicted on the frescoes of Qusayr 'Amra.
7 It is possible to trace isolated motifs such as the rosette designs; see Overlaet 1993, p. 116, fig. 104, and p. 278, cat. no. 129. See Watt 2004, p. 340, cat. no. 239, for an example of a Chinese silk textile, excavated in a tomb decorated with Western-influenced pearl roundels. See Desrosiers 2004, p. 223, for a fragment from a Central Asian workshop in the Musée National du Moyen Âge, Thermes et Hôtel de Cluny, Paris, dated to the late seventh or early eighth century; Heller 2006, pp. 178–88; and Watt 2004, cat. no. 244, for two textiles with Tibetan inscriptions with similar motifs.
8 Fluck 2008; O'Connell 2009.
9 *Examiner and Times*, ca. 1889, p. 10, quoted in Pritchard 2006, p. 1.
10 Pritchard 2006, p. 1 (the Victoria and Albert Museum was then called the South Kensington Museum). The provenances of all the pieces in London, Manchester, Brooklyn, and Brussels can ultimately be traced to Egypt.
11 Information on the Chester nominal file, V&A Archives (MA/1/C1212).
12 On the "Coptic" textiles acquired by the Museum from Chester, see Persson 2010, esp. pp. 5–6. Of the textiles, 659 were returned.

13 Day 1952 concluded that these pieces came from different textiles but based her information about fragment 1385-1888 on technical information supplied to her by John Beckwith, at that time a curator in the Victoria and Albert's Textiles Department, but who subsequently made his name as a specialist in sculpture. Donald King (see text at n. 16) himself seems never to have quite made up his mind about whether this piece came from the Marwan *tiraz* or not.
14 Persson 2010, pp. 1–2, 6.
15 Pritchard 2006, p. 1.
16 The letter states, "I have long wondered whether it might not be possible to bring together permanently two parts of an Arabic inscription which is of some importance for the early history of silk-weaving. One part, bearing the name of the Khalif Marwan, is on a piece of silk in the [V&A]. . . . The other part refers to Ifriqiya and is on a piece of silk in the Whitworth Art Gallery. . . . I think there is no doubt that the value and interest of this inscription would be enhanced both for epigraphists and textile-specialists if the two parts could be re-united." Letter dated July 9, 1958, among correspondence on file in the Whitworth Art Gallery archives, now copied for addition to the Whitworth Gallery files in the V&A Archives (RP/1958/2496).
17 All fragments A and C have the same weaving mistake, confirming that they come from the same textile. Personal communication from Frances Pritchard, curator, the Whitworth Art Gallery.
18 This analysis is the fruit of a collaboration between the V&A and the research project Caracterización de las producciones textiles de la Antigüedad Tardía y Edad Media temprana: tejidos coptos, sasánidas, bizantinos e hispanomusulmanes en las colecciones públicas españolas (Characterization of Late Antique and Early Medieval Textile Production: Coptic, Sasanian, Byzantine, and Spanish Muslim Textiles in Spanish National Collections) (HAR2008-04161) directed by Dr. Laura Rodríguez Peinado, Universidad Complutense de Madrid, Departamento de Historia del Arte I (Medieval).
19 The dyes were analyzed through high-performance liquid chromatography (HPLC), extracting threads with a thickness varying between 5 and 1 mm by means of 100 μL of methanol/hydrochloric acid/water 1:2:1. The chromatography was performed under the conditions described in Wouters et al. 2008. The analyses of the mordants were carried out using a Phillips XL-100 scanning electron microscope (SEM) equipped with an EDX microanalyzer. Samples were taken by Elizabeth-Anne Haldane, Senior Textile Conservator at the Victoria and Albert Museum.
20 Six of the seven samples showed madder, while in one case red was obtained from a mixture of madder with kermes. The red color obtained from madder has varying tones, including an orangey red, whereas the mixture of madder with kermes gives a deeper intensity to the red. This technique of combining different dyes (madder + kermes and also real purple + kermes) is documented as early as the first century C.E. (Wouters et al. 2008, pp. 8–9).
21 Indigo was usual in textiles of this period. It is worth remembering that indigo and woad were the only sources of blue indigenous to the Mediterranean Basin and the Middle East.
22 The yellow dye was not detected in three of the samples, probably because the volatility of the dyes, which are more sensitive to light, often presents difficulties in detection. The same reason might also explain why the only dye detected in the green threads is indigo, used for blue; the yellow dye combined with it to make green, being fugitive, has since disappeared (Hofenk de Graaff and Roelofs 2006, pp. 41–42; Verhecken-Lammens et al. 2006, pp. 246–47). The Persian berries detected as the

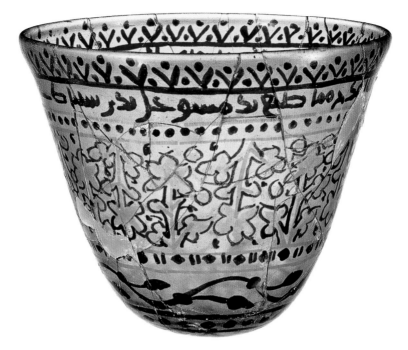

yellow in the one sample are also known as dyer's buckthorn or Avignon berries and come from the *Rhamanaceae* family. According to the medieval sources, they were much used as a dye in the Middle Ages, imported from Smyrna (modern-day Izmir) and Aleppo (Cardon 2003, pp. 158–59). They also appear in Late Antique recipes such as the *Papyrus Graecus Holmensis* (Hofenk de Graaff 2004, pp. 194–201).

23 See Cabrera et al. 2011 for the alum, ferrous sulfate, and copper sulfate found to be the usual ones for this type of textile. The presence of elements other than alum, sulfur, iron, and copper was not taken into account for the interpretation of the mordant data. The mordant is a complex mixture of mineral salts in which normally variable portions of alum, ferrous sulfate, and copper sulfate are combined. In certain cases, some of these metals are not present, except the alum, which is a common denominator for all mixtures. Contaminants such as silicon (Si), potassium (K), calcium (Ca), and chlorine (Cl) come from dust, burial conditions, humidity, washings, and so on, while phosphorus (P) and calcium (Ca) can be present owing to the contact with bones in the burial conditions in which these textiles have been preserved.

24 Hofenk de Graaff and Roelofs 2006, p. 44, detected Persian berry dye in textiles from Central Asia dated by Carbon-14 analysis to between 600 and 900. Gayo and Arteaga 2005, p. 130, identified Persian berry dye in textiles from the ninth–tenth century from the Iberian Peninsula. Verhecken 2007 found none in Late Antique or Byzantine textiles from Egypt. However, yellow dye from Persian berries has recently been detected in two Late Antique Egyptian textiles from the Museu Tèxtil i d'Indumentària in Barcelona (Cabrera, forthcoming Ph.D. diss.).

References: (A) Combe et al. 1931–56, vol. 1, p. 28; Day 1952; Jones and Michell 1976, p. 73; Baker 1995, p. 39; Contadini 1998, pp. 59–60; (B) Day 1952; Poster 2003, pp. 214–15, no. 87; Pritchard 2006, p. 2; (C) Pritchard 2006, p. 2.

174. Luster-Painted Cup

.

Damascus, 786/787
Bluish colorless glass, with dark brown and yellow stains; free blown and stained, tooled on the pontil
H. 10 cm (3 15⁄16 in.); Diam. of cup 13.2 cm (5 3⁄16 in.)
Inscribed: In Arabic,

بسم الله الرحمن الرحيم بركة من الله لمن يشرب بهذا القدح
مما صنع بدمشق على يدي سنباط [؟] فى سنة [١]

(In the name of God the Merciful, the Compassionate, God's blessing on the person who drinks from this cup, which was made in Damascus by the hand of Sunbāṭ (?) in the year 1).
Provenance: Purchased from Mohammad Yegameh, Frankfurt, in 1969.
Condition: The cup was broken and has been repaired; about 10 percent is missing. The surface is lightly weathered, resulting in a milky white film. The glass contains scattered small bubbles.
The Corning Museum of Glass, Corning, New York (69.1.1)

This cup belongs to a group of luster-painted glass objects with inscriptions that provide information about their production. Its colorless body, with a small base and flared rim, is decorated both inside and outside in a combination of brown and yellow pigments. The ornamentation is arranged in horizontal bands: writing appears on an upper register, while schematic plant motifs, dots, and lines adorn the rest of the surface. As is typical of early Islamic art, the inscription comprises the place of production, the craftsman's name, and a blessing. Expensive to produce, a luster-painted cup was a status

symbol for the owner, whose name was sometimes included in the inscription.

Several examples of luster-painted glass have been excavated in Egypt, where the technique developed in about the fourth century.[1] A cup in the Museum of Islamic Art, Cairo, similar in size and decoration to the Corning Museum vessel was found in Fustat (today's Cairo).[2] The Museum of Islamic Art also has a fragment with a Kufic inscription dated A.H. 163 (779–80) in Coptic numerals that states that it was made in Egypt (Misr).[3]

Excavations in Syria have revealed that it, too, was a center of production for luster glass. A beaker with an inscription conveying good wishes associated with drinking states that the vessel was made in Damascus. It is datable to the period associated with the Abbasid caliph al-Mu'tasim (r. 833–42).[4]

MM

1 See Carboni and Whitehouse 2001, pp. 199–201, and Caiger-Smith 1985, pp. 24–25.
2 This cup includes a benedictory inscription offering good wishes for the health and glory of 'Abd al-Samad b. 'Ali (722–802), the governor of Mecca, Medina, and Basra. Scanlon and Pinder-Wilson 2001, p. 110, no. 45a.
3 See ibid., pp. 110–11.
4 The Syrian beaker is in the collection of the National Museum of Damascus. See *Syrie* 1993, p. 420.

References: Blair 1998, p. 184; Carboni and Whitehouse 2001, pp. 208–9.

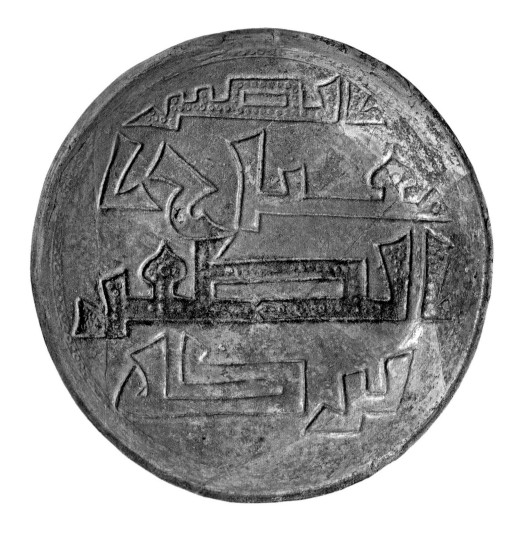

175. Dish with Molded Kufic Inscription

......................

Iraq, 9th century
Yellow- and green-glazed ceramic with
molded decoration
H. 2.2 cm (⅞ in.), Diam. 16.8 cm (6⅝ in.)
Inscribed: In Arabic,

الصبر مفتاح الظفر بركة

(Patience is the key to victory. Blessing)
Condition: The dish is in good condition.
The David Collection, Copenhagen (50/1999)

The flat form of this rimless dish allows the inscription to stand out as the sole decorative motif. The object belongs to a group of early Islamic ceramics influenced by the shapes and relief decoration of molded metalwork. The color scheme of yellow and green, however, is reminiscent of Chinese Tang dynasty (618–906) pottery that would have been available at the Abbasid court.

The dominant presence of the Kufic script highlights the importance of epigraphic decoration on works of art from the earliest centuries of the Islamic era. The content of the inscription is a short maxim about the virtues of patience. An extra letter at the end of the second line is either the result of miscopying by an illiterate ceramist or was added to fill the space for the sake of compositional balance. The first and third words, patience and victory, are filled with small dots and highlighted in green to emphasize their significance. The phrase ends with the word *baraka*, or blessing, the most frequently used word in benedictory inscriptions and one that often appears on objects dating to the early periods, either within a sentence or standing alone.[1] MM

1 A similar dish in the collection of the British Museum (ME OA 1963.4-24.1) is inscribed with a couplet on the theme of patience and endurance by the poet Muhammad ibn Bashir al-Khariji (d. 846). See Pinder-Wilson 1963–64. Another plate, in the collection of the Freer Gallery of Art, Smithsonian Institution, Washington, D.C., belongs to the same group but is larger and displays, instead of an inscription, geometric interlacing with palmettes, executed in the same manner. See Atıl 1973, p. 17.

References: Von Folsach 2001, fig. 99; Blair and Bloom 2006, p. 102.

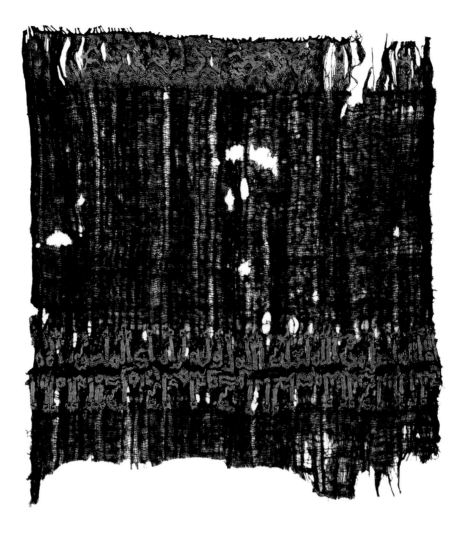

176. Fragment from a Turban with a *Tiraz* Inscription

....................

Egypt, Tinnis, late 10th century
Plain weave in blue linen with inscription in golden
yellow silk thread
17.3 × 19.3 cm (6¹³⁄₁₆ × 7⅝ in.)
Inscribed: In Arabic,

(١) . . . [لا إله] إلا الله نصر من الله لعبد الله و وليّه نزار أبى
المنصور الإما[م العزيز بالله أمير المؤمنين]
(٢) . . . [صلوات الله عليه وعلى أبائّه الطاهرين و] أبنائه اله
الاكرمين (sic) (sic)
(ما أمر) بعمله فى طراز الخاصّة بتنّيس سنة سبع
[وسبعين وثلثمية]

1) (. . . [There is no God] but God, the assistance of God
to the slave of God and His friend Nizar Abu al-Mansur
al-ima[m al-'Aziz billah,] . . .); 2) (. . . [the blessings of God
upon him and upon his pure ancestors and] his noble
descendants; this was ordered to be made in the private
tiraz workshop of Tinnis in the year 37[7] or 37[9].)
Provenance: Collection of Antonis Benakis (1873–1954);
part of the original Benaki Museum, which was given to
the Greek state in 1931 and inaugurated on April 22 of
that year.
Condition: There is an area of loss at the top right corner,
and there are scattered holes throughout.
Benaki Museum, Athens (14997)

This blue linen fragment, probably part of
a turban, has a decorative band at the
top and two lines of inscription in Kufic
script woven in golden yellow silk thread at
the bottom. The content of the text follows
the typical form for *tiraz* textiles, conveying
good wishes to the Fatimid caliph al-'Aziz
(r. 975–96).[1] It provides information on the
textile's provenance, naming Tinnis as the
place where it was woven and identifying
the workshop as state-run. The fabrication
year, given at the end of the inscription, is
illegible, but an approximate dating is pos-
sible based on the readable text.[2]

In the first few centuries after the Arab
conquests, Egypt, continuing a strong pre-
Islamic tradition, developed several important
weaving centers. These centers employed a
great variety of materials and techniques. In
particular, the production of the famous
workshops of the Nile Delta produced fab-
rics incorporating precious materials that
were considered indicators of wealth and
rank. Written Arabic sources document that
the city of Tinnis was renowned for its luxu-
rious textiles.[3] MM

1 See Fluck, p. 183.
2 See Combe 1940, p. 262, pl. 2.
3 See Lev 1999.

References: Combe et al. 1931–56, vol. 5 (1932), p. 192,
no. 1919; Combe 1940, p. 262, no. 2; *Trésors fatimides* 1998,
p. 104, cat. no. 24; Ballian 2006, p. 80, fig. 77; Moraitou
2008a, p. 62.

Faith, Religion, and the Material Culture of Early Islam

Finbarr B. Flood

To write about the material culture of religion in Early Islam is to indulge an anachronism rooted in the Enlightenment dogma that religious belief is a personal, private affair, distinguishable from the secular sphere of public action. In addition, to focus on the religious dimensions of Early Islamic material culture is to commit what critics of the very concept of Late Antiquity—a concept central to this volume—have identified as one of its cardinal sins: an excessive focus on religiosity.[1] Such criticisms reflect broader skepticism about a shift in emphasis from discontinuity and rupture to continuity and transformation in recent histories of the eastern Mediterranean between roughly the fifth and eighth centuries. This shift has been especially marked in scholarship on the early culture and history of Islam. The advent of Islam and its conquest of the eastern territories of Byzantium in the seventh century were once taken to mark the end of Late Antiquity. Alternatively, Islam was integrated into Late Antique history as the end point in a narrative of decline that began with the abandonment of classical administrative structures and aesthetic canons in the second or third century C.E.[2]

Recent archaeological investigations have confirmed that many of the material transformations central to these narratives of decline were in fact under way well before the advent of Islam, but few scholars today would characterize them in this way. One consequence is that recent scholarship has tended to subsume the culture and history of Early Islam into an extended Late Antiquity rather than seeing them as its terminal points.[3] While the upper limits of this new "long Late Antiquity" are a little vague, most scholars now accept that the art and architecture of Early Islam form part of the art of Late Antiquity rather than marking a substantial break with it.

These welcome developments have done much to address the imbalances of a historiography rooted in a priori notions of cultural and sectarian difference. However, they also entail the risk that by emphasizing continuities and intersectarian similarities rather than narratives of conflict and rupture, contemporary scholarship has lurched from one end of an interpretive spectrum to the other. Part of the challenge in dealing with the cultural histories of the eastern Mediterranean during the period covered by this volume lies in the need to acknowledge the complex dialectic of alterity and identity that marked contemporary cultural forms and practices. In this respect, a focus on the art and architecture produced to articulate the religious beliefs, or to facilitate the religious practices, of the early Muslim community may be justified, despite the anachronisms that it entails. It is in the sphere of religious identity and its public articulation that one might reasonably expect the finely honed cultural negotiations necessitated by the emergence of a major new religion to be most apparent. The use of distinctive scripts and formats for Early Islamic sacred texts (see Flood, p. 265) or of particular kinds of ornament for sacred space points in this direction.

Most narratives of Islamic history begin around 570 with the birth of the Prophet Muhammad in Mecca, a city in the Hijaz region of western Arabia. Mecca is said to have been the site of a major annual pilgrimage focused on the Ka'ba, a distinctive cuboid shrine that lay at the center of a sacred enclosure.[4] At the time of Muhammad's birth into the Quraysh, the dominant Meccan tribe, the eastern Mediterranean and Near East were divided between two "superpowers," Byzantium and the Sasanian Empire, each with its own Arab client state, the Ghassanids and Lakhmids, respectively. Arabia lay on the margins of these empires, although what little is known of its material culture suggests a relation to both.[5]

Orphaned at an early age, Muhammad was raised by his uncle, who was involved in long-distance trade and with whom he may have traveled to Syria. According to Muslim tradition, about the age of forty, he received the first of a series of divine revelations transmitted by the angel Gabriel, revelations that would later constitute the text of the Qur'an. Following these revelations, the Prophet began to preach against the polytheistic religions of Mecca. While the presence of Jews and Christians in pre-Islamic Arabia is well documented, the nature of these polytheistic religions has to be gleaned from later texts, which were often shaped by polemical concerns. They seem to have included worship of both aniconic and anthropomorphic cult images, a pattern documented for Late Antique Syria.[6]

The defining characteristic of the new religion was its emphasis on *tawhid*, the uniqueness and unity of God. The rejection of polytheism earned the Prophet and his followers the wrath of the

Meccan elite. As a result, in 622 the nascent Muslim community migrated to the city of Yathrib (later Medina), two hundred miles (322 km) to the north. This foundational act of migration, the *hijra*, rather than the birth of the Prophet, was to be adopted by the early Muslim community as the year zero of its new calendar. In 630 that community was in a sufficiently powerful position to take the city of Mecca, an event that marked the decisive victory of Islam. After that conquest, the Ka'ba and its surroundings were cleared of their images, although according to some accounts, Muhammad spared a painting of Jesus on the lap of the Virgin inside the shrine.[7]

The communitarian values of the new religion were articulated in its five ritual requirements, referred to as the Pillars of the Religion (*arkan al-din*): to profess faith in one god and in the belief that Muhammad is his messenger; to pray five times a day (initially toward Jerusalem, then after 624 toward the Ka'ba); to fast during Ramadan, the ninth month of the Islamic lunar calendar; to give a percentage (usually one-fortieth) of one's salary as mandatory alms for charitable purposes; and, for those Muslims financially and physically able, to make the pilgrimage to Mecca at least once, during Dhu'l-Hijja, the last month of the Muslim calendar. Four of these five emphasize practice in relation to belief, with consequences for the material needs and obligations of Muslims.

The Prophet Muhammad died in 632, two years after the conquest of Mecca, and was buried within the mosque he had constructed in Medina. The following decades were marked by periodic instability related to the question of succession and doctrinal disputes. Of the Prophet's four successors, three were assassinated. One of these killings, that of Caliph Uthman in 656, provoked the first of two debilitating civil wars, in which the Prophet's son-in-law, 'Ali (r. 656–61), was opposed by a faction led by Mu'awiya ibn Abi Sufyan (r. 661–80), the governor of Damascus. The victorious emergence of Mu'awiya's party laid the groundwork for a permanent split between Sunnis and Shi'ites (Shi'at 'Ali, the party of 'Ali). It also marked a shift in the balance of power, both tribal and geographic, by establishing the line of the Umayyads, the first Islamic dynasty, which was based in Syria rather than in the Hijaz. The resulting disjunction between centers of political and religious authority was never to be overcome and played a role in the second civil war (681–92). This erupted after Mu'awiya's death, during the early years of the caliphate of 'Abd al-Malik ibn Marwan (r. 685–705). The decade saw dissent against Umayyad rule, led by Shi'ite factions (including the Prophet's grandson Hussein) and various heterodox groups, as well as the emergence of a countercaliph in Mecca, 'Abdallah ibn al-Zubayr, who controlled access to the Meccan sanctuary between 683 and 692, when he was decisively defeated by 'Abd al-Malik.[8]

Remarkably, the conquests through which the adherents of the new faith established their rule over vast swaths of the known world took place during these turbulent decades. By 651 the Sasanian Empire had ceased to exist, its former lands incorporated into the burgeoning territories of the emerging Islamic state. In the preceding decades, Syria, Palestine, Egypt, and the North African territories of Byzantium had been taken. Less than a century after the Prophet's death, Muslim armies had reached the Atlantic and advanced into southern France, while in the east they raided the mountain valleys of Afghanistan, seized large parts of Central Asia, conquered much of the southern regions of the Indus Valley (present-day Pakistan), and advanced toward the western territories of Imperial China.

The conquests of the early Muslims mark one of the most remarkable achievements in human history. Yet, from the point of view of material culture, surprisingly little exists with which to document their impact or indeed the early history of the Muslim community itself. There are reports of attempts, as early as the 640s, to codify the text of the revelations comprising the Qur'an and perhaps the architecture of the mosque (see Flood, p. 265). It is also becoming increasingly clear that the reign of Mu'awiya saw sporadic minting of coinage in Syria and, conceivably, plans for major architectural projects on the Temple Mount in Jerusalem (not brought to fruition until the last decade of the seventh century).[9] However, apart from a few rock-carved inscriptions found along pilgrimage routes in Arabia, some papyri, and tombstones with confessionally indeterminate inscriptions, there is little material documentation for the early Muslim community before the late 680s and 690s, when invocations of the Prophet and quotations from the Qur'an began to appear.[10] The first dated occurrence of

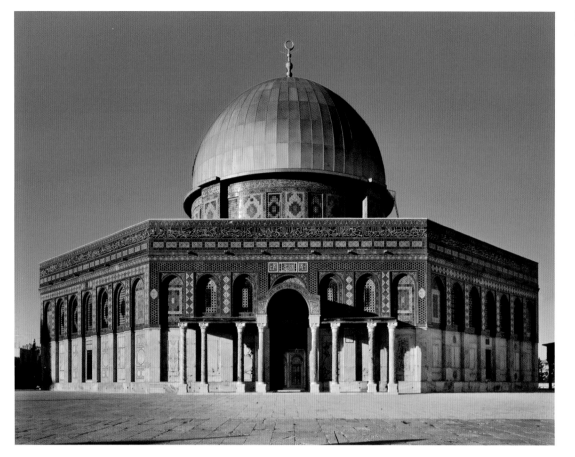

Fig. 95. Dome of the Rock, Jerusalem, completed 691/92

the word "Muslim" in an extant Arabic inscription is not before 741; previous texts had used the term "believer." It has recently been suggested that the earliest incarnation of Islam was as a community of believers (*mu'minun*) that shared a faith in fundamental axioms, such as one god, revealed scripture, and an afterlife, but was otherwise "conceptualized independent of confessional identities."[11]

One does not have to subscribe to this controversial view in order to recognize the period between roughly 690 and 720 as a watershed, fundamental to the self-definition of the Muslim community under the aegis of Umayyad rule. Marked by a proliferation of religious rhetoric in official texts, including the use of the title *khalifat Allah* (deputy of God, from which "caliph" derives), this period also saw significant investments in monumental architecture, coinage bearing religious texts, and the production of spectacular Qur'an manuscripts (cat. nos. 188–190), probably at the behest of the Umayyad elite. Although these developments appear to come from nowhere, they are likely to be related to the emergence of well-defined state structures, witnessed by major reforms, including the replacement of Greek and Persian by Arabic for administrative purposes, and the consistent minting of an Islamic coinage.[12] The reforms followed 'Abd al-Malik's victory over Ibn al-Zubayr in 692 and his infliction of a decisive defeat on the Byzantines at Sebastopolis in the same year, both of which freed up resources previously expended on tribute and warfare.

It was in these circumstances that the Umayyads erected the Dome of the Rock, a monument as spectacular as it is unexpected (fig. 95). The choice of Jerusalem, the sacred city of the two earlier monotheistic religions, rather than Damascus, the Umayyads' administrative center, is significant. The shrine was built atop the platform on which the Jewish Temple had stood before its destruction by the Romans in 70 C.E., and which was known in Arabic as al-Haram al-Sharif (the Noble Sanctuary). It assumed the form of a double octagon framing a rocky outcrop and crowned with a high dome. The lavish interior was adorned with marble and metal veneers as well as with gold-ground glass mosaics inlaid with mother-of-pearl. Featuring images of trees, jewelry, and winged motifs, these mosaics originally extended to the exterior before they were replaced by tiles in the sixteenth century.[13] An Arabic inscription, 787 feet (240 m) long, encircling the summit of both sides of the octagon bears citations of Qur'anic texts and historical information, including the year A.H. 72 (691/92 C.E.), which most scholars accept as the date of completion (fig. 96).

In its form, decoration, and topographic relationships, the Dome of the Rock—visible from afar across the city of Jerusalem (fig. 10)—engaged in a dynamic dialogue with the most celebrated monuments of monotheism. Its marbles and mosaics seem to have been planned with reference to accounts of the Solomonic and Herodian temples, while its measurements, architecture, and topographic relation to the Aqsa Mosque (located on the Haram

platform to the south) evoke the formal, metrological, and spatial relations of the tomb of Christ to its adjoining basilica, the Church of the Holy Sepulchre.[14] Its well-defined geometric form and double ambulatory around a sacred rock also inevitably call to mind the focal shrine of Islam, the Ka'ba of Mecca.[15]

While the engagement of the building with iconic monuments of the three monotheistic faiths is clear, its precise raison d'être is not. It has sometimes been described as a mosque, but its form precludes this. A number of theories, none necessarily exclusive, have been offered to explain the form and iconography of the shrine.[16] There may have been an attempt to overcome the distance between sacral and political geography, after the shift in political power from Arabia to Syria, although this does not mean that the intention was to divert the pilgrimage to Mecca or usurp the place of the Ka'ba, as was claimed by medieval chroniclers.[17] Mu'awiya had been crowned in Jerusalem, a city that was evidently important to the development of an Umayyad dynastic image, perhaps because of its association with Davidic and Solomonic kingship.[18] A suggested allusion to the victory of Islam or of 'Abd al-Malik, based on the depiction in mosaic of hanging crowns and jewelry (fig. 96), would accord with this theme and may have been enhanced by the suspension of resonant objects, including the crown of Khusrau II, the defeated Sasanian ruler, and the horns of the ram sacrificed by Abraham in place of Isaac (a pair of which also hung in the Ka'ba).[19]

In addition, the location of the Dome of the Rock, certain elements of its iconography, and the fact that it was open to the public on Mondays and Thursdays, the same days as the Jewish Temple had been, have led to suggestions that it was intended as a restoration of the Jewish Temple.[20] It has even been suggested that the building was conceived as a baldachin to house the divine presence on the Day of Judgment, a function that may explain analogies with a series of pre-Islamic octagonal commemorative structures in Jerusalem and elsewhere.[21] Such interpretations acknowledge the role that Jerusalem plays in Islamic eschatological traditions as the site of the events of the Last Days; they may have been given additional impetus by the circulation of Messianic traditions related to the approach of the end of the first Islamic century in the decades after the building's construction.

The Dome of the Rock is in many ways a unicum, but in its harnessing of preexisting forms and techniques to address both inter- and intrasectarian concerns, it can be considered paradigmatic of Early Islamic religious art. Providing the clearest statement of these concerns, the mosaic inscriptions (figs. 96, 98) emphasize themes common to Christianity (belief in the Last Days, the prophecy of Jesus, and the venerability of the Virgin), while stressing the Muslim belief that Jesus was merely one in a line of mortal prophets, of whom Muhammad was the last.[22] That chapter 112 of the Qur'an (*Surat al-Ikhlas*) is the only one repeated in the inscriptions suggests that it emblematized both the limits and possibilities of shared belief. Its text, implicitly rejecting the core Christian doctrines of the Incarnation and Trinity, had been affixed to the doors of Egyptian churches by 'Abd al-Malik's brother, the governor of that country, along with

Fig. 96. Dome of the Rock, Jerusalem, completed 691/92; detail of the interior mosaics showing hanging crowns, jewelry, and inscription. © Said Nuseibeh

Fig. 97. Church of the Kathisma, Jerusalem; mosaic pavement with palm tree laid late 7th–early 8th century. Photo Sandu Mendrea, courtesy Israel Antiquities Authority

Fig. 98. Dome of the Rock, Jerusalem, completed 691/92; detail of the interior mosaics showing palm tree and inscription. © Said Nuseibeh

a statement asserting the common prophetic missions of Jesus and Muhammad.[23]

Qur'an 112 was also chosen to appear on a radically new coin type introduced by 'Abd al-Malik at the end of the 690s (cat. no. 91). The adoption of this epigraphic coin ended a brief series of experiments with a figural iconography between 691/92 and 697.[24] Although modeled on Byzantine prototypes, the first issues soon demonstrated an adaptive use of existing iconographic motifs. For example, the cross-on-steps depicted on the obverse of earlier Byzantine issues was transformed, first by the removal of its crossbar, then by its reconfiguration into a kind of staff topped by a sphere (cat. nos. 86B, 88B, and fig. 65). Usually described as a negation of the cross, a symbol of Byzantine imperium and doctrinal difference to Muslims, this altered image may also have given visual expression to a literary image of the caliph as the axis or fulcrum of his community found in contemporary Arabic poetry.[25] If so, it anticipated the appearance of a standing figure, usually identified as the caliph himself, on gold, silver, and copper coins minted from 693/94 (cat. no. 89), perhaps in response to the introduction of a bust of Christ on coins minted by the Byzantine emperor Justinian II (r. 685–711).[26]

Both monument and coins were clearly designed with the Christian majority in mind, but the common assumption that the Arabic texts in the Dome of the Rock constituted an address to the Christians of Jerusalem begs unanswerable questions about access and visibility. More likely, they were intended to articulate a focal statement of Muslim communal belief. Just as earlier priests and rabbis had worried about the allure of synagogue and church to their respective communities, so the Jerusalemite geographer al-Muqaddasi (b. 945 or 946) tells us that the Umayyads built the Dome of the Rock and the Damascus mosque to counterbalance the impressive, richly decorated Christian churches of the region.[27] There is some evidence for the sharing of sacred space between Muslims and Christians in the decades immediately following the conquests of the 630s, and complaints about Muslim visitation to Christian pilgrimage sites in Jerusalem are frequent well into the Early Islamic period.[28] Moreover, the cult of saints such as Sergios, long popular among Arab Christians, continued to attract pilgrims of both faiths (see Ratliff, p. 86); decades after the completion of the Dome of the Rock, a Friday mosque, a mosque capable of accommodating the entire male Muslim population for the Friday prayer, was built by the caliph Hisham (r. 724–43) at Rusafa in northern Syria to connect with the church and shrine of the saint.[29]

It is against this background that one should probably understand the dialogue with Christian pilgrimage sites manifest in the Dome of the Rock. Along with the Holy Sepulchre, these sites included the fifth-century Church of the Kathisma, a double

octagon built around a rock on which the Virgin was believed to have rested. A concave niche excavated in the southern part of the church and tentatively identified as an early eighth-century mihrab (prayer niche) has given rise to suggestions that the status of the Virgin in Islamic tradition led Muslims to pray there. In the late seventh or early eighth century, the Kathisma was provided with a floor mosaic featuring palm trees that were less ambitious than but clearly inspired by the Umayyad mosaics in the Dome of the Rock (figs. 97, 98).[30] Other analogies are offered by the Church of the Ascension on the Mount of Olives, originally a circular structure built around a rock from which Jesus was believed to have ascended to heaven and which bore marks identified as his footprints. The rock under the Dome of the Rock bore similar marks at its southern end, described at various times as the footprint of God, of Isaac and, more consistently, as the trace of the Prophet Muhammad.[31]

Only in the 680s did the Prophet's name regularly appear in public texts, most notably on coins minted by the partisans of the rebel Ibn al-Zubayr. The convention of invoking Muhammad on coinage seems to have been taken up by 'Abd al-Malik as a way to cast Umayyad rule in a more pious mold.[32] The Prophet is alluded to or mentioned by name no fewer than eight times in the interior inscriptions of the Dome of the Rock and four more times on the Umayyad metal plaques covering the northern and eastern entrances, a prominence that contrasts with the more qualified emphasis on Jesus. Two of the Dome of the Rock inscriptions (including one on the eastern gate, facing the Mount of Olives, where the righteous will assemble) emphasize the Prophet's intercession on behalf of his community on the Day of Resurrection, an event in which the Rock and its environs will occupy a central role.[33] These sentiments anticipate invocations of Muhammad on many eighth- and ninth-century tombstones, which also employ Qur'anic quotations referring to the Last Days or paradise.[34]

The unusual prominence of the Prophet in the Dome of the Rock inscriptions may have been part of the same series of competitive iconographic experiments witnessed on Umayyad coinage. It also calls into question a scholarly consensus that, whatever its original meaning, the Dome of the Rock was never intended to commemorate what pious Muslims to this very day believe that it does: the Night Journey (isra') and Ascension (mi'raj) of Muhammad, described in chapter 17 of the Qur'an. The first clear epigraphic indication that the "farthest mosque" (masjid al-aqsa) mentioned in Qur'an 17:1 was identified with the Haram al-Sharif is provided by a mosaic of 1035 in al-Aqsa Mosque citing that text. However, textual sources indicate that the association had already been made in the Umayyad period, possibly as part of Umayyad attempts to enhance the status of Jerusalem.[35] The association of the Prophet Muhammad with the Dome of the

Rock is reinforced by other elements of the building, among them a polished black stone disk incised with a star motif, now set within a ninth- or tenth-century marble mihrab in the cave beneath the rock. This seems to be one of a series set in place during the Umayyad and Abbasid periods at locations in which the Prophet was believed to have prayed.[36]

Such commemorative artifacts collapsed space and time, making the historical Prophet accessible to the pious long after his death, even outside of Arabia. Their veneration was subject to periodic censure from theologians worried that popular pilgrimage practices were usurping the rites specific to the sanctuary in Mecca. Nevertheless, the growth of pilgrimage spurred the production of artifacts designed to meet the needs of pilgrims, among them a series of glass flasks produced before and after the Arab conquest of the city, their representational iconography varied to reflect the respective beliefs and needs of Christian, Jewish, and Muslim patrons (cat. nos. 60, 72, 186).

Although it is often said that Islam lacks a devotional art, the commemorative aspects of pilgrimage seem to have provided a powerful impetus to the generation of graphic images of sacred places. The Persian scholar Nasir-i Khusrau, who visited Jerusalem in 1047, wrote that he measured the monuments of the Haram and drew them in his journal, which raises the intriguing possibility

Fig. 99. The Mosque of Medina on a fragmentary paper scroll, 9th–10th century, Dar al-Kutub, Cairo, 513. Visible in the top left corner is the chamber containing the tomb of the Prophet and the graves of the first two caliphs. The fourth grave (not generally shown on later images) probably reflects traditions that the Prophet's daughter, Fatima, is buried there or that a tomb within the chamber was reserved for Jesus.

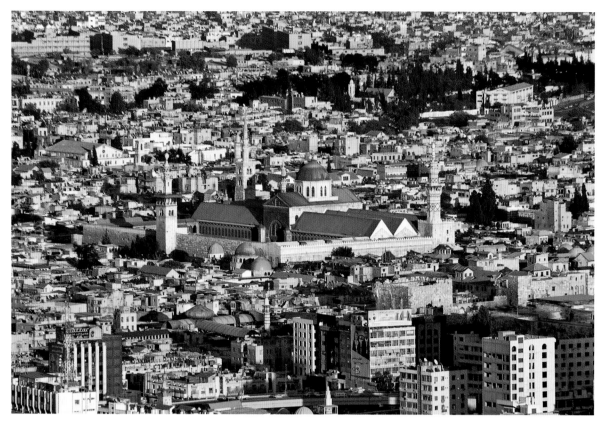

Fig. 100. View of the Friday
Mosque, Damascus, 705–15

that some pilgrims produced images of the sites they visited.[37] Such personal records found a commercial counterpart in the scrolls produced to commemorate pilgrimage, illustrated with images of Mecca, Medina, and sometimes Jerusalem.[38] The scrolls are well documented from the twelfth century onward, but a fragmentary Egyptian paper scroll showing what is likely to be the earliest extant image of the Mosque of the Prophet in Medina (fig. 99) suggests that they were produced as early as the ninth or tenth century.[39] On the fragment, a schematic view of the mosque and Muhammad's tomb is combined with hadith (traditions of the Prophet) and praises of the Prophet and tomb;[40] these anticipate the illustrated texts containing eulogies of Muhammad and his tomb and relics that were to become popular in the Islamic world from the thirteenth and fourteenth centuries onward. The apotropaic, or protective, function of these later texts and their images is also foreshadowed by the fragment, whose vertical format establishes a relation to the magical or talismanic scrolls produced in Egypt before and after the Muslim conquest.

Less canonical talismanic practices survived on the margins of established religion, both figuratively and literally. In the tenth century, for example, at the entrance to the Great Mosque of Hims in northern Syria, there stood a stone bearing the image of a man with a scorpion's tail, one of a number of antique spolia in Syria invested with apotropaic or talismanic properties.[41] Clay impressed with the image protected the house against reptiles; dissolved in water and consumed, it cured the bite of the beast.[42] The context and function recall analogous Byzantine practices,

including the ingestion of dust or plaster from sacred images and the carrying away of clay tokens impressed with images of sacred persons from pilgrimage sites, including the Holy Sepulchre and the shrine of Saint Symeon Stylites the Elder at Qal'at Sem'an (cat. no. 64). Combining sacred image and matter, these clay tokens were also said to repel snakes and reptiles, and, dissolved in water, to have curative properties.[43] The tokens impressed with the talismanic image from Hims belong to the same universe of magic and medicine, but they also find analogies in other Early Islamic pilgrimage practices, including the purchase of tablets comprised of earth from the Shi'ite shrines at Kerbala and Najaf in Iraq, which may represent further continuities with earlier pilgrimage rituals.[44]

The location of the scorpion talisman of Hims underlines the role of congregational, or Friday, mosques as the ritual and geographic heart of the community. Whether built within existing urban landscapes or in new cities founded on an orthogonal plan, congregational mosques in Syria and the Jazira, including those at Aleppo, Damascus, Edessa, Jerash, and Tiberias, were generally located at the crossroads of the city, in close proximity to existing commercial and religious centers.[45]

The architectural history of the early mosque is somewhat obscure, with few extant remains dating before the early eighth century. While the Qur'an does refer to mosques (masajid: places of prostration), their architectural form is unclear from the text, although there is some suggestion that they could be distinguished from the sanctuaries of Jews and Christians.[46] The basic formal features of the congregational mosques founded in Syria and Iraq seem to

have been established by 700, and perhaps as early as a decade after the Prophet's death in 632. In all cases, a hypostyle, or pillared hall, was preceded by a courtyard that was sometimes surrounded on three sides by a portico. This combination remained consistent, although in Syria a "basilical" plan characterized by parallel aisles was favored, and in Iraq a squarer and internally undifferentiated plan.

In its basic arrangement, the early mosque shows similarities with basilical churches, some synagogues, and pre-Islamic Arabian temples. It has been generally assumed that it developed organically from the house of the Prophet at Medina, a multifunctional space that served the three basic functions later associated with congregational mosques: community prayer, the delivery of the Friday sermon (khutbah), and the reception of petitioners. Recently, however, this scenario has been challenged by a suggestion that the form was deliberately created by the Meccan elite, perhaps as early as the reign of the caliph 'Umar (r. 634–44), when attempts to assemble the text of the Qur'an are also reported.[47]

If the 640s were, as it seems, a significant moment in the codification of both sacred architecture and sacred text, the patronage of the Umayyad caliphs between roughly 690 and 710 represented a second, more extensively documented phase. Pre-Umayyad mosques appear to have been relatively unpretentious structures. The Umayyad period witnessed a monumentalization and decorative elaboration of the congregational mosque, perhaps related to the codification of religious ritual.[48] Fragments from luxury Qur'ans datable to the late seventh or the eighth century indicate a concomitant increase in size and ornamentation (cat. nos. 188–190). This implies a coordinated investment in the architecture of the mosque as well as in its liturgical furnishings, seen elsewhere in the elevation of the Prophet's minbar (pulpit), which became a standard liturgical element of the congregational mosque, used for delivery of the khutbah.[49]

The extent of the undertaking is clear from the patronage of al-Walid I (r. 705–15). This son of 'Abd al-Malik constructed or completed the Aqsa Mosque in Jerusalem; rebuilt the Mosque of the Prophet in Medina, the Friday Mosque of Sana'a in Yemen, and the Mosque of 'Amr in Fustat, the capital of Egypt; and refurbished the Meccan sanctuary.[50] Many of al-Walid's mosques have been replaced by later structures, but the jewel in the crown of his architectural program, the Friday Mosque of Damascus (705–15), is reasonably well preserved (fig. 100).[51] This edifice supplanted the Cathedral of Saint John, in one of the few documented cases in which a church was transformed into a mosque.[52] The cathedral had itself replaced a polytheist temple; many of the columns reused in the mosque were already ancient, some having served in both temple and church. Behind the mosque lay the palace of the Umayyad caliphs, a pattern followed in many other administrative centers, where the governor's palace (dar al-imara) lay directly behind the qibla wall, the wall that indicated the direction of Mecca, of the Friday mosque.[53]

The mosques rebuilt by al-Walid saw the introduction of several new formal features, including a mihrab in the form of a concave niche, which was an honorific device in the vocabulary of Late Antique art (cat. no. 24). In Medina at least, this marked the place where the Prophet had led the prayers a century earlier.[54] In many of al-Walid's mosques, the niche was preceded by

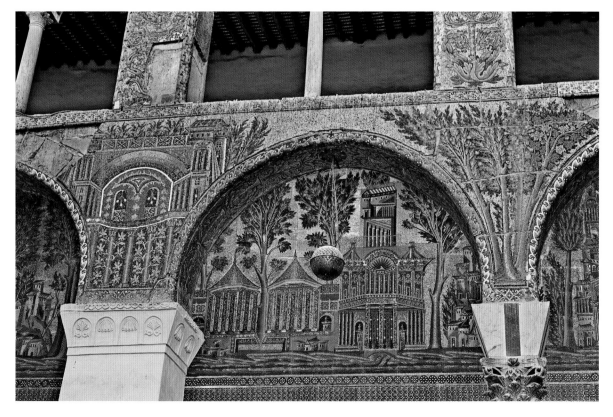

Fig. 101. Friday Mosque, Damascus, 705–15; view of the mosaics on the western courtyard wall

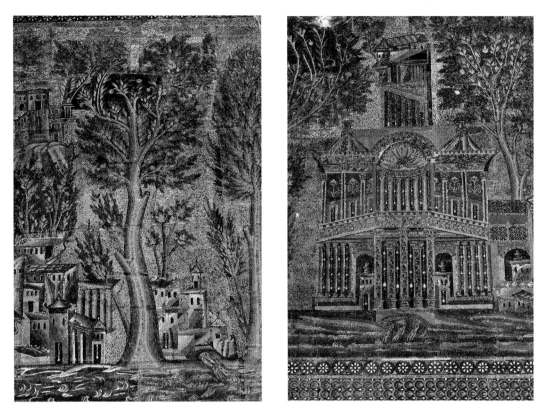

Fig. 102. Friday Mosque, Damascus, 705–15; detail of the mosaics on the western courtyard wall showing a pastoral scene punctuated by tall trees

Fig. 103. Friday Mosque, Damascus, 705–15; detail of the mosaics on the western courtyard wall showing a fanciful pavilion with hanging pearl chains

a nave created by widening the intercolumnar spaces along a single bay, usually at the center of the prayer hall, and by a dome directly in front of the mihrab. While this axial nave imparted a strong directional organization to an otherwise undifferentiated pillared space, whether it had a precise liturgical or other function is unclear.[55]

Al-Walid's building program saw the canonization of an existing decorative vocabulary entailing the use of marble, gold-ground mosaic, and gilded inscriptions arranged in narrow bands on a deep blue ground. This color combination may have been chosen for either its visual or symbolic properties, but its consistent association with projects of the Umayyad elite suggests the latter.[56] The preference for gold-on-blue inscriptions set the tone for later Qur'anic inscriptions in imperial contexts (cat. no. 192).

Closely related to that used in the Dome of the Rock, the decorative vocabulary of al-Walid's mosques omitted certain features apparently specific to the meaning of the Jerusalem shrine (crowns and jewelry, for example) and made extensive use of architectural and architectonic images that were only secondary within it. Such themes predominate in a spectacular mosaic panel, 115 feet (35 m) long, on the western courtyard wall of the Damascus mosque (fig. 101). Offering a glimpse of the mosque's original splendors, the mosaics illustrate pastoral scenes punctuated by depictions of architecture, pavilions, monumental trees, and flowing rivers (fig. 102). The scenes have been variously identified as topographic renderings of Damascus itself or of the cities under Umayyad control, although they lack the identifying labels found in comparable floor mosaics from Jordanian churches

(cat. nos. 1, 79A).[57] Alternatively, they have been read as an evocation of paradise as described in the Qur'an and hadith—a petrified, superlative version of the natural world, characterized by a golden radiance and bejeweled architecture.[58] Similar combinations of rivers, fruit trees, and garden pavilions were used to evoke paradisiacal landscapes in pre-Islamic Syrian church mosaics.[59] The ubiquity of the motif of pearl chains hanging in doorways (fig. 103), and the manner in which it has been adapted from Byzantine eschatological iconography, recall not only Islamic traditions that the denizens of paradise will shine with pearl-like beauty but also metaphorical comparisons between radiant female beauties and pearls in pre-Islamic Arabic poetry.[60]

The mosaics in Damascus and Medina (but not, interestingly, those in Jerusalem) were reportedly executed with help from the Byzantine emperor, and there are indeed iconographic parallels with Byzantine mosaics from both religious and secular contexts (see Evans, p. 4), including pastoral scenes in the sixth-century floor mosaics of the palace of the Byzantine emperors in Constantinople (fig. 5). There are also Arabian precedents informed by Byzantine practice, among them al-Qalis, the cathedral built in Sana'a during the sixth-century Ethiopian occupation, which is said to have had mosaics featuring trees.[61] Few wall mosaics survive from the sixth and seventh centuries, but the gap might be filled by other media. The large, imposing, regularly spaced fruit trees in the Damascus mosaics may, for example, be compared to those on a series of large-scale Egyptian tapestry wall hangings probably dating to the fifth or sixth century (cat. no. 2), which also show little evidence for the presence of images of animate beings.[62]

Despite precedents for aniconic wall decorations, the exclusion of figural imagery and the promotion of architectural and vegetal imagery as primary subjects in the decoration of Umayyad mosques and shrines undoubtedly reflect a deliberate choice, for such characteristics are common to the illuminations of several fragmentary Umayyad Qur'ans, which may have been produced in Syria (cat. nos. 189, 190). The most spectacular example of this style of illumination is a unique double frontispiece that appears to offer alternative views of one or more mosques (fig. 110). This work can be related to a "family" of illustrated Christian and Jewish scriptural codices, produced in Egypt or Syria between the seventh and tenth centuries, that featured architectural motifs and frontispieces (see Flood, p. 265). In its details, it is closely allied with the formal and decorative aspects of the mosques built by al-Walid and typified by the Friday Mosque of Damascus. The similarities include the trees and plants that sprout along the qibla wall in one view (fig. 110), recalling the decoration of the prayer halls in Damascus and Medina, and the narrow vine scroll that frames the scenes, recalling a celebrated gilded marble vine scroll that encircled the prayer hall in Damascus and that may ultimately have been modeled on a similar feature in the church of Hagia Sophia in Constantinople.[63]

Like the sudden appearance of the Dome of the Rock, the decoration of Umayyad mosques and the illuminations of early Qur'an manuscripts suggest that in the construction of an Umayyad visual identity, architecture was privileged as paradigmatic. The representational imagery used in these early Qur'ans (baskets, chalices, columns, lamps, trees, vases) also occurs in the illumination of earlier Christian Gospel manuscripts, especially their canon tables (cat. no. 39). This is perhaps not surprising, since evidence exists for Christian (including Iraqi) calligraphers having worked on early copies of the Qur'an.[64] There are, however, two key differences: the omission of the birds that usually flank the vessels in Christian manuscripts (compare fig. 110 and cat. no. 39) and the redeployment and reorientation of architectonic elements so that they no longer function according to their structural logic (cat. no. 189).

The occlusion of figurative imagery invariably raises the specter of the *Bilderverbot*, the prohibition on image making that is often said to have shaped the development of both Jewish and Islamic art. So far as Islam is concerned, the key documents are the hadith. These recommend that artists take trees as their subjects rather than animate beings (*hayawan*), a distinction based on the capacity to possess breath or spirit (*ruh*). Although the canonical collections of hadith were compiled only at the end of the eighth century or the beginning of the ninth, there is little reason to assume that they did not circulate earlier.[65] The focus on inanimate forms, trees, and vegetation in Umayyad religious art is perfectly in keeping with the spirit of the hadith. Paradoxically,

however, it may be alterations to the floor mosaics of more than sixty churches in Jordan and Palestine that offer the first evidence for their practical impact on existing figurative art (see Flood, p. 117, and cat. no. 79).

The role of aniconism in distinguishing Muslim sacred space and texts is clear, but it should not be equated with the rejection of representation. Despite the privileging of word over image in modern scholarship on early Islam, Early Islamic sacred space was extraordinarily rich in images of architecture, jewelry, plants, rivers, trees, and vessels, which occupied far more wall space than texts, however carefully chosen. There are indications of experimental attempts to evoke living beings by nonfigurative means in Umayyad religious art (cat. no. 190), and a preference for aniconism in religious art was not reflected to the same extent in all media and regions. The lead seal of the caliph 'Abd al-Malik combined Qur'anic texts with images of paired birds and lions; glass pilgrim flasks featuring stylized figural imagery may have been used to carry away oil or unguent from the Dome of the Rock (cat. no. 186); and as late as the 780s, a silver censer bearing figures, gifted by the pious caliph 'Umar ibn al-Khattab (d. 644), was used on Fridays and during Ramadan at the Mosque of the Prophet in Medina.[66] In certain cases at least, images were evidently tolerated by some, even within mosques, as long as they did not form part of monumental or permanent decorative schemes.[67]

According to one recent evaluation, aniconism or iconophobia manifest in subtractions from an existing artistic vocabulary was the "only self-consciously Islamic trait" in an Umayyad art that otherwise looked to established Late Antique, Byzantine, and Sasanian artistic norms.[68] This sentiment illustrates the dangers of emphasizing continuities between Late Antique, Byzantine, and Early Islamic art at the expense of innovation, as well as the disproportionate part that the *Bilderverbot* has played in shaping the reception of Early Islamic religious art. In fact, the treatment of sacred space and texts displays three consistent features that might be considered hallmarks of Umayyad religious art and architecture (and perhaps Umayyad art in general). The selective omission of elements within an existing visual vocabulary, evidently considered inappropriate to the new religion, is just one of these.[69] Equally relevant is a preference for formal reconfiguration at the syntactic level. For example, the prayer hall of the Umayyad mosque in Damascus employs the pedimented facade found in earlier Syrian basilical churches, but rather than fronting the shorter end of the prayer hall, it marks the entrance to the axial nave at the center of the mosque's long side.[70] The third, related characteristic is the amplification, through monumentalization or repetition, of minor or secondary elements in the pre-Islamic arts of Syria and the eastern Mediterranean. Examples include the use of single columns or arcades as major features in the illuminations

of early Qur'ans (cat. nos. 189, 190), the elevation of trees to the principal subjects of floor and wall mosaics, and the multiplication of motifs used more sparingly in Byzantine iconography, among them the hanging pearls in the Damascus mosaics (fig. 103).[71]

These three formal operations—selective omission, syntactic innovation, and amplification—represent deliberate manipulations of established forms and iconographies. They addressed the need to walk a tightrope between continuity and innovation, to articulate a visual identity (both dynastic and sectarian) that was at once sufficiently differentiated from its competitors to be coherent and yet sufficiently legible to be intelligible to its intended audiences. Arabic texts may have conferred a sense of distinction on Muslim places of worship,[72] but in terms of linguistic access and visibility, they had a limited audience. By contrast, the selective use of specific forms (concave niches, columns, domes, naves, pillared halls) and materials (gilding, marble, mosaic) that had belonged to an earlier Byzantine and Syrian artistic repertoire ensured familiarity, while the innovative twists in the manner of their deployment conferred a distinction from previous usage. Here, it is surely significant that the reorientation of ornament in certain Umayyad Qur'an codices (cat. no. 189) prefigures a more dramatic reorientation of the sacred codex itself from a vertical to horizontal format (cat. nos. 191–193), a development that marked the Qur'an as visually distinct from either the codices of the Christians or the scrolls of the Jews (see Flood, p. 265).[73] The reluctance to figure animate beings in sacred space and texts might be understood as an integral part of this broader context of competitive self-definition. Analogies exist in an "aniconic turn" among the Jewish communities of Palestine just before or shortly after the Muslim conquest of the region—an attempt perhaps to distinguish the space of the synagogue from that of Christian churches.[74]

Most of the material discussed in this essay represents the patronage of elites and entails facets of both dynastic and sectarian self-definition. Yet, it is worth noting that Early Islamic tombstones also perpetuate the combination of architectonic elements, texts, and vegetation established as canonical in Umayyad religious art. The earliest dated grave stele that uses a *hijri* date commemorates an Egyptian man who died in A.H. 31 (652 C.E.) and is a simple incised affair.[75] The carvings on such tombstones became increasingly elaborate during the eighth and ninth centuries (cat. nos. 180, 183), sometimes making use of architectural elements such as capitals and columns.[76] Religious art found in domestic or more private contexts employs a similar iconographic range: a floor mosaic from a wealthy dwelling of the Umayyad or early Abbasid period at al-Ramla depicts what appears to be a mihrab in the form of an arch borne on capitals

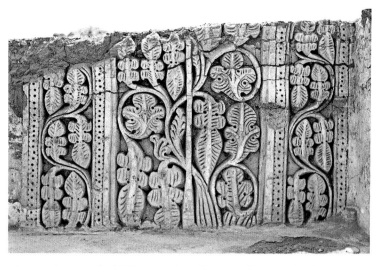

Fig. 104. Stucco mihrab, Western Palace, Room 1.2, Raqqa, early 9th century

and columns within which a Qur'anic inscription appears;[77] recent excavations of a series of palaces at Raqqa, in northern Syria, which served as the Abbasid capital between 796 and 808, have produced a stucco mihrab decorated with a large, treelike vine (fig. 104).

The material evidence for attempts to distinguish Early Islamic religious art and architecture from that of other monotheistic traditions finds a literary counterpart in the hadith, juridical texts, and the Ordinances of 'Umar, the statutes that reportedly governed the treatment of Christians and Jews in the conquered lands. Emphasizing that Muslim imitation of practices associated with unbelievers produces identity with them, these texts all stress the need for differentiation (*ghiyar*) in relation to modalities of architectural decoration, dress, hairstyle, and social practice in order to make sectarian difference immediately apparent to the eye.[78] Such concerns with boundary definitions are particularly focused on ritual practices, including modes of calling the faithful to prayer and prayer itself; some jurists even denounced as characteristically Christian or Jewish the practice of reading the Qur'an rather than reciting it from memory.[79] Similarly, the hadith denounce the construction of tombs, sometimes along with images, while the elaboration of tombstones and funerary practices with Christian antecedents attracted criticism from conservative jurists.[80] Such concerns find parallels in contemporary Christian and Jewish texts. Written before 708, Jacob of Edessa's proscriptions against the use of textiles embroidered with the Muslim profession of faith for altar cloths, church curtains, or priests' vestments provide interesting counterparts to the hadith forbidding the general use of figured textiles for clothing or curtains.[81]

The need for periodic reiteration and reinforcement of these regulations indicates that they were honored more in the breach than in the observance; indeed, they may have often had a performative purpose, seeking to establish or actively reinforce modes of distinction that were less clear-cut in practice. Nevertheless,

these rules highlight the role of the visual in both asserting and undermining modes of differentiation considered essential to constructing or maintaining the boundaries between different communities of faith.

For some conservative members of the early Muslim community, however, even the nuanced reimagining of an antecedent architectural vocabulary was not sufficient to convey the distinctive character of the new religion in visual terms. On the contrary, the monumentalization of the mosque and the materiality of even aniconic ornament—specifically marble and mosaic—were considered decadent ostentations that risked causing confusion between different monotheistic places of worship. According to a hadith, the Prophet condemned the elevation of mosques as a practice akin to that of the Christians and Jews, as well as a sign that the end of time was near. The second caliph, 'Umar, is reported to have condemned the ornamentation of mosques as evil, and objections to the embellishment of Qur'anic texts may underlie the production of a group of small early Qur'an manuscripts devoid of decorative and textual elaboration.[82] Concerns with excessive height and ornamentation are anticipated in earlier Syrian Christian discourses on asceticism, which trace an inverse relation between the spiritual heights to which the Syrian stylites aspired and the depths plumbed by their successors in erecting lofty structures. Writing in the fifth or sixth century, Isaac of Antioch contrasts the ostentatious monasteries of his day with the simple rustic structures of an earlier generation, comparing the former to churches or even palaces.[83] Similarly, when the caliph al-Walid came to Medina to inspect the Mosque of the Prophet as he had rebuilt it in 707, he was reproached by the son of Uthman, the third caliph, who contrasted the simple mosque built by his father with the lavish structure erected by al-Walid, declaring, "We built it in the manner of mosques, you built it in the manner of churches."[84]

The governor responsible for overseeing the rebuilding of the mosque in Medina later reigned as the caliph 'Umar II (r. 717–20). When he acceded to the caliphate, the pious 'Umar apparently turned against the lavish ornamentation favored by al-Walid, for he reportedly attempted to efface the glittering mosaics and golden ornaments of the Umayyad Mosque in Damascus, sending the gold that they contained to the public treasury.[85] At the same time, 'Umar is said to have banned Christians from entering the mosque.[86] The context and timing of these events may shed new light on a question that has long been central to the entangled histories of Byzantium and Early Islam: the possible relationship between Islamic aniconism and the beginnings of Byzantine Iconoclasm (see Flood, p. 117). The removal of the Chalke icon by Emperor Leo III in 726 or 730, which is usually seen as initiating the period of Byzantine Iconoclasm, occurred shortly after an edict was

apparently issued by the caliph Yazid II (r. 720–24) that targeted both Christian symbols and images of animate beings. While Yazid's edict is not mentioned in Muslim sources until the ninth century, it does feature a century earlier in Iconophile attempts to smear the Iconoclasts by depicting them as crypto-Muslims.[87] The edict is often spoken about as if it came out of the blue, but it makes more sense to see it as one in a series of moves designed to effect what Oleg Grabar called the "symbolic appropriation of the land."[88]

As has frequently been pointed out, despite the chronological coincidence between these events, the controversies over images in Byzantium and the Umayyad caliphate were quite different in nature (cat. no. 79).[89] However, 'Umar II's attempt to "purify" the Damascus mosque by removing its aniconic golden ornaments provides a broader context in which to view Yazid's edict, which it anticipates, albeit on a small scale, by just a few years. His endeavor coincided with the failure of a major Umayyad assault on Constantinople, which had been planned for many years (the topography of Umayyad Damascus may even have been planned as a mimetic appropriation of Constantinople in advance of the expected seizure of the real thing).[90] Although the Byzantine forces initially gave ground, by 718 the siege had clearly failed and 'Umar called home the troops.[91] The psychological impact of defeat was apparently considerable, coinciding as it did with the end of the first Islamic century. Despite their eventual outcome, these events also brought home to the Byzantines their vulnerability in the face of determined Muslim armies. The experience has even been deemed responsible for the rejection of icons by Leo III (r. 717–41), initiating the period of Byzantine Iconoclasm.[92]

This may be too simplistic an explanation for an extremely complex concatenation of events, but seen in a cross-cultural perspective, the timing is suggestive. Leo III and 'Umar II both came to power in 717, the year that Arab armies almost captured Constantinople. At the end of that siege, both seem to have turned against established modes of embellishing sacred space: in one case rejecting the presence of icons, in the other turning against ostentatious forms of ornament. Parallel reactions to the failed Umayyad assault on Constantinople would explain the curious chronological coincidence without insisting upon any direct relationship between their theological concerns. Although this must remain a hypothesis, it is worth noting reports that the person charged with executing Yazid's edict against images in 721 or 723 was none other than Maslama ibn 'Abd al-Malik, the Umayyad general who had led the unsuccessful assault on Constantinople.[93]

The failure of this major assault on Constantinople was to have a significant impact on the architectural patronage of the Umayyad elite. The last decades of Umayyad rule saw a palpable

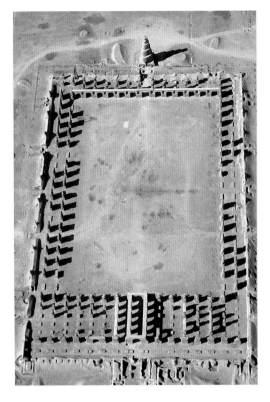

Fig. 105. Aerial view of mosque and minaret, Abu Dulaf Mosque, Samarra, 859–61

increase in media, forms, and techniques derived from the traditions of the former Sasanian lands in Iran and Iraq, ranging from the proliferation of stucco ornament to the growing sense of monumentality in palace architecture, typified by the massive scale of the palace at Mshatta (see Ballian, p. 209, and fig. 89).[94] Umayyad expenditure on architecture also appears to have provoked a backlash, anticipated perhaps by 'Umar II's interventions in Damascus. Upon his accession, the Umayyad caliph Yazid III (r. 744) was forced to guarantee not to "place stone upon stone" or "brick upon brick," while also promising not to accumulate wealth and to deploy any economic surplus in the service of the poor.[95] The opposition to Umayyad rule that gained strength in the second quarter of the eighth century culminated in the

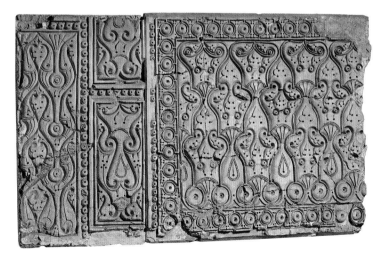

Fig. 106. Beveled-style stucco wall covering, House 1, Room 1, Samarra, 9th century. Stiftung Preußischer Kulturbesitz, Staatliche Museen zu Berlin—Museum für Islamische Kunst (I.3467)

Abbasid revolution, which gathered pace in the eastern provinces of the caliphate and overthrew the first Islamic dynasty in 750.

In 762 the successor Abbasid dynasty founded its capital in Baghdad, which was destined to play a more enduring role in the fortunes of the Islamic world than had Umayyad Damascus. A circular city founded on a Sasanian rather than Byzantine model, Baghdad was centered on the palace of the Abbasid caliphs rather than on the adjacent Friday mosque, a topographic detail that hints at a growing formalization of courtly ritual. Unfortunately, our knowledge of Abbasid Baghdad derives entirely from textual sources. We are better informed about the more northerly Iraqi city of Samarra, which was founded as a new capital around 836 and abandoned by 893, when the capital reverted to Baghdad.[96] Samarra's mosques and palaces far exceeded their Umayyad predecessors in scale. Moreover, the Friday mosques of the caliph al-Mutawwakkil (r. 847–61), including the Abu Dulaf Mosque (859–61) at Samarra, introduced significant formal innovations, including the provision of an open enclosure (*ziyada*) around the mosque and a single spiral minaret located opposite the main mihrab, on a central axis (fig. 105). Built of brick rather than the stone used in Syria and embellished in stucco, the mosques of Samarra continued nonetheless to employ the Byzantine-derived materials and techniques first adopted in the Umayyad mosques of Syria, including marble cladding and glass mosaic (the latter now used more sparingly to distinguish the qibla wall).[97]

The distinctive "abstract" forms and styles of ornament developed in Samarran mosques and palaces—manifest in marble, stucco (fig. 106), and wood (cat. no. 165), and even in portable arts such as ceramics (cat. no. 166)—were to have a profound impact on the art and architecture of the Islamic world.[98] It is clear, however, that their antecedents lie in the late Umayyad and early Abbasid architecture of Syria.[99]

Paradoxically, the spread of the decorative styles developed in Samarra can be related to a process of political fragmentation that gradually undermined the unity of the Abbasid caliphate. This had already begun after the Abbasid revolution of 750, when al-Andalus, the Islamic territories of southern Spain, was lost to the fugitive Umayyad prince 'Abd al-Rahman. It increased exponentially from the last decades of the ninth century, as provincial governors in eastern regions such as Sindh and Sistan established their de facto independence. In the following century, fragmentation was exacerbated by the rise in North Africa of the Fatimids, Isma'ili Shi'ites who captured Egypt in 969 and claimed the title of caliph.

The loss of Egypt had been foreshadowed a century earlier when Ahmad ibn Tulun, the Abbasids' provincial governor, rebelled and established an independent line that ruled between 868 and 905. To supplant the Early Islamic settlement of Fustat, Ibn Tulun founded a new capital, al-Qitai, the sole remaining

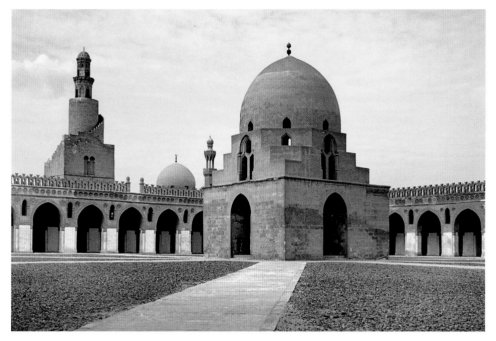

Fig. 107. Inner courtyard, Mosque of Ibn Tulun, Cairo, 879

Fig. 108. Capital from the Mosque of Ibn Tulun, Cairo, 879

monument of which is the massive congregational mosque built in 879. The scale of this mosque, its use of brick piers and pointed arches, and the presence of innovative formal features such as an outer enclosure and a spiral minaret (rebuilt in the late thirteenth century) are sufficient to indicate a heavy debt to the mosques of Samarra, where Ibn Tulun had lived (fig. 107). In addition, its carved woodwork (cat. no. 181) and stucco ornament (fig. 108) show the impact of the visually ambiguous decorative styles developed in Samarra in the decades after 850 and disseminated from there throughout the Islamic world.[100]

The migrations and transformations of Late Antique vegetal ornament from Umayyad Syria to Abbasid Iraq and back to the Mosque of Ibn Tulun return us to the dialectic between continuity and discontinuity discussed at the outset as one that has traditionally structured writing on Umayyad and early Abbasid art and architecture. This dialectic is directly related to debates about where to locate the upper limits of the "long Late Antiquity," to the historiography of the early mosque, and to the Mosque of Ibn Tulun, in particular, thanks to the pioneering work of the German art historian Alois Riegl on the history of ornament.

In his groundbreaking book *Stilfragen*, Riegl anticipated the spirit of much recent scholarship, rejecting the idea that Late Antique and Early Islamic art witnessed a decline of classical Greco-Roman ideals and seeing instead a continuous, vibrant development of both Byzantine and Islamic ornament from that of Greece. Nevertheless, in tracing the parallel development of Late Antique vine ornament in Byzantine and Islamic art (cat. nos. 119; 120B, C; 121A−C, E), Riegl identified a specific moment when the two diverged, when Islamic ornament took a different path that

eventually led to the characteristic convolutions of the arabesque.[101] Working with the materials available to him in the 1890s, Riegl located this moment in the stucco ornament from the Mosque of Ibn Tulun (fig. 108), unaware that the specific styles he saw in the stucco and woodwork of the Egyptian mosque had in fact been developed in Samarra. Excavations at the Abbasid capital would not begin until two decades after the publication of *Stilfragen*, and the relationship between Abbasid and Tulunid ornament was first noted only in 1913.[102] Nevertheless, Riegl's intuition is shared by many scholars today, who regard the stucco, wood, and marble ornaments of Samarran mosques and palaces as evidence for the emergence of new ways of imagining and treating forms inherited from both Late Antiquity and Umayyad art.

Riegl's brilliant intuition also reminds us of what is at stake in the use of art and architecture as indexes of the cultural continuities and discontinuities between Late Antiquity, Byzantium, and Early Islam. Despite his endeavor to emphasize common roots and overcome the idea that the transition from Late Antiquity to Early Islam witnessed cultural decline, Riegl failed to transcend the binary opposition between Semitic abstraction and Hellenic naturalism that structured much nineteenth-century scholarship on Early Islam. As a consequence, the repetitive, stylized vegetal motifs derived from Late Antique vine ornament in the Mosque of Ibn Tulun represented for him an enduring Oriental spirit reemerging from under a thin veneer of Hellenic culture laid in the Near East by Alexander the Great and his Hellenized successors.[103] Within the racially inflected debates of nineteenth-century scholarship at least, this return of the repressed thus marked a final, decisive break with Late Antiquity.

177. Panel with Vine Scroll

....................

Egypt or Syria, 8th century
Wood
40.5 × 21 cm (15 15/16 × 8 ¼ in.)
Provenance: Purchased from an art dealer in 1945.
Condition: The wood is dry. There are cracks throughout.
Several holes, which may have been used to attach the
panel to a support, are visible.
Museum of Islamic Art, Cairo (15468)

Centered on the eastern Mediterranean
and the Near East, the Umayyad
dynasty (661–750) inherited artistic tradi-
tions directly associated with the visual cul-
tures of both Byzantium and the Sasanian
Empire. The present eighth-century wood
panel in Cairo represents a curious example
of this aesthetic borrowing. Its central
design—a basketlike vase from which stem
two branches bearing clusters of grapes and
palmette-vine leaves—can be directly related
to motifs found in key contemporaneous
religious and secular buildings in the region.[1]
The earliest of these appear in the mosaics
adorning the interior of the Dome of the
Rock in Jerusalem (691/92), the first monu-
ment of Islam. Although abstract and styl-
ized, these mosaics feature vine stems that
rise from vases and urns (fig. 96). Similarly,
twenty reused Byzantine wood panels carved
with naturalistic vine scrolls issuing from
vases survive from al-Aqsa Mosque,
Jerusalem (705), the third most important

monument in Islam.[2] These panels, employed
to form a decorated soffit, shed light on the
possible use of the Cairene example.[3] Finally,
the carved facade of Qasr al-Mshatta
(743–44), a palace in the Jordanian desert,
shows the same motif as well (cat. no. 142B).
The theme carved on the Cairo panel—a
direct reference to Hellenistic art by way of
Byzantium—thus served as the language
linking significant monuments, with differ-
ent functions, that were founded during the
first century of Islam. IRA

1 It is very difficult to trace this panel to a specific
 building, since its archaeological and provenance
 records are lost. See Salah Sayour, "Wooden Panel," in
 Discover Islamic Art: Museum With No Frontiers, 2010,
 http://www.discoverislamicart.org/database_item
 .php?id=object;ISL;eg;Mus01;35;en.
2 Creswell 1989, p. 78, dated the Aqsa panels to the
 rebuilding of the mosque by the Abbasid caliph al-
 Mahdi (r. 775–85), while others have ascribed them
 to the building program of the Umayyad caliph ʻAbd
 al-Malik ibn Marwan (r. 685–705); see Jones and
 Michell 1976, p. 280. More recently, Carbon-14 dat-
 ing has determined that the panels were first used in
 the Byzantine period, then reused in al-Aqsa Mosque;
 see Liphschitz et al. 1997, pp. 1047, 1049. The Aqsa
 panels are currently divided between the Rockefeller
 Museum and the Islamic Museum at al-Haram al-
 Sharif, both in Jerusalem.
3 For more on these panels, see Marçais 1940.

References: Jones and Michell 1976, p. 280, cat. no. 430;
Salah Sayour, "Wooden Panel," in *Discover Islamic Art:
Museum With No Frontiers*, 2010, http://www.discover
islamicart.org/database_item.php?id=object;ISL;eg;
Mus01;35;en.

Religious Inscriptions in Early Islamic Art

Linda Komaroff

Epigraphy is the most important form of
embellishment in Islamic religious monu-
ments and their associated furnishings and
adjunctive elements; it was used not only to
decorate but also to enlighten. Whether quot-
ing from the Qurʾan or offering invocations,
Early Islamic religious inscriptions, like secu-
lar inscriptions, can be used to establish date,
context, and meaning (see Moraitou, p. 237).

In buildings, quotations from the Qurʾan
were carefully placed in areas of particular
significance, such as the wall facing Mecca,
especially the section surrounding the
mihrab. While Qurʾanic inscriptions cer-
tainly served a polemic or didactic function,

they often were situated so as to be difficult
or even impossible to read, suggesting a
more symbolic intent. Such may be the case
with the lengthy carved wood frieze in the
Mosque of Ibn Tulun, Cairo, estimated to
include about one-fifteenth of the Qurʾan,
which was set below the ceiling about eight
meters (a little more than eight yards) from
the ground, rendering it virtually invisible
(cat. no. 181).[1]

Beginning with the inscriptions in the ear-
liest Islamic building, the Dome of the Rock
in Jerusalem, it is apparent that the choice of
Qurʾanic passages was deliberate and that over
time particular verses came to be associated

with certain types of monuments and objects.[2]
For example, funerary inscriptions not only
in tombs but also on cenotaphs and grave-
stones (cat. no. 178) frequently include the
Throne Verse, emphasizing the omnipotence
of God:

> God! There is no god but He, the Living,
> the Everlasting.
> Neither slumber nor sleep seizes Him.
> To Him belongs all that is in heaven and
> on earth.
> Who is there that can intercede with
> Him except by His leave?
> He knows what lies before them and
> what is after them.

And they comprehend nothing of His
knowledge except as He wills.
His Throne comprises the heavens and
the earth;
The preserving of them oppresses him not.
He is the All-High, the All-Glorious.[3]

Sometimes limited space, such as on
tombstones, did not permit the inclusion of
the entire verse; there, a fragment must have
served as a stand-in for the full text.[4]

Qur'anic quotations relating to paradise
as the reward of the believer who will be
forgiven his sins and shielded from the tor-
ments of hell also occur with some fre-
quency in a funerary context (e.g., *Ali 'Imran*
[3:14–17]), as on a marble cenotaph in Cairo
(cat. no. 182). The inclusion or omission of
Qur'anic citations may signal changes in
doctrine and faith over time and space.[5]
Other texts may do the same, as for example
another Arabic inscription on the same mar-
ble cenotaph. It attests to the significant doc-
trinal shift that occurred in Egypt in 969
with the advent of Fatimid rule, establishing
the Isma'ili Shi'ite branch of Islam, as it
invokes the caliph, who traced his descent
from the Prophet Muhammad through his
daughter Fatima.[6] The text carved on a small
portable wood mihrab (cat. no. 184) likewise
bears witness to the new ascendancy of Shiism
in Egypt, as it is inscribed in the names of
the Prophet Muhammad, his family, and the
Imams as descended through Fatima.[7]

178. Section of a Carved Frieze with Qur'anic Inscriptions

....................

Egypt, 9th century
Wood, possibly teak
32 × 192 cm (12⅝ × 75⁹⁄₁₆ in.)
Inscribed: In Arabic, in Kufic script,

بسم الله الرحمن الرحيم الله لا اله الا هو الحى القيوم لا تاخذه
سنة ولا نوم له ما فى السموات وما فى الارض
من ذا الذى [....]
لا يحيطون بشئ من علمه الا بما شاء وسع كرسيه السموات و
الارض ولا يؤده حفظهما وهو العل العظيم. حسبى الله

text divided into two lines beginning with the bismillah
at the upper right (In the name of God, the Merciful, the
Compassionate), followed by most of the Throne Verse
(Qur'an 2:255) "Allah! There is no god but He,- the
living, The Self-subsisting, Supporter of all
No slumber can seize Him nor sleep. His are all things in
the heavens and on earth. who is thee . . . /
Nor shall they compass aught of His knowledge, except
as He willeth, His throne doth extend over the heavens
and the earth, and He feeleth no fatigue in guarding and
preserving them for He is the Most High, The Supreme
(in glory)." Concluding at the lower left with the invoca-
tion "God suffices me."
Provenance: Discovered at the 'Ain al-Sira cemetery in
southern Cairo; purchased before 1903.
Condition: There are areas of loss along the top edge.
Museum of Islamic Art, Cairo (2462)

Given the rarity of wood in Egypt, the
meticulous execution of the low-relief
carving, and the overall quality of the design,
this section of a frieze may have been part of
a cenotaph marking the burial place of an
individual of some importance.[1] The central
decoration consists of a series of seven square
compartments separated by rosette or lancet
leaves and filled with vegetal and abstract
ornament that draws on and combines the
Late Antique scrolling vine with the wing
motif derived from the Sasanian crown.[2] The
use of the latter device, shown here issuing
from a pair of stylized horns and set against a
scrolling trilobed-leaf background, helps to
document the gradual transformation of a
Sasanian royal symbol into a strictly sym-
metrical vegetal design and aids in dating the
wood frieze to the ninth century.

Two narrow bands of inscription frame
the central register. Written in a somewhat
squat Kufic script, the hooked forms of the
descending letters are in rhythmic balance

with the ascending and slightly pointed *alifs*
and *lams*. The text includes the famous Throne
Verse (Qur'an 2:255) emphasizing God's
dominion over heaven and earth, which is
frequently quoted in funerary inscriptions.[3]

LK

1 See David-Weill 1931, p. 43, no. 2462, pl. 1, and Pauty
 1931, p. 12, pl. IX. See also Ettinghausen et al. 2001,
 pp. 64–65, fig. 97, and O'Kane 2006, pp. 24–27, no. 15.
 In spite of its scarcity as a raw material, carved wood
 survives in a considerable number of Early Islamic
 examples from Egypt, preserved in its dry climate.
2 On the Sasanian crown motif, see, for example,
 Gonosová 2007, pp. 43ff.
3 On the inscriptions, see David-Weill 1931, p. 43,
 no. 2462, where the author notes the inclusion of
 another verse, al-Tawba (9):13. This may in fact have
 been a typographical error repeated in all subsequent
 catalogues. Perhaps David-Weill meant al-Tawba
 (9):129, "[For if they turn away say] God suffices
 me . . ." and similarly al-Zumar (39):38. See Dodd and
 Khairallah 1981, vol. 1, pp. 57–58, and vol. 2, pp. 9–19,
 for numerous references to mausoleums, tombstones,
 and cenotaphs inscribed with the Throne Verse.

References: David-Weill 1931, p. 43, no. 2462; Pauty 1931,
p. 12, pl. IX; Jones and Michell 1976, p. 281, cat. no. 343;
O'Kane 2006, pp. 24–27, no. 15.

179. Inscribed Marble Panel

....................

Egypt, 9th century
Marble
36 × 49 × 4.5 cm (14³⁄₁₆ × 19⁵⁄₁₆ × 1¾ in.)
Inscribed: In Arabic, بسم الله الرحمن الرحيم (In the name of
God the Merciful the Compassionate)
Provenance: Collection of Antonis Benakis (1873–1954); part
of the original Benaki Museum, which was given to the
Greek state in 1931 and inaugurated on April 22 of that year.
Condition: The panel is in good condition.
Benaki Museum, Athens (10779)

This marble panel is probably one side
of a four-sided cenotaph, or honorific
empty tomb. Cenotaphs are found in mau-
soleums, where they mark the burial place
of the deceased. Such structures are usually
rectangular and decorated with inscriptions,
here, with the phrase "In the name of God
the Merciful the Compassionate." In funer-
ary epigraphy, inscriptions typically begin
with this invocation, followed by verses from
the Qur'an and details about the deceased
(cat. 180).

179

The inscription, in the Kufic script characteristic of the ninth century, represents a decorative variant of the Arabic calligraphy that was developed during this period. Foliate terminations, including half-palmettes, replace the austere, angular forms of the earlier letters. Evoking the ornamental qualities of the Arabic alphabet, artists integrated inscriptions into their general design schemes; this marble slab exhibits a very simple version of this practice. The embellished letters complement the floral motif above the first word, *Allah*.[1] MM

1 For more examples of ornamental Kufic script, see *Trésors fatimides* 1998, pp. 162–64, and Jones and Michell 1976, pp. 302–3.

Reference: Ballian 2006, p. 85.

180. Tombstone of Ism'ail ibn 'Abd al-Salam ibn Sawwar

....................

Egypt, 9th century
Marble
71.5 × 28 × 4 cm (28⅛ × 11 × 1⁹⁄₁₆ in.)
Inscribed: In Arabic,

بسم الله الرحمن/ الرحيم هذا ما/ تشهد به اسمعيل/ بن عبد
السلم بن سو/ ار الا اله الا اللّٰ/ وحده لا شريك
له/...//.../... وان/ محمدا عبده ورسو/ له صلى الله عليه
وسلم/ وان الموت الجنة/ والنار حق.../...

(In the name of God the Compassionate/the Merciful this is/the testimony of Ism'ail/ibn 'Abd al-Salam ibn Saw-/war that there is no God but God/the one there is no partner with him ... /... /... and that/Muhammad is his servant and his messenger/may God bless him and give him peace/and that death and paradise/and fire are truth ...).

Provenance: Collection of Antonis Benakis (1873–1954); part of the original Benaki Museum, which was given to the Greek state in 1931 and inaugurated on April 22 of that year.
Condition: The lower part is missing, and there is an area of loss at the top right corner.
Benaki Museum, Athens (10783)

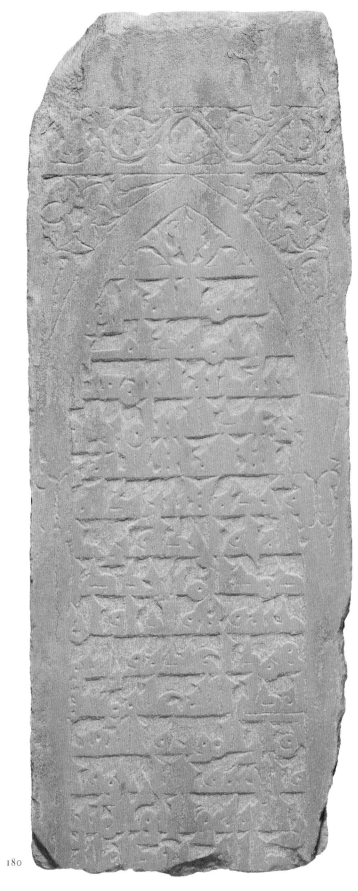

180

The Kufic inscription on this tombstone fragment is set under a pointed arch resting on two columns with stylized floral capitals. Multipetaled flowers with long leaves flank the top of the arch, and the register above is decorated with a foliate scroll with five-lobed leaves. The text comprises the name of the deceased, Ism'ail ibn 'Abd al-Salam ibn Sawwar, the profession of faith and other allusions to the uniqueness of God and to the Prophet Muhammad, and references to the afterlife. The last lines are illegible.

181

Although the date of the tombstone, which would have appeared at the end of the inscription, is missing from this fragment, the object can be dated to the ninth century. Early Islamic tombstone decoration was primarily epigraphic, with the occasional inclusion of floral motifs, and an arch frequently framed the text.[1]

According to Islamic law and the hadith, that is, the traditions of the Prophet Muhammad, Muslim burial practices should be very spare, to avoid the sanctification and worship of the dead. However, the large number of extant funerary monuments, from simply decorated tombstones to luxurious mausoleums, indicates that this Islamic principle has long been ignored. MM

1 For similar dated examples, see Piotrovskii 1999, p. 208, and Bittar 2003, pp. 61, 75.

References: Unpublished.

181. Section of an Epigraphic Frieze from the Mosque of Ibn Tulun
.

Egypt, Cairo, ca. 879
Pinewood
29.5 × 123 × 1.8 cm (11⅝ × 48⁷⁄₁₆ × ¹¹⁄₁₆ in.)
Inscribed: In Arabic, in Kufic script, from *al-Baqara* (2):133,
واله ابيك ابرهيم ([and]the God of thy father[s], Abraham)
Provenance: From the Ibn Tulun Mosque, Cairo (Fustat). Purchased in Cairo in 1848 by P. H. Delaporte, French consul to Egypt; Nouveau Drouot, Paris, October 29, 1985, lot 158; private Swiss collection; permanent loan to Institut du Monde Arabe, Paris, 1995–2000; acquired by the David Collection, 2002.
Condition: The frieze is is good condition.
The David Collection, Copenhagen (1 / 2002)

The Mosque of Ibn Tulun (876–79; fig. 107), one of Cairo's landmark buildings, was built for Ahmad ibn Tulun (r. 868–84), who governed Egypt on behalf of the Abbasid caliph before establishing his own semiautonomous dynasty. This enormous congregational mosque emulated the architecture of the temporary Abbasid capital, Samarra, north of Baghdad, in its plan, building materials, and much of its decoration (fig. 105).[1] Following Iraqi tradition, Ibn Tulun's mosque was constructed of brick and faced with stucco. Its surviving carved stucco ornament (fig. 108), though dominated by the types of vegetal designs associated with Abbasid Samarra, shows traces of late classical Byzantine influence.[2] The building also retains a large amount of woodwork, including the long frieze inscribed with verses from the Qur'an, to which this panel belonged.

It is one of several sections of the epigraphic frieze that was removed from the mosque.[3] Set above the interior arcade, the frieze would have run some 1¼ miles (two kilometers), utilizing an astonishing amount of imported pine.[4] The inscription is written in a simple rectilinear script, generically known as Kufic, here monumentalized by the slight thickening of the terminals of the letters; this panel includes three words from a longer section of the Qur'an: [We shall worship thy God and] the God of thy fathers, Abraham [and Ishmael and Isaac—the one God . . .]."[5] LK

1 Behrens-Abouseif 1989, pp. 51ff.
2 For example, the soffits of the arches; ibid., p. 56.
3 It was removed as early as 1848, when it was purchased by the French consul in Egypt following restorations to the mosque. Five sections are in the Museum of Islamic Art, Cairo (622–26), and another

is in the Musée du Louvre, Paris (on loan from the Institut National des Langues et Civilisations Orientales [1948 HI 10]). See Blair and Bloom 2006, p. 99. Another small panel is said to be in the Musée de la Chartreuse, Douai.
4 It was estimated to include about one-fifteenth of the entire text of the Qur'an. See Creswell 1932–40, vol. 2, p. 345; also Blair and Bloom 2006, p. 99.
5 Blair and Bloom 2006, p. 99.

References: Calligraphie islamique 1988, pp. 52–53; Blair and Bloom 2006, p. 99, cat. no. 34.

182. Inscribed Cenotaph Frieze
.

Egypt, 10th century
Marble, 13 × 193 cm (5⅛ × 76 in.)
Inscribed: In Arabic, across three faces,
Face A
. . . واولو العلم قائما بالقسط لا اله الا هو العزيز الحكيم.
ان الدين عند . . . /
Face B
المؤمنين صلوات الله عليه و على ابائه الطاهرين وابنائه
الاكرمين ولربيبه الامين /
Face C
منقوش فى رخامه دفنت معهم تاريخ المكتوب فيها شوال سنه
خمس و /
(. . . and those endued with knowledge, standing firm on justice. There is no god but He, The Exalted in power, The Wise.)
Provenance: Entered the Ministry of Antiquities from the Ministry of Waqfs in 1901.
Condition: The frieze is in stable condition with some cracks.
Museum of Islamic Art, Cairo (2908)

Covering three sides of the frieze, the floriated Kufic inscription here combines verses from the Qur'an (3:18–19),[1] on Face C, with a text referring to an unnamed Fatimid caliph and his relatives.[2] Although the date survives in an incomplete state and the actual burial site is unknown, Wiet has

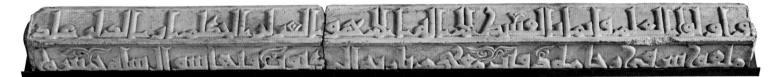

proposed that the marble came from the Turbat al-Za'faran (Saffron Tomb), in the mausoleum of the Great Eastern Fatimid Palace, in the heart of Fatimid al-Qahira (today's Cairo), where the Khan al-Khalili bazaar is now. When Caliph al-Mu'izz conquered Egypt in 969, he brought the remains of the first Fatimid imams with him and reinterred them in these tombs/mausoleums. A more recent proposal for the source of this frieze is the burials adjacent to the no longer extant Mosque of the Qarafa, located east of Fustat in the Qarafa al-Kubra (Southern Necropolis), which was also reserved for the relatives of the Fatimid caliphs.[3] IRA

1 These verses from the *Surat Al 'Imran* (Family of 'Imran) are significant in the context of a cenotaph that, according to the remainder of the inscription, was buried with the deceased. In verse 15, which precedes those inscribed on the frieze, the joys of paradise are described; verses 18–19, which are carved on the frieze itself, refer to the qualities of the righteous believer, who will attain those joys.
2 The transcription of the Arabic and a French translation of this inscription were published in Combe et al. 1931–56, vol. 6, p. 54; and later by Wiet 1971, pp. 34–35, no. 51, pl. IV; an English translation was later published in Jones and Michell 1976, p. 302: ([commander of] the Faithful, may God's blessings be upon him and his pure ancestors and upon his most honorable descendants and upon his trusted relations [including non-blood relatives]/carved on a piece of marble buried with them and inscribed with the date, Shawwal of the year 5 . . .). The respective interpretations are identical save for the word ربيبه which was translated in the French as "relatives by marriage" and in the English as "stepson [or father]." This word can have different meanings depending on the context; in this particular case, "relations [including non-blood relatives]" is more appropriate since the meaning encompasses a person's step- and foster children as well as confederates and allies. A more recent reading, *Trésors fatimides* 1998, p. 164, cat. no. 109, states that the name of the Fatimid caliph al-Hakim (r. 996–1021) is inscribed on the back, which does not appear in the earlier transcription published in Combe et al. or by Wiet, and which was later cited in Jones and Michell.
3 The entry cited in note 1 above states that the frieze was found in the Qarafa (necropolis), but Wiet indicates only that it entered the storerooms of the Ministry of Antiquities in 1901.

References: Combe et al. 1931–56, vol. 6 (1935), p. 54, no. 2104; Wiet 1971, pp. 34–35, no. 51, pl. IV; Jones and Michell 1976, p. 302, cat. no. 478; *Trésors fatimides* 1998, p. 164, cat. no. 109.

183. Tomb Stele Fragment with Kufic Inscription
....................

Antioch, 9th century
Marble
29.2 × 40.6 × 7 cm (11½ × 16 × 2¾ in.)
Inscribed: In Arabic, in Kufic script,

[بسم الله الر]

([In the name of God, the Com-])

حمن الرحيم

(passionate, the Merciful.)

هذا قبر

(This is the grave of)

سليمان ﺑ[ن]
محمد

(Sulayman ibn Muhammad)

ال[. . .]

([traces of letters, perhaps starting with al-]); along the right side, to the right of vertical band,

هو الح[ي]

(He is the Liv[ing])
Provenance: Purchased by the Committee for the Excavations of Antioch and its Vicinity, June 25, 1935.
Condition: The stele is broken on all sides, resulting in the loss of writing from the upper, bottom, and left sides.
Byzantine Collection, Dumbarton Oaks, Washington, D.C. (BZ.1938.89)

This broken marble stele contains the beginning of a funerary inscription in four readable lines on the left. The inscription would have started with a now-missing top line. It clearly continued for an unreadable fifth line and presumably for an additional line or two containing the date of death, if not perhaps some additional religious phrases. Those lines are separated by a vertical band with a meander pattern in relief from a single partially preserved vertical line of text that records six or seven letters, which has been read as "He is the Living,"[1] although there are difficulties with that reading, since the *h* at the beginning seems to be preceded by the letter *l*, perhaps forming the end of the word "Allah." In any event, the statement "He is the Living," often followed by the word "the Eternal," is frequently used for Muslim

funerary inscriptions. "He is the Living, the Eternal" is found near the start of the long Throne Verse from the Qur'an (2:255), which in its entirety is also often seen in Islamic funerary inscriptions. RS

1 Faris 1938, pp. 168–69.

Reference: Faris 1938, pp. 168–69, no. 17.

184. Portable Mihrab
....................

Egypt, 10th century
Wood
15.5 × 8 cm (6⅛ × 3⅛ in.)
Inscribed: In Arabic; outer band
[بسم الله الرحمن الرحيم بمحمد] / بعلي بفاطمة بالحسن
بالحسين بعلي بن الحسين/بمحمد بن علي بجعفر بن محمد
بموسى بن/ جعفر بعلي بن موسى
([In the name of Allah, the merciful the compassionate, in the name of Muhammad] in the name of 'Ali in the name of Fatima, in the name of al-Hasan, in the name of al-Hussein, in the name of 'Ali son of al-Hussein, in the name of Muhammad son of 'Ali, in the name of Ja'far son of Muhammad, in the name of Musa son of Ja'far, in the name of 'Ali son of Musa); inner band
بمحمد بن علي بعلي بن محمد بالحسن بن علي/ بالحجة
القائم الحمد لله . . .
([In the name of Muhammad son of] 'Ali, in the name of 'Ali son of Muhammad, in the name of Hasan son of 'Ali, in the name of the standing Proof, thank[s be to God] . . .)
Provenance: Collection of Antonis Benakis (1873–1954); part of the original Benaki Museum, which was given to the Greek state in 1931 and inaugurated on April 22 of that year.
Condition: There is an area of loss at the lower right corner.
Benaki Museum, Athens (9802)

In a mosque, a mihrab is an architectural niche that indicates the direction of prayer, which is always toward Mecca, Islam's holiest city. Muslims pray five times a day, but it is only on Fridays at noon that they are expected to visit a mosque for communal worship. This portable mihrab was intended to accompany the worshipper during private prayers, probably when traveling.

183

184

The mihrab's decoration consists of a pointed arch with two slender columns framed by two lines of text in Kufic script. Following the usual practice for decorating mihrabs in mosques, the inscriptions here contain verses from the Qur'an. In this instance, they invoke the names of the Prophet Muhammad and his family—his daughter Fatima; her husband, Ali, and their sons, Hasan and Hussein—as well as the twelve Shi'ite imams. The invocation of the imams confirms that the mihrab was made for a Shi'ite Muslim, as one would expect during the Fatimid dynasty (909–1171).

A number of similar mihrabs survive in museums, including the Museum of Islamic Art, Cairo, and the Musée du Louvre, Paris.[1] As a group, these objects demonstrate the sacred nature of the Arabic language when used as decoration. No other form of adornment is necessary to make this mihrab an object of veneration. It functions like an icon in a Christian context, substituting words for an image. MM

1 See Anglade 1988, p. 54 (with further bibl.), and *Trésors fatimides* 1998, p. 151, fig. 92, for a reproduction of the Cairo example.

Reference: Ballian 2006, p. 75, fig. 70.

185. Inscribed Floor Mat

Israel, Tiberias, 10th century
Plain weave in undyed bast fiber; inscription and decoration in brocading weft; fringe along one edge
223 × 115 cm (87¹³⁄₁₆ × 45¼ in.)
Inscribed: In Arabic,

بركة كاملة ونعمة شاملة وسعادة متواصلة لصاحبه ممّا آمر بعمله
فى طراز الخاصّة بطبريّة

(Perfect blessing and absolute well-being and constant happiness to the owner, this that was commissioned from the private workshop of Tabariya)
Provenance: Acquired by Antonis Benakis (1873–1954) in Egypt in 1929; collection of Antonis Benakis; part of the original Benaki Museum, which was given to the Greek state in 1931 and inaugurated on April 22 of that year.

Condition: The mat is in good condition. There are several holes near the top and bottom.
Benaki Museum, Athens (14735)

This fine floor covering belongs to a group of loom-woven reed mats. The sparse decoration includes self-patterned borders with interlocking lozenges and two pairs of plain brown brocaded bands. The inscription is a typical combination of benediction and details about the work's creation. The text is repeated on both ends of the mat, with a decorative treatment of the Arabic letters, even in this austere Kufic script.

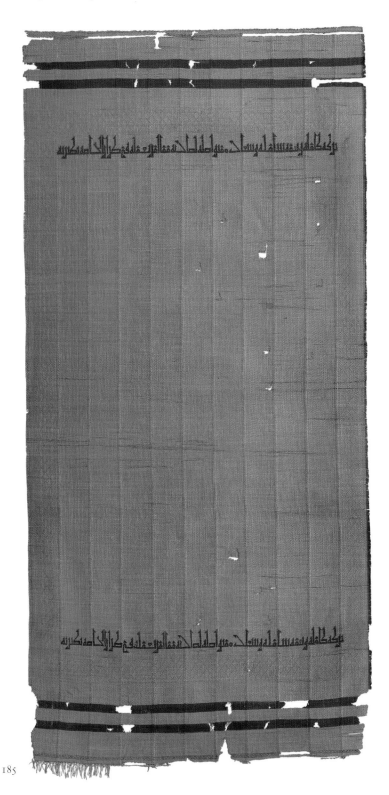

185

Floor coverings such as this, commonly found in domestic and religious interiors, may have been used during prayer sessions. According to the Geniza records—letters and documents discovered in the synagogue of Fustat (in today's Cairo)—they were regularly commissioned as made-to-measure objects, often in pairs, and were arranged to fill all the available space.[1] Written Arabic sources mention the region of Tiberias (modern Tabariya), in the Jordan Valley, as a reed-growing area and a center for the production of high-quality woven floor coverings.[2]

A similar woven reed mat, now in the collection of The Metropolitan Museum of Art, is attributed to the same workshop and date. It has an analogous layout, with two benedictory *tiraz* inscriptions for an anonymous owner.[3] Another complete but much smaller example, attributed to the same workshop, is in the collection of the Benaki Museum. It shows two parallel lines of inscription that repeat the word *baraka* (blessing) in a poorly executed Kufic script.[4]

<div style="text-align:right">MM</div>

1 Goitein 1983, pp. 127–28.
2 Combe 1939. The eleventh-century Persian traveler Nasir-i Khusrau mentions in his *Safarnama* (Book of Travels): "In the town of Tiberias [Tabariya] they make reed prayer mats, sold there for five dinars." Nasir-i Khusrau 2001, p. 24.
3 Dimand 1942.
4 Moraitou 2008a.

References: Combe et al. 1931–56, vol. 4 (1932), no. 1542; Combe 1939; *Trésors fatimides* 1998, p. 204, cat. no. 188; Ballian 2006, p. 77, fig. 73; Moraitou 2008a, p. 63.

186. Hexagonal Pilgrim Jug

.....................

Palestine, late 7th–early 8th century
Glass, molded
13.5 × 6 cm (5⁵⁄₁₆ × 2⅜ in.)
Provenance: Purchased together with a collection of Byzantine and Roman glass and some terracottas via Mr. Audley Miller in Oxford from an unnamed dealer in Gloucestershire in 1949 (1949.141–.182). Donald Harden's entries in the registers state that the collection "seems to have been formed in Syria or Palestine."
Condition: The vessel is in good condition.
The Ashmolean Museum, Oxford (AN1949.144.a)

This unprepossessing jug is of considerable importance for the history of Islamic art. It belongs to a group of mold-blown glass flasks whose iconographic programs include eschatological motifs, ritual objects, and allusions to the sacred topography of Jerusalem (in or around which they were likely made). It has long been recognized that such jugs were produced for

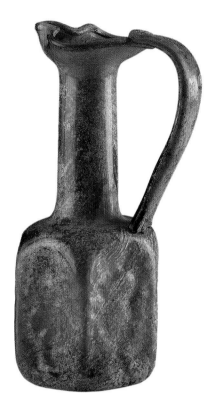

Christians and Jews (cat. nos. 60, 72),[1] but it was not until the late 1990s that Julian Raby demonstrated the existence of a third, smaller class of flasks apparently produced for Muslims.[2] This vessel, the best-known example of the latter group, features a figurative image similar to that found on the coinage issued in the name of the caliph 'Abd al-Malik in the years between 693–94 and 697 (cat. no. 89).[3] Here, the image, conventionally known as the "standing caliph," appears alongside motifs including an *ethrog*, a lozenge, and a star; related flasks feature other motifs also found on 'Abd al-Malik's coinage.

The meaning of some motifs and of the ensemble remains uncertain. The flasks may reflect Umayyad attempts to promote Jerusalem and its sanctity in Islam. They certainly bear witness to attempts to develop and disseminate a distinctive Umayyad iconography in media other than coinage in the decade during or after the completion of the Dome of the Rock (692). Their function in an Islamic context is unclear. Based on their use by Christian pilgrims to carry away earth, oil, and water sanctified as *eulogiai* (blessings) through contact with the Holy Sepulchre and other shrines, it has been suggested that Muslims collected in the flasks the unguents used to anoint the rock beneath the Dome of the Rock. Related functions in other contexts are also possible. Excavations at the Church of the Kathisma

in Jerusalem, to which the Dome of the Rock has strong formal affinities, have, for example, produced evidence for an elaborate canalization of water across the surface of the rock at the center of the building, on which the Virgin is believed to have rested. The find of a hexagonal glass flask there suggests that this water was collected by pilgrims. Muslims are known to have visited sites associated with the Virgin in and around Jerusalem, and the "neutral" iconography of the Kathisma flask has led to suggestions that it may have been used by Muslim pilgrims.[4]

<div style="text-align:right">FBF</div>

1 Barag 1970, 1971.
2 Reworking an existing iconographic repertoire, the flasks find a more literal (and aniconic) counterpart in a series of molded clay lamps from Early Islamic Palestine on which crosses and images of animate beings have been erased; see Dauterman Maguire 2009.
3 See, however, Hoyland 2007, pp. 593–96; Flood 2009, pp. 114–15.
4 Avner 2006–7, p. 547.

Reference: Raby 1999.

187. Textile Fragment Depicting a Male Figure under an Arch

.....................

Egypt, 11th–12th century
Tapestry weave in polychrome silk and undyed linen on plain weave ground of undyed linen
24.8 × 15.7 cm (9¾ × 6³⁄₁₆ in.)
Provenance: Acquired by Antonis Benakis (1873–1954) in Egypt in 1929; collection of Antonis Benakis; part of the

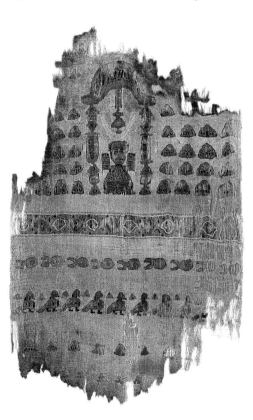

The main decorative feature on this nar-
row linen and silk textile is a male fig-
ure seated under an arch with distinctive
slender columns and a hanging lamp in the
center. The figure assumes the orans position,
his hands raised in prayer. The arch appears
to be inscribed in Arabic, but the script is
illegible. It may include the standard bismil-
lah (In the name of God). Rows of stylized
floral motifs flank the arch, and below it are
several decorative bands, two of which fea-
ture stylized birds and fish.

Depictions of worshipers are not part of
the usual iconographic repertoire found on
Islamic metalwork, ceramics, woodwork,
ivory, and textiles. Worshippers in the orans
position, typically associated with Christian
iconography from the Late Antique period
onward, are found in examples of Coptic
art.[1] In an Islamic context, the figure with
arms raised in an attitude of supplication
indicates the leader of prayer in a mosque.
Early Islamic coins depicting the sovereign
in this pose served a political purpose, assert-
ing the right to deliver the khutbah, or
weekly Friday sermon, in the mosque.[2] It is
difficult to posit a similar meaning when this
iconography is found on a textile, although
it appears again on a ninth-century carpet
fragment in the Bouvier Collection, which
shows the bust of a figure under a lamp with
his arms raised.[3] The Benaki Museum owns
two unpublished fragments dating from the
eleventh to twelfth century that depict wor-
shipers in this pose. MM

1 For example, see the fifth- to sixth-century screen
 curtain with a representation of a couple praying
 under an apse and a Coptic inscription in Greek
 script, Cormack and Vasilakē 2008, p. 424.
2 See Treadwell 1999.
3 See Cornu 1993, p. 120, cat. no. 60.
4 Benaki Museum (15039, 15041). Fragment 15039 is a
 narrow strip with the same dimensions as the present
 fragment. It is decorated in bands, the last of which
 depicts a row of figures with hands raised.

References: Ballian 2006, p. 81; Moraitou 2008a, p. 63.

The Qur'an

Finbarr B. Flood

According to Islamic tradition, the Qur'an
comprises a series of revelations from God,
transmitted by the angel Gabriel to the
Prophet Muhammad in Mecca and Medina
between about 610 and the Prophet's death in
632. For believers, the Qur'an represents the
words of God rather than divinely inspired
scripture. The interrelationship between ver-
bal and textual transmission is evoked in the
angel's first words to the Prophet, which
commanded him to recite in the name of he
"who has taught by the pen" (Qur'an 96:1–4).
In Arabic the written Qur'an is distinguished
from its verbal revelation by the term *mushaf*
(pl. *masahif*), derived from the word for folio
or leaf. This distinction has been reproduced
in the historiography of the early Qur'an,
with a division of labor between historians
who work on the revelation and those who
work on its material incarnation. Recent
scholarship on both is fraught with contro-
versy,[1] which has, paradoxically, spurred new
research the results of which broadly accord
with the history of the material Qur'an pre-
served in Islamic tradition.

In the words of a later jurist, the Qur'an
was initially "preserved in the hearts of men,"
with some parts being transcribed before or
shortly after the death of the Prophet.[2] The
threat of loss occasioned by the aging of the
Prophet's contemporaries prompted the first
caliphs to endeavor to preserve the revelation.
The third caliph, Uthman (r. 644–61), is said
to have been the first to have the revelation
collated and copied as a *mushaf*.[3] Divergences
between spoken and written Arabic, in which
eighteen graphemes transcribe twenty-eight
phonemes, were also relevant to Uthman's
undertaking. In the absence of conventional
marks indicating how the text should be
vocalized, distinguishing between different
letters with similar basic forms and indicating
short (and sometimes long) vowels, variant
readings are possible. Having standardized
the writing of the text in its entirety, Uthman
is said to have dispatched copies to Damascus,
Basra, Kufa, and Mecca. While subsequent
variants reportedly were destroyed, problems
related to the divergence of oral and textual
transmission arose periodically thereafter. In
the tenth century, seven regional variants

were canonized, followed later by others.[4] The
early history of the Qur'an is thus bound up
with the attempt to refine the orthography
of the *mushaf*, in part by the adoption (prob-
ably from Syriac) of dashes and dots, con-
ventional marks intended to aid reproduction
of the verbal utterance (cat. nos. 189, 193).[5]

A major problem in tracing this history is
the lack of early dated examples. Several
Qur'ans claimed as Uthmanic are in fact of
later date.[6] Inscribed dates on extant manu-
scripts do not occur before the ninth century;
works that might be of earlier date lack their
beginnings and ends, where one would nor-
mally find the historical information that
would be used to date them. Study of folios
and fragments has therefore been based on
codicological, paleographic, philological, and
stylistic analysis, resulting in an opacity that
has precluded unanimity of scholarly opin-
ion on the early development of the material
Qur'an; the scenario outlined here repre-
sents the current consensus but may change
with future research.[7]

Most scholars now accept that the earliest
extant written versions of the Qur'an were
executed in a slanted script identified with
the Hijaz region of western Arabia on the
basis of a passing reference in a tenth-century
text.[8] While the manuscripts are convention-
ally referred to as Hijazi, the use of this term
is no indication that their production was
centered in or confined to Arabia; Syria and
Iraq may also have been places of production.[9]
Moreover, although folios of this type are
often said to come from Hijazi Qur'ans,
questions have been raised as to whether
they formed part of complete Qur'an codices
(*masahif*). It has been suggested, for example,
that such folios formed part of draft copies
intended to function as aids to recitation from
memory.[10] Diacriticals are used more sparingly
in Hijazi fragments than in Arabic inscriptions
and papyri of the same period, which may
indicate an attempt to distinguish scripture
from other kinds of texts.[11] However, the
absence of such marks also enabled the text to
be vocalized in different ways; the conservative
orthography of the Hijazi fragments may,
therefore, reflect the dominance and fluidity
of recitation over the fixity of textualization

during a period marked by controversy over the relative status and value of both.[12]

The suggested time frame for production of Hijazi Qur'ans is from about 650 to 700, although later additions and emendations indicate that many were in use as late as the ninth and tenth centuries.[13] They are written in brown ink on specially prepared parchment, with text arranged in a single column of about twenty-five lines per page (fig. 109). Hijazi Qur'ans adopt the vertically oriented codex format used for earlier Christian manuscripts and show strong codicological and paleographic affinities to Syriac Gospels, although their lack of a textual margin is distinctive. Their large size (usually about 13 × 9⅞ in. [33 × 25 cm] per folio) is comparable to that of Byzantine luxury Gospel manuscripts (cat. no. 21), possibly indicating a public use.[14] They lack the elaborate decoration found in later Qur'ans, with title pages and spaces between chapters (suras) left blank and little ornament within the text (those found were often added later).[15]

As Hijazi was not a formal script, it was not standardized.[16] Toward the end of the seventh century, it seems to have been superseded by a more angular, proportionate script, the earliest dated appearance of which is in the inscriptions of the Dome of the Rock, those executed both in mosaic (figs. 96, 98) and on a series of repoussé copper plaques that covered its exterior entrances. A similar script appears on the epigraphic coins of 'Abd al-Malik (cat. no. 91). The Dome of the Rock inscriptions constitute the earliest dated quotations of Qur'anic texts; they were clearly designed by calligraphers, possibly from Medina.[17]

Although carefully chosen for their content (see Flood, p. 244), the Dome of the Rock inscriptions occur on thin bands located below the roof level of the octagon; they are virtually illegible from the ground. It seems likely that their content was mediated, verbalized for pilgrims by those who knew it and could recite it by rote. The likelihood of this is heightened by the fact that the quotations are variants on the canonical text, recalling reports that early reciters of the Qur'an felt free to alter word order and to use synonyms, even after the standardization of the text by Uthman.[18] In other words, the Dome of the Rock inscriptions may lie on the cusp between an oral and a textual tradition at a moment when the balance was tipping decisively in favor of the

Fig. 109. Folio from a Hijazi Qur'an (recto). Ink on parchment, 8th century. The Nasser D. Khalili Collection of Islamic Art, London (KFQ 60)

latter. This development is directly related to what has been called "the conscious invention" of a distinct calligraphic tradition, manifest in the dissemination of the formalized angular script used in the Dome of Rock inscriptions to both official texts and Qur'anic manuscripts.[19] The undertaking can be related to major reforms in the Umayyad state during the reigns of 'Abd al-Malik (r. 685–705) and al-Walid I (r. 705–15), including the replacement of Greek (and Persian in the east) by Arabic as the official language of administration,[20] and the attempt to forge a distinct visual identity, to which the Dome of the Rock itself bears witness.

There is a close iconographic relationship between the decoration of Umayyad mosques and shrines and the remnants of several Qur'ans that appear to date from this formative period, many of which come from a large cache of manuscripts discovered in 1972 in the ceiling of the Great Mosque of Sana'a in Yemen and from similar stores in the Mosque of 'Amr in Fustat (cat. nos. 189, 190) and the Great Mosque of Damascus.[21] Among the Sana'a fragments were remnants of one of the most spectacular Qur'ans ever made.[22] Its large folios (measuring 20⅛ × 18½ in. [51 × 47 cm] or larger) and nearly square format represented a departure from vertically oriented Hijazi Qur'ans (fig. 109),

of which its script seems to be a more standardized variant. When complete, the Qur'an would have contained more than 520 folios. The text was prefaced by an elaborate series of paintings, including a double frontispiece that appears to offer combined perspectives of two distinct mosques (fig. 110). The attention to detail is astonishing, including the depiction of a mihrab with patterned marble columns and visible wicks and flames in the lamps that hang within the building and its arcades. Carbon-14 and chemical analyses have suggested a date in the late seventh or early eighth century.

There are significant conceptual, formal, and iconographic similarities between the mosques depicted in the Sana'a Qur'an and those built by the Umayyad caliph al-Walid I (see Flood, p. 244),[23] and the Qur'an may have been intended for use in one of them (including the Sana'a mosque); like Uthman before him, the caliph 'Abd al-Malik is said to have sponsored a revised text of the Qur'an, which was dispatched to the major mosques of the caliphate.[24] The use of architectural illuminations relates the Sana'a manuscript to a group of Umayyad Qur'ans (cat. nos. 189, 190 and fig. 111]), and there are even indications that others in this group may once have featured full-page architectural scenes.[25] The coincidence between the experience of architectural space and its depiction in miniature suggests a deliberate emphasis on architecture and its representation as a mode of dynastic and sectarian self-definition.

The Umayyad Qur'ans belong to a "family" of Christian and Jewish sacred texts featuring similar architectural scenes, including parchment folios from two tenth-century Hebrew Pentateuchs depicting the Ark of the Covenant (cat. no. 75) and Ezekiel's temple (cat. no. 76) and architectural scenes executed in micrography for the frontis- or finispieces of a Karaite Bible completed in Tiberias in 895.[26] Other parallels are provided by parchment quires from the earliest dated Arabic Gospel, produced in Palestine or Syria about 860–61 (cat. no. 34), among them a terminal bifolium in which a combined side and front view of a basilical church hung with lamps is confronted with the image of an altar (fig. 112).[27] Most of this comparative material postdates the Umayyad period, but the recent redating of an important Ethiopian Bible, kept in the monastery of Abu Garima in Tigre, to the late fifth or early sixth century on the basis of Carbon-14

analysis, may change this. Garima I contains canon tables comparable to those in the Rabbula Gospels (cat. no. 39), while Garima II includes a full-page rendering of a pedimented church or temple hung with chandeliers (fig. 113).[28] The building's arched openings at the basement level recall the basement story and jars (provision for ablutions?) on one of the Sana'a frontispieces (fig. 110).[29] It is not clear whether the architectural scene, which may have been executed in Syria, formed part of a frontis- or finispiece, or whether it was originally one of a pair. Nevertheless, the depiction of sacred space within Christian and Jewish texts of the pre- and Early Islamic period suggests that the Sana'a frontispieces and the illuminated Qur'ans to which they are related represent an Umayyad variant on a more widespread tradition.

Despite these analogies, the absence of animal and human figures in the illuminations of the Umayyad Qur'ans differentiates them from Christian manuscripts (see Flood, p. 244). At some point, probably about or before the middle of the eighth century, a change in format from vertical to horizontal conferred a more visible distinction on the material Qur'an (cat. nos. 191, 193).[30] This visible difference is paralleled by less apparent divergences from Christian manuscripts, including a preference for bifolia gathered in groups of five (quinions).[31] The precise reasons for the wholesale adoption of the horizontal format are unclear, but if dated correctly, it would coincide with a moment

of concern about the differentiation of Muslim bodies, mosques, and practices from those of other monotheists (see Flood, p. 244). Prefigured by the square format of

Fig. 110 (above, left and right). Double frontispiece from a luxury Qur'an found in the ceiling of the Great Mosque of Sana'a. Ink and pigment on parchment, early 8th century. Dar al-Mukhtutat, Sana'a, Yemen (20-33.1). © Dr. Hans-Caspar Graf von Bothmer

Fig. 111. Cat. no. 190, folios 32r and 32v

Fig. 112. Cat. no. 34 (Arabic NF Ms. 16), bifolium showing an altar (left) and a basilica (right)

some Umayyad Qur'ans (cat. nos. 188–190), this reorientation was perhaps intended to distinguish the Qur'an not only from Christian codices and Jewish scrolls but also from written copies of the hadith, conventional rather than divine in origin.[32]

Like Umayyad Qur'ans, horizontal Qur'ans made use of the angular script known as Kufic (or, less commonly, as early Abbasid).[33] Kufic Qur'ans are perhaps most noteworthy for their profligate use of space (and thus parchment), with wide margins and often few lines of text per page that made their production expensive and time-consuming. One of the best-known examples was produced at Tyre in or before 876 for Amajur, the Abbasid governor of Damascus. The Amajur Qur'an, whose large folios (5⅛ × 15¾ in. [13 × 40 cm]) bore only three lines of script per page, may have used up to 750 sheepskins. It is also one of the earliest to bear a date.[34] It is divided into thirty distinct sections (*juz'*; pl. *azja'*), one for each day of the lunar month; other Kufic Qur'ans are divided into seven, for the days of the week. In the most elaborate Kufic Qur'ans, each *juz'* opened with a double-page frontispiece featuring lavishly gilded geometric and vegetal ornament.[35] In addition, distinctions between chapters were generally marked by a gilded rectangular text box from which a treelike palmette extended horizontally into the margin, a development from illuminated Umayyad Qur'ans (cat. no. 190).

Fig. 113. Depiction of a church or temple in Abu Garima Ethiopian Gospel, Monastery of Abu Garima, Tigre

Other illuminations included rosettes marking every fifth and tenth verse of a chapter or the fourteen points in the text where prostration is prescribed. The ends of verses were variously marked with pyramidal arrangements of gold balls or several diagonal strokes of the pen. Covers were usually wooden boards wrapped in molded, stamped, or tooled leather bearing geometric patterns. With the exception of the image of the cross, there are close parallels between the leather covers of early Gospels and those of Qur'ans, the latter represented by important examples

from the Great Mosques of Qairawan in Tunisia and Sana'a in Yemen.[36]

The Amajur Qur'an was stored in two boxes, but the largest Kufic Qur'ans, which measured more than 26¾ × 20⅞ in. (68 × 53 cm) and could contain six hundred folios, apparently were bound in a single volume (cat. no. 190 and fig. 111), making their daily use impractical.[37] In addition, following a precedent established by the Dome of the Rock inscriptions, Kufic Qur'ans exploited the angularity and malleability of the Kufic script for aesthetic effect, elongating proportionally spaced letter forms to establish visually harmonious rhythms.[38] Despite the use of red dots to facilitate vocalization, this aesthetic manipulation of the text was often at odds with legibility. It seems likely that Kufic Qur'ans were intended not to be read but to function as aide-mémoire for reciters who had committed the Qur'an to heart. By contrast, reports of an Umayyad *mushaf* being carried in procession from palace to mosque in Medina suggest that the large vertical-format Umayyad Qur'ans (cat. nos. 188, 189) were intended for display, which may explain the coincidence between their ornamentation and that of early mosques.[39]

Several dated Kufic Qur'ans were produced for high functionaries of the Abbasid state, and the expense entailed in their production occasionally was heightened by the use of dyed parchment and even chrysography, perhaps following Byzantine precedents (cat. no. 21). The use of gold had been pioneered in the illuminations of earlier Qur'ans (cat. no. 189). This despite juridical objections, similar to those raised against Christian texts written in gold on purple parchment, as early as the fourth century.[40] The most celebrated example, the so-called Blue Qur'an (cat. no. 192), which made use of indigo-dyed parchment, was once attributed to al-Andalus or Fatimid North Africa but has been more plausibly, if not conclusively, attributed to Abbasid Iraq.[41]

Until the late ninth or early tenth century, Qur'anic texts, whether on coins, manuscripts, or monuments, were written in Kufic script.[42] This exclusivity may reflect a conservative treatment of scripture, but it also seems to reflect a distinction between scribes who worked in quotidian contexts and those responsible for inscribing the Qur'an. The continued use of parchment, even though paper had been adopted in the Abbasid chancery as early as the late eighth

or early ninth century, also points in this direction. The situation began to change in the late ninth to early tenth century, when a new, more proportional and rounded style of Kufic script, characterized by the use of both thick and thin pen strokes and variously known as Broken Kufic, Eastern Kufic, or New Style, came into use for Qur'ans.[43] Traditionally, the development of the new script is attributed to the Abbasid vizier Ibn Muqla (d. 940), although this may be either a later attempt to assign authorship to an organically occurring development or the product of interference between two distinct scribal genres (or both).[44] About the same time we witness a reversion to the vertical format favored in Hijazi Qur'ans, although horizontal Kufic Qur'ans continued to be produced for about a century.

The course of the tenth century saw further major changes, including the introduction of paper support, new carbon-black inks, and the use of cursive scripts. These developments increased the legibility of the text while further eroding the distinction between scribal practices employed in religious and secular contexts. Although Kufic continued in use in subsidiary contexts for several centuries, with the exception of al-Andalus and the Maghreb (where a more conservative tradition prevailed), by the year 1000 the Qur'an was being written in cursive scripts and on a paper medium.

188. Folio from a Qur'an

Syria (?), late 7th–early 8th century (?)
Brown ink and pigments on parchment; the back side has been reinked with a black carbon ink; decorative details in red, green, yellow, and white
46.5 × 39.9 cm (18 5/16 × 15 11/16 in.)
Condition: The folio is in good condition with limited water damage and losses on the lower margin. The verso has been reinked.
The David Collection, Copenhagen (26/2003)

This folio from a large luxury manuscript contains portions of the later, shorter suras (chapters) of the Qur'an. The recto, which contains the full text of Sura 91, "The Sun," demonstrates the use of ornamental chapter dividers: an upper band of green and red lozenges, a lower band of zigzagging yellow and white leaves. Other ornaments include red circles to indicate the end of every five verses, and green, red, and yellow stars to mark every ten verses; these elements find parallels in the mosaic inscriptions of the Dome of the Rock.

This folio is one of two that are closely related to fragments of a large codex discovered in the Great Mosque of Sana'a in Yemen in 1972; finds from the same cache in 1965 disappeared before they could be studied.[1] Since the comparable material has been tentatively ascribed to Umayyad Syria, it should be noted that similar chapter dividers in the form of narrow polychromatic geometric bands were used in pre-Islamic Syriac Bibles.[2] These Qur'ans differ from earlier Hijazi Qur'ans (see Flood, p. 265, and fig. 109) in their scale and square format; other differences include the use of margins, ornamental chapter dividers, verse markers, angular Kufic script, and twenty lines of verse per page. They belong instead to a distinct stylistic group identified by the late Estelle Whelan, who suggested that variations between this group of vertical-format Qur'ans and another comprised of horizontal Kufic Qur'ans might represent differences in contemporary centers of production and function rather than different moments in the evolution of the material Qur'an.[3] Alternatively, they may represent an intermediary phase before the emergence of a strong preference for horizontal-format Kufic Qur'ans (cat. nos. 191–193).[4]

FBF

1 Another folio from what seems to be the same Qur'an is now in a private collection; see Roxburgh 2007, p. 15, fig. 5. On the Sana'a codex (Dar al-Makhtutat 01-29.2), see Puin 1985, pp. 10–11, cat. no. 36; Piotrovskii 1999, pp. 104–5, cat. nos. 41, 42 (Hans-Caspar Graf von Bothmer). On the full circumstances of the find, see George 2010, pp. 17–19.
2 George 2010, p. 58, fig. 34.
3 In particular, Whelan (1990, pp. 122–23) comments on differences in format, ornament, and script between this group and another comprised of horizontal-format Kufic Qur'ans.
4 George 2010, pp. 74–89.

Reference: Blair and Bloom 2006, p. 98, cat. no. 33.

Recto

Verso

189. Folios from a Qur'an

Probably Syria, ca. 700–725
Ink and pigments; 42 folios
37 × 31 cm (14⁹⁄₁₆ × 12³⁄₁₆ in.)
Provenance: These folios belong to approximately one quarter of a Qur'an acquired by Jean-Joseph Marcel, a member of the Napoleonic expedition to Egypt (1798–1801), in the Mosque of 'Amr in Fustat.[1] The same mosque was the source of numerous fragments of early Qur'an manuscripts, among them catalogue number 190, now dispersed between international museum collections.[2] Acquired by the Imperial Public Library (now the National Library of Russia) in 1864.
Condition: The folios are unbound and have suffered rodent and insect damage.
National Library of Russia, Saint Petersburg (Marcel 13), fols. 3, 8, 11, 15

Fol. 3

The vertical format, scale, and use of roughly twenty-five lines of text per page relate this lavishly illuminated early Qur'an to the so-called Hijazi Qur'ans thought to predate it (fig. 109). The script shows affinities to both Hijazi and the more angular Kufic script that seems to have superseded it for Qur'anic calligraphy by the early eighth century. Diacritical marks in the form of black dots distinguish different letter forms, while red dots indicate short vowels. As in other early Qur'ans (cat. no. 190), the end of each verse is indicated by a series of oblique lines.[3]

The most striking aspect of the Qur'an is the use of elaborate architectural and vegetal motifs to mark the divisions between chapters. Some dividers consist of rectangular frames enclosing repeated rosettes, representing a more elaborate version of those seen in catalogue number 188. Others make use of spectacular combinations of architecture and vegetation. In this folio the end of Sura 17, "The Children of Israel," is distinguished from the beginning of Sura 18, "The Cave," by a gilded green and red striated and spiral column supporting a vase, from which emerges a tightly scrolled vine (fol. 3). Below, a later inscription in red ink gives the name of the chapter and the number of verses it contains. On other folios, scrolls with flowers or fruit-bearing vines grow horizontally across the page, issuing from baskets or amphorae set atop multisectioned gilded columns (fol. 8). Some of these columns are themselves perched precariously on amphorae, as if to underline the subversion of function entailed in depicting an architectural element horizontally, divorced from any architectural context. The attention to detail is as astonishing as the variety and subtlety with which the limited palette has been deployed, sometimes to distinguish

different colors of marble in adjoining sections of the same columnar structure. A similar palette is seen in the chapter divisions of catalogue number 188, but the architectural and vegetal ornament employed here is far more ambitious in its precision and meticulously representational character.

A possible relationship to the use of columns (sometimes topped by crosses) as decorated initials in pre-Islamic Latin Gospels cannot be ruled out,[4] but the conceptual and formal reconfiguration witnessed here is a hallmark of Umayyad religious art and architecture in general (see Flood, p. 244). The details of both script and ornament relate to the mosaics in the Dome of the Rock and in other monuments of the Umayyad period.[5] In its use of illuminations featuring architecture and vegetation, this Qur'an may be compared with at least three others that have been dated to the Umayyad period;[6] the array of architectural elements used as chapter divisions, however, render it closest in spirit (if not in scale) to catalogue number 190.[7] In all three of these Qur'ans, representational ornament illuminates the iconographic significance of the text. The lamp that hangs in arches depicted within some

columnar chapter dividers likely refers to scripture as a source of enlightenment (Qur'an 42:52) while recalling the so-called Light Verse (Qur'an 24:35), in which the light of God is compared to that of a hanging lamp.[8] In later Qur'ans the same idea was sometimes given expression through chrysography (cat. no. 192).[9]

On iconographic and paleographic grounds this manuscript has been assigned to the late seventh or early eighth century.[10] The provenance is no indication of an Egyptian origin; based on the content of its illuminations, and on a mode of vocalization and verse counts later identified with Damascus, a Syrian origin is quite likely.[11]

FBF

Jean-Joseph Marcel (1776–1854), director of Napoleon's printing office, took to France 3,000 manuscripts from Alexandria and Cairo, including 132 early Qur'ans later acquired by Russia.[12] Recently "rediscovered," dated, and localized by François Déroche and Alain George, Marcel 13 contains three fragments: Suras 17:62(60)–23:12(12); 24:48(49)–61(61); and 34:18(19)–41:10(11).[13] Other sections of the Qur'an, originally one or more

Fol. 8

Fol. 11

Fol. 15

volumes, are found in Marcel 11 (eleven folios) and Marcel 15 (ten folios), and probably also in MS Arab. 330c in the Bibliothèque Nationale de France, Paris (nine folios). All are written in the so-called Umayyad script and similarly decorated. Four of the ten ornamented Sura-headings in Marcel 13 shown here recall the architectural style of early (and not only) Arabic

codices.[14] Parallels are also found in Jewish manuscripts, including catalogue numbers 75 and 76 and the Hebrew Book of the Prophets copied in Jerusalem in 988–89, where gold-ornamented columns with triangular bases and palmette "heads" appear between three text columns.[15] Many earlier Christian Gospels begin with canon tables inscribed under arcades (cat. no. 39). ov

1 The acquisition of Marcel's collection was published in the Report of the Imperial Public Library for the Year 1864 (Saint Petersburg, 1865), pp. 22–24.

2 Déroche 2009, pp. 10–13.

3 In what appears to be an early incarnation of *abjad*, a system in which letters are ascribed a numerical value, on some folios a golden letter outlined in brown gives the verse count after every fifth verse. It is not clear, however, whether this system was consistently applied throughout the manuscript. George 2009, pp. 92–93, fig. 10.

4 Nordenfalk 1970, pl. 45.

5 George 2010, p. 78.

6 The three Qur'ans in question are the famous Sana'a Qur'an (fig. 110), catalogue number 190, and an unpublished manuscript found in the Umayyad Mosque in Damascus, several folios of which feature composite architectural and vegetal motifs, including in two cases gilded columns bearing chalices, arranged horizontally to divide chapters. Déroche 2002, pp. 629–40, fig. 11; Déroche 2004a, pp. 254–56.

7 The abstract vegetal motifs that sit atop some columns (for example, fol. 33r) are similar to the crowning elements on one of the mihrabs depicted in the Sana'a Qur'an (fig. 110). The form of the gilded arch that divides the two sections of column on the same folio and the transparent globular lamp that hangs within it are also closely related to the arcades and lamps of the Sana'a frontispieces.

8 Flood 1999.

9 George 2009, pp. 105–6.

10 Déroche 2004a, pp. 240–42; Déroche 2009, p. 154; George 2010, pp. 75–78.

11 George 2010, p. 78. Note, however, that the text of at least one sura was later amended to reflect an alternative reading: Déroche 2009, p. 148.

12 On the history of the Marcel collection, see Vasilyeva 2007, pp. 442–51. See the online exhibition *Early Qur'ans from the J.-J. Marcel collection,* http://www.nlr .ru/eng/exib/Koran/.

Recto

Verso

13 Déroche 2004a; Déroche 2004b, p. 100, fig. 33,
 pp. 115–20; George 2010, pp. 75–78.

14 Most illustrative among Arabic manuscripts are the
 Qur'an fragments at the Manuscript House in Sana'a,
 Yemen, especially two pages showing a mosque typi-
 cally resembling the Great Mosque built in Damascus
 by the Umayyad caliph al-Walīd I (fig. 110). See
 Piotrovsky 1999, pp. 131–32.

15 The decorations appear at the end several leaves of
 the Masoretic text, National Library of Russia, Firk
 (Hebr. II B of 39, fols. 152r and 154r). See Levitt
 Kohn 2007, pp. 80–82.

References: Piotrovsky 1999; Déroche 2004a; Déroche
2004b, p. 115, fig. 33; Levitt Kohn 2007; Vasilyeva 2007;
George 2009, pp. 86, 92–93, fig. 10; George 2010,
pp. 75–78, 80, 148, figs. 50, 51.

190. Folio from a Qur'an

....................

Probably Syria, ca. 700–725
53.7 × 62 cm (21⅛ × 24⁷⁄₁₆ in.)
Brown and black ink and pigments on parchment
Provenance: Acquired by Jean-Louis Asselin de Cherville
(1772–1822; French consul in Cairo beginning 1816),
from the Mosque of 'Amr ibn al-'As in Fustat (Cairo);
collection of Jean-Louis Asselin de Cherville until 1822;
in 1833 the Bibliothèque Royale (now the Bibliothèque
Nationale) purchased Asselin de Cherville's entire collec-
tion of 1,515 manuscripts.
Condition: The folio has been trimmed at the top; the
upper left corner is damaged. There are additional small
losses of parchment. The ink and pigment are worn in
areas.
Bibliothèque Nationale de France, Paris (Arabe 324c),
fol. 39

This folio comes from the largest known
Kufic Qur'an, originally comprising up
to six hundred folios measuring at least
26¾ × 20⅞ in. (68 × 53 cm).[1] Its scale
relates it to a group of unusually large Kufic
Qur'ans that may have been intended for
display in mosques.[2] Carbon-14 dating sug-
gests a date range of 640 to 765 for the
group.[3] The size and use of frankly represen-
tational architectural illuminations, some-
thing of a hallmark of Umayyad Qur'ans
(cat. no. 189), also support an early dating.

The script relates to that of at least four
extant Qur'an manuscripts, including the
Sana'a Qur'an (fig. 110).[4] As is the case with
catalogue number 189, a later hand has
inscribed some chapter titles in red ink. The
end of each verse is indicated by a series of
oblique lines. In addition, every fifth verse is
marked by a rosette, and every tenth verse by
a four-pointed rhomboid inscribed in a
square. The chapter dividers consist of thick
horizontal belts featuring guilloche, rhom-
boid, and arcade designs, stepped where nec-
essary to accommodate the preceding text
block, as in other Qur'ans of the Umayyad
and Abbasid periods. These bands project
into the margins and terminate in arches
(sometimes tasseled) filled with abstract veg-
etal motifs or miniature columns bearing
elaborate floral sprays (fig. 111), recalling the
more large-scale use of similar ornament in
catalogue number 189. The dividing bands
are crowned with architectural motifs, often
in the form of continuous arcades featuring
horseshoe or rounded arches, within which
stylized lamps sometimes hang.[5] The use of
dwarf arcades finds antecedents in the minia-
ture canon tables that appear in some earlier
luxury Greek and Latin Gospels.[6] In this
manuscript, however, the architecture is far
more elaborate in its construction, with
arcades often supporting crenelations and
stepped pyramidal structures resembling cor-
beled domes.

The columnar chapter dividers of cata-
logue number 189 are more precise and
sophisticated in their execution, but the vari-
ety of architectural forms here lends this
manuscript an especially exuberant quality.
In several cases, the mid- or terminal points
of these structures support double- or
quadruple-winged motifs, calling to mind
those in the Dome of the Rock mosaics and
on some funerary monuments of the Early
Islamic period (cat. no. 167). Their striking
anthropomorphism recalls the use of winged
and vegetal motifs to evoke angelic creatures
in Byzantine, Coptic, and Jewish art. It has
been suggested, for example, that the two
leaves flanking the Ark of the Covenant in
catalogue number 75 were intended to evoke
the cherubim.[7] Precedents for the use of
abstract, aniconic, or vegetal devices to allude
to angelic and living beings by nonfigurative
means likely exist in Umayyad art as well.[8]
While its architectural illuminations relate
this Qur'an to others of the Umayyad period,
it is also possible that its vegetal illuminations
attest to a bold iconographic experiment—
an attempt to recall the angelic mediation
central to the revelation while avoiding the

literal depiction of living creatures.[9] Such an enterprise would be in keeping with the unusual scale of the Qur'an and the considerable investment of resources to which it bears witness.

<div align="right">FBF</div>

1 Other folios from the same Qur'an now preserved in the Bibliothèque Nationale de France, Paris (fig. 111), the Dar al-Kutub (the former Khedivial Library), Cairo, and the Forschungs- und Landesbibliothek, Gotha (Ms Or.A462), were, like those in catalogue number 189, acquired in the Mosque of 'Amr; see Moritz 1905, pls. 1–12; Nebes et al. 1997, pp. 105–7; Déroche and von Gladiss 1999, fig. 5.
2 These include a Qur'an folio of identical size now in a private collection, the famous Sana'a Qur'an, which measures 20⅛ × 18½ in. (51 × 47 cm) (fig. 110), and a vertical-format Qur'an from Katta Langar in Uzbekistan whose folios measured at least 20½ × 12⅝ in. (52 × 32 cm); see Piotrovskii 1999, pp. 100–104, cat. nos. 36–41 (Hans-Caspar Graf von Bothmer); Déroche 1999; Roxburgh 2007, p. 8, fig. 3; Dutton 2007, pp. 75–77. See also a large-scale Kufic Qur'an preserved in the Mashhad al-Hussein in Cairo: Munajjid 1971, pp. 53–54; Déroche 2004b, p. 28, fig. 4.
3 Déroche 2003, p. 261.
4 George 2010, pp. 87, 152.
5 Similar designs appear on a full-page illumination from another Umayyad Qur'an: ibid., pp. 87–88, fig. 58.
6 M. Brown 2006, pp. 238–39, 306, cat. no. 70.
7 Metzger 1958, p. 209; Levy 1993–94, pp. 82–83; Raby 1999, pp. 129–33, figs. 18–24.
8 Rosen-Ayalon 1989, pp. 54–55; J. Wilkinson 1992, pp. 133–39; Flood 2001, pp. 39–41; Avner 2011, p. 42.
9 See also early traditions concerning the existence of a heavenly Qur'an that only the angels are permitted to touch; Kister 2008, p. 310.

References: Tisserant 1914, p. xxxii, no. 42; Déroche 1983, pp. 75–77, no. 45; Guesdon and Vernay-Nouri 2001, cat. no. 14; Déroche 2004b, pp. 115, 117, figs. 34, 41; George 2010, p. 87, fig. 57.

191A, B. Two Folios from a Qur'an

....................

Damascus, late 8th century
Ink, pigments, and gold leaf on parchment

A. Folio with Verses from Qur'an 21:19–25

32.1 × 39.4 cm (12⅝ × 15½ in.)
Condition: The folio's condition is fair. There are some uneven, torn, and creased edges and areas where media are flaking. The ink and pigment are more stable and intact on the verso of the parchment than on the recto, where ink loss is severe. The acid in the iron-gall ink has so discolored the parchment that the text on each side is faintly visible on the other and has also caused some small tears in the parchment.
Brooklyn Museum, New York, Gift of Joan Palisi in memory of her husband, Dr. Joseph J. Palisi of Brooklyn, New York (1995.186)

B. Folio with Verses from Qur'an 43:37–44

31 × 39 cm (12³⁄₁₆ × 15⅜ in.)
Condition: The folio's condition is fair. A horizontal tear along the base of the fourth line of text has been mended on the recto. There are some losses along the edges, as well as a few areas of creasing and small tears in the parchment. Some of the text on the recto is visible on

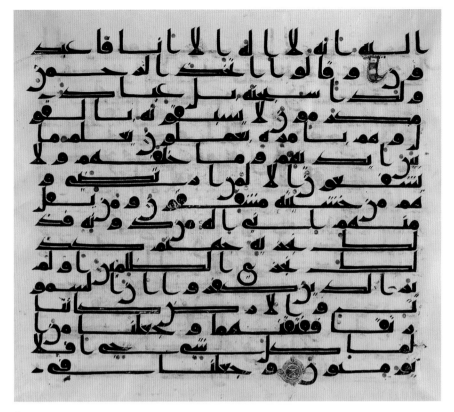

A, recto

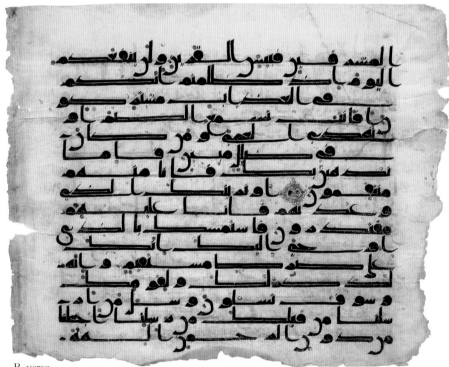

B, verso

the verso, probably because the acidity of the iron-gall ink weakened the paper.
The David Collection, Copenhagen (18/1965)

Originally from the same bound codex, this pair of elegantly scripted folios—one in the Brooklyn Museum, the other in the David Collection, Copenhagen—illustrates the exceptional skill and care with which Qur'ans were made. They are the product of practices developed in pre-Islamic Egypt and Syria and of innovations that appeared after the advent of Islam. For example, the physical structure of the parchment codex followed classical and ancient Near Eastern traditions, associated largely with Christian scriptures but also with Late Antique literary texts.[1] The most dramatic Islamic innovation was the Arabic script, which made a bold statement about the new religion and power by means of monumental inscriptions, coinage, and religious and official texts.

The Brooklyn folio displays verses from *Surat al-'anbiya'* ("The Prophets"; verso: Qur'an 21:25–31), while the Copenhagen leaf shows verses from *Surat al-zukhruf* ("The Ornaments of Gold"). Each page contains sixteen lines of text, written in Kufic script—the script of choice for copying Qur'ans in the Early Islamic period.[2] Although seemingly more unified in geometry and proportion, and perhaps more elaborately ornamented than their seventh-century predecessors in Hijazi script (see fig. 109), extant Qur'ans written in Kufic display a wide variety of styles. Penned in brownish black iron-gall ink, the calligraphy on the present folios is embellished with vowel- and verse-marking motifs in colored pigments and gold leaf.[3] Their physical and stylistic similarities suggest that the folios belong to a dispersed manuscript attributed by François Déroche to Damascus at the end of the eighth century.[4]

Déroche observed that the script here displays characteristic features, such as the extensive use of *mashq* (the elongation of letters along a horizontal axis) and a pronounced semicircular final *nun* (the Arabic letter n). Groups of five verses end in the letter *alif* painted green and gold and outlined in red, as seen on the second text line of the Brooklyn page, while four-pointed circular motifs in red, green, and gold mark the ends of groups of ten verses (seen in both leaves). Red dots indicate vocalizations; short, oblique strokes drawn with the same color ink as the text are diacritical marks; and groups of three short strokes identify further verse endings.[5]

These Qur'an leaves exhibit an extraordinary visual harmony of geometry and proportion through the carefully orchestrated forms of the letters and the spatial relationships between letters, diacritical marks, and illuminated motifs, as well as between the text box and the page itself. Although scholars have long noted the important role of geometry, proportion, and script size in Arabic calligraphy, Alain George has recently emphasized the architectural nature of "geometrical codification" in Kufic codices and suggested that those relationships mirror the ones found in monumental architectural inscriptions.[6] The significance of these brilliantly calligraphed and illuminated leaves cannot be understood fully, however, without considering the oral tradition from which the Arabic language emerged. Because the Qur'an was revealed orally and

not written down until after the death of Prophet Muhammad, early scripts without guiding vocalizations and diacritical marks posed ambiguities for the reader. Thus the early Qur'anic codex served as a memory aid for those who knew the text by heart. In addition to their aesthetic appeal, these intriguing compositions of letters and marks call upon the aural and oral senses of their beholders, relying on the written and illuminated text, a reciter, and a listener to activate collectively the meaning of the textual content in its entirety.[7]

LA

1 In particular, Islamic codices appear to have incorporated aspects of Syriac scribal practices, as suggested by a quire arrangement whereby the flesh side of a parchment folio faces the hair side of another folio. This is in contrast to Greek, Coptic, and Christian-Palestinian Aramaic (CPA) codices, where flesh faces flesh or hair faces hair. Rectangular bands of geometrical ornamentation also appear in Syriac codices; see George 2010, pp. 38, 46, and Bloom 2001, pp. 26–28. It should be noted, however, that the codex form existed in Syria and Egypt well before the fourth century C.E.

2 Although the label continues to be used in order to avoid the introduction of a new or more confusing term, "Kufic" unfortunately implies that a single script originated in Kufa (or al-Kufah) in modern Iraq, when no substantiated evidence exists to support this and when there are, in fact, a great variety of angular Arabic scripts. François Déroche's proposed term "early Abbasid script" is similarly misleading, since Kufic script predates the Abbasid period (Déroche 1992, p. 34). For an excellent overview of the history of Kufic script and the various terms used to describe it, see George 2010, pp. 19, 55–93, and Blair 2006b, p. 104.

3 For a discussion of the types of ink used in Islamic manuscripts and a description of *hibr* (the Arabic term for the iron-gall ink composed of metal tannates and gallnuts), see Bloom 2001, p. 107, and Blair 2006b, pp. 61–62.

4 Déroche based his conclusions about the date and place of production of other folios from this dispersed Qur'an on a paleographic study of three folios from the same manuscript housed in the Nasser D. Khalili Collection, London. Citing the horizontal elongation of letters as a characteristic feature of what he called "Style F," he also noted that it appeared only in material from Damascus. Yet, as none of that material is dated, he made stylistic comparisons to a milestone in Tbilisi dated about A.H. 100 (718/19 C.E.) and to an inscription of the caliph al-Mahdi dated A.H. 160 (776/77 C.E.), which led him to suggest a late eighth-century date for the dismantled manuscript (Déroche 1992, pp. 42, 120–22, pl. 66. Folios from that Qur'an had previously been associated with tenth-century Tunis, in Falk 1985, p. 37, cat. no. 4. The same attribution for the David Collection folio in von Folsach 1990, p. 34, no. 2, was updated to "Damascus at the end of the eighth century" in the revised edition of that catalogue, von Folsach 2001, p. 54, no. 1. While the Brooklyn Museum and David Collection folios probably come from the same Qur'an, they contain verses from chapters located far from each other in the manuscript; each was probably bound separately in its own *juz'* (section). Other leaves from the manuscript have been located in public and private collections, including but not limited to Los Angeles, Kuwait, and Istanbul, as well as on the art market

during the past thirty years. The locations of the leaves follow the "References," below.

5 Déroche 1992, pp. 120–22, pl. 66. Déroche suggests that the diacritical marks on these pages were added at a later date, noting that in the Early Islamic period many calligraphers avoided using aids that made the text more legible. However, a conservation study of the Brooklyn Museum folio by Kristi Dahm in 2002 determined that the diacritical marks were made with similar (if not the same) ink as that used for the text and that the degree of wear and strike-through (seepage of ink through a page) for the diacritical marks matched that of the text, indicating that the marks were not a later addition (see the object file for the folio in the Arts of the Islamic World Collection, Brooklyn Museum). Some of the red dots were applied over the text ink and may have been added later, although this can also not be determined for certain.

6 George's use of the term "geometrical codification" is a reference to the sysyematic application of elaborate rules of geometry and proportion in Early Islamic Qur'ans, which he proposes was developed before the time of Ibn Muqla (886–940), the Baghdad-born calligrapher credited with inventing Arabic cursive script and with setting its standards of proportionality based on the letter *alif* (whose height is defined by the thickness of the pen). For George's discussion of the geometry of early Qur'anic manuscripts, see George 2003. In his reference to architecture, George 2010, pp. 56–57, refers, in particular, to the inscriptions on the Dome of the Rock in Jerusalem, adding that the initial stages of this codification can be tied to 692, the year when that important monument and its inscriptions were completed. Noting the architectural iconography of illuminations that appear in some of the early Qur'an manuscripts, he suggests that this iconography mirrored that of religious monuments by Umayyad mosaicists, who were, in turn, following Byzantine practices; moreover, he proposes that manuscripts were probably illuminated by artists trained in Byzantine or Syriac scriptoria (ibid., pp. 67, 85–86).

7 The revelation of the Qur'an arrived within a cultural context steeped in oral tradition. In pre-Islamic Arabic, poetry had enjoyed pride of place as the highest art form, but it had been transmitted orally through aural interpretation, memorization, and recitation rather than through the written word. As Bloom 2001, p. 95, observes, in medieval Islamic society a text was "activated only by reading it aloud," and the written text, in fact, "served primarily as an adjunct to memory."

References: (A) Unpublished; (B) von Folsach 1990, p. 34, no. 2 (attributed to Tunis, tenth century); von Folsach et al. 1996, p. 136, fig. 45, p. 141, cat. no. 93; von Folsach 2001, p. 54, no. 1 (reattributed to Damascus, end of eighth century).

Other fragments from the same Qur'an: Karatay 1962, no. 42; Pal 1973, pp. 84–85, no. 141 (10 folios); Falk 1985, p. 37, cat. no. 4 (attributed to Tunisia, late tenth century); Qaddumi 1987, LNS 101 MS (b), p. 25; Déroche 1992, pp. 120–22, pl. 66; Black and Saidi 2000, pp. 10–11, no. 2; Fraser and Kwiatkowski 2006, pp. 27–29, cat. no. 4; Christie's, London, June 16, 1987 (lot 72), October 15, 1996 (lots 45–48), October 12, 2004 (lot 1), October 23, 2007 (lot 1); Sotheby's, London, April 15, 1985 (lots 40–44), November 21, 1985 (lots 284, 285), November 20, 1986 (lots 255, 256), December 4, 1987 (lots 182, 183), October 11, 1991 (lot 885), April 30, 1992 (lot 317), October 22, 1993 (lot 30), October 18, 1995 (lot 5), April 23, 1997 (lot 40), April 29, 1998 (lots 1, 2), April 13, 2000 (lots 2, 3).

A, recto

192A, B. Two Folios from a Qur'an

......................

Probably Tunisia, Qairawan, ca. 900–950
Gold leaf, silver, and ink on parchment colored
with indigo

A. Folio with Verses from Qur'an 4:23–25

28.5 × 37.5 cm (11¼ × 14¾ in.)
Condition: The folio is in very good condition.
Los Angeles County Museum of Art, Los Angeles,
purchased with funds provided by the Nasli M.
Heeramaneck Collection, gift of Joan Palevsky
(M.86.196)

B. Folio with Verses from Qur'an 4:51–59

24.8 × 38.1 cm (9¾ × 15 in.)
Condition: The folio is in very good condition.
Brooklyn Museum, New York, Gift of Beatrice Riese
(1995.51a–b)

These parchment pages come from a manuscript known as the Blue Qur'an. Although its date, place of production, and the rationale behind its rare color scheme remain the subject of debate, what is clear is that such a spectacular and costly manuscript must have been the product of courtly patronage.[1] Furthermore, it likely bears some connection with Byzantine manuscript production, which paired purple- as well as blue-colored parchments with metallic inks (cat. no. 21).[2] Its text is written in gold in a rectilinear script often referred to as Kufic,[3] fifteen lines per page, each of which is colored a deep blue; the verse markers, chapter headings, and divisions are in silver.[4] More than one hundred pages survive from an estimated six hundred; these are dispersed among collections in North America, Europe, and the Middle East, with more than half of them in Tunisia, where the manuscript was probably made.[5]

Jonathan Bloom, the first scholar to study the manuscript seriously, suggested that its 114 chapters had originally been divided into seven parts, since most of the pages in Western collections belong to the initial seventh of the text.[6] He proposed that it was produced under the Fatimid dynasty (909–1171) before its conquest of Egypt in 969 and the subsequent transfer of the capital from Qairawan to Cairo. His North African attribution was based on the large number of pages preserved in two Tunisian collections—about sixty-seven[7]—and a reference to an inventory of the library of the Great Mosque of Qairawan, dated 1294, describing a large-format manuscript of the Qur'an in seven sections written in gold on blue parchment with silver verse markers.[8]

Other provenances have been posited, such as the tenth-century Umayyad court in southern Spain, on account of the manuscript's blue-and-gold color scheme, which is found in the famed mosaic decoration surrounding the mihrab of the Great Mosque of Cordoba.[9] Sicily has been proposed as another western Islamic attribution, with a date between 850 and 950, on the tenuous assumption of some connection with the Rossano Gospels, a mid-sixth-century Byzantine manuscript on purple parchment.[10] The Blue Qur'an has also been ascribed to Baghdad in the early Abbasid period, about 750–850, for which the most compelling argument is based on a number of references to Abbasid gold-on-blue inscriptions that have not survived.[11] Given the lack of clear

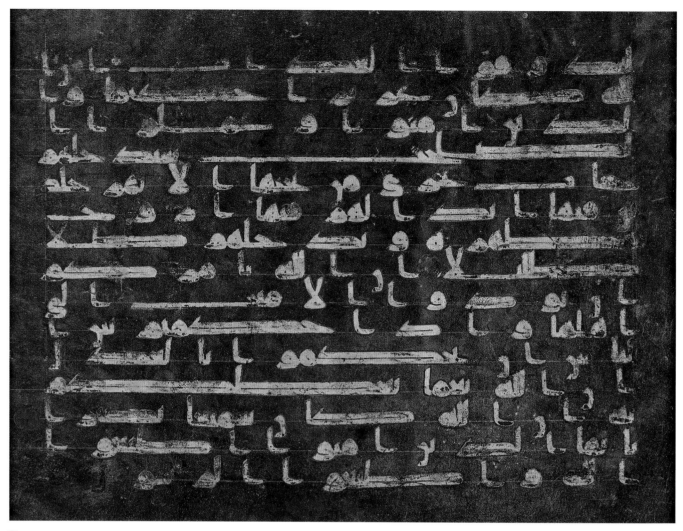

B, recto

evidence that the manuscript was produced elsewhere and later brought to North Africa, the Tunisian attribution and Fatimid patronage remain the most plausible.

The Blue Qur'an is so far unique among Islamic manuscripts on parchment because of its striking coloration. Other examples of colored-parchment Qur'an pages have survived, but these are paler and orange- or pink-hued.[12] Chrysography, or writing in gold, is more common in Qur'anic calligraphy and is not surprising given the importance of the text. New evidence suggests that the Blue Qur'an was not written in gold ink. Rather, the text may have been copied with a pen carrying a transparent adhesive such as glair, a mixture of egg white and vinegar, to which gold leaf was applied and subsequently neatened by outlining in dark ink.[13] LK

1 See Bloom forthcoming, for a summary of all relevant literature. I am grateful to the author for sharing with me his unpublished manuscript.
2 See R. Nelson 2005, pp. 72–74. He suggests that the Byzantine manuscripts may have passed into the Islamic world as courtly gifts.
3 Déroche 1992, pp. 36–37, 43–45, and 92–95, classifies it as "Group D" among the early Abbasid scripts.
4 George 2009, pp. 89–92, suggests that the silver orna-

ment—rosettes and medallions to separate or mark the verses and chapter headings—was added later.
5 See Bloom forthcoming. Also see George 2009, pp. 110–11, an appendix itemizing all known pages.
6 The first published reference to the manuscript, in 1912, was that of the Swedish diplomat and art dealer Fredrik R. Martin (F. Martin 1971, p. 106), who had acquired some pages in Constantinople before 1912. He proposed that the manuscript had been commissioned by the Abbasid caliph al-Ma'mun (r. 813–33) for the tomb of his father Harun al-Rashid in Mashhad; see Bloom 1986, superseded by Bloom 1989. To aid in recitation, manuscripts of the Qur'an were most commonly divided into thirty parts, one for each day of the month according to the Muslim calendar. Another way of organizing the text was in seven sections, for the days of the week.
7 George 2009, pp. 110–11.
8 Bloom 1986, p. 62; Bloom 1989, p. 97. But see Stanley 199–, p. 9, for the most up-to-date analysis and interpretation of the library inventory.
9 Stanley 199–, pp. 12–15.
10 Fraser and Kwiatkowski 2006, pp. 46–47.
11 George 2009, pp. 98–103.
12 For example, Déroche 1992, p. 58.
13 Bloom forthcoming. A complete understanding of how the gold was applied awaits full technical analysis and publication, as does the precise manner in which the pages were colored blue.

Reference: (A, B) Komaroff 2005, fig. 7.

193. Folio from a Qur'an

.....................

Scribe: Hasan ibn 'Ali ibn Ahmad ibn Ja'far ibn Abi Haram al-Tanukhi

Lebanon, Tyre, 9th–10th century[1]

Dark brown and black inks, red pigment, and gold leaf on parchment

19.1 × 25.5 cm (7½ × 10¹⁄₁₆ in.)

Provenance: Acquired by Jean-Louis Asselin de Cherville (1772–1822), France's consular agent in Egypt from 1816 until his death; purchased in 1833 by the Bibliothèque Royale (now the Bibliothèque Nationale) de France as part of Asselin de Cherville's entire collection of manuscripts.[2]

Condition: The folio's condition is good. Some of the calligraphy was reinforced with black ink at a later date. Bibliothèque Nationale de France, Paris (Arabe 346), folio 13

This folio belongs to a group of eighteen Qur'an leaves of the same format, bound together but originating in different volumes.[3] Shown here, set forth in a widely spaced Kufic script, are verses 12–13 from Qur'an 49, *Al-Hujurat* ("The Rooms").

The text was copied in iron-gall ink, with red dots indicating short vowels and a six-petaled gold rosette marking the end of verse 12.[4] Like most early Qur'an manuscripts

on parchment, the pages of this volume are formatted horizontally in codex form, which distinguishes them from vertically oriented Christian codices and the horizontal roll of Jewish scriptures. The choice of format—possibly guided by the horizontally driven Kufic script—may reflect a desire to showcase the new Islamic religion and the Arabic writing in which its message is conveyed, or it may have been a purely aesthetic decision. Whereas the use of *mashq* (letter extension) allows for an evenly balanced text box on some Kufic folios (see cat. no. 191), here the blank surface of the page is actively engaged, with letters dispersed evenly over seven lines, and words occasionally split between one line and the next, another feature associated with early angular scripts.[5]

Although there are important differences (certain letter forms; vocalizations in red, rather than gold; and seven, not five, lines per page), the present folio shares features with leaves from the well-known Qur'an made for Amajur (r. 870–78), the Abbasid governor of Damascus, which was originally endowed upon a mosque in Tyre.[6] The most notable of these features is an emphasis on geometry and proportion, a combination valued greatly since Late Antiquity and one that would be increasingly celebrated and reflected in tenth-century Arabic philosophical texts and calligraphy, respectively.[7]

LA

1 Marie-Geneviève Guesdon (in *Liban* 1998, p. 234) identifies Tyre in modern Lebanon as the place where the volume of which this leaf is a part was produced, based on a cursive inscription on the verso of folio 13 stating that the volume was produced for a *waqf* (endowment) in a religious structure outside of Tyre. The name of the scribe responsible for the calligraphy on this leaf is also given on folio 13v. Scholars generally accept a date for the present folio in the first half of the ninth century to the first half of the tenth, following François Déroche, who noted similarities in its calligraphic style with another style in use during that period.
2 On the collection, see Berthier 2000, p. 12.
3 Folios 1–8 include verses 1–17 from chapter 49, and folios 9–18 include verses starting at chapter 52, verse 23, and ending at chapter 53, verse 33.
4 See, for example, the two red dots stacked vertically below the letter *ya* on the fourth line of the present page.
5 For instance, the letter *ha* at the beginning of the text on this page, at top right, completes the last word on the preceding page.
6 For reproductions and discussions of leaves from the Amajur Qur'an, see George 2003, Bloom 2001, pp. 104–5, fig. 42 (SE 5643, Museum for Turkish and Islamic Art, Istanbul). See also George 2010, p. 56, fig. 31 (EA 1996.53, Ashmolean Museum, Oxford). In addition to some similarly shaped letters (for example, *alif*, with its wide heel curving to the right), the present folio and those from Amajur's Qur'an share a bold engagement of blank space between letters.
7 George 2010, pp. 102–9, links the advent of the "proportioned script" in the tenth century with an increased understanding of the relationship between geometry, proportion, and the human senses (that is, the visual beauty created by geometry and proportion in form and color or the aural beauty of proportion in music). This heightened awareness was brought about not only through translated classical Greek and Roman texts (for example, those of Vitruvius and Plato) but also through treatises by contemporary Islamic figures such as Al-Kindi (ca. 800–870) or Ibn al-Haytham (ca. 965–1039).

References: Déroche 1983, pp. 28, 30, 32, 33, no. 64, p. 86; *Liban* 1998, pp. 234–35.

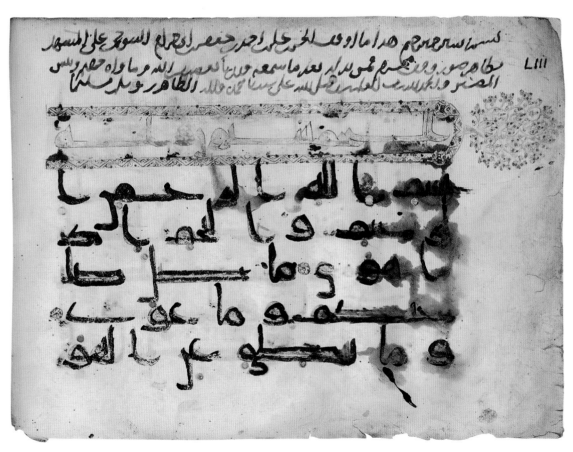

Fol. 13v

NOTES TO ESSAYS

BIBLIOGRAPHY

INDEX

PHOTOGRAPH CREDITS

Notes to Essays

BYZANTIUM

Byzantium and Islam: Age of Transition (7th–9th Century)
Helen C. Evans

1 Haldon 2000, pp. 23–24; Ostrogorsky 1969, pp. 68–71.
2 Haldon 1990, pp. 45–48, 59–60.
3 See Evans and Wixom 1997 and Evans 2004, for Metropolitan Museum of Art exhibition catalogues that explore the Byzantine Empire from the ninth through the fifteenth century, including contacts with the Islamic world. See Kennedy 2006, pp. 133–43, for detailed information on connections with Islam.
4 Haldon 1990, p. 10; Haldon 2000, pp. 56–57; Kaegi 2003, p. 88; Beaucamp 2007.
5 Kaegi 1992, pp. 256–58; Kaegi 2003, pp. 87, 272–77, 283; Haldon 2000, p. 29.
6 Av. Cameron 1996, chaps. 7–10.
7 Kaegi 2003, p. 36.
8 M. Mango 1994, p. 109.
9 Herrin 1987, pp. 198–200; Kaegi 2003, pp. 112, 136, 139.
10 Kaegi 1992, p. 53; Kaegi 2003, pp. 241–42, 278, 307; Shahîd 2009.
11 Haldon 1990, p. 50; Kaegi 2003, pp. 229–33.
12 Kaegi 2003, pp. 239–43; Ostrogorsky 1969, pp. 110–11.
13 Kaegi 2003, p. 312.
14 Ostrogorsky 1969, pp. 124–25; Haldon 1990, pp. 63–64.
15 Kennedy 2006, pp. 141–83, esp. pp. 147–83; Kaegi 1992, pp. 266–68; Kaegi 2003, pp. 237, 303; Haldon 1990, p. 50; Kennedy 2001, p. 227.
16 Shahîd 1979; Johnson 1991; Robin 1999.
17 Wolska 1962, p. 8. Kosmas 1909, Lib. XI, p. 323 (in Greek). I thank Stephanie Georgiadis and Lika Chkuaseli for tracing this footnote for me.
18 Herrin 1987, pp. 87–88, 108–9, 123–25; she notes Kosmas Indikopleustes' interest in the religion.
19 Kazhdan 1991b; Herrin 1987, pp. 108–9, 123–24.
20 Kiss 2007.
21 Papadakis 1991; Gregory 1991a, 1991c, 1991b; Baldwin et al. 1991; Herrin 1987, pp. 55–56.
22 Evans 1982.
23 Vryonis 1985, pp. 54–55.
24 Kennedy 2006, pp. 3–27.
25 Fulghum 2001–2, pp. 14, 18, fig. 1.
26 Kennedy 2006, pp. 3–27, esp. pp. 14–15 for Attarouthi.
27 Tate 1992b; M. Mango 1991c.
28 Leader-Newby 2004, pp. 123–219; Zalesskaia 2006b.
29 R. Ward 1993, p. 40.
30 El-Cheikh 2004, pp. 1–5, 54–71, esp. p. 60.
31 Papanikola-Bakirtzē 2002, pp. 492–93, cat. no. 673 (Robert Hallman), from the collection of The Metropolitan Museum of Art (14.1.140); Crum and White 1926, p. 320, no. 611.
32 Mavroudi 2009.
33 See Manaphēs 1990, p. 370, fig. 11, and p. 371, fig. 13, for a richly illuminated copy of his works in Arabic of 1612.
34 Herrin 1987, p. 344; Kazhdan 1991a.
35 Brubaker 2009.
36 Evans and Wixom 1997, p. 340, fig. 11.6.
37 Brubaker 2009; Schick 1998, pp. 87–88; Schick 1988, pp. 218–20; Fine 2010, p. 84.
38 Kaegi 1992, pp. 237–86.
39 Hawting 1987, pp. 10, 63.
40 Av. Cameron 1996, pp. 171–90.
41 Kennedy 2001.
42 See O. Grabar 1964, p. 88, for the argument that the Arabs drew on classical traditions, not contemporary Byzantine ones, in their new territories; see Kennedy 2001, p. 219, for the opposite view: "Insofar as the Muslims were the heirs of late antiquity, they inherited the world of Heraclius, not of Constantine; the cities and villages they came to rule were those of the early 7th, not the 4th century; and comparisons which look back from the formation of the early Islamic world to homogenous late antiquity can be either unhelpful or actually misleading." See Schick 1998, pp. 74–101, for the continuity between the Byzantine and Islamic periods in the eastern Mediterranean.

Gerasa
Lisa R. Brody

1 Surface surveys and very small-scale excavations were undertaken in the late nineteenth and early twentieth centuries. Continuous interest in the site led to more systematic exploration and conservation of the ruins after World War I, culminating in the expedition begun by Yale University and the British School of Archaeology in Jerusalem (1928–30) and continued by Yale and the American Schools of Oriental Research (1930–31, 1933–34). See Crowfoot 1931 and Kraeling 1938.
2 Zayadine 1986–89. See also Ostrasz 1989; Damgaard and Blanke 2004.
3 See Browning 1982.
4 N.H. 5.16.74.
5 For lamps excavated at Gerasa, see cat. nos. 27, 126.
6 For discussions of the later history of Gerasa, see March 2009; Wharton 1995.
7 On the Umayyad mosque discovered at Jerash, see Walmsley 2003a, 2003b; Walmsley and Damgaard 2005.

Heraclius
Helen C. Evans

1 Ostrogorsky 1969, pp. 92–112; Haldon 1990, pp. 41–53; Kaegi 2003, pp. 1–18.
2 Kaegi 2003, p. 194; Herrin 1987, pp. 204–5 and n. 86.
3 Kaegi 2003, pp. 19–57.
4 Ibid., pp. 27–30, for the wealth of Africa in the period; Birley 2002, p. 1; P. Brown 1969, pp. 18–28.
5 Kaegi 2003, pp. 43–49.
6 Ibid., pp. 87–89, 111.
7 Ibid., pp. 100–228, esp. pp. 205–9.
8 Ibid., pp. 210–16, 269–71; Herrin 1987, pp. 206–11.
9 Kaegi 2003, pp. 216–18.
10 El-Cheikh 2004, pp. 39–54, esp. pp. 41–52.
11 Evans 2004, pp. 537–39, cat. no. 323B (Stephen K. Scher).
12 Kaegi 2003, pp. 106–7, 265–323; Haldon 1990, pp. 48–78.

Classical Survival
Helen C. Evans

1 A. Grabar 1967, pp. 298–300; Hanfmann 1980, p. 93.
2 Brilliant 1979.
3 Ibid., pp. 127–29; Zalesskaia 2006a.
4 Leader-Newby 2006; Leader-Newby 2004, pp. 157–58, 174–76.
5 Leader-Newby 2006, p. 72.
6 Al. Cameron 2007, pp. 36–46.
7 Stauffer 1995, pp. 13–15.

Sasanian Expansion to the Mediterranean
Alexander Nagel

1 Dignas and Winter 2007; Daryaee 2009, p. 4.
2 Daryaee 2009, p. 29.
3 Magness 2011; Piccirillo 2011.

Christian Communities during the Early Islamic Centuries
Brandie Ratliff

1 On the significance of Jerusalem and its development as a holy city, see Wilken 1992. For an overview of early monasticism, see Harmless 2008. Harmless 2004 provides a more detailed discussion, including the role of monasteries in early church controversies, with an extensive bibliography.
2 For a general discussion, see Haldon 1990, pp. 327–48; for anti-Chalcedonian persecutions, also see van Rompay 2006.
3 For Syria-Palestine, see Shboul and Walmsley 1998, pp. 257–58; for Egypt, see Sijpesteijn 2007, pp. 444–51.
4 See Humphreys 2010.
5 For Syria-Palestine, see Levy-Rubin 2011, p. 156; for Egypt, see Sijpesteijn 2007, p. 442.
6 Levy-Rubin 2011, pp. 157, 160; Shboul and Walmsley 1998, p. 256; Schick 1995, pp. 81–82.
7 Ognibene 2002, pp. 44–48.
8 Piccirillo and Alliata 1994, pp. 242–46, nn. 1, 2.
9 For the date of the church, see Di Segni 1992.
10 Piccirillo 1992, p. 65.
11 See, for example, Bowersock 2006.
12 Avni 2011, pp. 115, 118–19.
13 Ibid., p. 120.
14 On the impact of the Arab-Islamic conquest in Egypt, see the general comments in Sijpesteijn 2007, pp. 441–42.
15 Sheehan 2010, pp. 88–92.
16 Innemée 2011, pp. 63–64.
17 Literary and papyrological evidence further contributes to our understanding of the Christian communities in the Early Islamic centuries. For surveys of the literary sources, see Hoyland 1997b and D. Thomas and Roggema 2009. See Foss 2007 for a discussion of the usefulness of vitae in reconstructing

the history of the period. On the huge collection of papyri from the Monastery of Apa Apollo at Bawit, which provide information on the monastery and its environs, see Clackson 2000a, Delattre 2007, and Clackson 2008.

18 On the Great Mosque in Damascus, see Key Fowden 2002, pp. 129–34; see also Khalek 2011, esp. pp. 85–134, and, in this volume, Flood, p. 244.

19 See Avner 2006–7.

20 Walmsley 2007, pp. 81–82.

21 On these topics, see Bashir 1991, Troupeau 1975, and Kilpatrick 2003.

22 The following discussion of the Christological controversies of the fourth to the sixth century is drawn from Daley 2008 and Gray 2005.

23 In his letter to John, Cyril affirmed that Christ was "of two natures" and that it was acceptable to say that specific biblical texts pertain to one or the other nature. This compromise was on the condition that the more radical division of Christ associated with Nestorios was rejected. The agreement is often referred to as the Formula of Union.

24 The word *hypostasis* is frequently translated as "person," but it is perhaps better understood as "individual characteristic" or "distinguishable reality." In the context of the definition of Christ formulated at Chalcedon, the term suggests that to refer to Christ's humanity or his divinity in abstraction is to identify each incompletely; see Higton 2011.

25 Haldon 1990, pp. 48–49. In 638 Heraclius issued the *Ekthesis*, in which further discussion of the problem of energies was forbidden and the new Monothelete formula was set out—only to create further divisions in the church (Haldon 1990, p. 49) that continued to cause problems for Constans II (r. 641–68). In fact, the doctrine met with opposition in most areas. The exceptions were the Chalcedonian communities in Syria and Palestine, and that was a factor in persuading the emperor to continue to support Monotheletism. For a discussion of the role of the Judaean desert monasteries in the Monothelete controversy, see Levy-Rubin 2001. In 646, in North Africa, local synods rejected the teaching, and two years later Constans II issued his *Typos* forbidding further discussion of the issue (Haldon 1990, pp. 56–57).

26 Haldon 1990, p. 68.

27 See Griffith 2001 on intrareligious dialogues and Griffith 2008a, pp. 75–105, on interreligious dialogues.

28 Davis 2004, pp. 1–3.

29 Davis 2008, pp. 53–54.

30 Davis 2004, pp. 103–8.

31 Griffith 2008a, pp. 64–65.

32 Ibid., pp. 131–34. By the seventh century, the Church of the East had introduced Christianity into South Asia, Iran, and across the silk routes into China and India.

33 Ibid., pp. 134–36.

34 Ibid., pp. 137–39.

35 Ibid., pp. 48–51.

36 See Ballian, p. 200, and Flood, p. 244. For a discussion of the restrictions on Christian communities, see Noth 2004.

37 On Byzantine Iconoclasm, see Brubaker and Haldon 2011.

38 For Theodore Abu Qurrah, see Griffith 2008a, pp. 59–91, bibl. nn. 47, 48.

39 The debate was recorded in an anonymous Syriac document; see Griffith 2011, p. 200.

40 For John of Damascus, see Louth 2002 and Griffith 2008b.

41 For an overview of altered mosaics, see the tables compiled in Schick 1995, pp. 190–92.

42 See Ognibene 2002, pp. 153–459, for a complete catalogue of the alterations made to the pavement in the Church of Saint Stephen.

43 Islam recognizes Jesus ('Isa) as a Prophet and Envoy or Messenger to whom God revealed the Gospels (*Injil*); he is the prophet who predicts the coming of Muhammad. Although the Qur'an recounts his miraculous birth, it denies Jesus' divinity, his crucifixion, and his resurrection. For an overview of Jesus in the Islamic tradition, see Anawati 2001.

44 Griffith 2008a, pp. 92–99.

45 Ibid., pp. 106–27, 158–59.

Sinai from the Seventh to the Ninth Century: Continuity in the Midst of Change

Hieromonk Justin of Sinai

1 Mayerson 1964, pp. 172–73.

2 Ibid., p. 177.

3 Haldon 1997, p. 50.

4 Skrobucha 1966, pp. 53–54.

5 Brock 1987, p. 57, note b.

6 Eutychios 2010, p. 282.

7 Moritz 1918, p. 4.

8 Brubaker and Haldon 2011, pp. 320–22.

9 Anastasios 2010, pp. 174–75.

10 Georges Florovsky, quoted on the cover of John of the Ladder 1959.

11 Ibid., p. 225.

12 Hesychios 1979, p. 163.

13 Philotheos 1983, p. 25.

Icons from the Monastery of Saint Catherine at Mount Sinai

Kathleen Corrigan

1 The number is derived from Weitzmann 1976. Four of these icons are now in Kiev. Several icons of the Virgin in Rome, and some thirteen painted panels from Egypt, mainly of saints and other holy figures, make up the rest of the corpus of icons from this period (cat. nos. 52, 53). For the icons from Egypt, see Auth 2005, pp. 19–36, with a list of panel paintings on pp. 33–36, some of which date to the fifth–sixth century.

2 See Weitzmann 1976, esp. pp. 4–8, where he discusses the problems of dating and localization. It has also been suggested that several of these early panels were gifts to the monastery from its founder, Justinian I (r. 527–65); however, there is no real evidence for this attribution. On the connection to Justinian, see T. Mathews 2006.

3 See the most recent discussion of these issues in Brubaker and Haldon 2011, chap. 1.

4 For example, Weitzmann 1976, icons B.41, B.42, and B.45.

5 See Corrigan 2011.

Arab Christians

Sidney H. Griffith

1 Kaegi 1992, 2003.

2 Griffith 2008a.

3 For more on the controversies between these communities, see Ratliff, p. 32, and Bolman, p. 69.

4 For more on Monoenergism and Monotheletism, see Evans, p. 14, and Ratliff, p. 32.

5 Louth 2002.

6 Abu Qurrah 2006; Keating 2006.

The Syriac Church

Nancy Khalek

1 Acts 11:26.

2 Murray 1975, p. 4.

3 Jl. Walker 1999, pp. 602–3.

4 Brock 2006.

5 Khalek 2011, pp. 5–9.

Coptic Christianity

Elizabeth S. Bolman

1 While the word "Copt" derives from the Greek and Arabic for "Egyptian," "Copts" and "Coptic" are commonly used to refer to Egyptian Christians and Egyptian Christianity.

2 Davis 2004, p. 124.

3 For the shift to Arabic, see Swanson 2010, p. 16; Davis 2008, pp. 201–2.

4 Swanson 2010, pp. 21, 33–34; Rubenson 1996.

5 Davis 2008, pp. 50–51.

6 Scholars have also called this doctrinal position "Monophysitism," a term that the present-day Coptic Orthodox Church finds objectionable.

7 Davis 2004, pp. 81–82.

8 Ibid., p. 125

9 Swanson 2010, pp. 11–12.

10 Sheehan 2010, p. 79.

11 Davis 2001, pp. 152–53.

12 Coquin 1974, p. 98. Sheehan 2010, p. 89.

13 Swanson 2010, p. 66.

14 Davis 2004, p. 125. Swanson 2010, pp. 4–6, 17–19.

15 Swanson 2010, pp. 21, 33–34.

16 Ibid., pp. 5, 17–21, 29–31, 33.

17 Ibid., p. 35.

18 Ibid., p. 37.

19 Ibid., p. 47; Davis 2008, pp. 237–38.

The White Monastery Federation and the Angelic Life

Elizabeth S. Bolman

1 Layton 2002.

2 This date is based on an unpublished stylistic analysis by William Lyster of a decorative motif used on the throne in a painting of the Virgin and Child in the White Monastery Church.

3 Layton 2007.

4 These include coins of Phocas (Focas), Heraclius and his son Constantine, and Constans II. Gabra 2003; Mohamed and Grossmann 1991, p. 63.

5 Halkin 1932, pp. 157–58 (for an English translation, see Veilleux 1981, pp. 55–56); Schroeder 2007, pp. 121–23.

6 Schroeder 2007, pp. 90–125.

7 The White Monastery has the larger of the two churches, but the one at the Red Monastery preserves the only intact, intentionally created sculptural program in a Late Antique church in Egypt. Severin 2008.

8 Bolman 2007b.

9 Roberts 1989, pp. 66–121; Bolman 2006; T. Thomas 2002a, pp. 39, 41, 46.

10 Layton 2002, 2007; Krueger 2010; Bolman 2007a; Schroeder 2007, pp. 90–125.

11 Krueger 2010.

12 Evangelatou 2005, pp. 121–22.

13 For similar Late Antique censers, see Weitzmann 1979a, pp. 626–27, cat. nos. 563, 564 (Archer St. Clair).

14 Misihah 1959.

15 Bolman and Lyster 2002, pp. 140–54.

16 Orlandi 2002, pp. 220, 225.

17 Heinz Halm, following Ibn Wasil (1207–1298), suggests there were probably "more than 120,000" books in the Fatimid library. Ibn Abi Tayyi (d. ca. 1233), however, claimed there were "1,600,000 volumes in it." Halm 1997, pp. 92–93; P. Walker 2002, pp. 43–44, 89.

18 In the mid-eighth century, the Arabs learned from China how to make paper, and the technique soon spread to Egypt. Bloom 2001, pp. 8–9.

19 I am grateful to Stephen Emmel for the information that there is no definitive evidence for the use of paper at the White Monastery. Email communication, March 23, 2011.

The Coptic Monastery of Bawit

Dominique Bénazeth

1 Sculptures from Bawit and Saqqara are on display in the galleries dedicated to Coptic art at The Metropolitan Museum of Art, New York. The Coptic Museum in Cairo preserves magnificent sculptures found during the official excavations of the two sites conducted in the early twentieth century. Some of the sculptures from Bawit went to the Musée du Louvre as *partage*.

2 The excavations were undertaken by the following institutions: 1901–13: the Institut Français d'Archéologie Orientale in Cairo (IFAO); 1976 and 1984, then 1985: the Service of Egyptian Antiquities; since 2003: the Musée du Louvre in collaboration with the IFAO, with the authorization of the Supreme Council of Egyptian Antiquities.

3 Herbich and Bénazeth 2008.

4 See cat. no. 52B. For reports on the recent excavations, see the *Bulletins de l'IFAO*.

5 The icons were discovered in 1902; see cat no. 53. The icon of Christ protecting Abbot Mena is in the Musée du Louvre, Paris (E 11565); see Rutschowscaya 1998.

6 Chassinat 1911.

7 Rutschowscaya 2010a, 2010b; Tomoum 2010, pp. 129–35, figs. 79–81. The polychrome sculptures of archangels are preserved at the Coptic Museum, Cairo (12816, 12821).

To Travel to the Holy

Brandie Ratliff

1 In Late Antiquity, neither Greek nor Latin had a word for pilgrimage. For discussions of the vocabulary used to describe religiously motivated travel to a holy place and the shortfalls of the modern terms "pilgrim" and "pilgrimage," see C. Mango 1995, pp. 1–3; Frank 2000, pp. 7–8; J. Wilkinson 2002, pp. 56–57; Vikan 2010, p. 3. On early interest in biblical Palestine, see Holum 1990, p. 69, and Wilken 1992, pp. 83–84. See Wilken 1992, pp. 166–72, on the use of the term "Holy Land" in our period. The literature on pilgrimage is vast. For an introduction to eastern pilgrimage and a discussion of the written sources, see Maraval 2004. J. Wilkinson 2002 translates into English the most important western Holy Land itineraries during our period. See Vikan 2010 for a discussion of pilgrimage, especially as it relates to material culture. On pilgrimage visits to ascetics and monasteries, see Frank 2000. For a discussion of the role of relics in pilgrimage, see Donceel-Voûte 1995.

2 Holum 1990, pp. 74–76; Vikan 2010, p. 4. One of the most popular legends relating to Constantine's building campaign was the discovery in Jerusalem of the True Cross by his mother, Helena; see J. Drijvers 1992, esp. pt. 2, chap. 4, pp. 95–118.

3 See Maraval 2004, pp. 137–51, for an overview of motivations for pilgrimage.

4 J. Wilkinson 2002, pp. 70–71.

5 *Anacreonticon*, 19.45, quoted in Vikan 2010, p. 2.

6 Piacenza, *Travels*, secs. 4, p. 131; 11, pp. 136–37; 22, p. 140, in J. Wilkinson 2002.

7 Piacenza, *Travels*, secs. 11, pp. 136–37; 18, pp. 138–39; 39, p. 147, in J. Wilkinson 2002.

8 For discussion of the role of blessings removed from the holy site, see Leyerle 2008 and Vikan 2010. See Frank 2006 on pilgrim souvenirs and memory.

9 Harvey 2006a, p. 159.

10 Montserrat 1998, pp. 273-75.

11 See the discussion in Maraval 2004 on the social composition of pilgrim groups.

12 Syriac *Life*, sec. 56, pp. 135–37, in Doran 1992.

13 On the Persian king, see Theodoret, *Life*, sec. 20, pp. 80–81, in Doran 1992. For Arab Christians, see Theodoret, *Life*, secs. 16, pp. 78–79, and 21, p. 81, in Doran 1992; see also Shahîd 1998, p. 382.

14 Key Fowden 2002, pp. 129–34; see also Khalek 2011, esp. pp. 85–134, and the comments in Flood, p. 244.

15 It is generally assumed that pilgrimage continued in the centuries between the Arab conquest and the beginning of the Crusades but that it was greatly reduced in scale. However, it seems unlikely that in a region that was mostly Christian for decades after the change in administration, pilgrimage would be dramatically affected. Some sites, such as Qal'at Sem'an and the Wondrous Mountain (see Ratliff, p. 94), declined during the seventh century; others—Abu Mina, the shrine of Saint Sergios at Rusafa (ancient Sergiopolis), and the Holy Monastery of Saint Catherine at Mount Sinai—attracted pilgrims well into the Middle Ages; in the case of Mount Sinai, the monastery remains today an important pilgrimage destination (see Hieromonk Justin of Sinai, p. 50).

16 Kraemer 1958, pp. 205–6, no. 72, dated March 684 (?); pp. 207–8, no. 73, dated December 683 (?). A third fragment, an account diary probably dating to the years immediately before the Muslim conquest of the area, records another trip to Mount Sinai; see Kraemer 1958, pp. 251–60, no. 89.

17 For a discussion of those texts as a source of historical information about the period, see Foss 2007. See also the more general comments in Talbot 2001 about the usefulness of hagiographic sources in reconstructing pilgrimage after the Arab conquest.

18 Foss 2007, pp. 112–13. For a critical edition of the Arabic translation of Leontios of Damascus's Greek text of the saint's life and an English translation, see Leontius 1999.

19 Foss 2007, p. 101. See Lamoreaux and Cairala 2000 for a critical edition of the Arabic text and an English translation.

20 Foss 2007, pp. 101–2.

21 Ibid., p. 110. See Dick 1961 for a French translation of the Arabic biography.

22 See Biddle 1999 on the tomb of Christ and the history of the shrine. On the Church of the Holy Sepulchre, see Corbo 1981–82.

23 The main liturgy of a feast day would be celebrated at a church tied to the historical event being commemorated. A lengthy procession would precede the liturgy, with worshippers stopping at several sites along the way for prayers. For example, see the description of the services for Holy Week and Easter celebration in the fourth-century text of Egeria; J. Wilkinson 1999, secs. 30–40, pp. 151–59. On the stational liturgy of Jerusalem, see Baldovin 1987, pp. 45–104.

24 Avner (2006–7) argues that the numerous minor sites along the Jerusalem–Bethlehem road would have heightened the pilgrim's anticipation of arriving at the site of the Nativity (p. 541). Pipes preserved near the rock where Mary sat suggest that water was brought in contact with the rock in order to sanctify it, whereupon it was distributed to pilgrims (pp. 546–47). A series of prayer niches around the Judaean desert monasteries may be another example of stations leading to a sacred destination; see Hirschfeld 1992, pp. 223–24.

25 See Timbe 1998 on Bibliothèque Nationale de France Copte 68. That manuscript records a ritual procession on the feast day of Apa Shenoute to sites in the desert surrounding the White Monastery before reaching the monastery itself (p. 415). The manuscript is dated to the fifteenth or sixteenth century, but Timbe argues that it preserves a tradition that evolved not long after Apa Shenoute's death in the fifth century (p. 441).

26 P. Grossmann 1998, pp. 283–84.

27 Ibid., pp. 284–86. Almost any substance could be sanctified through contact with an object, person, or place considered to be holy. At the tombs of martyrs and saints like Menas, reliquaries commonly had a hole in the lid and one in the base through which oil, water, or wax was passed. The liquid that came in contact with the relics was considered to be sanctified through contact. It was then collected, either by pilgrims or by the administrators of the cult, who then distributed it to the faithful. See Donceel-Voûte 1995, pp. 187–88.

28 P. Grossmann 1998, pp. 286–96, 298–300. The only preserved pilgrimage complex and town comparable to Abu Mina is Qal'at Sem'an; see Ratliff, p. 94, for an overview of that site and relevant bibliography.

29 P. Grossmann 1998, pp. 296–98. The revival of the site seems to have lasted until the middle of the ninth century.

30 See Key Fowden 1999 for a discussion of the cult of Saint Sergios, including pilgrimage to Rusafa.

31 On the geography of Rusafa, see Key Fowden 1999, pp. 1–3.

32 Ibid., pp. 98, 134. On Arab pilgrims, see also Shahîd 1998, pp. 379–80.

33 Donceel-Voûte 1995, pp. 190–92.

34 The foundational discussion of Late Antique pilgrimage art is Weitzmann 1974. Gary Vikan has continued to explore the field; see Vikan 2010 with relevant bibliography. On the relationship between memory and pilgrimage art, see Frank 2006.

35 Several iconographic types are known, including examples that pair Menas with other saints. On ampullae with the image of Saint Menas, see Kiss 1989; Lambert and Demeglio 1994, pp. 206–24; Witt 2000; Bangert 2010, pp. 299, 306–7. Other types of ceramic objects are also associated with the site; see Bangert 2010, pp. 307–9.

36 For a discussion of votives, see Vikan 2010, pp. 71–78.

37 Piacenza, *Travels*, sec. 18, pp. 138–39, in J. Wilkinson 2002.

38 The term "tactile piety" is borrowed from Wilken 1992, p. 116. Harvey (2006b, p. 157) describes the rituals of Late Antique Christianity as "sensorily engaged."

The Stylites of Syria

Brandie Ratliff

1 *Life* by Antonios, secs. 29–32, pp. 98–100, and Syriac *Life*, secs. 125–27, pp. 192–94, in Doran 1992. For a discussion of Symeon's corporeal relics, which were divided between Antioch and Constantinople, see Eastmond 1999.

2　On the geographic profile of the pilgrims, see Theodoret of Cyrrhos, sec. 11, pp. 74–75, in Doran 1992. From the second through the early seventh century, a network of well-populated villages occupied the Limestone Massif, which reaches from Antioch to Aleppo and as far south as Apamea. The area is known for some seven hundred villages with finely cut limestone architecture. Tchalenko 1953–58 is the most thorough survey of the region; see, more recently, Tate 1992a, who significantly revises Tchalenko's conclusions about the economy of the region.

3　The lives are as follows: that of Theodoret of Cyrrhus, chapter 26 of his *History of the Monks of Syria*, written about 444, when Symeon was still alive; a Greek vita written by the monk Antonios, a disciple in the monastic community serving Symeon, written not long after his death in 459; and a Syriac vita, the longest, also written by someone in the monastic community not long after the saint's death. These are translated into English and presented together in Doran 1992. For bibliography on critical editions of the texts, the relationships between the texts, and the different perspectives on the saint presented by them, see Harvey 1988, 1998, 1999, and 2006b, pp. 186–97.

4　Theodoret in particular focuses on Arab pilgrims, recounting conversions and miracles relating to them; Doran 1992, p. 40. Nomadic Arabs gathered at Qal'at Sem'an for baptism and celebrations of Symeon's feast day; see Key Fowden 1999, p. 148. For the saint's use of oil, water, dust, and *hnana*, see the Syriac *Life* in Doran 1992: oil (sec. 29, pp. 118–19; sec. 88, pp. 167–68); water (sec. 38, pp. 122–23; sec. 56, pp. 135–37); dust (sec. 33, p. 120; sec. 34, pp. 120–21; sec. 89, p. 168); and *hnana* (sec. 38, pp. 122–23; sec. 39, pp. 124–25; sec. 88, pp. 167–68).

5　Situated near the road running north to Cyrrhus from the Antioch–Chalkis highway, the pilgrimage complex takes its name from the tenth-century fortress built within the existing Late Antique structure; see Biscop 2006. The first systematic survey of the site was overseen by Georges Tchalenko; see Tchalenko 1953–58, vol. 1, pp. 205–76. In recent decades, the Mission Française de Qal'at Sem'an, directed by Jean-Pierre Sodini, has done much work at the site. While not documented, the construction of the complex has traditionally been assigned to the reign of the Byzantine emperor Zeno (r. 474–91). However, Sodini has recently suggested that it be assigned to sometime around 470, during the reign of Leo I (r. 457–74), who was encouraged by Symeon's acolyte Daniel the Stylite to bring the saint's relics to Constantinople. Sodini argues that in return for sending relics to Constantinople, Leo had the complex built; see Sodini 2010, pp. 298–301.

6　For a summary of the buildings at the site, see Sodini 2007, pp. 109–16; Sodini 2010, pp. 301–10. For a proposed chronology of construction at the site, see Sodini et al. 2002–3.

7　Ceramic finds and inscriptions attest to the continued occupation of the site after the Arab conquest and before the Byzantine reconquest; the site seems to have been abandoned by the early thirteenth century. See summaries of the later period of the site in Sodini 2007, pp. 118–20, and Sodini et al. 2002–3, pp. 351–55. For a discussion of the inscriptions and historical sources for this period, see Jarry 1966; Nasrallah 1970, 1971a, 1971b.

8　Symeon's allegiances were claimed by Chalcedonians and non-Chalcedonians. See Harvey 1993, p. 224, n. 24, which summarizes the scholarly debate over Symeon's allegiances. See also van den Ven 1962–70, vol. 1, pp. 168–70, n. 6.

9　For an overview of the longevity and geographic coverage of this form of asceticism, see Schachner

2010, pp. 329–35, and his *Gazetteer of Stylites and Stylite Martyria*, pp. 381–86; see also Peña et al. 1975, pp. 60–84. The classic study on stylite saints is Delehaye 1923. For bibliography discussing the origins of the stylites, see Schachner 2010, p. 330, n. 5.

10　In his *Gazetteer*, Schachner (2010, pp. 382–84) lists twenty-eight stylites in Syria, most of whom were located near major ancient thoroughfares. In Peña et al. 1975, pp. 87–159, ten stylites are identified in the immediate vicinity of Symeon's column.

11　Harvey 2006a, pp. 151–61; Harvey 1998, pp. 526–34.

12　See the summary of evidence in Schachner 2010, pp. 381–86.

13　Ibid., pp. 354–60. The columns consisted of three parts: base, shaft, and platform. For a discussion of stylite columns, see ibid., pp. 335–53, and Callot 1989. While most preserved columns are either monoliths or composites, there is evidence of a towerlike column; see M. Mango 2005, pp. 340–42.

14　The Wondrous Mountain is situated on the Roman road connecting Antioch and Seleucia Pieria; see Djobadze 1986, pp. 57–115; van den Ven 1962–70, vol. 1, pp. 191–221; Lafontaine-Dosogne 1967, pp. 67–135.

15　The life of Symeon the Younger is edited, with a French translation, in van den Ven 1962–70. Van den Ven argues that the life was written by a contemporary, vol. 1, pp. 101–8. For a summary of Symeon's miracles, see vol. 1, pp. 181–91; on pilgrims to the monastery, vol. 1, pp. 156–67.

16　See discussions in van den Ven 1962–70, pp. 167–70, and Harvey 1998, pp. 535–39. It has been suggested that the site was developed as a Chalcedonian alternative to Qal'at Sem'an; see Sodini 2010, pp. 319–21.

17　Djobadze 1986, p. 58. Djobadze's point that the work at the site could not have been completed entirely by unskilled laborers seems valid. The beautiful carving found on many of the fragments would have taken a high degree of skill; see, for example, ibid., pl. 34, fig. 134, pl. 38, figs. 150 and 152, and pl. 39, figs. 154 and 156.

18　Ibid., pp. 57–59. Several hermitages, a cemetery, and a monastery have been identified in the vicinity. Djobadze notes that the site lacks the ancillary structures seen at Qal'at Sem'an, which would have clearly been needed to support the number of pilgrims reported in the life. He suggests that such structures were standing in the early eighteenth century (pp. 114–15).

19　Ibid., pp. 57–59, 95–96.

20　Ibid., pp. 59, 96, 204–5, 210–11.

21　For a general overview of representations of stylites, see Peña et al. 1975, pp. 175–215, and associated plates.

22　See examples from a private collection in Munich in Wamser 2004, p. 209, cat. nos. 304–307.

23　Département des Antiquités Grecques, Étrusques et Romaines (Bj 2180). The plaque, from the church of Ma'arrat al-Nu'man in northwestern Syria, bears an inscription dedicating it to Saint Symeon. See Bianchini 1992, p. 114, cat. no. 61.

24　Harvey 2006b, pp. 181–97. The production and export of storax and cinnamon, ingredients in incense, played a major role in the Syrian economy; Pentcheva 2010, p. 22.

25　Vikan 2010, p. 51. Two tokens show a pilgrim offering incense to the stylite and bear inscriptions referring to the act; ibid., p. 51 and p. 33, fig. 19. Following Vikan, Pentcheva (2010, p. 38) calls attention to an episode of healing in chapter 231 of the Younger's life that involves prayer and the burning of incense over a token; she also notes examples of charred tokens in the collection of Christian Schmidt.

Mosaics during the Byzantine and Early Islamic Periods

Robert Schick

1　See especially Piccirillo 1992.

2　Ibid., p. 191, fig. 277.

3　Puech 2011.

4　Piccirillo 1992, p. 219, fig. 345 and additional figures on following pages.

5　For the date, see Schick 1995, pp. 472–73, pls. 13, 14.

6　Piccirillo 1992, p. 220, fig. 346.

7　Ibid., p. 344, fig. 760.

Jews and Judaism between Byzantium and Islam

Steven Fine

1　Eusebius 2004, p. 130, n. 732.

2　M. Woods 1918; Vincent 1961; Benoit 1961; Avi-Yonah 1993; Fine 2005, pp. 82–85.

3　See the most recent survey of the Jewish material, Hachlili 2009.

4　Fine 2005, pp. 198–207.

5　Ibid., pp. 191–98.

6　Greenfield 1978.

7　On the Samaritans in general, see Crown 1989. The Samaritan population in Israel and the West Bank now numbers more than seven hundred.

8　On Samaritan synagogues, see Magen 1993 and Pummer 1999.

9　Naveh 1978, pp. 93–102, nos. 60, 64.

10　The development of this conception is traced in Fine 1997. See also Fine 2005, pp. 210–11.

11　Nau 1913, p. 382, translated in Sivan 2008, p. 178.

12　See Fine 1998.

13　Bloch 1961; Bloch 1974, p. 46.

14　Linder 1987, pp. 73–75.

15　Jacobs 2004.

16　See Fine 1999.

17　Gil 1992, pp. 9–10; Horowitz 2006, pp. 229–47.

18　Baumgarten 1999; Fine 2005, p. 108.

19　Foerster 1993.

20　Narkiss 1990.

21　King 1985.

22　Avrin 1981.

23　Crown 1989, pp. 55–81; Shehadeh 1989.

24　The standard history of this period is Gil 1992.

25　Franklin 2001, pp. 176–77.

26　See Erder 2003.

27　Mann 1972, vol. 2, pp. 75–76.

28　The most recent scholarship on these relations is assembled in Polliack 2003. See also Polliack 2006. Today Qaraites number between thirty thousand and forty thousand, mainly in Israel and in northern California.

29　Gil 1992, pp. 173, 820–25.

30　S. Ward 1984.

Christian Mosaics in Early Islamic Jordan and Palestine: A Case of Regional Iconoclasm

Finbarr B. Flood

1　Ognibene 1998.

2　As noted by Fowden 2004a, pp. 294–95, among others. For a contrary view, see Maguire 2009.

3　C. Mango 1972, pp. 32–34.

4　J. Wilkinson 1992, pp. 133–39.

5 As noted by Ognibene 2002, pp. 130–40; Griffith 2007, pp. 358–67; Guidetti 2010a, pp. 71–72.

6 Van Reenen 1990, p. 33; Flood forthcoming, chap. 2.

7 Urbach 1959; Blidstein 1973–74.

8 Bowersock 2006, pp. 103–5, 109–11. For a critique of attempts to link these alterations specifically to the edict of Yazid, see Duval 2003a, pp. 111–14.

9 Such was the case in the Church of Saint Stephen at Umm al-Rasas and the church at Massuh: Piccirillo 1998, p. 270, fig. 2; Ognibene 2002, p. 101, S16. On the relative roles of the cross and images as subjects of contention, see King 1985.

10 Fine 2000, p. 194.

11 Bashir 1991; Ognibene 2002, p. 102. The excavators of the Church of the Kathisma in Jerusalem tentatively identified a concave niche in the southern part of the church as an early eighth-century mihrab (prayer niche), but the identification has not been conclusively proven; see Avner 2011, pp. 41–42.

12 Schick 1995, pp. 209–19; Hoyland 1997b, p. 608.

13 Abu Qurrah 1997, p. 55.

14 Alterations to the mosaics of the church at 'Ayn al-Kanisah were later reversed and figural iconographies restored; Ognibene 1998; Ognibene 2002, p. 382.

15 For a discussion of these altered images in terms of hybridization, see Verstegen 2011.

COMMERCE

"Ornaments of excellence" from "the miserable gains of commerce": Luxury Art and Byzantine Culture

Thelma K. Thomas

The first quotation in the title is found in a sixth-century epigram by the bilingual lawyer and poet Dioskuros of Aphrodito, Egypt, citing the virtues of its patrician subject, Flavius Apion, as a plea for his assistance: MacCoull 1988, p. 64, citing H6. Encomium. A.D. 551–53. P.Cair. Masp.II 67177. I also use the phrase to refer to the relation between the artwork and the subject it glorifies.

1 Trilling 2003, p. 21, separates ornament from function. He also notes:

 Ornament is all around us; we have chosen not to notice it. This is a matter of taste, of pleasure, but the change has a much deeper social basis. Ornament was bound up with wealth and display, with power, luxury, and personal magnificence. Today few of us have the opportunity to cultivate magnificence, so we rarely learn to appreciate it. More often we do just the opposite, making our lack of susceptibility a badge of both egalitarianism and sophistication. If personal magnificence is *vulgar*, then ornament too is touched by vulgarity: a far more serious taint, clingy, contagious, and hard to eradicate" (p. 12).

 As is the case for many scholars, the work of Oleg Grabar has been important for my thinking on ornament; see O. Grabar 1992b. For the preceding period of Late Antique art, see Swift 2009. On luxury art, see Althaus and Sutcliffe 2006, Kalavrezou 1997, and Buettner 2006.

2 Parker 2002, p. 55, for the phrase "rhetoric of excess"; more generally, Dalby 2000.

3 Trilling 1997, p. 225. As a product of fine craft or advanced technology, the ornament of luxury art comments on a different kind of excellence than proposed in the headnote above, as suggested, for example, by Gell 1992, p. 43: "There seems every justification . . . for considering art objects initially as

those objects which demonstrate a certain technically achieved level of excellence, 'excellence' being a function, not of their characteristics simply as objects, but of their characteristics as *made* objects, as products of technologies."

4 Janes 1999a, p. 474.

5 Janes 1998, esp. pp. 94–152. Golden—and purple—temples, as well as audience halls and tombs of the elite, appear in popular literature spanning the sixth to tenth century, as in Alexander's visit to the golden temple-tomb of Dionysos; see Pseudo-Callisthenes 1889, pp. 101–2.

6 Grierson 1991.

7 Morrisson 2002; Grierson 1999; and Foss, p. 136.

8 Cutler 1994b, esp. p. 295, on gifting to churches. On silver stamps, see Dodd 1961 and 1964. More generally, see M. Mango 1999a. On cross-cultural continuities of silver in luxury art, see also Ettinghausen 1972. On the association of silver coinage with the Sasanian Empire until its fall in the early seventh century, see Banaji 2006.

9 Cutler 1999b; for a fuller treatment of ivory in Byzantine art, see Cutler 1994a.

10 D. Graf 1999, p. 695. See below in this essay, as well as Thomas, p. 148, and Colburn, p. 161.

11 Cutler 2008b and 1999a; also J. Nelson 2010. On diplomatic exchanges between Persian and the Late Roman and Early Byzantine emperors, see Canepa 2009. On the collecting and hoarding of objects in precious materials, typically in gold, silver, and gems but also purple silk and ivory, see Janes 1999b; and M. Mango 1999b.

12 "Tyrian" refers to the legendary place of discovery of the murex mollusk from which the dye was obtained: McCormick et al. 1991.

13 On this and other developments in weaving technology during this period, see Wild 2003, p. 141; and see Colburn, p. 161. Mechanical repetition seems to have been desirable in itself, because it was laboriously imitated in other techniques; see Maguire 1995, esp. p. 59; and below in this essay.

14 Kitzinger 1954, p. 113, linked mechanical reproduction by impression to "celestially produced" images. Hahn 1990 has influenced recent scholarship on the concept of sealing for the production of iconic images as discussed; see Pentcheva 2006b, pp. 634–36. See also Nesbitt 1991.

15 Maguire 1997.

16 Bruhn 1993. Older coins or imitation coins with images of ancient rulers were especially potent: Maguire 1997, p. 1040.

17 On adaptations of Byzantine coinage: Georganteli and Cook 2006; Foss 2008; and Foss, p. 136.

18 Appadurai 1986, p. 6: "Commodities, properly understood, are not the monopoly of modern, industrialized economies." Commodities are goods intended for exchange, thus gift and commodity circulation share a "common spirit." Cutler 1994b, esp. p. 296. On the movements of artisans, see Cutler 2009, chap. 5.

19 Foundational for the study of Late Antique–Early Byzantine self-display through material goods and ornament is MacMullen 1964 (phrase at p. 441).

20 Hollingsworth 1991. See note 74 below.

21 Dagron 2002, esp. p. 400. Haldon 2006, esp. pp. 606–12.

22 Eastmond 2008. Although archaeologists have tended to study continuations of trade networks solely through the evidence of pottery, Marlia Mundell Mango offers a more inclusive, long-term view of Byzantine material culture, markets, and products in M. Mango 2009.

23 See the useful collection of essays on material culture in Brubaker and Haldon 2001.

24 On combinations of techniques, see Dandridge 2000. Entwistle and Adams 2010 collect a series of articles

on fine metalwork, especially gold, as do Daim and Drauschke 2010. On enameling, see Buckton 1988, Cutler 2008a, and Giannichedda 2007.

25 Particularly important for Byzantine luxury art of this period is what Gell terms "the halo effect of technical 'difficulty'" (Gell 1992, p. 46); Sheng 1999, e.g., at p. 155. On automata, see Bes 2007, p. 10. None of these mechanized fountains survives. They are known mainly from written descriptions and representations; see Dolezal and Mavroudi 2002. For a broader view of "fine technology," see Trilling 1997.

26 Canepa 2009, pp. 22–24 and 127: both realms cultivated a sense of "'global' royal legitimacy." Several articles in Harris 2007 are useful for contextualizing these long-distance exchanges, esp. Dark 2007. On a wider range of art historical issues associated with largely modern and contemporary notions of "globalization," see Flood et al. 2010.

27 Helms 1993, for example, pp. 160–70. The Family of Kings at the Umayyad hunting lodge/estate of Qusayr 'Amra is represented wearing Byzantine-style silk robes, distinguished by crowns and ethnic features, and identified by name: on this monument, see Fowden 2004b.

28 Ibn al-Zubayr 1996, para. 73, pp. 99–101; discussed in O. Grabar 1997, pp. 117–21.

29 The narrator describes the wedding feast for the daughter of the caliph al-Ma'mun (r. 813–33): "When I was there, I thought I heard the echo of sailors talking to each other. Lo, the servants appeared drawing a silver boat with ropes of floss silk, filled with strong costly mixed scents. With that, they daubed the beards of the entourage. Then they drew the small boat to the common people and perfumed them" (Ibn al-Zubayr 1996, para. 118, p. 128).

30 Even al-Ma'mun found this gift to be excessive: Ibn al-Zubayr 1996, para. 119, pp. 128–30. On the prodigious wealth and close connections to the Constantinopolitan court of the uppermost tier of elite society in Early Byzantine Egypt, see Sarris 2006, e.g., p. 18: Flavius Strategius III (father of the subject of "ornaments of excellence"), organizing the grain shipment from Egypt, representing the emperor in negotiations with the Persians in 531–32, and serving as *comes* while settling a dispute between the empire and Arab Miaphysite allies. He was a member of a "trans-regional aristocracy of service" (p. 88), whose wealth derived from both trade ventures and agriculture.

31 In this episode, it is possible to glimpse the value of the lady's gift change from al-Ma'mun's first misperception of it as from a provincial striver to a gift from someone of appropriate wealth and status. Appadurai 1986, p. 4, considers the "regimes of value" inflecting such transactions as the "desire and demand, reciprocal sacrifice and power interact[ing] to create economic value in specific situations." Sarris 2006, pp. 88–89, cites several examples of extremely wealthy Egyptian women, including "Flavia Christodote, daughter of a former patrician, whose estate . . . [likely consisted] of landholdings throughout the region. The papyri reveal that Christodote was owed no less than 4,392 solidi by an Alexandrian banker by the name of Flavius Eustathius, to whom she made it clear that she was willing to pursue the matter as far as Constantinople. As a woman of substance, Christodote was not to be messed with."

32 Vryonis 1962; Kazhdan and Talbot 1991.

33 Parker 2002, esp. pp. 58ff.; often linking their discovery to the campaigns of Alexander the Great, p. 80; on silk, pp. 60–61; see note 5 above and note 35 below.

34 Book II.137, after Kosmas 1897, p. 47. Clark 2008, p. 10, n. 1. In locating paradise in the East beyond India and Ocean, Kosmas drew on an ancient

tradition widespread in Early Christian thought; see Podskalsky et al. 1991 and Mayerson 1993.

35 Maguire 1987, pp. 26, 37. On manuscripts as luxury art, especially appropriate for this essay, is Lowden 1992a.

36 Kosmas referred to the import of cultivated silk from the *Bombyx mori* moth in contrast to the coarser, less lustrous wild silk (tussah) grown domestically; Wild 2003, p. 141.

37 Book II.138 (Kosínas 1897, p. 49).

38 Parker 2002, pp. 84–87 and passim; at p. 86: "The underlying thought, we might say, is that an object is known by knowing its origin, whether topographical or personal." Casson 1989; Sidebotham 2011 and 2009.

39 The Muziris Papyrus is in the Austrian National Library, Vienna (P.Vindob.G40822): Casson 1990, pp. 205–6, n. 29. McCormick 2001, p. 425. Trombley 2001. See also Kingsley and Decker 2001, p. 15.

40 The Muziris Papyrus specifies a surprisingly high 25 percent of the cargo. Byzantine import tax rates were much lower, at 10 percent, and a low internal rate of 2–2.5 percent: Laiou 1991a, esp. p. 489; Oikonomidès 1991. See also Muthesius 1993, p. 10.

41 *Liber Pontificalis* to Gregory the Great, under the entry for Sylvester (r. 314–35) at pp. 55–58. Precious cloth appears in the papal donations of the *Liber Pontificalis* during the reign of Justinian but does not appear in great quantities until the late seventh century.

42 D'Arms 1981, pp. 21–22.

43 Libanius, *Orat.* 3, cited in D'Arms 1981, p. 8.

44 Delmaire 2003, esp. pp. 89–95. Compare to Stillman 2000, p. 22, on silk and jewelry as the clothing of the righteous in paradise, and pp. 31–38, on sumptuous dress during Umayyad rule.

45 Pellat 1954, p. 154.

46 Ibid., pp. 159–61, on "rare merchandise, produce, slaves, stones, etc. imported from foreign lands." Entries for India, China, and Byzantium begin the list. See also McCormick 2001, p. 591. On knowledge of products and markets, see Appadurai 1986, pp. 41–56.

47 Eunuchs were owned as slaves or employed in the wealthiest households, with their own hierarchy of high offices within the imperial court. Eunuchs held a similar range of personal and administrative positions within the courts of the early caliphates, as well as those of India and China. See Tougher 1997.

48 O. Grabar 1982, p. 29. Grabar refers to much later texts of the thirteenth century. However, the types of items, "spices, precious stones, unfinished silk or cotton," are in line with those listed by Kosmas Indikopleustes. Such lists also suggest that portability and circulation were critically important aspects of the development of material and visual culture: Hoffman 2001. Some categories of luxury art were meant to acculturate: Hilsdale 2005.

49 As they had been traveling for centuries: Dark 2007, p. 5, discusses evidence for trade and artistic developments between the Roman and Kushan empires:
This link with the Roman Empire involved not only the export of things but also beliefs, values and concepts—so that South Asian cultural history will need to be revised in the light of this pattern of links. For example, in 180, Pantenaeus, a Sicilian Christian sailing from Roman Alexandria could even, it seems, find a local Christian community in India. Thus archaeology and texts leave us in no doubt that there was regular contact between the Roman Empire and India, with both economic and cultural consequences.

50 L. James 2003, e.g., p. 224; Pellat 1954.

51 Compare attitudes toward silken vestments in the third century, in Harlow 2005, to those of the fourth century and later, in Parani 2007; for a broader scope, see Ball 2005.
The economic implications for trade in luxury goods are huge. For one example, no doubt representative of many: "A papyrus of A.D. 325 [*P.Oxy.*

3758] shows that the councillors of Oxyrhynchus, by order of the governor of Egypt, purchased 150 *paragaudia*—gold-embroidered silk chitons—each one costing 65,000 *denarii*" (Garnsey and Whittaker 1998, p. 336).

52 Hall 2004, at p. 225, notes Egeria's enthusiastic description of the precious materials, including silk, at the major shrines associated with the Life of Christ:
[At] the Great Church on Golgotha . . . and at the Anastasis and the Cross and Bethlehem, the decorations really are too marvelous for words. All you can see is gold and jewels and silk [*sirico*]; the hangings are entirely silk [*olesirica*] with gold stripes, the curtains are the same, and everything they use for the services at the festival is made of gold and jewels. You simply cannot imagine the number, and the sheer weight of the candles and tapers and lamps and everything else they use for the services.
Muthesius 2004 explores evidence for the use of silk in imperial and ecclesiastical vestments and as the object of cult and binding scriptures. NB: See Novel 80 of Leo the Wise, as in Freshfield 1938, p. 7, n. 23, on access to "scraps of trim and clippings" of imperial purple in the tenth century; and McCormick et al. 1991, p. 1760. On the development of church vestments, see Walter 1982; Norris 1949, p. 63, attributes widespread use of silk in clerical vestments to the sixth century in the Eastern empire, Rome, and Western kingdoms.

53 Ball 2005, p. 29.

54 Fulghum 2001–2, the best recent art historical overview of Byzantine textiles, notes the use of lattice-patterned silk in representations of heavenly space in an extended discussion of silks marking liminal, exalted spaces; on pp. 28–29 citing a miniature, *The Second Parousia* (Second Coming of Christ, on Judgment Day), in a ninth-century manuscript of Kosmas Indikopleustes, Vat. Cod. Gr. 699, fol. 89r, and on p. 20, the back of the twelfth-century icon of *The Ladder of Divine Ascent* of Saint John Klimax at the Holy Monastery of Saint Catherine, Sinai, Egypt.

55 Oikonomidès 1986.

56 See, for example, Muthesius 1993, p. 47.

57 Ibid., pp. 60–61, offers an insightful reading of material and labor costs in Diocletian's Edict on Maximum Prices in relation to Cairo Genizah documents of the tenth to eleventh century.

58 On silk dyes, see Muthesius 1997, pp. 27–33.

59 Book XXV, 13–31, in Procopius 1935, p. 93, quotation (here slightly modernized) on p. 299; Lopez 1945, p. 11–12.

60 D. Graf 1999, p. 695, mentions the Hephthalites as well; Procopius, *Wars* I.3, on Persian provocation of the Hepthalites; I.20, on the attempted agreement with the Ethiopians; II.28–30, on the Laz and Armenians.

61 Lopez 1945, pp. 12–14, describes the sixth-century promotion of sericulture as the beginning of "a slow industrial revolution."

62 Procopius, *Wars* 4.17; Theophanes 1982, Book IV, 270. Muthesius 1993, pp. 18–20; Jacoby 1991–92, pp. 453–54.

63 Hall 2004, pp. 221–54, provides useful discussions of the social contexts of Late Antique (mainly fourth- to sixth-century) artisans including those in the cloth industry.

64 Muthesius 1993, p. 57; Shahîd 2002, p. 77. The Slavs were part of the northern sphere linked by trade in luxury goods as well as ever-shifting networks of political alliances.

65 McCormick 2001, pp. 719–28; "European Exports to Africa and Asia," pp. 729–58.

66 Also known as *The Book of the Prefect*. Koder 1991. On legislation concerning silk, see Muthesius 1993,

p. 59, table 1, "Continuity in Silk Legislation" (citing the Theodosian Code, the Justinianic Code, and the Basilics); see also pp. 8, 57–58, 65. M. Mango 2000; Ilieva and Thomov 1998.

67 As they did in Umayyad cities taken over from the empire: Kennedy 1985a, Tsafrir 2009, and Laiou 1991b.

68 Enlightening in this respect is to compare the imperial *Book of the Eparch* to the merchant's *Periplus*, cited above, notes 42 and 73.

69 Cutler 1999c, p. 647, sees *The Book of Ceremonies* Byzantine/Arab as equivalent to *The Audiences of the Caliphs*; Constantine 1990.

70 Ibn al-Zubayr 1996, p. 289, n. 29, suggests *siqlatun* may be a type of linen with gold thread; O. Grabar 1997, p. 119, notes the term is often translated as "scarlet."

71 On long-standing cultural connections between Rome and Persia, see Dark 2007 (pp. 5–6):
For example, Bishapur had a temple constructed in the manner of Roman Syria, an honorific column commemorating its foundation and townhouses decorated with what appear to be Antiochan mosaics. Although the settlement of Roman captives may have had some part in promoting Roman culture in these places, the employment of craftworkers such as mosaicists from the Empire attests continuing cultural connections and trade. These were not isolate prisoner-of-war camps, but thriving urban centres that retained their connections with the Mediterranean world.

72 The stepped contour is characteristic "Zandaniji" silk. The term "Zandaniji" has posed a particularly difficult challenge to interpretation. It is "now associated with a type of silk cloth which probably came from the Sogdian region": Shepherd 1981; Martiniani-Reber 2004. At various times, this has meant a cotton cloth, both worn by princes and material suitable for a servant working in the stable to wear; Vogelsang-Eastwood 2003, p. 159. Particularly popular were traditional Sasanian motifs of the hunt, birds and animals from the Sasanian Zoroastrian pantheon, and pearl borders evocative of Persian beaded crowns. Along with silk from Persia came motifs and themes of Persian silk: Gonosová 1987; and Canepa 2009, p. 216, in relation to grand monuments of the Justinianic period, H. Polyeuktos and Hagia Sophia, pp. 216–20. Peirce and Tyler 1936 offer still useful comments on the silk industry before Justinian and on adaptations of Persian styles and motifs. See also Ettinghausen 1972 for consideration of cross-cultural translations and transformations of motifs.

73 Important studies of these patterns include Trilling 1985 and Gonosová 1987. On interrelated developments in weaving techniques and cloth production, including silks, see the following excellent essays: Wild 2003, p. 151, discussing larger medallions; Allgrove-McDowell 2003, p. 154, on Sasanian centers of textile production—including silk—and the use of Roman weavers; Vogelsang-Eastwood 2003, pp. 159–62, notes the Early Islamic inheritance of production centers and markets in Iraq, Iran, Syria, and Egypt, and, p. 164, the development of an extremely profitable, well-organized textile industry, like the Byzantine industry, well regulated and taxed, with markets reaching all the way to Scandinavia, p. 165.

74 Allgrove-McDowell 2003, p. 157, on Arab adoption of Sasanian textile factories. Wild 2003, p. 151:
Many of the most famous individual Byzantine silks belong to the centuries after Arab expansion when the barely controlled movement of textiles across political frontiers led to a brisk, and to observers, confusing, exchange of technical ideas and iconographic themes between the imperial workshops of Constantinople and workshops in central Asia and the rest of the Islamic world. In the eighth century, for instance, certainly by

A.D. 746, it became a widespread practice to weave with a paired main warp, a valuable dating criterion. Of course, this criterion is noticeable only by technical specialists on close inspection that is rarely possible.

Conceptualization of this increasing resemblance and other cultural linkages might be considered through an archaeological model described by Dark 2007, pp. 9–10: "In [Colin] Renfrew's 'Peer-Polity Interaction 'theory' interacting polities come to resemble each other more closely over time through the process of interaction itself. This is very similar to the neo-classical economic theory of 'convergence,' in which competitors become increasingly alike through competitive emulation." Dark suggests as well the possible applicability of International Relations (IR) theorizing of current global politics, especially theories of globalization: extensive discussion (pp. 12–14) is interesting in this light for recasting some of the usual suspects for initiating the descent of Byzantine culture into a dark age as "supra-territorial security threats" (p. 14).

75 A fine overview is presented in Golombek 1988. See also Marzuq 1955, pp. 54–79; Serjeant 1972; and Muthesius 1993, p. 67.

76 *Book of the Eparch* V.2 (Freshfield 1938, p. 19). This broad view of Syria has ancient roots: see Dalby 2000, pp. 168–72. The complexities of the actual circulation patterns and the commodification of "Saracen" silks find some explanation in Appadurai 1986, p. 48: "Culturally constituted stories and ideologies about commodity flows are commonplace in all societies." This usage also intersects with venerable traditions of luxuries coming from the East: Parker 2002; Mayerson 1993, p. 173, notes a mention of "Saracen Indians"!

77 Burns 2006.

78 Ibid.

79 Ibid., pp. 376–90.

80 Ibid., pp. 391–95. These badges date to the thirteenth and fourteenth centuries, whereas the cloth has been variously attributed in modern times to the eighth-to-ninth-century Islamicate world and to tenth-to-eleventh-century Byzantium.

81 McCormick 2001, e.g., pp. 720–22; Brubaker and Haldon 2001, pp. 80–108.

82 Maguire 1995, p. 56; and Maguire 1987, p. 83:
By the end of the seventh century depictions of birds, beasts, and plants in churches had begun to fall into disfavor. In part this was because churches that appeared to display such symbols instead of portrait images of Christ and his saints could be associated with miaphysite views [of Christian Churches in Syria and Egypt, as opposed to the Greek orthodox Church of the Empire], and eventually with iconoclasm. . . . In the early ninth century the orthodox Patriarch Nikephoros, speaking of the animals depicted in the sanctuaries of churches, especially those woven into textiles, saw no religious value in them but argued that their purpose was purely ornamental: "The forms of the other animals were not originally produced so as to be raised up to the altar and to be worshipped, but for decoration and for the seemly adornment of the cloths on which they had been worked."

83 Notably, Muthesius 1997 and Martiniani-Reber 1986.

84 On archaeological textiles from Egypt, Rutschowscaya 1990; on "reading" objects, T. Thomas 2002b.

85 On approaches to the dating of textiles, see De Moor and Fluck 2007 and De Moor 2007. Prof. Sabine Schrenk has established a web page for collecting and providing access to information on the radiocarbon dating of ancient textiles, see http://www.textile-dates.info/the_project_start.php and Bénazeth 2006. On this phenomenon in other arts, especially for issues of transformation and value, see Cutler

2009, chap. 13; and Golombek 1988, p. 29. The reuse of precious stuffs is also attested in the Cairo Genizah documents, where "'old' garments are considered the 'best.' This appreciation of textile antiques was applied to furnishings . . . as well as garments."

86 Muthesius 1997, pp. 34–43.

87 Brubaker and Haldon 2001, p. 86. Longman 1930, p. 122, typically attributes this "Hellenistic" style ("impressionistic drapery," "light and shade," "feeling of life") to Alexandria rather than the stylistic tradition of Coptic Egypt, chracterized by declining Hellenistic standards, certainly a view subject to revision since the redating of the wooden lintel fom Al-Muallaqah from the fifth to the eighth century: McCoull 1986. Considerations of "high" style as Hellenistic or classicizing, or as reflections of essential ethnic traits, have largely been replaced by contextual concerns; see C. Mango et al. 1991.

88 The Annuciation silk, however, cannot be securely attributed to Constantinople (642). As no silks have been found within the capital, and only a very few small scraps have been found in archaeological contexts within the shrunken territory of the empire after the seventh century, it is impossible to chart the full range of styles presented by silks produced within the empire. Linscheid 2001 and 2004; Ball 2005, e.g., p. 6.

89 Rutschowscaya 1990 surveys the full range of textile finds; Thomas 2007 addresses scholarship. See cat. no. 83. Goitein 1967 is dense with information on Egyptian medieval (mainly tenth to thirteenth century) production, transport, and trade of silk, as well as other luxury and bulk goods.

90 As in Schrenk 2004 and Thomas forthcoming. On the close relationship between compound woven silks and tapestry emulations: Kitzinger 1946; Thompson 1986 considers these designs in silk and wool cloths from the seventh through the tenth century.

91 In tabular form in Muthesius 1993, p. 14, fig. 2. The silks attributed to Egypt form two groups of "Twill, single main warp," the "so-called Alexandrian Group," dated 700–850, and "Antinoe, Achmim and others" dated 500–900.

92 Only a fraction of the textiles associated with these sites is securely documented as having been excavated there. For brief overviews with bibliographies, see Schrenk 2006, Fluck 2008, and De Moor et al. 2006a. For both sites: Muthesius 1997, p. 81, on the Akhmim group, and pp. 81–82 on the Antinoë group; Martiniani-Reber 1986, 2004.

93 These were not necessarily the burials of the wealthiest members of society; perhaps some or all belonged to those who derived their incomes from "the miserable gains of commerce," as well as those belonging to the new elite of service in governmental administration and the military: Haldon 2006, p. 631; also appropriate for Islamic society under the Umayyads and Abbasids: Wickham 2004.

94 See also MMA 1987.440.1.

95 De Moor et al. 2006a, *passim*. Explicitly identified as the ancient Near Eastern Tree of Life in Lechler 1937. On plant motifs, see Sheppard 1981.

96 Kosmas Indikopleustes described and illustrated some of these plants, of which date palm, pepper and banana, and coconut trees (fols. 146r, 202v, and 203r, respectively) present motifs similar to those used in the silks (see also the archer in fol. 202r). On the trade in these items, see McCabe 2009 and McCormick 2001, p. 710. See also Detienne 1994. Visually combining objects of exotic, distant origin with the aesthetics of skilled crafting is discussed in Helms 1993, p. 198. Their representation may, when combined with animals, refer to the wonders of Creation (Maguire 1987, p. 75, on the Ge [Earth] Silk, from the coffin of Saint Cuthbert at Durham), or to gardens. Golombek 1988, p. 31:

According to Rustah, the tent of the Prophet was made of a woolen textile decorated with fabulous beasts, eagles, confronted lions, human figures, and Christian crosses. The tent commissioned by the Fatimid vizier, al-Yazuri, portrayed all the animals in the world. Another tent, made for the Hamdanid prince Sayf al-Dawlah and celebrated in an ode by Mytannabi in 947, had all this and more. It was erected to receive Sayf al-Dawlah after his capture of the Byzantine forces of Barquyah. Inside was a scene depicting the Byzantine emperor paying homage to Sayf al-Dawlah, surrounded by a pearl-lined border containing images of wild animals and tame beasts and vegetation. The poet refers to the border as a garden which is animated by the fluttering of the tent walls.

97 For this motif in ninth-century Constantinople, see Sheppard 1965. Flood 2001, pp. 57–77, discusses the *Karma*, the mosque's "great golden jeweled vine" (p. 57), and its Late Antique associations. These are relevant to present concerns with sumptuous paradisical motifs, cross-cultural translation of ornament and technology, and prestigious distinction in artistic production. Peirce and Tyler 1941 use the phrase "metropolitan style" to refer to a shared repertory of courtly arts of urban centers across Eurasia. Guest and Kendrick 1932 discuss a related, slightly later Elephant silk with an Arabic inscription: "Blessed from God and prosperity," naming its owner, Abu Nasr, and its production in Baghdad. Although the basis for early art historical studies of Byzantine silk, style is treated in passing in recent studies, mainly as a feature useful for identifying groups of textiles: Thomas 2007, pp. 145–48.

98 A recent article, Wixom 2003, helps us visualize such fountains and explores their associations with the paradisical "fountain of life."

99 De Moor et al. 2006a and note 72 above.

100 Although focusing on the preservation or degradation of stylistic and iconographic traditions as defined ethnically, Grube 1962, p. 78, noted close similarities between the Amazon compositions of the Panopolitan silks and the third-century Amazon shield from Dura Europos. Peirce and Tyler 1941, p. 29, describe the style as "Byzantine pseudo-antique." Ancient subjects could be seen as claims to the past: Canepa 2009, p. 51: "The distant past became an arena for the rhetorical battle that played out in diplomatic communication." It is also possible that "abstract" styles have been misconstrued. For example, just as the candelabra tree represents no actual plant, the elephant in the Elephant silk (fig. 58) seems to represent no actual elephant (in stiff stance and in the articulation of anatomical features by regularized and abstracted, nearly geometric shapes, the prettified face with cosmetically enhanced eyes, and sharply pointed toenails).

101 "Surfacescapes," a term coined by Jonathan Hay (2010, p. 8) for addressing an aesthetic dimension often neglected in Chinese art studies, is also useful for the study of Byzantine luxury arts, including silk. Hay describes an understanding of decorative objects "located in a space between the human body and the building where decoration, otherwise subordinated to human gesture or to architectural structure, constituted its own ephemeral environment by placing objects on display, even as they were used." Of course, some of these silks might, as clothing, relate more closely to the body. See note 95 above.

102 Maguire 1999, p. 243; Trilling 1995.

103 Specific color schemes may have had meaningful associations as well: L. James 2003.

104 E.g., Maguire 1995, pp. 64, 69.

105 Maguire 1999, passim.

106 Noted generations ago by Beckwith 1960. On the full range of associations in a related, later tradition, see Shalem 2004.

107 MacCoull 1988, p. 64: "your famous forebear Basil came from God, [bringing] the ornaments of excellence. . . . Never, never was there anyone like you in noble birth, quick with every kind of beautiful wisdom." Fulghum 2001–2, p. 27, cites a poem identifying motifs on the exterior of a tent with the owner within, such that the cloth symbolizes the owner. See above, headnote and note 95.

108 Scarborough and Kazhdan 1991; Hoffman 2000. More broadly, Dauterman Maguire and Maguire 2007, pp. 58–96.

109 Dale 1993. For the roots of this tradition: Leader-Newby 2004 and Swift 2009. Perhaps the many Joseph tapestries and silks should be understood as associating the wearer with Joseph, a revered prophet in the Jewish, Christian, and Islamic traditions, and an admired princely figure in popular tales, along with Zachariah, to a lesser extent. See, for example, al-Kisa'i 1997 and Klar 2009. Their popularity as Christian saints and their portrayal on these silks is noted in Grube 1962, p. 76.

110 Heraclius was heroized, in part, for his defeat of the Persians. The unity of themes proclaimed by his "publicist," George of Pisidia, fits into this typological figuring: Whitby 2002, pp. 156–57:

> The unity is further sustained by the creation of a consistent yet evolving typology for the emperor, by which he is repeatedly assimilated to a range of mythical and biblical heroes—Heracles above all, but also Perseus, Orpheus, Moses, Elijah, and Christ himself—and likened to commonplace types, the wise helmsman, the caring doctor. In addition, particular fields of imagery are regularly invoked: water, rivers, the ocean; light, fire, the heavenly bodies; the natural and animal worlds.

Conrad 2002 explores positive portrayals of Heraclius in Islamic "messenger stories." The legend of Bahram Gur developed from an oral tradition; his exploits are recounted during this period by al-Tabari (838–923): Meisami and Starkey 1998, vol. 1, p. 128. For a representation of Bahram Gur on silk, see the silk from the reliquary of Saint Calais, from the Church of Saint Calais, which represents the legendary scene when he killed an onager and the lion attacking it with a single arrow, dated to the ninth century and attributed to Constantinople: J. Durand 1992, p. 195, cat. no. 130. Stories of the Alexander Romance were widely circulated at this time: Gero 1993, and as in note 5 above; a tapestry roundel of the seventh to ninth century, with an inscription identifying the equestrian figure shown twice in its symmetrical composition, depicts Alexander as a hunter, victorious, being crowned by erotes (The Textile Museum, Washington, D.C., 11.18). On medieval Middle Eastern Amazons, see Kruk 1993.

111 Jeffreys 1998, pp. xxx–xli, for historical setting.

112 E.g., Grottaferrata Book 4, 895–930 (Jeffreys 1998, pp. 118–21). L. James 1996, pp. 85–90, offers an extended discussion of color aesthetics in the clothing of Digenes Akritas; see also sections on color and morality, p. 90; color and meaning, pp. 102–9.

113 Grottaferrata Book 7 (Jeffreys 1998, pp. 202–15); themes of paradise and luxury are more prominent in the Escorial version, lines 1615–69 (Jeffreys 1998, pp. 356–61).

114 Grottaferrata Book 8 (Jeffreys 1998, pp. 216–35).

Arab-Byzantine Coins: Money as Cultural Continuity

Clive Foss

1 For an overview of this coinage, see Foss 2008; Album and Goodwin 2002.

2 The papyri reveal especially valuable information for understanding administration and finance; see Sijpesteijn 2007 and Foss 2009.

3 An important Syrian hoard of bronze coins reveals this phenomenon: Phillips and Goodwin 1997.

4 See Pottier et al. 2008.

5 The text is translated in Palmer 1993, pp. 31ff.

6 Theophanes 1997, discussed by Bates 1986, pp. 247ff.

7 As suggested by Jamil 1999.

8 First proposed by Foss 2001, p. 9; Hoyland 2007 would go a step further and identify all the standing caliph figures as the Prophet.

9 See the references in Foss 2008, p. 104.

Weights and Measures from Byzantium and Islam

Stefan Heidemann

1 Brands 2004; Kennedy 1985a.

2 Sams 1982; Garbsch 1988a; Garbsch 1988b, pp. 192–94; Visy 1994.

Silks

Thelma K. Thomas

1 Shepherd 1971, p. 246.

Dress Styles from Syria to Libya

Cäcilia Fluck

1 For a discussion of specific materials and techniques, see Colburn, p. 161.

2 Such a tunic is clearly visible on a female figure on the so-called Dionysos Hanging in the Abegg Foundation; see Schrenk 2004, pp. 26–27, no. 1 (second figure from the left).

3 See Vogelsang-Eastwood 2004. A considerable number of such Persian-style garments have been found in the tombs of the town of Antinoë in Middle Egypt; see various authors in Fluck and Vogelsang-Eastwood 2004. The garments were not necessarily worn together.

4 For an example of tight leggings, see, for instance, the second figure from the right on the fragment of a hanging in the Abegg Foundation; see Schrenk 2004, p. 71, no. 16 (with striped leggings). For the bulkier verions of this garment, see the statues of princes at Khirbat al-Mafjar and Qasr al-Hayr West, both of the eighth century; see Ettinghausen et al. 2001, p. 43, fig. 49, and p. 44, fig. 51.

5 T. Thomas 2007, esp. pp. 148–49.

6 For the styles of earlier centuries, see, for instance, Stauffer 2000, esp. pp. 32–40.

7 See, for instance, Kajitani 1981, p. 66.

8 The Berlin silk has been missing since World War II. For an image of two mirrored riders barefoot and dressed in Roman tunics, see von Falke 1913, pp. 85–86, pls. 27, 28, fig. 107. For the silk in the Museo Sacro, see Volbach 1966, pp. 126–27, no. 59. For the adoption of this particular shade of red by commoners, see, for instance, De Jonghe et al. 1999, p. 121.

9 Vibert-Guigue and Bishah 2007, pp. 4, 7–8, 12, 15–16.

10 Ettinghausen et al. 2001, esp. pp. 43–49, figs. 49, 50–54, 64. For Qusayr 'Amra, see also Vibert-Guigue and Bishah 2007, esp. pls. 142b (depiction of the royals) and 149 (various textile patterns used in the paintings).

11 Ettinghausen et al. 2001, p. 45; see also Baer 1999b, pp. 32–35.

12 For an excellent overview of Early Islamic costume (the Umayyad and Abbasid periods), see Stillman 1986, pp. 732–38. A few workmen in simple shirts are depicted in wall paintings at Qusayr 'Amra; see Sourdel-Thomine and Spuler 1990, pp. 160–61, fig. 34.

13 See Fluck and Helmecke 2012.

Materials and Techniques of Late Antique and Early Islamic Textiles Found in Egypt

Kathrin Colburn

1 Carroll 1988, pp. 34–44.

2 Stauffer 2008, pp. 9–66.

3 In Egypt linen and wool were commonly spun with a leftward twist (Z direction). Wool also appears with a rightward twist (S direction), but it is unusual. For an explanation of twist, see Burnham 1980, p. 161.

4 Ibid., p. 139, for plain weave, and pp. 144–49 for tapestry weave.

5 For a discussion of red and purple dyes in Roman and Coptic Egypt, see Wouters 2009, pp. 182–85.

6 Dye analysis of the colored yarns was undertaken using high-performance liquid chromatography (HPLC) with a photodiode (PDA) detector in 2011 by Nobuko Shibayama, Associate Research Scientist, Department of Scientific Research, The Metropolitan Museum of Art, New York. Shibayama identified the following dyes: weld, a madder-type dye, an indigo-tin-containing dye such as woad or indigo, and a tannin dye.

7 Wouters 1995, p. 42.

8 De Moor et al. 2010, p. 44.

9 Dye analysis of colored yarns was performed using X-ray fluorescence spectroscopy (XRF) and high-performance liquid chromatography (HPLC) with a photodiode (PDA) detector in 2011 by Nobuko Shibayama. Shibayama identified a madder-type dye and an indigotin-containing dye such as woad or indigo.

10 Stauffer 1995, p. 31 (MMA 90.5.873), p. 33 (MMA 90.5.817, 90.5.687), p. 37 (MMA 63.178.2).

11 With textiles found in Egypt, the warp was commonly two yarns with an S-twist plied into a Z direction.

12 Burnham 1980, pp. 14–18.

13 Ibid., p. 29, for weft-faced compound weave (samit), and p. 201 for taqueté. See Thomas, p. 148.

14 Assistance in the radiocarbon age determinations was provided by Nobuko Shibayama and Tony Frantz, Research Scientists, Department of Scientific Research, The Metropolitan Museum of Art. The tests were performed by Beta Analytic, Inc. in 2011.

15 Dye analysis of the colored warp and weft yarn was performed using high-performance liquid chromatography (HPLC) with a photodiode (PDA) detector in 2011 by Nobuko Shibayama, Associate Research Scientist, Department of Scientific Research, The Metropolitan Museum of Art. Shibayama identified a madder-type dye.

16 See n. 14.

17 See Fluck, p. 183.

Animal Motifs

Mina Moraitou

1 For a discussion of animal forms, see Dauterman Maguire and Maguire 2007, pp. 58–96.

2 For representative examples of animal motifs on Coptic textiles, see Lorquin 1992.

3 See Behrens-Abouseif 1997.
4 See Baer 1983, pp. 155–56, and Fehervári 1976, nos. 6, 34, 38, 39, 47–49.

Vine Rinceaux

Gabriele Mietke

1 Persia: Ettinghausen 2007, pp. 47–59; Arabian Peninsula: Finster 1996, pp. 305–6, p. 307, fig. 21, p. 316, fig. 32, p. 318; Indian subcontinent: Rowland 1956.
2 Toynbee and Ward-Perkins 1950; Shalem 2004, p. 98, n. 60 (bibl.).
3 Vine and vine scrolls are ubiquitous in Late Antique art. Numerous examples can be found in Dunbabin 1978; Alföldi-Rosenbaum and Ward-Perkins 1980; Donceel-Voûte 1988; Fıratlı 1990; Enss 2005.
4 Harrison 1986, pp. 4–5 (chronology), p. 118, fig. A, p. 120, fig. B, p. 127, fig. F, photographs 87–91, 93–100, 131, 151, 154, 155, 157. See also two column drums in Istanbul: Fıratlı 1990, pp. 102–3, no. 190, pl. 61, and the ambo from the Church of Saint George in Thessaloniki of Constantinopolitan origin: Fıratlı 1990, pp. 96–97, pls. 56, 57; Warland 1994. They combine the vine with a Christian subject, referring to its symbolic meaning.
5 Friedländer 1912, pp. 245–46: ll. 652–57, p. 286. The original frieze was replaced by a stucco frieze during the restoration by the Fossati brothers in the mid-nineteenth century, but the vine scroll seems to have been modeled after an original piece still preserved at that time: Hawkins 1964, pp. 131–33, figs. 1–3.
6 Mainstone 1988, pp. 43, 192. A field on the western wall is framed by similar scrolls in opus sectile springing from kantharoi: Kähler 1967, fig. 64.
7 Flood 1997, pp. 57–59.
8 Hillenbrand 1982, pp. 1–3; Enderlein and Meinecke 1992.
9 Enderlein and Meinecke 1992, pp. 157–58.
10 Deichmann 1956, pp. 63–84.
11 Talgam 2004, vol. 1, pp. 47–119.
12 Enderlein and Meinecke 1992, p. 156; Fowden 2004a, p. 285.
13 Hamilton 1959, p. 104 (for numerous examples, see plates); Hillenbrand 1982, pp. 1–3.
14 Hamilton 1959, pp. 42–43.
15 Talgam 2004, vol. 1, pp. 48–68. For a striking example of two sculptures of enthroned princes from Qasr al-Hayr al-Gharbi, one in a Sasanian, the other in a Roman-Byzantine style, see Fowden 2004b, p. 121, fig. 39, and p. 122, fig. 40.
16 Qusayr 'Amra: Vibert-Guigue and Bishah 2007; Qasr al-Hayr al-Gharbi: Schlumberger 1986.
17 Hillenbrand 1982.
18 Fowden 2004a, pp. 283–85.

Inscribed Textiles

Cäcilia Fluck

1 Inscribed fabrics from other regions are less numerous; see, for instance, von Falkenhausen 2000.
2 Vogelsang-Eastwood 1995, pp. 40–41.
3 Fluck and Helmecke 2006, pp. xiii–xiv.
4 Fluck 2006, pp. 152, 161; van der Vliet 2006, pp. 24, 28.
5 Lombard 1978, pp. 219–25; Salim 1995, pp. 22–23; Helmecke 2006, pp. 175–76 (with further references); Fluck and Helmecke forthcoming.
6 Helmecke 2006, p. 175.
7 Figurative and ornamental decoration apparently remained popular at this time. However, we cannot say whether these textiles were used exclusively by Christians.

8 Helmecke 2006, esp. p. 177; Niewöhner-Eberhard 2006, pp. 196, 199.
9 Van der Vliet 2006, pp. 42–57.

Inscribed Objects

Robert Schick

1 Khairy and 'Amr 1986, p. 147, no. 7, fig. 7.
2 'Amr 1989.
3 'Amr 1988, p. 167, fig. 11.
4 Khairy and 'Amr 1986, p. 144, no. 1, fig. 1, and p. 145, no. 2, fig. 2; for a parallel example, see p. 145, no. 3, fig. 3.
5 Ibid., p. 150, no. 12, fig. 10.

Jewelry: Ideologies and Transformation

Stephen R. Zwirn

1 Janes 1998, passim.
2 K. Brown 1979.
3 "There are ornaments in vast numbers, which hang from iron rods: armlets, bracelets, necklaces, rings, tiaras, plaited girdles, belts, emperors' crowns of gold and precious stones, and the insignia of an empress," quoted from J. Wilkinson 1977, Anonymous Pilgrim, sect. 18, p. 83.
4 Juynboll 1986; reference specifically to treasures in Ctesiphon, the Sasanian capital, p. 108.
5 Janes 1998.
6 Jenkins and Keene 1983, p. 15.
7 Wenzel 1993. Early Islamic rings developed from Roman and Sasanian types are distinguished from their precedents by their Arabic inscriptions; recognizable styles and shapes follow. See ibid., Sasanian rings, nos. 5–30 (drawings, pp. 184–87), and early Islamic rings, nos. 31–86 (drawings, pp. 188–96). See also Musche 1988 for all types of Sasanian jewelry, pp. 289–330, pls. 102–17.
8 Jenkins and Keene 1983, cat. no. 5. See the stucco figure from Khirbat al-Mafjar, eighth century: Ettinghausen et al. 2001, fig 57.
9 For the addorsed birds, see Atıl 1990, p. 79, cat. no. 16.
10 Baldini Lippolis 1999, pp. 96–97, drop earrings (seventh century).
11 Mizzi 1965–82, vol. 4, pp. 415–16, with source identified with 'Ubayd Allah ibn 'Umar (d. 147/764) (according to Juynboll 1986, p. 111, n. 25), a notable jurist in Medina.
12 Juynboll 1986, p. 111, n. 25, based on a mid-eighth-century tradition.
13 Almagro et al. 1975, pls. 5; 9a, b; 19; 27a, c, where the patron is identified as al-Walid I (r. 705–15); Fowden 2004b identifies Walid II (r. 743–44) as the patron, in the decade before his accession.
14 The breast chain, made up of four interconnected chains, was worn over the shoulders and around the torso by women. Known in numerous representations, few examples exist; see K. Brown 1984; C. Johns 2010, pp. 23–27.
15 Jenkins and Keene 1983, p. 15.
16 Ross 2005, no. 6E.
17 Qur'an, Sura 2:137; Jenkins and Keene 1983, p. 24, cat. no. 6.
18 El-Cheikh 2004, pp. 21–81.

Women

Mina Moraitou

1 Piccirillo 1992, pp. 38–39.
2 Ibid., pp. 51–57; Bowersock 2006, pp. 81–86.

3 Fowden 2004b, pp. 87–88.
4 See Piccirillo 1992, fig. 78; Schlumberger 1986, pl. 35.
5 See Piccirillo 1992, p. 38, and compare, for example, with two textiles from Egypt depicting the river Nile as a man and the Earth as a woman, in Alaoui 2000, cat. nos. 1, 2.
6 Schlumberger 1986, pls. 34, 37.
7 Such as Mshatta, Khirbat al-Mafjar, and Qasr al-Hayr al-Gharbi; see Baer 1999a.

ISLAM

Country Estates, Material Culture, and the Celebration of Princely Life: Islamic Art and the Secular Domain

Anna Ballian

1 Cutler 1995, p. 317; A. Walker and Luyster 2009, pp. 1–8. For Byzantine secular art, see Dauterman Maguire and Maguire 2007.
2 I would like to acknowledge the contribution of Oleg Grabar in this field of studies. His seminal work The Formation of Islamic Art (1973) has profoundly influenced many generations of Islamic art historians.
3 J. Johns 2003, pp. 411–18; I have borrowed Hillenbrand's (1982) application of the phrase "dolce vita"; Hamilton 1988, pp. 20–22, 32–37, 46–48, 103–8.
4 The latter accusation may not be far from the truth. See Tabari 1989, p. 194.
5 El-Cheikh 2004, pp. 154–55.
6 Herzfeld 1910; Leisten 2005.
7 It is interesting that the term "Late Antiquity" was used for the first time by Alois Riegl, who undertook a pioneering analysis of acanthus and foliate decoration, starting with ancient Egyptian and Greek examples and moving on, via Rome and Byzantium, to the arabesque. See Elsner 2002.
8 Lammens 1930.
9 Sauvaget 1967.
10 O. Grabar 1973, p. 145.
11 Hillenbrand 1981, pp. 63–64, 75, 81; Hillenbrand 1999a, pp. 29–34.
12 O. Grabar 1992a, pp. 191–92; Kitzinger 1976, pp. 166–67, 189–94.
13 In the eastern Roman Empire and the lands bordering it, Late Antiquity is considered by most scholars to have lasted from the fourth through the eighth century. We owe the concept of Late Antiquity to Peter Brown, and a comprehensive assessment can be found in Bowersock et al. 1999. The study that best combines the approach of a classicist with that of an Islamic scholar is Fowden 2004b. For an excellent overview of scholarship on the subject of Late Antiquity and the Umayyads, see Tohme 2005.
14 Rabbat 2003, pp. 80–81.
15 Demange 2010, pp. 310–363.
16 Gero 1992.
17 Bilad al-Sham encompassed modern-day Syria, Jordan, Palestine, and part of Lebanon.
18 Bacharach 1996; Milwright 2009, pp. 34–41.
19 For the importance of the Syrian desert, see P. Brown 1971, pp. 82–83; Kennedy 1985b, pp. 163–64.
20 King 1992; MacAdam 1994.
21 Schlumberger 1986; O. Grabar et al. 1978.
22 King 1987; Genequand 2004b; Milwright 2009, pp. 36–37.
23 Genequand 2006b, pp. 4–5.
24 According to Genequand 2006b, pp. 12–13, of all the known Umayyad castles, only Qasr al-Hallabat, in Jordan, and Qasr al-Bakhra, near Palmyra, are rebuilt Roman forts.

25 A different perspective is given by historical and philological studies of the Arab Christian tribes in Bilad al-Sham before the Muslim conquest, which cast doubts on a number of long-standing assumptions, such as their nomadic way of life. The fundamental works are Shahîd 1995; Shahîd 2002. See also Walmsley 2007, pp. 139–41; Genequand 2006a.

26 The custom of assembling the Arab tribes predates the Umayyad period. The Ghassanids convened such meetings in a village called al-Jabiya in the Golan Heights, where roughly a hundred years later Marwan I (r. 684–85) was recognized as the fourth Umayyad caliph by the assembled Arabs of the Kalb tribe; see Bacharach 1996, p. 29.

27 Genequand 2009.

28 Shahîd 1992; Tohme 2009.

29 Schlumberger 1986; Genequand 2006a. In addition to the examples noted in this introduction there are also Qasr al-Hallabat and Qasr al-Burqu'; see Key Fowden 2004, pp. 183–86. The latter, located in the isolated desert region of Hawran but close to routes used by nomads, is the oldest qasr associated with the caliph (then prince) Walid I. It is dated A.H. 81 (710 C.E.). See King 1992, p. 372; Bacharach 1996, pp. 31–32.

30 Kennedy 1985b, p. 164; Key Fowden 2004, pp. 163–67, 177; Schlumberger (1986, pp. 1–2) maintains that Qasr al-Hayr al-Gharbi was built over an earlier Roman settlement, but this is not accepted by Genequand (2006a, pp. 66–69), who also attributes the Qasr al-Hayr dam to the Umayyad period. On Umayyads and monasteries, see Hamilton 1988, pp. 86–99.

31 The German Archaeological Institute carries out excavations in the Rusafa area. Ulbert 1986; Sack 1996.

32 Caliph Hisham's links with Rusafa were remembered there until the thirteenth century, when the monastery, also called Rusafat Hisham, was described by Yakut al-Rumi as one of the wonders of the world for its beauty and its architecture. See Key Fowden 2004b, p. 186.

33 Pentz 1992; Kennedy 1985a; Walmsley 2007, pp. 34–47.

34 Foote 2000, p. 31.

35 Walmsley 2007, pp. 48–70.

36 Schick 1998, pp. 90–94; Sodini and Villeneuve 1992; Orssaud 1992.

37 Northedge and Kennet 1994.

38 The gift is mentioned by the eleventh-century Khurasani historian Al-Bayhaqi; cited in Lane 1958, pp. 10–11.

39 Von Saldern 1998; Carboni and Whitehouse 2001, pp. 110–11, cat. nos. 27, 28; Walmsley 2007, pp. 64–65.

40 For the incense burners, see Allan 1982, pp. 41–42, nos. 93–99, pp. 78–81; Melikian-Chirvani 1982, p. 32, fig. 7; for the bucket, see Pitarakis 2005, p. 25.

41 Ettinghausen 1972; Demange 2006, pp. 73–74; Harper 2006, pp. 78, 88–91.

42 Shboul and Walmsley 1998, pp. 280–81, fig. 4. Dionysiac subjects seem also to have been part of the Umayyad literary tradition; see Fowden 2004b, pp. 259–65. On "the good life" and Pan, a minor pagan deity, depicted sometimes on the mosaic floors of churches, see Maguire 1999, p. 249. For the Dionysiac mosaics found at Madaba, Jordan, see Piccirillo 1992, pp. 76–77.

43 For the earliest and latest opinions on so-called Coptic art, see Bagnall 2007, pp. 1–8. On textiles, see T. Thomas 2007; for metalwork, see Drandaki 2011.

44 Barnet and Dandridge 2006, pp. 10–17.

45 A number of the ewers from the unpublished Tiberias treasure have similar feet, as does an example, also unpublished, in the Benaki Museum, Athens (13140). Depictions of ewers on Fatimid ceramics and the ceiling of the Capella Palatina, Palermo, all stand

on a high conical foot; see Grube and Johns 2005, pl. XXXVII, fig. 29.6. Punched decoration and punched inscriptions are common on sixth- and seventh-century metalwork. For buckets, see Drandaki 2002, p. 43. For a group of ewers, see Drandaki 2011.

46 Hillenbrand 1999a, p. 37.

47 Fowden 2004b, pp. 57–64.

48 Canepa 2009, pp. 188–223.

49 Hoffman 2008, pp. 107–9.

50 Ettinghausen 1977, pp. 34–36; Piccirillo 1992, pp. 38, 174, fig. 226; Demange 2006, pp. 130–31, cat. no. 73.

51 Hamilton 1988, pp. 22–23, 172–75, frontispiece, figs. 5, 30; Harper 1979b.

52 Fowden 2004b, pp. 114–41; Demange 2006, pp. 51–52, 56, cat. no. 9 (Jens Kröger). A frieze of partridges decorates the base of the dome in a small chamber at Khirbat al-Mafjar; see Hamilton 1988, pp. 38–39. For birds on columns, see also the mosaic floor from the upper church of the Priest John in Mount Nebo; Piccirillo 1992, p. 175, fig. 228.

53 The subject of the mosaic is usually identified as an allegory of Umayyad power: the peace the caliphs maintain in their empire is shown on one side of the tree and their wrath against their enemies is seen on the other. But since the mosaic comes from a small room, probably a private space next to the bathhouse, other interpretations are possible. In Arabic poetry, a gazelle is compared to the (female) beloved, and the lion is a symbol of male strength or courage. See Ettinghausen 1977, pp. 38–39; Behrens-Abouseif 1997.

54 Four names are legible: those of Caesar, the Byzantine emperor; Roderick, king of the Visigoths (who was defeated by Muslim forces in 711 or 712, a date that gives us a terminus post quem for the wall painting); Kisra, or Khusrau, a Sasanian king, recognizable by his winged crown; and the Negus, ruler of Ethiopia. The other two cannot be firmly identified, as the inscriptions are damaged, but the images are thought to represent the emperor of China and the Khaqan, ruler of the Turks.

55 O. Grabar 1973, pp. 46–48; Fowden 2004b, pp. 197–226.

56 Tabari 1989, p. 243. Yazid III was indeed the son of a captive Sasanian princess.

57 Hoffman 2008.

Qasr al-Mshatta

Anna Ballian

1 Creswell 1932–40, vol. 1, pp. 350–89; Creswell 1989, pp. 201–14.

2 Enderlein and Meinecke 1992, pp. 146–47; Leisten 2005.

3 Hillenbrand 1981, p. 71, pl. 10.

4 Another well-known use of the triconch in sixth-century Syria is in the Constantinopolitan-designed palace of Qasr ibn Wardan.

5 O. Grabar 1987a; Walmsley 2007, pp. 100–104.

6 Tabari 1989, pp. 103–4.

7 Enderlein and Meinecke 1992, p. 145, n. 38. The sons of Sulaym supported Walid when he was being pursued and fled to the place where he was ultimately murdered; see Tabari 1989, p. 156.

Al-Fudayn

Anna Ballian

1 MacAdam 1994, pp. 75–76.

2 Humbert 1986, pp. 354–58; Voie royale 1986, p. 267; Augé et al. 1997, pp. 161–62; Umayyads 2000, pp. 133–35.

3 The name comes from the so-called Letter of the Archimandrites, a Syriac list of Miaphysite clerics from the reign of Justin II (r. 565–78). Key Fowden 2004, pp. 184–85.

4 Fowden 2004b, pp. 153–56.

Al-Qastal

Anna Ballian

1 Carlier and Morin 1984; Voie royale 1986, pp. 263–65; Umayyads 2000, pp. 112–14.

2 Addison 2000.

3 Bishah 2000.

4 Bacharach 1996, pp. 36–37. It is likely that the original structure was from the time of 'Abd al-Malik ibn Marwan (r. 685–705), who, when he distributed agricultural land to his descendants, gave the region of al-Balqa to Yazid.

5 Bishah 2000, pp. 436–37; Fowden 2004b, pp. 152–53. For al-Azdi, see Robinson 2006.

An Abbasid Residence at al-Humayma

Rebecca M. Foote

1 For examples, see Oleson et al. 1995, 1999. The Humayma Hydraulic Survey and Excavation Project was directed by Professor J. P. Oleson of the Greek and Roman Studies Department, University of Victoria, from its inception in 1986 until 2007, and has since been directed by Dr. M. B. Reeves of the Classics Department of Queens University, Kingston, Ontario. Codirectors and assistant directors have included K. 'Amr, R. Shick, E. de Bruijn, A. Sherwood, and the author. The institutions and foundations that financially supported our work include the Social Sciences and Humanities Research Council of Canada, the Fondation Max van Berchem, the Taggart Family Foundation, Dumbarton Oaks, the American Schools of Oriental Research, and the Department of Antiquities of Jordan. The American Center of Oriental Research provided logistical support over the many campaigns of excavation.

Ornamental Motifs in Early Islamic Art

Mina Moraitou

1 Hillenbrand 1999b.

2 See Bishah 1993.

3 http://www.princeton.edu/~syria/AreaC.htm.

4 See O. Grabar 1992b, pp. 155–93.

5 For Qasr al-Hayr al-Gharbi, see, for example, Schlumberger 1986, pls. 73, 75.

6 For this collection of early Qur'ans, see Moritz 1905, nos. 2, 5, 11.

7 See Haase 2007b.

8 Ettinghausen et al. 2001, pp. 57–58, and bibliographical references.

9 See ibid., pp. 104–7, and Hillenbrand 1999a, p. 45.

10 For a representative example, see the mosque of Ibn Tulun in Cairo. Creswell 1989, pp. 391–406.

Fustat

Iman R. Abdulfattah

1 Amsar were intended to permanently house the Muslim soldiers and segregate them from the local indigenous population.

2 The origin of the name Fustat is still subject to debate. It may come from the Arabic word for tent, in reference to 'Amr ibn al-'As's first camp. The second, more accepted hypothesis is that the name is the Arabization of the Latin *fossatum* (ditch). See Kubiak 1987, p. 11; Jomier 1965, p. 957. Historically, the settlement of Fustat is referred to as Misr al-Fustat or Fustat-Misr, meaning "the city of tents." See Jomier 1965, pp. 957–58.

3 Jomier 1965, p. 959.

4 The most significant excavations are those led by Ali Bahgat for the Museum of Islamic Art, Cairo (1912–25); George T. Scanlon for the American Research Center in Egypt (1964–81); Waseeda University, Japan (1978–84); and Roland-Pierre Gayraud for the Institut Français d'Archéologie Orientale (1985–present).

5 Kubiak 1987, p. 17.

Secular Inscriptions

Mina Moraitou

1 Godart 2009, p. 144.

2 Milestones were placed on roads to indicate the distance from cities. For a recent publication with a discussion of the formula used for inscriptions in the early years of Islam, see Bacharach 2010, p. 7.

3 For glass objects, see Carboni and Whitehouse 2001, p. 87. For an ivory pyx from Aden datable between 778 and 784, see Shalem 2005; for ivory caskets from tenth-century Umayyad Spain, see Blair 2005.

4 It is worth mentioning that an important group of inscribed ceramics is represented by the opaque white-glazed wares from Iraq, which, in addition to naming the owners or makers, display good wishes and blessings.

Faith, Religion, and the Material Culture of Early Islam

Finbarr B. Flood

1 E. James 2008, pp. 26–27.

2 In *The Decline of the West*, a book published in the aftermath of Germany's defeat in World War I, for example, the German historian Oswald Spengler made the startling suggestion that the Roman emperor Diocletian (r. 284–305) was the first caliph and the Pantheon the first mosque (Spengler 1926–28, vol. 1, p. 72, vol. 2, p. 178).

3 P. Brown 1984; Kennedy 1985b; Fowden 1993, pp. 141–42; Foss 1997; Silberman 2001; Sizgorich 2004, p. 12; Hoyland 2007, pp. 591–92; O. Grabar 2008; Milwright 2009, pp. 30–41.

4 Rubin 1986.

5 For a convenient overview, see al-Ghabban et al. 2010; Finster 2010.

6 For example, Hubal, the idol of the Ka'ba, is said to have been a statue of a man executed in red agate that had been brought from southern Syria or Iraq and supplied with a golden hand to replace a lost original; see Lecker 1993; King 2002b; Hawting 2006. For the general religious background, see Fowden 1999.

7 King 2002a; King 2004.

8 For a summary of these developments, see Kennedy 1986, 2007.

9 Elad 1995, pp. 23–24, 33; Foss 2002; J. Johns 2003, pp. 418–23; Hoyland 2006, pp. 399–403; Heidemann 2010, pp. 156–65.

10 Hoyland 1997a, pp. 82–87; J. Johns 2003, pp. 424–33; Hoyland 2006; Halevi 2007, pp. 14–17; Milwright 2009, pp. 24–29.

11 F. Donner 2002–3, p. 11; F. Donner 2010a. For a critique, see Elad 2002. There are analogies with recent reconceptualizations of the nature of Late Antique Judaism, its relationship to Christianity, and the construction of "hard" confessional boundaries between the two in the centuries before the advent of Islam; see Boyarin 2004.

12 Latz 1958, pp. 85–86.

13 For a convenient description, see Creswell 1969, vol. 1, pt. 1, pp. 65–132; O. Grabar 2006, pp. 76–96.

14 Soucek 1976; Chen 1980; Shani 1999; Flood 2001, pp. 175–76.

15 Busse 1988; Khoury 1993.

16 For a convenient overview, see Necipoğlu 2008, pp. 23–45.

17 Goitein 1950; Elad 1995, p. 53.

18 Elad 1995, pp. 23–24, 33; J. Johns 2003, pp. 418–23.

19 O. Grabar 1959; Rabbat 1989, 1993; Elad 1995, p. 52.

20 Elad 1995, pp. 51, 53–58; Shani 1999, pp. 176–78.

21 Van Ess 1992, pp. 95–103; O. Grabar 2006, pp. 98–106.

22 The epigraphic program is reproduced in C. Kessler 1970; O. Grabar 1996, pp. 50–56; Whelan 1998, pp. 3–8. For an in-depth discussion, see Necipoğlu 2008, pp. 45–57.

23 Griffith 1992, p. 127.

24 Bates 1986; Heidemann 2010.

25 Jamil 1999. See, however, Heidemann 2010, pp. 178–82.

26 For an alternative identification, see Hoyland 2007, pp. 593–96.

27 Muqaddasi 1967, p. 159; Fine 1999, p. 234. A similar sentiment is reflected in a hadith that calls upon Muslims to assert the oneness of God verbally when confronted with the sight of a church or synagogue; see Kister 1989, p. 328.

28 Bashir 1991; Elad 1995, pp. 63, 66–76.

29 Sack 1996; Key Fowden 1999, 2002. Some of the earliest dated Arabic inscriptions come from shrines of the saint: Hoyland 2008, p. 55. An undated early mosque from the site of al-Bakhra', near Palmyra, similarly adjoins a church; see Genequand 2004a, pp. 236–38. The development of Christian liturgical and healing structures in or beside Pharaonic temples in Egypt during the fifth and sixth centuries offers interesting parallels; see Frankfurter 2008, p. 150.

30 The mosaic perhaps entailed a reference to the palm tree described in Qur'an 19:23–26 as sheltering the Virgin when she gave birth to Jesus; see Lavas 2001, pp. 90–93; Avner 2006–7, pp. 549–51; Avner 2011.

31 The identification with God was an anthropomorphism later rejected as heterodox if not heretical; see van Ess 1988; van Ess 1992, p. 98. The imprint on the rock is today identified as the footprint of the Prophet Muhammad, but seems to have acquired this identity consistently only from the end of the eleventh century. The first such identification seems to be that of Ibn al-'Arabi (d. 1148) (1998, vol. 4, p. 217).

32 Hoyland 1997b, p. 549; J. Johns 2003, pp. 426–29; Hoyland 2006, pp. 396–97; Hoyland 2007, p. 594.

33 O. Grabar 2006, pp. 91–95.

34 Hoyland 1997b; Halevi 2007, pp. 14–42; Juvin 2010, pp. 494–95, cat. nos. 284–286.

35 Elad 1992; Elad 1995, p. 21.

36 Flood 1999. A similar obsidian disk associated with the Prophet is preserved today in a small shrine on Jabal Harun, near Petra in Jordan, with visiting pilgrims kissing and touching the stone in order to absorb its *baraka* (blessing); see Fowden 2010, p. 568.

37 Nasir-I Khusrau 2001, p. 43.

38 Aksoy and Milstein 2000.

39 A painting of the Last Days and the footprint of the Prophet existed in the Jerusalem Haram by the fourteenth century but was conceivably executed earlier (Elad 1995, pp. 57–58).

40 *Arabic Papyri* 2008, n.p., inv. no. 513.

41 Flood 2006; Gonnella 2010. The form and location recall those of the scorpion-men of ancient Mesopotamian art and literature, hybrid creatures that guarded the entrances to magical landscapes; see Reiner 1987, pp. 28–29.

42 Flood 2006, pp. 150–51.

43 Kitzinger 1954, pp. 147–48; Vikan 1984; Vikan 1989; Vikan 2010, pp. 23–24, 31–33.

44 Thanks to a passing reference in a satirical text, we know that this practice was established by the tenth century: see Bosworth 1976, vol. 1, pp. 86, 88; vol. 2, p. 199.

45 Walmsley and Damgaard 2005; Walmsley 2007; Cytryn-Silverman 2009.

46 J. Johns 1999, pp. 88–93.

47 Ibid., pp. 109–10.

48 Whelan 1998, p. 13; Guidetti 2010b, pp. 345–46, 349–50; F. Donner 2010b.

49 Meier 1981.

50 Flood 2001, pp. 184–92.

51 Creswell 1969, vol. 1, pt. 1, pp. 142–213.

52 The transformation into mosques of two churches at Umm al-Jimal in northern Jordan during the Umayyad period may have resulted from the conversion of some of the town's inhabitants; see Lenzen 2003, p. 86.

53 In Jerusalem, for example, a palace complex outside the southern wall of the Haram al-Sharif appears to have been connected by a bridge to al-Aqsa Mosque; see Ben-Dov 1971, pp. 43–44.

54 Whelan 1986.

55 Sauvaget 1947, pp. 145–49; O. Grabar 1987b, pp. 118–19; Flood 2001, pp. 181–83, 192–93.

56 Flood 2001, pp. 218–19; George 2009, pp. 97–98.

57 Rabbat 2003; Bowersock 2006, pp. 72–89.

58 A reading supported by the medieval identification of similar scenes in the rebuilt Mosque of the Prophet at Medina as depictions of the palaces and trees of paradise: see Finster 1970–71; Brisch 1988.

59 Duval 2003b, pp. 243–45.

60 Flood 2001, pp. 15–41.

61 The Ethiopians were Miaphysites, and there are indications of a preference for aniconic decoration (including mosaics) in the Miaphysite churches of Syria and the Jazira in both the pre- and Early Islamic periods; see M. Mango 1977; King 1980; King 2004, p. 221.

62 Stauffer 1991, pp. 35–53.

63 Flood 2001, pp. 63–65, 189–90.

64 Déroche 2004a, p. 263; Kister 2008, pp. 330–31; Zadeh 2009, p. 453; George 2010, pp. 52–53, 86.

65 Paret 1981, pp. 213–72; van Reenen 1990.

66 Ibn Rustah 1892, p. 66; Soucek 2003, p. 299.

67 In addition, the presence of an automaton featuring moving snakes and squawking birds at the entrance to the Umayyad mosque in Damascus and the talismanic scorpion-man at the gate of the Great Mosque of Hims suggest a contextual approach marked by greater latitude in the treatment of exterior space; see Flood 2001, pp. 118–31.

68 Fowden 2004a, pp. 285, 289.

69 Examples include the eventual replacement of the cross on Umayyad coinage and the occlusion of images of animate creatures from the otherwise common vocabulary of church and mosque ornament or Bible and Qur'an illumination.

70 The horizontal arrangement of represented columns in Qur'anic manuscripts (cat. no. 189), defying their structural logic as columns in a way entirely appropriate to their function as chapter dividers, is another case in point.

71 O. Grabar 1987b, pp. 89, 130, reiterated in George 2010, p. 83.

72 See Bierman 1998, pp. 17–20, 31–48.

73 Déroche 2002, p. 616; Déroche 2003, pp. 258, 260. See also Déroche 2004a, pp. 263–64, on how com-

petitive rivalries with Christianity may have shaped the development of early Qur'ans.

74 Barber 1997; Fine 2000, p. 194.

75 Hawary 1930.

76 Hawary and Rached 1932; Halevi 2007, pp. 14–42. Particularly fine examples survive from the al-Maʻla cemetery near Mecca: see Juvin 2010, pp. 494–95, cat. nos. 284–286.

77 Rosen-Ayalon 1976, pp. 116–19, pl. 23c.

78 Noth 2004, pp. 115, 118–19, 328.

79 Kister 2008, p. 329.

80 Kister 1989, pp. 331–40; Halevi 2007.

81 Hoyland 1999, p. 153.

82 Ibn Majah 1993–94, vol. 1, pp. 407–8, nos. 739–741; George 2010, pp. 91–93, figs. 60–62.

83 Vööbus 1960, p. 149; Brock 1973, p. 17.

84 Bierman 1998, p. 53.

85 Jahiz 1938–45, vol. 1, pp. 56–57; Flood 2001, p. 244; Hamdouni Alami 2010, pp. 159–88.

86 Katz 2002, pp. 163–64.

87 Vasil'ev 1956; Guidetti 2010a. For a suggested date of 723 for Yazid's edict, see Bowersock 2006, pp. 104–5. For a skeptical review of the evidence for Leo III's actions, see Brubaker and Haldon 2011.

88 O. Grabar 1987b, pp. 43–72. See also King 1985; Griffith 1992.

89 As noted by Kitzinger 1954, p. 134, Bowersock 2006, pp. 92–93; Brubaker and Haldon 2011, pp. 105–17.

90 Flood 2001, pp. 163–83, 228–33.

91 Brooks 1899; Guilland 1959.

92 P. Brown 1973, p. 25; Barnard 1974, p. 144; Hoyland 1997b, p. 525.

93 Vasil'ev 1956, pp. 38–39, 43–44.

94 Hillenbrand 1981; Walmsley 2007, pp. 100–104.

95 Tabari 1879–1901, vol. 2, pp. 1834–35; Tabari 1989, p. 194.

96 Northedge 2007.

97 Creswell 1932–40, vol. 2, pp. 254–76, 278–82; Leisten 2003, pp. 35–69.

98 Herzfeld 1923.

99 Forerunners include extraordinary faux-marble painted dadoes from an Umayyad mansion at Balis and a series of stucco vegetal friezes and alabaster capitals from Raqqa (cat. no. 154), both sites in northern Syria; see Allen 1988, pp. 10–12, figs. 29, 33, 34; Meinecke 1999; Haase 2007b; Leisten 2008. For a balanced discussion of continuity and innovation in Samarran wall paintings, see Hoffman 2008.

100 Creswell 1932–40, vol. 2, pp. 332–54; Bloom 1993, pp. 22–23; Swelim 1994, pp. 177–216.

101 Riegl 1992, pp. 267, 287, nn. 385–88. Among the sources on Islamic art used by Riegl, Achille Prisse d'Avennes's *L'art arabe* of 1877 appears to have been most influential. On Riegl and Late Antiquity, see Liebeschuetz 2004, pp. 254–55. On the arabesque, see Allen 1988, pp. 1–16.

102 Flury 1913.

103 Riegl 2004, p. 329.

Religious Inscriptions in Early Islamic Art

Linda Komaroff

1 Creswell 1932–40, vol. 2, p. 345.

2 Among several studies by this author, see O. Grabar 1996, pp. 56–71. Also see Dodd and Khairallah 1981, vol. 1, pp. 19–26.

3 *Al-Baqara* (2):255. See Blair 1998, p. 198.

4 Perhaps, for example, cat. no. 183.

5 See Blair 1998, p. 199.

6 See Bloom 1987 for a discussion of evidence to be gleaned from mainly tenth-century grave steles in Egypt.

7 Other variations in the texts on tombstones have to do with the manner in which the deceased is

introduced. The formulaic epitaph on the Egyptian tombstone of Ismaʻil ibn ʻAbd al-Salam ibn Sawwar (cat. no. 180), in which the deceased testifies to his own faith, preceded by the bismillah, is typical of the ninth century, as it occurs on a large number of dated grave markers from Egypt; see Blair 1998, pp. 196–98.

The Qur'an

Finbarr B. Flood

1 Whelan 1998, pp. 2–3; Madigan 2001; Motzki 2001; F. Donner 2008; Schoeler 2010.

2 The text was written on materials as diverse as palm leaves, potsherds, scraps of leather, and the shoulder bones of animals; see al-Nawawi 2003, p. 110.

3 Welch 2005; Gilliot 2008. On the development and early history of Arabic script, see Abbott 1939; Blair 2006b, pp. 77–84; Hoyland 2008; George 2010, pp. 21–27.

4 In some Abbasid-era Qur'ans, these variants are indicated by the addition of differently colored dots that enable the consonantal skeleton (*rasm*) to be vocalized in different ways; see Whelan 1990, p. 121; Dutton 1999, 2000; George 2010, pp. 138–39.

5 Kaplony 2008; George 2010, p. 51.

6 Munajjid 1971, pp. 45–52; Rezvan 2004.

7 Whelan 1990. See also Blair 2006b, pp. 108–19, drawing upon an article by the late Estelle Whelan that was never published. For a response, see Déroche 2009, pp. 113–17. Blair's recent endorsement of the recent study by Alain George, which subscribes to Déroche's evolutionary scheme, seems to represent a change in position.

8 Hijazi is based on the identification of distinctive rightward-slanting letters with those described by Ibn al-Nadim (d. 995 or 998); see Robin 2006; Déroche 2009, pp. 109–13; Déroche 2006b, pp. 173–74.

9 Déroche 2009, p. 156.

10 See Schoeler 1992, p. 30; Schoeler 2006, p. 113; Zadeh 2009, p. 458. See also Hilali forthcoming.

11 Déroche 2006a, p. 178; al-Ghabban 2008, pp. 234–35.

12 Zadeh 2009, pp. 457–60.

13 Déroche 2002, p. 641.

14 Déroche 2009, pp. 125–26, 151.

15 Déroche 2006a, p. 178; al-Ghabban 2008, pp. 234–35. Where letters do not join, a word may be broken and continued between successive lines. This *scripta continua* is used in late antique manuscripts and in some seventh-century rock-cut Arabic inscriptions from the Hijaz, among them a foundation text in the name of the caliph Muʻawiya dated 677–78; see Miles 1948; Blair 2006b, p. 86.

16 In one of the earliest extant manuscripts, at least five distinct scribal hands can be recognized, their collaboration perhaps intended to speed production; see Déroche 2002, pp. 616–17, 627; Déroche 2009, pp. 127–30, 172, 177.

17 Whelan 1998, pp. 10–14; Blair 2006b, pp. 184–86. Diacriticals are used more consistently in some sections than others, suggesting that the implementation of designs was subject to vagaries related to the organization of labor; see Kaplony 2008, pp. 94–99; George 2010, p. 66.

18 Schoeler 1997, pp. 431–32; Whelan 1998, pp. 6–8.

19 George 2010, p. 60.

20 Latz 1958, pp. 85–86, 94.

21 H. von Bothmer et al. 1999; Dreibholz 2003. The creation of these repositories of worn Qur'ans may reflect tensions between the theological invulnerability of scripture as the word of God and its vulnerability as an artifact subject to wear. Similar problems arose in relation to Christian codices and Jewish scrolls; the Quinisext Council held in Constantinople in 692 forbade the disposal or reuse of parchment inscribed with sacred text, while Islamic jurists would eventually develop elaborate protocols for the storage and ritual disposal of worn Qur'an codices; see Sadan 1986; Herrin 2009, pp. 216–17.

22 H. von Bothmer 1986, 1987a, 1987b.

23 Jenkins 1985; H. von Bothmer 1987b; Flood 2001, pp. 194–205; George 2010, pp. 74–88.

24 Al-Kindi in Newman 1993, p. 458; Hoyland 1997b, pp. 500–501, Hamdan 2010.

25 George 2010, pp. 87–88, fig. 58.

26 Pinder-Wilson and Ettinghausen 1961; Levy 1993–94. The popularity of architectural frontis- and finispieces for Qaraite Bibles may reflect an exegetical tradition (invoked in the Bible of 895) in which the three standard divisions of the Tanakh, the canonical Hebrew Bible, were identified, with the tripartite structure of the Temple: courtyard, temple, and holy of holies; see Wieder 1957, pp. 166–67, n. 6.

27 R. Nelson and Collins 2006, cat. no. 32, fig. 2.

28 It has been suggested that the building is part of a royal *paradeisos* inspired by Sasanian models, but this argument is unconvincing; the building shows far stronger affinities with depictions of Heavenly Bethlehem and Jerusalem in contemporary Syrian church mosaics, and may therefore be a representation of the Heavenly Temple. For the former suggestion, see Lepage 1990, p. 809, fig. 3. A particularly close parallel is offered by the depiction of Heavenly Bethlehem in the fifth-century mosaics from a church at Tayyibat al-Imam in northern Syria; see Duval 2003b, p. 243, fig. 17.

29 Leroy 1960; Mercier 2000, pp. 40–43, fig. 2.

30 A few examples of horizontal Hijazi Qur'ans exist but it is uncertain whether they represent earlier experiments or a more conservative tradition that continued into the Abbasid period; see Déroche 1992, p. 32, no. 2; Déroche 2002, p. 616; Déroche 2003, p. 260; George 2010, pp. 91–93.

31 Déroche 1992, pp. 18–19; Déroche 1995, p. 45; Blair 2006b, pp. 103–4; Blair 2008, pp. 74–75.

32 Déroche 2002, p. 616; Déroche 2003, p. 260; Déroche 2006a, pp. 172–73; Déroche 2006b, p. 176. For concerns about potential confusion in early Islam, see Schoeler 2006, pp. 116–17, 125. On early Torah scrolls, see Sirat et al. 1994. The endeavor might be compared to the use of the cross on the leather covers of earlier Gospel manuscripts, or to the occasional use of Qur'an 79:56—"None but the pure may touch"—on the covers of later *masahif* to alert viewers to the nature of the codex; see Déroche 2006a, pp. 176, 179; Lowden 2007, pp. 46–47; Zadeh 2009.

33 The blanket use of the term obscures both the existence of differences that may indicate chronological or regional variations and broad commonalities. François Déroche has identified up to seventeen variants of the script. For an illustrated overview, see George 2010, pp. 147–59.

34 Déroche 1990–91; George 2003; Blair 2008, p. 76. Beginning in the ninth century (and a century later in the western Mediterranean), dated inscriptions recording family births or endowment to mosques as *waqf* (mortmain) appear, providing a terminus ante quem for their production; see Déroche 1989, p. 102; George 2010, pp. 83–84.

35 For examples, see Déroche 1992, pp. 73, 123–24, 130, nos. 24, 67, 73; Stanley 199-, pp. 108–9, no. 14, from the Blue Qur'an.

36 Marçais and Poinssot 1952; Déroche 1986; Dreibholz 1997; Lowden 2007, pp. 17–24.

37 Déroche 2003, p. 261; Déroche 2006a, p. 176.

38 The endeavor recalls rare, early experiments with using differently colored inks for alternating lines of

the Qur'an; see Déroche 2006a, p. 170; George 2010, pp. 56–57.

39 Whelan 1990, pp. 122–23; Blair 2006b, p. 114; George 2010, p. 86. For the later ritual use of an Uthmanic Qur'an in Cordoba, see Dessus-Lamare 1938; Zadeh 2008.

40 See Lowden 2007, p. 32; George 2010, pp. 90–93. For a discussion of the relevant theological issues, see Flood forthcoming, chap. 3. In addition to the Blue Qur'an, folios from at least two different Kufic

Qur'ans written in gold exist: Stanley 199-, pp. 106–7, no. 11; Déroche 1992, pp. 90–91, no. 41.

41 Bloom 1989, 1991; George 2010. For other examples of Qur'ans written on dyed parchment, see Déroche 1992, p. 58, no. 11; Déroche 1995, p. 26.

42 Whelan 1990, p. 122.

43 Déroche 1992, pp. 132–83; Bloom 2001, pp. 104–9; Blair 2006b, pp. 143–237; New Style had the advantage of being more legible than Kufic while remaining amenable to many of its aesthetic manipulations.

There is some dispute as to whether this development can be related to contemporary controversies surrounding the question of whether the Qur'an was created or uncreated; see Tabbaa 1991; Soucek 2003, p. 301; George 2010, pp. 138–43. On the details of the controversy, see Madelung 1985.

44 See Whelan 1990, pp. 123–24; Blair 2006b, pp. 125–26, 144–45; George 2010, pp. 134–37.

Bibliography

Abbott 1939. Nabia Abbott. *The Rise of the North Arabic Script and Its Kur'anic Development, with a Full Description of the Kur'an Manuscripts in the Oriental Institute.* Chicago, 1939.

Aben 1979. K. H. Aben. "Een koptisch kinderjurkje." *Mededelingenblad der Vereniging van Vrienden van het Allard Pierson Museum,* no. 17 (1979), pp. 12–13.

Abu Qurrah 1897. Theodore Abu Qurrah. *De culu imaginum libellus a codice Arabico nunc primum editus Latine versus illustratus.* Translated by Johannes Arendzen. Bonn, 1897.

Abu Qurrah 1986. Theodore Abu Qurrah. *Traité du culte des icônes: Introduction et texte critique.* Translated by Ignace Dick. Rome, 1986.

Abu Qurrah 1997. Theodore Abu Qurrah. *A Treatise on the Veneration of the Holy Icons.* Translated by Sidney H. Griffith. Louvain, 1997.

Abu Qurrah 2006. *Theodore Abu Qurrah.* Translated by John C. Lamoreaux. Provo, Utah, 2006.

Addison 2000. Erin H. Addison. "The Mosque at al-Qastal." *Annual of the Department of Antiquities of Jordan* 44 (2000), pp. 477–90.

Aga-Oglu 1945. Mehmet Aga-Oglu. "About a Type of Islamic Incense Burner." *Art Bulletin* 27 (March 1945), pp. 28–45.

Aksoy and Milstein 2000. Şule Aksoy and Rachel Milstein. "A Collection of Thirteenth-Century Illustrated Hajj Certificates." In *M. Uğur Derman Festschrift,* edited by Irvin C. Schick, pp. 101–34. Istanbul, 2000.

al-Ghabban 2008. 'Ali ibn Ibrahim al-Ghabban. "The Inscription of Zuhayr, the Oldest Islamic Inscription (24 AH/AD 644–645), the Rise of the Arabic Script, and the Nature of the Early Islamic State." *Arabian Archaeology and Epigraphy* 19 (2008), pp. 210–37.

al-Ghabban et al. 2010. 'Ali ibn Ibrahim al-Ghabban et al. *Routes d'Arabie: Archéologie et histoire du royaume d'Arabie Saoudite.* Exh. cat. Paris, 2010.

al-Khamis 1998. Ulrike al-Khamis. "An Early Islamic Bronze Ewer Reexamined." *Muqarnas* 15 (1998), pp. 9–19.

al-Kisa'i 1997. Muhammad ibn 'Abd Allah al-Kisa'i. *Tales of the Prophets.* Translated by Wheeler M. Thackston Jr. Chicago, 1997.

al-Nawawi 2003. Abu Zakariyya Yahyá al-Nawawi. *Etiquette with the Quran: Tibyan fi adab hamalat al-Qur'an.* Burr Ridge, Ill., 2003.

Alaoui 2000. Brahim Alaoui, ed. *L'art copte en Égypte: 2000 ans de christianisme.* Exh. cat. Paris, 2000.

Album and Goodwin 2002. Stephen Album and Tony Goodwin. *Sylloge of Islamic Coins in the Ashmolean,* vol. 1, *The Pre-Reform Coinage of the Early Islamic Period.* Oxford, 2002.

Alföldi-Rosenbaum and Ward-Perkins 1980. Elisabeth Alföldi-Rosenbaum and John Ward-Perkins. *Justinianic Mosaic Pavements in Cyrenaican Churches.* Rome, 1980.

Allan 1982. James W. Allan. *Nishapur: Metalwork of the Early Islamic Period.* New York, 1982.

Allan 1986. James W. Allan. *Metalwork of the Islamic World: The Aron Collection.* London, 1986.

Allan 2004. James W. Allan. "Metal Vessels." In *Serçe Limani: An Eleventh-Century Shipwreck,* vol. 1, *The Ship and Its Anchorage, Crew, and Passengers,* edited by George F. Bass et al., pp. 345–60. College Station, Texas, 2004

Allen 1988. Terry Allen. *Five Essays on Islamic Art.* Occidental, Calif., 1988.

Allgrove-McDowell 2003. Joan Allgrove-McDowell. "The Sasanians, AD 224–642." In *The Cambridge History of Western Textiles,* edited by David Jenkins, vol. 1, pp. 153–58. Cambridge, 2003.

Almagro et al. 1975. Martín Almagro, Juan Caballero, Juan Zozaya, and Antonio Almagro. *Qusayr 'Amra, residencia y baños omeyas en el desierto de Jordania.* Madrid, 1975.

Althaus and Sutcliffe 2006. Frank Althaus and Mark Sutcliffe, eds. *The Road to Byzantium: Luxury Arts of Antiquity.* Exh. cat. London, 2006.

'Amr 1988. Abdel-Jalil 'Amr. "More Islamic Inscribed Pottery Lamps from Jordan." *Berytus* 34 (1988), pp. 161–68.

'Amr 1989. Abdel-Jalil 'Amr. "Two Early Abbasid Inscribed Pottery Lamps from Geras." *Zeitschrift des Deutschen Palästina-Vereins* 104 (1989), pp. 146–49.

Anastasios 2010. Anastasios of Sinai. "Diverse Narratives Concerning the Saintly Fathers in the Desert of Mount Sinai." Translated by Daniel Caner in *History and Hagiography from the Late Antique Sinai.* Liverpool, 2010.

Anawati 2011. G. C. Anawati. "'Isa." In *The Encyclopaedia of Islam,* 2d ed., 2011, http://o-brillonline.nl.library.metmuseum.org/subscriber/entry?entry=islam_COM-0378.

Anglade 1988. Elise Anglade. *Catalogue des boiseries de la section islamique, Musée du Louvre.* Paris, 1988.

Antiquities 2007. Supreme Council of Antiquities. *Egyptian Textiles Museum.* Cairo, 2007.

Apostolaki 1951. Anna Apostolaki. "Mithraike pompe." *Archaiologikē Ephēmeris* (1950–51), pp. 118–48.

Appadurai 1986. Arjun Appadurai. "Commodities and the Politics of Value." In *The Social Life of Things: Commodities in Cultural Perspective,* edited by Arjun Appadurai, pp. 3–63. Cambridge, 1986.

Arabic Papyri 2008. *Arabic Papyri, National Library of Egypt.* Cairo, 2008.

I. Arce 2008. Ignacio Arce. "The Palatine City at Amman Citadel: The Construction of a Palatine Architecture under the Umayyads (II)." In *Residences, Castles, Settlements: Transformation Processes from Late Antiquity to Early Islam in Bilad al-Sham,* edited by Karin Bartl and Abd al-Razzaq Moaz, pp. 183–216. Rahden, 2008.

J. Arce 2005. Javier Arce. "Un grupo de sítulas decoradas de la Antigüedad tardía: Función, cronología, significado." *Antiquité Tardive* 13 (2005), pp. 141–58.

Argyriadē 1991. Maria Argyriadē. *Dolls: In Greek Life and Art from Antiquity to the Present Day.* Athens, 1991.

Arveiller-Dulong and Nenna 2005. Véronique Arveiller-Dulong and Marie-Dominique Nenna. *Les verres antiques,* vol. 2, *Vaisselles et contenants du Ier siècle au début du VIIe siècle après J.-C.* Paris, 2005.

Atıl 1973. Esin Atıl. *Ceramics from the World of Islam.* Washington, D.C., 1973.

Atıl 1975. Esin Atıl. *Art of the Arab World.* Exh. cat. Washington, D.C., 1975.

Atıl 1990. Esin Atıl, ed. *Islamic Art & Patronage: Treasures from Kuwait.* Exh. cat. New York, 1990.

Atıl et al. 1985. Esin Atıl, William T. Chase, and Paul Jett. *Islamic Metalwork in the Freer Gallery of Art.* Exh. cat. Washington, D.C., 1985.

Atiya 1952. Aziz S. Atiya. "The Monastery of St. Catherine and the Mount Sinai Expedition." *Proceedings of the American Philosophical Society* 96, no. 5 (1952), pp. 578–86.

Atiya 1955. Aziz S. Atiya. *The Arabic Manuscripts of Mount Sinai: A Hand-List of the Arabic Manuscripts and Scrolls Microfilmed at the Library of the Monastery of St. Catherine, Mount Sinai.* Baltimore, 1955.

Atiya 1959. Aziz S. Atiya. "The Arabic Palimpsests of Mount Sinai." In *The World of Islam: Studies in Honour of Philip K. Hitti,* edited by James Kritzeck and R. Bayly Winder, pp. 109–20. London, 1959.

Atiya 1967. Aziz S. Atiya. "Codex Arabicus (Sinai Arabic Ms. no. 514)." In *Homage to a Bookman: Essays on Manuscripts, Books and Printing Written for Hans P. Kraus on His 60th Birthday,* edited by Hellmut Lehmann-Haupt, pp. 75–82. Berlin, 1967.

Augé et al. 1997. Christian Augé, Marie-Hélène Bayle, and Francesco Benedetuci. *Jordanie: Sur les pas des archéologues.* Exh. cat. Paris, 1997.

Auth 2005. Susan H. Auth. "Brother George the Scribe: An Early Christian Panel Painting from Egypt in Context." *Eastern Christian Art* 2 (2005), pp. 19–36.

Avi-Yonah 1993. Michael Avi-Yonah. "Na'aran." In *New Encyclopedia of Archaeological Excavations in the Holy Land,* edited by Ephraim Stern, vol. 3, pp. 1075–76. New York, 1993.

Avner 2006–7. Rina Avner. "The Kathisma: A Christian and Muslim Pilgrimage Site." *ARAM* 18–19 (2006–7), pp. 541–57.

Avner 2011. Rina Avner. "The Dome of the Rock in Light of the Development of Concentric Martyria in Jerusalem: Architecture and Architectural Iconography." *Muqarnas* 27 (2011), pp. 31–50.

Avni 2011. Gideon Avni. "Continuity and Change in the Cities of Palestine during the Early Islamic Period: The Cases of Jerusalem and Ramla." In *Shaping the Middle East: Jews, Christians, and Muslims in an Age of Transition, 400–800 C.E.,* edited by Kenneth G. Holum and Hayim Lapin, pp. 115–33. Bethesda, Md., 2011.

Avrin 1974. Leila Avrin. "The Illuminations of the Moshe Ben-Asher Codex of 895 C.E." 2 vols. Ph.D. diss., University of Michigan, 1974.

Avrin 1981. Leila Avrin. *Micrography as Art.* Jerusalem, 1981.

Baader 1980. Gerhard Baader. "Articella." In *Lexikon des Mittelalters,* vol. 1, edited by Robert Auty et al., cols. 1069–70. Munich, 1980.

Baader 1984. Gerhard Baader. "Early Medieval Latin Adaptations of Byzantine Medicine in Western Europe." *Dumbarton Oaks Papers* 38 (1984), pp. 251–59.

Bacharach 1996. Jere L. Bacharach. "Marwanid Umayyad Building Activities: Speculations on Patronage." *Muqarnas* 13 (1996), pp. 27–44.

Bacharach 2010. Jere L. Bacharach. "Signs of Sovereignty: The Shahāda, Qur'anic Verses, and the Coinage of 'Abd al-Malik." *Muqarnas* 27 (2010), pp. 1–30.

Baer 1983. Eva Baer. *Metalwork in Medieval Islamic Art.* Albany, N.Y., 1983.

Baer 1999a. Eva Baer. "Female Images in Early Islam." *Damaszener Mitteilungen* 11 (1999), pp. 13–24.

Baer 1999b. Eva Baer. "The Human Figure in Early Islamic Art: Some Preliminary Remarks." *Muqarnas* 16 (1999), pp. 32–41.

Baginski and Tidhar 1980. Alisa Baginski and Amalia Tidhar. *Textiles from Egypt, 4th–13th Centuries C.E.* Exh. cat. Jerusalem, 1980.

Bagnall 2007. Roger S. Bagnall, ed. *Egypt in the Byzantine World, 300–700.* Cambridge, 2007.

Bagnall and Cribiore 2006. Roger S. Bagnall and Raffaella Cribiore. *Women's Letters from Ancient Egypt, 300 BC–AD 800.* Ann Arbor, 2006.

Bagnoli 2010. Martina Bagnoli, ed. *Treasures of Heaven: Saints, Relics, and Devotion in Medieval Europe.* Exh. cat. Cleveland, 2010.

Baker 1995. Patricia L. Baker. *Islamic Textiles.* London, 1995.

Baldini Lippolis 1991. Isabella Baldini Lippolis. "Gli orecchini a corpo semilunato: Classificazione tipologica." *Corso di cultura sull'arte ravennate e bizantina* 38 (1991), pp. 67–101.

Baldini Lippolis 1999. Isabella Baldini Lippolis. *L'oreficeria nell'Impero di Costantinopoli tra IV e VII secolo.* Bari, 1999.

Baldovin 1987. John F. Baldovin. *The Urban Character of Christian Worship: The Origins, Development, and Meaning of Stational Liturgy.* Rome, 1987.

Baldwin et al. 1991. Barry Baldwin, Alexander P. Kazhdan, and Nancy Patterson Ševčenko. "Cyril, Patriarch of Alexandria." In *The Oxford Dictionary of Byzantium*, edited by Alexander P. Kazhdan et al., vol. 1, pp. 572–73. New York, 1991.

Ball 2005. Jennifer L. Ball. *Byzantine Dress: Representations of Secular Dress in Eighth- to Twelfth-Century Painting.* New York, 2005.

Ballian 2006. Anna Ballian, ed. *Benaki Museum: A Guide to the Museum of Islamic Art.* Athens, 2006.

Ballian and Drandaki 2003. Anna Ballian and Anastasia Drandaki. "A Middle Byzantine Silver Treasure." *Benaki Museum* 3 (2003), pp. 47–80.

Balog 1976. Paul Balog. *Umayyad, 'Abbasid and Tulunid Glass Weights and Vessel Stamps.* New York, 1976.

Banaji 2006. Jairus Banaji. "Precious Metal Coinages and Monetary Expansion in Late Antiquity." In *Dal dinarius al dinar: L'Oriente e la moneta romana: Atti dell'Incontro di Studio, Roma 16–18 settembre 2004*, edited by Federico de Romanis and Sara Sorda, pp. 265–303. Rome, 2006.

Bangert 2010. Suzanne Bangert. "The Archaeology of Pilgrimage: Abu Mina and Beyond." In *Religious Diversity in Late Antiquity*, edited by David M. Gwynn and Susanne Bangert, pp. 283–327. Leiden, 2010.

Bank 1985. Alisa V. Bank. *Byzantine Art in the Collections of Soviet Museums.* Enl. ed. Leningrad, 1985.

Barag 1970. Dan Barag. "Glass Pilgrim Vessels from Jerusalem, Part I." *Journal of Glass Studies* 12 (1970), pp. 35–63.

Barag 1971. Dan Barag. "Glass Pilgrim Vessels from Jerusalem, Parts II and III." *Journal of Glass Studies* 13 (1971), pp. 45–63.

Barag and Wilkinson 1974. Dan Barag and John Wilkinson. "The Monza-Bobbio Flasks and the Holy Sepulchre." *Levant* 6 (1974), pp. 179–87.

Baramki and Avi-Yonah 1934. Dimitri Baramki and Michael Avi-Yonah. "An Early Christian Church at Khirbat 'Asida." *Quarterly of the Department of Antiquities in Palestine* 3 (1934), pp. 17–19.

Baratte 1989. François Baratte. *Trésors d'orfèvrerie Gallo-Romains.* Exh. cat. Paris, 1989.

Barber 1997. Charles Barber. "The Truth in Painting: Iconoclasm and Identity in Early-Medieval Art." *Speculum* 72 (1997), pp. 1019–36.

Barnard 1974. Leslie W. Barnard. *The Graeco-Roman and Oriental Background of the Iconoclastic Controversy.* Leiden, 1974.

Barnet and Dandridge 2006. Peter Barnet and Pete Dandridge, eds. *Lions, Dragons, and Other Beasts: Aquamanilia of the Middle Ages, Vessels for Church and Table.* Exh. cat. New Haven, 2006.

Bashir 1991. Sulayman Bashir. "Qibla Musharriqa and Early Muslim Prayer in Churches." *Muslim World* 81 (1991), pp. 267–82.

Basilios 1991. Archbishop Basilios. "Liturgical Instruments." In *The Coptic Encyclopedia*, edited by Aziz S. Atiya, vol. 5, cols. 1469–74. New York, 1991.

Bates 1986. Michael L. Bates. "History, Geography and Numismatics in the First Century of Islamic Coinage." *Revue Suisse de Numismatique* 65 (1986), pp. 231–62.

Baumeister 1972. Theofried Baumeister. *Martyr Invictus: Der Martyrer als Sinnbild der Erlösung in der Legende und im Kult der frühen koptischen Kirche.* Münster, 1972.

Baumgarten 1999. Joseph Baumgarten. "Art in the Synagogue: Some Talmudic Views." In *Jews, Christians, and Polytheists in the Ancient Synagogue: Cultural Interaction during the Greco-Roman Period*, edited by Steven Fine, pp. 62–78. London, 1999.

Beaucamp 2007. Joelle Beaucamp. "Byzantine Egypt and Imperial Law." In *Egypt in the Byzantine World, 300–700*, edited by Roger S. Bagnall, pp. 271–87. Cambridge, 2007.

Beckwith 1960. John Beckwith. *Caskets from Cordoba.* London, 1960.

Beckwith 1963. John Beckwith. *Coptic Sculpture: 300–1300.* London, 1963.

Behrens-Abouseif 1989. Doris Behrens-Abouseif. *Islamic Architecture in Cairo.* Leiden, 1989.

Behrens-Abouseif 1997. Doris Behrens-Abouseif. "The Lion-Gazelle Mosaic at Khirbat al-Mafjar." *Muqarnas* 14 (1997), pp. 11–18.

Beit-Arié 1992. Malachi Beit-Arié. *Hebrew Manuscripts of East and West: Toward a Comparative Codicology.* London, 1992.

Beit-Arié et al. 1997. Malachi Beit-Arié, Colette Sirat, and Mordechai Glatzer. *Codices hebraicus litteris exarati quo tempore scripti fuerint exhibentes*, vol. 1, *Jusqu'à 1020.* Turnhout, 1997.

Belting-Ihm and Belting 1966. Christa Belting-Ihm and Hans Belting. "Das Kreuzbild im 'Hodegos' des Anastasios Sinaites: Ein Beitrag zur Frage nach den ältesten Darstellung des toten Crucifixus." In *Tortulae: Studien zu altchristlichen und byzantinischen Monumenten*, edited by Walter Nikolaus Schumacher, pp. 30–39. Freiburg-im-Bresgau, 1966.

Ben-Dov 1971. Meir Ben-Dov. "The Omayyad Structures near the Temple Mount." In *The Excavations in the Old City of Jerusalem near the Temple Mount: Preliminary Report of the Second and Third Seasons, 1969–1970*, edited by Benjamin Mazar, pp. 37–44. Jerusalem, 1971.

Bénazeth 1992. Dominique Bénazeth. *L'art du métal au début de l'ère chrétienne.* Paris, 1992.

Bénazeth 1994. Dominique Bénazeth. "Joueuse de crotales." In *Musiques au Louvre*, pp. 46–47. Paris, 1994.

Bénazeth 1995. Dominique Bénazeth. "Alexandrie chrétienne." *Dossiers d'Archéologie* 201 (March 1995), pp. 68–72.

Bénazeth 1997. Dominique Bénazeth. "Un monastère dispersé: Les antiquités de Baouit conservées dans les musées d'Égypte." *Bulletin de l'Institut Français d'Archéologie Orientale* 97 (1997), pp. 43–66.

Bénazeth 2000. Dominique Bénazeth. "Les sculptures de Baouit réemployées au XIXe siècle." In *Études coptes VI: Huitième journée d'études, Colmar, 29–31 mai 1997*, edited by Anne Boud'hors, pp. 59–67. Paris and Louvain, 2000.

Bénazeth 2001. Dominique Bénazeth. *Catalogue général du Musée Copte du Caire*, vol. 1, *Objets en métal.* Cairo, 2001.

Bénazeth 2006. Dominique Bénazeth. "From Thais to Thaïas: Reconsidering Her Burial in Antinoopolis (Egypt)." In *Textiles in Situ: Their Find Spots in Egypt and Neighbouring Countries in the First Millenium CE*, edited by Sabine Schrenk, pp. 69–83. Riggisberg, 2006.

Bénazeth and Boud'hors 2003. Dominique Bénazeth and Anne Boud'hors. "Les clés de Sohag: Somptueux emblèmes d'une austère réclusion." In *Études coptes VIII: Dixième journée d'études, Lille 14–16 juin 2001*, edited by Christian Cannuyer, pp. 19–36. Lille, 2003.

Bénazeth et al. 1999. Dominique Bénazeth, Maximilien Durand, and Marie-Hélène Rutschowscaya. "Le rapport de l'objet copte à l'écrit: Des textiles aux vêtements liturgiques." In *Égyptes . . . L'Égyptien et le copte*, edited by Nathalie Bosson and Sydney H. Aufrère, pp. 145–56. Exh. cat. Lattes, 1999.

Bendall 2003. Simon Bendall. "The Byzantine Coinage of the Mint of Jerusalem." *Revue Numismatique* 159 (2003), pp. 307–22.

Benoit 1961. Pierre Benoit. "Note additionelle." *Revue Biblique* 68 (1961), pp. 174–77.

Bernabò 2008. Massimo Bernabò, ed. *Il Tetravangelo di Rabbula.* Rome, 2008.

Bernus-Taylor and Delpont 2000. Martha Bernus-Taylor and Éric Delpont. *Les Andalousies de Damas à Cordoue.* Exh. cat. Paris, 2000.

Bertelli et al. 1992. Carlo Bertelli, Salvatore Lilla, Giulia Orofino, and Guglielmo Cavallo, eds. *Dioscurides Neapolitanus, Biblioteca Nazionale di Napoli, Codex ex Vindobonensis Graecus 1: Commentarium.* Rome, 1992.

Berthier 2000. Annie Berthier, ed. *Manuscrits, xylographes, estampages: Les collections orientales du Département des Manuscrits [Bibliothèque Nationale].* Paris, 2000.

Bes 2007. Philip Bes. "Technology in Late Antiquity: A Bibliographic Essay." In *Technology in Transition, A.D. 300–650*, edited by Luke Lavan et al., pp. 3–39. Leiden, 2007.

BHG 1957. *Bibliotheca Hagiographica Graeca.* 3 vols. Edited by François Halkin. 3d ed. Brussels, 1957.

BHG 1984. *Bibliotheca Hagiographica Graeca: Novum Auctarium.* Edited by François Halkin. Brussels, 1984.

Bianchini 1992. Marie-Claude Bianchini, ed. *Byzance: L'art byzantin dans les collections publiques françaises*. Exh. cat. Paris, 1992.

Biddle 1999. Martin Biddle. *The Tomb of Christ*. Gloucestershire, 1999.

Biebel 1936. Franklin M. Biebel. "The Mosaics of Hammam Lif." *Art Bulletin* 18 (1936), pp. 540–51.

Bierman 1998. Irene A. Bierman. *Writing Signs: The Fatimid Public Text*. Berkeley, 1998.

Birley 2002. Anthony R. Birley. *Septimius Severus: The African Emperor*. New ed. Reprint, London, 2002.

Biscop 2006. Jean-Luc Biscop. "The 'Kastron' of Qal'at Sim'an." In *Muslim Military Architecture in Greater Syria: From the Coming of Islam to the Ottoman Period*, edited by Hugh Kennedy, pp. 75–83. Leiden, 2006.

Bishah 1982. Ghazi Bishah. "The Second Season of Excavations at Hallabat, 1980." *Annual of the Department of Antiquities of Jordan* 26 (1982), pp. 133–43.

Bishah 1986. Ghazi Bishah. "Notes on Some Newly Discovered Umayyad Remains." *Annual of the Department of Antiquities of Jordan* 30 (1986), pp. 7–14 (Arabic section).

Bishah 1993. Ghazi Bishah. "From Castellum to Palatium: Umayyad Mosaic Pavements from Qasr al-Hallabat in Jordan." *Muqarnas* 10 (1993), pp. 49–56.

Bishah 2000. Ghazi Bishah. "Two Ummayad Mosaic Floors from Qastal." *Liber Annuus* 50 (2000), pp. 431–38.

Bittar 2003. Thérèse Bittar. *Pierres et stucs épigraphiés*. Paris, 2003.

Black and Saidi 2000. Crofton Black and Nabil Saidi. *Islamic Manuscripts*. London, 2000.

Blair 1992. Sheila S. Blair. "What Is the Date of the Dome of the Rock?" In *Bayt al-Maqdis*, vol. 1, *'Abd al-Malik's Jerusalem*, edited by Julian Raby and Jeremy Johns, pp. 59–88. Oxford, 1992.

Blair 1998. Sheila S. Blair. *Islamic Inscriptions*. Edinburgh, 1998.

Blair 2005. Sheila S. Blair. "What the Inscriptions Tell Us: Text and Message on the Ivories from al-Andalus." *Journal of the David Collection* 2, no. 1 (2005), pp. 75–100.

Blair 2006a. Sheila S. Blair. "Uses and Functions of the Qur'anic Text." *Mélanges de l'Université Saint-Joseph* 59 (2006), pp. 183–208.

Blair 2006b. Sheila S. Blair. *Islamic Calligraphy*. Edinburgh, 2006.

Blair 2008. Sheila S. Blair. "Transcribing God's Word: Qur'an Codices in Context." *Journal of Qur'anic Studies* 10 (2008), pp. 72–97.

Blair and Bloom 2006. Sheila S. Blair and Jonathan M. Bloom. *Cosmophilia: Islamic Art from the David Collection, Copenhagen*. Exh. cat. Chestnut Hill, Mass., 2006.

Bleiberg 2005. Edward Bleiberg. *Tree of Paradise: Jewish Mosaics from the Roman Empire*. Exh. cat. Brooklyn, 2005.

Blidstein 1973–74. Gerald Blidstein. "Nullification of Idolatry in Rabbinic Law." *Proceedings of the American Academy for Jewish Research* 41 (1973–74), pp. 1–44.

Bloch 1961. Peter Bloch. "Siebenarmige Leuchter in christlichen Kirchen." *Wallraf-Richartz-Jahrbuch* 23 (1961), pp. 55–190.

Bloch 1974. Peter Bloch. "Seven-Branched Candelabra in Christian Churches." *Journal of Jewish Art* 1 (1974), pp. 44–49.

Bloch 1983. Peter Bloch, ed. *Ex aere solido: Bronzen von der Antike bis zur Gegenwart*. Exh. cat. Berlin, 1983.

Bloom 1986. Jonathan M. Bloom. "Al-Ma'mun's Blue Koran?" *Revue des Études Islamiques* 54 (1986), pp. 61–65.

Bloom 1987. Jonathan M. Bloom. "The Mosque of the Qarafa in Cairo." *Muqarnas* 4 (1987), pp. 7–20.

Bloom 1989. Jonathan M. Bloom. "The Blue Koran: An Early Fatimid Kufic Manuscript from the Maghrib." In *Les manuscrits du Moyen-Orient: Essais de codicologie et de paléographie*, edited by François Déroche, pp. 95–99. Paris, 1989.

Bloom 1991. Jonathan M. Bloom. "The Early Fatimid Blue Koran Manuscript." *Graeco-Arabica* 4 (1991), pp. 171–78.

Bloom 1993. Jonathan M. Bloom. "On the Transmission of Designs in Early Islamic Architecture." *Muqarnas* 10 (1993), pp. 21–28.

Bloom 2001. Jonathan M. Bloom. *Paper before Print: The History and Impact of Paper in the Islamic World*. New Haven, 2001.

Bloom forthcoming. Jonathan M. Bloom. "The Blue Koran Revisited." In *Proceedings of the Fifth International Conference of Paleography and Codicology, Madrid, 2010*, edited by François Déroche et al. Forthcoming.

Bolman 2002. Elizabeth S. Bolman, ed. *Monastic Visions: Wall Paintings in the Monastery of St. Antony at the Red Sea*. New Haven, 2002.

Bolman 2006. Elizabeth S. Bolman. "Late Antique Aesthetics, Chromophobia, and the Red Monastery, Sohag, Egypt." *Eastern Christian Art* 3 (2006), pp. 1–24.

Bolman 2007a. Elizabeth S. Bolman. "Depicting the Kingdom of Heaven: Paintings and Monastic Practice in Early Byzantine Egypt." In *Egypt in the Byzantine World, 300–700*, edited by Roger S. Bagnall, pp. 408–33. Cambridge, 2007.

Bolman 2007b. Elizabeth E. Bolman. "The Red Monastery Conservation Project, 2004 Campaign: New Contributions to the Corpus of Late Antique Art." In *Interactions: Artistic Interchange between the Eastern and Western Worlds in the Medieval Period*, edited by Colum Hourihane, pp. 261–81. Princeton, 2007.

Bolman 2011. Elizabeth Bolman. "Painted Skins: The Illusions and Realities of Architectural Polychromy, Sinai and Egypt." In *Approaching the Holy Mountain: Art and Liturgy at St. Catherine's Monastery in the Sinai*, edited by Sharon Gerstel and Robert S. Nelson, pp. 119–40, 563–74. Turnhout, 2011.

Bolman and Lyster 2002. Elizabeth S. Bolman and William Lyster. "The Khurus Vault: An Eastern Mediterranean Synthesis." In *Monastic Visions: Wall Paintings in the Monastery of St. Antony at the Red Sea*, edited by Elizabeth S. Bolman, pp. 127–54. New Haven, 2002.

Bologna 2008. Ferdinando Bologna, ed. *L'enigma degli avori medievali da Amalfi a Salerno*. Exh. cat. 2 vols. Pozzuoli, Italy, 2008.

Bosson and Aufrère 1999. Nathalie Bosson and Sydney H. Aufrère, eds. *Égyptes . . . L'Égyptien et le copte*. Exh. cat. Lattes, 1999.

Bosworth 1965. C. E. Bosworth. "Misr." In *The Encyclopaedia of Islam*, vol. 7, p. 146. Leiden, 1965.

Bosworth 1976. C. E. Bosworth. *The Mediaeval Islamic Underworld: The Banu Sasan in Arabic Society and Literature*. 2 vols. Leiden, 1976.

Boud'hors and Calament 2004. Anne Boud'hors and Florence Calament. "Un ensemble de stèles fayoumiques inédites: à propos de la stèle funéraire de Pantoleos de Toutôn." In *Coptic Studies on the Threshold of a New Millennium*, edited by Mat Immerzeel and Jacques van der Vliet, vol. 1, pp. 447–75. Leuven, 2004.

Bowersock 2006. Glen W. Bowersock. *Mosaics as History: The Near East from Late Antiquity to Islam*. Cambridge, Mass., 2006.

Bowersock et al. 1999. Glen W. Bowersock, Peter Brown, and Oleg Grabar, eds. *Late Antiquity: A Guide to the Postclassical World*. Cambridge, Mass., 1999.

Boyarin 2004. Daniel Boyarin. *Border Lines: The Partition of Judaeo-Christianity*. Philadelphia, 2004.

Boyd and Mango 1992. Susan A. Boyd and Marlia Mundell Mango, eds. *Ecclesiastical Silver Plate in Sixth-Century Byzantium*. Washington, D.C., 1992.

Brands 2004. Gunnar Brands. "Die spätantike Stadt und ihre Christianisierung." In *Die spätantike Stadt und ihre Christianisierung*, edited by Gunnar Brands and Hans-Georg Severin, pp. 1–26. Wiesbaden, 2003.

Breck 1919. Joseph Breck. "Two Early Christian Ivories of the Ascension." *Metropolitan Museum of Art Bulletin* 14, no. 11 (November 1919), pp. 242–44.

Bréhier 1945. Louis Bréhier. "Objets liturgiques de métal découverts en Syrie." *Revue Archéologique* 24 (1945), pp. 93–106.

Brightman 1896. Frank Edward Brightman. *Liturgies Eastern and Western: Being the Texts Original or Translated of the Principal Liturgies of the Church*, vol. 1, *Eastern Liturgies*. Oxford, 1896.

Brilliant 1979. Richard Brilliant. "Mythology." In *Age of Spirituality: Late Antique and Early Christian Art, Third to Seventh Century*, edited by Kurt Weitzmann, pp. 126–31. Exh. cat. New York, 1979.

Brisch 1988. Klaus Brisch. "Observations on the Iconography of the Mosaics in the Great Mosque of Damascus." In *Content and Context of Visual Arts in the Islamic World*, edited by Priscilla P. Soucek, pp. 131–37. University Park, Pa., 1988.

Brock 1973. Sebastian Brock. "Early Syrian Asceticism." *Numen* 20, no. 1 (1973), pp. 1–19.

Brock 1985. Sebastian Brock. "The Thrice-Holy Hymn in the Liturgy." *Sobornost* 7, no. 2 (1985), pp. 24–34.

Brock 1987. Sebastian Brock. "North Mesopotamia in the Late Seventh Century: Book XV of John Bar Penkaye's *Riš Melle*." *Jerusalem Studies in Arabic and Islam* 9 (1987), pp. 51–75.

Brock 2003. Sebastian Brock. "Syriac on Sinai: The Main Connection." In *Eukosmia: Studi miscellanei per il 75. di Vincenzo Poggi S.J.*, edited by Vincenzo Ruggieri and Luca Pieralli, pp. 103–17. Catanzaro, 2003.

Brock 2004. Sebastian Brock. "Transformations of the Edessa Portrait of Christ." *Journal of Assyrian Academic Studies* 18, no. 1 (2004), pp. 46–56.

Brock 2006. Sebastian P. Brock. *The Bible in the Syriac Tradition*. Piscataway, N.J., 2006.

Bronces 1990. *Los bronces romanos en España*. Exh cat. Madrid, 1990.

Brooks 1899. E. W. Brooks. "The Campaign of 716–718, from Arabic Sources." *Journal of Hellenic Studies* 19 (1899), pp. 19–31.

K. Brown 1979. Katharine R. Brown. "The Mosaics of San Vitale: Evidence for the Attribution of Some Early Byzantine Jewelry to Court Workshops." *Gesta* 18, no. 1 (1979), pp. 57–62.

K. Brown 1984. Katharine R. Brown. *The Gold Breast Chain from the Early Byzantine Period in the Römisch-Germanisches Zentralmuseum.* Mainz, 1984.

M. Brown 2006. Michelle P. Brown, ed. *In the Beginning: Bibles before the Year 1000.* Exh. cat. Washington D.C., 2006.

P. Brown 1969. Peter Brown. *Augustine of Hippo.* Berkeley, 1969.

P. Brown 1971. Peter Brown. "The Rise and Function of the Holy Man in Late Antiquity." *Journal of Roman Studies* 61 (1971), pp. 80–101.

P. Brown 1973. Peter Brown. "A Dark-Age Crisis: Aspects of the Iconoclastic Controversy." *English Historical Review* 88 (1973), pp. 1–33.

P. Brown 1984. Peter Brown. "Late Antiquity and Islam: Parallels and Contrasts." In *Moral Conduct and Authority: The Place of Adab in South Asian Islam,* edited by Barbara Daly Metcalf, pp. 23–37. Berkeley, 1984.

Browning 1982. Iain Browning. *Jerash and the Decapolis.* London, 1982.

Brubaker 1977. Leslie Brubaker. "The Relationship of Text and Image in the Byzantine Manuscripts of Cosmas Indicopleustes." *Byzantinische Zeitschrift* 70, no. 1 (1977), pp. 42–57.

Brubaker 1999. Leslie Brubaker. *Vision and Meaning in Ninth-Century Byzantium.* Cambridge, 1999.

Brubaker 2009. Leslie Brubaker. "Eighth-Century Iconoclasms: Arab, Byzantine, Carolingian, and Palestinian." In *Anathēmata Eortika: Studies in Honor of Thomas F. Mathews,* edited by Joseph D. Alchermes et al., pp. 73–81. Mainz, 2009.

Brubaker and Haldon 2001. Leslie Brubaker and John F. Haldon. *Byzantium in the Iconoclast Era (ca. 680–850): The Sources, an Annotated Survey.* Aldershot, 2001.

Brubaker and Haldon 2011. Leslie Brubaker and John F. Haldon. *Byzantium in the Iconoclast Era, c. 680–850: A History.* Cambridge, 2011.

Bruhn 1993. Jutta-Annette Bruhn. *Coins and Costume in Late Antiquity.* Exh. cat. Washington, D.C., 1993.

Brunner 1974. Christopher J. Brunner. "Middle Persian Inscriptions on Sasanian Silverware." *Metropolitan Museum Journal* 9 (1974), pp. 109–21.

Bucking 2007. Scott Bucking. "Scribes and Schoolmasters? On Contextualizing Coptic and Greek Ostraca Excavated at the Monastery of Epiphanius." *Journal of Coptic Studies* 9 (2007), pp. 21–47.

Buckton 1988. David Buckton. "Byzantine Enamel and the West." *Byzantinische Forschungen* 13 (1988), pp. 235–44.

Buckton 1994. David Buckton, ed. *Byzantium: Treasures of Byzantine Art and Culture from British Collections.* Exh. cat. London, 1994.

Buettner 2006. Brigitte Buettner. "Toward a Historiography of the Sumptuous Arts." In *A Companion to Medieval Art: Romanesque and Gothic in Northern Europe,* edited by Conrad Rudolph, pp. 466–87. Oxford, 2006.

Bühl 2008. Gudrun Bühl, ed. *Dumbarton Oaks: The Collections.* Washington D.C., 2008.

Bujard 2005. Jacques Bujard. "Les objects métalliques d'Umm al-Walid (Jordanie)." *Antiquité Tardive* 13 (2005), pp. 135–40.

Bujard and Schweizer 1992. Jacques Bujard and François Schweizer, eds. *Entre Byzance et l'Islam: Umm er-Rasas et Umm el-Walid: Fouilles genevoises en Jordanie.* Exh. cat. Geneva, 1992.

Bujard and Schweizer 1994. Jacques Bujard and François Schweizer. "Aspect métallurgique de quelques objets byzantins et omeyyades découverts récemment en Jordanie." In *L'oeuvre d'art sous le regard des sciences,* edited by Anne Rinuy and François Schweizer, pp. 191–209. Exh. cat. Geneva, 1994.

Burkitt 1897. Francis Crawford Burkitt, ed. *Fragments of the Books of Kings According to the Translation of Aquila, from a MS. formerly in the Geniza at Cairo, Now in the Possession of C. Taylor and S. Schechter.* Cambridge, 1897.

Burnham 1980. Dorothy K. Burnham. *Warp and Weft: A Textile Terminology.* Toronto, 1980.

Burns 2006. E. Jane Burns. "Saracen Silk and the Virgin's Chemise: Cultural Crossings in Cloth." *Speculum* 81 (2006), pp. 365–97.

Buschhausen 1986. Helmut Buschhausen. *Byzantinische Mosaiken aus Jordanien.* Exh. cat. Vienna, 1986.

Buschhausen et al. 1995. Helmut Buschhausen, Ulrike Horak, and Hermann Harrauer. *Der Lebenskreis der Kopten: Dokumente, Textilien, Funde, Ausgrabungen.* Exh. cat. Vienna, 1995.

Busse 1988. Heribert Busse. "Jerusalem and Mecca, the Temple and the Kaaba: An Account of Their Interrelation in Islamic Times." In *The Holy Land in History and Thought,* edited by Moshe Sharon, pp. 236–46. Leiden, 1988.

Butler 1920. Howard Crosby Butler. *Syria: Publications of the Princeton University Archaeological Expeditions to Syria in 1904–5 and 1909, Division II: Architecture; Section B: Northern Syria.* Leiden, 1920.

Bystrikova 1965. M. G. Bystrikova. "K voprosu ob ikonograficheskih temah na koptskih hudojestvennuh tkanyah." *Soobshcheniia Gosudarstvennogo Ėrmitazha* 26 (1965), pp. 28–31.

Byzantine 1985. *Byzantine and Post-Byzantine Art.* Exh. cat. Athens, 1985.

Byzantion 2010. *From Byzantion to Istanbul: 8000 Years of a Capital.* Exh. cat. Istanbul, 2010.

Cabrera 2001. Ana Cabrera. "Caracterización de las producciones textiles en Al-Andalus (siglos IX al XIV): Estudio sobre tintes." In *Tejer y vestir: De la antigüedad al Islam,* edited by Manuela Marin, pp. 395–415. Madrid, 2001.

Cabrera et al. 2011. Ana Cabrera et al. "Late Antiquity Textiles from Egypt: Dye Analyses of Spanish Collections." In *Textiles y tintes en la ciudad antigua,* edited by Carmen Alfaro et al., pp. 137–42. Valencia, 2011.

Cabrol 1907. Fernand Cabrol. *Dictionnaire d'archéologie chrétienne et de liturgie.* 15 vols. Paris, 1907.

Caiger-Smith 1985. Alan Caiger-Smith. *Lustre Pottery: Technique, Tradition, and Innovation in Islam and the Western World.* London, 1985.

Caillet 1985. Jean-Pierre Caillet. *L'antiquité classique, le haut moyen âge et Byzance au Musée de Cluny.* Paris, 1985.

Calligraphie islamique 1988. *Calligraphie islamique: Textes sacrés et profanes.* Exh. cat. Geneva, 1988.

Callot 1989. Olivier Callot. "À propos de quelques colonnes de stylites syriens." In *Architecture et poésie dans le monde grec: Hommage à Georges Roux,* edited by Roland Étienne et al., pp. 107–22. Lyon, 1989.

Camber 1981. Richard Camber. "A Hoard of Terracotta Amulets from the Holy Land." In *Actes du XVe congrès international d'études byzantines, Athènes, Septembre 1976,* vol. 2A, *Art et archéologie, communications,* pp. 99–106. Athens, 1981.

Al. Cameron 2007. Alan Cameron. "Poets and Pagans in Byzantine Egypt." In *Egypt in the Byzantine World, 300–700,* edited by Roger S. Bagnall, pp. 21–46. Cambridge, 2007.

Av. Cameron 1984. Averil Cameron. "The History of the Image of Edessa." In *Okeanos: Essays Presented to Ihor Ševčenko,* edited by Cyril Mango and Omeljan Pritsak, pp. 80–94. Cambridge, Mass., 1984.

Av. Cameron 1996. Averil Cameron. *Changing Cultures in Early Byzantium.* Aldershot, 1996.

Campbell 1985. Sheila D. Campbell, ed. *The Malcove Collection: A Catalogue of the Objects in the Lillian Malcove Collection of the University of Toronto.* Toronto, 1985.

Canepa 2009. Matthew P. Canepa. *The Two Eyes of the Earth: Art and Ritual of Kingship between Rome and Sasanian Iran.* Berkeley, 2009.

Carboni and Whitehouse 2001. Stefano Carboni and David Whitehouse. *Glass of the Sultans.* Exh. cat. New Haven, 2001.

Cardon 2003. Dominique Cardon. *Le monde des teintures naturelles.* Paris, 2003.

Carlier and Morin 1984. Patricia Carlier and Frédéric Morin. "Recherches archéologiques au château de Qastal (Jordanie)." *Annual of the Department of Antiquities of Jordan* 28 (1984), pp. 343–83.

Carra 2000. Rosa Maria Bonacasa Carra. "Ossi e avori 'alessandrini' a Roma." In *Aurea Roma: Dalla città pagana alla città cristiana,* edited by Serena Ensoli and Eugenio La Rocca, pp. 353–58. Exh. cat. Rome, 2000.

Carroll 1988. Diane Lee Carroll. *Looms and Textiles of the Copts.* Seattle, 1988.

Cassianus 1965. Johannes Cassianus. *Institutions cénobitiques.* Edited by Jean-Claude Guy. Paris, 1965.

Casson 1989. Lionel Casson. *The Periplus Maris Erythraei: Text with Introduction, Translation, and Commentary.* Princeton, 1989.

Casson 1990. Lionel Casson. "New Light on Maritime Loans: P. Vindob. G 40822." *Zeitschrift für Papyrologie und Epigraphik* 84 (1990), pp. 195–206.

Cavallo 1982. Guglielmo Cavallo. "La cultura italo-greca nella produzione libraria." In *I Bizantini in Italia,* pp. 496–612. Milan, 1982.

Cecchelli 1959. Carlo Cecchelli, ed. *The Rabbula Gospels.* Olten, 1959.

Chaserant et al. 2009. Françoise Chaserant, François Leyge, and Dominique Heckenbenner. *Une autre Égypte: Collections coptes du Musée du Louvre.* Exh. cat. Paris, 2009.

Chassinat 1911. Émile Chassinat. *Fouilles à Baouît.* vol. 1, fasc. 1. MIFAO, vol. 13. Cairo, 1911.

Chen 1980. Doron Chen. "The Design of the Dome of the Rock in Jerusalem." *Palestine Exploration Quarterly* 112 (1980), pp. 41–50.

Chester 1872. Rev. Greville J. Chester. "Notes on the Ancient Christian Churches of Musr El Ateekah, or Old Cairo, and Its Neighbourhood." *Archaeological Journal* 29 (1872), pp. 120–34.

Cheynet and Morrisson 1994. Jean-Claude Cheynet and Cécile Morrisson. "Texte et image sur les sceaux Byzantins: Les raisons d'un choix iconographique." In *Studies in Byzantine Sigillography, 4,* edited by Nicolas Oikonomidès, pp. 9–32. Washington, D.C., 1994.

Clackson 2000a. Sarah J. Clackson. *Coptic and Greek Texts Relating to the Hermopolite Monastery of Apa Apollo.* Oxford, 2000.

Clackson 2000b. Sarah Clackson. Review of *Writing, Teachers, and Students in Graeco-Roman Egypt,* by

R. Cribiore. *Journal of Egyptian Archaeology* 86 (2000), pp. 194–201.

Clackson 2008. Sarah J. Clackson. *It Is Our Father Who Writes: Orders from the Monastery of Apollo at Bawit.* Cincinnati, 2008.

Clark 2008. Travis Lee Clark. "Imaging the Cosmos: The Christian Topography of Kosmas Indikopleustes." Ph.D. diss., Temple University, 2008.

Clédat 1904. Jean Clédat. *Le monastère et la nécropole de Baouît.* vol. 1, pt. 1. Cairo, 1904.

Clédat 1906. Jean Clédat. *Le monastère et la nécropole de Baouit.* vol. 1, pt. 2. Cairo, 1906.

Clédat 1999. Jean Clédat. *Le monastère et la nécropole de Baouît.* Edited by Dominique Bénazeth and Marie-Hélène Rutschowscaya. MIFAO, vol. 114. Cairo, 1999.

Clermont-Ganneau 1884. Charles Clermont-Ganneau. *Mission en Palestine et en Phénicie entreprise en 1881.* Paris, 1884.

Cody 1991. Aelred Cody. "Calendar, Coptic." In *The Coptic Encyclopedia*, edited by Aziz S. Atiya, vol. 2, cols. 433–36. New York, 1991.

J. Collins 1993. John Joseph Collins. *Daniel: A Commentary on the Book of Daniel.* Minneapolis, 1993.

M. Collins 2000. Minta Collins. *Medieval Herbals: The Illustrative Traditions.* Toronto, 2000.

Combe 1939. Étienne Combe. "Natte de Tibériade au Musée Benaki à Athénes." In *Mélanges syriens offerts à monsieur René Dussaud*, vol. 2, pp. 841–44. Paris, 1939.

Combe 1940. Étienne Combe. "Tissus fatimides du Musée Bénaki." In *Mélanges Maspero*, vol. 3, *Orient islamique*, pp. 259–72. Cairo, 1940.

Combe et al. 1931–56. Étienne Combe, Jean Sauvaget, and Gaston Wiet. *Répertoire chronologique d'épigraphie arabe.* 16 vols. Cairo, 1931–56.

Compareti 2005. Matteo Compareti. "Sasanian Textile Art: An Iconographic Approach." *Studies on Persianate Societies* 3 (2005), pp. 143–63.

Compareti 2006. Matteo Compareti. "Iconographical Notes on Some Recent Studies on Sasanian Religious Art (with an Additional Note on an Ilkhanid Monument, by Rudy Favaro)." *Annali di Ca' Foscari* 45 (2006), pp. 163–200.

Compareti 2009. Matteo Compareti. "Sasanian Textiles: An Iconographical Approach." In *Encyclopaedia Iranica*, www.iranica.com/articles/sasanian-textiles.

Connor 2004. Carolyn L. Connor. *Women of Byzantium.* New Haven, 2004.

Conrad 2002. Lawrence I. Conrad. "Heraclius in Early Islamic Kerygma." In *The Reign of Heraclius (610–641): Crisis and Confrontation*, edited by Gerrit J. Reinink and Bernard H. Stolte, pp. 113–56. Leuven, 2002.

Constantine 1990. Constantine VII Porphyrogenitus. *Three Treatises on Imperial Military Expeditions.* Translated and edited by John Haldon. Vienna, 1990.

Contadini 1998. Anna Contadini. *Fatimid Art at the Victoria and Albert Museum.* London, 1998.

Contadini 2010. Anna Contadini. "Translocation and Transformation: Some Middle Eastern Objects in Europe." In *The Power of Things and the Flow of Cultural Transformations*, edited by Lieselotte E. Saurma-Jeltsch and Anja Eisenbeiss, pp. 42–64. Berlin, 2010.

Conway 2008. Colleen M. Conway. *Behold the Man: Jesus and Greco-Roman Masculinity.* Oxford, 2008.

Cooney 1947. John D. Cooney. "The Byzantine Exhibition in Baltimore: The Coptic Section." *Journal of the American Oriental Society* 67 (1947), pp. 323–26.

Coquin 1974. Charalambia Coquin. *Les edifices chrétiens du Vieux-Caire*, vol. 1, *Bibliographie et topographie historiques.* Cairo, 1974.

Corbo 1981–82. Virgilio C. Corbo. *Il Santo Sepolcro di Gerusalemme: Aspetti archeologici dalle origini al periodo crociato.* 3 vols. Jerusalem, 1981–82.

Cormack 1986. Robin Cormack. "Patronage and New Programs of Byzantine Iconography." In *The 17th International Byzantine Congress, Major Papers*, pp. 609–38. New Rochelle, N.Y., 1986.

Cormack and Vasilakē 2008. Robin Cormack and Maria Vasilakē, eds. *Byzantium, 330–1453.* Exh. cat. London, 2008.

Cornu 1992. Georgette Cornu. *Tissus islamiques de la collection Pfister.* Vatican City, 1992.

Cornu 1993. Georgette Cornu, ed. *Tissus d'Égypte: Témoins du monde arabe, VIIIe–XVe siècles: Collection Bouvier.* Exh. cat. Geneva, 1993.

Corrigan 1992. Kathleen Corrigan. *Visual Polemics in the Ninth-Century Byzantine Psalters.* Cambridge, 1992.

Corrigan 1995. Kathleen Corrigan. "Text and Image on an Icon of the Crucifixion at Mount Sinai." In *The Sacred Image East and West*, edited by Robert Ousterhout and Leslie Brubaker, pp. 47–62. Urbana, Ill., 1995.

Corrigan 2009. Kathleen Corrigan. "The Three Hebrews in the Fiery Furnace: An Early Byzantine Icon at Mt. Sinai." In *Anathēmata Eortika: Studies in Honor of Thomas F. Mathews*, edited by Joseph D. Alchermes et al., pp. 93–103. Mainz, 2009.

Corrigan 2011. Kathleen Corrigan. "Visualizing the Divine: An Early Byzantine Icon of the 'Ancient of Days' at Mount Sinai." In *Approaching the Holy Mountain: Art and Liturgy at St. Catherine's Monastery in the Sinai*, edited by Sharon Gerstel and Robert S. Nelson. Turnhout, 2011.

Cortese and Calderini 2006. Delia Cortese and Simonetta Calderini. *Women and the Fatimids in the World of Islam.* Edinburgh, 2006.

Cotsonis 2005. John Cotsonis. "The Contribution of Byzantine Lead Seals to the Study of the Cult of the Saints (Sixth–Twelfth Century)." *Byzantion* 75 (2005), pp. 383–497.

Couleurs 2001. *Au fil du Nil: Couleurs de l'Égypte chrétienne.* Exh. cat. Paris, 2001.

Coupry 2003. Claude Coupry. "Peintures coptes sur bois: Analyse de pigments." In *Études coptes VIII: Dixième journée d'études, Lille, 14–16 juin 2001*, edited by Christian Cannuyer, pp. 99–106. Lille, 2003.

Creswell 1932–40. K. A. C. Creswell. *Early Muslim Architecture.* 2 vols. Oxford, 1932–40.

Creswell 1969. K. A. C. Creswell. *Early Muslim Architecture.* 2 vols. 2d ed. Oxford, 1969.

Creswell 1989. K. A. C. Creswell. *A Short Account of Early Muslim Architecture.* Rev. and enl. ed. by James W. Allan. Cairo, 1989.

Cribiore 2000. Raffaella Cribiore. *Writing, Teachers, and Students in Graeco-Roman Egypt.* Atlanta, 1996.

Cribiore 2001. Raffaella Cribiore. *Gymnastics of the Mind: Greek Education in Hellenistic and Roman Egypt.* Princeton, 2001.

Crislip 2006. Andrew Crislip. "A Coptic Request for Materia Medica." *Zeitschrift für Papyrologie und Epigraphik* 157 (2006), pp. 165–67.

Crowfoot 1931. John W. Crowfoot. *Churches at Jerash: A Preliminary Report of the Joint Yale–British School Expeditions to Jerash, 1928–1930.* British School of Archaeology in Jerusalem, Supplementary Papers 3. London, 1931.

Crown 1989. Alan D. Crown, ed. *The Samaritans.* Tübingen, 1989.

Crum and White 1926. Walter E. Crum and Hugh G. Evelyn White. *The Monastery of Epiphanius at Thebes*, vol. 2, *Coptic Ostraca and Papyri, Greek Ostraca and Papyri.* New York, 1926.

Cuming 1990. Geoffrey J. Cuming, ed. *The Liturgy of St. Mark.* Rome, 1990.

Curatola 1993. Giovanni Curatola, ed. *Eredità dell'Islam: Arte islamica in Italia.* Exh. cat. Venice, 1993.

Ćurčić and Chatzētryphōnos 2010. Slobodan Ćurčić and Euangelia Chatzētryphōnos. *Architecture as Icon: Perception and Representation of Architecture in Byzantine Art.* Exh. cat. Princeton, 2010.

Cutler 1985. Anthony Cutler. *The Craft of Ivory: Sources, Techniques, and Uses in the Mediterranean World: A.D. 200–1400.* Washington, D.C., 1985.

Cutler 1994a. Anthony Cutler. *The Hand of the Master: Craftsmanship, Ivory, and Society in Byzantium (9th–11th Centuries).* Princeton, 1994.

Cutler 1994b. Anthony Cutler. "Uses of Luxury: On the Functions of Consumption and Symbolic Capital in Byzantine Culture." In *Byzance et les images*, edited by André Guillou and Jannic Durand, pp. 289–327. Paris, 1994.

Cutler 1995. Anthony Cutler. "Sacred and Profane: The Locus of the Political in Middle Byzantine Art." In *Arte profana e arte sacra a Bisanzio*, edited by Antonio Iacobini and Enrico Zanini, pp. 315–38. Rome, 1995.

Cutler 1999a. Anthony Cutler. "Gifts and Gift Giving." In *Late Antiquity: A Guide to the Postclassical World*, edited by Glen W. Bowersock et al., pp. 469–70. Cambridge, Mass., 1999.

Cutler 1999b. Anthony Cutler. "Ivory." In *Late Antiquity: A Guide to the Postclassical World*, edited by Glen W. Bowersock et al., pp. 521–22. Cambridge, Mass., 1999.

Cutler 1999c. Anthony Cutler. "The Parallel Universes of Arab and Byzantine Art (with Special Reference to the Fatimid Era)." In *L'Égypte fatimide, son art et son histoire*, edited by Marianne Barrucand, pp. 635–48. Paris, 1999.

Cutler 2005. Anthony Cutler. "Ivory Working in Umayyad Córdoba: Techniques and Implications." In *The Ivories of Muslim Spain: Papers from a Symposium Held in Copenhagen from the 18th to the 20th of November 2003*, edited by Kjeld von Folsach and Joachim Meyer, pp. 36–47. Copenhagen, 2005.

Cutler 2008a. Anthony Cutler. "Ivory, Steatite, Enamel, and Glass." In *The Oxford Handbook of Byzantine Studies*, edited by Elizabeth Jeffreys et al., pp. 453–61. New York, 2008.

Cutler 2008b. Anthony Cutler. "Significant Gifts: Patterns of Exchange in Late Antique, Byzantine, and Early Islamic Diplomacy." *Journal of Medieval and Early Modern Studies* 38 (Winter 2008), pp. 79–101.

Cutler 2009. Anthony Cutler. *Image Making in Byzantium, Sasanian Persia, and the Early Muslim World.* Farnham, 2009.

Cytryn-Silverman 2009. Katia Cytryn-Silverman. "The Umayyad Mosque of Tiberias." *Muqarnas* 26 (2009), pp. 37–61.

Da Costa 2010. Kate Da Costa. "Economic Cycles in the Byzantine Levant: The Evidence from Lamps at Pella in Jordan." *Levant* 42 (2010), pp. 70–87.

Dagron 2002. Gilbert Dagron. "The Urban Economy, Seventh–Twelfth Centuries." In *The Economic History*

of Byzantium: From the Seventh through the Fifteenth Century, edited by Angeliki E. Laiou, vol. 2, pp. 393–461. Washington, D.C., 2002.

Daim and Drauschke 2010. Falko Daim and Jörg Drauschke, eds. *Byzanz: Das Römerreich im Mittelalter.* Exh. cat. 4 vols. Mainz, 2010.

Dalby 2000. Andrew Dalby. *Empire of Pleasures: Luxury and Indulgence in the Roman World.* London, 2000.

Dalby 2010. Andrew Dalby. *Tastes of Byzantium: The Cuisine of a Legendary Empire.* London, 2010.

Dale 1993. Thomas E. A. Dale. "The Power of the Anointed: The Life of David on Two Coptic Textiles in the Walters Art Gallery." *Journal of the Walters Art Gallery* 51 (1993), pp. 23–42.

Daley 2008. Brian E. Daley. "Christ and Christologies." In *The Oxford Handbook of Early Christian Studies*, edited by Susan Ashbrook Harvey and David G. Hunter, pp. 886–905. Oxford, 2008.

Damgaard and Blanke 2004. Kristoffer Damgaard and Louise Blanke. "The Islamic Jarash Project: A Preliminary Report on the First Two Seasons of Fieldwork." *Assemblage* 8 (2004), available at http://www.assemblage.group.shef.ac.uk/issue8/damgaardandblanke.html.

Da'nah 1969. Sulaiman Da'nah. "Hafriyat al-Fusayfisa', al-Istirahah—Jerash." *Annual of the Department of Antiquities of Jordan* 14 (1969), pp. 58–60.

Dandridge 2000. Pete Dandridge. "Idiomatic and Mainstream: The Technical Vocabulary of a Late Roman Crossbow." *Metropolitan Museum Journal* 35 (2000), pp. 71–86.

Dandridge 2005. Pete Dandridge. "The Exhibition of Unlacquered Silver at the Metropolitan Museum of Art." *Journal of the American Institute for Conservation* 44, no. 3 (2005), pp. 175–83.

Dannheimer 1979. Hermann Dannheimer. "Zur Herkunft der 'koptischen' Bronzegefässe der Merowingerzeit." *Bayerische Vorgeschichtsblätter* 44 (1979), pp. 123–47.

Dark 2007. Ken R. Dark. "Globalizing Late Antiquity: Models, Metaphors, and the Realities of Long-Distance Trade and Diplomacy." In *Incipient Globalization? Long-Distance Contacts in the Sixth Century*, edited by Anthea Harris, pp. 3–14. Oxford, 2007.

Darmon 1995. J.-P. Darmon. "Les mosaïques de la synagogue de Hammam Lif: Un réexamen du dossier." In *Fifth International Colloquium on Ancient Mosaics*, pt. 2, edited by Roger Ling, pp. 7–29. Ann Arbor, 1995.

D'Arms 1981. John H. D'Arms. *Commerce and Social Standing in Ancient Rome.* Cambridge, Mass., 1981.

Daryaee 2009. Touraj Daryaee. *Sasanian Persia: The Rise and Fall of an Empire.* London, 2009.

Dassmann and Engemann 1995. Ernst Dassmann and Josef Engemann, eds. *Akten des XII. Internationalen Kongresses für christliche Archäologie.* 3 vols. Münster, 1995.

Dauterman Maguire 2009. Eunice Dauterman Maguire. "Muslims, Christians, and Iconoclasm: A Case Study of Images and Erasure on Lamps in the Johns Hopkins University Archaeological Collection." In *Byzantine Art: Recent Studies: Essays in Honor of Lois Drewer*, edited by Colum Hourihane, pp. 121–52. Tempe, Ariz., 2009.

Dauterman Maguire and Maguire 2007. Eunice Dauterman Maguire and Henry Maguire. *Other Icons: Art and Power in Byzantine Secular Culture.* Princeton, 2007.

Dauterman Maguire et al. 1989. Eunice Dauterman Maguire, Henry P. Maguire, and Maggie J. Duncan-Flowers. *Art and Holy Powers in the Early Christian House.* Exh. cat. Urbana, Ill., 1989.

David-Weill 1931. Jean David-Weill. *Catalogue général du Musée Arabe du Caire: Les bois à épigraphes*, vol. 1, *Jusqu'à l'époque mamlouke.* Cairo, 1931.

Davidson 1919. Israel Davidson, ed. *Mahzor Yannai: A Liturgical Work of the VIIth Century. Edited from Genizah Fragments.* New York, 1919.

Davies and Fouracre 2010. Wendy Davies and Paul Fouracre, eds. *The Languages of Gift in the Early Middle Ages.* Cambridge, 2010.

Davis 2001. Stephen J. Davis. "Ancient Sources for the Coptic Tradition." In *Be Thou There: The Holy Family's Journey in Egypt*, edited by Gawdat Gabra, pp. 133–62. Cairo, 2001.

Davis 2004. Stephen J. Davis. *The Early Coptic Papacy: The Egyptian Church and Its Leadership in Late Antiquity.* Cairo, 2004.

Davis 2008. Stephen J. Davis. *Coptic Christology in Practice: Incarnation and Divine Participation in Late Antique and Medieval Egypt.* Oxford, 2008.

Dawes and Baynes 1977. Elizabeth Dawes and Norman H. Baynes, trans. *Three Byzantine Saints.* Crestwood, N.Y., 1977.

Day 1942. Florence Day. "Early Islamic and Christian Lamps." *Berytus* 7 (1942), pp. 65–79.

Day 1952. Florence Day. "The Tiraz Silk of Marwan." In *Archaeologica Orientalia in Memoriam Ernst Herzfeld*, edited by George C. Miles, pp. 39–61. Locust Valley, N.Y., 1952.

De Jonghe et al. 1999. Daniël De Jonghe, Sonja Daemen, Marguerite Rassart-Debergh, Antoine De Moor, and Bruno Overlaet, eds. *Ancient Tapestries of the R. Pfister Collection in the Vatican Library.* Vatican City, 1999.

De Moor 2007. Antoine De Moor. "Radiocarbon Dating of Ancient Textiles: State of Research." In *Methods of Dating Ancient Textiles of the 1st Millennium AD from Egypt and Neighbouring Countries*, edited by Antoine De Moor and Cäcilia Fluck, pp. 99–111. Tielt, 2007.

De Moor and Fluck 2007. Antoine De Moor and Cäcilia Fluck, eds. *Methods of Dating Ancient Textiles of the 1st Millennium AD from Egypt and Neighbouring Countries.* Tielt, 2007.

De Moor et al. 2004a. Antoine De Moor, Mark Van Strydonck, and Chris Verhecken-Lammens. "Radiocarbon Dating of a Particular Type of Coptic Woollen Tunics." In *Coptic Studies on the Threshold of a New Millennium*, edited by Mat Immerzeel and Jacques Van der Vliet, vol. 2, pp. 1425–42. Leuven, 2004.

De Moor et al. 2004b. Antoine De Moor, Mark Van Strydonck, and Chris Verhecken-Lammens. "Radiocarbon Dating of Two Sasanian Coats and Three Post-Sasanian Tapestries." In *Riding Costume in Egypt: Origin and Appearance*, edited by Cäcilia Fluck and Gillian Vogelsang-Eastwood, pp. 181–87. Leiden, 2004.

De Moor et al. 2006a. Antoine De Moor, Sabine Schrenk, and Chris Verhecken-Lammens. "New Research on the So-Called Akhmīm Silks." In *Textiles in Situ: Their Find Spots in Egypt and Neighbouring Countries in the First Millenium CE*, edited by Sabine Schrenk, pp. 85–94. Riggisberg, 2006.

De Moor et al. 2006b. Antoine De Moor, Chris Verhecken-Lammens, and Mark Van Strydonck.

"Relevance and Irrelevance of Radiocarbon Dating of Inscribed Textiles." In *Textile Messages: Inscribed Fabrics from Roman to Abbasid Egypt*, edited by Cäcilia Fluck and Gisela Helmecke, pp. 223–31. Leiden, 2006.

De Moor et al. 2008. Antoine De Moor, Chris Verhecken-Lammens, and André Verhecken. *3500 jaar textielkunst: De collectie art in headquARTers.* Tielt, 2008.

De Moor et al. 2010. Antoine De Moor, Ina Vanden Berghe, Mark van Strydonck, Mathieu Boudin, and Cäcilia Fluck. "Radiocarbon Dating and Dye Analysis of Roman Linen Tunics and Dalmatics with Purple Coloured Design." *Archaeological Textiles Newsletter*, no. 51 (Fall 2010), pp. 34–47.

de Vaux 1938. Roland de Vaux. "Une mosaïque byzantine à Ma'in (Transjordanie)." *Revue Biblique* 47 (1938), pp. 227–58.

Deichmann 1956. Friedrich Wilhelm Deichmann. *Studien zur Architektur Konstantinopels im 5. und 6. Jahrhundert nach Christus.* Baden-Baden, 1956.

Delatte and Derchain 1964. Armand Delatte and Philippe Derchain. *Les intailles magiques gréco-égyptiennes.* Paris, 1964.

Delattre 2007. Alain Delattre. *Papyrus coptes et grecs du monastère d'apa Apollô de Baouît conservés aux Musées Royaux d'Art et d'Histoire de Bruxelles.* Brussels, 2007.

Delattre 2010. Alain Delattre. "Des linteaux et des noms: Une enquête prosopographique à Baouît." In *Études coptes XI: Treizième journée d'études, Marseille, 7–9 juin 2007*, edited by Anne Boud'hors and Catherine Louis, pp. 25–30. Paris, 2010.

Delehaye 1923. Hippolyte Delehaye. *Les saints stylites.* Brussels, 1923.

Delmaire 2003. Roland Delmaire. "Le vêtement, symbole de richesse et de pouvoir, d'après les textes patristiques et hagiographiques du Bas-Empire." In *Costume et société dans l'Antiquité et le haut Moyen Âge*, edited by François Chausson and Hervé Inglebert, pp. 85–98. Paris, 2003.

Demange 2006. Françoise Demange, ed. *Les Perses sassanides: Fastes d'un empire oublié (224–642).* Exh. cat. Paris, 2006.

Déroche 1983. François Déroche. *Manuscrits musulmans*, vol. 1, *Les manuscrits du Coran.* Paris, 1983.

Déroche 1986. François Déroche. "Quelques reliures médiévales de provenance damascaine." *Revue des Études Islamiques* 54 (1986), pp. 85–99.

Déroche 1989. François Déroche. "À propos d'une série de manuscrits coraniques anciens." In *Les manuscrits du Moyen-Orient: Essais de codicologie et de paléographie*, edited by François Déroche, pp. 101–11. Paris, 1989.

Déroche 1990–91. François Déroche. "The Qur'an of Amağur." *Manuscripts of the Middle East* 5 (1990–91), pp. 59–66.

Déroche 1992. François Déroche. *The Nasser D. Khalili Collection of Islamic Art*, vol. 1, *The Abbasid Tradition: Qur'ans of the 8th to the 10th Centuries A.D.* London, 1992.

Déroche 1995. François Déroche. "L'emploi du parchemin dans les manuscrits islamiques: Quelques remarques préliminaires." In *The Codicology of Islamic Manuscripts: Proceedings of the Second Conference of Al-Furqan Islamic Heritage Foundation*, edited by Yasin Dutton, pp. 17–57. London, 1995.

Déroche 1999. François Déroche. "Note sur les fragments coraniques anciens de Katta Langar (Ouzbékistan)." *Cahiers d'Asie Centrale* 7 (1999), pp. 65–73.

Déroche 2002. François Déroche. "New Evidence about Umayyad Book Hands." In *Essays in Honour of Salah al-Din al-Munajjid*, pp. 611–42. London, 2002.

Déroche 2003. François Déroche. "Manuscripts of the Qur'an." In *Encyclopaedia of the Qur'an*, edited by Jane Dammen McAuliffe, vol. 3, pp. 254–75. Leiden, 2003.

Déroche 2004a. François Déroche. "Colonnes, vases et rinceaux sur quelques enluminures d'époque omeyyade." *Comptes-rendus des Séances de l'Académie des Inscriptions et Belles-Lettres* 148 (2004), pp. 227–64.

Déroche 2004b. François Déroche. *Le livre manuscrit arabe: Préludes à une histoire*. Paris, 2004.

Déroche 2006a. François Déroche. "Studying the Manuscripts of the Qur'an, Past and Future." *Mélanges de l'Université Saint-Joseph* 59 (2006), pp. 163–81.

Déroche 2006b. François Déroche. "Written Transmission." In *The Blackwell Companion to the Qur'an*, edited by Andrew Rippin, pp. 172–86. Malden, Mass., 2006.

Déroche 2009. François Déroche. *La transmission écrite du Coran dans les débuts de l'Islam: Le codex Parisino-petropolitanus*. Leiden, 2009.

Déroche and von Gladiss 1999. François Déroche and Almut von Gladiss. *Der Prachtkoran im Museum für Islamische Kunst: Buchkunst zur Ehre Allahs*. Exh. cat. Berlin, 1999.

Desrosiers 2004. Sophie Desrosiers. *Soieries et autres textiles de l'antiquité au XVIe siècle*. Paris, 2004.

Dessus-Lamare 1938. Alfred Dessus-Lamare. *Le Mushaf de la mosquée de Cordoue et son mobilier mécanique*. S.l., 1938.

Detienne 1994. Marcel Detienne. *The Gardens of Adonis: Spices in Greek Mythology*. Princeton, 1994.

Devreesse 1954. Robert Devreesse. *Introduction à l'étude des manuscrits grecs*. Paris, 1954.

Di Segni 1992. Leah Di Segni. "The Date of the Church of the Virgin in Madaba." *Liber Annuus* 42 (1992), pp. 251–57.

Di Segni 1998. Leah Di Segni. "The Greek Inscriptions." In *Mt. Nebo: New Archaeological Excavations*, edited by Michele Piccirillo and Eugenio Alliata, pp. 425–67. Jerusalem, 1998.

Dick 1961. Ignace Dick, ed. and trans. "La passion arabe de S. Antoine Ruwah, néo-martyr de Damas." *Le Museon* 74 (1961), pp. 109–33.

Diethart 1991. Johannes Diethart. "Review." *Tyche* 6 (1991), p. 233.

Dietrich 1991. Albert Dietrich, ed. *Die Dioskurides-Erklärung des Ibn al-Baitār: Ein Beitrag zur arabischen Pflanzensynonymik des Mittelalters*. Göttingen, 1991.

Dignas and Winter 2007. Beate Dignas and Engelbert Winter. *Rome and Persia in Late Antiquity: Neighbours and Rivals*. Cambridge, 2007.

Dijkstra and Greatrex 2009. Jitse Dijkstra and Geoffrey Greatrex. "Patriarchs and Politics in Constantinople in the Reign of Anastasius (with a Reedition of O.Mon.Ephiph. 59)." In *Millennium 6/2009: Yearbook of the Culture and History of the First Millennium C.E.*, pp. 223–64. Berlin, 2009.

Dimand 1930. Maurice S. Dimand. "Coptic Tunics in the Metropolitan Museum of Art." *Metropolitan Museum Studies* 2, no. 2 (May 1930), pp. 239–54.

Dimand 1931. Maurice S. Dimand. "Coptic and Egypto-Arabic Textiles." *Bulletin of the Metropolitan Museum of Art* 26 (April 1931), pp. 89–91.

Dimand 1933. Maurice S. Dimand. "Parthian and Sasanian Art." *Metropolitan Museum of Art Bulletin* 28 (April 1933), pp. 79–81.

Dimand 1937. Maurice S. Dimand. "Studies in Islamic Ornament." *Ars Islamica* 4 (1937), pp. 293–337.

Dimand 1938. Maurice S. Dimand. "An Egypto-Arabic Panel with Mosaic Decoration." *Metropolitan Museum of Art Bulletin* 33 (March 1938), pp. 78–79.

Dimand 1942. Maurice S. Dimand. "Two Abbasid Straw Mats Made in Palestine." *Metropolitan Museum of Art Bulletin* 1 (Summer 1942), pp. 76–79.

Dimand 1944. Maurice S. Dimand. *A Handbook of Muhammadan Art*. 2d ed. New York, 1944.

Dimand 1967. Maurice S. Dimand. "Some Early Sasanian Silver Vessels." In *A Survey of Persian Art*, vol. 14, *New Studies, 1938–1960*, edited by A. U. Pope. London, 1967.

Dimand and McAllister 1940. Maurice S. Dimand and H. E. McAllister. *Near Eastern Jewelry: A Picture Book*. New York, 1940.

Djobadze 1986. Wachtang Z. Djobadze. *Archeological Investigations in the Region West of Antioch on-the-Orontes*. Stuttgart, 1986.

Dodd 1961. Erica Cruikshank Dodd. *Byzantine Silver Stamps*. Washington, D.C., 1961.

Dodd 1964. Erica Cruikshank Dodd. "Byzantine Silver Stamps. Supplement I: New Stamps from the Reigns of Justin II and Constans II." *Dumbarton Oaks Papers* 18 (1964), pp. 237–48.

Dodd 1972. Erica Cruikshank Dodd. "On a Bronze Rabbit from Fatimid Egypt." *Kunst des Orients* 8 (1972), pp. 60–76.

Dodd 1974. Erica Cruikshank Dodd. *Byzantine Silver Treasures*. Bern, 1974.

Dodd 1987. Erica Cruikshank Dodd. "Three Early Byzantine Silver Crosses." *Dumbarton Oaks Papers* 41 (1987), pp. 165–79.

Dodd and Khairallah 1981. Erica Cruikshank Dodd and Shereen Khairallah. *The Image of the Word: A Study of Quranic Verses in Islamic Architecture*. 2 vols. Beirut, 1981.

Dolezal and Mavroudi 2002. Mary-Lyon Dolezal and Maria Mavroudi. "Theodore Hyrtakenos' Description of the Garden of St. Anna and the Ekphrasis of Gardens." In *Byzantine Garden Culture*, edited by Antony Littlewood et al., pp. 121–29. Washington, D.C., 2002.

Donceel-Voûte 1988. Pauline Donceel-Voûte. *Les pavements des églises byzantines de Syrie et du Liban: Décor, archéologie et liturgie*. Louvain-la-Neuve, 1988.

Donceel-Voûte 1995. Pauline Donceel-Voûte. "Le rôle des reliquaires dans les pèlerinages." In *Akten des XII. Internationalen Kongresses für christliche Archäologie*, edited by Ernst Dassmann and Josef Engemann, vol. 3, pp. 184–205. Münster, 1995.

F. Donner 2002–3. Fred M. Donner. "From Believers to Muslims: Confessional Self-Identity in the Early Islamic Community." *Al-Abhath* 50–51 (2002–3), pp. 9–53.

F. Donner 2008. Fred M. Donner. "The Qur'an in Recent Scholarship: Challenges and Desiderata." In *The Qur'an in Its Historical Context*, edited by Gabriel S. Reynolds, pp. 29–50. London, 2008.

F. Donner 2010a. Fred M. Donner. *Muhammad and the Believers: At the Origins of Islam*. Cambridge, Mass., 2010.

F. Donner 2010b. Fred M. Donner. "Umayyad Efforts at Legitimation: The Silent Heritage of the Umayyads." In *Umayyad Legacies: Medieval Memories from Syria to Spain*, edited by Antoine Borrut and Paul M. Cobb, pp. 187–211. Leiden, 2010.

H. Donner 1992. Herbert Donner. *The Mosaic Map of Madaba: An Introductory Guide*. Kampen, 1992.

Doran 1992. Robert Doran, trans. *The Lives of Simeon Stylites*. Kalamazoo, Mich., 1992.

Drandaki 2002. Anastasia Drandaki. "ΥΠΑΙΝΩΝ ΧΡΩ ΚΥΡΙ(Ε)" (A Late Roman Brass Bucket with a Hunting Scene). *Mouseio Benaki* 2 (2002), pp. 27–53.

Drandaki 2005. Anastasia Drandaki. "Copper Alloy Jewellery at the Benaki Museum: 4th to 7th Century." *Antiquité Tardive* 13 (2005), pp. 65–76.

Drandaki 2011. Anastasia Drandaki. "From Centre to Periphery and Beyond: The Diffusion of Models in Late Antique Metalware." In *Wonderful Things: Byzantium through Its Art*, edited by Antony Eastmond and Elizabeth James. Burlington, Vt., 2011.

Drandaki forthcoming. Anastasia Drandaki. *Metalwork in Late Antiquity: The Benaki Museum Collection*. Forthcoming.

Dreibholz 1997. Ursula Dreibholz. "Some Aspects of Early Islamic Bookbindings from the Great Mosque of Sana'a, Yemen." In *Scribes et manuscrits du Moyen-Orient*, edited by François Déroche and Francis Richard, pp. 16–34. Paris, 1997.

Dreibholz 2003. Ursula Dreibholz. *Frühe Koranfragmente aus der Grossen Moschee in Sanaa=Early Quran Fragments from the Great Mosque in Sanaa*. Yemen, 2003.

H. Drijvers 1998. Han J. W. Drijvers. "The Image of Edessa in the Syriac Tradition." In *The Holy Face and the Paradox of Representation*, edited by Herbert L. Kessler and Gerhard Wolf, pp. 13–31. Bologna, 1998.

J. Drijvers 1992. Jan Willem Drijvers. *Helena Augusta: The Mother of Constantine the Great and the Legend of Her Finding of the True Cross*. Leiden, 1992.

Du Bourguet 1964a. Pierre Du Bourguet, ed. *L'art copte*. Exh. cat. Paris, 1964.

Du Bourguet 1964b. Pierre Du Bourguet. *Musée national du Louvre: Catalogue des étoffes coptes*. Paris, 1964.

Duffy 1999. John Duffy. "Embellishing the Steps: Elements of Presentation and Style in The Heavenly Ladder of John Climacus." *Dumbarton Oaks Papers* 53 (1999), pp. 1–17.

Dunbabin 1978. Katherine M. D. Dunbabin. *The Mosaics of Roman North Africa: Studies in Iconography and Patronage*. Oxford, 1978.

Dunbabin 1999. Katherine M. D. Dunbabin. *Mosaics of the Greek and Roman World*. Cambridge, 1999.

J. Durand 1992. Jannic Durand, ed. *Byzance: L'art byzantin dans les collections publiques françaises*. Exh. cat. Paris, 1992.

J. Durand 1999. Jannic Durand. *Byzantine Art*. Paris, 1999.

M. Durand and Rettig 2002. Maximilien Durand and Simon Rettig. "Un atelier sous contrôle califal identifié dans le Fayoum: Le tiraz privé de Tutun." In *Égypte, la trame de l'histoire: Textiles pharaoniques, coptes et islamiques*, edited by Maximilien Durand and Florence Saragoza, pp. 167–70. Exh. cat. Paris, 2002.

M. Durand and Saragoza 2002. Maximilien Durand and Florence Saragoza, eds. *Égypte, la trame de l'histoire: Textiles pharaoniques, coptes et islamiques*. Exh. cat. Paris, 2002.

Dussaud 1912. René Dussaud. *Les monuments palestiniens et judaïques*. Paris, 1912.

Dutton 1999. Yasin Dutton. "Red Dots, Green Dots, Yellow Dots and Blue: Some Reflections on the Vocalisation of Early Qur'anic Manuscripts. Part I." *Journal of Qur'anic Studies* 1 (1999), pp. 115–40.

Dutton 2000. Yasin Dutton. "Red Dots, Green Dots, Yellow Dots and Blue: Some Reflections on the

Vocalisation of Early Qur'anic Manuscripts. Part 2." *Journal of Qur'anic Studies* 2 (2000), pp. 1–24.

Dutton 2007. Yasin Dutton. "An Umayyad Fragment of the Qur'an and Its Dating." *Journal of Qur'anic Studies* 9 (2007), pp. 57–87.

Duval 1974. Noël Duval. "Le dossier de l'église d'El Moussat (au sud-ouest de Sfax, Tunisie)." *Antiquités Africaines* 8 (1974), pp. 157–73.

Duval 2003a. Noël Duval. "Architecture et liturgie dans la Jordanie byzantine." In *Les églises de Jordanie et leurs mosaïques*, edited by Noël Duval, pp. 35–114. Beirut, 2003.

Duval 2003b. Noël Duval. "Les représentations architecturales sur les mosaïques chrétiennes de Jordanie." In *Les églises de Jordanie et leurs mosaïques*, edited by Noël Duval, pp. 211–85. Beirut, 2003.

Eastmond 1999. Antony Eastmond. "Body vs. Column: The Cults of St. Symeon Stylites." In *Desire and Denial in Byzantium*, edited by Liz James, pp. 87–100. Aldershot, 1999.

Eastmond 2008. Antony Eastmond. "Art and the Periphery." In *The Oxford Handbook of Byzantine Studies*, edited by Elizabeth Jeffreys et al., pp. 770–76. New York, 2008.

Effenberger 2000. Arne Effenberger, ed. *Konstantinopel: Scultura bizantina dai Musei di Berlino*. Exh. cat. Ravenna, 2000.

Effenberger 2008. Arne Effenberger. *Das Museum für Byzantinische Kunst im Bode-Museum*. Munich, 2008.

Effenberger and Severin 1992. Arne Effenberger and Hans-Georg Severin. *Das Museum für Spätantike und Byzantinische Kunst*. Berlin, 1992.

Eisen 1927. Gustav A. Eisen. *Glass: Its Origin, History, Chronology, Technic and Classification to the Sixteenth Century*. 2 vols. New York, 1927.

El-Cheikh 2004. Nadia Maria El-Cheikh. *Byzantium Viewed by the Arabs*. Cambridge, Mass., 2004.

Elad 1992. Amikam Elad. "Why Did 'Abd al-Malik Build the Dome of the Rock? A Re-examination of the Muslim Sources." In *Bayt al-Maqdis*, vol. 1, *'Abd al-Malik's Jerusalem*, edited by Julian Raby and Jeremy Johns, pp. 33–58. Oxford, 1992.

Elad 1995. Amikam Elad. *Medieval Jerusalem and Islamic Worship: Holy Places, Ceremonies, Pilgrimage*. Leiden, 1995.

Elad 2002. Amikam Elad. "Community of Believers of 'Holy Men' and 'Saints' or Community of Muslims? The Rise and Development of Early Muslim Historiography." *Semitic Studies* 47, no. 2 (2002), pp. 241–308.

Elbern 1965. Victor H. Elbern. "Eine frühbyzantinische Reliefdarstellung des älteren Symeon Stylites." *Jahrbuch des Deutschen Archäologischen Instituts* 80 (1965), pp. 280–304.

Elbern 2004. Victor H. Elbern. "Zehn Kelche und eine Taube: Bemerkungen zum liturgischen Schatzfund von Attarouhti." *Oriens Christianus* 88 (2004), pp. 233–53.

Elsner 1997. Jaś Elsner. "Replicating Palestine and Reversing the Reformation: Pilgrimage and Collecting at Bobbio, Monza and Walsingham." *Journal of the History of Collections* 9, no. 1 (1997), pp. 117–30.

Elsner 2002. Jaś Elsner. "The Birth of Late Antiquity: Riegl and Strzygowski in 1901." *Art History* 25 (2002), pp. 358–79.

Enderlein and Meinecke 1992. Volkmar Enderlein and Michael Meinecke. "Graben–Forschen–Präsentieren: Probleme der Darstellung vergangener Kulturen am Beispiel der Mschatta-Fassade." *Jahrbuch der Berliner Museen* 34 (1992), pp. 137–72.

Enderlein et al. 2001. Volkmar Enderlein et al. *Museum für Islamische Kunst: Staatliche Museen zu Berlin Preussischer Kulturbesitz*. Mainz, 2001.

Engemann 1986. Josef Engemann. "Zur Position von Sonne und Mond bei Darstellungen der Kreuzigung Christi." In *Studien zur spätantiken und byzantinischen Kunst*, edited by Otto Feld and Urs Peschlow, pp. 95–101. Bonn, 1986.

Enss 2005. Elisabeth Enss. *Holzschnitzereien der spätantiken bis frühislamischen Zeit aus Ägypten*. Wiesbaden, 2005.

Entwistle 2003. Chris Entwistle. "Lay Not Up for Yourselves Treasures upon Earth: The British Museum and the Second Cyprus Treasure." In *Through a Glass Brightly: Studies in Byzantine and Medieval Art and Archaeology Presented to David Buckton*, edited by Chris Entwistle, pp. 226–35. Oxford, 2003.

Entwistle and Adams 2010. Chris Entwistle and Noël Adams, eds. *Intelligible Beauty: Recent Research on Byzantine Jewellery*. London, 2010.

Erder 2003. Yoram Erder. "The Mourners of Zion." In *Karaite Judaism: A Guide to Its History and Literary Sources*, edited by Meira Polliack, pp. 213–35. Leiden, 2003.

Errera 1907. Isabelle Errera. *Catalogue d'étoffes anciennes et modernes*. 2d ed. Brussels, 1907.

Ettinghausen 1972. Richard Ettinghausen. *From Byzantium to Sasanian Iran and the Islamic World: Three Modes of Artistic Influence*. Leiden, 1972.

Ettinghausen 1977. Richard Ettinghausen. *La peinture arabe*. New ed. Geneva, 1977.

Ettinghausen 1979. Richard Ettinghausen. "The Taming of the Horror Vacui in Islamic Art." *Proceedings of the American Philosophical Society* 123 (February 20, 1979), pp. 15–28.

Ettinghausen 2007. Richard Ettinghausen. "Dionysiac Motifs." In *Late Antique and Medieval Art of the Mediterranean World*, edited by Eva R. Hoffman, pp. 47–59. Malden, Mass., 2007.

Ettinghausen et al. 2001. Richard Ettinghausen, Oleg Grabar, and Marilyn Jenkins-Madina. *Islamic Art and Architecture, 650–1250*. New Haven, 2001.

Eugenidou and Albani 2002. Despoina Eugenidou and Jenny Albani, eds. *Byzantium: An Oecumenical Empire*. Exh. cat. Athens, 2002.

Eusebius 2004. Eusebius of Caesarea. *Onomasticon: The Place Names of Divine Scripture*. Translated and edited by R. Steven Notley and Zeev Safrai. Leiden, 2004.

Eutychios 2010. Eutychios of Alexandria. "*Annals*: On Justinian's Constructions at Mount Sinai." Translated by Daniel Caner in *History and Hagiography from the Late Antique Sinai*. Liverpool, 2010.

Evangelatou 2005. Maria Evangelatou. "The Symbolism of the Censer in Byzantine Representations of the Dormition of the Virgin." In *Images of the Mother of God: Perceptions of the Theotokos in Byzantium*, edited by Maria Vasilakē, pp. 117–31. Aldershot, 2005.

Evans 1982. Helen C. Evans. "Nonclassical Sources for the Armenian Mosaic near the Damascus Gate in Jerusalem." In *East of Byzantium: Syria and Armenia in the Formative Period*, edited by Nina G. Garsoïan et al., pp. 217–22. Washington, D.C., 1982.

Evans 2004. Helen C. Evans, ed. *Byzantium: Faith and Power (1261–1557)*. Exh. cat. New York, 2004.

Evans and Wixom 1997. Helen C. Evans and William D. Wixom, eds. *The Glory of Byzantium: Art and Culture of the Middle Byzantine Era, A.D. 843–1261*. Exh. cat. New York, 1997.

Evans et al. 2001. Helen C. Evans, Melanie Holcomb, and Robert Hallman. "The Arts of Byzantium." *Metropolitan Museum of Art Bulletin* 58 (Spring 2001).

Falk 1985. Toby Falk, ed. *Treasures of Islam*. Exh. cat. London, 1985.

Fansa and Bollmann 2008. Mamoun Fansa and Beate Bollmann, eds. *Die Kunst der frühen Christen in Syrien: Zeichen, Bilder und Symbole vom 4. bis 7. Jahrhundert*. Exh. cat. Mainz, 2008.

Fantoni and Crinelli 1997. Anna Rita Fantoni and Lorenzo Crinelli, eds. *Treasures from the Italian Libraries*. London, 1997.

Faraone forthcoming. Christopher A. Faraone. "Text, Image, and Medium: The Evolution of Greco-Roman Magical Gemstones." In *Recent Research on Engraved Gemstones in Late Antiquity: A Conference Held at the British Museum, May 28–30, 2009*. Forthcoming.

Faris 1938. Nabih Faris. "Kufic Inscriptions." In *Antioch-on-the-Orontes*, vol. 2, *The Excavations 1933–1936*, edited by Richard Stillwell, pp. 166–69. Princeton, 1938.

Féhervári 1976. Géza Féhervári. *Islamic Metalwork of the Eighth to the Fifteenth Century in the Keir Collection*. London, 1976.

Féhervári 2000. Géza Féhervári. *Ceramics of the Islamic World in the Tareq Rajab Museum*. New York, 2000.

Fine 1996. Steven Fine, ed. *Sacred Realm: The Emergence of the Synagogue in the Ancient World*. Exh. cat. New York, 1996.

Fine 1997. Steven Fine. *This Holy Place: On the Sanctity of the Synagogue during the Greco-Roman Period*. Notre Dame, 1997.

Fine 1998. Steven Fine. "'Chancel' Screens in Late Antique Palestinian Synagogues: A Source from the Cairo Genizah." In *Religious and Ethnic Communities in Later Roman Palestine*, edited by Hayim Lapin, pp. 67–85. Potomac, Md., 1998.

Fine 1999. Steven Fine. "Non-Jews in the Synagogues of Late-Antique Palestine: Rabbinic and Archeological Evidence." In *Jews, Christians, and Polytheists in the Ancient Synagogue: Cultural Interaction during the Greco-Roman Period*, edited by Steven Fine, pp. 198–214. London, 1999.

Fine 2000. Steven Fine. "Iconoclasm and the Art of Late-Antique Palestinian Synagogues." In *From Dura to Sepphoris: Studies in Jewish Art and Society in Late Antiquity*, edited by Lee I. Levine and Zeev Weiss, pp. 183–94. Portsmouth, R.I., 2000.

Fine 2005. Steven Fine. *Art and Judaism in the Greco-Roman World: Toward a New Jewish Archaeology*. Cambridge, 2005.

Fine 2006. Steven Fine. "Archaeology and the Interpretation of Rabbinic Literature." In *How Should Rabbinic Literature Be Read in the Modern World?*, edited by Matthew Kraus, pp. 199–217. Piscataway, N.J., 2006.

Fine 2010. Steven Fine. *Art and Judaism in the Greco-Roman World: Toward a New Jewish Archaeology*. Rev. ed. Cambridge, 2010.

Finster 1970–71. Barbara Finster. "Die Mosaiken der Umayyadenmoschee von Damaskus." *Kunst des Orients* 7 (1970–71), pp. 83–141.

Finster 1996. Barbara Finster. "Arabien in der Spätantike." *Archäologischer Anzeiger* 2 (1996), pp. 287–319.

Finster 2010. Barbara Finster. "Arabia in Late Antiquity: An Outline of the Cultural Situation in the Peninsula at the Time of Muhammad." In *The Qur'an in Context: Historical and Literary Investigations into the Qur'anic Milieu*, edited by Angelika Neuwirth et al., pp. 61–114. Leiden, 2010.

Fıratlı 1990. Nezih Fıratlı. *La sculpture byzantine figurée au Musée Archéologique d'Istanbul.* Paris, 1990.

Flood 1997. Finbarr Barry Flood. "Umayyad Survivals and Mamluk Revivals: Qalawunid Architecture and the Great Mosque of Damascus." *Muqarnas* 14 (1997), pp. 57–79.

Flood 1999. Finbarr B. Flood. "Light in Stone: The Commemoration of the Prophet in Umayyad Architecture." In *Bayt al-Maqdis*, vol. 2, *Jerusalem and Early Islam*, edited by Jeremy Johns, pp. 311–59. Oxford, 1999.

Flood 2001. Finbarr Barry Flood. *The Great Mosque of Damascus: Studies on the Makings of an Umayyad Visual Culture.* Leiden, 2001.

Flood 2006. Finbarr B. Flood. "Image against Nature: Spolia as Apotropaia in Byzantium and the Dar al-Islam." *Medieval History Journal* 9 (2006), pp. 143–66.

Flood 2009. Finbarr B. Flood. "Review of Oleg Grabar, The Dome of the Rock (Cambridge 2006)." *Journal of Palestine Studies* 38, no. 4 (2009), pp. 113–15.

Flood forthcoming. Finbarr B. Flood. *Islam and Image: Paradoxical Histories.* London, forthcoming.

Flood et al. 2010. Finbarr Barry Flood, David Joselit, Alexander Nagel, Alessandra Russo, Eugene Wang, Christopher Wood, and Mimi Yiengpruksawan. "Roundtable: The Global before Globalization." *October* 133 (Summer 2010), pp. 3–19.

Fluck 1996. Cäcilia Fluck. "Koptische Textilien mit Inschriften in Berlin—1. Teil." *Bulletin de la Société d'Archéologie Copte* 35 (1996), pp. 161–72.

Fluck 1997. Cäcilia Fluck. "Koptische Textilien mit Inschriften in Berlin—Teil II." *Bulletin de la Société d'Archéologie Copte* 36 (1997), pp. 59–70.

Fluck 2004. Cäcilia Fluck. "Zwei Reitermäntel aus Antinoopolis im Museum für Byzantinische Kunst, Berlin: Fundkontext und Beschreibung." In *Riding Costume in Egypt: Origin and Appearance*, edited by Cäcilia Fluck and Gillian Vogelsang-Eastwood, pp. 137–52. Leiden, 2004.

Fluck 2006. Cäcilia Fluck. "'Denkt liebevoll an mich . . .': Textilien mit Inschriften im Museum für Byzantinische Kunst, Berlin." In *Textile Messages: Inscribed Fabrics from Roman to Abbasid Egypt*, edited by Cäcilia Fluck and Gisela Helmecke, pp. 151–71. Leiden, 2006.

Fluck 2008. Cäcilia Fluck. "Akhmim as a Source of Textiles." In *Christianity and Monasticism in Upper Egypt*, vol. 1, *Akhmim and Sohag*, edited by Gawdat Gabra and Hany N. Takla, pp. 211–23. Cairo, 2008.

Fluck 2010. Cäcilia Fluck. "Kinderkleidung im römischen und spätantiken Ägypten: Ein Projekt der DressID Studien Gruppe C: 'Gender and Age.'" *Mitteilungen der Anthropologischen Gesellschaft in Wien* 140 (2010), pp. 177–87.

Fluck and Finneiser 2009. Cäcilia Fluck and Klaus Finneiser. *Kindheit am Nil: Spielzeug, Kleidung, Kinderbilder aus Ägypten in den Staatlichen Museen zu Berlin.* Exh. cat. Berlin, 2009.

Fluck and Helmecke 2006. Cäcilia Fluck and Gisela Helmecke. "Introduction." In *Textile Messages: Inscribed Fabrics from Roman to Abbasid Egypt*, edited by Cäcilia Fluck and Gisela Helmecke, pp. xiii–xxii. Leiden, 2006.

Fluck and Helmecke 2012. Cäcilia Fluck and Gisela Helmecke. "Egypt's Post-Pharaonic Textiles." In *Coptic Civilization*, edited by Gawdat Gabra. Cairo, 2012.

Fluck and Mälck 2007. Cäcilia Fluck and Kathrin Mälck. "Radiocarbon Analysed Textiles in the Skulpturensammlung und Museum für Byzantinische Kunst, Berlin." In *Methods of Dating Ancient Textiles of the 1st Millennium AD from Egypt and Neighbouring Countries*, edited by Antoine De Moor and Cäcilia Fluck, pp. 150–66. Tielt, 2007.

Fluck and Vogelsang-Eastwood 2004. Cäcilia Fluck and Gillian M. Vogelsang-Eastwood, eds. *Riding Costume in Egypt: Origin and Appearance.* Leiden, 2004.

Fluck et al. 2000. Cäcilia Fluck, Petra Linscheid, and Susanne Merz. *Textilien aus Ägypten*, vol. 1, *Textilien aus dem Vorbesitz von Theodor Graf, Carl Schmidt und dem Ägyptischen Museum Berlin.* Wiesbaden, 2000.

Flury 1913. Samuel Flury. "Samarra und die Ornamentik der Moschee des Ibn Tulun." *Der Islam* 4 (1913), pp. 421–32.

Foerster 1993. G. Foerster. "The Synagogue at Tell es-Sultan." In *The New Encyclopedia of Archaeological Excavations in the Holy Land*, edited by Ephraim Stern, vol. 2, pp. 698–99. New York, 1993.

Foote 1999. Rebecca M. Foote. "Frescoes and Carved Ivory from the Abbasid Family Homestead at Humeima." *Journal of Roman Archaeology* 12 (1999), pp. 423–28.

Foote 2000. Rebecca M. Foote. "Commerce, Industrial Expansion, and Orthogonal Planning: Mutually Compatible Terms in Settlements of Bilad al-Sham during the Umayyad Period." *Mediterranean Archeology* 13 (2000), pp. 25–38.

Forrer 1891a. Robert Forrer. *Die Graeber- und Textilfunde von Achim-Panopolis.* Strassburg, 1891.

Forrer 1891b. Robert Forrer. *Römische und byzantinische Seiden-Textilien aus dem Gräber-Felde vom Achmim-Panopolis.* Strassburg, 1891.

Forsyth 1968. William H. Forsyth. "Reports of the Departments, Medieval Art and The Cloisters: The Main Building." *Metropolitan Museum of Art Bulletin* 27 (October 1968), pp. 112–13.

Foss 1997. Clive Foss. "Syria in Transition, AD 550–750: An Archaeological Approach." *Dumbarton Oaks Papers* 51 (1997), pp. 189–269.

Foss 2002. Clive Foss. "A Syrian Coinage of Mu'awiya?" *Revue Numismatique* 158 (2002), pp. 353–65.

Foss 2007. Clive Foss. "Byzantine Saints in Early Islamic Syria." *Analecta Bollandiana* 125 (2007), pp. 93–119.

Foss 2008. Clive Foss. *Arab-Byzantine Coins: An Introduction, with a Catalogue of the Dumbarton Oaks Collection.* Washington, D.C., 2008.

Fournet 1993. Jean-Luc Fournet. "L'inscription grecque de l'église al-Mu'allaqa: Quelques corrections." *Bulletin de l'Institut Français d'Archéologie Orientale* 93 (1993), pp. 237–44.

Fowden 1993. Garth Fowden. *Empire to Commonwealth: Consequences of Monotheism in Late Antiquity.* Princeton, 1993.

Fowden 1999. Garth Fowden. "Religious Communities." In *Late Antiquity: A Guide to the Postclassical World*, edited by Glen W. Bowersock et al., pp. 82–106. Cambridge, Mass., 1999.

Fowden 2004a. Garth Fowden. "Late-Antique Art in Syria and Its Umayyad Evolutions." *Journal of Roman Archaeology* 17 (2004), pp. 282–304.

Fowden 2004b. Garth Fowden. *Qusayr 'Amra: Art and the Umayyad Elite in Late Antique Syria.* Berkeley, 2004.

Fowden 2010. Garth Fowden. "Review of Zbigniew T. Fiema and Jaakko Frösén, Petra, the Mountain of Aaron. The Finnish Archaeological Project in Jordan. Volume I: The Church and the Chapel." *The Classical Review* 60, no. 2 (2010), pp. 566–68.

Frank 2000. Georgia Frank. *The Memory of the Eyes: Pilgrims to Living Saints in Christian Late Antiquity.* Berkeley, 2000.

Frank 2006. Georgia Frank. "Loca Sancta Souvenirs and the Art of Memory." In *Pèlerinages et lieux saints dans l'antiquité et le moyen âge: Mélanges offerts à Pierre Maraval*, edited by Béatrice Caseau et al., pp. 193–201. Paris, 2006.

Frankfurter 2008. David Frankfurter. "Iconoclasm and Christianization in Late Antique Egypt: Christian Treatments of Space and Image." In *From Temple to Church: Destruction and Renewal of Local Cultic Topography in Late Antiquity*, edited by Johannes Hahn et al., pp. 135–60. Leiden, 2008.

Franklin 2001. Arnold E. Franklin. "Shoots of David: Members of the Exilarchal Dynasty in the Middle Ages." Ph.D. diss., Princeton University, 2001.

Fraser and Kwiatkowski 2006. Marcus Fraser and Will Kwiatkowski. *Ink and Gold: Islamic Calligraphy.* Exh. cat. London, 2006.

Frazer 1975. Margaret E. Frazer. "Pilgrim's Flask." In *The Metropolitan Museum of Art: Notable Acquisitions, 1965–1975*, p. 160. New York, 1975.

Freshfield 1938. Edwin Hanson Freshfield. *Roman Law in the Later Roman Empire: Byzantine Guilds, Professional and Commercial; Ordinances of Leo VI, c. 895, from The Book of the Eparch.* Cambridge, 1938.

Friedländer 1912. Paul Friedländer, ed. *Johannes von Gaza und Paulus Silentiarius: Kunstbeschreibungen Justinianischer Zeit.* Leipzig, 1912.

Friedman 1989. Florence D. Friedman. *Beyond the Pharaohs: Egypt and the Copts in the 2nd to 7th Centuries A.D.* Exh. cat. Providence, R.I., 1989.

Frings 2010. Jutta Frings, ed. *Byzanz: Pracht und Alltag.* Exh. cat. Bonn, 2010.

Froschauer 2006. Harald Froschauer. "Koptische Textilien mit Inschriften in der Papyrussammlung der Österreichischen Nationalbibliothek." In *Textile Messages: Inscribed Fabrics from Roman to Abbasid Egypt*, edited by Cäcilia Fluck and Gisela Helmecke, pp. 131–50. Leiden, 2006.

Fulghum 2001–2. Mary Margaret Fulghum. "Under Wraps: Byzantine Textiles as Major and Minor Arts." *Studies in the Decorative Arts* 9 (Fall–Winter 2001–2), pp. 13–33.

Gaborit-Chopin 2003. Danielle Gaborit-Chopin. *Ivoires médiévaux: Ve–XVe siècle.* Paris, 2003.

Gabra 2003. Gawdat Gabra. "Die Münzschätze aus dem Schenute-Kloster bei Sohag." In *Ägypten–Münster: Kulturwissenschaftliche Studien zu Ägypten, dem Vorderen Orient und verwandten Gebieten*, edited by Anke Ilona Blöbaum et al., pp. 125–28. Wiesbaden, 2003.

Gabra and Eaton-Krauss 2006. Gawdat Gabra and Marianne Eaton-Krauss. *The Treasures of Coptic Art in the Coptic Museum and Churches of Old Cairo.* Cairo, 2006.

Gabra and Eaton-Krauss 2007. Gawdat Gabra and Marianne Eaton-Krauss. *The Illustrated Guide to the Coptic Museum and Churches of Old Cairo.* Cairo, 2007.

Garbsch 1988a. Jochen Garbsch. "Waagen der Antike." *Mitteilungen der Freunde der Bayerischen Vor- und Frühgeschichte* 46 (1988), pp. 1–7.

Garbsch 1988b. Jochen Garbsch. "Wagen oder Waagen?" *Bayerische Vorgeschichtsblätter* 53 (1988), pp. 191–222.

Garnsey and Whittaker 1998. Peter Garnsey and C. R. Whittaker. "Trade, Industry, and the Urban Economy." In *The Cambridge Ancient History*, vol. 13, *The Late Empire, A.D. 337–425*, edited by Averil Cameron and Peter Garnsey, pp. 312–37. Cambridge, 1998.

Gasparri 1986. Carlo Gasparri. "Dionysos." In *Lexicon Iconographicum Mythologiae Classicae*, vol. 3.1, cols. 414–566. Zürich, 1986.

Gaster 1901. Moses Gaster. *Hebrew Illuminated Bibles of the IXth and Xth Centuries . . . and a Samaritan Scroll of the Law of the XIth Century*. London, 1901.

Gayet 1900. Albert Gayet. *Le costume en Égypte: Du IIIe au XIIIe siècle*. Exh. cat. Paris, 1900.

Gayo and Arteaga 2005. Lola Gayo and Ángela Arteaga. "Analisis de colorantes de un grupo de tejidos hispanomusulmanes." *Bienes Culturales*, no. 5 (2005), pp. 123–35.

Gell 1992. Alfred Gell. "The Technology of Enchantment and the Enchantment of Technology." In *Anthropology, Art, and Aesthetics*, edited by Jeremy Coote and Anthony Shelton, pp. 40–63. Oxford, 1992.

Genequand 2004a. Denis Genequand. "Al-Bakhra' (Avatha), from the Tetrarchic Fort to the Umayyad Castle." *Levant* 36 (2004), pp. 225–42.

Genequand 2004b. Denis Genequand. "Châteaux omeyyades de la Palmyrène." *Annales Islamologiques* 38 (2004), pp. 3–44.

Genequand 2006a. Denis Genequand. "Some Thoughts on Qasr al-Hayr al-Ghabri, Its Dam, Its Monastery and the Ghassanids." *Levant* 38 (2006), pp. 63–84.

Genequand 2006b. Denis Genequand. "Umayyad Castles: The Shift from Late Antique Military Architecture to Early Islamic Palatial Building." In *Muslim Military Architecture in Greater Syria: From the Coming of Islam to the Ottoman Period*, edited by Hugh Kennedy, pp. 3–25. Leiden, 2006.

Genequand 2009. Denis Genequand. "Économie de production, affirmation du pouvoir et dolce vita: Aspects de la politique de l'eau sous les Omeyyades au Bilad al-Sham." In *Stratégies d'acquisition de l'eau et société au Moyen-Orient depuis l'Antiquité*, edited by Michel Mouton and Mohamed Al-Dbiyat, pp. 155–77. Beirut, 2009.

Georganteli and Cook 2006. Eurydice Georganteli and Barrie Cook. *Encounters: Travel and Money in the Byzantine World*. Exh. cat. London, 2006.

George 2003. Alain George. "The Geometry of the Qur'an of Amajur: A Preliminary Study of Proportion in Early Arabic Calligraphy." *Muqarnas* 20 (2003), pp. 1–15.

George 2009. Alain George. "Calligraphy, Colour and Light in the Blue Qur'an." *Journal of Qur'anic Studies* 11 (2009), pp. 75–125.

George 2010. Alain George. *The Rise of Islamic Calligraphy*. London, 2010.

Gerard et al. 1997. Martine Gerard, Catherine Metzger, Alain Person, and Jean-Pierre Sodini. "Argiles et eulogies en forme de jetons: Qal'at Sem'an en est-il une source possible?" In *Materials Analysis of Byzantine Pottery*, edited by Henry Maguire, pp. 9–24. Washington, D.C., 1997.

Gerasa 2010. "A Floor Mosaic from Gerasa." *Yale University Art Gallery Bulletin* (2010), pp. 81–83.

Gerhards 1984. Albert Gerhards. *Die griechische Gregoriosanaphora: Ein Beitrag zur Geschichte des Eucharistischen Hochgebets*. Münster, 1984.

Gerhards 1994. Albert Gerhards. "'Meine Natur hast Du in Dir gesegnet': Zur Gestalt, Theologie und Spiritualität der koptischen Eucharistiefeier, besonders des Eucharistischen Hochgebets." In *Die koptische Kirche: Einführung in das ägyptische Christentum*, edited by Albert Gerhards and Heinzgerd Brakmann, pp. 46–64. Stuttgart, 1994.

Gero 1992. Stephen Gero. "The Legend of the Monk Bahiira, the Cult of the Cross and Iconoclasm." In *La Syrie de Byzance à l'Islam*, edited by Pierre Canivet and Jean-Paul Rey-Coquais, pp. 47–58. Damascus, 1992.

Gero 1993. Stephen Gero. "The Legend of Alexander the Great in the Christian Orient." *Bulletin of the John Rylands University Library* 75 (1993), pp. 3–9.

Ghirshman 1948. Roman Ghirshman. "Études iraniennes, II: Un ossuaire en pierre sculptée." *Artibus Asiae* 11 (1948), pp. 292–310.

Ghirshman 1962. Roman Ghirshman. *Persian Art: The Parthian and Sasanian Dynasties*. New York, 1962.

Giannichedda 2007. Enrico Giannichedda. "Metal Production in Late Antiquity: From Continuity of Knowledge to Changes in Consumption." In *Technology in Transition, A.D. 300–650*, edited by Luke Lavan et al., pp. 187–209. Leiden, 2007.

Gignac 1975. Francis T. Gignac. "A Sixth Century Letter in the Michigan Collection." *Zeitschrift für Papyrologie und Epigraphik* 17 (1975), pp. 10–14.

Gil 1992. Moshe Gil. *A History of Palestine, 634–1099*. Cambridge, 1992.

Gilliot 2008. Claude Gilliot. "Origines et fixation du texte coranique." *Études* 409, no. 6 (2008), pp. 643–52.

Göbl 1968. Robert Göbl. *Sasanidische Numismatik*. Braunschweig, 1968.

Godart 2009. Louis Godart, ed. *Giordania: Crocevia di popoli e di culture*. Exh. cat. Rome, 2009.

Goitein 1950. S. D. Goitein. "The Historical Background to the Erection of the Dome of the Rock." *Journal of the American Oriental Society* 70, no. 2 (1950), pp. 104–8.

Goitein 1967. S. D. Goitein. *A Mediterranean Society: The Jewish Communities of the Arab World as Portrayed in the Documents of the Cairo Geniza*, vol. 1, *Economic Foundation*. Berkeley, 1967.

Goitein 1983. S. D. Goitein. *A Mediterranean Society: The Jewish Communities of the World as Portrayed in the Documents of the Cairo Geniza*, vol. 4, *Daily Life*. Berkeley, 1983.

Goldschmidt and Weitzmann 1930–34. Adolph Goldschmidt and Kurt Weitzmann. *Die byzantinischen Elfenbeinskulpturen des X.–XIII. Jahrhunderts*. 2 vols. Berlin, 1930–34.

Goldstein 2005. Sidney M. Goldstein. *Glass: From Sassanian Antecedents to European Imitations*. London, 2005.

Golombek 1988. Lisa Golombek. "The Draped Universe of Islam." In *Content and Context of Visual Arts in the Islamic World*, edited by Priscilla P. Soucek, pp. 25–49. University Park, Pa., 1988.

Gonnella 2010. Julia Gonnella. "Columns and Hieroglyphs: Magic Spolia in Medieval Islamic Architecture of Northern Syria." *Muqarnas* 27 (2010), pp. 103–20.

Gonosová 1987. Anna Gonosová. "The Formation and Sources of Early Byzantine Floral Semis and Floral Diaper Patterns Reexamined." In *Studies on Art and Archaeology in Honor of Ernst Kitzinger on His Seventy-Fifth Birthday*, edited by William Tronzo and Irving Lavin, pp. 227–37. Washington, D.C., 1987.

Gonosová 1990. Anna Gonosová. "On the Alexandrian Origin of the Vatican Annunciation and Nativity Silks." In *Sixteenth Annual Byzantine Studies Conference, Abstracts of Papers*, pp. 9–10. Baltimore, 1990.

Gonosová 1991. Anna Gonosová. "Blattion." In *The Oxford Dictionary of Byzantium*, edited by Alexander P. Kazhdan et al., vol. 1, p. 296. New York, 1991.

Gonosová 2007. Anna Gonosová. "Exotic Taste: The Lure of Sasanian Persia." In *Late Antique and Medieval Art of the Mediterranean World*, edited by Eva R. Hoffman, pp. 40–46. Malden, Mass., 2007.

Gonosová and Ševčenko 1991. Anna Gonosová and Nancy Patterson Ševčenko. "Silk." In *The Oxford Dictionary of Byzantium*, edited by Alexander P. Kazhdan et al., vol. 3, pp. 1896–97. New York, 1991.

Goodwin 2005. Tony Goodwin. *Arab-Byzantine Coinage*. London, 2005.

Gousset 1982. Marie-Thérèse Gousset. "Un aspect du symbolisme des encensoirs romans: La Jérusalem Céleste." *Cahiers Archéologiques* 30 (1982), pp. 81–106.

A. Grabar 1958. André Grabar. *Les ampoules de Terre Sainte*. Paris, 1958.

A. Grabar 1966. André Grabar. *The Golden Age of Justinian*. New York, 1966.

A. Grabar 1967. André Grabar. *The Golden Age of Justinian: From the Death of Theodosius to the Rise of Islam*. New York, 1967.

A. Grabar 1972. André Grabar. *Les manuscrits grecs enluminés de provenance italienne, IXe–XIe siècles*. Paris, 1972.

O. Grabar 1959. Oleg Grabar. "The Umayyad Dome of the Rock in Jerusalem." *Ars Orientalis* 3 (1959), pp. 33–62.

O. Grabar 1964. Oleg Grabar. "Islamic Art and Byzantium." *Dumbarton Oaks Papers* 18 (1964), pp. 67–88.

O. Grabar 1967. Oleg Grabar. "An Introduction to the Art of Sasanian Silver." In *Sasanian Silver: Late Antique and Early Mediaeval Arts of Luxury from Iran*, pp. 60–67. Exh. cat. Ann Arbor, 1967.

O. Grabar 1968. Oleg Grabar. "La grande mosquée de Damas et les origines architecturales de la Mosquée." In *Synthronon: Art et archéologie de la fin de l'Antiquité et du Moyen Âge*, pp. 107–14. Paris, 1968.

O. Grabar 1973. Oleg Grabar. *The Formation of Islamic Art*. New Haven, 1973.

O. Grabar 1982. Oleg Grabar. "Trade with the East and the Influence of Islamic Art on the 'Luxury Arts' in the West." In *Il Medio Oriente e l'Occidente nell'arte del XIII Secolo*, edited by Hans Belting, pp. 27–32. Bologna, 1982.

O. Grabar 1987a. Oleg Grabar. "The Date and Meaning of Mshatta." *Dumbarton Oaks Papers* 41 (1987), pp. 243–47.

O. Grabar 1987b. Oleg Grabar. *The Formation of Islamic Art*. Rev. and enl. ed. New Haven, 1987.

O. Grabar 1992a. Oleg Grabar. "L'art omeyyade en Syrie, source de l'art islamique." In *La Syrie de Byzance à l'Islam*, edited by Pierre Canivet and Jean-Paul Rey-Coquais, pp. 187–93. Damascus, 1992.

O. Grabar 1992b. Oleg Grabar. *The Mediation of Ornament*. Princeton, 1992.

O. Grabar 1996. Oleg Grabar. *The Shape of the Holy: Early Islamic Jerusalem.* Princeton, 1996.

O. Grabar 1997. Oleg Grabar. "The Shared Culture of Objects." In *Byzantine Court Culture from 829 to 1204,* edited by Henry Maguire, pp. 115–29. Washington, D.C., 1997.

O. Grabar 2006. Oleg Grabar. *The Dome of the Rock.* Cambridge, Mass., 2006.

O. Grabar 2008. Oleg Grabar. "Umayyad Art: Late Antique or Early Islamic?" In *Residences, Castles, Settlements: Transformation Processes from Late Antiquity to Early Islam in Bilad al-Sham,* edited by Karin Bartl and Abd al-Razzaq Moaz, pp. 1–12. Rahden, 2008.

O. Grabar et al. 1978. Oleg Grabar et al. *City in the Desert: Qasr al-Hayr East.* 2 vols. Cambridge, Mass., 1978.

Graeven 1899. Hans Graeven. "Der heilige Markus in Rom und in der Pentapolis." *Römische Quartalschrift* 13 (1899), pp. 109–26.

D. Graf 1999. David Graf. "Silk." In *Late Antiquity: A Guide to the Postclassical World,* edited by Glen W. Bowersock et al., pp. 695–96. Cambridge, Mass., 1999.

G. Graf 1944–53. Georg Graf. *Geschichte der christlichen arabischen Literatur.* 5 vols. Vatican City, 1944–53.

Gray 2005. Patrick T. R. Gray. "The Legacy of Chalcedon: Christological Problems and Their Significance." In *The Cambridge Companion to the Age of Justinian,* edited by Michael Maas, pp. 215–38. Cambridge, 2005.

***Greek Treasures* 2004.** *Hoi Hellēnikoi thesauroi = The Greek Treasures / Mouseio Hermitaz tēs Hagias Petroupolēs = The Hermitage Museum of Saint Petersburg.* Athens, 2004.

Greenfield 1978. Jonas C. Greenfield. "The Languages of Palestine, 200 B.C.E.–200 C.E." In *Jewish Languages: Theme and Variation,* edited by Herbert H. Paper, pp. 143–54. Cambridge, Mass., 1978.

Gregory 1991a. Timothy E. Gregory. "Alexandrian School." In *The Oxford Dictionary of Byzantium,* edited by Alexander P. Kazhdan et al., vol. 1, p. 62. New York, 1991.

Gregory 1991b. Timothy E. Gregory. "Clement of Alexandria." In *The Oxford Dictionary of Byzantium,* edited by Alexander P. Kazhdan et al., vol. 1, pp. 470–71. New York, 1991.

Gregory 1991c. Timothy E. Gregory. "Origen." In *The Oxford Dictionary of Byzantium,* edited by Alexander P. Kazhdan et al., vol. 3, p. 1534. New York, 1991.

Grierson 1968a. Philip Grierson. *Catalogue of the Byzantine Coins in the Dumbarton Oaks Collection and in the Whittemore Collection,* vol. 2, pt. 1, *Phocas to Theodosius III, 602–717: Phocas and Heraclius (602–641).* Washington, D.C., 1968.

Grierson 1968b. Philip Grierson. *Catalogue of the Byzantine Coins in the Dumbarton Oaks Collection and in the Whittemore Collection,* vol. 2, pt. 2, *Phocas to Theodosius III, 602–717: Heraclius Constantine to Theodosius III (641–717).* Washington, D.C., 1968.

Grierson 1991. Philip Grierson. "Solidus." In *The Oxford Dictionary of Byzantium,* edited by Alexander P. Kazhdan, vol. 3, p. 1924. New York, 1991.

Grierson 1999. Philip Grierson. *Byzantine Coinage.* 2nd ed. Washington, D.C., 1999.

Griffith 1988. Sidney H. Griffith. "The Monks of Palestine and the Growth of Christian Literature in Arabic." *Muslim World* 78 (1988), pp. 1–28.

Griffith 1989. Sidney H. Griffith. "Anthony David of Baghdad, Scribe and Monk of Mar Sabas: Arabic in

the Monasteries of Palestine." *Church History* 58 (March 1989), pp. 7–19.

Griffith 1992. Sidney H. Griffith. "Images, Islam and Christian Icons: A Moment in the Christian / Muslim Encounter in Early Islamic Times." In *La Syrie de Byzance à l'Islam,* edited by Pierre Canivet and Jean-Paul Rey-Coquais, pp. 121–38. Damascus, 1992.

Griffith 1997. Sidney H. Griffith. "From Aramaic to Arabic: The Languages of the Monasteries of Palestine in the Byzantine and Early Islamic Periods." *Dumbarton Oaks Papers* 51 (1997), pp. 11–31.

Griffith 2001. Sidney H. Griffith. "'Melkites,' 'Jacobites' and the Christological Controversies in Arabic in Third / Ninth-Century Syria." In *Syrian Christians under Islam: The First Thousand Years,* edited by David Thomas, pp. 9–55. Leiden, 2001.

Griffith 2007. Sidney H. Griffith. "Christians, Muslims and the Image of the One God: Iconophilia and Iconophobia in the World of Islam in Umayyad and Early Abbasid Times." In *Die Welt der Götterbilder,* edited by Brigitte Groneberg et al., pp. 347–80. Berlin, 2007.

Griffith 2008a. Sidney H. Griffith. *The Church in the Shadow of the Mosque: Christians and Muslims in the World of Islam.* Princeton, 2008.

Griffith 2008b. Sidney H. Griffith. "John of Damascus and the Church in Syria in the Umayyad Era: The Intellectual and Cultural Milieu of Orthodox Christians in the World of Islam." *Hugoye* 11, no. 2 (1998), pp. 207–237.

Griffith 2011. Sidney H. Griffith. "Images, Icons, and the Public Space in Early Islamic Times: Arab Christians and the Program to Claim the Land for Islam." In *Shaping the Middle East: Jews, Christians, and Muslims in an Age of Transition, 400–800 C.E.,* edited by Kenneth G. Holum and Hayim Lapin, pp. 197–210. Bethesda, Md., 2011.

Grimm-Stadelmann 2008. Isabel Grimm-Stadelmann. "Theophilos, der Aufbau des Menschen: Kritische Edition des Textes mit Einleitung, Übersetzung und Kommentar." Ph.D. diss., Ludwig-Maximilians-Universität, Munich, 2008.

Grisar 1907. Hartmann Grisar. *Il Sancta Sanctorum ed il suo tesoro sacro: Scoperte e studii dell'autore nella Cappella Palatina lateranense del medio evo.* Rome, 1907.

Grohmann 1957. Adolf Grohmann. "The Origin and Early Development of Floriated Kufic." *Ars Orientalis* 2 (1957), pp. 183–213.

P. Grossmann 1991. Peter Grossmann. "Babylon." In *The Coptic Encyclopedia,* edited by Aziz S. Atiya, vol. 2, cols. 317–23. New York, 1991.

P. Grossmann 1998. Peter Grossmann. "The Pilgrimage Center of Abû Mînâ." In *Pilgrimage and Holy Space in Late Antique Egypt,* edited by David Frankfurter, pp. 281–302. Leiden, 1998.

R. Grossmann 2002. Richard A. Grossmann. *Ancient Glass: A Guide to the Yale Collection.* New Haven, 2002.

Grube 1962. Ernst J. Grube. "Studies in the Survival and Continuity of Pre-Muslim Traditions in Egyptian Islamic Art." *Journal of the American Research Center in Egypt* 1 (1962), pp. 75–97.

Grube 1976. Ernst J. Grube. *Islamic Pottery of the Eighth to the Fifteenth Century in the Keir Collection.* London, 1976.

Grube and Johns 2005. Ernst J. Grube and Jeremy Johns. *The Painted Ceilings of the Cappella Palatina.* Geneva, 2005.

Grube et al. 1994. Ernst J. Grube et al. *Cobalt and Lustre: The First Centuries of Islamic Pottery.* London, 1994.

Guerrini 1957. Lucia Guerrini. *La stoffe copte del Museo Archeologico di Firenze.* Rome, 1957.

Guesdon and Vernay-Nouri 2001. Marie-Geneviève Guesdon and Annie Vernay-Nouri. *L'art du livre arabe: Du manuscrit au livre d'artiste.* Exh. cat. Paris, 2001.

Guest and Kendrick 1932. Rhuvon Guest and Albert F. Kendrick. "The Earliest Dated Islamic Textiles." *The Burlington Magazine* 60 (April 1932), pp. 185–87, 191.

Guidetti 2010a. Mattia Guidetti. "L'Editto di Yazid II': Immagini e identità religiosa nel Bilad al-Sham dell'VIII secolo." In *L'VIII secolo: Un secolo inquieto,* edited by Valentino Pace, pp. 69–79. Friuli, 2010.

Guidetti 2010b. Mattia Guidetti. "Sacred Topography in Medieval Syria and Its Roots between the Umayyads and Late Antiquity." In *Umayyad Legacies: Medieval Memories from Syria to Spain,* edited by Antoine Borrut and Paul M. Cobb, pp. 339–63. Leiden, 2010.

Guilland 1959. Rodolphe Guilland. "L'expédition de Maslama contre Constantinople (717–718)." *Études Byzantines* (1959), pp. 109–33.

Günzburg and Stasov 1989–90. David Günzburg and Vladimir Stasov. *Ornementation des anciens manuscrits hébreux de la Bibliothèque Impériale Publique de St. Pétersbourg.* Jerusalem, 1989–90.

Guscin 2009. Mark Guscin. *The Image of Edessa.* Leiden, 2009.

Gutas 1998. Dimitri Gutas. *Greek Thought, Arabic Culture: The Graeco-Arabic Translation Movement in Baghdad and Early 'Abbasid Society (2nd–4th / 8th–10th Centuries).* London, 1998.

Haase 2007a. Claus-Peter Haase, ed. *A Collector's Fortune: Islamic Art from the Collection of Edmund de Unger.* Munich, 2007.

Haase 2007b. Claus-Peter Haase. "The Development of Stucco Decoration in Northern Syria of the 8th and 9th Centuries and the Bevelled Style of Samarra." In *Facts and Artefacts: Art in the Islamic World,* edited by Annette Hagedorn and Avinoam Shalem, pp. 439–60. Leiden, 2007.

Habib 1967. Ra'uf Habib. *The Coptic Museum: A General Guide.* Cairo, 1967.

Hachlili 1996. Rachel Hachlili. "Synagogues in the Land of Israel: The Art and Architecture of the Late Antique Synagogues." In *Sacred Realm: The Emergence of the Synagogue in the Ancient World,* edited by Steven Fine, pp. 96–129. Exh. cat. New York, 1996.

Hachlili 2001. Rachel Hachlili. *The Menorah, the Ancient Seven-Armed Candelabrum: Origin, Form, and Significance.* Leiden, 2001.

Hachlili 2009. Rachel Hachlili. *Ancient Mosaic Pavements: Themes, Issues, and Trends.* Leiden, 2009.

Hagedorn and Weber 1968. Dieter Hagedorn and M. Weber. "Die griechisch-koptische Rezension der Menandersentenzen." *Zeitschrift für Papyrologie und Epigraphik* 3 (1968), pp. 15–50.

Hahn 1990. Cynthia Hahn. "Loca Sancta Souvenirs: Sealing the Pilgrim's Experience." In *The Blessings of Pilgrimage,* edited by Robert Ousterhout, pp. 85–96. Urbana, Ill., 1990.

Haldimann 1992. M. Haldimann. "Les implantations omeyyades dans la Balqa: L'apport d'Umm el-Walid." *Annual of the Department of Antiquities of Jordan* 36 (1992), pp. 307–18.

Haldon 1990. John F. Haldon. *Byzantium in the Seventh Century: The Transformation of a Culture.* Cambridge, 1990.

Haldon 1997. John F. Haldon. *Byzantium in the Seventh Century: The Transformation of a Culture.* Rev. ed. Cambridge, 1997.

Haldon 2000. John F. Haldon. *Byzantium: A History.* Charleston, S.C., 2000.

Haldon 2006. John Haldon. "Social Transformation in the 6th–9th C. East." In *Social and Political Life in Late Antiquity*, edited by William Bowden et al., pp. 603–47. Leiden, 2006.

Halevi 2007. Leor Halevi. *Muhammad's Grave: Death Rites and the Making of Islamic Society.* New York, 2007.

Halkin 1932. François Halkin, ed. *Sancti Pachomii Vitae Graecae.* Brussels, 1932.

Hall 2004. Linda Jones Hall. *Roman Berytus: Beirut in Late Antiquity.* London, 2004.

Halm 1997. Heinz Halm. *The Fatimids and Their Traditions of Learning.* London, 1997.

Hamdan 2010. Omar Hamdan. "The Second Masahif Project: A Step towards the Canonization of the Qur'anic Text." In *The Qur'an in Context: Historical and Literary Investigations into the Qur'anic Milieu*, edited by Angelika Neuwirth et al., pp. 795–835. Leiden, 2010.

Hamdouni Alami 2010. Mohammed Hamdouni Alami. *Art and Architecture in the Islamic Tradition: Aesthetics, Politics and Desire in Early Islam.* London, 2010.

Hamilton 1959. Robert W. Hamilton. *Khirbat al Mafjar: An Arabian Mansion in the Jordan Valley.* Oxford, 1959.

Hamilton 1988. Robert W. Hamilton. *Walid and His Friends: An Ummayad Tragedy.* Oxford, 1988.

Hammerschmidt 1957. Ernst Hammerschmidt. *Die koptische Gregoriosanaphora: Syrische und griechische Einflüsse auf eine ägyptische Liturgie.* Berlin, 1957.

Hammerstaedt 1999. Jürgen Hammerstaedt. *Grieschische Anaphorenfragmente aus Ägypten und Nubien.* Wiesbaden, 1999.

Hanfmann 1980. George M. A. Hanfmann. "The Continuity of Classical Art: Culture, Myth, and Faith." In *Age of Spirituality: A Symposium*, edited by Kurt Weitzmann, pp. 75–99. Exh. cat. New York, 1980.

Harden 1968. Donald B. Harden. *Masterpieces of Glass: A Selection.* Exh. cat. London, 1968.

Harden 1987. Donald B. Harden. *Glass of the Caesars.* Exh. cat. Milan, 1987.

Harding 1951. G. Lankester Harding. "Excavations on the Citadel, Amman." *Annual of the Department of Antiquities of Jordan* 1 (1951), pp. 7–16.

Harlow 2005. Mary Harlow. "Dress in the Historia Augusta: The Role of Dress in Historical Narrative." In *The Clothed Body in the Ancient World*, edited by Liza Cleland et al., pp. 143–53. Oxford, 2005.

Harmless 2004. William Harmless. *Desert Christians: An Introduction to the Literature of Early Monasticism.* Oxford, 2004.

Harmless 2008. William Harmless. "Monasticism." In *The Oxford Handbook of Early Christian Studies*, edited by Susan Ashbrook Harvey and David G. Hunter, pp. 493–517. Oxford, 2008.

Harper 1971. Prudence O. Harper. "Sources of Certain Female Representations in Sasanian Art." In *Atti del convegno internazionale sul tema: La Persia nel Medioevo*, pp. 503–15. Rome, 1971.

Harper 1978. Prudence O. Harper. *The Royal Hunter: Art of the Sasanian Empire.* Exh. cat. New York, 1978.

Harper 1979a. Prudence O. Harper. "Court Silver of Sasanian Iran." In *Highlights of Persian Art*, edited by Richard Ettinghausen and Ehsan Yarshater, pp. 97–115. Boulder, 1979.

Harper 1979b. Prudence O. Harper. "Thrones and Enthronement Scenes in Sasanian Art." *Iran* 17 (1979), pp. 49–64.

Harper 1988. Prudence O. Harper. "Boat-Shaped Bowls of the Sasanian Period." *Iranica Antiqua* 23 (1988), pp. 331–45.

Harper 1991. Prudence O. Harper. "The Sasanian Ewer: Questions of Origin and Influence." In *Near Eastern Studies Dedicated to H.I.H. Prince Takahito Mikasa*, edited by Masao Mori et al., pp. 67–84. Wiesbaden, 1991.

Harper 1998. Prudence O. Harper. "Sasanian Silver Vessels: Recent Developments." In *The Art and Archaeology of Ancient Persia: New Light on the Parthian and Sasanian Empires*, edited by Vesta S. Curtis et al., pp. 67–73. London, 1998.

Harper 2006. Prudence O. Harper. *In Search of a Cultural Identity: Monuments and Artifacts of the Sasanian Near East, 3rd to 7th Century A.D.* New York, 2006.

Harper and Marshak 2006. Prudence O. Harper and Boris I. Marshak. "La vaisselle en argent." In *Les Perses sassanides: Fastes d'un empire oublié (224–642)*, edited by Françoise Demange, pp. 70–137. Exh. cat. Paris, 2006.

Harper and Meyers 1981. Prudence O. Harper and Pieter Meyers. *Silver Vessels of the Sasanian Period.* New York, 1981.

Harrak 2001. Amir Harrak. "Recent Archaeological Excavations in Takrit and the Discovery of Syriac Inscriptions." *Hugoye* 4 (January 2001), pp. 103–8.

Harris 2007. Anthea Harris, ed. *Incipient Globalization? Long-Distance Contacts in the Sixth Century.* Oxford, 2007.

Harrison 1986. Richard Martin Harrison. *Excavations at Saraçhane in Istanbul*, vol. 1, *The Excavations, Structures, Architectural Decoration, Small Finds, Coins, Bones, and Molluscs.* Princeton, 1986.

Harvey 1988. Susan Ashbrook Harvey. "The Sense of a Stylite: Perspectives on Simeon the Elder." *Vigiliae Christianae* 42 (December 1988), pp. 376–94.

Harvey 1993. Susan Ashbrook Harvey. "The Memory and Meaning of a Saint: Two Homilies on Simeon Stylites." *ARAM* 5 (1993), pp. 219–41.

Harvey 1998. Susan Ashbrook Harvey. "The Stylite's Liturgy: Ritual and Religious Identity in Late Antiquity." *Journal of Early Christian Studies* 6, no. 3 (1998), pp. 523–39.

Harvey 1999. Susan Ashbrook Harvey. "Olfactory Knowing: Signs of Smell in the Vitae of Simeon Stylites." In *After Bardaisan: Studies on Continuity and Change in Syriac Christianity in Honor of Professor Han J. W. Drijvers*, edited by Gerrit J. Reinink and Alexander C. Klugkist, pp. 23–34. Leuven, 1999.

Harvey 2006a. Susan Ashbrook Harvey. "Praying Bodies, Bodies at Prayer: Ritual Relations in Early Syriac Christianity." In *Prayer and Spirituality in the Early Church*, vol. 4, *The Spiritual Life*, edited by Pauline Allen et al., pp. 149–67. Strathfield, NSW, Australia, 2006.

Harvey 2006b. Susan Ashbrook Harvey. *Scenting Salvation: Ancient Christianity and the Olfactory Imagination.* Berkeley, 2006.

Hasluck 1929. Frederick W. Hasluck. *Christianity and Islam under the Sultans.* Oxford, 1929.

Hasson 1987. Rachel Hasson. *Later Islamic Jewelry.* Exh. cat. Jerusalem, 1987.

Hausdorf 2008. Daniel Hausdorf. "An Early Islamic Wooden Panel Decorated with Mosaics in the Collection of The Metropolitan Museum of Art, New York: Technical Investigations and Comparative Studies on This and Contemporaneous, Closely Related Objects." Thesis, Fachhochschule Potsdam, 2008.

Hausmann 1984. Ulrich Hausmann. "Zur Eroten- und Gallier-Ikonographie in der alexandrinischen Kunst." In *Alessandria e il mondo ellenistico-romano: Studi in onore di Achille Adriani*, edited by Nicola Bonacasa and Antonino Di Vita, vol. 2, pp. 283–95. Rome 1984.

Hawary 1930. Hassan Hawary. "The Most Ancient Islamic Monument Known Dated A.H. 31 (A.D. 652) from the Time of the Third Calif 'Uthman." *Journal of the Royal Asiatic Society* 62 (1930), pp. 321–33.

Hawary and Rached 1932. Hassan Hawary and Hussein Rached. *Catalogue général du Musée Arabe du Caire: Stèles funéraires.* vol. 1. Cairo, 1932.

Hawkins 1964. Ernest S. W. Hawkins. "Pilaster and Stucco Cornices in Haghia Sophia, Istanbul." In *Actes du XIIe congrès international d'études byzantines*, vol. 3, pp. 131–35. Belgrade, 1964.

Hawting 1987. Gerald R. Hawting. *The First Dynasty of Islam: The Umayyad Caliphate AD 661–750.* Carbondale, Ill., 1987.

Hawting 2006. Gerald R. Hawting. *The Idea of Idolatry and the Emergence of Islam: From Polemic to History.* Cambridge, 2006.

Hay 2010. Jonathan Hay. *Sensuous Surfaces: The Decorative Object in Early Modern China.* Honolulu, 2010.

Hayes 1984. John W. Hayes. *Greek, Roman, and Related Metalware in the Royal Ontario Museum.* Toronto, 1984.

Heidemann 2010. Stefan Heidemann. "The Evolving Representation of the Early Islamic Empire and Its Religion on Coin Imagery." In *The Qur'an in Context: Historical and Literary Investigations into the Qur'anic Milieu*, edited by Angelika Neuwirth et al., pp. 149–96. Leiden, 2010.

Helmecke 2006. Gisela Helmecke. "Tiraz-Inschriften im Berliner Museum für Islamische Kunst." In *Textile Messages: Inscribed Fabrics from Roman to Abbasid Egypt*, edited by Cäcilia Fluck and Gisela Helmecke, pp. 173–91. Leiden, 2006.

Helms 1993. Mary W. Helms. *Craft and the Kingly Ideal: Art, Trade, and Power.* Austin, 1993.

Herbich and Bénazeth 2008. Tomasz Herbich and Dominique Bénazeth. "Le kôm de Baouit: Étapes d'une cartographie." *Bulletin de l'Institut Français d'Archéologie Orientale* 108 (2008), pp. 165–204.

Hermitage 1990. *Bada'i 'al-fann al-islami fi-Mathaf al-Harmitaj bi-al-Ittihad al-Sufiyati = Masterpieces of Islamic Art in the Hermitage Museum.* Exh. cat. Kuwait, 1990.

Hermitage 2007. *Aleksandr Velikiĭ, put' na Vostok = Alexander the Great: The Road to the East.* Exh. cat. Saint Petersburg, 2007.

Herrin 1987. Judith Herrin. *The Formation of Christendom.* Princeton, 1987.

Herrin 2009. Judith Herrin. "Book Burning as Purification." In *Transformations of Late Antiquity: Essays for Peter Brown*, edited by Philip Rousseau and Manolis Papoutsakis, pp. 205–22. Farnham, 2009.

Herzfeld 1910. Ernst Herzfeld. "Die Genesis der islamischen Kunst und das Mschatta-Problem." *Der Islam* 1 (1910), pp. 27–63, 105–44.

Herzfeld 1923. Ernst Herzfeld. *Der Wandschmuck der Bauten von Samarra und seine Ornamentik.* Berlin, 1923.

Herzfeld 1927. Ernst Herzfeld. *Die Malereien von Samarra.* Berlin, 1927.

Hesychios 1979. Saint Hesychios the Priest. "On Watchfulness and Holiness." In *The Philokalia: The Complete Text*, vol. 1, translated and edited by G. E. H. Palmer et al., pp. 162–98. London, 1979.

Heusch and Meinecke 1989. Jan-Christoph Heusch and Michael Meinecke. *Die Residenz des Harun al-Rashid in Raqqa.* Damascus, 1989.

Higton 2011. Mike Higton. "Hypostasis." In *The Cambridge Dictionary of Christian Theology*, edited by Ian A. McFarland et al., pp. 229–30. New York, 2011.

Hilali forthcoming. Asma Hilali. "Le palimpseste de San'a' et la canonisation du Coran: Nouveaux éléments." *Cahiers du Centre Gustave Glotz* 21 (2011), forthcoming.

Hillenbrand 1981. Robert W. Hillenbrand. "Islamic Art at the Crossroads: East versus West at Mshatta." In *Essays in Islamic Art and Architecture*, edited by Abbas Daneshvari, pp. 63–87. Malibu, 1981.

Hillenbrand 1982. Robert W. Hillenbrand. "La dolce vita in Early Islamic Syria: The Evidence of Later Umayyad Palaces." *Art History* 3 (1982), pp. 1–35.

Hillenbrand 1999a. Robert W. Hillenbrand. *Islamic Art and Architecture.* London, 1999.

Hillenbrand 1999b. Robert W. Hillenbrand. "Umayyad Woodwork in the Aqsa Mosque." In *Bayt al-Maqdis*, vol. 2, *Jerusalem and Early Islam*, edited by Jeremy Johns, pp. 271–310. Oxford, 1999.

Hilsdale 2005. Cecily J. Hilsdale. "Constructing a Byzantine 'Augusta': A Greek Book for a French Bride." *Art Bulletin* 87 (September 2005), pp. 458–83.

Hirschfeld 1992. Yizhar Hirschfeld. *The Judean Desert Monasteries in the Byzantine Period.* New Haven, 1992.

Hoerning 1889. Reinhart Hoerning. *British Museum Karaite Mss: Descriptions and Collation of Six Karaite Manuscripts of Portions of the Hebrew Bible in Arabic Characters.* London, 1889.

Hofenk de Graaff 2004. Judith H. Hofenk de Graaff. *The Colourful Past: Chemistry and Identification of Natural Dyestuffs.* Riggisberg, 2004.

Hofenk de Graaff and Roelofs 2006. Judith H. Hofenk de Graaff and Wilma G. Th. Roelofs. "Dyestuffs along the Silk Road: Identification and Interpretation of Dyestuffs from Early Middle Textiles." In *Central Asian Textiles and Their Contexts in the Early Middle Ages*, edited by Regula Schorta, pp. 35–49. Riggisberg, 2006.

Hoffman 2000. Eva R. Hoffman. "The Beginnings of the Illustrated Arabic Book: An Intersection between Art and Scholarship." *Muqarnas* 17 (2000), pp. 37–52.

Hoffman 2001. Eva R. Hoffman. "Pathways of Portability: Islamic and Christian Interchange from the Tenth to the Twelfth Century." *Art History* 24 (March 2001), pp. 17–50.

Hoffman 2008. Eva R. Hoffman. "Between East and West: The Wall Paintings of Samarra and the Construction of Abbasid Princely Culture." *Muqarnas* 25 (2008), pp. 107–32.

Hofmann-de Keijzer 2005. Regina Hofmann-de Keijzer. "Farbstoffe in Koptischen Textilien." In *Verletzliche Beute: Spätantike und frühislamische Textilien aus Ägypten*, edited by Peter Noever, pp. 26–36. Exh. cat. Ostfildern-Ruit, 2005.

Holland 1986. Lionel Holland. "Islamic Bronze Weights from Caesarea Maritima." *American Numismatic Society Museum Notes* 31 (1986), pp. 171–201.

Hollingsworth 1991. Paul A. Hollingsworth. "Dark Ages." In *The Oxford Dictionary of Byzantium* (e-reference edition), edited by Alexander P. Kazhdan et al. New York, 1991, http://www.oxford-byzantium.com entry?entry=t174e0864.s003 (accessed June 15, 2011).

Holum 1990. Kenneth G. Holum. "Hadrian and St. Helena: Imperial Travel and the Origins of Christian Holy Land Pilgrimage." In *The Blessings of Pilgrimage*, edited by Robert Ousterhout, pp. 66–81. Urbana, Ill., 1990.

Horak 1992. Ulrike Horak, ed. *Illuminierte Papyri Pergamente und Papiere I.* Vienna, 1992.

Horn 1992. Jürgen Horn. *Studien zu den Märtyrern des nördlichen Oberägypten*, vol. 2, *Märtyrer und Heilige des XI. bis XIV. oberägyptischen Gaues, Ein Beitrag zur Topographia Christiana Ägyptens.* Wiesbaden, 1992.

Horowitz 2006. Elliott Horowitz. *Reckless Rites: Purim and the Legacy of Jewish Violence.* Princeton, 2006.

Hoyland 1997a. Robert G. Hoyland. "The Content and Context of Early Arabic Inscriptions." *Jerusalem Studies in Arabic and Islam* 21 (1997), pp. 77–102.

Hoyland 1997b. Robert G. Hoyland. *Seeing Islam as Others Saw It: A Survey and Evaluation of Christian, Jewish, and Zoroastrian Writings on Early Islam.* Princeton, 1997.

Hoyland 1999. Robert G. Hoyland. "Jacob of Edessa on Islam." In *After Bardaisan: Studies on Continuity and Change in Syriac Christianity in Honor of Professor Han J. W. Drijvers*, edited by Gerrit J. Reinink and Alexander C. Klugkist, pp. 149–60. Leuven, 1999.

Hoyland 2006. Robert G. Hoyland. "New Documentary Texts and the Early Islamic State." *Bulletin of the School of Oriental and African Studies* 69, no. 3 (2006), pp. 395–416.

Hoyland 2007. Robert G. Hoyland. "Writing the Biography of the Prophet Muhammad: Problems and Solutions." *History Compass* 5 (2007), pp. 581–602.

Hoyland 2008. Robert G. Hoyland. "Epigraphy and the Linguistic Background to the Qur'an." In *The Qur'an in Its Historical Context*, edited by Gabriel S. Reynolds, pp. 51–69. London, 2008.

Hoyland 2010. Robert G. Hoyland. "Mount Nebo, Jabal Ramm, and the Status of Christian Palestinian Aramaic and Old Arabic in Late Roman Palestine and Arabia." In *The Development of Arabic as a Written Language*, edited by M. C. A. MacDonald, pp. 29–45. Oxford, 2010.

Humbert 1986. Jean-Baptiste Humbert. "El-Fedein-Mafraq." *Liber Annuus* 36 (1986), pp. 354–58.

Humphreys 2010. R. Stephen Humphreys. "Christian Communities in Early Islamic Syria and Northern Jazira: The Dynamics of Adaptation." In *Money, Power and Politics in Early Islamic Syria: A Review of Current Debates*, edited by John Haldon, pp. 45–56. Burlington, Vt., 2010.

Hunger 1978. Herbert Hunger. *Die hochsprachliche profane Literatur der Byzantiner.* Munich, 1978.

Hunt 2003. Lucy-Anne Hunt. "Stuccowork at the Monastery of the Syrians in the Wadi Natrun: Iraqi-Egyptian Artistic Contact in the 'Abbasid Period." In *Christians at the Heart of Islamic Rule: Church Life and Scholarship in 'Abbasid Iraq*, edited by David Thomas, pp. 93–127. Leiden, 2003.

Ibn al-'Arabi 1998. Muhammad ibn 'Abd Allah Ibn al-'Arabi. *Al-Qabas: Fi sharh muwatta' Mālik ibn Anas.* 4 vols. Edited by Ayman Nasr al-Azhari and 'Ala' Ibrahim al-Azhari. Beirut, 1998.

Ibn al-Salah 1975. Ahmad ibn Muhammad Ibn al-Salah. *Zur Kritik der Koordinatenüberlieferung im Sternkatalog des Almagest.* Edited by Paul Kunitzsch. Göttingen, 1975.

Ibn al-Zubayr 1996. Ahmad ibn al-Rashid ibn al-Zubayr. *Book of Gifts and Rarities.* Translated and edited by Ghada-al-Hijjawi al-Qaddumi. Cambridge, Mass., 1996.

Ibn Majah 1993–94. Muhammad ibn Yazid Ibn Majah. *Sunan ibn-i Majah.* 2 vols. Translated by Muhammad Tufail Ansari. Lahore, 1993–94.

Ibn Rustah 1892. Ahmad ibn 'Umar Ibn Rustah. *Kitab al-'Alaq al-nafisa.* Edited by M. J. de Goeje. Leiden, 1892.

Ilan 1991. Zvi Ilan. *Bate-keneset kedumim be-Erets-Yiśra'el=Ancient Synagogues in Israel* (in Hebrew). Tel Aviv, 1991.

Ilieva and Thomov 1998. Annetta Ilieva and Thomas S. Thomov. "The Shape of the Market: Mapping the Book of the Eparch." *Byzantine and Modern Greek Studies* 22 (1998), pp. 105–16.

Imai 1983. Imai Ayako, ed. *The Metropolitan Museum of Art: Selections from the Collection of the Ancient Near East Department.* Exh. cat. Tokyo, 1983.

Innemée 1992. Karel C. Innemée. *Ecclesiastical Dress in the Medieval Near East.* Leiden, 1992.

Innemée 2011. Karel C. Innemée. "A Newly Discovered Painting of the Epiphany in Deir al-Surian." *Hugoye* 14, no. 1 (2011), pp. 63–85.

Israeli 2003. Yael Israeli. *Ancient Glass in the Israel Museum: the Eliahu Dobkin Collection and Other Gifts.* Jerusalem, 2003.

Israeli and Mevorah 2000. Yael Israeli and David Mevorah, eds. *Cradle of Christianity: Treasures from the Holy Land.* Exh. cat. Jerusalem, 2000.

Jacobs 2004. Andrew S. Jacobs. *Remains of the Jews: The Holy Land and Christian Empire in Late Antiquity.* Stanford, Calif., 2004.

Jacoby 1991–92. David Jacoby. "Silk in Western Byzantium before the Fourth Crusade." *Byzantinische Zeitschrift* 84/85 (1991–92), pp. 452–500.

Jacoby 2004. David Jacoby. "Silk Economics and Cross-Cultural Artistic Interaction: Byzantium, the Muslim World, and the Christian West." *Dumbarton Oaks Papers* 58 (2004), pp. 197–240.

Jaeger 1947. Werner Jaeger. "Greek Uncial Fragments in the Library of Congress in Washington." *Traditio* 5 (1947), pp. 79–102.

Jahiz 1938–45. Abu 'Uthman ibn Bahr Jahiz. *Al-Hayawan.* 7 vols. Edited by 'Abd al-Salam Muhammad Harun. Cairo, 1938–45.

E. James 2008. Edward James. "The Rise and Function of the Concept 'Late Antiquity.'" *Journal of Late Antiquity* 1, no. 1 (2008), pp. 20–30.

L. James 1996. Liz James. *Light and Colour in Byzantine Art.* Oxford, 1996.

L. James 2003. Liz James. "Color and Meaning in Byzantium." *Journal of Early Christian Studies* 11 (Summer 2003), pp. 223–33.

Jamil 1999. Nadia Jamil. "Caliph and Qutb: Poetry as a Source for Interpreting the Transformation of the Byzantine Cross on Steps on Umayyad Coinage." In *Bayt al-Maqdis*, vol. 2, *Jerusalem and Early Islam*, edited by Jeremy Johns, pp. 11–58. Oxford, 1999.

Janes 1998. Dominic Janes. *God and Gold in Late Antiquity.* Cambridge, 1998.

Janes 1999a. Dominic Janes. "Gold." In *Late Antiquity: A Guide to the Postclassical World*, edited by Glen W. Bowersock et al., p. 474. Cambridge, Mass., 1999.

Janes 1999b. Dominic Janes. "Treasure." In *Late Antiquity: A Guide to the Postclassical World*, edited by Glen W. Bowersock et al., pp. 732–33. Cambridge, Mass., 1999.

Jarry 1966. Jacques Jarry. "Trouvailles épigraphiques a Saint-Symeon." *Syria* 43 (1966), pp. 105–11.

Jeffreys 1998. Elizabeth Jeffreys, ed. and trans. *Digenis Akritis: The Grottaferrata and Escorial Versions*. Cambridge, 1998.

Jehle 2008. Hiltrud Jehle. "Technologische Aspekte an den Elfenbeinarbeiten des Museums für Byzantinische Kunst." In *Spätantike und byzantinische Elfenbeinbildwerke im Diskurs*, edited by Gudrun Bühl et al., pp. 139–47. Wiesbaden, 2008.

Jenkins 1985. Marilyn Jenkins. "A Vocabulary of Umayyad Ornament: New Foundations for the Study of Early Qur'an Manuscripts." In *Masahif San 'a'*, pp. 19–23. Exh. cat. Kuwait, 1985.

Jenkins and Keene 1983. Marilyn Jenkins and Manuel Keene. *Islamic Jewelry in the Metropolitan Museum of Art*. Exh. cat. New York, 1983.

Jenkins-Madina 1986. Marilyn Jenkins-Madina. "Islamic Glass: A Brief History." *Metropolitan Museum of Art Bulletin* 44 (1986), pp. 1–56.

Jewelry 1979. Jewelry: Ancient to Modern. Exh. cat. New York, 1979.

Jobst et al. 1997. Werner Jobst, Behçet Erdal, and Christian Gurtner. *Istanbul: Büyük saray mozayiği: araıtırmalar, onarım ve sergileme, 1983–1997 = Istanbul: The Great Palace Mosaic: The Story of Its Exploration, Preservation, and Exhibition, 1983–1997*. Istanbul, 1997.

Joel and Peli 2005. Guillermina Joel and Audrey Peli. *Suse: Terres cuites islamiques*. Paris, 2005.

Joguin 2001. M. Joguin. "Des pots et des hommes: L'exemple d'Umm el-Walid." *Studies in the History and Archaeology of Jordan* 7 (2001), pp. 641–45.

John of the Ladder 1959. Saint John of the Ladder. *The Ladder of Divine Ascent*. Translated by Archimandrite Lazarus Moore. London, 1959.

C. Johns 2010. Catherine Johns. *The Hoxne Late Roman Treasure: Gold Jewellery and Silver Plate*. London, 2010.

J. Johns 1999. Jeremy Johns. "The 'House of the Prophet' and the Concept of the Mosque." In *Bayt al-Maqdis*, vol. 2, *Jerusalem and Early Islam*, edited by Jeremy Johns, pp. 59–112. Oxford, 1999.

J. Johns 2003. Jeremy Johns. "Archaeology and the History of Early Islam: The First Seventy Years." *Journal of the Economic and Social History of the Orient* 46 (2003), pp. 411–36.

Johnsén 2007. Henrik Rydell Johnsén. *Reading John Climacus: Rhetorical Argumentation, Literary Convention, and the Tradition of Monastic Formation*. Lund, 2007.

Johnson 1991. D. W. Johnson. "Axum." In *The Oxford Dictionary of Byzantium*, edited by Alexander P. Kazhdan et al., vol. 1, p. 259. New York, 1991.

Jomier 1965. J. Jomier. "Fustat." In *The Encyclopaedia of Islam*, vol. 2, pp. 957–59. Leiden, 1965.

Jones and Michell 1976. Dalu Jones and George Michell, eds. *The Arts of Islam*. Exh. cat. London, 1976.

Juckel 2003. Andreas Juckel. "Ms. Schøyen 2530/Sinai syr. 3 and the New Testament Peshitta." *Hugoye* 6 (July 2003), pp. 1–25.

Juvin 2010. Carine Juvin. "The Tombstones from the al-Ma'la Cemetery in Mekka." In *Routes d'Arabie: Archéologie et histoire du royaume d'Arabie Saoudite*, edited by 'Ali ibn Ibrahim al-Ghabban, pp. 490–521. Exh. cat. Paris, 2010.

Juynboll 1986. G. H. A. Juynboll. "The Attitude towards Gold and Silver in Early Islam." In *Pots & Pans: A Colloquium on Precious Metals and Ceramics in the Muslim, Chinese and Graeco-Roman Worlds*, edited by Michael Vickers, pp. 107–16. Oxford, 1985.

Kaegi 1992. Walter E. Kaegi. *Byzantium and the Early Islamic Conquests*. Cambridge, 1992.

Kaegi 2003. Walter E. Kaegi. *Heraclius: Emperor of Byzantium*. Cambridge, 2003.

Kähler 1967. Heinz Kähler. *Die Hagia Sophia*. Berlin, 1967.

Kajitani 1981. Kajitani Nobuko. *Koputo gire* (Coptic Fragments). Kyoto, 1981.

Kakovkin 1984. Aleksandr I. Kakovkin. "Pozdnii pamy-atnik koptskoi jivopisi iz sobraniya Ermitaja." *Kavkaz i Vizantiiia*, no. 4 (1984), pp. 218–23.

Kakovkin 2004. Aleksandr I. Kakovkin. *Sokrovishcha koptskoĭ kollektsii Gosudarsvennogo Ermitazha*. Saint Petersburg, 2004.

Kalavrezou-Maxeiner 1985. Ioli Kalavrezou-Maxeiner. *Byzantine Icons in Steatite*. Vienna, 1985.

Kalavrezou 1990. Ioli Kalavrezou. "Images of the Mother: When the Virgin Mary Became Meter Theou." *Dumbarton Oaks Papers* 44 (1990), pp. 165–72.

Kalavrezou 1997. Ioli Kalavrezou. "Luxury Objects." In *The Glory of Byzantium: Art and Culture of the Middle Byzantine Era, A.D. 843–1261*, edited by Helen C. Evans and William D. Wixom, pp. 218–23. Exh. cat. New York, 1997.

Kalavrezou 2003. Ioli Kalavrezou, ed. *Byzantine Women and Their World*. Exh. cat. New Haven, 2003.

Kamil 1970. Murad Kamil. *Catalogue of All Manuscripts in the Monastery of St. Catherine on Mount Sinai*. Wiesbaden, 1970.

Kaplony 2008. Andreas Kaplony. "What Are Those Few Dots For? Thoughts on the Orthography of the Qurra Papyri (709–710), the Khurasan Parchments (755–777), and the Inscription of the Jerusalem Dome of the Rock (692)." *Arabica* 55 (2008), pp. 91–112.

Karatay 1962. Fehmi Edhem Karatay. *Topkapı Sarayı Müzesi Kütüphanesi Arapca yamalar kataloğlu*. Istanbul, 1962.

Kartsonis 1986. Anna D. Kartsonis. *Anastasis: The Making of an Image*. Princeton, 1986.

Katsaros 1993. Vasilēs Katsaros. "Leo the Mathematician: His Literary Presence in Byzantium during the Ninth Century." In *Science in Western and Eastern Civlization in Carolingian Times*, edited by Paul Leo Butzer and Dietrich Lohrmann, pp. 383–98. Basel, 1993.

Katz 2002. Marion Holmes Katz. *Body of Text: The Emergence of the Sunni Law of Ritual Purity*. Albany, N.Y., 2002.

Kaufmann 1886. David Kaufmann. "Études d'archéologie juive, I: La Synagogue du Hammam Lif." *Revue des Études Juives* 13 (1886), pp. 46–61.

Kawatoko and Shindo 2010. Mutsuo Kawatoko and Yoko Shindo, eds. *Artifacts of the Medieval Islamic Period Excavated in al-Fustat, Egypt*. Tokyo, 2010.

Kazhdan 1991a. Alexander P. Kazhdan. "John of Damascus." In *The Oxford Dictionary of Byzantium*, edited by Alexander P. Kazhdan et al., vol. 2, pp. 1063–64. New York, 1991.

Kazhdan 1991b. Alexander P. Kazhdan. "Nestorianism." In *The Oxford Dictionary of Byzantium*, edited by Alexander P. Kazhdan et al., vol. 2, pp. 1459–60. New York, 1991.

Kazhdan and Talbot 1991. Alexander P. Kazhdan and Alice-Mary Talbot. "Mines." In *The Oxford Dictionary of Byzantium*, edited by Alexander P. Kazhdan et al., pp. 1375–76. New York, 1991.

Keating 2006. Sandra Toenies Keating. *Defending the "People of Truth" in the Early Islamic Period*. Leiden, 2006.

Kelekian 1928. Dikran G. Kelekian. *Important Documents of Coptic Art in the Collection of Dikran G. Kelekian*. New York, 1928.

Kendrick 1918. Albert F. Kendrick. "Early Textiles from Damietta." *The Burlington Magazine* 32 (January 1918), pp. 10–11, 14–15.

Kendrick 1921. Albert F. Kendrick. *Catalogue of Textiles from Burying-Grounds in Egypt*, vol. 2, *Period of Transition and of Christian Emblems*. London, 1921.

Kendrick 1922. Albert F. Kendrick. *Catalogue of Textiles from Burying-Grounds in Egypt*, vol. 3, *Coptic Period*. London, 1922.

Kennedy 1985a. Hugh Kennedy. "From Polis to Madina: Urban Change in Late Antique and Early Islamic Syria." *Past and Present* 106 (1985), pp. 3–27.

Kennedy 1985b. Hugh Kennedy. "The Last Century of Byzantine Syria: A Reinterpretation." *Byzantinische Forschungen* 10 (1985), pp. 141–83.

Kennedy 1986. Hugh Kennedy. *The Prophet and the Age of the Caliphates*. London, 1986.

Kennedy 2001. Hugh Kennedy. "Islam." In *Interpreting Late Antiquity: Essays on the Postclassical World*, edited by Glen W. Bowersock et al., pp. 219–37. Cambridge, 2001.

Kennedy 2007. Hugh Kennedy. *The Great Arab Conquests: How the Spread of Islam Changed the World We Live In*. London, 2007.

Kennedy 2006. Hugh Kennedy. *The Byzantine and Early Islamic Near East*. Aldershot, 2006.

Kent and Painter 1977. J. P. C. Kent and K. S. Painter, eds. *Wealth of the Roman World: Gold and Silver, AD 300–700*. Exh. cat. London, 1977.

C. Kessler 1970. Christel Kessler. "'Abd al-Malik's Inscription in the Dome of the Rock: A Reconsideration." *Journal of the Royal Asiatic Society* (1970), pp. 2–14.

H. Kessler 1995. Herbert L. Kessler. "Gazing at the Future: The Parousia Miniature in Vat. Gr. 699." In *Byzantine East, Latin West: Art-Historical Studies in Honor of Kurt Weitzmann*, edited by Christopher Moss and Katherine Kiefer, pp. 365–71. Princeton, 1995.

H. Kessler 2007. Herbert L. Kessler. "'Byzantine Art and the West': Forty Years after the Athens Exhibition and Dumbarton Oaks Symposium." In *Medioevo mediterraneo: L'Occidente, Bisanzio e l'Islam*, edited by Arturo Carlo Quintavalle, pp. 57–72. Milan, 2007.

Key Fowden 1999. Elizabeth Key Fowden. *The Barbarian Plain: Saint Sergius between Rome and Iran*. Berkeley, 1999.

Key Fowden 2002. Elizabeth Key Fowden. "Sharing Holy Places." *Common Knowledge* 8, no. 1 (2002), pp. 124–46.

Key Fowden 2004. Elizabeth Key Fowden. "Christian Monasteries and Umayyad Residences in Late Antique Syria." In *Studies on Hellenism, Christianity, and the Umayyads*, edited by Garth Fowden and Elizabeth Key Fowden, pp. 149–92. Athens, 2004.

Khairy and 'Amr 1986. Nabil Khairy and Abdel-Jalil 'Amr. "Early Islamic Inscribed Pottery Lamps from Jordan." *Levant* 18 (1986), pp. 143–53.

Khalek 2011. Nancy Khalek. *Damascus after the Muslim Conquest: Text and Image in Early Islam*. New York, 2011.

Khalili 2005. Nasser D. Khalili. *The Timeline History of Islamic Art and Architecture*. London, 2005.

Khoury 1993. Nuha Khoury. "The Dome of the Rock, the Ka'ba and Ghumdan: Arab Myths and Umayyad Monuments." *Muqarnas* 10 (1993), pp. 57–65.

Kilpatrick 2003. Hilary Kilpatrick. "Monasteries through Muslim Eyes: The Diyarat Books." In *Christians at the Heart of Islamic Rule: Church Life and Scholarship in 'Abbasid Iraq*, edited by David Thomas, pp. 19–37. Leiden, 2003.

King 1980. G. R. D. King. "Some Christian Wall-Mosaics in Pre-Islamic Arabia." *Proceedings of the Seminar for Arabian Studies* 10 (1980), pp. 37–43.

King 1982. G. R. D. King. "The Architectural Motif as Ornament in Islamic Art: The Marwan II Ewer and Three Wooden Panels in the Museum of Islamic Art in Cairo." *Islamic Archaeological Studies* 2 (1982), pp. 23–57.

King 1985. G. R. D. King. "Islam, Iconoclasm, and the Declaration of Doctrine." *Bulletin of the School of Oriental and African Studies* 48 (1985), pp. 267–77.

King 1987. G. R. D. King. "The Distribution of Sites and Routes in the Jordanian and Syrian Deserts." *Proceedings of the Seminar for Arabian Studies* 20 (1987), pp. 91–105.

King 1992. G. R. D. King. "Settlement Patterns in Islamic Jordan: The Umayyads and Their Use of the Land." *Studies in the History and Archaeology of Jordan* 4 (1992), pp. 369–75.

King 2002a. G. R. D. King. "The Prophet Muhammad and the Breaking of the Jahiliyyah Idols." In *Studies on Arabia in Honour of Professor G. Rex Smith*, edited by John F. Healey and Venetia Porter, pp. 91–122. Oxford, 2002.

King 2002b. G. R. D. King. "The Sculptures of the Pre-Islamic Haram at Mekka." In *Cairo to Kabul: Afghan and Islamic Studies Presented to Ralph Pinder-Wilson*, edited by Warwick Ball and Leonard Harrow, pp. 144–50. London, 2002.

King 2004. G. R. D. King. "The Paintings of the Pre-Islamic Ka'ba." *Muqarnas* 21 (2004), pp. 219–29.

Kingsley and Decker 2001. Sean Kingsley and Michael Decker, eds. *Economy and Exchange in the East Mediterranean during Late Antiquity*. Oxford, 2001.

Kiss 1989. Zsolt Kiss. *Les ampoules de Saint Ménas découvertes à Kôm el-Dikka (1961–1981)*. Warsaw, 1989.

Kiss 2007. Zsolt Kiss. "Alexandria in the Fourth to Seventh Centuries." In *Egypt in the Byzantine World, 300–700*, edited by Roger S. Bagnall, pp. 187–206. Cambridge, 2007.

Kister 1989. M. J. Kister. "Do Not Assimilate Yourselves . . . 'La tashabbahu.'" *Jerusalem Studies in Arabic and Islam* 12 (1989), pp. 321–71.

Kister 2008. M. J. Kister. "La yamassuhu illa 'l-mutahharun . . . Notes on the Interpretations of a Qur'anic Phrase." *Jerusalem Studies in Arabic and Islam* 34 (2008), pp. 309–23.

Kitzinger 1946. Ernst Kitzinger. "The Horse and Lion Tapestry at Dumbarton Oaks: A Study in Coptic and Sassanian Textile Design." *Dumbarton Oaks Papers* 3 (1946), pp. 1–72.

Kitzinger 1954. Ernst Kitzinger. "The Cult of Images in the Age before Iconoclasm." *Dumbarton Oaks Papers* 8 (1954), pp. 83–150.

Kitzinger 1976. Ernst Kitzinger. *The Art of Byzantium and the Medieval West*. Bloomington, 1976.

Klar 2006. Marianna Klar. "Stories of the Prophets." In *The Blackwell Companion to the Qur'an*, edited by Andrew Rippin, pp. 338–49. Malden, Mass., 2006.

Knauer 2004. Elfriede R. Knauer. "A Quest for the Origin of the Persian Riding Coats: Sleeved Garments with Underarm Openings." In *Riding Costume in Egypt: Origin and Appearance*, edited by

Cäcilia Fluck and Gillian Vogelsang-Eastwood, pp. 7–28. Leiden, 2004.

Knauf 1984. Ernst Axel Knauf. "Bemerkungen zur frühen Geschichte der arabischen Orthographie I." *Orientalia* 53 (1984), pp. 456–58.

Koder 1991. Johannes Koder. *Das Eparchenbuch Leons des Weisen*. Vienna, 1991.

Kolta 1991. Kamal Sabri Kolta. "Medicine, Coptic." In *The Coptic Encyclopedia*, edited by Aziz S. Atiya, vol. 5, cols. 1578–82. New York, 1991.

Komaroff 2005. Linda Komaroff. *Islamic Art at the Los Angeles County Museum of Art*. Los Angeles, 2005.

Komaroff 2011. Linda Komaroff, ed. *Gifts of the Sultan: The Arts of Giving at the Islamic Courts*. Exh. cat. New Haven, 2011.

Kosmas 1897. Kosmas Indikopleustes. *The Christian Topography of Cosmas, an Egyptian Monk*. Translated and edited by J. W. McCrindle. London, 1897.

Kosmas 1909. Kosmas Indikopleustes. *The Christian Topography*. Edited by E. O. Winstedt. Cambridge, 1909.

Kraeling 1938. Carl H. Kraeling, ed. *Gerasa: City of the Decapolis*. New Haven, 1938.

Kraemer 1958. Casper J. Kraemer. *Excavations at Nessana*, vol. 3, *Non-Literary Papyri*. Princeton, 1958.

Krause 1991. Martin Krause. "Mummification." In *The Coptic Encyclopedia*, edited by Aziz S. Atiya, vol. 2, cols. 1696–98. New York, 1991.

Kröger 1982. Jens Kröger. *Sasanidischer Stuckdekor*. Mainz, 1982.

Krueger 2010. Derek Krueger. "The Old Testament and Monasticism." In *The Old Testament in Byzantium*, edited by Paul Magdalino and Robert Nelson, pp. 199–221. Washington, D.C., 2010.

Kruk 1993. Remke Kruk. "Warrior Women in Arabic Popular Romance: Qannâsa bint Muzâhim and Other Valiant Ladies, Part I." *Journal of Arabic Literature* 24 (1993), pp. 213–30.

Kruk 1994. Remke Kruk. "Warrior Women in Arabic Popular Romance: Qannâsa bint Muzâhim and Other Valiant Ladies, Part II." *Journal of Arabic Literature* 25 (1994), pp. 16–33.

Kubiak 1987. Władysław Kubiak. *Al-Fustat: Its Foundation and Early Urban Development*. Cairo, 1987.

B. Kühnel 1987. Bianca Kühnel. *From the Earthly to the Heavenly Jerusalem: Representations of the Holy City in Christian Art of the First Millennium*. Rome, 1987.

E. Kühnel 1971. Ernst Kühnel. *Die islamischen Elfenbeinskulpturen: VIII.–XIII. Jahrhundert*. Berlin, 1971.

E. Kühnel and Bellinger 1952. Ernst Kühnel and Louisa Bellinger. *Catalogue of Dated Tiraz Fabrics: Umayyad, Abbasid, Fatimid*. Washington, D.C., 1952.

E. Kühnel and Wachtsmuth 1933. Ernst Kühnel and Friedrich Wachtsmuth. *Die Ausgrabungen der zweiten Ktesiphon-Expedition 1931/32: Vorläufiger Bericht*. Berlin, 1933.

Labatt 2011. Annie Labatt. "Laboratory of Images: Emerging Iconographies in Eighth–Ninth Century Rome." Ph.D. diss., Yale University, 2011.

Lacau 1901. Pierre Lacau. "Textes de l'Ancien Testament en copte sahidique." *Recueil de Travaux Relatifs à la Philologie et à l'Archéologie Égyptienne et Assyrienne*, no. 23 (1901), pp. 103–24.

Lafontaine-Dosogne 1967. Jacqueline Lafontaine-Dosogne. *Itinéraires archéologiques dans la région d'Antioche: Recherches sur le monastère et sur l'iconographie de S. Syméon Stylite le Jeune*. Brussels, 1967.

Laiou 1991a. Angeliki E. Laiou. "Commerce and Trade." In *The Oxford Dictionary of Byzantium*, edited by Alexander P. Kazhdan et al., pp. 489–91.

Laiou 1991b. Angeliki E. Laiou. "Fair." In *The Oxford Dictionary of Byzantium* (e-reference edition), edited by Alexander P. Kazhdan et al. New York, 1991, http://www.oxford-Byzantium.com/entry?entry=t174.e1883 (accessed June 15, 2011).

Lambert and Demeglio 1994. Chiara Lambert and Paola Pedemonte Demeglio. "Ampolle devozionali ed itinerari di pellegrinaggio tra IV e VII secolo." *Antiquité Tardive* 2 (1994), pp. 205–31.

Lamm 1936. Carl J. Lamm. "Some Woollen Tapestry Weavings from Egypt in Swedish Museums." *Le Monde Oriental* 30 (1936), pp. 43–77.

Lamm 1937. Carl J. Lamm. *Cotton in Mediaeval Textiles of the Near East*. Paris, 1937.

Lamm 1938. Carl J. Lamm. "Dated or Datable Tiraz in Sweden." *Le Monde Oriental* 32 (1938), pp. 103–25.

Lammens 1930. Henri Lammens. *Études sur le siècle des Omayyades*. Beirut, 1930.

Lamoreaux and Cairala 2000. John C. Lamoreaux and Cyril Cairala, eds. and trans. *The Life of Timothy of Kakhushta: Two Arabic Texts*. Turnhout, 2000.

Lane 1958. Arthur Lane. *Early Islamic Pottery*. 4th rev. ed. London, 1958.

Lassus 1932. Jean Lassus. "Images de stylites." *Bulletin d'Études Orientales* 2 (1932), pp. 67–82.

Lassus 1935–36. Jean Lassus. *Inventaire archéologique de la région au nord-est de Hama*. 2 vols. Damascus, 1935–36.

Latz 1958. Josef Latz. *Das Buch der Wezire und Staatssekretäre von Ibn 'Abdus al-Gahšiyari*. Bonn, 1958.

Launois 1957. Aimée Launois. "Estampilles et poids faibles en verre omeyyades et abbassides au Musée Arabe du Caire." *Annales Islamologiques* 3 (1957), pp. 1–83.

Lavas 2001. Georgios P. Lavas. "The Kathisma of the Holy Virgin: A Major New Shrine." *Deltion Newsletter* 2 (2001), pp. 60–101.

Lawson 2009. Todd Lawson. *The Crucifixion and the Qur'an: A Study in the History of Muslim Thought*. Oxford, 2009.

Layton 2002. Bentley Layton. "Social Structure and Food Consumption in an Early Christian Monastery: The Evidence of Shenoute's Canons and the White Monastery Federation, A.D. 385–465." *Le Muséon* 115 (2002), pp. 25–55.

Layton 2007. Bentley Layton. "Rules, Patterns, and the Exercise of Power in Shenoute's Monastery: The Problem of World Replacement and Identity Maintenance." *Journal of Early Christian Studies* 15, no. 1 (2007), pp. 45–73.

Lazarev 1986. Viktor N. Lazarez. *Istoriia vizantiĭskoĭ zhivopisi*. Moscow, 1986.

Le Strange 1965. Guy Le Strange. *Palestine under the Moslems: A Description of Syria and the Holy Land from A.D. 650 to 1500 (1890)*. Reprint, Beirut, 1965.

Leader 2000. Ruth. E. Leader. "The David Plates Revisited: Transforming the Secular in Early Byzantium." *Art Bulletin* 82 (September 2000), pp. 407–27.

Leader-Newby 2004. Ruth E. Leader-Newby. *Silver and Society in Late Antiquity: Functions and Meanings of Silver Plate in the Fourth to Seventh Centuries*. Aldershot, 2004.

Leader-Newby 2006. Ruth E. Leader-Newby. "Classicism and Paideia in Early Byzantine Silver from the Hermitage." In *The Road to Byzantium:*

Luxury Arts of Antiquity, edited by Frank Althaus and Mark Sutcliffe, pp. 67–73. Exh. cat. London, 2006.

Lechler 1937. George Lechler. "The Tree of Life in Indo-European and Islamic Cultures." *Ars Islamica* 4 (1937), pp. 369–419.

Lecker 1993. Michael Lecker. "Idol Worship in Pre-Islamic Medina (Yathrib)." *Le Muséon* 106 (1993), pp. 331–46.

Leisten 2003. Thomas Leisten. *Excavation of Samarra*, vol. 1, *Architecture: Final Report of the First Campaign 1910–1912*. Mainz am Rhein, 2003.

Leisten 2005. Thomas Leisten. "Mshatta, Samarra, and al-Hira: Ernst Herzfeld's Theories Concerning the Hira-Style Revisited." In *Ernst Herzfeld and the Development of Near Eastern Studies, 1900–1950*, edited by Ann C. Gunter and Stefan R. Hauser, pp. 371–84. London, 2005.

Leisten 2008. Thomas Leisten. "For Prince and Country(side): The Marwanid Mansion at Balis on the Euphrates." In *Residences, Castles, Settlements: Transformation Processes from Late Antiquity to Early Islam in Bilad al-Sham*, edited by Karin Bartl and Abd al-Razzaq Moaz, pp. 377–94. Rahden, 2008.

Lenzen 2003. Cherie J. Lenzen. "Ethnic Identity at Beit Ras/Capitolias and Umm al-Jimal." *Mediterranean Archaeology* 16 (2003), pp. 73–87.

Leontios 1999. Leontios of Damascus. *The Life of Stephen of Mar Sabas*. 2 vols. Edited and translated by John C. Lamoreaux. Louvain, 1999.

Lepage 1990. Claude Lepage. "Contribution de l'ancien art chrétien d'Éthiopie à la connaissance des autres arts chrétiens." *Comptes-rendus des Séances de l'Académie des Inscriptions et Belles-Lettres* 134 (1990), pp. 799–822.

Leroy 1960. Jules Leroy. "L'évangéliaire éthiopien du couvent d'Abba Garima et ses attaches avec l'ancien art chrétien de Syrie." *Cahiers Archéologiques* 11 (1960), pp. 131–43.

Leroy 1964. Jules Leroy. *Les manuscrits syriaques à peintures conservés dans les bibliothèques d'Europe et d'Orient*. Paris, 1964.

Leroy 1974. Jules Leroy. *Les manuscrits coptes et coptes-arabes illustrés*. Paris, 1974.

Lev 1999. Yaacov Lev. "Tinnis: An Industrial Medieval Town." In *L'Égypte fatimide, son art et son histoire*, edited by Marianne Barrucand, pp. 83–104. Paris, 1999.

Levine 2005. Lee I. Levine. *The Ancient Synagogue: The First Thousand Years*. 2d ed. New Haven, 2005.

Levitt Kohn 2007. Risa Levitt Kohn, ed. *The Dead Sea Scrolls: From Scroll to Codex*. Exh. cat. San Diego, 2007.

Levy 1993–94. Yaffa Levy. "Ezekiel's Plan in an Early Karaite Bible." *Jewish Art* 19–20 (1993–94), pp. 68–85.

Levy-Rubin 2001. Milka Levy-Rubin. "The Role of the Judaean Desert Monasteries in the Monthelite Controversy in Seventh-Century Palestine." In *The Sabaite Heritage in the Orthodox Church from the Fifth Century to the Present*, edited by Joseph Patrich, pp. 283–300. Louvain, 2001.

Levy-Rubin 2011. Milka Levy-Rubin. "Changes in the Settlement Pattern of Palestine Following the Arab Conquest." In *Shaping the Middle East: Jews, Christians, and Muslims in an Age of Transition, 400–800 C.E.*, edited by Kenneth G. Holum and Hayim Lapin, pp. 155–72. Bethesda, Md., 2011.

Lewis 1900. Agnes Smith Lewis, ed. and trans. *Select Narratives of Holy Women from the Syro-Antiochene or Sinai Palimpsest*. London, 1900.

Leyerle 2008. Blake Leyerle. "Pilgrim Eulogiae and Domestic Ritual." *Archiv für Religionsgeschichte* 10 (2008), pp. 223–37.

Liban 1998. *Liban: L'autre rive*. Exh. cat. Paris, 1998.

Liddell and Scott 1968. Henry George Liddell and Robert Scott, comps. *A Greek-English Lexicon*. Oxford, 1968.

Lieber 2010. Laura Lieber. *Yannai on Genesis: An Invitation to Piyyut*. Cincinnati, 2010.

Liebeschuetz 2004. J. H. W. G. Liebeschuetz. "The Birth of Late Antiquity." *Antiquité Tardive* 12 (2004), pp. 253–61.

Linder 1987. Amnon Linder. *The Jews in Roman Imperial Legislation*. Detroit, 1987.

Linscheid 2001. Petra Linscheid. "Early Byzantine Textiles from Amorium, Anatolia." *Archaeological Textiles Newsletter* 32 (2001), pp. 17–18.

Linscheid 2004. Petra Linscheid. "Middle Byzantine Textiles from Amorium, Anatolia." *Archaeological Textiles Newsletter* 38 (2004), pp. 25–27.

Liphschitz et al. 1997. Nili Liphschitz, Gideon Biger, Georges Bonani, and W. Wolfli. "Comparative Dating Methods: Botanical Identification and 14C Dating of Carved Panels and Beams from the Al-Aqsa Mosque in Jerusalem." *Journal of Archaeological Sciences* 24 (November 1997), pp. 1045–50.

Lombard 1978. Maurice Lombard. *Les textiles dans le monde musulman VIIe au XIIe siècle*. Paris, 1978.

Longman 1930. Lester D. Longman. "Two Fragments of an Early Textile in the Museo Cristiano." *Art Bulletin* 12 (June 1930), pp. 115–30.

Lopez 1945. Robert S. Lopez. "Silk Industry in the Byzantine Empire." *Speculum* 20 (January 1945), pp. 1–42.

Lopez 1951. Robert S. Lopez. "The Dollar of the Middle Ages." *Journal of Economic History* 11 (Summer 1951), pp. 209–34.

Lorquin 1992. Alexandra Lorquin. *Les tissus coptes au Musée National du Moyen Âge–Thermes de Cluny*. Paris, 1992.

Louth 2002. Andrew Louth. *St. John Damascene: Tradition and Originality in Byzantine Theology*. Oxford, 2002.

Loverdou-Tsigarida 1983. Katia Loverdou-Tsigarida. "Osteia plakidia tou mouseiou Mpenaki me phytiki diakosmisi." In *Aphierōma stē mnēmē Stylianou Pelekanidē*, pp. 213–27. Thessaloniki, 1983.

Lowden 1992a. John Lowden. "The Luxury Book as Diplomatic Gift." In *Byzantine Diplomacy: Papers of the Twenty-Fourth Spring Symposium of Byzantine Studies, Cambridge, March 1990*, edited by Jonathan Shepard and Simon Franklin, pp. 249–60. Aldershot, 1992.

Lowden 1992b. John Lowden. *The Octateuchs: A Study in Byzantine Manuscript Illumination*. University Park, Pa., 1992.

Lowden 1999. John Lowden. "The Beginnings of Biblical Illustration." In *Imaging the Early Medieval Bible*, edited by John Williams, pp. 9–59. University Park, Pa., 1999.

Lowden 2007. John Lowden. "The Word Made Visible: The Exterior of the Early Christian Book as Visual Argument." In *The Early Christian Book*, edited by William E. Klingshirn and Linda Safran, pp. 15–47. Washington, D.C., 2007.

Lukonin and Ivanov 1996. Vladimir Lukonin and Anatolii A. Ivanov. *Lost Treasures of Persia: Persian Art in the Hermitage Museum*. Washington, D.C., 1996.

Lydon 2004. John E. Lydon. "Silk: The Original Liquid Crystal Polymer." *Liquid Crystals Today* 13, no. 3 (2004), pp. 1–13.

Lyster 2008. William Lyster, ed. *The Cave Church of Paul the Hermit at the Monastery of St. Paul, Egypt*. New Haven, 2008.

MacAdam 1994. Henry Innes MacAdam. "Settlements and Settlement Patterns in Northern and Central Jordan, ca. 550–ca. 570." In *The Byzantine and Early Islamic Near East*, vol. 2, *Land Use and Settlement Patterns*, edited by G. R. D. King and Averil Cameron, pp. 49–94. Princeton, 1994.

MacCoull 1986. Leslie S. B. MacCoull. "Redating the Inscription of El-Moallaqa." *Zeitschrift für Papyrologie und Epigraphik* 64 (1986), pp. 230–34.

MacCoull 1988. Leslie S. B. MacCoull. *Dioscorus of Aphrodito: His Work and His World*. Berkeley, 1988.

MacCoull 2007. Leslie S. B. MacCoull. "Philosophy in Its Social Context." In *Egypt in the Byzantine World, 300–700*, edited by Roger S. Bagnall, pp. 67–82. Cambridge, 2007.

Mackie 1989. Louise W. Mackie. "Textiles." In *Fustat Expedition Final Reports*, vol. 2, *Fustat C*, edited by Władysław Kubiak and George T. Scanlon, pp. 81–97. Winona Lake, Ind., 1989.

Mackie 1992. Louise W. Mackie. "Pattern Books for Drawloom Weaving in Fes, Morocco." *Bulletin du Centre Internationale d'Études des Textiles Anciens* 70 (1992), pp. 169–76.

MacMullen 1964. Ramsay MacMullen. "Some Pictures in Ammianus Marcellinus." *Art Bulletin* 46 (December 1964), pp. 435–55.

Madelung 1985. Wilferd Madelung. "The Origins of the Controversy Concerning the Creation of the Koran" (1974). In *Religious Schools and Sects in Medieval Islam*. London, 1985.

Madigan 2001. Daniel Madigan. *The Qur'an's Self-Image: Writing and Authority in Islam's Scripture*. Princeton, 2001.

Maehler 1985. Herwig Maehler. "Review of Michigan Papyri XIV." *Gnomon* 57 (1985), pp. 33–35.

Magdalino 1998. Paul Magdalino. "The Road to Baghdad in the Thought-World of Ninth-Century Byzantium." In *Byzantium in the Ninth Century: Dead or Alive?*, edited by Leslie Brubaker, pp. 195–213. Aldershot, 1998.

Magdalino 2006. Paul Magdalino. *L'orthodoxie des astrologues: La science entre le dogme et la divination à Byzance (VIIe–XIVe siècle)*. Paris, 2006.

Magen 1993. Yitzhak Magen. "Samaritan Synagogues." In *Early Christianity in Context: Monuments and Documents*, edited by Frédéric Manns and Eugenio Alliata, pp. 193–230. Jerusalem, 1993.

Magen 2008. Yitzhak Magen. *The Samaritans and the Good Samaritan*. Jerusalem, 2008.

Magness 2011. Jodi Magness. "Archaeological Evidence for the Sasanian Persian Invasion of Jerusalem." In *Shaping the Middle East: Jews, Christians, and Muslims in an Age of Transition, 400–800 C.E.*, edited by Kenneth G. Holum and Hayim Lapin, pp. 85–98. Bethesda, Md., 2011.

Maguire 1987. Henry Maguire. *Earth and Ocean: The Terrestrial World in Early Byzantine Art*. University Park, Pa., 1987.

Maguire 1990. Henry Maguire. "Garments Pleasing to God: The Significance of Domestic Textile Designs in the Early Byzantine Period." *Dumbarton Oaks Papers* 44 (1990), pp. 215–24.

Maguire 1995. Henry Maguire. "Magic and the Christian Image." In *Byzantine Magic*, edited by Henry Maguire, pp. 51–71. Washington, D.C., 1995.

Maguire 1996. Henry Maguire. *The Icons of Their Bodies: Saints and Their Images in Byzantium.* Princeton, 1996.

Maguire 1997. Henry Maguire. "Magic and Money in the Early Middle Ages." *Speculum* 72 (October 1997), pp. 1037–54.

Maguire 1998. Henry Maguire. *Rhetoric, Nature, and Magic in Byzantine Art.* Aldershot, 1998.

Maguire 1999. Henry Maguire. "The Good Life." In *Late Antiquity: A Guide to the Postclassical World,* edited by Glen W. Bowersock et al., pp. 238–57. Cambridge, Mass., 1999.

Maguire 2009. Henry Maguire. "Moslems, Christians, and Iconoclasm: Erasures from Church Floor Mosaics during the Early Islamic Period." In *Byzantine Art: Recent Studies: Essays in Honor of Lois Drewer,* edited by Colum Hourihane, pp. 111–19. Tempe, Ariz., 2009.

Mainstone 1988. Rowland J. Mainstone. *Hagia Sophia: Architecture, Structure and Liturgy of Justinian's Great Church.* New York, 1988.

Makariou 2000. Sophie Makariou, ed. *Memorias do imperio Arabe.* Exh. cat. Santiago de Compostela, 2000.

Malbon 1990. Elizabeth Struthers Malbon. *The Iconography of the Sarcophagus of Junius Bassus.* Princeton, 1990.

Mälck 2004. Kathrin Mälck. "Technische Analyse der Berliner Reitermäntel und Beinlinge." In *Riding Costume in Egypt: Origin and Appearance,* edited by Cäcilia Fluck and Gillian Vogelsang-Eastwood, pp. 163–73. Leiden, 2004.

Manaphēs 1990. Kōnstantinos A. Manaphēs, ed. *Sinai: Treasures of the Monastery of Saint Catherine.* Athens, 1990.

Manginis 2010. Georgios Manginis. "Hagia Koryphe (Jabal Musa) in Sinai, Egypt." Ph.D. diss., School of Oriental and African Studies, London, 2010.

C. Mango 1972. Cyril Mango. *The Art of the Byzantine Empire, 312–1453: Sources and Documents.* Toronto, 1972.

C. Mango 1995. Cyril Mango. "The Pilgrim's Motivation." In *Akten des XII. Internationalen Kongresses für christliche Archäologie,* edited by Ernst Dassmann and Josef Engemann, vol. 3, pp. 1–9. Münster, 1995.

C. Mango 2000. Cyril Mango. "Constantinople as Theotokoupolis." In *The Mother of God: Representations of the Virgin in Byzantine Art,* edited by Maria Vasilakē, pp. 17–25. Exh. cat. Milan, 2000.

C. Mango et al. 1991. Cyril Mango, Ihor Ševčenko, and Anthony Cutler. "Style." In *The Oxford Dictionary of Byzantium,* edited by Alexander P. Kazhdan et al., p. 1970. New York, 1991.

M. Mango 1977. Marlia Mundell Mango. "Monophysite Church Decoration." In *Iconoclasm,* edited by Anthony Bryer and Judith Herrin, pp. 58–74. Birmingham, 1977.

M. Mango 1986. Marlia Mundell Mango. *Silver from Early Byzantium: The Kaper Koraon and Related Treasures.* Exh. cat. Baltimore, 1986.

M. Mango 1991a. Marlia Mundell Mango. "David Plates." In *The Oxford Dictionary of Byzantium,* edited by Alexander P. Kazhdan et al., vol. 1, pp. 590–91. New York, 1991.

M. Mango 1991b. Marlia Mundell Mango. "Largitio Dishes, Silver." In *The Oxford Dictionary of Byzantium,* edited by Alexander P. Kazhdan et al., vol. 2, pp. 1179–80. New York, 1991.

M. Mango 1991c. Marlia Mundell Mango. "Syria." In *The Oxford Dictionary of Byzantium,* edited by Alexander P. Kazhdan et al., vol. 3, pp. 1997–2000. New York, 1991.

M. Mango 1994. Marlia Mundell Mango. "Imperial Art in the Seventh Century." In *New Constantines: The Rhythm of Imperial Renewal in Byzantium, 4th–13th Centuries,* edited by Paul Magdalino, pp. 109–38. Aldershot, 1994.

M. Mango 1999a. Marlia Mundell Mango. "Silver." In *Late Antiquity: A Guide to the Postclassical World,* edited by Glen W. Bowersock et al., pp. 696–97. Cambridge, Mass., 1999.

M. Mango 1999b. Marlia Mundell Mango. "Treasure Hoards." In *Late Antiquity: A Guide to the Postclassical World,* edited by Glen W. Bowersock et al., p. 733. Cambridge, Mass., 1999.

M. Mango 2000. Marlia Mundell Mango. "The Commercial Map of Constantinople." *Dumbarton Oaks Papers* 54 (2000), pp. 189–207.

M. Mango 2005. Marlia Mundell Mango. "A New Stylite at Androna in Syria." In *Mélanges Jean-Pierre Sodini,* pp. 329–42. Paris, 2005.

M. Mango 2009. Marlia Mundell Mango. "Byzantine Trade: Local, Regional, Interregional, and International." In *Byzantine Trade, 4th–12th Centuries: The Archaeology of Local, Regional, and International Exchange,* edited by Marlia Mundell Mango, pp. 3–14. Farnham, 2009.

M. Mango et al. 1989. Marlia Mundell Mango, Cyril Mango, Angela Care Evans, and Michael Hughes. "A 6th-Century Mediterranean Bucket from Bromeswell Parish, Suffolk." *Antiquity* 63 (1989), pp. 295–311.

Mann 1972. Jacob Mann. *Texts and Studies in Jewish History and Literature.* 2 vols. Reprint, New York, 1972.

Marangou 1976. Lila Marangou. *Bone Carvings from Egypt,* vol. 1, *Graeco-Roman Period.* Tübingen, 1976.

Maraval 1985. Pierre Maraval. *Lieux saints et pèlerinages d'Orient.* Paris, 1985.

Maraval 2004. Pierre Maraval. *Lieux saints et pèlerinages d'Orient.* 2d ed. Paris, 2004.

Marçais 1940. Georges Marçais. "The Panels of Carved Wood." In *K. A. C. Creswell, Early Muslim Architecture,* vol. 2, pp. 127–37. Oxford, 1940.

Marçais and Poinssot 1952. Georges Marçais and Louis Poinssot. *Objets kairouanais, IXe au XIIIe siècle: Reliures, verreries, cuivres et bronzes, bijoux.* vol. 2. Tunis, 1952.

March 2009. Charles March. *Spatial and Religious Transformations in the Late Antique Polis: A Multi-disciplinary Analysis with a Case-study of the City of Gerasa.* Oxford, 2009.

Markiewicz 2009. Tomasz Markiewicz. "The Church, Clerics, Monks and Credit in the Papyri." In *Monastic Estates in Late Antique and Early Islamic Egypt: Ostraca, Papyri, and Essays in Memory of Sarah Clackson,* edited by Anne Boud'hors et al., pp. 178–202. Cincinnati, 2009.

Marshak 1972. Boris I. Marshak. "Bronzovyi kuvshin iz Samarkanda" (The Bronze Ewer from Samarkand). In *Sredniaia Aziia i Iran* (Central Asia and Iran), edited by Anatolii A. Ivanov and Sergei A. Sorokin, pp. 61–90 (English summary, pp. 180–81). Leningrad, 1972.

Marshak 1986. Boris I. Marshak. *Silberschätze des Orients: Metallkunst des 3.–13. Jahrhunderts und ihre Kontinuität.* Leipzig, 1986.

Marshak 2006. Boris I. Marshak. "Le décor de la vaisselle en argent à la fin de la période sassanide et au début de l'époque islamique." In *Les Perses sassanides: Fastes d'un empire oublié (224–642),* edited by Françoise Demange. Exh. cat. Paris, 2006.

F. Martin 1971. Fredrik R. Martin. *The Miniature Painting and Painters of Persia, India and Turkey from the 8th to the 18th Century* (1912). Reprint, London, 1971.

M. Martin 1997. Max Martin. "Wealth and Treasure in the West, 4th–7th Century." In *The Transformation of the Roman World, AD 400–900,* edited by Leslie Webster and Michelle Brown, pp. 48–66. Berkeley, 1997.

Martiniani-Reber 1986. Marielle Martiniani-Reber. *Lyon, Musée historique des tissus: Soieries sassanides, coptes et byzantine, Ve–XIe siècles.* Paris, 1986.

Martiniani-Reber 1997. Marielle Martiniani-Reber. *Textiles et mode sassanides: Les tissus orientaux conservés au département des Antiquités égyptiennes.* Paris, 1997.

Martiniani-Reber 2004. Marielle Martiniani-Reber. "Témoignages textiles des relations entre Égypte et Proche-Orient (VIIe–IXe siècles)." *Antiqité Tardive* 12 (2004), pp. 113–19.

Marzuq 1955. Muhammad 'Abd al-'Aziz Marzuq. *History of Textile Industry in Alexandria, 331 B.C.–1517 A.D.* Alexandria, 1955.

Maspero 1908. Gaston Maspero. "Un encensoir copte." *Annales du Service des Antiquités de l'Égypte* 9 (1908), pp. 148–49.

Matheson 1980. Susan B. Matheson. *Ancient Glass in the Yale University Art Gallery.* New Haven, 1980.

K. Mathews 1999. Karen Rose Mathews. "Expressing Political Legitimacy and Cultural Identity through the Use of Spolia on the Ambo of Henry II." *Medieval Encounters* 5, no. 2 (1999), pp. 156–83.

T. Mathews 2006. Thomas F. Mathews. "Early Icons of the Holy Monastery of Saint Catherine at Sinai." In *Holy Image, Hallowed Ground: Icons from Sinai,* edited by Robert S. Nelson and Kristen M. Collins, pp. 39–55. Exh. cat. Los Angeles, 2006.

Matz 1968–75. Friedrich Matz. *Die dionysischen Sarkophage.* 4 vols. Berlin, 1968–75.

Matzulevich 1929. Leonid Matzulevich. *Byzantinische Antike: Studien auf Grund der Silbergefässe der Ermitage.* Berlin, 1929.

Mavroudi 2002. Maria Mavroudi. *A Byzantine Book on Dream Interpretation: The Oneirocriticon of Achmet and Its Arabic Sources.* Leiden, 2002.

Mavroudi 2007a. Maria Mavroudi. "Late Byzantium and Exchange with Arabic Writers." In *Byzantium: Faith and Power (1261–1557): Perspectives on Late Byzantine Art and Culture,* edited by Sarah T. Brooks, pp. 62–75. New Haven, 2007.

Mavroudi 2007b. Maria Mavroudi. "Occult Science and Society in Byzantium: Considerations for Future Research." In *The Occult Sciences in Byzantium,* edited by Paul Magdalino and Maria Mavroudi, pp. 39–95. Geneva, 2007.

Mavroudi 2009. Maria Mavroudi. "Islamic Divination in the Context of its 'Eastern' and 'Western' Counterparts." In *Falnama: The Book of Omens,* edited by Massumeh Farhad and Serpil Bağci, pp. 222–29. Exh. cat. Washington, D.C., 2009.

Mayerson 1964. Philip Mayerson. "The First Muslim Attacks on Southern Palestine (AD 633–634)." *Transactions and Proceedings of the American Philological Association* 95 (1964), pp. 155–99.

Mayerson 1993. Philip Mayerson. "A Confusion of Indias: Asian India and African India in the Byzantine Sources." *Journal of the American Oriental Society* 113 (1993), pp. 169–74.

McCabe 2009. Anne McCabe. "Imported Materia Medica, 4th–12th Centuries, and Byzantine Pharmacology." In *Byzantine Trade, 4th–12th Centuries:*

The Archaeology of Local, Regional, and International Exchange, edited by Marlia Mundell Mango, pp. 273–92. Farnham, 2009.

McCarren 1980. Vincent P. McCarren, ed. *Michigan Papyri XIV.* Chico, Calif., 1980.

McCormick 2001. Michael McCormick. *Origins of the European Economy: Communications and Commerce, A.D. 300–900.* Cambridge, 2001.

McCormick et al. 1991. Michael McCormick, Alexander P. Kazhdan, and Anthony Cutler. "Purple." In *The Oxford Dictionary of Byzantium,* edited by Alexander P. Kazhdan et al., pp. 1759–60. New York, 1991.

McKenzie 2007. Judith McKenzie. *The Architecture of Alexandria and Egypt, c. 300 B.C. to A.D. 700.* New Haven, 2007.

Meier 1981. Fritz Meier. "Der Prediger auf der Kanzel (minbar)." In *Studien zur Geschichte und Kultur des Vorderen Orients: Festschrift für Bertold Spuler zum siebzigsten Geburtstag,* edited by Hans R. Roemer und Albrecht Noth, pp. 225–48. Leiden, 1981.

Meimaris 1985. Yiannis. E. Meimaris. *Katalogos tōn neōn aravikōn cheirographōn tēs Hieras Monēs Hagias Aikaterinēs tou Orous Sina.* Athens, 1985.

Meinecke 1995. Michael Meinecke. "al-Rakka." In *The Encyclopaedia of Islam,* 2d ed., vol. 8, p. 410. Leiden, 1995.

Meinecke 1999. Michael Meinecke. "Abbasidische Stuckdekorationen aus ar-Raqqa." In *Bamberger Symposium: Rezeptionen in der islamischen Kunst,* edited by Barbara Finster et al., pp. 247–67. Stuttgart, 1999.

Meisami and Starkey 1998. Julie Scott Meisami and Paul Starkey, eds. *Encyclopedia of Arabic Literature.* 2 vols. London, 1998.

Melikian-Chirvani 1982. Assadullah Souren Melikian-Chirvani. *Islamic Metalwork from the Iranian World, 8th–18th Centuries.* London, 1982.

Menander 1964. Menander of Athens. *Menandri Sententiae.* Edited by Siegfried Jäkel. Leipzig, 1964.

Mercier 2000. Jacques Mercier. "La peinture éthiopienne à l'époque axoumite et au XVIIIe siècle." *Comptes-rendus des Séances de l'Académie des Inscriptions et Belles-Lettres* 144 (2000), pp. 35–71.

Merkelbach and Stauber 2002. Reinhold Merkelbach and Josef Stauber, eds. *Steinepigramme aus dem griechischen Osten,* vol. 4, *Die Südküste Kleinasiens, Syrien und Palaestina.* Munich, 2002.

Metlich and Schindel 2004. Michael A. Metlich and Nikolaus C. Schindel. "Egyptian Copper Coinage in the 7th Century AD: Some Critical Remarks." *ONS Newsletter* 179 (Spring 2004), pp. 11–15.

Metzger 1958. Mendel Metzger. "Quelques caractères iconographiques et ornementaux de deux manuscrits hébraïques du Xe siècle." *Cahiers de Civilisation Médiévale* 1 (1958), pp. 205–13.

Michałowski 1974. Kazimierz Michałowski. *Faras: Malowidła ścienne w zbiorach Muzeum Narodowego w Warszawie* **(Title trans TK).** Warsaw, 1974.

Michel 2001. Anne Michel. *Les églises d'époque byzantine et umayyade de Jordanie, Ve–VIIIe siècle: Typologie architecturale et aménagements liturgiques.* Turnhout, 2001.

Midant-Reynes and Denoix 2010. Béatrix Midant-Reynes and Sylvie Denoix. "Travaux de l'Institut Français d'Archéologie Orientale 2009–2010." *Bulletin de l'Institut Français d'Archéologie Orientale* 110 (2010), pp. 370–73.

Migeon 1909. Gaston Migeon. *Les arts du tissu.* Paris, 1909.

Miles 1948. George C. Miles. "Early Islamic Inscriptions Near Ta'if in the Hijaz." *Journal of Near Eastern Studies* 7 (1948), pp. 236–42.

Miles 1967. George C. Miles. "The Earliest Arab Gold Coinage." *American Numismatic Society Museum Notes* 13 (1967), pp. 205–29.

Milik 1960. Józef T. Milik. "Notes d'épigraphie et de topographie jordaniennes." *Liber Annuus* 10 (1960), pp. 147–84.

Milwright 2009. Marcus Milwright. *An Introduction to Islamic Archaeology.* Edinburgh, 2009.

Miner 1947. Dorothy E. Miner, ed. *Early Christian and Byzantine Art.* Exh. cat. Baltimore, 1947.

Misihah 1959. Hishmat Misihah. "A Bronze Censor [sic] in the Coptic Museum, no. 5144." *Annales du Service des Antiquités de l'Égypte* 56 (1959), pp. 31–33.

Mizzi 1965–82. Yusuf ibn al-Zaki 'Abd al-Rahman Mizzi. *Tuhfat al-ashraf bi-ma'rifat al-atraf.* 13 vols. Edited by 'Abd al-Samad Sharaf al-Din. Bhiwandi, 1965–82.

Mohamed and Grossmann 1991. Mahmoud Ali Mohamed and Peter Grossmann. "On the Recently Excavated Monastic Buildings in Dayr Anba Shinuda: Archaeological Report." *Bulletin de la Société d'Archéologie Copte* 30 (1991), pp. 53–63.

Montserrat 1998. Dominic Montserrat. "Pilgrimage to the Shrine of SS Cyrus and John at Menouthis in Late Antiquity." In *Pilgrimage and Holy Space in Late Antique Egypt,* edited by David Frankfurter, pp. 257–80. Leiden, 1998.

Monuments 1997. *Byzantine and Post-Byzantine Monuments of Thessaloniki.* 2d ed. Thessaloniki, 1997.

Moraitou 2001. Mina Moraitou. "Umayyad Ornament on Early Islamic Woodwork: A Pair of Doors in the Benaki Museum." *Mouseio Benakē* 1 (2001), pp. 159–72.

Moraitou 2008a. Mina Moraitou. "Early Islamic Textiles." *Hali,* no. 156 (Summer 2008), pp. 62–64.

Moraitou 2008b. Mina Moraitou. "Woodcarving." *Hali,* no. 156 (Summer 2008), pp. 76–77.

Moritz 1905. Bernhard Moritz. *Arabic Palaeography: A Collection of Arabic Texts from the First Century of the Hidjra till the Year 1000.* Cairo, 1905.

Moritz 1918. Bernhard Moritz. *Beiträge zur Geschichte des Sinaiklosters im Mittelalter nach arabischen Quellen.* Berlin, 1918.

Morphy 2009. Howard Morphy. "Art as a Mode of Action: Some Problems with Gell's Art and Agency." *Journal of Material Culture* 14 (2009), pp. 5–27.

Morris 1943. Frances Morris. "Notes on an Early Silk Weave." *Bulletin of the Needle and Bobbin Club* 27 (1943), pp. 40–47.

Morrisson 2002. Cécile Morrisson. "Byzantine Money: Its Production and Circulation." In *The Economic History of Byzantium: From the Seventh through the Fifteenth Century,* edited by Angeliki E. Laiou, vol. 3, pp. 909–66. Washington, D.C., 2002.

Motzki 2001. Harald Motzki. "The Collection of the Qur'an: A Reconsideration of Western Views in Light of Recent Methodological Developments." *Der Islam* 78 (2001), pp. 1–34.

Mouterde and Poidebard 1945. René Mouterde and Antoine Poidebard. *Les limes de Chalcis; organisation de la steppe en haute Syrie romaine.* Paris, 1945.

Munajjid 1971. Salah al-Din Munajjid. *Dirasat fi tarikh al-khatt al-'Arabi (Studies on the History of the Arabic Script).* Beirut, 1971.

Muqaddasi 1967. Muhammad ibn Ahmad Muqaddasi. *Kitab Ahsan al-taqasim fi ma'rifat al-aqalim.* Edited by M. J. de Goeje. Leiden, 1967.

Murray 1975. Robert Murray. *Symbols of Church and Kingdom: A Study in Early Syriac Tradition.* London, 1975.

Musche 1988. Brigitte Musche. *Vorderasiatischer Schmuck zur Zeit der Arsakiden und der Sasaniden.* Leiden, 1988.

Musil 1907. Alois Musil. *Kusejr 'Amra und Schlösser östlich von Moab.* Vol. 2. Vienna, 1907.

Muthesius 1993. Anna Muthesius. "The Byzantine Silk Industry: Lopez and Beyond." *Journal of Medieval History* 19 (1993), pp. 1–67.

Muthesius 1997. Anna Muthesius. *Byzantine Silk Weaving: AD 400 to AD 1200.* Vienna, 1997.

Muthesius 2004. Anna Muthesius. *Studies in Silk in Byzantium.* London, 2004.

Narkiss 1969. Bezalel Narkiss. *Hebrew Illuminated Manuscripts.* Jerusalem, 1969.

Narkiss 1972. Bezalel Narkiss. "Illuminated Hebrew Children's Books from Mediaeval Egypt." In *Studies in Art,* edited by Moshe Barasch, pp. 58–71. Jerusalem, 1972.

Narkiss 1984. Bezalel Narkiss. *Kitve-yad 'Ivriyim metsuyarim (Hebrew Illuminated Manuscripts).* Jerusalem, 1984.

Narkiss 1990. Bezalel Narkiss. *Illuminations from Hebrew Bibles of Leningrad.* Jerusalem, 1990.

Nasir-i Khusrau 2001. *Nasir-i Khusraw's Book of Travels (Safarnamah).* Translated and edited by Wheeler M. Thackston. Costa Mesa, Calif., 2001.

Nasrallah 1970. Joseph Nasrallah. "Le couvent de Saint-Siméon l'Alépin: Témoignages littéraires et jalons sur son histoire." *Parole de l'Orient* 1, no. 2 (1970), pp. 327–56.

Nasrallah 1971a. Joseph Nasrallah. "À propos des trouvailles épigraphiques a Saint-Siméon-l'Alépin." *Syria* 48 (1971), pp. 165–78.

Nasrallah 1971b. Joseph Nasrallah. "L'orthodoxie de Siméon Stylite l'Alépin et sa survie dans l'Église melchite." *Parole de l'Orient* 2, no. 2 (1971), pp. 345–64.

Nasrallah 1988. Joseph Nasrallah. *Histoire du mouvement littéraire dans l'Église melchite du Ve au XXe siècle,* vol. 2, pt. 2, 750–Xe S. Louvain, 1988.

Nau 1913. François Nau. "Résumé de monographies syriaques." *Revue de l'Orient Chrétien* 18 (1913), pp. 379–89.

Naveh 1978. Joseph Naveh. *'Al pesefas va-even: Ha-ketovot ha-Aramiyot yeha-'Ivriyot mi-bate ha-keneset ha-'atikim = On Stone and Mosaic: The Aramaic and Hebrew Inscriptions from Ancient Synagogues* (in Hebrew). Tel Aviv, 1978.

Nebes et al. 1997. Norbert Nebes, Tilman Seidensticker, and Hans-Caspar Graf von Bothmer, eds. *Orientalische Buchkunst in Gotha.* Exh. cat. Gotha, 1997.

Necipoğlu 2008. Gülru Necipoğlu. "The Dome of the Rock as Palimpsest: 'Abd al-Malik's Grand Narrative and Sultan Süleyman's Glosses." *Muqarnas* 25 (2008), pp. 17–105.

Nektarios 1980. Nektarios, Patriarch of Jerusalem. *Epitomē tēs Hierokosmikēs Historias (Synopsis of Ecclesiastical and Secular History).* Venice, 1677. Facsimile ed., Athens, 1980.

J. Nelson 2010. Janet L. Nelson. "Introduction." In *The Languages of Gift in the Early Middle Ages,* edited by Wendy Davies and Paul Fouracre, pp. 1–17. Cambridge, 2010.

R. Nelson 2005. Robert S. Nelson. "Letters and Language/Ornament and Identity in Byzantium and Islam." In *The Experience of Islamic Art on the Margins of Islam*, edited by Irene A. Bierman, pp. 61–88. Reading, U.K., 2005.

R. Nelson and Collins 2006. Robert S. Nelson and Kristen M. Collins, eds. *Holy Image, Hallowed Ground: Icons from Sinai.* Exh. cat. Los Angeles, 2006.

Nesbitt 1991. John W. Nesbitt. "Seals and Sealing." In *The Oxford Dictionary of Byzantium*, edited by Alexander P. Kazhdan et al., pp. 1859–60. New York, 1991.

Nesbitt 2003. John W. Nesbitt. "Apotropaic Devices on Byzantine Lead Seals and Tokens in the Collections of Dumbarton Oaks and the Fogg Museum of Art." In *Through a Glass Brightly: Studies in Byzantine and Medieval Art and Archaeology Presented to David Buckton*, edited by Chris Entwistle, pp. 107–13. Oxford, 2003.

Newman 1993. N. A. Newman, ed. *The Early Christian-Muslim Dialogue: A Collection of Documents from the First Three Islamic Centuries, 632–900 A.D.* Hatfield, Pa., 1993.

Nicholas of Sion 1984. Nicholas of Sion. *The Life of Saint Nicholas of Sion.* Translated and edited by Ihor Ševčenko and Nancy Patterson Ševčenko. Brookline, Mass., 1984.

Nicolle 1997. David Nicolle. "Arms of the Umayyad Era: Military Technology in a Time of Change." In *War and Society in the Eastern Mediterranean, 7th–15th Centuries*, edited by Yaacov Lev, pp. 9–100. Leiden, 1997.

Niewöhner-Eberhard 2006. Elke Niewöhner-Eberhard. "Die Tiraz-Inschrift aus dem Lüneburger Schatz der Goldenen Tafel." In *Textile Messages: Inscribed Fabrics from Roman to Abbasid Egypt*, edited by Cäcilia Fluck and Gisela Helmecke, pp. 193–219. Leiden, 2006.

Noever 2005. Peter Noever, ed. *Verletzliche Beute: Spätantike und frühislamische Textilien aus Ägypten = Fragile Remnants: Egyptian Textiles of Late Antiquity and Early Islam.* Exh. cat. Ostfildern-Ruit, 2005.

Nordenfalk 1970. Carl Nordenfalk. *Die spätantiken Zierbuchstaben.* Stockholm, 1970.

Norris 1949. Herbert Norris. *Church Vestments: Their Origin and Development.* London, 1949.

Northedge 2007. Alastair Northedge. *The Historical Topography of Samarra.* 2d rev. ed. London, 2007.

Northedge and Kennet 1994. Alastair Northedge and Derek Kennet. "The Samarra Horizon." In Ernst Grube et al., *Cobalt and Lustre: The First Centuries of Islamic Pottery*, pp. 21–35. London, 1994.

Noth 2004. Albrecht Noth. "Problems of Differentiation between Muslims and Non-Muslims: Re-reading the 'Ordinances of 'Umar' (al-Shurut al-'Umariyya)." In *Muslims and Others in Early Islamic Society*, edited by Robert G. Hoyland, pp. 103–24. Aldershot, 2004.

O'Connell 2007. Elisabeth R. O'Connell. "Transforming Monumental Landscapes in Late Antique Egypt: Monastic Dwellings in Legal Documents from Western Thebes." *Journal of Early Christian Studies* 15 (2007), pp. 239–73.

O'Connell 2009. Elisabeth R. O'Connell. "Representation and Self-Presentation in Late Antique Egypt: 'Coptic' Textiles in the British Museum." In *Textiles as Cultural Expressions*, edited by A. Svenson Perlman, pp. 1–10. Earlesville, Md., 2009.

Ognibene 1998. Susanna Ognibene. "The Iconophobic Dossier." In *Mount Nebo: New Archaeological Excavations, 1967–1997*, edited by Michele Piccirillo and Eugenio Alliata, pp. 372–89. Jerusalem, 1998.

Ognibene 2002. Susanna Ognibene. *Umm al-Rasas: La Chiesa di Santo Stefano ed il "Problema Iconofobico."* Rome, 2002.

Oikonomidès 1986. Nicolas Oikonomidès. "Silk Trade and Production in Byzantium from the Sixth to the Ninth Century: The Seals of the Kommerkiarioi." *Dumbarton Oaks Papers* 40 (1986), pp. 33–53.

Oikonomidès 1991. Nicolas Oikonomidès. "Kommerkion." In *The Oxford Dictionary of Byzantium*, edited by Alexander P. Kazhdan et al., pp. 1141–42. New York, 1991.

O'Kane 2006. Bernard O'Kane, ed. *The Treasures of Islamic Art in the Museums of Cairo.* Cairo, 2006.

Oleson et al. 1995. John P. Oleson, Khairieh 'Amr, Rebecca M. Foote, and Robert Schick. "The Humeima Excavation Project, Jordan: Preliminary Report of the 1993 Season." *Annual of the Department of Antiquities of Jordan* 39 (1995), pp. 317–54.

Oleson et al. 1999. John P. Oleson, Khairieh 'Amr, Rebecca M. Foote, Judy Logan, M. Barbara Reeves, and Robert Schick. "Preliminary Report of the al-Humayma Excavation Project, 1995, 1996, 1998." *Annual of the Department of Antiquities of Jordan* 43 (1999), pp. 411–50.

Olszowy-Schlanger 2003. Judith Olszowy-Schlanger. "Learning to Read and Write in Medieval Egypt: Children's Exercise Books from the Cairo Geniza." *Journal of Semitic Studies* 48, no. 1 (Spring 2003), pp. 47–69.

Omont 1902. Henri Omont. *Facsimilés des miniatures des plus anciens manuscrits grecs de la Bibliothèque Nationale du VIe au XIe siècle.* Paris, 1902.

Orlandi 2002. Tito Orlandi. "The Library of the Monastery of St. Shenute at Atripe." In *Perspectives on Panopolis: An Egyptian Town from Alexander the Great to the Arab Conquest*, edited by A. Egberts et al., pp. 211–31. Leiden, 2002.

Orssaud 1992. Dominique Orssaud. "Le passage de la céramique byzantine à la céramique islamique: Quelques hypothèses à partir du mobilier trouvé à Déhès." In *La Syrie de Byzance à l'Islam*, edited by Pierre Canivet and Jean-Paul Rey-Coquais, pp. 219–28. Damascus, 1992.

Ortiz 1993. *Kollektsiia Dzhordzha Ortisa: Drevnosti ot Ura do Vizantii = The George Ortiz Collection: Antiquities from Ur to Byzantium.* Exh. cat. Berne, 1993.

Ostrasz 1989. Antoni Ostrasz. "The Hippodrome of Gerasa: A Report on Excavations and Research 1982–1987." *Syria* 66 (1989), pp. 51–77.

Ostrogorsky 1969. George Ostrogorsky. *History of the Byzantine State.* New Brunswick, N.J., 1969.

Overlaet 1993. Bruno Overlaet, ed. *Splendeur des Sassanides: L'empire perse entre Rome et la Chine (224–642).* Exh. cat. Brussels, 1993.

Paetz gen. Schieck 2002. Annette Paetz gen. Schieck. "Textile Bilderwelten. Wechselwirkungen zwischen Ägypten und Rom: Untersuchungen an 'koptischen' Textilien unter besonderer Berücksichtigung unbearbeiteter Sammlungsbestände in Nordrhein-Westfalen." Ph.D. diss., Universität zu Köln, 2002.

Pagan 1941. *Pagan and Christian Egypt: Egyptian Art from the First to the Tenth Century A.D.* Exh. cat. Brooklyn, 1969.

Pal 1973. Pratapaditya Pal, ed. *Islamic Art: The Nasli M. Heeramaneck Collection.* Los Angeles, 1973.

Pancaroğlu 2004. Oya Pancaroğlu. "The Itinerant Dragon-Slayer: Forging Paths of Image and Identity in Medieval Anatolia." *Gesta* 43, no. 2 (2004), pp. 151–64.

Papaconstantinou 2001. Arietta Papaconstantinou. *Le culte des saints en Égypte des Byzantins aux Abbassides: L'apport des inscriptions et des papyrus grecs et coptes.* Paris, 2001.

Papadakis 1991. Aristeides Papadakis. "Alexandria, Patriarchate of." In *The Oxford Dictionary of Byzantium*, edited by Alexander P. Kazhdan et al., vol. 1, p. 61. New York, 1991.

Papamichalopoulos 1932. Kōnstantinos N. Papamichalopoulos. *Hē Monē tou Orous Sina* (The Monastery of Mount Sinai). Athens, 1932.

Papanikola-Bakirtzē 2002. Dēmētra Papanikola-Bakirtzē, ed. *Everyday Life in Byzantium.* Exh. cat. Athens, 2002.

Parani 2003. Maria G. Parani. *Reconstructing the Reality of Images: Byzantine Material Culture and Religious Iconography (11th–15th Centuries).* Leiden, 2003.

Parani 2007. Maria G. Parani. "Defining Personal Space: Dress and Accessories in Late Antiquity." In *Objects in Context, Objects in Use: Material Spatiality in Late Antiquity*, edited by Luke Lavan et al., pp. 497–527. Leiden, 2007.

Paret 1981. Rudi Paret. *Schriften zum Islam: Volksroman, Frauenfrage, Bilderverbot.* Stuttgart, 1981.

Parker 2002. Grant Parker. "*Ex Oriente Luxuria*: Indian Commodities and Roman Experience." *Journal of the Economic and Social History of the Orient* 45 (2002), pp. 40–95.

Paul of Nicaea 1996. *Manuale medico.* Translated and edited by Anna Maria Ieraci Bio. Naples, 1996.

Pauty 1931. Edmond Pauty. *Catalogue général du Musée Arabe du Caire: Les bois sculptés jusqu'à l'époque ayyoubide.* Cairo, 1931.

Peers 2007. Glenn Peers. "Vision and Community among Christians and Muslims: The Al-Muallaqa Lintel in Its Eighth-Century Context." *Arte Medievale* 6, no. 1 (2007), pp. 25-46.

Peirce and Tyler 1932–34. Hayford Peirce and Royall Tyler. *L'art byzantin.* 2 vols. Paris, 1932–34.

Peirce and Tyler 1936. Hayford Peirce and Royall Tyler. "The Prague Rider-Silk and the Persian-Byzantine Problem." *The Burlington Magazine* 68 (May 1936), pp. 213–15, 218–22, 224.

Peirce and Tyler 1941. Hayford Peirce and Royall Tyler. "Elephant-Tamer Silk, VIIIth Century." *Dumbarton Oaks Papers* 2 (1941), pp. 19–26.

Pelekanidēs 1977. Stylianos M. Pelekanidēs. *Meletes palaiochristianikēs kai Byzantinēs archaiologias* (Studies of Early Christian and Byzantine Archaeology). Thessaloniki, 1977.

Pellat 1954. Charles Pellat. "Gahiziana, I: Le 'Kitab al-Tabassur bi-l-tigara' attribué à Gahiz." *Arabica* 1 (May 1954), pp. 153–65.

Peña et al. 1975. Ignace Peña, Pascal Castellana, and Romuald Fernández. *Les Stylites syriens.* Milan, 1975.

Pentcheva 2006a. Bissera V. Pentcheva. *Icons and Power: The Mother of God in Byzantium.* University Park, Pa., 2006.

Pentcheva 2006b. Bissera V. Pentcheva. "The Performative Icon." *Art Bulletin* 88 (December 2006), pp. 631–55.

Pentcheva 2010. Bissera V. Pentcheva. *The Sensual Icon: Space, Ritual, and the Senses in Byzantium.* University Park, Pa., 2010.

Pentz 1992. Peter Pentz. *The Invisible Conquest: The Ontogenesis of Sixth and Seventh Century Syria.* Copenhagen, 1992.

Persson 2010. Helen Persson. "Collecting Egypt: The Textile Collection of the Victoria and Albert Museum." *Journal of the History of Collections* (2010), pp. 1–11.

Petrie 1926. Sir W. M. Flinders Petrie. *Glass Stamps and Weights Illustrated from the Egyptian Collection in University College, London.* London, 1926.

Petsopoulos 1987. Yanni Petsopoulos, ed. *East Christian Art.* Exh. cat. London, 1987.

Pfister 1948. Rodolphe Pfister. "Le rôle de l'Iran dans les textiles d'Antinoë." *Ars Islamica* 13–14 (1948), pp. 46–74.

Philon 1980. Helen Philon. *Early Islamic Ceramics: Ninth to Late Twelfth Centuries.* London, 1980.

Philothea of Sinai 1983. Philothea of Sinai. "Les nouveaux manuscrits syriaques du Mont Sinaï." In *Ille Symposium Syriacum, 1980,* edited by René Lavenant, pp. 333–39. Rome, 1983.

Philothea of Sinai 2008. Philothea of Sinai. *Nouveaux manuscrits syriaques du Sinaï.* Athens, 2008.

Philotheos 1983. Saint Philotheos of Sinai. "Forty Texts on Watchfulness." In *The Philokalia: The Complete Text,* vol. 3, translated and edited by G. E. H. Palmer et al., pp. 16–31. London, 1983.

Phōtopoulos and Delēvorrias 1997. Dionysēs Phōtopoulos and Angelos Delēvorrias. *Greece at the Benaki Museum.* Athens, 1997.

Piatnitskii et al. 2000. Yuri Piatnitskii, Oriana Baddeley, Earleen Brunner, and Marlia Mundell Mango, eds. *Sinai, Byzantium, Russia: Orthodox Art from the Sixth to the Twentieth Century.* Exh. cat. London, 2000.

Piatnitskii et al. 2005. Yuri Piatnitskii, Vincent Boelle, and Marlies Kleiterp, eds. *Byzantium-Jerusalem: Pilgrim Treasures from the Hermitage.* Exh. cat. Amsterdam, 2005.

Piccirillo 1989. Michele Piccirillo. *Chiese e mosaici di Madaba.* Jerusalem, 1989.

Piccirillo 1992. Michele Piccirillo. *The Mosaics of Jordan.* Amman, 1992.

Piccirillo 1998. Michele Piccirillo. "Les mosaïques d'époque omeyyad des églises de la Jordanie." *Syria* 75 (1998), pp. 263–78.

Piccirillo 2011. Michele Piccirillo. "The Province of Arabia during the Persian Invasion (613–629/630)." In *Shaping the Middle East: Jews, Christians, and Muslims in an Age of Transition, 400–800 C.E.,* edited by Kenneth G. Holum and Hayim Lapin, pp. 99–114. Bethesda, Md., 2011.

Piccirillo and Alliata 1989. Michele Piccirillo and Eugenio Alliata. "La chiesa del monastero di Kayanos alle ʿAyoun Mousa sul monte Nebo." In *Quaeritur inventus colitur: Miscellanea in onore di padre Umberto Maria Fasola,* pp. 563–86. Vatican City, 1989.

Piccirillo and Alliata 1994. Michele Piccirillo and Eugenio Alliata, eds. *Umm al-Rasas Mayfaʿah I: Gli scavi del complesso di Santo Stefano.* Jerusalem, 1994.

Piguet-Panayotova 1998. Dora Piguet-Panayotova. "Silver Censers." In *Acta XIII congressus internationalis archaeologiae christianae,* edited by Nenad Cambi and Emilio Marin, pp. 639–60. Rome, 1998.

Piguet-Panayotova 2009. Dora Piguet-Panayotova. "The Attarouthi Chalices." *Mitteilungen zur Spätantiken Archäologie und Byzantinischen Kunstgeschichte* 6 (2009), pp. 9–47.

Pinder-Wilson 1960. Ralph Pinder-Wilson. "An Islamic Ewer in Sassanian Style." *British Museum Quarterly* 22, nos. 3–4 (1960), pp. 89–94.

Pinder-Wilson 1963–64. Ralph Pinder-Wilson. "A Lustre Relief Dish of the Early Islamic Period." *British Museum Quarterly* 27, nos. 3–4 (1963–64), pp. 91–94.

Pinder-Wilson 1991. Ralph Pinder-Wilson. "The Islamic Lands and China." In *Five Thousand Years of Glass,* edited by Hugh Tait, pp. 112–43. London, 1991.

Pinder-Wilson and Ettinghausen 1961. Ralph H. Pinder-Wilson and Richard Ettinghausen. "The Illuminations in the Cairo Moshe-b. Asher Codex of the Prophets Completed in Tiberias in 895 AD." In *Der hebräische Bibeltext seit Franz Delitzsch,* edited by Paul Kahle, pp. 95–98. Stuttgart, 1961.

Piotrovskii 1999. Mikhail B. Piotrovskii. *Earthly Beauty, Heavenly Art: Art of Islam.* Exh. cat. Amsterdam, 1999.

Piotrovskii and Rogers 2004. Mikhail B. Piotrovskii and J. M. Rogers, eds. *Heaven on Earth: Art from Islamic Lands.* Exh. cat. Munich, 2004.

Piotrovskii et al. 2007. Mikhail B. Piotrovskii, Georgiĭ Vilinbakhov, and V. I. Matveev, eds. *Bogi na monetakh: Drevniaia Gretsiia, Rim, Vizantiia=Gods on Coins: Ancient Greece, Rome, and Byzantium.* Exh. cat. Saint Petersburg, 2007.

Pitarakis 2005. Brigitte Pitarakis. "Une production caractéristique de cruches en alliage cuivreux (Ve–VIIIe siècles): Typologie, techniques et diffusion." *Antiquité Tardive* 13 (2005), pp. 11–27.

Pitarakis 2006. Brigitte Pitarakis. "Objects of Devotion and Protection." In *Byzantine Christianity,* edited by Derek Krueger, pp. 164–81. Minneapolis, 2006.

Pitarakis 2007. Brigitte Pitarakis. "L'orfèvre et l'architecte: Autour d'un groupe d'édifices constantinopolitains du Ve siècle." In *The Material and the Ideal: Essays in Medieval Art and Archaeology in Honour of Jean-Michel Spieser,* edited by Anthony Cutler and Arietta Papaconstantinou, pp. 63–74. Leiden, 2007.

Pitarakis 2009. Brigitte Pitarakis. "The Material Culture of Childhood in Byzantium." In *Becoming Byzantine: Children and Childhood in Byzantium,* edited by Arietta Papaconstantinou and Alice-Mary Talbot, pp. 167–203. Washington, D.C., 2009.

Podany and Matheson 1999. Jerry Podany and Susan B. Matheson. "Urban Renewal: The Conservation of a City Mosaic from Ancient Gerasa." *Yale University Art Gallery Bulletin* (1999), pp. 20–31.

Podskalsky et al. 1991. Gerhard Podskalsky, Alexander P. Kazhdan, and Anthony Cutler. "Paradise." In *The Oxford Dictionary of Byzantium,* edited by Alexander P. Kazhdan et al., vol. 3, p. 1582. New York, 1991.

Politis 1995. Konstantinos Politis. "Excavations and Restorations at Dayr ʿAyn ʿAbata 1994." *Annual of the Department of Antiquities of Jordan* 39 (1995), pp. 477–91.

Politis forthcoming. Konstantinos D. Politis. *Sanctuary of Lot at Deir ʿAin ʿAbata, Jordan: Excavations 1988–2003.* Forthcoming.

Polliack 2003. Meira Polliack, ed. *Karaite Judaism: A Guide to Its History and Literary Sources.* Leiden, 2003.

Polliack 2006. Meira Polliack. "Rethinking Karaism: Between Judaism and Islam." *AJS Review* 30, no. 1 (2006), pp. 67–93.

Pormann 2004. Peter E. Pormann. *The Oriental Tradition of Paul of Aegina's Pragmateia.* Leiden, 2004.

Poster 2003. Amy G. Poster. *Journey through Asia: Masterpieces in the Brooklyn Museum of Art.* Brooklyn, N.Y., 2003.

Pottier 2004. Henri Pottier. *Le monnayage de la Syrie sous l'occupation perse (610–630)=Coinage in Syria under Persian Rule (610–630).* Paris, 2004.

Pritchard 2006. Frances Pritchard. *Clothing Culture: Dress in Egypt in the First Millennium AD: Clothing from Egypt in the Collection of the Whitworth Art Gallery, the University of Manchester.* Exh. cat. Manchester, 2006.

Procopius 1935. Procopius. *Works,* vol. 6, *The Anecdota, or Secret History.* Translated by H. B. Dewey. Cambridge, Mass., 1935.

Pseudo-Callisthenes 1889. Pseudo-Callisthenes. *The History of Alexander the Great, Being the Syriac Version of the Pseudo-Callisthenes.* Translated and edited by Ernest A. Wallis Budge. Cambridge, 1889.

Puech 1984. Émile Puech. "L'inscription christopalestinienne d'ʿAyoun Mousa (Mont Nebo)." *Liber Annuus* 34 (1984), pp. 319–28.

Puech 2011. Émile Puech. "Notes d'épigraphie christopalestinienne de Jordanie." In *In Memoriam: Fr Michele Piccirillo, ofm (1944–2008): Celebrating His Life and Work,* edited by Claudine Dauphin and Basema Hamarneh, pp. 75–94. Oxford, 2011.

Puin 1985. Gerd-Rüdiger Puin. "Methods of Research on Qur'anic Manuscripts: A Few Ideas." In *Masahif Sanʿa',* pp. 9–17. Exh. cat. Kuwait, 1985.

Pummer 1999. Reinhard Pummer. "Samaritan Synagogues and Jewish Synagogues: Similarities and Differences." In *Jews, Christians, and Polytheists in the Ancient Synagogue: Cultural Interaction during the Greco-Roman Period,* edited by Steven Fine, pp. 105–42. London, 1999.

Qaddumi 1987. Ghadah Hijjawi Qaddumi. *Variety in Unity.* Exh. cat. Kuwait, 1987.

Quibell 1909. James Edward Quibell, ed. *Excavations at Saqqara,* vol. 3, 1907–1908. Cairo, 1909.

Rabbat 1989. Nasser Rabbat. "The Meaning of the Umayyad Dome of the Rock." *Muqarnas* 6 (1989), pp. 12–21.

Rabbat 1993. Nasser Rabbat. "The Dome of the Rock Revisited." *Muqarnas* 10 (1993), pp. 67–75.

Rabbat 2003. Nasser Rabbat. "The Dialogic Dimension in Umayyad Art." *Res* 43 (Spring 2003), pp. 78–94.

Rabinowitz 1985. Zvi Meir Rabinowitz, ed. *The Liturgical Poems of Rabbi Yannai According to the Triennial Cycle of the Pentateuch and the Holidays.* Jerusalem, 1985.

Raby 1999. Julian Raby. "In Vitro Veritas: Glass Pilgrim Vessels from 7th-Century Jerusalem." In *Bayt al-Maqdis,* vol. 2, *Jerusalem and Early Islam,* edited by Jeremy Johns, pp. 113–90. Oxford, 1999.

Rahmani 1993. L. Y. Rahmani. "Eulogia Tokens from Byzantine Bet Shecan." *ʿAtiqot* 22 (1993), pp. 109–19.

Ratliff 2008. Brandie Ratliff. "The Monastery of Saint Catherine at Mount Sinai and the Christian Communities of the Caliphate." *Sinaiticus* (2008), pp. 14–17.

Rawska-Rodziewicz 2007. Elzbieta Rawska-Rodziewicz. *Bone and Ivory Carvings from Alexandria: French Excavations 1992–2004.* Cairo, 2007.

Rawson 1982. Jessica Rawson. *The Ornament on Chinese Silver of the Tang Dynasty (AD 618–906).* London, 1982.

Reeg 1977. Gottfried Reeg. *Die antiken Synagogen in Israel,* vol. 2, *Die samaritanischen Synagogen.* Wiesbaden, 1977.

Reif 1990. Stefan C. Reif. "Aspects of Medieval Jewish Literacy." In *The Uses of Literacy in Early Medieval Europe,* edited by Rosamond McKitterick, pp. 134–55. Cambridge, 1990.

Reif 1998. Shulie Reif and Stefan C. Reif. *History in Fragments: A Genizah Centenary Exhibition Mounted at Cambridge University Library, November 1997–February 1998, to Mark the Hundredth Anniversary of the Arrival of the Taylor-Schechter Collection.* Exh. cat. Cambridge, 1998.

Reif 2000. Stefan C. Reif. *A Jewish Archive from Old Cairo: The History of Cambridge University's Genizah Collection.* Richmond, Surrey, 2000.

Reiner 1987. Erica Reiner. "Magic Figurines, Amulets, and Talismans." In *Monsters and Demons in the Ancient and Medieval Worlds,* edited by Ann E. Farkas et al., pp. 27–36. Mainz, 1987.

Renan 1883. Ernest Renan. "Les mosaïques de Hammam-Lif." *Revue Archéologique* 1 (1883), pp. 157–63.

Renan 1884. Ernest Renan. "Les mosaïques de Hammam-Lif: Nouvelles observations." *Revue Archéologique* 2 (1884), pp. 273–75.

Renner 1963. Dorothee Renner, ed. *Koptische Kunst: Christentum am Nil.* Exh. cat. Essen, 1963.

Revel-Neher 1984. Elisabeth Revel-Neher. *L'Arche d'Alliance dans l'art juif et chrétien du second au dixième siècles: Le signe de la rencontre.* Paris, 1984.

Rezvan 2004. Efim A. Rezvan. *The Qur'an of 'Uthman (Saint Petersburg, Katta-Langar, Bukhara, Tashkent).* Saint Petersburg, 2004.

Rice 1958. David S. Rice. "A Drawing of the Fatimid Period." *Bulletin of the School of Oriental and African Studies* 21, nos. 1–3 (1958), pp. 31–39.

Riddle 1980. John M. Riddle. "Dioscorides." In *Catalogus translationum et commentariorum: Mediaeval and Renaissance Latin Translations and Commentaries,* vol. 4, edited by Paul Oskar Kristeller and F. Edward Cranz, pp. 1–143. Washington, D.C., 1980.

Riddle 1985. John M. Riddle. *Dioscorides on Pharmacy and Medicine.* Austin, 1985.

Riegl 1992. Alois Riegl. *Problems of Style: Foundations for a History of Ornament.* Princeton, 1992.

Riegl 2004. Alois Riegl. *Historical Grammar of the Visual Arts.* New York, 2004.

Roberts 1989. Michael J. Roberts. *The Jeweled Style: Poetry and Poetics in Late Antiquity.* Ithaca, N.Y., 1989.

Robin 1999. Christian Julien Robin. "Yemen." In *Late Antiquity: A Guide to the Postclassical World,* edited by Glen W. Bowersock et al., pp. 752–53. Cambridge, 1999.

Robin 2006. Christian Julien Robin. "La réforme de l'écriture arabe à l'époque du califat médinois." *Mélanges de l'Université Saint-Joseph* 59 (2006), pp. 319–65.

Robinson 2006. Chase F. Robinson. "A Local Historian's Debt to al-Tabari: The Case of al-Azdi's Ta'rikh al-Mawsil." *Journal of the American Oriental Society* 126, no. 4 (2006), pp. 521–35.

Rocca 2000. Giancarlo Rocca, ed. *La sostanza dell'effimero: Gli abiti degli ordini religiosi in Occidente.* Exh. cat. Rome, 2000.

Rodley 1994. Lyn Rodley. *Byzantine Art and Architecture: An Introduction.* Cambridge, 1994.

Rogers 2008. J. M. Rogers. *The Arts of Islam: Treasures from the Nasser D. Khalili Collection.* Exh. cat. Sydney, 2008.

Rosen-Ayalon 1976. Myriam Rosen-Ayalon. "The First Mosaic Discovered in Ramla." *Israel Exploration Journal* 26 (1976), pp. 104–19.

Rosen-Ayalon 1989. Myriam Rosen-Ayalon. *The Early Islamic Monuments of al-Haram al-Sharif.* Jerusalem, 1989.

Rosenthal 1988. F. Rosenthal. "Mandil." In *The Encyclopaedia of Islam,* 2d ed., vol. 6, pp. 402–3. Leiden, 1988.

Ross 1962. Marvin C. Ross. *Catalogue of the Byzantine and Early Mediaeval Antiquities in the Dumbarton Oaks Collection,* vol. 1, *Metalwork, Ceramics, Glass, Glyptics, Painting.* Washington, D.C., 1962.

Ross 2005. Marvin C. Ross. *Catalogue of the Byzantine and Early Medieval Antiquities in the Dumbarton Oaks Collection,* vol. 2, *Jewelry, Enamels, and Art of the Migration Period.* 2d ed. Washington, D.C., 2005.

Rosser-Owen 2004. Mariam Rosser-Owen. *Ivory: 8th to 17th Centuries: Treasures from the Museum of Islamic Art, Qatar.* Exh. cat. Doha, 2004.

Roth 1953. Cecil Roth. "Jewish Antecedents of Christian Art." *Journal of the Warburg and Courtauld Institutes* 16 (1953), pp. 24–44.

Roth-Gerson 1987. Lea Roth-Gerson. *Ha-Ketovot ha-Yevaniyot mi-bate ha-keneset be-Erets Yiśra'el* (Greek Inscriptions from the Synagogues of Eretz Israel) (in Hebrew). Jerusalem, 1987.

Rowland 1956. Benjamin Rowland Jr. "The Vine-Scroll in Gandara." *Artibus Asiae* 19 (1956), pp. 353–60.

Roxburgh 2007. David J. Roxburgh. *Writing the Word of God: Calligraphy and the Qur'an.* Exh. cat. New Haven, 2007.

Rubenson 1996. Samuel Rubenson. "The Transition from Coptic to Arabic." *Égypte Monde Arabe,* nos. 27–28 (1996), available at http://ema.revues.org/index1920.html.

Rubin 1986. Uri Rubin. "The Ka'ba: Aspects of Its Ritual Functions and Position in Pre-Islamic and Early Islamic Times." *Jerusalem Studies in Arabic and Islam* 8 (1986), pp. 97–131.

Rutgers 1995. Leonard V. Rutgers. *The Jews in Late Ancient Rome: Evidence of Cultural Interaction in the Roman Diaspora.* Leiden, 1995.

Rutschowscaya 1986. Marie-Hélène Rutschowscaya. *Catalogue des bois de l'Égypte copte.* Paris, 1986.

Rutschowscaya 1990. Marie-Hélène Rutschowscaya. *Coptic Fabrics.* Paris, 1990.

Rutschowscaya 1992. Marie-Hélène Rutschowscaya. *La peinture copte.* Paris, 1992.

Rutschowscaya 1998. Marie-Hélène Rutschowscaya. *Le Christ et l'abbé Ména.* Paris, 1998.

Rutschowscaya 2010a. Marie-Hélène Rutschowscaya. "Nouvelles peintures découvertes dans le monastère de Baouit." In *Études coptes XI: Treizième journée d'études, Marseille, 7–9 juin 2007,* edited by Anne Boud'hors and Catherine Louis, pp. 45–51. Paris, 2010.

Rutschowscaya 2010b. Marie-Hélène Rutschowscaya. "Ce que racontent les murs d'un ermitage copte . . ." In *Sur les pas des Araméens chrétiens: Mélanges offerts à Alain Desreumaux,* edited by Françoise Briquel Chatonnet and Muriel Debié, pp. 311–23. Paris, 2010.

Rutschowscaya 2010c. Marie-Hélène Rutschowscaya. "Recent Discoveries from Bawit." In *Coptic Art Revealed,* edited by Nadja Tomoum, pp. 128–37. Exh. cat. Cairo, 2010.

Sack 1996. Dorothée Sack. *Die grosse Moschee von Resafa-Rusafat Hišam.* Mainz, 1996.

Sacopoulo 1957. Marina Sacopoulo. "Le linteau copte dit d'Al-Moâllaka." *Cahiers Archéologiques* 9 (1957), pp. 99–115.

Sadan 1976. Yusuf Sadan. *Le mobilier au Proche-Orient médiéval.* Leiden, 1976.

Sadan 1986. Yusuf Sadan. "Genizah and Genizah-like Practices in Islamic and Jewish Tradition." *Bibliotheca Orientalis* 43 (1986), pp. 36–58.

St. Clair 1996. Archer St. Clair. "Evidence for Late Antique Bone and Ivory Carving on the Northeast Slope of the Palatine: The Palatine East Excavation." *Dumbarton Oaks Papers* 50 (1996), pp. 369–74.

St. Clair 2003. Archer St. Clair. *Carving as Craft: Palatine East and the Greco-Roman Bone and Ivory Carving Tradition.* Baltimore, 2003.

Saliba and Komaroff 2005. George Saliba and Linda Komaroff. "Illustrated Books May Be Hazardous to Your Health: A New Reading of the Arabic Reception and Rendition of the Materia Medica of Dioscorides." *Ars Orientalis* 35 (2005), pp. 6–65.

Salim 1995. Muhammad 'Abbas Muhammad Salim. "Textilien mit gewirktem und gesticktem Dekor aus Ägypten." In *Mittelalterliche Textilien I: Ägypten, Persien und Mesopotamien, Spanien und Nordafrika,* edited by Karel Otavsky and Muhammad 'Abbas Muhammad Salim, pp. 21–26. Riggisberg, 1995.

Saller and Bagatti 1949. Sylvester Saller and Bellarmino Bagatti. *The Town of Nebo (Khirbet el-Mekhayyat), with a Brief Survey of Other Ancient Christian Monuments in Transjordan.* Jerusalem, 1949.

Sams 1982. G. Kenneth Sams. "The Weighing Implements." In *Yassi Ada,* vol. 1, *A Seventh-Century Byzantine Shipwreck,* edited by George F. Bass and Frederick H. van Doorninck Jr., pp. 202–30. College Station, Texas, 1982.

Sanders 1998. Paula A. Sanders. "The Fatimid State, 969–1171." In *The Cambridge History of Egypt,* vol. 1, *Islamic Egypt, 640–1517,* edited by Carl F. Petry, pp. 151–74. Cambridge, 1998.

Sangiorgi 1906. Giorgio Sangiorgi. "Cimeli dell'industria tessile orientale." *L'Arte* 9 (1906), pp. 193–98.

Sarre 1930. Friedrich Sarre. "Bronzeplastik in Vogelform: Ein sasanidisch-frühislamisches Räuchergefäsz." *Jahrbuch der Preussischen Kunstsammlungen* 51 (1930), pp. 159–64.

Sarre 1934. Friedrich Sarre. "Die Bronzekanne des Kalifen Marwan II im arabischen Museum in Kairo." *Ars Islamica* 1 (1934), pp. 10–16.

Sarris 2006. Peter Sarris. *Economy and Society in the Age of Justinian.* Cambridge, 2006.

Sauvaget 1947. Jean Sauvaget. *La mosquée omeyyade de Médine: Étude sur les origines architecturales de la mosquée et de la basilique.* Paris, 1947.

Sauvaget 1967. Jean Sauvaget. "Châteaux umayyades de Syrie: Contribution à l'étude de la colonisation arabe au Ier et IIème siècles de l'hégire." *Revue des Études Islamiques* 35 (1967), pp. 1–49.

Savage-Smith and Belloli 1985. Emily Savage-Smith and Andrea P. A. Belloli. *Islamicate Celestial Globes: Their History, Construction, and Use.* Washington, D.C., 1985.

Scanlon 1968. George T. Scanlon. "Ancillary Dating Materials from Fustat." *Ars Orientalis* 7 (1968), pp. 1–17.

Scanlon and Pinder-Wilson 2001. George T. Scanlon and Ralph Pinder-Wilson. *Fustat Glass of the Early Islamic Period: Finds Excavated by the American Research Center in Egypt, 1964–1980.* London, 2001.

Scarborough 1988. John Scarborough. "Classical Antiquity: Medicine and Allied Sciences, an Update." In *History of Medicine,* edited by Rebecca Greene, pp. 5–36. New York, 1988.

Scarborough and Kazhdan 1991. John Scarborough and Alexander P. Kazhdan. "Physiologos." In *The Oxford Dictionary of Byzantium*, edited by Alexander P. Kazhdan et al., p. 1674. New York, 1991.

Schachner 2010. Lukas Amadeus Schachner. "The Archaeology of the Stylite." In *Religious Diversity in Late Antiquity*, edited by David M. Gwynn and Susanne Bangert, pp. 329–97. Leiden, 2010.

Schick 1988. Robert Schick. "Christian Life in Palestine during the Early Islamic Period." *The Biblical Archaeologist* 51 (1988), pp. 218–240.

Schick 1995. Robert Schick. *The Christian Communities of Palestine from Byzantine to Islamic Rule.* Princeton, 1995.

Schick 1998. Robert Schick. "Palestine in the Early Islamic Period: Luxuriant Legacy." *Near Eastern Archaeology* 61 (1998), pp. 74–108.

Schlumberger 1939. Daniel Schlumberger. "Les fouilles de Qasr el-Heir el-Gharbi (1936–1938): Rapport préliminaire." *Syria* 20 (1939), pp. 324–73.

Schlumberger 1986. Daniel Schlumberger. *Qasr el-Heir el Gharbi: Texte et planches.* Paris, 1986.

Schoeler 1992. Gregor Schoeler. "Schreiben und Veröffentlichen: Zu Verwendung und Funktion der Schrift in den ersten islamischen Jahrhunderten." *Der Islam* 69 (1992), pp. 1–43.

Schoeler 1997. Gregor Schoeler. "Writing and Publishing: On the Use and Function of Writing in the First Centuries of Islam." *Arabica* 44 (1997), pp. 423–35.

Schoeler 2006. Gregor Schoeler. *The Oral and the Written in Early Islam.* London, 2006.

Schoeler 2010. Gregor Schoeler. "The Codification of the Qur'an: A Comment on the Hypotheses of Burton and Wansbrough." In *The Qur'an in Context: Historical and Literary Investigations into the Qur'anic Milieu*, edited by Angelika Neuwirth et al., pp. 779–94. Leiden, 2010.

Scholem 2008. Gershom G. Scholem. *Magen-David: Toldotav Shel Semel.* En-Harod, Israel, 2008.

Scholl 1994. Reinhold Scholl. "Eine beschriftete Bronzekanne aus dem 6.Jh.n.Chr." *Zeitschrift für Papyrologie und Epigraphik* 103 (1994), pp. 231–40.

Schrenk 2004. Sabine Schrenk. *Textilien des Mittelmeerraumes aus spätantiker bis frühislamischer Zeit.* Riggisberg, 2004.

Schrenk 2006. Sabine Schrenk. "Silks from Antinoopolis." In *Central Asian Textiles and Their Contexts in the Early Middle Ages*, edited by Regula Schorta, pp. 23–33. Riggisberg, 2006.

Schroeder 2007. Caroline T. Schroeder. *Monastic Bodies: Discipline and Salvation in Shenoute of Atripe.* Philadelphia, 2007.

Schuette and Müller-Christensen 1963. Marie Schuette and Sigrid Müller-Christensen. *Das Stickereiwerk.* Tübingen, 1963.

Schulze et al. 2006. Wolfgang Schulze, Ingrid Schulze, and Wolfgang Leimenstoll. "Heraclian Countermarks on Byzantine Copper Coins in Seventh-Century Syria." *Byzantine and Modern Greek Studies* 30, no. 1 (2006), pp. 1–27.

Segall 1938. Berta Segall. *Katalog der Goldschmiede-Arbeiten.* Athens, 1938.

Seipel 1998. Wilfried Seipel, ed. *Schätze der Kalifen: Islamische Kunst zur Fatimenzeit.* Exh. cat. Vienna, 1998.

Seipel 2002. Wilfried Seipel, ed. *Faras: Die Kathedrale aus dem Wüstensand.* Exh. cat. Vienna, 2002.

Serjeant 1942. R. B. Serjeant. *Islamic Textiles: Material for a History Up to the Mongol Conquest.* Beirut, 1942.

Serjeant 1972. R. B. Serjeant. *Islamic Textiles: Material for a History Up to the Mongol Conquest.* Reprint, Beirut, 1972.

Ševčenko 1993–94. Nancy Patterson Ševčenko. "The Representation of Donors and Holy Figures on Four Byzantine Icons." *Deltion tēs Christianikēs Archailogikēs Hetaireias* 17 (1993–94), pp 157–64.

Severin 2008. Hans-Georg Severin. "On the Architectural Decoration and Dating of the Church of Dayr Anbâ Bišûy ("Red Monastery") near Sûhâg in Upper Egypt." *Dumbarton Oaks Papers* 62 (2008), pp. 75–112.

Shahîd 1979. Irfan Shahîd. "Byzantium in South Arabia." *Dumbarton Oaks Papers* 33 (1979), pp. 23–94.

Shahîd 1992. Irfan Shahîd. "Ghassanid and Umayyad Structures: A Case of *Byzance après Byzance.*" In *La Syrie de Byzance à l'Islam*, edited by Pierre Canivet and Jean-Paul Rey-Coquais, pp. 299–307. Damascus, 1992.

Shahîd 1995. Irfan Shahîd. *Byzantium and the Arabs in the Sixth Century.* vol. 1. Washington, D.C., 1995.

Shahîd 1998. Irfan Shahîd. "Arab Christian Pilgrimages in the Proto-Byzantine Period (V–VII Centuries)." In *Pilgrimage and Holy Space in Late Antique Egypt*, edited by David Frankfurter, pp. 373–89. Leiden, 1998.

Shahîd 2002. Irfan Shahîd. *Byzantium and the Arabs in the Sixth Century*, vol. 2, pt. 1, *Toponymy, Monuments, Historical Geography, and Frontier Studies.* Washington, D.C., 2002.

Shahîd 2009. Irfan Shahîd. "The Ghassanid Structure Outside Sergiopolis/Rusafa: Church or Praetorium?" In *Anathēmata Eortika: Studies in Honor of Thomas F. Mathews*, edited by Joseph D. Alchermes et al., pp. 283–87. Mainz, 2009.

Shalem 2004. Avinoam Shalem. *The Oliphant: Islamic Objects in Historical Context.* Leiden, 2004.

Shalem 2005. Avinoam Shalem. "Trade in and the Availability of Ivory: The Picture Given by the Medieval Sources." In *The Ivories of Muslim Spain: Papers from a Symposium Held in Copenhagen from the 18th to the 20th of November 2003*, edited by Kjeld von Folsach and Joachim Meyer, pp. 25–35. Copenhagen, 2005.

Shani 1999. Raya Shani. "The Iconography of the Dome of the Rock." *Jerusalem Studies in Arabic and Islam* 23 (1999), pp. 158–207.

Sharon 1986. M. Sharon. "Ludd." In *The Encyclopaedia of Islam*, 2d ed., vol. 5, pp. 798–803. Leiden, 1986.

Shboul and Walmsley 1998. Ahmad Shboul and Alan Walmsley. "Identity and Self-Image in Syria-Palestine in the Transition from Byzantine to Early Islamic Rule: Arab Christians and Muslims." *Mediterranean Archeology* 11 (1998), pp. 255–87.

Sheehan 2010. Peter Sheehan. *Babylon of Egypt: The Archaeology of Old Cairo and the Origins of the City.* Cairo, 2010.

Shehadeh 1989. Haseeb Shehadeh. "The Arabic Translation of the Samaritan Pentateuch." In *The Samaritans*, edited by Alan D. Crown, pp. 481–516. Tübingen, 1989.

Sheng 1999. Angela Sheng. "Why Ancient Silk Is Still Gold: Issues in Chinese Textile History." *Ars Orientalis* 29 (1999), pp. 147–68.

Shepherd 1971. Dorothy G. Shepherd. "Alexander: The Victorious Emperor." *Bulletin of the Cleveland Museum of Art* 58 (October 1971), pp. 244–50.

Shepherd 1981. Dorothy G. Shepherd. "Zandaniji Revisited." In *Documenta Textilia: Festschrift für Sigrid Müller-Christensen*, edited by Mechthild Flury-Lemberg and Karen Stolleis, pp. 105–22. Munich, 1981.

Sheppard 1965. Carl D. Sheppard. "A Radiocarbon Date for the Wooden Tie Beams in the West Gallery of St. Sophia, Istanbul." *Dumbarton Oaks Papers* 19 (1965), pp. 237–40.

Sheppard 1981. Carl D. Sheppard. "A Note on the Date of Taq-i-Bustan and Its Relevance to Early Christian Art in the Near East." *Gesta* 20 (1981), pp. 9–13.

Shinan 1992. Avigdor Shinan. "The Aramaic Targum as a Mirror of Galilean Jewry." In *The Galilee in Late Antiquity*, edited by Lee I. Levine, pp. 241–51. New York, 1992.

Shiyyab 2006. Adnan Shiyyab. *Der Islam und der Bilderstreit in Jordanien und Palästina: Archäologische und kunstgeschichtliche Untersuchungen unter Berücksichtigung der "Kirche von Ya'mun."* Munich, 2006.

Shuqayr 1916. Na"um Shuqayr. *Tarikh Sina al-qadim wa-al-hadith wa-jughrafiyatuha, ma'a khulasat tarīkh Misr wa-al-Sham wa-al-'Iraq wa-Jazirat al-'Arab wa-ma kana baynaha min al-'ala'iq al-tijarīyah wa-al-harbiyah wa-ghayriha 'an tariq Sina' min awwal 'ahd al-tarikh ilá al-yawm = The History of Sinai and Arabs, with a Resumé of the History of Egypt, Syria, Mesopotamia, and Arabia, etc.* Misr, Egypt, 1916.

Sidebotham 2009. Stephen E. Sidebotham. "Northern Red Sea Ports and Their Networks in the Late Roman/Byzantine Period." In *Byzantine Trade, 4th–12th Centuries: The Archaeology of Local, Regional, and International Exchange*, edited by Marlia Mundell Mango, pp. 329–52. Farnham, 2009.

Sidebotham 2011. Steven E. Sidebotham. *Berenike and the Ancient Maritime Spice Route.* Berkeley, 2011.

Sijpesteijn 2004a. Petra M. Sijpesteijn. "Request to Buy Coloured Silk from Early Islamic Egypt." In *Gedenkschrift Ulrike Horak*, edited by Hermann Harrauer and Rosario Pintaudi, pp. 255–72. Florence, 2004.

Sijpesteijn 2004b. Petra M. Sijpesteijn. "Shaping a Muslim State: Papyri Related to a Mid-Eighth-Century Egyptian Official." Ph.D. diss., Princeton University, 2004.

Sijpesteijn 2004c. Petra M. Sijpesteijn. "Travel and Trade on the River." In *Papyrology and the History of Early Islamic Egypt*, edited by Petra M. Sijpesteijn and Lennart Sundelin, pp. 115–51. Leiden, 2004.

Sijpesteijn 2007. Petra M. Sijpesteijn. "The Arab Conquest of Egypt and the Beginning of Muslim Rule." In *Egypt in the Byzantine World, 300–700*, edited by Roger S. Bagnall, pp. 437–55. Cambridge, 2007.

Silberman 2001. Neil Asher Silberman. "Thundering Hordes: The Image of the Persian and Muslim Conquests in Palestinian Archaeology." In *Studies in the Archaeology of Israel and Neighboring Lands in Memory of Douglas L. Esse*, edited by Samuel R. Wolff, pp. 611–23. Chicago, 2001.

Simaika 1937. Marcus H. Simaika. *Guide sommaire du Musée Copte et des principales églises du Caire.* Cairo, 1937.

Sinai 1999. Holy Monastery and Archdiocese of Sinai. *The New Finds of Sinai.* Athens, 1999.

Sirat et al. 1994. Colette Sirat, Michèle Dukan, and Ada Yaderni. "Rouleaux de la Tora antérieurs à l'an mille." *Comptes-rendus des Séances de l'Académie des Inscriptions et Belles-Lettres* 138 (1994), pp. 861–87.

Sivan 2008. Hagith Sivan. *Palestine in Late Antiquity.* Oxford, 2008.

Sizgorich 2004. Thomas Sizgorich. "Narrative and Community in Islamic Late Antiquity." *Past and Present* 185 (2004), pp. 9–42.

Skalova and Gabra 2003. Zuzana Skalova and Gawdat Gabra. *Icons of the Nile Valley.* Giza, 2003.

Skalova et al. 1999. Zuzana Skalova, Youhanna Nessim Youssef, Sobhi Shenuda, and Magdi Mansour. "Looking through Icons: Note on the Egyptian-Dutch 'Conservation of Coptic Icons Project': 1989–1996." In *Ägypten und Nubien in spätantiker und christlicher Zeit: Akten des 6. Internationalen Koptologenkongresses, Münster, 20.–26. Juli 1996*, edited by Stephen Emmel et al., pp. 375–87. Weisbaden, 1999.

Sklare 2003. David Sklare. "A Guide to Collections of Karaite Manuscripts." In *Karaite Judaism: A Guide to Its History and Literary Sources*, edited by Meira Polliack, pp. 893–923. Leiden, 2003.

Skrobucha 1966. Heinz Skrobucha. *Sinai.* London, 1966.

Smeaton 1937. Winifred Smeaton. "Tattooing among the Arabs of Iraq." *American Anthropologist* 39, no. 1 (1937), pp. 53–61.

Smith and Day 1989. Robert H. Smith and Leslie P. Day. *Pella of the Decapolis*, vol. 2, *Final Report on the College of Wooster Excavation in Area IX, the Civic Complex, 1979–1985.* Wooster, Ohio, 1989.

Snelders and Immerzeel 2004. Bas Snelders and Mat Immerzeel. "The Thirteenth-Century Flabellum from Deir al-Surian in the Musée Royal de Mariemont (Morlanwelz)." *Eastern Christian Art* 1 (2004), pp. 113–39.

Sodini 1989. Jean-Pierre Sodini. "Remarques sur l'iconographie de Syméon l'Alépin, le premier stylite." *Monuments et Mémoires de la Fondation Eugène Piot* 70 (1989), pp. 29–53.

Sodini 1993. Jean-Pierre Sodini. "Nouvelles eulogies de Syméon." In *Les saints et leur sanctuaire à Byzance: Textes, images et monuments*, edited by Catherine Jolivet-Lévy et al., pp. 25–34. Paris, 1993.

Sodini 1995. Jean-Pierre Sodini. "Eulogies trouvées à Qal'at Sem'an (Saint-Syméon près d'Alep) ne représentant pas le saint." In *Orbis romanus christianusque ab Diocletiani aetate usque ad Heraclium: Travaux sur l'antiquité tardive rassemblés autour des recherches de Noël Duval*, edited by François Baratte, pp. 225–36. Paris, 1995.

Sodini 1998. Jean-Pierre Sodini. "Les paons de Saint-Polyeucte et leurs modèles." In *Aetos: Studies in Honour of Cyril Mango*, edited by Ihor Ševčenko and Irmgard Hutter, pp. 306–13. Stuttgart, 1998.

Sodini 2007. Jean-Pierre Sodini. "Saint-Syméon, lieu de pèlerinage." *Cahiers de Saint-Michel de Cuxa* 38 (2007), pp. 107–20.

Sodini 2010. Jean-Pierre Sodini. "Saint-Syméon: L'influence de Saint-Syméon dans le culte et l'économie de l'Antiochène." In *Les sanctuaires et leur rayonnement dans le monde méditerranéen de l'antiquité à l'époque moderne*, edited by Juliette de La Genière et al., pp. 295–322. Paris, 2010.

Sodini and Villeneuve 1992. Jean-Pierre Sodini and Estelle Villeneuve. "Le passage de la céramique byzantine à la céramique omeyyade en Syrie du Nord, en Palestine et en Tranjordanie." In *La Syrie de Byzance à*

l'Islam, edited by Pierre Canivet and Jean-Paul Rey-Coquais, pp. 195–218. Damascus, 1992.

Sodini et al. 2002–3. Jean-Pierre Sodini, Jean-Luc Biscop, Dominique Orssaud, and Pierre-Marie Blanc. "Qal'at Sem'an et son environnement: Essai de synthèse." *Annales Archéologiques Arabes Syriennes* 45–46 (2002–3), pp. 345–57.

Sokoloff 1990. Michael Sokoloff. "Epigraphical Notes on the Palestinian Talmud" (in Hebrew). *Yearbook of Bar-Ilan University* 18–19 (1990), pp. 218–21.

Sörries 1993. Reiner Sörries. *Christlich-antike Buchmalerei im Überblick.* 2 vols. Wiesbaden, 1993.

Soteriou 1956–58. George Soteriou and Maria Soteriou. *Eikones tēs Monēs Sina* (Icons of Mount Sinai). 2 vols. Athens, 1956–58.

Sotheby's 2001. *Arts of the Islamic World: Including 20th Century Middle Eastern Painting.* Sale cat., May 3, 2001. London, 2001.

Sotheby's 2008. *Arts of the Islamic World Including Fine Carpets and Textiles.* Sale cat., October 8, 2008. London, 2008.

Sotheby's 2010. *Arts of the Islamic World: Including Fine Carpets and Textiles.* Sale cat., October 6, 2010. London, 2010.

Soucek 1976. Priscilla P. Soucek. "The Temple of Solomon in Islamic Legend and Art." In *The Temple of Solomon: Archaeological Fact and Medieval Tradition in Christian, Islamic, and Jewish Art*, edited by Joseph Gutmann, pp. 73–124. Missoula, 1976.

Soucek 2003. Priscilla P. Soucek. "Material Culture and the Qur'an." In *Encyclopaedia of the Qur'an*, edited by Jane Dammen McAuliffe, vol. 3, pp. 296–330. Leiden, 2003.

Sourdel-Thomine and Spuler 1990. Janine Sourdel-Thomine and Bertold Spuler. *Die Kunst des Islam.* Berlin, 1990.

Spatharakis 1976. Iohannis Spatharakis. *The Portrait in Byzantine Illuminated Manuscripts.* Leiden, 1976.

Spengler 1926–28. Oswald Spengler. *The Decline of the West.* 2 vols. Translated by Charles Francis Atkinson. London, 1926–28.

Spier 2007. Jeffrey Spier, ed. *Picturing the Bible: The Earliest Christian Art.* Exh. cat. New Haven, 2007.

Spier 2010. Jeffrey Spier. *Treasures of the Ferrell Collection.* Wiesbaden, 2010.

Spieser 1995. Jean-Michel Spieser. "À propos du linteau d'Al-Moallaqa." In *Orbis Romanus Christianusque ab Diocletiani aetate usque ad Heraclium: Travaux sur l'Antiquité Tardive rassemblés autour des recherches de Noël Duval*, pp. 311–20. Paris, 1995.

Staal 1969. Harvey Staal, ed. *Codex Sinai Arabic 151: Pauline Epistles.* 2 vols. Salt Lake City, 1969.

Staal 1983. Harvey Staal, ed. *Mt. Sinai Arabic Codex 151: I, Pauline Epistles.* 2 vols. Louvain, 1983.

Stanley 199-. Tim Stanley. *The Qur'an and Calligraphy: A Selection of Fine Manuscript Material.* London, 199-.

Stauffer 1991. Annemarie Stauffer. *Textiles d'Égypte de la collection Bouvier = Textilien aus Ägypten aus der Sammlung Bouvier.* Exh. cat. Fribourg, 1991.

Stauffer 1992a. Annemarie Stauffer. "Une soierie 'aux Amazones' au Musée Gustav-Lübcke à Hamm: À propos de la diffusion des cartons pour la production des soies figurées aux VIIe–Xe siècles." *Bulletin du Centre International d'Études des Textiles Anciens* 70 (1992), pp. 45–52.

Stauffer 1992b. Annemarie Stauffer. *Spätantike und koptische Wirkereien: Untersuchungen zur ikonographischen*

Tradition in spätantiken und frühmittelalterlichen Textilwerkstätten. Bern, 1992.

Stauffer 1995. Annemarie Stauffer. *Textiles of Late Antiquity.* Exh. cat. New York, 1995.

Stauffer 2000. Annemarie Stauffer. "II. Material und Technik." In *Die Textilien aus Palmyra: Neue und alte Funde*, edited by Andreas Schmidt-Colinet et al., pp. 8–40. Mainz, 2000.

Stauffer 2008. Annemarie Stauffer. *Antike Musterblätter: Wirkkartons aus dem spätantiken und frühbyzantinischen Ägypten.* Wiesbaden, 2008.

Staunen 1995. Das Staunen der Welt: Das Morgenland und Friedrich II. (1194–1250). Exh. cat. Berlin, 1995.

E. Stern 1995. E. Marianne Stern. *Roman Mold-Blown Glass: The First through Sixth Centuries.* Rome, 1995.

H. Stern 1954. Henri Stern. "Quelques oeuvres sculptées en bois, os et ivoire de style omeyyade." *Ars Orientalis* 1 (1954), pp. 119–31.

H. Stern 1958. Henri Stern. "Les mosaïques de l'église de Sainte-Constance à Rome." *Dumbarton Oaks Papers* 12 (1958), pp. 157–218.

H. Stern 1963. Henri Stern. "The Ivories on the Ambo of the Cathedral of Aix-la-Chapelle." *The Connoisseur* (July 1963), pp. 166ff.

K. Stern 2008. Karen B. Stern. *Inscribing Devotion and Death: Archaeological Evidence for Jewish Populations of North Africa.* Leiden, 2008.

K. Stern 2010. Karen B. Stern. "Mapping Devotion in Roman Dura Europos: A Reconsideration of the Synagogue Ceiling." *American Journal of Archaeology* 114 (July 2010), pp. 473–504.

Stevenson 1921. Edward Luther Stevenson. *Terrestrial and Celestial Globes: Their History and Construction, Including a Consideration of Their Value as Aids in the Study of Geography and Astronomy.* New Haven, 1921.

Stillman 1986. Yedida K. Stillman. "Libas." In *The Encyclopaedia of Islam*, new ed., vol. 5, pp. 732–47. Leiden, 1986.

Stillman 2000. Yedida K. Stillman. *Arab Dress: A Short History from the Dawn of Islam to Modern Times.* Leiden, 2000.

Strzygowski 1904. Josef Strzygowski. *Koptische Kunst: Catalogue général des antiquités égyptiennes du Musée du Caire.* Vienna, 1904.

Sukenik 1935. Eleazar Lipa Sukenik. *The Ancient Synagogue of El-Hammeh (Hammath-by-Gadara): An Account of the Excavations Conducted on Behalf of the Hebrew University, Jerusalem.* Jerusalem, 1935.

Swanson 2001. Mark N. Swanson. "The Martyrdom of 'Abd al-Masih, Superior of Mount Sinai (Qays Al-Ghassani)." In *Syrian Christians under Islam: The First Thousand Years*, edited by David Thomas, pp. 107–29. Leiden, 2001.

Swanson 2010. Mark N. Swanson. *The Coptic Papacy in Islamic Egypt (641–1517).* Cairo, 2010.

Swelim 1994. M. Tarek Swelim. "The Mosque of Ibn Tulun: A New Perspective." Ph.D. diss., Harvard University, 1994.

Swift 2009. Ellen Swift. *Style and Function in Roman Decoration: Living with Objects and Interiors.* Farnham, 2009.

Syrie 1993. Syrie: Mémoire et civilisation. Exh. cat. Paris, 1993.

Tabari 1879–1901. Muhammad ibn Jarir Tabari. *Ta'rikh al-rusul wa-al-muluk.* 15 vols. Edited by M. J. de Goeje. Leiden, 1879–1901.

Tabari 1989. Muhammad ibn Jarir Tabari. *The Waning of the Ummayad Caliphate.* Translated and annotated by Carole Hillenbrand. Albany, N.Y., 1989.

Tabbaa 1991. Yasser Tabbaa. "The Transformation of Arabic Writing: Part 1, Qur'anic Calligraphy." *Ars Orientalis* 21 (1991), pp. 119–48.

Tafazzoli 1974. Ahmad Tafazzoli. "A List of Trades and Crafts in the Sassanian Period." *Archäologische Mitteilungen aus Iran* 7 (1974), pp. 191–96.

Tahan 2007. Ilana Tahan. *Hebrew Manuscripts: The Power of Script and Image.* London, 2007.

Tait 1991. Hugh Tait, ed. *Five Thousand Years of Glass.* London, 1991.

Talbot 2001. Alice-Mary Talbot. "Byzantine Pilgrimage to the Holy Land from the Eighth to the Fifteenth Century." In *The Sabaite Heritage in the Orthodox Church from the Fifth Century to the Present*, edited by Joseph Patrich, pp. 97–110. Leuven, 2001.

Talgam 2004. Rina Talgam. *The Stylistic Origins of Umayyad Sculpture and Architectural Decoration.* 2 vols. Wiesbaden, 2004.

Tassinari 1993. Suzanne Tassinari. *Il vasellame bronzeo di Pompeii.* Rome, 1993.

Tate 1992a. Georges Tate. *Les campagnes de la Syrie du nord du IIe au VIIe siècle: Un exemple d'expansion démographique et économique dans les campagnes à la fin de l'antiquité.* Paris, 1992.

Tate 1992b. Georges Tate. "Prospérité des villages de la Syrie du Nord au VIe siècle." In *Ecclesiastical Silver Plate in Sixth-Century Byzantium*, edited by Susan A. Boyd and Marlia Mundell Mango, pp. 93–98. Washington, D.C., 1992.

Tchalenko 1953–58. Georges Tchalenko. *Villages antiques de la Syrie du nord: Le massif du Bélus à l'époque romaine.* 3 vols. Paris, 1953–58.

Theophanes 1982. Theophanes the Confessor. *The Chronicle of Theophanes: An English Translation of Anni Mundi 6095–6305 (A.D. 602–813).* Translated and edited by Harry Turtledove. Philadelphia, 1982.

D. Thomas and Roggema 2009. David Thomas and Barbara Roggema, eds. *Christian Muslim Relations: A Bibliographical History*, vol. 1, *600–900.* Leiden, 2009.

T. Thomas 1997. Thelma K. Thomas. "Christians in the Islamic East." In *The Glory of Byzantium: Art and Culture of the Middle Byzantine Era, A.D. 843–1261*, edited by Helen C. Evans and William D. Wixom, pp. 364–71. Exh. cat. New York, 1997.

T. Thomas 2000. Thelma K. Thomas. *Late Antique Egyptian Funerary Sculpture: Images for This World and the Next.* Princeton, 2000.

T. Thomas 2002a. Thelma K. Thomas. "The Medium Matters: Reading the Remains of a Late Antique Textile." In *Reading Medieval Images: The Art Historian and the Object*, edited by Elizabeth Sears and Thelma K. Thomas, pp. 38–48. Ann Arbor, 2002.

T. Thomas 2002b. Thelma K. Thomas. "Understanding Objects." In *Reading Medieval Images: The Art Historian and the Object*, edited by Elizabeth Sears and Thelma K. Thomas, pp. 9–15. Ann Arbor, 2002.

T. Thomas 2007. Thelma K. Thomas. "Coptic and Byzantine Textiles Found in Egypt: Corpora, Collections, and Scholarly Perspectives." In *Egypt in the Byzantine World, 300–700*, edited by Roger S. Bagnall, pp. 137–62. Cambridge, 2007.

Thompson 1965. Deborah Thompson. "A Fatimid Textile of Coptic Tradition with Arabic Inscription." *Journal of the American Research Center in Egypt* 4 (1965), pp. 145–50.

Thompson 1971. Deborah Thompson. *Coptic Textiles in the Brooklyn Museum.* New York, 1971.

Thompson 1985. Deborah Thompson. "'Miniaturization' as a Design Principle in Late Coptic Textiles of the Islamic Period: Observations on the Classification of Coptic Textiles." *Journal of the American Research Center in Egypt* 22 (1985), pp. 55–71.

Thompson 1986. Deborah Thompson. "The Evolution of Two Traditional Coptic Tape Patterns: Further Observations on the Classification of Coptic Textiles." *Journal of the American Research Center in Egypt* 23 (1986), pp. 145–56.

Thorndike 1964. Lynn Thorndike. "The Relation between Byzantine and Western Science and Pseudo-Science before 1350." *Janus* 51 (1964), pp. 1–48.

Tihon 1993. Anne Tihon. "L'astronomie à Byzance à l'époque iconoclaste." In *Science in Western and Eastern Civlization in Carolingian Times*, edited by Paul Leo Butzer and Dietrich Lohrmann, pp. 181–204. Basel, 1993.

Tilke 1923. Max Tilke. *Orientalische Kostüme in Schnitt und Farbe.* Berlin, 1923.

Till 1951. Walter C. Till. *Die Arzneikunde der Kopten.* Berlin, 1951.

Timbe 1998. Janet Timbe. "A Liturgical Procession in the Desert of Apa Shenoute." In *Pilgrimage and Holy Space in Late Antique Egypt*, edited by David Frankfurter, pp. 415–41. Leiden, 1998.

Timm 1984. Stefan Timm. *Das christlich-koptische Ägypten in arabischer Zeit.* Wiesbaden, 1984.

Tisserant 1914. Eugène Tisserant. *Specimina codicum orientalium.* Bonn, 1914.

Tohme 2005. Lara G. Tohme. "Out of Antiquity: Umayyad Baths in Context." Ph.D. diss., MIT, 2005.

Tohme 2009. Lara G. Tohme. "Spaces of Convergence: Christian Monasteries and Umayyad Architecture in Greater Syria." In *Negotiating Secular and Sacred in Medieval Art: Christian, Islamic, and Buddhist*, edited by Alicia Walker and Amanda Luyster, pp. 129–45. Farnham, 2009.

Tomoum 2010. Nadja Tomoum, ed. *Coptic Art Revealed.* Exh. cat. Cairo, 2010.

Török 2005a. László Török, ed. *After the Pharaohs: Treasures of Coptic Art from Egyptian Collections.* Exh. cat. Budapest, 2005.

Török 2005b. László Török. *Transfigurations of Hellenism: Aspects of Late Antique Art in Egypt AD 250–700.* Leiden, 2005.

Torp 1965. Hjalmar Torp. "Two Sixth-Century Coptic Stone Reliefs with Old Testament Scenes." *Acta ad Archaeologiam et Artium Historiam Pertinentia* 2 (1965), pp. 105–19.

Tóth 2010. Bálint Lászlo Tóth. "The Six Techniques of Pierced Jewellery in Late Antiquity and Their Evolution." In *Intelligible Beauty: Recent Research on Byzantine Jewellery*, edited by Christopher Entwhistle and Noël Adams, pp. 1–19. London, 2010.

Tougher 1997. Shaun F. Tougher. "Byzantine Eunuchs: An Overview, with Special Reference to Their Creation and Origin." In *Women, Men, and Eunuchs: Gender in Byzantium*, edited by Liz James, pp. 168–84. London, 1997.

Tov 2001. Emanuel Tov. *Textual Criticism of the Hebrew Bible.* 2d rev. ed. Minneapolis, 2001.

Toynbee and Painter 1986. Jocelyn M. C. Toynbee and Kenneth S. Painter. "Silver Picture Plates of Late Antiquity: A.D. 300 to 700." *Archaeologia* 108 (1986), pp. 15–65.

Toynbee and Ward-Perkins 1950. Jocelyn M. C. Toynbee and John Ward-Perkins. "Peopled Scrolls: A Hellenistic Motif in Imperial Art." *Papers of the British School at Rome* 18 (1950), pp. 1–43.

Treadwell 1999. W. Luke Treadwell. "The 'Orans' Drachms of Bishr ibn Marwan and the Figural Coinage of the Early Marwanids." In *Bayt al-Maqdis*, vol. 2, *Jerusalem and Early Islam*, edited by Jeremy Johns, pp. 223–69. Oxford, 1999.

Trésors fatimides 1998. *Trésors fatimides du Caire.* Exh. cat. Paris, 1998.

Trever and Lukonin 1987. Kamilla V. Trever and Vladiir G. Lukonin. *Sasanidskoe serebro, sobranie Gosudarstvennogo Ermitazha = Sassanid Silver in the Hermitage Collection.* Moscow, 1987.

Trilling 1982. James Trilling. *The Roman Heritage: Textiles from Egypt and the Eastern Mediterranean, 300 to 600 A.D.* Exh. cat. Washington, D.C., 1982.

Trilling 1985. James Trilling. *The Medallion Style: A Study in the Origins of Byzantine Taste.* New York, 1985.

Trilling 1995. James Trilling. "Medieval Interlace Ornament: The Making of a Cross-Cultural Idiom." *Arte Medievale* 9 (1995), pp. 59–86.

Trilling 1997. James Trilling. "Daedalus and the Nightingale: Art and Technology in the Myth of the Byzantine Court." In *Byzantine Court Culture from 829 to 1204*, edited by Henry Maguire, pp. 217–30. Washington, D.C., 1997.

Trilling 2003. James Trilling. *Ornament: A Modern Perspective.* Seattle, 2003.

Trombley 2001. Frank R. Trombley. "Mediterranean Sea Culture between Byzantium and Islam c. 600–850 A.D." In *The Dark Centuries of Byzantium (7th–9th C.)/Hoi skoteinoi aiōnes tou Vyzantiou (7os–9os ai.)*, edited by Eleōnora Kountoura-Galakē, pp. 133–69. Athens, 2001.

Troupeau 1975. Gerard Troupeau. "Les couvents chrétiens dans la littérature arabe." *Nouvelle Revue du Caire* 1 (1975), pp. 265–79.

Trümpelmann 1965. Leo Trümpelmann. "Die Skulpturen von Mschatta." *Archäologischer Anzeiger* 2 (1965), cols. 235–76.

Tsafrir 2009. Yoram Tsafrir. "Trade, Workshops, and Shops in Bet/Shean/Scythopolis, 4th–8th Centuries." In *Byzantine Trade, 4th–12th Centuries: The Archaeology of Local, Regional, and International Exchange*, edited by Marlia Mundell Mango, pp. 61–82. Farnham, 2009.

Ulbert 1986. Thilo Ulbert. *Resafa*, vol. 2, *Die Basilika des Heiligen Kreuzes in Resafa-Sergiupolis.* Mainz, 1986.

Ullmann 1961. Manfred Ullmann. *Die arabische Überlieferung der sogenannten Menander-Sentenzen.* Wiesbaden, 1961.

Umayyads 2000. *The Umayyads: The Rise of Islamic Art.* Exh. cat. Beirut, 2000.

Upton 1932. J. M. Upton. "The Expedition to Ctesiphon, 1931–1932." *Metropolitan Museum of Art Bulletin* 27 (August 1932), pp. 188–97.

Urbach 1959. Efraim E. Urbach. "The Rabbinical Laws of Idolatry in the Second and Third Centuries in the Light of Archaeological and Historical Facts." *Israel Exploration Journal* 9 (1959), pp. 149–65, 229–45.

V&A Museum 1963. *Late Antique and Byzantine Art.* London, 1963.

van den Ven 1962–70. Paul van den Ven, ed. and trans. *La vie ancienne de S. Syméon Stylite le jeune (521–592).* 2 vols. Brussels, 1962–70.

van der Vliet 2006. Jacques van der Vliet. "'In a Robe of Gold': Status, Magic, and Politics on Inscribed

Christian Textiles from Egypt." In *Textile Messages: Inscribed Fabrics from Roman to Abbasid Egypt*, edited by Cäcilia Fluck and Gisela Helmecke, pp. 23–67. Leiden, 2006.

van Esbroeck 1976. Michel van Esbroeck. "Saint Philotheos d'Antioche." *Analecta Bollandiana* 94 (1976), pp. 107–35.

van Ess 1988. Josef van Ess. *The Youthful God: Anthropomorphism in Early Islam.* Phoenix, Ariz., 1988.

van Ess 1992. Josef van Ess. "'Abd al-Malik and the Dome of the Rock: An Analysis of Some Texts." In *Bayt al-Maqdis*, vol. 1, *'Abd al-Malik's Jerusalem*, edited by Julian Raby and Jeremy Johns, pp. 89–104. Oxford, 1992.

van Loon 2005. Gertrud J. M. van Loon. "A Note to the Provenance of the Panel of 'Brother George the Scribe.'" *Eastern Christian Art* 2 (2005), pp. 37–38.

van Reenen 1990. Daan van Reenen. "The Bilderverbot: A New Survey." *Der Islam* 67 (1990), pp. 27–77.

van Rompay 2005. Lucas van Rompay. "Society and Community in the Christian East." In *The Cambridge Companion to the Age of Justinian*, edited by Michael Maas, pp. 239–66. Cambridge, 2005.

Vasilakē 2000. Maria Vasilakē, ed. *The Mother of God: Representations of the Virgin in Byzantine Art.* Exh. cat. Milan, 2000.

Vasil'ev 1956. Aleksandr A. Vasil'ev. "The Iconoclastic Edict of the Caliph Yazid II, A.D. 721." *Dumbarton Oaks Papers* 9–10 (1956), pp. 25–47.

Vasilyeva 2007. Olga V. Vasilyeva. "On the History of J.-J. Marcel's Qur'an Collection" (in Russian). In *Obshtuvane s Iztoka: Iubileen sbornik, posveten na 60-god-ishninata na Stoianka Kenderova*, pp. 442–51. Sofia, 2007.

Vassilaki, Maria. See Vasilakē.

Vatican Collections **1982.** *The Vatican Collections: The Papacy and Art.* Exh. cat. New York, 1982.

Veilleux 1981. Armand Veilleux, trans. *Pachomian Koinonia*, vol. 2, *Pachomian Chronicles and Rules.* Kalamazoo, Mich., 1981.

Verdier 1980. Philippe Verdier. "A Medallion of Saint Symeon the Younger." *Bulletin of the Cleveland Museum of Art* 67 (1980), pp. 17–27.

Verhecken 2007. André Verhecken. "Relation between Age and Dyes of 1st Millennium AD Found in Egypt." In *Methods of Dating Ancient Textiles of the 1st Millennium AD from Egypt and Neighbouring Countries*, edited by Antoine De Moor and Cäcilia Fluck, pp. 206–13. Tielt, 2007.

Verhecken-Lammens 1994. Chris Verhecken-Lammens. "Two Coptic Wool Tunics in the Collection of the Abegg-Stiftung: A Detailed Analysis of the Weave Techniques Used." *Riggisberger Berichte* 2 (1994), pp. 73–103.

Verhecken-Lammens et al. 2006. Chris Verhecken-Lammens, Antoine De Moor, and Bruno Overlaet. "Radio-Carbon Dated Silk Road Samites in the Collection of Katoen Natie, Antwerpen." *Iranica Antiqua* 41 (2006), pp. 233–301.

Verstegen 2011. Ute Verstegen. "Adjusting the Image—Processes of Hybridization in Visual Culture: A Perspective from Early Christian and Byzantine Archaeology." In *Conceptualizing Cultural Hybridization: A Transdisciplinary Approach*, edited by Philipp Wolfgang Stockhammer, pp. 67–94. Heidelberg, 2011.

Vibert-Guigue and Bishah 2007. Claude Vibert-Guigue and Ghazi Bishah. *Les peintures de Qusayr*

'Amra: Un bain ommeyyade dans la bâdiya jordanienne. Beirut, 2007.

Viguera Molins 2001. María Jesús Viguera Molins, ed. *El esplendor de los Omeyas cordobeses: La civilización musulmana de Europa Occidental.* Exh. cat. 2 vols. Granada, 2001.

Vikan 1984. Gary Vikan. "Art, Medicine, and Magic in Early Byzantium." *Dumbarton Oaks Papers* 38 (1984), pp. 65–86.

Vikan 1989. Gary Vikan. "Ruminations on Edible Icons: Originals and Copies in the Art of Byzantium." *Studies in the History of Art* 20 (1989), pp. 47–59.

Vikan 1990a. Gary Vikan. "Art and Marriage in Early Byzantium." *Dumbarton Oaks Papers* 44 (1990), pp. 145–63.

Vikan 1990b. Gary Vikan. "Pilgrims in Magi's Clothing: The Impact of Mimesis on Early Byzantine Pilgrimage Art." In *The Blessings of Pilgrimage*, edited by Robert Ousterhout, pp. 97–107. Urbana, Ill., 1990.

Vikan 1991. Gary Vikan. "Guided by Land and Sea: Pilgrim Art and Pilgrim Travel in Early Byzantium." In *Tesserae: Festschrift für Josef Engemann*, pp. 74–92. Münster, 1991.

Vikan 1994. Gary Vikan. "Two Unpublished Pilgrim Tokens in the Benaki Museum and the Group to Which They Belong." In *Thymiama: Stē mnēmē tēs Laskarinas Boura*, vol. 1, *Keimena*, pp. 341–46. Athens, 1994.

Vikan 1995. Gary Vikan. *Catalogue of the Sculpture in the Dumbarton Oaks Collection from the Ptolemaic Period to the Renaissance.* Washington, D.C., 1995.

Vikan 2010. Gary Vikan. *Early Byzantine Pilgrimage Art.* Rev. ed. Washington, D.C., 2010.

Vincent 1961. Louis-Hugues Vincent. "Un sanctuaire dans la région de Jéricho, la synagogue de Na'arah." *Revue Biblique* 68 (1961), pp. 161–73.

Visy 1994. Zsolt Visy. "Römische und byzantinische Schnellwaagen aus der Türkei." In *Akten der 10. Internationalen Tagung über antike Bronzen*, edited by Jutta Ronke, pp. 435–44. Stuttgart, 1994.

Vogelsang-Eastwood 1995. Gillian M. Vogelsang-Eastwood. *Die Kleider des Pharaos: Die Verwendung von Stoffen im Alten Ägypten.* Hannover, 1995.

Vogelsang-Eastwood 2000. Gillian Vogelsang-Eastwood. "Textiles." In *Ancient Egyptian Materials and Technology*, edited by Paul T. Nicholson and Ian Shaw, pp. 268–98. Cambridge, 2000.

Vogelsang-Eastwood 2003. Gillian Vogelsang-Eastwood. "The Arabs, AD 600–1000." In *The Cambridge History of Western Textiles*, edited by David Jenkins, vol. 1, pp. 158–65. Cambridge, 2003.

Vogelsang-Eastwood 2004. Gillian M. Vogelsang-Eastwood. "Sasanian 'Riding-Coats': The Iranian Evidence." In *Riding Costume in Egypt: Origin and Appearance*, edited by Cäcilia Fluck and Gillian M. Vogelsang-Eastwood, pp. 209–29. Leiden, 2004.

Voie royale **1986.** *La Voie royale: 9000 ans d'art au royaume de Jordanie.* Exh. cat. Paris, 1986.

Volbach 1942. Wolfgang F. Volbach. *I tessuti del Museo Sacro Vaticano.* The Vatican, 1942.

Volbach 1952. Wolfgang Fritz Volbach. *Elfenbeinarbeiten der Spätantike und des frühen Mittelalters.* 2d ed. Mainz, 1952.

Volbach 1966. Wolfgang F. Volbach. *Il tessuto nell'arte antica.* Milan, 1966.

Volbach 1976. Wolfgang Fritz Volbach. *Elfenbeinarbeiten der Spätantike und des frühen Mittelalters.* 3d ed. Mainz am Rhein, 1976.

Volbach and Lafontaine-Dosogne 1968. Wolfgang Fritz Volbach and Jacqueline Lafontaine-Dosogne. *Byzanz und der christliche Osten.* Berlin, 1968.

D. von Bothmer 1950. Dietrich von Bothmer. *Greek, Etruscan, and Roman Antiquities: An Exhibition from the Collection of Walter Cummings Baker, Esq.* Exh. cat. New York, 1950.

D. von Bothmer 1961. Dietrich von Bothmer. *Ancient Art from New York Private Collections.* Exh. cat. New York, 1961.

H. von Bothmer 1986. Hans-Caspar Graf von Bothmer. "Frühislamische Koran-Illuminationen: Meisterwerke aus den Handschriften der Grossen Moschee in Sanaa/Yemen." *Kunst und Antiquitäten* 1 (1986), pp. 22–33.

H. von Bothmer 1987a. Hans-Caspar Graf von Bothmer. "Architekturbilder im Koran: Eine Prachthandschrift der Umayyadenzeit aus dem Yemen." *Pantheon* 45 (1987), pp. 4–20.

H. von Bothmer 1987b. Hans-Caspar Graf von Bothmer. "Masterworks of Islamic Book Art: Koranic Calligraphy and Illumination in the Manuscripts Found in the Great Mosque in Sanaa." In *Yemen: 3000 Years of Art and Civilisation in Arabia Felix*, edited by Werner Daum, pp. 178–81. Exh. cat. Frankfurt, 1987.

H. von Bothmer et al. 1999. Hans-Caspar Graf von Bothmer, Karl-Heinz Ohlig, and Gerd-Rüdiger Puin. "Neue Wege der Koranforschung." *Magazin Forschung (Universität des Saarlandes)* 1 (1999), pp. 33–46.

von Falck 1996. Martin von Falck. *Ägypten Schätze aus dem Wüstensand: Kunst und Kultur der Christen am Nil.* Exh. cat. Wiesbaden, 1996.

von Falke 1913. Otto von Falke. *Kunstgeschichte der Seidenweberei.* vol. 1. Berlin, 1913.

von Falkenhausen 2000. Lothar von Falkenhausen. "Die Seiden mit chinesischen Inschriften." In *Die Textilien aus Palmyra: Neue und alte Funde*, edited by Andreas Schmidt-Colinet et al., pp. 58–81. Mainz, 2000.

von Folsach 1990. Kjeld von Folsach. *Art from the World of Islam in the David Collection.* Copenhagen, 1990.

von Folsach 2001. Kjeld von Folsach. *Art from the World of Islam in the David Collection.* Rev. and exp. ed. Copenhagen, 2001.

von Folsach and Meyer 2005. Kjeld von Folsach and Joachim Meyer, eds. *The Ivories of Muslim Spain: Papers from a Symposium Held in Copenhagen from the 18th to the 20th of November 2003.* 2 vols. Copenhagen, 2005.

von Folsach et al. 1996. Kjeld von Folsach, Torben Lundbaek, and Peder Mortensen, eds. *Sultan, Shah, and Great Mughal: The History and Culture of the Islamic World.* Exh. cat. Copenhagen, 1996.

von Gladiss 1998. Almut von Gladiss. *Schmuck im Museum für Islamische Kunst.* Berlin, 1998.

von Saldern 1998. Axel von Saldern. "Byzantine Glass: Problems of Terminology and Chronology." In *Gilded and Enamelled Glass from the Middle East*, edited by Rachel Ward, pp. 1–3. London, 1998.

Vööbus 1960. Arthur Vööbus. *History of Asceticism in the Syrian Orient.* 3 vols. Louvain, 1960.

Vorderstrasse 2010. Tasha Vorderstrasse. "Trade and Textiles from Medieval Antioch." *Al-Masaq* 22, no. 2 (2010), pp. 151–71.

Vryonis 1962. Speros Vryonis Jr. "The Question of the Byzantine Mines." *Speculum* 37 (1962), pp. 1–17.

Vryonis 1985. Speros Vryonis Jr. "Aspects of Byzantine Society in Syro-Palestine: Transformations in the Late Fourth and Fifth Centuries." In *Byzantine Studies in*

Honor of Milton V. Anastos, edited by Speros Vryonis Jr., pp. 43–63. Malibu, 1985.

A. Walker and Luyster 2009. Alicia Walker and Amanda Luyster, eds. *Negotiating Secular and Sacred in Medieval Art: Christian, Islamic, and Buddhist.* Farnham, 2009.

D. Walker and Froom 1992. Daniel Walker and Aimée Froom. *Tiraz: Inscribed Textiles from Islamic Workshops.* Exh. cat. New York, 1992.

Jl. Walker 1999. Joel Walker. "Nestorians." In *Late Antiquity: A Guide to the Postclassical World*, edited by Glen W. Bowersock et al., pp. 602–3. Cambridge, Mass., 1999.

Jn. Walker 1956. John Walker. *A Catalogue of the Arab-Byzantine and Post-Reform Umaiyad Coins [in the British Museum].* London, 1956.

P. Walker 2002. Paul E. Walker. *Exploring an Islamic Empire: Fatimid History and Its Sources.* London, 2002.

Walmsley 2003a. Alan Walmsley. "The Friday Mosque of Early Islamic Jarash in Jordan: The 2002 Field Season of the Danish-Jordanian Islamic Jarash Project." *Journal of the C. L. David Collection* 1 (2003), pp. 110–31.

Walmsley 2003b. Alan Walmsley. "The Newly Discovered Congregational Mosque of Jarash in Jordan." *Al-Usur al-Wusta: The Bulletin of Middle East Medievalists* 15, no. 2 (2003), pp. 17–24.

Walmsley 2007. Alan Walmsley. *Early Islamic Syria: An Archaeological Assessment.* London, 2007.

Walmsley and Damgaard 2005. Alan Walmsley and Kristoffer Damgaard. "The Umayyad Congregational Mosque of Jarash in Jordan and Its Relationship to Early Mosques." *Antiquity* 79 (2005), pp. 362–78.

Walter 1982. Christopher Walter. *Art and Ritual of the Byzantine Church.* London, 1982.

Walter 2003. Christopher Walter. *The Warrior Saints in Byzantine Art and Tradition.* Aldershot, 2003.

Wamser 2004. Ludwig Wamser, ed. *Die Welt von Byzanz: Europas östliches Erbe: Glanz, Krisen und Fortleben einer tausendjährigen Kultur.* Exh. cat. Munich, 2004.

Wamser and Zahlhaas 1998. Ludwig Wamser and Gisela Zahlhaas, eds. *Rom und Byzanz: Archäologische Kostbarkeiten aus Bayern.* Exh. cat. Munich, 1998.

Wander 1973. Steven Wander. "The Cyprus Plates: The Story of David and Goliath." *Metropolitan Museum of Art Journal* 8 (1973), pp. 89–104.

Wander 1975. Steven Wander. "The Cyprus Plates and the Chronicle of Fredegar." *Dumbarton Oaks Papers* 29 (1975), pp. 345–46.

R. Ward 1993. Rachel Ward. *Islamic Metalwork.* New York, 1993.

S. Ward 1984. Seth Ward. "Construction and Repair of Churches and Synagogues in Islamic Law." Ph.D. diss., Yale University, 1984.

Warland 1994. Rainer Warland. "Der Ambo aus Thessaloniki: Bildprogramm, Rekonstruktion, und Datierung." *Jahrbuch des Deutschen Archäologischen Instituts* 109 (1994), pp. 371–85.

Watson 2004. Oliver Watson. *Ceramics from Islamic Lands.* London, 2004.

Watt 2004. James C. Y. Watt, ed. *China: Dawn of a Golden Age, 200–750 AD.* Exh. cat. New York, 2004.

Weibel 1952. Adèle C. Weibel. *Two Thousand Years of Textiles: The Figured Textiles of Europe and the Near East.* New York, 1952.

Weitzmann 1960a. Kurt Weitzmann. "The Mandylion and Constantine Porphyrogennetos." *Cahiers Archéologiques* 11 (1960), pp. 163–84.

Weitzmann 1960b. Kurt Weitzmann. "The Survival of Mythological Representations in Early Christian and Byzantine Art and Their Impact on Christian Iconography." *Dumbarton Oaks Papers* 14 (1960), pp. 43–68.

Weitzmann 1970. Kurt Weitzmann. *Illustrations in Roll and Codex: A Study of the Origin and Method of Text Illustration.* 2d ed. Princeton, 1970.

Weitzmann 1972. Kurt Weitzmann "The Ivories of the So-called Grado Chair." *Dumbarton Oaks Papers* 26 (1972), pp. 43–91.

Weitzmann 1974. Kurt Weitzmann. "Loca Sancta and the Representational Arts of Palestine." *Dumbarton Oaks Papers* 28 (1974), pp. 31–55.

Weitzmann 1976. Kurt Weitzmann. *The Monastery of Saint Catherine at Mount Sinai: The Icons.* Princeton, 1976.

Weitzmann 1979a. Kurt Weitzmann, ed. *Age of Spirituality: Late Antique and Early Christian Art, Third to Seventh Century.* Exh. cat. New York, 1979.

Weitzmann 1979b. Kurt Weitzmann. *The Miniatures of the Sacra Parallela, Parisinus Graecus 923.* Princeton, 1979.

Weitzmann and Anderegg 1964. Kurt Weitzmann and Fred Anderegg. "Mount Sinai's Holy Treasures." *National Geographic* 125, no. 1 (January 1964), pp. 109–27.

Weitzmann and Galavaris 1990. Kurt Weitzmann and George Galavaris. *The Monastery of Saint Catherine at Mount Sinai: The Illuminated Greek Manuscripts.* Princeton, 1990.

Welch 2005. A. T. Welch. "al-Kuran." In *The Encyclopaedia of Islam*, 2d ed., vol. 5, pp. 400–432. Leiden, 2005.

Wenzel 1988. Marian Wenzel. "Islamic Gold Sandwich Glass: Some Fragments in the David Collection, Copenhagen." *Journal of the Royal Asiatic Society of Great Britain and Ireland*, no. 1 (1988), pp. 45–72.

Wenzel 1993. Marian Wenzel. *Ornament and Amulet: Rings of the Islamic Lands.* New York, 1993.

Wharton 1995. Annabel Wharton. *Refiguring the Post Classical City: Dura Europos, Jerash, Jerusalem, and Ravenna.* Cambridge, 1995.

Wharton 2000. Annabel Wharton. "Erasure: Eliminating the Space of Late-Antique Judaism." In *From Dura to Sepphoris: Studies in Jewish Art and Society in Late Antiquity*, edited by Lee I. Levine and Zeev Weiss, pp. 195–214. Portsmouth, R.I., 2000.

Whelan 1986. Estelle Whelan. "The Origins of the Mihrab Mujawwaf: A Reinterpretation." *International Journal of Middle East Studies* 18, no. 2 (1986), pp. 205–23.

Whelan 1990. Estelle Whelan. "Writing the Word of God: Some Early Qur'an Manuscripts and Their Milieux, Part I." *Ars Orientalis* 20 (1990), pp. 113–47.

Whelan 1998. Estelle Whelan. "Forgotten Witness: Evidence for the Early Codification of the Qur'an." *Journal of the American Oriental Society* 118 (1998), pp. 1–14.

Whitby 2002. Mary Whitby. "George of Pisidia's Presentation of the Emperor Heraclius and His Campaigns: Variety and Development." In *The Reign of Heraclius (610–641): Crisis and Confrontation*, edited by Gerrit J. Reinink and Bernard H. Stolte, pp. 157–73. Leuven, 2002.

Whitcomb 1994. Donald Whitcomb. "Ayla in the Balance: Glass and Bronze Weights from Aqaba Excavations." *Yarmouk Numismatics* 6 (1994), pp. 34–55.

Whitehouse 2001. David Whitehouse. *Roman Glass in the Corning Museum of Glass.* vol. 2. Corning, N.Y., 2001.

Wickham 2004. Chris Wickham. "Conclusion." In *The Byzantine and Early Islamic Near East*, vol. 6, *Elites Old and New in the Byzantine and Early Islamic Near East*, edited by John Haldon and Lawrence I. Conrad, pp. 285–97. Princeton, 2004.

Wieder 1957. Naphtali Wieder. "'Sanctuary' as a Metaphor for Scripture." *Journal of Jewish Studies* 8 (1957), pp. 165–75.

Wiet 1971. Gaston Wiet. *Catalogue général du Musee de l'Art Islamique du Caire: Inscriptions historiques sur pierre.* Cairo, 1971.

Wild 2003. John Peter Wild. "The Later Roman and Early Byzantine East, AD 300–1000." In *The Cambridge History of Western Textiles*, edited by David Jenkins, vol. 1, pp. 140–53. Cambridge, 2003.

Wilfong 1998. Terry G. Wilfong. "The Non-Muslim Communities: Christian Communities." In *The Cambridge History of Egypt*, vol. 1, *Islamic Egypt, 640–1517*, edited by Carl F. Petry, pp. 175–97. Cambridge, 1998.

Wilken 1992. Robert L. Wilken. *The Land Called Holy: Palestine in Christian History and Thought.* New Haven, 1992.

C. Wilkinson 1960. Charles K. Wilkinson. "The First Millennium B.C." *Metropolitan Museum of Art Bulletin* 18 (April 1960), pp. 260–68.

C. Wilkinson 1973. Charles K. Wilkinson. *Nishapur: Pottery of the Early Islamic Period.* New York, 1973.

J. Wilkinson 1977. John Wilkinson. *Jerusalem Pilgrims before the Crusades.* Warminster, 1977.

J. Wilkinson 1992. John Wilkinson. "Column Capitals in the Haram al-Sharif." In *Bayt al-Maqdis*, vol. 1, *'Abd al-Malik's Jerusalem*, edited by Julian Raby and Jeremy Johns, pp. 125–39. Oxford, 1992.

J. Wilkinson 1999. John Wilkinson, trans. *Egeria's Travels.* 3d ed. Warminster, 1999.

J. Wilkinson 2002. John Wilkinson. *Jerusalem Pilgrims before the Crusades.* New ed. Warminster, 2002.

J. G. Wilkinson 1847. Sir John Gardner Wilkinson. *Hand-book for Travellers in Egypt.* London, 1847.

Williamson 2003. Paul Williamson. "On the Date of the Symmachi Panel and the So-called Grado Chair Ivories." In *Through a Glass Brightly: Studies in Byzantine and Medieval Art and Archaeology Presented to David Buckton*, edited by Chris Entwistle, pp. 47–50. Oxford, 2003.

Williamson 2008. Paul Williamson. "Gli avori della cosiddetta 'Cattedra di Grado': Lo stato delle ricerche." In *L'enigma degli avori medievali da Amalfi a Salerno*, edited by Ferdinando Bologna, vol. 1, pp. 155–59. Pozzuoli, Italy, 2008.

Williamson 2010. Paul Williamson. *Medieval Ivory Carvings: Early Christian to Romanesque.* London, 2010.

Winlock and Crum 1926. Herbert E. Winlock and Walter E. Crum. *The Monastery of Epiphanius at Thebes*, vol. 1, *The Archaeological Material, The Literary Material.* New York, 1926.

Wipszycka 1991. Ewa Wipszycka. "Textiles, Coptic, Organization of Production." In *The Coptic Encyclopedia*, edited by Aziz S. Atiya, vol. 7, cols. 2219–21. New York, 1991.

Witt 2000. Janette Witt. *Werke der Alltagskultur*, vol. 1, *Menasampullen.* Wiesbaden, 2000.

Wittkower 1939. Rudolf Wittkower. "Eagle and Serpent: A Study in the Migration of Symbols." *Journal of the Warburg Institute* 2 (April 1939), pp. 293–325.

Wixom 1999. William D. Wixom, ed. *Mirror of the Medieval World.* Exh. cat. New York, 1999.

Wixom 2003. William D. Wixom. "A Glimpse at the Fountains of the Middle Ages." *Cleveland Studies in the History of Art* 8 (2003), pp. 6–23.

Wolska 1962. Wanda Wolska. *La Topographie Chrétienne de Cosmas Indicopleustès: Théologie et science au VIe siècle.* Paris, 1962.

Wolska-Conus 1989. Wanda Wolska-Conus. "Stéphanos d'Athènes et Stéphanos d'Alexandrie." *Revue des Études Byzantines* 47 (1989), pp. 5–89.

D. Woods 2004a. David Woods. "The Crosses on the Glass Pilgrim Vessels from Jerusalem." *Journal of Glass Studies* 46 (2004), pp. 191–95.

D. Woods 2004b. David Woods. "Some Dubious Stylites on Early Byzantine Glassware." *Journal of Glass Studies* 46 (2004), pp. 39–66.

M. Woods 1918. Maitland Woods. "Palestine, Past and Present: Third Article." *Kia Ora Coo-Ee: The Magazine for the Anzacs in the Middle East* (September 15, 1918), p. 7, at http://www.nzetc.org/tm/scholarly/tei-ReiKaOr-t1-g1-t7-body1-d11.html.

Wouters 1993. Jan Wouters. "Dye Analysis of Coptic Textiles." In *Coptic Textiles from Flemish Private Collections*, edited by Antoine De Moor, pp. 53–64. Zottegern, 1993.

Wouters 1995. Jan Wouters. "Dye Analysis in a Broad Perspective: A Study of 3rd- to 10th-Century Coptic Textiles from Belgian Private Collections." *Dyes in History and Archeology* 13 (1995), pp. 38–45.

Wouters 2009. Jan Wouters. "Red and Purple Dyes in Roman and Coptic Egypt." In *Clothing the House: Furnishing Textiles of the 1st Millennium AD from Egypt and Neighbouring Countries*, edited by Antoine De Moor and Cäcilia Fluck, pp. 182–85. Tielt, Belgium, 2009.

Wouters et al. 2008. Jan Wouters et al. "Dye Analyses of Selected Textiles from Three Sites in the Eastern Desert of Egypt." *Dyes in History and Archaeology*, no. 21 (2008), pp. 1–16.

D. Wright 1980. David H. Wright. "The School of Princeton and the Seventh Day of Creation." *University Publishing* 9 (1980), pp. 7–8.

W. Wright 1870. William Wright. *Catalogue of Syriac Manuscripts in the British Museum.* vol. 1. London, 1870.

Wulff 1909. Oskar Wulff. *Beschreibung der Bildwerke der christlichen Epochen*, vol. 3, *Altchristliche und mittelalterliche byzantinische und italienische Bildwerke*, pt. 1, *Altchristliche Bildwerke*. 2d ed. Berlin, 1909.

Wulff and Volbach 1926. Oskar K. Wulff and Wolfgang F. Volbach. *Spätantike und koptische Stoffe aus ägyptischen Grabfunden: In den Staatlichen Museen, Kaiser-Friedrich-Museum, Ägyptisches Museum, Schliemann-Sammlung.* Berlin, 1926.

Yarshater 2008. Ehsan Yarshater, ed. *The Cambridge History of Iran*, vol. 3, *The Seleucid, Parthian, and Sasanian Periods*. Cambridge, 2008.

Yeroulanou 1999. Aimilia Yeroulanou. *Diatrita: Gold Pierced-Work Jewellery from the 3rd to the 7th Century.* Athens, 1999.

Zacos and Veglery 1972. Geõrgios Zacos and A. Veglery. *Byzantine Lead Seals.* vol. 1. Basel, 1972.

Zadeh 2008. Travis Zadeh. "From Drops of Blood: Charisma and Political Legitimacy in the Translation of the 'Uthmanic Codex' of al-Andalus." *Journal of Arabic Literature* 39 (2008), pp. 321–46.

Zadeh 2009. Travis Zadeh. "Touching and Ingesting: Early Debates over the Material Qur'an." *Journal of the American Oriental Society* 129 (2009), pp. 443–66.

Zalesskaia 2006a. Vera N. Zalesskaia. "The Classical Heritage in Byzantine Art." In *The Road to Byzantium: Luxury Arts of Antiquity*, edited by Frank Althaus and Mark Sutcliffe, pp. 49–57. Exh. cat. London, 2006.

Zalesskaia 2006b. Vera N. Zalesskaia. "Classicism and Paideia in Early Byzantine Silver from the Hermitage." In *The Road to Byzantium: Luxury Arts of Antiquity*, edited by Frank Althaus and Mark Sutcliffe, pp. 67–72. Exh. cat. London, 2006.

Zalesskaia 2006c. Vera N. Zalesskaia. *Pamiatniki vizantiĭskogo prikladnogo iskusstva IV–VII vekov: Katalog kollektsii=Monuments of Byzantine Applied Arts, 4th–7th Centuries: Catalogue of the Hermitage Collection.* Saint Petersburg, 2006.

Zalesskaia 2007. Vera N. Zalesskaia. "Interpretatsia nadpisi na kovshe s dionisiiskoi stsenoi iz muzeev Moskovskogo Kremia." *Auxiliary Historical Disciplines* 30 (2007), pp. 28–34.

Zapheiropoulou 2002. Diana Zapheiropoulou, ed. *L'approccio all'uomo bizantino attraverso l'occhio di un collezionista.* Exh. cat. Athens, 2002.

Zayadine 1986–89. Fawzi Zayadine, ed. *Jerash Archaeological Project.* 2 vols. Amman, 1986–89.

Ziffer 1996. Irit Ziffer. *Omanut ha-matekhet ha-Islamit / Islamic Metalwork.* Exh. cat. Tel Aviv, 1996.

Index

David (biblical king)
David Plates (cat. no. 6), *9*, *16*, **16–17**, *17*, 18, 41, 59, 128, 133, 208
Islam and, 247
Jewish claims of descent from, 104–5
lions associated with, 154
in Rabbula Gospels (cat. no. 39), 66
Syriac translation of Book of Kings with portrait of (cat. no. 31), **59**, *59*, 66, 124
textile fragment with episodes from life of (cat. no. 7), **18**, *18*, 133
Dayr Anba Bishoi (Red Monastery, Sohag). *See under* Sohag, White Monastery Federation at
Dayr 'Ayn 'Abata cream ware jug, with inscription (cat. no. 129), 9, 186, **188–89**, *189*
deacon, attributes indicating status as, 43, 71
Dead Sea Scrolls, 105
Decapolis, 8, 11
deer, 172
Deir Sem'an (Telneshe, Telanissos), 91, 94, 97
Deir al-Surian, Wadi al-Natrun, Church of the Holy Virgin, 34
dhimmi, 103
diaper design, pattern sheet with (cat. no. 98), **149**, *149*, 156
Digenes Akritas, 133, 156, 287n112
Diglot, Greek-Arabic (cat. no. 32), **60**, *61*
Diocletian (emperor), 203, 209, 285n57, 290n2
Dionysiaka (Nonnos of Panopolis), 18
Dionysos and Dionysian themes, 9, 18–20, **20**, *20*, 31, 112, 167n5, 175, 176, 181, 192, 196, 197, 206–7, 209, 213, 289n42
Dionysos, golden temple-tomb of, 284n5
Dionysos Hanging, 287n2
Dioscorides manuscripts
Austrian National Library, Vienna, 23
Bibliothèque Nationale de France, Paris, 23
Naples Dioscorides (cat. no. 14), 9, *10*, 18, **23–25**, *24*
Dioskuros of Aphrodito, 284n
Diphilos (comedic writer), 27n11
dirham weight, 144, 147
disk design, panel fragment with (cat. no. 164), *231*, **231**
diyarat literature (set in monasteries), 34, 205
Diyarbakir (Amida), 27, 66, 86
Doctrine of Addai, 66
dolls, figurines of women identified as, 193–95
Dome of the Rock, Jerusalem, 38, 60, 136, 200, 201, 214, 223, 224, 228, *246*, 246–49, *247*, *248*, 252, 253, 258, 264, 266, 268, 270, 272, 274n6, 290n31
doors
Bawit, door jamb probably from (cat. no. 51B), 8, 76, *83*, **83–84**
lotus and palmettes, door panel with (cat. no. 165), 174, 224, **231–32**, *232*
pair of wooden doors with carved decoration (cat. no. 160), 30n7, 177, 224, *227*, **227–28**, *228*
double-pearled borders, 235
double-sided icon with Saint Theodore and Archangel Gabriel, from Bawit (cat. no. 53), 8, 82, *85*, **85–86**
double-sided pendant with Virgin and Child and Christ Pantokrator (cat. no. 61), **93**, *93*
dove, Attarouthi Treasure (cat. no. 22N), 8, 9, **41–44**, *42*
drawings
of enthroned prince, Qusayr 'Amra, 200, *206*
of Job and his family represented as Heraclius and his family (cat. no. 4), **15**, *15*
of Mosque of the Prophet, Medina, *249*, 250
of nude figure holding musical instrument and vase of flowers, 194

dress. *See* clothing
Dura-Europos, 27, 156, 286n100

eagles
aquamanile in shape of eagle, from Hermitage Museum (cat. no. 169), 64, 66n3, 172, 207, 220n3, *234*, **234–35**, 235, 237
as motif, 207
openwork censer topped with eagle with snake in its beak (cat. no. 122C), 9, 124, 152, 172, 176, **180–81**, *181*, 216
wall hanging fragment with (cat. no. 170), **235**, *235*
earrings with pairs of birds/peacocks, 189–90
pair of crescent-shaped earrings with peacocks (cat. no. 131B), 190, **191**, *191*, 192
pair of earrings with birds (cat. no. 132), 190, *191*, **191–92**
single crescent-shaped earring with peacock (cat. no. 131A), 190, **191**, *191*, 192
single teardrop-shaped gold earring with addorsed birds in repoussé, 190
Eastern Kufic, 269
Edessa, 32, 66, 94, 120, 121n1, 250
Egeria (pilgrim writer), 88, 282n23, 285n52
eight-pointed star, textile fragment with inhabited vine in (cat. no. 119B), 161, 175, **176–77**, *177*, 257
Ein Gedi synagogue, 103
Ein Samsam synagogue, stone relief of Daniel in the Lion's Den from, 102, *105*
Ekthesis, 281n25
elephant motif, silk textiles with, *130*, 131, 286n97, 286n100
embroidered silk medallion with Annunciation and Visitation scenes, *131*, 148
embroidery, 28, *131*, 132, 148, 151n10, 161, 165, 183
Emesa, 138
enameling, 126, 226
Enoch, Brother (Epiphanios monk), 164
enthroned prince, drawing of, Qusayr 'Amra, 200, *206*
Entry of Christ into Jerusalem, 71, 73, 79
Ephesus, Council of, 35–36, 66
Ephraim ben Buya'a, 114
Ephrem the Syrian, Saint, *58*, 66
epigraphy. *See* inscriptions
Epiphania (sister and mother-in-law of Emperor Heraclius), 15
Epiphanios, Monastery of, 9, 19, 25, 26, 27, 164
Epistle of Paul to the Romans (cat. no. 36), **63**, *63*
Epistles and Acts, Arabic (cat. no. 35), *62*, **62–63**
Epistles of Paul from the Peshitta (cat. no. 40), **68–69**, *69*
estrangela, 68–69
Etchmiadzin relief, 45
Ethiopians, 7
Ethnika of Stephen of Byzantium, 57, 58n3
ethrog, 107, 110–11, 264
Eucharist, 9, 71, 73, 84
Eudokia (daughter of Emperor Heraclius), 15
Eudokia/Fabia (wife of Emperor Heraclius), 5
eulogiai, 88, 92, 96, 264
eunuchs, 128, 285n47
Euphemios (patriarch of Constantinople), 27n4
Euripides, 26n11, 99
Eusebius of Caesarea, 68n3, 102
Eutychios of Alexandria, 51
evil eye, 132, 177, 194
ewers
with dancing female figures within arcades (cat. no. 20), 20, **31**, *31*, 175, 176, 192, 206

Ibn Yazid, ewer signed by (cat. no. 152), 207, **219–20**, *220*
Islamic, 207
Marwan ewer (cat. no. 171), 172, 181, 207, 224, **235–36**, *236*
from Tiberias treasure, 289n45
with vegetal decoration (cat. no. 156), 20, 176, 224, **225**, *225*
See also bird-shaped vessels
Exodus, Qaraite Book of (cat. no. 77), **114–16**, *115*
Ezbontinos, Staurachios, 33

Fabia/Eudokia (wife of Emperor Heraclius), 5
face of doll, painted linen textile, 195
fan or fly whisk, textile fragment with confonted animals from (cat. no. 172A), **236**, *237*
fan pattern, stone architectural block carved with, from al-Qastal (cat. no. 149B), *217*, **217–18**
fans, liturgical. *See* rhipidia
Faras, 72, 78
Fatima (daughter of Muhammad), 249, 259, 263
Fatimids, 51, 70, 77, 144, 147, 172, 174, 194, 197, 224, 226, 230, 237, 243, 256, 259, 262, 263, 268, 275, 276, 289n45
Fayyum, 69, 135, 166, 171, 184, 185, 188, 235
Fayyum shawl fragments (cat. no. 125), *163*, **184–85**, *185*
Fayyumi-Sahidic dialect of Coptic, 183
females. *See* women
figurines
brazier with female figurines found at al-Fudayn (cat. no. 143), 181, **212–13**, *213*
carved and painted bone figurines of women (cat. no. 135), *194*, **194–95**
crotales, woman playing (cat. no. 137), *195*, **195–96**
crouching hare (cat. no. 118), and comparative pieces, 172, **174**, *174*
incised bone figurines of women (cat. no. 134), *193*, **193–94**, 194
Venus/Aphrodite, 193n2
Fihl (Pella), 215, 219
First Cyprus Treasure, 17
First Gaster Bible (cat. no. 74), **112–13**, *113*
First Saint Petersburg Pentateuch (cat. no. 75), 102, **113–14**, *114*, 266, 272
fishing scenes and Neptune, ladle with (cat. no. 11), 8, **20–21**, *21*, 193
flasks
continuity of Islamic with Byzantine and Roman work, 206
with dancers (cat. no. 139), 175, 176, 192, **196–97**, *197*
glass flask with green cameo decoration (cat. no. 116), **173**, *173*, 206
luster-painted (cat. no. 155), 20, 176, 206, 224, **224–25**
with Nereids (cat. no. 12), 8, *21*, **21–22**, 193
with Saint Menas, *87*
See also ampullae
Flavia Christodote, 284n31
Flavius Apion, 284n
Flavius Eustathius, 284n31
Flavius Strategius III, 284n30
floor mat, inscribed (cat. no. 185), 237, *263*, **263–64**
fly whisk or mat fan, textile fragment with confonted animals from (cat. no. 172A), **236**, *237*
Focas (Phokas; emperor), 5, 138, 143
footed bowl with relief decoration and green glaze (cat. no. 157), *225*, **225–26**

marginalia, 53, 80

Mark the Evangelist, Saint, 7, 37, *44*, **44–49**, *45–47*, 49, 67, 69, *70*

marriage ring, octagonal (cat. no. 56), 7, 54, **89–90**, *90*

Martha (mother of Saint Symeon Stylites the Younger), 98

Martina (wife and niece of Emperor Heraclius), 15

Martyrios (in receipt for garments), 165

Marwan ibn al-Hakam (Marwan I, caliph), 238, 289n26

Marwan ibn Muhammad (Marwan II, caliph), 235, 238

Marwan ewer (cat. no. 171), 172, 181, 207, 224, **235–36**, *236*

Marwan *tiraz* fragments (cat. no. 173), 237, *238*, **238–41**, *239*

Mashhad, 276n6

mashq, 274, 277

Maslama ibn 'Abd al-Malik (general), 224, 255

Massacre of the Innocents, 67

Massuh, church at, 284n9

Massuot Yitzhak, chancel screen with crosses from, 103, *105*

mat fan or fly whisk, textile fragment with confronted animals from (cat. no. 172A), **236**, *237*

materia medica, 23–25

Matrona (benefactor), 100, 101

Maurice Tiberios (emperor), 17, 193n4

Maximian, cathedra of, Ravenna, 49, 229

Maximos the Confessor, 37

Maximou (Amazon), 156

Mecca, 202, 203, 210, 221, 244–45, 247, 249, 250, 251, 258, 262, 265

medical recipe, ostrakon with (cat. no. 15B), 9, **26**, *26*

Medina (Yathrib), 50, 203, 214, 221, 245, 250, 251

Medina, Mosque of the Prophet at, *249*, 251, 252, 253, 255, 290n58

Meleager and Atalanta, plate with (cat. no. 8), **19**, *19*, 193

Meletios (medical writer), 23

Melkite Church, 38, 62, 66, 121

melote, 78

Memphis and Alexandria, floor mosaic depicting (cat. no. 1), Church of Saints Peter and Paul, Gerasa (Jerash), 8, 9, **12**, *12*

Mena the monk, with keys, *79*

Menander's *Sentences*, ostrakon with (cat. no. 15A), 9, 19, **25–26**, *26*

Menas, Saint, *48*, 49, 80, *87*, 87–88, 282n27, 282n35

menorahs, 102, 103, *104*, *105*, *106*, *107*, *108*, 109–12, *110*, *111*, *116*

Menouthis, 86

Mersin necklace with pendants, 190–91

Miaphysites, 37, 43, 56, 60, 69, 72, 137, 204, 212, 284n30, 286n82, 289n3, 290n61

Michael I (patriarch of Alexandria), 87

Michael VII (emperor), 93n1

Michal (daughter of Saul, wife of David), 16

mihrab (prayer niche), 34, 104, 114, 116, *212*, 213, 229, 233, 249, 251–52, *254*, 256, 258, 259, 262–63, *263*, 266, 271n7, 275, 284n11

portable (cat. no. 184), **262–63**, *263*

Mildenhall Treasure, 19

milestones, 237, 290n2

military saints, 43–44, 86

minbar (pulpit), 228, 230, 251

Miracle of the Loaves and Fishes relief, Bawit (cat. no. 51C), 8, 10, 76, *83*, **83–84**

mi'raj (Ascension of Muhammad), 249

Misr al-Fustat. *See* Fustat

mithqal and *mithqual*-dinar, 144, 146, 147

Mithra, 28n3

molded Kufic inscription, dish with (cat. no. 175), 186, 205, 237, **242**, *242*

monastic dress or habit, 71, 78

monasticism, 50–51, 58n6, 69, 75–77, 81–82, 204–5

See also specific monasteries

Monoenergism and Monotheletism, 14, 37, 60, 281n25

Monophysitism, 281n6

months, personifications of, 166, 167n1–3

mordants, 240

mosaics, 98–100, 117, 132, 207–8, 252

See also specific locations

Moses of Nisibis, 68

mosques, 245, 250–55, 266

See also specific structures

Mount Athos, 51

Mount Gerizim, 102, *105*

Mount Nebo mosaics, 13, 98, *99*, 112n13, 289n52

Mount Sinai. *See* Sinai, Monastery of Saint Catherine at

"Mourners of Zion" *(Aveilei Zion)*, 105

El-Moussat church, 112n12

Mshatta palace. *See* Qasr al-Mshatta

al-Mu'alla bin Tarif, 43

al-Mu'allaqa lintel (cat. no. 42), 37, *70–71*, **71–72**, 195, 286n87

Mu'awiya (caliph), 6, 136, 140, 200, 246, 247, 291n15

Muhammad (Prophet), 15, 50, 71, 117, 137, 139, 142, 202, 221, 244–45, 248, 251, 259, 260, 263, 281n43, 286n96, 290n31

Achtiname (Testament) of Muhammad (cat. no. 37), 10, 51, **63–64**, *64*

Gabriel (Archangel), revelations from, 244, 265

isra' (Night Journey) of, 249

mi'raj (Ascension) of, 249

tomb of, *249*, 250

Muhammad ibn Bashir al-Khariji, 242n1

Muhammad ibn Shurahbil, 146

al-Mu'izz (caliph), 262

mummies, *129*, *130*, 164, 183

al-Mundir (Alamoundaros), 205

al-Muqaddasi (geographer), 44, 248

mushaf, 265

musicians

acrobats and female musicians, relief with (cat. no. 138), 192, **196**, *196*

crotales, statuette of woman playing (cat. no. 137), *195*, **195–96**

nude figure holding musical instrument and vase of flowers, drawing of, 194

oud, wall hanging fragment with female musician playing (cat. no. 140), **197**, *197*

painted floor with musicians and hunter, Qasr al-Hayr al-Gharbi, *204*

women portrayed as, 192

al-Mu'tasim (caliph), 241

al-Mutawakkil 'ala Allah (caliph), 147, 256

al-Muwaqqar, 203, 216, 237

Muziris Papyrus, 285n39–40

mythological motifs, tunic with (cat. no. 110), 131, 160, *169*, **169–70**

Naanah, *110*

Na'aran (Naarah, Noorath, Ayn Duq), synagogue of, *102*, 102–3, *103*, *106*

Nabataeans, 221

Nudhur son of Stafan (potter), 187

Najaf, 250

Naples Dioscorides (cat. no. 14), 9, *10*, 18, **23–25**, *24*

Naqlun, Monastery of Archangel Gabriel at, 69

Naqsh-e Rustam tower monument, 27

Narratio, 58

Nasir-i Khusrau, 249–50, 264n2

Nativity Cycle, Monastery of Bawit, *82*

Nativity scene in polychrome silk weft-faced compound twill, *148*, 152

Nawwar (cooking pot owner), 214

necklaces

Aphrodite Anadyomene, necklace and pendant with (cat. no. 133), **193**, *193*

with lapis and gold beads, coins, and a cross, 193n4

from Mersin, 190–91

with pendants (cat. no. 130), 132, *190*, **190–91**

the Negus (Ethiopian ruler), 289n54

Nemean lion, 154

Neptune and fishing scenes, ladle with (cat. no. 11), 8, **20–21**, *21*, 193

Nereids

flask with (cat. no. 12), 8, *21*, **21–22**, 193

textile fragment with (cat. no. 13), 18, **22**, *22*, 196

Nessana (Nitzana), papyrus fragments from, 87

Nestorian Christians (Church of the East), 7, 60, 66, 281n32

Nestorios (bishop and theologian), 35, 36, 66, 281n23

New Rome. *See* Constantinople

New Style Kufic, 269

Nicaea, Council of, 32, 35, 36, 66

niello image of Virgin and Child, 93

Night Journey (isra') of Muhammad, 249

Nikephoros (patriarch of Constantinople), 286n82

Niketas, 14

Nikolaos Sabbatios, 57, 58n5

Nikopolis, altered mosaic depicting (cat. no. 79A), 8, 10, 12, 39, 117, **118**, *119*

Nilotic motifs, 8, 14, 32, 99, 172, 208

wood architectural relief with (cat. no. 136), **195**, *195*

Nineveh, battle of, 27

Nishapur, 206, 225

Nisibis, 37, 66

Nitzana (Nessana), papyrus fragments from, 87

noble equestrians, silks with (cat. no. 103A–C), **154–55**, *156*, **157**, *157*

Nonnos of Panopolis, 18

Noorath (Na'aran, Naarah, Ayn Duq), synagogue of, *102*, 102–3, *103*, *106*

Obed (archdeacon), 101

octagonal marriage ring (cat. no. 56), 7, 54, **89–90**, *90*

Odysseus, 21

oil lamps. *See* lamps

Oman, 214

On the Divine Images (John of Damascus), 38, 60

On the Nature of Man (Meletios), 23

On Watchfulness and Holiness (Hesychios the Priest), 51

opus sectile, 175

orant position, 43, *48*, 70, 70–71, 74, 88

orbiculi. *See* roundels

order for veils or handkerchiefs (cat. no. 107), **166**, *166*

Origen, 107

ornamental motifs in Islamic art, 223–24

Orthodox Church of Constantinople, 4, 8, 10, 11

ostraka

medical recipe, ostrakon with (cat. no. 15B), 9, **26**, *26*

Menander's *Sentences*, ostrakon with (cat. no. 15A), 9, 19, **25–26**, *26*

Persian occupation, letter referring to (cat. no. 16), **27**, *27*

textile production, ostraka referring to (cat. no. 104), **164**, *164*

Raqqa, 203, 206, 222n7, 223, 224, 254, 291n99

ratl, 144

Ravenna
cathedra of Maximian, 49, 229
Galla Placidia, Saint Lawrence mosaic from
Mausoleum of, 41n4
Orthodox baptistry of Bishop Neon, mosaic dome of,
132, *133*
palace mosaics from, 8
San Vitale mosaics, 59, 189, 208

Razatis (Roch Vehan; Persian general), 17

receipt for garments (cat. no. 106), **165–66**, *166*

Red Monastery, Sohag. *See under* Sohag, White Monastery
Federation at

relics, 282n27

reliquaries
with images of Virgin, 93n4
miniature gold reliquaries and reliquary pendants with
images of Virgin, 93n4
True Cross (cat. no. 54), 7, *87*, *88*, **88–89**, 126

Revelation, liturgical fans depicting beasts of, *73*, 73–74

rhipidia (liturgical fans)
Brooklyn Museum fans (cat. no. 44), **72–74**, *73*
Coptic Museum fan, Cairo, *73*, 74

ribat, 166

riding coat, Persian-style (cat. no. 114), 9, 131, 132, 171,
171, *171*, 221

rinceaux work. *See* vine rinceaux

ring weight (cat. no. 96), *146*, **146–47**

rings
early Islamic, 288n7
with image of Virgin and Child, 93
octagonal marriage ring (cat. no. 56), 7, 54, **89–90**,
90

riyat, 166

Roderick (king of the Visigoths), 289n54

Roman History (Herodian), 27

Roman roads, 203

Romano of Antioch, 68n1

Romanos I Lekapenos (emperor), 58, 126

Romanos, Apa (Egyptian monk), 135

Romans, Epistle of Paul to (cat. no. 36), **63**, *63*

Rome, 69, 102, 124, 192, 208

rope decoration, jug with, from Umm al-Walid (cat.
no. 151A), 206, **219**, *219*

rosette, architectural fragment from Mshatta carved with
(cat. no. 142A), 30n7, 180, 190, **210–11**, *211*, 228

Rossano Gospels, 41n3, 41n5, 275

roundels (orbiculi)
with Alexander the Great, 159n7
with Amazon and bismillah, 132, 148, 156, *159*
with Amazons (cat. nos. 103D–E), **154**, **155–57**, *158*,
159
candelabra tree motif, 132, *148*
embroidered silk medallion with Annunciation and
Visitation scenes, 131, 148, 286n88
emperor, probably Heraclius (cat. no. 5), *15*, **15–16**
on richly decorated tunic (cat. no. 112), **169–70**, *170*
survival of, 161, 163

Rusafa (Sergiopolis), 34, *37*, 87–88, 90, 203, 205, 248,
282n15, 289n32

Sacra Parallela (cat. no. 80), 53, **118–20**, *120*

Sahidic dialect of Coptic, 80

Sa'id al-Fudayni, 213

Sa'id ibn Khalid ibn 'Amr ibn 'Uthman, 212

Saint Apollo, Monastery of, Bawit. *See* Bawit, Monastery
of

Saint Barbara (formerly Abu Qir and Yuhanna), Church
of, Cairo, 34, 180

Saint Calais, Church of, 287n110

Saint Catherine, Monastery of, Sinai. *See* Sinai,
Monastery of Saint Catherine at

Saint George, Church of, Antioch, 67, 68n1

Saint George, Church of, Madaba, 5, 12

Saint George, Church of, Thessaloniki, 288n4

Saint Jeremiah, Monastery of, Saqqara, 55, 57, 70, 81, 84

Saint John, Monastery of, Beth Zagba, 67

Saint John the Baptist, Basilica of, Damascus, 34, 38,
251

Saint John the Baptist, Church of, Gerasa (Jerash), 12

Saint-Lupicin panel, 45

Saint Mary Deipara, Syrian Convent of, 68

Saints Peter and Paul, Church of, Gerasa (Jerash), *11*, **12**

Saint Polyeuktos, Church of, Constantinople, *175*

Saint Sergios, Basilica of, Rusafa. *See* Rusafa

Saint Stephen, mosaics of Church of, Umm al-Rasas,
32–33, *34*, 39, 99, 100, 118, 284n9

Salaman (deacon and church steward), 101

Salerno ivories, 49

Salome, Dance of, 196

Samaritan Hebrew and Aramaic, 102

Samaritans, 15, 32, 102, 103, 104, *105*, 107, 109–10, 283n7

Samarra, 173, 197, 205, 208, 210, 224, 231–33, 235, 256–57,
261, 291n99

Samson and the Lion, silks with (cat. no. 102), 9, *122*, *153*,
153–54, *154*

San Vitale mosaics, Ravenna, 59, 189, 208

Sana'a
cathedral of (al-Qalis), 7, 252
Great Mosque of, 251, 266, 268
Umayyad Qur'an found at, 214, 253, 266–67, *267*, 269,
271n6–7, 272, 273n2

sandwich glass, 206, 226

Santa Costanza, mausoleum of, Rome, 181n3

Saqqara, Monastery of Saint Jeremiah in, 55, 57, 70, 81,
84

sarcophagi, 19, 22, 96, 181n3, 197n5, 228n1

Sasanian Persians, 4, 5, 11, 14, 15, 20, 27–32, 66, 103, 125,
138, 141, 142, 149, 172, 175–76, 189, 192, 200–202,
204, 206–9, 218, 220, 221, 225, 228, 233, 235, 244,
245, 256, 259

satyrs, 19, 175, 207, 213

Saul (biblical king), 16, 18

Sayf al-Dawlah (Hamdanid prince), 286n96

Scetis, 70

Scheherazade, 192

science, Byzantine and Islamic, 23–25

scorpion talisman, Hims, 250, 290n41, 290n67

screens. *See* "chancel" screens in synagogues and
churches

Scythopolis (Beth Shean) Samaritan synagogue, 103,
105

seals, *9*, 93, 124–25, 128

Sebastopolis, 246

secco paintings, Red Monastery Church, Sohag, 69, 70,
76–77, *77*, *78*, 81

Second Coming of Christ, 71

Second Cyprus Treasure, 17

Seetzen, Ulrich Jasper, 11

Seleucia, 29

Selim I (sultan), 64

Sem'ān Daği (the Wondrous Mountain), 94–95, 96, 97,
282n15, 283n14–18

senmurw, 210.209

Sentences (Menander), 25–26

Sepphoris, synagogue at, 112n11

Septimius Severus (emperor), 14, 209

Sergiopolis. *See* Rusafa

Sergios and Bakchos, Saints, 43–44, 69, 74, 87–88, 90, 205,
248, 282n15

Sergios I (patriarch of Constantinople), 5, 37

Sergios II of Madaba (bishop), 33

serta, 69

Severos (patriarch of Antioch), 27n4, 37, 43, 66

Sevso Treasure, 19n1

Shahba mosaics, 21, 22

Shalabim, Samaritan synagogue at, 102, *105*

Shapur I (Sasanian Persian ruler), 27, 31n3

shawls
Coptic inscription, textile fragment with (cat.
no. 124A), 163, **183–84**, *184*, 185
Fayyum shawl fragments (cat. no. 125), *163*, **184–85**,
185
Tutun shawls, 183, 185

Shenoute (leader of White Monastery Federation,
Sohag), 71, 75, 76, **78**, *78*, 87, 282n25

Shi'ites, 246, 256, 259, 263

shofarim, 107, 110, 111

Silenus, 9, *19*, **19–20**, *20*, 30

silk
Islamic prohibition on wearing of, 190
as precious material, 124, 128–33, 148, 285–86n74,
285n51–52, 285n72
See also specific objects

Silk Road, 128, 206

silver, as precious material, 124

silver relief with stylite iconography, 95

Sinai, Monastery of Saint Catherine at, *38*, *50*, 50–51
bird-shaped vessel from (cat. no. 38), **64–66**, *65*, 172,
181, 207, 235, 237
icons, *53–58*, **53–58**, 127, 128, 281n2
manuscripts, 59, **59–64**, *61–64*, 121, **134**, *134*
pilgrimage to, 50, 51, 87

Sisinnios, Saint, mural painting of, Bawit, 160, *161*

six kings fresco, Quasayr 'Amra, *207*, 208

Slavs, 4, 125, 285n64

sleeve fragment with animal motif band (cat. no. 115B),
161, *162*, **172–73**, *173*

Sohag, White Monastery Federation at, 75–77
censer with scenes from life of Christ (cat. no. 48), 8,
79, *79*
coin hoard from, 75
Isaiah manuscript folios (cat. no. 49), 8, 69, 77, **79–80**,
80
key (cat. no. 47), 8, **79**, *79*
pilgrimage processions at, 87, 282n25
Red Monastery, 15, 18, 34, *36*, 69, *70*, 71, 75–76, *75–77*,
78, 78n4, 79, 80, *81*, 281n7
White Monastery, 15, 18, 69, *75*, 75–77, 79, 281n7

Solomon Levi ben Buya'a, 114

Sophronios (patriarch of Jerusalem), 86

Soterochus (bishop of Caesarea), 27n4

Sousse (Hadrumentum, Justinianipolis), 5

The Spiritual Meadow (John Moschus), 51

spolia, 205, 250

standing caliph motif
on glass hexagonal pilgrim jug (cat. no. 186), **264**,
264
statue, Khirbat al-Mafjar, 205, 208

star, eight-pointed, textile fragment with inhabited vine
in (cat. no. 119B), 161, 175, **176–77**, *177*, 257

Star of David, 116

statuettes. *See* figurines

Photograph Credits

Amman, www.billlyons.com / Courtesy of the Department of Antiquities, Amman: image p. 198, cat. nos. 79, 92, 97, 100, 126D–G, 127, 129, 141–151, 153, figs. 78, 81, 82, 90–93

Ann Arbor, Michigan, Kelsey Museum of Archaeology, University of Michigan: fig. 60; Papyrus Collection, University of Michigan Library: cat. nos. 83, 106, 107

Antwerp, © Chris Verhecken-Lammens and Antoon De Vylder: fig. 69

Athens, Benaki Museum: cat. nos. 17, 123A, 125A, 140, 176; Photograph: Leonidas Kourgiantakis / Courtesy of the Benaki Museum: cat. no. 135B; Photograph: Stefanos Samios / Courtesy of the Benaki Museum: cat nos. 132, 161B, 162, 184; Photograph: Makis Skadaressis / Courtesy of the Benaki Museum: cat. no. 160; Photograph: Vasilios Tsonis / Courtesy of the Benaki Museum: frontispiece, cat. nos. 93, 99D, 117, 121A, 121C–G, 124A, 159, 164, 165, 170, 172A, 179, 180, 185, 187

Berlin, © 2008 Antje Voigt-SMB-Museum für Byzantinsche Kunst: cat. no. 114; © 2011 Antje Voigt-SMB-Museum für Byzantinsche Kunst: cat. nos. 46, 63, 65A, 120A, 139; © DAI, Orient-Abteilung / photograph: Peter Grunwald: fig. 104

Brooklyn, New York, www.BibleLandPictures.com / Alamy: figs. 10, 15, 44; dbimages / Alamy: fig. 100; mauritius images GmbH / Alamy: fig. 41; Geoffrey Morgan / Alamy: fig. 39; B. O'Kane / Alamy: fig. 101; Brooklyn Museum: cat. nos. 44, 73, 108, 110, 191A, 192B

Cairo, Photograph: E. Bolman / © American Research Center in Egypt (ARCE): figs. 28, 30; Photograph: Patrick Godeau / © American Research Center in Egypt (ARCE): fig. 13; Photograph: Arnaldo Vescovo / © American Research Center in Egypt (ARCE): figs. 22, 23, 27, 29, 32; From *The Treasures of Coptic Art in the Coptic Museum and Churches of Cairo*, edited by Gawdat Gabra and Marianne Eaton-Krauss / © 2007 by the American University in Cairo Press: cat. nos. 42, 47, 53, 138; From *The Treasures of Islamic Art in the Museums of Cairo*, edited by Bernard O'Kane / © 2006 by the American University in Cairo Press: cat. nos. 118, 163, 167, 178; Photograph: E. Bolman: fig. 25; Courtesy of the National Library & Archives of Egypt (Dar al-Kutub): fig. 99; Drawing by Nicholas Warner: fig. 26

Caldwell, New Jersey, Photograph: Bruce White / Image © The Metropolitan Museum of Art: fig. 16

Cambridge, Massachusetts, Photograph: Anna-Marie Kellen, The Photograph Studio, The Metropolitan Museum of Art / Courtesy of the Foss Collection, Cambridge: cat. no. 88C

Cambridge, United Kingdom, © University of Cambridge / Courtesy of the Syndics of Cambridge University Library: cat. nos. 68, 78

Copenhagen, The David Collection: back jacket / cover illustration, cat. nos. 121B, 155, 156, 166, 175, 181, 188, 191B

Corning, New York, The Corning Museum of Glass: cat. no. 174

Crawley, Australia, Aerial Photographic Archive for Archaeology in the Middle East (APAAME), archive accessible from http://www.flickr.com/photos/apamme/collections / photograph: Robert Bewley: fig. 89 (APAAME_20070419_RHB-0186.tif); Aerial Photographic Archive for Archaeology in the Middle East (APAAME), archive accessible from http://www.flickr.com/photos/apamme/collections /

photograph: Isabelle Rueben: figs. 80 ((APAAME_20080909_IAR-0092.dng), 83 (APAAME_20080908_IAR-0065.dng)

Damascus, Photograph: John Wreford / Courtesy of Finbarr B. Flood: figs. 102, 103

Florence, Biblioteca Medicea Laurenziana / Courtesy of the Ministero per i Beni e Attività Culturali – Italia: cat. no. 39, fig. 21 (cat. no. 39)

Jerusalem, Photograph: Ardon Bar-Hama / Courtesy of the Deutsches Evangelisches Institut für Altertumswissenschaft des Heiligen Landes: cat. no. 69; École Biblique: figs. 42, 43; Courtesy of the Israel Antiquities Authority, figs. 45–48, 85, 97; Zev Radovan / www.BibleLandPictures.com: figs. 49–51

London, Philippe Maillard / akg-images: cat. nos. 48, 135A; © The British Library Board: cat. nos. 21A, 40, 74, 77, 81; © The Trustees of the British Museum: cat. nos. 24J, 58, 62B, 103B, 116, 123B, 135C, 158, fig. 65; © Nour Foundation / Courtesy of the Khalili Family Trust: fig. 109; © V&A Images / Victoria and Albert Museum, London: cat. nos. 5, 24A, 24I, 103F, 103G, 120B, fig. 59

London, Brooklyn, Manchester, and Brussels, © V&A Images / Victoria and Albert Museum; Brooklyn Museum; The Whitworth Art Gallery, The University of Manchester; Musées Royaux d'Art et d'Histoire: cat. no. 173A–C; fig. 94

Milan, Castello Sforzesco, Civiche Raccolte d'Arte Applicata: front jacket / cover illustration, cat. nos. 24B–F, 24H, 24L, 24M

Mount Nebo, Jordan, Courtesy of the Franciscan Archaeological Institute-Mount Nebo, Custody of the Holy Land: cat. nos. 66A, 67

Mount Nebo and Amman, Jordan, Courtesy of the Franciscan Archaeological Institute-Mount Nebo, Custody of the Holy Land, and the American Center of Oriental Research, Amman: figs. 1, 11, 12, 40

Naples, Biblioteca Nazionale "Vittorio Emanuele III" Napoli / Courtesy of the Ministero per i Beni e Attività Culturali – Italia: cat. nos. 4, 14, fig. 7 (cat. no. 14)

Newcastle upon Tyne, United Kingdom, Photograph: Gertrude Bell / Courtesy of the Gertrude Bell Archive, Newcastle University: fig. 79

New Haven, Connecticut, Yale University Art Gallery: cat. nos. 62C, 126A–C; Yale University Art Gallery / Photograph courtesy of Christopher Gardner: cat. no. 1; Yale University Art Gallery, Gerasa Collection: figs. 4, 8, 9

Newark, New Jersey, The Newark Museum: cat. no. 52A

Newark, New Jersey, Auch, Bawit, and Paris, Reproduced from Sotheby Parke-Bernet, Inc. (New York), Sale Number 4497Y, December 11, 1980, lot 312 / Wolfgang Kurth and Maggie Nimkin, Sotheby's Photography Department; D. Bénazeth; G. Poncet: fig. 35

New York, Courtesy of the American Numismatic Society: cat. nos. 86B, 88D, 89C, 91B, fig. 63 (cat. no. 89A); bpk, Berlin / Museum für Islamische Kunst, Staatliche Museen zu Berlin - SPK / Art Resource, NY: fig. 106; bpk, Berlin / Skulpturensammlung und Museum für Byzantinische Kunst, Staatliche Museen zu Berlin - SPK / Juergen Liepe / Art Resource, NY: cat. no. 120C; bpk, Berlin / Museum für Islamische Kunst, Staatliche Museen zu Berlin - SPK / Georg Niedermeiser / Art Resource, NY: cat. no. 154;

Digital Image © [2011] Museum Associates / LACMA. Licensed by Art Resource, NY: cat. nos. 157, 192A; Erich Lessing / Art Resource, NY: fig. 5, 24K; Newark Museum / Art Resource, NY: fig. 56; Daniel Arnaudet, Réunion des Musées Nationaux / Art Resource, NY: cat. no. 128; Jean-Gilles Berizzi, Réunion des Musées Nationaux / Art Resource, NY: image p. 122, cat. nos. 23, 102B, 103D; Les frères Chuzeville, Réunion des Musées Nationaux / Art Resource, NY: cat. no. 122C; Hervé Lewandowski, Réunion des Musées Nationaux / Art Resource, NY: cat. no. 137; Thierry Ollivier, Réunion des Musées Nationaux / Art Resource, NY: cat. no. 24N; Franck Raux, Réunion des Musées Nationaux / Art Resource, NY: cat. nos. 70, 71; Scala / Art Resource, NY: figs. 58, 61, 84, 87, 95; Vanni / Art Resource, NY: fig. 2, 107; Photograph: Finbarr B. Flood: fig. 108; © Georg Gerster / Photo Researchers, Inc.: fig. 105

Oxford, Ashmolean Museum, University of Oxford: cat. nos. 89B, 186

Paris, Bibliothèque Nationale de France: cat. nos. 21B, 49, 80, 190, 193, fig. 111 (cat. no. 190); Photograph: Jean Clédat / Courtesy Centre Millet (EPHE): fig. 33; Photograph: J.-L. Bovot. Fouilles Louvre-Ifao: fig. 34; Photograph: Jacques Mercier: fig. 113; © 2009 Musée du Louvre / Georges Poncet: cat. nos. 2, 52B; Photograph: Jean Clédat / Courtesy of the Musée du Louvre: fig. 31

Philadelphia, Courtesy of the Penn Museum, images #195101 and 195102: cat. no. 88B

Rome, © Andrea Jemolo: fig. 77; © Sandro Vannini: cat. nos. 171, 177, 182

Saint Petersburg, Photograph © Andrei Terebenin, Vladimir Terebenin / Courtesy of the National Library of Russia, Saint Petersburg: cat. nos. 75, 76, 189; Photograph © The State Hermitage Museum / Vladimir Terebenin, Leonard Kheifets, Yuri Molodkovets, Alexander Koksharov: cat. nos. 7–9, 11–13, 43, 61, 103C, 169

San Francisco, © 1992 Said Nuseibeh, www.studiosaid.com: figs. 96, 98

Saarbruecken, Germany, © Dr. Hans-Caspar Graf van Bothmer: fig. 110

Sinai, Egypt, Father Daniel, Holy Monastery of Saint Catherine: fig. 18; Holy Monastery of Saint Catherine: hardcover case illustration, cat. nos. 25, 26–38, 82, figs. 17 (cat. no. 34), 19, 20, 55, 112 (cat. no. 34)

Thessaloniki, Greece, Tsolozidis Collection: cat. nos. 64B, 65B

Tbilisi, Photograph: Daniel Kershaw, The Metropolitan Museum of Art / Courtesy of the Georgian National Museum, Tbilisi: cat. no. 152

Toronto, Toni Hafkenscheid: cat. nos. 64A, 122B

Ürümqi, China, Courtesy of the Cultural Heritage Bureau of Xinjiang Uygur Autonomous Region: fig. 57

Vatican City, Photo Vatican Museums: cat. no. 101, fig. 66

Vienna, ÖNB/Wien: cat. nos. 98, 105A

Washington, D.C., Dumbarton Oaks, Byzantine Collection: cat. nos. 24G, 41, 55, 56, 59, 84, 85, 87, 88A, 89D, 89E, 90, 91C, 102A, 103A, 109, 131B, 133, 183, fig. 64 (cat. no. 91A)

Winchester, United Kingdom, Photograph © Dr. John Crook: fig. 36